ART ACROSS TIME

ART ACROSS TIME

THIRD EDITION

Volume I

Prehistory to the Fourteenth Century

LAURIE SCHNEIDER ADAMS

John Jay College City University of New York

Boston Burr Ridge, IL Dubuque, IA Madison, WI New York San Francisco St. Louis Bangkok Bogotá Caracas Kuala Lumpur Lisbon London Madrid Mexico City Milan Montreal New Delhi Santiago Seoul Singapore Sydney Taipei Toronto

To the Memory of Howard McP. Davis and Rudolf Wittkower

The McGraw-Hill Companies

Published by McGraw-Hill, an imprint of The McGraw-Hill Companies, Inc., 1221 Avenue of the Americas, New York, NY 10020. Copyright © 2007, 2002, 1999, by Laurie Schneider Adams. All rights reserved. No part of this publication may be reproduced or distributed in any form or by any means, or stored in a database or retrieval system, without the prior written consent of The McGraw-Hill Companies, Inc., including, but not limited to, in any network or other electronic storage or transmission, or broadcast for distance learning.

This book is printed on acid-free paper.

1234567890 DOW/DOW 09876

ISBN-13: 978-0-07-296972-6 ISBN-10: 0-07-296972-5

Editor in Chief: Emily Barrosse Publisher: Lisa Moore Marketing Manager: Sharon Loeb Developmental Editor: Julia Moore Project Managers: April Wells-Hayes and Christina Gimlin Manuscript Editor: Carol Flechner Lavout: Roberta Flechner Art Director: Jeanne Schreiber Text Designers: Linda Robertson and Jeanne Schreiber Cover Designer: Linda Robertson Art Editors: Robin Mouat and April Wells-Hayes Illustrators: Patti Isaacs and John McKenna Photo Research Coordinator: Alexandra Ambrose Photo Research: Robin Sand Production Supervisor: Randy Hurst Composition: 9/11.5 Versailles by Prographics Printing: Pantone 195c, 70# Focus Gloss by RR Donnelley Willard

Cover art: Front: Diana, fresco from bedroom of a villa in Stabia, ca. 50 BCE. Museo Archeologico Nazionale, Naples, Italy. Photo: Scala/Art Resource, NY. Back: Buddhist or Shinto guardian figure, Kamakura period. Private collection. Photo: Art Resource, NY.

Credits: The credits section for this book begins on page C-1 and is considered an extension of the copyright page.

Library of Congress Cataloging-in-Publication Data
Adams, Laurie.
Art across Time / Laurie Schneider Adams. — 3rd ed.
p. cm.
Includes bibliographical references and index.
ISBN 0-07-296525-8 (alk. paper)
1. Art — History. I. Title.

N5300.A3 2006 709—dc22

2005058443

The Internet addresses listed in the text were accurate at the time of publication. The inclusion of a Web site does not indicate an endorsement by the authors or McGraw-Hill, and McGraw-Hill does not guarantee the accuracy of the information presented at these sites.

www.mhhe.com

Contents in Brief

Maps xiii

Preface xiv Introduction: Why Do We Study the History of Art? 1

- Part I
 - 1. The Art of Prehistory 28
 - 2. The Ancient Near East 51
 - 3. Ancient Egypt 81
 - 4. The Aegean 117

Part II

- 5. The Art of Ancient Greece 136
- 6. The Art of the Etruscans 189
- 7. Ancient Rome 209
- 8. Early Christian and Byzantine Art 266

Part III

- 9. The Early Middle Ages 318
- 10. Romanesque Art 365
- **11.** Gothic Art 394
- 12. Precursors of the Renaissance 449

v

Notes N-1 Glossary G-1 Suggestions for Further Reading R-1 Acknowledgments C-1 Photo Credits C-2 Index I-1

Contents

Maps xiii

Preface xiv

Introduction: Why Do We Study the History of Art? 1

The Western Tradition 1

The Artistic Impulse 2 Chronology 2

Why Is Art Valued? 4 Material Value 4 Intrinsic Value 4 Religious Value 4 Nationalistic Value 4 Brancusi's Bird: Manufactured Metal or a Work of Art? 5 Psychological Value 6

Art and Illusion 6 Images and Words 7 Artists and Gods 7

Art and Identification 9 Reflections and Shadows: Legends of How Art Began 9 Image Magic 9 Architecture 11

Why Do We Collect Art? 12

Archaeology and Art History 13

How Do We Approach Art? 13 The Methodologies of Art 13 *The Archaeological Dig* 14

How Do We Talk about Art? 18 Composition 18 Plane 18 Balance 18 Line 19 Shape 20 Light and Color 21 Texture 23

StylisticTerminology 24

PART ONE

The Art of Prehistory 28

The Stone Age in Western Europe 28

Upper Paleolithic (c. 50,000/45,000–c. 8000 в.с.) 28 Upper Paleolithic Sculpture (c. 25,000 в.с.) 29 Carving 30 Categories of Sculpture 30 Pigment 30 Modeling 31 Upper Paleolithic Painting in Spain and France (c. 30,000–c. 10,000 в.с.) 32 Shamanism 35 METHODS OF INTERPRETATION Dating and Meaning of the Cave Paintings 39

Window on the World One: Rock Paintings of Australia (c. 75,000/50,000 B.c.-the present) 41

Mesolithic (c. 8000–c. 6000/4000 в.с.) 44

Neolithic (c. 6000/4000 B.C.–c. 2000 B.C.) 44 Malta 45 Northern Europe 46 *The Celts 48 Post-and-Lintel Construction 48*

2 The Ancient Near East 51

The Neolithic Era 51 Chronology of the Ancient Near East and Principal Sites 52 Jericho 52 Catal Hüyük 52

Mesopotamia 54 Mesopotamian Religion 55 The Uruk Period (c. 3500–3100 в.с.) 55 Inanna 56 Ziggurats 56 Cylinder Seals 58

From Pictures to Words 58 Gilgamesh 59

Sumer: Early Dynastic Period (c. 2800–2300 в.с.) 59 Tell Asmar 59 Ur 60

Akkad (c. 2300–2100 в.с.) 62 Sargon of Akkad 62

Neo-Sumerian Culture (c. 2100–1900/1800 в.с.) 64 Lagash 64 The Ziggurat of Ur 66

Ancient Egypt 81

The Gift of the Nile 81 Hymn to Hapy 81

Religion 82

The Pharaohs82Egyptian Gods83

The Egyptian Concept of Kingship 84 Chronology of Egyptian Kings 84 The Palette of Narmer 84 Royal Names: Serekhs and Cartouches 86

Writing and History 86

The Egyptian View of Death and the Afterlife 87 Mummification 88 Funerary Texts 89

The Old Kingdom (c. 2649–2150 в.с.) 90 Pyramids 90 Babylon (c. 1900–539 в.с.) 67 The Law Code of Hammurabi 67

Anatolia: The Hittites (c. 1450–1200 B.C.) 68

Assyria (с. 1300–612 в.с.) 69 Assyrian Kings 69

The Neo-Babylonian Empire (612–539 в.с.) 73 Round Arches 73 Glazing 74

Iran (c. 5000–331 B.C.) 74

The Scythians

(8th–4th centuries B.C.) 74 Destroying the Archaeological Record 75 Recent Discoveries: The Filippovka Cemetery 76

Achaemenid Persia (539–331 в.с.) 77 Columns 79

The Egyptian System of Proportion 94 Sculpture 94 *METHODS OF INTERPRETATION Menkaure and Khamerernebty, an Old Kingdom Pharaoh and His Queen: Formalism, Iconography, Feminism, Context 96 Papyrus Manuscripts 98*

The Middle Kingdom (c. 1991–1700 B.C.) 98

The New Kingdom (c. 1550–1070 в.с.) 100 Temples 100 Painting 105 The Amarna Period (c. 1349–1336 в.с.) 106 Tutankhamon's Tomb 108

Egypt and Nubia 109 Early Kush 110 Reconquest 110 The "Fifty" Sons of Ramses II: A Recent Archaeological Find 112

117

The Napatan Period 113 Meroë 113

4 The Aegean

Cycladic Civilization (c. 3000–11th century B.C.) 117

Minoan Civilization

(c. 3000–c. 1100 B.C.) 119 The Palace at Knossos 119 *Minoan Fresco* 120 Minoan Religion 122 *Minoan Scripts* 123 Pottery 123 Recent Discoveries at Thera 124 The Frescoes 124

Mycenaean Civilization (c. 1600–1100 в.с.) 127 The Legend of Agamemnon 128 Cyclopaean Masonry 130

PART TWO

5 The Art of Ancient Greece 136

Cultural Identity 136

Government and Philosophy 136 Delphi 138

Literature and Drama 139 Women in Ancient Greece 140 Plato on Artists 140 Socrates: "Know Thyself" 141

"Man Is the Measure of AllThings" 141 Greek Gods and Roman Counterparts 142

Painting and Pottery 143 Geometric Style (c. 1000–700 в.с.) 143 Orientalizing Style (c. 700–600 в.с.) 143 Archaic Style (c. 600–480 в.с.) 145 *Greek Vase Media and Shapes* 145 *Medusa 146* Late Archaic to Classical Style (c. 530–400 в.с.) 146 Classical to Late Classical Style (c. 400–323 в.с.) 148 Mosaic 148

Sculpture 150 Orientalizing Style: The Lions of Delos (7th century B.C.) 150 Archaic Style (c. 600–480 B.C.) 150 Early Classical Style (c. 480–450 B.C.) 152 *The Lost-Wax Process* 154 Classical Style (c. 450–400 B.C.) 158 Polykleitos of Argos 158 *The Canon* 158 Grave Stelae 159

The Development of Greek Architecture and Architectural Sculpture 160 Archaic Style (c. 600–480 B.C.) 160 The Orders of Greek Architecture 162 Early Classical Style (c. 480–450 B.C.) 163 The Labors of Herakles 167 Classical Style (c. 450–400 в.с.) 169 The Parthenon (448–432 B.C.) 170 Plan of the Parthenon 171 Late Classical Style (4th century B.C.) 178 Greek Theater 179 Sculpture 180 Fourth-Century Grave Stelae 182

Hellenistic Sculpture (323–31 в.с.) 182 The Trojan Horse 186 Summary of Greek Styles and Techniques 187

Etruscan Materials 190

Architecture 190 Vitruvius on Architecture 190

Pottery and Sculpture 191

Women in Etruscan Art 193

Funerary Art 194 Cinerary Containers 194 Tombs 195 Sarcophagi 196 Tomb Paintings 198

Window on the World Two: China: Neolithic to First Empire (c. 5000–206 B.C.) 201

Ancient Rome 209

Virgil's Aeneid 210 Chronology of Roman Periods and Corresponding Works of Art and Architecture 211 Ovid 212

Architectural Types 212 Domestic Architecture 212 Roman Building Materials 212 Arches, Domes, and Vaults 213 Pliny the Elder and Pliny the Younger 214 Public Buildings 217 Julius Caesar 217 Suetonius on Nero's Golden House 224 Religious Architecture 226 Sibyls 227 Commemorative Architecture 230 The Dacians 233 Josephus on the Jewish Wars 235

Sculptural Types 236 Sarcophagi 236 Portraits 237 Marcus Aurelius: Emperor and Philosopher 240 Marble in Ancient Rome: Color Symbolism 242

Mural Paintings 243

The Tomb of Emperor Qin: I (late 3rd century B.C.) 201 Precursors: Neolithic to the Bronze Age (c. 5000–221 B.C.) 202 *Major Periods of Early Chinese History 202 Bronze: The Piece-Mold Method 203 Writing: Chinese Characters 204 Chinese Philosophy 205*

The Tomb of Emperor Qin: II (late 3rd century B.C.) 206

Cross-Cultural Trends 250 Faiyum Painting 250 Rome and Carthage 250 *The Punic Gods 252*

Window on the World Three: Developments in South Asia: The Indus Valley Civilization (to the 3rd century A.D.) 254

The Indus Valley Civilization (c. 2700–1750 в.с.) 254

The Vedic Period (c. 1759–322 в.с.) 258

The Upanishads 258

The Early Vedas 258

Buddha and Buddhism 258

Buddhist Architecture and Sculpture 260

The Maurya Period (c. 321–185 B.C.) 260

The Shunga Period (c. 185 B.C.-A.D. 30) 261

The Kushan Period (c. A.D. 78/143–3rd century) 263

Early Christian and Byzantine Art 266

A New Religion 266 Dura Europos 266 Early Developments in Christianity 268 Christianity and the Scriptures 268 Frequently Depicted Scenes from the Life of Jesus 269 The Catacombs 270 Constantine and Christianity 270 Christian Symbolism 271

The Divergence of East and West 271

8

Early Christian Art 271 Sarcophagi 271 Basilicas 272 Saint Peter 273 Mosaic Technique 275

Centrally Planned Buildings 276 Santa Costanza 276 Galla Placidia 277

Justinian and the Byzantine Style 280 San Vitale 280 METHODS OF INTERPRETATION The Mosaics of Justinian and Theodora, Emperor and Empress of the Byzantine Empire: Formalism, Iconography, Feminism, Biography 286

Maximian's Ivory Throne 287 Hagia Sophia 288 Domes, Pendentives, and Squinches 291 The Expansion of Justinian's Patronage 293

The Development of the Codex 294 Parchment 294 The Vienna Genesis 294 Image and Icon 296

Later Byzantine Developments 297 Byzantine Metalwork 302

Window on the World Four: Developments in Buddhist Art (1st–7th centuries A.D.) 305

Rock-Cut Architecture 305

Gupta Sculpture 307

The Ajanta Caves (late 5th century A.D.) 308

Indian Mural Painting 309

Buddhist Expansion in China (2nd–7th centuries A.D.) 312

PART THREE

The Early Middle Ages 318

Islam 319 The Dome of the Rock, Jerusalem 319 Islamic Calligraphy 320 Mosques 321

Northern European Art 327 Anglo-Saxon Metalwork 327 Beowulf 328

The Viking Era (c. 800–1000)328The Scandinavian Cosmos330

The Norse Pantheon 330 Rune Stones and Picture Stones 331

Hiberno-Saxon Art 332 Stone Crosses 333 Manuscript Illumination 333 Manuscript Illumination 333

The Carolingian Period 336 The Palace Chapel 336 Manuscripts 338 Revelation and the Four Symbols of the Evangelists 339 Monasteries 340 Monasticism: Chastity, Obedience, and Poverty 340

The Ottonian Period 342

Window on the World Five: Mesoamerica and the Andes (1500 B.C.-A.D. 1500) 347

Mesoamerica 347

Olmec (flourished c. 1200–900 в.с.) 348

Teotihuacán (flourished c. 350–650)

Мауа (с. 1100 в.с.–А.д. 1500) 351

10 Romanesque Art 365

349

Economic and Political Developments 365 Feudalism 365 The Crusades 366

Pilgrimage Roads 366 The Stavelot Reliquary Triptych 368 Pilgrims, Relics, and the Liber Sancti Jacobi (Book of Saint James) 369 Solomon's Temple and the Holy Sepulcher 370

Architecture 370 Sainte-Foy at Conques 370 Saint-Pierre at Moissac 374

11 Gothic Art 394

The Origins of the Gothic Style in France 394

Early Gothic Architecture: Saint-Denis 395

Elements of Gothic Architecture 396 Ribbed Vaults 396 Piers 397 The Maya Calendar 351 Maya Religion 352 Classic Maya 352 Postclassic Maya: Chichén Itzá (flourished 9th–13th centuries) 355 The Aztec Empire (c. 1300–1525) 356 Art of the Andes 358 Chavín: The Beginning 359 Coastal Cultures and the Cult of Irrigation 360 The Highland Empires of Tiwanaku and Wari 362 The Inka Empire: The End of an Era (c. 1438–1532) 363

Autun 381

The Stave Church of Norway and Stone Interlace 383

The Italian Romanesque Cathedral Complex at Pisa 384

Mural Painting 386

The Bayeux "Tapestry" 387

Romanesque Precursors of Gothic: Caen and Durham 390

Flying Buttresses 397 Pointed Arches 398 Stained-Glass Windows 398

The Age of Cathedrals 398 Chartres 398 *Guilds 399* Workers and Master Builders 400 *Saint Augustine's* City of God 400

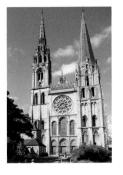

The Exterior Architecture of Chartres 401 The Exterior Sculpture of Chartres 405 *Antichrist 409* The Interior of Chartres 410

Later Developments of the French Gothic Style 412 Amiens 412 Reims 416

Gothic Architecture and Scholasticism 419 Sainte-Chapelle 420

English Gothic 422 Canterbury Cathedral 422 *Thomas à Becket 424 Chaucer's* Canterbury Tales (c. 1387) 425 Salisbury Cathedral 426 King's College Chapel, Cambridge 428 Window on the World Six: Buddhist and Hindu Developments in East Asia and South Asia (6th-13th centuries) 434 Buddhist Paradise Sects 434 The Pagoda 436 The Buddhist Monastery: Horyu-ii 437 Hinduism 439 The Hindu Artist 440 The Hindu Temple 440 The Vishnu Temple (6th century) 441 The Orissan Temple (8th–13th centuries) 443 Synthesis of Buddhism and Hinduism at Angkor 444 Angkor Wat (12th century) 444 Angkor Thom (13th century) 447

The Spread of Gothic 429

12 Precursors of the Renaissance 449

Thirteenth-Century Italy 449 Nicola Pisano 449 Training an Artist 450 Cimabue 452

Fourteenth-Century Italy 452 Giotto 453 Dante's Divine Comedy 454 Tempera: Painstaking Preparation and Delicate Detail 454 The Arena Chapel 454 Altarpieces 455 Fresco: A Medium for Speed and Confidence 457 Virtues and Deadly Sins 457 Giotto's Saint Francis 462 Saint Francis of Assisi (1181/2–1226) 463 Duccio's Maestà 464 The Kiss of Judas 466

Ambrogio Lorenzetti and the
Effects of Good Government468Boccaccio on the Black Death470

The International Gothic Style 471 Simone Martini 471 Claus Sluter 473 The Limbourg Brothers 475

Notes N-1 Glossary G-1 Suggestions for Further Reading R-1 Acknowledgments C-1 Photo Credits C-2 Index I-1

Maps

Prehistoric Europe 32 Australia 41 The Ancient Near East and the Middle East 51 Ancient Egypt and Nubia 82 The Ancient Aegean 117 Ancient Greece and the Eastern Mediterranean 137 Etruscan and Roman Italy 189 Chinese Archaeological Sites 201 The Roman Empire, A.D. 14-284 209 South Asia 254 The Buddhist World 255 The Byzantine Empire under Justinian I, A.D. 565 282 South Asia 305 The Expansion of Islam, 622-c. 750 318 Northern Europe in the Middle Ages 328 The Holy Roman Empire under Charlemagne, 814 336 Mesoamerica in relation to North and South America 347 Mesoamerica 347 The Central Andes 358 Romanesque and Gothic Sites in Western Europe, including Pilgrimage Routes to Santiago de Compostela 367 East Asia 436 Leading Art Centers of the Renaissance in Western Europe 451

Preface

We are bombarded with images from birth and tend to assume that we understand their meaning. But the paradoxical fact is that, although children read pictures before words, a picture is more complex than a word—hence the proverbial "a picture is worth a thousand words." One aim of *Art across Time* is, therefore, to introduce readers to the complexity of images, while also surveying the history of those images. Context is a particular area of concern, for works of art lose much of their meaning if separated from the time and place in which they were created. Context also includes function, patronage, and the character and talent of the individual artist.

The complexity of the visual arts has led to different approaches to reading images. Throughout the text, therefore, there are discussions of methodology as well as new boxes entitled "Methods of Interpretation," and there is a brief survey of the modern methodologies of art-historical interpretation in the Introduction.

While comprehensive, *Art across Time* avoids an encyclopedic approach to art history and attempts instead a more manageable narrative that is suitable for a one-year survey course. Certain key works and artists are given more attention than in some books, while other works and artists are omitted entirely. An effort is made to present the history of art as a dynamic narrative grounded in scholarship, a narrative that is a dialogue between modern viewers and their past.

"Windows on the World"

Sections entitled "Window on the World" provide an introduction to the art of certain non-Western cultures. They highlight specific periods within cultures, particularly when they are thematically related to, or have significantly influenced, Western art. Some of the Windows-such as Aboriginal rock paintings in the chapter on prehistory and Japanese woodblock prints in the chapter on Impressionism (Chapter 22)are placed within Western chapters. Others-for example, those dealing with the Indus Valley civilization, Mesoamerica, and the Far East-are placed chronologically between Western chapters. The Windows offer a sense of the range of world art and remind readers that the history of Western art is only one of many art-historical narratives. These narratives reflect the differences, as well as the similarities, between cultures and emphasize the complexity of the visual arts by taking Western readers far afield of their accustomed territory and exposing them to unfamiliar ways of thinking about the arts. As with the European artists of the early twentieth century who collected African and Oceanic sculpture in search of new, non-Classical ways of representing the human figure, so viewers who encounter such

works for the first time are encouraged to stretch their own limits of seeing and understanding.

Boxes

Within chapters, readers will find boxes that encapsulate background information necessary for the study of art. These boxes take students aside, without interrupting the flow of the text, to explain media and techniques as well as different philosophies of art from Plato to Marx, Burke to Freud, and Winckelmann to Greenberg. Significant works of literature related to the arts are also covered: epics such as *Gilgamesh*, the *Iliad* and the *Odyssey*, the *Edda*, and *Beowulf*, as well as excerpts of Romantic, Dada, and contemporary poetry. One box shows Beauford Delaney quoting Balzac, an example of a personal artistic genealogy within the broader narrative of art history. Another illustrates the symbolism of color in Roman marble sculptures.

Illustration Program

The illustrations in *Art across Time* are in a consistently large format, which encourages careful looking. All of the paintings are reproduced in color, and the percentage of color is higher than in any other survey text presently on the market. Two shades of black are used for the black-and-white illustrations, resulting in greater tonal density, and all illustrations are printed on a five-color press for optimal quality. Occasionally, more than one view of a sculpture or a building is illustrated to give readers a sense of its three-dimensional reality. This has been increased for the third edition.

A new feature in the illustration program of this edition is the placement of "Connections"—small, repeated images —to show thematic continuity in the arts. Thus, for example, a small figure of Titian's *Venus of Urbino* accompanies Manet's *Olympia*. A similar system is also used for comparative purposes.

Architectural discussions are enhanced with labeled plans, sections, and axonometric diagrams. Diagrams of the Mesopotamian cone mosaic technique, of the Greek lostwax method, of altarpieces, and of lithography and cantilever have been added. Many of the picture captions include anecdotes or biographical information about the artists; these are intended to encourage readers to identify with painters, sculptors, and architects, and they also provide a sense of the role of artists in society. Maps both define geographical context and indicate changing national boundaries over time.

Other Pedagogical Features

Languages as well as the visual arts have a history, and the etymology of art-historical terms is, therefore, provided. This reinforces the meanings of words and reveals their continuity through time. In the chapter on ancient Greece, transcriptions of terms and proper names are given according to Greek spelling, with certain exceptions in deference to convention: Acropolis, Euclid, Socrates, and Laocoön, all of which would be spelled with a "k" rather than a "c" in Greek. Likewise, Roman names and terms are given according to Latin transcription. The first time an art-historical term appears in the text, it is **boldfaced** to indicate that it is also defined in the glossary at the back of the book.

At the end of each chapter, a chronological time line of the works illustrated is useful for review purposes. This lists contemporaneous developments in other fields as well as cross-cultural artistic developments, and it contains selected images for review.

New to the Third Edition

At the request of reviewers and adopters of the second edition, the text is divided into seven parts. Each two-page part opener incorporates a time line that, in addition to placing key works of art in a chronological continuum, highlights other important developments relevant to the cultural contextualization of art. The part openers have been redesigned for the third edition and now include an introductory paragraph surveying developments covered in each part. The Introduction, formerly Chapter 1, has been updated.

In addition to the numerous text refinements, several substantial changes should be noted. The Window on the World for Mesoamerica has been rewritten, and Georgia Riley de Havenon, a pre-Columbian specialist, has contributed sections on Aztec and Andean art. The coverage of the Renaissance and Gothic periods has been reorganized. With the help of Robert Maxwell of the University of Michigan, Gothic diagrams have been redrawn to improve accuracy and pedagogy. Additional diagrams have been included and the number of color plates has been expanded in the Windows as well as throughout the text.

Finally, the last chapter has been updated to include recent artistic developments—especially globalization.

Supplements

Interactive CD-ROM

Art across Time's Core Concepts in Art CD-ROM, available free to students with every new copy of the textbook in any of its iterations, provides valuable supplemental materials. Below is a brief description and table of contents. **Description** Conceived, designed, and written by students for students under the leadership of Bonnie Mitchell (Bowling Green State University), one of the preeminent multimedia designers, *Art across Time's* Core Concepts in Art CD-ROM provides supplemental exercises and information in the areas students experience difficulties.

Contents

- **Elements of Art:** Allows students to interact with the formal elements of art by working through over 70 interactive exercises illustrating line, shape, color, light, dark, and texture.
- **Art Techniques:** Takes students on a tour of art studios. *Art Techniques* illustrates working with a variety of media from bronze pouring, to painting, to video techniques with extensive, narrated video segments.
- **Chapter Resources:** Study resources correlated to each chapter of *Art across Time;* both a review and test preparation. Students will find key terms, chapter summaries, and a self-correcting study quiz to help prepare for inclass tests, midterms, and finals. Also included is an exercise on methodologies that demonstrates the application of different methods to Van Eyck's *Arnolfini Portrait*.
- **Research and the Internet:** Introduces students to the research process from idea generation, to organization, to researching on- and off-line, and includes guide-lines for incorporating sources for term papers and bibliographies.
- **Study Skills:** Helps your students adjust to the rigors of college work. The *Study Skills* section of the CD-ROM provides practical advice on how to succeed at college.

Online Learning Center

Recently, the Internet has played an increasing role in college education; *Art across Time* is, therefore, supported by an Online Learning Center <http://www.mhhe.com/art acrosstime> that offers additional resources for students wishing to quiz themselves. They can send the results to their instructor via e-mail, link to additional research topics on the World Wide Web, use the pronunciation guide, follow links to artists, and more.

Student Study Guide

The student study guides are designed as chapter-bychapter workbooks to accompany *Art across Time*. Perforated pages allow professors to assign exercises to be handed in along with each reading assignment. The exercises include brief essays, fill-in-the-blanks, matching artists with works and works with their sites. In addition, students are asked to identify key figures and define terms.

Finally, slide sets for qualifying adopters and an instructor's manual complete the impressive supplemental support package for *Art across Time*. For more information, please contact your local McGraw-Hill sales representative, or e-mail <art@mcgraw-hill.com>.

Acknowledgments

Many people have been extremely generous with their time and expertise during the preparation of this text. John Adams has helped on all phases of the book's development. Marlene Park was especially helpful during the formative stages of the one-volume text. Others who have offered useful comments and saved me from egregious errors include Steve Arbury, Paul Barolsky, Hugh Baron, James Beck, Allison Coudert, Jack Flam, Sidney Geist, Mona Hadler, Ann Sutherland Harris, Arnold Jacobs, Donna and Carroll Janis, Genevra Kornbluth, Carla Lord, Maria Grazia Pernis, Catherine Roehrig, Elizabeth Simpson, Leo Steinberg, and Rose-Carol Washton Long.

For invaluable assistance with the chapters on antiquity, I am indebted to Larissa Bonfante, Professor of Classics at New York University; Ellen Davis, Associate Professor of Art and Archaeology at Queens College, CUNY; and Oscar White Muscarella of the Department of Ancient Near Eastern Art at the Metropolitan Museum of Art, New York. Carol Lewine, emerita, Queens College, CUNY, lent her expertise to the medieval chapters and Mark Zucker, professor at Louisiana State University, vetted the Renaissance and Baroque chapters.

For assistance with illustrations, I have to thank, among others, ACA Galleries, Margaret Aspinwall, Christo and Jeanne-Claude, Anita Duquette, Michael Findlay, Georgia de Havenon, the Flavin Institute, Duane Hanson, M. Knoedler and Co., Inc., John Perkins, Carroll Janis, Ronald Feldman Gallery, Robert Miller Gallery, Pace Gallery, and Allan Stone Gallery.

For assistance in developing the third edition, I would like to thank Julia Moore and, at McGraw-Hill, Joseph Hanson and Lyn Uhl. April Wells-Hayes and Christina Gimlin shepherded the book through production, and Robin Sand did an excellent job of researching the photographs. The expert editing of Carol Flechner improved the text immeasurably, and the effective layout is due to the finely honed skills of Roberta Flechner. Jeanne Schreiber deserves high praise for the new design of the third edition and the excellent quality of the covers. Thanks also to Linda Toy and Alexis Walker for their expertise and commitment to the quality of the book.

Reviewers

Thanks to our reviewers of the third edition: Roger Aikin, Creighton University; Steve Arbury, Radford University; Peter Barr, Siena Heights College; Vince Bodily, Ricks College; Kelly Dennis, University of Connecticut; Kimberly Francev, University of Arizona; Mitchell Frank, Carleton University; Richard Green, Eastern Arizona College; Pamela Hall, Glendale Community College; Kim Hartswick, George Washington University; LuAnn S. Kanabay, University of Connecticut; Janette Knowles, Ohio Dominican University; Ellen Konowitz, State of University of New York at New Paltz; Jane Kyle, University of Portland; Lisa Livingston, Modesto Junior College; David Ludley, Clayton College & State University; Virginia Marquardt, Marist College; Floyd Martin, University of Arkansas-Little Rock; Dr. Andrew Marvick, Southwestern Oklahoma State University; Beth A. Mulvaney, Meredith College; Fr. James Neilson O. Praem, St. Norbert College; Mallory O'Connor, Santa Fe Community College; Michelle Pacansky-Brock, Sierra College; Donald Paoletta, Nebraska Wesleyan University; Kristin Ringelberg, Elon College; Gil Rocha, Richland Community College; Jerry Soneson, University of Northern Iowa; Carolyn Tate, Texas Tech University; Rita Tekippe, State of University of West Georgia; Radford Thomas, Radford University; Gavin Townsend, University of Tennessee-Chattannoga; Anne Betty Weinshenker, Montclair State.

Introduction

Why Do We Study the History of Art?

e study the arts and their history because they teach us about our own creative expressions and those of our past. Studying the history of art is one way of exploring human cultures—both ancient and modern—that have not developed written documents. For example, the prevalence of animals in the prehistoric cave paintings of western Europe reveals the importance of animals in those societies. Female figurines with oversized breasts and hips express the wish to reproduce and ensure the survival of the species. Prehistoric structures, whether oriented toward earth or sky, provide insights into the beliefs of early cultures. If such objects had not been preserved, we would know far less about ancient cultures than we now do.

We would also know less about ourselves, for art is a window onto human thought and emotion. For example, van Gogh's self-portraits are explicitly autobiographical. From what is known about his life, he was sustained by his art. In figure **I.1** he depicts himself in front of a painting that we do not see, even though we might suspect that

The Western Tradition

"Western art" is the product of a group of cultures that have historically been thought of as sharing common traditions. Some of these cultures, such as that of medieval France, developed in the Western Hemisphere, but others, such as that of ancient Babylon (in modern Iraq), did not. Likewise, some cultures that were geographically western, such as that of the Maya (in modern Mexico and Central America), have not traditionally been considered part of the West. This book follows the conventional (Western) usage of the terms Western and non-Western: the Western world comprises North America and Europe, as well as ancient Egypt and the ancient Near East, while the non-Western world comprises all areas and traditions outside those boundaries. It is important, however, to be aware that these categories are based as much on ideas about culture as on geography.

it, too, is a self-portrait. For there are several elements in the painting that assert the artist's presence. Van Gogh's self-image predominates; he holds a set of brushes and a palette of unformed paint composed of the same colors used in the picture. At the center of the palette is an intense orange, the distinctive color of his beard, as well as

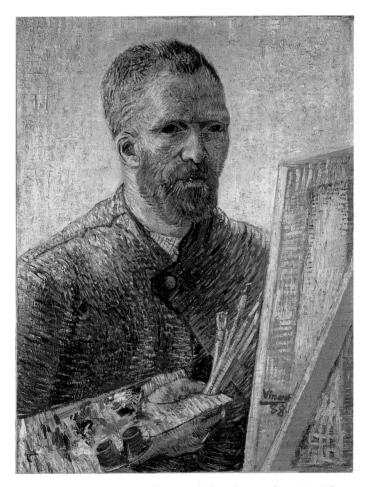

I.1 Vincent van Gogh, Self-Portrait before his Easel, 1888. Oil on canvas; $25\% \times 19\%$ in. (65.5 \times 50.5 cm). Rijksmuseum, Amsterdam. Vincent van Gogh Foundation.

of his name (Vincent) and the date ('88), with which he simultaneously signs both the painting we see and the painting we do not see.

The arts exemplify the variety of creative expression from one culture to the next. This book surveys the major periods and styles of Western art (see box, p. 1), with certain highlights of non-Western art included to give readers a sense of differences—as well as similarities—between works of art around the world.

In the West, the major visual arts fall into three broad categories: pictures, sculpture, and architecture. Pictures (from the Latin word *pingo*, meaning "I paint") are two-dimensional images (from the Latin *imago*, meaning "likeness"), with height and width, and are usually flat. Pictures are not only paintings, however: they include mosaics, stained glass, tapestries, drawings, prints, and photographs.

Sculptures (from the Latin word *sculpere*, meaning "to carve"), unlike pictures, are three-dimensional: besides height and width, they have depth. Sculptures have traditionally been made of a variety of materials such as stone, metal, wood, and clay. More modern materials include glass, plastics, cloth, string, wire, television monitors, and even animal carcasses.

Architecture, which literally means "high (*archi*) building (*tecture*)," is the most utilitarian of the three categories. Buildings are designed to enclose and order space for specific purposes. They often contain pictures and sculptures as well as other forms of visual art. Some ancient Egyptian tombs, for example, were filled with statues of the deceased. Many churches are decorated with sculptures, paintings, mosaics, and stained-glass windows illustrating the lives of Christ and the saints. And Buddhist caves and temples contain sculptures and paintings representing events in the life of the Buddha.

The Artistic Impulse

Art is a vital and persistent aspect of human experience. But where does the artistic impulse originate? We can see that it is inborn by observing children, who make pictures, sculptures, and model buildings before learning to read or write. Children trace images in the earth, build snowmen and sand castles, and decorate just about anything—from their own faces to the walls of their houses. All are efforts to impose order on disorder and to create form from formlessness. Although it may be difficult to relate an Egyptian pyramid or a Greek temple to a child's sand castle or toy tower, all express the natural impulse to build.

In the adult world, creating art is a continuation and development of the child's inborn impulse to play. This is clear from the statements of artists themselves: Picasso said that he was unable to learn math because every time he looked at the number 7 he thought he saw an upsidedown nose. The self-taught American artist Horace Pippin described his impulse to attach drawings to words when learning to spell.

One powerful motive for making art is the wish to leave behind after death something of value by which to be remembered. The work of art symbolically prolongs the artist's existence. This parallels the pervasive feeling that by having children one is ensuring genealogical continuity into the future. Several artists have made such a connection. In an anecdote about Giotto, the fourteenth-century Italian artist, the poet Dante asks Giotto why his children are so ugly and his paintings so beautiful; Giotto replies that he paints by the light of day but reproduces in the darkness of night. According to his biographers, Michelangelo said that he had no human children because his works were his children. The twentieth-century Swiss artist Paul Klee also referred to his pictures as children and equated artistic genius with procreation. His German contemporary Josef Albers cited this traditional connection between creation and procreation in relation to color: he described a mixed color as the offspring of two original colors, and compared it to a child who combines the genes of two parents.

Related to the role of art as a memorial is the wish to preserve one's likeness after death. Artists are often commissioned to paint portraits, or likenesses, of specific people. They also make self-portraits—likenesses of themselves. "Painting makes absent men present and the dead seem alive," wrote Leon Battista Alberti, the fifteenthcentury Italian humanist. "I paint to preserve the likeness of men after their death," wrote Albrecht Dürer in sixteenthcentury Germany.

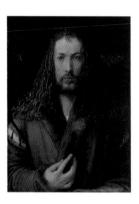

See figure 16.11. Albrecht Dürer, *Self-Portrait,* 1500.

Chronology

The Christian calendar, traditionally used in the West, is followed throughout this book. Other religions, such as Hinduism, Buddhism, Islam, and Judaism, have different dating systems.

Dates before the birth of Jesus are followed by the letters B.C., an abbreviation for "before Christ." Dates after his birth are denoted by the letters A.D., from the Latin phrase anno Domini, meaning "in the year of our Lord." The newer terms B.C.E. ("before the common era," equivalent to B.C.) and C.E. ("common era," equivalent to A.D.) are considered more religiously neutral, but they are less historical. There is no year O, so A.D. 1 immediately follows 1 B.C. If neither B.C. nor A.D. accompanies a date, A.D. is understood. When dates are approximate or tentative, they are preceded by "c.," an abbreviation for the Latin word *circa*, meaning "around."

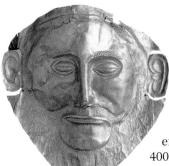

See figure 4.27. "Mask of Agamemnon," from Mycenae, c. 1500 B.C.

As early as the Neolithic era (in western Europe c. 6000/ 4000–2000 B.C. [see box] and the seventh millennium in the Near East), skulls were modeled into faces

with plaster, and shells were inserted into the eye sockets. In ancient Egypt, a pharaoh's features were painted on the outside of his mummy case so that his *ka*, or soul, could recognize him. The Mycenaeans made gold death masks of their kings, and the Romans preserved the images of their ancestors by carving marble portraits from wax death masks.

It is not only the features of an individual that are valued as an extension of self after death. A **patron**, someone who commissions (sponsors) works of art, often ordered more monumental tributes. For example, the Egyptian pharaohs spent years planning and overseeing the construction of their pyramids, not only in the belief that such monumental tombs would guarantee their existence in the afterlife, but also as a statement of their power while on earth. In ancient China, the emperor Qin was buried with a "bodyguard" of several thousand life-sized **terra-cotta** statues of warriors, chariots, and horses (fig. **I.2**). Their function was literally to guard his body in the afterlife.

In fifth-century-B.C. Athens, the Parthenon was built to house a colossal sculpture of the patron goddess Athena

and, at the same time, to embody the intellectual and creative achievements of Athenian civilization. Over two thousand years later, Louis XIV, king of France, built his magnificent palace at Versailles as a monument to his political power, to his reign, and to the glory of France. And in the same period in India, the Mughal emperor Shah Jahan commissioned the Taj Mahal as a memorial to his wife, Mumtaz Mahal (fig. **I.3**).

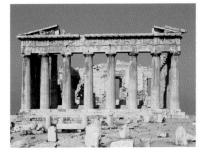

See figure 5.48. The Parthenon, Athens, 448–432 B.C.

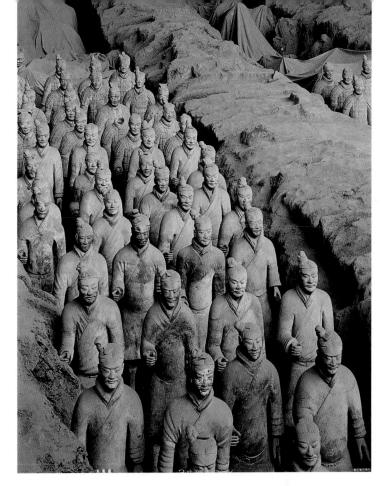

1.2 Bodyguard of the emperor Qin, terra-cotta warriors, Qin dynasty (221–206 B.C.), in situ. Lintong, Shaanxi Province, China.

I.3 (below) Taj Mahal, Agra, India, 1632–1648.

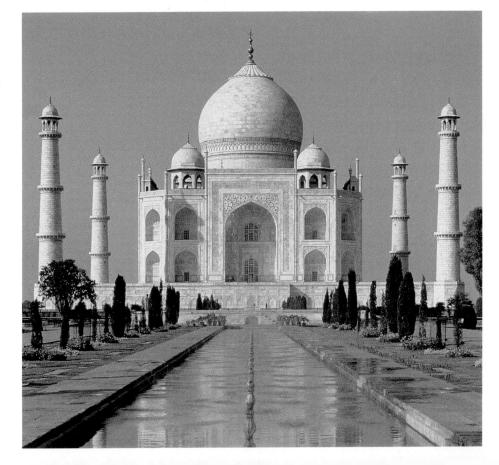

Why Is Art Valued?

Works of art are valued not only by artists and patrons, but also by entire cultures. In fact, the periods of history that we tend to identify as high points of human achievement are those in which art was most highly valued and encouraged.

During the Gothic era in Europe (c. 1200–1400/1500), a significant part of the economic activity of every cathedral town revolved around the construction of its cathedral, the production of sculpture, and the manufacture of stained-glass windows. In medieval India, the construction of a Hindu temple brought similar economic benefits, the largest temples supporting permanent communities of artists and other temple workers. The fourteenth- and fifteenth-century banking families of Italy spent enormous amounts of money on art to adorn public spaces, churches, chapels, and private palaces.

Today institutions as well as individuals fund works of art, and there is a flourishing art market throughout the world. More people than ever before buy and enjoy art —often as an investment—and the auctioning of art has become an international business. Art theft is also international in scale, and the usual motive is money. Well-known stolen works may be difficult to fence and thus are often held for ransom. The outrage that a community feels when some works of art disappear (or are vandalized) reflects their cultural importance. Various ways in which art is valued are explored below.

Material Value

Works of art may be valued because they are made of a precious material. Gold, for example, was used in Egyptian art to represent divinity and the sun. These associations recur in Christian art, which reserved gold for the background of religious icons (the word icon is derived from the Greek word eikon, meaning "image") and for halos on divine figures. During the Middle Ages in Europe, ancient Greek bronze statues were not valued for their aesthetic character (their beauty), nor for what they might have revealed about Greek culture. Instead, their value lay in the fact that they could be melted down and re-formed into weapons. Through the centuries art objects have been stolen and plundered, in disregard of their cultural, religious, or artistic significance, simply because of the value of their materials. Even the colossal cult statue of Athena in the Parthenon disappeared without a trace, presumably because of the value of the gold and ivory from which it was made.

Intrinsic Value

A work of art may contain valuable material, but that is not the primary basis on which its quality is judged. Its intrinsic value depends largely on the general assessment of the artist who created it and on its own aesthetic character. The Mona Lisa, for example, is made of relatively modest materials-paint and woodbut it is a priceless object nonetheless and arguably the Western world's most famous image (see fig. 14.16). Leonardo da Vinci, who painted it around 1503 in Italy, was acknowledged as a genius in his own day, and his work has stood the test of time. The works of van Gogh have also endured, although he was ignored in his lifetime. Intrinsic value is not always apparent; it varies in different times and places, as we can see in the changing as-

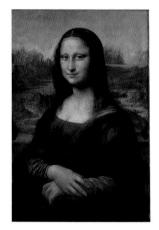

See figure 14.16. Leonardo da Vinci, *Mona Lisa*, c. 1503–1505.

sessment of van Gogh's works. "Is it art?" is a familiar question that expresses the difficulty of defining "art" and of recognizing the aesthetic value of an object (see box, p. 5).

Religious Value

One of the traditional ways in which art has been valued is in terms of its religious significance. Paintings and sculptures depicting gods and goddesses make their images accessible. Such buildings as the Mesopotamian **ziggurat** (stepped tower), temples in many cultures, and Christian churches have served as symbolic dwellings of the gods, relating worshipers to their deities. Tombs express the belief in an afterlife. During the European Middle Ages, art often served an educational function. One important way of communicating Bible stories and legends of the saints to a largely illiterate population was through the sculptures, paintings, mosaics, wall hangings, and stained-glass windows in churches. Beyond its didactic (teaching) function, the religious significance of a work of art may be so great that entire groups of people identify with the object.

Nationalistic Value

Works of art have nationalistic value inasmuch as they express the pride and accomplishment of a particular culture. Nationalistic sentiment was a primary aspect of the richly carved triumphal arches of ancient Rome, which were gateways for returning military victors. Today, as in the past, statues of national heroes stand in parks and public squares in cities throughout the world.

Sometimes the nationalistic value of art is related to its religious value. In such cases, rulers take advantage of the patriotism of their subjects to impose a new religious system and to enhance its appeal through the arts. In the fourth century, under the Roman emperor Constantine, art was used to reinforce the establishment of Christianity as

Brancusi's *Bird:* Manufactured Metal or a Work of Art?

A trial held in New York City in 1927 illustrates just how hard it can be to agree on what constitutes "art." Edward Steichen, a prominent American photographer, had purchased a bronze sculpture entitled *Bird in Space* (fig. **1.4**) from the Romanian artist Constantin Brancusi, who was living in France. Steichen imported the sculpture to the United States, whose laws do not require payment of customs duty on original works of art as long as they are declared to customs on entering the country. But when the customs official saw the *Bird*, he balked. It was not art, he said: it was "manufactured metal." Steichen's protests fell on deaf ears. The sculpture was admitted into the United States under the category of "Kitchen Utensils and Hospital Supplies," which meant that Steichen had to pay \$600 in import duty.

Later, with the financial backing of Gertrude Vanderbilt Whitney, an American sculptor and patron of the arts, Steichen appealed the ruling of the customs official. The ensuing trial received a great deal of publicity. Witnesses discussed whether the Bird was a bird at all, whether the artist could make it a bird by calling it one, whether it could be said to have characteristics of "birdness," and so on. The conservative witnesses refused to accept the work as a bird because it lacked certain biological attributes, such as wings and tail feathers. The more progressive witnesses pointed out that it had birdlike qualities: upward movement and a sense of spatial freedom. The court decided in favor of the plaintiff. The Bird was declared a work of art, and Steichen got his money back. In today's market, Brancusi Birds would sell for millions of dollars.

1.4 Constantin Brancusi, *Bird in Space*, 1928. Bronze, unique cast; $54 \times 8\frac{1}{2} \times 6\frac{1}{2}$ in. (137.2 \times 21.6 \times 16.5 cm). Museum of Modern Art, New York. Given anonymously. Brancusi objected to the view of his work as abstract. In a statement published shortly after his death in 1957, he declared: "They are imbeciles who call my work abstract; that which they call abstract is the most realist, because what is real is not the exterior form but the idea, the essence of things." well as imperial power. Centuries earlier, the Indian emperor Ashoka had commissioned monuments throughout his realm to proclaim his conversion to Buddhism. Both Constantine and Ashoka patronized the arts in the service of revolutionary developments in politics and religion.

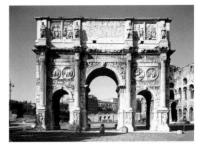

See figure 7.40. Arch of Constantine, Rome, c. A.D. 313.

Works of art need not represent national figures or even national or religious themes to have nationalistic value. In 1945, at the end of World War II, the Dutch authorities arrested an art dealer, Hans van Meegeren, for treason. They accused him of having sold a painting by the great seventeenth-century Dutch artist Jan Vermeer to Hermann Goering, the Nazi Reichsmarschall and Hitler's most loyal supporter. When van Meegeren's case went to trial, he lashed out at the court: "Fools!" he cried, "I painted it myself." What he had sold to the Nazis was actually his own forgery, and he proved it by painting another "Vermeer" under supervision while in prison. It would have been treason to sell Vermeer's paintings, which are considered national treasures, to the German enemy.

Another expression of the nationalistic value of art can be seen in recent exhibitions made possible by shifts in world politics. Since 1989, which marked the end of the Cold War between communist Eastern Europe and the West, Russia has been sending works of art from its museums for temporary exhibitions in the United States. In such circumstances, the traveling works become a kind of diplomatic currency, improving relations between nations.

The nationalistic value of certain works of art has frequently made them spoils of war. When ancient Babylon was defeated by the Elamites in c. 1170 B.C., the victors stole the stele of Naram-Sin (see fig. 2.17) and the law code of Hammurabi (see fig. 2.21). In the early nineteenth century, when Napoleon's armies overran Europe, they plundered thousands of works that are now part of the French national art collection in the Musée du Louvre, in Paris.

When the nineteenth-century German archaeologist Heinrich Schliemann excavated ancient Troy, in modern Turkey, he removed a hoard of gold from the site and brought it to Germany. During World War II, the Russians invaded Germany and took the treasure to Russia. They later denied any knowledge of its whereabouts, admitting only in 1994 that they had it. The issue that then arose was who owned the

gold—Turkey, Germany, or Russia. The Turks argued that it was theirs by right of origin, the Germans claimed that they had excavated and essentially "discovered" it, and the Russians pointed out that they had been victors in the war (which Germany had started). The nationalistic value of art can be so great that countries whose works have been taken go to considerable lengths to recover them. Thus, at the end of World War II, the Allied armies assigned a special division to recover the vast numbers of artworks stolen by the Nazis. A United States army task force discovered Hermann Goering's two personal hoards of stolen art in Bavaria, one in a medieval castle and the other in a bomb-proof tunnel in nearby mountains. The task force arrived just in time, for Goering had equipped an "art train" with thermostatic temperature control to take "his" collection to safety. At the Nuremberg war trials, Goering claimed that his intentions had been purely honorable: he was protecting the art from air raids.

Another example of the nationalistic value of art can be seen in the case of the Elgin Marbles. In the early

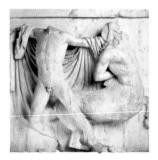

See figure 5.53. Lapith and Centaur, from south metope XXVII of the Parthenon, 5th century B.C.

nineteenth century, when Athens was under Turkish rule, Thomas Bruce, seventh earl of Elgin, obtained permission from Turkey to remove sculptures from the Parthenon and other buildings on the Acropolis. At huge personal expense (£75,000), Lord Elgin sent the sculptures by boat to England. The first shipment sank, but the remainder of the works reached their destination in 1816 and the British Museum in London purchased the sculp-

tures for only £35,000. The Elgin Marbles, also known as the Parthenon Marbles, are still in the British Museum, where they are a tourist attraction and are studied by scholars. For years, the Greeks have been pressing for the return of the sculptures, but the British have refused. This kind of situation is a product of historical circumstance. Although Lord Elgin broke no laws and probably saved the sculptures from considerable damage, he is seen by many Greeks as having looted their cultural heritage.

Modern legislation in some countries is designed to avoid similar problems by restricting or banning the export of national treasures. International cooperation agreements (protocols) attempt to protect cultural property and archaeological heritage worldwide.

Psychological Value

Another symbolic value of art is psychological. Our reactions to art span virtually the entire range of human emotion. They include pleasure, fright, amusement, avoidance, and outrage.

One of the psychological aspects of art is its ability to attract and repel us, and this is not necessarily a function of whether or not we find a particular image aesthetically pleasing. People can become attached to a work of art, as Leonardo was to his *Mona Lisa* (see fig. 14.16). Instead of delivering it to the patron, Leonardo kept the painting until his death. Conversely, one may wish to destroy certain works because they arouse anger. In London in the early twentieth century, a suffragette slashed Velázquez's *Rokeby Venus* (see fig. 17.54) because she was offended by what she

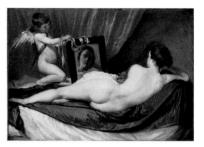

See figure 17.54. Diego Velázquez, Venus with a Mirror (Rokeby Venus), c. 1648.

considered to be its sexist representation of a woman. During the French Revolution of 1789, mobs protesting the injustices of the royal family destroyed statues and paintings of earlier kings and queens. In 1989 and 1990, when Eastern Europe began to rebel against communism, the protesters tore down statues of their former leaders. In Afghanistan, the fundamentalist Islamic Taliban regime blew up colossal statues of the Buddha because the statues were figurative and thus seen as not conforming to the rules of the Koran (Qu'ran). In so doing, the Taliban breached the UNESCO Convention of 1972 and the Geneva Convention riders of 1977 and 1997. Both forbid the destruction of cultural property. All these examples illustrate intense responses to the symbolic power of art.

Art and Illusion

Before considering illusion and the arts, it is necessary to point out that when we think of illusion in connection with an image, we usually assume that the image is true to life, or naturalistic (cf. **naturalism**). This is often, but not always, the case. With certain exceptions, such as some Judaic and Islamic art, Western art was mainly representational until the twentieth century. **Representational**, or **figurative**, art depicts recognizable natural forms or created objects (see p. 24). When the subjects of representational pictures and sculptures are so convincingly portrayed that they may be mistaken for the real thing, they are said to be illusionistic (cf. **illusionism**). Where the artist's purpose is to fool the eye, the effect is described by the French term **trompe-l'oeil**.

The deceptive nature of pictorial illusion was simply but eloquently stated by the Belgian Surrealist painter René Magritte in *The Betrayal of Images* (see box, p. 7). This work is a convincing (although not a *trompe-l'oeil*) rendition of a pipe. Directly below the image, Magritte reminds the viewer that in fact it is not a pipe at all—"*Ceci n'est pas une pipe*" ("This is not a pipe") is Magritte's explicit message. To the extent that observers are convinced by the image, they have been betrayed. Even though Magritte was right about the illusion falling short of reality, the observer nevertheless enjoys having been fooled.

Images and Words

Artists express themselves through a visual language which has pictorial, sculptural, and architectural, rather than verbal, elements. As a result, no amount of description can replace the direct experience of viewing art. As discussed on pages 18–23, the artist's language consists of formal elements such as line, shape, space, color, light, dark, and so forth, whereas discussion about art is in words. Imagine, for example, if the words in Magritte's *The Betrayal of Images* (fig. **1.5**) read "This is a pipe" (*Ceci est une pipe*) or even only "Pipe," instead of "This is not a pipe" (*Ceci n'est pas une pipe*). Although we might receive the same meaning of "pipeness" from both the word and the image, our experience of the verbal description would be quite different from our experience of its subject.

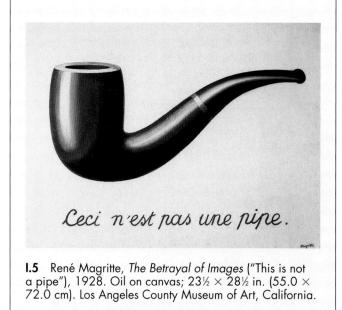

The pleasure produced by *trompe-l'oeil* images is reflected in many anecdotes, perhaps not literally true but illustrations of underlying truths. For example, the ancient Greek artist Zeuxis was said to have painted grapes so realistically that birds pecked at them. In the Renaissance, a favorite story recounted that the painter Cimabue was so deceived by Giotto's realism that he tried to brush off a fly that Giotto had painted on the nose of a painted figure. The twentieth-century American sculptor Duane Hanson was a master of *trompe-l'oeil*. He used synthetic materials to create statues that look so alive that it is not unusual for people to approach and speak to them.

In these examples of illusion and *trompe-l'oeil*, artists produce only a temporary deception. But such may not always be the case. For instance, the Latin poet Ovid relates the tale of the sculptor Pygmalion, who was not sure whether his own statue was real. Disillusioned by the infidelities of women, Pygmalion turned to art and fashioned a beautiful girl, Galatea, out of ivory. He dressed her and brought her jewels and flowers. He undressed her and took her to bed. During a feast of Venus (the Roman goddess of love and beauty), Pygmalion prayed for a wife as lovely as his Galatea. Venus granted his wish by bringing the statue to life.

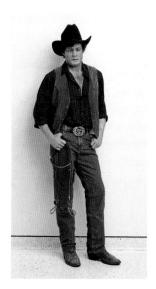

See figure 29.6. Duane Hanson, *The Cowboy*, 1995.

The fine line between reality and illusion, and the fact

Artists and Gods

that gods are said to create reality and artists create illusion, have given rise to traditions equating artists with gods. Both are seen as creators, the former making replicas of nature and the latter making nature itself. Alberti referred to the artist as an *alter deus*, Latin for "other god," and Dürer said that artists create as God did. Leonardo wrote in his *Notebooks* that artists are God's grandsons and that painting, the grandchild of nature, is related to God. Giorgio Vasari, the Italian Renaissance biographer of artists, called Michelangelo "divine," a reflection of the notion of divine inspiration. The nineteenth-century American painter James McNeill Whistler declared that artists are "chosen by the gods."

Artists have been compared with gods, and gods have been represented as artists. In ancient Babylonian texts, God is described as the architect of the world. In the Middle Ages, God is sometimes depicted as an architect drawing the universe with a compass (fig. **I.6**). Legends in the Apocrypha, the unofficial books of the Bible, portray Christ as a sculptor who made clay birds and breathed life into them. Legends such as these are in the tradition of the supreme and omnipotent male artist-as-genius, and they reflect the fact that the original meaning of *genius* was "divinity."

The comparison of artists with gods, especially when artists make lifelike work, has inspired legends of rivalry between these two types of creator. Even when the work itself is not lifelike, the artist may risk incurring divine anger. For example, the Old Testament account of the Tower of Babel illustrates the dangers of building too high and rivaling God by invading the heavens. God reacted by confounding the speech of the builders so that they seemed to each other to be "babbling" incomprehensibly. They scattered across the earth, forming different language groups. In the sixteenth-century painting by the

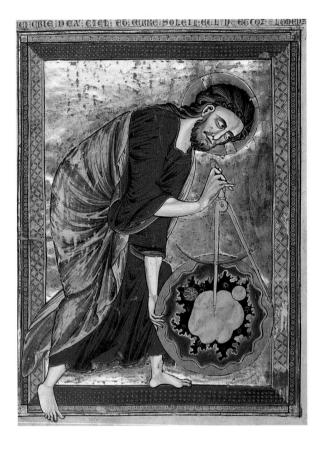

1.6 God as Architect (God Drawing the Universe with a Compass), from the Bible moralisée, Reims, France, fol. lv, mid-13th century. Illumination; 8½ in. (21.2 cm) wide. Österreichische Nationalbibliothek, Vienna.

> Flemish artist Pieter Bruegel the Elder (fig. **I.7**), the Tower of Babel seems about to cave in from within, although it does not actually do so. Bruegel's tower is thus a metaphor for the collapsed ambition of the builders. A related story is told by the Roman historian Pliny: the emperor Nero angered the god Jupiter by erecting a colossal statue of himself. Jupiter destroyed the image of the presumptuous mortal with a thunderbolt.

> Some legends endow sculptors and painters with the power to create living figures without divine intervention. In Greek mythology, the sculptor Daedalos was reputed to have made lifelike statues that could walk and talk. Prometheus, on the other hand, was not satisfied with merely lifelike works: he wanted to create life itself. Since the ancient Greeks believed that human beings were made of earth (the body) and fire (the soul), Prometheus knew that he needed more than clay to create living figures. He therefore stole fire from the gods, and they punished him with eternal torture.

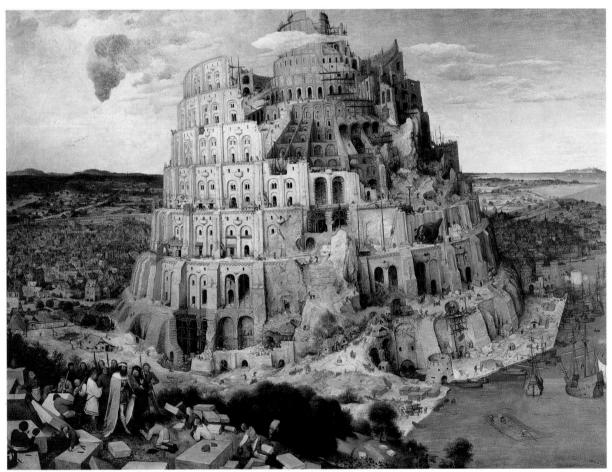

1.7 Pieter Bruegel the Elder, *The Tower of Babel*, 1563. Tempera on panel; 3 ft. 9 in. \times 5 ft. 1 in. (1.14 \times 1.55 m). Kunsthistorisches Museum, Vienna.

Art and Identification

Reflections and Shadows: Legends of How Art Began

Belief in the power of images extends beyond the work of human hands. In many societies, not only certain works of art but also reflections and shadows are thought to embody the spirit of an animal or the soul of a person. Ancient traditions trace the origin of image making to drawing a line around a reflected image or shadow. Alberti recalled the myth of Narcissus—a Greek youth who fell in love with his own image in a pool of water—and compared the art of painting to the reflection. The Roman writer Quintilian, on the other hand, identified the first painting as a line traced around a shadow. A Buddhist tradition recounts that the Buddha was unable to find an artist who could paint his portrait. As a last resort, he had an outline drawn around his shadow and filled it in with color himself.

A Greek legend attributes the origin of sculpture to a young woman of Corinth, who traced the shadow of her lover's face cast on the wall by lamplight. Her father, a potter, filled in the outline with clay, which he then **fired** (burned in a kiln). This story became particularly popular during the Romantic period in Europe and has been memorialized in *The Corinthian Maid* (fig. **I.8**) by the English painter Joseph Wright of Derby. Legends such as this indicate that works of art are inspired not only by the impulse to create form, but also by the discovery or recognition of forms that already exist and the wish to capture and preserve them.

Image Magic

People in many cultures believe that harm done to an image of someone will hurt the actual person. In sixteenthcentury England, Queen Elizabeth I's advisers summoned a famous astrologer to counteract witchcraft when they

discovered a wax effigy of the queen stuck through with pins.

Sometimes, usually in cultures without strong traditions of figural art, people fear that pictures of themselves may embody-and snatch away-their souls. Many nineteenth-century Native Americans objected to having their portraits painted. One of the outsiders who did paint their portraits was George Catlin, whose memoirs record suspicious and occasionally violent reactions. Even today, with media images permeating so much of the globe, people in remote

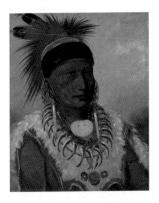

See figure 20.25. George Catlin, The White Cloud, Head Chief of the lowas, 1844–1845. Oil on canvas; 28 × 22% in. (71.1 × 58.1 cm). National Gallery of Art, Washington, D.C.

areas may resist being photographed for fear of losing themselves if their image is taken away. In fact, the very language we use to describe photography reflects this phenomenon: we "take" pictures and "capture" our subjects on film.

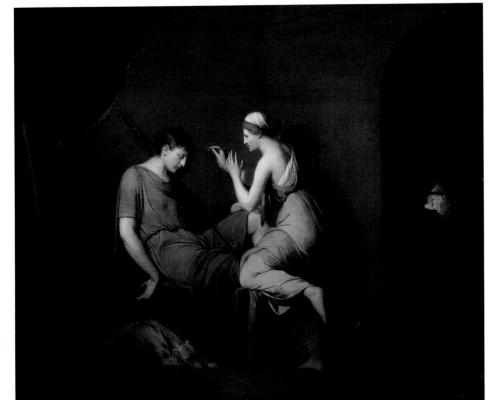

1.8 Joseph Wright of Derby, *The Corinthian Maid*, 1782–1784. Oil on canvas; 41% × 51½ in. (1.06 × 1.30 m). National Gallery of Art, Washington, D.C. Paul Mellon Collection.

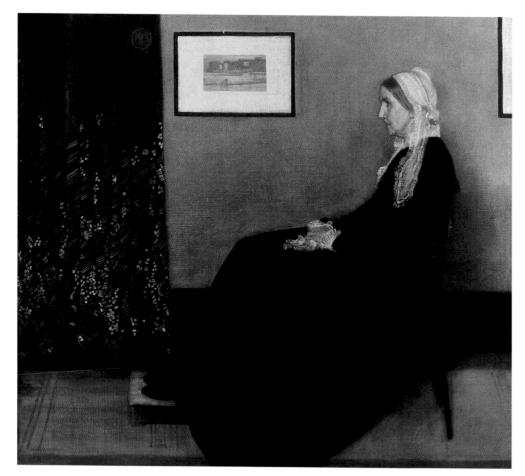

I.9 James Abbott McNeill Whistler, Arrangement in Black and Gray (Portrait of the Artist's Mother), 1871. Oil on canvas; 4 ft. 9 in. × 5 ft. 4½ in. (1.45 × 1.64 m). Musée d'Orsay, Paris.

Portraits can also create very strong impressions. The nineteenth-century English art critic John Ruskin fell in love with an image on two separate occasions. He became so enamored of the marble tomb effigy of Ilaria del Caretto in Lucca, Italy, that he wrote letters home to his parents describing the statue as if it were a living girl. Later, when Ruskin was in a delusional state, he persuaded the Accademia, a museum in Venice, to lend him a painting of Saint Ursula by the sixteenth-century artist Carpaccio. Ruskin kept it in his room for six months and became convinced that he had been reunited with his former fiancée, a young Irish girl named Rose la Touche, whom he merged in his mind with the painted saint. A less extreme form of the identification of a woman with an image concerns Whistler's famous portrait of his mother (fig. I.9). "Yes," he replied when complimented on the picture. "One does like to make one's mummy just as nice as possible."

The ability to identify with images and the sense that a replica may actually contain the soul of what it represents have sometimes led to an avoidance of images. Certain religions prohibit their adherents from making pictures and statues of their god(s) or of human figures in sacred contexts. In Judaism, the making of figurative images is expressly forbidden in the second commandment: "Thou shalt not make unto thee any graven image, or any likeness of any thing that is in heaven above, or that is in the earth beneath, or that is in the water under the earth" (Exodus 20:4). Before receiving these instructions, the Israelites had been worshiping a golden calf, which Moses destroyed when he brought them the Commandments. Years later, the prophet Jeremiah declared both the pointlessness and the dangers of worshiping objects instead of God the Creator.

In Islam, as in Judaism, the human figure is generally avoided in religious art. The founder of Islam, the prophet Muhammad, condemned those who would dare to imitate God's work by making figurative art. As a result, Islamic art developed its characteristic emphasis on complex patterns.

During the Iconoclastic Controversy in the eighth and ninth centuries, Christians argued vehemently over the potential dangers of creating any images of holy figures. Like the Jews, Christians wishing to destroy existing images and to prohibit new ones believed that such works of art would lead to idolatry, or worship of the image itself rather than what it stood for.

A different interpretation of this connection between images and gods can be seen in Hindu beliefs about religious sculpture, which is intensely figurative. Hindu statues are considered available for their associated deities to inhabit. Because they are thought capable of changing their outer appearances in order to become manifest and comprehensible to human worshipers, the gods can enter sculptures that have the appropriate forms. Hindu sculpture is thus conceived of as a sacred vessel for the divine presence.

In the modern era, as societies have become increasingly technological, traditional imagery seems to have lost some of its magic power. But art still engages us. A peaceful landscape painting, for example, provides a respite from everyday tensions as we contemplate its rolling hills or distant horizon. A still life depicting fruit in a bowl reminds us of the beauty inherent in objects we take for granted. And it remains true that abstract works of art containing no recognizable objects or figures can involve us in the rhythms of their shapes, the movements of their lines, and the moods of their colors. Large public sculptures, many of which are nonrepresentational, mark our social spaces and humanize them. Architecture, too, defines and enriches our environment. In addition, contemporary images, many in electronic media, exert power over us in both obvious and subtle ways by drawing on our image-making traditions. Movies and television affect our tastes and aesthetic judgments. Advertising images influence our decisions-what we buy and which candidates we vote for. Computer-based digital art is one of the fastest growing art fields. Such modern media use certain traditional techniques of image making to convey their messages.

Architecture

As is true of pictures and sculptures, architecture evokes a response by identification. A building may seem inviting or forbidding, gracious or imposing, depending on how its appearance strikes the viewer. One might think of a country cottage as welcoming and picturesque, or of a haunted house as endowed with the spirits of former inhabitants who inflict mischief on trespassers.

Architecture is more functional, or utilitarian, than pictures and sculptures. Usually the very design of a building conforms to the purpose for which it was built. The criterion for a successful building is not only whether it looks good, but also whether it fulfills its function well. A hospital, for example, may be aesthetically pleasing, but its ultimate test is whether it serves the patients and medical staff adequately. A medieval castle was not only a place to live, it was also a fortress requiring defensive features such as a moat, drawbridge, towers, small windows, and thick, crenellated walls.

Beyond function, the next most important consideration in architecture is its use of space. The scale (size) of buildings and the fact that, with very few exceptions, they can enclose us make our responses to them significantly different from our reactions to pictures or sculptures. Pictures convey only the illusion of space. Sculptures occupy actual, three-dimensional space, although the observer generally remains on the outside of that space looking in.

In the ancient world, many buildings, such as Egyptian pyramids and Greek temples, were intended to be experiSee figure W3.10. The Great Stupa at Sanchi, Madhya Pradesh, India, 3rd century B.C.

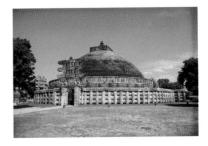

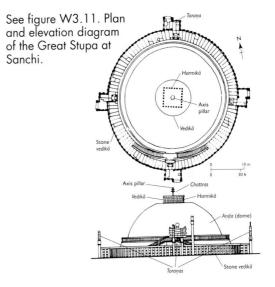

enced either exclusively or primarily from the outside. But a Buddhist stupa had a solid core and, therefore, no interior at all. Its hemispherical shape represented the Buddha's original burial mound, which became a symbol of the cosmos. Worshipers enter the sacred space surrounding a stupa through a gateway marking the transition from the ordinary to the spiritual world. They walk around the perimeter of the stupa in a ritual circumambulation that reiterates the Buddha's own spiritual journey. When religious structures do have interiors, access to their inner sanctuaries is frequently restricted. Psychologically as well as aesthetically, therefore, our response to architecture is incomplete until we have experienced it physically. Because such an experience involves time and motion as well as vision, it is particularly challenging to describe architecture through words and pictures.

The experience of architectural space appears in everyday language. We speak of "insiders" and "outsiders," of being "in on" something, and of being "out of it." The significance of "in" and "out" recurs in certain traditional architectural arrangements. In parts of the ancient world, the innermost room of a temple, its sanctuary, was considered the most sacred, the "holy of holies," which only a high priest or priestess could enter. Likewise, an appointment with a VIP is often held in an inner room that is generally closed to the public at large. Access is typically through a series of doors, so that in popular speech we say of people who have influence that they can "open doors."

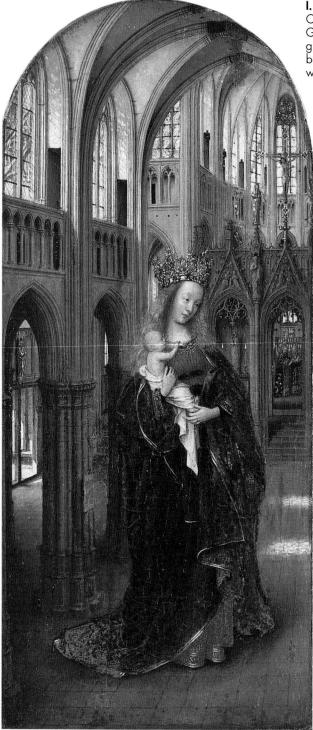

Our identification with the experience of being inside begins before birth. Unborn children exist in the enclosed space of their mother's womb, where they are provided with protection, nourishment, and warmth. This biological reality has resulted in a traditional association between women and architecture. The inner sanctum of Hindu temples, for example, is called a **garbha griha**, meaning "womb chamber." In medieval Christianity, the intuitive

1.10 Jan van Eyck, *The Virgin in a Church*, c. 1410–1425. Oil on panel; $12\frac{1}{4} \times 5\frac{1}{2}$ in. (31.0 × 14.0 cm). Gemäldegalerie, Staatliche Museen, Berlin. It is thought that, given the narrowness of this picture, it may originally have been part of a **diptych**—a work consisting of two panels—in which case the other section is lost.

> relationship between motherhood and architecture gave rise to a popular metaphor equating the Virgin Mary (as mother of Christ) with the Church building. This metaphor is given visual form in Jan van Eyck's fifteenth-century painting *The Virgin in a Church* (fig. **I.10**). Here Mary is enlarged in relation to the architecture, identifying her with the Church as the House of God. Van Eyck portrays an intimacy between the Virgin and Christ that evokes both the natural closeness of mother and child and the spiritual union between the human and the divine.

> This union is an important aspect of the sense of space in religious architecture. The vast interior spaces of Gothic cathedrals, for example, are awe-inspiring, making worshipers feel small compared to an all-encompassing God. The upward movement of the interior space, together with the tall towers and spires on either side of the entrance, echo the Christian belief that paradise is up in the heavens. The rounded spaces of certain other places of worship, such as the domed ceilings of some mosques, likewise symbolize the dome of heaven. In a sense, then, these religious buildings stand as a kind of transitional space between earth and sky, between our limited time on earth and beliefs about infinite time, or eternity.

> Just as we respond emotionally and physically to the open and closed spaces of architecture, so our metaphors indicate our concern for the structural security of our buildings. "A house of cards" or a "castle in the air" denotes instability and irrational thinking. This notion is reflected in the old joke "Neurotics build castles in the air, and psychotics live in them." Since buildings are constructed from the bottom up, a house built on a "firm foundation" can symbolize stability, rational thinking, forethought, and advance planning. In the initial stages of a building's conception, the architect makes a plan. Called a ground plan, or floor plan, it is a detailed drawing of each story of the structure, indicating where walls and other architectural elements are located. Although in everyday speech we use the term to plan in a figurative sense, unless the architect constructs a literal and wellthought-out plan, the building, like a weak argument, will not stand up.

Why Do We Collect Art?

In antiquity, art was valued as booty taken from conquered peoples. In ancient Egypt, Babylon, China, and India, looted art was exhibited in temples and palaces to enhance the power of rulers and priests. Even today, the value of art as military booty has not been entirely eliminated. In 1992, when the National Museum in Kabul, Afghanistan, was hit by rockets, looters pillaged the collection. Afghanistan's location made it a crossroads of trade for thousands of years, and this was reflected in unique objects from many different cultures that have now disappeared. Experts believe that some of these thefts were "commissioned" by agents working for unscrupulous collectors.

Ancient cultures have a long history of royal and aristocratic art collecting. In Europe, art collecting for the intrinsic value of the works began in Hellenistic Greece (323–31 B.C.). Romans plundered Greek art and also had a thriving industry copying Greek art, which was collected, especially by emperors. During the Middle Ages, the Christian Church was the main collector of art in Europe.

Interest in collecting ancient art revived in the West during the Renaissance and continued in royal families for several centuries. Some of these royal collections became the basis for major museums—in the late eighteenth century, the Louvre was opened in Paris, and the Russian and British royal collections were opened to the public in the early nineteenth century. By that time more and more private individuals collected art, and since then dealers, auction houses, museums, and the media have further expanded collecting.

Archaeology and Art History

The works of art illustrated in this book are the subject of two academic fields: archaeology and art history. Archaeology (from the Greek words *archaios*, meaning "old" or "beginning," and *logos*, meaning "word") is literally a study of beginnings. The value of such study was expressed by the German author Johann Wolfgang von Goethe in 1819 as follows:

He who'd know what life's about Three millennia must appraise; Else he'll go in fear and doubt, Unenlightened all his days.¹

A related sentiment was expressed by Sigmund Freud when he declared that "only a good-for-nothing is not interested in his past."

The primary aim of the archaeologist is the reconstruction of history from the physical remains of past cultures. These remains are not confined to the arts, but can be anything from bone fragments and debris, safety pins and frying pans, to entire water-supply systems of buried cities. Unvandalized graves protected from the elements and hidden from the view of potential plunderers yield some of the best evidence. On occasion, cities such as Pompeii and Herculaneum in southern Italy are discovered relatively intact, providing a remarkable glimpse of the past. In its early days in the nineteenth century, archaeology was largely the province of amateur explorers and collectors of antiquities. There was little or no concern for preserving the cultural or historical context of the finds.

Today archaeology is more scientific and professional, calling on many other disciplines to assist with analyzing its discoveries by material, stylistic type, function, and date, as well as in preserving them (see box, p. 14). Ecology, for example, elucidates aspects of the natural environment, some of which can be used for dating. Statistics indicating population size and growth in a particular culture can clarify its development and longevity. Other fields that contribute to archaeology include chemistry, physics, computer science, linguistics (where there is evidence of writing), sociology, anthropology, and art history.

Art history is the study of the history of the visual arts. It should be distinguished from art appreciation, which is primarily about aesthetics. Philosophers of both the East and the West have discussed the nature of aesthetics since antiquity. While art history has a venerable tradition in China, it did not become an academic discipline in the West until the nineteenth century. Art history in the West has traditionally dealt with the analysis of individual works of art and their grouping into larger categories of style. Art historians recognize that many factors contribute to the production of a work, including its culture (time and place), artist, patron, medium, and function. Art history is used by archaeologists as well as other scholars studying everyday life, religious practices, means of warfare, and so forth. Stylistic analysis of works of art helps archaeologists date layers of cultures and is of great importance to cultural and economic historians in determining patterns of trade.

How Do We Approach Art?

The complexity of images has led to the development of various interpretative approaches. Principal among these so-called methodologies of art-historical analysis are formalism, iconography and iconology, Marxism, feminism, biography and autobiography, semiology, deconstruction, and psychoanalysis. Generally, art historians approach works using some combination of these methods.

The Methodologies of Art

Formalism Chronologically, the earliest codified methodology is **formalism**, which grew out of the nineteenthcentury aesthetic of "Art for Art's Sake"—artistic activity as an end in itself. Adherents of pure formalism view works of art independently of their context, function, and content. They respond to the formal elements and to the aesthetic effect that the arrangement of those elements creates. Two philosophers, Plato in ancient Greece and Immanuel Kant in eighteenth-century Germany, can be seen as precursors of formalist methodology. They

The Archaeological Dig

Archaeologists locate buried cultures by observing anomalies in topography such as earth mounds, traces of roads, and the geological disposition of rocks and minerals. Aerial photography is particularly helpful for this purpose. The location chosen for excavation is known as the site. Typically, each site has a director, a trained archaeologist who oversees the excavation. Under the director are various supervisors, staffers, and volunteers. Architectural drawings are made to record the remains of buildings and reconstruct their original plans. Finds are photographed, drawn, catalogued, and analyzed by specialists. A conservator advises on preserving objects. A foreman hires and oversees local workers and attends to necessities such as food, water, and medical supplies.

Archaeological Dating Techniques

The role of archaeology in studying prehistoric periods (i.e., those for which no contemporary written records exist) is crucial. Central to archaeological methods is the establishment of time sequences for events and objects. During the twentieth century a number of techniques have been developed for arriving at the age of ancient objects and the chronology of prehistoric events.

Through **stratigraphy** (the geological study of the layers [strata] of the earth), objects deposited in these layers can be dated. Stratigraphy rests on the principle—known as the Law of Superposition—that, in the absence of external factors, older (earlier) materials in an archaeological deposit are found lower than newer (later) materials. By careful excavation and meticulous record keeping, archaeologists are able to relate objects to each other both vertically (to determine their relative chronology) and horizontally (for clues to cultural patterns within individual periods). **Seriation,** another method of fixing relative dates, is based on the reconstruction of changes in style or type that can be observed in archaeological artifacts (e.g., tools, ceramics) over time. For instance, in any group of examples of a particular kind of object, the percentage of the total is small at the start of its production phase, increases as the object becomes popular and widely used, and decreases through its phases of declining popularity and eventual disuse.

Dendrochronology (tree-ring dating) is the study of information contained in the annual growth layers of trees. It was discovered in 1917 that trees in any particular area have identical sequences of wide and narrow rings, each ring corresponding to one year's growth. This natural phenomenon has allowed archaeologists to reconstruct historic and prehistoric ring sequences and to assign accurate dates to prehistoric sites. Dendrochronology is valuable in areas such as North America and Europe, where there is an abundance of wood and charcoal remains, but is of less value where such materials are scarce.

Radiocarbon dating, which was first developed in 1947, provides a method of determining the precise age of carbonized wood and other organic materials such as antler, bone, and shell. Each living organism has a trace of radiocarbon (carbon 14), which begins to decay when death occurs. By measuring the residual carbon 14 content of an object, it is possible to establish, within fairly narrow limits, its actual age.

Archaeometry involves the application of analytical techniques from the physical sciences and engineering to archaeological materials. Its interdisciplinary nature requires close cooperation between the archaeologists and experts in various fields in dating objects. The work of the archaeometrist is facilitated by computer analysis, with its potential for storing vast amounts of data.

believed in an ideal, essential beauty that transcends time and place. Other formalist writers on art did relate changes in artistic style to cultural change. This approach was demonstrated by the Swiss art historian Heinrich Wölfflin, considered one of the founders of modern art history. In his *Principles of Art History*, first published in German in 1915, he demonstrated the respective formal consistency of Renaissance and Baroque styles.

In order to grasp the effect of formal elements, we take as an example Brancusi's *Bird in Space* (see fig. I.4). Imagine how different it would look lying in a horizontal plane. A large part of the effect of the work depends on its verticality. But it also has curved outlines, sleek proportions, and a highly reflective bronze surface. Its golden color might remind one of the sun and thus reinforce the association of birds and sky. Imagine the *Bird* made of another material (Brancusi did make some white marble *Birds*); its aesthetic effect would be very different. Even more radical an idea: what if the texture of the *Bird* were furry instead of hard and smooth? Consider, for example, the *Fur-covered Cup, Saucer, and Spoon* of 1936 (fig. **I.11**) by the Swiss artist Meret Oppenheim. When we experience the formal qualities of texture in these two sculptures, we respond to the *Bird* from a distance, as if it were suspended in space, as the title indicates. But the *Cup* evokes an immediate tactile response because we think of drinking from it, of touching it to our lips, and its furry texture repels us. At the same time, however, the *Cup* amuses us because of its contradictory nature. Whereas our line of vision soars vertically *with* the *Bird, we* instinctively withdraw *from* the *Cup*.

Iconography and Iconology In contrast to formalism, the **iconographic** method emphasizes content over form in individual works of art. The term itself denotes the "writing" (*graphe* in Greek) of an image (from the Greek

I.11 Meret Oppenheim, Fur-covered Cup, Saucer, and Spoon (Le Déjeuner en Fourrure), 1936. Cup 4% in.
(10.9 cm) diameter; saucer 9% in.
(23.7 cm) diameter; spoon 8 in.
(20.2 cm) long; overall height 2% in.
(7.3 cm). Museum of Modern Art, New York.

word *eikon*), and implies that a written text underlies an image. In Bruegel's *Tower of Babel* (see fig. I.7) the biblical text is Genesis 11:6, in which God becomes alarmed at the height of the tower. He fears that the builders will invade his territory and threaten his authority. The iconographic elements of Bruegel's picture include the tower as well as the figures and other objects depicted. The actual tower referred to in the Bible was probably a ziggurat commissioned by King Nebuchadnezzar of ancient Babylon, who is depicted with his royal entourage at the lower left of the picture. He has apparently come to review the progress of the work, which—according to the text—is about to stop. Bruegel shows this by the downward pull at the center of the tower that makes it seem about to cave in. He also

See figure 11.11. West façade of Chartres Cathedral, France, c. 1140–1150.

refers to God's fear that the tower will reach into the heavens by painting a small, white cloud overlapping the top of the tower. The cloud thus heightens dramatic tension by referring to the divine retribution that will follow. Recognizing the symbolic importance of this iconographic detail significantly enriches our understanding of the work as a whole.

Iconology refers to the interpretation or rationale of a group of works, which is called a **program**. In a Gothic cathedral, for example, an iconographic approach would consider the textual basis for a single statue or scene in a stained-glass window. Iconology, on the other hand, would consider the choice and arrangement of subjects represented in the entire cathedral and explore their interrelationships.

Marxism The Marxist approach to art history derives from the writings of Karl Marx, the nineteenth-century German social scientist and philosopher whose ideas were developed into the political doctrines of socialism and communism. Marx himself, influenced by the industrial revolution, was interested in the process of making art and its exploitation by the ruling classes. He contrasted the workers (proletariat) who create art with the propertyowning classes (the bourgeoisie) who exploit the workers, and believed that this distinction led to the alienation of artists from their own productions. Marxist art historians, and those influenced by Marxism, study the relationship of art to the economic factors (e.g., cost and availability of materials) operating within its social context. They analyze patronage in relation to political and economic systems. Marxists study form and content not for their own sake, but for the social messages they convey and for evidence of the manipulation of art by the ruling class to enhance its own power.

A Marxist reading of the message of Bruegel's *Tower* might associate the builders with the proletariat and God with the bourgeoisie. In between is Nebuchadnezzar, who, because he is a king, is not punished as the workers are. It is they who assume the brunt of God's anger; their language is confounded and they are scattered across the earth, whereas Nebuchadnezzar continues to rule his empire. Bruegel emphasizes the greater importance of Nebuchadnezzar in relation to the workers by his larger size, his

upright stance, and his royal following. The workers are not only much smaller, but some kneel before the king.

Feminism Feminist methodology assumes that the making of art, as well as its iconography and its reception by viewers, is influenced by gender. Like Marxists, feminists are opposed to pure formalism on the grounds that it ignores the message conveyed by content. Feminist art historians have pointed out ways in which women have been discriminated against by the male-dominated art world. They have noted, for example, that before the 1970s the leading art-history textbooks did not include female artists. Through their research, they have also done a great deal to establish the importance of women's contributions to art history as both artists and patrons-rescuing significant figures from obscurity as well as broadening our sense of the role of art in society. Feminists take issue with traditional definitions of art and notions of artistic genius, both of which have historically tended to exclude women. The fact that traditionally it has been difficult for women to receive the same training in art as men, due in part to family obligations and the demands of motherhood and partly to social taboos, is an issue that the feminists have done much to illuminate.

Taking the example of this introductory chapter, a feminist might point out that of all the illustrations of works of art only one is by a woman (Meret Oppenheim, see fig. I.11). Furthermore, its subject is related to the woman's traditional role as the maker and server of food in the household. At the same time, the work is a visual joke constructed by a woman that combines female sexuality with eating and drinking. The "household" character of the *Cup* contrasts with the "divine" character of *God as Architect* (*God Drawing the Universe with a Compass*) (fig. I.6). As depicted in this Introduction, the male figures are gods, kings, soldiers, and workers, whereas female figures (except *The Corinthian Maid*, fig. I.8) are mothers.

Biography and Autobiography Biographical and autobiographical approaches to art history interpret works as expressions of their artists' lives and personalities. These methods have the longest history, beginning with the mythic associations of gods and artists described above. Epic heroes such as Gilgamesh and Aeneas are credited with the architectural activity of building walls and founding cities. The anecdotes of Pliny the Elder about ancient Greek artists have a more historical character, which was revived in fourteenth-century Italy. Vasari's Lives of the Artists, written in the sixteenth century, covers artists from the late thirteenth century up to his own time and concludes with his autobiography. From the fifteenth century on, the genre of biography and autobiography of artists has expanded into various literary forms-for example, sonnets (Michelangelo), memoirs (Vigée-Lebrun), journals (Delacroix), letters (van Gogh), and, more recently, films and taped interviews.

The biographical method emphasizes the notion of authorship and can be used to interpret iconography, using the artist's life as an underlying "text." This being said, there are certain standard conventions in artists' biographies and autobiographies that are remarkably consistent and that arise in quite divergent social and historical contexts. These conventions parallel artists with gods, especially in the ability to create illusion. They also include episodes in which an older artist recognizes talent in a child destined to become great, the renunciation of one's art (or even suicide) when confronted with the work of superior artists, sibling rivalry between artists, artists who are rescued from danger by their talent, and women as muses for (male) artists.

Whistler's portrait of his mother (see fig. I.9) obviously has autobiographical meaning. By placing his own etchings on the wall beside her, he relates her dour personality to his black-and-white drawings and etchings, rather than to his more colorful paintings. Vincent van Gogh's *Self-Portrait before*

His Easel (1888) in figure I.1 is one of many self-portraits that reflect the artist's inner conflicts through the dynamic tension of line and color. In works such as these, it is possible to apply the biographical method because the artist's identity is known and because he makes aspects of himself manifest in his imagery. When works are entirely anonymous, such as Emperor Qin's "bodyguard" (fig. I.2), biographical read-

ings in terms of the

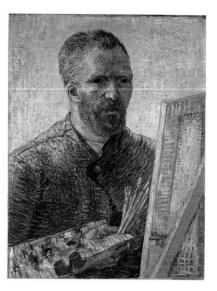

See figure I.1. Vincent van Gogh, Self-Portrait before His Easel, 1888.

artist(s) are more difficult, although they may sometimes be applied to the patron.

Semiology Semiology—the science of signs—takes issue with the biographical method and with much of formalism. It has come to include elements of structuralism, poststructuralism, and deconstruction. Structuralism developed from a branch of language study called structural linguistics in the late nineteenth and early twentieth centuries as an attempt to identify universal and meaningful patterns in various cultural expressions. There are several structuralist approaches to art, but in general they diverge from the equation of artists with gods, from the Platonic notion of art as *mimesis* (making exact copies of nature), and from the view that the meaning of a work is conveyed exclusively by its author.

In the structural linguistics of the Swiss scholar Ferdinand de Saussure, a "sign" is composed of "signifier" and "signified." The former is the sound or written element (such as the four letters *p-i-p-e*) and the latter is the concept of what the signifier refers to (in this case, a pipe). A central feature of this theory is that the relation between signifier and signified is entirely arbitrary. Saussure insists on that point specifically to counter the notion that there is an ideal essence of a thing (as stated by Plato and Kant). He is also arguing against the tradition of a "linguistic equivalent." The notion of linguistic equivalents derived from the belief that, in the original language spoken by Adam and Eve, words matched the essence of what they referred to so that signifier and signified were naturally related to each other. Even before Adam and Eve, the logocentric (word-centered) Judaic God had created the world through language: "Let there be light" made light, and "Let there be darkness" made darkness. The New Testament Gospel of John (1:1) takes up this notion again, opening with "In the beginning was the Word."

For certain semioticians, however, some relation between signifier and signified is allowed. These would agree

that Magritte's painted pipe is closer to the idea of pipeness than the four letters *p-i-p-e*. But most semioticians prefer to base stylistic categories on signs rather than on formal elements. For example, Magritte's pipe and Oppenheim's cup do not resemble each other formally, and yet both have been related to Dada and Surrealism. Their similarities do not lie in

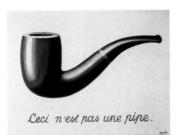

See figure 1.5. René Magritte, The Betrayal of Images ("This is not a pipe"), 1928.

shared formal elements, but rather in their ability to evoke surprise by disrupting expectations. We do not expect to read a denial of the "pipeness" of a convincing image of a pipe written by the very artist who painted it. Nor do we expect fur-covered cups and spoons because the fur interferes with their function. The unexpected—and humorous—qualities of the pipe and the cup could be considered signs of certain twentieth-century developments in imagery. Another element shared by these two works is the twentieth-century primacy of everyday objects, which can also be considered a sign.

Deconstruction The analytical method known as deconstruction is most often associated with Jacques Derrida, a French poststructuralist philosopher who writes about art and written texts. Derrida's deconstruction opens up meanings rather than fixing them within structural patterns. But he shares with the structuralists the idea that works have no ultimate meanings conferred by their authors.

Derrida's technique for opening up meanings is to question assumptions about works. Whistler's mother (see fig. I.9), for example, seems to be sitting for her portrait, but we have no proof from the painting that she ever did so. Whistler could have painted her from a photograph or from memory, in which case our initial assumption about the circumstances of the work's creation would be incorrect, even though the portrait is a remarkably "truthful" rendering of a puritanical woman.

Derrida also opens up the Western tendency to binary pairing: right/left, positive/negative, male/female, and so forth. He notes that one of a pair evokes its other half and plays on the relationship of presence and absence. Since a pair of parents is a biological given, where, a Derridean might ask, is Whistler's father? In the pairing of father

and mother, the present parent evokes the absent parent. There is, in Whistler's painting, no reference to his father, only to himself via the etchings hanging on the wall. The absent father, the present mother, the etchings of the son-the combination invites speculation about their relationships: was the son trying to displace the father? Such psychological considerations lead us to the psychoanalytic methodologies.

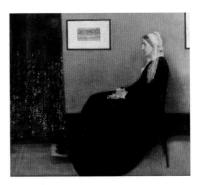

See figure 1.9. James Abbott McNeill Whistler, Arrangement in Black and Gray (Portrait of the Artist's Mother), 1871.

Psychoanalysis The branch of psychology known as psychoanalysis was originated by the Austrian neurologist Sigmund Freud in the late nineteenth century. Like art history, psychoanalysis deals with imagery, history, and creativity. Like archaeology, it reconstructs the past and interprets its relevance to the present. The imagery examined by psychoanalysts is found in dreams, waking fantasies, jokes, slips of the tongue, and neurotic symptoms, and it reveals the unconscious mind (which, like a buried city, is a repository of the past). In a work of art, personal imagery is reworked into a new form that "speaks" to a cultural audience. It thus becomes part of a history of style (and, for semioticians, of signs).

Psychoanalysis has been applied to art in different ways and according to different theories. In 1910 Freud published the first psychobiography of an artist, in which he explored the personality of Leonardo da Vinci through the artist's iconography and working methods. For Freud, the cornerstone of psychoanalysis was the Oedipus complex, which refers to various aspects of children's relationships to their parents. In the case of a boy, the Oedipus complex includes his wish for a romance with his mother and the elimination of his father. The Oedipus complex of a girl is more complicated because her first love object is her mother and she is expected to grow up and love a man.

As we have seen, the Oedipus complex can be applied to Whistler's painting of his mother. An oedipal reading of that work is enriched by the fact that it contains an underpainting—a preliminary painting covered up by the final painting—of a baby. An oedipal reading of Brancusi's *Bird* would have to consider the artist's relationship to his peasant father, an ignorant and abusive man who would have preferred his son to have been born a girl. In that light, the sculpture has been interpreted as a phallic self-image, declaring its triumph over gravity and outshining the sun. With *Bird in Space*, Brancusi symbolically "defeats" his father and "stands up" for himself as a creator.

According to classical psychoanalysis, works of art are "sublimations of instinct" through which instinctual energy is transformed by work and talent into aesthetic form. The ability to sublimate is one of the main differences between humans and animals, and it is necessary for creative development in any field. Because art is expressive, it reveals aspects of the artist who creates it, of the patron who funds it, and of the culture in which it is produced.

How Do We Talk about Art?

The visual arts have their own language, and the artist thinks in terms of that language, just as a musician thinks in sounds and a mathematician in numbers. The basic visual vocabulary consists of the so-called **formal elements**, which include line, shape, space, color, light, and dark. When artists combine these elements in a characteristic way, they are said to have a **style**. In order to describe and analyze a work of art, it is helpful to be familiar with the artist's perceptual vocabulary.

Composition

In its broadest sense, the **composition** of a work of art is its overall plan or structure. It denotes the relationship among component parts, and it involves balance and harmony, the relationships of parts to each other and to the whole work, and the effect on the viewer. The composition of a work depends on how the formal elements are arranged and is distinct from the subject matter, content, or theme.

Plane

A **plane** is a flat surface having a direction in space. Brancusi's *Bird* (fig. I.4) rises in a vertical plane, Magritte's *pipe* (fig. I.5) lies in a relatively horizontal plane, and the figure of God in *God as Architect (God Drawing the Universe with a Compass)* (fig. I.6) bends over to create two diagonal planes. Stonehenge (see fig. 1.22) is a building that

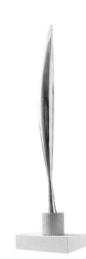

See figure I.4. Constantin Brancusi, *Bird in Space*, 1928.

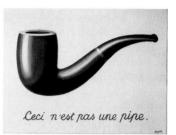

See figure I.5. René Magritte, *The Betrayal of Images* ("This is not a pipe"), 1928.

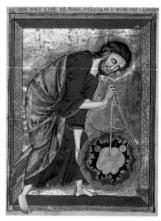

See figure 1.6. God as Architect (God Drawing the Universe with a Compass), mid-13th century.

occupies a circular plane because it is round, whereas the towers of Gothic cathedrals are vertical planes and Greek temples lie in horizontal planes.

A plane can also be thought of as a flat surface. We thus speak of a **picture plane** when referring to the flat surface of a painting or a **plane of relief** when referring to the surface of a relief sculpture (see Chapter 1).

Balance

In a successful composition, the harmonious blending of formal elements creates **balance**. The simplest form of balance is **symmetry**, in which there is an exact correspondence of parts on either side of an axis or dividing line. In other words, the left side of a work is a mirror image of the right side. The Taj Mahal (fig. I.3) is a symmetrical building, meaning that if we draw a line through its center, we will have two equal parts.

Balance can also be achieved by nonequivalent elements. In *God as Architect (God Drawing the Universe with a Compass)* (fig. I.6), the weight of the figure is not evenly distributed on either side of the central axis. But

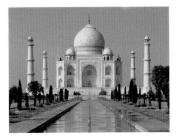

See figure I.3. Taj Mahal, Agra, India, 1632–1648.

even though the parts are not arranged symmetrically, there is an equilibrium between them that produces an aesthetically satisfying result. This is known as **asymmetrical balance**.

Line

A line is the path traced by a moving point. For the artist, the moving point is the tip of the brush, pen, crayon, or whatever instrument is used to create an image on a surface. In geometry, a line has no width or volume; its only quality is inherent in its location, a straight line being defined as the shortest distance between two points. In the language of art, however, a line can have many qualities, depending on how it is drawn (fig. I.12). A vertical line seems to stand stiffly at attention, a horizontal line lies down, and a diagonal seems to be falling over. Zigzags have an aggressive, sharp quality, whereas a wavy line is more graceful and, like a curve, more naturally associated with the outline of the human body. Parallel lines are balanced and harmonious, implying an endless, continuous movement, while perpendicular, converging, and intersecting lines meet and create a sense of force and counterforce. The thin line (a) seems delicate, unassertive, even weak. The thick one (b) seems aggressive, forceful, strong. The undulating line (c) suggests calmness, like the surface of a calm sea, whereas the more irregularly wavy line (d) implies the reverse. The angular line (e) climbs upward like the edge of a rocky mountain. (Westerners understand (e) as going up and (f) as going down, since we read from left to right.)

Expressive Qualities of Line Many of the lines in figure I.12 are familiar from geometry and can, therefore, be described formally. But the formal qualities of line also convey an expressive character because we identify them with our bodies and our experience of nature. By analogy with a straight line being the shortest distance between two points, a person who follows a straight, clear line in thought or action is believed to have a sense of purpose. "Straight" is associated with rightness, honesty, and truth, while "crooked"—whether referring to a line or a person's character—denotes the opposite. We speak of a "line of work," a phrase adopted by the former television program *What's My Line?* When a baseball player hits a line drive, the bat connects firmly with the ball, and a "hardliner" takes a strong position on an issue.

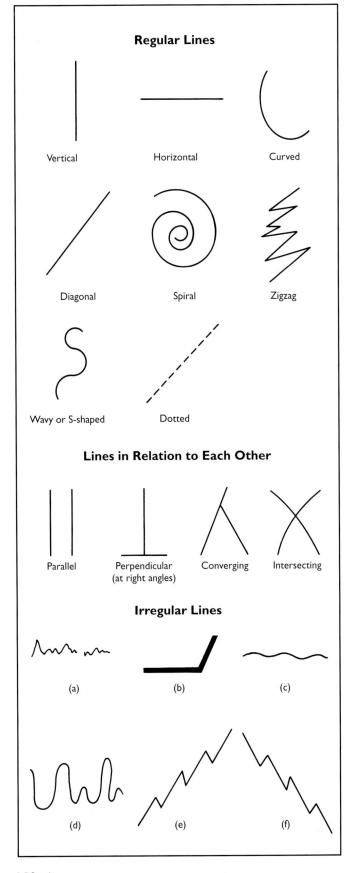

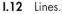

1.13 Lines used to create facial expressions.

It is especially easy to see the expressive impact of lines in the configuration of the face (fig. **I.13**). In (a), the upward curves create a happy face, and the downward curves of (b) create a sad one. These characteristics of upward and downward curves actually correspond to the emotions as expressed in natural physiognomy. And they are reflected in language when we speak of people having "ups and downs" or of events being "uppers" or "downers."

Alexander Calder's (1898–1976) *Cat* (fig. **I.14**) merges the linear quality of the written word with the pictorial quality of what the word represents. The curve of the *c* outlines the face, a dot stands for the eye, and a slight diagonal of white in the curve suggests the mouth. The large *A* comprises the body, feet, and tail, while the tiny *t* completes the word, without interfering with reading the ensemble as a cat. The figure seems to be walking because the left diagonal of the *A* is lower than the right one, and the short horizontals at the base of the *A* suggest feet. Not only is this cat a self-image—*C A* are the artist's initials reversed—but it contradicts the semiotic argument that signifier (*c*-*a*-*t*) and signified (the mental image of a cat) have no natural relation to each other.

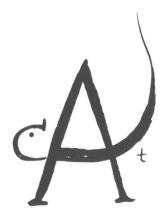

1.14 Alexander Calder, *Cat*, 1976. 22 × 30 in. (55.9 × 76.2 cm).

The importance of line in the artist's vocabulary is illustrated by an account of two ancient Greek painters, Apelles, who was Alexander the Great's portraitist, and Apelles' contemporary Protogenes. Apelles traveled to Rhodes to see Protogenes' work, but when he arrived at the studio, Protogenes was away. The old woman in charge of the studio asked Apelles to leave his name. Instead, Apelles took up a brush and painted a line of color on a panel prepared for painting. "Say it was this person," Apelles instructed the old woman.

When Protogenes returned and saw the line, he recognized that only Apelles could have painted it so well. In response, Protogenes painted a second, and finer, line on top of Apelles' line. Apelles returned and added a third line of color, leaving no more room on the original line. When Protogenes returned a second time, he admitted defeat and went to look for Apelles.

Protogenes decided to leave the panel to posterity as something for artists to marvel at. Later it was exhibited in Rome, where it impressed viewers for its nearly invisible lines on a large surface. To many artists, the panel seemed a blank space, and for that it was esteemed over other famous works. After his encounter with Protogenes, it was said that Apelles never let a day go by without drawing at least one line. This anecdote was the origin of an ancient proverb, "No day without a line."

Shape

Lines enclosing space create shapes. Shapes are another basic unit, or formal element, used by artists. There are regular and irregular shapes. Regular ones are geometric and have specific names. Irregular shapes are also called "biomorphs," or biomorphic (from the Greek words *bios*, "life," and *morphe*, "shape"), because they seem to move like living, organic matter (fig. **I.15**).

Expressive Qualities of Shape Like lines, shapes can be used by artists to convey ideas and emotions. Open shapes create a greater sense of movement than closed shapes (see fig. I.15). Similarly, we speak of open and closed minds. Open minds allow for a flow of ideas, flexibility, and the willingness to entertain new possibilities; closed minds, in contrast, are not susceptible to new ideas.

Specific shapes can evoke associations with everyday experience. Squares, for example, are symbols of reliability, stability, and symmetry. To call people "foursquare" means that they are forthright and unequivocal, that they confront things "squarely." If something is "all square," a certain equity or evenness is implied; a "square meal" refers to both the amount and content of the food. When the term "brick" is applied to people, it means that they are good-natured and reliable. Too much rectangularity, on the other hand, may imply dullness or monotony—to call someone "a square" suggests overconservatism or conventionality.

The circle has had a special significance for artists since the Neolithic era. In the Roman period, the circle was considered a divine shape and thus most suitable for temples. This view persisted in the Middle Ages and the Renaissance, when the circle was considered to be the ideal church plan—even though such buildings were rarely constructed.

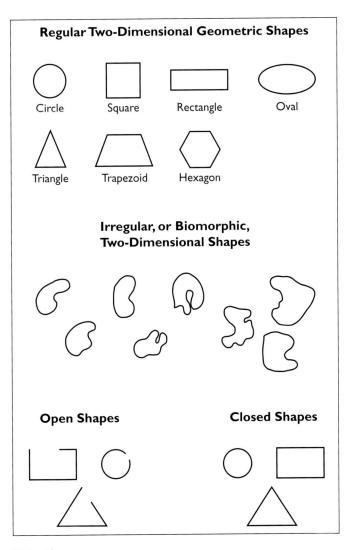

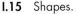

Lines are two-dimensional, but the use of **modeling** lines to form **hatching** or **crosshatching** (fig. **I.16**) creates the illusion of mass and volume, making a shape appear three-dimensional. Hatching and crosshatching can also suggest shade or **shading** (the gradual transition from light to dark) on the side of an object that is turned away from a light source.

Light and Color

The technical definition of light is electromagnetic energy of certain wavelengths that, when it strikes the retina of the eye, produces visual sensations. The absence, or opposite, of light is dark.

Rays of light having certain wavelengths create the sensation of color, which can be demonstrated by passing a beam of light through a prism (fig. **I.17**). This breaks the light down into its constituent **hues**. Red, yellow, and blue are the three **primary colors** (hues) because they cannot

1.16 Drawing of solid shapes showing hatching and crosshatching. The lines inside the objects create the illusion that they are solid and also suggest that there is a source of light coming from the upper left and shining down on the objects. Such lines are called modeling lines.

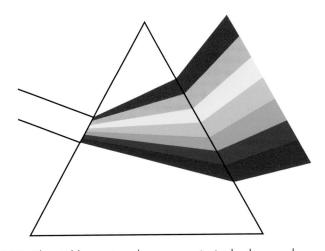

1.17 The visible spectrum has seven principal colors—red, orange, yellow, green, blue, indigo (or blue-violet), and violet—that blend together in a continuum. Beyond the ends is a range of other colors, starting with infrared and ultraviolet, which are invisible to the human eye. If all the colors of the spectrum are recombined, white light is again reproduced.

be produced by mixing any other colors. A combination of two primary colors produces a **secondary color**: yellow and blue make green, red and blue make purple, yellow and red make orange. A **tertiary color** is made by mixing a secondary and a primary color.

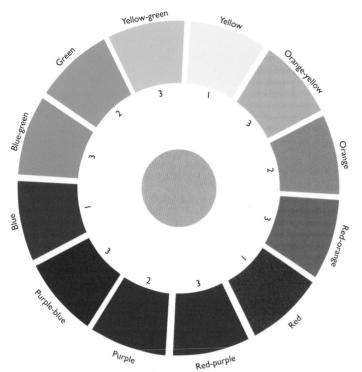

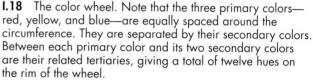

The **color wheel** (fig. **I.18**) illustrates the relationships between the various colors. The farther away hues are, the less they have in common and the higher their contrast. Hues directly opposite each other on the wheel (red and green, for example) are the most contrasting and are known as **complementary colors**. They are often juxtaposed when a strong, eye-catching contrast is desired. Mixing two complementary hues, on the other hand, has a neutralizing effect and lessens the intensity of each. This can be seen in figure I.18 as you look across the wheel from red to green. The red's intensity decreases, and the gray circle in the center represents a "standoff" between all the complementary colors.

The relative lightness or darkness of an object is its **value**, which is a function of the amount of light reflected from its surface. Gray is darker in value than white but lighter in value than black. The value scale in figure **I.19** provides an absolute value for different shades.

Value is characteristic of both **achromatic** works of art—those with no color, consisting of black, white, and shades of gray—and **chromatic** ones (from the Greek word *chroma*, meaning "color"). On a scale of color values

(fig. **I.20**), yellow reflects a relatively large amount of light, approximately equivalent to "high light" on the neutral scale, whereas blue is equivalent to "high dark." The normal value of each color indicates the amount of light it reflects at its maximum intensity. The addition of white or black would alter its value (i.e., make it lighter or darker) but not its hue. The addition of one color to another would change not only the values of the two colors, but also their hues.

Intensity, which is also called saturation, refers to the relative brightness or dullness of a color. Dark red (red mixed with black) is darker in value, but less intense than pink (red mixed with white). There are four methods of changing the intensity of colors. The first is to add white. Adding white to pure red creates light red or pink, which is lighter in value and less intense. If black is added, the result is darker in value as the red is added, the result is less intense but retains the same value. The fourth way of changing a color's intensity is to add its complementary hue. This makes the mixed color less intense and more neutral than the original.

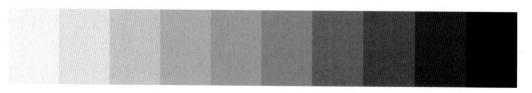

1.19 This ten-step value scale breaks the various shades from white to black into ten gradations. The choice of ten is arbitrary because there are many more values between pure white and pure black. Nevertheless, it illustrates the principle of value gradations.

1.20 A color value scale. The central row contains a range of neutrals from white to black; the rows above and below match the twelve colors from the color wheel with the neutrals in terms of the amount of light reflected from each.

Expressive Qualities of Color Just as lines and shapes have expressive qualities, so too do colors. Artists select colors for their effect. Certain ones appear to have intrinsic qualities. Bright or warm colors convey a feeling of gaiety and happiness. Red, orange, and yellow are generally considered warm, perhaps because of their associations with fire and the sun. It has been verified by psychological tests that the color red tends to produce feelings of happiness. Blue and any other hue containing blue—green, violet, blue-green—are considered cool, possibly because of their association with the sky and water. They produce feelings of sadness and pessimism.

Colors can also have symbolic significance and suggest abstract qualities. A single color, such as red, can have multiple meanings. It can symbolize danger, as when one waves a red flag in front of a bull. But to "roll out the red carpet" means to welcome someone in an extravagant way, and we speak of a "red-letter day" when something particularly exciting has occurred. Yellow can be associated with cowardice, white with purity, and purple with luxury, wealth, and royalty. We might call people "green with envy," "purple with rage," or "in a brown study" if they are quietly gloomy.

Texture

Texture is the quality conveyed by the surface feel of an object. This may be an actual surface or a simulated or represented surface. The surface of Oppenheim's *Furcovered Cup* (see fig. I.11), for example, is actually furry,

but the gold of Mary's crown in figure I.10 is simulated. The cup is made of real fur, whereas van Eyck has painted the crown so that it only looks like real gold.

See figure I.11. Meret Oppenheim, Fur-covered Cup, Saucer, and Spoon (Le Déjeuner en Fourrure), 1936.

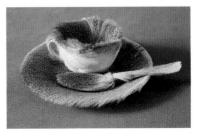

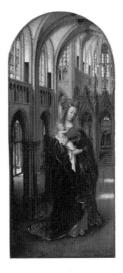

See figure I.10. Jan van Eyck, The Virgin in a Church, c. 1410–1425.

Stylistic Terminology

Subject matter refers to the actual elements represented in a work of art, such as figures and objects or lines and colors. **Content** refers to the themes, values, or ideas in a work of art, as distinct from its form. The following terms are used to describe representational, or figurative, works of art that depict their subject matter so that it is relatively recognizable:

- **naturalistic:** depicting figures and objects more or less as we see them. Often used interchangeably with "realistic."
- **realistic:** depicting figures and objects to resemble their actual appearances, rather than in a distorted or abstract way.

1.21 Theo van Doesburg, study 1 for *Composition (The Cow)*, 1916. Pencil on paper; $4\% \times 6\%$ in. (11.7 \times 15.9 cm). Museum of Modern Art, New York. Purchase.

• **illusionistic:** depicting figures, objects, and the space they occupy so convincingly that the appearance of reality is achieved.

Note that an image may be representational without being realistic. Figures **I.21–I.24** are recognizable as images of a cow and are therefore representational, but only figures I.21–I.23 can be considered relatively naturalistic.

If an image is representational but is not especially faithful to its subject, it may be described as

- idealized: depicting an object according to an accepted standard of beauty.
- **stylized**: depicting certain features as nonorganic surface elements rather than naturalistically or realistically.
- **romanticized:** depicting its subject in a nostalgic, emotional, fanciful, and/or mysterious way.

1.22 Theo van Doesburg, study 2 for *Composition (The Cow)*, 1917. Pencil on paper; $4\% \times 6\%$ in. (11.7 \times 15.9 cm). Museum of Modern Art, New York. Purchase.

1.24 Theo van Doesburg, study for Composition (The Cow), c. 1917 (dated 1916). Tempera, oil, and charcoal on paper; $15\% \times 22\%$ in. (39.7 \times 57.8 cm). Museum of Modern Art, New York. Purchase.

1.23 Theo van Doesburg, study 3 for *Composition (The Cow),* 1917. Pencil on paper; $4\% \times 6\%$ in. (11.7 \times 15.9 cm). Museum of Modern Art, New York. Gift of Nelly van Doesburg.

If the subject matter of a work has little or no relationship to observable reality, it may be called

- **nonrepresentational** or **nonfigurative**: the opposite of representational or figurative, implying that the work does not depict (or claim to depict) real figures or objects.
- **abstract**: describes forms that do not accurately depict real objects. The artist may be attempting to convey the essence of an object rather than its actual appearance. Note that the subject matter may be recognizable (making the work representational), but in a nonnaturalistic form.

The transition from naturalism to geometric abstraction is encapsulated in a series by the early-twentieth-century Dutch artist Theo van Doesburg (figs. I.21–I.25). He gradu-

ally changed his drawing of a cow from I.21, which could be called naturalistic, figurative, or representational, to image **I.25**, which is an abstract arrangement of flat squares and rectangles. In I.21 and I.22, the cow's form is recognizable as that of a cow-it is composed of curved outlines and a shaded surface that creates a three-dimensional illusion. In image I.23, the cow form is still recognizable, especially since it follows I.21 and I.22. It is now devoid of curves but still shaded---it has become a series of volumet-ric (solid, geometric) shapes. Even in image I.24, the general form of the cow is recognizable in terms of squares, rectangles, and triangles, but there is no longer any shading. As a result, each distinct color area is flat. In image I.25, however, the shapes can no longer be related to the original natural form. It is thus a pure abstraction and is also nonfigurative and nonrepresentational.

1.25 Theo van Doesburg, study for Composition (The Cow), c. 1917. Oil on canvas; $14\frac{3}{4} \times 25$ in. (37.5 \times 63.5 cm). Museum of Modern Art, New York. Purchase.

The Art of Prehistory

Window on the World One: Rock Paintings of Australia

- 2 The Ancient Near East
- **3** Ancient Egypt

1

4 The Aegean

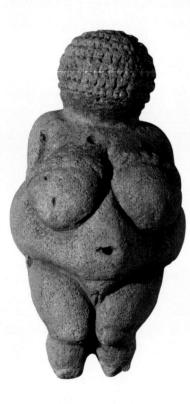

CHAPTER PREVIEWS

PREHISTORY TO THE BRONZE AGE IN WESTERN EUROPE

Paleolithic (c. 50,000–c. 8000 B.C.) Ice Age ends c. 30,000 B.C. Use of stone tools and weapons Hunting-and-gathering life style First evidence of sculpture (c. 25,000 B.C.) First evidence of painting (c. 25,000 B.C.) Shamanism

Rock Paintings of Australia

The Dreaming Mesolithic (c. 8000–6000/4000 B.C.) Tassili rock painting, Algeria Transition to agriculture Neolithic (c. 6000/4000–c. 1500 B.C.) Settled communities Megalithic architecture Ggantija Temple, Malta Stonehenge, England

THE ANCIENT NEAR EAST, c. 9000-300 B.C.

Neolithic (c. 9000–5th millennium B.C.) Jericho skulls; Çatal Hüyük; polytheism Mesopotamia (c. 4500–c. 600 B.C.) Ziggurats; urbanization; cylinder seals Cuneiform; the *Epic of Gilgamesh* Akkad: Sargon; Naram-Sin Neo-Sumerian: Gudea Babylon: Hammurabi's law code Assyrian Empire, Neo-Babylonian Empire Anatolia: Hittite Empire (c. 1450–1200 B.C.) Neo-Babylonian Empire (612–539 B.C.) Iran (c. 5000–331 B.C.); Achaemenid Empire Scythians (8th–4th centuries B.C.); Animal Style

ANCIENT EGYPT, c. 5450-31 B.C.

Predynastic (5450–3100 B.C.) Unification of Upper and Lower Egypt (3100 B.C.) Palette of Narmer: pharaonic rule; polytheism Old Kingdom (2649–2150 B.C.) Beginning of monumental royal art and architecture Middle Kingdom (c. 1991–1700 B.C.) New Kingdom (1550–1070 B.C.) Amarna period (c. 1349–1336 B.C.) Akhenaten's monotheism: worship of the Aten Nubia: cross-cultural influences

ТНЕ AEGEAN, с. 3000-1100 в.с.

Cycladic Bronze Age (c. 3000–1100 B.C.): marble idols Minoan (c. 3000–1100 B.C.) Myth of Europa; palace at Knossos; Linear A Thera destroyed (c. 1500 B.C.); frescoes Mycenae (c. 1600–1100 B.C.) Citadels; megaron; Cyclopaean masonry; tholos tombs; Linear B Trojan War (c. 1180 B.C.)

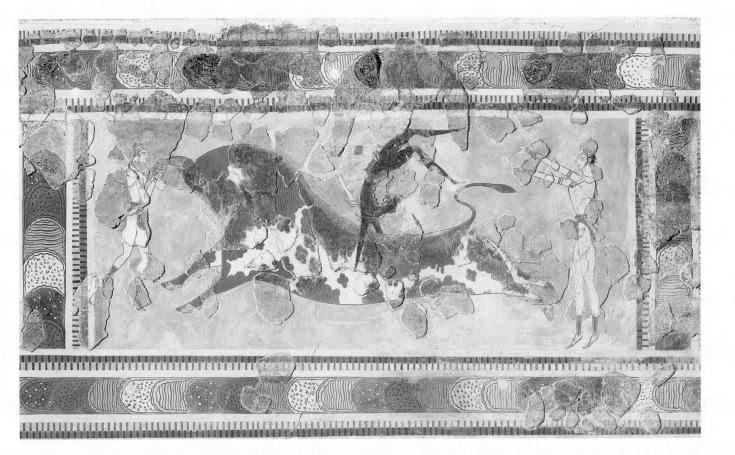

The human race existed for many millennia before producing works of art. We do not know how or when art began; but since their appearance, the arts have provided us with visual records of cultures, of history, and of the human creative impulse. Paleolithic (Old Stone Age) artists carved small-scale sculptures and painted life-size images on cave walls. In Neolithic (New Stone Age) periods, when settled communities formed, monumental stone architecture began.

The rise of cities and the invention of writing (c. 3000 B.C.) in ancient Mesopotamia (modern Iraq) ushered in a period of enormous artistic creativity, including the first literary epic—the *Epic of Gilgamesh*. Ancient Egypt was home to one of the world's longest-lasting civilizations, ruled from about 3100 B.C. to 31 B.C. by dynasties of pharaohs. Their monumental royal art has been preserved by elaborate burials and a dry climate. North of Egypt, Cycladic artists created marble idols dating from the Bronze Age (c. 3000–1100 B.C.). On the Mediterranean island of Crete, the palace period of the seafaring Minoans flourished from about 2000 B.C. but declined when the island was invaded around 1400 B.C. by Mycenaeans from the Greek mainland. The warrior culture of Mycenae is immortalized not only in its impressive art and architecture, but also in the Homeric epics that recount the Trojan War (c. 1180 B.C.) and its aftermath—the *Iliad* and *Odyssey*—and in the dramatic works of later Greek playwrights.

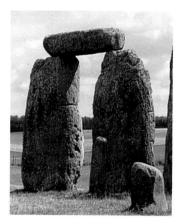

The Art of Prehistory

Where we? Where do we come from? Where are we going? These are the three most universal questions. They are about time—past, present, and future—as well as about the nature of the human condi-

tion. The more we know about our past, the better we understand our present. We will begin by going back in time to early periods of the human race in western Europe, to the study of prehistory (see map, p. 32). Prehistory refers to the time before people developed writing systems and, therefore, before the existence of written documents. In one sense, the term *prehistory* is a misnomer because objects and images are actually historical records of a sort. The challenge lies in discovering how to read such nonverbal information.

The Stone Age in Western Europe

To organize the vast span of prehistory, scholars currently divide the Stone Age in western Europe into three large time periods. The dates of these periods fluctuate as new research reshapes our understanding of prehistoric societies. Paleolithic (from the Greek words *paleos*, meaning "old," and *lithos*, meaning "stone") is the earliest of the three periods. It is subdivided into three shorter periods: Lower (beginning c. 1,500,000 years ago), Middle (beginning c. 45,000/50,000 years ago). The Mesolithic ("middle stone") period extends from around 8000 to 6000 B.C. in southeastern Europe, and around 8000 to 4000 B.C. throughout the rest of Europe. The Neolithic ("new stone") period dates from about 6000/4000 to 2000 B.C. and continues for another thousand years in northwestern Europe.

The designation of these early periods as Stone Age derives from people's dependence on tools and weapons made of stone. As metalworking technology developed in different regions at different times, metal would eventually supersede stone for many purposes. Then, as now, technological and social change went hand in hand, bringing the Stone Age to a gradual close.

Upper Paleolithic (c. 50,000/45,000-c. 8000 B.C.)

By the beginning of the Upper Paleolithic era in Europe, our own subspecies, *Homo sapiens sapiens* (literally "wise wise man"), had supplanted the earlier *Homo sapiens* people, who had developed complex cultures. We can gain some understanding of what Paleolithic society may have been like by interpreting physical remains. But because ideas cannot be fossilized, there is much that will never be known.

Inferences about Paleolithic religion have been drawn from ritual burial practices. Red ocher—possibly symbolizing blood—was sprinkled on corpses, and various objects of personal adornment (such as necklaces) were buried with them. Bodies were arranged in the fetal position, often oriented toward the east and the rising sun, which must have seemed reborn with every new day. Such practices have been interpreted as a sign of belief in life after death and offer some insight into the way Paleolithic people answered the third question posed at the start of this chapter: Where are we going?

Paleolithic cultures were nomadic, subsisting by hunting and gathering, and moving from place to place in search of food. They lived communally, building shelters at cave entrances and under rocky overhangs. Their tents were made of animal skins and their huts of mud, plant fibers, stone, and bone. Fire had already been used for some 600,000 years, and there is evidence of hearths in Paleolithic homes.

Although the invention of writing was still a long way off, people made symbolic marks on hard surfaces, such as bone and stone, possibly to keep track of time. The sophistication of Upper Paleolithic art suggests that language had also been developed, which in itself requires a sense of sequence and time.

The earliest surviving works of Western art correspond roughly to the final stages of the Ice Age in Europe and date back to about 30,000 B.C. Before that time, objects were made primarily for utilitarian purposes, although many have aesthetic qualities. It is important to remember, however, that our modern, Western concept of "art" would almost certainly have been alien to prehistoric people. For them, as for many later cultures, an object's aesthetic value was inseparable from its function.

Upper Paleolithic Sculpture

(с. 25,000 в.с.)

Upper Paleolithic artists produced a wide range of small sculptures made of ivory, bone, clay, and stone. These depict humans, animals, and combinations of the two. Many show a high level of technical skill, with finely carved lines representing natural surface details. Artists created other portable objects such as spear throwers (sticks against which spear shafts were fitted to increase the range and impact of the spear), musical instruments, and objects of personal adornment (such as beads and pendants).

Perhaps the most famous Paleolithic sculpture is the small limestone statue of a woman, the so-called Venus of *Willendorf* (fig. **1.1a**, **b**, and **c**), variously dated from 25,000 to 21,000 B.C. Although this figure can be held in the palm of one's hand, it is a monumental object with a sense of organic form. The term monumental can mean literally "very big" or, as is the case here, "having the quality of appearing very big." In fact, the Venus of Willendorf is only 4% inches (11.5 cm) high. It is evidence of a well-developed aesthetic sensibility and was carved by an experienced artist (see box, p. 30). The rhythmic arrangement of bulbous oval shapes emphasizes the head, breasts, torso, and thighs. The scale of these parts of the body in relation to the whole is guite large, while the facial features, neck, and lower legs are virtually eliminated. The arms, resting on the breasts, are so undeveloped as to be hardly noticeable.

The Venus of Willendorf is a strikingly expressive figure. But what, we might ask, did she mean to the artist who carved her? And what was her function in her cultural context? Unfortunately, we can only speculate. The artist has emphasized those parts of the body related to reproduction and nursing. Furthermore, a comparison of the front with the side and back shows that, although it is **a sculpture in the round** (see box, p. 30), more attention has been lavished on the front. This suggests that the figure was intended to be viewed from the front.

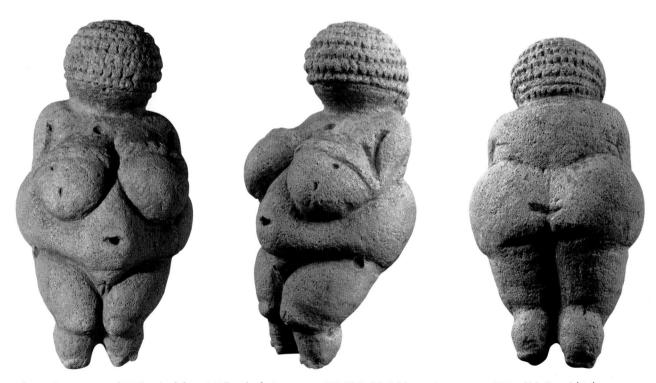

1.1a, b, and **c** Venus of Willendorf, from Willendorf, Austria, c. 25,000–21,000 B.C. Limestone; 4% in. (11.5 cm) high. Naturhistorisches Museum, Vienna.

Carving

Carving is a subtractive technique in which a sculptor uses a sharp instrument such as a knife, gouge, or chisel to remove material from a hard substance such as bone, wood, or stone. After an image is shaped, it can be sanded, filed, or polished. The *Venus of Willendorf* was not polished, although some Paleolithic sculptures were. It is made of limestone, which does not polish as well as other types of stone.

The Venus of Willendorf is one of a number of prehistoric female figurines that scholars have nicknamed Venus (after the much later Roman goddess of love and beauty), although there is no evidence as to who, if anyone, the figurines were meant to represent. They all exaggerate the breasts and hips, suggesting a cultural preoccupation with fertility, on which the survival of the species depends. Unlike many Upper Paleolithic art forms, these female figurines are found throughout Europe and are thought to be roughly contemporaneous (c. 25,000-21,000 B.C.). Some, like the Venus of Willendorf, are relatively naturalistic; others are abstract. Their interpretation as fertility goddesses is one possibility among several. Another theory suggests that these figures were used for some kind of ritual exchange between groups of people during periods of environmental instability, when such interaction would have been necessary for collective survival.

Most prehistoric sculptures are in the round, but Paleolithic artists also made **relief** sculpture (see box). A good example of relief is the so-called *Venus of Laussel* (fig. **1.2**), which has traces of the red ocher **pigment** (see box) also

Categories of Sculpture

Sculpture in the round and in **relief** are the two most basic categories of sculpture. Sculpture in the round refers to any sculpture that is completely detached from its original material so that it can be seen from all sides, such as the *Venus of Willendorf* (fig. 1.1a, b, c). The *Venus of Laussel* (fig. 1.2) remains partly attached to its original material, in this case limestone, so that it is shown in relief—that is, there is at least one angle from which the image cannot be seen. Sculpture in relief is more pictorial than sculpture in the round because some of the original material remains and forms a background plane.

There are different degrees of relief. In **high relief**, the image stands out relatively far from the background plane. In **low relief**, also called bas-relief (*bas* means "low" in French), the surface of the image is closer to the background plane. When light strikes a relief image from an angle, it casts a stronger shadow on high relief than on low relief and thus defines the image more sharply. Reliefs can also be **sunken**, in which case the image or its outline is slightly recessed into the surface plane, as in much ancient Egyptian carving (see Chapter 3).

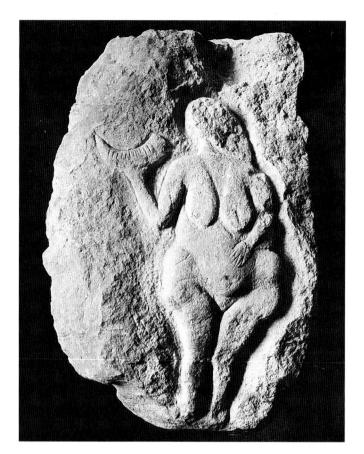

1.2 Venus of Laussel, from Laussel, Dordogne, France, c. 25,000–23,000 B.C. Limestone; 17% in. (44.0 cm) high. Fouilles Lalanne, Musée d'Aquitaine, Bordeaux, France.

Pigment

Pigment (from the Latin word *pingere*, meaning "to paint") is the basis of color, which is the most eye-catching aspect of most paintings. Pigments are colored powders made from organic substances, such as plant and animal matter, or inorganic substances, such as minerals and semiprecious stones. Cave artists either applied powdered mineral colors directly to damp walls or mixed their pigments with a liquid, the **medium** or **binder**, to adhere them to dry walls.

Technically, the medium is a liquid in which pigments are suspended (but not dissolved). The term **vehicle** is often used interchangeably with "medium." If the liquid binds the pigment particles together, it is referred to as the binder or binding medium. Binders help paint adhere to surfaces, increasing the durability of images. Cave painters used animal fats and vegetable juices, water, or blood as their binding media.

Pigment is applied to the surface of a painting, called its **support.** Supports vary widely in Western art—paper, canvas, pottery, even faces and the surface of one's body. For the cave artist, the walls of the cave were the supports.

Modeling

Modeling, unlike carving, is an additive process and its materials (such as clay) are pliable rather than hard. The primary tools are the artist's hands, especially the thumbs, although various other tools can be used. Until the material dries and hardens, the work can still be reshaped.

Clay that has been heated (fired) in a **kiln** (a special oven) is more durable and waterproof. A Paleolithic kiln for firing clay statues of women and animals has been found in eastern Europe, and a variety of finely crafted, decorated clay vessels was made in western Europe during the Neolithic period.

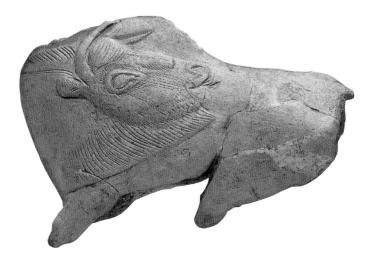

1.3 Bison with turned head, from La Madeleine, Tarn, France, c. 11,000–9000 B.C. Reindeer horn; 4½ in. (10.5 cm) long. Musée des Antiquités Nationales, Saint Germain-en-Laye.

present on the *Venus of Willendorf*. Although there is no archaeological evidence, the red color might have represented the blood of childbirth, an association reinforced by the form itself. The pelvis and breasts are exaggerated, although the arms are slightly more prominent than those of the *Venus of Willendorf*. In her right hand, the *Venus of Laussel* holds an animal horn.

In addition to female figurines, Upper Paleolithic artists produced portable representations of animals. Most often found are horses, bison, and oxen; less frequently found are deer, mammoths, antelope, boar, rhinoceri, foxes, wolves, bears, and an occasional fish or bird. A bison carved from reindeer horn (fig. **1.3**) illustrates the naturalism of Paleolithic animal art. The finely

incised (cut) lines of the beard and the sharp turn of the head reveal a keen observation of detail as well as the capacity to render the illusion that the animal is turning in space.

Two sculptures of bison were found more than 700 yards (640 m) inside a cave at Tuc d'Audoubert in Ariège, in the Dordogne region of France (fig. **1.4**). The animals are naturalistically **modeled** (see box) in high relief from the clay floor of the cave. Their manes and facial features, on the other hand, are incised, probably with a sharp flint blade. The Tuc d'Audoubert bison seem to emerge from the ground as if rising out of the cave's mud floor. This merging of natural and created form is characteristic of much Stone Age art.

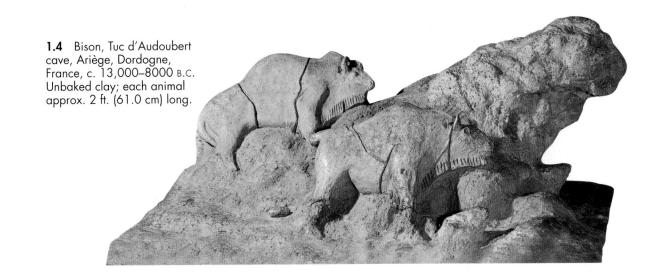

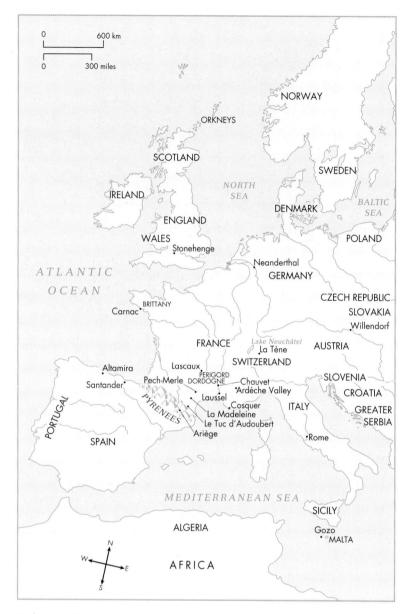

Prehistoric Europe.

Upper Paleolithic Painting in Spain and France (c. 30,000–c. 10,000 в.с.)

Most surviving European Paleolithic cave paintings are located in over two hundred caves in the cliffs of northern Spain, especially the Pyrenees Mountains, and the Périgord and Dordogne regions in France. The concentration of cave art in this part of Europe has puzzled scholars. Some now think that the treeless plains, uncovered as the glaciers retreated northward, would have supported unusually large herds of animals, which in turn would have supported whatever human populations existed in the area. The well-preserved state of these cave paintings when they were first discovered was due mainly to the fact that most of the caves are limestone and had been sealed up for thousands of years. After exposure to the modern atmosphere and visitor traffic, the paintings began to deteriorate so rapidly that some caves have been closed to the public.

Like the Tuc d'Audoubert bison, the paintings that have survived are primarily found deep within caves, in interiors that are difficult to reach and uninhabitable. They seem to have served as sanctuaries where fertility, initiation, and hunting rituals were performed and seasonal changes recorded. The predominance of animal representations is in part a reflection of the importance of hunting. But the animals most often depicted do not coincide with those that were hunted most, suggesting that these images had other meanings as well.

Cosquer and Chauvet Two Upper Paleolithic caves were discovered in the 1980s and 1990s in southern and southeastern France. In 1985, the deep-sea diver Henri Cosquer found a passage 121 feet (36.88 m) below sea level near Marseilles. An ascending passage led to a cave, now named after him, that had remained above sea level when the coastal water level rose, cutting it off from land. Six years later, Cosquer discovered a wealth of art-paintings and engravings-on the walls and ceilings of the cave. The images have been securely dated to two periods. The first group, dating to about 25,000 B.C., consists of stenciled hands surrounded by red and black pigment, and of repeated indented lines called "finger tracings." The second group, from c. 16,000 B.C., consists of painted and engraved animals.

One of the most unusual features of Cosquer cave art is the large number of sea animals, including seals, auks, a fish, and forms presently interpreted as jellyfish (fig. **1.5**). Also unusual is

the fact that precise dating is possible because samples of the charcoal used in the paintings, as well as pieces of charcoal recovered from the cave floor, have been subjected to radiocarbon testing (see box, p. 14).

In 1994, three speleologists (cave explorers) found the entrance to an underground cave complex in the Ardèche Valley, in southeast France. They came upon an interior chamber, now named for Jean-Marie Chauvet, a member of the team. The cave proved to be the largest so far known in this region and contains over three hundred wall paintings, engravings, Paleolithic bear skeletons and a bear's skull set on a rock, evidence of fires, and footprints. Radiocarbon analysis indicates a very early date of around 30,000 B.C. for some of the paintings, which are generally outlined in red or black pigment. As at other Upper Paleolithic caves in southern France and northern Spain, they

1.5 Jellyfish, Cosquer cave, near Marseilles, France, c. 25,000 B.C. Painting on a black stalagmite.

represent mainly animals along with some signs especially red dots and handprints. These animal images are unusual, however, in that there are many rhinoceri and large felines.

Spotted figures identified as a panther and a hyena (fig. **1.6**) are, according to the explorers, unprecedented in cave art of the Ardèche region. They are outlined in red ocher,

which is characteristic of the animals close to the cave entrance. The curved edges and the rock itself impart a sense of natural bulk similar to that found elsewhere in Paleolithic animal art. Also conveyed is the hyena's characteristic aggression: its head, accentuated by the spots, juts forward on a downward diagonal that visually overwhelms the smaller animal below.

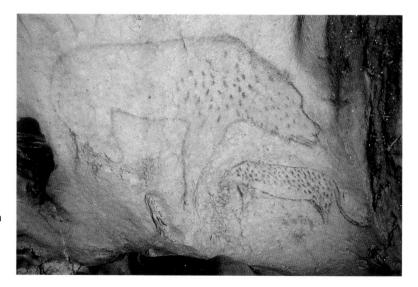

1.6 Hyena and panther, Chauvet cave, Ardèche Valley, France, c. 25,000–17,000 B.C. Red ocher on limestone wall. Courtesy of J. Clottes, the Regional Office of Cultural Affairs, Rhône-Alpes, and the Ministry of Culture and Communication (Direction du Patrimoine, sous Direction de l'Archéologie).

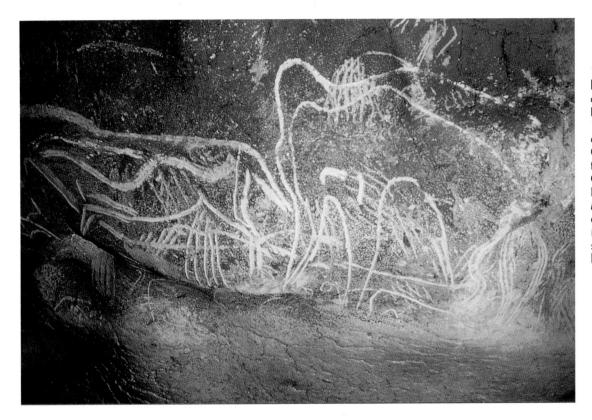

1.7 Mammoths and horses, Chauvet cave, Ardèche Valley, France, c. 25,000– 17,000 B.C. Engraving on limestone wall. Courtesy of J. Clottes, the Regional Office of Cultural Affairs, Rhône-Alpes, and the Ministry of Culture and Communication (Direction du Patrimoine, sous Direction de l'Archéologie).

Altogether, thirty-four images of mammoths were found at Chauvet, of which twenty-one are engraved into the rock and thirteen are painted. The two superimposed engraved examples in figure **1.7** are depicted as if following an engraved horse, whose mane is indicated by a thick line. This one was placed over a series of parallel incised lines identified as claw marks by explorers. The overlapping images are unexplained but may have been made at different times and ritually repeated. Note that we see *through* the animals in a way that is not naturalistic, and it is not clear whether the significance of the superimposition is formal or iconographic.

The so-called "Lion Panel," part of which is shown in figure **1.8**, represents various species of animals proceeding

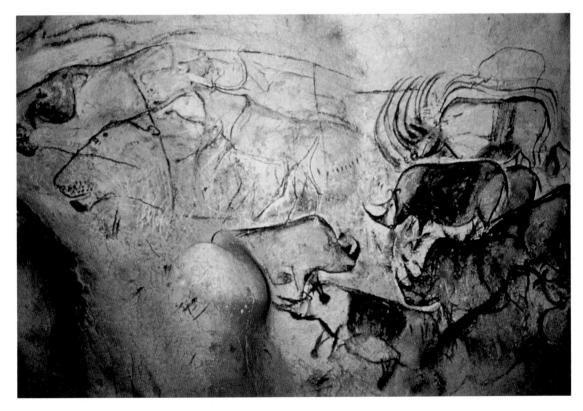

1.8 Left section of the "Lion Panel," Chauvet cave, Ardèche Valley, France, c. 25,000– 17,000 B.C. Black pigment on limestone wall. Courtesy of J. Clottes, the Regional Office of Cultural Affairs, Rhône-Alpes, and the Ministry of Culture and Communication (Direction du Patrimoine, sous Direction de l'Archéologie). across a niche in the wall. Visible here are three large lions and numerous smaller, but more densely painted, rhinoceri. Some are shaded, which enhances the sense of massive bulk. One faces a group that seems to be moving toward it. It is not clear whether this is a coherent scene or a ritual repetition. Some are superimposed—those at the top while the others are spread across the surface of the wall. Under the painting of the lions, traces of red pigment can be seen, as well as the outline of a deer. Like the other animals rendered in black, these are deep within the interior of the cave, suggesting that the red paintings precede the black ones chronologically.

Since the Cosquer and Chauvet caves are recent discoveries, explorers and archaeologists are in the early stages of studying them. As with all finds, the caves expand our knowledge even as they raise new questions.

Pech-Merle At Pech-Merle, in the Dordogne region of France, several handprints have been found on cave walls and are also quite common elsewhere in the Paleolithic period. The hands were placed against a wall with the fingers spread out (fig. **1.9**). Pigment was then applied around them, leaving the shape of the hand visible. Sometimes, the hand itself was covered with pigment and pressed onto the wall. Handprints were also made by pressing against a damp clay wall to leave an impression. The example in figure 1.9 is a small hand of the first type, and it is juxtaposed with black shapes.

The significance of these hands has proved to be elusive. According to one scholar, André Leroi-Gourhan (see box, p. 39), the hand is a female sign and the dots a male one. Another scholar, Henri Breuil, believed such handprints may have been made during initiation ceremonies. Many of the hands appear to be missing one or more fingers, a fact that has elicited several interpretations—from ritual amputation to frostbite. Another hypothesis is that they represent a code of hand signals used by hunters to communicate silently while stalking their prey (similar signals are still used today in certain hunting societies).

Shamanism

Shamanism exists today in certain small-scale societies throughout the world and seems to have been a feature of some prehistoric cultures. Shamans, from the Tunguso-Manchurian word saman (meaning "to know"), function as intermediaries between the human and the spirit worlds. They communicate with spirits by entering a tranceinduced by rhythmic movement or sound, hallucinogenic drugs, fasting, and so forth-during which one or more spirits "possess" them. Shamans are revered healers and problem solvers in their communities and are feared for the harm they could do if angered. They foretell the future, cure the sick, and assist in such rites of passage as birth and death. Shamans are highly individualistic, often living on the fringes of society, and do not participate in organized religion. They generally wear ritual costumes made of animal skins and horns or antlers (see fig. 1.10a and b), and carry ritual objects such as rattles. Dancing and chanting typically accompany shamanic ceremonies.

1.9 Handprints, Pech-Merle, Dordogne, France, c. 16,000 B.C. The cave at Pech-Merle is an underground complex that seems to have been in use periodically for about five thousand years. In addition to handprints, the cave paintings include animals and geometric signs. **Trois-Frères** Cave art has often been interpreted as evidence of an intimate relationship between image making and religious practice. Figure **1.10**, from the cave of Trois-Frères in Ariège, shows a hybrid creature—part human, part animal—in the midst of superimposed animals. Human figures are rare in Upper Paleolithic cave art, and their interpretation is debated. This particular painting seems to represent either a ritual or a supernatural event.

In contrast to the animals, which are nearly always in profile, this creature turns and stares out of the rock. His pricked-up ears and alert expression suggest that he is aware of an alien presence. The figure can be read as a man dressed as a stag. His pose and costume suggest that he may be a shaman (see box, p. 35) engaged in a ceremonial identification with the animal. Alternatively, the figure can be interpreted as an animal-god.

1.10a (above) Shaman, Trois-Frères cave, Ariège, Dordogne, France, c. 13,000–11,000 B.C. 24 in. (60.0 cm) high.

1.10b (right) Drawing by Henri Breuil. Breuil described the process of making his drawing from the original surface of the cave wall: "How the artist who drew it could have worked four meters (13 ft.) above the floor was a problem which I had to solve myself and without a ladder . . . there is a small, projecting rock where one's right foot can rest; then, taking a firm hold . . . and making a complete half turn, it is possible to sit quite comfortably on the uneven surface. . . . It is difficult to hold at the same time a lamp, one's paper and pencil and a drawing board for the retouching of a tracing, taking care at the same time not to slide downwards."¹

Lascaux The most famous examples of cave art in France are the wall paintings at Lascaux, in the Dordogne (figs. **1.11**, **1.12**, **1.13**, **1.14**). Located deep within the recesses of the caves, they consist of a wide range of animal species and a few human stick figures painted with earth-colored pigments—brown, black, yellow, and red. The pig-

ments were ground from minerals such as ocher, hematite, and manganese and applied to the natural white limestone surfaces of the walls. The Lascaux artists created their figures by first drawing an outline and then filling it in with pigment. The pigment itself was stored in hollow bones plugged at one end, which may also have been used

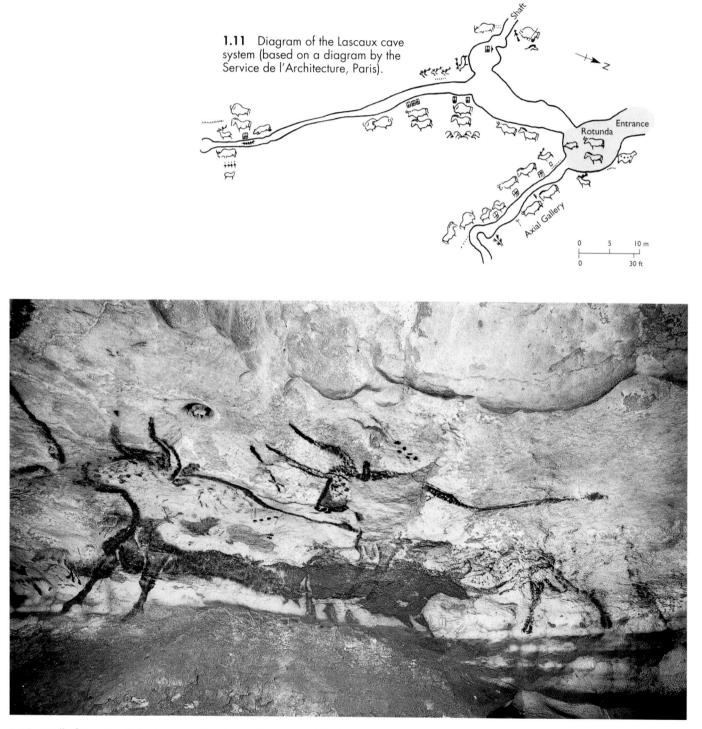

1.12 Hall of Running Bulls, Lascaux, Dordogne, France, c. 15,000–13,000 B.C. Paint on limestone rock; individual bulls 13–16 ft. (3.96–4.88 m) long. Note that the white bulls are superimposed over other animals. At Lascaux, as at Chauvet, artists did not always cover up previous representations before adding new ones.

1.13 "Chinese Horse," Lascaux, Dordogne, France, c. 15,000–13,000 B.C. Paint on limestone rock; horse 5 ft. 6 in. (1.42 m) long. The animal acquired its nickname because it resembles Chinese ceramic horses of the Han dynasty.

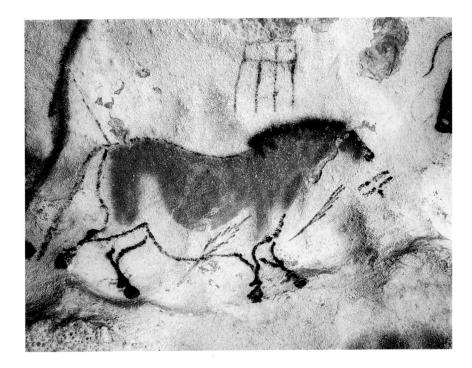

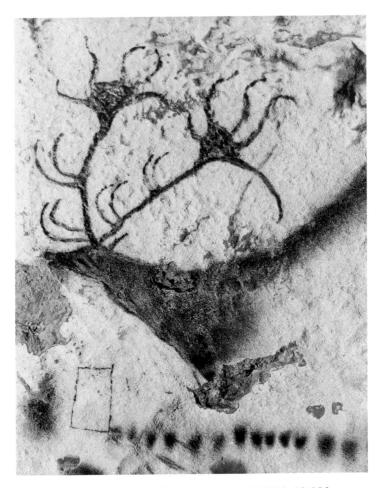

1.14 Reindeer, Lascaux, Dordogne, France, c. 15,000–13,000 B.C. Paint on limestone rock. Stags are less common than horses in Paleolithic art. Like the horse, however, this figure has a pronounced dorsal curve that enhances the impression of downhill movement.

to blow the pigment onto the walls. Some of these bone tubes, still bearing traces of pigment, have been found in the caves. These finds, and their interpretation, exemplify the way in which deductions about the use of objects in a prehistoric society are made. Perhaps if the bones containing pigment had been found out of context—that is, far from the paintings—different conclusions about their use might have been drawn.

The Lascaux animals are among the best examples of the Paleolithic artist's ability to create the illusion of motion and capture the essence of certain species by slightly exaggerating characteristic features. Since many Lascaux animals are superimposed, they have been read as examples of image magic. According to this theory, the act of making the image was an end in itself, possibly a symbolic capture of the animal by fixing its likeness on the cave wall.

One Lascaux painting that has given rise to different interpretations is the so-called "Chinese Horse" (fig. 1.13), whose sagging body suggests pregnancy and the imminent delivery of a foal. The two diagonal forms in this detail, one almost parallel to the horse's neck and the other overlapping its lower outline, have been variously identified as plants or as arrows. Because of their similarity to surviving specimens, they may be harpoons. Leroi-Gourhan argues that they are phallic symbols, and therefore male signs, while he reads the lines above the horse as female. The animal's pregnant appearance would be consistent with the paired malefemale imagery of Leroi-Gourhan's structuralist approach (see box, p. 39).

METHODS OF INTERPRETATION

Dating and Meaning of the Cave Paintings

Dating

The French abbot Henri Breuil was the dominant figure in studies of western European cave painting from the early twentieth century until his death in 1961. He dated cave paintings according to a system of development in which "primitive" (in the sense of "schematic" or "abstract") images preceded naturalistic ones. In particular, he noted that some animals are rendered with profile heads and frontal horns, which he called "twisted perspective."

In the 1980s, the French scholar André Leroi-Gourhan developed a system dividing cave painting into four styles that also progressed from "primitive" to complex and naturalistic. Today, however, scholars reject the notion of both an identifiable origin of cave painting and of its stylistic progression. They read artistic development more dynamically, as undergoing various stylistic shifts influenced by changes in technology and other cultural factors. Current scholarship also emphasizes the diversity of Upper Paleolithic art from place to place. The "animal art" of cave paintings in southern France and northern Spain exemplifies one such regional style.

Meaning

In the nineteenth century, reflecting the popular view of "Art for Art's Sake," works of art were thought to have been created for purely aesthetic purposes. Cave paintings were believed to have been made by male artists in their leisure time. In his personal mythic account of the first artist, Whistler described this "first artist" as a man who declined to hunt or fight. Instead, he "stayed by the tents with the women, and traced strange devices with a burnt stick upon a gourd...this devisor of the beautiful—who perceived in Nature...certain curvings, as faces are seen in the fire—this dreamer apart, was the first artist."²

At the turn of the century, the French archaeologist Salomon Reinach read art mainly in social terms. In his view, cave painting was the act of creating an image in order to influence reality, especially to produce magic that would ensure a successful hunt. In the 1920s, Breuil elaborated the notion of cave paintings as attempts at magical control of reality. He also believed that the caves themselves were used as religious sanctuaries in which worship and initiation rites took place.

Leroi-Gourhan's interpretations were based on anthropological structuralism, which sought to identify universal structures in thought, social organization, and cultural expressions such as myth and religion. He disagreed with the hunting-magic theories and devised instead a system of reading certain signs as binary oppositions of male and female forces. For example, he interpreted triangles, ovals, and rectangles as female, and barbed shapes, dots, and short marks as signifying the phallus (see fig. 1.14). Subsequent interpretations have identified multiple sign systems, each with its own symbols, meanings, and functions.

The most recent views locate the significance of cave painting in an environmental context. Thus the depictions of animals reveal changes in season (for instance, a bison's heavy winter coat) and climate (such as the presence of particular species). The concentration of cave art in southwest France and northern Spain is now thought to indicate a corresponding increase in the population of those areas. As a result, rituals and ceremonies involving art became necessary, possibly to reinforce political power.

Fig. 1.7. Mammoths and horses, Chauvet cave.

Fig. 1.9. Handprints, Pech-Merle.

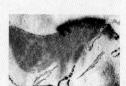

Fig. 1.13. "Chinese Horse," Lascaux.

Fig. 1.14. Reindeer, Lascaux.

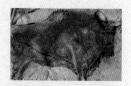

Fig. 1.16. Standing bison, Altamira cave.

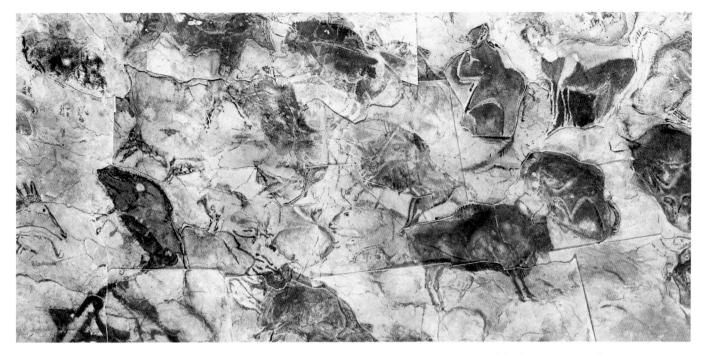

1.15 Ceiling view, Altamira cave, Spain, c. 12,000 B.C. The outlines, limbs, and manes are of black manganese. The interiors are mainly of red ocher with some shading.

Another remarkable group of cave paintings was discovered in 1879 in Santander, Spain (figs. **1.15** and **1.16**). Here the natural bulges in the rock correspond to the contours of various animals—mainly bison, but also boar, horses, deer, and a wolf. Artists perceived the outline in nature and then enhanced the forms with reds, yellows, and browns, and shaded them in black. In addition to paint, carving was used to shape the figures. The standing bison (fig. 1.16) illustrates the monumentality of Stone Age animal representations. The artist has emphasized the bison's thick neck and shoulder muscles, where its main physical strength resides, in contrast to its small head and thin legs.

1.16 (below) Standing bison, Altamira cave, Spain, c. 12,000 B.C. 6×5 ft. (1.8 \times 1.5 m). The shaded application of ocher creates the impression of a three-dimensional mass. The black outline and details are of manganese.

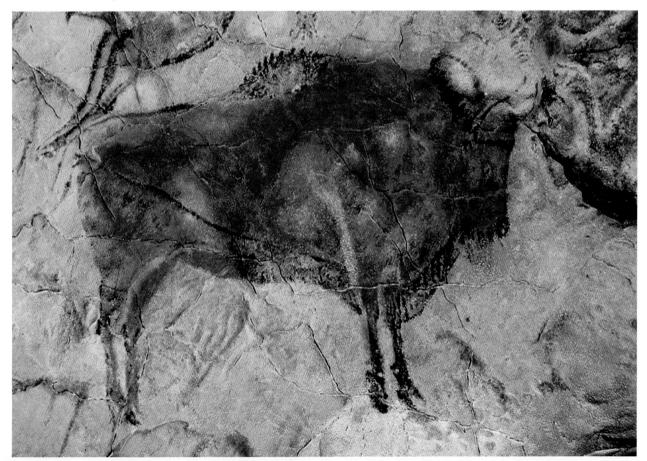

Window on the World One

Rock Paintings of Australia (c. 75,000/50,000 B.C.–the Present)

R ock paintings, carvings, and other art objects have continued to be produced since the Stone Age by certain cultures around the world. A few of these societies that have persisted into our own era appear to have something in common with those of Paleolithic western Europe. There is uncertainty in dating works created by such cultures and in pinning down the antiquity of their mythological traditions.

Nevertheless, these "modern Stone Age" societies may provide valuable clues to the way art functioned in prehistoric Europe.

In the outback of Australia, huntingand-gathering societies, called Aboriginal, have had an unusually long history. Revolutionary archaeological finds in 1996 in a remote part of northwestern Australia at the site of Jinmium challenged basic assumptions about when and where humans evolved (see map). Stone tools and other objects from this site suggest that Australia was inhabited as long ago as 174,000 B.C. Carved rocks discovered there may be roughly 75,000 years old. Recent evidence—a red ocher "crayon"—indicates that people may have been making rock paintings for the past 75,000 years. If accepted, these dates are far older than scholars had believed

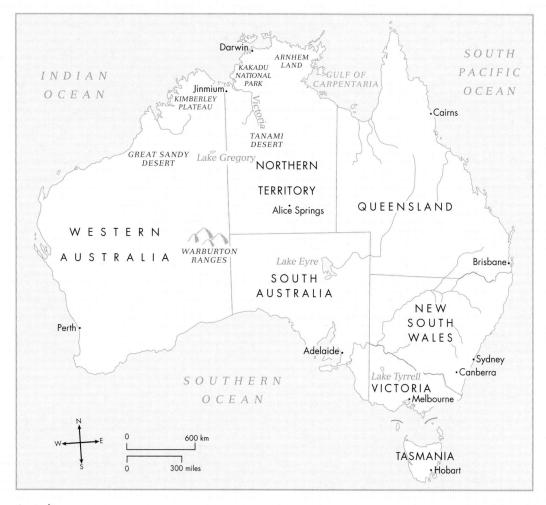

Australia.

possible. Australia is an island that had been relatively isolated from the rest of the world until the eighteenth and nineteenth centuries. Nevertheless, there are remarkable visual similarities between European Paleolithic and Aboriginal rock paintings, including handprints, naturalistic animals, and hunting scenes.

Aside from these works, our knowledge of ancient Aboriginal mythology, ritual, tradition, and social customs comes from contemporary Aborigines. Their society is divided into clans that "own" certain myths and sacred images. Myth and imagery thus assume a concrete value and are considered to be cultural possessions. They have a totemic (ancestral) significance, and it is thus possible that many of the animals represented in Australian rock art are, in fact, totems of particular clans.

The ancestral character of Australian Aboriginal art and religion is related to what has been translated into Western languages as the "Dreaming." This phenomenon is not a sleep dream, but rather a mythological plane of existence. For Aborigines, "Dreamtime" is the order of the universe, which encompasses cosmological time from its beginning to an indefinite future. Included in Dreamtime are ancestors who created and ordered the world and the human societies that populate it. Dreamtime is accessible through the performance of certain rituals-such as creating rock paintings-accompanied by singing and chanting. In the Aboriginal Dreaming, therefore, is contained a wealth of cultural mythology, much of which is revealed in the visual arts.

The Wandjinas, or Cloud Spirits, for example, appear in numerous rock pictures, usually painted in black, red, and yellow on a white ground (fig. W1.1). They combine human with cloud forms and are ancestral creators from the Dreamtime. According to Aboriginal myth, Wandjinas made the earth, the sea, and the human race. They are depicted frontally with large heads, massive upper bodies, and lower bodies that taper toward the feet. Around their heads are feathers and lightning. Their faces typically lack mouths, although the eyes and nose are present. If Wandjinas are offended, they unleash lightning and cause rains and flooding, but they can also bring fertility. Paintings of them are believed to have special powers and, therefore, are approached with caution.

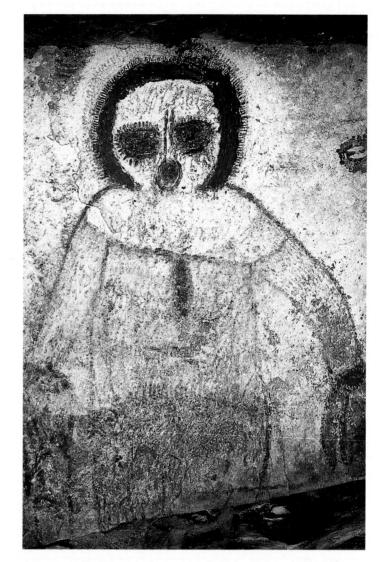

W1.1 Wandjina, Rowalumbin, Barker River, Napier Range, Kimberley, Australia. These rock paintings were discovered in 1837 by an expedition led by George Grey. He described his first view of the Wandjinas as follows: "They appeared to stand out from the rock; and I was certainly rather surprised at the moment that I first saw this gigantic head and upper part of a body bending over and staring down at me."³

The oldest identifiable style of Aboriginal rock painting, referred to as the Mimi style, is found in Arnhem Land in northern Australia (fig. W1.2). Mimi, in Aboriginal myth, are elongated spirits living in rocks and caves. They are taller than humans and are so light that they can be blown away and destroyed by the wind. If a Mimi entices a man to its cave and tricks him into eating its food or sleeping with a Mimi woman, then the human turns into a Mimi and cannot return to his human condition. Mimi are often represented hunting, as they are in figure W1.2, and are believed to have taught hunting to the Aborigines.

The kangaroo, which is indigenous only to Australia and adjacent islands,

is a frequent subject of Aboriginal rock art. Kangaroos have been hunted for thousands of years, probably as a source of food. Those represented in figure W1.3 are trying to escape from a group of hunters, who are both male and female. That the kangaroos are hopping is clear from their poses-the one in the center has just landed and tilts slightly back on its feet. The kangaroo on the left leans forward as if it were trying to regain its balance. In paintings such as this, Aboriginal artists used two relatively different styles: a naturalistic one for animals and a schematic one for humans. This distinction is also a characteristic of western European Upper Paleolithic cave paintings.

The kangaroo in figure **W1.4** is a good example of the **polychrome** (consisting of more than one color) "X ray" style. It is rendered in brown and white as if displaying the inner organic struc-

ture of bone and muscle. Because of its flattened pose, it is stylized rather than naturalistic. The fish-shaped head reflects the appearance of aquatic animals in Aboriginal rock iconography that took place following a rise in sea level around 8000 B.C. The skeletal figure on the right is the fearsome Lightning Man, who is surrounded by an electrical circuit.

W1.2 Mimi hunters, Kakadu National Park, Arnhem Land, Northern Territory, Australia. Rock painting. In the Mimi style, as here, figures are painted in red ocher. These hunters carry spears and boomerangs.

> **W1.3** (below) Men and women hunting kangaroos, Unbalanya Hill, Arnhem Land, Northern Territory, Australia. Rock painting.

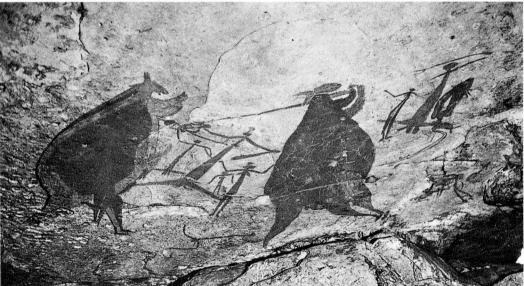

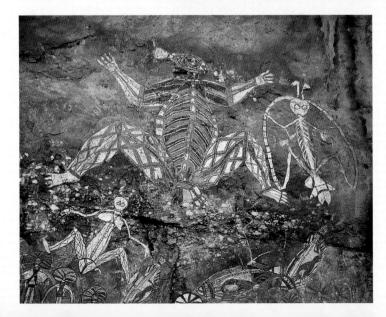

W1.4 Kangaroo with Lightning Man, Nourlangie Rock, Kakadu National Park, Arnhem Land, Northern Territory, Australia. Rock painting. In Dreamtime, the Lightning Man, called Namarrkon or Namarragon, lived in the sky and carried a lightning spear. He tied stone clubs to his knees and elbows so that he would always be prepared to hurl thunder and lightning. For most of the year he lived at the far ends of the sky, absorbing the light of the Sun Woman. When the wet season came, he descended to the earth's atmosphere in order to keep an eye on the human race. When displeased, he hurled spears of lightning across the sky and onto the earth. Some 30 miles (48 km) east of Oenpelli, there is a taboo Dreaming site where Namarrkon is said to have settled. This site is avoided by Aborigines, who fear his wrath.

Mesolithic (c. 8000-c. 6000/4000 в.с.)

The Mesolithic era was a period of transition more noteworthy for its important cultural and environmental changes than for its artistic legacy. It followed the end of the Ice Age and the rapid development of a more temperate climate about 11,000 B.C. With the retreat of the glaciers, forests expanded. Animals that had been hunted in the Paleolithic era died out or migrated, and people began to congregate around bodies of water, where fishing became a major source of food. By the end of the Mesolithic period, many nomadic hunter-gatherer societies had become increasingly settled, differentiated, predominantly agricultural communities.

An African rock painting of the fifth to fourth millennium B.C. from the Sahara appears to represent the period of transition from nomadic hunting and gathering to farming (fig. **1.17**). It shows human figures and domesticated cattle from the Tassili, in modern-day Algeria. Both the figures—who resemble contemporary cattle herders in parts of Africa—and the animals are rendered with considerable naturalism and freedom of movement.

Neolithic (c. 6000/4000-c. 2000 в.с.)

In western Europe, as elsewhere throughout the world, the revolutionary shift from hunting and gathering to farming led to a more settled existence and contributed to the development of a new art form: monumental stone architecture.

The two most impressive types of monumental Neolithic architecture in western Europe are the limestone tombs and temples on Malta, an island between Italy and North Africa, and a type of structure known as a megalith found in parts of France, Spain, Italy, and northern Europe (especially Great Britain). Megaliths (from the Greek word *megas,* meaning "big") are built of huge stones without the use of mortar.

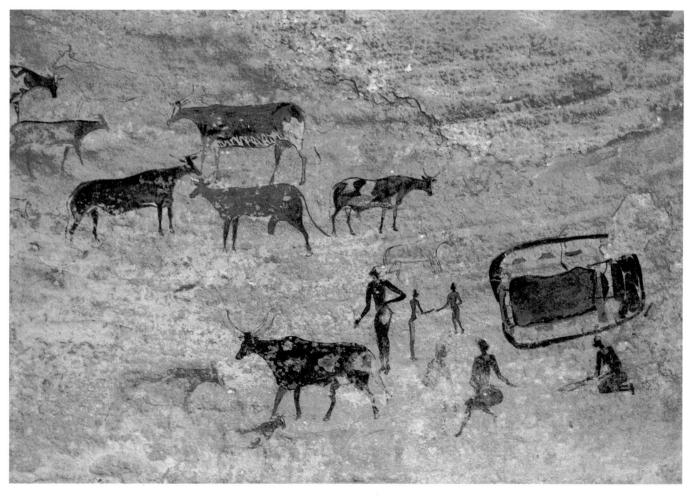

1.17 Saharan rock painting, Tassili, Algeria, Cattle or Pastoralist period, 5th–4th millennium B.C. Photo: Sonia Halliday, Weston Turville, United Kingdom.

Malta

The megaliths on Malta and the adjoining island of Gozo are now dated to before 3000 B.C. Maltese temples are freestanding structures, the products of a civilization that lasted some eight hundred years and then disappeared following an invasion. The biggest temple, Ggantija (meaning "Tower of the Giants"), discovered on Gozo, is located on a hill and faces downward. Its façade (front) was originally nearly 50 feet (15.24 m) high, and its exterior was constructed of rough, uncut limestone slabs, which were rolled to the site on limestone balls. The diagram in figure 1.18 shows that the exterior wall surrounded two temples. The one to the south, at the left, is earlier, and its sanctuary, which is trilobed (i.e., having three rounded projections), is larger than the oval space preceding it. In the northern temple, at the right, the sizes are reversed-the sanctuary is small compared with the oval forecourt in front of it.

Attention was focused on the elaborate interior sanctuaries, which were reached through a series of decreasing and expanding spaces. The narrower spaces contained a **parapet** (a wall around a terrace or balcony), and one curve of the oval forecourt of the southern temple is lined with platforms that resemble altars. There is also evidence that the stone oval at the entrance to this temple was a hearth used in ceremonies and rituals.

Seventeen temples have been excavated so far on Malta. These, like Ggantija, show evidence of libations (poured offerings), divination (forecasting the future), collective human burial, and the presence of an important priesthood. Animal sacrifices—especially of rams and pigs—were performed in the Maltese temples. Artistic production in this religious context includes paintings and sculptures on the walls of the innermost sacred chambers, as well as many female figures.

The most dramatic surviving statue from the Maltese temples is the fragment of a huge figure, possibly a mother goddess (fig. **1.19**). Her large, bulbous

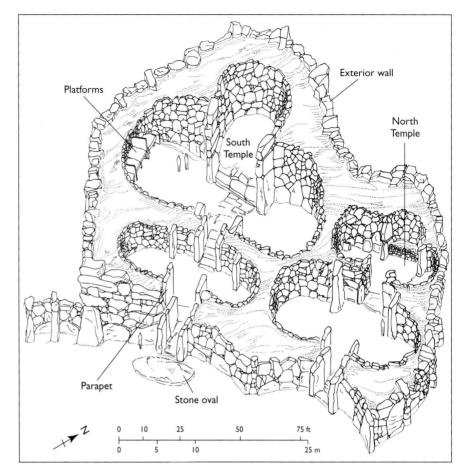

1.18 (above) Reconstruction drawing of the temple at Ggantija, Gozo, Malta.

1.19 "Mother goddess," Tarxien, Malta, before 2500 B.C. Stone fragment.

legs, covered to just below the knees by a pleated skirt, leave no doubt that in her original state she was an imposing and literally gigantic figure. This colossal statue and the abundance of smaller obese female figures point to the presence of a fertility cult. A number of them were ritually covered around the legs with red ocher, suggesting the blood of childbirth, while the rounded plans (see fig. 1.18) of the megalithic tombs and temples on Malta have been interpreted as symbolizing wombs.

The connection between an earth goddess and human burial is most direct at the Maltese site of Hal Saflieni, where a **necropolis**—city of the dead—has yielded the remains of over 7,000 human bodies in addition to statues of females. On Malta, the combination of womblike architectural space with the sculptures of obese women argues for the importance of a chthonian (underground) goddess. At Ggantija, holes apparently provided worshipers with access to the underworld through ritual libations poured into them. Images of the sick or crippled and sculptures of reclining females suggest that the temple was endowed with curative powers. These seem to have been thought most effective if the invalid lay on the sanctuary floor.

Northern Europe

The Neolithic megaliths in Ireland, Britain, France, Spain, and Italy are of a different character from those discovered

on Malta. In northern Europe, three distinctive types of stone structure regularly occur: the menhir. dolmen, and cromlech—these terms are Celtic in origin (see box, p. 48). They are not only visually impressive and mysterious reminders of the ancient past, but are also imbued with fascinating symbolic associations. For megalithic builders, stone as a material was an integral part of cults honoring dead ancestors. Whereas most Neolithic dwellings in western Europe were made of impermanent material such as wood, the tombs-or "houses of the dead"-were of stone so that they would outlast mortal time. Even today we associate these qualities of durability and stability with stone. For example, we speak of things being "written in stone" when we mean that they are unchanging and enduring, and to "stonewall" means to hold up a proceeding for as long as possible. One who is "stoned" is unable to move because of excessive consumption of alcohol or other drugs.

Menhirs Menhirs (from two Celtic words: *men*, meaning "stone," and *hir*, meaning "long") are unhewn or slightly shaped single stones (monoliths), usually standing upright in the ground. They were erected individually, in clusters, or in rows as at Carnac (fig. **1.20**) in Brittany, probably an important Neolithic religious center in what is now northern France. Menhirs have been interpreted as symbolizing the phallic power of the male fertilizing Mother Earth.

1.20 Alignment of menhirs, Carnac, Brittany, France, c. 4000 B.C. Stone; 6–15 ft. (1.83–4.57 m) high. The Carnac menhirs, numbering almost three thousand, are arranged in parallel rows nearly 13,000 ft. (4000 m) long. A small village has grown up around the menhirs.

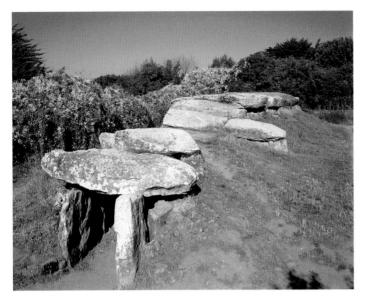

1.21 Dolmen, Carnac, Brittany, France, c. 4000 B.C.

Dolmens Dolmens (from the Celtic word *dol*, meaning "table") are chambers or enclosures consisting of two or more vertical stones supporting a large single stone, much as legs support a table (fig. **1.21**). The earliest dolmens were built as tombs, each enclosing a body. Later additions turned them into passageways. Some interior dolmen walls were decorated with carvings, and others were painted. Occasionally a pillar stood in the center of a burial chamber. Dolmens, like menhirs, were imbued by Neolithic people with symbolic associations. In contrast to the

impermanence of houses built for the living (usually made of mud, plant fibers, and wood), stone burial monuments functioned as links between present time and eternity.

Cromlechs Cromlechs (from the Celtic words *crom*, meaning "circle," and *lech*, meaning "place") are megalithic structures in which groups of menhirs are arranged to form circles or semicircles. By far the greatest number of Neolithic stone circles is found in Britain. Cromlechs must have played a major role in their cultures since the effort required to build them was extraordinary. Although the function and symbolism of their circular forms have not been determined, cromlechs clearly marked sacred spaces.

The most famous Neolithic cromlech in western Europe is Stonehenge (fig. **1.22**), which was built in several stages from roughly 2800 to 1500 B.C. Rising dramatically from Salisbury Plain in southern England, Stonehenge has fascinated its visitors for centuries. The plan in figure **1.23** indicates all stages of construction (Neolithic and later), with the dark sections showing the megalithic circles as they stand today. Many of the original stones have now fallen. The aerial view in figure **1.22** shows the present disposition of the remaining stones and the modern pathway traversed by tourists.

This circular area of land on a gradually sloping ridge was a sacred site before 3000 B.C. Originally, barrows (burial mounds) containing individual graves were surrounded by a ditch roughly 350 feet (107 m) in diameter. A mile-long

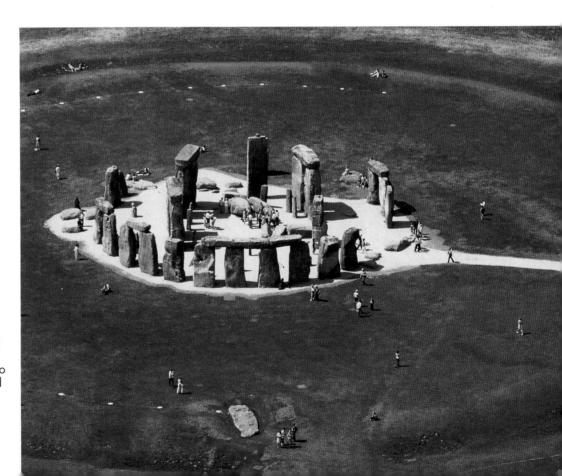

1.22 Stonehenge, Salisbury Plain, England, c. 2800– 1500 B.C. Diameter of circle 97 ft. (29.57 m); height approx. 13 ft. 6 in. (4.00 m). Interpretations of this remarkable monument have ranged from the possible—a kind of giant sundial used to predict seasonal change and astronomical phenomena—to the purely fanciful—a Druid ritual site or a form of architectural magic conjured by Merlin, King Arthur's magician.

The Celts

Celtic terms are used for Neolithic megaliths in western Europe because a large number of them are located in regions later inhabited by Celtic peoples.

The Celts were first identified in the basin of the upper Danube River and southern Germany in the second millennium B.C. Although of mixed origins, they spoke related Indo-European languages. From the early ninth century B.C., the Celts began to migrate throughout western Europe, occupying France, Spain, Portugal, northern Italy (they sacked Rome in 390 B.C.), the British Isles, and Greece. Gaelic-speaking Celts settled in Ireland, Scotland, England, and Wales, and Celtic dialects are still spoken in Great Britain, Ireland, and northern France.

"avenue" was hollowed out of the earth and ran in an east–west direction. Fifty-six pits (known as Aubrey Holes after their seventeenth-century discoverer) were added inside the circular ditch and filled with rubble or cremated human bones. Around the same period, the Heel Stone, a block of sarsen (a local sandstone) 16 feet (4.88 m) high, was set in place outside the ditch in the entrance causeway to the northeast. The first stone circle, consisting of smaller stones called bluestones, imported from Wales (over 100 miles, or 160 km, away), was constructed around 2500 B.C.

Over the next four hundred years, a new group of people settled in western Europe and was assimilated into the

 0
 10
 20
 30
 40 m

 0
 50
 100 ft
 Avenue
 Fallen or missing

 Heel
 Intels
 Intels
 Intels

 Main road
 0
 Intels
 Outer wall of cromlech

 Trillithon
 Intels
 Intels
 Outer wall of cromlech

 North
 0
 Altar:
 0
 Intels

 0
 Altar:
 0
 South
 Intels

 Intels
 Intels
 Intels
 Intels
 Intels

The rigidly organized social structure of the Celts was ruled by a chief. They worshiped many gods and believed in the immortality of the soul. Celtic priests, called Druids, supervised education, religion, and the administration of justice. The rich Celtic oral tradition forms the basis of much European folklore.

Modern scholars disagree about the distinctiveness of the Celts as a separate people. Some scholars argue that there is a nationalistic aspect to the distinction between Celts and other ethnic groups, while others point to ancient Roman textual references to the Celts, suggesting that they were indeed a distinct group.

native population. The origin of these Beaker People, so called after their beaker-shaped pottery, is still a matter of debate. They brought with them a knowledge of metal-working, new building techniques, and pottery. Partly as a consequence of new technology, the Stone Age gave way to the Bronze Age. Nevertheless, before the total disappearance of the Stone Age in western Europe, its most famous architectural monument was completed, apparently by the Beaker People themselves. In the final stages of construction at Stonehenge, huge sarsen blocks were brought to the site from Marlborough Downs, a distance of some 20 miles (32 km). From these larger monoliths, the outer circle and inner U-shape were constructed.

The cromlech at Stonehenge is a series of concentric circles and horseshoe- or U-shaped curves (see figs. 1.22 and 1.23). The outer circle is a **post-and-lintel construction** (fig. 1.24; see box). Each post is a sarsen block 13 feet

In this system of construction, vertical uprights (posts) sup-

port a horizontal element (the lintel). Figure **1.24** is a diagram of the most basic single post-and-lintel form, called a **trilithon.** In later eras, this simple system was elaborated into highly complex structures.

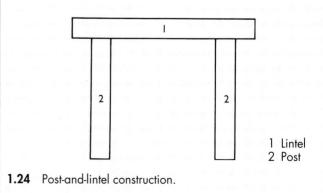

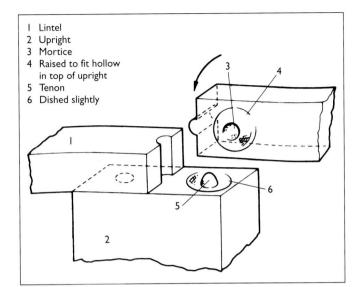

1.25 Lintel and tenon.

(3.96 m) high and is rougher on the outside than on the inside, bulging at its center and then gradually tapering at the top. Projecting above each post was a **tenon**, which fitted into a hole carved out of the lintel (fig. **1.25**). For the outer wall, the lintels were slightly curved to create a circle when attached end to end.

From the inside ring (fig. **1.26**), one can see part of the outer ring and several individual posts and lintels. A second, inner circle consists entirely of single upright bluestones. Inside those are five very large **trilithons** (a pair of sarsen posts supporting a single lintel) arranged in a U-shape. An even smaller U-shape of bluestones parallels the arrangement of the five posts-and-lintels. Within the U of bluestones, one stone lies on the ground. This is referred to as the "altar stone," although there is no evidence that it was ever used as an altar. We do not know how bluestones weighing up to 40 tons (40,640 kg) and sarsens weighing up to 50 tons (50,800 kg) were transported or how the lintels were raised above the posts, but such engineering feats required large-scale social organization and an enormous commitment of resources over a long period of time.

While continuing archaeological activity steadily increases our knowledge of Stonehenge, we still cannot identify its function with absolute certainty. Clearly the presence of circular stone rings throughout western Europe points to a common purpose. Some scholars think that rites, processions, and sacred dances were held in and around the megalithic structures, celebrating the resurgence of life in spring and summer. These practices correlate with what we know of early agricultural societies, for which the timing of seasonal change was of crucial importance.

Also consistent with agricultural preoccupations are interpretations of Stonehenge and other megalithic struc-

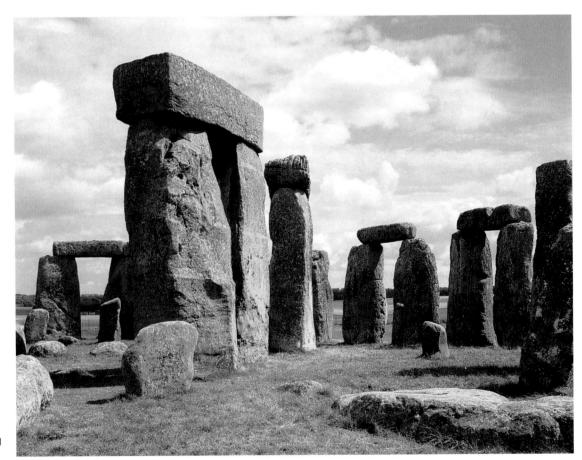

tures as astronomical observatories, used to predict lunar eclipses and to keep track of time. At Stonehenge, for example, the absence of a roof reinforces the relationship of the structure with the sky and celestial phenomena. Carnac (see fig. 1.20) has been described as an observatory in which each menhir functions as a point on a landscape graph. Elsewhere, direct evidence of astronomical markings on carved stones has been found. The circular monuments in particular are aligned according to the positions of the sun and moon at critical times of year. Earlier cromlechs were oriented toward sunrise at the winter solstice,

and later ones at the summer solstice. At Stonehenge, the avenue is aligned with the rising summer sun. An observer standing in the middle of the circle about 1800 B.C. would have seen the sun rise over the Heel Stone on June 21, the summer solstice. Other stones are aligned with the northernmost and southernmost points of moonrise.

The greatest megalithic monument of the Neolithic era in western Europe was also among the last. Around 2000 B.C., as the use of metal increased, the construction of large stone monuments began to decline.

Style/Period

c. 75,000 в.с.

50,000 B.C.

10.000 B.C.

2000 B.C.

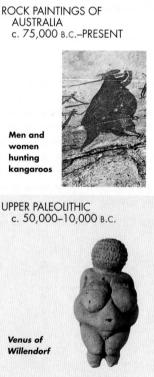

MESOLITHIC c. 8000-c. 6000/4000 b.c.

NEOLITHIC c. 6000/4000c. 2000/1800 b.c.

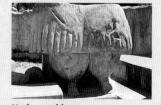

Works of Art

Wandjina (**W1.1**) Mimi hunters (**W1.2**) Men and women hunting kangaroos (**W1.3**) Kangaroo with Lightning Man (**W1.4**)

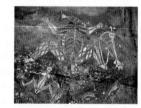

Kangaroo with Lightning Man

Venus of Willendorf (1.1) Venus of Laussel (1.2) Jellyfish (1.5), Cosquer cave Hyena (1.6), Chauvet cave Mammoths (1.7), Chauvet cave "Lion Panel" (1.8), Chauvet cave Handprints (1.9), Pech-Merle Hall of Running Bulls (1.12), Lascaux "Chinese Horse" (1.13), Lascaux Reindeer (1.14), Lascaux Reindeer (1.14), Lascaux Shaman (1.10), Ariège Bison (1.4), Tuc d'Audoubert Altamira cave (1.15), Santander Standing bison (1.16), Santander Bison with turned head (1.3), La Madeleine

Saharan rock painting (1.17), Tassili

Menhirs (1.20), Carnac Dolmen (1.21), Carnac Temple at Ggantija (1.18), Gozo Stonehenge (1.22, 1.23, 1.26), Salisbury Mother goddess (1.19), Tarxien

Stonehenge

Cultural/Historical Developments

Wandjina

Hunting and gathering Evidence of recording time Use of stone tools Last Ice Age (18,000–15,000 в.с.)

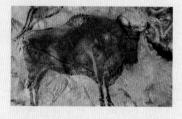

Standing bison

Bow and arrow invented (c. 10,000 B.C.) Wheat and barley cultivated (c. 9000 B.C.)

Development of agriculture; domestication of sheep and goats (c. 6000 B.C.) Megalithic.monuments Copper smelting developed (c. 4500 B.C.) Invention of the potter's wheel (c. 4500-4000 B.C.)

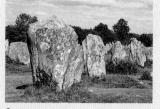

Carnad

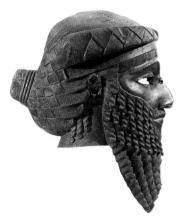

The Ancient Near East

I twas in the ancient Near East (see map) that people first invented writing, which enabled communities to keep records and create a permanent body of literature. The Near East produced the first known

epic poetry, written history, religious texts, and economic records. These provide insights into the origins of human thought and civilization. They also shed light on the artistic products of ancient Near Eastern civilization in a way that is not possible for preliterate times. Before exploring the invention of writing and its relation to art history, however, we shall consider the rise of Neolithic cultures in this part of the world (see box, p. 52).

The Neolithic Era

Neolithic cultures developed some four thousand years earlier in the Near East than in Europe. As with Neolithic cultures in western Europe, those in the Near East emerged during the transition from a nomadic way of life to a more settled one that was centered around agriculture and animal herding. Droughts and floods made growing crops and establishing permanent communities difficult in certain areas. In response, people learned to manage water supplies by building large-scale irrigation systems. The social structures that made this possible—that is, organized labor and stabilized political power—contributed to the development of increasingly complex urban societies.

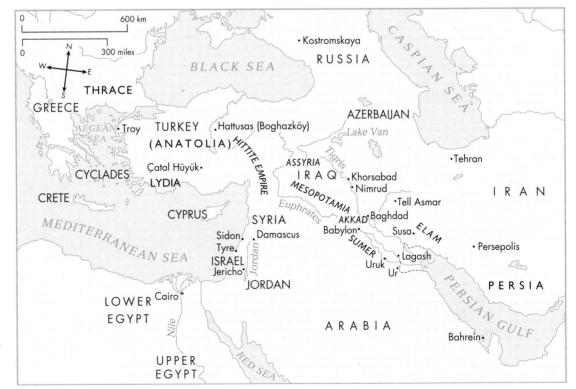

The ancient Near East and the Middle East.

Chronology of the Ancient Near East and Principal Sites

NEOLITHIC ERA

с. 9000-4500/4000 в.с.

MESOPOTAMIA

Uruk period с. 3500-3100 в.с. Sumer Early Dynastic period с. 2800-2300 в.с. Akkad с. 2300-2100 в.с. Neo-Sumerian period c. 2100-1900/1800 B.C. Babylon Old Babylonian period с. 1800-1600 в.с. Neo-Babylonian period с. 612-539 в.с. Assyrian Empire с. 1300-612 в.с.

ANATOLIA

Hittite Empire c. 1450–1200 B.C.)

ANCIENT IRAN c. 5000–331 B.C. Achaemenid Persia 559–331 B.C.

THE SCYTHIANS

8th-4th centuries B.C.

Jericho (in the West Bank) Çatal Hüyük (in modern Turkey)

Modern Iraq Uruk

Sumer Tell Asmar Ur Akkad

Lagash

Babylon

Assur

Modern Turkey Hattusas (modern Boghazköy)

Modern Iran Persepolis (near modern Shiraz)

Modern Russia and Ukraine

Agricultural rituals celebrated fertility and the vegetation cycles of birth-death-rebirth. Perhaps the most constant artistic and religious presence in the Neolithic religions of the Near East was a female deity and her male counterpart. Neolithic architecture reflects increasingly elaborate concepts of sacred space in which religious buildings symbolize the cosmic world of the gods. Archaeologists have also excavated mud-brick fortification walls and found evidence of town planning.

Jericho

The Neolithic settlement of Jericho, located in the West Bank, is one of the world's oldest fortified sites. It was originally built c. 8000–7000 B.C., when it was surrounded by a ditch and walls 5 to 12 feet (1.52 to 3.65 m) thick, from which rose a tower some 30 feet (over 9 m) high. The biblical account of Joshua's attack on Jericho (Joshua 6) refers

2.1 Neolithic plastered skull, from Jericho, с. 7000 в.с. Life-sized. Archaeological Museum, Amman, Jordan. Skulls such as this reflect an attempt to reconstitute the image of the dead person by modeling the features in plaster. The hair was painted, and cowrie shells were embedded into the eye sockets.

to a much later settlement at the site. His success lives on today in the refrain of the spiritual: "Joshua fought the battle of Jericho, and the walls came tumbling down."

Jericho's walls protected a city of rectangular houses and public buildings made of mud brick and erected on stone foundations. Mud brick was the mainstay of ancient Near Eastern architecture, used for ordinary buildings as well as for public architecture. Manufactured from an inexpensive, readily available material, it was easy to work with and suited to the climate. The walls of Jericho's mudbrick houses were plastered and painted.

In addition to providing shelter for the living, dwellings in Jericho housed the dead. Corpses buried under the floors indicate a concern with protective ancestors, a conclusion reinforced by one of the most intriguing archaeological finds, the so-called "Jericho Skulls" (fig. **2.1**). These uncanny skull "portraits" are almost literal renderings of the transition between life and death. The dead person's detached skull served as a kind of **armature** on which to rebuild the face and presumably to preserve the memory of the deceased.

Çatal Hüyük

Similar burials in houses are found at the site of Çatal Hüyük in Anatolia (modern Turkey). Dating from c. 6500– 5500 B.C., it is the largest Neolithic settlement site so far discovered in the ancient Near East.

In the ruins of Çatal Hüyük, archaeologists unearthed evidence of one of the most developed Neolithic cultures, in which agriculture and trade were well established and stoneware and ceramics were made. The layout of the town suggests that it was planned without streets (fig. **2.2**). Instead, one-story mud-brick houses were connected to each other by their rooftops, and scholars assume that ladders provided access from ground level; it is possible that this was for defense. Windows were small, and a ventila-

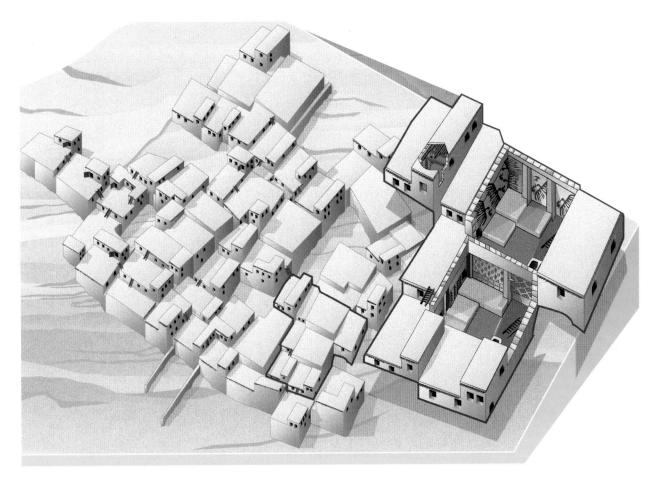

2.2 Reconstruction of Çatal Hüyük, Turkey.

tion shaft allowed smoke from ovens and hearths to escape. The interiors of the houses were furnished with built-in benches made of clay, probably used for seats and beds.

Skeletons were buried under floors and benches. Some of the skeletons were coated with red ocher, while the necks and heads of others were decorated with blue and green pigments. Deposits of jewelry and weapons accompanied the remains, suggesting that they were thought necessary in an afterlife.

Little is known of the religious beliefs at Çatal Hüyük since it was a preliterate culture. However, archaeologists have identified chambers that may have functioned as shrines. Male and female deities appear in human form, standing or seated with their sacred animals (fig. **2.3**).

2.3 Anatolian goddess giving birth, from Çatal Hüyük, Turkey, c. 6500–5700 B.C. Baked clay; 8 in. (20.3 cm) high. Museum of Anatolian Civilizations, Ankara, Turkey. The monumental— specifically steatopygous—forms are reminiscent of the *Venus of Willendorf* (see fig. 1.1) and other prehistoric fertility figures. This particular figure was found in a clay bin, and its original context is unknown.

The Çatal Hüyük shrines contained murals painted on a white plaster background with natural pigments bound with fats. They illustrate hunting scenes, rituals, human hands, geometric patterns, and a variety of unidentified symbols. Bovine heads and horns are also illustrated at Çatal Hüyük.

Mesopotamia

Mesopotamia (in modern Iraq) was the center of ancient Near Eastern civilization. Its name is derived from the Greek words *mesos* (middle) and *potamos* (river). Mesopotamia is literally the "land between the rivers"—the Tigris and the Euphrates. The Mesopotamian climate was harsh, and its inhabitants developed irrigation to make the land fertile. The southern and western terrain was open and without natural protection; as a result, Mesopotamian cities were vulnerable to invasion and accessible to trade.

The Neolithic period in Mesopotamia ended c. 4500/ 4000 B.C. It was followed by urbanization and the construction of the first known monumental temples, dedicated to each city's patron deity or deities. Mesopotamian temples were oriented with their corners toward the four cardinal points of the compass, reflecting religious beliefs that related sacred architecture to earth and sky (see box).

Some temples were decorated with **cone mosaics** (figs. **2.4** and **2.5**). Thousands of long, thin cones made of baked clay were embedded in mud walls and columns, leaving

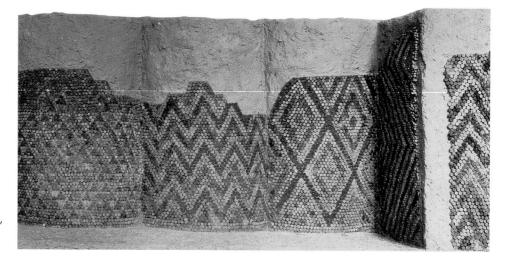

2.4 (right) Cone mosaics, from Uruk, c. 3500 B.C. Staatliche Museen, Berlin.

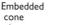

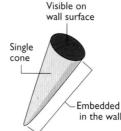

only the circular ends of the cones visible. They were dipped in black, red, or tan pigments and arranged in geometric patterns. Since they also reinforced the walls, the cones served a structural as well as an aesthetic purpose.

Technological advances in early Mesopotamia included the potter's wheel and metalworking. Metallurgy brought about substantial changes in spheres of activity ranging from warfare to art. Metal weapons were superior to stone, and objects such as drinking vessels and ornaments could now be fashioned from new materials.

Mesopotamian Religion

Mesopotamian religion was polytheistic (from the Greek words *poly*, meaning "many," and *theos*, meaning "god") —that is, people believed in many deities. These gods were represented anthropomorphically (human in form and character), but were superhuman in power and immortal. The main gods were

Enlil	God of the air: a productive, beneficent creator who ensures good harvests
Anu	Supreme god of the heavens
Enki (Akkadian Ea)	God of water, arts and crafts, and wisdom
Ninhursag	The Great Mother and Lady of the Mountain, goddess of the earth, and Anu's consort
Utu (Akkadian Shamash)	Sun god, judge, and protector—see figure 2.21
Nanna (Akkadian Sin)	God of the moon
Inanna (Akkadian Ishtar)	Goddess of fertility, love, and war
Nergal and Ereshkigal	Queen and king of the underworld, who rule from a lapis lazuli palace with seven gates

Our knowledge of Mesopotamian religious practices comes from cuneiform (see p. 58) texts of prayers, rituals, legends, and myths. The mythological texts are primarily literary in nature, and some show remarkable parallels to the Old Testament.

The Sumerians conceived of the universe as created by a primal sea. By "universe" they meant a flat earth, the vault of heaven, and the atmosphere in between. Sun, moon, planets, stars, and deities existed within this atmosphere. The human race was created out of clay for the sole purpose of serving the gods. When people died, their spirits were ferried across a river into a gloomy existence below the earth—hence the numerous inscriptions on tablets, in temples, and on sculptures asking the gods for a long life.

Ceremonies were performed in Mesopotamian temples before a god's image, which was conceived of as literally inhabited by the god. Such images enjoyed a royal life, being fed, clothed, and housed (along with their entire families) in the temple.

The Uruk Period (c. 3500-3100 B.C.)

The city of Uruk (called Erech in the Bible and Warka in present-day Iraq) has given its name to a period sometimes known as Protoliterate, when the earliest writing developed. This coincides with the rise of city-states (powerful, independent cities that rule allied territories) within the Uruk period, beginning around 3500 B.C.

It is possible that the festival in honor of the goddess Inanna (see box, p. 56) is the subject of the impressive alabaster vase (fig. **2.6**) found at Uruk. It is 3 feet (91.4 cm) in height and is decorated with four horizontal bands **(registers)** of low relief. In the top register, a goddess receives a figure carrying a basket of fruit. In the next register, nude men proceed from right to left, also bearing offerings. In the third register, rams alternate with ewes and march around the vase in the opposite direction. Barley stalks alternate with date palms at the

2.6 Carved vase, from Uruk, c. 3500-3000 B.C. Alabaster; height 36 in. (91.4 cm). Iraq Museum, Baghdad. The abundance of vegetation in the iconography of this vase reinforces its relationship to festivals of seasonal renewal and rebirth. The association of these rites with Inanna is almost certainly derived from the role of the Neolithic mother goddess.

Inanna

Evidence of the Mesopotamian goddess of fertility, love, and war is found in precincts dedicated to her as early as the fourth millennium B.C. Inanna to the Sumerians and Ishtar to the Akkadians, she was the wife of the shepherd-god Dumuzi, referred to in the Bible as Tammuz. Their courtship and sacred marriage, his death and return, and her descent into the underworld are sung in several Mesopotamian hymns.

Inanna had multiple aspects to which these hymns were addressed. She was the "holy priestess of heaven," "thundering storm," "lady of evening and of morning," and "joy of Sumer." She was also fearsome and had to be propitiated with offerings such as the alabaster vase in figure 2.6, which may depict Inanna herself. One of the hymns to Inanna has been translated as follows:

In the pure places of the steppe, On the high roofs of the dwellings, On the platforms of the city, They make offerings to her: Piles of incense like sweet-smelling cedar, Fine sheep, fat sheep, long-haired sheep, Butter, cheese, dates, fruits of all kinds.¹

In the course of the third millennium B.C., Inanna became the central deity in the most important rite of Sumer's New Year festival. In the hieros gamos (sacred marriage), the Sumerian king (who stood for Dumuzi) and a priestess (standing for Inanna) were married in a ceremonial reenactment of the divine union. The purpose of the rite was to ensure agricultural fertility in the coming year.

bottom. The abundance of vegetal iconography on this vase suggests its association with agricultural festivals of renewal and rebirth.

Several stylistic conventions evident here remain characteristic of ancient Near Eastern art throughout its history. Though the figures are stocky and modeled threedimensionally, they occupy a flat space, which is partly defined by their poses. Legs and heads are in profile, the torsos turn slightly, and the eyes are frontal, creating a composite or synthesized view of the human form. There is no indication of space extending back behind the figures, who walk as if on a thin ledge. In the top register, figures and objects seem suspended in mid-air.

Despite the flat space of the Uruk vase and of much relief and pictorial art in ancient Mesopotamia, the white marble head of a female (fig. 2.7), also from Uruk, demonstrates the artist's command of three-dimensional form. The eyebrows meet over the nose (a convention of Mesopotamian statues), and the face is organically modeled. The cheeks bulge slightly, creating the natural line from the nose to the corners of the mouth, and the lower lip curves outward from an indentation above the chin.

2.7 Female head, from Uruk, c. 3500-3000 B.C. White marble; 8 in. (20.3 cm) high. Iraq Museum, Baghdad.

Asymmetrical cheeks and the slight rise of the right side of the upper lip create the impression of an individual personality. The figure's eyebrows would originally have been inlaid (set into the surface), and other additions, such as hair and eyes, have probably disappeared.

Ziggurats

The ziggurat, derived from an Assyrian word meaning "raised up" or "high," is a uniquely Mesopotamian architectural form. Mesopotamians believed that each city was under the protection of a god or gods to whom the city's inhabitants owed service, and they built imitation mountains, or ziggurats, as platforms for those gods. Mountains were believed to embody some of the immanent powers of nature: they were sources of the life-giving water that flowed into the plains and made agriculture possible. The Mesopotamian goddess Ninhursag, a source of nourishment, was also the Lady of the Mountain. As a symbolic mountain, therefore, the ziggurat satisfied one of the basic requirements of sacred architecture-namely, the creation of a transitional space between people and their gods.

56

2.8 The White Temple on its ziggurat, Uruk, c. 3500-3000 B.C. Stone and polished brick; temple approx. 80×60 ft. (24.38×18.29 m); ziggurat c. 140×150 ft. (42.70×45.70 m) at its base and 30 ft. (9.10 m) high. It was called the "White Temple" because of the white paint on its outer walls.

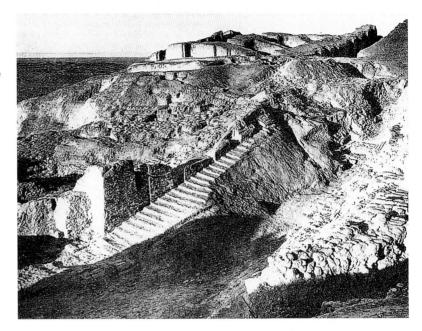

Ziggurats are examples of **load-bearing construction**, a system of building that began in the Neolithic period. Their massive walls had small openings or none at all. They were usually solid, stepped structures, tapering toward the top, with wide bases supporting the entire weight of the ziggurat.

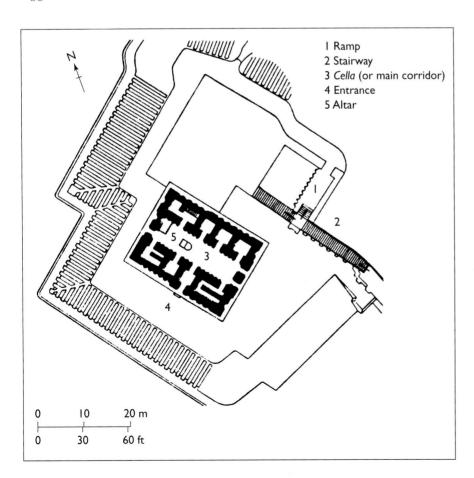

At Uruk the earliest surviving ziggurat (fig. **2.8**) dates from between 3500 and 3000 B.C. It was a solid clay structure reinforced with brick and asphalt. White pottery jars were embedded into the walls, their rims creating a surface pattern of white circles framing the dark round spaces of their interiors.

> The Uruk ziggurat supported a shrine, the "White Temple," which was accessible by a stairway. Like the ziggurat, the temple was oriented toward the four cardinal points, an arrangement that became standard. Figure 2.9 shows the plan of the rectangular White Temple, which is believed to have been dedicated to Anu, the sky god. It was divided into several rooms off a main corridor (the cella), which contained the altar. The temple probably housed a statue of the god, although no such statue has been found. Ziggurats remained characteristic structures throughout Mesopotamian history and became increasingly elaborate as belief systems and technology evolved.

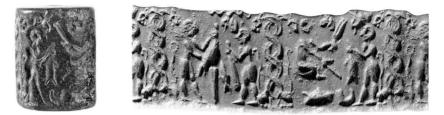

2.10 Cylinder seal and impression, from Uruk, c. 3500–3000 B.C. Greenish black serpentine; 1.16 in. (29.5 mm) high, diameter 1 in. (25.0 mm). The Pierpont Morgan Library, New York. The scene shown has been interpreted as a leather shop (note the man carrying an animal hide).

Cylinder Seals

The earliest examples of **cylinder seals**, which are classed as **glyptic art** (from the Greek word *glyptos*, meaning "carved"), were produced during the Uruk period. The seal in figure **2.10** is a small stone cylinder into which an image has been carved. In a process known as **intaglio** printing, the seal's hard, incised surface would have been pressed against a soft surface, leaving a raised impression of the animals in reverse. When a cylinder seal was rolled across a clay tablet or the closure on a container, it created a continuous band of images. Seal impressions were used originally to designate ownership, to keep inventories and accounts, and later to legalize private and state documents. They offer a rich view of Mesopotamian iconography and of the development of pictorial style during a three-thousand-year period.

From Pictures to Words

The use of seal impressions to designate ownership contributed to the development of writing. In the course of the Uruk period, abstract wedge-shaped characters began to appear on clay and stone tablets (fig. 2.11). The earliest known written language comes from Sumer, in southern Mesopotamia, and persisted as the language of the priestly and intellectual classes throughout Mesopotamian history. Its script is called cuneiform from the Latin word cuneus, meaning "wedge." After c. 2300 B.C., a Semitic language, Akkadian, belonging to a people who may have come from the west, became more prevalent than Sumerian. The Sumerian and Akkadian cultures coexisted for many centuries, and their languages roughly correspond to the two main geographical divisions of Mesopotamia-Sumer and Akkad. Both lie between the Tigris and Euphrates rivers, Sumer in the south and Akkad in the north.

Some time after the invention of writing, a Mesopotamian literature developed. The written word, which originated in response to a practical need for daily record-keeping, became a tool of creative expression. Much epic poetry of Mesopotamia deals with the origins of gods and humans, the history of kingship, the founding of cities, and the development of civilization (see box). These themes are also familiar in later literature. A Sumerian flood myth in which the human race is nearly destroyed, for example, describes an event much like the biblical flood (Genesis 6–8). According to Sumerian tradition, the flood occurred shortly before the invention of writing and, therefore, separated preliterate Mesopotamia from its literate, historical era.

2.11 Clay tablet with the pictograph text that preceded cuneiform, probably from Jemdet Nasr, Iraq, c. 3000 B.C. $3\frac{1}{4} \times 3\frac{1}{4}$ in. (8.0 \times 8.0 cm). British Museum, London. Sumerians used a numerical system with a base of 60, as well as a decimal system.

Gilgamesh

The *Epic of Gilgamesh* is the oldest surviving epic poem, and it is preserved on cuneiform tablets from the second millennium B.C. It recounts Gilgamesh's search for immortality as he undertakes perilous journeys through forests and the underworld, encounters gods, and struggles with moral conflict. The opening lines introduce Gilgamesh as the hero who saw and revealed the mysteries of life:

The one who saw the abyss he who knew everything, Gilgamesh, who saw things secret, opened the place hidden, and carried back word of the time before the Flood.²

Sumer: Early Dynastic Period (c. 2800–2300 в.с.)

The gradual transition to full literacy occurred during the growth of approximately a dozen powerful city-states ruled by dynasties, or royal families. Lists of these ancient Sumerian rulers have survived. Other documents provide the picture of a society in which people played increasGilgamesh finally attains immortality as the builder of Uruk's walls. He establishes urban civilization and lays the foundations of historical progress. The poem also refers to his having "cut his works into a stone tablet." Just as the megalithic builders of Neolithic Europe revered stone as a permanent material, so Gilgamesh founded a city ringed with stone walls and ensured that the record of his achievements was written in stone. This is consistent with the historical fact that the earliest writing was actually inscribed on stone or clay tablets. The works of Gilgamesh were thus literally as well as figuratively "carved in stone."

ingly specialized roles (such as canal builders, artisans, merchants, and bureaucrats) under the administration of a class of priests.

Tell Asmar

Many small cult figures were produced during the Early Dynastic period, such as those from Tell Asmar (figs. **2.12** and **2.13**), a Sumerian site about 50 miles (80 km) north-

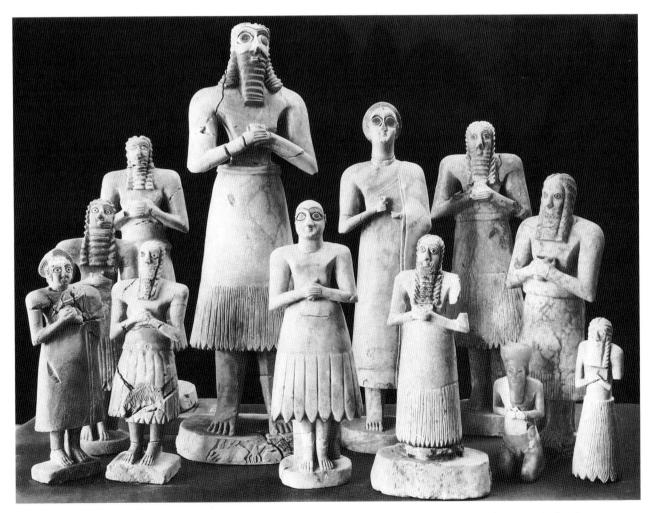

2.12 Statues from the Abu Temple at Tell Asmar, c. 2700–2500 B.C. Limestone, alabaster, and gypsum; tallest figure approx. 30 in. (76.3 cm) high. Iraq Museum, Baghdad, and Oriental Institute, University of Chicago.

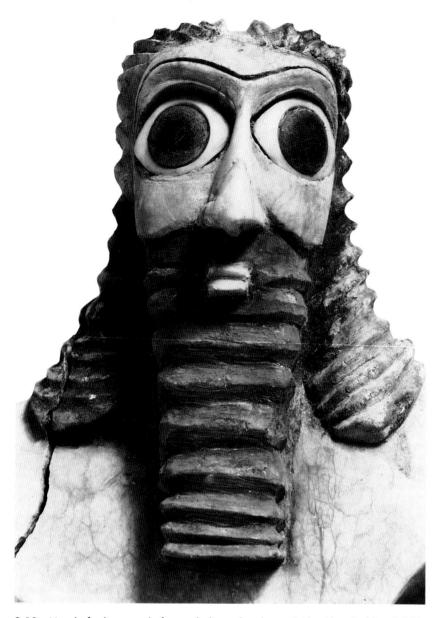

2.13 Head of a large male figure dedicated to the god Abu (detail of fig. 2.12).

east of modern Baghdad, in Iraq. Most hold a cup, but some hold a flower or branch. Male and female are distinguished by costume. Men tend to wear less above the waist than women (in this case, the bare-chested men wear skirts, whereas the women wear robes that cover one shoulder). The figures are made of pale stone, their hair, beards, and other features emphasized with black pitch. The eyes are shells, and the pupils are inlaid with black limestone. The largest male statue has no attributes of divinity and is, therefore, thought to represent an important or wealthy person dedicating himself to the god Abu. All the statues probably represent worshipers of varying status whose sizes were determined by the amount of money their donors paid for them. As such, these figures are rendered with so-called **hierarchical proportions**, a convention equating size with status.

The statues are cylindrical, and many stand on curved bases, reflecting the Mesopotamian preference for rounded sculptural shapes. Also characteristic, as in the Uruk head (see fig. 2.7), is the combination of stylization-visible here in the horizontal ridges of the males' hair and beards-with suggestions of organic form in the cheeks and chin. The frontal poses and vertical planes of these figures endow them with an air of imposing solemnity. Their frontality is further emphasized by the prominence of large, wide-open eyes staring straight ahead. The importance accorded the eye in these figures indicates that they are in the presence of divinity.

Ur

At the Sumerian site of Ur, the English archaeologist Sir Leonard Woolley (1880– 1960) discovered evidence of the richness of Early Dynastic culture. The most impressive finds came from the "royal" cemetery, so called because of the great wealth of materials recovered there and the power reflected in the organization, construction, and furnishing of the burials. They were filled with chariots, harps, sculptures, headdresses, and jewelry. In addition, bodies of people who may have been ritually killed in order to provide companions for the royal family in the afterlife were also found.

The elegant lyre sound box (fig. **2.14a**) from Ur indicates the importance of music and musical instruments in Sumerian society. The significance of the gold bearded bull's head and the inlay decoration at the

front of the box (fig. **2.14b**) is uncertain, but it is likely that they served a ritual purpose and had mythological meaning. Certainly the motif of the bull's head is known from as early as around 6000 B.C., when it was one of the manifestations of the male god at Çatal Hüyük. At Ur, the head was combined with a stylized human beard of **lapis lazuli**, illustrating the ancient Near Eastern taste for combinations of species.

Figure **2.15** (p. 62) shows a restored Sumerian lyre from Ur presently located in the British Museum in London. The box itself is hollow in order to improve the quality of the sound.

2.14a and **b** The scorpion-man, who appears in the bottom scene on the front of the box, may be one of the fearsome guardians of the sun described in the *Epic of Gilgamesh*. In addition to hybrid forms combining animals with other animals and animals with humans, ancient Near Eastern art is populated by animals—such as the goat holding a cup and walking upright—who act like humans. These figures could represent either mythological creatures or people dressed as animals.

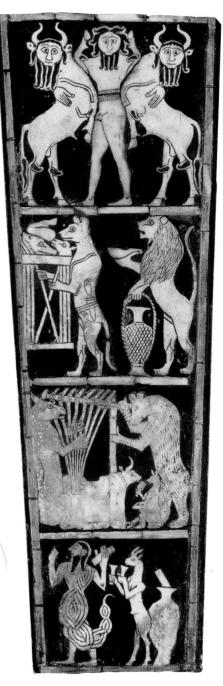

2.14b Inlay from the front of a sound box (detail of fig. 2.14a).

2.14a Lyre sound box, from the tomb of Queen Puabi, Ur, c. 2685 B.C. Wood with inlaid gold, lapis lazuli, and shell; approx. 13 in. (33 cm) high. University Museum, University of Pennsylvania, Philadelphia.

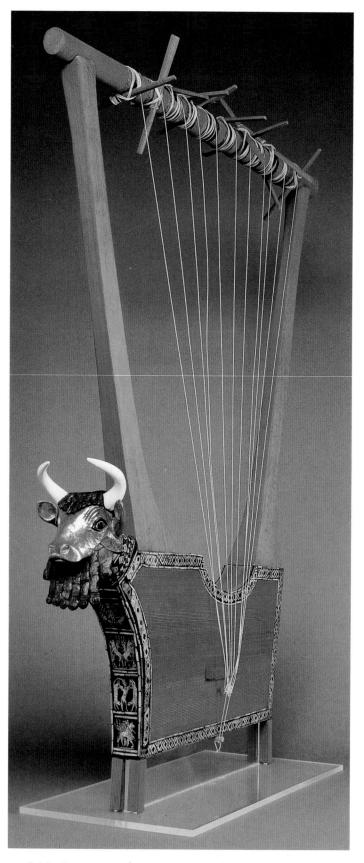

2.15 Restoration of a Sumerian Lyre, from Ur, c. 2600 B.C. Wood, gold leaf, and inlay; height of bull's head c. 12 in. (30 cm). British Museum, London.

Akkad (c. 2300–2100 в.с.)

The Akkadians were a Semitic-speaking Mesopotamian people who lived to the north of Sumer. We know little about them before their territorial expansion in the twenty-fourth century B.C. From their capital at Akkad (near modern Baghdad), the Akkadians dominated one city-state after another until they ruled Mesopotamia. They assimilated much of Sumerian culture, but there were some important changes. City-states were now subordinate to a larger political entity, an empire, and Akkadian became the dominant language. Some Akkadian gods were merged with those of Sumer, and some Akkadian rulers elevated themselves to divine status.

The founder of the Akkadian dynasty, Sargon I, reigned for over half a century, from c. 2300 to 2250 B.C. (see box), gaining control of most of Mesopotamia and the lands beyond the Tigris and Euphrates rivers. A near-life-sized bronze head (fig. **2.16**) may be his portrait. Its high level of artistry and technical skill indicates that metal sculpture on a monumental scale was not new, but earlier examples have not survived. It was made by the *cire-perdue*, or lostwax, method discussed in Chapter 5 (see p. 154). Throughout history metal objects were often melted down for reuse, making large-scale metal sculptures from antiquity rare today. This head, found in debris, is all that remains of a full-length statue.

The power of this work resides in the self-confident facial features emerging from the framework of stylized hair. The eye sockets would originally have been inlaid with precious stones, which have since been gouged out—possibly by enemies seeking to mutilate the head. At the back of the head, the hair is bound in a bun and is elaborately designed in a regular arrangement of surface patterns. Large curved eyebrows meet on the bridge of an assertive nose. A striking V-shape frames the lower face in the form of a beard made of spiraling curls. In this head, the energy and rhythm of the stylizations combine with an organic facial structure to produce an air of regal determination.

Sargon of Akkad

With Sargon, we encounter another "first" in Western history—namely, the legendary birth story of one who is destined for greatness. These tales typically link humble origins to later fame. Sargon's story is inscribed on a tablet and recounts his lowly illegitimate birth. His mother sends him down a river in a basket (which resonates with the biblical account of Moses in the bulrushes). A man named Akki, who is drawing water, finds Sargon and raises him as his own son. Later, Sargon rules in the city of Agade, or Akkad, the inhabitants of which are called Akkadians.

The stele of Naram-Sin is an impressive image of the king's power, for it proclaims the military, political, and religious authority of Naram-Sin. He is identified as a god by the horned cap of divinity and dominates the scene by his large size and central, elevated position. His straight back and fearless stance are manifestations of virility and his potency as both man and ruler. Around his neck he wears a necklace with a protective bead. Also exerting a protective force are the stars shining prominently over Naram-Sin. Together with the landscape

details, they reflect the Akkadian taste for depicting nature.

Two defeated enemies are before the ruler, one praying for mercy and the other trying to pull a spear from his neck. Naram-Sin

2.16a and b Head of an Akkadian ruler (Sargon I?), from Nineveh, Iraq, c. 2300 B.C. Bronze; 12 in. (30.0 cm) high. Museum of Antiquities, Baghdad.

Sargon I's grandson, Naram-Sin, recorded his victory over a mountain people, the Lullubians, in a commemorative stele (fig. 2.17)—an upright stone marker. This form of record keeping used inscriptions and/or relief images to commemorate important events. When the Epic of Gilgamesh says that the hero "cut his works into a stone tablet" (see box, p. 59), the author was probably referring to a stele. Today when we speak of "making one's mark," we mean essentially the same thing as the Mesopotamians did when they made marks in stone "markers" that were intended to last.

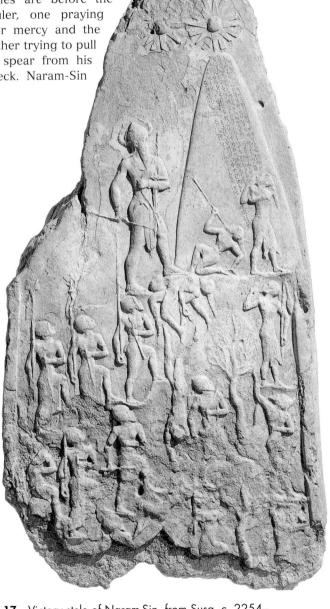

2.17 Victory stele of Naram-Sin, from Susa, c. 2254-2218 B.C. Pink sandstone; 6 ft. 6 in. (1.98 m) high. Louvre, Paris. This stele suffered an ironic twist of fate when it was taken as booty by invaders. What had been created to mark an Akkadian victory was looted to mark their defeat.

and his victorious followers march unhindered up the mountain while the defeated soldiers fall. This opposition exemplifies the convention in which going up denotes success and downward movement denotes failure or death. In a related convention, Naram-Sin steps on a defeated foe, indicating triumph. Furthermore, the nudity of Naram-Sin's victims indicates that they are dead. To the degree that Naram-Sin's own body is exposed, the artist was displaying an image of physical perfection that was a sign of his inherent "goodness," or "rightness," as a ruler. He is intentionally portrayed with his right side most visible to the viewer, in keeping with a Mesopotamian belief that a ruler's right side—including his right arm and right ear—had to be both intact and well formed for his state to prosper.

Neo-Sumerian Culture (c. 2100–1900/1800 B.C.)

After flourishing for about two hundred years, the Akkadian dynasty was defeated by the Guti—mountain people from the northeast who ruled Mesopotamia for roughly sixty years. Only the city-state of Lagash managed to hold out, and it prospered. When the Sumerians overthrew the Guti, there was a revival of Sumerian culture in the newly united southern city-states, a period referred to as Neo-Sumerian.

2.18 Head of Gudea, from Lagash, Iraq, c. 2100 B.C. Diorite; 9 in. (22.9 cm) high. Museum of Fine Arts, Boston. Francis Bartlett Donation of 1912.

Lagash

Gudea, the ruler of Lagash after the period of Guti dominance, initiated an extensive construction program that included several temples. His building activity was made possible by his ability to maintain peace in his own territory, despite continual political upheavals surrounding Lagash. Gudea embodied the transition between gods and humans. Just as the ziggurats linked earth with the heavens, so Mesopotamian rulers were viewed as the gods' chosen intermediaries on earth. Such ideas formed the basis for the continuing belief in the divine right of kings.

Gudea's image is familiar from a series of similar statues made of diorite, a hard black stone, which had to be imported. He either stands or sits, usually with hands folded in an attitude of prayer (figs. **2.18** and **2.19a** and **b**). Whether standing or seated, Gudea wears a robe over his left shoulder leaving his right shoulder bare; the bottom of the robe flares out slightly into a bell curve. He either is bald or wears a round cap (fig. 2.18), which is decorated with rows of small circles formed by incised spiral lines.

Gudea's affinity with the Sumerian gods is revealed in his account of a dream in which a god instructed him to restore a temple. In the dream, Gudea saw the radiant, joyful image of the god Ningirsu wearing a crown and flanked by lions. He was accompanied by a black storm bird, while a storm raged beneath him. Ningirsu told Gudea to build his house; but Gudea did not understand until a second god, Nindub, appeared with the plan of a temple on a lapis lazuli tablet.

The Gudea in figure 2.19a is compact; there is no space between the arms and the body, and the neck is short and thick. This contraction of space contributes to Gudea's monumentality, as does his controlled and dignified pose. The typical Mesopotamian combination of organic form with surface stylization can be seen in the juxtaposition of the incised eyebrows (fig. 2.18) with the more naturalistically modeled cheeks and chin.

The temple plan resting on Gudea's lap (fig. 2.19b) identifies his role as an architectural patron. His gesture of prayer establishes his relation with the gods and their divine patronage as revealed in his dream (see caption). In the ancient world, dreams were thought of as external phenomena, usually messages through which gods communicated with mortals, especially kings. As such, dreams,

2.19b Detail of the temple plan on Gudea's lap.

2.19a Gudea with a temple plan, from Lagash, Iraq, c. 2100 B.C. Diorite; 29 in. (73.7 cm) high. Louvre, Paris.

like temples, could establish a link between people and their gods. And it was precisely in those terms that Gudea described his completed temple. He said that it rose up from the earth and reached toward heaven, that its radiance illuminated his country. The metaphor in which the temple is a source of light relates the structure to the radi-

ant Ningirsu, who appears in the dream. The dream itself is a source of intellectual light, or enlightenment, originating with the gods and transmitted to their earthly representative in the person of Gudea. In all of these images, the temple, like dream and dreamer, functions as a symbolic bridge between heaven and earth.

The Ziggurat of Ur

The Neo-Sumerian period reached a peak under Ur-Nammu, the first king of its last important dynasty, the Third Dynasty of Ur. He supervised the construction of the great ziggurat at Ur (fig. **2.20**), which is more complex than the one in Uruk. Three stages were constructed around a mud-brick core and culminated in a shrine, accessible by a short stairway on the northeast side. The mud brick was faced with baked brick embedded in mortar made of bitumen (a type of asphalt). Leading to a vertical gate, which provided the only point of entry to the upper levels, were three long stairways, each composed of one hundred steps. The ziggurat walls curve gradually outward while sloping toward the center of the structure, which functioned aesthetically to reduce the rigidity of straight walls. The ancient Near Eastern preference for rounded sculptural shapes thus carried over into architectural design.

A cuneiform tablet records Ur-Nammu's contribution to the building process. It states that the god Marduk ordered him to build the ziggurat with a secure foundation and stages that reach to the heavens: "I caused baked bricks to be made," the ruler declared; "... I caused streams of bitumen to be brought by the Canal Arahtu.... I took a reed and myself measured the dimensions.... For my Lord Marduk I bowed my neck, I took off my robe, the sign of my royal blood, and on my head I bore bricks and earth."³ The area around Ur-Nammu's ziggurat was eventually expanded into a sacred architectural complex containing several temples, workshops, factories, and a commercial center with law courts.

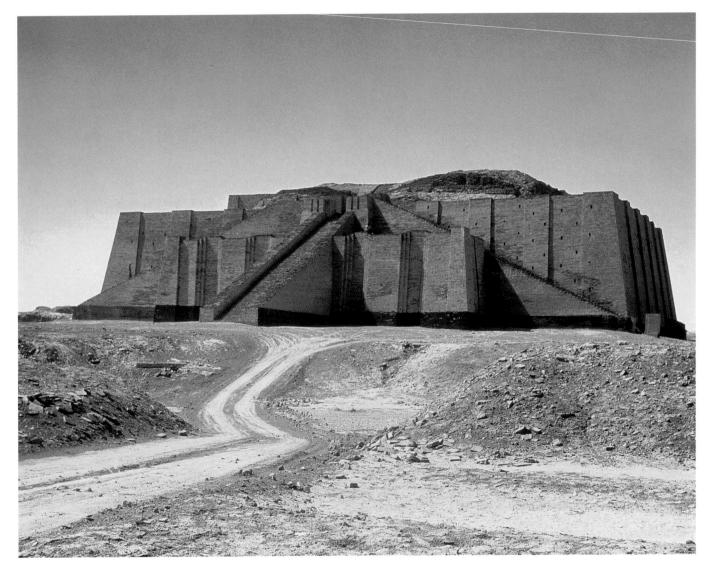

Babylon (c. 1900–539 B.C.)

When the last Neo-Sumerian king was overthrown by foreign invaders, Mesopotamia reverted to rule by independent city-states. Over the next few centuries, continuing warfare, as well as invasions from all directions, led to the frequent rise and fall of different cultural groups. Mesopotamia was next united under the Amorites, a Semiticspeaking people from Arabia, who established their capital at Babylon and ushered in the Old Babylonian period (с. 1800-1600 в.с.).

The most famous king of the Amorite dynasty was Hammurabi (flourished c. 1792-1750 B.C.). Hammurabi is best known for his law code (see box), which he inscribed on a black basalt stele (fig. 2.21a and b). The text was based on local Sumerian legal traditions and remains an important historical document, articulating the relationship

bility of society. when thrown into water.

The Law Code of Hammurabi

The text of Hammurabi's law code, comprising 300 statutes, is written in Akkadian in 51 cuneiform columns. It provides a unique glimpse into the social and legal structure of ancient Mesopotamia. Though the stated purpose of Hammurabi's laws was to protect the weak from the strong, they also maintained traditional class distinctions: the lower classes were more severely punished for crimes committed against the upper classes than vice versa. There was no intent to create social equality in the protection of the weak, or in the expressed concern for orphans and widows, but rather to maintain the continuity and sta-

Three types of punishment stand out in the law code of Hammurabi. The Talion Law-the equivalent of the biblical "eye for an eye"-operated in the provision calling for the death of a builder whose house collapsed and killed the owner. In some cases, the punishment fit the crime; for example, if a surgical patient died, the doctor's hand was cut off. Perhaps the most illogical punishment was the ordeal in which the guilt or innocence of an accused adulteress depended on whether she sank or floated

> 2.21b (right) Stele (detail of fig. 2.21a).

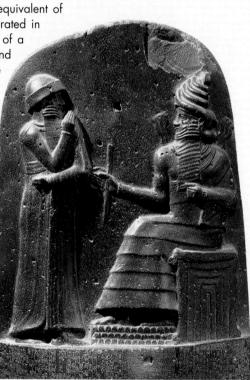

2.21a (left) Stele inscribed with the law code of Hammurabi, Susa, capital of Elam (now in Iran); c. 1792–1750 B.C. Basalt; height of stele approx. 7 ft. (2.13 m), height of relief 28 in. (71.10 cm). Louvre, Paris. Hammurabi stands before the Akkadian sun god, Shamash, who is enthroned on a symbolic mountain. Shamash wears the horned cap of divinity and an ankle-length robe. He holds the ring and rod of divine power and justice, and rays emanate from his shoulders. Here the conventional pose of the god in relief sculpture serves a double purpose: the torso's frontality communicates with the observer, while the profile head and legs turn toward Hammurabi. Hammurabi receives Shamash's blessing on the law code, which is inscribed on the remainder of the stele. The god's power over Hammurabi is evident in his greater size; were Shamash to stand, he would tower over the mortal ruler.

of law to society. Its cultural importance is reflected in its value as booty: Hammurabi's stele, like Naram-Sin's, was carried off to Susa (a rival city-state east of the Tigris River) by invading Elamite armies.

Babylon was sacked by Hittites from Anatolia (see below) c. 1600 B.C., ending the Old Babylonian period. For the next half millennium, Mesopotamia was under the control of a weak foreign dynasty, the Kassites, one of many groups penetrating the region from western Iran. This was a time of great political and cultural turmoil. Despite the disruption in patterns of trade, however, influences from farther west—what are now Syria, Egypt (see Chapter 3), and the Aegean world (see Chapter 4)—did reach Mesopotamia through immigrants from these lands. Meanwhile, Babylon remained a renowned cultural center.

Anatolia: The Hittites (c. 1450–1200 B.C.)

The Hittites were Indo-Europeans who settled in Anatolia around 2000/1900 B.C. Their capital city, Hattusas, was located in modern Boghazköy, in central Turkey. Like the Mesopotamians, they kept records in cuneiform on clay tablets, which were stored on shelves, systematically catalogued and labeled as in a modern library. These archives, comprising thousands of tablets, are the first known records in an Indo-European language. Because their written records have survived, the cultural and artistic achievements of the Hittites are well documented. The Hittites cremated their dead and buried the ashes and bones in urns, so that they left little large-scale tomb art. There is, however, much evidence of monumental palaces, temples, cities, and massive fortified walls decorated with reliefs. The predominance of fortifications and the location of palaces and **citadels** (elevated, fortified cities) reflect the need for protection from invading armies as well as the military power of the Hittites themselves.

The western entrance to the citadel at Hattusas (fig. **2.22**) is a good example of the monumental fortified **Cy-clopaean** (see Chapter 4) walls constructed by the Hittites. The guardian lions are a traditional motif in ancient art because of the belief that lions never sleep. Here they project forward from the stone wall as if emerging from natural into man-made form. Their heads and chests are in high relief, while some details, such as the mane, fur, and eyes, are incised. At 7 feet (2.13 m) tall, they would have towered over anyone approaching the gate.

The most distinctive Hittite sculptures are, like the guardian lions, in relief, usually carved on the lower levels of city walls. Figure **2.23** is an over-life-sized representation of a powerful Hittite war god. He is armed and helmeted, and wears a short tunic. Conforming to ancient Near Eastern convention, his head and legs are depicted in profile with his torso in front view. And, as in the art of Mesopotamia, the sculptor has achieved a remarkable synthesis of stylization (the eye and kneecaps) with organic form. As in the stele of Naram-Sin, this relief projects an image of divine authority, and, like the guardian lions, the war god symbolically protects the city.

2.22 Lion Gate (Royal Gate), Hattusas, Boghazköy, Turkey, c. 1400 B.C. Stone; lions approx. 7 ft. (2.13 m) high. The lions face the visitor approaching the citadel. The direct confrontation, combined with the open, roaring mouths, served as a warning and symbolically protected the inhabitants.

Assyria (c. 1300–612 в.с.)

A northern Assyrian city-state emerged as the next unifying force in Mesopotamia. Located along the Tigris in modern Syria, its capital city was named for Assur, the chief Assyrian deity, equivalent in authority to the Babylonian Marduk (whom he closely resembled) and the Sumerian Enlil. Excavations carried out in Assur in the early twentieth century uncovered a culture extending back to 3000 B.C. At the end of Hammurabi's reign in c. 1750 B.C., Assur had become a prominent fortified city. By 1300 B.C. Assur's rulers were in communication with the leaders of Egypt, indicating that they had achieved international status. Assyria borrowed much from Babylon, which remained culturally prominent during its political decline, as well as from foreign cultures to the west. **2.23** Hittite war god, from the King's Gate, Hattusas, Boghazköy, Turkey, c. 1400 B.C. 6 ft. 6³/₄ in. (2.00 m) high.

The Assyrian state is particularly well documented through both its texts and the remains of architectural and sculptural projects undertaken to reflect the might and glory of its kings (see box). The region in and around Assyria had a great deal more stone available than the rest of Mesopotamia. As a result, the Assyrians' determination to memorialize their accomplishments in stone could be satisfied without importing materials.

Assyrian military strength grew rapidly under Assurnasirpal II. The only known sculpture in the round representing him (fig. **2.24**) depicts an imposing figure in a rigid frontal pose. He wears an ankle-length robe, his arms are close to his body, and his stylized hair and beard fill the space around his neck. He holds the scepter of kingship in his right hand and a mace in his left. Inscribed across his chest are his name, titles, and conquests. In contrast to Gudea, whose inscriptions record his architectural achievements, Assurnasirpal II's statue proclaims his god-given power.

The king's might is also the theme of alabaster reliefs that lined the walls of his palace in present-day Nimrud

Assyrian Kings

Under Assurnasirpal II (reigned 883–859 B.C.), Assyria became a formidable military force. His records are filled with boastful claims detailing his cruelty. He says that he dyed the mountains red, like wool cloth, with the blood of his slaughtered enemies. From the heads of his decapitated enemies he erected a pillar, and he covered the city walls with their skins.

The first imperial king, Tiglath-Pileser I (reigned c. 1114–1076 B.C.), recorded his intent to conquer the world and claimed that the god Assur had commanded him to do so.

The last powerful king of Assyria, Assurbanipal II (reigned 668–633 B.C.), combined cruelty with culture. He established a great library, consisting of thousands of tablets recording the scientific, historical, literary, religious, and commercial achievements of his time. Also included in his collection were the Mesopotamian creation and flood epics, which were deciphered in the late nineteenth century. Today, most of Assurbanipal's library is in the British Museum in London. **2.24** King Assurnasirpal II, from Nimrud, Iraq, c. 883–859 B.C. British Museum, London.

and Khorsabad. Figure **2.25** shows Assurnasirpal II standing at the back of a horse-drawn chariot, his bow and arrow aimed at a rearing lion. The king's dominance over lions, a favorite subject in Assyrian art, is a metaphor for the subjugation of his enemies. The dynamic energy of the scene is reinforced by opposing diagonal planes and the accentuation of muscular tension. Overlapping of the horses creates an illusion of three-dimensional space.

The battle relief in figure 2.26 represents a city at war, with Assyrian invaders shooting arrows and attacking the defenders' walls with a battering ram. At the center of the relief, two wounded enemy soldiers have toppled from the ramparts and plunge to their deaths. Here, too, opposing diagonals convey energetic movement. The upper figures are cut off by the crenellated fortifications, and the bowmen at the right overlap each other, enhancing pictorial depth. The wealth of such details in the Assyrian reliefs, and in Assyrian art generally, makes them particularly valuable as cultural records.

An unusually empathic relief from the reign of Assurbanipal II represents a lioness who has been mortally wounded in the king's lion hunt (fig. **2.27**). The powerful musculature of the animal's forelegs and shoulders is sharply—and tragically—contrasted with the limp hindquarters. Pierced through by three arrows and bleeding heavily from her wounds, the lioness drags her lifeless rear legs and roars in pain.

Over the course of the empire's history, the Assyrian capital shifted several times. The palace that king Sargon II (reigned 721–705 B.C.) built at Dur Sharrukin (present-day Khorsabad, in the far north) is the most fully excavated large-scale example, revealing the complexity of Assyrian royal architecture.

Figure **2.28** (p. 72) is the plan of the palace, a mud-brick structure on a **plinth** (platform), whose rectangular rooms lay at right angles to each other. Number 5 on the plan (the concentric squares at the left) denotes Sargon's ziggurat. This was built in several levels, which were formed from a ramp in the shape of a squared-off spiral that decreased in size

as it approached the top. This meant that priests and other high-status worshipers moved continuously around the structure as they ascended it.

Access to the palace required entering the huge gate of the citadel and traversing the open square. A ramp was provided so that chariots could be driven across the square to the palace gate. The approach to the throne room itself

> was through a carefully controlled program of architectural and sculptural propaganda, designed to intimidate visitors. They would have entered the palace complex through one of the entrances at the lower end of a courtyard (4 on the plan). From the courtyard, they would proceed to the ambassadors' courtyard (3), whose monumental reliefs, like those carved during the reign of Assurnasirpal II, reminded viewers

of the king's military achievements on the one hand and his relationship with the gods on the other. In order to reach the throne room (2), visitors had to pass through an entrance guarded by monumental limestone figures called **Lamassu** (fig. **2.29**, p. 79).

Twice as tall as the Hittite lions guarding the gateway at Hattusas (see fig. 2.22), the Lamassu were divine genii combining animal and

human features—in this case, the body and legs of a bull with a human head. The hair, beard, and eyebrows are stylized. The figure wears the cylindrical, three-horned crown of divinity. As is typical of ancient Near Eastern art, the Lamassu combines naturalism the suggestion of bone and muscle under the skin—with surface stylization—the areas of patterned texture across the body. Rising from above the forelegs in a sweeping curve are wings that fill the limestone blocks from which the Lamassu is carved.

The wings draw the eye of the viewer to the side of the Lamassu, a transition reinforced by the "re-use" of the forelegs in the side view, which essentially creates a "fifth leg." This striking visual device enhances the architectural function of an entrance, which is to mark a point of access: the Lamassu appears to confront approaching visitors and simultaneously to stride past them. By narrowing the space through which visitors must pass, the Lamassu builds up tension as one approaches the king. Sargon's palace was thus an elaborate structural and pictorial

 $\pmb{2.25}$ King Assurnasirpal II hunting lions, from Nimrud, Iraq, c. 883–859 B.C. Alabaster relief; 3 ft. 3 in. \times 8 ft. 4 in. (99.0 cm \times 2.54 m). British Museum, London.

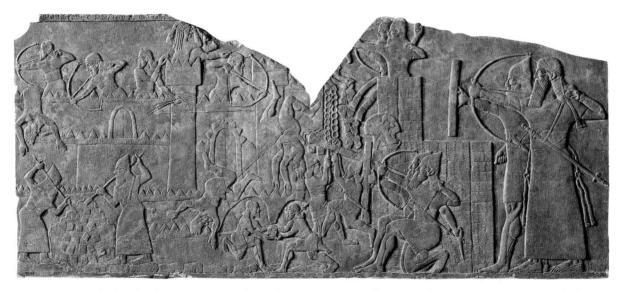

2.26 City attacked with a battering ram, palace of King Assurnasirpal II, Nimrud, Iraq, c. 883–859 B.C. Relief; approx. 39 in. (99.0 cm) high. British Museum, London.

2.27 Dying Lioness (detail of the Great Lion Hunt), from the palace of King Assurbanipal II, Nineveh, c. 668–627 B.C. Alabaster relief; height 13¼ in. (33.7 cm). British Museum, London.

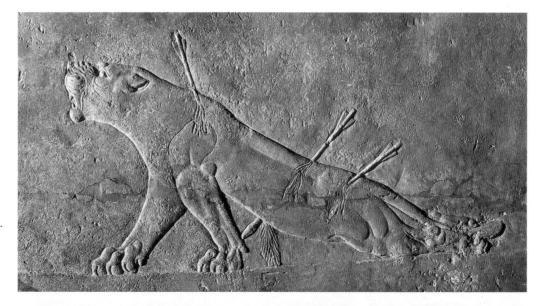

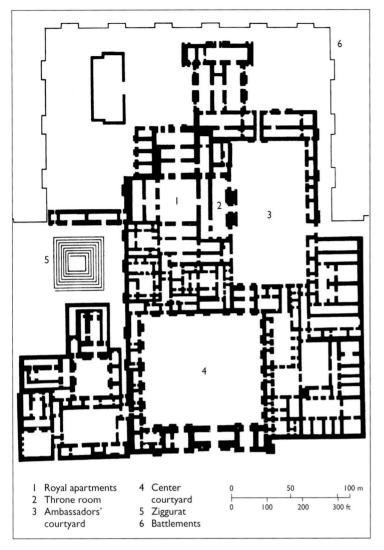

expression of the notion that power resides in an interior space, access to which becomes a rite of passage. Once visitors entered the throne room, they were confronted with brightly painted walls and a throne backed up against a wall. Inscribed on the base of the throne were warnings against rebellion and revolution.

With the rise of Assyrian palace architecture, the importance of the ziggurat declined. Originally, Mesopotamian palaces had been adjuncts to the ziggurat and places from which a ruler administered a city-state. Under the militaristic Assyrians, the relationship between religious and administrative centers changed. The power of the Assyrian king was now reflected in immense fortifications and reliefs showing his victories and his cruelty, and the ziggurat became an accessory to the palace.

Throughout its history the Assyrian empire faced constant pressure from within and without, and its militaristic art reflects the chronic warfare necessary to maintain control of its territory. Within a century after Sargon II's reign, the Assyrian Empire collapsed. Its capital at Nineveh fell in 612 B.C. to an alliance of Medes (from what is today Iran) and Scythians (originally from modern Russia and the Ukraine). Babylonian clay tablets record the events surrounding the end of Assyrian power and the rise of a Neo-Babylonian Empire. **2.28** Plan of Sargon II's palace. Sargon's pride in his palace and his wish to be remembered for it are revealed in his so-called Great Inscription: "Palace of Sargon, the great king, the powerful king, king of legions, king of Assyria, viceroy of the gods at Babylon, king of the Sumers and of the Akkads, favorite of the great gods. The gods Assur, Nebo [god of knowledge, literature, and agriculture], and Marduk have conferred on me the royalty of the nations, and they have propagated the memory of my fortunate name to the ends of the earth."⁴ The throne room (2) was decorated with murals, and the walls of the ambassadors' courtyard (3) were highlighted with reliefs. The ziggurat (5) differed from others in Mesopotamia in having elaborate surface movement created by recesses in the walls and crenellations at the top.

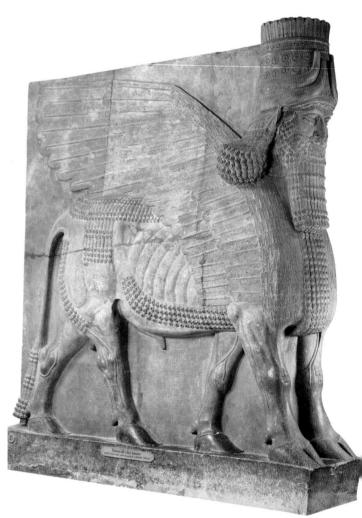

2.29 Lamassu, from the gateway, Sargon II's palace at Dur Sharrukin (now Khorsabad, Iraq), c. 720 B.C. Limestone; 14 ft. (4.26 m) high. Louvre, Paris. The ancient visitor to the palace would experience the Lamassu first as standing and then as walking. The Lamassu stands as the observer faces him and walks as he passes by, all the while seeming to keep an eye out for the king's protection.

The Neo-Babylonian Empire (612–539 B.C.)

Babylon had been ruled by Assyria for about two and a half centuries when the new southern dynasty reversed the balance of power. The greatest of the Neo-Babylonian kings, Nebuchadnezzar (reigned 604–562 B.C.), restored some of Babylon's former splendor.

Among the many architectural monuments that Nebuchadnezzar commissioned for his capital city was a ziggurat dedicated to the god Marduk, which is thought to have been the Tower of Babel referred to in the Bible (see p. 8). Another was the Ishtar Gate (fig. **2.30**), one of eight gateways with round **arches** (see box) that spanned a

Round Arches

An arch may be thought of as a curved lintel connecting two vertical supports, or posts. The round arch, as used in the lshtar Gate, is semicircular and stronger than a horizontal lintel. This is because a round arch carries the thrust of the weight onto the two vertical supports rather than having all the stress rest on the horizontal. The Greeks, Etruscans, and Romans developed rounded arches for many other purposes besides gateways (see Chapters 5, 6, and 7). Later still, in medieval Europe, round arches were revived in Romanesque churches and cathedrals (see Chapter 10).

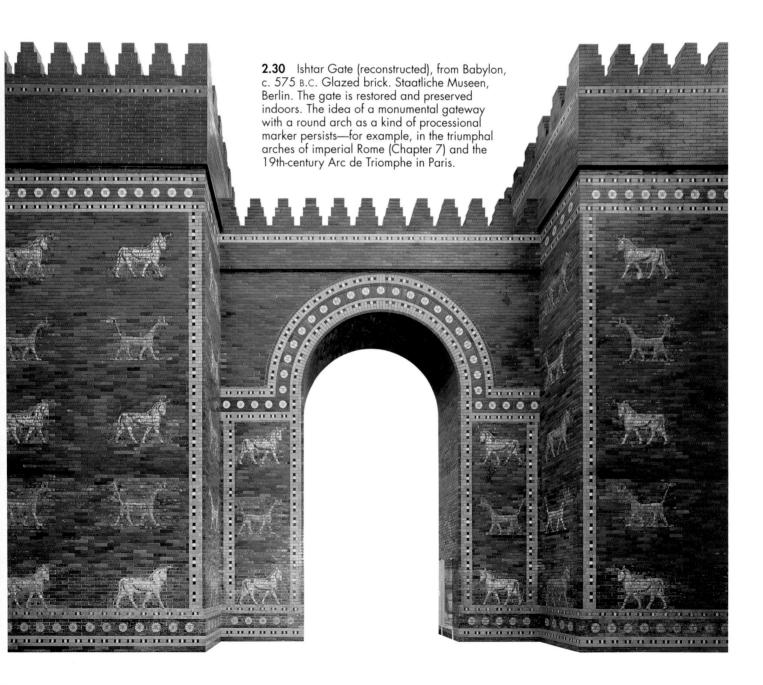

Glazing

Glazing is a technique for adding a durable, waterresistant finish to clay objects. Glazes can be clear, white, or colored and are typically made from ground mineral pigments mixed with water. The minerals become vitreous (glasslike) and fuse with the clay bodies of the objects when fired at high temperatures in kilns.

processional route through the city. The gate was named in honor of the Akkadian goddess of love, fertility, and war. It was **faced** (covered on the surface) with **glazed** bricks (see box). Set off against a deep blue background are rows of bulls and dragons (sacred to Marduk) in relief. They proceed in horizontal planes either toward or away from the arched opening. Geometric designs in white and gold frame the animal imagery and outline the gate's architectural forms.

In 539 B.C. Babylon came under the rule of yet another conqueror, Cyrus the Great of Persia (modern Iran), and became part of the Achaemenid Empire.

the standing goats (there is a second one on the other side) and the top two registers for the repeated animals, the artist creates a unity between the painted images and the three-dimensional form of the object.

An unusual sculpture dating from 3100–2999 B.C. merges the form of a bull with a human pose (fig. 2.32; see box). The figure wears a patterned skirt and kneels as if before a deity. Extended forward between the hooves is a spouted vessel that may have been an offering. Small limestone pebbles inside the figure suggest that it was used as a rattle or cult instrument. Its shiny surface and compact tension contribute to its curious combination of elegance and monumentality. Because this figure is unique in ancient art, and because its original context is unknown, its significance has so far eluded researchers.

The Scythians (8th–4th centuries B.c.)

The influence of early Iranian art persists in the much later animal art of the Scythians, a migratory people originally from southern Russia. Because they were nomadic, the Scythians' art was portable. It is characterized by vivid forms and a high degree of technical skill. A stag from the seventh century B.C. (fig. **2.33**) is typical of Scythian gold

Iran (c. 5000–331 в.с.)

To the east of Mesopotamia lay ancient Iran, whose name derives from the Indo-European Aryans, and by the fifth millennium B.C. a distinctive pottery style had emerged. A large painted pottery beaker from Susa, the capital of Elam in the southwest, exemplifies the artistic sophistication of the early Iranians (fig. 2.31). It combines elegant form with a preference for animal subjects, which are characteristic of Iranian art. The central image is a stylized goat, whose body is composed of two curved triangles; its head and tail are smaller triangles, with individual hairs on the beard and tail rendered as nearly parallel lines. The two large curved horns are particularly striking. They occupy two-thirds of the framed space and encircle a stylized plant form.

The goat stands still and upright in contrast to the dogs, whose outstretched forelegs suggest that they are racing around the upper part of the beaker. A sense of slower movement is created by the repeated long-necked birds, who seem to be parading along the top row in the opposite direction. By using the largest visible surface of the beaker for

objects.

This one was used to decorate a shield. Its pose matches the description by the fifth-century-B.C. Greek historian Herodotos of animals that were typically sacrificed by the Scythians. The artist has captured a naturalistic likeness of the animal, while at the same time forming its antlers into an abstract series of curves and turning its legs into birds. Such visual metaphors, in which the forms of one animal are transformed into those of another, are characteristic of Scythian animal art. They also enhance the illusion of motion; although it is clear from the folded, bird-shaped legs that the stag is static, there is a sense of movement in the curvilinear patterning.

2.31 Beaker, from Susa, capital of Elam (now in Iran), c. 5000-4000 B.C. Painted pottery; 11¼ in. (28.6 cm) high. Louvre, Paris. The images painted on the beaker are consistent with the fact that the viewer is more aware of its circularity at the rim and base than on the broader surface in between.

Destroying the Archaeological Record

Objects such as the kneeling bull in figure 2.32 create significant problems for archaeologists and raise questions about the plunder of archaeological sites. This particular work, like many others from ancient civilizations around the world, is certainly authentic (i.e., not a modern forgery), but it has no provenience. That is, it appeared on the art market without any record of its place of origin. Presumably because it was one of thousands of objects plundered for profit, the circumstances of its removal from the ground are unknown. It can be identified as Proto-Elamite on the basis of stylistic and iconographic analysis, through comparison with related works excavated in known circumstances, but it cannot be assigned a specific context. We do not know, for example, what city it is from or whether it might have been found in a house, a palace, or a temple; its purpose is also unknown. Once the archaeological record of such an object is destroyed, a piece of history is lost forever. As a work of art, from a purely aesthetic point of view, the figure is immensely satisfying. As a visual document and expression of a time and place, it remains a mystery.

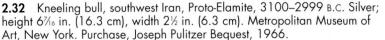

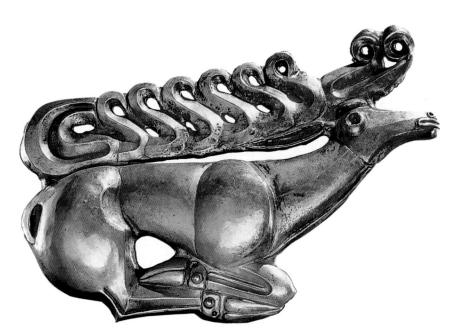

2.33 Stag, from Kostromskaya, Russia, 7th century B.C. Chased gold; 12½ in. (31.7 cm) long. State Hermitage Museum, St. Petersburg. As with the Paleolithic cave paintings and carvings of western Europe (see Chapter 1), this Scythian work is the product of artists familiar with the animals around them.

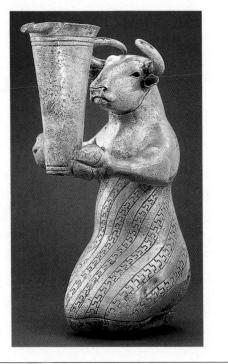

Recent Discoveries: The Filippovka Cemetery

In 1986, excavations began in the nomadic cemetery at Filippovka, located in the Eurasian steppes north of the Caspian Sea. The twenty-five burials discovered there yielded remarkable gold objects, despite having been plundered. Most impressive are the twenty-six stags dating to the fourth century B.C., of which figure **2.34** is an example. It is made of wood

covered in hammered gold, which is attached with bronze nails. The base is silver over wood. Stylizations are evident in the body markings, and the elaborate, curvilinear antlers are reminiscent of the earlier Scythian shield emblem (see fig. 2.33). But scholars are debating both the dates of the burials and the identity of the culture that produced them.

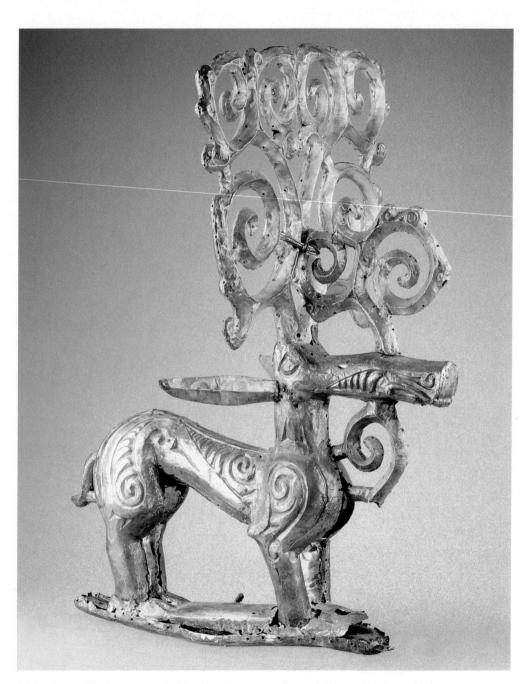

2.34 Stag, 4th century B.C. Gold, silver, bronze, and wood; 20 in. (50.0 cm) high. Archeological Museum, Ufa.

Achaemenid Persia (539–331 B.C.)

The Persians, Indo-European–speaking people affiliated with the Medes, settled southeast of Susa in a region of Iran now known as Fars. The Assyrian empire was brought down by a coalition of Medes, Scythians, and Babylonians in 612 B.C., creating a power vacuum. King Cyrus II (reigned 559–530 B.C.), called Cyrus the Great, founded the Persian Achaemenid dynasty, which was to become the largest empire in the ancient world. He first conquered the Medes, followed by Lydia (in Anatolia) and, in 539 B.C., Babylon (in Mesopotamia). Cyrus's son seized Egypt, and under later rulers the Achaemenids' vast territory stretched as far as the Aegean islands. The Assyrians —who had preceded the Persians as empire builders in the ancient Near East—influenced the Persians in several ways, most notably in their manner of celebrating kingship.

The Persians followed the religious teachings of Zoroaster (c. 628–551 B.C.), who taught that the world's two central forces were light and dark: Ahuramazda was light and Ahriman was dark. There were no Achaemenid temples since religious rituals were held outdoors, where fires burned on altars. The most elaborate Achaemenid architectural works were palaces, of which the best example is at Persepolis (literally, in Greek, "city of the Persians"). It was begun c. 520 B.C. by Darius I (reigned 521–486 B.C.), and work continued over many years under his successors, especially Xerxes and Artaxerxes I. The palace at Persepolis was built on a stone platform 40 feet (12.19 m) high and consisted of multicolumned buildings. Access to the platform was along a double stairway leading to the main gate, which was known as "All Lands."

The most important structure was the Apadana (Audience Hall; fig. **2.35**), where the king received foreign delegations. This and the throne room were huge squares that gave onto open verandas and contained tall, imposing stone columns.

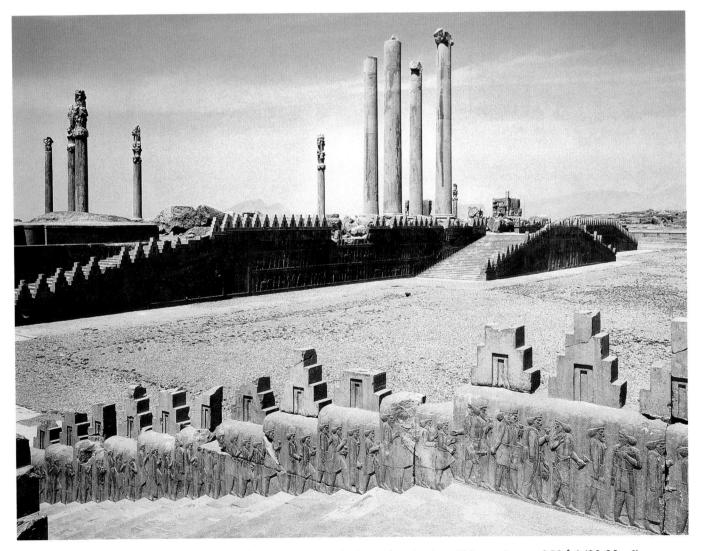

2.35 Apadana (Audience Hall) of Darius and stairway, Persepolis (in modern Iran), c. 500 B.C. Approx 250 ft.² (23.23 m²). The Apadana was decorated with one hundred columns 40 feet (12.19 m) high. Originally painted, the shafts show influences from other cultures, including Egypt (Chapter 3) and Greece (Chapter 5), but the bull capitals were unique to Persia.

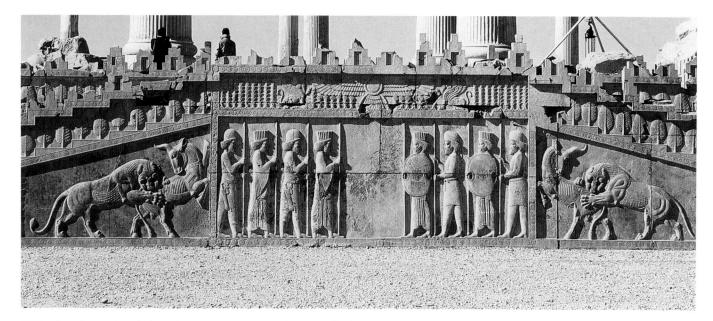

2.36 Royal guards, relief on the stairway to the Audience Hall of Darius, Persepolis, c. 500 B.C. Photo: R. Ottria.

Reliefs lining the walls and stairways were originally painted and emphasized the king's grandeur. In contrast to the aggressive military scenes on Assyrian reliefs, Persian reliefs depict solemn tribute bearers calmly presenting offerings to the king. This distinction is consistent with the political styles of the two civilizations: unlike the cruel repression that characterized the Assyrian Empire, the Persian Empire was generally administered in an orderly and tolerant way. The wall in figure **2.36** shows members of the king's royal guard, whose broad, slightly curved drapery folds contribute to the sense of slow, ceremonial movement. Their stylizations, particularly the curvilinear

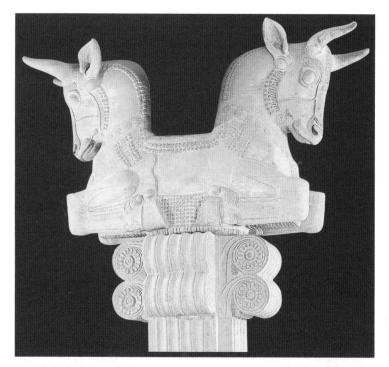

hair and beard patterns, are typically Achaemenid. Vast numbers of such figures, like the repeated columns of the Apadana and the columned halls of Persepolis (see box), are intended to focus attention on the centrality and greatness of the king. The motif of the lion attacking the bull is characteristic of Achaemenid art.

Paired bulls facing in opposite directions (fig. **2.37**) were set on top of the capitals at Persepolis. The bulls themselves form the **impost block**, whose function was to carry the wooden ceiling beams on a "saddle" created by joining the bulls' foreparts. With their legs tucked under them, the bulls illustrated here convey a sense of calm. The representation of bulls at the palace associates the king with the power and virility that this animal traditionally embodies. Bull capitals at Persepolis may also be an architectural metaphor for the position of the king as "head of state."

Some of the iconography at Persepolis was assimilated from different Near East cultures. For example, motifs included crenellated walls like those of Sargon's palace at Khorsabad, Assyrian-derived guardians of gateways, and Egyptian and Greek architectural elements. The Achaemenid capital city was described in an inscription of Darius, referring to his palace in Susa: "This is the palace I erected. ... Its ornament was brought from afar."⁵ According to Darius, Babylonians dug the earth, packed the rubble, and

2.37 Bull capital, Persepolis, c. 500 B.C.

Columns

A **column**, like a **pillar**, is a tall, slender upright. Columns can be freestanding and sculptural, but they are usually architectural supports—the "posts" of the post-andlintel system of elevation. At Persepolis, columns consist of three main parts: a lower **base**, a vertical **shaft**, and a **capital** on top on which the horizontal lintel rests. The term *capital* comes from the Latin word *caput*, meaning "head," and refers to its position at the top of the column.

molded the brick. Cedar timber came from Lebanon and was transported by Assyrians to Babylon. Gold came from Sardis and Bactria, silver and copper from Egypt, and ivory from Ethiopia. The stonecutters were Ionians and Sardians (from Sardis, in Lydia).

Achaemenid artists were also expert in metalwork. The gold lion drinking vessel in figure **2.38** is clearly an object fit for a king. Not only the intrinsic value of its material, but

also the complexity of its design and structure, suggest that it comes from a royal workshop. It is formed from several pieces of gold, but their sophisticated fusion makes it difficult to locate the joints. Thin gold threads were used—altogether over 144 feet (44 m) of them—for the cup itself. Like the bulls on the Persepolis capital, the gold lion conveys a sense of compressed space and muscular tension. Its combination of stylized elements-such as the horseshoe-shaped leg muscle, the bulges on either side of the nose, the wing feathers and body hair-with convincing organic form is typical of much ancient Near Eastern art. So is the metamorphosing of the work from one form (the lion) into another (the drinking vessel). But the specific nature of the stylizations and the merging of elegance with monumental power are characteristic of the Achaemenid aesthetic.

Persian domination of the Near East came to an end nearly 200 years after Darius I began the palace at Persepolis. In 331 B.C., Alexander the Great, king of Macedonia (the northern part of modern Greece), conquered the Achaemenids and went on to create an even larger empire (see Chapter 5).

2.38 Achaemenid drinking vessel, Persian, 5th century B.C. Gold; 6¼ × 9 in. (17.1 × 22.9 cm). Metropolitan Museum of Art, New York. Fletcher Fund, 1954 (54.3.3). Photograph © 1982 Metropolitan Museum of Art.

	Style/Period	Works of Art	Cultural/Historical Developments
9000 B.C.	NEOLITHIC c. 9000–4500/4000 b.c.	Plastered skull (2.1), Jericho Reconstruction of Çatal Hüyük (2.2) Anatolian goddess (2.3), Çatal Hüyük Two leopards (2.4), Çatal Hüyük	Development of agriculture; domestication of sheep and goats (c. 6000 B.C.) Earliest cities in Mesopotamia (5000–4000 B.C.) Copper smelting developed (c. 4500 B.C.)
5000 B.C.	ANCIENT IRANIAN c. 5000–331 b.c.	Beaker (2.31), Susa Plastered skull Kneeling bull (2.32), Iran	Kneeling bull
4000 B.C. 50	URUK c. 3500–3100 B.C.	Cone mosaics (2.5), Uruk Carved vase (2.6), Uruk Female head (2.7), Uruk White Temple, ziggurat (2.8), Uruk Cylinder seal (2.10), Uruk Clay tablet, pictographic text (2.11), Iraq	First bronze casting (c. 4000 B.C.) Sumerians settle at site of Babylon (4000–3000 B.C.) Height of Sumerian civilization (3500–3000 B.C.) Development of cuneiform script in Sumer (3500–3000 B.C.)
3000 B.C.	SUMERIAN Early Dynastic c. 2800–2300 B.C. Neo-Sumerian c. 2100–1900/1800 B.C.	Statues (2.12), from Tell Asmar Lyre sound box (2.14), Ur Head of Gudea (2.18), Iraq Gudea with temple plan (2.19), Iraq Ziggurat (2.20), Ur	Gilgamesh, legendary king of Uruk (2750 B.C.) Great Pyramids built at Giza, Egypt (2500 B.C.) First known epic poem, the <i>Epic of Gilgamesh</i> , recorded on cuneiform tablets (2000–1000 B.C.)
2000 в.с.	АККАDIAN с. 2300–2100 в.с.	Head of Akkadian ruler (2.16) Victory stele of Naram-Sin (2.17)	
	OLD BABYLONIAN c. 1800–1600 b.c.	Stele, law code of Hammurabi (2.21)	Sargon I (?) Victory stele of Naram-Sin
	НІТТІТЕ с. 1450–1200 в.с.	Lion Gate (2.22), Boghazköy Hittite war god (2.23), Boghazköy	Beginning of Judaism (1200 B.C.) End of the Trojan War (c. 1180 B.C.)
1000 в.с.	ASSYRIAN c. 1300–612 в.с.	Assurnasirpal II (2.24), Nimrud Assurnasirpal II and Lions (2.25), Nimrud City attacked with a battering ram (2.26), Nimrud Sargon II's palace (2.28), Khorsabad Lamasu (2.29), Khorsabad Dying Lioness (2.27), Nineveh	Phoenicians develop alphabetic script (c. 1100 B.C.) Israelite kingdom founded; reign of David and his son Solomon (reigned 961–922 B.C.)
	SCYTHIAN 8th-4th centuries B.C.	Stag (2.33), Kostromskaya	Assurnasirpal II
500 B.C.	NEO-BABYLONIAN 612–539 b.c.	Ishtar Gate (2.30), Babylon Ishtar Gate	Neo-Babylonian Empire reaches zenith under Nebuchadnezzar (reigned 604–562 в.с.); conquest of Egypt (605) and Jerusalem (586) Birth of Buddha (c. 563 в.с.) Birth of Confucius (c. 550 в.с.)
300 B.C.	ACHAEMENID 539–331 B.C.	Apadana of Darius (2.35), Persepolis Royal guards (2.36), Persepolis Bull capital (2.37), Persepolis Achaemenid drinking vessel (2.38) Stag (2.34), Filippovka	Birth of Herodotos, "father of history" (485 B.C.)

Ancient Egypt

The Gift of the Nile

Located in northeast Africa (see map), Egypt was the site of one of the most powerful and longest-lasting

civilizations in the ancient world. In the Neolithic period. before about 7000 B.C., farming communities had settled along the banks of the Nile. The inhabitants used stone tools and made ivory and bone objects and hand-built pottery. Until its unification around 3100 B.C., ancient Egypt had been divided into Upper Egypt in the south and Lower Egypt in the north. Egypt was defined by its most important geographical feature, the Nile, the world's longest river. Because annual floods kept the land fertile, Egypt was called "the gift of the Nile." The Nile flows northward for some 4,160 miles (6695 km) from its source in central Africa through Egypt. At Memphis, near Cairo, the Nile divides and spreads into its delta, a wide alluvial triangle of about 14,500 square miles (23,335 km²), now lush and fertile but in antiquity a region of marsh and scrub. From the delta, the river empties into the Mediterranean Sea.

The search for the source of the Nile became an obsession with nineteenth-century explorers. In fact, however, the Nile is a combination of two rivers. Rainfall in the highlands of east-central Africa drains into a series of lakes, especially Lake Victoria, to form the headwaters of the White Nile. After flowing north through a large area of swamp, the river reaches Khartoum, where it joins its twin, the Blue Nile, rising in the Ethiopian mountains. North of Khartoum, the Nile enters what was ancient Nubia, where vegetation and marshland give way to desert on either side. At six points, the river passes over outcrops of rock known as the cataracts (huge waterfalls—from the Greek word *katarrhaktes,* meaning "down-swooping"). At the northernmost of these, the First Cataract, the Nile enters Lower Egypt at Aswan.

Rainfall in central Africa and melting snows from the Ethiopian highlands caused the Nile to flood each year,

reaching its highest point in Egypt by the end of August. The average flood level measured nearly 25 feet (8 m), high enough to flood the whole valley up to the edge of the desert but not so high as to overwhelm villages and dikes. When the waters receded, the soaked earth was covered with a fresh deposit of rich, dark silt. This led the Egyptians to call their land Kemet ("The Black") as opposed to

Hymn to Hapy

Hapy was the personification of the Nile and was regularly honored with festivals and hymns. This one, from which only excerpts are given, was written during the Middle Kingdom:

Hail to you, Hapy, Spring from earth, Come to nourish Egypt! . . .

Who floods the fields that Re has made, To nourish all who thirst; Lets drink the waterless desert, His dew descending from the sky...

When he is sluggish, noses clog, Everyone is poor; As the sacred loaves are pared, A million perish among men. When he plunders, the whole land rages, . . .

Food provider, bounty maker, Who creates all that is good! Lord of awe, sweetly fragrant, Gracious when he comes . . .

Conqueror of the Two Lands, He fills the stores, Makes bulge the barns, Gives bounty to the poor.¹

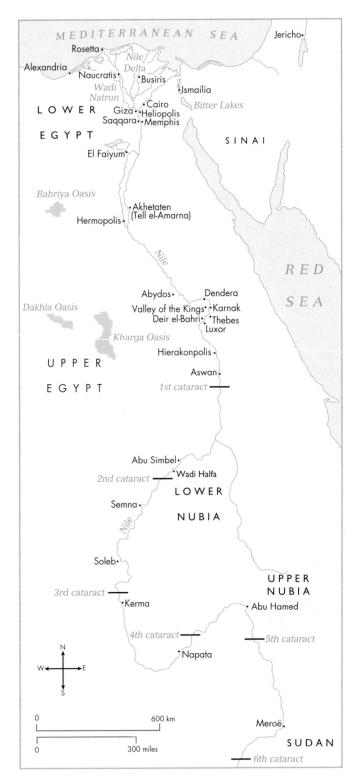

Ancient Egypt and Nubia.

the desert, Deshret ("The Red"). By autumn, the land was once again ready for planting, its fertility renewed.

This pattern was generally predictable from year to year, as were the sunny, cloudless skies. Occasionally, however, the Nile failed to rise to the expected levels, and the resulting food shortages reminded the Egyptians of their dependence on the annual flood. This concern is reflected in a hymn to the Nile god Hapy (see box) as well as in the Bible (Genesis 41), in which Joseph interprets the pharaoh's dream of seven fat and seven lean cattle as meaning seven years of plenty and seven of famine. The predictability of life—the rising and setting of the sun, the monthly waxing and waning of the moon, the annual flood, sowing and harvesting—induced in the ancient Egyptians a sense of order and inevitability. Every natural phenomenon, especially the daily return of the sun and the annual flood of the Nile, seemed a continual rebirth, and this theme was central to the development of Egyptian religion.

Religion

The Egyptians, like their Near Eastern neighbors, were polytheists. Gods were manifest in every aspect of nature. They influenced human lives and ordered the universe. They could appear in human or animal form, or as various combinations of humans and animals.

Archaeological evidence suggests that prehistoric Egyptian religion consisted of local gods and cults that were confined to a particular district, or *nome*. After the unification of Upper and Lower Egypt c. 3100 B.C., the importance of these local deities increased or diminished with the military and political fortunes of their districts. For example, the sky god Horus, usually represented as a falcon, was originally a local god who later achieved national status.

Egyptian gods had spheres of influence that could intersect or overlap, producing numerous compound deities. Single gods could also have multiple aspects—such as Horus-the-child, representing the potential power of a child, and Horus-in-the-horizon, denoting the power of daybreak or sunset.

The result of this belief system was a pantheon (meaning "all the gods" of a people, from the Greek words *pan*, meaning "all," and *theoi*, meaning "gods") of enormous complexity (see box). Over time, the number was increased by the introduction of foreign gods into Egypt. Like most polytheists, the Egyptians did not find the religious ideas of other cultures incompatible with their own, and they incorporated new deities either singly or in combination. This process of fusion is known as syncretism. One such syncretistic immigrant assimilated into the Egyptian pantheon was the Syrian goddess Astarte, who was related to the Babylonian Ishtar (see Chapter 2).

The Pharaohs

From approximately 3100 B.C., Egypt was ruled by pharaohs (kings) whose control of the land and its people was virtually absolute. Egyptian monumental art on a vast scale begins with pharaonic rule, originating when King Menes united Upper and Lower Egypt. Much of our knowledge of Egyptian chronology comes from ancient

Egyptian Gods

Isis

A few of the principal gods of ancient Egypt in their most typical guises are listed here:²

Ŭ	Creat and of Thebase identified with Dates		guarding coffins and canopic jars	
Amon	Great god of Thebes; identified with Ra as Amon-Ra; sacred animals, the ram and goose	Maat	Goddess of truth, right, and orderly conduct; depicted as a woman with an ostrich feather on her head	
Anubis	Jackal god, patron of embalmers; god of the necropolis, who ritually "opens the mouth" of			
	the dead	Mut	Wife of Amon; originally a vulture goddess, later depicted as a woman	
Aten	God of the sun disk; worshiped as the great creator god by Akhenaten	Osiris	God of the underworld, identified as the dead king; depicted as a mummified king	
Bes	Helper of women in childbirth, protector against			
	snakes and other dangers; depicted as a dwarf with features of a lion	Ptah	Creator god of Memphis, patron god of craftsmen; depicted as a mummy-shaped man	
Нару	God of the Nile in flood; depicted as a man with pendulous breasts, a clump of papyrus (or a lotus) on his head, and bearing tables laden with offerings		Falcon-headed sun god of Heliopolis, supreme judge; often linked with other gods, whose cults aspire to universality (e.g., Amon- Ra); depicted as falcon-headed	
Hathor	Goddess with many functions and attributes; often depicted as a cow, or woman with a cow's	Serapis	Ptolemaic period; combines characteristics of Egyptian (Osiris) and Greek (Zeus) gods	
	head or horned headdress; mother, wife, and daughter of Ra; protector of the royal palace; domestic fertility goddess; identified by the Greeks with Aphrodite (see Chapter 5)	Seth	God of storms and violence; brother and murderer of Osiris, rival of Horus; depicted as a pig, ass, hippopotamus, or other animal	
Horus	Falcon god, originally the sky god; identified with the king during his lifetime; the son of Osiris and Isis, and avenger of the former			

king lists, the most comprehensive of which was compiled in the fourth century B.C. by a priest, Manetho. His list begins with the legendary reign of the gods, followed by that of the human kings from Menes to Alexander the Great. Manetho divided Egyptian history into thirty dynasties, or royal families (a thirty-first was added later).

One problem with Manetho's list has been to identify the sequence of the names. Since Egypt had no absolute system of dating (such as B.C./A.D.), each pharaoh treated the first year of his reign as the year one. However, with the help of other king lists, inscriptions naming more than one king, references to astronomical observations that can be precisely dated, and correlations with evidence from outside Egypt, nineteenth- and twentieth-century scholars have compiled a relative chronology (see box, p. 84). Nevertheless, even this changes as new archaeological discoveries are made.

Modern scholars have divided Egyptian history into Predynastic and Early Dynastic periods, followed by the Old, Middle, and New Kingdoms, and the Late Dynastic period. These were punctuated by "intermediate periods" of anarchy or central political decline as well as by periods of foreign domination. For thousands of years following Menes' unification, Egypt had many periods of durable power, when artists worked for the state and its rulers within the confines of a political and religious hierarchy. Between the Middle and New Kingdoms, there was a period of more than one hundred years during which a group of Semitic rulers, based in the northeastern Delta, controlled Lower Egypt. Known as the Hyksos, from the Egyptian word *heqau-khasut* (meaning "princes of foreign countries"), these rulers are credited with having introduced the horse-drawn chariot to Egypt. During the New Kingdom, some important changes occurred. For example, the first queen to have assumed pharaonic status and to have presided over an artistic revival, Hatshepsut (see p. 103), co-ruled Egypt with Thutmose III from c. 1479 to 1458 B.C., and later the pharaoh Akhenaten (reigned c. 1349–1336 B.C.) made revolutionary changes in the hierarchy of gods.

Divine mother, wife of Osiris, and mother of

Horus; one of four protector goddesses,

From the end of the New Kingdom, Egypt's preeminent position as a powerful monarchy was weakened by foreign infiltration. During the Late Dynastic period, Egypt twice fell under Persian rule—from 525 to 404 B.C. and again in 343 B.C. In 332 B.C., the Persians were defeated by Alexander the Great, who annexed all Persian territory, including Egypt, to his empire. After his death in 323 B.C., control of Egypt passed to the Macedonian general Ptolemy, whose successors ruled until the Roman conquest in 30 B.C. His descendants established the capital of Egypt at Alexandria, on the Mediterranean coast just west of the Delta, and infused Egypt with ideas from the Greek-speaking world.

Chrono	logy	of	Egyp	otian	Kings
--------	------	----	------	-------	-------

(all dates before 664 B.C. are approximate)

Predynastic period		5450–3100 в.с.
Early Dynastic period	Dynasties 1–2	3100–2649 в.с.
Old Kingdom	Dynasties 3–6	2649-2150 в.с.
First Intermediate period	Dynasties 7–11	2143-1991 в.с.
Middle Kingdom	Dynasties 12–14	1991–1700 в.с.
Second Intermediate period	Dynasties 15–17 (including the Hyksos period)	1640–1550 в.с.
New Kingdom	Dynasties 18–20	1550-1070 в.с.
Third Intermediate period	Dynasties 21–25	1070–660 в.с.
Late Dynastic period	Dynasties 26–30	688–343 в.с.
	Persian kings	343-323 в.с.
Ptolemaic period	Macedonian kings	323–31 в.с.

The Egyptian Concept of Kingship

For the ancient Egyptians, kingship was a divine state. As in Mesopotamia (Chapter 2), kings mediated between their people and the gods. In Egypt, however, the kings were themselves considered gods. They ruled according to the principle of maat, divinely established order (personified by Maat, the goddess of truth and orderly conduct; cf. box, p. 83). From the Third Dynasty, the compound god Amon-Ra, in the guise of the reigning pharaoh, was believed to impregnate the queen with a son who would be heir to the throne. This divine conception by Amon-Ra was part of each pharaoh's official personality and iconography. A queen could be either the king's mother or his principal wife. Marriages occasionally took place between a pharaoh and his sister, half sister, or daughter, when this was politically useful. The ambiguous position of the queen by comparison with that of the pharaoh reflects her complementary role. Certain exceptions notwithstanding, Egyptian kingship was not for women. The queen was the king's means of renewal by providing him with male heirs to the throne or with daughters for creating alliances through advantageous marriages.

In entering into incestuous marriages, the king, like the gods, was distinct from the general population of Egypt. Although there are many uncertainties about daily life in ancient Egypt, texts indicate that monogamous marriage was considered a positive and natural state, and that the Egyptian commoner tended to have one wife at a time. Infidelity, especially if committed by the wife, was grounds for divorce, as were impotence, infertility, dislike of a wife, or the wish to marry another woman. A primary purpose of marriage was the production of children, and household deities of fertility-including Hathor and Bes-were worshiped in the home. In Egypt, as in the Near East, homosexuality was viewed as counterproductive to the ideal of fertility. Widows and orphans were disadvantaged members of society, although adoption was an established institution.

Despite the gaps in our knowledge, it seems clear that Egyptian kingship derived its divinity from the association of pharaohs with gods. The royal family modeled its behavior on that of the gods, separating itself from those it ruled. Egyptian kings did not maintain power by setting an example to the public at large, but rather by their distinction from it. In the transfer of kingship from father to son or some substitute for a son, Egypt created another avenue of identification with the gods.

The Palette of Narmer

The links between divine and earthly power noted in earlier civilizations reappear in an important Egyptian ritual object, the Palette of Narmer (figs. 3.1 and 3.2). It dates from the beginning of pharaonic rule and is an excellent example of an image of power. On both sides, the palette is decorated in low relief. The large scene in figure 3.1 is depicted according to certain conventions that lasted for over two thousand years in Egypt. For example, King Narmer (thought to be Menes, the first pharaoh) is the biggest figure-his size and central position indicate his importance. His composite pose, in which head and legs are rendered in profile view with eye and upper torso in frontal view, is an Egyptian convention. This is a conceptual, rather than a naturalistic, approach to the human figure, for the body parts are arranged as they are understood and not as they are seen in reality. The entire body is flat, as is the kilt, with certain details such as the kneecaps rendered as stylizations, rather than as underlying organic structure.

Narmer wears the tall, white conical crown of Upper Egypt (the *hedjet*) and threatens a kneeling enemy with a mace. He holds him by the hair, an act that symbolizes conquest and domination. Two more enemies, either fleeing or already dead, occupy the lowest register of the palette. Behind Narmer on a suspended horizontal strip is a servant whose small size, like the low positions of the enemies, identifies him as less important than the king. In Egypt, as in Mesopotamia, therefore, artists used a system

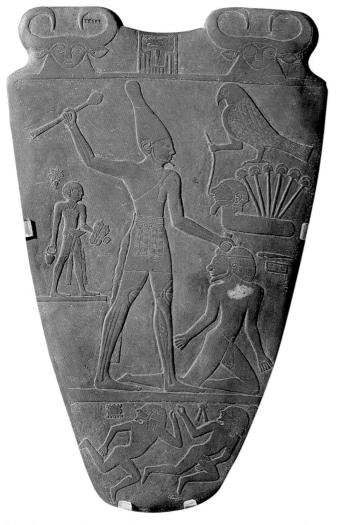

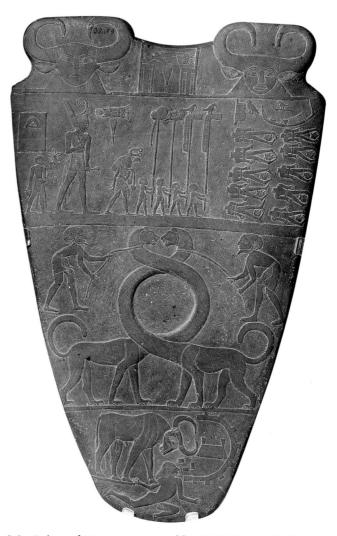

3.1 Palette of Narmer, from Hierakonpolis, c. 3100 B.C. Slate; 25 in. (63.5 cm) high. Egyptian Museum, Cairo. This is called the Upper Egypt side because Narmer wears the white crown.

3.2 Palette of Narmer (reverse of fig. 3.1). This is called the Lower Egypt side because the pharaoh wears the red crown.

of hierarchical proportions. The servant holds Narmer's sandals, showing that the king is on holy ground (just as Muslims remove their shoes before entering a mosque). In front of Narmer, at the level of his head, is Horus, the falcon god of sky and kingship, who, with a human hand, holds a captive human-headed creature at the end of a rope. From the back of this figure rise six **papyrus** plants, which represent Lower Egypt. The image of Horus dominating symbols of Lower Egypt parallels Narmer, crowned as the king of Upper Egypt and subduing an enemy.

At the top center of each side of the palette is a rectangle known as a *serekh* (see box, p. 86). A *serekh* contained a king's name in hieroglyphs (pictures symbolizing words that were the earliest Egyptian writing system; see p. 86). On either side of the *serekh*, frontal heads of the cow goddess Hathor indicate that she guards the king's palace. The other side of the palette (fig. 3.2) contains three registers below the Hathor heads and the pharaoh's name. At the top, Narmer wears the red crown of Lower Egypt (the *deshret*). His sandal bearer is behind him, and he is preceded by standard-bearers. At the far right, ten decapitated enemies lie with their heads between their feet. These figures are meant to be read from above, as a row of bodies lying side by side. Such shifting viewpoints are characteristic of Egyptian pictorial style.

Two felines, roped by bearded men, occupy the central register. Their elongated necks frame an indented circle similar to those that held liquid for mixing eye makeup on smaller palettes. This one, however, was found as a dedication in a temple and is larger than those used in everyday life. Although derived from such palettes, the Palette of Narmer was most likely a ceremonial, rather than a

Royal Names: Serekhs and Cartouches

During the First, Second, and Third Dynasties, the chief name, or "Horus name," of the reigning pharaoh was written in the top half of a rectangular frame known as a *serekh*, a flattened representation of his palace. This was symbolic of the king as the god Horus, himself depicted as a falcon surmounting the *serekh*.

During the third millennium B.C., it became customary for kings to take five titled names. The Horus name was followed by "He of the Two Ladies," signifying that the king was under the protection of two goddesses, the Wadjet of Lower Egypt and the Nekhbet of Upper Egypt. The third name was "Horus of Gold," a reference to the sunlit sky. In the Fourth Dynasty, a fourth name was added, "King of Upper and Lower Egypt," known as the *prenomen*, or throne name; it was enclosed in a cartouche, a rectangle with a semicircle at either end, signifying the passage of the sun around the universe and the pharaoh's dominion over it. Completing the series of five titles was a second cartouche, containing the *nomen*, or birth name, "Son of Ra" (the sun god).

Figure **3.3** is a diagram of the *serekh* from the Palette of Narmer, and figure **3.4** shows Akhenaten's cartouches.

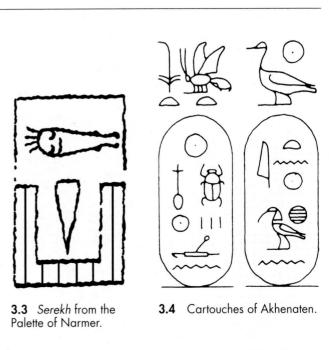

practical, object. It is not certain what the felines, called serpopards, mean, but their intertwined necks could refer to Narmer's unification of Egypt (signified by his two crowns). In the lowest register, a bull—probably a manifestation of Narmer himself—subdues another fallen enemy before architectural symbols.

Every image on the palette conveys Narmer's might and importance. He is protected by the gods. He is taller, more central, and more powerful than any other figure. He destroys his enemies and their cities. The iconographic message of this work is a political one. Like much of the Egyptian art that survived the next two thousand years, the Palette of Narmer is a statement of power, for it celebrates the king's divine right to rule and illustrates his ability to do so.

Writing and History

By around 3100 B.C., the Egyptians were using a form of picture writing known as hieroglyphic (from the Greek words *hieros*, or "sacred," and *glypho*, "I carve"). This method of writing was slow, so for everyday purposes the Egyptians developed a faster system, an abridged form of hieroglyphic called hieratic.

In the seventh century B.C., a simpler form of writing, known as demotic (because it was used by the ordinary people, *demos* in Greek), became standard for all but religious texts. These three systems—hieroglyphic, hieratic, and demotic—remained in use until the Christian era, when they were replaced by Coptic, which was composed of Greek letters and supplemented by seven demotic signs. From the fifth century A.D. to 1822, reading ancient Egyptian scripts was a lost art.

In 1799, soldiers of Napoleon's French Expeditionary Force, working on fortifications at the village of Rashid (called Rosetta by Europeans) in the western Delta, discovered a slab of black basalt—the Rosetta Stone (fig. **3.5**)—built into an old wall. The importance of the Rosetta Stone lay in its three separate inscriptions, each a version of the same text in a different script and two languages hieroglyphics, demotic, and Greek. The Greek version was soon translated and found to be a decree passed by a council of Egyptian priests in honor of the first anniversary of the coronation of the pharaoh Ptolemy V Epiphanes (205–180 в.с.).

Primary credit for deciphering the Rosetta Stone goes to Jean-François Champollion (1790–1832), a young French scholar who realized that hieroglyphs could be divided into two categories: ideograms, which recorded an idea pictorially, and phonograms, which denoted sounds representing one or more consonants (the Egyptian script had no vowels), independent of their meaning. Some hieroglyphs could be either ideograms or phonograms, depending on their context. Ideograms were also used as determinatives, which helped to indicate the meaning of a word spelled phonetically (e.g., a hieroglyph

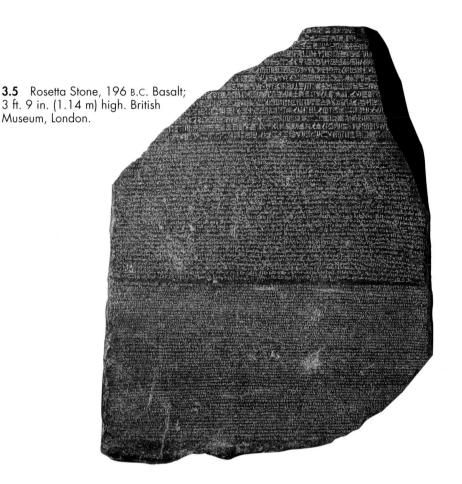

of walking legs to indicate motion, or of a hawk, the fastest bird, to represent swift things in general or anything for which speed is an attribute).

The stone was probably about 5 to 6 feet (1.52–1.82 m) high originally, with a rounded top (now missing) that contained the winged disk of Horus of Edfu depicted over the figure of Ptolemy V standing in the presence of various gods. A similar scene on a stele of 182 B.C., with the text of the same decree, enabled scholars to fill in the missing portions around the edge of the stone.

Once the Egyptian text on the Rosetta Stone was deciphered, the meanings of thousands of preserved Egyptian texts became available for study. Reading the king lists was the starting point for establishing a chronology of ancient Egypt, and other texts have clarified ancient Egyptian art and its cultural context.

The Egyptian View of Death and the Afterlife

For the ancient Egyptians, death was not the end of life but the transition to a similar existence on another plane. To ensure a fortuitous afterlife, the deceased had to be physically preserved along with earthly possessions and other reminders of daily activities. This was first achieved by simple burial in the dry desert sands. Later, coffins insulated the body, and artificial means of preservation were used. But in case the body of the deceased did not last, an image could serve as a substitute. The dead person's *ka* (soul) was believed able to enter the surrogate before journeying to the next world.

The *ka* was only one aspect of the Egyptian triple concept of the spirit. In its aspect as a "double," the *ka* was viewed as the life force that continued after death and permitted the deceased to eat and drink offerings provided by relatives and priests. The *akh* was more detached from the body than the *ka* and resided in the heavens as the spiritual transformation of the dead person. The third aspect of the spirit, the *ba*, was literally in touch with the deceased, and its mobility in and out of the body was reflected in its depiction in art as a bird with a human head.

Procedures such as mummification highlight the ancient Egyptian preoccupation with a material existence in the afterlife. Enormous resources were devoted to providing for the dead, both on an individual level and, in the case of the royal family and its court, on a grand scale involving the whole society. Much of the art and writings that have survived is funerary, preserved in the desert for thousands of years.

Mummification

The Egyptians evolved a seventy-day process of embalming corpses. According to the Greek historian Herodotos (History II.85–90), writing in the fifth century B.C., the first step was the removal of the internal organs, except for the heart, which was believed to be the seat of understanding and was therefore left intact. The body was then packed in dry natron (a natural compound of sodium carbonate and sodium bicarbonate found in Egypt), which dehydrated the cadaver and dissolved its body fats. Then the corpse was washed, treated with oils and ointments, and bandaged with as many as twenty layers of linen in a way that conformed to its original shape. The substances applied to its skin caused the body to turn black; later travelers took this to mean that the body had been preserved with pitch, for which the Arabic term is mumiya—hence the English terms mummy and mummification. Ornaments placed on the body or inside the wrappings included amulets (charms against evil or injury), scarabs (representations of dung beetles used as protective devices, symbolic of the sun; fig. 3.6), wedjats (eyes of Horus; fig. 3.7), and djeds (pillars symbolizing stability).

No less important than preservation of the body was the preservation of organs that had been removed. These were embalmed and placed in four so-called **canopic jars** (fig. **3.8**), but the brain was discarded as useless. Each jar held a particular organ and was under the protection of one of Horus's four sons. Each son had a characteristic head (man, baboon, jackal, and falcon). Until c. 1300 B.C., the jars had human-headed stoppers, but later they were carved in the form of the head of the relevant protective deity. Even in the Late Period, when the organs were usually wrapped and replaced in the body cavity, a substitute set of canopic jars was left at the burial site.

Before c. 2000 B.C., a mask made of linen stiffened with plaster (cartonnage) was molded to the contours of the face, creating an effect reminiscent of the skulls from Neolithic Jericho (see fig. 2.1). After that time, a separate mask often covered the face, and these came to be made from valuable materials, including, for those who could afford it, gold.

A single mummy might have been nested inside several coffins. Eventually, the mummy's shape—bandaged and masked—became the model for the coffin itself. Coffins were made of wood or cartonnage and placed inside stone sarcophagi.

3.6 Diagram of a scarab.

3.7 Diagram of a *wedjat* (the eye of Horus).

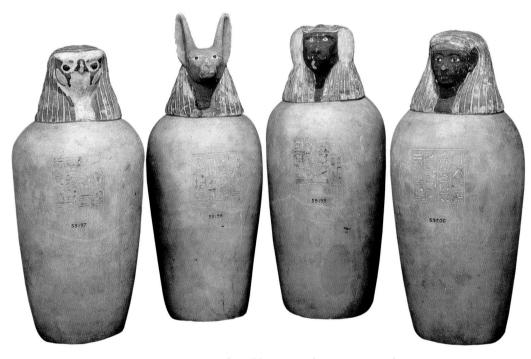

3.8 Canopic jars of Neshkons. British Museum, London.

Funerary Texts

Funerary texts written on tomb walls, coffins, and papyrus reveal the Egyptian use of words as magic to protect the deceased. These texts contain spells designed to preserve the dead person's name and pleas for his well-being in the afterlife. They recount his virtues, attest to his good character, and invoke the protection of his body from harmful creatures such as snakes and scorpions. Over seven hundred different formulas have been identified, but no single tomb contains a complete set of the texts. At first, Pyramid Texts were confined to the pyramids of the pharaohs, but around the twentieth century B.C. they begin to appear on nonroyal coffins, which may be evidence of a relaxation of royal prerogatives.

The Pyramid Text quoted below, known as *Utterance* 407, is from the east wall of the antechamber of the pyramid of Teti (Sixth Dynasty) at Saqqara. It describes the king joining the sun god Re after death and refers to the Opening of the Mouth ritual (see p. 105), followed by the assertion that he will become a judge in the afterlife:

Teti has purified himself: May he take his pure seat in the sky! Teti endures: May his beautiful seats endure! Teti will take his pure seat in the bow of Re's bark: The sailors who row Re, they shall row Teti! The sailors who convey Re about lightland, They shall convey Teti about lightland! Teti's mouth has been parted, Teti's nose has been opened, Teti's ears are unstopped. Teti will decide matters, Will judge between two, Teti will command one greater than he! Re will purify Teti, Re will guard Teti from all evil!3

During the Middle Kingdom, the wooden coffins of private individuals were inscribed with Coffin Texts, which included myths and funerary incantations. Also

3.9 Vignette from Paynedjem's *Book of the Dead,* from Thebes, Twenty-first Dynasty, c. 990–969 B.C. Painted papyrus; height 13 in. (33.0 cm).The British Museum.

from this period are the earliest known maps—called the *Book of Two Ways*—designed to help the dead find their way in the perilous transition from life to afterlife, the journey through the underworld. They were also guided by the *Book of the Dead*, the modern name for the compilations of religious and magical texts found in numerous burials, which the ancient Egyptians called the *Chapter of Coming Forth by Day*. The title refers to the ability of the deceased to leave their tombs. Although no complete copy of this book exists, numerous extracts have survived.

From Hatshepsut's reign on, the *Book of the Dead* was written on papyrus. The example in figure **3.9** shows a high priest of Amon (at the right) presenting an offering to Osiris. The god holds the crook and flail—originally instruments of animal husbandry and planting—which signify fertility and rebirth. His green face alludes to his role as a vegetation god.

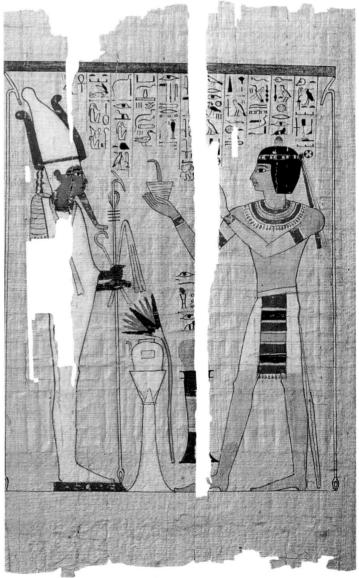

The Old Kingdom (c. 2649–2150 B.C.)

Menes's unification of Egypt was followed by long periods of relatively stable, highly centralized government during which artists worked for the state and its rulers within the confines of a political and religious hierarchy. Egyptian artists worked, as did their contemporaries in Mesopotamia, for individual patrons as well as for the state. Since the ruling classes controlled the wealth in these hierarchical societies, their art is both more impressive and often better preserved than that of less wealthy patrons. We see this clearly in funerary art. Those in power could afford durable materials such as stone for their memorials, as well as precious materials such as gold and gems, and could finance elaborate burial sites designed to endure for eternity.

Pyramids

The most monumental expression of the Egyptian pharaoh's power was the pyramid, his burial place and zone of passage into the afterlife. Pyramids were preceded by smaller structures called **mastabas**, from the Arabic word for "bench" (fig. **3.10**). These were originally made of mud brick and later were faced with cut stones. A mastaba is a single-story trapezoidal structure containing a vertical shaft leading to an underground burial chamber where the dead body lay in a **sarcophagus** (from the Greek words *sarcos*, meaning "flesh," and *phagein*, "to eat"). Another room (the *serdab*), located at ground level, contained the *ka* statue of the deceased. Adjoining this was an additional room for receiving mourners with offerings.

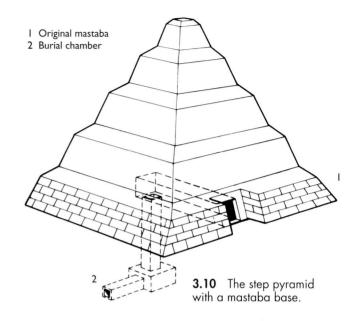

Eventually, the number of underground chambers was increased in some mastabas to accommodate burials of entire families.

From 2630 to 2611 B.C., King Zoser's architect, Imhotep, constructed a colossal structure within a sacred architectural precinct at Saqqara, on the west bank of the Nile about 30 miles (48 km) south of Cairo. To the basic mastaba Imhotep added five more mastaba forms of decreasing size, one on top of the other, resulting in a **step pyramid** (fig. **3.11**). Inside, a vertical shaft some 90 feet (27.43 m) long led to the burial chamber. The exterior was faced with limestone, most of which has now disappeared. The purpose of Zoser's building complex was to function as a vast

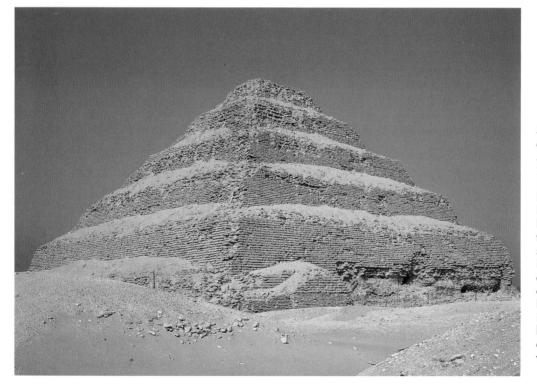

3.11 Step pyramid, funerary complex of King Zoser, Saqqara, Egypt, c. 2630-2611 B.C. Limestone; 200 ft. (61.00 m) high. Its architect, Imhotep, was a priest at Heliopolis and is reputed to have been the first Egyptian to build monumental stone structures. His name is inscribed inside the pyramid, where he is designated "First after the King of Upper and Lower Egypt." He became a legendary figure in ancient Egypt, revered for his wisdom as a magician, astronomer, and healer, and was worshiped as a god.

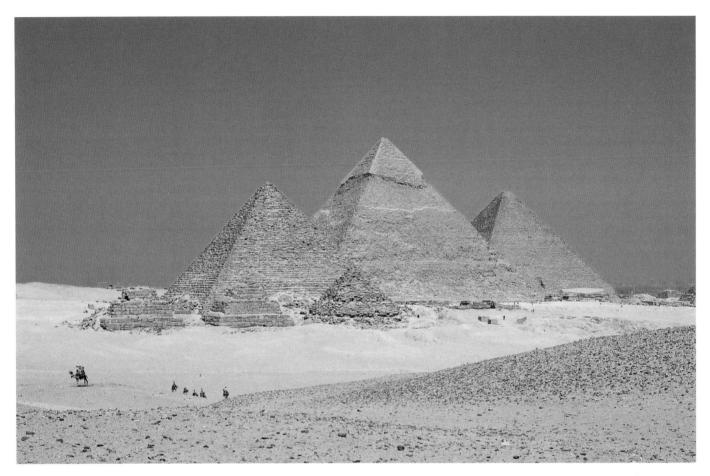

3.12 Pyramids at Giza, Egypt, c. 2551–2472 B.C. Limestone; pyramid of Khufu approx. 480 ft. (146.00 m) high, base of each side 755 ft. (230.00 m) long. The Giza pyramids were built for three Old Kingdom pharaohs of the Fourth Dynasty: Khufu (c. 2551–2528 B.C.), Khafre (c. 2520–2494 B.C.), and Menkaure (c. 2490–2472 B.C.). Khufu's pyramid—the largest of the three—was over twice as high as Zoser's step pyramid at Saqqara.

architectural "stage set"—some of the buildings were only façades backed with rubble—to serve him in the afterlife. Later on, the site was maintained as a cult center for both Zoser and Imhotep. In contrast to Mesopotamia, where it is the name of the royal patron that has lasted, at Saqqara it was the architect who received credit for the conception and execution of the building.

The next major development in pyramid design was the purely geometric pyramid, an evolution of Imhotep's step pyramid. Four triangular sides slant inward from a square base so that the apexes of each triangle meet over the center of the square. Originally, the sides were smooth and faced with polished limestone. A capstone, probably gilded, reflected the sun and signified the pharaoh's divine solar identification. Surveying techniques made it possible to orient the four corners of the plan precisely to the cardinal points of the compass. The purpose of this was to align the pyramids with significant positions of the sun.

Of the eighty-odd pyramids known to exist, the three outstanding examples were built by, and for, three Old Kingdom pharaohs of the Fourth Dynasty: the pyramid of Khufu (the largest, known as the Great Pyramid); the pyramid of his son Khafre, 22 feet (6.71 m) shorter and 15 percent smaller in volume; and the pyramid of Khafre's son Menkaure, only 10 percent of the size of Khufu's (fig. **3.12**). All three are near Cairo at Giza, on the west bank of the Nile, facing the direction of sunset (symbolizing death), as was customary for Old Kingdom burial sites. Across the river to the northeast was Heliopolis (from the Greek words *helios*, meaning "sun," and *polis*, or "city"), the center of the cult associated with the sun god Ra.

Although the Giza monuments have been surrounded by desert since antiquity, recent archaeological excavations suggest that the site was once a river harbor. Each of the pyramids was connected by a causeway (elevated road) to its own valley temple at the edge of the original floodplain of the Nile. Upon the death of the king, his body was transported across the Nile by boat to the valley temple. It was then carried along the causeway to its own funerary temple, where it was presented with offerings of food and drink, and the Opening of the Mouth ceremony was performed (see p. 105).

The pyramid was intended primarily as a resting place for the king's body, and burial chambers were constructed

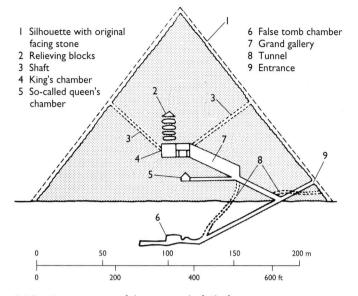

3.13 Cross section of the pyramid of Khufu.

either in the rock under the pyramid or in the pyramid itself. In Khufu's case (fig. **3.13**), the burial chamber is in the middle of the pyramid, slightly less than halfway between the ground and the top. It is reached by a sloping passageway that runs into the grand gallery, an enormous foyer 153 feet long and 28 feet high (46.63×8.53 m) with a

corbeled roof (see Chapter 4). The king's chamber measures 34 by 17 feet (10.33×5.16 m), and its roof is composed of nine slabs of granite weighing 400 tons. The granite sarcophagus containing the body of Khufu was so large that it could not have been moved through the passages of the pyramid. Instead, it was placed in the chamber, and the pyramid was built around it.

In addition to the king's chamber, there were smaller chambers, possibly for the body of the queen, the organs of the deceased, and worldly goods for the journey to the afterlife. The chambers were connected by a maze of passages, including dead-ends designed to foil grave robbers. In this latter objective, the builders failed; during the Middle Kingdom a succession of thieves penetrated the pyramids at Giza and plundered them.

Construction of the pyramids was a considerable feat of engineering and organization. Herodotos (c. 484–430 B.C.), who traveled to Egypt in the fifth century B.C. and questioned the priests at Heliopolis, reported that the laborers "worked in gangs of a hundred thousand men, each gang for three months"⁴ (*History* II.124). Some of the workers were probably seasonal—for example, peasants during the flooding of the Nile—but there would also have been a core of full-time masons and other craftsmen. Housing for 4,000 workers has been excavated near the pyramid of Khafre.

The pyramids at Giza were part of a vast funerary complex (fig. **3.14**) that included temples, chapels for offerings and ceremonies, mastabas for noble families, and cause-

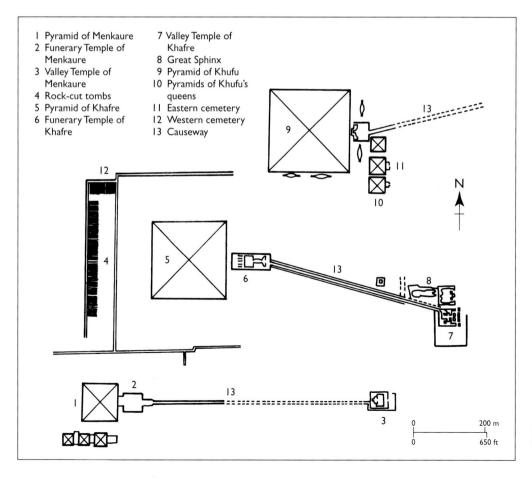

3.14 Plan of the Giza funerary complex.

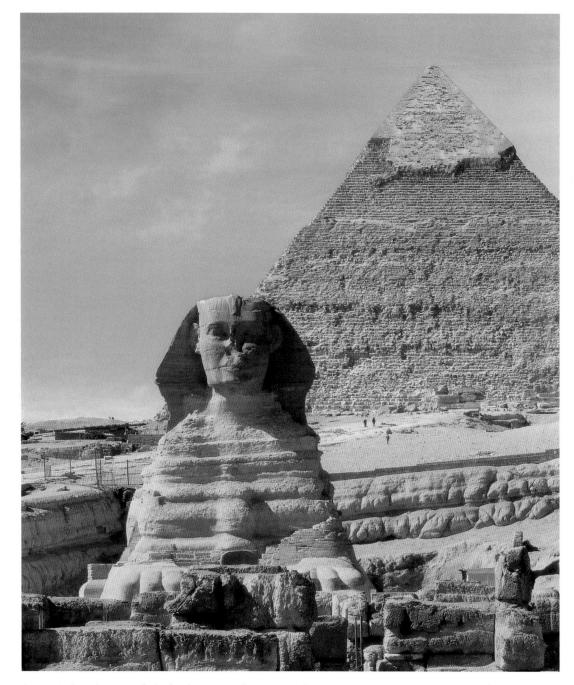

3.15 Colossal statue of Khafre, known as the Great Sphinx, Giza, c. 2520–2494 B.C. Sandstone; 66 ft. (20.12 m) high, 240 ft. (73.15 m) long.

ways linking the structures. From the pyramid of Khafre, a processional road led to his valley temple, guarded by the Great **Sphinx** (fig. **3.15**), a colossal human-headed creature with a lion's body carved out of the living rock. The location of the sphinx suggests that it represented Khafre

himself. It also faces the rising sun, which reinforces its association with the pharaoh. Surrounding the sphinx's head is the trapezoidal pharaonic headcloth (the *Nemes* headdress) that fills up the naturally open space above the shoulders and enhances the sculpture's monumentality.

.

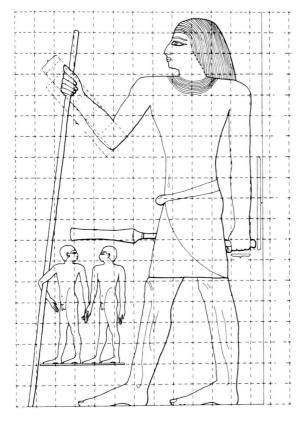

3.16 Egyptian proportional grid.

The Egyptian System of Proportion

Egyptian artists used a grid system to control the proportions of human figures (fig. **3.16**) in art. This allowed them to make identical multiples of statues such as the one illustrated in figure 3.17. The proportional system followed by Egyptian artists changed only slightly over time, a reflection of the unusual stability of Egyptian art. This system could be adjusted to any scale, from small statuettes (see fig. 3.24) to colossal works such as the Giza sphinx, ensuring exact proportions for each. It could be used for paintings and reliefs as well as for free-standing sculptures.

In figure 3.16, the distance from the hairline to the ground is 18 units, from the base of the nose to the shoulder 1 unit, and from the fingers of a clenched fist to the elbow 4½ units. Note the characteristic way of depicting the human body: the shoulders and the one visible eye are frontal; the head, arms, and legs are in profile, whereas the waist is nearly in profile but is turned sufficiently to show the navel. One purpose of this system was to arrive at a conventional, instantly recognizable image.

Sculpture

Nearly all the Egyptian sculpture that has been preserved was originally created for tombs or temples. Egyptian artists followed certain conventions for sculptures both in the round and in relief. The more important the personage represented, the more rigorously the conventions were observed.

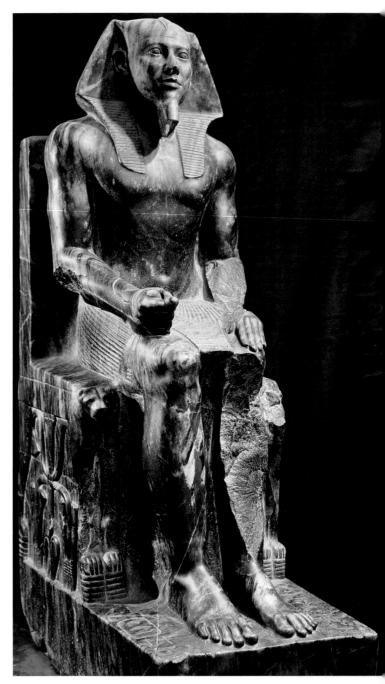

3.17a (front view) Seated statue of Khafre, from Giza, c. 2520–2494 B.C. Diorite; 5 ft. 6 in. (1.68 m) high. Egyptian Museum, Cairo.

An over-life-sized diorite statue of Khafre (fig. **3.17a**, **b**) illustrates the conventional representation of a seated pharaoh. Khafre sits in an erect, regal posture, both hands on his lap, his right fist clenched and his left hand lying flat above his knee. The sculptor began with a rectangular block of stone to which the planes of the figure still conform. Khafre's throne and its base comprise a stepped arrangement with two verticals (corresponding to the king's

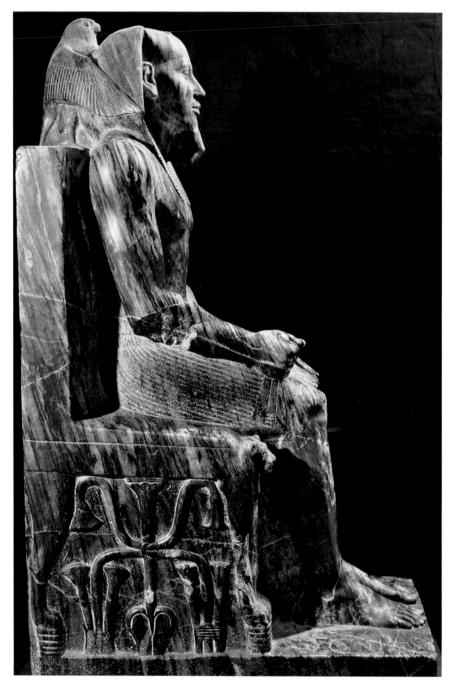

3.17b (side view) Seated statue of Khafre.

torso, upper arms, and calves) meeting three horizontals (his forearms, thighs, and feet) at right angles. Spaces between body and throne are eliminated because the original diorite remains, serving to unify the king and his throne. The symbolic identification of king and throne is thus formally enhanced by the sculptors of this period.

The lions carved on Khafre's throne are the king's guardians and images of regal power in their own right.

Horus, who protects the back of Khafre's head, was the son of Isis, a mother goddess called the "Pharaoh's throne." Both gods reinforce Khafre's divine right of kingship. The association of a ruler and his throne is reflected in modern usage when we refer to the "seat of power."

A good example of standing figures from the Old Kingdom can be seen in the statue of Khafre's son Menkaure (whose pyramid at Giza is illustrated in figure 3.12) and Queen Khamerernebty (fig. **3.18a**). The artist began with an upright rectangular block, which remains visible in the base, between the figures, and at the back (fig. **3.18b**).

The statue of Khafre and that of Menkaure and Khamerernebty were found in their valley temple along with a series of similar figures. Their function was to embody the ka of the royal personages and to receive food and drink brought by worshipers. Priests were believed to have the magic power to transform the images into real people who could eat the offerings.

The sculptures of Prince Rahotep and his wife Nofret (fig. 3.19, p. 97) also exhibit distinctions between representations of male and female. Princess Nofret is fully clothed, and her right hand lies flat, protruding from her garment. Her husband wears only a lower garment, and both fists are clenched. Since the soft limestone from which these figures are carved is porous, their original paint has been preserved. This fortunate circumstance reveals the elaborate jewelry worn by aristocratic Egyptian women and the stylized eye outlines also current in Mesopotamian art. The difference in Rahotep's brown skin tone and Nofret's, which is yellow ocher, is a convention of Egyptian painting and painted sculpture

to distinguish male from female. Note also the hieroglyphs on the slab behind the figures; they denote the names and titles of the couple.

METHODS OF INTERPRETATION

Menkaure and Khamerernebty, an Old Kingdom Pharaoh and His Queen (fig. 3.18); Formalism, Iconography, Feminism, Context

T he rectangular block of stone from which this statue was carved is retained in the final sculpture, making the king and queen literally and figuratively "set in stone." In this case, the formal elements reinforce the iconographic meaning of the figures. The king is taller, his shoulders are broader, his pose

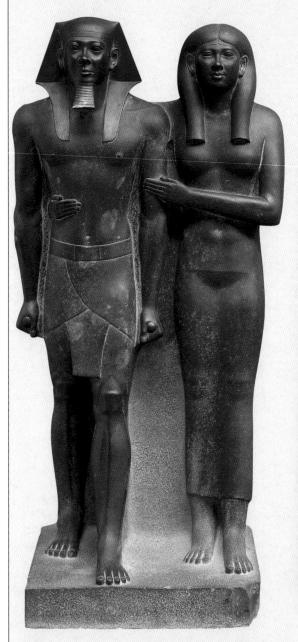

3.18a Menkaure and Queen Khamerernebty, from Giza, 2490–2472 B.C. Slate; 4 ft. 6½ in. (1.39 m) high. Courtesy, Museum of Fine Arts, Boston.

is more rigid, his fists are tighter, and his assertive left leg is extended farther forward than the queen's. He wears the traditional trapezoidal *Nemes* headdress and ceremonial beard typical of Old Kingdom pharaohs. These formal and symbolic features create the impression that he is more forceful and more

powerful than she. The flattening of the tunic suggests solidity and forcefulness, and contrasts with the queen's garment, which is formed more softly around the curves of her body.

Feminist art historians have identified the queen's pose as indicating her support of the pharaoh. That she places one arm around his waist and the other on his arm has been interpreted as the queen conferring power on her spouse. This interpretation is consistent with the cultural context of ancient Egyptian royalty, which was matrilineal in character. Egyptians recognized that maternity is always more certain than paternity. Nevertheless, despite the important role of the queen, her more naturalistic depiction signified a lesser rank than the king's in the strict and accepted hierarchy of Egyptian society.

Because of the importance of eternal life in Egyptian religion, representations of kings and queens emphasized their association with the gods. The very choice of the medium had meaning in ancient Egypt. For this reason, hard stone, such as obsidian, granite, diorite, and slate

> —the latter used to carve King Menkaure and his queen—was the preferred medium for royal sculpture. Stone was the longest-lasting, most durable sculptural material the Egyptians had available.

```
3.18b Side view of figure 3.18a.
```

3.19 Prince Rahotep and his wife Nofret, c. 2551–2528 B.C. Painted limestone; 3 ft. 11½ in. (1.20 m) high. Egyptian Museum, Cairo. The eyes are inlaid with rock crystal; facial features and Nofret's headband and necklace are painted.

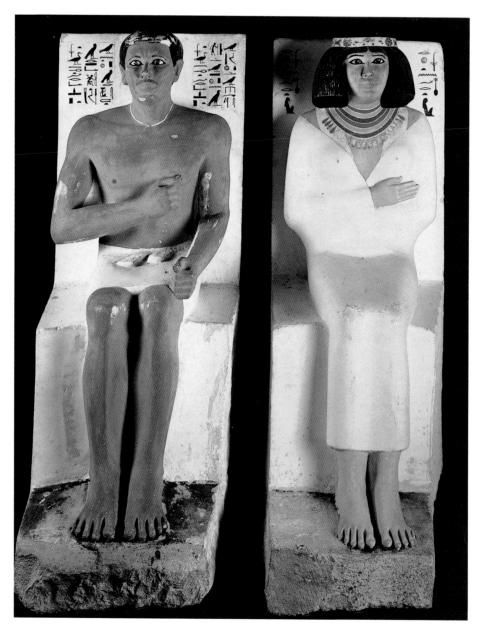

3.20 Seated scribe, from Saqqara, c. 2551-2528 B.C. Limestone; 21 in. (53.3 cm) high. Louvre, Paris. The scribe retains his original paint, which makes his eyes seem lifelike. In ancient Egypt, scribes were among the most educated people, having to study law, mathematics, and religion, as well as reading and writing.

Compared with the sculptures of Khafre and Rahotep, the seated scribe (fig. 3.20) is less monumental though no less impressive. He sits cross-legged, in the pose that is conventional for scribes. A papyrus scroll (see box, p. 98) extends across his lap, and his right hand is poised to write. In contrast to statues of pharaohs and nobles, the lower rank of the scribe allows the sculptor to reflect his relatively individual character. Furthermore, the sculptor has cut away the limestone between the arms and body as well as around the head and neck, thereby reducing the monumentality of this statue as compared with that of Khafre. The depiction of the scribe is also more personalized than that of either Khafre or Rahotep-he has a roll of fat around his torso, a potbelly, and sagging breasts. This particular scribe must have been of high status because he had his own tomb.

Papyrus Manuscripts

The most important Egyptian writing surface was made from the papyrus plant, which grew in the marshes along the Nile. Papyrus stems were cut into lengths of about 12 inches (30.5 cm). The rind was peeled off and the pith cut lengthwise into thin slices. One layer of slices was laid side by side with a second layer on top of it at right angles. The two layers were bonded together by pressing, with no adhesive other than the natural starch of the papyrus. Once dry, the resulting smooth and light-colored surface was polished with a wood or stone tool. Papyrus sheets could be joined together at the edges (with the fibers running in the same direction) and then rolled up into scrolls. Pigments for writing texts were solid tablets made of carbon (black) or of ground ocher (red) that were then mixed with gum. They were dissolved as the scribe wet his brushes and rubbed them over the tablet's surface—much as watercolor paint is used today. Brushes were made from the trimmed stems of other marsh plants. Bristles, which held a supply of wet pigment, were made by chewing one end of their stems to separate the fibers. During the Late period, pens were also used; these were made from reeds that had been cut to a point and split in two at the tip.

The Middle Kingdom (c. 1991–1700 B.C.)

Monumental architecture continued in the Middle Kingdom, though much of it was destroyed by New Kingdom pharaohs for use in their own colossal building projects. Besides pharaohs' pyramids, a new form of tomb was introduced. This was rock-cut architecture, in which the sides of cliffs were excavated to create artificial cave chambers. Rock-cut tombs became popular with aristocrats and highlevel bureaucrats in the Eleventh and Twelfth Dynasties.

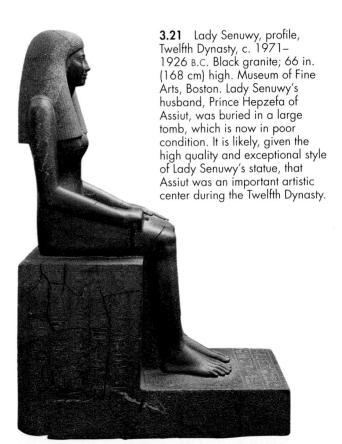

Middle Kingdom sculpture is often somewhat more naturalistic, and royal figures less imposing than in the Old Kingdom. Forms tend to be more rounded, and faces show occasional hints of an expression. Although the graceful seated statue of Lady Senuwy (figs. **3.21** and **3.22**) retains the closed space between arms and body, and lower legs and seat, associated with statues of Old Kingdom pharaohs, there is a narrow space behind the figure that emphasizes the gradual curve of the wig and back. Compared with the statue of Nofret (see fig. **3.19**), Lady Senuwy is slim and her features more delicate. Hers is one of the finest and most elegant large-scale statues from the Middle Kingdom.

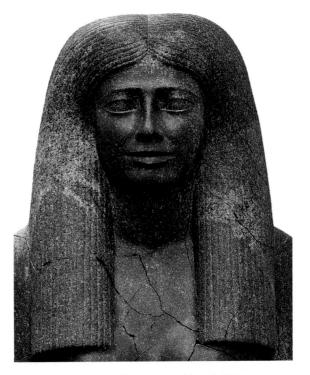

^{3.22} Lady Senuwy (front view of fig. 3.21).

3.23 Sesostris I, from Lisht, Twelfth Dynasty, c. 1971– 1926 B.C. Wood. Egyptian Museum, Cairo.

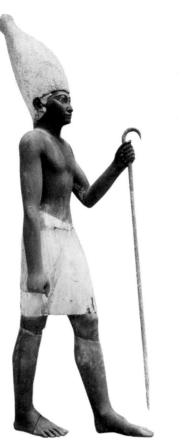

3.24 Sesostris I, from Lisht, Twelfth Dynasty, c. 1971– 1926 B.C. Painted wood and stucco; 23 in. (58.5 cm) high. Metropolitan Museum of Art, New York. Gift of Edward S. Harkness, 1914 (14.3.17). Photograph © 1993 Metropolitan Museum of Art.

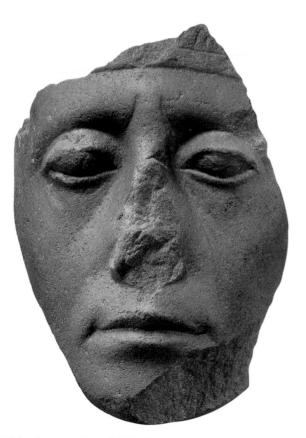

3.25 Sesostris III, c. 1878–1841 B.C. Quartzite; 6½ in. (16.5 cm) high. Metropolitan Museum of Art, New York. Gift of Edward S. Harkness, 1926.

The political turbulence and invasions of the First Intermediate period that preceded the Middle Kingdom disrupted confidence in the pharaoh's absolute divine power. Although pharaonic rule quickly reasserted itself, certain works of art reflect a new national mood. This can be seen by comparing two well-preserved wooden statuettes of Sesostris I (figs. **3.23** and **3.24**) with the fragmentary portrait of Sesostris III (fig. **3.25**). The figure of Sesostris I on the left wears the conical white crown of Upper Egypt (the *hedjet*); the other figure, the red crown of Lower Egypt (the *deshret*). Because these are made of wood, they are entirely carved in the round. Nevertheless, they are slimmer and less imposing than the Old Kingdom images of Khafre (see fig. 3.17) and Menkaure (see fig. 3.18).

The portrait of Sesostris III is one of the best examples of the new approach to royal representation in the Middle Kingdom. Sesostris III referred to himself as the shepherd of his people, and his portrait seems to show concern. There are bags under his eyes, and his cheeks are fleshy. Worry lines crease the surface of his face, and his forehead forms into a slight frown. This is no longer solely an image of divine, royal power. Instead, by departing from earlier conventions of royal representation, the sense of a specific personality emerges.

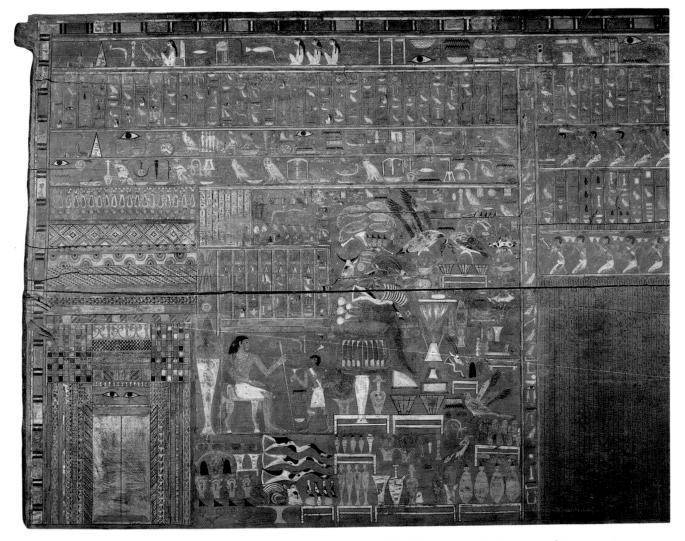

3.26 Painted coffin of Djehuty-nekht, from Bersheh, Twelfth Dynasty, c. 1971–1926 B.C. Cedar. Museum of Fine Arts, Boston.

The coffin in figure **3.26** illustrates some of the textural qualities of Middle Kingdom painting. The detailed, occasionally illusionistic patterns were drawn by an artist with a fine linear sensibility. Slight shading creates a tactile quality enhanced by the grain of the cedar surface. The eyes are those of Horus and are framed above the painted "false door" of the coffin over which they keep watch. The "door" itself allowed the *ka* to leave and reenter the coffin at will.

The New Kingdom (c. 1550–1070 в.с.)

After the instability of the Second Intermediate period, during which the so-called Hyksos invasion occurred, Egypt once again recovered its political equilibrium. The pharaohs of the New Kingdom reestablished control of the entire country and reasserted their power. They expanded into the surrounding regions of the north and south to form an empire of enormous wealth.

Temples

As durable and impressive as the tombs, Egyptian temples provided another way of establishing the worshiper's relationship with the gods. The first known Egyptian temples in the Neolithic period were in the form of huts preceded by a forecourt. From the time of Menes at the beginning of the dynastic period, a courtyard, hallway, and inner sanctuary were added. The columned hallway, called a **hypostyle** (from the Greek words *hupo*, meaning "under," and *stulos*, "pillar"), is shown in its fully developed New Kingdom form in figure **3.27**. It was constructed in the postand-lintel system of elevation and had two rows of tall central columns flanked by rows of shorter columns on either side.

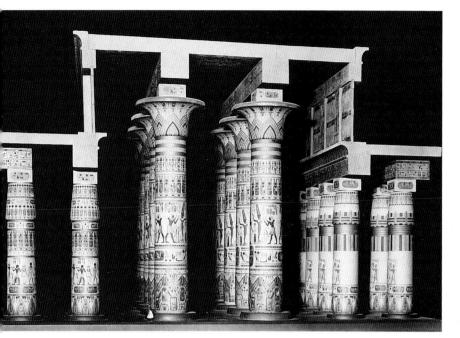

(above) Model of the hypostyle 3.27 hall, temple of Amon-Ra, Karnak, Egypt, c. 1294-1213 B.C. Metropolitan Museum of Art, New York. Bequest of Levi Hale Willard, 1890. The central hypostyle columns have capitals that seem to grow upward and curve outward from the shaft like the lotus blossom. The shafts were covered with painted low-relief scenes and hieroglyphs. Their enormous scale is hard to imagine from a photograph, but the base of each column would reach to the waist of an adult of average height. The side columns are derived from the papyrus plant.

The Pylon Temple The standard Egyptian temple, called a **pylon** temple after the two massive sloping walls (pylons) flanking the entrance, was designed symmetrically along a single axis. The plan in figure **3.28** is typical, showing the spaces through which worshipers moved from the bright outdoors into the courtyard. As they approached the entrance, they were flanked by rows of identical statues facing each other. Some temple entrances were flanked by **obelisks** (tall, tapering, four-sided pillars ending in a pointed tip called a **pyramidion**) and colossal royal statues (fig. **3.29**).

Beyond the courtyard stood the hypostyle hall, its massive columns casting shadows and creating an awe-inspiring atmosphere. The upper, or **clerestory**, windows let in small amounts of light that enhanced the effect of the shadows. Most

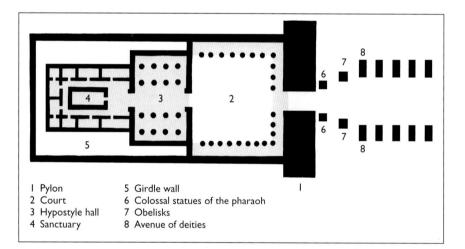

3.28 (above) Plan of a typical pylon temple.

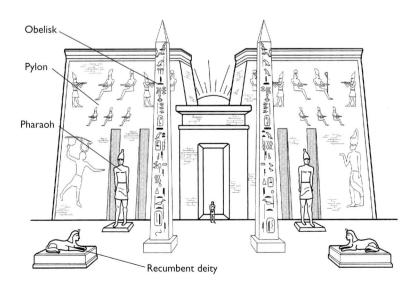

3.29 (left) Diagram of a pylon facade. The obelisks were derived from the sacred *benben* stone, worshiped as a manifestation of Amon at Heliopolis. At dawn, the rays of the rising sun caught the *benben* stone before anything else, and the stone was thus believed to be the god's dwelling place. The obelisks flanking the pylon entrance were arranged in relation to positions of the sun and moon and, like the pyramids, were probably capped with gold.

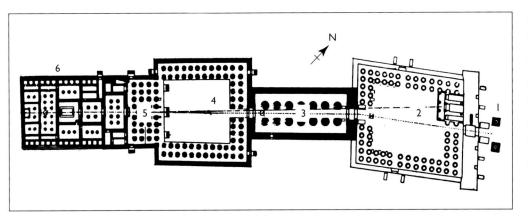

3.30 Plan of the temple of Amon-Mut-Khonsu, Luxor, Egypt, begun c. 1390 B.C. Reading the plan from right to left, number 1 refers to the pylons, flanking the entrance. From the entrance, one proceeded through three open-air, colonnaded courtyards (2, 3, 4). Then the worshiper was plunged into the darkened and mysterious realm of the hypostyle hall (5), beyond which lay the sanctuary complex (6).

people never entered the temples, but watched from the outside the processions for which the temples were planned. Occasionally the elite were allowed to enter the courtyards, while the priests carried the images of the gods in and out of the innermost sanctuaries in boat-shaped shrines called barks. The transitional quality of this architecture is carefully designed to evoke the feeling of a mysterious enclosure—a space inhabited by pharaohs and gods.

The New Kingdom temple at Luxor is dedicated to a triad of gods: Amon-Mut-Khonsu. This triad was worshiped at the New Kingdom capital city of Thebes, and its importance steadily increased. The plan of the temple (fig. **3.30**) shows that the hut and courtyard of the Neolithic era had developed into a much more elaborate structure. At the far end is the sanctuary—the "holy of holies"—a small central room with four columns shown at the far left of the plan. It was there that the priests tended the statues of the gods.

Ancient Egyptian temples were considered microcosms of the universe, and as such they contained both earthly and celestial symbolism. Column designs were derived from the vegetation of Egypt and represented the earth (see caption). Inside the temple (fig. **3.31**), the original ceil-

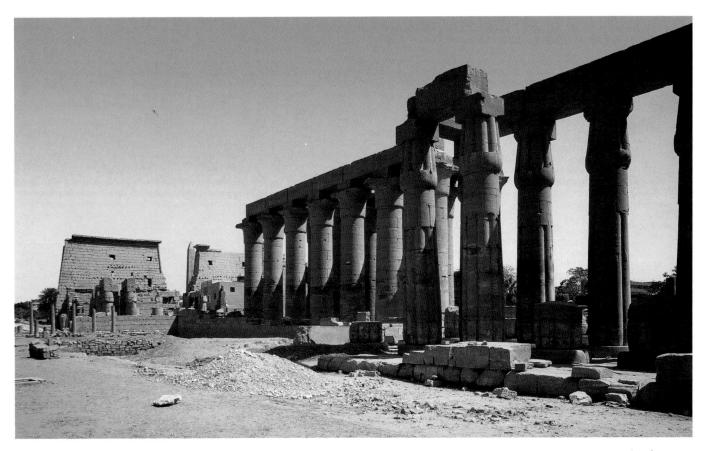

3.31 Court and pylon of Ramses II (1279–1213 B.C.) and colonnade and court of Amenhotep III (1390–1352 B.C.), temple of Amon-Mut-Khonsu, Luxor, Nineteenth Dynasty. Columns 30 ft. (9.00 m) high. Here the foreground columns are constructed in the form of bundles of papyrus reeds, and those behind are lotus flowers. Papyrus represented Lower Egypt and lotus represented Upper Egypt.

ing was painted blue and decorated with birds and stars denoting its symbolic role as the cosmos.

It is clear from Egyptian temple architecture, as well as from the pyramids, that colossal size was highly regarded. The scale of these structures emphasized the enormous power of the gods and the pharaoh, and made ordinary worshipers feel insignificant by comparison. Similarly, the vast numbers of colossal columns were intended to create an overwhelming effect. There were many large statues of the pharaoh lining the temple courtyards, as there were rows of sphinxes preceding the entrances. This insistence on repetition was designed to impress worshipers with the king's power and fertility.

Hatshepsut's Mortuary Temple and Sculpture The Eighteenth Dynasty is notable for its female pharaoh, Hatshepsut (reigned c. 1473–1458 B.C.), the wife and half sister of Thutmose II. When Thutmose II died, *his* son by a minor queen, Thutmose III, was underage. Around 1479 B.C., Hatshepsut became regent for her stepson/nephew but exerted her right to succeed her father and was crowned king of Egypt in 1473 B.C. Although female rulers of Egypt were not unprecedented, Hatshepsut's assumption of specifically male aspects of her office—such as the title of king—was a departure from tradition. Despite her successor's attempts to obliterate her monuments, many of them survive to document her productive reign.

It is not known why Hatshepsut became king nor why Thutmose III tolerated it. Hatshepsut's strong character and political acumen must have contributed to her success. She claimed that her father had chosen her as king, and she used the institution of co-regency to maintain her power without having to eliminate her rival. Above all, she selected her officials wisely, particularly Senenmut, who was her daughter's guardian as well as her first minister and chief architect.

Hatshepsut, like other pharaohs, assumed royal titles and iconography, and had her own divine conception depicted in her temple reliefs. In keeping with the conventional scene, the compound god Amon-Ra was shown handing the *ankh* symbol ($^{\circ}$), hieroglyph for "life," to Hatshepsut's mother, Queen Ahmose. In this imagery, Hatshepsut proclaimed her divine right to rule Egypt as king. She also referred to herself in texts as the female Horus, evoking the traditional parallel between a pharaoh and Horus. (Horus was the falcon-headed son of the underworld god Osiris, born after the murdered Osiris was brought back to life. Horus claimed kingship as the son of the dead Osiris. Likewise, when the Egyptian throne was handed down from father to son, it was seen as a symbolic transfer from Osiris to Horus.)

Despite acknowledging her female gender, Hatshepsut chose to be represented as a man in many of her statues. The example in figure **3.32** depicts her in the traditional assertive pose of standing pharaohs, wearing a ceremonial headdress and beard. Instead of the clenched fists of Old Kingdom pharaohs such as Menkaure (see fig. 3.18), Hatshepsut extends her arms forward and lays her hands flat on her trapezoidal garment.

The main architectural achievement of Hatshepsut's reign was the terraced mortuary temple at Deir el-Bahri

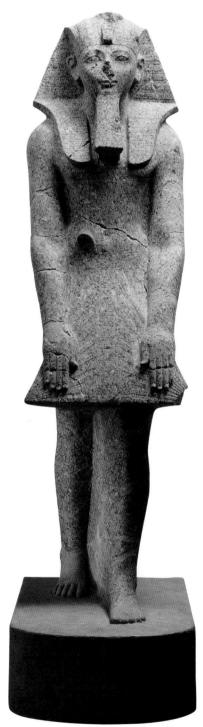

3.32 Statue of Hatshepsut as pharaoh, Eighteenth Dynasty, c. 1473–1458 B.C. Granite; 7 ft. 11 in. (2.41 m) high. Metropolitan Museum of Art, New York. Hatshepsut was the second known queen who ruled Egypt as pharaoh. The earlier queen, Sobekneferu, ruled in the Twelfth Dynasty but, unlike Hatshepsut, did not preside over an artistic revival.

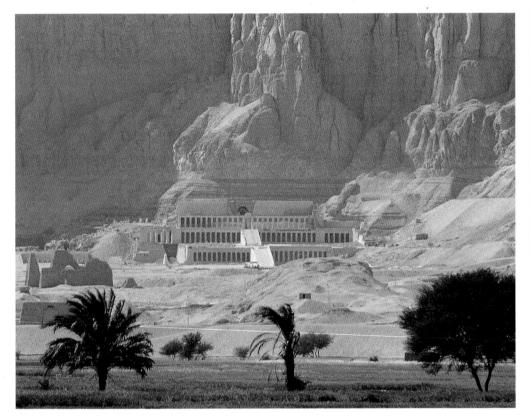

(fig. **3.33**). The primary function of the Egyptian mortuary temple was twofold: first, to worship the king's patron deity during his lifetime and, second, to worship the king himself after his death. The function of the Deir el-Bahri complex as a mortuary temple for both Hatshepsut and her father reinforced her image as his successor. At the same time, the major deities Amon, Hathor, and Anubis were worshiped in shrines within the temple complex. On the exterior, terraces with rectangular supports and polygonal columns blended impressively with the vast rocky site.

Hatshepsut's architect Senenmut was the main artistic force behind the temple and its decoration. His special status is reflected in the fact that his tomb, which was never completed, was begun inside the royal religious complex, and its unfinished ceiling was decorated with texts usually reserved for a pharaoh's burial.

In the black granite statue in figure **3.34**, Senenmut holds his ward, the young princess Nefrura, daughter of Hatshepsut. The figures are frontal, and, despite their rather iconic, even rigid poses, there is a suggestion of protectiveness in Senenmut's large hands enveloping his ward. This iconography projects an image of his close relationship with the pharaoh.

At the end of Hatshepsut's reign, Thutmose III, then in his late twenties, finally assumed sole power (c. 1458 B.C.). He demolished the images and cartouches of Hatshepsut and emphasized his own role as the successor of his father, Hatshepsut's brother/spouse Thutmose II. Whereas Hatshepsut's reign had been notable for diplomacy, Thutmose III became a great conqueror, gaining control of Nubia and invading the Near East. **3.34** Statue of Senenmut and Nefrura, Eighteenth Dynasty, c. 1473– 1458 B.C. Black granite; 24 in. (61.0 cm) high. British Museum, London. The number of statues of Senenmut is exceptional for an official who was not a member of the royal family. The fate of Nefrura at the end of Hatshepsut's reign is not known. 3.33 Funerary temple of Queen Hatshepsut, Deir el-Bahri, Egypt, Eighteenth Dynasty. Sandstone and rock. Construction of this temple began in the reign of Thutmose I (1504-1492 B.C.) and continued during the reign of his daughter Hatshepsut (1473–1458 B.C.). Most of the projecting colonnades have been restored after vandalism during the reign of Thutmose III (1479–1425 B.C.). They adorn the three large terraces, which are connected to each other by ramps. The inner sanctuary is located inside the cliff.

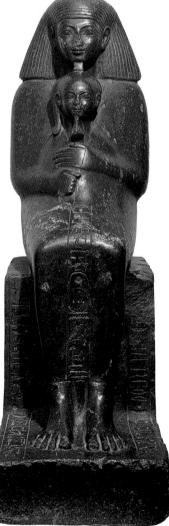

3.35 Nebamun hunting birds, from the tomb of Nebamun, Thebes, Egypt, c. 1390–1352 B.C. Fragment of a painting on gypsum plaster. British Museum, London.

Painting

Walls of Egyptian New Kingdom tombs and temples were covered with reliefs and paintings. Both provided the *ka* with familiar scenes from the earthly existence of the deceased. They also offer the modern viewer a wealth of information about life in ancient Egypt.

Mural Painting A painting on gypsum plaster from the tomb of Nebamun (fig. **3.35**), a New Kingdom official, shows him hunting birds. He is accompanied by his wife and daughter, and surrounded by animals and landscape. Following the conventional Egyptian pose, his head and legs are in profile, his torso and eye are frontal, and he wears a trapezoidal kilt. Nebamun's wife and daughter are small and curvilinear by comparison, continuing the Old Kingdom tradition of increasing naturalism for decreasing rank. Paintings of this period, however, were slightly more naturalistic than those of the Old Kingdom. Note that Ne-

bamun's wife is rendered with brown skin rather than with the conventional lighter skin of Egyptian women in art, as seen in the statues of Rahotep and Nofret (see fig. 3.19). The birds turn more freely in space than the human figures, and on the fish there is evidence of shading, which conveys a sense of volume.

Papyrus A New Kingdom painting on papyrus from the *Book of the Dead* (fig. **3.36**) illustrates the Opening of the Mouth ceremony, which ritually "opened the mouth" of the dead body and restored its ability to breathe, feel,

3.36 Opening of the Mouth ceremony, from the *Book of the Dead* of Hunefer, New Kingdom, Nineteenth Dynasty, c. 1295–1186 B.C. Pigment on papyrus. British Museum, London.

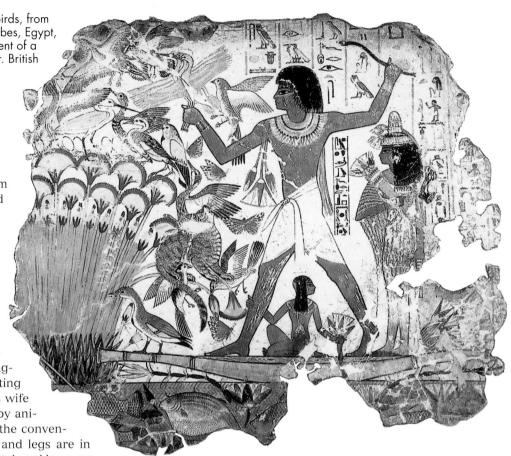

hear, see, and speak. In this scene, described in the rows of hieroglyphics at the top, the ritual is performed on the Nineteenth Dynasty mummy of the scribe Hunefer. Reading the image from left to right, we see a priest in a leopard skin, an altar, and two priests in white garments with

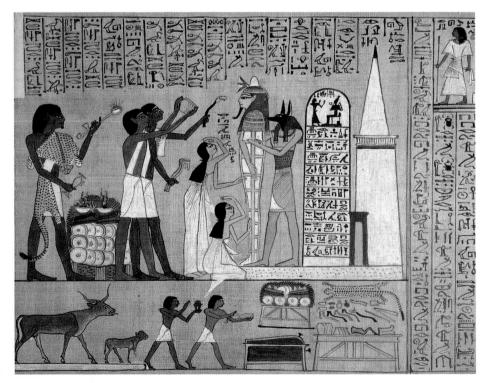

upraised ritual objects. Two mourning women are directly in front of the upright mummy. Behind the mummy is Anubis, the jackal-headed mortuary god. The two forms behind him are a stele covered with hieroglyphs and surmounted by a representation of Hunefer appearing before a god, and a stylized tomb façade with a pyramid on top. Note the similarity between the iconography of the powerrevealing scene at the top of the stele and that on the law code of Hammurabi (see fig. 2.21). Both are images of power and signify communication between the god and a mortal. In both, the seated god combines a frontal and profile pose, while the smaller mortal—as if commanding less space—is more nearly in profile.

In spite of the remarkable social, political, and artistic continuity of ancient Egypt, it is clear from the fresco fragment in figure 3.35 and from Hunefer's papyrus that certain changes had occurred in the nearly sixteen hundred years between the beginning of the Old Kingdom and the end of the New Kingdom. The most important cultural change, however, took place in around 1353 B.C., some four years into the reign of a revolutionary pharaoh, Amenhotep IV.

The Amarna Period (c. 1349–1336 B.C.)

Generations of scholars have tried to answer the questions surrounding King Amenhotep IV, who challenged the entrenched religious cults and threatened the very existence of the established priesthood that had held power in Egypt for centuries. By the Fourth Dynasty, the sun god Ra had superseded Horus as the supreme deity. Ra's cult was introduced north of Cairo at Heliopolis, the city of the sunrise. By the Twelfth Dynasty, Amon had superseded Ra in this position; and then in the Eighteenth Dynasty, Amenhotep IV adopted a new, and unpopular, religious system that was relatively monotheistic.

His primary god was the Aten, represented as the sun disk, and Amenhotep accordingly changed his name to Akhenaten (meaning "servant of the Aten"). He effaced the names and images of the other gods. Presumably to escape the influence of the priests, he moved the capital down the Nile (i.e., north) from the major cult center of Thebes to Akhetaten (now known as Tell el-Amarna, from which the term for this period is derived). Akhenaten chose the site and name for his new capital because the sun rising over the horizon at that point resembled the hieroglyph for sunrise.

The following stanza from the "Hymn to Aten" reflects the revolutionary character of Akhenaten's change from a polytheistic belief system to the worship of a single, allpowerful god:

You are the one God,

shining forth from your possible incarnations as Aten, the Living sun,

Revealed like a king in glory, risen in light, now distant, now bending nearby. You create the numberless things of this world from yourself, who are One alone cities, towns, fields, the roadway, the River; And each eye looks back and beholds you

to learn from the day's light perfection.

O God, you are in the Sun-disk of Day, Over-seer of all creation

—your legacy

passed on to all who shall ever be; For you fashioned their sight, who perceive your

universe, that they praise with one voice

all your labors.⁵

Nothing is known of the origin of Akhenaten's ideas, which greatly influenced artistic style during his reign. Statues of Akhenaten (fig. **3.37**) and his family differ dramatically from those of traditional pharaohs. He looks as if he had unusual, if not deformed, physical features. Here Akhenaten holds the crook (now partly broken off) and flail, attributes of Osiris and of Egyptian royalty. He wears the combined *hedjet* and *deshret* crowns of Upper and Lower Egypt. Carved into the surface of his body—by his right shoulder and at his waist—are his cartouches (see fig. 3.4).

Despite the traditional attributes of pharaonic power and the iconography of royalty, Akhenaten broke with artistic convention. Rather than always being represented as an assertive and dominating king identified with the gods, Akhenaten often shows himself as a priest of Aten. In the statue illustrated in figure 3.37, however, he is shown as a pharaoh, despite being elongated, thin, potbellied, and curvilinear. Although some scholars believe that Akhenaten suffered from acromegaly-a condition caused by an overactive pituitary gland, resulting in enlarged hands, feet, and face-others think these proportions reflect changes consistent with his religious and social innovations. More recent scholarship argues that the Amarna style reflects an exaggeration of Akhenaten's actual appearance. The entire royal family, and eventually others as well, were similarly represented.

The best-known sculpture from Akhenaten's reign is a painted limestone bust of his wife, Nefertiti (fig. **3.38**). The well-preserved paint adds to its naturalistic impression. This is enhanced by the organically modeled features, the sense that taut muscles lie beneath the surface of the neck, and the open space created by the long, elegant curves at the sides of the neck. Instead of wearing the queen's traditional headdress, Nefertiti's hair is covered by a tall crown, creating an elegant upward motion.

A small relief in which Akhenaten and Nefertiti play with their three daughters illustrates some of the stylistic and iconographic changes under Akhenaten (fig. **3.39**). The king and queen are seated and rendered with a naturalism unprecedented for Egyptian royal figures. Their fluid, curved outlines—repeated in their drapery patterns —add a new sense of individual motion within threedimensional space, which is enhanced by the flowing bands of material behind their heads.

3.37 Akhenaten, from Karnak, Egypt, 1353–1350 B.C. Sandstone; approx. 13 ft. (3.96 m) high. Egyptian Museum, Cairo. Akhenaten was the son of Amenhotep III and his principal wife, Tiy. Amenhotep III ruled Egypt for thirty-eight years. During Tiy's lifetime, he married a Mittani (from Mesopotamia), two Babylonian princesses, and then made his own daughter his principal wife.

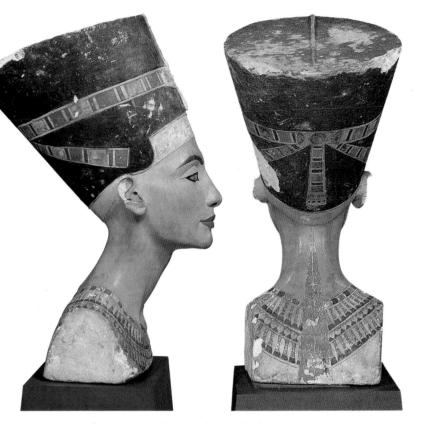

3.38a, b Bust of Nefertiti (side and back views), Amarna period, 1349–1336 B.C. Painted limestone, approx. 19 in. (48.3 cm) high. Ägyptisches Museum, Staatliche Museen, Berlin. Nefertiti was Akhenaten's principal wife, even though, presumably for diplomatic reasons, he also had Mittani and Babylonian wives. Nefertiti was given artistic prominence and was important in Akhenaten's sun cult. The blue crown in this sculpture is unique to her.

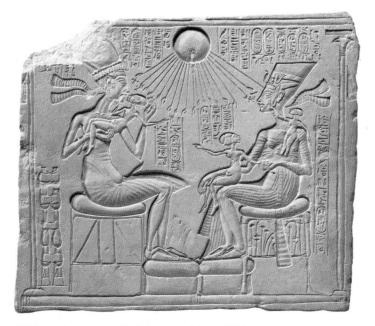

3.39 Akhenaten and Nefertiti and their children, Amarna period, 1349–1336 B.C. Limestone relief; 13×15 in. (33.0 \times 38.1 cm). Staatliche Museen, Berlin.

Although the children are represented with the unnatural proportions of miniature adults, their behavior and relative freedom of movement endow them with a childlike character. The child on Nefertiti's lap points eagerly toward her father, while the other one, perched on her shoulder, seems to be pulling on her mother's earring. Akhenaten holds a third child, whom he kisses. The intimacy of a scene such as this reflects the new humanity characteristic of the Amarna style.

Hieroglyphs are carved at the top of the scene; several cartouches are visible on the right. In the middle of the hieroglyphs is the sun disk Aten, with rays of light that end in hands—some holding the *ankh* hieroglyph—which seem to reach out to the royal family. Unlike earlier representations of gods in Egyptian art, Aten was embodied in the pure shape of the circle rather than in human or animal form.

Akhenaten's new cult posed a danger to the established priesthood and its traditions. At the close of his seventeenyear reign, despite certain innovations, Egypt reverted to its previous beliefs, reinstated the priestly hierarchy, and revived traditional artistic style. Akhenaten's tomb has been identified, but his mummy has never been located. Subsequent Egyptian rulers did their best to eradicate all traces of his religion and its expression in art.

Tutankhamon's Tomb

After Akhenaten's death, the pharaoh Tutankhamon (reigned c. 1336–1327 в.с.) returned to the worship of Amon, as his name indicates. He died at eighteen, and his only claim to historical significance is the fact that his tomb, with its four burial chambers, was discovered intact. In 1922 an English Egyptologist, Howard Carter, was excavating in the Valley of the Kings, to the west of the Nile and the New Kingdom temples of Karnak and Luxor. To the delight of his patron, Lord Carnarvon, Carter found one tomb whose burial chamber and treasury room had not yet been plundered. It yielded some five thousand works of art and other objects, including the mummified body of the king himself.

Tutankhamon's mummy wore a solid gold portrait mask (fig. 3.40). It was inlaid with blue glass in imitation of lapis lazuli, a blue stone considered valuable by the Egyptians because it had to be imported from Afghanistan or Iran. Three coffins, one inside the other, protected the mummy. All three were in the form of the king as Osiris. The two outer coffins were made of gilded wood; the innermost coffin was solid gold and weighed 243 pounds (110 kg). The mummy and its three coffins rested inside a large rectangular stone sarcophagus. The coffinette in figure 3.41 is one of four that contained the pharaoh's organs. These small coffins were housed in a wooden shrine that was placed in another room of the tomb. Each was made of beaten gold, decorated with inlaid colored glass and semiprecious stones. The shape of the canopic coffins conforms to that of the large coffins, and they also depict Tutankhamon as Osiris with the crook and flail.

A comparison of Tutankhamon's effigy with the images produced under Akhenaten shows that the rigid, frontal pose has returned. The natural spaces are closed, thus restoring the conventional iconography of kingship. Like Akhenaten, Tutankhamon holds the crook and flail. Protecting his head are two goddesses, Wadjet the cobra and Nekhbet the vulture. The wings wrapped around Tutankhamon's upper body belong to the deities on his forehead, and their claws hold signs indicating the unity of Upper and Lower Egypt. In this iconography, Tutankhamon, like Narmer nearly nineteen hundred years earlier, is represented as being under divine protection and as the ruler over a vast domain.

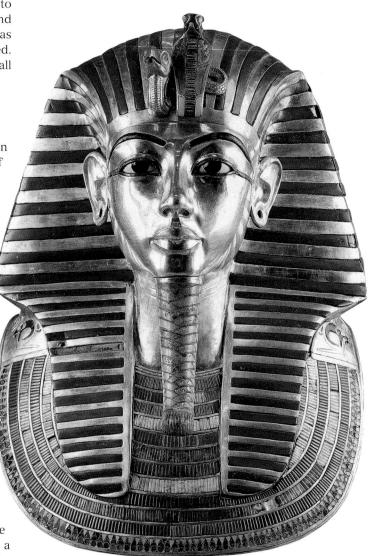

3.40 Mask of Tutankhamon, c. 1327 B.C. Gold inlaid with enamel and semiprecious stones. Egyptian Museum, Cairo.

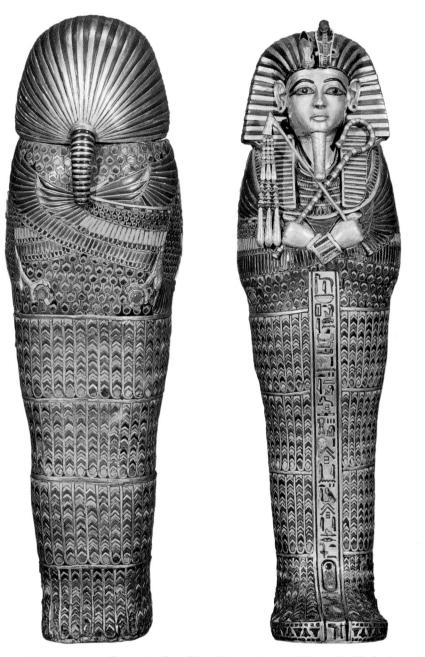

3.41~ Canopic coffinette (coffin of Tutankhamon), c. 1327 B.C. Gold inlaid with enamel and semiprecious stones; 15% in. (40.0 cm) high. Egyptian Museum, Cairo.

Over forty years after Carter's discovery, the contents of Tutankhamon's tomb became one of the world's most popular and widely traveled museum exhibitions, appearing in Paris, London, Russia, and the United States. But Lord Carnarvon did not live to see it. Just five months after Tutankhamon's tomb was opened, Carter's patron died of an infection, which the popular press attributed to the mummy's curse.

Egypt and Nubia

Throughout the history of ancient Egypt, in written texts and in works of art, there are continual references to other lands in the Near East and on the African continent. The land called Punt by the Egyptians, for example, is believed to have been located to the southeast along the Red Sea. It

3.42 King and queen of Punt, from Hatshepsut's funerary temple, Deir el-Bahri, c. 1473–1458 B.C. Painted relief. Egyptian Museum, Cairo.

was a source of exotic spices and incense, and appears as the destination of an Egyptian expedition on reliefs from Hatshepsut's Deir el-Bahri temple. According to those reliefs, Punt was rich in palm trees and giraffes, and was ruled by a heavy (steatopygous) woman (fig. **3.42**). To date, however, little is known of Punt and its relation to Egyptian trade. It remains for archaeologists to explore further this part of the ancient world.

Early Kush

Much more information is available about the land south of the Nile's first cataract (now southernmost Egypt and the Sudan), which was called Nubia by the Romans. To the Egyptians, this area was variously the Land of the Bow (after the Nubians' standard weapon), the Land of the South, and Kush. As in Egypt, the Nile's floods were crucial to the development of Nubian culture, which was enhanced by the wealth of its natural resources—gold, copper, and semiprecious gems—and its location along a major African trade route. As a result of these advantages, Nubia had links to sub-Saharan Africa, to Egypt, and to the Mediterranean world.

In Neolithic Nubia, agriculture had developed, and cattle was domesticated. Artisans began making distinctive pottery that was technically and artistically accomplished. The finest Nubian work is the "eggshell" pottery, so called for the thinness of its walls. The two examples in figure **3.43** are decorated with fingerprints (on the right) and designs derived from basket weaving (on the left). In the former, the artist simultaneously creates a design and makes a personal signature, or "mark." In the latter, the artist incorporates the material "history" of the craft into the surface pattern.

During the Old Kingdom, Egypt frequently raided Nubia, usually for natural resources and probably also to capture slaves. By the Middle Kingdom, however, Egypt had definite plans to subjugate Lower (northern) Nubia, and Twelfth Dynasty pharaohs invaded the region with a view to mining copper and gold, and taking control of the valuable trade route. Their successes were reinforced by the construction of massive fortresses and a highly organized communication system.

Reconquest

When the Egyptian delta was conquered by the Hyksos c. 1600 B.C., the Kushites seized the opportunity to expand their own power. They moved north to Aswan by the first cataract, took control of the trade route, and enjoyed considerable cultural expansion. Once the Hyksos were expelled, however, the Egyptians recolonized Nubia. The Egyptian viceroy who ran the administration of Nubia bore the titles "King's Son of Kush" and "Overseer of the

3.43 Nubian "eggshell" vessels, c. 3100– 2890 B.C. Ceramic; left, 6½ in. (15.4 cm) high; right, 4½ in. (12.2 cm) high. British Museum, London.

3.44 Nubians bringing offerings to Egypt, Thebes, Nineteenth Dynasty, c. 1295–1186 B.C. Fresco. British Museum, London.

Southern Lands." Egypt once again profited from Nubian gold mines and imported Nubian captives for labor or slave markets and even to work as policemen.

A Nineteenth Dynasty fresco fragment from Thebes depicts Nubians with gifts for the Egyptian pharaoh (fig. **3.44**). The man at the left carrying interlocked gold rings is followed by another with ebony logs and giraffe tails. A monkey perches on the third figure, who holds a leopard skin and carries a basket of fruit. Behind him, the arms of a fourth man leading a monkey on a leash are visible.

A painted relief from the Theban tomb of Huy, Nubia's viceroy under Tutankhamon, shows Heqanufer, the local prince of Mi'am, bowing to the pharaoh (fig. **3.45**). A princess follows in an ox-drawn chariot. Works such as these illustrate the natural resources of Nubia—especially gold—that the Egyptians wanted, as well as the degree to which Nubians adopted Egyptian culture.

3.45 Presentation of Nubian tribute to Tutankhamon (restored), tomb chapel of Huy, Thebes, Eighteenth Dynasty, c. 1336–1327 B.C. Wall painting; $6 \times 17\%$ ft. (1.82 \times 5.24 m). Metropolitan Museum of Art, New York. Egyptian Exhibition of Metropolitan Museum of Art. Rogers Fund, 1930 (30.4.21).

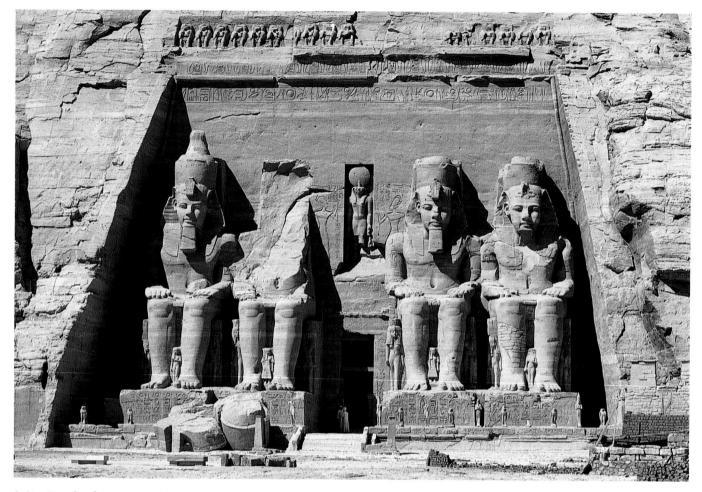

3.46 Temple of Ramses II, Abu Simbel, Nubia, 1279–1213 B.C.

In the course of the New Kingdom's Eighteenth and Nineteenth Dynasties, the Egyptians built their most imposing temples in Nubia. Figure **3.46** shows the façade of Ramses II's rock-cut temple at Abu Simbel, one of a series of six colossal structures south of Aswan. Four huge seated statues of Ramses II represent him in a traditional royal pose. The trapezoidal shapes of the ceremonial beards and headdresses are formal echoes of the space framing them. Ramses' purpose in having such works constructed in Nubia was to proclaim to the Nubians his identification with the gods Amon and Ra, as well as to emphasize Egyptian domination over Nubia. A smaller temple nearby, dedicated to his wife, Queen Nefertari, conveyed her identification with the goddess Hathor (Ra's wife). Pharaoh and queen together, therefore, presided over Nubia, asserting their divinity in vast monuments of stone (see box).

During the last hundred years of the New Kingdom (c. 1170–1070 B.C.), both Egypt and Nubia declined. The Egyptian colonial administration collapsed along with its building programs. And Nubia, with a decreasing population, entered three hundred years of obscurity.

The "Fifty" Sons of Ramses II: A Recent Archaeological Find

In 1995, an excavation led by the American archaeologist Kent Weeks revealed the largest New Kingdom tomb so far known in Egypt's Valley of the Kings. Although robbed in antiquity, the tomb is a rich find, still in the early stages of excavation. It contains at least sixty-seven chambers, and inscriptions indicate that fifty or more of Ramses II's sons were buried there (very few human remains have been recovered to date). It was formerly assumed that each male member of the royal family had a separate tomb; this new evidence, therefore, raises questions about family relationships at the highest level of Egyptian society as well as about communal burial practices in ancient Egypt.

The Napatan Period

Beginning in the eighth century B.C., Nubia (still called Kush by the Egyptians) reemerged into what would be an era of artistic development and political influence. Scholars divide this phase of Nubian history into two distinct stages. In the earlier stage, called Napatan after a religious center, Nubians invaded Egypt and established Kushite control of their former colonizers. Four Kushite kings of Egypt in the Twenty-fifth Dynasty conquered the country, revived artistic production, and continued the Egyptian cult of Amon.

The small granite sphinx of Taharqo reflects the appropriation of Egyptian pharaonic iconography by Nubian kings and their use of Egyptian artistic conventions (fig. **3.47**). Although endowed with Nubian facial features, Taharqo's sphinx wears the pharaonic headcloth and is protected by Wadjet the cobra and Nekhbet the vulture on his forehead. There is also a cartouche in sunken relief on his chest.

Meroë

In the seventh century B.C., the Assyrians (see Chapter 2) invaded Egypt and ousted the Kushite kings. By the third century B.C., a new stage of Nubian cultural development can be identified. The economic and artistic high point

of this period is referred to as Meroitic, after the site of Meroë, south of Napata. Royal Kushite burials shifted from Napata to Meroë when Meroitic culture began to absorb influences from sub-Saharan Africa on the one hand and from Greece (Chapter 5) and Rome (Chapter 7) on the other. Meroë's location in relation to important trade routes between Africa, the Red Sea, and the Mediterranean contributed to its significance. It imported bronze, glass, and silver, and exported ebony, ivory, and gold. Meroë also provided the Roman emperors with elephants. Under the Greek Ptolemies (323–30 B.C.), who ruled Egypt after Alexander the Great wrested it from the Persians, the Kushites continued to trade with Egypt.

Archaeological exploration of Meroë is still incomplete, but the significance of the area in antiquity is clear from classical accounts. In about 430 B.C., Herodotos (*History* II.29) described the arduous journey by boat, followed by forty days on foot and another boat trip from Aswan to Meroë. He reported that two important Greek gods, Zeus and Dionysos (see Chapter 5), had penetrated Meroë and were worshiped there. At the same time, however, it is clear from inscriptions that Egyptian gods such as Amon and Isis were the objects of popular cults. There were also indigenous Nubian gods. In religious beliefs, therefore—as in politics, economics, and the arts—Meroë was a melting pot that contributed to, and was a result of, its strategic international position.

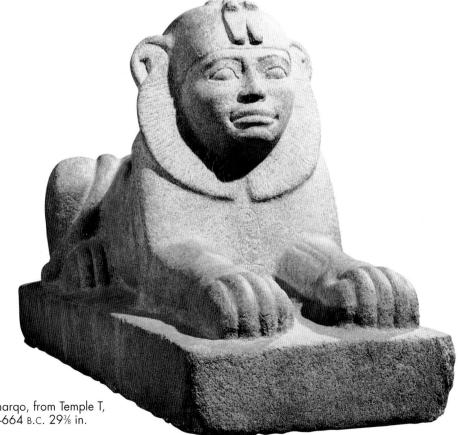

3.47 Sphinx of Taharqo, from Temple T, Kawa, Nubia, 690–664 B.C. 29% in. (74.7 cm) high.

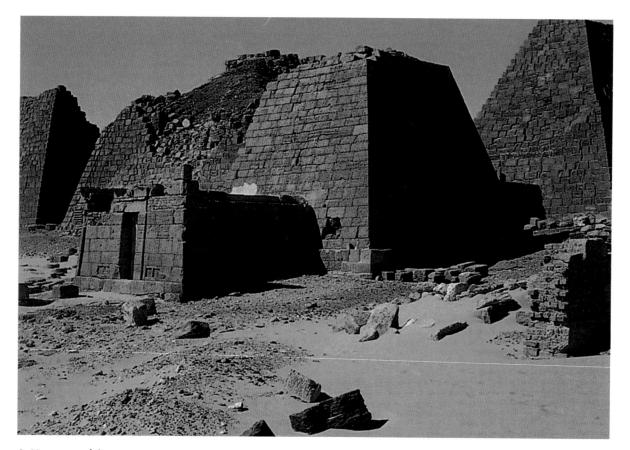

3.48 Ruins of the Meroë pyramids, Nubia, 3rd-1st century B.C.

Meroitic inscriptions dating from the second century B.C. have been discovered, but they are imperfectly understood. Since no related languages have survived, scholars once again must rely on physical evidence. The most impressive buildings from Meroë are the pyramids, whose ruins are illustrated in figure **3.48**. They are derived from Egyptian pyramids but rise more steeply than those at Giza and have flat, rather than pointed, caps. Scholars believe that these flat tops may each have supported a sun disk, indicating worship of a sun god. Burial chambers were underground, and the deceased, as in Egypt, were mummified. The outer stone blocks, and the structures themselves, are smaller than Old Kingdom Egyptian royal pyramids. They are closer in form to New Kingdom examples built for private individuals, even though those at Meroë were royal tombs.

In 1820–1821, a French traveler, F. Cailliaud, accompanied the Egyptian army into the Sudan and made drawings of the pyramids at Meroë. The example in figure **3.49** belonged to Queen Amanishakheto (first century B.C.) and was in a relatively good state of preservation. According to Cailliaud's drawing, the entrance, inspired by Egyptian temple pylons, was decorated with reliefs of the ruler's triumph over Meroë's enemies. Excavations of the interior of the pyramid were carried out some thirteen years later by the Italian physician Giuseppe Ferlini. His account of the excavation reflects the careless and unscientific procedures current in nineteenth-century archaeology, including the destruction of some objects and the removal of others from the site.

Among the goldwork from Amanishakheto's tomb were nine so-called shield rings, of which figure **3.50** is a typical example. The god Amon is depicted in the guise of a naturalistic ram's head under a sun disk. Behind the disk is a chapel façade with smaller circles flanked by uraei. Blue glass is fused into the circle, which is soldered onto its gold background. The red glass on top of the sun disk was glued into the gold circle. It is not certain what purpose was served by the shield rings, but it is possible that they were pendants similar to the decorative pieces worn by Sudanese women of today on their foreheads.

The excavation of Amanishakheto's tomb confirms Meroë's artistic independence from Egypt as well as its absorption of Egyptian and Greek forms. Stonecutters from Greece may have worked at Meroë. Amanishakheto's tomb has also contributed to our knowledge of local society, the position of women, and the organiza**3.49** Tomb of Amanishakheto, Meroë, Nubia, late 1st century B.C. Drawing from F. Cailliaud, *Voyage à Méroé* (Paris, 1823–27), plate XLI.

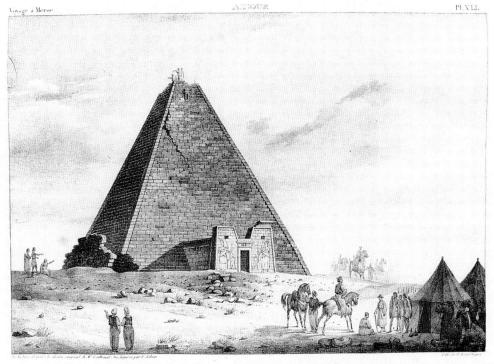

VUE PARTICULIERE D'UNE CRANDE PYRAMIDE DE LOUESTĂ UNE LITE DUNE.

tion of the royal family in this part of sub-Saharan Africa. The king's mother, who was given the title Kandake, was below the king in the royal hierarchy, but in certain cases, such as Amanishakheto's, the Kandake herself ruled. This is reflected in a New Testament text referring to a eunuch "under Candace [Kandake] queen of the Ethiopians" (Acts 8:27).

After the first century A.D., Nubian civilization fell into a gradual decline. The Ethiopian kingdom of Axum rivaled Meroë for trade routes, particularly with Rome. Meroë was occupied by nomads during the fourth century, which marked the end of the region's thriving culture. From the sixth to the twelfth centuries, Christianity (Chapter 8) made inroads into Nubia, and trade with Mediterranean cultures, especially Egypt, was revived. For the next four hundred years, Nubia was infiltrated by various groups. In the fourteenth century, it became predominantly Islamic (Chapter 9).

Egypt itself underwent a series of conquests, first by the Assyrians (c. 673–657 B.C), followed by the Persians in 525 B.C., and by Alexander the Great in 332 B.C. In 58 B.C., the Romans invaded Egypt and annexed it in 30 B.C. Since the early seventh century, Egypt has been part of the Islamic world.

3.50 "Shield ring" with ram's head of Amon before a chapel, Meroë, Nubia, c. 200 B.C. Gold, glass paste, and carneol; 2½ in. (2.5 cm) high. Ägyptisches Museum, Staatliche Museen zu Berlin.

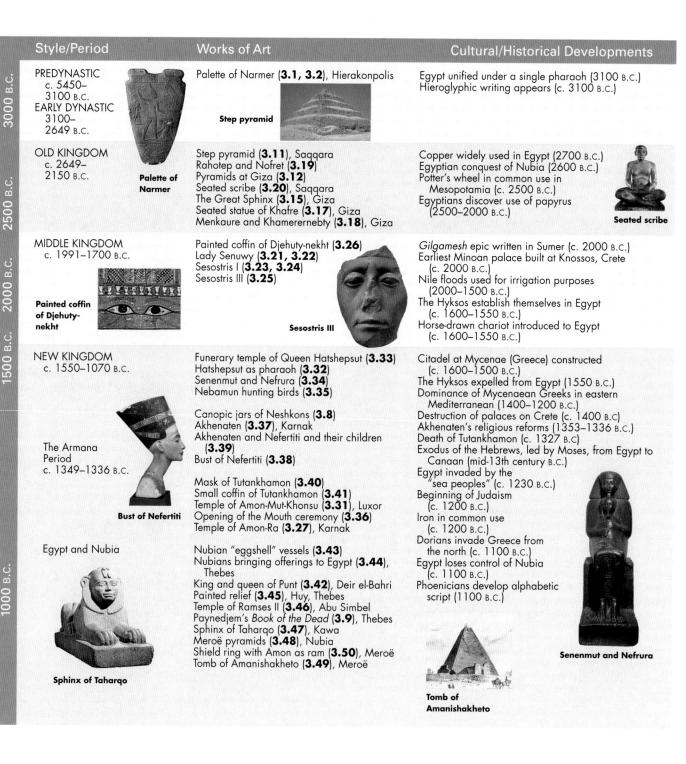

The Aegean

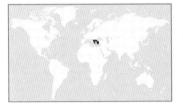

F rom about 3000 to 1100 B.C., three distinct cultures—Cycladic, Minoan, and Mycenaean—flourished on the islands in the Aegean Sea and on parts of mainland Greece (see map). These cultures chron-

ologically overlapped the Old, Middle, and New Kingdoms of ancient Egypt (see Chapter 3), and there is evidence of contact between them. Before the late nineteenth century, however, Aegean culture was known only in myths and legends—most of the works of art discussed in this chapter were discovered around 1850 or later. As a result, much less is known of the Aegean cultures than of those in Egypt and the ancient Near East.

Cycladic Civilization (c. 3000–11th century B.C.)

The Cyclades, so named because they form a circle (from the Greek word kuklos), are a group of islands in the southern part of the Aegean Sea. Typical of many island populations, the inhabitants of the Cyclades were accomplished sailors, fishermen, and traders. They also hunted and farmed, the latter requiring permanent village settlements. Cycladic culture is essentially prehistoric because of the absence of a writing system. Scholars, therefore, rely on physical evidence and written accounts dating from the later, historical period of Greece (beginning around 900 B.C.). In the fifth century B.C., for example, Herodotos described the inhabitants of the Cyclades as notorious pirates. But the earliest surviving artistic evidence of Cycladic culture dates from the Bronze Age, when people learned to make bronze from copper and tin. Many works of art, including pottery, metalwork, and marble sculpture from Cycladic graves, have a provenience despite extensive plundering.

The most impressive examples of Cycladic art are sculptures that date from the early Bronze Age and are made of marble. They range in height from nearly 5 feet (1.5 m) (figs. **4.1** and **4.2**) to only a few inches (fig. **4.3**). Today they are called idols (from the Greek word *eidolon*, meaning "image"), and they are thought to have been objects of worship. Most were found lying down in graves.

Figures of females are much more numerous than those of males. Their purpose is unknown, but it is assumed that they were carried in religious processions, for they are unable to stand on their own. The large female in figure 4.1 has long, thin proportions, with the breasts and pubic triangle accentuated. The view from the side (fig. 4.2) shows that the idol forms a narrow vertical, extending at the back

The ancient Aegean.

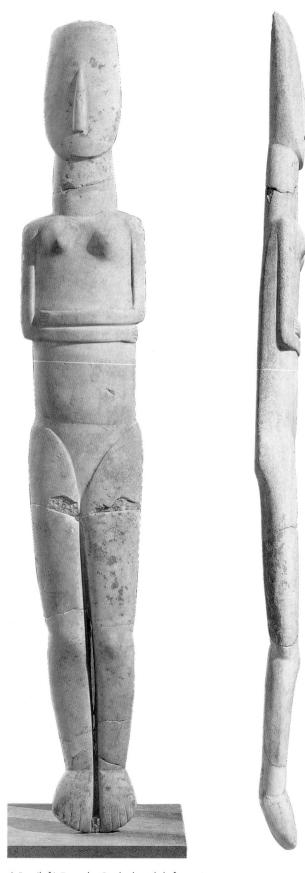

4.1 (left) Female Cycladic idol, from Amorgos, 2700–2300 B.C. Marble; 4 ft. 10½ in. (1.49 m) high. National Archaeological Museum, Athens.

4.2 (right) Female Cycladic idol (side view of fig. 4.1).

4.3 (right) Male Cycladic flute player, from Keros, c. 2700–2300 B.C. Marble. National Archaeological Museum, Athens.

from the top of the head to the hips. Legs and feet fall into three slight zigzag planes, and the angle of the feet makes it impossible for them to support the statue.

Seen from the front, the figure is composed mainly of geometric sections. Note that the head is a slightly curving rectangle-its only articulated feature is the long, pyramidal nose. The neck is cylindrical, and the torso is divided into two squares by the horizontals of the lower arms. Although the overriding impression of its shapes is geometric, certain features, such as the breasts and knees, have a convincing organic quality and seem to protrude naturally from beneath the surface of the body. Despite formal differences between the Cycladic idols representing women and earlier prehistoric sculptures such as

the *Venus of Willendorf* (see fig. 1.1) and the so-called Mother Goddess of Malta (see fig. 1.19), all seem to be images of divine female power.

The male Cycladic idols are composed mainly of cylindrical shapes and are often depicted playing musical instruments. The man in figure 4.3 plays a double pipe and tilts his head so far back that it is nearly at a right angle to his neck. The area of greatest formal movement in this sculpture is where the diagonals of the arms and pipe meet the tilting head and long neck. Arms, legs, and torso are shorter and sturdier than those of the female. The relative solidity of this statue is reinforced by the horizontal plane of the feet and their little **pedestal**, which provide actual support.

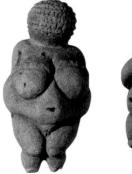

See figures 1.1a and b. Venus of Willendorf, from Austria, c. 25,000– 21,000 B.C.

Minoan Civilization (c. 3000–c. 1100 B.C.)

The modern Greek island of Crete, to the south of the Cyclades and northwest of the Nile Delta, was the home of another important Bronze Age culture. It was destroyed twice, once in 1700 B.C. by an earthquake and again, two or three centuries later, by an invasion from the Greek mainland. The culture that flourished on Crete was all but forgotten until the early twentieth century, when the British archaeologist Sir Arthur Evans (1851–1941) decided to search for it. Inspired by his knowledge of later Greek myths about the pre-Greek Aegean, Evans initiated excavations that would establish a historical basis for the myths.

In Greek mythology (see box, p. 142), Crete was the home of King Minos, son of Zeus and the mortal Europa. Minos broke an oath to Poseidon, who had guaranteed his kingship. In revenge, the sea god caused Minos's wife to fall in love with a bull. The offspring of their unnatural union was the Minotaur, a monstrous creature, part man and part bull, who lived at the center of a labyrinth in the palace of Minos at Knossos. Every year the Minotaur killed and ate seven girls and seven boys sent as annual tribute from Athens on the Greek mainland to Knossos.

Eventually, the Athenian hero Theseus killed the Minotaur and was rescued by Minos's daughter Ariadne from the labyrinth. They set sail from Crete and landed on the island of Naxos, where Theseus deserted Ariadne. The Greek wine god Dionysos found Ariadne and married her. Theseus, meanwhile, had sailed home to Athens, but he forgot the prearranged signal to his father, King Aegeus, indicating that he was returning safely. Believing his son dead, Aegeus threw himself into the sea and drowned. The Aegean Sea is named after the unfortunate king.

The Palace at Knossos

Sir Arthur Evans called the culture he discovered Minoan, after the legendary King Minos. *Minos* may be either a generic term for a ruler, like the designations *king* and *pharaoh*, or the name of a particular ruler. The major Minoan site was Knossos, which had been inhabited since early Neolithic times. Its palace (figs. **4.4** and **4.5**) was the traditional residence of Minos and the largest of several known palaces on Crete.

In Greek mythology, the palace was called a "labyrinth," which Evans believed originally meant "house of the double axe." The latter was a cult object in the Minoan era and is represented in paintings and reliefs throughout the palace at Knossos. Double axes may have been used to sacrifice bulls, which were sacred animals in ancient Crete. The later Greek meaning of *labyrinth*, a complex, mazelike structure, may have been applied to the palace because of the asymmetrical, meandering arrangement of rooms, corridors, and staircases (see figure 4.4). Greek coins of Knossos that were minted in the historical period generally contained maze patterns.

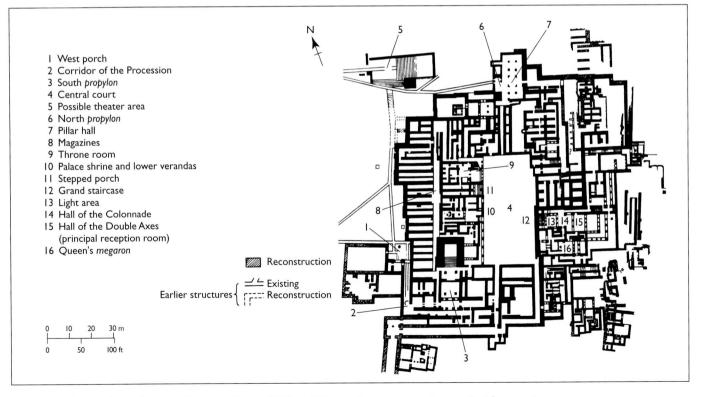

4.4 Plan of the palace of Minos, Knossos, Crete, 1600–1400 B.C. Area approx. 4 acres (1.6 hectares).

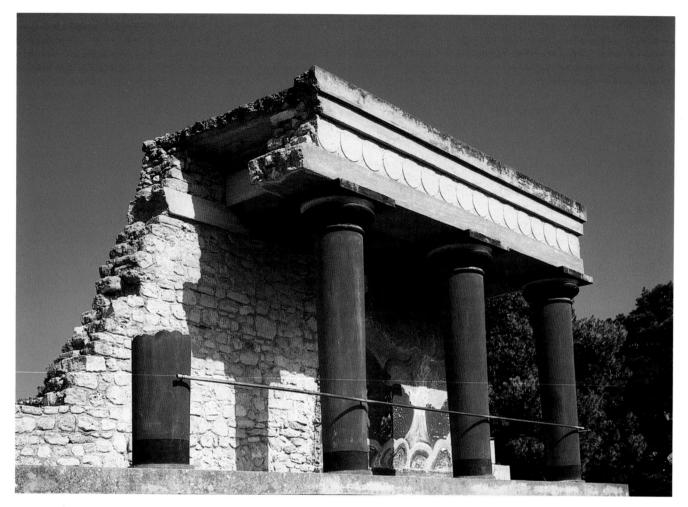

4.5 Partly restored west portico of the north entrance passage with a reconstructed relief fresco of a charging bull, palace of Minos, Knossos, Crete.

The palace itself was not fortified since Crete is an island and had a large naval fleet, which protected it against invasion. Like other Aegean and Near Eastern palaces, Knossos was more than a royal residence; it also served as a commercial and religious center. Industry, trade, and justice were administered from the palace, which had a wellorganized system for receiving and distributing local agricultural products and imported luxury goods. Much of this wealth was stored in large terra-cotta (literally "cooked earth") jars.

Minoan Fresco

Minoan wall paintings are *buon* (true) *fresco*—pigments mixed with water and applied to damp lime (calcium-based) plaster. As the plaster dries, the coloring bonds with it, making *buon fresco* more durable than *fresco secco*. Minoan artists used *fresco secco*, in which paint is applied to a dry wall, for additional details. The details in *secco* were painted over the true fresco, which had to be applied quickly before the plaster dried. The palace at Knossos is constructed according to the post-and-lintel system of elevation, with low ceilings and stone masonry walls. The short, wooden columns that taper downward are unique in the ancient world. Those visible in figure 4.5 have been reconstructed on the basis of fragments of **fresco painting** (see box).

The so-called *Toreador Fresco* (fig. 4.6) is perhaps the best-known wall painting from Knossos. It represents a charging bull, two girls, and one boy. The girl at the left grasps the bull's horns, the boy somersaults over his back, and the girl at the right stands ready to catch him. Given the sacred character of the bull in the Minoan era and the myth of the Minotaur, it is believed that this fresco depicts a ritual sport, possibly involving the sacrifice of the bull, the athletes, or both. As in Egyptian paintings, females are depicted with lighter skin color than males, and in each case a profile head is combined with a frontal eve. In other ways, however, the Minoan paintings differ from those of Egypt-in the predominance of curvilinear form and the dynamic movements of figures in space. Although in the Toreador Fresco three different human figures are represented, their poses correspond to a sequence of movement that could be made by a single figure. Such depictions of time and sequencing are more characteristic of Minoan

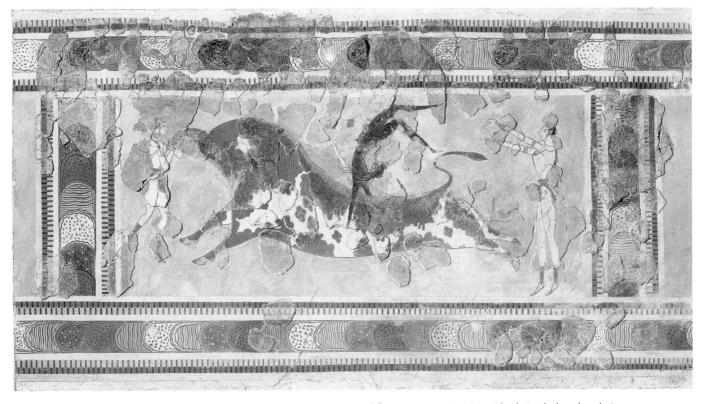

4.6 Toreador Fresco, from Knossos, Crete, c. 1500 B.C. Reconstructed fresco; 32 in. (81.3 cm) high (including border). Archaeological Museum, Herakleion, Crete. This wall painting was discovered in fragmentary condition and has been pieced back together. The darker areas belong to the original mural; the lighter sections are modern restorations. The abundance of bull imagery at Knossos was almost certainly related to the myth of the Minotaur and to the worship of the bull in Minoan religion.

than of Egyptian iconography. The border designs simulate different colored stones.

The sea-faring economy of ancient Crete can be seen in the attention to aquatic iconography at Knossos. This is apparent in the queen's *megaron*, in the fresco showing dolphins and other forms of sea life (fig. **4.7**). The predominance of curves and the impression of lively movement the dolphins appear to be leaping freely in the waves—is characteristic of Minoan pictorial style.

One of the most imposing, although heavily restored, Knossos frescoes decorated the so-called "throne room" (fig. **4.8**). The throne—actually a stone chair—is made of gypsum; its seat is indented and tilted back for increased comfort. Scholars generally believe that a woman, probably a priestess, sat here as part of a religious ritual, for symbolic griffins such as those in the fresco behind the throne always flank a female in Aegean art. These griffins, a mixture of eagle and lion, are set in a landscape of undulating terrain and tall flowers.

Though posed symmetrically and stylized, the griffins are rendered with curved outlines and rudimentary shading that creates a sense of three-dimensional contour. By placing some of the plants behind the animals, the artist has enhanced the illusion of depth. The expansive, generalized quality of this particular landscape, which differs from the more constrained and detailed Egyptian landscapes, is characteristic of Aegean painting.

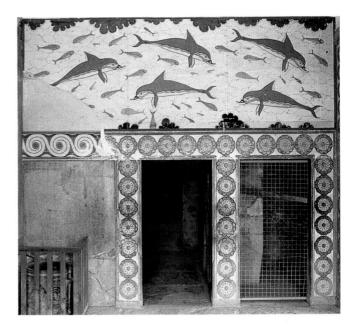

4.7 The queen's *megaron*, palace of Minos, Knossos, Crete, c. 1600–1400 B.C.

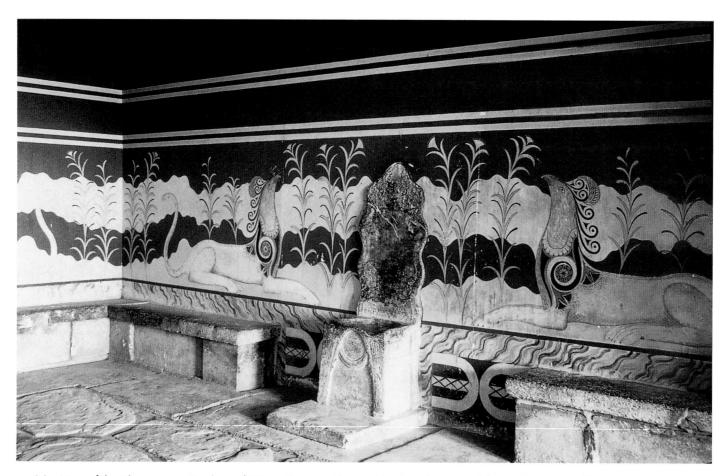

4.8 View of the "throne room," palace of Minos, Knossos, Crete, with a heavily restored fresco depicting griffins.

Minoan Religion

Little is known of Minoan religious beliefs. We have only archaeological evidence to shed light on Minoan religion because scholars have been unable to decipher the Minoan language (see box). Shrines were located on mountaintops or inside the palaces, which played an important role in religious ceremonies. Images of what seem to be priests and priestesses, of bulls, double axes, trees, columns, and elevated poles occur in scenes of religious ceremonies. Trees, pillars, and poles were venerated in rites celebrating the coming of spring, apparently a practice dating back to the Bronze Age.

Another recurring motif in Minoan art is a female—a goddess or priestess—holding snakes. This frontal figure has a thin, round waist and wears a conical flounced skirt. Her breasts are exposed, and a cat perches on top of her headdress. Faïence is a technique for glazing earthenware and other ceramic vessels by using a glass paste, which, after firing, produces bright colors and a lustrous sheen. The precise significance of the small statue of the so-called *Snake Goddess* (fig. **4.9**) is not known. However, the motif of a male or female deity dominating animals, referred to as the "Master" or "Mistress of the Beasts," occurs earlier in the ancient Near East and later in Greek art. As creatures of the earth, snakes were associated with fertility and agriculture, and did not have the evil connotations with which they later became endowed in the West.

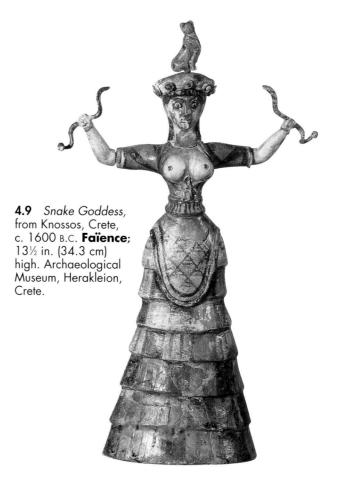

Minoan Scripts

In the Aegean, two kinds of script, Linear A and Linear B, are preserved on clay tablets. Linear A, the written Minoan script and language, developed about 2000 B.C. and remains undeciphered. Linear B came into use by about 1400 B.C. Linear B adapted the Minoan script to write early Greek after the Mycenaean domination of Crete. Because it was used mainly for inventory lists and palace records, Linear B (which was deciphered in 1952) provides evidence of Mycenaean administration but reveals little about religion and social practices.

4.10 Upper part of the Harvester Vase, from Hagia Triada, Crete, c. 1650–1450 B.C. Serpentine; diameter 4½ in. (11.3 cm). Archaeological Museum, Herakleion, Crete.

The so-called Harvester Vase (fig. **4.10**), a serpentine **rhyton** used in religious rituals, dates to around 1500 B.C. and reflects the Minoan tradition of lively, dynamic representation. Its relief decoration exemplifies Minoan skill in carving and depicts a procession of men setting out to harvest. One man, shaking a sistrum (rattle) and singing, is followed by three more singers. Others carry long forked harvest implements that form curved diagonals, echoing both the shape of the vase and the exuberance of the figures.

Pottery

The spouted jar from the older palace at Knossos illustrates an early pottery type called Kamares ware, dating to c. 1800 B.C. (fig. **4.11**). (The term *Kamares* is from the Kamares Cave, in the mountains above Phaistos, where examples of this type of pottery were first discovered.) Com-

pared with Egyptian imagery, the Kamares example is, like the Harvester Vase, freer and more curvilinear. The abstract pattern formed by white lines on the characteristic blue-black ground of Kamares ware suggests floral design, with its undulating motion and whirling, circular arrangement of shapes. A few details are enhanced by orange, which adds to the vibrant quality of the jar's design. Kamares ware is an art of shape and color in which patterns are integrated in a balanced, organic manner with the shape of the vessel.

The Octopus Vase (fig. **4.12**) from Palaikastro is also enlivened by vigorous surface design related to natural forms. Although the image of an octopus and other forms of sea life are discernible on the vase, the artist's obvious delight in the swirling patterns of the arms and their little round suction cups retains an abstract character. These, in turn, are repeated formally in the large oval eyes of the octopus, which echo the holes made by the handles and seem to stare directly at the viewer. The iconography of this object, like the dolphins

in the queen's *megaron,* reflects the fact that the Minoans were seafarers.

4.12 Octopus Vase, from Palaikastro, Crete, c. 1500 B.C. 11 in. (27.9 cm) high. Archaeological Museum, Herakleion, Crete.

Recent Discoveries at Thera

In the 1960s, the island now known as Santorini in the southern Cyclades yielded exciting new archaeological material. Called Thera by the ancient Greeks, Santorini is a volcanic island, parts of which are covered with thick layers of ash and pumice.

The Greek archaeologist Spyridon Marinatos began to excavate near the modern town of Akrotiri, on the south coast of the island facing Crete. His excavations confirmed that an enormous volcanic eruption had buried a flourishing Cycladic culture of the late Bronze Age with a welldeveloped artistic tradition. The date of this disaster has been placed as late as 1500 B.C. or as early as around 1628 B.C.—in either case, occurring during the heyday of Minoan civilization. Since no human remains have been found in the ashes, the inhabitants were evidently able to evacuate the island before the volcano erupted.

The geographical location of Thera, north of Crete, places it squarely within the trading and seafaring routes of the Aegean, Egypt, Syria, and Palestine. To date, archaeologists have uncovered large portions of an ancient and affluent town. The paved, winding streets and houses of stone and mud brick indicate a high standard of living. Homes had basements for storage, workroom space, and upper-story living quarters. Implements for grinding grain reflect an active farming as well as seafaring economy. Walls, as in Crete, were reinforced with timber and straw for flexibility in the event of earthquakes. Interior baths and toilets were connected by clay pipes to an extensive drainage and sewage system under the streets. Such elaborate attention to comfortable living conditions is not found again in the West until the beginning of the Roman Empire over a thousand years later (see Chapter 7).

The Frescoes

Equally remarkable was the attention paid to art in Theran culture. The walls of public buildings as well as private houses were decorated with frescoes, which constitute an important new group of paintings. They represent a wide range of subjects: landscapes, animals, people engaging in sports and rituals, boats, and battles. When first discovered, most of the frescoes were covered with volcanic ash, which had to be carefully removed by brush. The paintings had fallen from the walls and were restored piece by piece to their original locations.

Theran pictures are characteristically framed at the top with painted borders, often created by abstract geometric patterns. The most significant painting discovered on Thera is the large *Ship Fresco*, the left section of which is reproduced in figure **4.13**. It was painted in a long horizontal strip, or **frieze**, that extended over windows and doorways (fig. **4.14**). The scene includes harbors, boats, cities and villages, human figures, landscape, sea life, and land animals, all of which provide information about the culture of ancient Thera. Some of the houses have several stories, the boats are propelled by paddles and sails, and the style of dress is distinctively Theran.

Various interpretations of the *Ship Fresco* have been proposed, from the straightforward return of a fleet to the depiction of a ceremonial rite. Although there is some overlapping to show depth, the landscape is rendered with no sense of spatial diminution and appears to "frame" the city. Distance is indicated by proximity to the top of the fresco—boats below; buildings on land; hills, trees, and animals at the horizon. The leaping dolphins, like the stags being chased by a lion in figure **4.15**, seem to reflect the general aura of excitement that pervades the scene.

4.13 Ship Fresco (left section), from Akrotiri, Thera, c. 1650–1500 B.C. 15³/₄ in. (40 cm) high. National Archaeological Museum, Athens.

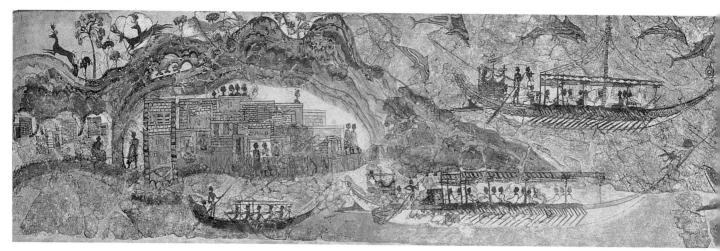

4.14 Diagram showing the original arrangement of the Ship Fresco at Akrotiri, in situ.

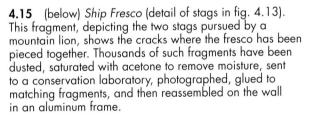

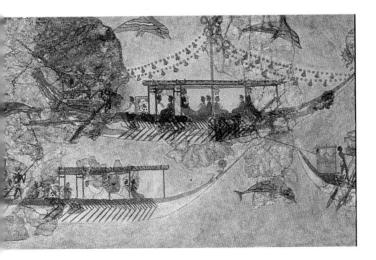

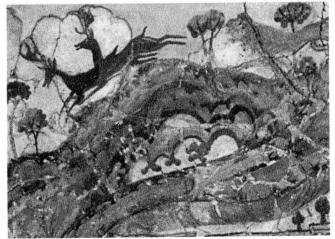

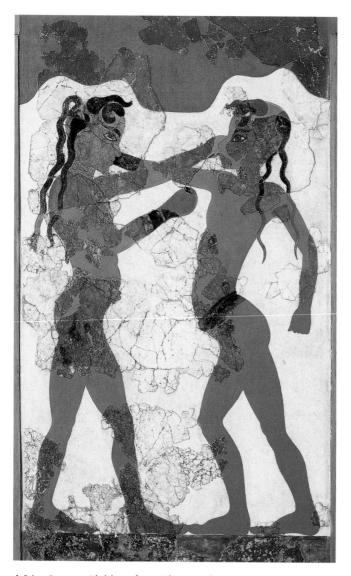

4.16 Boxing Children, from Akrotiri, Thera, c. 1650–1500 B.C. Fresco; 9 ft. × 3 ft. 1 in. (2.74 × 0.94 m) high. National Archaeological Museum, Athens.

The fresco of *Boxing Children* (fig. **4.16**) offers a largerscale depiction of human figures than does the *Ship Fresco*. As is true of painted figures from Egypt and Crete, these stand on a flat base rather than in a naturalistic space. They also retain the convention of a frontal eye in a profile face. Like Minoan figures and in contrast to Egyptian ones, the curved outlines and shifting planes of movement create a sense of vigorous, sprightly energy. The significance of these boxers remains controversial, but it is likely that they are engaged in a coming-of-age ritual. The boy to the left wears jewelry and is receiving a blow from the boy to the right. His lighter face and upwardly turned eye show that he has been hit by his opponent and is in pain. This emphasis suggests that he is the initiate.

In contrast to the boxers, the so-called *Crocus Gatherer* (fig. **4.17**) is light-skinned, following the convention of Minoan and Egyptian representations of females. She holds a basket in her left hand and reaches for a flower with her

right. Although her body is frontal-she is in a squatting position—she turns her head to speak to a companion. Her curly black hair, whose ringlets echo the lines of her ear, is held in place by a blue headband. She wears a large earring and three necklaces, a short-sleeved dress and an overskirt. The stylized outline of her eye is reminiscent of ancient Near Eastern eye outlines (see fig. 2.7), although her physiognomy is more specific. Again more like Minoan than Egyptian painting, she is set in a spacious landscape amid mountains and rocks. The iconography of this fresco is based on religious ritual. Crocuses are the source of saffron, which was considered valuable for medicinal as well as for ritual purposes. The girl depicted here is one of four collecting saffron for presentation to a nature goddess, who is depicted on a raised platform receiving the saffron from a monkey.

When hitherto unknown cultures such as that on Thera are uncovered for the first time, modern views of history are necessarily modified. The precise role of Thera in the Minoan era remains to be determined. Some people believe it is the source of the story of the lost Atlantis, described by Plato in his *Timaeus* and *Kritias;* others strongly disagree. In any case, new archaeological finds reveal the dynamic, ever-changing nature of our perception of history.

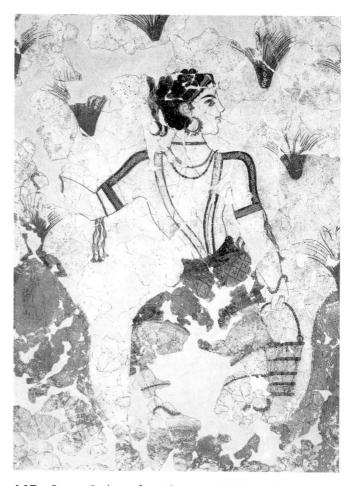

4.17 Crocus Gatherer, from Thera, pre-1500 B.C. Fresco; approx. 35 × 32 in. (88.9 × 81.3 cm). National Archaeological Museum, Athens.

Mycenaean Civilization (c. 1600–1100 B.C.)

In the late 1860s, Heinrich Schliemann, a successful German businessman, became an archaeologist. Like Evans, Schliemann was convinced that certain Greek myths were based on historical events. He focused his search on the legends of the Trojan War and its heroes described by Homer (see box, p. 128). In 1870, Schliemann first excavated the site of Troy on the west coast of Turkey. Years later he excavated Mycenae, the legendary city of Agamemnon, in the northeast of the Peloponnese, on the Greek mainland. The subsequent excavations of other similar Greek sites have revealed that a Mycenaean culture flourished between c. 1600 and 1100 B.C. After the eruption of Thera, the Aegean was dominated by the Mycenaeans, who began by conquering Crete and ruling the island from Knossos.

Also called Late Helladic after "Hellas," the historical Greek name for Greece (*Greece* was the name used by the Romans), Mycenaean culture takes its name from its first excavated and foremost site of Mycenae. Here, as elsewhere, the citadel was built on a hilltop and fortified with massive stone walls. The palace, or *megaron* (literally "large room" in Greek), was rectangular. One entered the *megaron* through a front porch supported by two columns and continued through an antechamber into the throne room, where four columns surrounded a circular hearth (fig.

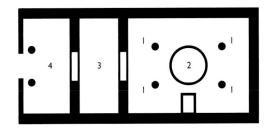

4.18 Plan of a Mycenaean *megaron*. Within a rectangular structure, the throne room had four columns (1) enclosing a circular hearth (2) in the center. Access to the throne room was through an antechamber (3) and a front porch (4) with two columns.

4.18). The king's throne was centered and faced the hearth. This arrangement had pre-Mycenaean antecedents on the Greek mainland and would be elaborated in later Greek temple architecture.

Like the Minoans, the Mycenaeans apparently had no temples separate from their palaces. Shrines have been found within the palaces, which were lavishly decorated and furnished with precious objects and painted pottery. Figure **4.19** shows a reconstruction of the *megaron* at Mycenae. The walls, floors, and perhaps the interior columns were covered with paintings.

The best-preserved fresco from Mycenae has similarities with Minoan fresco style. The so-called Mycenaean

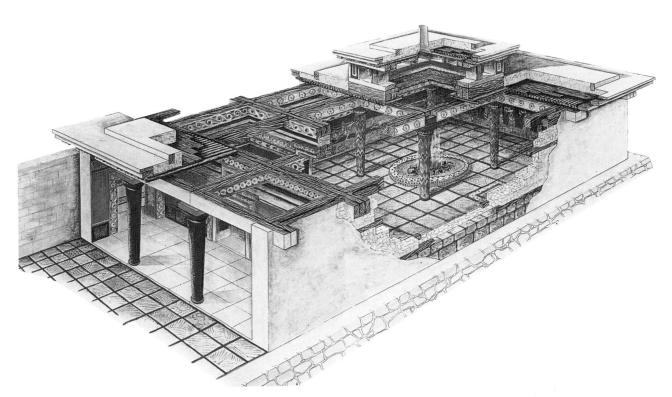

4.19 Reconstruction drawing of the *megaron* at Mycenae showing the front porch with two columns and the interior hearth enclosed by four columns.

The Legend of Agamemnon

Mycenae was the legendary home of King Agamemnon, who led the Greek army against King Priam of Troy in the Trojan War. Agamemnon's brother, King Menelaus of Sparta, had married Helen, known throughout history as the beautiful and notorious Helen of Troy. Priam's son Paris abducted Helen, and Agamemnon was pledged to avenge the offense against his family. But as soon as the Greek fleet was ready to sail, the winds refused to blow because Agamemnon had killed a stag sacred to the moon goddess Artemis. As recompense for the stag, and in return for allowing the winds to blow, Artemis exacted the sacrifice of Agamemnon's daughter Iphigenia. Ten years later the war ended, and Agamemnon returned to Mycenae, bringing with him the Trojan seeress Kassandra. He was murdered by his wife, Klytemnestra, who had not forgiven him for Iphigenia's death, and her lover, Aegisthos. Agamemnon's children, Orestes and Elektra, then killed Klytemnestra and Aegisthos to avenge their father's death.

These tales were well known to the historical Greeks: the Trojan War from the *lliad*, written in the eighth century B.C. and attributed to Homer; and the tragedy of Agamemnon's family from plays of Aeschylos and Euripides (fifth century B.C.).

"Goddess" (fig. **4.20**) was discovered in the cult center of the citadel. Her face is rendered in profile with a frontal eye, but her naturalism is enhanced by the curvilinear form of her body. She smiles slightly and seems to contemplate the necklace held in her right hand. The thin black lines framing her torso, outlining her eye, and defining her eyebrow recall those of the Theran *Crocus Gatherer* (see fig. 4.17). Her elaborate jewelry and coiffure indicate that she was a personage of high status, even possibly a goddess.

Unlike the nobility, most people lived in small stone and

mud-brick houses below the citadel. In times of siege, they sought refuge within its walls. The defensive fortifications of the Mycenaean cities reflect a society more involved in war than were the Minoans and, thus, more concerned with protection from invaders. These considerations led to building the thick, monumental walls that surround most Mycenaean citadels. They were constructed of large, rough-cut, irregular blocks of stone such as those visible in figures **4.21** and **4.22**. Because of the enormous weight of such stones, the later Greeks called the walls Cyclopaean (see box, p. 130).

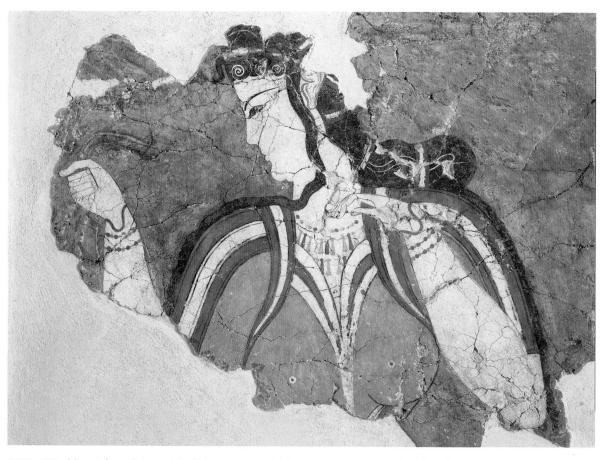

4.20 "Goddess," from the citadel of Mycenae, c. 1200 B.C. Fresco. National Archaeological Museum, Athens.

4.21 Lion Gate, Mycenae, 13th century B.C. Limestone; approx. 9 ft. 6 in. (2.90 m) high.

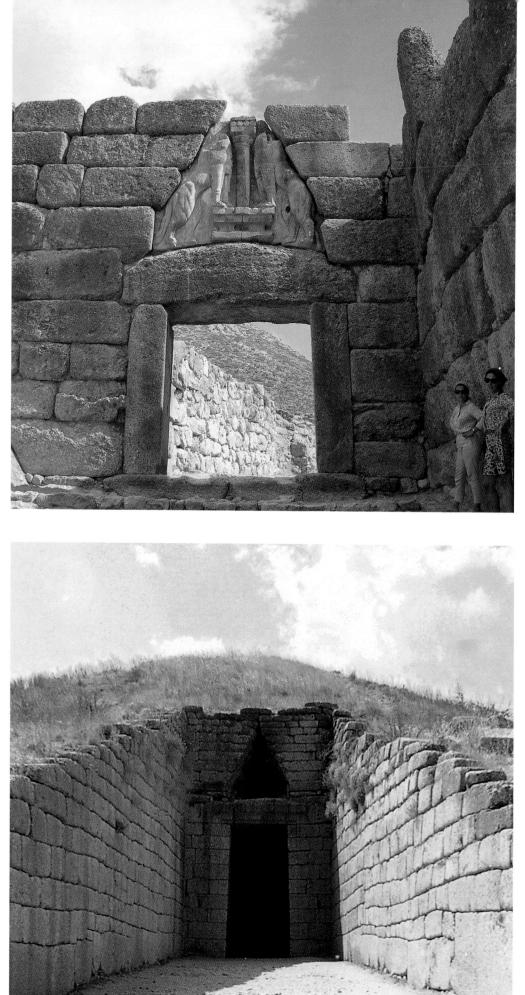

4.22 Façade and *dromos* of the Treasury of Atreus, Mycenae, 13th century B.C. Originally the door was framed by half columns made of gypsum.

The Lion Gate crowned the entrance to the citadel of Mycenae (fig. 4.21), which was centered authoritatively at the end of a long approachway. Its opening is framed by a post-and-lintel structure, and the triangular section over the lintel is called a relieving triangle because it lessens the weight on the lintel. This was formed by corbeling, or arranging layers, called courses, of stones so that each level projects beyond the lower one. When the stones meet at the top they create an arch. Filling in the triangle is a relief of two lions placing their paws on a concave Minoan altar. They flank a Minoan-style column, which is a symbol of the Nature Goddess. The relief is thus an image showing the lions obedient to the goddess as "Mistress of the Beasts" and the power immanent in her symbol. The heads of the lions are missing. Originally they were carved separately to project frontally and fulfill their traditional role as guardians.

The largest and most dramatic surviving structure at Mycenae exemplifies the culmination of Mycenaean royal

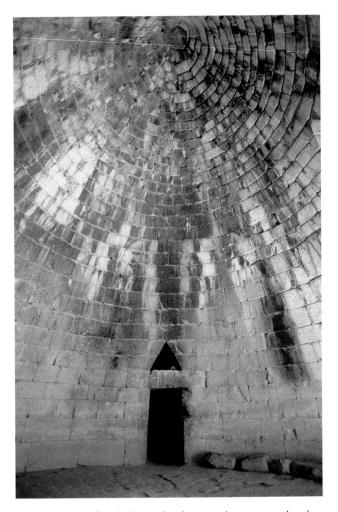

4.23 Interior of a *tholos* tomb, showing the entrance lintel and a door to the side chamber, Treasury of Atreus, Mycenae, 13th century B.C. Diameter of interior 43 ft. (13.11 m), height 40 ft. (12.00 m); doorway 17 ft. 8 in. \times 8 ft. 10 in. (5.38 \times 2.69 m).

Cyclopaean Masonry

Cyclopaean masonry is named for a mythological race of giants, or Cyclopes, who were believed strong enough to lift the blocks of stone found at Mycenaean sites. The Cyclopes are described by Homer in the Odyssey as having a single round eye in the center of their foreheads (the name derives from the Greek words *kuklos*, meaning "circle," and *ops*, meaning "eye"). In Book 9 of the Odyssey, Odysseus escapes from the Cyclops Polyphemos by putting out his single eye with a stake (cf. fig. 5.6) and tying himself and his men to the undersides of a flock of sheep.

tomb architecture in the thirteenth century B.C. This tomb, or **tholos** (Greek for "round building"), has been called both the Treasury of Atreus and the tomb of Agamemnon, who was Atreus's son (figs. 4.22 and **4.23**). It is not known who was buried there, but because of its enormous size, it was doubtless intended for royalty.

Figure 4.23 shows a section of the ceiling with corbeled courses in a circular arrangement of rectangular stones corresponding to the curved sides. The courses diminish in diameter as they approach the top of the chamber, which is crowned by a round capstone. Most likely the construction of such large tombs had been influenced by the design of smaller *tholoi* used earlier for communal burials on Crete.

One entered the *tholos* through a *dromos*, or roadway, 118 feet (36.00 m) long, whose walls were faced with rectangular stone blocks (see figs. 4.22 and 4.24). Above the

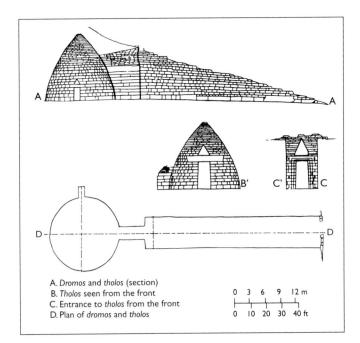

4.24 Plan and sections of a tholos.

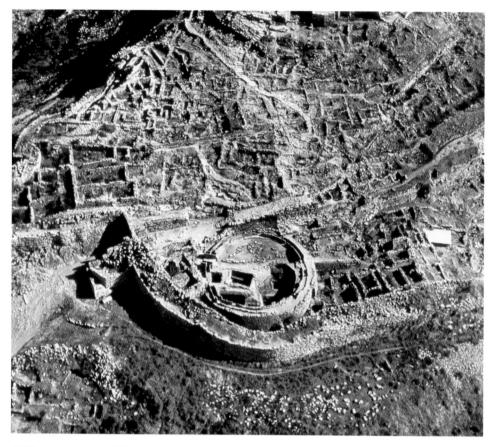

4.25 Aerial view of Grave Circle A and its surroundings, Mycenae.

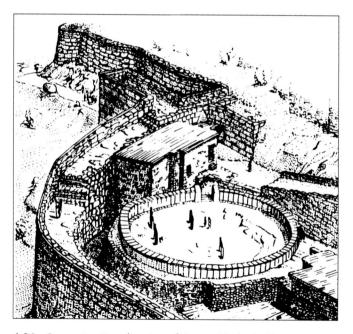

4.26 Reconstruction drawing of Grave Circle A, Mycenae, as it looked in the late 13th century B.C.

rectangular entrance to the *tholos* was an enormous lintel weighing over 100 tons. It separates the doorway from a triangle that relieves the weight borne by the lintel.

Once the dead body had been placed inside the *tholos*, the door was closed and the entrance walled up with stones until such time as it had to be reopened for later burials. All that would have been visible from the exterior was the mound of earth covering the tomb and the *dromos*. Unfortunately, both of the royal tombs discussed above were plundered before their modern excavation. However, excavations of unplundered graves, especially the earlier shaft graves at Mycenae, have yielded remarkable objects.

There is some connection between the *tholoi* and earlier Mycenaean shaft graves, which were set within circular walls. One such grave circle inside the citadel can be seen in the aerial view in figure **4.25**. The reconstruction of these ruins (fig. **4.26**) shows the massive, Cyclopaean walls and the disposition of the graves within them.

The mask in figure **4.27**, the so-called "Mask of Agamemnon," is a good example of the goldwork found in the shaft graves of Mycenae, although the gold was imported. The mask may have covered the face of a ruler Schliemann called "Agamemnon" but who actually lived three hundred years earlier. Despite stylizations such as the scroll-shaped ears, the more distinctive features—the thin lips and curved

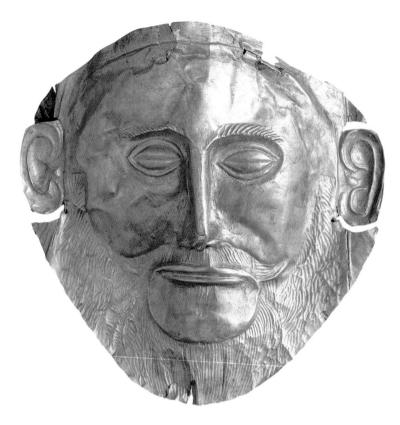

mustache—are those of a particular person, indicating that this was a death mask.

Two gold cups from a *tholos* tomb at the site of Vapheio, in the region around Sparta (fig. **4.28**), were also buried with a king. There is some controversy over the origin of the two cups, but the one on the left seems to be the work of a Minoan artist, while the one on the right is Mycenaean. The scene on the left cup shows a man tying up a bull, possibly for the ritual Minoan bull sport. Landscape forms —trees and earth—are depicted with considerable naturalism. Also reflecting a concern for naturalism is the sense of time, noted above in the *Toreador Fresco* (see fig. 4.6): here the bull first sniffs the ground and then is enticed by a cow. The man's thin waist and flowing curvilinear outlines recall the human figures in Minoan painting.

The cup on the right is Mycenaean in execution. It is cruder than the Minoan cup and stresses the violence of a struggling bull caught in a net. The style of the Mycenaean cup is more powerful than that of the Minoan one, and its forms are generally more abstract. The relief on both cups

4.28 Minoan and Mycenaean cups from Vapheio, near Sparta, c. 16th century B.C. Gold; 3½ in. (8.9 cm) high. National Archaeological Museum, Athens.

was made using the *repoussé* technique (from the French word pousser, meaning "to push"), in which an artist hammers out the scenes from the inside of the cup. Final details were added on the outside. On the Vapheio cups a smooth lining of gold was attached on the inside.

The rediscovery of the Minoan-Mycenaean civilizations in the late nineteenth and early twentieth centuries, and the more recent finds at Thera, have restored some missing links of Western history. Minoan and Mycenaean cultures came to light as a result of the conviction of a few scholars

-notably Sir Arthur Evans, Heinrich Schliemann, and Spyridon Marinatos-that certain old legends and myths had a basis in fact. There remains much to be learned, and archaeologists continue to probe the earth for clues to the past. Although the fall of Mycenae was followed by several hundred years of a so-called "Dark Age," about which we have archaeological but no literary information, the Aegean cultures provide a transition from Egypt and the ancient Near East to the later art and culture of historical Greece, which is the subject of the next chapter.

Style/Period Works of Art **Cultural/Historical Developments** Female Cycladic idol (4.1, 4.2), Amorgos CYCLADIC 3000 B.C. c. 3000-11th Male Cycladic flute player (4.3), Keros century B.C. MINOAN Kamares jar (4.11), Knossos Great Pyramids built at Giza (c. 2551-2472 B.C.) c. 3000-Harvester Vase (4.10), Hagia Triada Linear Á used in Crete (c. 2000 B.C.) с. 1100 в.с. Palace of Minos (4.4, 4.5), Knossos Earthquake destroys Crete Snake Goddess (4.9), Knossos (c. 1700 B.C.) "Throne room," griffin fresco (**4.8**), Knossos Earthquake destroys Thera (modern Santorini) (c. 1628-1500 B.C.) The queen's megaron (**4.7**), Knossos Toreador Fresco (**4.6**) Linear B used in Crete and Greece Cycladic idol Knossos (c. 1400 B.C.) Octopus Vase (4.12), Palaikastro **Boxing Children Toreador Fresco** Thera Ship Fresco с. 1650-1500 в.с. (4.13-4.15), Thera Boxing Children (4.16), Thera Crocus Gatherer (4.17), Thera Mycenaean megaron (4.18, 4.19) Beginning of decline of "Mask of Agamemnon" (4.27), Mycenae Mycenaean power MYCENAEAN Vapheio cups (4.28), near Sparta (c. 1200 B.C.) Lion Gate (4.21), Mycenae Treasury of Atreus (4.22–4.24), Mycenae с. 1600-1100 в.с. Iron comes into common use (c. 1200 B.C.) Trojan War; sack of Troy "Goddess" fresco (4.20), Mycenae (c. 1180 B.C.) Mycenae destroyed "Mask of (c. 1100 B.C.) 200 B.C Agamemnon' Dorians invade Greece Vapheio cup from the north (c. 1100 B.C.) Queen's meaaron

The Art of Ancient Greece

5

The Art of the Etruscans

Window on the World Two: China

7 Ancient Rome

Window on the World Three: Developments in South Asia

8 Early Christian and Byzantine Art

Window on the World Four: Developments in Buddhist Art

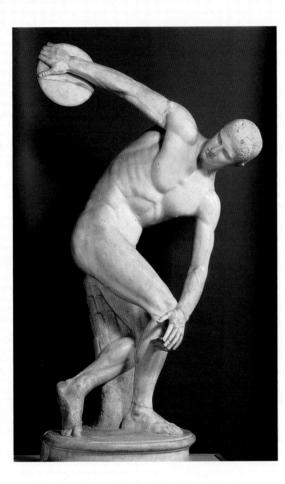

CHAPTER PREVIEWS

THE ART OF ANCIENT GREECE, c. 800-1st CENTURY B.C.

Homeric epics written down (c. 800 B.C.) Greek alphabet; Delphic oracle; Olympian gods Battle of Marathon: Persian defeat (490 B.C.) Philosophy: Plato; Socrates; Aristotle Theater: Aeschylos; Sophokles; Euripides; Aristophanes "Man is the measure of all things" Vase painting; mosaics; monumental sculpture Orders of architecture: Doric; Ionic; Corinthian Periklean Athens (c. 450–400 B.C.) The Parthenon; canon of Polykleitos Herodotos ("father of history") Peloponnesian War: Sparta defeats Athens Alexander the Great dies (323 B.C.) Hellenistic period

THE ART OF THE ETRUSCANS, c. 1000-100 B.C.

Naval control of the Mediterranean (7th–5th century B.C.) Necropoleis (cities of the dead); ash urns; tomb frescoes; temples; mirrors; bronze sculpture Status of women; augury

China: Neolithic to First Empire, c. 5000–206 в.с. Bronze Age: Shang; Zhou Iron Age: Emperor Qin (Shihuangdi) Unification of China; Great Wall (begun 3rd century B.C.) Piece-mold bronze casting; calligraphy Terra-cotta army

ANCIENT ROME, 6th CENTURY B.C.-4th CENTURY A.D.

Lengendary founding by Romulus and Remus (753 B.C.) Rule by kings to 509 B.C. Republic (509–27 B.C.); Latin language; government by senate and patricians Punic Wars against Carthage (264–146 B.C.) Empire (27 B.C.–A.D. 476) Augustus first emperor; Virgil's Aeneid Domestic architecture; public buildings; concrete The Forum; round arches; domes; barrel vaults Assimilation of Greek forms and Greek gods Portraiture; wall paintings; country villas Rome falls to Germanic invaders (A.D. 476) South Asia, c. 2700 B.C.–3rd Century A.D.

Indus Valley civilization (2700–1750 B.C.) Stamp seals; bronze and stone sculpture Vedas and Upanishads Buddha born (563 B.C.) Development of Buddhism: Ashoka's pillars; stupas Gandharan and Mathuran sculpture

EARLY CHRISTIAN AND BYZANTINE ART, 1st-9th CENTURIES

Crucifixion of Jesus (c. A.D. 33) Constantine's Edict of Milan (A.D. 313) Early Christian art: catacombs, Old Saint Peter's Martyria, mosaics, basilicas Byzantine Empire: Justinian and Theodora (6th century) San Vitale; Hagia Sophia; domes on pendentives The codex (Vienna Genesis) Iconoclastic Controversy (8th–9th centuries)

Developments in Buddhist Art, 1st–7th Centuries India: Gupta sculpture; Ajanta Caves China: Silk Roads; Yungang Caves; Longmen Caves Paradise sects

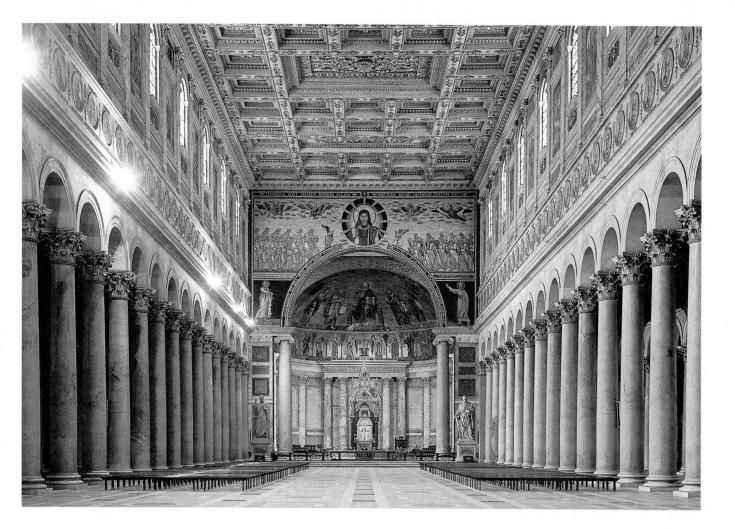

The historical period of Greece dates from about 800 B.C. and provides the basis of much of Western culture—its art and architecture, theater, philosophy, poetry, and politics. From approximately 450 B.C. to 400 B.C., the Classical style flourished and continues to influence Western art to the present day. The civilization of Etruria (c. 1000–100 B.C.), located on the Italian peninsula, is distinctive but less well known than that of Greece because we cannot read its language. Etruscan culture influenced Rome, which rose to power in the early sixth century B.C. and formed a republic. Under Augustus (ruled 27 B.C.–A.D. 14), however, Rome became an empire and remained as such until A.D. 476, the official date of the fall of Rome. Beginning in the first century A.D., the teachings of Jesus challenged the divinity of the Roman emperor. By the fourth century, Christianity had become the dominant religion in Rome, and the arts were transformed to suit the needs and beliefs of Christians.

Meanwhile, evidence from the Indus Valley (c. 2700–1750 B.C.), in modern Pakistan, suggests early contact with Mesopotamia. In the Far East, the prevailing religions—Hinduism and, from the sixth century B.C., Buddhism—inspired figurative sculptures, paintings, and temples on a vast scale.

5

The Art of Ancient Greece

T he time referred to as the historical Greek period emerged some four hundred years after the decline of the Minoan-Mycenaean cultures around 1100 B.C. (see map). Because the art of writing had been lost,

little is known of Greek history from 1100 to 800 B.C. From around 800 B.C. until the end of the first century B.C., Greek culture is relatively well documented, including the achievements of its artists, writers, philosophers, and scientists. These have had a significant and long-lasting impact on Western civilization. Writing was revived, and the Greek language has persisted relatively unchanged to the present day. The Greek alphabet was an adaptation of Phoenician, a Near Eastern Semitic language. The English word *alphabet*, in fact, combines the first two letters of the Greek alphabet—*alpha* and *beta*, equivalent to the Semitic *aleph* and *beth*, and to the modern English *A* and *B*.

The exact origins of the Hellenes, as the Greeks called themselves, are unknown. By around 800 B.C., two related Greek peoples had settled in Greece—the Dorians, who inhabited the mainland, and the Ionians, who occupied the easternmost strip of the mainland (including Athens), the Aegean islands, and the west coast of Anatolia (modern Turkey). Later, the Greeks established colonies in southern Italy, Sicily, France, and Spain. As such colonizing activity suggests, the Greeks were accomplished sailors, and their economy depended to some degree on maritime trade. They were also successful in cultivating their rocky terrain and in manufacturing pottery and metal objects.

Cultural Identity

Greece was not unified by a strong sense of its identity as a nation until the invasions of 490 and 480 B.C. by the Persians, who were long-standing enemies of the Greeks. But after defeating the Persians, the Greeks thought of themselves as the most civilized culture in the world, a view reflected in their sense of being a single people, superior to all others. The modern meaning of the word *barbarian* is "uncivilized" or "primitive," but for the ancient Greeks any foreigner was a barbarian (*barbaros*). Greeks considered anyone who spoke a foreign language—unintelligible words sounding like "bar-bar"—to be less civilized than they.

Greece was not only the most civilized country in its own estimation, it was also the most central. The site of the sacred oracle at Delphi (see box, p. 138), where futures were foretold, omens read, and dreams interpreted, was called the *omphalos*, or navel, of the world. The oracle, actually a priestess believed to be divinely inspired, advised on political matters as well as on private ones. As a result, the Delphic oracle drew emissaries from all over the Mediterranean world and became an established center of international influence. Inscribed in stone at Delphi was the prescription "Know thyself," which expressed a new emphasis on individual psychology and personal insight.

There was also a new perception of history. Rather than marking the passage of time in terms of kings and dynasties, as the Egyptians and the Mesopotamians had, the Greeks reckoned time in Olympiads—four-year periods beginning with the first Olympic Games, held in 776 B.C. The games (called Panhellenic, meaning "all the Greeks") were restricted to Greek-speaking competitors and reinforced the Greek sense of cultural unity. The Olympic Games were so important that all wars on Greek territory were halted so that athletes could travel safely to Olympia to participate. In this way, the destructive forces of battle were transformed into the more peaceful pursuit of athletic competition.

Government and Philosophy

The Athenians abhorred the rule of autocratic kings and pharaohs that characterized other Mediterranean cultures. When the Greek rebels Harmodios and Aristogeiton killed the son of the tyrant Peisistrates in the sixth century B.C.,

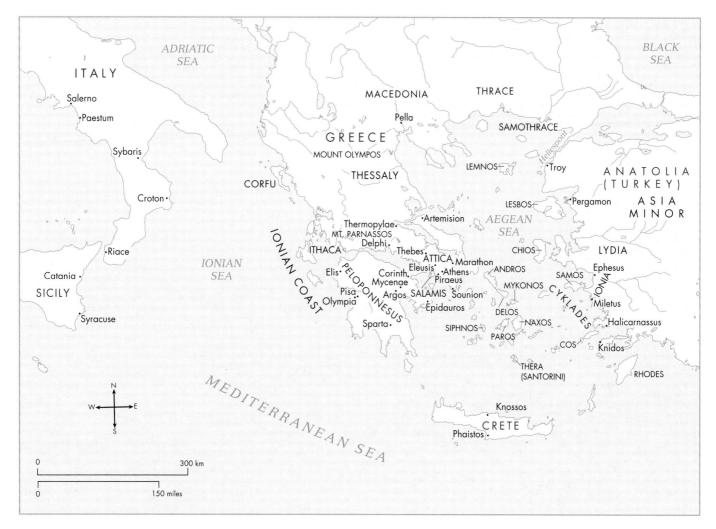

Ancient Greece and the eastern Mediterranean.

Athens honored them as champions of liberty. The Athenian citizens commissioned portrait statues of the heroes —this was one of the highest honors in ancient Greece because it preserved an individual's fame for posterity. The Persians symbolically challenged Athenian liberty by plundering the statues of Harmodios and Aristogeiton, which were not replaced until 477/6 B.C., after the Greek victory over Persia.

The Greek aversion to tyranny led to the establishment of independent city-states. Each city-state, or *polis*, required some degree of citizen participation in its government. Even though the Greeks, like most ancient Mediterranean cultures, kept slaves and did not allow women to engage in politics (see box, p. 140), the *polis* was an important foundation of modern democracy. The ideas embodied in the Athenian democracy of the second half of the fifth century B.C. inspired Thomas Jefferson, when he wrote the Declaration of Independence and framed the American Constitution in the late eighteenth century. The very word *democracy* is derived from the Greek words *demos* (people) and *kratos* (power). Greek philosophers discussed the nature of government at length. Foremost among them is Plato (c. 428– 348 B.C.). His writings include *The Republic* and *The Laws*, which examine his ideal state and the laws required for its proper functioning. Plato's spokesman and teacher, Socrates (see box on p. 141 and fig. 5.3), had developed a new method of teaching known as Socratic dialogue—a process of question and answer through which the truth of an argument is elicited from the student. Demanding close observation of nature and human character, the Socratic method reflects the Greek interest in the centrality of man in relation to the natural world, which is consistent with the Greek artists' pursuit of naturalism and the study of human form.

Aristotle (384–322 B.C.), Plato's most distinguished student and tutor of Alexander the Great, stands out among the ancient Greek philosophers for the diversity of his interests. In addition to natural sciences such as botany, physics, and physiology, Aristotle wrote on philosophy, metaphysics, ethics, politics, logic, rhetoric, and poetry. His *Poetics* established the basis for subsequent discussions of tragedy, comedy, and epic poetry in Western literary criticism. Aristotle did not discuss the visual arts as specifically as Plato had (see box, p. 140), but his views on aesthetics have had a substantial influence on Western philosophy.

Philosophy and science, like philosophy and aesthetics, were very much interrelated in ancient Greece. In the sev-

enth century B.C., for example, Thales of Miletos had founded the first Greek school of philosophy and argued that the origin of all matter was water. In the sixth century B.C., the Pythagorean philosophers of Samos recognized that the earth was a sphere. It was here that the Pythagorean theorem was formulated: $A^2 + B^2 = C^2$ (the square

Delphi

The Greek site of Delphi on the northern slopes of Mount Parnassos in Phokis was one of the most spectacular settings in the ancient world—and it remains so today. In the Mycenaean era (c. 1600 B.C.), Delphi had been a sanctuary dedicated to the Titan earth goddess Gaia. By the eighth century B.C., it had become the sanctuary of Apollo, whose temple lies at the beginning of the Sacred Way (figs. **5.1** and **5.2**). According to Greek myth, when Apollo left Delos, he went to Delphi and killed the Python, a dragon that guarded the oracle and stood for the mysterious power of the underworld. In this transfer of Delphi from Gaia and the Python to Apollo, the Greeks saw a development from the forces of darkness to the rationality of light, from the primitive to the intellectual, and from a matriarchal past to patriarchy.

Delphi was also the site of the Pythian Games. At first these contests were held every eight years and were reserved for music and poetry in honor of Apollo. From 582 B.C., the games were expanded to include athletics, as at Olympia, and took place every four years. The victors were rewarded with a wreath from Apollo's sacred laurel tree and with a portrait statue erected in the sanctuary.

5.1 Temple of Apollo at Delphi, east view, 346-320 B.C.

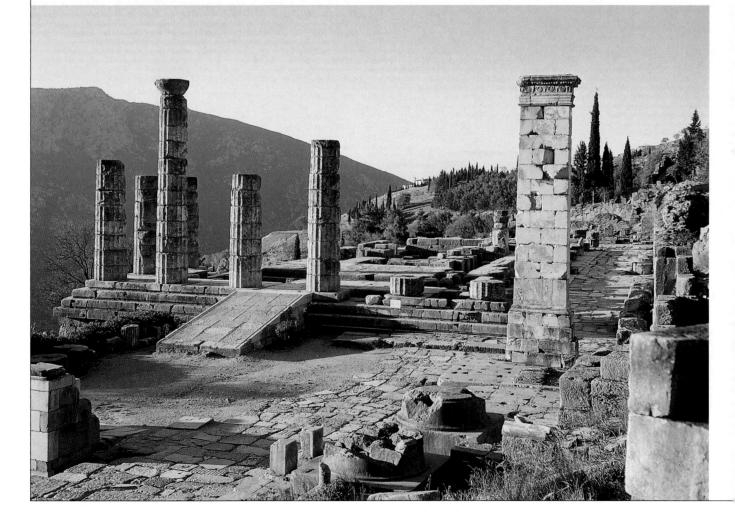

of the hypotenuse of a right-angled triangle is equal to the sum of the squares of the other two sides). Similar mathematical relationships determined the proportions of Classical Greek temples (see p. 158). In the fourth century B.C., Euclid developed number theory and plane geometry.

Literature and Drama

The literary legacy of Greece is one of the most remarkable bequeathed to Western civilization. The *Iliad*, attributed to Homer, is the account of the Trojan War and its heroes, and the *Odyssey* tells the story of Odysseus's ten-year

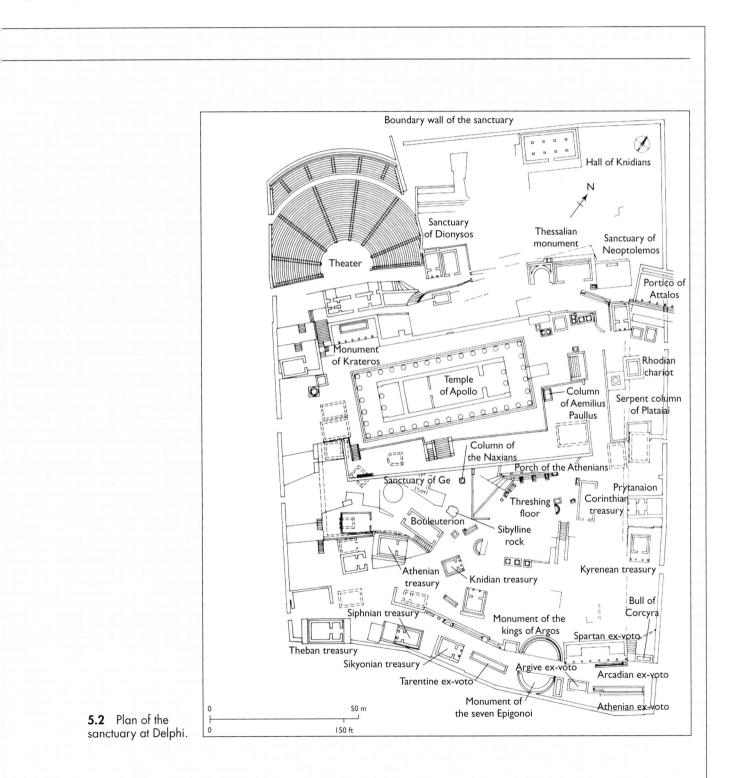

In the period of Greek history depicted by Homer, aristocratic women led lives of relative independence, as did the women of Sparta from the sixth century B.C. onward. In Athens and other parts of Greece during the Classical period (fifth century B.C.), however, women lived under severe constraints. They ventured outside the house mainly for religious processions and festivals restricted to women, and could not vote or hold public office. In the words of Aristotle: "The deliberative faculty is not present at all in the slave, in the female it is inoperative, in the child undeveloped."

In the private sphere, women occupied segregated quarters of the house. Greek marriages were monogamous. As in all ancient cultures, marriage was an economic transaction arranged by the parents of the couple, generally within a circle of relatives so as to preserve property within the family. The woman was usually much younger than the man, and the couple often had no previous acquaintance. If an unmarried woman had no brothers, she was obliged upon the death of her father to marry his closest relative in order to carry on the family.

Once married, a woman became her husband's responsibility. She had no independent status, and her life was devoted to childbearing and looking after the family and household. Perikles is quoted by the Greek historian Thucydides (c. 460– 400 B.C.) as having said that a woman should "be spoken of as little as possible among men, whether for good or ill." Women could own nothing apart from personal possessions and could not be party to any transaction worth more than a nominal amount. A man could divorce his wife by declaration before witnesses; a wife could do so only by taking her husband to court and proving serious offenses.

Athenian men were required by law to marry daughters of Athenian citizens. As a result, some men developed relationships outside marriage with *hetairai*—companions who often were courtesans. *Hetairai* generally came from Ionia and were more intellectual and better educated than Athenian women. The best-known *hetaira* of the fifth century B.C. is the Milesian Aspasia, who was the companion of Perikles. He eventually divorced his wife to marry her.

Ideas about female emancipation begin to appear in literature from the end of the fifth century B.C., and some of the most memorable characters in Greek plays are females, although they were acted by male youths. From the fourth century onward—and increasingly so in the Hellenistic period (323 B.C. to the first century)—education was accessible to some women, and there are reports of women studying philosophy and painting, and writing poetry.

The Roman historian Pliny the Elder mentions by name one laia of Kyzikos, who lived in the early first century B.C. Her "hand," he wrote, "was quicker than that of any other painter, and her artistry was of such high quality that she commanded much higher prices than the most celebrated painters of the same period."

Sappho, the most famous poetess in antiquity, lived at the turn of the seventh century B.C. and was much admired by Plato and other writers. Little is known of her life except that she was born on the island of Lesbos (from which comes the word *lesbian*). Her poems, inspired by Aphrodite, tell of her love for girls as well as for boys and were accompanied by the music of the lyre. Today her work survives only in fragments, but she is known to have written nine books of odes, elegies (poems that mourn the dead), and *epithalamia* (lyric odes to a bride and bridegroom). She composed in various meters—the Sapphic meter is believed to have been her invention.

Plato on Artists

Great philosopher though he was, Plato did not have much use for artists. In Book X of *The Republic*, he proposes banishing them from his ideal state. For Plato, art had no reality except as technique (*techne*) and as imitation (*mimesis*) of nature. But nature itself, he argued, is *only* a mere shadow of the essential truth, which he called the "Good and Beautiful" (*kalos k'agathos*), and it is the philosopher, rather than the poet or artist, who is capable of interpreting it.

The original creator, according to Plato, is God, who creates in relation to the philosophical essence. Craftsmen and

journey home to Ithaca after the war. These epic poems were originally recited and then were written down sometime around 800 B.C. They are noteworthy for their literary style and emphasis on the power and psychology of human heroes. The same is true of the tragedies of Aeschylos, Sophokles, and Euripides and the comedies of Aristophanes, all of which laid the foundation of Western theater. Aeschylos's trilogy *The Oresteia*, written during the fifth artisans are below God, for they make useful objects that, like nature, merely reflect the essential. The painter, who makes an image of the object, is lower still and, therefore, even further from the truth.

Poets do not fare much better than artists in Plato's ideal state for, in his view, they appeal to passion rather than to truth. Although Plato loved Homer, he recommended banishing his works along with those of the artists and admitting only hymns to God and poetry praising famous men.

century B.C., dramatized the tragedy of Agamemnon's family after his return to Mycenae from the Trojan War (see p. 186). And it was Sophokles who gave the world the Oedipus plays, from which Freud recognized that poets had understood human psychology long before the development of psychoanalysis. Events and characters of Greek literature were often illustrated by artists, whose interest in psychology paralleled that of the writers and philosophers.

Socrates: "Know Thyself"

Socrates (470–399 B.C.) left no writings. He was the philosophical spokesman and central figure of Plato's *Dialogues* who advocated self-knowledge in the search for truth. Ultimately a martyr to his intellectual integrity, Socrates chose death rather than exile from the Athens he loved. He explains the philosophical rationale for his choice in Plato's *Apology*.

Figure 5.3 reflects the appearance of Socrates as described by the Athenian general Alkibiades in Plato's Symposium. Alkibiades compares Socrates to two unattractive satyrs (mythological creatures who are part human and part goat), Silenos and Marsyas (the latter found the flute that Athena had discarded and challenged Apollo to a musical contest). Silenos was associated with the drunken orgies of Dionysos, and Alkibiades notes that small statues of Silenos found in Athenian shops open up to reveal the image of a god. Similarly, he says, Socrates' words open up into images of Truth and Beauty: "They are ridiculous when you first hear them; ... he clothes himself in language that is like the skin of the wanton Satyr." The ignorant laugh, but whoever looks below the surface sees the divine beauty in his words. According to Alkibiades, these words have even more charm than the music of Marsyas, for Socrates charms and stirs the souls of his listeners. "I saw in him," Alkibiades says, "divine and golden images of such fascinating beauty that I was ready to do in a moment whatever Socrates commanded."

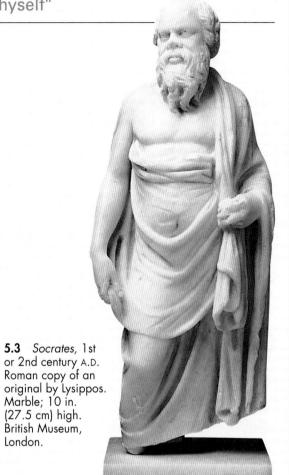

"Man Is the Measure of All Things"

The ancient Greek contributions to Western civilization are inextricably linked to this saying, which set Greece apart from other ancient Mediterranean cultures. In Greek religion, gods were not only **anthropomorphic** (human in form), but had human personalities and conflicts (see box, p. 142). They participated in human events, such as the Trojan War, and tried to influence their outcomes. The gods are referred to as the Olympians because they resided on Mount Olympos after having overthrown their primitive, cannibalistic forerunners, the so-called Titans.

Greece also differed from other Mediterranean cultures, especially Egypt, in its view of death and rituals for the dead. For example, the Greeks believed that certain rituals were necessary for the "shade" of the deceased to pass into the shadowy underworld of Hades. Without proper burial rituals, a spirit might be condemned to wander restlessly forever. To memorialize the deceased, the Greeks erected modest grave markers.

The surviving works of art from ancient Greece emphasize the individual above all. In contrast to the adherence to tradition of Egyptian art, Greek art evolved rapidly from stylization toward naturalism. The treatment of nature and humanity's place in it—ideal as well as actual—differentiated the Greek use of **canons** of proportion from the Egyptian grid. In Greek art, measurements were in relation to human scale and organic form.

The Greek attitude to artists indicated a new interest in the relationship of creators to their work. As far as one can tell, the Greeks were the first Western people to sign their works (for example, fig. 5.7). They were also the first to mention female as well as male artists, indicating that despite the restricted role of women in Greek society—a few exceptional women achieved professional success. The Greeks gave their artists a new status consistent with their cultural view that man, rather than gods, is the "measure of all things."

Greek god	Function/subject	Attribute	Roman counterpart
Zeus (husband and brother of Hera)	King of the gods, sky	Thunderbolt, eagle	Jupiter
Hera (wife and sister of Zeus)	Queen of the gods, women, marriage, maternity	Veil, cuckoo, pomegranate, peacock	Juno
Athena (daughter of Zeus)	War in its strategic aspects, wisdom, weaving, protector of Athens	Armor, shield, gorgoneion, Nike	Minerva
Ares (son of Zeus and Hera)	War, carnage, strife, blind courage	Armor	Mars
Aphrodite	Love, beauty	Eros (her son)	Venus
Apollo (son of Zeus and Leto)	Solar light, reason, prophecy, medicine, music	Lyre, bow, quiver	Phoebus
Helios (later identified with Apollo)	Sun		Phoebus
Artemis (daughter of Zeus and Leto)	Lunar light, hunting, childbirth	Bow and arrow, dogs	Diana
Selene (later identified with Artemis)	Moon	Crescent moon	
Hermes (son of Zeus and Maia)	Male messenger of the gods, trickster and thief; good luck, wealth, travel, dreams, eloquence	Winged sandals, winged cap, caduceus (winged staff entwined with two serpents)	Mercury
Hades (brother of Zeus, husband of Persephone)	Ruler of the underworld	Cerberos (a triple-headed dog)	Pluto
Dionysos (son of Zeus and Semele)	Wine, theater, grapes, panther skin	Thyrsos (staff), wine cup	Bacchus
Hephaistos (son of Hera)	Fire, the art of the blacksmith, crafts	Hammer, tongs, lameness	Vulcan
Hestia (sister of Zeus)	Hearth, domestic fire, the family	Hearth	Vesta
Demeter (sister of Zeus)	Agriculture, grain	Ears of wheat, torch	Ceres
Poseidon (brother of Zeus)	Sea	Trident, horse	Neptune
Herakles (son of Zeus and a mortal woman, the only hero admitted by the gods to Mount Olympos and granted immortality)	Strength	Lion skin, club, bow and quiver	Hercules
Eros (son of Aphrodite)	Love	Bow and arrow, wings	Amor/Cupic
Iris	Female messenger of the gods (especially of Hera), rainbow	Wings	
Hebe (daughter of Zeus and Hera)	Cup bearer of the gods, youth	Сир	
Nike	Victory	Wings	Victoria
Persephone (daughter of Zeus and Demeter, wife of Hades)	The underworld	Scepter, pomegranate	

.

Painting and Pottery

The earliest Greek style, called Geometric (c. 1000–700 B.C.), is known only from pottery and small-scale sculpture. The Orientalizing style (c. 700–600 B.C.) shows influences from Eastern art, and, around the same time, monumental sculptures began to develop. The broad stylistic categories of Greek art that follow Orientalizing are Archaic, Classical, and Hellenistic.

Geometric Style (c. 1000-700 B.C.)

Since most of the monumental mural paintings of ancient Greece have been lost, the development of pictorial style is best known through images on pottery (see box, p. 145). The earliest recognizable style in Greek art after the

destruction of the Mycenaean cultures c. 1100 B.C. is Geometric. The lively, rectilinear **meander patterns** circling the body of the *amphora* (or two-handled storage jar) in figure **5.4** are typical of developed Geometric pottery design. Each pattern is framed by horizontal borders that encircle the pot to emphasize its shape, and two rows of stylized animals decorate the neck. Because the original function of the *amphora* was to serve as a grave marker, its main scene is a *prothesis* (lying-in-state of the dead). The deceased lies on a horizontal bier, held up and flanked by rows of figures who create a sense of motion through ritual gestures of mourning. Their torsos are composed of flat black triangles, and their heads are rounded. Typical of Geometric vase painting are the flat, two-dimensional renderings and the lively, stylized forms painted in a dark glaze (actually a **slip**, or refined clay) over a light-colored surface.

Orientalizing Style (c. 700-600 B.C.)

In the eighth century B.C., influences from the Near East and Egypt enter Greek art in a recognizable way. The Greek assimilation of Eastern iconography reflects contact

and trade as well as an interest in the artistic possibilities of certain motifs and forms.

In the Orientalizing *amphora* shown in figure **5.5**, dated c. 675–650 B.C., the shapes have become larger and more curvilinear than those of the Geometric style, and the geometric patterns are now relegated to borders of the mythological representations. The scene on the neck

5.4 Geometric *amphora*, 8th century B.C. Terra-cotta; 5 ft. 1 in. (1.55 m) high. National Archaeological Museum, Athens.

(fig. **5.6**) illustrates Odysseus and his men driving a stake into the eye of the Cyclops Polyphemos. The poses of Odysseus and his companion show similarities with earlier Aegean painting, particularly the nearly frontal shoulder, profile legs and head, and frontal eye. As in Minoan and Theran nudes (see the *Boxing Children* in figure 4.16), there is a hint of a turn at the waist to account for the spatial discrepancy between torso and legs.

On the body of the vase, the artist has represented the beheading of Medusa by the hero Perseus (see box, p. 146). Medusa's two immortal Gorgon sisters, shown in figure 5.6, are running from her decapitated body lying horizontally in figure 5.5. The Gorgon heads resemble those on bronze cauldrons that were imported into Greece from the Near East, and the protruding snakes suggest the cauldron **protomes**, or tops of animals. Both events depicted on this *amphora* represent Greek heroes—Odysseus and

Perseus—as destroying the primitive forces of terror (Medusa) and cannibalism (Polyphemos).

In Book IX of the *Odyssey*, the one-eyed Titan, the Cyclops Polyphemos, imprisons the Greek Odysseus and his men in his cave on the island of Sicily. After Polyphemos devours six of the men, Odysseus gives him wine and blinds him with a large stake. The cunning Odysseus has previously told the Cyclops that his name is Nobody, so that when Polyphemos calls for help he can only report that Nobody is harming him. The next day, Odysseus and his men tie themselves to the underbellies of Polyphemos's sheep. When in the morning Polyphemos sends his sheep out of the cave to graze, he feels their backs to make sure that the Greeks are not using his sheep to escape. But he does not feel their undersides, and so Odysseus and the rest of his men go free.

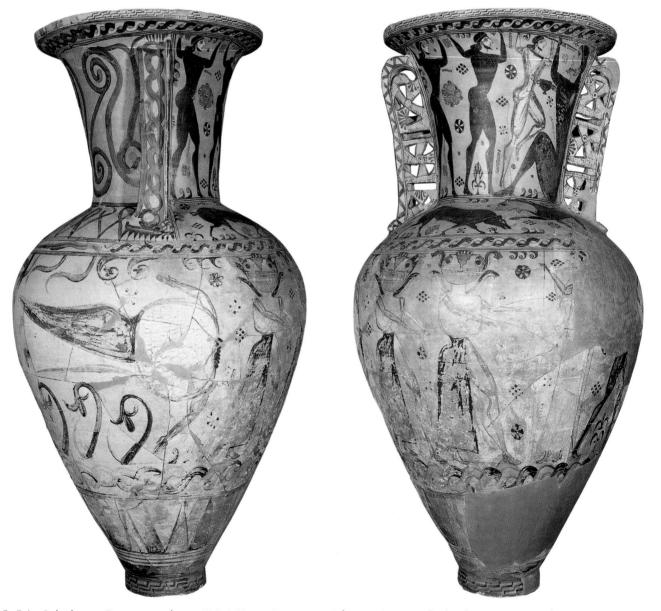

5.5, 5.6 Polyphemos Painter, amphora, 675–650 B.C. Terra-cotta; 4 ft. 8 in. (1.42 m) high. Eleusis Museum, Eleusis.

Archaic Style (c. 600–480 B.C.)

The painting technique used during the Archaic period (from the Greek word archaios, meaning "old") is known as black-figure (c. 600-480 B.C.) (see box). The amphora with a scene of Achilles and Ajax Playing a Board Game is an excellent example (fig. 5.7). Patterning still functions as a border device, and, as in Orientalizing, the central image is a narrative scene. Exekias, the most insightful and dramatic black-figure artist known to us, was a panel painter as well as a vase painter. In this scene, he transforms the personal rivalry between the two Greek heroes of the Trojan War into a board game. He emphasizes the intense concentration of Homer's protagonists by the combined diagonals of their spears and their gaze, all of which focus our attention on the game board. Ajax and Achilles are identified by inscriptions. They wear elaborately patterned cloaks, arm and thigh armor enlivened with elegant spiral designs, and greaves (shin protectors). The stylized frontal eye persists from Mesopotamian, Egyptian, and Aegean art, but here the postures are rendered more three-dimensionally.

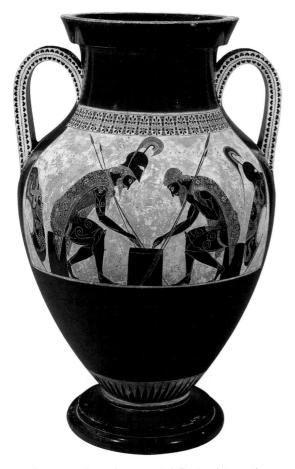

5.7 Exekias, amphora showing Achilles and Ajax Playing a Board Game, 540–530 B.C. Terra-cotta; entire vessel 24 in. (60.9 cm) high. Musei Vaticani, Rome.

This *amphora* was signed by Exekias as both potter and painter. He integrates form with characterization to convey the impression that Achilles, the younger warrior on the left, will win the game. On the right, Ajax leans farther forward than his opponent so that the level of his head is slightly lower, and he has removed his helmet. Achilles' helmet and tall crest indicate his dominance.

Greek Vase Media and Shapes

Greek vases were made of terra-cotta. On **black-figure** vases, the artist painted the figures in black silhouette with a slip made of clay and water. Details were added with a sharp tool by incising lines through the painted surface and exposing the orange clay below. The vase was then fired (baked in a kiln) in three stages. The final result was an oxidation process that turned the surface of the vase reddishorange and the painted areas black.

For **red-figure** vases, the process was reversed. Figures were left in red against a painted black background, and details were painted in black.

On **white-ground** vases, a wash of white clay formed the background. Figures were then applied in black, and additional colors were sometimes added after the firing.

As early as the Archaic period, certain shapes of vase became associated with specific uses (fig. **5.8**).

5.8 Greek vase shapes include (a) the **hydria**, a water jar with three handles; (b) the **lekythos**, a flask for storing and pouring oil; (c) the **krater**, a bowl for mixing wine and water (the Greeks drank their wine diluted); (d) the **amphora**, a vessel for storing honey, olive oil, water, or wine; (e) the **kylix**, a drinking cup; and (f) the **oenochoe**, a jug for pouring wine.

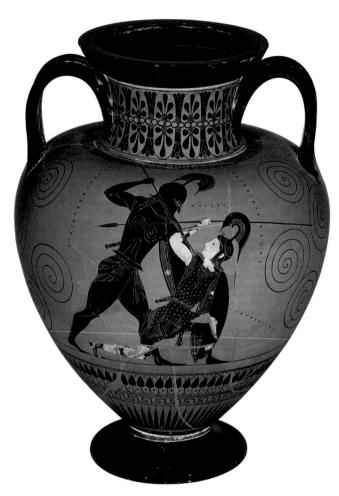

5.9 Exekias, *amphora* showing *Achilles and Penthesilea*, c. 525 B.C. Terra-cotta; 16¼ in. (41.3 cm) high. British Museum, London.

In another vase painting, Exekias uses the power of the gaze and the device of diagonal spears to enhance the tragic love between Achilles and the Amazon queen Penthesilea (fig. 5.9). The Greek hero leans forward, his entire body a forceful, towering diagonal, and drives his spear into the neck of his opponent. Identified with the luxurious East by her leopard skin, Penthesilea is on her knees in defeat. Both figures, as in the previous example, are partly three-dimensional, but their heads are in strict profile. With blood gushing from her neck, Penthesilea turns back, and her eye rolls upward to indicate that she is dving. Achilles, in turn, gazes at her and, at the point of her death, falls in love with her. Compared with the scene in figure 5.7, the confrontation here is intensified by the "locked in" gaze of the two combatants and is unrelieved by the intervening board game. Exekias's ability to capture such dramatic moments is consistent with contemporary developments in Greek theater and foreshadows Classical tragedy.

Medusa

Medusa, the only mortal of the three Gorgon sisters, turned to stone any man who looked at her. She had snaky hair, glaring eyes, fanged teeth, and emitted a loud roar. Following the wise advice of Athena to look at her only in the reflection of his shield, Perseus decapitated Medusa. He gave her head to Athena, who adopted it as her shield device. The Medusa head, or *gorgoneion*, subsequently became a popular armor decoration in the West, symbolically petrifying—that is, killing—the enemies of its wearer.

Late Archaic to Classical Style (c. 530–400 B.C.)

The **red-figure** painting technique was introduced in the late Archaic period and continued to be used until the fourth century B.C. It permitted freer painting and the representation of more natural form than had been possible in black-figure. Furthermore, the red color now used for skin tones was closer to the actual skin color of the Greeks than black had been.

The scene of the abduction of Europa on a bell *krater* of about 490 B.C. by the so-called Berlin Painter (fig. **5.10**) illustrates the transition from black-figure to red-figure painting. The decorative surface patterns have decreased, and more attention is given to organic form and movement. Black lines indicating the folds of Europa's dress appear three-dimensional in form and suggest the motion of her

5.10 Berlin Painter, bell *krater* showing *The Abduction of Europa*, c. 490 B.C. Terra-cotta; whole vessel 13 in. (33.0 cm) high. Museo Archeologico, Tarquinia. In this scene, Zeus takes the form of a bull and abducts the mortal Europa. The Greeks would have recognized the irony of the unsuspecting Europa being fascinated by Zeus' horn and rushing to her fate.

5.11 Penthesilea Painter, cup interior showing Achilles and Penthesilea, c. 455 B.C. Terra-cotta; diameter 17 in. (43.1 cm). Antike Sammlungen, Munich.

silea Painter (fig. 5.11). Here, the large figures seem about to burst the rim of the cup and suggest that the scene was based on a larger mural painting. At the right, a dead Amazon curves in line with the frame, while a vigorous Greek readies his dagger and spear at the left. In the center, Achilles and Penthesilea enact their tragic fate. Compared with the black-figure version by Exekias, this is more crowded, the figures are closer together, and there is more overlapping. We see Achilles plunging his sword straight down into the Amazon, as she clasps his breast. The development of the profile eye allows them to gaze into each other's eyes, turning the physical action of Exekias's scene into a psychological interaction.

In addition to increased organic form, the Greek painters of the mid-fifth century B.C. began to set figures in nature and to depict elements of landscape. The *kalyx krater* by an artist known as the Niobid Painter has an unidentified scene on one side (fig. **5.12**); the other, depicting *The Death of the Children of Niobe* (the Niobids) (fig. **5.13**), has

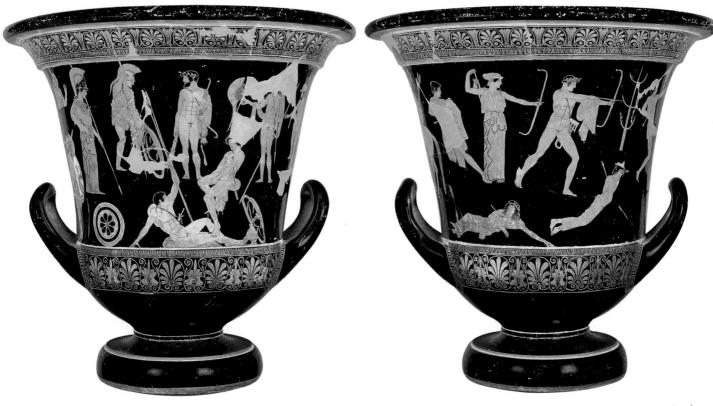

5.12 Niobid Painter, *kalyx krater*, side showing an unidentified scene, c. 455–450 B.C. 21¼ in. (53.9 cm) high. Louvre, Paris.

body-especially the large step that she takes with her

become less stylized, and human figures were represented

with greater naturalism. This development can be seen in

another painting of Achilles and Penthesilea by the Penthe-

By some thirty-five years later, red-figure painting had

heels lifted off the ground.

5.13 Niobid Painter, kalyx krater, side showing The Death of the Children of Niobe, c. 455–450 B.C. 21¼ in. (53.9 cm) high. Louvre, Paris.

a rudimentary tree and sloping terrain. Niobe was a mortal woman who boasted that she was greater than Leto because she had fourteen children. To punish Niobe for her arrogant pride, which the Greeks called *hubris*, Apollo (the son of Zeus and Leto) and his twin sister, Artemis, who were expert archers, killed all of Niobe's children. Figure 5.13 shows Artemis removing an arrow from her quiver while Apollo takes aim at his next victim. The gods' power is emphasized by the fact that they tower over the mortals, two of whom lie dead, draped over the rocky landscape in the foreground.

Classical to Late Classical Style (c. 450–323 B.C.)

During the late fifth century B.C., a technique of painting known as **white-ground** became popular on *lekythoi*, which were used as grave dedications. The example in figure **5.14**, of c. 410 B.C., shows a warrior sitting by a grave.

5.14 Reed Painter, Warrior by a Grave (white-ground lekythos), c. 410 B.C. Terracotta; 18% in. (48.0 cm) high. National Archaeological Museum, Athens. The use of foreshortening, which depicts the round shield as an oval because it is partly turned, indicates the Greek artist's interest in rendering forms as they appear in natural, threedimensional space. He is rendered as if in a three-dimensional space—his body moves naturally, bending slightly at the waist, and his head inclines as if in meditation or mourning. The drapery falls over his legs as it would in reality, and his left leg and shield are **foreshortened** (that is, they are shown in perspective).

The Greek interest in naturalism led to a delight in illusionism and *trompe-l'oeil*. Zeuxis, for example, as mentioned in the Introduction, was reputed to have painted grapes that fooled birds into believing they were real. By the late fifth century, Zeuxis was painting from live models and, therefore, directly from nature. One anecdote relates that he died laughing while staring at his painting of an old woman and that he painted Helen of Troy as a *hetaira* a courtesan—and charged admission when the picture was exhibited.

During the fourth century B.C, Apelles of Kos (see the Introduction) reputedly painted such realistic horses that live horses neighed when they saw them. Apelles became Alexander the Great's court painter (see below); one of his portraits, depicting Alexander with a thunderbolt, was so realistic that the fingers seemed to stand out from the picture plane. Apelles also painted Alexander's mistress, Pancaspe, and fell in love with her. As a measure of his esteem for Apelles, Alexander gave Pancaspe to him.

Apelles, like Zeuxis, had a sense of humor. He liked to hide when his works were exhibited so that he could hear viewers' comments. On one occasion, when a shoemaker observed that the artist had made a mistake in his rendition of a sandal strap, Apelles corrected it. Later the same shoemaker criticized a leg, and Apelles objected to his presumption, telling him not to rise above the sandal, which was his only area of expertise. This became the origin of the expression "Let a shoemaker stick to his last."

Mosaic

The best-preserved examples of large-scale Greek pictorial style are mosaics from the Hellenistic period (c. 323-31 B.C.). The so-called "Alexander Mosaic" in figure 5.15 is a Roman copy of a Greek fresco of around 300 B.C. It depicts Alexander the Great defeating the Persian king Darius II at the Battle of Issos (333 B.C.). Radical foreshortening-as in the central horse, seen from the rear-and the use of shading to convey a sense of mass and volume enhance the naturalistic effect of the scene. Repeated diagonal spears, clashing metal, and the crowding of men and horses evoke the din of battle. Alexander (fig. 5.16) sweeps into battle at the left, his wavy hair typical of royal portraiture as established in Greek art of the fourth century B.C. He rides a war-horse and focuses his gaze on the Persian leader, who is in a chariot. Darius turns to confront Alexander, but the chariot driver whips the horses as he tries to escape in the opposite direction. At the same time, action is arrested by dramatic details such as the fallen horse and the Persian soldier in the foreground who watches his own death throes reflected in a shield (fig. 5.17).

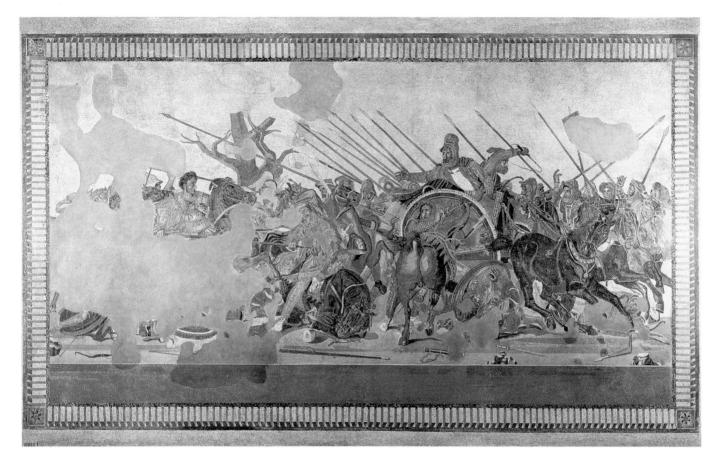

5.15 Battle of Issos, from the House of the Faun, Pompeii, 1st century B.C., after an original Greek fresco of c. 300 B.C. Mosaic; $106\frac{3}{4} \times 201\frac{1}{2}$ in. (271.1 \times 511.8 cm). Museo Archeologico Nazionale, Naples. Also known as the "Alexander Mosaic," this work is made of colored **tesserae**—little tiles. They are arranged in gradual curves called *opus vermiculatum* ("worm work") because they seem to replicate the slow motion of a crawling worm. Monumental mosaics such as this one were found on the floors of houses of the wealthy.

5.16 Detail of figure 5.15, showing Alexander.

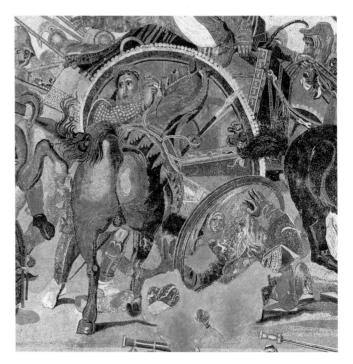

5.17 Detail of figure 5.15, showing a dying Persian.

Sculpture

Orientalizing Style: The Lions of Delos (7th century B.C.)

The row of impressive white marble lions (fig. **5.18**) on the island of Delos continues the traditional guardian function of such animals. Located in the middle of the Cyclades, Delos is a small island that was an important trading center inhabited from the third millennium B.C. Delos had been revered as Apollo's sanctuary because it was the god's birthplace. According to the myth, Zeus seduced Leto, a daughter of the Titans. His jealous wife, Hera, pursued the pregnant Leto until the latter found refuge on a barren rock in the sea. There she gave birth to the twin gods Apollo and Artemis, and thereafter Delos became a fertile island.

Because of its importance as a religious site, Delos was subjected to a long-lasting struggle for control. In the late seventh century B.C., it was under the rule of the neighboring island of Naxos. The Naxians erected the marble lions on the road leading north from the temple of Leto, and today five of them survive. They sit on their haunches, looking alert and ready to spring. The sense of contained energy combined with monumental form and stylization most evident in the rib cage—is characteristic of the early Greek styles. At the same time, the simplicity of the lions and their gleaming marble surfaces recall the Cycladic idols that had been produced in the Bronze Age. The ancient belief that lions sleep with their eyes open accounts for the guardian function of the Delos lions, as it had in Egypt, the Aegean, and the Near East. Their focus on the temple of Apollo's mother is consistent with the traditional association of lions with the sun, which continues to the present day in the zodiac: Leo (the lion) is the house of the sun.

Archaic Style (c. 600-480 B.C.)

Monumental sculpture of human figures began in Greece during the Archaic period. It is not known why the Greeks began making such works when they did, but it is clear that the early Archaic artists were influenced by Egyptian technique and convention.

In creating life-sized human figures, the Greeks learned from the Egyptians how to carve blocks of stone but adapted the technique to suit their own tastes. The *New York Kouros* (fig. **5.19**) was made around 600 B.C. A comparison of this figure with the statue of Menkaure (see fig. 3.18) highlights the similarities and differences between Egyptian and Archaic Greek life-sized statues of standing males. The *Kouros* maintains the standard Egyptian frontal pose. His left leg extends forward with no bend at knee, hips, or waist, and his arms are at his sides, fists clenched and elbows turned back. Nevertheless, the artist has made changes to emphasize human anatomy. The *Kouros* is cut away from the original rectangular block of marble, leaving open spaces between the arms and the body and

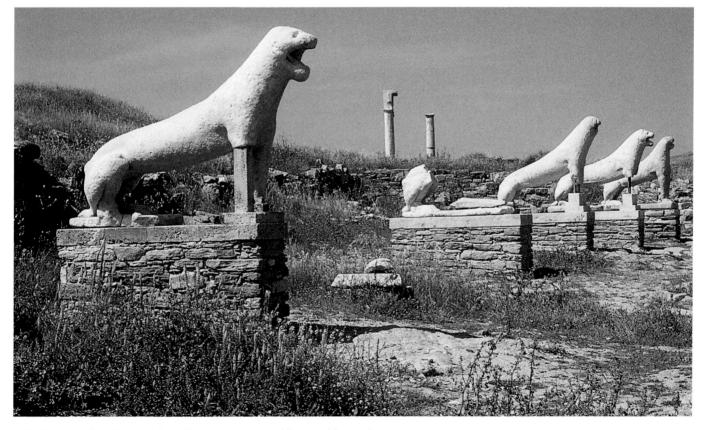

5.18 Terrace of the Lions, Delos, 7th century B.C. Marble; over-life-sized.

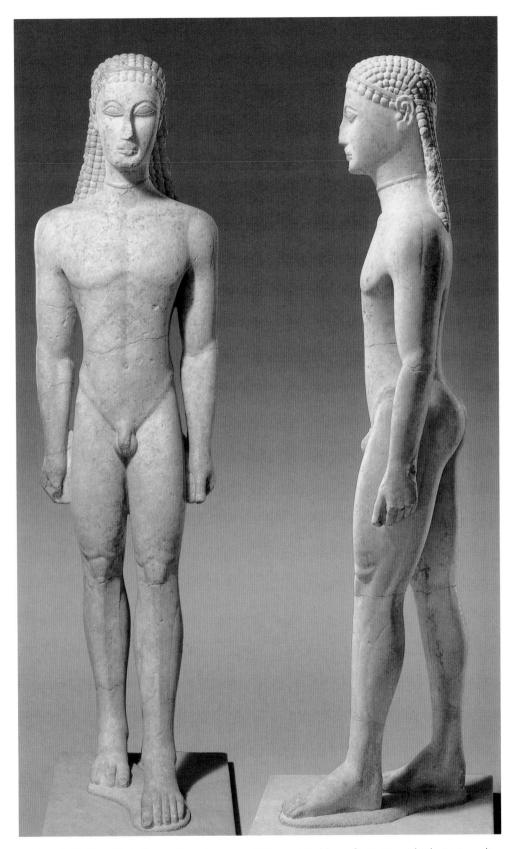

5.19c New York Kouros, detail of stylized hair.

- CONNECTIONS

See figure 3.18. Menkaure and Queen Khamerernebty, 2490–2472 B.C.

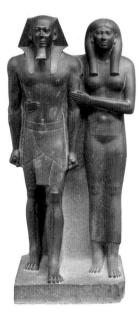

5.19a (left) New York Kouros from Attica, c. 600 B.C. Marble; 6 ft. (1.84 m) high. Metropolitan Museum of Art, New York. Fletcher Fund, 1932. Kouros, Greek for "boy" (kouroi, plural), is used to denote a type of standing male figure, typically carved from marble and usually commemorative in nature. Generally the kouroi either were grave markers or represented individuals honored in religious sanctuaries. Since this kouros appeared on the antiquities market with no provenience and has no identifying inscription, it is named for its present location. It is the earliest known life-sized sculpture of a standing male from the Archaic period.

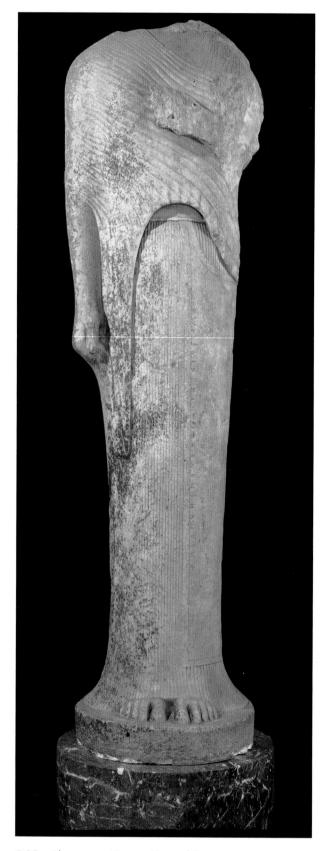

5.20 Cheramyes Master, Hera of Samos, from Samos, 570–560 B.C. Marble; 6 ft. 3½ in. (1.91 m) high. Louvre, Paris.

between the legs. This openness and the smaller shoulders decrease the tension and monumentality of the *New York Kouros* when compared with Menkaure.

In contrast to the rectangularity of Egyptian convention, the emphasis on the anatomy of the *Kouros* increases its tension. Various features of the *Kouros* are curved—the round kneecaps topped by two arcs and the lower outline of the rib cage. The hair is composed of small circles arranged in parallel rows, ending in a bottom row of cones. It falls over the back of the shoulders but does not fill up as much space as Menkaure's wig.

The most obvious difference between the *Menkaure* and the *New York Kouros* is the nudity of the latter. The Greek convention of nudity for male statues from the Archaic period signals the interest in human form, whereas Archaic statues of females were clothed for reasons of propriety. Furthermore, the stance of the *Kouros* is centered over the two legs, which, together with the muscular definition, suggests the power to move.

In the *Hera of Samos* (fig. **5.20**), as in the Delos lions, we find the characteristic Archaic combination of tension and geometric form. A votive figure, dedicated to Hera by a man whose name is engraved on the skirt, it originally stood outside the temple of Hera on the island of Samos. The statue is cylindrical, and the *chiton* (linen dress) is smooth except for finely incised folds. The upper part seems more three-dimensional, revealing the shape of the arms and breasts beneath. The elegance of this figure and the unified flow of curves at the bottom of the *chiton* create an unusual synthesis of grace and monumentality.

Archaic sculptures of standing women are referred to as *korai* (singular *kore*, Greek for "girl"). The *Peplos Kore* (fig. **5.21**) is named for her *peplos* (a woolen dress, pinned at the shoulders). Her pose is slightly less rigid than that of the earlier *New York Kouros*, as she bends her left arm forward. Compared with the *Hera*, the garment of the *Peplos Kore* reveals the contours of the body. Further distinguishing the *Peplos Kore* from earlier Archaic figures is the so-called "Archaic smile," which accentuates the fact of being alive. The artist has handled the smile organically by curving the lips upward and raising the cheekbones in response.

Early Classical Style (c. 480–450 B.C.)

From 499 to 494 B.C., Athens gave aid to the Ionian cities in their unsuccessful revolt against Persia. This provoked Darius the Great, king of Persia, to invade mainland Greece in 490 B.C., only to be defeated by the Athenians at the Battle of Marathon. Another invasion in 480 B.C. by Darius's son Xerxes was finally repelled in 479 B.C; this marked the end of Persian efforts to conquer Greece. A change in artistic style seems to have coincided with the Persians' final departure from Greek soil. The Early Classical style, sometimes called Severe (because the smile has disappeared and the forms are simpler) or Transitional

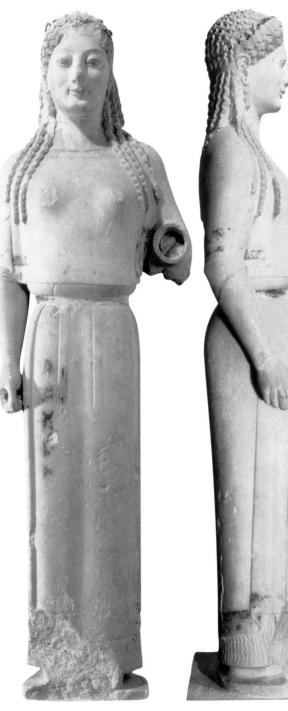

5.21a Peplos Kore, c. 530 B.C. Parian marble; 3 ft. 11³/₃ in. (1.21 m) high. Acropolis Museum, Athens. The Peplos Kore retains traces of paint on her dress and in her eyes, reminding us that Greek artists originally used color to enliven the appearance of their white marble figures.

5.21b *Peplos Kore* (side view of fig. 5.21a). Recent research indicates that the *Peplos Kore* is a representation of Athena.

(because it bridges the gap between Archaic and Classical), produced radical changes in the approach to the human figure.

The best example of the new developments can be seen in the marble *Kritios Boy*, attributed to the sculptor Kritios (fig. **5.22**). It is not known if the sculpture was made before or after the Persian Wars, but it reflects a moment of selfawareness in Greek history that is marked by the change from Archaic to Early Classical. Stylization has decreased, remaining primarily in the smooth, wavy hair and the circle of curls around the head. The flesh now seems to cover an organic structure of bone and muscle. The Archaic smile has disappeared, and the face, like the body, has

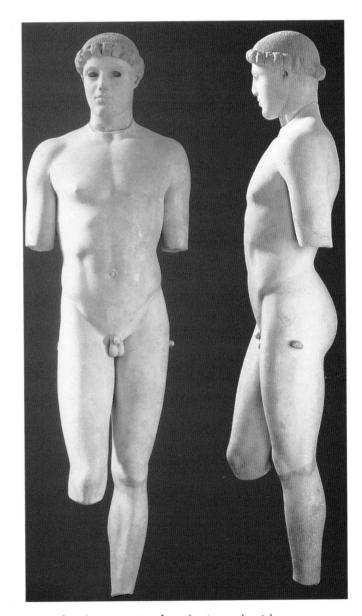

5.22a, b The Kritios Boy, from the Acropolis, Athens, c. 480 B.C. Parian marble; 33% in. (86.1 cm) high. Acropolis Museum, Athens.

The Lost-Wax Process

In casting bronze by the **lost-wax** method (also known by the French term *cire-perdue*), the artist begins by molding a soft, pliable material such as clay or plaster into the desired shape and covering it with wax. A second coat of soft material is superimposed on the wax and attached with pins or other supports. The wax is then melted and allowed to flow away, leaving a hollow space between the two layers of soft

material. The artist pours molten bronze into the mold, the bronze hardens as it cools, and the mold is removed. The bronze is now in the shape originally formed by the "lost" wax. It is ready for tooling, polishing, and the addition of features such as glass or stone eyes and ivory teeth to heighten the organic appearance of the figure.

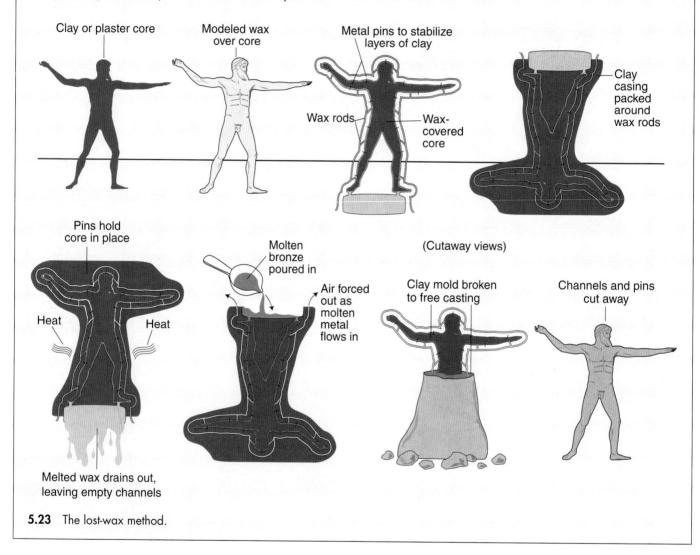

become idealized and neutral in expression. But perhaps the most important developments are that the head is turned slightly, and the right leg, which is forward, bends at the knee so that the left leg appears to hold the body's weight. The torso shifts so that the right hip and shoulder are lowered, a pose referred to as **contrapposto** (from the Latin words *positus*, meaning "positioned," and *contra*, meaning "against"). For the first time, a contrast between

rigid and relaxed elements allows the viewer to feel the inner workings of the human body.

Another Early Classical development, which originated in the Archaic period, was the widespread use of bronze as a medium for large-scale sculpture cast by the **lost-wax** process (see box). For smaller objects, however, bronze casting had been used since the Aegean period. Of the few Greek over-life-sized bronzes that have survived, the bronze

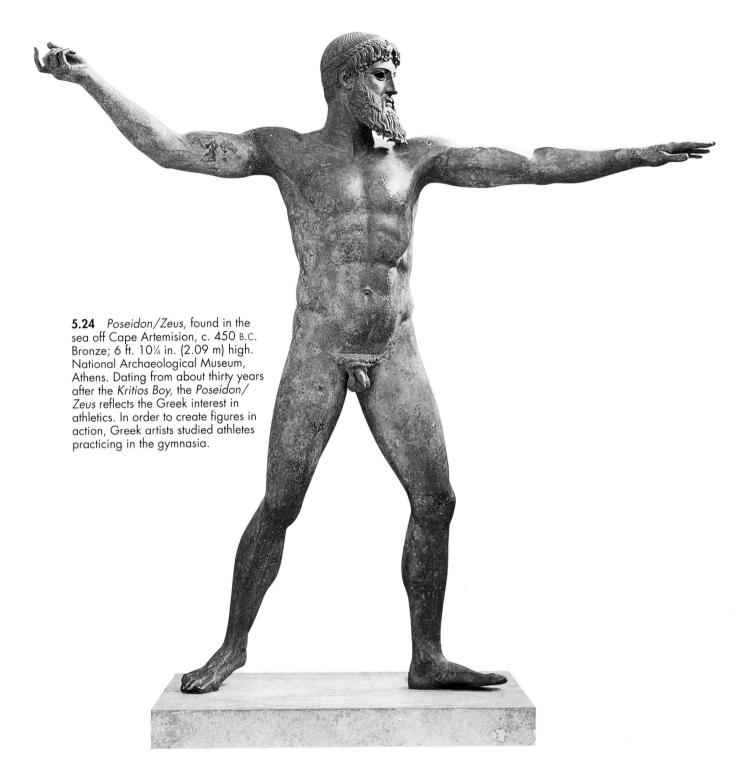

statue representing either Zeus hurling his thunderbolt or Poseidon his trident (fig. **5.24**) is one of the most impressive. By virtue of his pose, the god seems to command space. He focuses his aim, tenses his body, and positions himself as if ready to shift his weight, perfectly balanced between the ball of his right foot and his left heel. His slightly bent knees create the impression that he will spring at any moment. The intensity of his concentration and the force of an imminent thrust extend the viewer's experience of the sculpture toward the weapon's destination.

The Early Classical *Diskobolos* (*Discus Thrower*) is known only from Roman copies in marble (fig. **5.25**). The bronze original was cast by Myron between c. 460 and 450 B.C. A formal analysis of the statue shows that its design is based on the intersection at the neck of two arcs. One arc can be traced from the head, through the curve of the back to the left heel, and another from one hand to the other. The overriding movement of the *Diskobolos* is circular—the torso twists forward and brings the shoulders into line with the right thigh. This creates a unity of form, echoed by the domed head, the round discus and base, and finally the pose itself. For, in fact, Myron did not so

much create a pose as freeze in time the circular motion of a pivoting athlete.

In 1972, a pair of original Greek bronzes known as the *Warriors from Riace* was discovered in the sea off the southern coast of Italy near Riace. The figure illustrated here (fig. **5.26**) is in a remarkably good state of preserva-

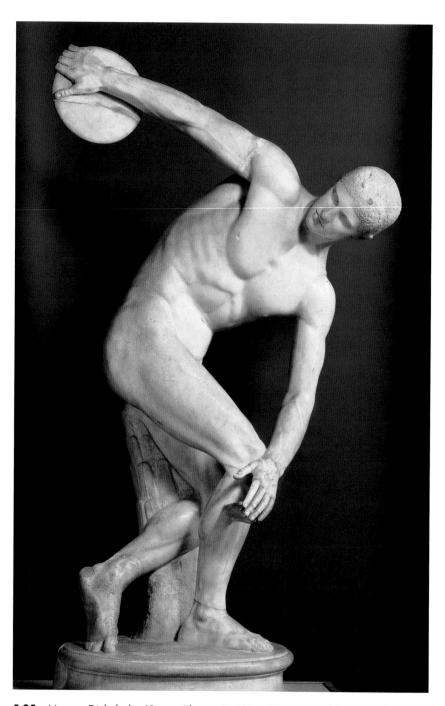

5.25 Myron, *Diskobolos* (*Discus Thrower*), 460–450 B.C. Marble copy of a bronze original; 5 ft. (1.53 m) high. Museo delle Terme, Rome.

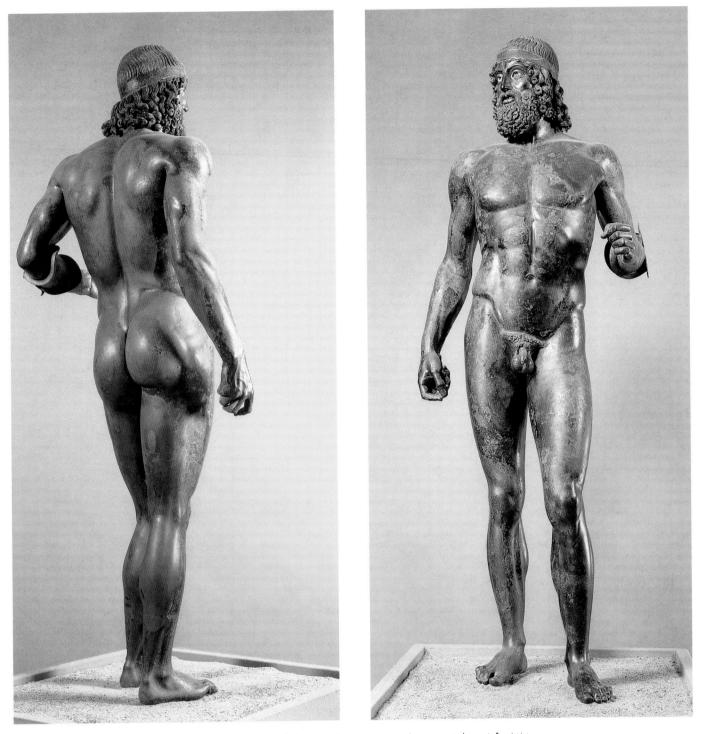

5.26a, b Warrior from Riace, c. 450 B.C. Bronze with bone, glass paste, and copper inlay; 6 ft. 6⁴/₂ in. (2.00 m) high. Museo Nazionale, Reggio Calabria, Italy.

tion after extensive restoration work. Inlaid eyes (made of bone and glass paste), copper eyelashes, lips, and nipples, and silver teeth create a vivid, lifelike impression compared with statues that have lost such details. Most scholars assign a date of about 450 B.C. to the work, placing it at

the end of Early Classical and the beginning of Classical. The dome-shaped head and flat, curvilinear stylizations of the hair are Early Classical elements, whereas the selfconfident, dynamic pose and organic form are characteristic of Classical style.

Classical Style (c. 450-400 B.C.)

The fifty-year span of Greek history from about 450 to 400 B.C. is referred to as the Classical, or High Classical, period. It corresponds to the aftermath of the Persian Wars, when Greek art evolved from the lavish designs of the Orientalizing and Archaic styles. The association of the Near Eastern cultures with luxury and opulence led the Greeks to reject the earlier, more decorative styles in favor of a new simplicity.

The modern term *classical*, which has multiple meanings—including "traditional," "lasting," and "of high quality"—referred originally to the Greek accomplishments of the second half of the fifth century B.C. Works of art produced in this period not only reflect the cultural and intellectual achievements of Greece itself; they have also had a far-reaching influence on subsequent Western art and culture. It is virtually impossible to understand any aspect of Western development without some familiarity with the achievements of Classical Greece.

Polykleitos of Argos

Polykleitos of Argos was esteemed by his contemporaries, and his work is thought of as the embodiment of Classical style. He is known to have created a canon (see box) that is no longer extant. Most of his sculpture was cast in bronze and is known today only through later Roman copies in marble. Ancient records document the fact that the *Doryphoros* (*Spear Bearer*) was originally bronze (fig. **5.27**). The figure held a spear in his left hand and stands like the

The Canon

Polykleitos called his *Spear Bearer* the "Canon," and he is said to have made it to embody the ideas in a lost treatise of the same name. It dealt with a series of proportions that related the body parts to each other and to the whole—for example, the finger to the hand, the hand to the forearm, the forearm to the arm. For Polykleitos, the application of consistent measurements, *symmetria* (*not* the equivalent of the modern term *symmetry*), was a means of achieving beauty.

The concept of symmetria was deeply rooted in Greek philosophy, which considered the orderliness of the universe to depend on regularity of measurement. Symmetria makes it possible for people to understand the world. It is the emphasis on the intelligible appearance that gives Greek art its ideal character.

Symmetria was also applied to architecture. Iktinos, one of the architects of the Parthenon (see p. 170), also wrote a treatise, which has disappeared. Modern measurements of the Parthenon reveal that the ratio 4:9 consistently governs its proportions. For example, the ratio of (a) the distance from the base of the columns to the top of the frieze to (b) the width of the façade is 4:9, as is the ratio of the width of the façade to the width of the long side.

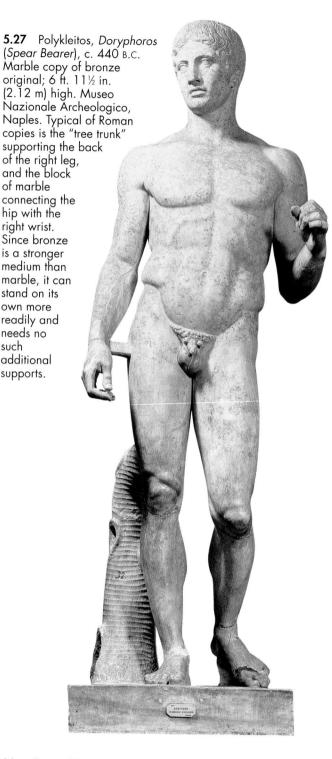

Kritios Boy, although with a slight increase in *contrap*posto and in the inclination of the head. The gradual Smotion of the body is more pronounced, and there is a greater sense of conviction in the body's underlying organic structure—notably the bulging kneecaps, the rib cage, and veins in the arms. The head is dome-shaped, as in the *Kritios Boy* and the *Diskobolos*, but the hair is longer and more three-dimensional. The result is a figure with a sense of organic animation.

A marble replica of a bronze sometimes attributed to Polykleitos is the *Wounded Amazon* of c. 430 B.C., which also embodies Classical style (fig. **5.28**). Compared with 5.28 Attributed to Polykleitos, Wounded Amazon, c. 430 B.C. Marble copy of bronze original; 6 ft. 7½ in. (2.02 m) high. Museo Capitolino, Rome. Amazons were female warriors from the east who helped defend Troy against the Greeks. The dress of the Amazon has numerous folds. creating an additional surface movement that interrupts the smooth skin of the body. The repeated bunches of short folds just below the waist can be related to the waves of the hair, creating a visual unity between parts that also conforms to the organic logic of the whole. This kind of unity, integrating the visual and the intellectual, is one of the predominant characteristics of the Classical style.

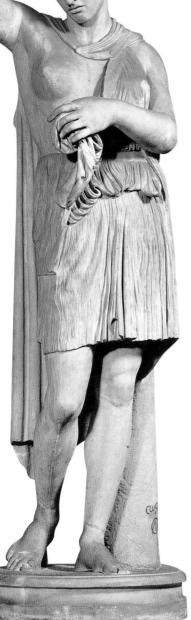

the Archaic *Peplos Kore* of a century earlier (fig. 5.21), the figure is relaxed; her body turns somewhat languidly, and she inclines her head and twists at the waist. The Archaic stylizations have disappeared, as has the smile. The hair is parted in the middle and seems to grow from the scalp. Whereas Archaic drapery has a columnar, architectural quality, Classical drapery follows the form and movement of the body.

Classical artists idealized the human form. Figures are usually young, with no trace of physical defect. They are

nicely proportioned and symmetrical in form (not necessarily in pose) but lack personality and facial expression. These qualities are evident in the *Amazon*, who turns toward a wound in her right side without indicating any pain or discomfort. The Classical preference for idealization thus overrides narrative content. Such conventions of Classical taste not only are evident in sculpture, but also reflect those of fifth-century-B.C. Greek theater. No violence or impropriety was performed on stage: when the plot involved such events, they were narrated by a messenger.

Grave Stelae

In the late fifth century, particularly in Athens, wealthy families began to erect grave monuments over burials. Representations of the deceased were shown as if alive in front of an architectural façade.

In the Stele of Hegeso (fig. **5.29**), the deceased gazes at a necklace that she has removed from the box held by her servant. The clothes reveal naturalistic forms and poses, while also creating their own graceful rhythms. Both Hegeso and her servant gaze downward, somewhat languidly, and convey an air of melancholy.

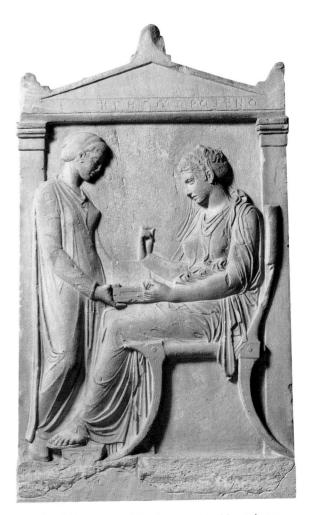

5.29 Stele of Hegeso, c. 410–400 B.C. Marble; 5 ft. 9 in. (175.2 cm) high. National Archaeological Museum, Athens.

The Development of Greek Architecture and Architectural Sculpture

The Greeks, like all ancient peoples, thought of temples as houses for the gods. In Greece, the temple plan was derived from the *megaron* plan found in Mycenaean palaces (see p. 127). At its most basic, the *megaron* consisted of a rectangular room with a front porch (**portico**), having two columns. The god's cult statue was housed in the main room (the **naos**) and faced toward the east to an outdoor altar where sacrifices were performed. The main rituals inside the temple involved the care of the statue itself, usually ceremonial dressing and cleaning. Temple interiors also became sanctuaries for fugitives.

Archaic Style (c. 600-480 B.C.)

In the course of the sixth century B.C., during the Archaic period, the basic temple form was developed further, often into two rooms with interior columns, front and back porches, and an outer colonnade on all sides. This latter feature was, in part, influenced by the monumental temples of Egypt, which had huge stone columns, capitals, and bases. In Greece, the proportions changed and the size diminished in accordance with human scale and the maxim that "man is the measure of all things." As in Egypt, the system of elevation was post and lintel, but in Greece the columns were placed on the outside of the building and formed a wall of

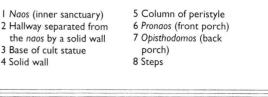

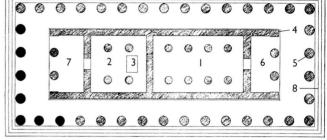

5.30 Plan of the temple of Apollo at Corinth.

columns separate from the *naos;* such temples are referred to as **peripteral**. The façades were elaborated by the Greeks into the so-called **Orders** of architecture (see box, p. 162).

Figure **5.30** is the plan of Apollo's temple on the mainland at Corinth. Constructed around 550 B.C., it is early Doric, and some of the massive, fluted columns are still standing (fig. **5.31**). Their shafts rise directly from the top step and have no base. The capitals, which are reminiscent of Minoan capitals, support the remnants of a horizontal architrave. We can see from the plan that the temple had a second room (the *opisthodomos*) behind the *naos* that housed the cult statue of Apollo.

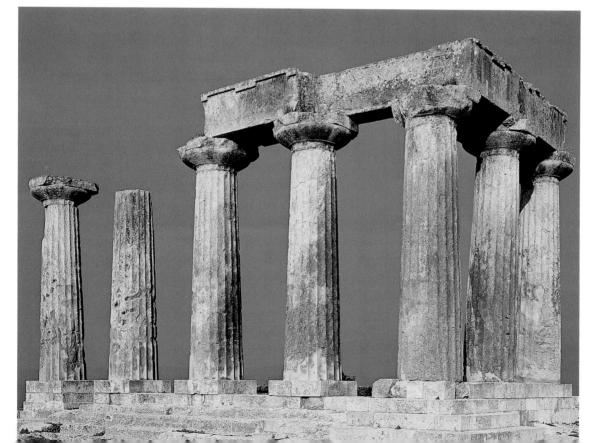

5.31 View of the temple of Apollo at Corinth, c. 550 B.C. Limestone, originally faced with stucco.

5.32 Reconstruction of the façade of the Siphnian Treasury in the sanctuary of Apollo at Delphi, 530–525 B.C. Delphi Museum.

In many cases, the *opisthodomos* was reserved for the safekeeping of valuables dedicated to the god and eventually became an official treasury. Sometimes treasuries were separate buildings, consisting of a front porch connected to a rectangular room that housed costly objects dedicated by individual cities at the large sanctuaries. An Archaic treasury of this kind in the Ionic Order can be seen in the reconstructed Siphnian Treasury (fig. **5.32**) from the sanctuary at Delphi.

The small treasury, 12 feet (3.66 m) in height, was built by the inhabitants of the Ionian island of Siphnos. The reconstruction in figure 5.32 shows a well-proportioned structure decorated with relief sculpture on the continuous Ionic frieze and sculpture on the triangular pediment. This is part relief, but the upper section is cut away at the back. The two caryatids, the statues of women functioning as columns, are early examples of their type; the earliest are also found at Delphi, in the Knidian Treasury. The winged sphinxes at the apex of the pediment were ultimately derived from Near Eastern prototypes. At the corners are winged females representing Nike, the Greek goddess of victory. Their lively grace, enhanced by the curves of their wings, adds a decorative element to the relatively ornate Ionic building. The egg and dart and leaf and dart patterns bordering various elements of the façade increase the richness of the design by comparison with the heavy structural appearance of Apollo's Doric temple at Corinth.

The subject of the frieze, a scene from the Trojan War, lends itself to action. The seated deities on the frieze (fig. **5.33**), representing Aphrodite, Artemis, and Apollo, are arguing about the outcome of the war with an intensity conveyed through animated gestures and stylized surface patterns. The two goddesses lean forward, while Apollo turns back toward them. His turn is unusual in Archaic art, for it reflects an attempt to suggest three-dimensional spatial movement. He is shown in back view from the waist up, but his head and legs are in profile. The drapery curves indicate a new awareness of the naturalistic twist required by such a pose and hint at the shoulder blade under the flesh.

5.33 Seated gods from the lonic frieze of the Siphnian Treasury. Parian marble; height of frieze 24%-26% in. (62.8-68.3 cm).

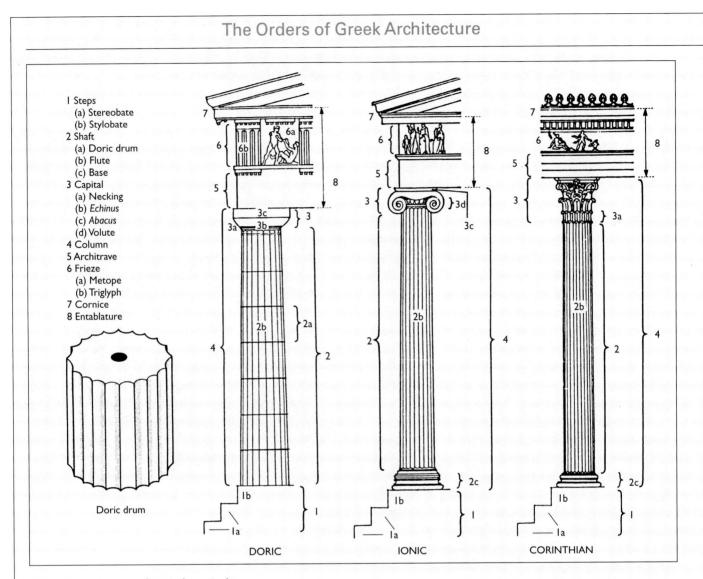

5.34 Doric, Ionic, and Corinthian Orders.

The Doric and Ionic Orders of Greek architecture (fig. **5.34**) had been established by about 600 B.C. and were an elaboration of the post-and-lintel system of elevation (see p. 48). Ancient Greek buildings, like the sculptures, were more human in scale and proportion than those in Egypt. And unlike the animal-based forms of ancient Iran, the Greek Orders were composed of geometric sections, each with its own individual meaning and logic. Each part was related to the others and to the whole structure in a harmonious, unified way.

The oldest Order, the Doric, is named for the Dorians, who lived on the mainland. Ionic—after Ionia, which includes the lonian islands and the west coast of Anatolia—is an eastern Order. Its greater elegance results from taller, thinner proportions and curvilinear elements and surface decoration. The Corinthian capital is most easily distinguished by its **acanthus**-leaf design.

Doric Order

The Doric Order begins with a base of three steps. Its shaft rises directly from the top step (the **stylobate**), generally to a height about five and a half times its diameter at the foot. The **shaft** is composed of individual sections—**drums**—cut horizontally and held together in the middle by a metal dowel (peg) encased in lead. Shallow, concave grooves known as **flutes** are carved out of the exterior of the shaft. Doric shafts do not stand in an exact vertical plane, but curve outward from about a quarter of the way up. The resulting bulge, or **entasis** (Greek for "stretching"), indicates that the Classical Greeks thought of their architecture as having an inner organic structure, with a capacity for muscular tension.

At the top of the shaft, three elements make up the Doric capital, which forms both the head of the column and the transition to the horizontal lintel. The **necking** is a snug band at

the top of the shaft. Above it is the **echinus** (Greek for "hedgehog" or "sea urchin")—a flat, curved element, like a plate, with rounded sides. The *echinus* forms a transition between the curved shaft and the flat, square **abacus** (Greek for "tablet") above. The *abacus*, in turn, creates a transition to the **architrave**—literally, a "high beam."

The architrave is the first element of the **entablature** (note the "tabl," related to "table"), which forms the lintel of this complex post-and-lintel system. The **frieze**, above the architrave, is divided into alternating sections—square **metopes** and sets of three vertical grooves, or **triglyphs** (from Greek *tri*, meaning "three," and *glyphos*, meaning "carving"). Finally, projecting over the frieze is the top element of the entablature—the thin, horizontal **cornice.** In Classical architecture, a triangular element known as a **pediment** rested on the cornice, crowning the front and back of the building.

The harmonious relationship between the parts of the Doric Order is achieved by formal repetitions and logical transitions. The steps, sides of the *abacus*, architrave, metopes, frieze, and cornice are rectangles lying in a horizontal plane. The columns, spaces between columns, flutes, and triglyphs are vertical. The schematic outline of the three steps, the *echinus*, and each individual drum would be a trapezoid (a quadrilateral with two parallel sides).

Groups of three predominate: three steps; a capital consisting of necking, *echinus*, and *abacus*; triglyphs; and the entablature, which is made up of the architrave, frieze, and cornice. The sudden shift from the horizontal steps to the vertical shaft is followed by a gradual transition via the capital to the entablature. The pediment may be read as a logical, triangular crown completing the trapezoid formed by the outline of the steps.

Ionic Order

The more graceful lonic Order has a round base with an alternating convex and concave profile. The shaft is taller in relation to its diameter, and the fluting is narrower and deeper. Elegant **volutes** (scroll shapes) replace the Doric echinus at each corner and virtually eclipse the thin *abacus*. In the lonic frieze, the absence of triglyphs and metopes permits a continuous narrative extending its entire length.

Corinthian Order

There is no evidence of the existence of the Corinthian Order earlier than the latter part of the fifth century B.C. The origin of the term *Corinthian* is obscure, but it suggests that the acanthusleaf capital was first designed by the metalworkers of Corinth and later transferred to marble. Unlike Doric and Ionic columns, Corinthian columns were used mainly in interiors by the Greeks—they were associated with luxury and, therefore, with "feminine" character.

Early Classical Style (c. 480–450 B.C.)

The temple of Zeus at Olympia, in the Peloponnese, shows the development of Doric architecture in the transitional Early Classical period. It was finished around 457 B.C., but the cult statue, which was one of the Seven Wonders of the ancient world, was not completed and installed until about twenty years later. Although it has long since been destroyed, the statue has been reconstructed from its image on coins (fig. **5.35**); the diagram shows a section (fig. **5.36**)

5.35a, b After Phidias, *Head of Zeus* and *Enthroned Zeus*, 2nd century B.C. Obverse and reverse of a coin minted by the Roman emperor Hadrian to celebrate the 228th Olympiad in A.D. 133. Staatliche Museen, Berlin, and Archaeological Museum, Florence.

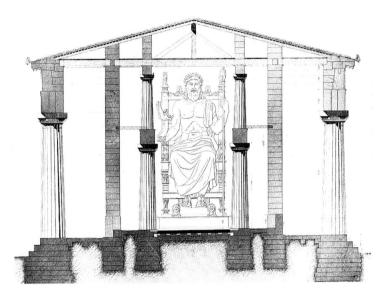

5.36 Sectional drawing of the temple of Zeus at Olympia, 465–457 B.C., showing the cult statue seen from the façade. The cult statue was the work of Phidias and was made later. It was a colossal statue, originally around 40 feet (12.19 m) high, and made of **chryselephantine** (from the Greek words *chrusos*, meaning "gold," and *elephantos*, meaning "ivory"), attached to a wooden frame.

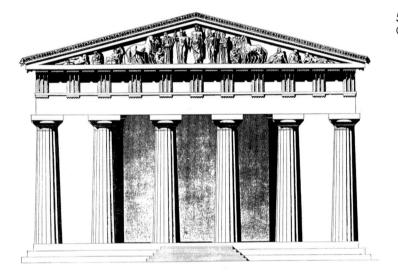

5.37 Reconstructed east façade of the temple of Zeus at Olympia.

as viewed from the east façade (fig. **5.37**). The proportions of the plan (fig. **5.38**), as compared with those of Apollo's temple at Corinth (see fig. 5.30), have decreased in length by the space of two columns. The building had a long, single *naos* with two rows of seven interior columns and an outer colonnade in a ratio of six columns to thirteen—at Corinth the ratio was six columns to fifteen.

The subject of the east pediment (fig. **5.39**) is the chariot race between Oinomaos, the old mythical king of Pisa, and Pelops, a young man who hoped to win the hand of the king's daughter. Because Oinomaos had been warned by an oracle that his son-in-law would kill him, he challenged his daughter's suitors to a race. Each previous unsuccessful suitor had been put to death, but Pelops had the linch-

pin removed from the wheel of Oinomaos's chariot, which overturned and killed the king, thus fulfilling the prophecy. At the center of the pediment, Zeus stands with Oinomaos and Pelops, who has won the race. The two quadrigas (chariots drawn by four horses) on either side refer to the life-and-death race, and at each corner are unidentified reclining figures. To the Eleans, who built the temple, the story of Oinomaos and Pelops mirrored their own victory over the Pisans.

The west pediment (fig. **5.40**) represents the mythical battle between the Lapiths (a Greek tribe) and the Centaurs, who were part human and part horse. According to this myth, the Lapiths invited the Centaurs to a wedding, at which the latter became drunk and tried to rape

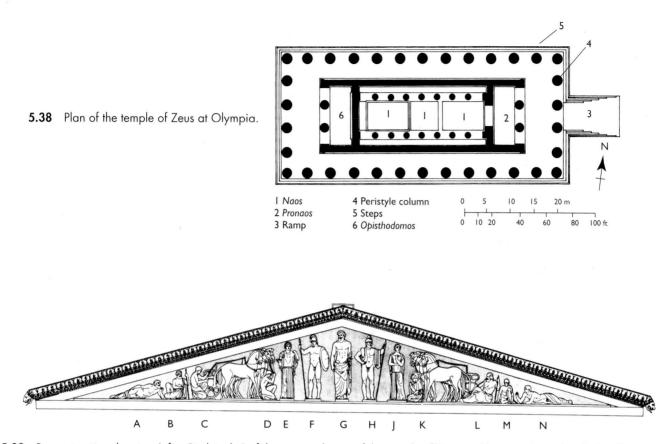

5.39 Reconstruction drawing (after Studniczka) of the east pediment of the temple of Zeus at Olympia: A. unidentified reclining figure; B. seer; C. Myrtilos with Oinomaos's chariot; D. youth; E. Sterope; F. Oinomaos; G. Zeus; H. Pelops; J. Hippodameia; K. girl in front of Pelops's chariot; L. seer; M. squatting youth; N. unidentified reclining figure.

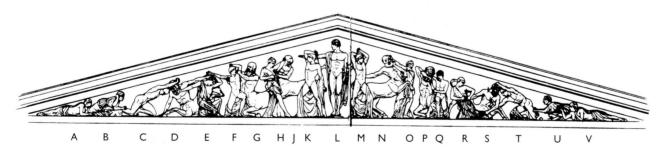

5.40 Reconstruction drawing (after Treu) of the west pediment of the temple of Zeus at Olympia: A, B. two Lapith women; C, D, E. Lapith rescues a Lapith woman from attack by a Centaur; F, G. Centaur assaults a Lapith boy; H, J, K. Perithöos protects his bride from a Centaur; L. Apollo; M, N, O. Theseus battles with a Centaur for a Lapith woman; P, Q. Centaur sinks his teeth into a Lapith boy's arm; R, S, T. Lapith protects a Lapith woman from attack by a Centaur; U, V. Lapith women watching the battle.

the Lapith boys and girls. Apollo's imposing presence at the center of the scene refers to his personification of intellect and reason (fig. **5.41**). He symbolically holds back the forces of disorder and irrationality as he directs the action with his gesture. Apollo's power and rectitude are implicit in his "straight," vertical pose, using only his outstretched *right* arm and divine gaze to control the Centaurs.

The geometric clarity of Apollo's commanding pose and gesture is contrasted with the energetic zigzags of the

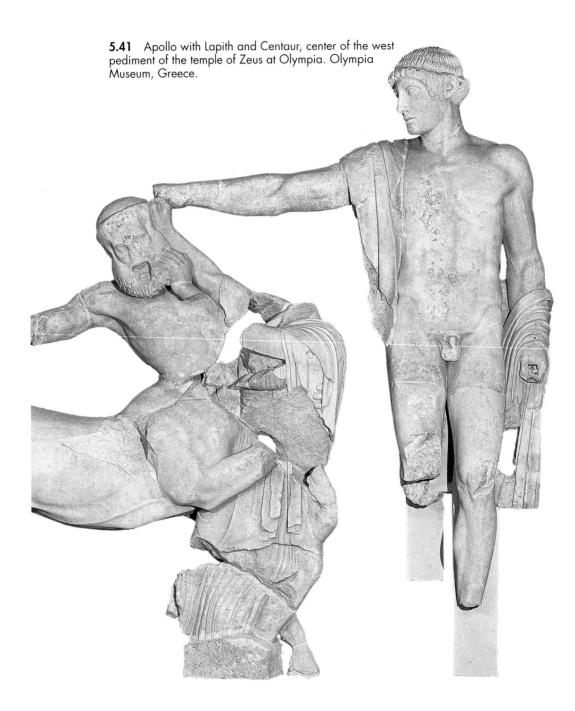

Centaur and its contorted facial expression. Apollo is idealized through his youthful form and calm demeanor, whereas the Centaur's features suggest old age, with straining muscles and bulging veins. But some stylization the patternistic treatment of the god's hair, ending in carefully arranged curls—persists. Nevertheless, compared with the Archaic sculptures on the Siphnian Treasury, the Olympian sculptures, like the *Kritios Boy* and the *Diskobo*- *los,* convey the new simplicity and subtlety of the Early Classical style.

The Olympia **metopes** depicted the twelve Labors of Herakles, six on the west and six on the east over the two porches (figs. **5.42**, **5.43**, and **5.44**). As a site sacred to Zeus and a center of politics and athletics, the sanctuary at Olympia had special significance for the Greeks. This is reflected in the iconography of the temple's sculptural

The Labors of Herakles

By the Archaic period, Olympia, which had long been a sacred sanctuary, was a cult center in honor of Zeus. Zeus' son Herakles established the borders of the Olympian precinct and was the legendary founder of the Olympic Games. The combination of brain and brawn that made Herakles a model for Greek athletes is illustrated by the twelve Labors he performed for Eurystheus, king of Tiryns (a Mycenaean site), at the command of the Delphic oracle. Because of his Labors and other exploits, Herakles was granted immortality by the gods.

As represented on the metopes of the temple of Zeus in Olympia, Herakles is endowed with intelligence and a canny problem-solving ability as well as with strength. In four instances, he is assisted by Athena, who typically offers wise advice, and in two by Hermes. Herakles performs six Labors on the Greek mainland (depicted on the west metopes at Olympia) and six in foreign lands (on the east metopes). They are as follows:

- 1. Herakles kills the Nemean lion. The lion's skin becomes one of his attributes.
- The Lernean Hydra was a poisonous water snake with seven heads that regenerated whenever one was cut off. Herakles cut off the heads and burned the stumps to prevent the heads from growing back.
- Herakles kills the dangerous birds in the marshes of Stymphalos (depicted here bringing them back to Athena).
- 4. Herakles ropes and captures the huge Cretan bull.
- 5. Herakles tames Artemis's sacred Keryneian hind.
- 6. Herakles kills Hippolyte, the Amazon queen, and steals her magic girdle.
- 7. Herakles captures the Erymanthian boar alive by chasing it into a snowfield and catching it in a net. He brings it to the king, who hides in a storage jar.

continued on p. 168

167

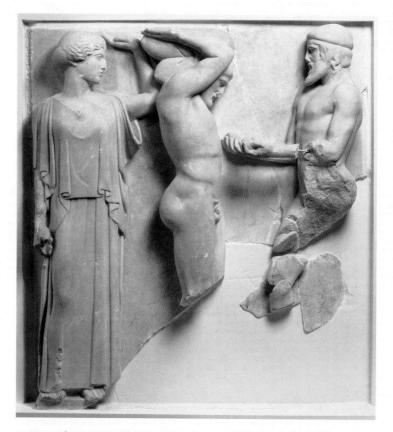

5.42 Athena, Herakles and Atlas, the Golden Apples of the Hesperides, metope from the east side of the temple of Zeus at Olympia. Marble; 5 ft. 3 in. (1.60 m) high.

The Labors of Herakles

continued

- 8. Herakles tames the mares of Diomedes, king of Thrace, by feeding them the flesh of their own master.
- Herakles travels to an island at the extreme west of Oceanos (the river believed to encircle the earth). There he kills the triple-bodied monster, Geryon, as well as the guardian dog and giant, and brings back Geryon's herd of oxen.
- 10. Herakles had to obtain the Golden Apples from the Tree of Life in the north African garden of the Hesperides. He offers to relieve Atlas from the burden of carrying the world on his shoulders if Atlas will obtain the apples for him. In the metope illustrated here (fig. 5.42), Herakles

supports the world, his head bowed by its weight, while Atlas holds the apples. Having accomplished his mission, Atlas is reluctant to resume his burden, but Athena (on the left) persuades him to do so.

- Herakles drags into daylight the three-headed dog Kerberos, guardian of Hades. In this task, Herakles is assisted by Hermes, who leads souls to the underworld.
- 12. The Augean stables in Elis housed huge herds of cattle, whose dung had not been cleared for thirty years. Herakles wagered the king that he could clean the stables in a single day. He made two holes in the stable walls, through which he diverted the River Alpheios, thereby accomplishing his task.

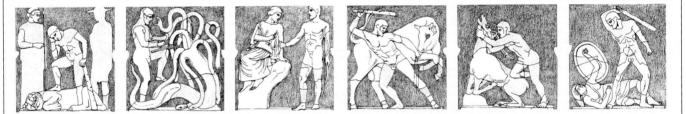

5.43 Olympia, diagram of the west end of the *naos* from the temple of Zeus, showing the Labors of Herakles: 1. Herakles kills the Nemean lion; 2. Herakles battles the Lernean Hydra; 3. Herakles brings the Stymphalian birds to Athena; 4. Herakles captures the Cretan bull; 5. Herakles tames the Keryneian hind; 6. Herakles kills the Amazon queen Hippolyte.

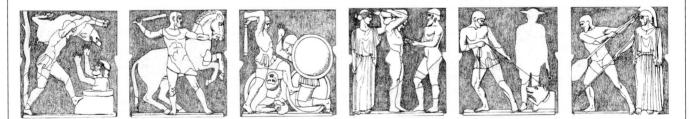

5.44 Olympia, diagram of the east end of the *naos* from the temple of Zeus, showing the Labors of Herakles: 7. Herakles with the Erymanthian boar; 8. Herakles with one of the mares of Diomedes; 9. Herakles kills Geryon; 10. Herakles and the Golden Apples of the Hesperides; 11. Herakles and Kerberos; 12. Herakles cleans the Augean stables.

program. On the east pediment, a myth was represented in free-standing sculptures, which alluded to recent historical events. For years, two neighboring Greek cities, Elis and Pisa, had been vying for control of Olympia. Finally, around 470 B.C., Pisa was destroyed by the Eleans. As a result of its victory, Elis increased its wealth and used the money to build a temple dedicated to Zeus. The temple's sculptural program was designed in such a way that the ancient myth could be read in relation to contemporary events.

Classical Style (c. 450-400 B.C.)

Athens, the capital of modern Greece, is located on the Saronic Gulf, just inland from the port of Piraeus. In the second half of the fifth century B.C., Athens was the site of the full flowering of the Classical style in the arts. This section considers that culmination as it was embodied in the buildings on the Acropolis (figs. **5.45** and **5.46**), particularly the Parthenon. The Acropolis (from the Greek words *akros,* meaning "high" or "upper," and *polis,* meaning "city") is an elevated rock supporting several temples, precincts, and other buildings. During the Mycenaean period, it had

been a fortified citadel, and its steep walls made the Acropolis difficult for invaders to scale.

The Classical period in Athens is also called the Age of Perikles, after the Greek general and statesman (c. 500– 429 B.C.) who initiated the architectural projects for the Acropolis. He planned a vast rebuilding campaign to celebrate Athenian art and civilization after the devastation of the Persian Wars. The Propylaea (entranceway) and the Parthenon (447–432 B.C.) were completed during his lifetime, but work on the Nike Temple (427–424 B.C.) and the Erechtheum (421–405 B.C.) was not begun until after his death.

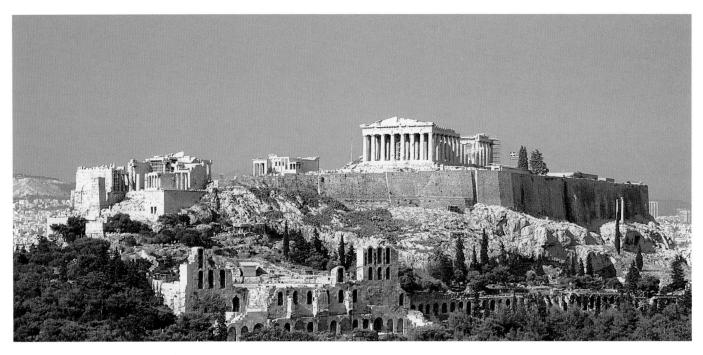

5.45 View of the Acropolis, Athens.

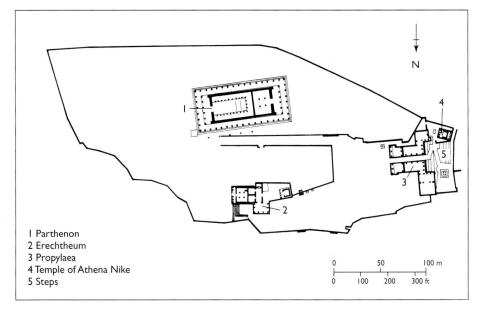

5.46 Plan of the Acropolis. This plan includes only the four Classical buildings that were rebuilt after the destruction of the Acropolis at the end of the Persian Wars (c. 480 B.C.). Like most Greek temples, they were made of marble, which was quarried from the local mountain, Pentelikos.

Financing for Perikles' building program had come from the Delian League. Because of Athens' sea power, it was able to force the rest of Greece to buy its protection against the Persian invaders. The treasury that housed the funds was located in Apollo's sanctuary on the island of Delos, but the treasure was transferred to the Athenian Acropolis in 454 B.C.

Athenian political rhetoric, which claimed to protect other Greek cities in the league, informs the iconography of the buildings on the Acropolis. It was also Perikles' justification for spending the war chest on art and architecture in Athens. The controversy that arose over this issue is described in Plutarch's *Life of Perikles*: Perikles' political enemies in the Athenian assembly accused him of disgracing their city by taking the league's money. "Surely," they argued, "Hellas is insulted with a dire insult and manifestly subjected to tyranny when she sees that with her own enforced contributions for the war [against the Persians], we are gilding and bedizening our city, which, for all the world like a wanton woman, adds to her wardrobe precious stones and costly statues and temples worth their millions."¹

Perikles replied that, as long as Athens waged war for her allies "and kept off the Barbarians," she alone deserved the money. "Not a horse, not a hoplite [a heavily armed Greek foot-soldier], but money simply" was, according to Perikles, the only contribution of the other Greek cities. And furthermore, once Athens had sufficiently equipped itself for war, it was only natural that she "should apply her abundance to such works as, by their completion, will bring her everlasting glory." This, he added, would also provide employment for many workers.

The Parthenon (448-432 B.C.)

The Parthenon was designed by the architects Iktinos and Kallikrates (see box). Phidias, a leading Athenian artist of his generation and a friend of Perikles, supervised the sculptural decorations. Completed in 432 B.C. as a temple to Athena, the patron goddess of Athens, the Parthenon celebrates Athena in her aspect as a virgin goddess. *Parthenos,* the Greek word for "virgin" (and the root of the word *parthenogenesis,* meaning "virgin birth"), was one of Athena's epithets.

The Parthenon (figs. **5.47**, **5.48**, and **5.49**) stands within a continuum of Doric temples. We have seen two earlier examples—at Corinth and at Olympia—but no previous Greek temple expresses Classical balance, proportion, and

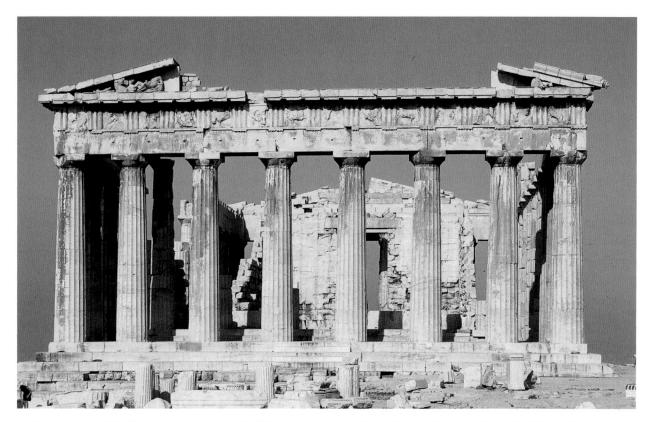

5.47 East end of the Parthenon, Athens, 447-438 B.C. Pentelic marble; 111×237 ft. (33.83×72.23 m). Once through the Propylaea at the western edge of the Acropolis, the visitor emerges facing east. Ahead and a little to the right are the remains of the western wall of the Parthenon. Its damaged state reflects centuries of neglect and misuse. In the 5th century A.D. the Parthenon became a Christian church, and in the 15th century the Turks conquered Athens and converted the temple into a mosque. They stored gunpowder in the building! When it was shelled by artillery in 1687, most of the interior and many sculptures were destroyed. Centuries of vandalism and looting, plus modern air pollution, have further contributed to the deterioration of the Parthenon.

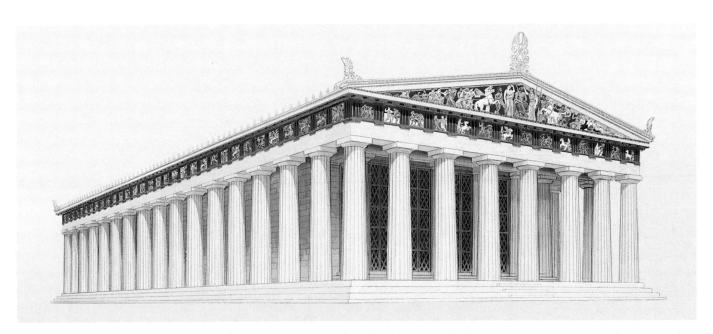

5.48 Reconstruction of the Parthenon, Athens. View of the east façade and south wall. The metopes and pediment sculptures are also reconstructed and show that they were originally painted.

Plan of the Parthenon

The Parthenon is constructed as a rectangle that is divided into two smaller rectangular rooms. A front and back porch and a **peristyle** (**colonnade**), supported by the three steps of the Doric Order, complete the structure. The temple was made entirely of marble, which was cut and fitted without the use of mortar.

The three lines on the perimeter of the plan represent the steps. The black circles indicate columns—those comprising the peristyle number eight on the short sides (east and west) and seventeen on the long sides (north and south), counting the corner columns twice. Each corner column serves a short and a long side, creating a smooth visual transition between them.

The inside wall of the Parthenon, supported by two steps, consists of six columns on a front and back porch, leading to a solid wall with a doorway to an inner room. The solid walls are indicated by thick black lines. The western entrance leads to the smaller room, which served as a treasury. The eastern entrance leads to the *naos*, or inner sanctuary. It was originally dominated by a monumental gold and ivory (**chryselephantine**) statue of Athena —its base is indicated on the plan by the rectangle inside the *naos*. An inner rectangle of Doric columns repeats the shape of the room and surrounds the statue on three sides.

Although constructed primarily in the Doric Order, the Parthenon had two features that were lonic. First, there were four lonic columns inside the treasury. And second, a continuous lonic frieze, which cannot be seen on the plan, ran around the top of the outside of the inner wall. The inclusion of lonic elements in the Parthenon expresses the Athenian interest in harmonizing the architectural and sculptural achievements of both eastern and western Greece.

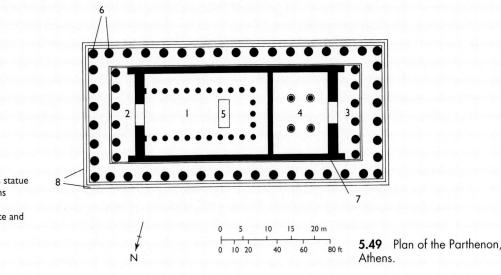

I Naos

- 2 Pronaos 3 Opisthodomos
- 4 Treasury
- 5 Base of Athena's statue
- 6 Peristyle columns
- 7 Solid wall
- 8 Steps (stereobate and stylobate)

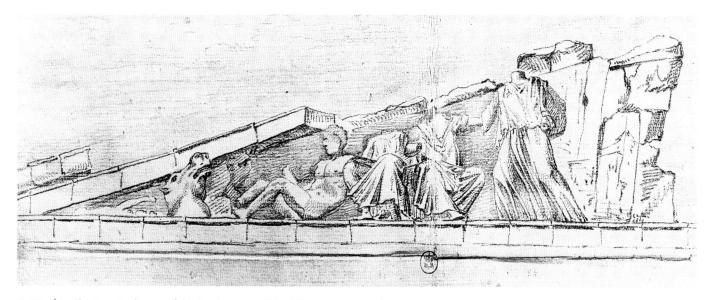

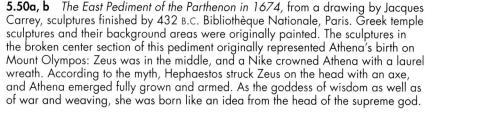

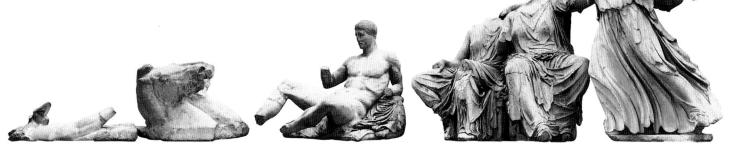

5.51 Sculptures from the left side of the east pediment of the Parthenon, finished by 432 B.C. Pentelic marble; left figure 5 ft. 8 in. (1.73 m) high. British Museum, London. The pediments are almost 100 feet (30.50 m) wide at the base and 11 feet (3.35 m) high at the central peak. The depth of the pediment bases is, however, only 36 inches (91.4 cm), thus restricting the space available for the sculptures. Since the sides of the pediments slope toward the corner angles, Phidias had to solve the problem of fitting the sculptures into a diminishing triangular space.

unity to the same extent as the Parthenon. Its exceptional aesthetic impact is enhanced by its so-called refinements, which are slight architectural adjustments to improve the visual impression of the building. For example, lines that look like horizontals actually curve upward toward the middle, thereby correcting the tendency of the human eye to perceive a long horizontal as curving downward toward the center. Other refinements involve the columns, all of which tilt slightly inward; those toward the corners of the building are placed closer together, creating a sense of stability and the illusion of a frame at each end.

The Parthenon sculptures, located in four sections of the building, were integrated harmoniously with the architecture. Their narrative content proclaimed the greatness of Classical Athens.

The Pediments A drawing of 1674 by the Frenchman Jacques Carrey illustrates the condition of the pediments

at that time (fig. 5.50). Carrey's rendering of the sculpture on the east pediment reveals a relatively good state of preservation, although the central figures had by then disappeared. The three goddesses on the left half of the east pediment (fig. 5.51)—possibly Iris or Hebe, and Demeter and Persephone, reading from the viewer's right to leftare posed so that they fit logically into the triangular space. Their repeated diagonal planes relate to the two diagonals of the pediment, while the graceful curves of their garments harmonize with the architectural curves of the Doric order below. The reclining male nude to the left could be either Herakles or Dionysos. His limbs, like those of the goddesses, form a series of zigzags. His torso forms a gentle curve, repeated in the domed head and organic musculature. Despite the naturalism of the pose and organic form, however, this figure is idealized: there is no facial expression or individual personality.

Mirroring the two seated females and the male on the left

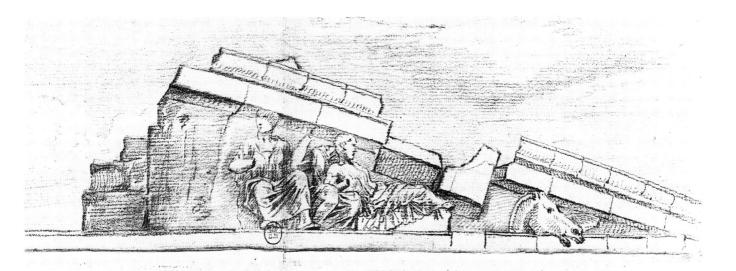

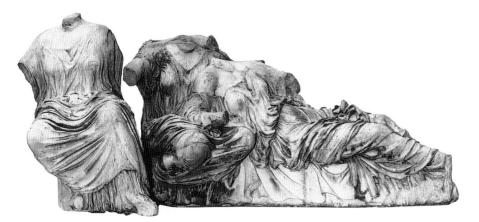

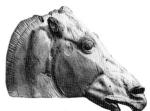

5.52a Sculptures from the right side of the east pediment of the Parthenon. Pentelic marble; left figure, 4 ft. 5 in. (1.35 m) high. British Museum, London. At the far left corner of the pediment, Helios's horses mark the rising of the sun because Athena was born in the east at dawn. The horse of the moon descends at the far right corner. The location of the scene on this pediment also corresponds to the sunrise in the east. The artist has thus formally integrated sculpture and architecture with iconography, time, and place.

5.52b A reconstruction of the three female figures in figure 5.52a, based on fragments found on the Acropolis.

of the pediment is the group of three goddesses on the right (fig. **5.52**). Their identity has been disputed by scholars because they have no attributes. Though posed slightly differently from their counterparts on the left, the groups otherwise match each other closely. The reclining goddess relates to Dionysos/ Herakles, and the two seated figures balance those of Demeter and Persephone in their poses and in the curvilinear garments outlining their bodies.

The most striking correspondence between the two sides of the east pediment occurs at the angles. On the far left are the marble remnants of Helios' horses, pulling the chariot of the sun. They rise, beginning their daily journey across the sky. On the far right, a single horse's head descends, echoing the triangular corner of the pediment (see fig. 5.52a). This horse, from the chariot of the moon goddess Selene, shows Phidias's understanding of anatomy, which he transformed into the Classical aesthetic. He creates the illusion of a triangular cheek plate with one curved side, blood vessels, and muscles pushing against the inside of the skin. The right eye seems to bulge from its socket, and the ear and mane to emerge convincingly from beneath the surface. The open mouth forms another triangular area, echoing the head, the cheek plate, and the pediment itself.

The Doric Metopes The Parthenon metopes illustrate four mythological battles. The best preserved were originally on the south frieze and represent the battle between Lapiths and Centaurs—also the subject of the west pediment at Olympia. The violent energy of the battle (fig. 5.53) contrasts dramatically with the relaxing gods on the east pediment. The strong diagonals of the Lapith, the repeated curved folds of his cloak, and the backward thrust of the Centaur enliven the metope.

The other three metope battles depicted Greeks against Amazons on the west, the Trojan War on the north, and Olympians overthrowing Titans on the east. Each set of metopes expressed an aspect of the Greek sense of superiority. The Lapiths and Centaurs demonstrated the universal human conflict between animal instinct or lust —exemplified by the drunken Centaurs—and rational selfcontrol—embodied by the Lapiths. The Greek victory over the Amazons dramatized the triumph of Greek warriors over the monstrous female warriors from the East. In the Trojan War, West again triumphed over East, and in the clash between Titans and Olympians, the more civilized Greek gods wrested control of the universe from their primitive, cannibalistic predecessors. As at Olympia, the sculptural program of the Parthenon represented mythological battles as a way of alluding to actual victories. The political subtext of the battles on the Parthenon metopes is thus the Athenian triumph over the Persians.

The Ionic Frieze Over the outside of the inner (*naos*) wall and colonnades of the Parthenon (figs. **5.54** and **5.55**), an Ionic frieze 525 feet (160.02 m) long illustrated the Great Panathenaic procession (fig. **5.56**). This was held every four years, and the entire city participated in presenting a sacred *peplos* to Athena. The continuous nature of the Ionic frieze, uninterrupted by triglyphs, is consistent with its content. Thus the shape of the frieze corresponds with the form of a procession. In order to maintain the horizontal plane of the figures, Phidias adopted a sculptural convention of **isocephaly** (from the Greek words *isos*, meaning "equal" or "level," and *kephale*, meaning "head"). When a work is isocephalic, all the heads are set at approximately the same level.

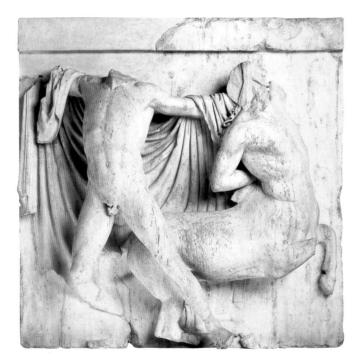

5.53 Lapith and Centaur, from south metope XXVII of the Parthenon. Pentelic marble; 4 ft. 5 in. (1.35 m) high. British Museum, London. Each metope is approximately 4 feet square (1.22 m^2) and contains high-relief sculpture. There were fourteen metopes on the short east and west sides, and thirty-two on the long north and south sides. Most are scenes of single combat.

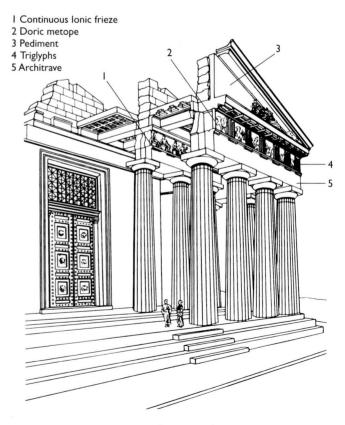

5.54 Cutaway perspective drawing (after G. Niemann) of the Parthenon showing the Doric and Ionic friezes and a pediment.

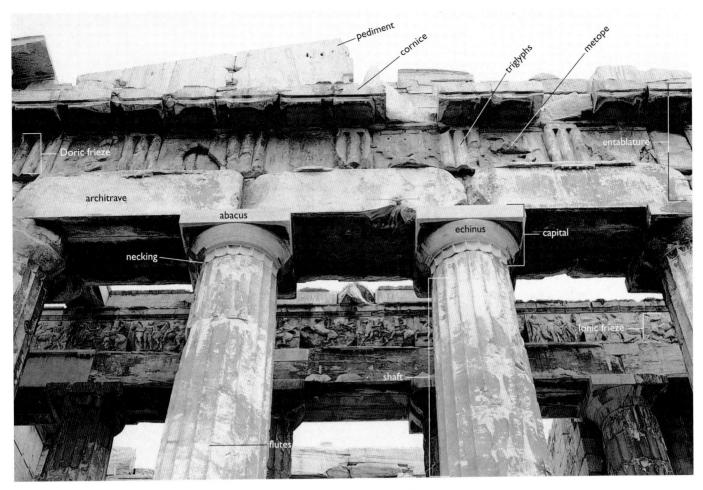

5.55 The Parthenon, looking up through the outer Doric peristyle at the lonic frieze.

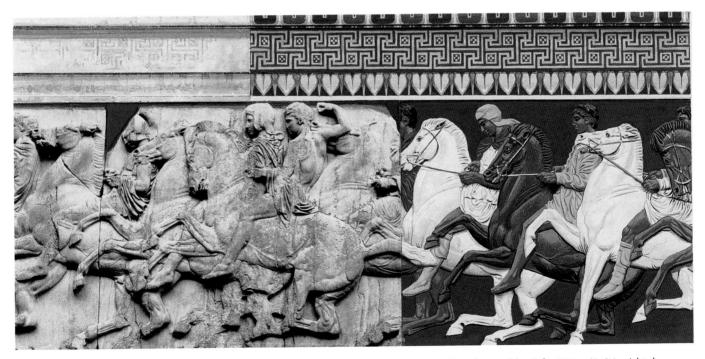

5.56 Equestrian group from the north lonic frieze of the Parthenon, c. 442–439 B.C. Pentelic marble; 3 ft. 5½ in. (1.06 m) high. British Museum, London. This illustrates Phidias's device of making the horses small in relation to the riders. He carved the horses' legs in higher relief than their bodies and heads. The effect is to cast heavier shadows on the lower part of the frieze, which, together with the multiple zigzags, increases the illusion of movement. This illustration shows the frieze partially restored, based on surviving paint traces.

The *Naos* The *naos* contained the cult statue of Athena. In the reconstruction in figure **5.57**, she is armed and represented in her aspect as the goddess of war. She stands and confronts her viewers directly, wearing Medusa's severed head on her leather aegis and holding a statue of Nike (goddess of victory) in her right hand and a shield in her left. Both the shield and the pedestal were decorated with reliefs by Phidias. The colossal scale of this statue was unprecedented and reflected Athena's importance as the patron goddess of Athens. (Phidias's statue of Zeus at Olympia was later, even though the temple predated the Parthenon.) Athena's central position in the Parthenon pediments and the offering of the *peplos* in the Ionic frieze signified her wisdom and power as well as the Athenians' devotion to her. The sectional drawing in figure **5.58**

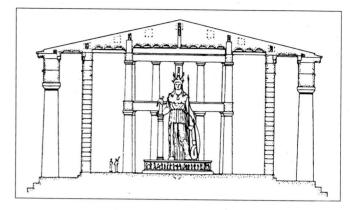

5.58 Sectional drawing showing the cult statue of Athena from the entrance of the Parthenon.

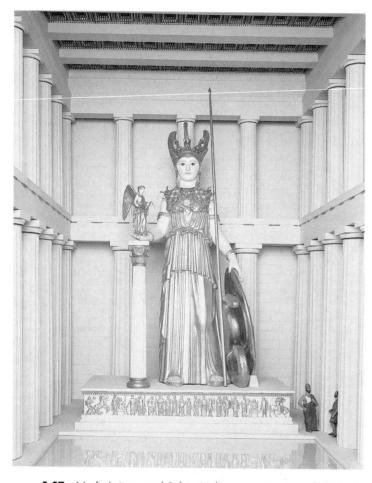

5.57 Neda Leipen and Sylvia Hahn, reconstruction of Phidias's Athena, from the naos of the Parthenon, original dedicated 438 B.C. Wood covered with gold and ivory plating; model approx. 4 ft. (1.22 m) high. Royal Ontario Museum, Toronto. The statue of Athena was over-life-sized, standing 40 feet (12.19 m) high on a pedestal. Phidias constructed the statue around a wooden frame, covering the skin area with ivory, and the armor and drapery with gold. The original statue has long since disappeared and has been reconstructed from descriptions, small copies, and images on coins.

shows her position in the temple as seen from the entrance. Comparing this with the section of Zeus' temple at Olympia, we can see that the Parthenon is wider, which gives it a lighter, less box-like quality that reflects the pleasing proportions of Classical architectural style.

The Temple of Athena Nike Athena was honored as the goddess of victory in the small marble Ionic temple of Athena Nike crowning the southern edge of the Acropolis (fig. **5.59**). It has a square *naos*, and a front porch, with four Ionic columns and three steps at the front and back. The small size and graceful Ionic Order of the Nike temple contrast with the heavier proportions of the Doric columns in the Parthenon.

The Nike temple, like the Parthenon, celebrated a military victory, but it is not known which one. The issue is complicated by the fact that it was designed before the Parthenon but finished later. Gold statues of Nike were originally housed in the temple but have since disappeared. The best surviving sculpture from the Nike temple is the relief of *Nike Adjusting Her Sandal* (fig. **5.60**) on a **balustrade** of the parapet. This figure combines a graceful, curved torso with diagonal planes in the legs. The sheer, almost transparent drapery (called "wet drapery" because it appears to cling to the body) falls in a pattern of elegant, repeated folds. Behind Nike are the remnants of her open wings. Their smooth surfaces contrast with the folds of the drapery and, at the same time, echo and frame the torso's curve.

The Erechtheum The Erechtheum (fig. **5.61**) stands on the northern side of the Acropolis, opposite the Parthenon. It replaced an old temple to Athena that housed a wooden, Archaic statue of the goddess. The temple was destroyed by the Persians, but the Athenians decided to leave the ruins to remind citizens of the sacrilegious act of sacking the Acropolis. A more complex Ionic building than the Nike temple, the Erechtheum is built on an uneven site. The eastern room was dedicated to Athena Polias, or Athena in her aspect as patron of the city.

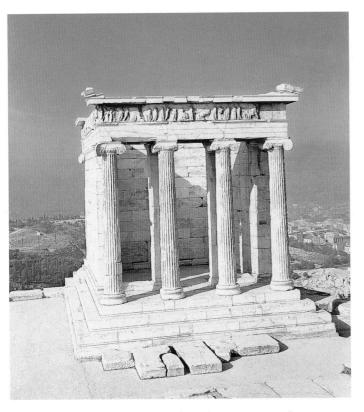

5.59 Temple of Athena Nike from the east, Acropolis, Athens, 427–424 B.C. Pentelic marble.

5.60 Nike Adjusting Her Sandal, from the balustrade of the temple of Athena Nike, 410–409 B.C. Pentelic marble; 3 ft. 5¾ in. (1.06 m) high. Acropolis Museum, Athens.

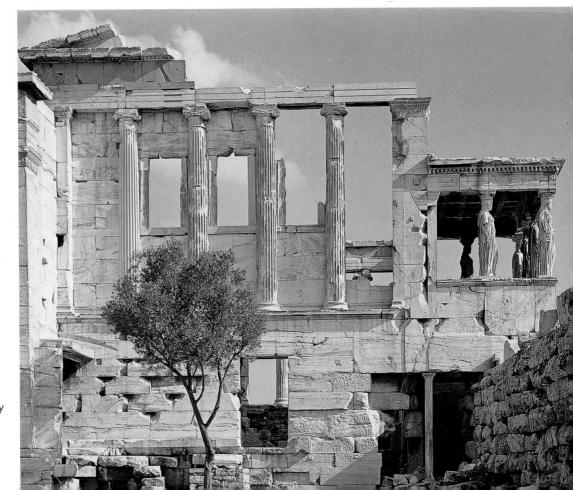

5.61 The Erechtheum, west side, Acropolis, Athens, 421–405 B.C. Porch figures approx. 8 ft. (2.44 m) high. This temple was named for Erechtheus, a legendary king of Athens who was worshiped with Athena and various other gods and ancestors. As a result of the large number of dedicatees, the building itself is unusually complex for a Classical Greek temple.

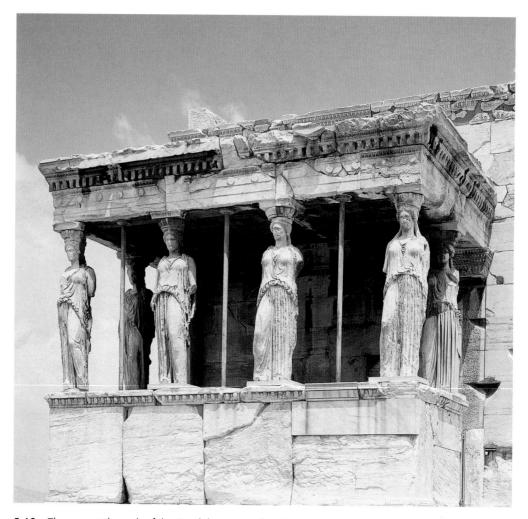

5.62 The caryatid porch of the Erechtheum, south side.

The small southern porch (fig. **5.62**) is distinctive for its six caryatids, a convention already in place in the Siphnian Treasury (see fig. **5.32**). But these now stand in a relaxed *contrapposto* pose; the drapery defines the body in an ideal form characteristic of the Classical style. As an ensemble, a perfect symmetry is maintained so that each set of three, right and left, is a mirror image of the other. The two corner caryatids, like the corner columns of the Parthenon, are perceived as being aligned with the front figures when viewed from the front and with the side figures when viewed from the sides, thus creating a smooth visual transition between front and side.

In the metaphorical transformation of columns into human form, several features are necessarily adapted. For example, the vertical drapery folds covering the support leg recall the flutes of columns. In the capital over the caryatid's head, the volute is omitted; but the *echinus* has been retained in the molded headdress, which creates a transition from the head to the *abacus*. At the same time, the headdress is an abstract geometric form, related to organic human form only by its proximity to the head. Whereas the Doric *echinus* effects a transition from vertical to horizontal and from curved elements to straight, the headdress satisfies the additional transition from human and organic to geometric and abstract. These caryatids thus illustrate the harmonious metaphorical relationship between ideal and organic, and between human and abstract form, that characterizes Classical style.

Late Classical Style (4th century B.C.)

By the end of the fifth century B.C., Athens had lost her political supremacy. Other Greek city-states, especially Sparta, began to exert political and military power over Greece. In the fourth century B.C., Philip II of Macedon, in northeastern Greece, conquered the Greek mainland, and his son Alexander the Great extended his empire. Nevertheless, the intellectual leaders of that period, notably Plato and Aristotle, continued to flourish in Athens.

5.63 Theater at Epidauros, c. 350 B.C. Stone; diameter 373 ft. (113.69 m). Curved rows of stone seats formed an inverted conical space in these impressive structures. Behind the orchestra was the rectangular stone backdrop, or *skene* (from which the modern English word scene is derived), and actors entered from the sides.

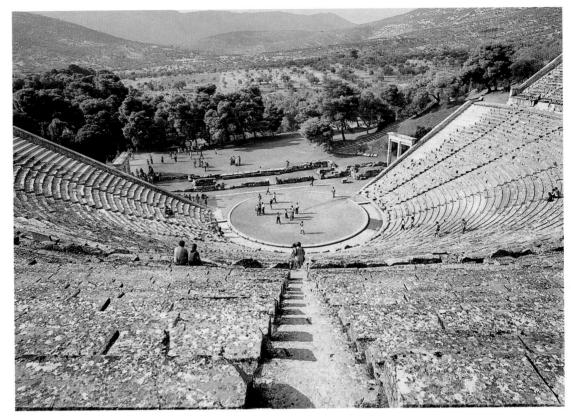

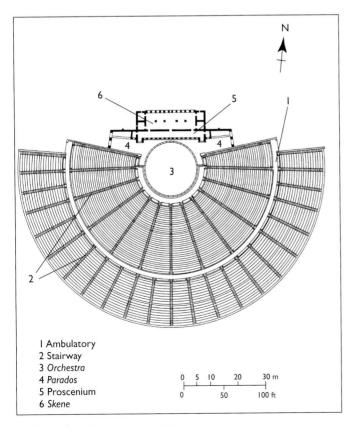

5.64 Plan of the theater at Epidauros.

The outdoor theater came into its own as an architectural form after the fifth century B.C. (see box). The best example is the theater at Epidauros (figs. **5.63** and **5.64**). It had a slightly more than semicircular seating area, with radiating stairways and a walkway a little more than halfway up—not unlike a modern sports arena. The auditorium was built around the *orchestra* (literally a place for dancing), a round space for the chorus where the action of the play unfolded. This was about 80 feet (24.38 m) in diameter and contained an altar dedicated to Dionysos.

Greek Theater

Greek theater originally grew out of rituals performed in honor of the wine god, Dionysos. The early theaters were hollow spaces in the hills, and in the fifth century B.C. these were developed to incorporate wooden benches arranged around an opening in a rock. Thus virtually embedded in nature, these theaters integrated drama with landscape. It was in such theaters—one was located below the Acropolis in Athens—that the great dramas by Aeschylos, Sophokles, and Euripides were performed. Greek theater began with a chorus of actors who sang and danced, and gradually individual roles performed by separate players emerged.

Sculpture

The leading Athenian sculptor of the Late Classical style was Praxiteles. A gentle S-shape, sometimes called the "Praxitelean curve," outlines the stance of Praxiteles' most famous statue, the *Aphrodite of Knidos* (fig. **5.65**), which is known only from Roman copies. The Aegean island of Kos originally commissioned the *Aphrodite* but rejected the finished work because of its nudity; the statue was then accepted by the Anatolian city of Knidos. Praxiteles' goddess has emerged from her bath and is shown standing beside a water jar (*hydria*). She picks up her garment with her left

hand and, while the gesture of her right hand implies modesty, at the same time it calls attention to her nudity. Compared with Classical sculptures, the *Aphrodite* has slightly fleshier proportions and a heavier, fuller face.

More than any previous Greek sculptor, Praxiteles celebrated the female nude. In fact, it was with this work that the female entered the canon of beauty in Greek art, which had been restricted to the male nude. The Aphrodite was admired by the Knidians, who exhibited it in such a way that viewers could completely encircle it. Some later anecdotes emphasize the erotic qualities of the statue. Others emphasize its realism. relating, for example, that the goddess emerged from the waves off the coast of Anatolia to see her likeness. So astonished was she by its accuracy that she cried out, "Where did Praxiteles see me naked?"

Lysippos of Sikyon (near Corinth), who was famous for his portrayals of athletes and portraits of great men, was among the important Greek sculptors of the fourth century B.C. whose work survives mainly in Roman copies. He introduced a new, more naturalistic approach to representing the human figure. In so doing, he became the key artist in the transition from Late Classical to Hellenistic style. His genius brought him to the attention of Alexander the Great, who made him his court sculptor.

The Roman historian Pliny the Elder (see Chapter 7) distinguished between the canon of Polykleitos, exemplified by the *Doryphoros*

> 5.65 Praxiteles, Aphrodite of Knidos, c. 350 B.C. Marble; 6 ft. 8¾ in. (2.05 m) high. Musei Vaticani, Rome.

(see fig. 5.27), and the newer style of Lysippos. Whereas Polykleitos's figures were idealized youths, according to Pliny, Lysippos preferred thinner bodies, smaller heads, more detailed hair, and an increase in surface movement. The result was a taller, lighter appearance and a livelier stance. This, in Pliny's view, changed external form in the direction of greater emotional accuracy. It also took into account the position of the viewer in relation to the sculpture by opening up the space around its central axis. One effect of Lysippos's canon can be seen in the *Apoxyomenos* (literally, in Greek, "one scraping himself")—originally a bronze and now known only in a Roman marble copy (fig. **5.66**). It represents a victorious athlete scraping the oil off his arm with a strigil.

The two views illustrated in figure 5.66 show the turn in the athlete's body compared with the relaxed *Doryphoros,* who stands within a single vertical axis. Here there is more movement away from the center because of the wider opening between the legs and the outstretched arms. The athlete seems to swivel, which draws observers into his space and engages them with his action.

Lysippos's sculpture of Socrates—the example shown here is a statuette (see fig. 5.3)—corresponds to Plato's description of his teacher's character. Socrates is represented as if walking slowly and thinking deeply, his wrinkled brow conveying a pensive mood. He is known to have been considered ugly and faunlike, with a snub nose, flowing mustache and beard, small rounded shoulders, and a potbelly; yet it is an affectionate rendition. When this sculpture is juxtaposed with the *Apoxyomenos*, some idea of Lysippos's range of types and character becomes clear.

See figure 5.3. Socrates, 1st or 2nd century A.D.

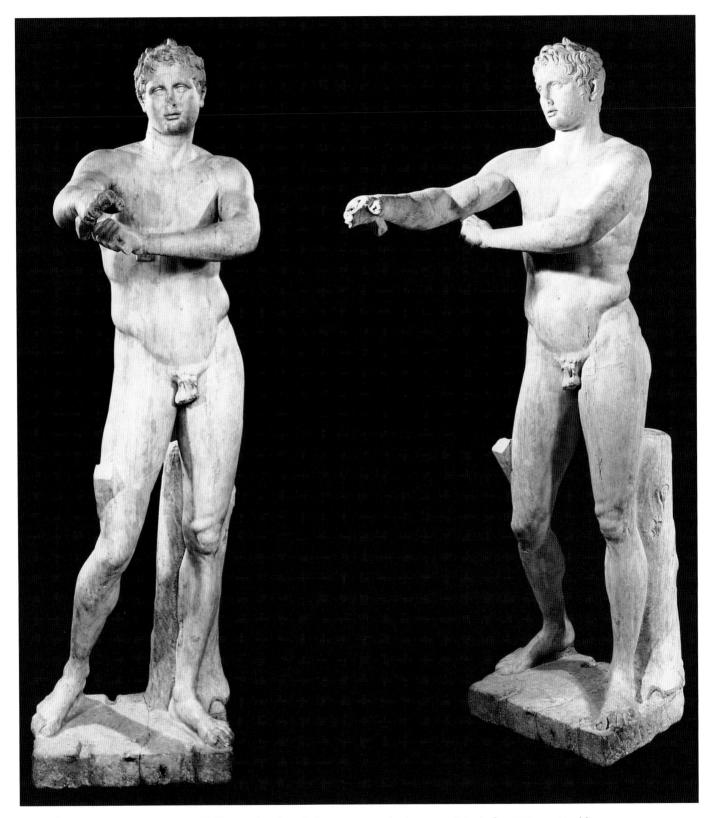

5.66a, b Lysippos, Apoxyomenos (Athlete with a Strigil), Roman copy of a bronze original of c. 320 B.C. Marble; 6 ft. 9 in. (2.05 m) high. Musei Vaticani, Rome. According to Pliny, this sculpture was particularly admired by the Roman emperor Tiberius, who had it moved from the public baths to his bedroom but returned it after the Roman citizens protested their loss.

Fourth-Century Grave Stelae

A similar taste for individual characterization can be seen in the grave stelae of the Late Classical period (fig. **5.67**). Compared with the Stele of Hegeso (see fig. 5.29), the relief here is more deeply carved so that the deceased youth resembles a freestanding figure leaning against a marble wall. He has died in the prime of life, a loss accentuated by the sculptor through the youth's heroic form and the representation of the aged, grieving father at the right. The weeping boy seated on the steps at the left and the dog sniffing the ground add touches of pathos that became typical of Greek art in subsequent centuries.

The Late Classical style formed a transition between the idealized sculptures of the second half of the fifth century B.C. and the Hellenistic style. In Hellenistic art, idealism gave way to increasing melodrama, and new types of representation developed.

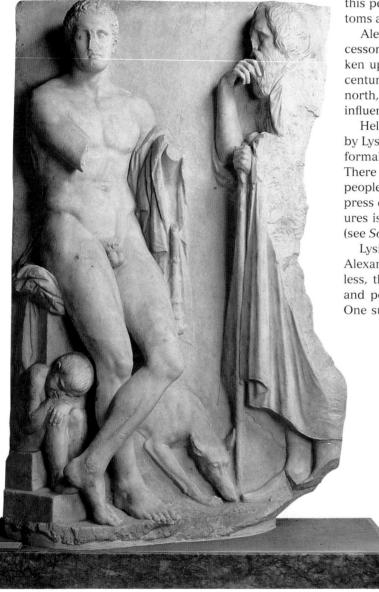

Hellenistic Sculpture (323–31 B.C.)

The Hellenistic period extended from the death of Alexander the Great (323 B.C.) to the beginning of the Roman Empire under Augustus, who assumed power in 31 B.C. and became emperor four years later (see Chapter 7). The term *Hellenistic* refers to the spread of Greek culture beyond Greece—especially to the East—as a result of Alexander's conquests.

When Philip II, king of Macedon, died in 336 B.C., his monarchy had already begun to dominate Greece. Within eleven years, his son Alexander had subjugated the rest of Greece and conquered Egypt, Phoenicia, Syria, and Persia (the latter in revenge for Xerxes' invasion of Greece). In 325 B.C., he pushed the limits of his kingdom to the Punjab, but rebellious troops forced his return westward. Wherever Alexander went, the process of Hellenization followed until it encompassed virtually the entire Middle East. But even though Greek culture was dominant during this period, it was exposed to diverse languages and customs and was therefore enriched by cross-fertilization.

Alexander died at the age of thirty-three. No single successor emerged after his death, and his kingdom was broken up into independent monarchies. During the second century B.C., European tribes invaded Greece from the north, and the Romans (see Chapter 7) began to exert their influence in Europe and the Mediterranean.

Hellenistic style continues the developments introduced by Lysippos and further expands the diversity of sculpture formally and iconographically as well as psychologically. There is an increase in portrait types, children and old people are represented, theatricality and melodrama express extremes of emotion, and the inner character of figures is conveyed through an emphasis on formal realism (see *Socrates*, fig 5.3).

Lysippos had established the official royal image of Alexander, but none of those portraits survives. Nevertheless, the type he created is known through descriptions and posthumous portraits of Alexander by later artists. One such example from the site of Pergamon in western

5.67 Attic grave stele, from near Athens, c. 350–330 B.C. Marble; 5 ft. 6 in. (1.68 m) high. National Archaeological Museum, Athens.

5.68a Head of Alexander, from Pergamon, c. 200 B.C. Marble; 1 ft. 4 in. (0.41 m) high. Archaeological Museum, Istanbul.

5.68b Alexander (side view of fig. 5.68a).

Turkey shows Alexander's slightly tilted head, as if he is gazing toward the heavens, with dreamy eyes, parted lips, fleshy facial texture, and a furrowed brow (fig. **5.68**). The wavy hair, brushed upward at the center of his forehead, became characteristic of Alexander's portraits (see fig. 5.16), and the general type was used in the Hellenistic period as a standard for all royal portraiture.

The full-length portrait of the orator Demosthenes by Polyeuktos, also a Roman copy, is an example of Hellenistic interest in character (fig. **5.69**). Demosthenes' life was beset by difficulties, including financial hardship and a speech impediment. He was a serious stutterer as a young man, but he trained himself to become the greatest public speaker in Athens. His political enemies succeeded in having him exiled from Athens on a trumped-up charge of corruption. In Polyeuktos's rendition, Demosthenes is an elderly, haggard man, with long, thin arms. His furrowed brow, concentrated gaze, and clenched fist convey extreme tension. The difficulties of his life are an integral part of the statue, which endows the portrait with a new, biographical accuracy.

The *Demosthenes* was one of several statues representing Athenian heroes opposed to the Macedonian rule of Athens that were set up in the *agora* (marketplace) of the city. Demosthenes was forced by the Macedonians to flee Athens. When he reached the island of Poros, he drank poison rather than submit to the enemy. An inscription on the base of the sculpture reads: "If your strength had equalled your resolution, Demosthenes, the Macedonian Ares [i.e., Alexander the Great] would never have ruled the Greeks."² 5.69 Polyeuktos, Demosthenes, c. 280 B.C. Marble copy of a Roman original; 6 tt. 6 in. (2.02 m) high. Ny Carlsberg Glyptotek, Copenhagen.

The outstretched wings and swirling clothes of the *Winged Victory* from Samothrace (fig. **5.70**) evoke the pressure of the wind as she descends from the heavens on the prow of a ship to commemorate a naval victory. The wind whips her garment with a sense of movement more activated than in Classical sculpture, and her wings are outspread in triumph. The forward diagonal of her torso seems forced against the

elements, and the position of her wings suggests that they have not yet settled. Adding to the sense of movement are the drapery masses sweeping across the front of the body, which are contrasted with the seemingly transparent drapery at the torso. The more deeply cut folds also increase the

areas of shadow in the skirt swirling around her legs, making it appear darker as well as heavier than the drapery covering the torso. From the side, the diagonal planes of the body and of the outspread wings come into view.

> Another type of Hellenistic sculpture can be seen in the marble *Aphrodite of Melos,* also known as the *Venus de Milo* (fig. **5.71**). This is a kind of revival style, for

5.70 (left) Winged Nike (Winged Victory), from Samothrace, c. 190 B.C. Marble; approx. 8 ft. (2.44 m) high. Louvre, Paris. The shifting spatial thrusts of the Nike are characteristic of the new Hellenistic command of form and motion in space.

> 5.71 (right) Aphrodite of Melos (also called Venus de Milo), c. 150–125 B.C. Marble; height 6 ft. 10 in. (2.08 m). Louvre, Paris.

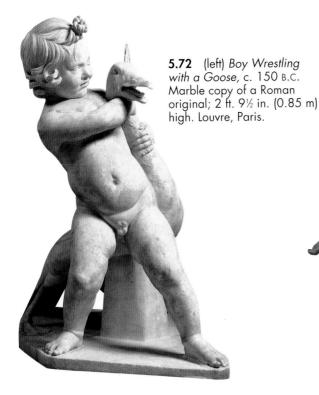

5.73 (above) *Sleeping Eros*, c. 150–100 B.C. Bronze; 2 ft. 6½ in. (0.78 m) long. Metropolitan Museum of Art, New York. Rogers Fund, 1943.

the figure recalls the sensual females carved by Praxiteles in the Late Classical period (see fig. 5.65). The proportions are fleshier than Classical-style proportions, and the draperies reveal the shape and movement of the bent leg. In addition, the sharp *contrapposto* and pronounced S-shaped curve echo those of Praxiteles' *Aphrodite of Knidos*.

Hellenistic sculptures of children show a variety of types that reflects the new approach to realism. The *Boy Wrestling with a Goose,* for example, is a study in contained energy locked in conflict (fig. **5.72**). He is depicted as a naturalistic toddler, with baby fat and childlike proportions. His stance is slightly precarious, as he leans backwards while strangling the goose. The repeated diagonals and open spaces draw viewers into the work and lead them to the formal climax of the struggle—the juxtaposition of the boy's head with that of the goose.

By contrast, the bronze sculpture of the *Sleeping Eros* depicts relaxation (fig. **5.73**). The god's weight lies heavily on the slanted surface of his support, and his arm hangs limply in response to the force of gravity. Although Eros twists at his waist and the diagonals open up spaces, all the tension of the wrestling boy is gone.

The bronze *Boxer* from around the turn of the first century B.C. reveals the ravaging effects of this violent sport (fig. **5.74**). His face, turned awkwardly over his right shoulder, is covered with scars. He wears the leather knuckle straps worn by Greek boxers which inflicted serious injury on their opponents. He himself has a broken nose and teeth, as well as cauliflower ears from years of being hit. His arms are still muscular, but his ribs are beginning to protrude from his chest, indicating the sagging flesh of age. Neither the function nor the context of this

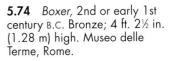

figure is known, but it shows—in a realistic, rather than an idealized, way—a man who has weathered a lifetime of fighting.

The Hellenistic interest in melodramatic pathos is again evident in the sculptural group of *Laocoön and His Two Sons* (fig. **5.75**), a Roman adaptation of a Hellenistic work. It depicts an incident from the end of the Trojan War in which Laocoön and his sons are devoured by a pair of serpents (see box). The choice of such a moment lends itself to the Hellenistic taste for violent movement. The zigzags and strenuous exertions of the human figures are bound by the snakes winding around them.

In the *Laocoön*, Classical restraint and the symmetry of the Parthenon sculptures have been abandoned. There is extra weight to the left as the tail of the snake encircles and pins down Laocoön's right arm. A counterbalancing diagonal is produced by the sharp turn of his head and is repeated by the leg, torso, and head of the boy on the right. In contrast to the Classical *Wounded Amazon* of Polykleitos (fig. 5.28), Laocoön and his children express pain through facial contortion and physical struggle—bulging muscles, veins, flesh pulled taut against the rib cage.

In the Great Altar of Zeus erected at Pergamon (fig. **5.76**), the Hellenistic taste for emotion, energetic movement, and exaggerated musculature is translated into relief sculpture. The two friezes on the altar celebrated the city and its superiority over the Gauls, who were a constant threat to the Pergamenes. Inside the structure, a small frieze depicted the legendary founding of Pergamon.

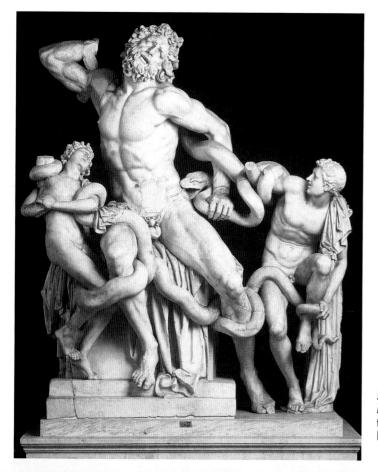

The Trojan Horse

According to a lost Homeric epic, the Greeks constructed a colossal wooden horse and filled it with armed soldiers. They tricked the Trojans into believing it was an offering to Athena that the Trojans should take inside their city walls. Laocoön, a Trojan seer, warned the Trojans that he did not trust the Greeks, "even bearing gifts." Thereupon, Athena sent two serpents to kill the seer and his children. The Trojans took this as a sign that Laocoön was not to be believed and accordingly opened their gates and pulled in the horse. The Greek soldiers emerged, let in the rest of the Greek army, and sacked Troy. References to the story are also found in the Odyssey (IV.271, VIII.492, XI.523).

Outside, the traditional depiction of the gods fighting the Titans was transformed. In a detail illustrating Athena's destruction of Alkyoneus (fig. **5.77**), a son of the Titan earth goddess Gaia (Apollo's predecessor at Delphi) (see p. 138), the energy inherent in the juxtaposed diagonals seems barely contained. This mythical battle between pre-Greek Titans and Greek Olympians recurs in Hellenistic art partly as a result of renewed political threats to Greek supremacy. But unlike the Classical version on the Parthenon metopes, that at Pergamon is full of melodrama, frenzy, and pathos.

King Attalos I defeated the powerful Gauls, who invaded Pergamon in 238 B.C. This victory made Pergamon a major political force. Later, under the rule of Eumenes II (197–c. 160 B.C.), the monumental altar dedicated to Zeus was built to proclaim the victory of Greek civilization over the barbarians. Greece tried to reassert its superiority, as Athens had done in building the Parthenon following the Persian Wars. But Hellenistic art, especially in its late phase, reflects the uncertainty and turmoil of the period. By the end of the first century B.C., the Romans were in complete control of the Mediterranean world, and, with the ascendancy of Augustus in 31 B.C., the scene was set for the beginning of the Roman Empire.

Compared with the art of the other Mediterranean cultures we have surveyed, Greek art stands out for its prime concern with the expression of what is human. This is equally reflected in the science, philosophy, government, literature, theater, and religion of ancient Greece. As far as one can tell from surviving texts, the Greeks were the first in the West to write historically about art and artists. Of the Greek styles covered in this chapter, it is the Classical style that has had the most lasting impact on Western art and thought. The very notion of "Classical" has set a standard to which Western artists have responded in various ways. Subsequent styles, as well as individual artists, can be seen as both continuing the Classical tradition and rebelling against it. In either case, indifference to the Classical achievements was—and remains—virtually impossible.

5.75 Laocoön and His Two Sons. Marble; 7 ft. (2.13 m) high. Musei Vaticani, Rome. The figures of Laocoön and his son on the viewer's left are 1st-century-A.D. Roman copies of a Hellenistic statue. The boy on our right is a Roman addition.

5.76 Great Altar of Zeus, west front, reconstructed and restored, from Pergamon, c. 180 B.C. Marble; height of the frieze, 7 ft. 6 in. (2.29 m). Pergamonmuseum, Berlin. The altar originally stood within the elaborate enclosure, in the open air, reminding the viewer of Zeus' role as supreme ruler of the sky.

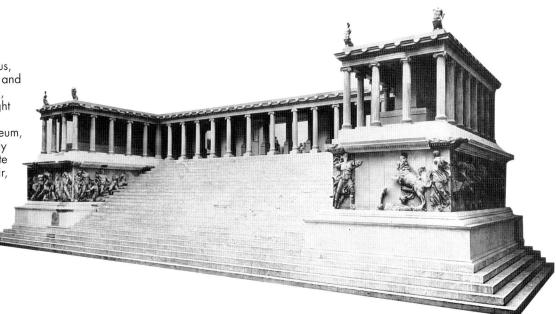

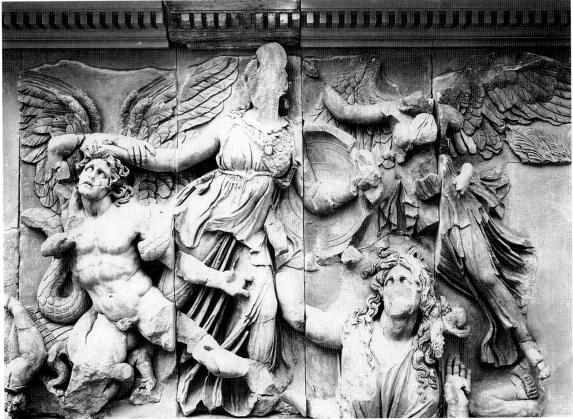

Antikensammlung, Staatliche Museen,

Summary of Greek Style and Techniques

Vase Painting

Berlin.

5.77 Athena Battling with Alkyoneus, from the great frieze of the Pergamon altar, east section, c. 180 B.C. Marble; 7 ft. 6 in. (2.29 m) high.

> Geometric (c. 1000-700 B.C.) Orientalizing (c. 700-600 B.C.) Black-Figure (c. 600-480 B.C.) Red-Figure (c. 530-400 B.C.) White-Ground (begins c. 420 B.C.)

Monumental Sculpture

Orientalizing (c. 700-600 B.C.) Archaic (c. 600-480 B.C.) Early Classical (c.480-450 B.C.) High Classical (c. 450-400 B.C.) Late Classical (c. 400-323 B.C.) Hellenistic (c. 323–31 B.C.)

Style/Period

GEOMETRIC с. 1000-700 в.с.

Terrace of the Lions ORIENTALIZING с. 700-600 в.с.

ARCHAIC с. 600-480 в.с.

Achilles and Ajax

EARLY CLASSICAL с. 480-450 в.с.

CLASSICAL c. 450-400 B.C.

Diskobolos

LATE CLASSICAL с. 400-300 в.с.

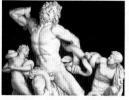

Laocoön and His Two Sons

Works of Art

Geometric amphora (5.4)

Athenian amphorae (5.5, 5.6, 5.9) Terrace of the Lions (5.18), Delos Geometric amphora

New York Kouros (5.19), Attica Cheramyes Master, Hera of Samos (5.20), Samos

Temple of Apollo (5.31), Corinth Exekias, Achilles and Ajax Playing a Board Game (5.7) Siphnian Treasury (**5.32–5.33**), Delphi Temple of Apollo (**5.1**), Delphi *Peplos Kore* (**5.21**) Exekias, Achilles and Penthesilea (5.9)

Seated gods

New York Kouros

Berlin Painter, Abduction of Europa (5.10) Kritios, Kritios Boy (5.22) Myron, Diskobolos (5.25 Temple of Zeus (**5.36–5.44**), Olympia Penthesilea Painter, Achilles and Penthesilea (5.11)

Niobid Painter, kalyx krater (5.12-5.13) Poseidon/Zeus (5.24) Warrior from Riace (5.26), Reggio Calabria

Reed Painter, Warrior by a Grave (5.14) The Parthenon (5.47, 5.50–5.58), Athens Polykleitos, Doryphoros (5.27) Polykleitos, Wounded Amazon (5.28) Temple of Athena Nike (**5.59–5.60**) The Erechtheum (**5.61–5.62**), Acropolis, Athens Stele of Hegeso (5.29)

Theater (5.63), Epidauros Praxiteles, Aphrodite of Knidos (5.65) Attic grave stele (5.67)

Lysippos, Apoxyomenos (5.66) Lysippos, Socrates (5.3) Polyeuktos, Demosthenes (5.69) Battle of Issos (**5.15**) Head of Alexander (**5.68**), Pergamon Winged Nike (**5.70**), Samothrace Aphrodite of Melos (**5.71**) Boy Wrestling with a Goose (**5.72**) Sleeping Eros (**5.73**) Bronze Boxer (5.74) Laocoön and His Two Sons (5.75) Altar of Zeus (5.76-5.77), Pergamon

Cultural/Historical Developments

- Development of heroic legend in Greece: Homer's poems (Iliad and Odyssey) put into present form (8th century, B.C.) Etruscans settle central Italy (c. 900–700 B.C.)
- Adoption of Phoenician alphabet by Greeks (c. 800 B.C.)
- Traditional date for beginning of Olympic Games (776 B.C.) First Greek colony on Italian mainland (Cumae)
- (750 B.C.)
- Circumnavigation of Africa by Phoenicians (c. 600 B.C.)
- Coins used as units of currency imported from Asia Minor into Greece (c. 650 B.C.)

Solon's reforms in Athens (593 B.C.) Thales of Miletus, beginning of natural philosophy (585 B.C.)

- Pythagoras, Greek mathematician and
- philosopher (581-497 B.C.) Pisistratos tyrant of Athens
- (560 B.C.) Cyrus of Persia gains control of Media (550 B.C.)
- Persians conquer Asia Minor (546 B.C.)
- Roman Republic established (509 B.C.)
- First democratic government established in Greece (510-508 B.C

Venus de Milo

- Persian Wars (499–449 B.C.); Ionian cities revolt from Persia with aid of Athens (499 B.C.); Athenians defeat Persians at Battle of Marathon (490 B.C.)
- Use of lost-wax process begins in Greece (6th century B.C.)

Herodotos, the "father of history" (c. 485–424 B.C.) Aeschylos, Oresteia (458 B.C.) Beginning of Perikles' dominance (458 B.C.) Age of Greek drama: Aeschylos (523–456 B.C.), Sophokles (496–406 B.C.), Euripides (c. 480–406 B.C.), Aristophanes (c. 450-c. 385 B.C.)

- Hippokrates, Greek physician, the "father of medicine" (c. 460–c. 377 B.C.) Demokritos, Greek philosopher and scientist who
- developed an atomic theory of the universe (c. 460–c. 370 B.C.)
- Age of Classical Greek philosophy: Socrates (470–399 B.C.), Plato (c. 428–348 B.C.), Aristotle 384-322 в.с.
- Beginning of the Parthenon (448 B.C.)

The Peloponnesian War; Athens defeated by Sparta; Spartan hegemony in Greece (404–371 B.C.) Trial and death of Socrates (399 B.C.) Plato, The Republic (c. 380-360 B.C. Alexander the Great conquers Egypt, Palestine, Phoenicia, and Persia (333–331 B.C.)

Death of Alexander the Great (323 B.C.) Euclid, Elements of Geometry (300 B.C.) The Colossus of Rhodes (290 B.C.) Archimedes, Greek

mathematician (287–212 в.с.) Heyday of Alexandria (Egypt) as the center of the new Hellenistic culture (275-215 B.C.)

Sleeping Eros

000 B.

700 B

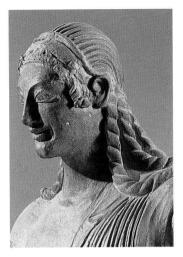

The Art of the Etruscans

T he civilization of the Etruscans, which flourished between c. 1000 and 100 B.C., was contemporary with the Greek culture discussed in the previous chapter. The Etruscans are important in Western his-

tory in their own right and because of their relationship to Greece and Rome. Their homeland, Etruria (modern Tuscany), occupied the west-central part of the Italian peninsula. It was bordered on the south by the river Tiber, which runs through Rome, and on the north by the Arno (see map).

6

The Greeks called the Etruscans Tyrrhenians, after whom the sea was named, and the Romans called them Tusci or Etrusci. Like the Greeks, the Etruscans never formed a single nation but coexisted as separate citystates with their own rulers. Unlike the Romans, they never established an empire.

Although Herodotos thought that the Etruscans had come from Lydia, in modern Turkey, scholars now believe that they were indigenous to, or at least developed their civilization in, Italy. They lived as a distinct group of people whose culture contributed to, and benefited from, the larger Mediterranean world. From the seventh to the fifth century B.C.—the period of their greatest power—the Etruscans controlled the western Mediterranean with their fleet and were an important trading nation. They rivaled the Greeks and the Phoenicians, and established commercial trade routes throughout the Aegean, the Near East, and North Africa. At the same time, the Etruscans were largely responsible for extending Greek influence to northern Italy and Spain.

The Etruscan language resembles none other that is presently known, and its origin is uncertain. The alphabet was taken from Greek in the seventh century B.C. In contrast to Greek script but similar to Phoenician (from which the Etruscan alphabet, like the Greek, ultimately derives), Etruscan is written from right to left. Etruscan literature—

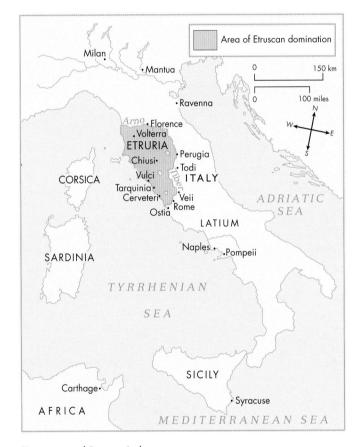

Etruscan and Roman Italy.

which, according to Roman sources, was rich and extensive —has all but disappeared. The writing that has survived is mostly in the form of epitaphs on graves or religious texts. Only a few Etruscan words, most of which are names and inscriptions, have been deciphered.

Our major source of information about the Etruscans comes from the tombs and *necropoleis*, which the Romans left undisturbed and which are buried under modern Italian towns. Most of these were carved out of rocky ground,

Etruscan Materials

Unlike Greek architecture, that of the Etruscans was constructed primarily of mud brick. Columns were made of wood and decorative details of terra-cotta or **tufa**, a soft, porous, volcanic rock that was easy to work.

Statues were typically made of terra-cotta or bronze, and the Etruscans were justly renowned for them in Rome as well as in classical Athens. They were skilled in bronze casting and engraved mythological scenes on the backs of bronze mirrors. For jewelry, gold was the preferred material.

especially in the south, and their contents provide by far the richest examples of Etruscan art. Very few Etruscan buildings have survived, partly because of the nature of the materials used—wood, mud, and tufa (see box). There are some remains of fortifications and urban organization, with streets arranged in a grid pattern.

Architecture

Greece was the inspiration for large-scale architecture in Etruria. The idea of erecting temples within open-air sanctuaries and sacred precincts came from Greece, and remains of temple foundations indicate that Etruscan plans were based on Greek prototypes. Late Archaic Etruscan temples, however, are distinct from the Greek in having gabled porches but not pediments. Etruscan architects used **wattle and daub** construction for the superstructure by reinforcing branches (wattle) with clay and mud (daub). Stone was used only for the podium. Roofs were tiled, and decorative sculpture was made of terra-cotta. Greek Archaic architecture, as well as the aristocratic social order, was favored in Etruria, where it lasted into the fifth century B.C.

The temple of Apollo at Veii (fig. **6.1**) has been reconstructed according to Etruscan temple proportions deThe earliest Etruscan paintings were on a tufa ground, and later ones were applied to clay plaster. Most surviving Etruscan examples are fresco, but some have been discovered in **tempera**, a combination of pigment, water, and egg yolk. The yolk makes the mixture thicker than fresco, and thus tempera paintings can be richer in color. The term derives from the French word *temper*, meaning "to bring to a desired consistency." It is not known when tempera was first used, but it became progressively more popular in Italy during the fifteenth century A.D.

scribed by the Roman architect and engineer Vitruvius (see box) of the Augustan period (30 B.C.–A.D. 14). In addition to the plan, the Etruscans incorporated the Greek wooden roof and *pronaos*. In contrast to those in Greek temples, however, these are set on a high podium rather than on steps, and the side walls are solid. This arrangement emphasizes the entrance wall as being at the front of the temple, whereas the Greek use of colonnaded walls minimizes the distinction between front and sides. It also gives Etruscan temples a heavier, more massive quality than their Greek counterparts.

Vitruvius on Architecture

Marcus Vitruvius Pollio, known as Vitruvius, was a Roman architect and engineer. During the Augustan period (30 B.C.– A.D. 14), Vitruvius wrote *De architectura*, a treatise on architecture in ten books, which was based on his own experience and on earlier works by Greek and Etruscan architects. It covered city planning and urban building, including the choice of site, materials, and construction types. Although the treatise has no particular literary merit, it is a good source of information on the architectural ideas and practices of antiquity.

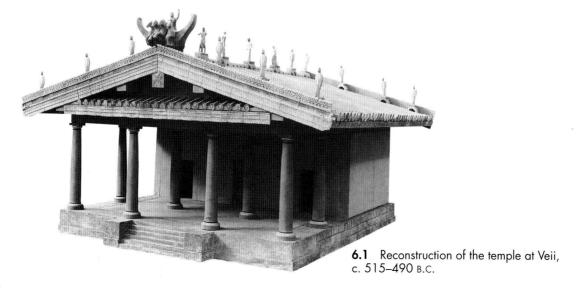

Pottery and Sculpture

6.2

In the Iron Age (Villanovan period, named for the site near modern Bologna in northern Italy), the Etruscans had elaborate burials that included objects of iron, bronze, and ivory. The Etruscans adopted—and adapted—such Greek social customs as the *symposium* (drinking party) and the practice of banqueting in a reclining position. For these functions they imported thousands of Greek vases. Etruscan tombs have yielded most of these imported Greek black- and red-figure vases, which were important sources of Greek pictorial style in Italy. Scenes and characters from Greek mythology liberally populate Etruscan imagery. A particularly rich source for these images appears in engravings on the backs of bronze mirrors, which were an Etruscan specialty (see fig. 6.6).

Capitoline Wolf, c. 500 B.C. Bronze; 2 ft. 9½ in.

The few surviving examples of Etruscan sculpture indicate a thriving industry in bronze. Like the Greeks, Etruscan artists cast bronze by the lost-wax method. The statue of a nursing she-wolf of around 500 B.C., the so-called *Capitoline Wolf*, captures the aggressive anger of a mother protecting her cubs (fig. **6.2**). She turns and becomes tense, as if suddenly startled, and bares her teeth at an unseen intruder. The stylized patterns of fur, especially around the neck, have affinities with Greek Archaic style.

The bronze *Wounded Chimera* from the fourth century B.C. depicts the mythological monster with a lion's body, a serpent's tail, and a goat's head—here emerging from the back (fig. **6.3**). The figure originally belonged to a group showing the Greek hero Bellerophon, who rode the winged horse Pegasus and killed the Chimera. Its pose convincingly indicates a readiness to spring toward an adversary. The hair along the spine literally stands on end; fear is

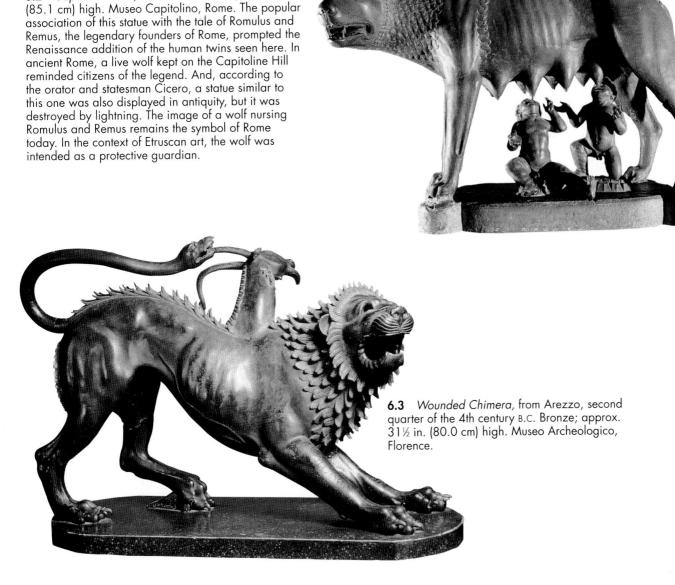

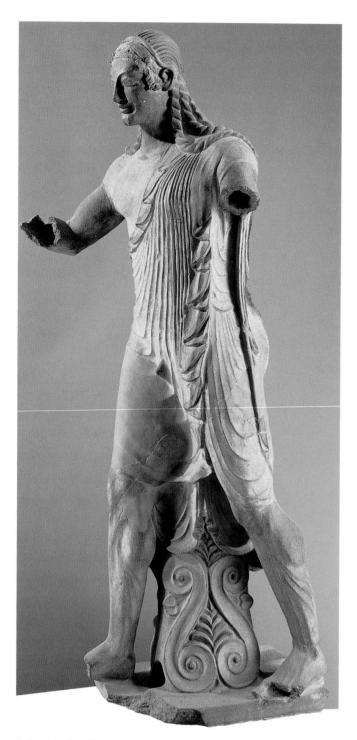

6.4 Apollo of Veii, from Veii, c. 515 B.C. Painted terra-cotta; approx. 5 ft. 10 in. (1.78 m) high. Museo Nazionale di Villa Giulia, Rome. Terra-cotta was a favorite Etruscan material for sculpture. It was modeled while still wet, and the smaller details were added with hand tools. In this statue, Apollo's energetic forward stride reflects the Etruscan interest in gesture, motion, and posture.

suggested through the open mouth, turned head, and raised eyebrows. The Archaic stylizations, especially the mane and whiskers, are similar to certain Achaemenid motifs (see Chapter 2) and hark back to the Near East.

To a considerable extent, the development of Etruscan art paralleled that of Greece, and the same terms are used to designate stylistic categories—Archaic, Classical, and **6.5** (right) Mars of Todi, early 4th century B.C. Bronze; 55½ in. (1.40 m) high. Musei Vaticani, Rome.

Hellenisticeven though the Etruscan dates are only roughly contemporaneous with their Greek counterparts. The Archaic style is exemplified by the life-sized terra-cotta Apollo of Veii (fig. 6.4), which originally decorated the roof of the temple (fig. 6.1). It corresponds to the Greek Late Archaic in style, but, unlike its Greek counterparts, the vouthful male figure is clothed rather than nude.

The Apollo

has some organic form (around the chest, for example), but the curvilinear stylizations and flat surface patterns of the drapery folds are more characteristic of Archaic. The same is true of the diagonal calf muscles fanning out from below the knees, with the lines on top of the feet suggesting that the toes continue to the ankles. The stylized hair, arranged in long locks, and the smile also belong to Greek Archaic convention. Despite the Greek influence on the *Apollo*, however, the sharp clarity of its forms and stylizations, as well as its determined stride, is characteristic of the forcefulness of early Etruscan art.

Closer to Greek Classical style is the bronze *Mars of Todi* (fig. **6.5**), dating from the early fourth century B.C. Named for the site of its discovery at Todi, north of Rome, it is the only nearly life-sized Etruscan bronze known from

before the second century B.C. Although later than the Greek Classical period, the *Mars* has certain affinities with the *Spear Bearer* (see fig. 5.27), especially its *contrapposto* pose. The figure represents a warrior (hence the designation Mars, after the Roman god of war). He wears a leather cuirass (breastplate) and a tunic, and he holds a libation bowl in his right hand and the remnant of a lance, on which he probably leaned, in his left. The rendering of the anatomy is organic, but the pose seems self-consciously animated compared with the relaxed pose of the *Spear Bearer*, and the anatomy is not unified as it is in Greek Classical sculpture.

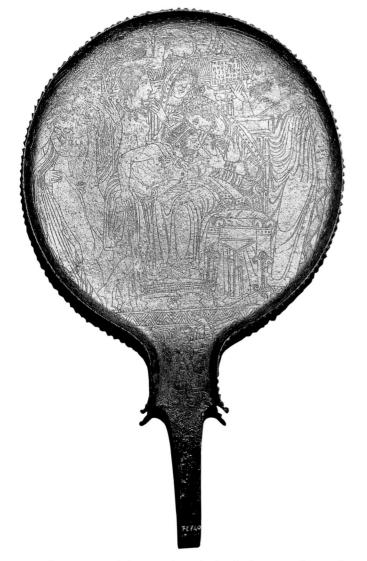

Women and Etruscan Art

The Etruscans differed from the Greeks in their attitude toward women. Judging from Etruscan art, Etruscan women participated more in public life with their husbands and held higher positions than in ancient Greece—a state of affairs of which the patriarchal Greeks heartily disapproved. Wealthy Etruscan women were also unusually fashion-conscious and wore elaborate jewelry commensurate with their rank.

The abundance of bronze mirrors that have been excavated from Etruria were used exclusively by women (fig. **6.6**)—a conclusion based on the fact that mirrors are found only in the graves of women. They were typically decorated with mythological scenes, and their inscriptions indicate that the women to whom they belonged were literate. Etruscan artists frequently depicted myths in which women dominate men by being older, more powerful, or higher in divine status. The scene illustrated here shows the adult Herakles being breastfed by the goddess Uni, the Etruscan equivalent of Hera, in the presence of male and female divinities.

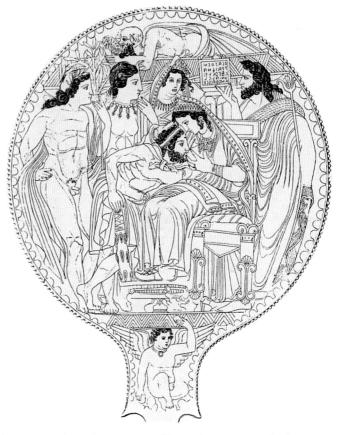

6.6a, b Scene and diagram from the back of a mirror from Volterra showing Uni (Hera) nursing Herakles in the presence of other gods, c. 300 B.C. Engraved bronze. Museo Archeologico, Florence. The Greek version of the myth illustrated here is known only from literature and does not appear in Greek art. It recounts the story of Zeus deceiving Hera into nursing—as a sign of acceptance and adoption—his son Herakles (meaning "the glory of Hera") by the mortal woman Alkmene. But Hera pulled away, and the milk from her breast spurted into the heavens, creating the Milky Way. In the Etruscan version, which is also represented on two other mirrors, Uni willingly nurses Herakles (Hercle in Etruscan). The fact that he is an adult reflects his acceptance into the pantheon of the gods and his attainment of immortality. Two gods, Aplu (the Etruscan Apollo) and Nethuns (the Etruscan Neptune), and two unidentified goddesses witness the initiation ritual. Behind Uni, another witness holds up a tablet with the inscription "This shows how Hercle became Uni's son." The satyr at the top of the mirror drinks wine—the antithesis of milk in Etruscan religion.

Funerary Art

The Etruscans clearly believed in an afterlife that was closer to the Egyptian concept than to the Greek, but it is not known what their view of that afterlife was. It seems to have been as materialistic as in ancient Egypt, since items used in real life such as mirrors, jewelry, weapons, and banquet ware accompanied the deceased. Of particular importance in the Etruscan view of death was the journey to the afterlife.

Cinerary Containers

In the seventh century B.C. and earlier, many Etruscans cremated their dead. They buried the ashes in individual tombs or cinerary urns, which often had lids in the form of human heads. The vessels themselves sometimes had body markings to indicate whether the remains were those of a male or a female.

In figure **6.7**, both the urn and the wide-backed chair on which it stands are made of bronze, but the head is terracotta. Its individualized features suggest that it was intended to convey at least a general likeness of the deceased. The metaphorical nature of this object, in which the body, base, and handles of the urn are equated with the corresponding human anatomy, implies a religious significance. The container of the ashes was intended to symbolize a reversal of the process of cremation, as if to keep the dead person alive through his or her image.

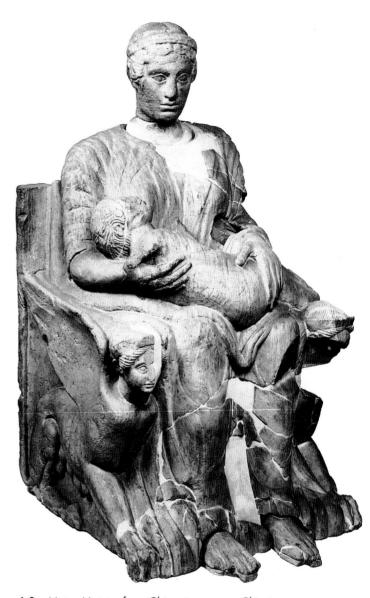

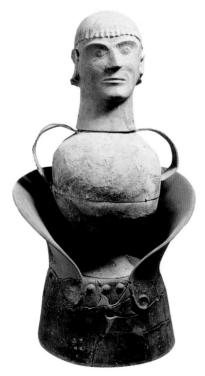

6.7 Cinerary urn, from Chiusi, 7th century B.C. Hammered bronze and terra-cotta; approx. 33 in. (83.8 cm) high. Museo Etrusco, Chiusi.

6.8 Mater Matuta, from Chianciano, near Chiusi, 460–440 B.C. Limestone; life-sized. Museo Archeologico, Florence.

Much later in date is an unusual limestone cinerary statue of a monumental female with a swaddled child lying across her lap (fig. **6.8**). The sad expression characteristic of Greek Severe style—Early Classical—is appropriate for this Etruscan funerary figure. On either side of the chair or throne is a sphinx, which testifies to the importance of the figure—probably a goddess and perhaps a protector of mothers who died in childbirth. This figure corresponds chronologically to the beginning of the Greek Classical style. Although the woman is organically sculpted and the drapery outlines her body, she nonetheless retains the stylized hair and general air of mournfulness typical of the Early Classical period.

Many cinerary urns took the form of houses and provide us with a a glimpse of Etruscan domestic architecture. The Iron Age urn from the Villanovan civilization, for example, is in the form of a hut, the first known house type in

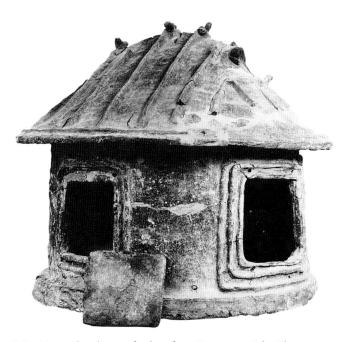

6.9 Urn in the shape of a hut, from Tarquinia, 9th–8th century B.C. Museo Archeologico, Tarquinia.

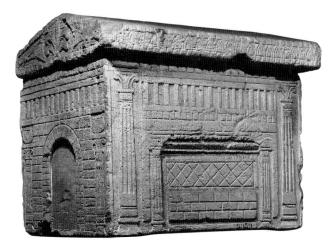

6.10 Cinerary urn in the form of a house, from Chiusi, c. 700–650 B.C. Museo Archeologico, Florence.

central Italy (fig. **6.9**). It consists of a single room enclosed by a circular wall and has a thatched roof supported by interior vertical posts. The example shown in figure **6.10** may have represented an upper-class house or palace, for it has an elegant, symmetrical façade with an arched doorway and a second-story gallery. (The arch, which was invented in Mesopotamia and used in Greece, was assimilated by the Etruscans and later elaborated by the Romans.) At the corners of the urn, Corinthian **pilasters** reinforce the structure. These are the flat, vertical elements resembling columns that project from, and are engaged in, the wall. The lid of the urn corresponds to the roof, with a curved pediment over the entrance and a palmette relief in the center.

Architectural urns provide clues to the development of Etruscan sculptural and architectural styles. The humanheaded urns reflect both a wish to preserve the likeness of the deceased and the importance of ancestors who were considered divine in the afterlife. Urns-as-houses express the metaphor in which the tomb or burial place is a "house for the dead."

Tombs

The attitudes to death suggested by objects such as the urns recur in the Etruscan custom of building larger-scale architectural tombs to "house" their families. Tombs were originally small and intended for individual burials, but beginning in the seventh century B.C. several rock-cut chambers were covered by larger earth mounds, or **tumuli**, and grouped together to replicate cities. In fact, it is from these Etruscan *necropoleis* that scholars have been able to reconstruct entire city and town plans and to elicit information about the urban architecture of Etruria.

The plan of the burial site known as the Tomb of the Shields and the Chairs at Cerveteri (fig. **6.11**) has a complex arrangement: the stepped passage (**1** on the plan) is flanked by similar tomb chambers (**2**), accessible through a door on each side of the entrance; at the far end is a set of three rooms (**4**); the central room (**3** on the plan and

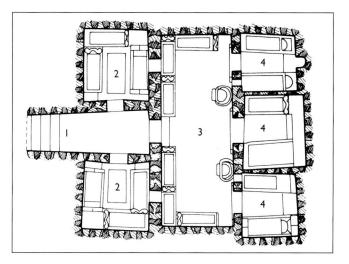

6.11 Plan of the Tomb of the Shields and the Chairs, Cerveteri, c. 550 B.C. Approx. 29 \times 34 ft. (8.84 \times 10.36 m).

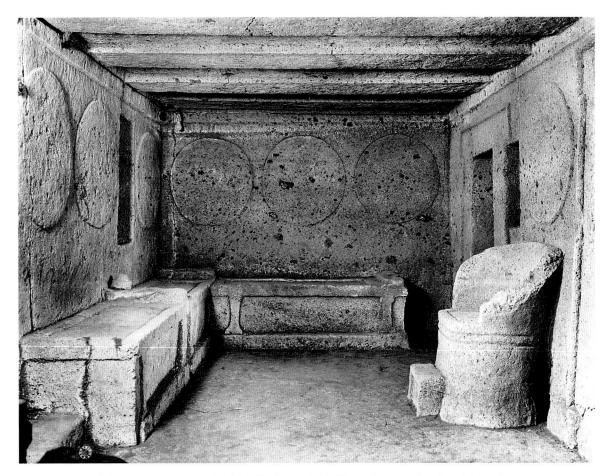

6.12 Interior of the central room, Tomb of the Shields and the Chairs (number 3 in fig. 6.11), Cerveteri, c. 550 B.C. Tufa; approx. $29 \times 11\%$ ft. (8.84 \times 3.51 m).

fig. **6.12**) has walls decorated with reliefs of round shields. There is a door at the right, with a lintel over the opening, and rectangular windows. Built-in furniture includes benches and a typically Etruscan curved-back chair with a footstool similar to that in the cinerary urn (see fig. 6.7). Funerary complexes such as this combined the universal need to provide burials with the particular Etruscan association of tombs with houses. They were intended to be dwelling places for the deceased.

Sarcophagi

Etruscan artists developed a new funerary iconography, which they translated into monumental sculpture in the sarcophagi of wealthy individuals. For example, a painted terra-cotta sarcophagus of around 520 B.C. from Cerveteri is in the form of a dining couch (fig. **6.13**). Like the urns, it was made to contain cremated remains rather than the bodies of the deceased. The figures represent a mar-

ried couple-the family unit was an important element in Etruscan art and society. The wife and husband are given similar status, reflecting the position of women in ancient Etruria. The covering over them alludes their marital state. They are rendered with Archaic features-long, stylized hair, smiles with corresponding raised cheekbones and upwardly slanting eyes, a circular cap for the woman and neatly parted hair for the man. The elegance of their curves and soft areas of their bodies, their finely pleated drapery, and almond-shaped eyes indicate contact with Greek Ionia. In contrast to Greek sculpture, however, these figures have no sense of skeletal structure and "stop" abruptly at the waist, indicating the Etruscan preference for stylistic effects over anatomical accuracy. The sharp bend at the waist and the animated gestures create the illusion of lively, sociable dinner companions, reclining in the style adopted for banqueting from the Greeks. The light flickering in the tomb, visible when opened by family members, would make the couple seem alive, as if to deny the fact of their deaths.

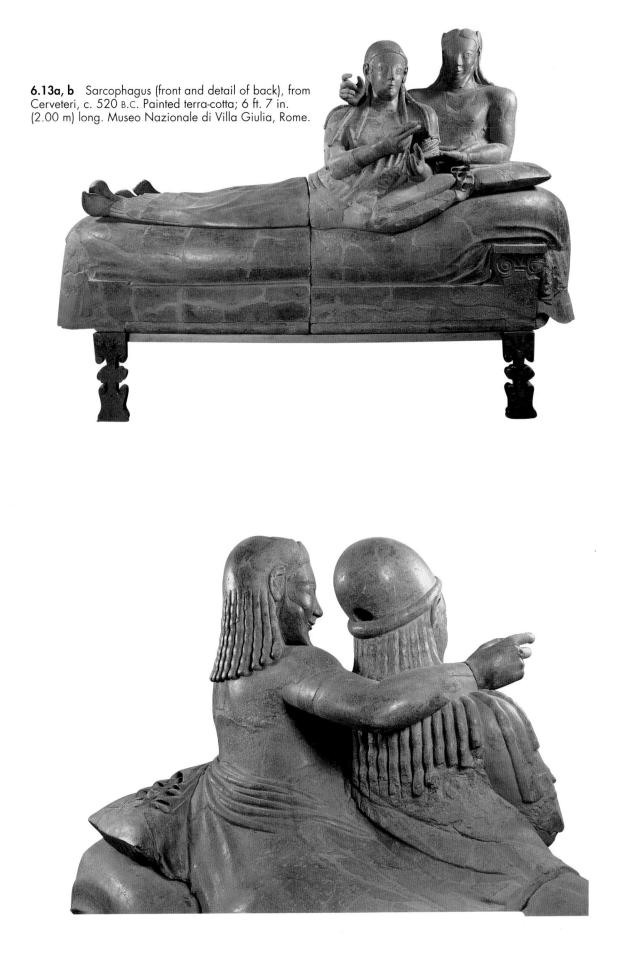

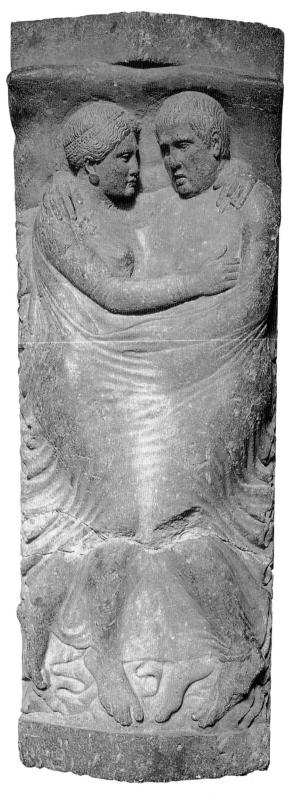

6.14 Sarcophagus of Ramtha Visnai, from Vulci, c. 300–280 B.C. Limestone; 7 ft. 1 $\frac{1}{4}$ in. \times 2 ft. 6 $\frac{3}{4}$ in. (2.18 \times 0.78 m). Courtesy Museum of Fine Arts, Boston. Gift of Mr. and Mrs. Cornelius C. Vermeule III. This restful scene expresses the ancient identification of sleep with death. The correlation is virtually universal—in Greek mythology, for example, Sleep and Death were twins—but in Etruscan tomb iconography the metaphor is rendered literally.

Another, later type of Etruscan sarcophagus contains a lid representing individual figures or couples in bed. A sarcophagus lid from Vulci (fig. **6.14**) shows an embracing husband and wife. The folds of the covering echo the curves of the arms, with shorter, more animated curves and diagonals over the zigzags of legs and feet.

In contrast to Greek art, Etruscan art shows the loving relationship between married couples. Here the pair, again with a covering over both of them, are nude above the waist, locked in a mutual gaze for eternity. Their nudity signifies their continuing sexual union even in death. Such public displays of affection between husband and wife were unheard of in Greek art and society, where men consorted more openly with courtesans (*hetairai*) than with their spouses.

Tomb Paintings

Etruscans used painted images as well as architecture and sculpture in the service of the dead. Hundreds of paintings have been discovered in the underground tombs of Tarquinia, a site northwest of Rome rich in archaeological finds. Tomb paintings were usually frescoes, although occasionally tempera was applied to dry plaster. Similar paintings probably adorned public and private buildings, but none has survived. Until the fourth century B.C., the most frequently represented subjects in Etruscan tomb paintings were funeral rites or optimistic scenes of aristocratic pleasures—banquets, sports, dances, and music making. Yet hints of death do appear, even in the sixth century B.C.

A painting from the Tomb of the Augurs, in Tarquinia, dates from c. 510 B.C. and represents two mourners (fig. 6.15). The figures stand on a horizontal ground line flanking the closed door leading to the underworld, and there is little indication of depth. Plant stems rise directly from the ground line and are the same brownish color. Aside from the blue leaves, the colors of the costume match the solemn mood. The mourners wear a simple, light yellow garment that falls to about mid-calf, but their shorter outer garment is black, as are their boots. Their gestures are the traditional stylized gestures of mourning and have a theatrical quality. They direct our attention to the closed door that leads to the next life, an image that reaffirms the architectural metaphor equating house and tomb. The form of the door, with the horizontal lintel at the top extending beyond the sides, is similar to the actual door visible in the Tomb of the Shields and the Chairs (see fig. 6.11).

A fresco in the Tomb of the Leopards at Tarquinia shows men and women reclining on banqueting couches while servants wait on them (fig. **6.16**). The seated banqueters have the same bend at the waist and animated gestures as the couple on the Cerveteri sarcophagus (see fig. 6.13), but their heads are in profile. Colors are mainly terra-cotta tones of brown on an ocher background, with drapery patterns, wreaths, plants, and other details in blues, greens, and yellows. As in Egyptian, Minoan, and Greek painting, Etruscan women are rendered with

6.15 Mourners at the Door of the Other World, Tomb of the Augurs, Tarquinia, c. 510 B.C. Note that the boots worn by the mourners resemble those of the war god in the Hittite relief from Boghazköy (see fig. 2.23). Pointed boots are typically worn by mountain people and are another example of influence from the Greek Ionian cities and Asia Minor. The scene at the right shows two wrestlers and the gold and bronze bowls for which they are competing.

See figure 2.23. Hittite war god, from the King's Gate, Hattusas, Boghazköy, Turkey, c. 1400 B.C.

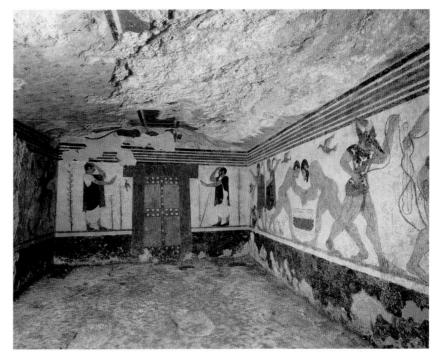

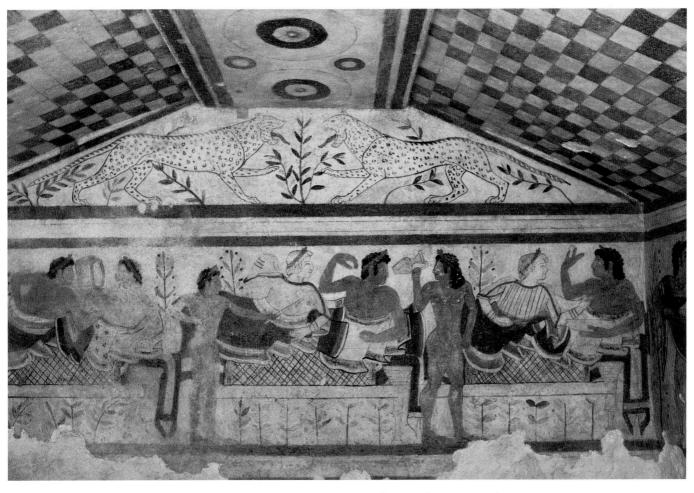

6.16 Tomb of the Leopards, Tarquinia, 480–470 B.C. Fresco. Here the influence of Egyptian and Aegean painting is quite evident. Women are lighter skinned than men, profile heads contain a frontal eye, and figures are outlined in black and dark brown.

lighter skin coloring than men. Above the banqueting scene, two leopards flank a stylized plant and symbolically protect the tomb from evil.

Compared with paintings in Greece, Etruscan paintings disregard anatomical accuracy and naturalistic movement in space, and the overall impression is one of spontaneity. Even though figure 6.16 illustrates an interior scene, for example, the presence of trees indicates a willingness to merge what is naturally outside with what is architecturally inside.

The Etruscans remained a culturally distinct group, retaining their own language, religion, and customs for nearly a millennium. Occupying a large section of Italy for much of the period of the Roman Republic, Etruscans were independent of the Romans in language and religious beliefs. Yet they taught the Romans a great deal about engineering, building, drainage, irrigation, and the art of augury—how to read the will of the gods and foretell the future from the entrails of animals and the flight of birds. In matters of fashion and jewelry, the Etruscans were the envy of Greek and Roman women alike. Their technical skill and craftsmanship prompted advances in jewelry, such as gold granulation, as well as in dentistry. Etruscans made bridges and dentures that enhanced oral health and were cosmetically pleasing.

Etruscan kings ruled Rome until the establishment of the Roman Republic in 509 B.C. By the early third century B.C., Etruria had become part of Rome's political organization, and two centuries later it had succumbed to full Romanization.

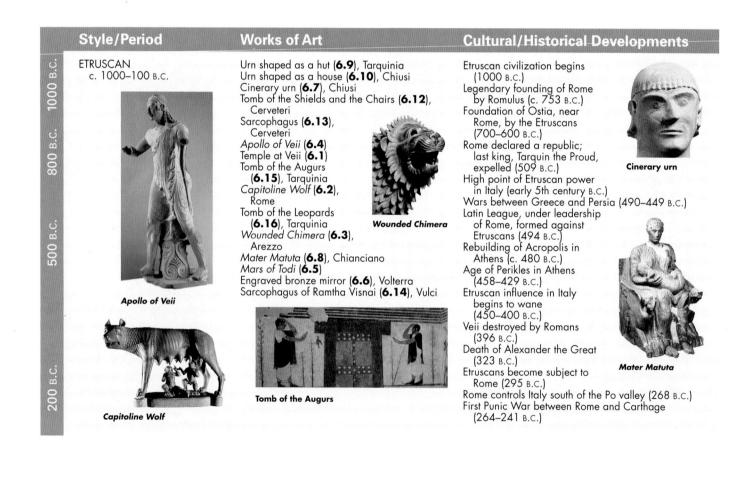

Window on the World Two

China: Neolithic to First Empire (c. 5000–206 в.с.)

The Tomb of Emperor Qin: I (late 3rd century B.C.)

I t is not only in the West that people created tombs with a view to taking their lives with them into death. In 1974, a group of peasants in the Chinese province of Shaanxi discovered evidence of an ancient burial hidden in an enormous mound of earth (see fig. I.2). Subsequent archaeological excavations revealed this to have been the burial of Shihuangdi, who became

filled with [models of (?)] palaces, towers, and [a] hundred officials, as well as precious utensils. . . . Artisans were ordered to install mechanically triggered crossbows set to shoot any

known as Emperor Qin (ruled 221-206

B.C.) after the states he ruled. He was

intruder. With quicksilver the various waterways of the empire, the Yangtze and Yellow Rivers, and even the great ocean itself were created and made to flow and circulate mechanically. The heavenly constellations were depicted above and the geography of the earth was laid below. Lamps were fueled with whale oil so that they might burn forever without being extinguished.¹

While not every detail of this account has been confirmed, it is certain that Shihuangdi unified China in the late

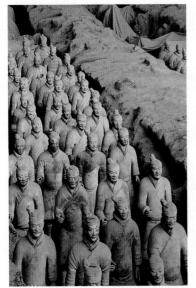

See figure 1.2. Bodyguard of the emperor Qin, terra-cotta warriors, Qin dynasty (221–206 B.C.), in situ. Lintong, Shaanxi Province, China.

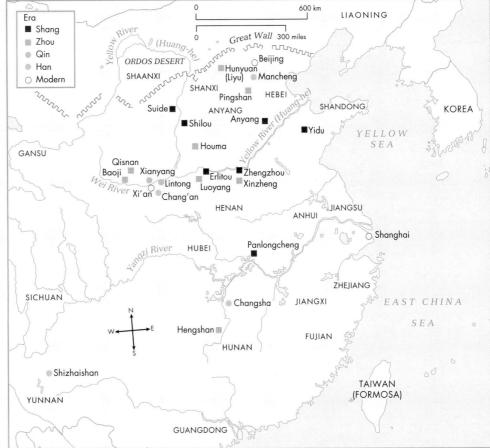

Chinese archaeological sites.

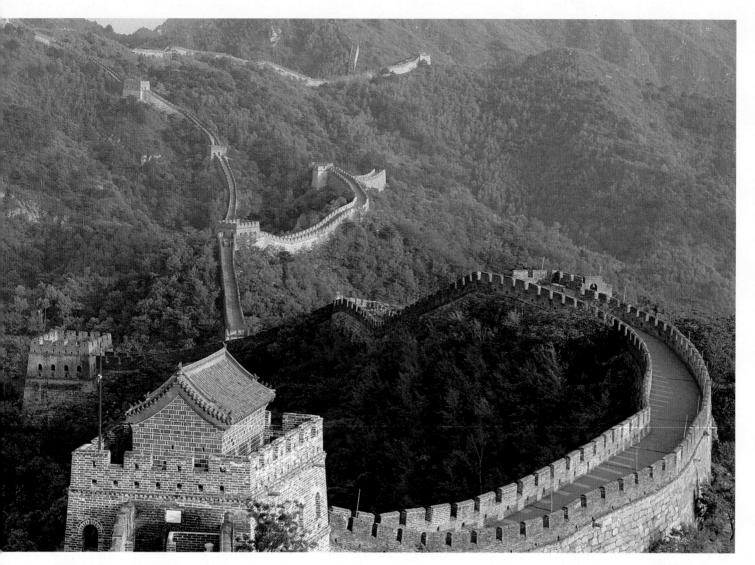

W2.1 The Great Wall, near Beijing, China, begun third century B.C. Length approx. 1,500 miles (2,414 km), height and width approx. 25 ft (7.62 m).

third century B.C., installed himself as emperor, financed monumental building campaigns and the arts with a view to solidifying his political position, and strengthened the country he ruled. Among his lasting accomplishments was the codification of the law, which he was famous for ruthlessly enforcing. He standardized weights, measures, and currency, established a

	ijor Perio	
Early	Chinese	History

BRONZE AGE Shang Dynasty Zhou Dynasty	с. 1700–1050 в.с. с. 1050–221 в.с.
IRON AGE Qin Dynasty	221–206 в.с.

written language, and adopted a canon for imperial art. His administrative system and division of China into provinces has lasted to the present day. He constructed a national network of roads, which facilitated the efficient mobilization and movement of troops. Emperor Qin also commissioned monumental palace architecture, and most of the Great Wall of China was built during his reign.

Parts of the Great Wall were already in place, but Qin ordered its reconstruction and completion as another means of unifying the country. It discouraged invasion along the borders. As a feat of engineering, the Great Wall was prodigious, requiring the work of around 700,000 laborers. All told, the wall extended some 1,500 miles. Figure **W2.1** shows a small section of the wall outside of Beijing and several of its watchtowers.

Precursors: Neolithic to the Bronze Age (c. 5000–221 B.C.)

Prior to the Qin dynasty, China had a long cultural and artistic tradition. In contrast to the Mediterranean world, whose civilizations rose and fell (that of Egypt lasted the longest), China has maintained a cultural continuity from the Neolithic era to the present. Although the origins of Chinese culture are obscure, legends refer to an early Bronze Age Xia dynasty and to stages in civilization brought about by heroes known as the Five Rulers.

There is evidence that between the fourth and third millennia B.C. pottery production was thriving. Crude Mesolithic pottery had been replaced by thin-walled, wheel-thrown wares: first, earthenware with black and red painted

Bronze: The Piece-Mold Method

Bronze is an alloy of copper and tin. Although the earliest manufactured metal objects were made exclusively of copper, it was soon discovered that adding tin increased its hardness, lowered its melting point, and made it easier to control.

In the Stone Age, most artifacts had been made from easily portable materials such as bone, clay, and stone. The introduction of bronze was a watershed in China, as in other civilizations, and precipitated a significant shift in the nature of its society. Sources of copper and tin had to be discovered, the ore mined, and the metal extracted. This was a huge undertaking as far as copper was concerned since its ore yields only a tiny proportion of refined metal. Elaborate kilns and fires of great intensity were needed to melt the large batches of metal. Cooling the finished objects to avoid cracks and other defects required constant supervision. Such tasks could be accomplished only in a society that was settled (i.e., nonnomadic) and in which labor was specialized.

The Chinese produced bronze vessels in twenty-seven basic shapes by an indigenous technique derived from pottery making. This differed from the lost-wax method (see p. 154) popular in Greece and elsewhere. First, a clay model of the vessel was made, and then it was encased with an outer layer of damp clay. When the outer layer dried, it was cut off in sections and fired to form a mold. Meanwhile, a thin layer was removed from the model, which became the core of the mold. The sections of the mold were reassembled around the core and held in place by bronze pegs (spacers). Molten bronze was then poured into the space between the mold and the core through a pouring duct. The thickness of the final object was a function of the difference in size between core and mold. When the bronze had cooled, the mold and core were removed, and the surface of the bronze was polished with abrasives.

Ancient Chinese bronzes remain unsurpassed in the technical virtuosity of their ornamentation. Decoration was an integral part of the casting process, created by designs on the inner surface of the mold. Portions of especially complicated pieces were cast separately and fitted together. This piecemold process made it possible to cast vessels of enormous size

Provide the second secon

W2.2 Diagram showing the Chinese system of bronze casting.

with elaborate surface ornamentation. It was not until the late Bronze Age that the Chinese began to cast bronze by the simpler lost-wax process, which permitted more flexibility of design but required more finishing after casting.

decoration, and then polished black vessels. By the third and second millennia B.C., jade was being imported from Siberia and carved into stylized animal figurines and other ceremonial objects.

Bronze was first used in the second millennium B.C. in the fertile valley of the Yellow River (see map), and its importance as both medium and symbol in ancient China cannot be overestimated (see box and fig. **W2.2**). As a material, bronze was of great value. It denoted power and was associated with the aristocracy, who monopolized its manufacture, use, and distribution. Social rank was measured by the number and size of bronzes one owned. Bronze was also used for weapons, which led to new success in warfare, and productivity in general increased as a result of improved metal tools. Ritual objects—preferably made of bronze—served the dead as well as the living, and bronze vessels containing offerings were dedicated to deceased ancestors. These were often used by shamans, who were members of the ruling aristocracy. They performed sacrifices to the spirits of ancestors or gods, who, in turn, were believed to protect the living. In times of war, the ritual bronzes were melted down and made into weapons to be recast into vessels when peace returned.

The two main Bronze Age dynasties were the Shang (c. 1700–1050 в.с.) and the Zhou (c. 1050–221 в.с.). The Shang was a complex agricultural society with a class system, an administrative bureaucracy, and urban centers. City walls were made of earth,

Writing: Chinese Characters

The Chinese writing system uses characters that represent entire words instead of letters in an alphabet. These characters have been written and read—in columns, running from top to bottom and right to left—for at least 3,000 years. Because of the sophistication of the earliest known characters, their prototypes may have originated as long ago as 4000 B.C., when they were applied to perishable materials such as textiles and leather. At Anyang, China's first city and capital of the Shang dynasty (c. 1700–1050 B.C.), archaeologists found characters written on oracle bones used in divination. Archivists at the Shang court wrote with brush and ink on slices of bamboo or wood that were then bound into books.

Figure **W2.3** shows the evolution of oracle script into seal script (still used for carved seals today) and finally into the same characters' standard modern forms. Many of the 4,500 Shang characters known, of which one-third have been identified, were **pictographs** (literally "written pictures"), or styl-

ized renderings of specific objects: the sun is circular; the moon is a partial circle (showing its changing shape in contrast to that of the sun); rivers consist of wavy lines; and mountains have three peaks facing upward. Other characters called **ideographs** (literally "written concepts") were more abstract, representing ideas through combinations of pictographs. The combination of sun and moon, for example, forms the idea of brightness.²

Chinese characters have become less pictorial over the centuries. Today about 90 percent of the 10,000 commonly used characters (out of a repertory of nearly 50,000) are composed of elements that convey meaning coupled with elements indicating pronunciation. Thus the combination of the character for "female person" with a character for the sound *ma* creates the notion of "mother." The five traditional styles in which the characters are written have been in use for at least 2,000 years, and writing is considered the highest art form in China.

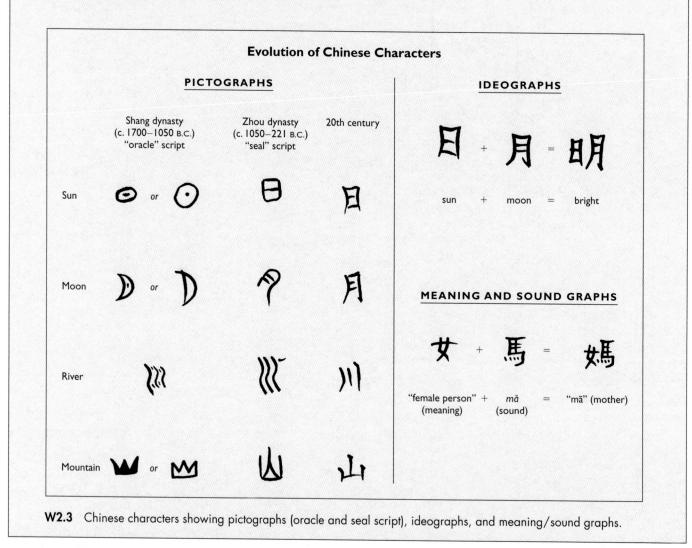

and there is evidence of some monumental architecture in the later Shang period. Of particular note are rectangular halls, over 90 feet (27.43 m) in length, with interior pillars arranged symmetrically. The Shang dynasty also produced the earliest form of China's **calligraphic** writing system.

This is known from inscriptions on so-called oracle bones used in divination rites in the mid-second millennium B.C. (see box and fig. W2.3).

ture, they conquered the Shang and

established a feudal state that lasted

for eight hundred years. Their chief

god was conceived of as heaven (tian)

and as the father of the Zhou king,

finial (an ornament at the top of an object) rendered in the shape of a

The four-ram wine vessel (fig. **W2.4**) is a good example of Shang dynasty bronze casting in the Anyang region of modern Hunan Province. Four rams, decorated in low relief with an abstract motif of crested birds, project from the body of the vessel, their legs forming its base. Above the rams, around the vessel's shoulder, are four horned drag-

ons. The entire surface is enlivened by curvilinear patterns that create an unusual synthesis of naturalism and geometric abstraction. While the insistence on symmetry (fig. **W2.5**) arrests formal movement, the surface patterns animate the object.

reinforcing his imperial power. The late Zhou period produced the two animate the object. great philosophies of China, Daoism The Zhou originated in modern and Confucianism (see box). In the Shanxi. A predominantly warrior cularts, the Zhou continued and elaborated Shang styles and techniques, especially in bronze. Whereas Shang forms can usually be identified, Zhou forms, though reminiscent of natural shapes, are elusive. During the late Zhou dynasty, China underwent several centuries of social upheaval. There is evidence of new influence from the animal art of the Scythian nomads (see Chapter 2), particularly in the interlace patterns and motifs characterized by metaphorical transitions from organic to geometric forms. This type of shifting imagery can be seen in a late Zhou

W2.4 Four-ram wine vessel, Ningziang Xian, Hunan Province, China, Shang dynasty, c. 1300–1030 B.C. Bronze; 23 in. (58.4 cm) high, 75 lbs. 14 oz. weight. Historical Museum, Beijing. **W2.5** Four-ram wine vessel (detail of fig. W2.4).

Chinese Philosophy

Daoism and Confucianism were the two great philosophies of ancient China. Daoism is based on the *Daode jing*, a text attributed to its legendary founder, Laozi, and thought to have been written in the fourth century B.C. It teaches individualism and transcendence through direct connection with the natural world. According to the *Daode jing*, "*Dao* [the Way] invariably does nothing and yet there is nothing that is not done."³ Confucius (whose Chinese name is Kongzi, 551–479 B.C.), on the other hand, emphasized strict adherence to social conventions and rituals—based on those of the Shang and Zhou dynasties—for the proper functioning of the state. Confucius's teachings were collected in the *Analects*, among whose maxims is "Devote yourself earnestly to the duties due to men, and respect spiritual beings, but keep them at a distance. This may be called wisdom."⁴ These two disparate philosophies have been reflected in Chinese art for the past two thousand years.

dragon (fig. **W2.6**), a masterpiece of formal complexity as the dragon both bites, and is bitten by, a bird. Such iconographic representations of oral aggression and transformation are similarly expressed in certain objects of the European Middle Ages (see fig. 9.24).

Shihuangdi began his reign as the centuries of upheaval known as the Warring States period (475-221 B.C.) came to an end. His wish to perpetuate his life after death had a long tradition in China. Until the fourth century B.C., in the late Zhou dynasty, rulers continued to be buried with their belongings and their animals. Slaves and servants, relatives and other members of the nobility were ritually killed in order to accompany the deceased. By the end of the Bronze Age in China, however, human sacrifice for burials had ceased. Wooden figures, or mingi (meaning "substitutes"), were used instead.

The Tomb of Emperor Qin: II (late 3rd century B.C.)

Some 700,000 people labored for fifteen years to build the Qin emperor's tomb complex. According to the historian's account cited above, Qin tried to take the entire universe with him—not just his friends, family, and possessions. In fact, he took approximately 7,000 life-sized painted terra-cotta warriors and horses, which were equipped with real chariots and bronze weapons. Their purpose was to provide Shihuangdi with a military bodyguard in the afterlife.

The hierarchy of military rank from infantryman to officer is represented in Emperor Qin's soldiers, deployed outside the burial chamber according to contemporary battle strategy. Although the figures conform to ideal types, they convey a sense of personality that is just short of portraiture. The hollow torsos are supported by sturdy cylindrical legs. Small details made separately were stuck to the surface while the clay was still wet. When the statues dried, they were fired, painted, and set on bases.

One of these, a terra-cotta kneeling archer (fig. W2.7), shows the warrior holding his bow and wearing plated armor and a kilt. His raised cheekbones and eyebrows, along with the slight suggestion of a smile, give him an air of individuality despite his conventional pose. The detail of the back of his head (fig. W2.8) shows incised lines, representing hair that has been tightly pulled into a topknot and

W2.7 Kneeling archer, from the tomb of Emperor Qin (trench 10, pit 2), Lintong, Shaanxi Province, 221–206 B.C. Terra-cotta; life-sized. Shaanxi Provincial Museum.

W2.8 Kneeling archer (detail of fig. W2.7).

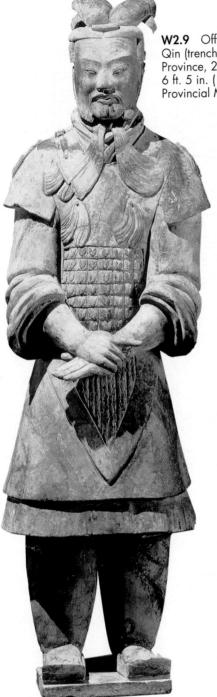

W2.9 Officer, from the tomb of Emperor Qin (trench 4, pit 2), Lintong, Shaanxi Province, 221–206 B.C. Terra-cotta, 6 ft. 5 in. (1.96 m) high. Shaanxi Provincial Museum.

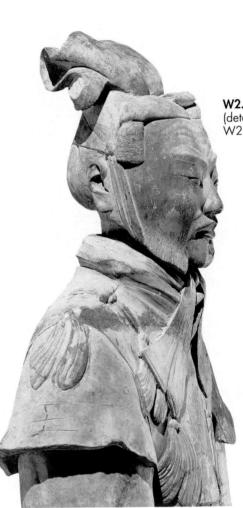

W2.10 Officer (detail of fig. W2.9).

strands of braids. Also visible are the modeling marks, made by the artist's thumbs, at the back of the neck and in the folds of the scarf. The statue of an officer (figs. **W2.9** and **W2.10**) stands upright, his hands forming a ritual gesture. He frowns slightly, as if weighing an important tactical decision, and his high rank is denoted by height and costume. In addition to an armored tunic, he wears a double robe with wide sleeves and an elaborate headdress tied under his chin. The terra-cotta cavalryman (fig. **W2.11**) is shorter and more plainly attired. He wears the short robe and vest that made riding easier and replaced the long robe worn before 300 B.C. He stands at attention and holds the reins of his horse, whose saddle replicates the leather and bronze of a real saddle. At the time of writing, Emperor Qin's burial chamber remains to be excavated, partly because it is thought to have been booby-trapped to protect against vandals. The burial chamber was located below streams and sealed off with bronze as another protective device. The emperor's 7,000 bodyguards, like the army that defended his imperial power, served as guardians of his body.

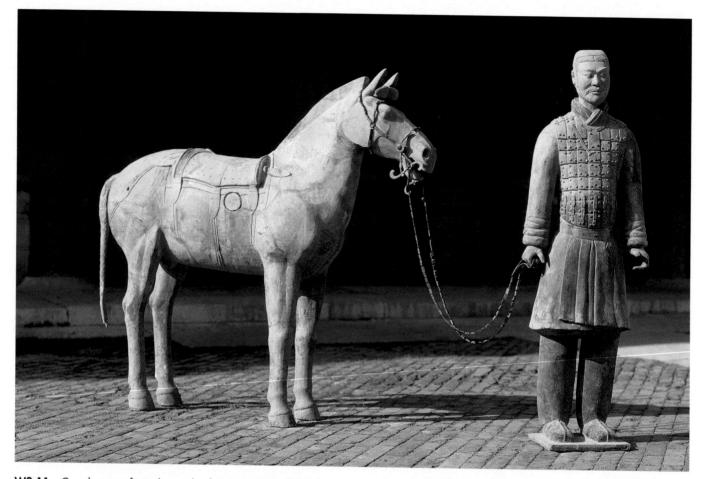

W2.11 Cavalryman, from the tomb of Emperor Qin (trench 12, pit 2), Lintong, Shaanxi Province, 221–206 B.C. Terra-cotta; man 5 ft. 10 in. (1.79 m) high, horse 5 ft. 7½ in. (1.69 m) high. Shaanxi Provincial Museum.

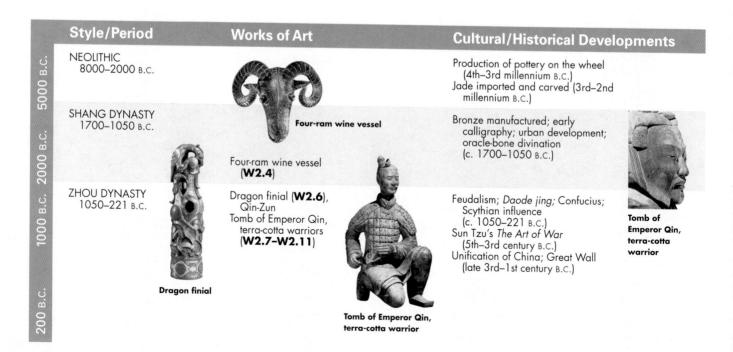

Ancient Rome

T he political supremacy of Athens lasted only about fifty years; Rome's endured for five hundred. Greece had been unified culturally, but Rome's empire became a melting pot of cultures and ideas. De-

spite Greece's belief in its own superiority over the rest of the world, it had never achieved long-term political unity. The political genius of Rome lay in its ability to encompass, govern, and assimilate cultures very different from its own. As time went on, Roman law made it increasingly easy for people from distant regions to attain citizenship, even if they had never been to Rome. Nevertheless, there was no doubt that the city itself was the center of a great empire. Rome's designation of itself as *caput mundi*—"head of the world"—signified its position as the hub of world power.

From the death of Alexander the Great in 323 B.C., Rome began its rise to power in the Mediterranean. By the first century A.D., the Roman Empire extended from Armenia and Mesopotamia in the east to the Iberian Peninsula in the west, from Egypt in the south to the British Isles in the north (see map). Everywhere the Roman legions went,

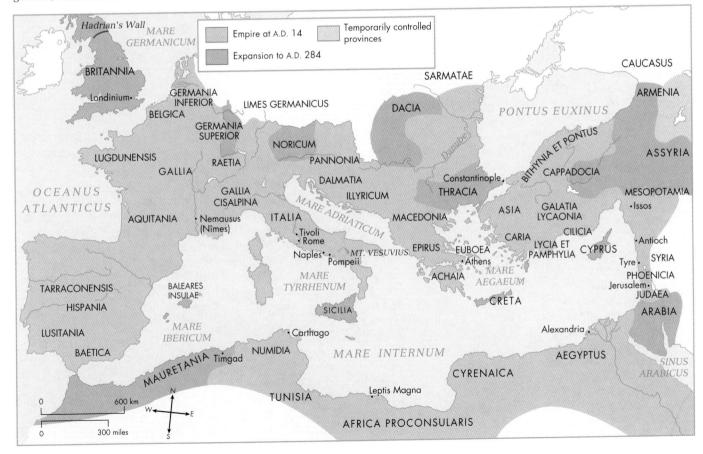

The Roman Empire, A.D. 14–284.

they took their culture with them, particularly their laws, their religion, and the Latin language. Only Greece and the Hellenized world kept Greek, rather than Latin, as the official language.

Roman citizenship was accessible to many more people than Athenian citizenship had been, and the position of women in Roman society was more dignified than in Athens. Instead of being confined to their quarters, they ate with their husbands and were free to go out without a chaperone. Upper-class women were involved in law, literature, and politics.

Before the second century B.C., Roman marriage, which was a contract, took the form of transfer of control of the woman from her father to her husband. To some degree, this required the bride's consent. If a woman lived with a man for a year without being absent for more than two nights, the couple was considered legally married. From the second century B.C. onward, the pace of emancipation accelerated. Married women could retain their legal identity, controlling their property, managing their affairs, and becoming independently wealthy. Divorce was more common, and during the empire laws were passed to encourage marriage and to increase the birthrate.

In religion and art, the Romans identified their own gods with counterparts in the Greek pantheon and adopted Greek iconography. Roman artists copied Greek art, and Roman collectors imported Greek works by the thousands. Although Greek monumental paintings have not survived, they, too, influenced Roman painters, especially in the Hellenistic period.

Greek art had tended toward idealization, to which the Romans added commemorative and narrative types based on history rather than myth. As in the Hellenistic style, Roman portraitists sought to preserve the features of their subjects. But they went much further in the pursuit of specific likenesses, making wax death masks modeled directly on the face of the deceased and copying them in marble.

The purpose of Roman portraiture was genealogical. As a family record, it connected present with past, just as Aeneas (see box) connected Roman origins with the fall of Troy and, through his mother, Venus, with the gods. Roman interest in preserving family lineage was also reflected in names. The typical Roman family was grouped into a clan, called a gens, by which individuals traced their descent. Portraits, whether sculptures or paintings, thus had a twofold function: they both preserved the person's image and contributed to the history of the family. Similarly, Roman reliefs usually depicted historical narratives, commemorating the actions of a particular individual rather than mythical events. Most commemorative reliefs adorned architectural works, and it was in architecture that the Romans were most innovative. At the same time, however, Rome produced an enormous body of literature, some of which dealt primarily with mythological stories derived from Greece. One of the major examples of such work is the Metamorphoses of Ovid (43 B.C.-A.D. 18) (see box, p. 212).

According to the official chronology, the city of Rome was founded by Romulus in 753 B.C., but legend based on

Virgil's Aeneid

During the reign of Rome's first emperor, Augustus, Virgil wrote the Aeneid, a Latin epic to celebrate Aeneas as the legendary founder of Rome. Composed in twelve books, it opens with the fall of Troy. Like Odysseus (see Chapter 5) and Gilgamesh (see Chapter 2) before him, Aeneas travels far and wide, even visiting the underworld. Virgil's frequent references to "pius Aeneas" evoke his hero's sense of duty and destiny. They also imply comparison with Augustus and create an image of the emperor as a predestined second founder of Rome—that is, as the ruler of a great empire under divine guidance. The connotations of this epic for the readers of first-century Augustan Rome were apparently that the founding of their city and Roman domination of the world had been the will of the gods.

In the Aeneid, Virgil defines the Roman view of its relationship to Greece and to Greek art by emphasizing that Rome's destiny was political rather than artistic:

Others will cast more tenderly in bronze Their breathing figures, I can well believe, And bring more lifelike portraits out of marble; Argue more eloquently, use the pointer To trace the paths of heaven accurately And accurately foretell the rising stars. Roman, remember by your strength to rule Earth's peoples—for your arts are to be these: To pacify, to impose the rule of law, To spare the conquered, battle down the proud.¹

Greek myth traces the origins of Rome and the Latin people to a different hero, namely, Aeneas. Tradition had it that the local twins Romulus and Remus were abandoned as infants and nursed by a wolf (see fig. 6.2). Romulus later killed Remus, built Rome on the Palatine Hill, and became its first king. He ruled Rome until the late eighth century B.C. and was followed by six kings, some of whom were Etruscans. In 509 B.C., the last king was overthrown and the Republic was established. For the next five centuries, Rome was ruled by two consuls, a senate, and an assembly. The consuls were elected every year and shared the military and judicial authority of the former kings. The senate was composed of former magistrates, and there was an assembly of citizens.

The Republic lasted until 27 B.C., when Octavian (who later took the title "Augustus") became the first emperor (see box, p. 211). The term *Augustus* originally meant "revered" and had religious connotations, but it came to mean "he who is supreme." *Caesar*, too, came to mean "ruler," as in the German *Kaiser*. For the next three hundred years, Rome was ruled by a succession of emperors. In A.D. 330, the emperor Constantine established an eastern capital of the Roman Empire in Byzantium, which he

Chronology of Roman Periods and Corresponding Works of Art and Architecture

PERIOD AND RULERS

Early Kings Rule by kings and a senate Late Kings Etruscan rulers. Ends 509 B.C. The Republic (509–27 B.C.) Rule by Senate and patrician citizens Punic Wars (264–146 B.C.)

Transition to Empire

Julius Caesar (46-44 B.C.)

Octavian/Augustus (27 B.C.-A.D.14)

Early Empire

Julio-Claudian dynasty (14–68) Tiberius (14–37) Caligula (37–41) Claudius (41–54) Nero (54–68)

Flavian dynasty (69–96) Vespasian (69–79) Titus (79–81) Domitian (81–96)

The so-called "Good Emperors" (96–180) Nerva (96–98) Trajan (98–117) Hadrian (117–138) Antoninus Pius (138–161) Marcus Aurelius (161–180)

A period of political stability and economic prosperity

Beginning of Decline Commodus (180–192) Political unrest and economic decline

The Severan Dynasty (193–235) Septimius Severus (193–211) Caracalla (211–217) Severus Alexander (222–235)

Anarchy (235–284)
Period of Tetrarchs (284–306)
Diocletian (284–305) institutes four co-rulers in an unsuccessful effort to restore stability to the empire.

Late Empire Constantine I (306–337)

WORKS OF ART

Tophet, 8th–1st century B.C. (**7.66**) "Baby bottle" vessel, 4th–3rd century B.C. (**7.68**) Mausoleum at Dougga, 2nd century B.C. (**7.69**) Temple of Portunus, late 2nd century B.C. (**7.23**) Temple of the Sibyl, early 1st century B.C. (**7.25**)

Villa of the Mysteries, c. 65–50 B.C. (**7.54–7.56**) Odyssey Landscapes, c. 50–40 B.C. (**7.57**) Bust of Julius Caesar, mid-1st century B.C. (**7.43**) Neo-Punic stele, 1st century B.C.–1st century A.D. (**7.67**) Pont du Gard, late 1st century B.C. (**7.22**) Ara Pacis, 13–9 B.C. (**7.31–7.33**) Frescoes from villa at Boscotrecase, 11 B.C. (**7.59**) Patrician with two ancestor busts, c. A.D. 13 (**7.45**) Aeneas Fleeing Troy, early 1st century A.D. (**7.65**) House of the Silver Wedding, early 1st century A.D. (**7.3**) Augustus of Prima Porta, early 1st century A.D. (**7.48**)

Unknown Barbarian (Parthian?), A.D. 20 (**7.53**) Young Woman with a Stylus, 1st century A.D. (**7.58**)

Landscape with Boats, 1st century A.D. (**7.60**) Roman forums, A.D. 46–117 (**7.11**) Hercules Strangling the Serpents, A.D. 63–79 (**7.62–7.63**) Colosseum, A.D. 72–80 (**7.19–7.20**) Still Life of Silver Objects, A.D. 75–76 (**7.61**) Arch of Titus, A.D. 81 (**7.38–7.39**) Portrait of a young Flavian lady, c. A.D. 90 (**7.46**) Portrait of an older Flavian lady, c. A.D. 90 (**7.47**)

City of Timgad, early 2nd century (**7.6**) Basilica Ulpia, 98–117 (**7.12–7.13**) Mummy case of Artemidoros, 100–200 (**7.64**) Trajan's Column, 113 (**7.34–7.35**) Trajan's markets, early 2nd century (**7.14**) Bust of Trajan, early 2nd century (**7.44**) *Insulae*, 2nd century (**7.4**)

Pantheon, c. 117–125 (**7.27**, **7.29–7.30**) Hadrian's Villa and Canopus, 118–138 (**7.8–7.9**) *Antinous,* c. 131–138 (**7.49**) Equestrian statue of Marcus Aurelius, 164–166 (**7.50**)

Circus at Leptis Magna, early 3rd century (**7.21**) Baths of Caracalla, 211–217 (**7.17–7.18**) *Caracalla*, 3rd century (**7.52**) Badminton Sarcophagus, c. 220 (**7.42**)

Arch of Constantine, c. 313 (**7.40–7.41**) Monumental head of Constantine, 313 (**7.51**) Dacian silver vase and helmet, 4th century (**7.36–7.37**)

Ovid

Another Roman poet who lived during the reign of Augustus was Publius Ovidius Naso (43 B.C.-A.D. 18), known as Ovid. His surviving poems include the Amores (which describe love in different moods) and the Heroides (love poems in the form of letters from legendary heroines to their husbands or lovers). Ovid's poetry is irreverent and witty. His longest work is the Metamorphoses, a hexameter poem in fifteen books. Its theme is the miraculous transformations of gods, and it contains a collection of Greek and Roman myths that has inspired countless works of art. In the Middle Ages, Ovid was applied to Christian themes and "moralized." During the Renaissance, especially in Italy, artists again used Ovid as an iconographic source for works depicting mythological subjects.

In A.D. 8, the emperor Augustus banished Ovid to Tomi on the Black Sea, where he died ten years later. His crime is unknown, but it may have been the immoral theme of his *Ars Amatoria*, a treatise on the arts of seduction.

renamed Constantinople (now Istanbul, in modern Turkey). After this period, the Western Empire, which had kept Rome as its capital, declined. The Goths overran the Western Empire in 476, which is considered to be the date of the fall of Rome.

In contrast to Greek art, Roman art does not show a consistent overall development of style. Instead, stylistic evolution is more clearly seen within certain types of painting, sculpture, and architecture. Further, since the Romans invented or elaborated several categories of works, this chapter is organized according to type; chronological sequences are followed within each type.

ArchitecturalTypes

During the empire, the Romans carried out extensive building programs, partly to accommodate their expanding territory and its growing population, and partly to glorify the state and the emperor. In so doing, the Romans assimilated and developed building and engineering techniques from the Near East, Greece, and Etruria. They also recognized the potential of certain building materials, particularly concrete, which allowed them to construct the monumental public buildings that are such an important part of the Roman legacy (see box).

Domestic Architecture

Roman interest in the material comforts of living led to the development of sophisticated domestic architecture. Many

examples have been preserved as a result of the eruption of Mount Vesuvius in A.D. 79. Volcanic ash covered Pompeii, near modern Naples, a port noted for agriculture and commerce; the nearby seaside resort of Herculaneum was buried in mud and lava, and was therefore more difficult to excavate than Pompeii. An eyewitness to the eruption of Vesuvius, Pliny the Younger (see box, p. 214), described the disaster from a safe distance across the Bay of Naples, yet both Pompeii and Herculaneum were forgotten until 1592, when a Roman architect digging a canal discovered some ancient ruins. Serious archaeological excavations of the buried cities did not begin until the eighteenth century, and they are still continuing today.

Roman domestic (from the Latin word domus, meaning "house") architecture was derived from both Etruscan and Greek antecedents but developed characteristics of its own. The main feature of the Roman domus was the atrium (figs. 7.2 and 7.3), a large hall entered through a corridor from the street. The atrium roof usually sloped inward, while a rectangular opening, the compluvium, allowed rainwater to collect in an impluvium (a sunken basin in the floor), from which it was channeled into a separate cistern. The compluvium was also the primary source of light in the domus. But, by the end of the first century B.C., the peristyle, with its colonnade, had become the focal point of the domus, and the atrium was little more than a foyer, or entrance hall. Additional rooms surrounding the peristyle included bedrooms, dining rooms, slave quarters, wine cellars, and storage space.

Roman Building Materials

Like the Etruscans, the Romans used brick as a basic building material. Under Augustus, however, marble became popular as a decorative facing over a brick core and was quarried in Carrara. According to Suetonius, the Roman lawyer and author of the *Lives* of the Twelve Caesars (c. A.D. 121), Augustus found Rome a city of brick and left it a city of marble. Today, much ancient Roman marble facing has disappeared because of looting, leaving visible the interior core of many buildings (e.g., the Colosseum, fig. 7.19).

Above all, the Romans built with concrete, a suitable material for large-scale public structures. Their concrete was a rough mixture of mortar, gravel, rubble, and water. It was shaped by wooden frames, and often wedge-shaped stones, bricks, or tiles were inserted into it before it had hardened, for reinforcement and decoration. Alternatively, a facing of plaster, stucco, marble, or other stone was added.

The Romans also used **travertine**—a hard, durable limestone that mellows to a golden yellow and the soft, easily carved tufa, which had been popular with the Etruscans (see Chapter 6).

Arches, Domes, and Vaults

Just as the Romans recognized the potential of concrete, which had been invented in the ancient Near East, so too they developed the arch and the **vault** (fig. **7.1**), which had previously been used in the ancient Near East and Etruria.

The round arch may be thought of as a curved lintel used to span an opening. A true arch is constructed of tapered (wedge-shaped) bricks or stones, called **voussoirs**, with a **keystone** at the center. The point at which the arch begins to curve from its vertical support is called the **springing**, because it seems to spring away from it. The arch creates an outward pressure, or thrust, which must be countered by a supporting **buttress** of masonry.

The arch is the basis of the vault—an arched roof made by a continuous series of arches forming a passageway. A row of round arches produces a **barrel** or **tunnel vault**, so called because it looks like the inside of half a barrel or the curved roof of a tunnel. It requires continuous buttressing and is a difficult structure in which to make openings for windows. Vaults formed by a right-angled intersection of two identical barrel vaults are called **groin** or **cross vaults**.

Arches and vaults have to be supported during the process of construction. This is usually done by building over wooden frames known as **centerings**, which are removed when the keystone is in place and the mortar has set.

A **dome** is made by rotating a round arch through 180 degrees on its **axis.** In its most basic form, it is a hemisphere. As is true of arches and vaults, domes must be buttressed, and, since their thrust is equally dispersed in all directions, the buttressing must be from all sides. Domes can be erected on circular or square bases. Ancient Roman domes, such as the one on the Pantheon (see fig. 7.28), were generally set on round bases. Domes on square bases are discussed in Chapter 8.

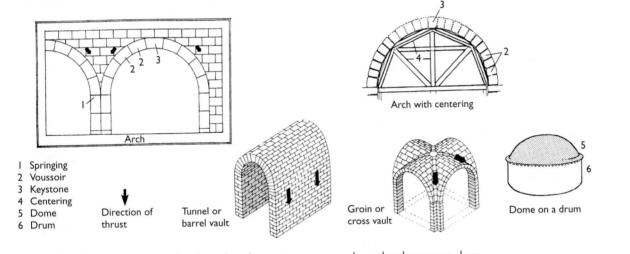

7.1 Arch, arch with centering, tunnel or barrel vault, groin or cross vault, and a dome on a drum.

7.2 (above) Plan of the House of the Faun, Pompeii, 2nd century B.C. 1. *atrium;* 2. *atrium tetrastylum;* 3, 4. courtyards surrounded by peristyles.

7.3 (right) Atrium and peristyle, House of the Silver Wedding, Pompeii, early 1st century A.D. Standing with our backs to the entrance, we can see the *compluvium* in the roof, which is supported by four Corinthian columns. The *impluvium* is in the center of the floor. Visible on the other side of the *atrium* is the *tablinium*, probably used for entertaining and for storing family documents and images of ancestors.

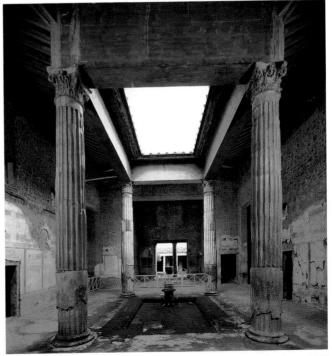

Pliny the Elder and Pliny the Younger

Gaius Plinius Secundus (A.D. 23/24–79), known as Pliny the Elder, was a Roman official who held military and civil positions in North Africa, Gaul (modern France), and Spain, and died in the eruption of Mount Vesuvius. He wrote a history of ancient art as well as works on grammar, military history, and oratory; most of his writings are lost, but his greatest achievement survives: the encyclopedic *Historia naturalis* (*Natural History*). This consists of thirty-seven books, covering topics that range from the elements of the universe, through continental geography and ethnology (of Europe, Asia, and Africa), to human physiology, zoology, botany, and the medicinal properties of plants, and discusses metallurgy as it relates to the

These houses had plain exteriors without windows. Rooms fronting on the street functioned as shops, or *tabernae* (from which we get the English word "tavern"). Behind the unassuming façades were interiors that were often quite luxurious—decorated with floor and wall mosaics, paintings, and sculptures. The typical professional or upper-class Roman house also had running water and sewage pipes.

For the middle and lower classes, especially in cities, the Romans built concrete apartment blocks or tenements, called *insulae* (the Latin word for "islands")—as in figure **7.4.** According to Roman building codes, the *insulae* could be as high as five stories. On the ground floor, shops and other commercial premises opened onto the street. The upper floors were occupied by families, who lived separately but shared kitchens and other facilities. As early as the first century A.D. Rome's urban population lived in such *insulae*. After they were burned by the great fire during Nero's reign (ruled A.D. 54–68), the *insulae* were rebuilt according to strict fire regulations. Their blocklike construction conformed to the typical town plan of the em-

use of minerals for medical purposes and to the arts. Pliny's history of ancient art remains a fundamental source.

His nephew, Pliny the Younger, produced voluminous correspondence that includes a vivid account of his uncle's role as commander of the fleet at Misenum, north of Pompeii. When he noticed a column of smoke rising from the nearby mountains, the elder Pliny launched a small boat and went to investigate. He soon realized that he was witnessing an eruption and, under a hail of stones, dictated his observations to a secretary. The next day, he went to the seashore for a closer look and was asphyxiated by the sulfurous fumes.

pire. Such plans were organized like a military camp, or *castra*, in which a square was divided into quarters by two streets intersecting in the middle at right angles. The *cardo* ran from north to south and the *decumanus* from east to west. Each quarter was then subdivided into square or rectangular blocks of buildings, such as the domestic houses and the *insulae*.

A new city, founded under the emperor Trajan (ruled A.D. 98–117) (see p. 231), in Timgad, in North Africa, followed the plan of the *castra* (fig. **7.5**). Its purpose was to provide a retirement colony for Trajan's soldiers. The plan was basically square, with gates for access to the city along roadways. Its relatively good state of preservation is seen in the aerial view in figure **7.6**, which shows the ruins of the theater, the square forum next to it, and the large triple arch spanning the cobbled road.

In addition to urban domestic architecture, the Romans invented the concept of the country **villa** as an escape from the city. Villas varied according to the tastes and means of their owners, and the most elaborate belonged to the emperors. Hadrian's (ruled A.D. 117–138) Villa

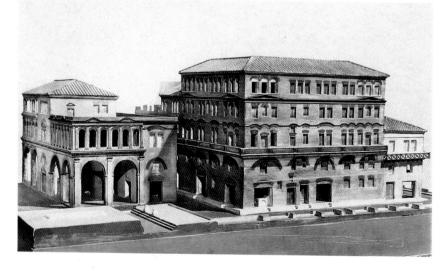

7.4 *Insula,* Ostia, reconstruction, 2nd century A.D. Brick and concrete.

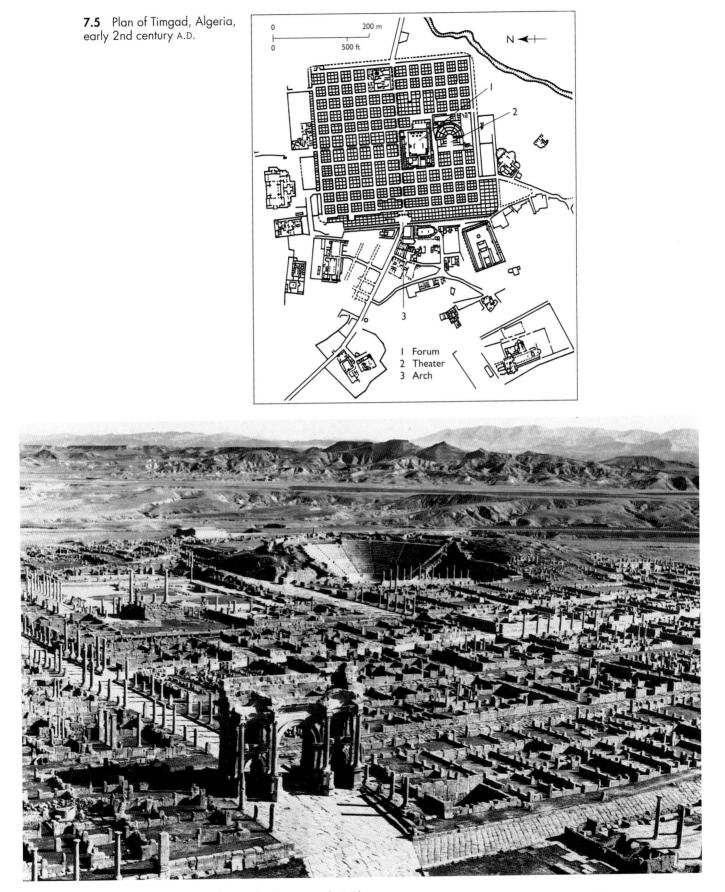

7.6 View from the west of the ruins of Timgad, Algeria, early 2nd century A.D.

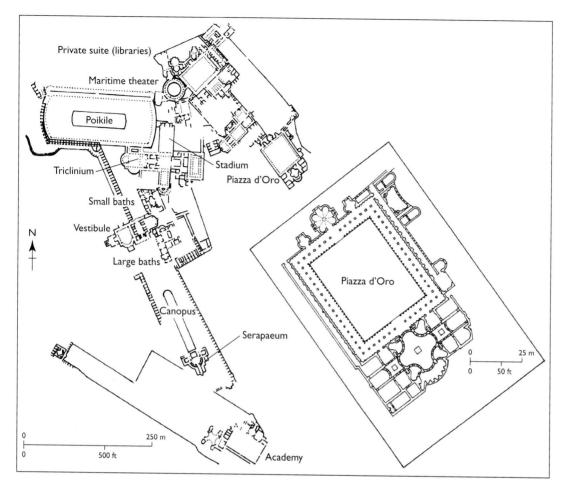

7.7 Plan of Hadrian's Villa, Tivoli, A.D. 118–138.

(fig. **7.7**), built from A.D. 118 to 138 near Tivoli, 15 miles (24 km) outside modern Rome, consisted of so many buildings—including libraries containing works in Greek and Latin, baths (fig. **7.8**), courtyards, temples, plazas, and a theater—that it occupied more than half a square mile (1.3 square km).

When Hadrian traveled, he collected ideas for his villa and later had monuments reproduced on its grounds. When visiting Alexandria, for example, Hadrian admired the Serapaeum, a temple dedicated to Serapisthe Egyptian god who combined features of Osiris, Zeus, and Hades, and was worshiped as ruler of the universe. Hadrian constructed his own canal and temple, and named them after the Egyptian temple. He used Ionic columns in his Serapaeum and Corinthian columns at the far end of the Canopus (fig. 7.9) to

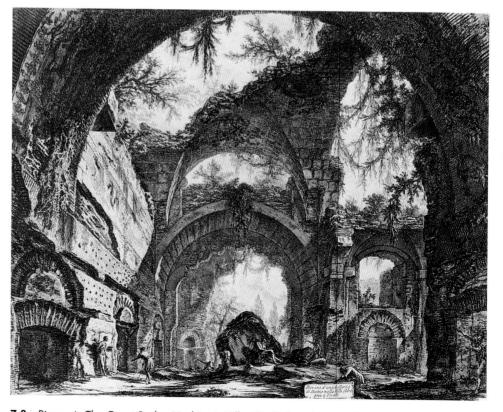

7.8 Piranesi, *The Great Baths, Hadrian's Villa, Tivoli,* from Views of Rome, 1770. Etching; 18 × 22 in. (45.7 × 55.6 cm). Istituto Nazionale per la Grafica, Rome.

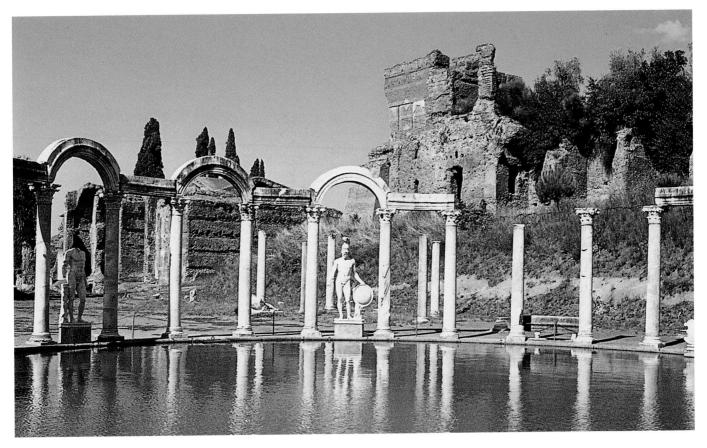

7.9 Canopus, Hadrian's Villa, Tivoli, c. A.D. 123–135.

support a structure of round arches alternating with lintels. Sculptures occupy the arched spaces and the entrance, which also contained fountains.

Public Buildings

As life in Rome and its provinces became increasingly complex, the need for public spaces and public buildings grew. Citizens gathered in open squares, and civic and administrative functions were performed in public buildings. These activities led to the development of two characteristic architectural types, the **forum** and the **basilica**.

The Forum The forum was typically a square or rectangular open space in front of a temple. Originally, the forum was a marketplace, its prototype being the smaller Greek *agora*. It was bounded on three sides by colonnades and on the fourth by a basilica (see below). This gave the forum a sense of order compared with the more random development of the *agora*. In Rome, the first known forum, the Forum Romanum, dates from the sixth century B.C. and it was this particular urban space that was conceived of as *caput mundi*. The Forum Romanum was regularly expanded during the Republic and the empire; but in the first century B.C., the Forum Julium became the prototype for all later imperial forums. Planned by Julius Caesar (see box) and completed by Augustus, it must have presented a magnificent architectural spectacle (it is now in ruins). The

Julius Caesar

Gaius Julius Caesar (c. 100–44 B.C.) was the greatest general and political figure of his generation, and an author famed in his own day for his Classical Latin prose. His sole surviving writings are the *Commentaries*, a personal account of the Gallic and civil wars. By the age of forty, Caesar shared the leadership of Rome with Pompey (his son-in-law) and Crassus, an arrangement known as the First Triumvirate (literally "Three Men"). He was consul in 59 B.C., and proconsul in Gaul (58–49 B.C.), where he waged a series of campaigns, going on to extend Roman rule north to Britain.

In 46 B.C., the senate appointed Caesar temporary dictator in order to give him the power to control growing civil unrest. Caesar used his power to enact several radical measures, including expanding the franchise of the provinces, regulating taxation, and reforming the calendar. His contempt for republicanism and his aristocratic tendencies aroused suspicion, and people feared that he intended to remain dictator permanently. On March 15, 44 B.C., a group of conspirators led by Marcus Junius Brutus and Gaius Cassius stabbed him to death, an event memorialized in Shakespeare's admonition to "beware the ldes of March," the ldes being the Roman term for the fifteenth day of the month.

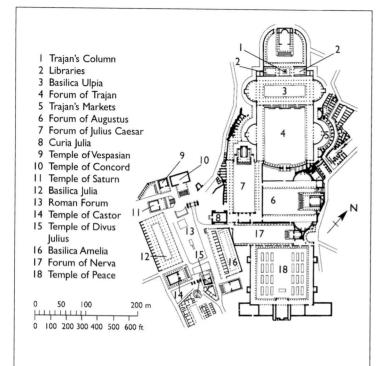

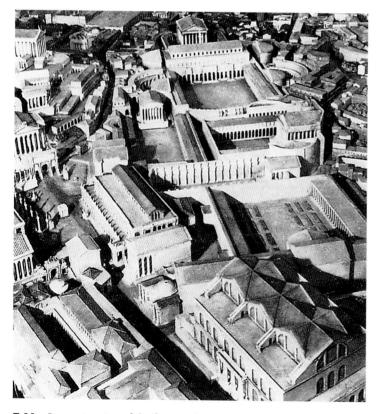

7.11 Reconstruction of the forums, Rome, c. A.D. 46–117. Museo della Civiltà Romana, Rome.

7.10 Plan of the Roman and imperial forums, Rome. When Roman civic leaders wished to address the populace, they entered the forum. Today the term *forum* refers to a place or opportunity for addressing groups of people—candidates for political office are said to have a forum for their views if they can arrange a time and place for voters to hear them speak.

plan in figure **7.10** indicates the variety of forms and the degree to which the Romans added to the basic rectangular conception of the forum, while the reconstruction in figure **7.11** illustrates the layout, fronted by a temple with colonnaded basilicas at the sides.

As a political, religious, social, and commercial center, the forum was a regular feature of most Roman town plans. Gradually, however, the shops were transferred elsewhere, and the forum remained a focal point for civic and social activity. It was a more or less enclosed space, usually restricted to pedestrian traffic. Meeting places for the town council (the *curia*) and the popular assembly (the *comitium*) were integrated into the forum.

The Basilica A basilica (from the Greek word basilikos, meaning "royal") was a large roofed building, usually at one end of a forum. It was used for commercial transactions and also served as a municipal hall and law court. According to Vitruvius (see p. 190), basilicas should be located in the warmest site so that in winter businessmen can confer in comfort. Basilicas were typically divided into three aisles: a large central aisle was flanked by smaller ones on either side, separated from one another by one or two rows of columns. The extra height of the center aisle, or nave (from the Latin word navis, meaning "ship," and derived from the idea of an inverted boat), permitted the construction of a second-story wall above the colonnades separating the nave from the aisles. Clerestory windows were built into the additional wall space to admit light into the building.

As shown in figure 7.12, Trajan's Forum adjoins the Basilica Ulpia (the name "Ulpia" comes from the gens to which Trajan belonged), which is basically rectangular in plan with an apse, or curved section, at each end. The apses contained statues of gods or emperors, provided space for legal proceedings, and often included a throne occupied by a statue of the emperor. The huge size of the basilica created a need for lighting, which the Romans solved by piercing the walls with clerestory windows above the colonnades on either side of the nave (fig. 7.13). The colonnades themselves provided an articulated space for socializing, people awaiting trial, and for those transacting business. Roofing was made of timber and covered with tiles, and the interior was adorned with marble and bronze.

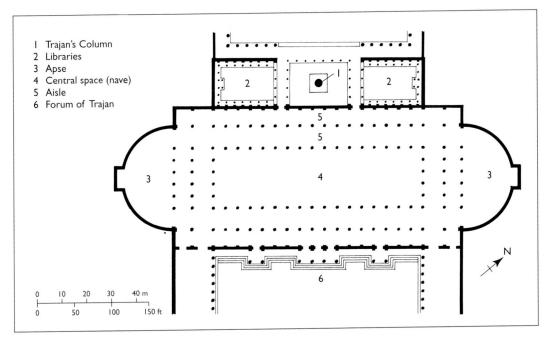

7.12 Apollodorus of Damascus, plan of the Basilica Ulpia, Forum of Trajan, A.D. 98–117.

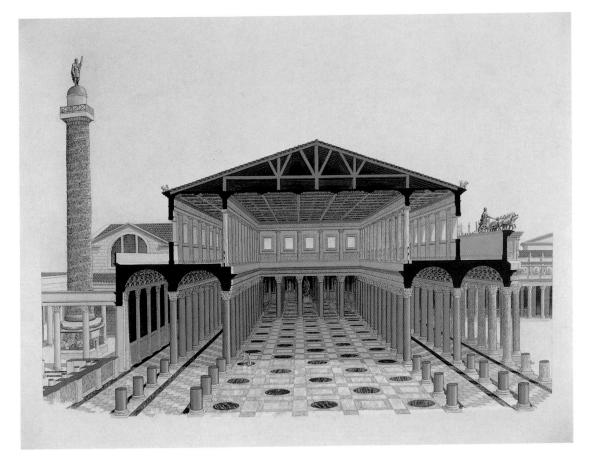

7.13 Reconstructed cross section of the Basilica Ulpia.

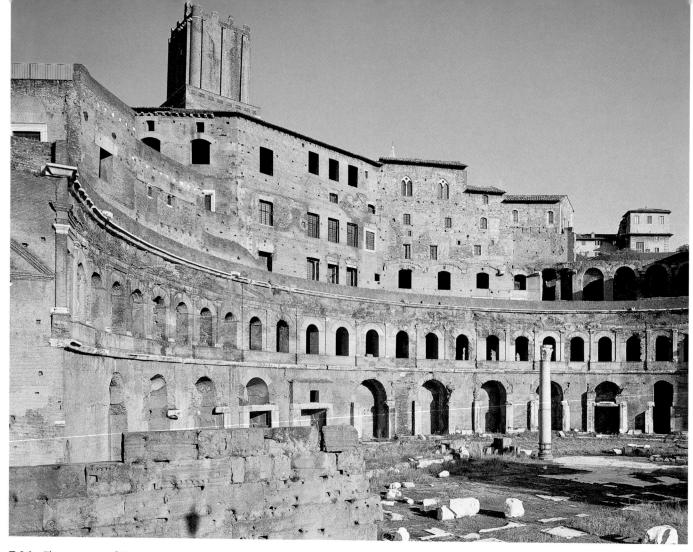

7.14 The remains of Trajan's markets as seen from the west.

The Markets of Trajan Trajan's markets were as noteworthy for their huge size as for their innovative engineering and architecture (fig. **7.14**). Their concrete core was faced with brick, with a few details in wood and stone. They were conceived as part of the total urban renovation that included Trajan's Forum (which was faced with marble); the isometric drawing of the surviving markets (fig. **7.15**) shows their structural relation to each other. Their original area is unknown, but they probably contained over 200 rooms (evidence of 127 survives today). The markets rise from the Forum along the incline of the Quirinal Hill.

The view from the west in figure 7.14 gives some idea of the imposing quality and architectural variety of Trajan's markets. They are constructed as a series of tiered, apsidal spaces with barrel-vaulted ceilings. Groin vaults were used for the main hall. In the upper levels, clerestory windows, as in the basilica, provided a source of interior lighting. The rooms housed offices and over 150 shops linked by a complex system of stairways and arcades. Shifting axes, flowing masses and spaces, and patterns of light and shadow created a dynamic interplay of solid forms with voids. As a totality, the markets served a social and commercial function for large numbers of people. The architect exploited the formal appeal of the façade, while departing from traditional columns and colonnades.

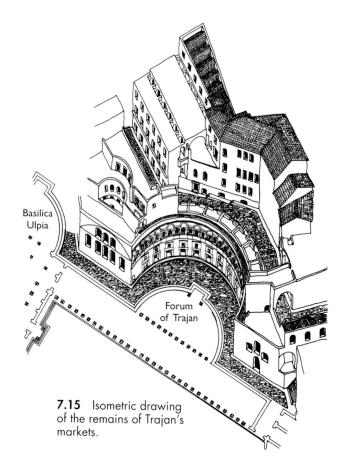

7.16 Plan of the Baths of Caracalla, Rome, A.D. 211–217. The total complex occupied approximately 35 acres (130,000 sq. m).

Public Baths Another type of monumental construction popular in ancient Rome was the public bath. Besides being a place for bathing, swimming, and socializing, the public bath was a museum filled with sculpture. It also provided facilities for playing ball, running, and wrestling. Romans attended the baths for health, hygiene, exercise, relaxation, and socializing. Amenities included a cold room (*frigidarium*), a warm room (*tepidarium*), a hot room (*caldarium*), steam rooms, changing rooms, libraries, and gardens.

Although every Roman city throughout the empire had public baths, Rome had the most. A catalogue of Roman buildings of A.D. 354 lists 952 baths of various sizes. Particularly magnificent were the vast baths of the emperor Caracalla, who ruled from A.D. 211 to 217 (figs. **7.16**, **7.17**, and **7.18**). The plan was constructed on two axes with the *frigidarium* at their intersection. As in the typical basilica construction, light entered the baths through clerestory windows and illuminated the myriad surface patterns created by marble, glass, painted decoration, and water.

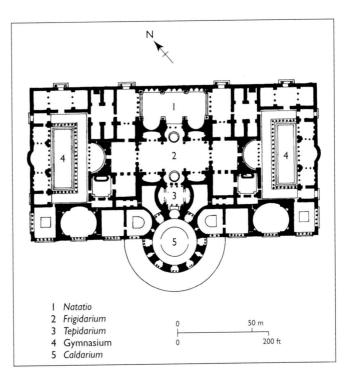

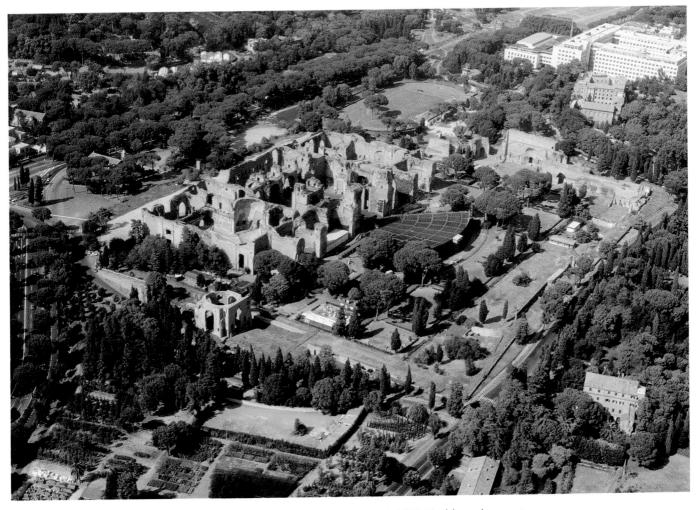

7.17 Aerial view of the ruins of the Baths of Caracalla, Rome, c. A.D. 211–217. Marble and concrete.

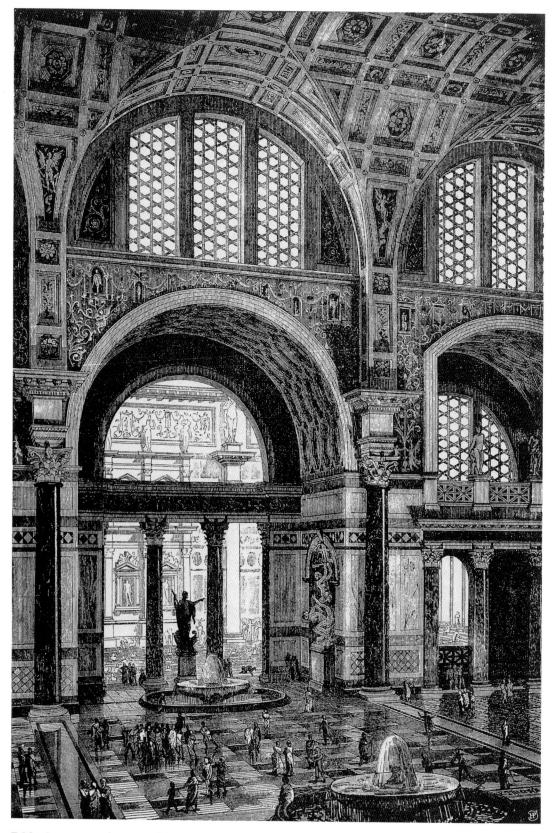

7.18 Restoration drawing of the Baths of Caracalla. The plan in figure 7.16 shows the enormous Corinthian columns that supported the groin vaults of the ceiling in this central hall.

The Colosseum Like the Greeks, the Romans built the aters for plays. In addition, the Romans built **amphithe-aters** (from the Greek words *amphi*, meaning "around" or "both," and *theatron*, meaning "theater") for spectator sports, games, and other lavish spectacles. The Colosseum (begun in A.D. 72 under Vespasian and inaugurated in A.D. 80 by his son Titus) (figs. **7.19** and **7.20**) has exterior **arcades** with three stories of round arches framed by

entablatures and engaged columns. The ground-floor columns are Tuscan (a later development of Doric), the second-floor columns are Ionic, and those on the third floor are Corinthian. On the fourth floor are small windows and engaged, rectangular Corinthian pilasters. This system, in which the columns are arranged in order of visual as well as structural strength, with the "heaviest" Doric type at the bottom, was regularly followed in Roman

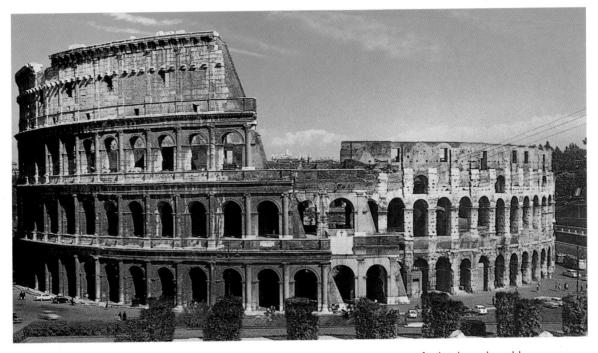

7.19 Side view of the Colosseum, Rome, c. A.D. 72–80. Concrete, travertine, tufa, brick, and marble; approx. 615×510 ft. (187.45 \times 155.45 m).

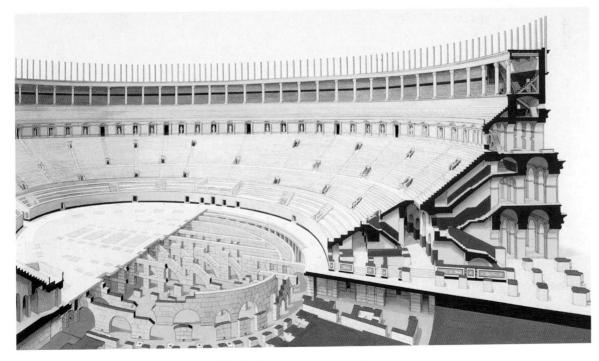

Suetonius on Nero's Golden House

The emperor Nero spent four years (A.D. 64–68) overseeing the construction of the Domus Aurea, or Golden House, so called because of its extensive use of gold decoration. It was a monument to his grandiosity. At the sight of it, Suetonius, the Roman biographer of the emperors, declared, "All Rome is transformed into a villa!"

There was nothing . . . in which [he] was more ruinously prodigal than in building. . . . Its vestibule . . . had a triple portico a mile long. There was a pond, too, like a sea . . . pastures and woods, with great numbers of wild and domestic animals. In the rest of the palace all parts were overlaid with gold and adorned with gems and mother-of-pearl. There were dining rooms with . . . ceilings of ivory, whose panels could turn and shower down flowers and were fitted with pipes for sprinkling the guests with perfumes. The main banquet hall was circular and constantly revolved day and night, like the heavens. He had baths supplied with seawater and sulphur water. When the palace was finished in this manner and he dedicated it, he deigned to say nothing more in the way of approval than that he was at last beginning to be housed like a human being.²

The entrance hall was large enough to accommodate an enormous statue of Nero, 120 feet (36.57 m) high, which he had commissioned. Because of the resentment that such egomaniacal displays engendered in the citizens of Rome, Nero's successor, Vespasian, had the statue decapitated. He then transformed it into a sun god by substituting a new head, and called this revised statue the Colossus, the origin of the name for the Colosseum.

architecture. The surface of the outer wall also becomes flatter as it rises, which carries the viewer's eye upward, while the repeated round arches of the circular arcades direct the eye around the building. The projecting cornice at the very top serves aesthetically to crown the structure.

The term *colosseum* comes from a colossal statue of Nero. Construction of the Colosseum started about A.D. 72 under the emperor Vespasian, who had come to power in A.D. 69. It was inaugurated in A.D. 80, a year after his death. More than 50,000 spectators proceeded along corridors and stairways through numbered gates to their seats. The concrete foundations were 25 feet (7.62 m) deep. Travertine (much of it dismantled and reused in the Middle Ages) was used for the framework of the piers, and tufa and brick-faced concrete were used for the walls between the piers. Originally there was marble on the interior, but it has disappeared.

The Colosseum was built around a concrete core, with an extensive system of halls and stairways for easy access. Two types of vault were used in the corridor ceilings—the simpler barrel vault and the groin vault (also called a cross vault). The upper wall was fitted with sockets, into which poles were inserted as supports for awnings; these were stretched by sailors across the open top of the arena to protect spectators from the sun. The Colosseum was designed for gladiatorial contests and combats between men and animals, or between animals alone. Because it was located over a pond formerly on Nero's property, it was possible to construct a built-in drainage system for washing away the blood and gore of combat. The Colosseum remains a monument to the political acumen of imperial Rome, offering spectacles that suited the popular taste for cruelty and violence as well as catering to the creature comforts of its citizens.

The Circus Another form of public entertainment in ancient Rome took place in the **circus**. Principally designed for chariot races, the circus could accommodate up to a dozen four-horse chariots. The resulting structures ranged in length from 1,300 to 1,970 feet (about 400 to 600 m). It has been estimated that the Circus Maximus, or Largest Circus, in Rome could hold more than 200,000 spectators. A more typical Roman circus (fig. **7.21**), dating

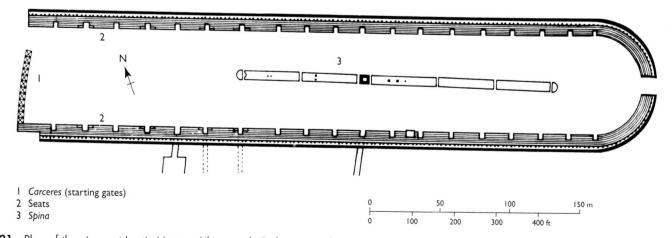

7.21 Plan of the circus at Leptis Magna, Libya, early 3rd century. The two long sides and the semicircular eastern end had seats. A low dividing wall, the *spina* ("spine"), ran up the middle of the **arena** (the sandy running surface). It was decorated with statues, fountains, and other ornaments. Conical pillars marked the ends of the wall where the contestants had to turn.

to the early third century A.D., was located at Leptis Magna, in present-day Libya, at the southern extreme of the Roman Empire.

Circus races began from the starting gates, or *carceres* (from the Latin word for "jail": cf. the English word *incarcerate*), because the gates remained closed until the race started. The race itself consisted of seven circuits in a counterclockwise direction. As the racers completed each lap, a marker indicated the number of remaining laps.

The Greek forerunners of the circus were the hippodrome for horse racing and the stadium for footracing. In Greece, however, the need for public spectacles was much more limited. The Roman populace craved entertainment, and the impetus for the huge imperial Roman building programs was as much to satisfy this craving as to express the power inherent in the emperor's ability to finance and execute them. **Aqueducts** An example of the Roman ability to turn necessity into practicality was the development of the bridge and **aqueduct** (or conductor of water, from the Latin words *ducere,* meaning "to lead," and *aqua,* meaning "water"). The most impressive example of a section of a Roman aqueduct is the Pont du Gard (fig. **7.22**), located near modern Nîmes in the south of France. Between 20 and 16 B.C., Marcus Agrippa (son-in-law and adviser to Augustus) commissioned an aqueduct system to bring water to Nîmes from natural springs some 30 miles (48.28 km) away. Much of the aqueduct was built below ground or on a low wall, but when it had to cross the gorge of the Gardon River, it was necessary to build a stone bridge to carry it.

The Pont du Gard was constructed in three tiers, each with narrow barrel vaults. Those on the first two tiers are the same size, while the third-story vaults, which carried the channel containing the water, were smaller. The top

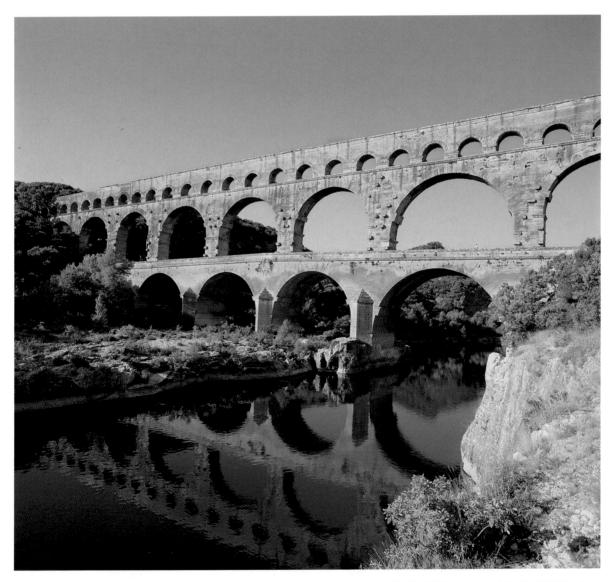

7.22 Pont du Gard, near Nîmes, France, late 1st century B.C. Stone; 854 ft. (260.30 m) long, 162 ft. (49.38 m) high. The aqueduct system maintains a constant decline of 1 to 3,000, resulting in a total drop of only 54 feet (16.46 m) over its whole length of 30 miles (48 km).

vaults and larger ones are in a ratio of 1:4. The voussoirs that make up the arches weigh up to 6 tons (6,096 kg) each. They were precisely cut to standard measurements, dressed (shaped and smoothed), and then fitted into place without mortar or clamps.

The vault system of construction was well suited to a massive engineering project such as the Pont du Gard. With the tunnel vaults arranged in a continuous series side by side, the lateral thrust of each vault is counteracted by its neighbor so that only the end vaults need buttressing. The placement of larger vaults below and smaller ones above serves both a structural purpose—support -and an aesthetic one: the repeated arches not only carry water, but also formally carry one's gaze across the river.

Reconstruction of the Parthenon.

Religious Architecture

Temples Roman temples were derived from Greek and Etruscan precedents. From Etruria came the podium (base), the high stairs, and the frontality of the temple (see Chapter 6). From Greece came the columns, the cella (equivalent to the Greek naos), the porch (pronaos), the Orders, the pediment, and the use of stone and marble. Many Greek architects worked in Rome and its provinces following the Roman conquest of Greece in 146 B.C. Their activity led to an infusion of Greek elements and a gradual shift toward the use of marble.

The Temple of Portunus (figs. 7.23 and 7.24), built in Rome in the late second century B.C., shows Greek influence in the entablature, which is supported on all four sides by slender Ionic columns. The corner columns, as in the Parthenon, serve both the long and the short sides simultaneously. Etruscan influence is apparent in the deeper porch, the raised podium, and the steps, which are restricted to the front porch and thus give the temple a welldefined frontal aspect. Later, during the empire, the frontality of the temple, raised on its podium, seemed to preside over the ritual space before it and was seen as a metaphor for the emperor's domination of the city and its inhabitants.

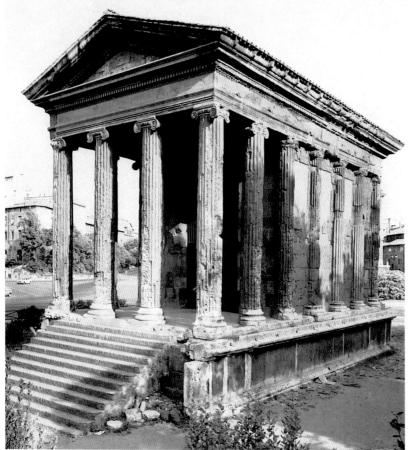

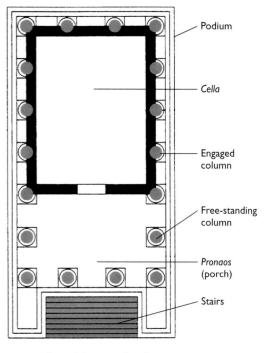

7.24 Plan of the Temple of Portunus.

One aspect in which the Roman temple differs from the Greek is in the relation of the columns to the wall. Whereas Greek temples are typically **peripteral** (surrounded by a colonnade of freestanding columns), the columns of the Temple of Portunus are freestanding only on the porch. The other columns are engaged in the back and side walls of the *cella*, hence the term *pseudoperipteral*. The Romans had thus moved beyond the Greek use of the column as the primary means of support and the colonnade as the organizing principle of architectural space. In the Temple of Portunus, the solid wall, made of rubblefaced concrete, is the supporting element, and the engaged columns, which originally were faced with travertine, have a purely decorative function.

Another Roman temple type having both Greek and Etruscan elements, and dating from the early first century B.C., can be seen in the circular Temple of the Sibyl at Tivoli (figs. **7.25** and **7.26**; see box). Like the Temple of Portunus, the Temple of the Sibyl stands on a podium. Its eighteen fluted Corinthian columns support an entablature with a continuous frieze of ox heads alternating with garlands. The steps are located only in front of the entrance. It is reminiscent of earlier round temples from Greece, of the *tholos* design of Mycenaean and Etruscan tombs, and of the round Etruscan huts (see fig. 6.9).

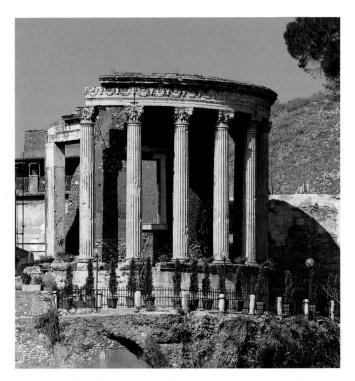

7.25 Temple of the Sibyl, Tivoli, early 1st century B.C. The foundations are of tufa, the temple itself of concrete faced with travertine ashlar. Also known as the Temple of Vesta (goddess of the hearth), the building is thought to be based on an earlier structure in Rome, where the sacred flame of the city was kept. In the eighteenth century, the column-capitals were copied for use on the façade of the Bank of England building in London.

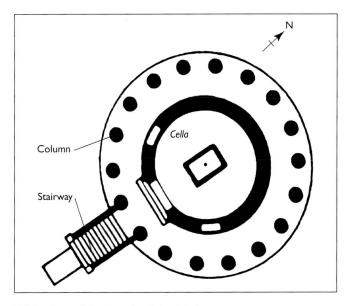

7.26 Plan of the Temple of the Sibyl.

Sibyls

Sibyls were women in Greek and Roman antiquity who interpreted events and predicted the future. They were generally priestesses presiding at oracular sites such as Delphi (see Chapter 5) and were believed to be divinely inspired. In Christian art—for example, on the Sistine Chapel ceiling (see Chapter 14)—they are often represented as having foretold the coming of Christ.

The Pantheon The round plan was used in the Pantheon, the most monumental ancient Roman temple, which was built during the reign of Hadrian (figs. 7.27-7.30). It consists of two main parts: a traditional rectangular portico supported by massive granite Corinthian columns; and a huge concrete rotunda (round structure), faced on the exterior with brick. Inscribed on the pediment of the portico is the name of Augustus's friend Marcus Agrippa, who had dedicated an earlier temple on the same site. The entire Pantheon stands on a podium with steps leading to the portico entrance. The transition from the rectangular entrance portico to the huge cylindrical rotunda creates the impression of moving from a Greek temple into a Roman space. The forecourt masked the striking absence of symmetry between the rectangular portico and the huge, cylindrical rotunda.

Once inside the rotunda, the visitor is confronted by a vast domed space illuminated only from the open *oculus* (Latin for "eye") in the center of the dome (fig. 7.30). The dome and the drum are in perfect proportion, the distance from the top of the dome to the floor being identical with the diameter of the drum. As is evident from the plan, the circle is inscribed in a square. The marble floor consists of

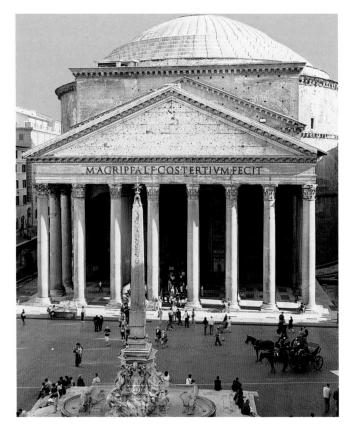

7.27 Exterior view of the Pantheon, Rome, A.D. 117–125. Marble, brick, and concrete. The Pantheon was dedicated in a literal sense to all (*pan*) the gods (*theoi*)—specifically, to the five planets then known (Jupiter, Mars, Mercury, Saturn, and Venus) and possibly also to the sun and moon.

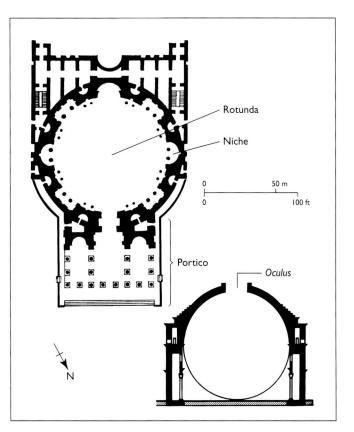

7.28 Plan and section of the Pantheon. The section shows the thickness of the dome tapering toward the top, from approximately 20 to 6 feet (6.09–1.83 m). Note the stepped buttresses on the lower half of the dome.

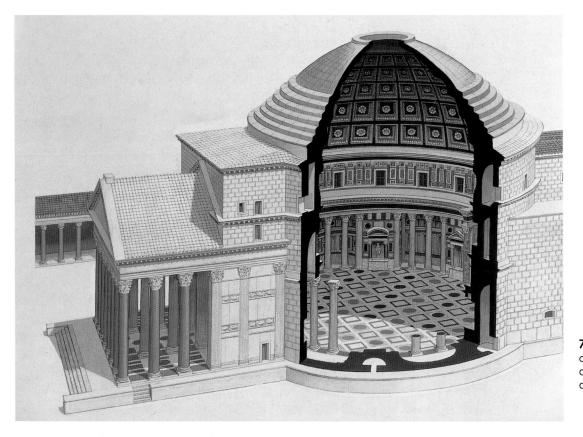

7.29 Reconstruction of the Pantheon with a cutaway of the dome.

7.30 Giovanni Paolo Panini, *The Interior* of the Pantheon, c. 1740. Oil on canvas; 4 ft. 2½ in. × 3 ft. 3 in. (1.28 × 0.99 m). National Gallery of Art, Washington, D.C. Samuel H. Kress Collection.

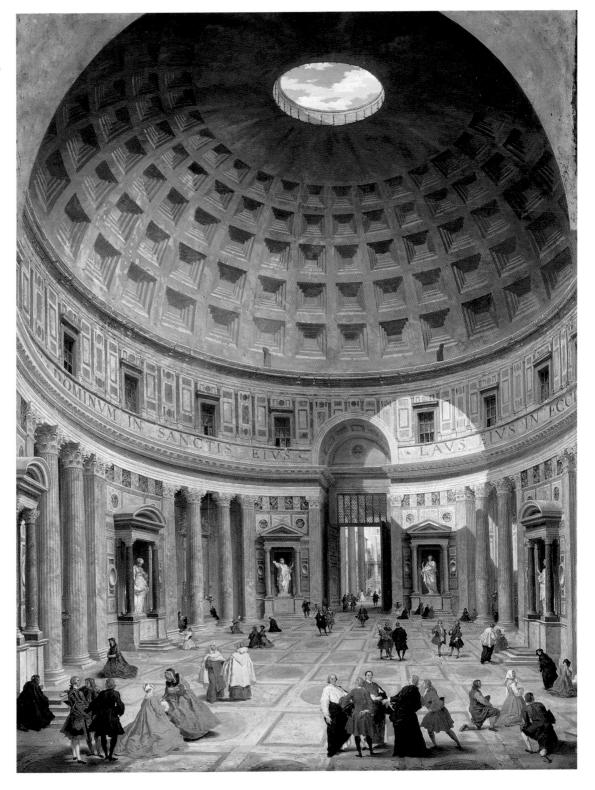

patterns of circles and squares, and the walls contain niches (each one for a different deity) with Corinthian columns supporting alternating triangular and rounded pediments. Between each niche is a recess with two huge columns flanked by two corner pilasters. A circular entablature forms the base of a short "second story." This, in turn, bears the whole weight of the dome, which is channeled down to the eight piers.

The dome itself has five **coffered** bands (rows of recessed rectangles in the ceiling), diminishing in size to-

ward the *oculus*. These reduce the weight of the structure and also create an optical illustion of greater height. The coffers were originally painted blue, and each had a gold rosette in the middle, enhancing the dome's role as a symbol of the sky—the dome of heaven. The blue paint repeated the blue sky that was visible through the *oculus*, which cast a circle of light inside the building. This reminded ancient visitors of the symbolic equation between the sun and the eye of Jupiter, the supreme celestial deity of Rome.

Commemorative Architecture

An important category of Roman architecture was developed specifically to commemorate the actions of individuals, usually emperors or generals.

The Ara Pacis The most symbolic marble monument of Augustus's reign was the Ara Pacis (Altar of Peace; fig. 7.31), built between 13 and 9 B.C. It was located on the exercise ground, the Campus Martius (literally the "field dedicated to Mars," god of war), and its purpose was to celebrate the *pax Augusta*, or "Peace of Augustus," after the emperor had made peace with the Gauls and returned to Rome. Like the later Pantheon, the Ara Pacis resolves the conflict between native tradition and Greek culture, and marks the beginning of truly Roman art.

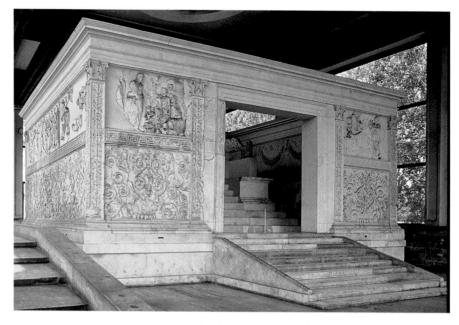

The actual altar (visible here through an opening in the enclosure), which was originally not covered, stood on a podium. Whereas the altar recalled the primitive open-air altars of early Roman times, the reliefs on the exterior of the marble frame were executed in a Classical Greek style. They depict Greek motifs, such as the processional frieze, but the subjects of the reliefs are Roman.

Elegant vine-scroll **traceries**, indicating peace and fertility under Augustus, are represented on the lower half of the frame, while the upper half illustrates the actual procession that took place at the founding of the altar. On the

7.31 West side of the Ara Pacis (Altar of Peace), Rome, 13–9 B.C. Marble; outer wall approx. 34 ft. 5 in. \times 38 ft. \times 23 ft. (10.49 \times 11.58 \times 7.01 m).

north side, senators and other officials, some with wives and children, are shown proceeding to the entrance. The south side depicts members of the imperial family (fig. **7.32**). Not seen in this illustration, the figure of Augustus has his head draped in the manner of the *Pontifex Maximus* (highest priest), the title denoting his role as the state's religious leader. Visible at the left of the relief illustrated are his wife, Livia, and Agrippa, whose covered

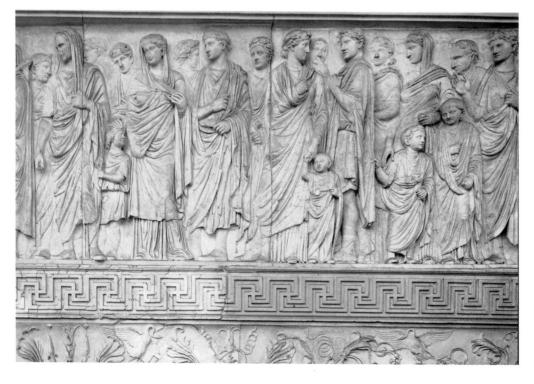

7.32 South side of the Ara Pacis, showing a detail of an imperial procession. Marble relief; approx. 5 ft. 3 in. (1.60 m) high.

7.33 Ara Pacis, showing a detail of a child tugging at an adult's toga. Note the artist's careful observation of human nature in the child's chubby rolls of fat around his ankles and dimpled elbows and knees. He is tired of walking and wants to be picked up and carried. Such accurate psychological characterization of specific age-related behavior is consistent with the Roman interest in portraiture.

head indicates that he is carrying out a religious rite. The presence of children (fig. **7.33**) refers to the dynastic aims of Augustus, who hoped to found a stable system of succession for the government. He also wanted aristocrats to reproduce, and he granted tax relief for large families, encouraging traditional morality and the importance of the family as an institution.

In contrast to the Greek frieze of the Parthenon, which depicted the Panathenaic procession that took place every four years, the Ara Pacis commemorates a specific event and portrays an actual procession with almost journalistic precision. It includes portraits of the individuals (the priests and others) who participated in the ritual.

Techniques of carving also differ, for the Ara Pacis is in higher relief than the Panathenaic procession, satisfying the Roman taste for spatial illusionism. The highest relief is reserved for the more prominent foreground figures, whose feet project from the base.

Visitors approached the altar by a stairway located on the western side. Each year, magistrates, priests, and vestal virgins (virgins consecrated to the service of Vesta, goddess of the hearth) made sacrifices on it. They ascended the stairs, entered the sacred space, and performed the sacrifices while facing east, toward the sunrise.

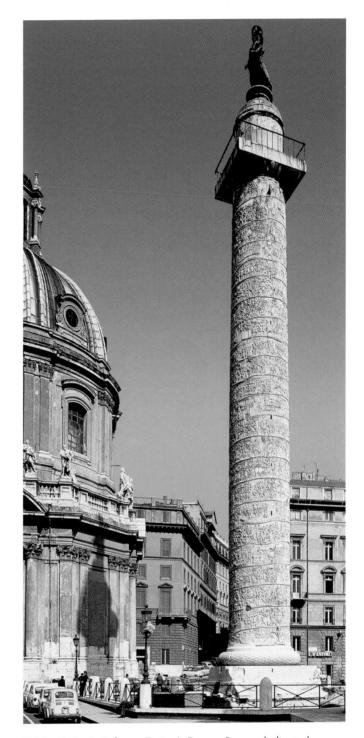

7.34 Trajan's Column, Trajan's Forum, Rome, dedicated A.D. 113. Marble; 125 ft. (38.10 m) high, including base; frieze 625 ft. (190.50 m) long. Although the upper scenes could not have been seen from the ground, they would have been visible from the balconies of nearby buildings. A gilded bronze statue of Trajan, since destroyed, originally stood at the top of the column. It has been replaced by a statue of Saint Peter.

Trajan's Column Single, free-standing, colossal columns had been used as commemorative monuments since the Hellenistic period. The unique Roman contribution was the addition of a documentary, ribbonlike narrative frieze, best exemplified in Trajan's Column (fig. **7.34**), which was completed by A.D. 113. It was erected in honor of the emperor's

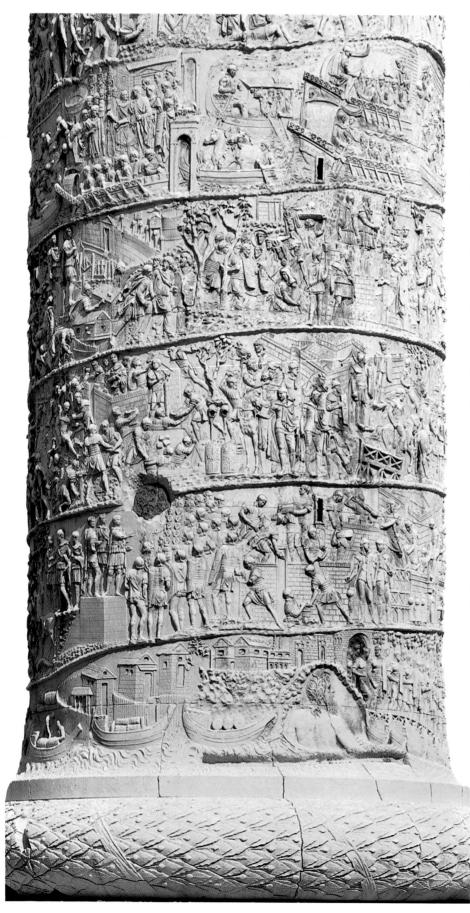

victories over the Dacians, the inhabitants of modern-day Romania (see box). There were originally two libraries flanking the column, one for Greek texts and the other for Latin.

The column consists of marble drums cut horizontally and imperceptibly joined together. Supporting it is a podium decorated with sculptures illustrating the spoils of war and containing a repository for Trajan's ashes. Inside the column shaft, a spiral staircase was illuminated by openings cut into the marble. The exterior shaft is covered with a continuous low-relief spiral sculpture over 625 feet (190.50 m) long and containing some 2,500 figures. In the first three bands of the spiral, at the beginning of the narrative (fig. 7.35), the Roman army prepares its campaign. On the first level, the personification of the giant bearded river god of the Danube appears under the arch of a cave. He watches as Trajan leads the Roman army out of a walled city. Boats and soldiers fill the river. The second level contains army camps, war councils, reconnaissance missions, and the capture of a spy. Background figures are raised above foreground figures, virtually eliminating any unfilled space. Zigzagging buildings faced with brickwork patterns and the diagonals of the boats add to the sense of surface movement. The formal crowding conveys the bustling activity of armies preparing for war. A powerful commemorative statement and campaign record, the frieze on Trajan's Column is one of the most informative historical documents of life in the Roman army.

7.35 The five lowest bands of Trajan's Column (detail). Marble relief; each band 36 in. (91.4 cm) high.

The Dacians

The Dacians, an Indo-European people related to the Thracians of northern Greece, occupied an area of modern Romania along the Danube. Because of their expertise in metallurgy, especially in working precious material such as gold and silver, they were a natural target for Roman conquest. In A.D. 101, the Romans under Trajan began campaigning against the Dacians and by 106 had occupied the whole country. The wealth of Dacian booty taken by Trajan paid for many Roman buildings and lavish gifts for his soldiers. It also helped to finance the soldiers' retirement colony at Timgad (see p. 214).

7.36 Dacian vase in the shape of a human head, 4th century. Silver; 6½ in. (16.5 cm) high. National History Museum, Bucharest.

The Triumphal Arch The triumphal arch was another Roman innovation that commemorated the military exploits of a victorious general or emperor. It marked a place of ritual passage into a city at the head of an army. These symbolic triumphal arches stood alone and were different from the arches in the city walls, which served as entrances for the populace. The earliest surviving examples of the triumphal arch precede the reign of Augustus by a century. They typically consisted of a rectangular block enclosing one or more round arches, and a short barrel vault like those on the Pont du Gard (see

7.37 Dacian helmet, 4th century. Gilded silver; 3½ in. (8.0 cm) high. National History Museum, Bucharest.

Two objects discovered in a Thracian tomb of the fourth century A.D., which was excavated in 1971, convey some idea of Dacian wealth. The tomb itself was built around a wooden core, approached, as at Mycenae, by a dromos. Two funerary rooms yielded precious objects and a chariot. The silver vase in figure **7.36** is in the form of a human head, with stylized plant forms across the forehead and a ring of vases on the neck. The inlaid pupils have disappeared. Characteristics of Greek sculpture and of ancient Near Eastern stylizations indicate the assimilation of features from different Mediterranean cultures. The helmet (fig. 7.37), with a pair of apotropaic eyes on the front, provides further evidence of such assimilation—in this instance, probably of Scythian influence. The eyes and ears give the helmet an anthropomorphic quality related to that of the vase. Certain details, notably the plant forms and the horned animals depicted in relief at the sides, combine stylization with naturalism in a manner reminiscent of Achaemenid art (see Chapter 2).

fig. 7.22). Most triumphal arches had either one or three openings. Pilasters framed the openings and supported an entablature, which was surmounted by a rectangular **attic**. This usually bore an inscription and supported sculptures of chariots drawn by horses or, occasionally, by elephants (of which none are extant). Chariots stood for the triumphal and divine power of the emperor, and elephants, imported from Africa, were owned only by emperors. Because of their bulk, strength, and long life, they were symbolic of the emperor's power and immortality.

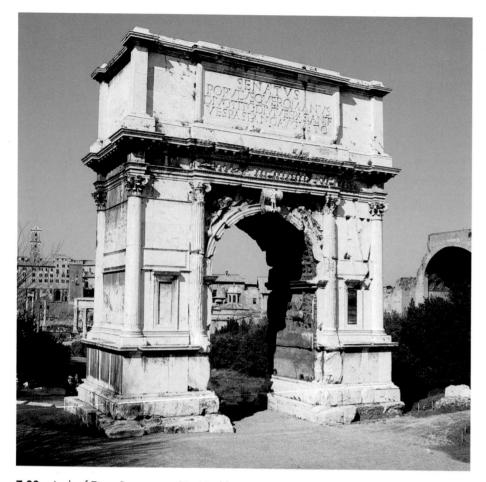

7.38 Arch of Titus, Rome, A.D. 81. Marble over concrete core; approx. 50 ft. (15.24 m) high, approx. 40 ft. (12.19 m) wide. The arch stands on the Via Sacra, or Sacred Way, in Rome. The Latin inscription on the attic proclaims that "the senate and people of Rome (SPQR) [dedicate the arch] to divine Titus, Vespasian Augustus, son of divine Vespasian."

The Arch of Titus (fig. 7.38), erected in A.D. 81 to commemorate Titus's capture of Jerusalem and suppression of a Jewish rebellion in A.D. 70-71, has a single opening. Its columns are of the Composite Order, a Roman Order combining elements of Ionic and Corinthian. On the spandrels (the curved triangular sections between the arch and the frame), winged Victories hold laurel wreaths. Reliefs, on either side of the piers (large rectangular supports) forming the passageway, depict scenes of Titus's triumphs. In the center of the vault (not visible in fig. 7.38), Titus is carried up to heaven on the back of an eagle, representing his apotheosis.

In a relief on the inner wall (fig. **7.39**), Titus's soldiers carry off their booty from the Jewish wars (see box). As in the frieze of the Ara Pacis, the figures project illusionistically from the surface of the relief. Soldiers raise the menorah (the sacred Jewish candelabrum with seven candlesticks), whose weight and prominence reflect

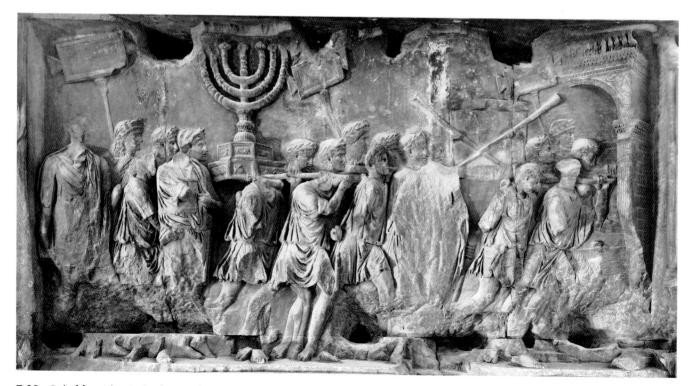

7.39 Relief from the Arch of Titus, detail showing the spoils of the temple of Jerusalem carried in a triumphal procession. Marble; 6 ft. 7 in. (2.00 m) high.

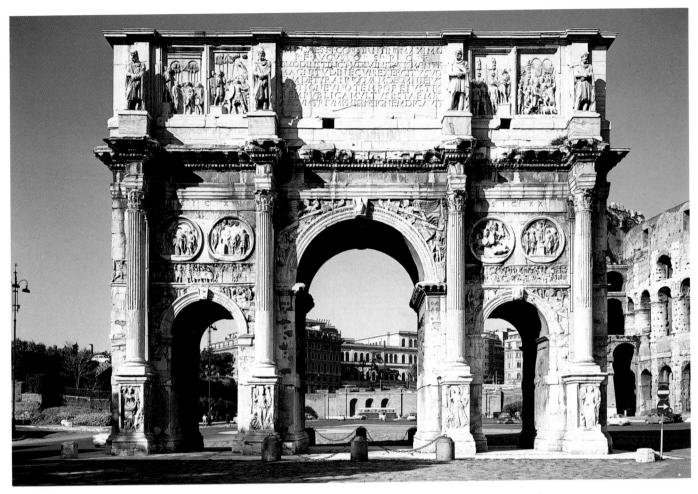

7.40 Arch of Constantine, Rome, c. A.D. 313. Marble; 70 ft. (21.33 m) high, 85 ft. 8 in. (26.11 m) wide.

its importance for the Jews and hence its role as a symbol of Roman victory. The base of the menorah is carved in perspective, reflecting the Roman taste for spatial effects and optical illusion.

Over two hundred years after the dedication of the Arch of Titus, the emperor Constantine the Great (ruled A.D. 306–337) erected the largest triumphal arch in Rome, near the Colosseum (fig. **7.40**). It commemorated his as-

sumption of sole imperial power in 312, after defeating his rival Maxentius at the Battle of the Milvian Bridge. This elaborate arch with three openings is decorated both with original reliefs and with those removed from earlier monuments in honor of other emperors (Trajan, Hadrian, and Marcus Aurelius; see below).

The juxtaposition of reliefs from different periods illustrates certain changes that took place in Roman sculpture

Josephus on the Jewish Wars

Josephus (c. A.D. 37–100), a Jewish soldier and historian, wrote a history of the Jewish wars that covers the capture of Jerusalem by Antiochus Epiphanes in 170 B.C. to Titus's seizure of Jerusalem in A.D. 70 (which he witnessed). Under the Flavian emperors (Vespasian, Titus, and Domitian, who together ruled from A.D. 69 to 96), Josephus was granted Roman citizenship, and he favored cooperation with the Romans. His history includes a description of the triumphal procession celebrating the victory of Vespasian (ruled A.D. 69–79) and his son Titus (ruled A.D. 79–81) after the sack of Jerusalem. His account reflects the Roman love of material splendor and its role in projecting an image of imperial power. He was struck by the abundance of gold and silver objects, which flowed "like a river," by the Babylonian tapestries, and by jewels set in golden crowns. "The most interesting of all," he wrote,

were the spoils seized from the temple of Jerusalem: a gold table weighing many talents, and a lampstand, also made of gold, which was made in a form different from that which we usually employ. For there was a central shaft fastened to the base; then spandrels extended from this in an arrangement which rather resembled the shape of a trident, and on the end of each of these spandrels a lamp was forged. There were seven of these, emphasizing the honor accorded to the number seven among the Jews.³

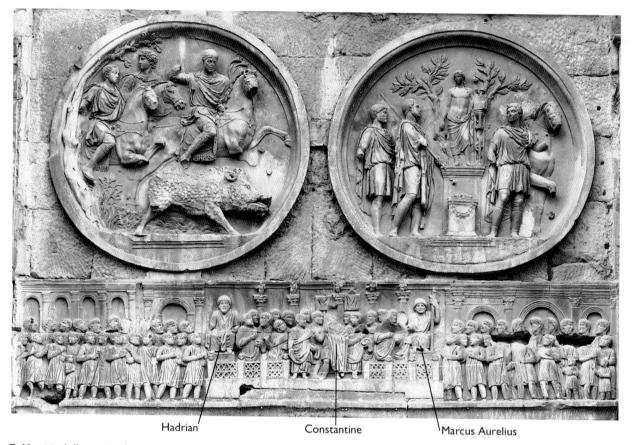

7.41 Medallions (Hadrianic, A.D. 117–138) and frieze (Constantinian, early 4th century) from the Arch of Constantine, Rome. Frieze approx. 3 ft. 4 in. (1.02 m) high.

in the course of the empire. The medallions in figure **7.41** are *spolia*, which are pieces taken from older reliefs and reused in new ones. They date from the early decades of the second century A.D. and are thought to be Hadrianic. On the left, three riders in a landscape hunt a boar. On the right, three worshipers stand before an altar of Apollo.

The horizontal reliefs below the medallions date from Constantine's reign. Constantine himself, now headless, sits at the center and makes a public speech. At either end are statues of Hadrian and Marcus Aurelius, both of whom were influenced by Greek taste. Lined up and listening to Constantine are figures accented by the arrangement of arches and columns. The style of the later reliefs is less naturalistic, more stylized and patterned, than that of the medallions: the proportions of the figures are stubbier, their heads are enlarged, their poses are more repetitious, and their carving is flatter. Since we do not know why reliefs of two different periods appear on the same arch, it is difficult to explain their iconographic relationship or even to confirm that there is one. What is clear, however, is the stylistic change. The reliefs belonging to Constantine's reign are more abstract than the Classical naturalism of the Ara Pacis and the Arch of Titus.

SculpturalTypes

Sarcophagi

The Romans produced three basic types of funerary art. Graves were marked in the Greek style by stelae or tombstones with inscriptions, reliefs, or both. Like the Etruscans, Romans used cinerary urns for cremation. But the most typical item of funerary art for the Romans was the sarcophagus, which had been used by the Etruscans and became an expression of status under Hadrian.

The early third-century sarcophagus in figure **7.42** reflects the symbolic use of Greek iconography in Roman art. Four standing nude males representing the seasons occupy *contrapposto* poses reminiscent of the *Doryphoros* (see fig. 5.27), but these are now more self-consciously affected, and the anatomy is differently proportioned. At the center, Bacchus sits astride a panther and holds a *thyrsos* (a phallic staff surmounted by a pine cone). The other figures are traditional participants in Bacchic rites—satyrs, goats, Cupids, and maenads (frenzied female followers of Bacchus). Foliage motifs refer to vines and thus to Bacchus's role as the god of wine.

7.42 Bacchus and the Four Seasons (the so-called Badminton Sarcophagus, named for the residence of its former owners in Great Britain), c. A.D. 220. Marble; 3 ft. 3 in. (99.1 cm) high. Metropolitan Museum of Art, New York. Joseph Pulitzer Bequest.

Portraits

Portraiture can be a means of keeping the deceased alive in memory. When the subject of a Roman portrait was an emperor, the image was also a means of extending his authority throughout the empire.

One of the portrait types most characteristic of Rome was the head detached from the body, or **bust**. Busts were usually carved in marble, often from a wax death mask, so that even the most specific physiognomic details—warts and all—were preserved. The portrait of Julius Caesar in figure **7.43** is clearly a likeness, its small but penetrating eves contrasting with the deep spaces under the eye-

brows. Indentations are carved under the cheekbones, creases spread from the sides of the nose, and the figure's left ear is slightly higher than the right. Such facial details create the impression of a specific personality, confident and self-assured, as one would expect of a great general and statesman.

The bust of Trajan, dating from the first half of the second century A.D., is one of many that survive (fig. **7.44**). Known as *optimus princeps*, meaning "the best leader," Trajan was a popular emperor. He improved the quality of life for Roman citizens—for example, establishing the retirement colony at Timgad. He was also considered a military genius, as commemorated in his column (see fig. **7.34**).

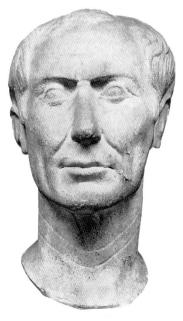

7.43 Bust of Julius Caesar, from Tusculum, mid-1st century B.C. Marble; 13 in. (33.0 cm) high; head 8% in. (22.0 cm) high. Museo di Antichità, Turin.

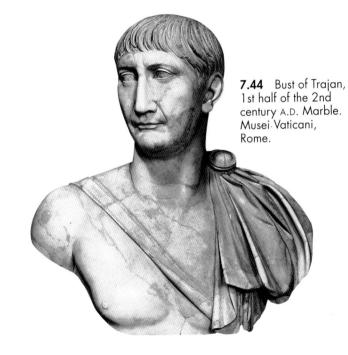

The portrait bust of Trajan shows the characteristic smooth hair covering his forehead, the long nose, and the prominent chin. The abrupt turn of his head suggests his alert attention to the welfare of his subjects.

The statue of the patrician with two ancestor busts (fig. 7.45) reflects the importance the Romans placed on preserving family genealogy in stone. The two ancestral images are elderly and appear serious. They are original, but the head of the patrician is a later substitute. The folds of the toga (the round-edged outer garment worn in public by Roman citizens) draw our attention to the two heads. A series of short, horizontally curved folds directs us from the patrician's waist to the bust at the left. A contrasting group of longer folds curves up gradually from the hem to the bust at the right. The toga thus creates a formal unity between the patrician and his ancestors that condenses time by bridging the gap between the dead and the living.

Portraits of upper-class Roman women became popular in the first century A.D.

7.45 Patrician with two ancestor busts, c. A.D. 13. Marble; life-sized. Museo Capitolino, Rome.

> Those illustrated here contrast the elaborate coiffure of a young Flavian lady (fig. 7.46) with the more subdued hairstyle of an older woman (fig. 7.47). The young woman wears the characteristic curls framing the face and rising upward in a top-heavy fashion. Deep carving creates strong oppositions of light and dark that add to the sense of mass supported by the delicate, smoothly carved surfaces of the face and neck. The older woman's wrinkles and bags under the eyes reveal the results of aging. Her hair weighs down on her head rather than rising up like that of the young woman, and thus corresponds to the "weight" of her

7.46 Portrait of a young Flavian lady, c. A.D. 90. Marble; 2 ft. 1 in. (63.5 cm) high. Museo Capitolino, Rome. Chronology can be determined by women's hair styles in Roman art because women tried to imitate the fashion of the current empress.

7.47 Portrait of an older Flavian lady, c. A.D. 90. Marble;9½ in. (24.1 cm) high. Museo Laterano, Rome.

age. It also shows the respect accorded "older and wiser" citizens of Rome.

One of the most important subjects of Roman sculpture in the round was, naturally, the emperor himself. In the Augustus of Prima Porta (fig. 7.48), the emperor is portrayed as both orator and general. Even though the head is a likeness, it is idealized. Augustus was seventy-six when he died after a long reign, but this statue represents a self-confident, dominating, and, above all, youthful figure. A possible source for this idealization is the Doryphoros of Polykleitos (see fig. 5.27). The similar stance suggests that the artist who made the Augustus was familiar with the Greek statue, probably from Roman copies.

The iconography of this statue emphasizes the power of Rome embodied in Augustus as emperor. By his right leg, Cupid (Venus's son) rides a dolphin and serves as a reminder that Augustus traced his lineage to Aeneas (also a son of Venus) and was thus descended from the gods. Among the little reliefs carved on Augustus's armor is Mother Earth with a cornucopia. This refers to the emperor's identification with the land as a source of plenty and to divine favor that has conferred power on Rome, giving it dominion over the earth. The association of Augustus with the earth also has an implied reference to Roman territorial conquests just as the canopy spread out

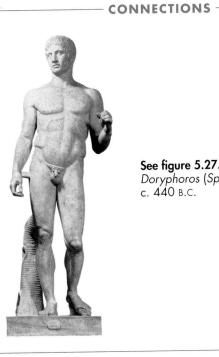

See figure 5.27. Polykleitos, Doryphoros (Spear Bearer), с. 440 в.С.

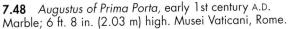

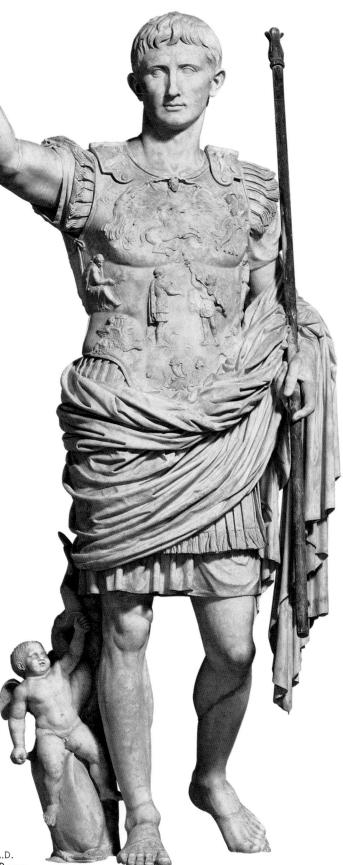

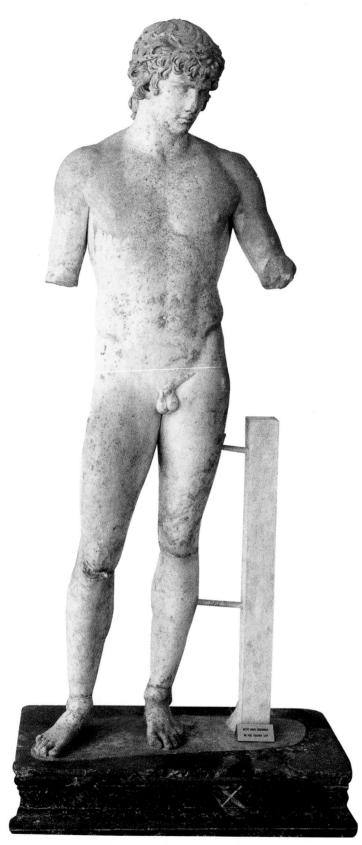

7.49 Antinous, c. A.D. 131–138. Marble; 70% in. (180.0 cm) high. Archaeological Museum, Delphi. When Antinous drowned in the Nile in 130, Hadrian was desolate. Priests tried to console him, saying that his beloved had become a star in the constellation of Aquila (the eagle).

by a sky god at the top of the breastplate indicates that Rome is under the protection of the gods. Another scene depicts a Parthian returning a military standard looted from the Romans.

The back of the *Augustus of Prima Porta* is unfinished, indicating that the statue was intended for a niche. Augustus is armed and raises his right hand to address his troops. The fact that he is barefoot may be a reference to his divinization or may indicate that the statue occupied a private space. The Roman deification of Augustus after his death harks back to the equation of god and ruler that was widespread in the ancient world.

The portrait statue of Antinous represents the Bithynian youth of great beauty who was the favorite of the emperor Hadrian (fig. **7.49**). The style of the work reflects Hadrian's attraction to Greek art and philosophy. Antinous drowned in the Nile in A.D. 130, and, after his death, Hadrian founded an Egyptian city (Antinoopolis) in his honor and dedicated many statues to him throughout the Roman Empire. Hadrian donated this particular statue to Apollo's sanctuary at Delphi (see Chapter 5). The relaxed pose, idealization, and naturalistic form of the *Antinous* recall the Classical style of the fifth century B.C. in Greece, and it is likely that it was carved by a Greek artist. The head, with its luxurious curls, and fleshy body reflect Hellenistic influence.

A type of imperial portrait invented by the Romans is the equestrian monument. The only surviving example is an equestrian bronze statue of the emperor Marcus Aurelius (reigned A.D. 161–180) (fig. **7.50**; see box). His beard conforms to the Greek fashion set by Hadrian and signifies that he is a philosopher. Greek influence also explains the organic form of the emperor and his horse. Veins, muscles, and skin folds of the horse are visible as he raises his right foreleg, turns his head, and lifts his left hind leg so

Marcus Aurelius: Emperor and Philosopher

Marcus Aurelius (ruled A.D. 161–180) was a Stoic philosopher and author of the *Meditations*, which he wrote in Greek. He had been interested in the arts from his youth and had the greatest respect for artists. "In their devotion to their art," he wrote, "[they] wear themselves to the bone, and immersing themselves in their tasks, go without washing or eating."⁴ Despite Marcus Aurelius's admiration for artists, however, he agreed with Plato (see Chapter 5) that art was mere imitation (*mimesis*) and, therefore, inferior to nature. that only the tip of his hoof touches the ground. His apparent eagerness to set out is controlled and counteracted by the more sedate emperor, who originally held reins that have since disappeared.

In the fourth century, the emperor Constantine, depicted in a colossal marble head, over 8 feet (almost 3 m) high, which is detached from its body (fig. **7.51**), expressed power in a different way. The head is clearly a portrait, as evidenced by such features as the long nose, cleft chin, clean-shaven cheeks, and thick neck; yet the predominant impression left by this sculpture is derived from its monumental size, the staring geometric eyes, and stylized hair. The restrained Classical character of earlier imperial sculptures has now disappeared, giving way to a new style, which expresses the emperor's power and makes him seem aloof from his subjects.

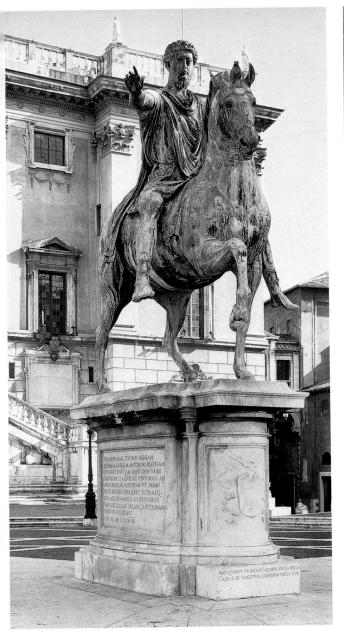

7.50 Equestrian statue of Marcus Aurelius (before restoration), A.D. 164–166. Bronze; 11 ft. 6 in. (3.50 m) high. Piazza del Campidoglio, Rome. In this statue, the emperor is unarmed, and his right arm is extended in the conventional gesture of an orator. But domination and conquest are implied by equestrian iconography. Documents indicate that a conquered enemy originally cowered under the horse's raised foreleg.

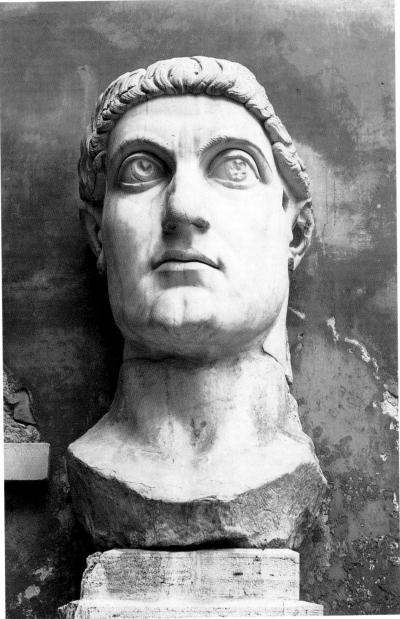

7.51 Monumental head of Constantine, from the Basilica of Constantine, Rome, A.D. 313. Marble; 8 ft. 6 in. (2.59 m) high. Palazzo dei Conservatori, Rome. The statue's original location on the throne in the apse of the basilica reflected the emperor's power over the Roman people.

Marble in Ancient Rome: Color Symbolism

The Roman interest in marble is evidenced by Augustus's reputation for having turned Rome from a city of concrete into a city of marble buildings. But sculptors as well as architects used marble, which was quarried throughout the Mediterranean—in Greece, Libya, Egypt, and Asia Minor—and imported by Rome. Different geological conditions produced marble in various colors. For example, a heavy concentration of iron in the earth produced red marble, and colliding plates of earth produced green serpentine; yellow marble is found in North Africa, white marble in Greece, and veined marble (*pavonazzetto*) in Phrygia.

Over time, Roman artists associated the nature and color of marble with specific types of figures and certain symbolic meanings. Red porphyry (the origin of the word *purple*) was the marble of choice for emperors and monumental cult statues. White was used for skin color and nudes. But in some imperial portraits, the skin is black, as it is in statues of Nubians. Figure **7.52** shows a third-century-A.D. bust of the vicious and tyrannical emperor Caracalla (ruled A.D. 211– 217) wearing red porphyry; his head and neck are of white (*lunense*) marble. The barbarian in figure **7.53**, in contrast, has black skin and a costume carved from *pavonazzetto* (white with purple veins). This represents a captive Near Easterner, possibly a Parthian, a member of the culture defeated by Augustus in A.D. 20. The figure has been reconstructed as one support of a tripod; he kneels to show his submission to the Roman emperor. The veined marble reflects the ancient Western view of Easterners as given to luxury and elegant dress—the term *pavonazzetto* means "peacock-like."

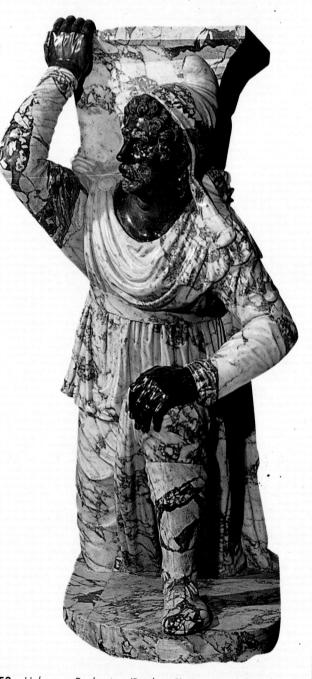

7.52 Caracalla, 3rd century A.D. Marble; 2 ft. 4½ in. (71.9 cm) high. Sala degli Imperatori, Museo Capitolino, Rome.

7.53 Unknown Barbarian (Parthian?), Augustan period. Marble; 5 ft. 3³/₄ in. (161.9 cm) high. Museo Archeologico Nazionale, Naples.

Mural Paintings

Roman murals are among the most significant legacies of the eruption of Mount Vesuvius in A.D. 79. Hundreds of wall paintings have been discovered among the ruins of Pompeii and Herculaneum. These provide the greatest evidence of Hellenistic painting, most of which no longer survive.

Roman mural paintings were executed in *buon fresco*, but with small amounts of wax added to increase the surface shine. As a result of the durability of this technique, as well as the covering of volcanic ash, many murals from Pompeii and Herculaneum have survived in relatively good condition, and they provide a remarkable panorama of Roman painting.

Scholars have divided the wall decoration of Pompeian houses into four styles, which are more or less chronological, although there is some overlap. The First Style is found during the period of the Republic (B.C.) and typically simulates the architecture of the wall itself. The Second Style begins under the Republic and continues into the early empire. The Third and Fourth Styles are imperial, ending with the eruption of Vesuvius. Each house was painted according to a particular style, depending on its chronology. As a result, the context of the house is necessary in order to determine the style of its wall paintings.

The best examples of Second Style frescoes are found at a country villa near Pompeii known as the Villa of the Mysteries. In the southwest corner, painted pilasters separate each section of a long narrative illustrating what is thought to be a mystery rite, part of a marriage ritual involving the Greek god Dionysos (Bacchus) and his wife, Ariadne (fig. **7.54**). Nearly life-sized figures, alternately real and mythological, enact the ritual on a shallow, stagelike floor that projects illusionistically beyond the surface of the wall. The vivid red background, known as Pompeian red, contributes to the dynamic and dramatic quality of the scenes. The narrative continues around the walls of the

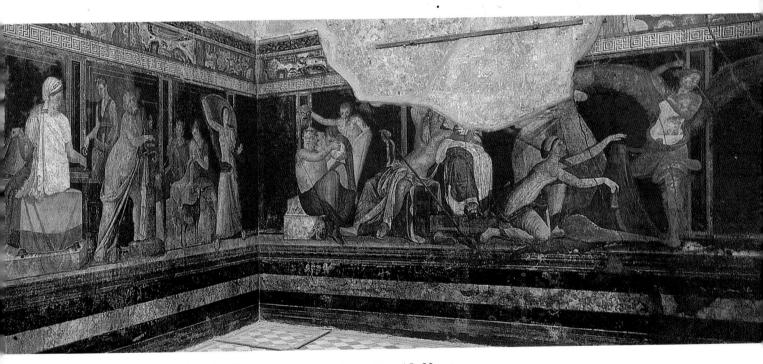

7.54 View of the frescoes at the Villa of the Mysteries, near Pompeii, c. 65–50 B.C.

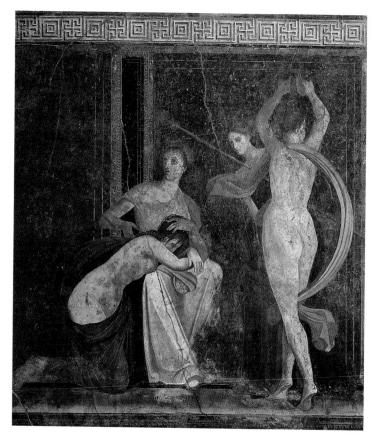

room, uninterrupted by shifts in the actual architecture. Figure **7.55** shows a girl kneeling at the lap of a seated woman while being beaten by a winged woman not visible in this illustration. To the right of the seated figure, a woman holds a *thyrsos*, and in front of her a dancing maenad (a frenzied follower of Bacchus) plays the cymbals. The organic form of the figures and their poses show the artist's command of three-dimensional space and of human anatomy, which points to the influence of Hellenistic style. Above the pilasters is an intricate meander pattern with panels imitating marble grain.

Although neither the exact meaning of these scenes nor their narrative order is agreed upon by scholars, it is clear that a sacred ritual is taking place. Its mysterious character is enhanced by the inconsistent sources of light and absence of cast shadows, which are at odds with the naturalism of the figures and the illusion of three-dimensional space. The *Dancing Satyr* (fig. **7.56**) reinforces the ritual eroticism that is a subtext of the main narrative.

A different type of Second Style painting was discovered in a house on the Esquiline Hill in Rome. The *Odyssey Landscapes* depict scenes from Books X through XII of the *Odyssey*. They transport the viewer from urban Rome to a distant mythological time and place, and depict large-scale landscapes with small figures in pale colors. Their perspective is more atmospheric than linear so that the illusion of depth increases as the forms lose clarity.

7.55 Fresco from the Villa of the Mysteries, south wall. 5 ft. 3 in. (1.62 m) high.

7.56 Dancing Satyr, fresco from the Villa of the Mysteries.

Figure **7.57** illustrates a scene from Book X. Odysseus has landed on an island inhabited by cannibalistic giants (the Laestrygonians). They pull on trees, lift up boulders, and carry off Odysseus's sailors for their dinner. Odysseus describes the attack on his men by the Laestrygonians as follows:

The mighty Laestrygonians came thronging from all sides, a host past counting, not like men but like the

Giants. They hurled at us from the cliffs with rocks huge as a man could lift, and at once there rose throughout the ships a dreadful din, alike from men that were dying and from ships that were being crushed. And spearing them like fishes they bore them home, a loathly meal.⁵

The painted scene, as in Homer's description, is filled with action. It is characterized by vigorous curves and diagonals, which are relieved by the more relaxed figures at the left. The artist's attention to details of naturalism, such as the cast shadows, the reflection of the animal drinking from a pool of water, and the background haze, again indicates Hellenistic influence. But the prevalence of landscape with human figures, like the pilaster frames, was a Roman innovation.

Portraiture was common in Roman upper-middle-class houses, and relief sculptures with round frames (tondos) were used for portraits of ancestors. But painted tondo portraits such as the Third Style Young Woman with a Stylus (fig. 7.58) were unusual. Shading enhances the cylindrical volume of the neck and the planes of the drapery folds. The head, ringed by curls, echoes the circular frame. Formal unity is thus maintained between figure and frame, yet the artist creates the impression of an individual frozen in thought. The girl wears a hairnet of the type fashionable

7.58 Young Woman with a Stylus (sometimes called Sappho), from Pompeii, 1st century A.D. Fresco; 11% in. (28.9 cm) diameter. Museo Nazionale Archeologico, Naples. The subject holds wax writing tablets in her left hand and a stylus in her right. Her contemplative expression suggests that she is pondering what to write.

7.57 Odysseus Being Attacked by the Laestrygonians, from the Esquiline Hill, Rome, c. 50–40 B.C. Fresco; 3 ft. 10 in. (1.16 m) high. Musei Vaticani, Rome.

during the reigns of Nero and Vespasian, and the stylus and book suggest that she was literate. More typical of the Third Style is the fresco in figure **7.59**, which creates the illusion of a framed painting on a flat wall. It does not depict distant landscape or narrative. Instead, the artist focuses on thin, delicate ornamentation and sets a miniature arrangement of trees, architecture, and human figures against a refined monochrome background.

A new development in Third Style fresco painting was the villa landscape, in which the architecture is increas-

7.59 Columns and pediment with pavilion, villa at Boscotrecase, near Pompeii, 11 B.C. Fresco; 7 ft. 11 in. × 4 ft. (3.65 × 1.21 m). Metropolitan Museum of Art, New York. Rogers Fund, 1920.

ingly consistent. An example from Pompeii, the *Landscape* with Boats (fig. **7.60**), shows how nature and architecture have become of primary interest, with people given less prominence than in either the Second Style or in Greek art. Here the buildings are set at oblique angles to the picture plane, which creates a convincing illusionistic recession in space. Behind the buildings are trees and mountains, the shaded surfaces of which enhance the sense of volume, while their placement toward the top of the wall makes them appear to be in the background. Human figures, notably those in the boat, occupy the foreground.

The still life of around A.D. 75–76 in figure **7.61** is an example of the Fourth Style, which combines elements from all three earlier styles. Here, silver objects are set on a table whose spatial projection is indicated by its diagonal recession. The solidity of the silver is indicated by the gradually shaded surfaces. Patches of white suggest light bouncing off a shiny surface. The **highlights**, together with the shading, create an illusion of three-dimensionality, which is characteristic of the Fourth Style.

This fresco was painted on the wall of a tomb enclosure where the *aedile* (public official) Vestorius Priscus, who died at age twenty-two, was buried. The silver is displayed to show the rank and position of the deceased. Shortly after this fresco was painted, Mount Vesuvius erupted and buried Pompeii.

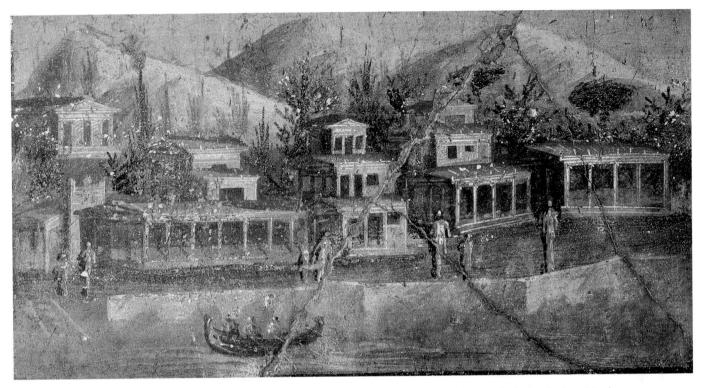

7.60 Landscape with Boats, from Pompeii, Third Style, 1st century A.D. Fresco. Museo Nazionale Archeologico, Naples.

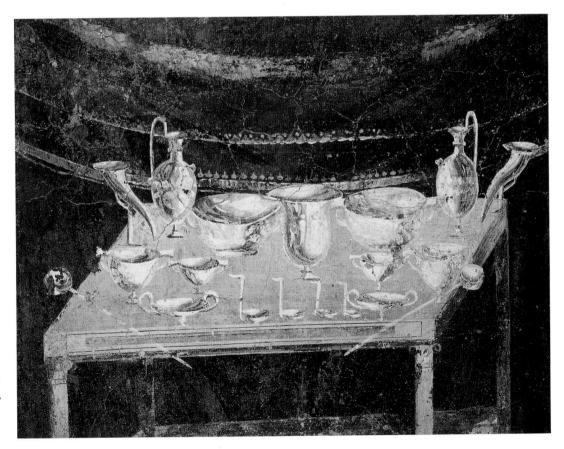

7.61 Still Life of Silver Objects, from the tomb of Vestorius Priscus, Pompeii, northeastern wall of the enclosure, A.D. 75–76. Fresco.

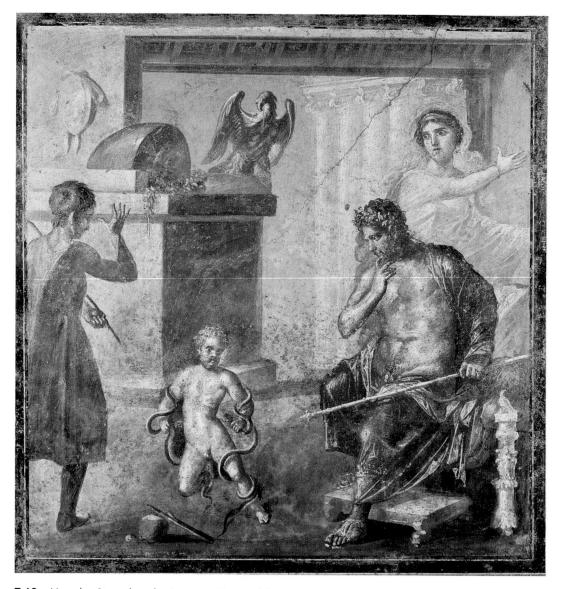

7.62 Hercules Strangling the Serpents, House of the Vettii, Pompeii, A.D. 63-79. Fresco.

A more complex narrative mural painting, from the House of the Vettii in Pompeii, represents the Greek myth in which the infant Hercules strangles a pair of snakes (fig. **7.62**). Hercules was the son of Jupiter and the mortal Alkmene. Juno, Jupiter's jealous wife, tried to kill the infant by sending two snakes to his nursery. Her plot failed when Hercules killed the snakes instead.

In this painting, a toddler-age Hercules is the focus of attention. At the right, Alkmene's mortal husband Amphitryon (who believes himself to be Hercules' father) watches in amazement. Alkmene's reaction to her son, however, is more ambivalent. On the one hand, her pose takes her away from the event as she seems to be running out of the picture plane. On the other hand, she turns to stare at Hercules, her riveted gaze enhanced by her wide-eyed expression. The play of shading across the torsos of Amphitryon and Hercules defines the natural structure of their bodies as well as their spatial positions. The figure at the left is rendered from the back, as if he, like the viewer, has just happened on the scene.

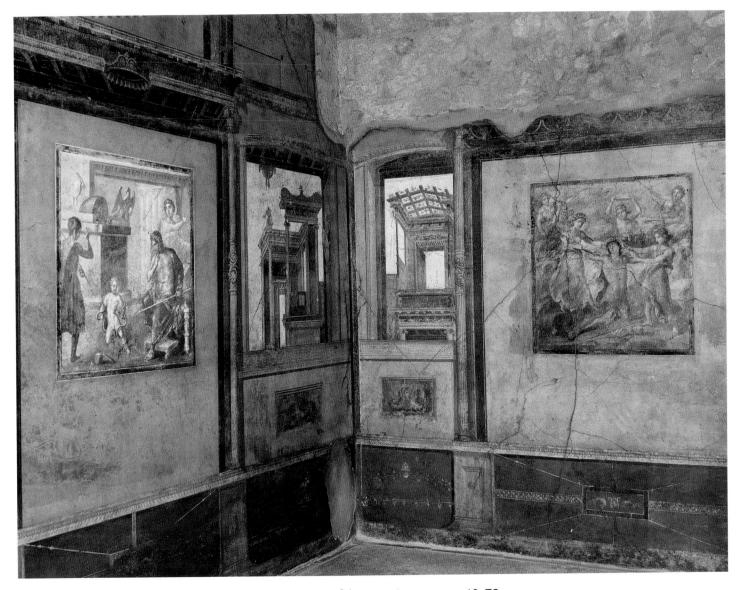

7.63 View of Hercules Strangling the Serpents in situ, House of the Vettii, Pompeii, A.D. 63-79.

The architectural elements within the picture add to the effect of depth. A slightly receding row of Ionic columns, like the oblique pavilions in figure 7.59, is perspectival. The floor of the room is rendered as a horizontal, enabling the viewer to determine the spatial locations of figures and objects. Amphitryon's footstool and the altar behind Hercules are placed so that each has a corner facing the picture plane. By darkening one side of the altar, the artist creates the illusion that both sides recede. The entire scene thus seems to occupy a convincing, if not mathematically precise, three-dimensional space.

Although the painting represents a Greek myth, certain iconographic details refer to the imperial concerns of Rome. Amphitryon is clearly a ruler, wearing a laurel wreath, enthroned, and holding a scepter. Perched on the altar is the eagle, which is at once a reference to Jupiter and to the Roman army. In addition, the divine origins of Hercules recall Roman legends tracing the origins of Rome to Aeneas and through him to the Greek gods. Hercules' formal similarity to the Hellenistic sculpture of *Laocoön* (see fig. 5.75) relates the image to the fall of Troy.

Figure **7.63** shows the painting in context with another mythological scene at the right: this depicts Pentheus, the ruler of Thebes, being torn apart and killed by the maenads, who had become enraged at his rejection of Bacchic rites. Here, Pentheus kneels in defeat, surrounded by the frenzied women about to tear him limb from limb. Both the mythological and architectural paintings in this room have the effect of windows cut into the wall, but they do not carry the entire wall into a fictive distance, as do those of the previous styles.

Cross-CulturalTrends

Faiyum Painting

Roman and Greek pictures, sculpture, architecture, religion, and even certain ideas about politics and government had much in common with each other. But the Romans translated what they borrowed from Greece into their own idiom. Greek and Roman culture, together with influences from the entire Mediterranean world, have had an enormous impact on the foundation and development of Western civilization.

Cross-fertilization in the visual arts can be seen in a group of paintings produced in Egypt during the Roman Empire. These works differ considerably from Roman murals at Pompeii and reflect a revival of the vivid illusionism of Greek art. They are believed to have been related to Hellenistic portraiture, of which no examples survive. Most come from the district of Faiyum, an area about 60 miles (97 km) south of Cairo in the Nile Valley. The earliest date to the first decades of the first century A.D., but the majority are from the second and third centuries.

Egypt had continued the practice of mummification (see Chapter 3), but the masks that had previously been placed over the mummy cases were replaced by portraits painted in encaustic on wood and later by tempera on wood. Figure 7.64 shows the mummy case of Artemidoros, a citizen of Faiyum, with his portrait painted directly on the wooden surface. The white tunic over the shoulders is typical of Hellenistic style. The slightly three-quarter view of the face and thick black eyebrows, the highlight on the nose, and shaded modeling of the forms are characteristic of Faiyum portraits and contribute to their realistic effect.

Below the portrait are mythological scenes, including an image of Anubis, the

7.64 Mummy case of Artemidoros, from Faiyum, A.D. 100–200. Stucco casing with portrait in encaustic on limewood with added gold leaf; 67.3 in. (170.9 cm) high, 17.7 in. (44.9 cm) wide, 14.4 in. (36.5 cm) deep. British Museum, London.

jackal-headed mortuary god of the dead, in the top register. The stylization of the scenes, compared with the

convincing likeness of the portrait, suggests that the ability to recognize the identity of the deceased continued to be a necessary feature of the Egyptian afterlife under Roman rule. In addition, the alert quality of the head, also found in banqueting figures on Etruscan sarcophagi, conveys a sense of immediacy that makes the dead person appear to be alive. Artemidoros, like the wax portrait described by the Greek poet Anakreon (see Chapter 5), indeed seems as if he is

Rome and Carthage

about to speak.

The history of the Roman Empire includes extensive cross-cultural influences throughout the Mediterranean world and as far east as modern Pakistan and India. A significant thread of Roman history was intertwined with the North African city of Carthage. Located in Tunisia, Carthage was bordered by Libya on the east and Algeria on the west. It was valuable to Rome for its agricultural produce, marble, and shipbuilding.

The native inhabitants of Tunisia, the nomadic Libyans (known as Berbers), occupied the region from the ninth millennium B.C. In the ninth or eighth century B.C., the Semitic Phoenicians from Tyre, in modern Lebanon, founded Carthage and called it New City. By the sixth century B.C., Carthage was the largest and most prosperous Mediterranean city, and an ally of the Etruscans. From the third to the second century B.C., Carthage was engaged in a series of wars with Rome, which are known as the Punic Wars (from Poeni, meaning "Phoenicians"-with its associated adjective punicus).

The Punic Wars left their mark on the history and literature of the Roman Empire, and two Carthaginian generals—Hamilcar Barca and his son Hannibal—have assumed legendary proportions. Hannibal performed one of the great feats of military history when he led his army and its elephants over the Alps in 218 B.C. (In the end, however, only one elephant survived.) Two years later, Rome had amassed over 100,000 troops, and in 202 B.C. the Roman general Publius Cornelius Scipio defeated Hannibal.

The Romans never forgot how close they

7.65 Aeneas Fleeing Troy, altar relief from Byrsa Hill, Carthage, Tunisia, early 1st century A.D. Bardo Museum, Tunisia.

had come to defeat, and Carthage played a significant role in the legend of the founding of Rome. In the Aeneid, Carthage is one of Aeneas's most memorable stops on his journey from Troy to Italy, for there he meets the Carthaginian queen, Dido, who falls in love with him. According to tradition, Dido was originally the princess Elissa of Tyre. She married her uncle, whom her brother the king killed for his money. Elissa fled to Cyprus and then to Tunisia, where she founded the city of Carthage. Early sources relate that the local ruler prom-

ised Elissa, now known as Dido, the amount of land that could be enclosed by the hide of an ox. Dido had the hide cut into thin strips and arranged them end to end, thereby enclosing a large area. When Aeneas finally leaves Carthage to follow his destiny to found Rome, Dido commits suicide and dies on a funeral pyre. She calls out for a hero to avenge her and her people—that avenger was Hannibal.

The Carthaginian relief in figure **7.65** shows Aeneas fleeing Troy with his father, Anchises, and son, Ascanius (see p. 210). The carving is provincial, but reflects Roman influence.

The site of Carthage has been known from antiquity, although it was not systematically excavated before the early 1970s, when developers began to threaten the

ancient ruins. UNESCO agreed to assist in sponsoring international excavations led by French, British, German, and American archaeological teams. As a result, the historical and cultural past of Carthage has begun to emerge from the mists of legend and myth—much like the Minoan and Mycenaean civilizations.

Dido's role in the history of Carthage, her relationship with

7.66 View of the Tophet, Carthage. The Bible (2 Kings 23:10) refers to the Tophet, a site in the Valley of Hinnom near Jerusalem, where the worshipers of Baal sacrificed their children. In the 7th century B.C., the king of Judah destroyed the Tophet and condemned the ritual of child sacrifice.

Aeneas, and its tragic aftermath are among the legends investigated by archaeologists. The original territory settled by Dido was thought to be on Byrsa Hill, which overlooks the harbor of Carthage. When the excavations were under way, evidence of domestic buildings and a town defended by fortified walls was discovered.

Further excavations have revealed that Carthaginians practiced child sacrifice: there were mass killings in times of stress and sacrifices to appease the city gods, Baal Hammon and Tanit (see box, p. 252). Archaeologists estimate that from 400 to 200 B.C. over 20,000 children between infancy and the age of four were cremated and their ashes buried in the Tophet (fig. **7.66**). Burials were in urns marked by vertical stelae, which show the influence of Greek grave markers (see Chapter 5). The contents of the urns, in contrast, show

The Punic Gods

The Punic religion was an amalgam of several Mediterranean influences combined with indigenous elements. The rulers of the Punic pantheon were Baal Hammon, creator of the universe, and his female consort, Tanit. Baal was a storm god related to the Phoenician sky god El, the Egyptian Seth, and the Greek Chronos (called Saturn by the Romans). Baal controlled rain and thunder, and wielded a thunderbolt. As giver of rain, he fertilized the earth and embodied the forces of creativity. Tanit is not a Phoenician name and may have been originally a Libyan fertility goddess. In ancient Carthage, she was queen of the dead, and a mother goddess associated with the Greek Hera and the Roman Juno.

Other important Punic gods were Eshmoun (from Phoenicia), who became equated with Asklepios (the Greek god of medicine), and Melqart, who was god of the city of Tyre and later associated with Hercules.

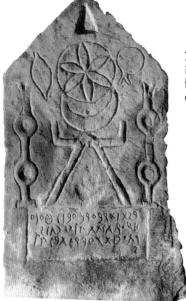

7.67 Neo-Punic stele with inscription and sign of Tanit, from Teboursouk, Tunisia, 1st century B.C.–1st century A.D.

Egyptian influence—in amulets and in images of the god Ptah (see Chapter 3) and of the apotropaic eye of Horus.

Figure **7.67** is a Neo-Punic stele with engraved signs and an inscription combining Greek and Phoenician letters. The goddess Tanit is shown in her standard iconography as a triangular body with upraised arms and elbows bent to form a right angle. The crescent moon is her emblem, and the sun disk above it is Baal Hammon's. Tanit's sign appears also on thousands of "baby bottle" vessels from the Hellenistic period (fig. **7.68**). The body of the vessel is transformed into a face with two eyes and a nose that functions as a "nipple." Liquid was poured into the "bottle" through the spout at the top. Tanit's emblem beneath the spout probably has symbolic meaning.

The art and architecture of Carthage reflect its cultural mix. Roman and Near Eastern ideas and motifs, together with native traditions, inform many Carthaginian works. The mausoleum at Dougga (fig. **7.69**), for example, is a tomb tower apparently built by a Phoenician architect. His name—Ateban, son of Iepmatath—is inscribed on the monument in a script having both Libyan and Punic characteristics. The Order of the columns is Greek, and they rise, as in most Doric temples, from the top of three steps. The structure is crowned, on the other hand, by the pyramid form characteristic of Egypt. Showing Near Eastern as well as Egyptian influence are the guardian animals at the four corners and the base of the pyramid. The synthetic nature of this mausoleum exemplifies the crosscultural influences in the North Africa of antiquity.

7.69 Mausoleum, Dougga, Tunisia, 2nd century B.C.

7.68 "Baby bottle" vessel from a Punic tomb, 4th–3rd century B.C. 4½ in. (10.9 cm) high. Bardo Museum, Tunisia.

Style/Period

500

Villa of the Mysteries frescoes

Bust of Julius Caesar

EMPIRE 27 B.C.-A.D. 476

C

Infant Hercules

Arch of Titus

Works of Art

Bust of Julius Caesar

(7.43), Tusculum

Tophet (**7.66**), Carthage "Baby bottle" vessel (**7.68**) Mausoleum (**7.69**), Dougga Temple of Portunus (7.23), Rome Temple of the Sibyl (7.25), Tivoli Villa of the Mysteries frescoes (7.54-7.56), Pompeii Odyssey Landscapes (7.57), Rome

> Augustus of Prima Porta

Odyssey Landscapes

Neo-Punic stele (**7.67**), Teboursouk Pont du Gard (**7.22**), Nîmes Ara Pacis (**7.31–7.33**), Rome Frescoes from villa at Boscotrecase (7.59), Pompeii Patrician with two ancestor busts (7.45) House of the Silver Wedding (7.3), Pompeii Augustus of Prima Porta (7.48) Aeneas Fleeing Troy (7.65), Carthage Unknown Barbarian (Parthian?) (7.53) Young Woman with a Stylus (**7.58**), Pompeii Landscape with Boats (**7.60**), Pompeii Roman and imperial forums (**7.11**), Rome Kolina dia mperiatri and the serpents (7.62–7.63), Pompeii
 Colosseum (7.19–7.20), Rome
 Still Life of Silver Objects (7.61), Pompeii
 Arch of Titus (7.38–7.39), Rome

Portrait of a young Flavian lady (7.46) Portrait of an older

Flavian Iady (**7.47**) Timgad (**7.6**), Algeria Basilica Ulpia (**7.13**), Rome Mummy case of Artemidoros

(**7.64**), Faiyum Trajan's Column (**7.34–7.35**), Rome

Pantheon (**7.27**, **7.29–7.30**), Rome Hadrian's Villa (**7.8–7.9**), Tivoli Antinous (**7.49**) Bust of Trajan (7.44) Insulae (7.4), Rome

Statue of Marcus Aurelius (**7.50**) Circus (**7.21**), Libya Baths of Caracalla (7.17-7.18), Rome

Caracalla (**7.52**) Badminton Sarcophagus (**7.42**) Dacian vase (**7.36**), Romania Dacian helmet (**7.37**), Romania Arch of Constantine (**7.40**), Rome Head of Constantine (**7.51**), Rome

Cultural/Historical Developments

Age of Perikles in Athens (458-429 B.C.) Etruscan influence in Italy begins to wane (450–400 B.C.) First Punic War between Rome and Carthage (264-241 B.C.) Carthaginians led by Hannibal invade Italy (218-211 B.C.)

Roman expansion: annexes Spain

(201 B.C.); controls Asia Minor, Syria, Egypt, Greece (146 B.C.) Sulla first dictator of Rome (82–79 B.C.) Slave rebellion led by Spartacus (72–71 B.C.)

"Baby bottle" vessel

- Julius Caesar conquers Gaul (58-50 B.C.)
- Classical Age of Latin literature (Virgil, Horace, Livy, Ovid) (50–10 B.C.)
- Flowering of Latin literature (Caesar, Catullus, Cicero, Lucretius)

Library of Alexandria destroyed by fire (47 B.C.)

Julius Caesar becomes dictator (46 B.C.) Caesar reforms Roman calendar; introduction of

solar year (46 B.C.)

Julius Caesar assassinated (44 B.C.) Caesar's assassins defeated at Philippi by Octavian and Mark Antony (42 B.C.

Antony marries Cleopatra (37 B.C.) Julio-Claudian dynasty (27 B.C.–A.D. 68) Augustus (Octavian) becomes emperor (27 B.C.)

Death of Virgil, Roman poet and author of the Aeneid (19 B.C.)

Judaea annexed by the Romans (A.D. 6) Crucifixion of Christ at Jerusalem (c. A.D. 33)

Roman conquest of Britain (A.D. 43-85)

Saint Paul preaches Christianity in Asia Minor and Greece; sent to Rome for trial (c. A.D. 60)

Great fire in Rome; Nero persecutes the Christians (A.D. 65)

Flavian dynasty (Vespasian, Titus, Domitian) (A.D. 69–96)

Revolt of Jews; Romans sack Jerusalem (A.D. 70)

The four Gospels written (A.D. 75-100)

Eruption of Vesuvius, destruction of Pompeii and Herculaneum (A.D. 79

Death of Pliny the Elder (A.D. 79)

The "Five Good Emperors" (Nerva, Trajan, Hadrian, Antoninus Pius, Marcus Aurelius) (A.D. 96–180) Roman Empire at its zenith (A.D. 98–117)

Trajan's conquest of Dacia (A.D. 101–106) Trajan's conquest of Armenia and Mesopotamia

(A.D. 113-117) Dead Sea Scrolls written (c. A.D. 130-168)

Jews expelled from Jerusalem; Jewish diaspora begins (A.D. 132–135)

Marcus Aurelius drives back invasions of Goths and

Huns (c. A.D. 161–180) Bishop of Rome becomes pope (c. A.D. 200) Codification of Jewish law in the Mishnah

(c. A.D. 200)

Imperial residence moved to Constantinople (c. A.D. 250)

Edict of Milan; Christianity legalized (A.D. 313) Sack of Rome by the Visigoths (A.D. 410)

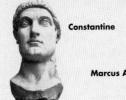

A.D. 500

Mar mun

Artemidoros

Marcus Aurelius

Window on the World Three

Developments in South Asia The Indus Valley Civilization (to the 3rd century A.D.)

I n 326 B.C., Alexander the Great led his armies into the northwest corner of south Asia (see map)—parts of modern Afghanistan, Pakistan, and India—then a part of the Achaemenid Empire (see Chapter 2). In so doing, he was eroding the power of Greece's traditional enemies—the Persians. In the second century B.C. Indo-Greeks ruled to the south, and, later, the Roman Empire established outposts in south Asia. Building upon a much older network of land and sea trade routes, the unprecedented territorial expansion of Greece and Rome created new contacts linking the Mediterranean and western Europe with parts of the East.

Transmitting cultural influence in the opposite direction—from East to West —were Buddhist missionaries sent to Greece and the Middle East in the third century B.C. by the Indian em-

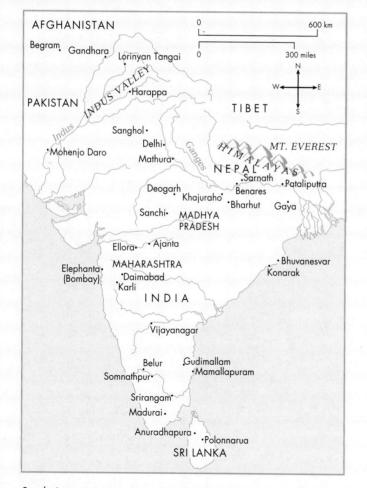

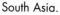

The Indus Valley Civilization (c. 2700–1750 в.с.)

peror Ashoka (ruled c. 273-232 B.C.).

Merchant caravans traveled along the

Silk Road, the 5,000 miles (8,047 km) of

linked trade routes that stretched from

China to Rome by the first century B.C.

(see map). From China, they transported

great quantities of finished goods such

as silk, bronzes, ceramics, and lacquer-

ware. Wool and linen textiles, glass-

ware, and valuable raw materials went

eastward from the Mediterranean world. As a result of such exchanges, certain styles and motifs infiltrated Eastern art

from the West, while others flowed in

the opposite direction.

The valley of the Indus River is located in modern Pakistan and northwest India, covering a vast area roughly equivalent to that of western Europe. Early in the third millennium B.C., its culture developed from a nomadic to a settled. urban civilization. Compared with the Mesopotamian and Egyptian civilizations, which were also centered around rivers, the Indus Valley culture adapted to a wider variety of natural environments. The first of hundreds of Indus Valley sites to be excavated (in the 1920s) were Mohenjo Daro and Harappa, which appear to have been artistic centers. The high point of Mohenjo Daro culture came in the second half of the third millennium B.C., during which time its population peaked at around 50,000. In addition to monumental stone architecture, archaeologists have found evidence of houses, mostly two stories high, made of mud brick and of more durable baked brick. The excavations

The Buddhist world.

also uncovered sewage systems, bronze and copper tools, large painted vases made on a potter's wheel and fired, and sculptures of terra-cotta, bronze, and stone. At Mohenjo Daro, as at most other large Indus Valley sites, many streets were laid out according to a grid. The ruins of a citadel in the west suggest a need for defensive architecture. It is curious that so far there is no evidence of religious or royal architecture, whether temples, tombs, or palaces. The existence of writing, like urbanization, distinguishes Indus Valley society from other cultures of the region.

Glyptic art, which was popular in Sumer and Akkad (see Chapter 2), is found in the Indus Valley civilization and to some scholars indicates contact with Mesopotamia. But Near Eastern seals are cylinders rolled across a soft surface, while those in the Indus Valley are square and held by a knob at the back. They were stamped face down to make an impression. Whereas Mesopotamian seals were indented so that the images they made were raised, the Indus Valley seals were carved in relief so that their stamped images were indented. The example in figure **W3.1** —one of some 2,000 seals depicting a range of subjects—represents a humped bull, or zebu, standing in a square field with an inscription incorporated into the overall design. The animal's stylized beard and thin, curved horns have a linear quality, while a sense of natural bulk is conveyed through the zebu's

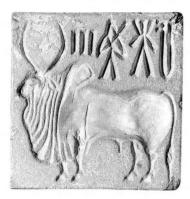

W3.1 Square stamp seal showing a zebu, from Mohenjo Daro, Indus Valley, c. 2300–1750 B.C. White steatite; 1½ in. (3.8 cm) high. National Museum, New Delhi.

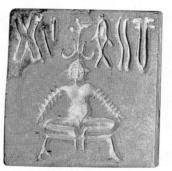

W3.2 Square stamp seal showing a yogi, Indus Valley civilization, c. 2500-1500 B.C. White steatite; approx. $1\frac{1}{2}$ in. $\times 1\frac{1}{2}$ in. $(3.2 \times 3.2 \text{ cm})$.

body, especially its hindquarters. Such rendering of organic form has remained typical of south Asian art.

Also characteristic is the iconography of the bull, which is often presented —as in Mesopotamia—in connection with human figures. The male figure in figure **W3.2** is seated in what seems to be a meditative yoga pose. He is sometimes horned and ithyphallic (having an erect and prominent phallus), which is probably symbolic of his power and fertility.

No monumental paintings are known from the Indus Valley civilization. Most of the few examples of Indus Valley sculpture from Mohenjo Daro and Harappa reflect the same full-bodied style that characterizes the bull seal, but there are rare examples of more stylized images. A work such as the *Bearded Man* (fig. **W3.3**) from Mohenjo Daro is reminiscent of Mesopotamian art and seems to combine Sumerian qualities with indigenous south Asian forms. Like the humped bull in figure W3.1, it is a synthesis of compact monumentality, stylization (the beard, hair, ears, and trilobed drapery pattern), and organic quality in the structure of the face (especially the lips and nose). The figure's heavylidded, inward gaze, however, contrasts sharply with the wide-eyed stare of Mesopotamian statues such as those from Tell Asmar (see figs. 2.12 and 2.13).

Entirely different in their aesthetic effect, and more purely organic, are

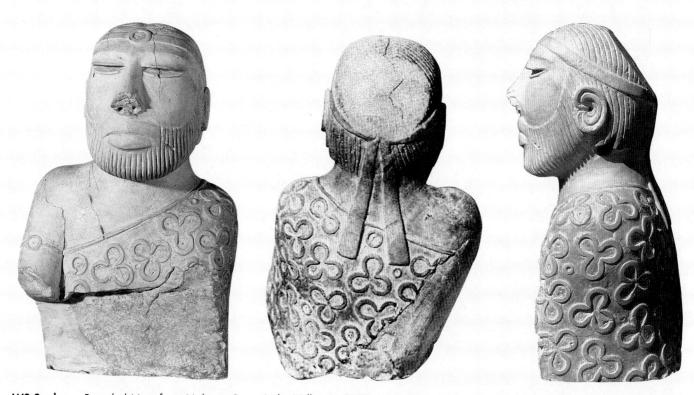

W3.3a, b, c Bearded Man, from Mohenjo Daro, Indus Valley, c. 2000 B.C. Limestone; 7 in. (17.8 cm) high. National Museum, New Delhi.

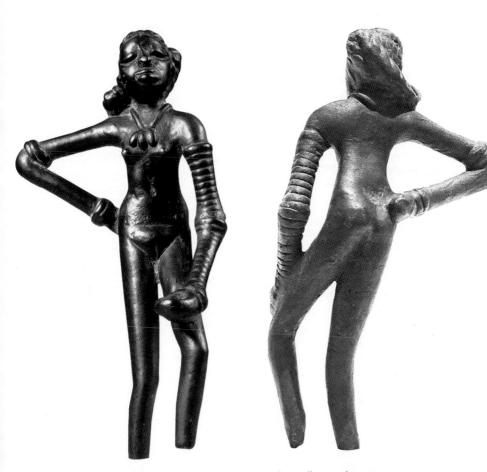

W3.4a, b Dancing Girl, from Mohenjo Daro, Indus Valley civilization, c. 2300–1750 B.C. Bronze; 4½ in. (10.8 cm) high. National Museum, New Delhi.

the nude sculptures (figs. **W3.4** and **W3.5**), which have more in common with later south Asian art. The *Dancing Girl* (fig. W3.4) from Mohenjo Daro is nude except for a necklace and armbands that may have had a ritual purpose. Despite her thin proportions,

she conveys an organic quality that derives both from the forms themselves (the indication of bone under the left shoulder, for example) and from the convincingly relaxed pose.

The nude male torso (fig. W3.5) differs from the *Dancing Girl* in its massive proportions and compactness. Its quality of *prana* (the sense that the image itself is filled with living breath) typifies south Asian sculpture. Although it is less than 4 inches (10 cm) high, the torso, like the *Venus of Willendorf* (see fig. 1.1), has the impact of a much larger work. The original meaning and function of this figure is not known, nor is the purpose of the small circles in the shoulders to which arms may have been attached.

The Indus Valley civilization declined around the middle of the eighteenth century B.C., perhaps owing to a combination of floods, invasions, and political overextension.

W3.5a, b, c Nude male torso, from Harappa, Indus Valley, c. 2000 B.C. Red sandstone; 3³/₄ in. (9.5 cm) high. National Museum, New Delhi.

The Vedic Period

(с. 1600-322 в.с.)

Around 1600-1500 B.C., waves of seminomadic Indo-European (Aryan) peoples invaded the Indus Valley and the surrounding regions from the northwest. There is no archaeological record of Aryan cities, burials, or works of art. Most of what we know about the invaders, who spoke an early version of Sanskrit, comes from their sacred literature, the Vedas (see box). One of the later Vedic texts, the Upanishads, describes the Aryan social hierarchy that became the Hindu caste system (see box). Descriptions in the Vedas of Aryan conquests are consistent with the archaeological evidence of fortified cities (citadels) found in the Indus Valley. Likewise, Vedic references to phallic worship by the local population appear to be confirmed by certain images from Harappa and Mohenjo Daro.

The founder of Buddhism (see below), Shakyamuni Buddha, was born Prince Siddhartha Gautama in modern Nepal in the mid-sixth century B.C. Buddha's teachings were a reaction against the traditional Vedic religious hierarchy, controlled by Brahmin priests. Two main Buddhist traditions emerged. both stressing the virtues of compassion and selflessness. One emphasizes the importance of breaking the cycle of reincarnation and achieving nirvana, and the other, the attainment of enlightenment for everyone. The latter accepts several buddhas, in addition to Shakyamuni, as well as bodhisattvas (those who delay Buddhahood). The first tradition promoted an ascetic, meditative path to spiritual growth, whereas the other taught that prayer and faith could also be routes to salvation. Despite its virtual disappearance from India by the tenth century, Buddhism eventually spread throughout Asia. The first of the Buddhist traditions was adopted primarily in Sri Lanka (formerly Ceylon) and southeast Asia, and the second in China, Japan, and Korea.

Buddha and Buddhism

Prince Siddhartha Gautama is believed to have been born around 563 B.C. in what is now Nepal. According to leg-

The Upanishads

The Upanishads, composed c. 800–600 B.C., are literally "knowledge derived from sitting at the feet of the teacher." These are the final set of Vedic texts. Instead of emphasizing priesthood and ritual, as the second set does, the Upanishads are philosophical and speculative. They illuminate the inner meaning of the earliest Vedas and explore the nature of knowledge and truth.

Individuals undergo numerous births in the cycle of different lives (samsara). In what form one is reborn depends on his or her karma—accumulated "credit" or "debt" created by a person's good or bad actions. Karmic status reflects one's position in the social hierarchy, known as the caste system. There were four castes: at the top were Brahmin priests, followed by warriors, farmers, and artisans. Lower yet were those without a caste—the "outcasts." Acceptance of one's proper place within this system leads, through a series of progressively better lives, to liberation (moksha) from the cycle of rebirth. Nirvana is the union of the liberated individual soul with Brahmin, the cosmic soul.

The Early Vedas

The Vedas (from the Sanskrit verb meaning "to know") are collections of Aryan religious literature. For thousands of years, the Vedas were transmitted orally from one generation of Brahmin priests to the next, syllable by syllable. The earliest, which date to the beginning of the second millennium B.C., invoke the Vedic gods in thousands of hymns chanted at sacrificial rituals. A second set codifies ritual practice and serves as handbooks for priests. Vedic priests sacrificed to the gods at fire altars. The fire itself embodied the god Agni (cf. "to ignite"), whose smoke carried offerings upward to the other deities. Agni was born when two sticks of wood were rubbed together, and he was therefore a natural product of the very material he consumed. Indra, the warrior god, personified thunder. Varuna was the guardian of cosmic order, and Rudra (the Howler) destroyed the unrighteous. Uma was the goddess of dawn, and Surya was the sun who crossed the sky in a chariot (as in Greek mythology). Soma, a polymorphous deity associated with an intoxicating elixir, was born, like Aphrodite, from the foam of the sea, and Yama was the god of death.

end, his mother, Queen Maya, gave birth to him through her side, while reaching up to touch a *sal* tree in the Lumbini Grove (figs. **W3.6** and **W3.7**). Siddhartha's father, the head of the Shakya clan, was told in prophecies that his son was destined either to rule the world or to become a great spiritual leader. In accordance with his own preference for the first option, Siddhartha's father raised his son in the sequestered atmosphere of the court. But at the age of twenty-nine, Siddhartha ventured outside the palace walls and encountered the suffering of humanity—disease, old age, and death.

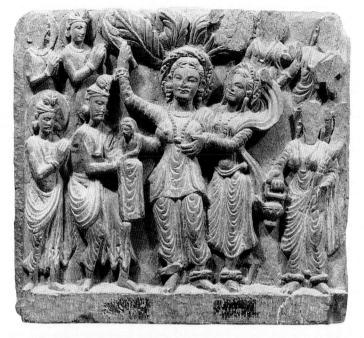

W3.6 Birth of the Buddha, relief from Gandhara, India, 2nd–3rd century. Gray schist; 15 in. (38.1 cm) high, 16½ in. (41.9 cm) wide. Ashmolean Museum, Oxford. Queen Maya stands under a *sal* tree in the Lumbini Grove and holds one of its branches. She is surrounded by human and divine attendants. To her right, the Vedic god Brahma receives the infant Siddhartha as he emerges from her side.

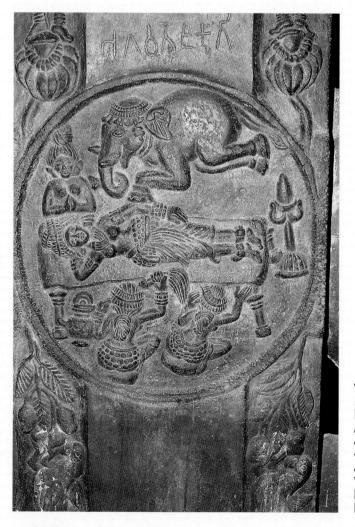

Disturbed by what he saw, he renounced materialism, left his wife and family, and rode out to save the world.

At first, Siddhartha became an ascetic and a beggar, devoting himself to meditation. He practiced extreme austerities while continuing his quest for knowledge. But after six years, starving and no closer to his goal, he ended his fast and adopted a moderate Middle Way. Then, in 537 B.C., while meditating under a pipal tree, Siddhartha resisted the seductive temptations of the demon Mara and achieved enlightenment. Henceforth this tree was known as the sacred bodhi ("enlightenment") tree, and its site as bodhgaya ("place of enlightenment"). Siddhartha, having become a buddha ("one who has awakened"), was now known as Shakyamuni ("the sage of the Shakya clan"). He preached his First Sermon in the Deer Park at Sarnath, which set in motion the Wheel (Chakra) of the Law (Dharma) and founded Buddhism. He spent the remainder of his life traveling and preaching his new philosophy. In 483 B.C., the last great miracle of Shakvamuni Buddha's life, the Mahaparinirvana, occurred: when he died, at the age of eighty, the cosmos caused his cremated remains to shine like pearls.

In social terms, Buddhism can be seen as an attempt to reform the rigidity of the caste system. Shakyamuni Buddha taught the Four Noble Truths as the basis of *Dharma*, according to which life is suffering (1), caused by desire (2). But one can overcome desire by conquering ignorance (3), and pursue an upright life by following the Eightfold Path (4):

- 1. Right understanding
- 2. Right goals
- 3. Right speech
- 4. Right behavior
- 5. Right calling
- 6. Right effort
- 7. Right alertness
- 8. Right thinking

W3.7 Dream of Queen Maya, from Madhya Pradesh, India, Shunga period, 2nd century B.C. 19 in. (48.3 cm) high. Relief from a vedikā of the Bharhut stupa, Indian Museum, Calcutta. Queen Maya's dream of a white elephant was interpreted as precognition of her pregnancy with Prince Siddhartha. The perspective of this scene defies our experience of natural reality, giving it a shifting quality. We see Maya from above, while the elephant floating over her is depicted in profile and the attendants at the side of her bed are in back view. In order to escape suffering, Shakyamuni Buddha advocated the extinction of all desire and all sense of self through meditation and spiritual exercises, which his disciples codified. Shakyamuni established the world's first monastic communities (the *Sangha*), and, after his death, Buddhist monasteries proliferated. Missionary monks spread Buddhist doctrine throughout the world.

Mirroring the multiplicity of Vedic deities, many buddhas emerged around the figure of Shakyamuni. Complementing these were wise and compassionate supernatural beings called bodhisattvas (from the Sanskrit terms for "enlightenment" and "existence"). Bodhisattvas delay their own buddhahood in order to help others attain enlightenment. In art they are identified by their princely attire, and they often flank a buddha. In later periods, the importance of Shakyamuni Buddha was overshadowed by cults of various buddhas and bodhisattvas, especially in the Himalayas and the Far East.

Buddhist Architecture and Sculpture

The Maurya Period (c. 321–185 в.с.)

Some eight hundred years after the Arvan invasion, urban culture began to reappear in northern India. The first ruler to unify a large territory after this revival was Chandragupta Maurya, who founded the Maurya dynasty in 321 B.C. From this point on, historical records increase. Chandragupta's grandson, Emperor Ashoka (ruled c. 273-232 B.C.), was one of south Asia's greatest kings, uniting almost all of the Indian subcontinent and parts of central Asia. A dozen years into his reign, at the peak of his military success, he renounced warfare and embraced the nonviolent message of Buddhism, which he promoted throughout his empire and beyond.

Ashoka erected a number of monumental monolithic stone pillars, 50 feet (15.2 m) high. They are thought to have been derived from a Vedic royal tradition of freestanding wooden poles crowned by copper animals, perhaps associated with early tree worship. Like the *bodhi* tree, under which Shakyamuni attained enlightenment, such pilW3.8 Lion capital, Ashokan pillar, from Sarnath, Uttar Pradesh, India, Maurya period, mid-3rd century B.C. Polished chunar sandstone; 7 ft. (2.13 m) high. Museum of Archaeology, Sarnath. According to tradition, the Buddha set in motion the Wheel of the Law (Dharmachakra) in his first sermon expounding the Four Noble Truths in the Deer Park at Sarnath.

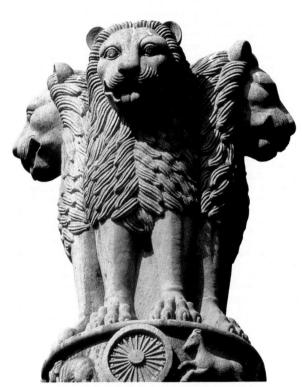

lars probably represent the axis of the world. This axis was believed to link heaven and earth, separating as well as connecting them. On these pillars, as on rocks and stone tablets, Ashoka inscribed edicts on Buddhist themes that reflected his political, social, and moral philosophy. Although there is no evidence of a connection between these pillars and later Roman single monumental columns (see p. 231), they clearly served a similar political purpose. Whereas Trajan's Column (cf. fig. 7.34) depicted his military campaigns and stood as a metaphor for both his earthly victories and his future apotheosis, Ashoka's pillars were legislative documents in stone. They, too, by virtue of their height, can be associated with success, and both are crowned by symbols that align the emperor with the gods.

Artistically, the pillars are significant because their capitals constitute the earliest surviving body of Buddhist monumental sculpture. The lion (fig. **W3.8**) and bull (fig. **W3.9**) capitals seem to continue the two iconographic and stylistic traditions evident nearly

> W3.9 Bull capital, Ashokan pillar, from Rampurva, Bihar, India, Maurya period, 3rd century B.C. Polished chunar sandstone; 8 ft. 8 in. (2.64 m) high. National Museum, New Delhi.

two thousand years earlier in the Indus Valley. Four lions joined at the back face outward toward east, west, north, and south. They are rigid and emblematic, their whiskers, manes, and claws stylized in a manner reminiscent of Achaemenid sculpture (cf. fig. 2.37). There are strong similarities to the art of Achaemenid Persia in the general

concept of animal capitals as well as in the particular stylizations. The Mauryas apparently borrowed portions of their imperial iconography from the more established empire to the west. In contrast, the bull capital is both iconographically and stylistically south Asian. Like the bull in the Mohenjo Daro seal and the nude male torso from Harappa, it is more organically modeled. Massive and fleshy, with a suggestion of underlying bone and muscle structure, it conveys the sense of a living animal.

These capitals demonstrate the Buddhist assimilation of earlier artistic conventions. As in the Near East and Egypt, lions in India are royal animals, and Shakyamuni Buddha himself was referred to as the "lion" of his clan. The bull, as in the Indus Valley seals, denotes fertility and strength. Both the lion and the bull stand on a circular *abacus*, which surmounts a bell-shaped element in the form of lotus petals (signifying purity). The meaning of the decorations in relief on the sides of the abaci has been debated by scholars. But the wheel on the lion's abacus is certainly Buddha's Wheel of the Law. which was set in motion during his first sermon. Wheel and lion are vertically aligned and, therefore, visually linked to denote the power (the lion) of the Buddha's teaching (the Law, or Dharma). The abacus of the bull capital is decorated with plant and water designs that refer to the fertility of nature. There can be no doubt that this iconography, like the reliefs on Trajan's Column, was intended to proclaim the power and prosperity of the empire. Together with the edicts on the shafts of the pillars, lion and bull also stand for the power of the Buddha's message.

The Shunga Period (c. 185 B.C.-A.D. 30)

At the end of Ashoka's reign, India was once again ruled by small republics and local dynasties. One of the latter,

the Shungas of central India, enlarged Ashoka's Great Stupa at Sanchi, India's most characteristic Buddhist monument (fig. W3.10). According to Buddhist texts, when the Buddha died (the Mahaparinirvana), he was cremated, and his ashes were divided and enshrined in eight stupas, or burial mounds. Emperor Ashoka further divided these relics among 64,000 legendary stupas that either have disappeared or have been incorporated into later structures. Stupas thus came to stand for the Mahaparinirvana, the last of the four great miracles of Shakyamuni's life. The hemispherical form of the stupa, however, predates Buddhism and, like the monumental pillars, has cosmological significance. Originally, remains or other relics were placed in a hole in the ground into which a pillar was set, and then earth was mounded around the pillar to prevent plundering. With the development of Buddhism under Ashoka, these mounds evolved into monumental stupas.

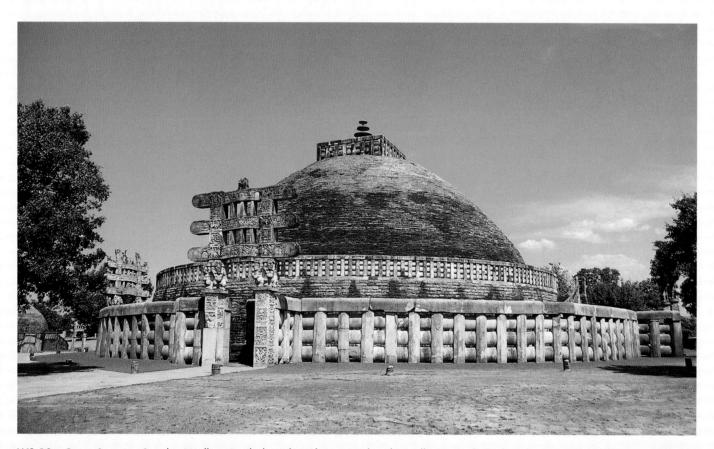

W3.10 Great Stupa at Sanchi, Madhya Pradesh, India, Shunga and early Andhra periods, 3rd century B.C. Diameter over 120 ft. (about 37 m). The cosmological significance of the stupa's organization is evident in its relationship to the worshiper. On entering one of the four *toraṇas*, one turns left and circumambulates the hemisphere in the direction of the sun (clockwise). In this symbolic passage enclosed by the tall *vedikā*, worshipers leave their worldly time and space and enter the spiritual realm. In so doing, they replicate Shakyamuni Buddha's departure from the world, the *Mahaparinirvana*.

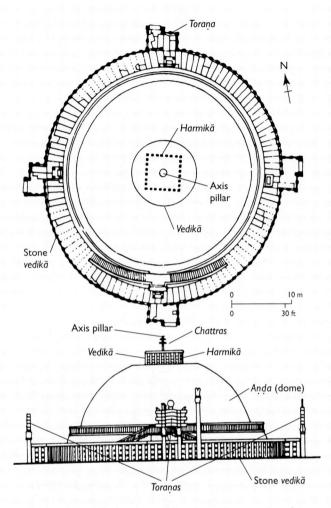

W3.11 Plan and elevation of the Great Stupa at Sanchi.

The Great Stupa at Sanchi, in Madhya Pradesh (figs. W3.10 and **W3.11**), was begun in brick during the reign of Ashoka and evolved further during the Shunga period. The large dome is mainly a product of the first century A.D. The interiors of the stupas were filled with rubble and presumably contained Shakyamuni's relics.

The outline of the stupa is a perfect circle, which Buddhists consider an ideal shape. The stupa was designed as a mandala, or cosmic diagram. The square at the center refers to the **harmikā** on the roof, and the small circle inside the square indicates the axis pillar supporting the **chattras**. The dark outer circle is the **vedikā**, and the four rectangular attachments are the **toraṇas**, oriented to the cardinal points of the compass and reflecting the identification of the stupa with the cosmos.

As is true of Western religious architecture, the stupa creates a transition between one's material and temporal life on earth and the cosmos beyond. The stupa's dome (the **anda**, meaning "egg") symbolizes the dome of heaven. It supports a square platform (the *har*-*mikā*), enclosed by a railing (the *vedikā*), through which a central axis pillar projects. Attached to the pillar are three umbrella-shaped *chattras*, royal symbols that honor the Buddha. The configuration of the enclosure recalls pre-Buddhist nature worship and the ancient south Asian practice of enclosing a sacred tree with a wooden fence.

Surrounding the stupa is a stone vedikā 11 feet (3.35 m) high, based on wooden fences. The vedikā is punctuated at the cardinal points by gateways, toraņas, 35 feet (10.67 m) high. These were added in the first century A.D. and also derived from wooden prototypes. An Ashokan pillar and staircase mark the main (southern) entrance to the sacred compound. The north toraņa (fig. **W3.12**) consists of two rectangular posts, on top of which

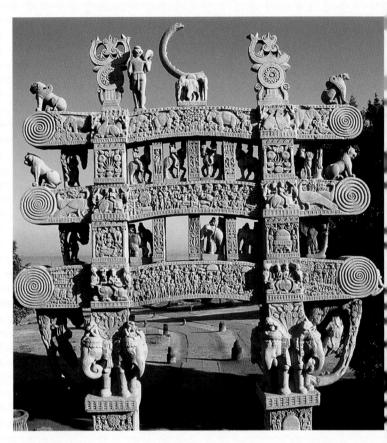

W3.12 North *torana* at Sanchi, Shunga and early Andhra periods, 1st century B.C.

four elephants and riders support three architraves linked by vertical elements. It is completely covered with relief sculpture. At the top of the *toraṇa's* posts, two *Dharmachakra* (Wheels of the Law) support tripartite forms symbolizing the *Triratna*—the Three Jewels of Buddhism: the Buddha himself, the *Dharma*, and the *Sangha* (the Buddhist monastic community). The architrave sections directly over the gateway sculptures depict Indian folktales, processions, and battles.

The sections that extend beyond the post depict *jatakās* (stories of the Buddha's previous lives as well as his last life as Shakyamuni). There are also many scenes of Buddhist worship and ceremonies such as one in which Ashoka ritually waters the sacred *bodhi* tree, which stands for the Buddha himself. As is characteristic of early Buddhist art, the Buddha is represented **aniconically**—that is, his presence is indicated only by means of symbols. Instead of being represented in human form, he appears in metonymic form as something with which he is associated, such as the *bodhi* tree, his throne, his honorific umbrella (related to the *chattras* at the top of a stupa), or a stupa itself. Another sign of Buddha's presence in art is a pair of footprints that refer to his first baby steps. These, in turn, were associated with an earlier tradition in which a god-king encompasses the world in a few strides.

At Sanchi, the toranas are decorated with representations of vakshas and vakshīs, indigenous pre-Buddhist fertility deities, male and female respectively (fig. W3.13). The yakshi on the bracket both swings from and is entwined in a mango tree, which bursts into life at her touch. Such images are the source for the depiction of Queen Maya giving birth to Siddhartha in the Lumbini Grove (cf. fig. W3.6). The form of the yakshīs at Sanchi, like the theme itself, is related to the ancient Indian predilection for sensual, organic sculpture. The voluptuous breasts and rounded belly suggest early pregnancy. The seductive pose is called tribhanga, or "three bends posture." Together with the prominently displayed pubic area, this pose promises auspicious abundance to worshipers.

The Kushan Period (c. A.D. 78/143–3rd century)

During the first century A.D., central Asian nomads called Kushans controlled the area now comprising Afghanistan, Pakistan, and northern India. The first extant images of the Buddha in human form date from this period, when Vedic religion still retained enormous popular appeal, partly because of its anthropomorphic gods. As a result, Buddhist artists began to develop an iconography in which buddhas and bodhisattvas were shown in human form.

The move toward representing the Buddha as a man in the Kushan period is first reflected in the Gandharan and Mathuran schools of art. The Gandharan region, located in modern Pakistan, was a crossroads of trade routes and hence a cultural melting pot. As a result, Gandharan artists were familiar with styles and motifs from other areas. It seems that both Greek and Roman artists had worked earlier around Gandhara, accounting for Hellenistic elements in Gandharan images of buddhas and bodhisattvas.

The two most typical images of the Buddha in Gandharan sculpture show him standing or sitting, often with a

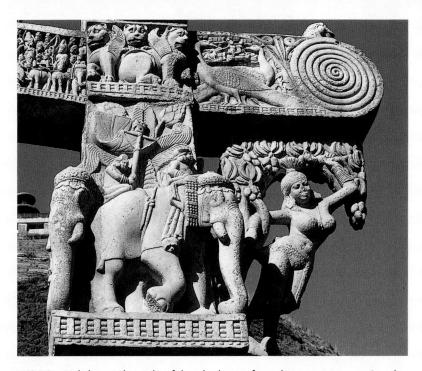

W3.13 Yakshī—to the right of the elephant—from the east toraṇa at Sanchi, Shunga and early Andhra periods, 1st century B.C. The presence of yakshīs in Buddhist art reflects the assimilation of indigenous Indian motifs into Buddhist iconography.

W3.14 Standing Buddha, from Gandhara, Afghanistan or Pakistan, Kushan period, 2nd–3rd century. Gray schist; 3 ft. 3 in. (99.0 cm) high. Museum für Indische Kunst, Berlin.

large halo or sun disk behind his head. In figure **W3.14** he is shown wearing a monk's robe, whose deeply carved, rhythmically curving folds recall depictions of togas in Roman sculpture. The statue's organic quality, with its rounded abdomen, is descended from the indigenous artistic tradition of the *prana*filled nude male torso from Harappa (fig. W3.5).

The *Standing Buddha* displays some traditional identifying physical features of Buddhist iconography. Many of these allude to his role as a spiritual ruler, among them the earlobes, elongated from the weight of heavy royal

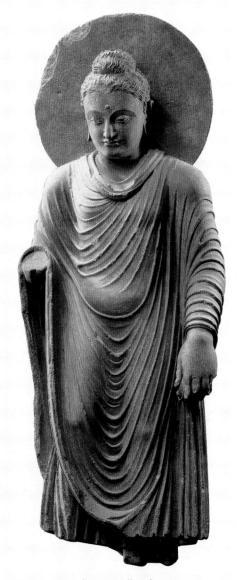

263

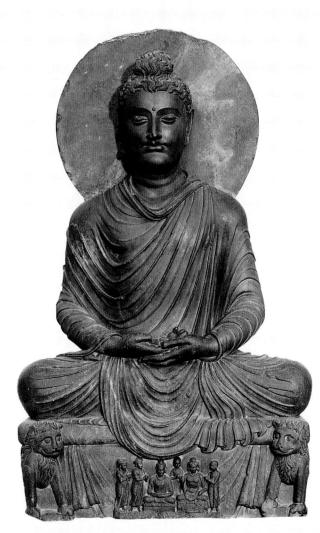

W3.15 Seated Buddha, from Gandhara, Afghanistan or Pakistan, Kushan period, 2nd century. Gray schist; 3 ft. 7½ in. (1.10 m) high. National Museums of Scotland, Edinburgh.

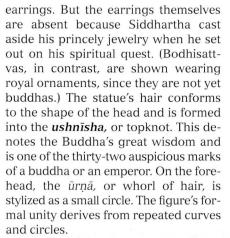

The same emphasis on curvilinear forms characterizes the *Seated Buddha* (fig. **W3.15**). The Buddha's hands rest peacefully on his lap, forming the gesture (*mudrā*) of meditation (*dhyāna*), in which the hands are held palm up, one resting on the other. *Dhyāna mu*- $dr\bar{a}$ denotes the intense inner focus through which Shakyamuni attained enlightenment. On either end of the throne is a lion—in keeping with the ancient tradition of lions guarding royal or sacred personages—symbolizing Shakyamuni Buddha himself. The face of this seated Buddha, like that of the standing example, is (aside from the fuller lips) reminiscent of beardless Greek and Roman Apollonian types.

Gandharan Buddhist architecture also reflects contemporary religious developments. For example, the secondcentury stupa at Loriyan Tangai in Gandhara (fig. **W3.16**) is more elaborate than the simple hemisphere at Sanchi. Here, a square base supports layered round tiers that end in a small dome. Rising from the dome is an inverted trapezoidal platform that supports a column of *chattras*. In contrast to the relatively plain plaster surface

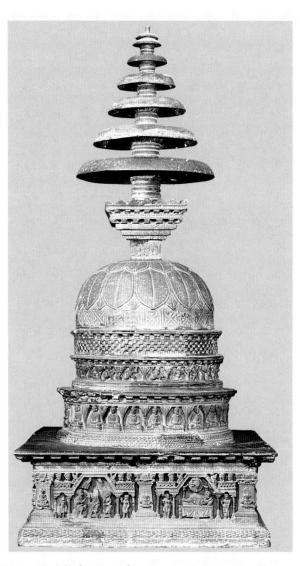

W3.16 Model of a stupa from Loriyan Tangai, Gandhara, Afghanistan or Pakistan, Kushan period, 2nd century. Gray schist; 4 ft. 9 in. (1.45 m) high.

of the Sanchi stupa, the stone masonry at the Gandharan stupa is covered with relief sculpture. Hellenistic influence is apparent in specific features such as the Corinthian pilasters and niches formed by round arches.

The degree of Westernization in Gandharan art can be seen by comparison with the indigenous south Asian style prevalent at Mathura, south of Delhi. A Seated Buddha (fig. W3.17) from Mathura, for example, has different proportions: an hourglass figure, with broad shoulders and a thin waist. The figure's taut, prana-filled body is fleshier, its physiognomy less Western, and its drapery folds so finely carved that the cloth appears nearly transparent. The hair is not loose and wavy, but instead is pulled tightly into a topknot -the ushnīsha-in the shape of a snail shell.

This representation of the Buddha shows him meditating under the bodhi tree at the very moment of his enlightenment. The branches are carved in low relief behind the Buddha's halo, and his facial expression reveals an inner calm. He raises his right hand in the abhaya mudrā gesture, which means "have no fear." Compared with Gandharan figures of the Buddha, the Mathuran example communicates more actively with worshipers. Standing behind him are richly dressed attendants with chauris (fly whisks), another royal symbol honoring the Buddha. Above are wise celestial beings flying toward Shakyamuni to worship him. Like his Gandharan counterpart, the Mathura Buddha sits on a lion throne, the unusual third lion in the center echoing his own dynamic frontal form.

Having established itself in south Asia, Buddhism spread throughout southeast Asia and the Far East. During the Gupta period (fourth through seventh centuries) and its aftermath, Buddhist art in India would undergo remarkable new developments (see "Window on the World Four").

Dancing Girl

Style/Period

CIVILIZATION

MAURYA PERIOD

321-185 в.с.

SHUNGA PERIOD

185 B.C.-A.D. 30

KUSHAN PERIOD c. A.D.

INDUS VALLEY

W3.17 Seated Buddha, from the Katra Mound, Mathura, Uttar Pradesh, India, Kushan period, early 2nd century. Spotted red sandstone; 2 ft. 3 in. (68.6 cm) high. Government Museum, Mathura.

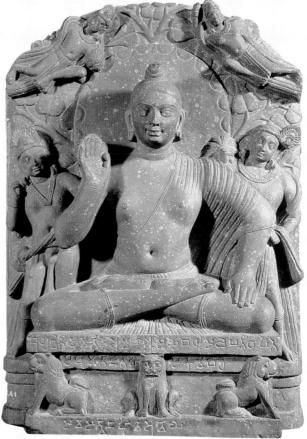

Cultural/Historical Developments

Aryan invasion of the Indus Valley (c. 1750 B.C.) Indus Valley script Etruscan civilization begins (1000 B.C.) Urbanization of the Indus Valley (800–700 B.C.) The Upanishads are composed (800–600 B.C.)

Alexander invades south Asia (326 B.C.) Reign of Ashoka (c. 273–232 B.C.)

Augustus becomes the first Roman emperor (27 B.C.) Birth of Christ (c. 1 B.C.)

Height of the Roman Empire (A.D. 98–117) Trajan conquers Dacia (A.D. 101–106) Dead Sea Scrolls written (c. A.D. 130–168)

Seated Buddha

Lion capital

Birth of the Buddha

Works of Art

Stamp seal (**W3.1, W3.2**), Mohenjo Daro Dancing Girl (**W3.4**), Mohenjo Daro Bearded Man (**W3.3**), Mohenjo Daro Nude male torso (**W3.5**), Harappa

Bull capital (**W3.9**) Lion capital (**W3.8**)

Great Stupa (**W3.10**), Sanchi Dream of Queen Maya (**W3.7**), Madhya Pradesh Yakshī (**W3.13**), Sanchi North torana (**W3.12**), Sanchi

Bearded Man

Seated Buddha (W3.15), Gandhara Seated Buddha (W3.17), Mathura Stupa (W3.16), Gandhara Birth of the Buddha (W3.6), Gandhara Standing Buddha (W3.14), Gandhara

Great Stupa

A.D. 400

2300 B.C.

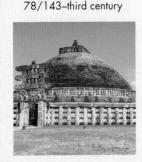

B

Early Christian and Byzantine Art

A New Religion

Around A.D. 33, during the reign of the Roman emperor Tiberius (A.D. 14–37), Jesus Christ was crucified

outside the city of Jerusalem, then part of the vast Roman Empire. The teachings of Jesus and his followers led to the establishment of the Christian religion, whose impact on Western art after the fall of the empire cannot be overestimated.

The gradual decline of the Roman Empire and the collapse of its political administration overlapped the development of Christianity, which was a minority religion until the fourth century A.D. In Rome itself, Christianity was first adopted by the urban lower and lower-middle classes, while the aristocracy, for the most part, continued to worship pagan gods. From the second century, however, many educated Romans and some members of the upper classes began to take an interest in the new religion. This encouraged its development and reinforced the emergence of a large, hitherto disenfranchised, segment of society.

For the origins of Christianity, we must look to Judaism and the Near East, which was the site of many religious cults that extended throughout the Mediterranean world, including Rome, during the first century A.D. These persisted into the third century, and most combined the Hellenistic influence spread by Alexander the Great with Eastern elements. Mystery cults centered around the Greek Dionysos, the Egyptian Isis, the Phrygian Kybele, and many others, while the Persians worshiped Mithras and Ahura Mazda. Whether an area was under Greek or Roman control, entrenched local customs persisted. Thus, for example, Egypt continued to worship animals, and its traditional priesthood performed traditional rites. The west coast of Anatolia was the site of a flourishing Greek culture with a cult of Artemis at Ephesus, of Asklepios at Pergamon, and of Apollo at Didyma. At Carthage as well, local versions of Greek deities were worshiped.

Dura Europos

In 1922, the little town of Dura Europos, once at the edge of the Roman Empire in what is now Syria, was discovered and subsequently excavated. Different types of buildings at Dura Europos reflect the multiplicity of religions practiced around the Mediterranean from the first to the fourth centuries A.D. Archaeologists found shrines dedicated to Persian deities as well as pagan Roman temples. A Jewish synagogue dating from around 245 A.D. was, despite biblical injunctions against graven images, decorated with painted scenes from the early books of the Old Testament, the name Christians gave to the Hebrew Bible. Some of the figures are identified by Greek inscriptions.

Figure **8.1** shows the west wall of the synagogue. There are three levels of Old Testament scenes and figures arranged horizontally, interrupted by a Torah niche. The Torah was a parchment or leather scroll containing the text of the Pentateuch, the first five books of the Old Testament (Genesis, Exodus, Leviticus, Deuteronomy, and Numbers). Portions of these books were read aloud on the Sabbath during worship in the synagogue. The Pentateuch was of particular importance because it comprises the Books of Moses and forms the basis of Jewish teaching.

Below the narrative scenes is a row of more emblematic imagery and panels of painted imitation stone. The detail in figure **8.2** depicts *Moses Giving Water to the Twelve Tribes of Israel.* Each tribe is represented as a single figure with upraised arms, standing at the entrance to a tent. These so-called **orant** figures (from the Latin word *orare,* meaning "to pray") symbolized seeking God and praying to him. Above the well is the *menorah* (the sacred Jewish candelabrum with seven candlesticks) framed by a 8.1 West wall of Dura Europos synagogue, c. 245. Tempera on plaster (reconstruction). Length of wall approx. 40 ft. (12.19 m). National Museum, Damascus, Syria.

Corinthian portico. Moses himself is a combination of a bearded Old Testament patriarch and a Roman statesman. He wears a toga, and there is a slight suggestion of *contrapposto* in the folds of drapery defining the bend of his right leg.

In addition to the synagogue, there was a Christian baptistery at Dura Europos and a private house where Christians worshiped. By around A.D. 240, the Christian meeting room that had originally held thirty worshipers had expanded to accommodate sixty.

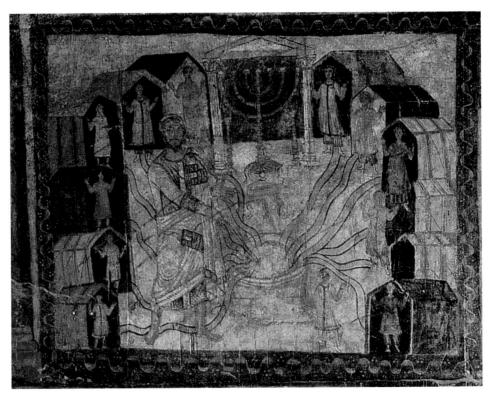

8.2 Moses Giving Water to the Twelve Tribes of Israel (detail of fig. 8.1).

Early Developments in Christianity

Many concepts of Christianity were based in Judaism, which also originated in the Near East. Both were founded on written texts that were believed to be the revealed word of God. They were similar in being monotheistic and in teaching a code of ethics to their adherents. As in certain pagan cults, Christianity offered a promise of eternal salvation, but the differences between them were considerable. For example, Christian rituals were not orgiastic, as were the cults of Dionysos, and they did not include animal or blood sacrifices, except in symbolic form. Christ's own sacrifice was foreshadowed in the Last Supper, when the bread stood for his body and red wine for his blood (see box). This celebration was originally performed by Jesus and his followers as part of the Jewish Passover. shortly before his death. He asked his followers to repeat it in his memory, and at first they did so in private dining rooms. It consisted of breaking bread, drinking wine, singing hymns, praying, and reading from the Bible. By the third century A.D., this re-creation of the Last Supper had become the liturgy of the Mass, conducted by a bishop. In the performance of the Mass, also called Holy Communion, the Lord's Supper, or Eucharist (Greek for "thanksgiving"), bread and wine are ritually substituted for the body and blood of Christ. The first detailed description of the Eucharist dates from around A.D. 155, which suggests that by then it was already an established rite.

In pagan texts, however, there is very little reference to Christian ritual before A.D. 250.

Christianity, like Judaism, placed greater emphasis on faith than paganism did and was also more engaged in notions of heresy. The missionary zeal of Christianity was always stronger than in Judaism; among pagans it was practically nonexistent. Many pagan cults were located at specific sites of worship such as sacred caves or islands. while cities had their own gods. Another common theme in paganism that distinguishes it from Christianity was the importance of visibly honoring the gods by various acts and offerings. These were necessary in order to propitiate the gods and appease their anger. In Christianity, the notion of divine retribution is primarily concerned with one's fate at the end of the world. Even though certain human transgressions arouse divine anger-a notable example from Christ's life being when he drove the money changers from the Temple in Jerusalem-Christianity promises salvation to those who repent of their sins.

Finally, Christians differed from the adherents of Near Eastern religions by refusing to worship the Roman emperor as the embodiment of the state. Christian monotheism rejected the Roman and Greek concepts of pantheism as well as the Near Eastern and Egyptian gods. These attitudes set Christianity at odds with the imperial Roman establishment and made its followers subject to persecution by Rome. In the first century A.D. under Nero (see p. 224), the Christians were blamed for the fires that destroyed

Christianity and the Scriptures

Scriptures are literally "what has been written." For Judaism and Christianity, the most authoritative scriptures are collected in the Bible (which is derived from the Greek word *biblos*, meaning "book"). The Jewish Bible consists of the Old Testament, to which Christians have added the New Testament. The Apocrypha (Greek for "secret" or "hidden") are Old and New Testament writings whose authenticity is questioned.

Established by the fourth century A.D., the New Testament was organized into three sections: the Gospels and Acts, the Epistles, and the Apocalypse (or Revelation). The four Gospels are essentially biographies of Jesus, written in about A.D. 70 to 80 by Saints Matthew, Mark, Luke, and John. The authors are called the four Evangelists (from the Greek word *euangelistes*, meaning "bearer of good news"). The Acts relate the works of Jesus's twelve apostles in spreading his teachings. The Epistles (or Letters), most of which were written by Saint Paul, contain further doctrine and advice on how to live as a Christian. The Apocalypse describes the end of the world and Christ's Second Coming as the final judge.

The most important figures in Christian art are the Holy Family, saints, and martyrs. The Holy Family consists of Mary (Christ's mother), Joseph (her husband), and Jesus. A saint is a person canonized by the Church. The term *martyr*, from the Greek word *martus*, originally meant "witness," specifically a witness to Jesus's works. Subsequently, *martyr* came to mean one who dies for a belief—in this case, Christianity. In Western art, saints, martyrs, and members of the Holy Family are usually depicted with a halo—a circle of light around their heads—to indicate their holiness.

An important distinction between Christian and Roman art can be seen in their respective approaches to history. Romans used works of art to record the past-particularly the exploits and triumphs of their rulers. Christian art focused more on the future as determined by the Christian faith. It was important, therefore, for Christians to encompass as much of the past as possible into present and future. One way in which they did this was by a method of historical revision called typology (from the Greek word tupos, meaning "example" or "figure"), which paired figures and events from the Old Testament (the Old Dispensation) with those of the New Testament (the New Dispensation). The purpose of typology was to reveal that history before Jesus had foreshadowed or prefigured the Christian era. Jesus, for example, calls himself greater than Solomon, the Old Testament king known for his wise judgments and temple building. Jesus is referred to as the new Adam, and Mary is the new Eve. Solomon and Adam are thus types for Jesus, and Eve is a type for Mary. As Christianity developed, this typological view of history was expanded to include pagan antiquity and contemporary events as well as the Old and New Testaments.

Frequently Depicted Scenes from the Life of Jesus

The Birth and Childhood of Jesus

In the Annunciation, the Virgin Mary is informed by the angel Gabriel that she will give birth to Jesus, the son of God. Often the miraculous conception is indicated by a ray of light, the white dove of the Holy Ghost, or both. When Mary is three months pregnant, she visits her aged, childless cousin Elizabeth (the Visitation) and finds her six months pregnant with John the Baptist. The two women are usually shown embracing.

Jesus is born in Bethlehem (the Nativity), which is celebrated on December 25 (Christmas). The standard iconography shows Mary reclining, the swaddled infant in a manger with an ox and an ass, and Joseph sleeping or dozing nearby. In the Adoration of the Magi, three wise men, or kings, follow a star from the East to Bethlehem in search of a newborn king. They bring gifts of gold, frankincense, and myrrh and kneel to worship Jesus. In the Presentation in the Temple, Mary and Joseph bring the infant Jesus to be consecrated at the Temple in Jerusalem. They present him to Simeon. God has promised Simeon that he will see the savior before he dies.

King Herod of Jerusalem has been warned that a newborn will overthrow him. Herod decrees the death of all boys under the age of two (the *Massacre of the Innocents*). Alerted to Herod's plans by an angel, Joseph flees with Mary and Jesus into Egypt (the *Flight into Egypt*).

At the age of twelve, Jesus disputes with the Jewish scholars in the Temple (Jesus among the Doctors).

The Ministry and Miracles of Jesus

John the Baptist baptizes Jesus in the river Jordan in the scene of the *Baptism*. The Holy Ghost or God, or both, may be present, usually hovering above Jesus.

Jesus "calls" his apostles in several scenes; the most commonly represented are the *Calling of Matthew*, the tax collector, and of the fishermen Peter and Andrew. Jesus walks on water when the apostles are caught in a storm on the Sea of Galilee. They see Jesus walking toward them on the water. Peter leaves the boat and begins to drown, but Jesus saves him and then calms the storm.

In the Marriage at Cana, Jesus is a guest at the celebrations, and, because the bridal couple cannot afford wine, he turns the water into wine. When Jesus takes three of his apostles, Peter, James, and John, to Mount Tabor to pray, he manifests his divine nature to them through the *Transfiguration*. Jesus appears in a heavenly white light, flanked by Moses

large areas of the city. And in the third century, when Goths and Germans invaded the empire, Christians were again blamed and made scapegoats. The worst persecutions occurred in 303, during the reign of Diocletian. As a result of the political liability of being a Christian in imperial Rome, and Elijah (the most important Old Testament prophet), and God declares that Jesus is his son.

In the *Resurrection of Lazarus,* Jesus restores the deceased Lazarus, brother of Mary and Martha, to life.

The Passion of Jesus

Jesus enters Jerusalem (the *Entry into Jerusalem*) riding a donkey and followed by his apostles. This event is celebrated on Palm Sunday. Inside Jerusalem, Jesus is angered at people transacting business in the Temple. In the *Expulsion of the Money Changers*, he chases them away.

At the Last Supper, Jesus announces that one of his apostles will betray him. He institutes the Eucharist, declaring that the bread is his body and the wine his blood. This doctrine is referred to as Transubstantiation. After the Last Supper, as a sign of humility, Jesus washes his apostles' feet (the Washing of the Feet). Peter objects and is admonished by Jesus. In the Betrayal, Judas accepts a bribe of thirty pieces of silver to identify Jesus to the Romans. He does so in the Kiss of Judas, where Jesus is arrested by Roman soldiers. Jesus is then brought before the high priest Caiaphas and the Roman governor Pontius Pilate. He is condemned to be whipped (the Flagellation) and crowned with thorns (the Mocking of Jesus). He is also tortured and mocked for claiming to be king of the lews.

Condemned to die by crucifixion, in the *Road to Calvary* Jesus carries his Cross to Calvary (Golgotha), where he is put to death. In the *Deposition*, he is taken down from the Cross, and his followers mourn him (the *Lamentation*). When the Virgin Mary alone mourns Jesus lying across her lap, the scene is referred to as the *Pietà*.

In the Entombment, Jesus is placed in his tomb. He is now beyond the confines of natural time and space, and enters the part of hell called Limbo (the Harrowing of Hell) to lead certain souls to salvation. Jesus has now become Christ, and three days after his burial, he rises from his tomb (the Resurrection), which is celebrated at Easter. When Mary Magdalen sees him, she reaches out to determine if he is real. But he repels her, saying, "Do not touch me" (Noli me tangere). Later, Christ meets two of the apostles and shares a meal with them (the Supper at Emmaus). In the Ascension, Christ rises to heaven in the presence of his mother and the apostles. In the Pentecost, the apostles are given the gift of tongues—shown in art as divine flames—with which to speak different languages and carry the message of Jesus throughout the world.

despite its appeal to the lower classes and the fervor of its adherents, Christianity remained an underground movement for nearly the first three hundred years of its existence. Memorial services were conducted in underground passages—the catacombs—located on the outskirts of Rome. Rome was never entirely safe for Christians before A.D. 313, when Emperor Constantine issued the Edict of Milan, granting tolerance to all religions, and especially to Christianity.

The Catacombs

Christians as well as Jews were relatively safe from Roman persecution when performing funerary rites in the catacombs, which were underground cemeteries in Rome. The derivation of the term is uncertain, but in Greek kata means "down," and in late Latin cumbere means "to lie down" (cf. the English recumbent). The latter is related to the cubit, an old unit of measurement from the elbow to the tip of the middle finger-that is, the length of the forearm on which one reclines. Under Hadrian, the Roman aristocracy began to renounce cremation of the dead in favor of inhumation, which was practiced by Christians and Jews. Niches cut out of rock in the catacombs contained the bodies, which were closed in by slabs or tiles. According to Roman law, burial grounds were sacrosanct, so the Romans rarely pursued Christians into the catacombs, where some of the earliest examples of Christian art can be found. After the sixth century, the catacombs fell into disuse and were forgotten until their accidental discovery in 1578.

8.3 Christ as the Good Shepherd, catacomb of Priscilla, Rome, 2nd–3rd century. Fresco.

Figure **8.3** shows a fresco depicting *Christ as the Good Shepherd* from the catacomb of Priscilla, dating from the late second or early third century. Christ carries a goat on his shoulders, with a second goat, a sheep, and a tree on either side of him. Each tree is surmounted by a bird. The motif of the Good Shepherd, which had been popular in Roman garden statuary and in the literary bucolic tradition, was assimilated by Early Christian artists as a symbol of compassion. Christ as the Good Shepherd was also incorporated into Christian liturgy, with the priest being paralleled with Christ and the congregation with the flock. The Dura Europos baptistery has an earlier example than figure 8.3 of the Good Shepherd in Christian guise, in which he is typologically paired with Adam and Eve.

Constantine and Christianity

Constantine followed Diocletian (ruled A.D. 284–305) as emperor of Rome, but not without a struggle. Under Diocletian, Rome had been ruled by a tetrarchy (a "government of four") consisting of himself and Maximian (designated *Augusti*, or emperors) and two others of lower rank (called Caesars). This arrangement was Diocletian's attempt to defend the weakening borders of the empire from invasions threatened by Persians to the east and Germans to the north. With four leaders, he reasoned, imperial power could be extended outside Rome, and in Rome itself rebellion would be discouraged. But Diocletian's plan failed, for the tetrarchy actually diluted the centralized administrative power of the emperor, a circumstance that is regarded as a significant factor in Rome's decline.

Although Constantine's edicts and some of his letters survive, the primary source for his assumption of sole power is the biography by Eusebius (A.D. 265–340), bishop of Caesarea, in Israel, which describes Constantine's victory over Maximian's son Maxentius at the Milvian Bridge in Rome. According to Eusebius, Constantine saw two visions before the battle. In one, the Cross appeared against a light with the words "In this sign you conquer." In the other, he was told to place the *Chi-Rho*—the first two letters of Christ in Greek—on the shields of his soldiers (see box). After this victory, Constantine issued the Edict of Milan because, according to Eusebius, he recognized the power of the Cross and the Christian God.

Constantine's precise relationship to Christianity is not known, although he clearly took a personal interest in the new religion; Eusebius says that he was baptized, although there is no other evidence of this. In 325, Constantine convened the Council of Nicaea (in modern Turkey), which established the doctrine that Christ and God were equally divine. This was in opposition to the view propagated by Arius of Alexandria and his followers that is referred to as the Arian heresy. Five years later, in 330, Constantine founded a new eastern capital at Byzantium, at least in part because the eastern regions of the Roman Empire were gaining in political importance. It was also there that Christianity had established the firmest foundations by the early years of the fourth century.

Christian Symbolism

Christ means the Anointed, Messiah, Savior, Deliverer and is written in Greek as $XPI\Sigma TO\Sigma$. The two letters X and P (Chi and Rho) are equivalent to the English Chr and, as Christ's monogram, were superimposed and written as

Ichthus, the Greek word for "fish," is an acronym for "Jesus Christ, Son of God, Savior." The I is the Greek equivalent of the English J (for "Jesus"), Ch stands for "Christ," Th for theou (Greek for "of God"), U for uios (Greek for "son"), and S for soter (Greek for "savior"). The ichthus and other cryptic signs and symbols were used by Christians to maintain secrecy during the Roman persecutions. Much Early Christian imagery is symbolic in nature and often takes the form of pictorial puzzles known as rebuses. Even after Christianity had become the official religion of Rome and secrecy was no longer necessary, certain images such as the fish, the Cross, the Lamb of God, and the Good Shepherd continued to have symbolic importance in art and liturgy.

The Divergence of East and West

The struggle to establish Christianity as the new official religion of Rome and the resulting controversies reflect the political and religious turmoil of the centuries immediately following the birth of Christ. The title of this chapter is also a reflection of those uncertain times. "Early Christian" is a historical more than a stylistic designation. It refers roughly to the first four centuries A.D. and to Christian works of art made during that period. The term *Byzantine*, derived from the city of Byzantium, is used to describe a style that originated in the Eastern Roman Empire, including works made in Italy under Byzantine influence. At first,

the two terms overlap. However, as Rome and the Western Empire were overrun by northern European tribes and the East rose to prominence under Justinian, the distinction between the Eastern and Western empires became more pronounced, and Early Christian and Byzantine cultures grew apart.

The geographical separation and political divergence of East and West was paralleled by a schism (split or division) within the Church itself. In Rome and the Western Empire, the pope was the head of the Church. The Eastern branch of the Church was led by a patriarch, whose power was bestowed on him by the Byzantine emperor.

Corresponding to the East-West division were the artistic styles produced by each branch of the Church. In the West, artists worked in the tradition of Hellenistic and Roman antiquity. This led to a proliferation of medieval styles from the seventh to the thirteenth centuries. Eastern artists were more influenced by Greece and the Orient, and remained so. As a result, the Byzantine style persisted in eastern Europe as late as the sixteenth century. Byzantine art also infiltrated the West, especially Italy, and maintained its influence there until the late thirteenth century. Just as republican and imperial Rome had assimilated other cultures, so Christianity and Christian art absorbed aspects of earlier religions and their iconography. Greek and Roman myths were endowed with Christian meaning and interpreted in a Christian light.

Early Christian Art

Sarcophagi

A good example of continuing Roman imagery in Early Christian art can be seen in the marble sarcophagus in the Church of Santa Maria Antiqua in Rome (fig. **8.4**). The front, visible here, includes Old and New Testament scenes as well as figures combining Roman with Christian meaning. Reading from left to right, the first character is the Old

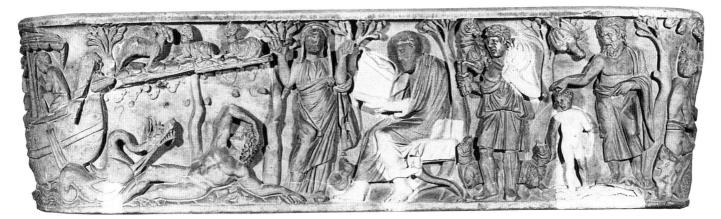

8.4 Early Christian sarcophagus, Santa Maria Antiqua, Rome, 4th century. Marble. Although the Christians continued to decorate their sarcophagi with reliefs, as the Greeks, Etruscans, and Romans had done, they omitted the effigy of the deceased from the cover of the tomb. They also abandoned cremation because they believed in bodily resurrection.

Testament figure of Jonah, who has emerged from the great fish that swallowed him. Jonah's form is based on the idealized, organic Classical reclining nude, while the fish is imaginary. This story was well suited to a Christian sarcophagus since Christians interpreted it as a typological prefiguration of the Resurrection of Christ. Just as Jonah spent three days inside the whale, so Christ was entombed for three days before his Resurrection. An Early Christian viewer would have recognized the implications of this iconography as a metaphor for the resurrection of the person buried in the sarcophagus.

To the right of Jonah on the sarcophagus are two Christian transformations of a Greco-Roman poet and his muse. The seated poet wears a Roman toga but is shown as a Christian poring over a religious text. The muse is also in Classical dress. She stands with her arms raised in a gesture that combines prayer and mourning with a visual reference to Christ's Cross. Spreading out from behind her palms are leafy tree branches, a reminder that the Cross was made of wood. Indeed, trees have replaced columns as architectural dividers between scenes. Because of their relationship to the wood of the Cross, trees were to become a central motif in Christian art.

Next on the right is the Good Shepherd with a sheep on his shoulders. At the far right, a large, bearded John the Baptist stands on the bank of the river Jordan (indicated by wavy lines) and baptizes a small, nude Jesus. In the upper left corner of the scene hovers the dove of the Holy Ghost, a traditional element in the iconography of the Baptism. This is another appropriate scene for a sarcophagus because baptism signifies rebirth into the Christian faith, and thus salvation. These themes—baptism as initiation into the faith and hence into a community—were important aspects of the Early Christian movement.

The opposition of the Baptism on one side of the sarcophagus and Jonah and the whale on the other demonstrates what was to become a traditional typological pairing of left and right in Christian art. This associates the old, or pre-Christian, era with the left, and the new, Christian, era with the right. Such pairing was extended to include standard notions of good and evil, dualities such as light and dark, and so forth. (The negative implications of the Latin word *sinister*, meaning "left," survive in modernday English.)

Basilicas

Christians worshiped in private homes until the early fourth century. But when Constantine issued the Edict of Milan in A.D. 313, they were free to construct places of worship. From that point on, Christianity was legally protected from persecution and soon became the official religion of the Roman Empire. New buildings were needed to accommodate the large and ever-growing Christian community. Unlike Greek and Roman temples, whose main purpose was to house the statue of a god, Christian churches were designed so that crowds of believers could gather together for worship. With the active support of Constantine, many churches were constructed in very few years—in Constantinople (the name Constantine had given to Byzantium; it is now Istanbul), in Italy, in the Holy Land, and elsewhere in the Roman Empire. Christian churches were modeled on the Roman basilica (see p. 218), a spacious structure designed to hold large numbers of people. Such Early Christian basilicas became the basis for church architecture in western Europe.

Old Saint Peter's None of the early Christian basilicas has survived in its original form, but an accurate floor plan of Old Saint Peter's (fig. **8.5**) has been reconstructed (fig. **8.6**; see box). The architectural design of the Christian basilica conformed to the requirements of Christian ritual; the altar, where the Mass was performed, was its focal point. The movable communion table used in Christian meeting places before 313 was replaced by a fixed altar that was both visible and accessible to worshipers. Both altar and apse were usually at the eastern end, and the **narthex** (vestibule) at the western entrance became standard in later churches.

The altar's location at the eastern end of the basilica served a symbolic as well as a practical function. It generally supported a crucifix with the image of Christ on the Cross turned to face the congregation. As Christ's Crucifixion took place in the east (Jerusalem), Christian basilicas and most later churches are oriented with the altar in the east. According to tradition, Christ was crucified facing

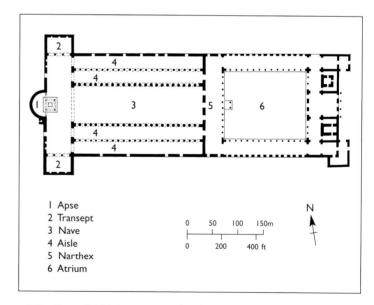

8.5 Plan of Old Saint Peter's basilica, Rome, 333–390. Interior approx. 368 ft. (112.16 m) long. Old Saint Peter's was the largest Constantinian church and became the prototype for later churches. Besides being a place of worship, it was the saint's **martyrium** (a building over the grave of a martyr); a marble canopy in the apse marked his grave.

CONNECTIONS -

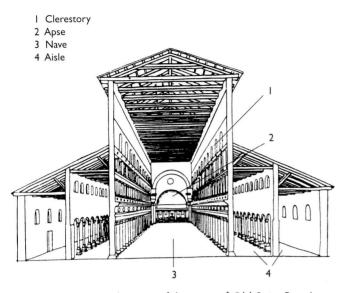

8.6 Reconstruction diagram of the nave of Old Saint Peter's basilica. Old Saint Peter's is similar to the pagan or secular basilica of pre-Christian Rome in having a long nave flanked by side aisles, clerestory windows on each side, an apse, and a wooden **gable** roof. Unlike pagan basilicas, which typically had an apse at each end, Old Saint Peter's had a single one opposite the entrance. The building was demolished in the 16th century when work on the New Saint Peter's began.

west, and therefore the cross on the altar usually faces the main western entrance of the church building.

Another symbolic aspect of church design was the new use of the apse. In the Roman basilicas, apses had often contained statues of emperors and were also the location of legal proceedings. In Early Christian apses, therefore, the image of Christ as Judge was particularly appropriate. It referred both to the Roman law courts and to the Christian belief in a Last Judgment.

An important new feature in Old Saint Peter's was the addition of a **transept** to the Roman basilica. This consisted of a transverse space, or cross arm, placed at right angles to the nave, and separated the apse from the nave. The transept, which contained a canopy marking Peter's grave, isolated the clergy from the main body of the church. With the transept, the building forms the shape of a cross—hence the adjective **cruciform** to describe basilicas with this feature.

The altar and apse at Old Saint Peter's were framed by a huge triumphal arch—a regular architectural element of Early Christian basilicas. The architects thus transformed the meaning of the Roman triumphal arch from the emperor's triumph to that of Christ.

The exterior of Old Saint Peter's, and of similar churches, was plain brick. The interior, on the other hand, was richly decorated with mosaics, frescoes, and marble columns. Their purpose was not only to exalt the deity, but also to

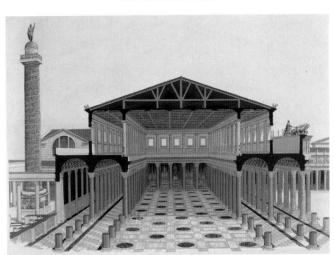

See figure 7.13. Reconstructed cross section of the Basilica Ulpia, A.D. 98–117.

Saint Peter

Saint Peter was Christ's first apostle. In Matthew 16:13–20, Christ gives Peter the keys to heaven with the words "Upon this rock I will build my church." That statement became the basis for the pope's authority, although interpretations differ as to whether "rock" refers to Peter or to his faith. The name Peter comes from the Greek word petros (meaning "rock"), from which comes the English word petrify, meaning "turn to stone." Rock is also a metaphor for something strong and lasting, as in "solid as a rock" or "Rock of Ages," and here denotes the solid and enduring character of faith. The infinite power of God is also reflected in the phrase from the Old Testament Book of Psalms, "God is my rock."

Saint Peter was the first bishop of Rome. Since that office later became the papacy, he is considered to have been the first pope. The basilica of Old Saint Peter's became the prototypical papal church, although it was in fact an exception to the traditional Christian orientation of churches toward the east and was initially built as a pilgrimage site and covered cemetery. During the fifteenth, sixteenth, and seventeenth centuries, Saint Peter's was rebuilt by several architects (see Chapters 14 and 17), and it is still the seat of papal power today. teach and inspire the worshipers. The fragmentary mosaic of *Christus-Sol* (Christ as Sun) of around A.D. 250 (fig. **8.7**) is from the Christian Mausoleum of the Julii, which was discovered in a pagan cemetery under Old Saint Peter's. It is a good example of the syncretistic character of Early Christian iconography: the vines of Dionysos, generally associated with the ritual drunken orgies of that god's festivals, have become the True Vine of Christ. The latter came to symbolize the Church body, based on Christ's statement "I am the vine, you are the branches." The pagan sun god, Sol/Apollo, is merged with Christ as Sun. The arms of the Cross and rays of light emanate from his head; he holds an orb, symbolizing the world over which he has dominion, and is accompanied by two horses pulling a chariot (indicated by the wheel). Another feature of this image is the implied association of the Roman emperor with a god, but here his pagan apotheosis is superseded by Christian resurrection.

8.7 *Christus-Sol,* from the Christian Mausoleum of the Julii under Saint Peter's necropolis, Rome, mid-3rd century. Vault mosaic.

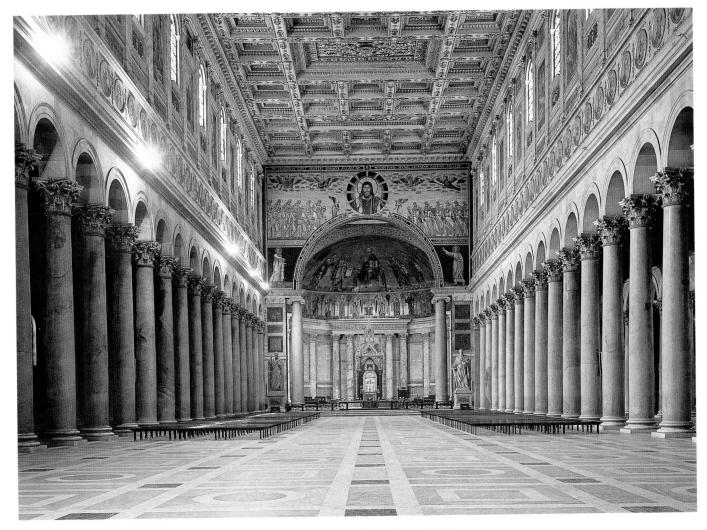

8.8 Saint Paul outside the Walls, Rome, begun 385 and restored after a fire in 1823.

The interior of Saint Paul outside the Walls (fig. **8.8**), although now restored, gives some idea of the original appearance of Early Christian churches. Wooden beams in the ceiling have been replaced by coffers, but the vast basilica-like space remains. Like Old Saint Peter's, it retains the wide nave, aisles, clerestory windows, and apse

of the Roman basilica. The triumphal arch has become a chancel arch, which is supported by Ionic columns, whereas those separating the nave from the aisles are Corinthian. The rich mosaic decoration, its iconography, and the predominance of gold contribute to the impressive effect of the interior.

Mosaic Technique

Unlike Hellenistic mosaic, made by arranging pebbles on the floor, Christian mosaic was made by adapting the Roman method of embedding *tesserae* into wet cement or plaster. *Tesserae* (from the Greek word meaning "squares" or "groupings of four") are more or less regular small squares and rectangles cut from colored stone or glass. Sometimes rounded shapes were used. The gold *tesserae* of the Byzantine style were made by pressing a square of gold leaf between two pieces of cut alass.

The term *mosaic* comes from the same word stem as *museum*, a place to house works of art, and *muse*, someone—usually a woman—who inspires an artist to create. When we muse about something, we ponder it in order to open our minds to new sources of inspiration. *Music* is also from the same word stem as *mosaic*.

Centrally Planned Buildings

Another type of structure favored by the Early Christians was the **centrally planned** round or polygonal building. It radiated from a central point and was surmounted by a dome, and it was often attached to a larger structure. Such buildings were used mainly as *martyria*, **baptisteries** (for performing baptisms), or **mausolea** (large architectural tombs). Centrally planned churches contained a central altar or a tomb and a cylindrical core with clerestory windows. A circular barrel-vaulted passage, or **ambulatory** (from the Latin word *ambulare*, meaning "to walk"), extended from between the central space to the exterior walls.

Santa Costanza

The martyrium of Santa Costanza (fig. **8.9**) was built just outside the walls of Rome for Constantine's daughter

Constantina, who died in 354. Her sarcophagus was placed opposite the door so that it was in the visitor's direct line of vision upon entering the building. The circular plan includes an inner colonnade of paired columns, separating the central space from the ambulatory and supporting round arches (fig. **8.10**). Composite capitals contain both the Ionic volute and the Corinthian acanthus leaves. The center of the building consists of a tall, cylindrical space surmounted by a dome.

Over the ambulatory, the barrel vaults are decorated with mosaics (see box), again illustrating the syncretistic assimilation of Classical themes by Christian artists. Figure **8.11** shows a detail of the Cupid and Psyche figures, which were reinterpreted by Christian authors as an allegory of the relationship between the body (Cupid) and the soul (Psyche). The circular shapes create the Cupid and Psyche pattern, and the other shapes are filled with birds and vine leaves.

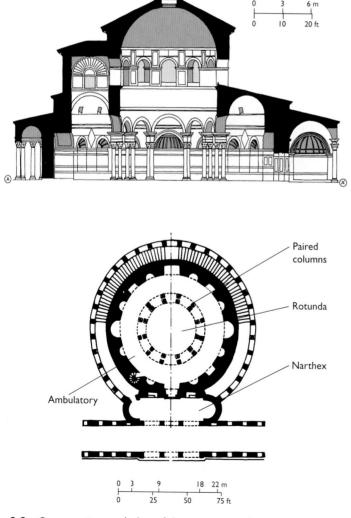

8.9 Cross section and plan of the martyrium of Santa Costanza, Rome, c. 350.

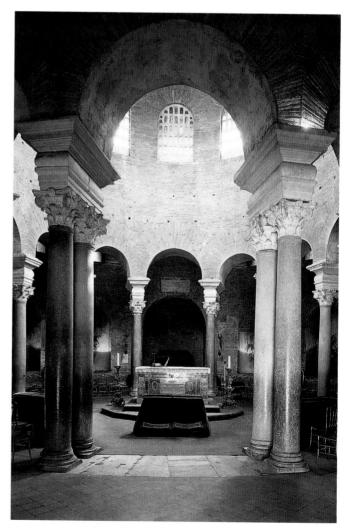

8.10 Interior of Santa Costanza, Rome, c. 350.

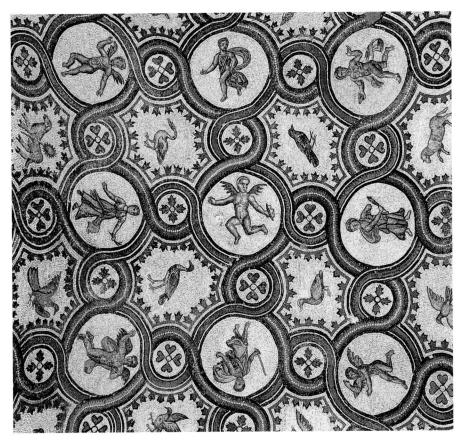

8.11 The ambulatory ceiling of Santa Costanza, Rome, c. 350. Mosaic.

Galla Placidia

The symmetrical cruciform mausoleum of the empress Galla Placidia (c. 390–450) was built in Ravenna, a city on the Adriatic coast of Italy. Galla Placidia was the daughter of Emperor Theodosius I. She was abducted by Alaric the Goth in 410 when his army defeated Rome. Four years later, she married the Goth king Ataulf, who died in 415. Galla Placidia then returned to her Christian family in Constantinople. When her son, Valerian III, was proclaimed emperor, she became regent and remained empress for twenty-five years—from 425 to 450.

Ravenna was of crucial importance to the Byzantine Empire because of its strategic location for trade between East and West. The exterior of Galla Placidia (fig. **8.12**) is of plain brick, but the four arms are varied by **blind niches** (in which there is only a slight recess in the wall) with round arches, a continuous cornice, and four pediments. Inside each arm is a vault, and the taller central crossing is surmounted by a dome. Spectacular mosaics decorate the inner walls and ceiling, and their iconography, which is imbued with sepulchral themes, attests to the piety of

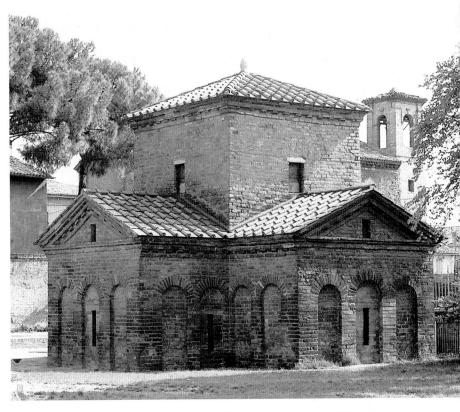

8.12 Exterior of the mausoleum of Galla Placidia, Ravenna, c. 425–426.

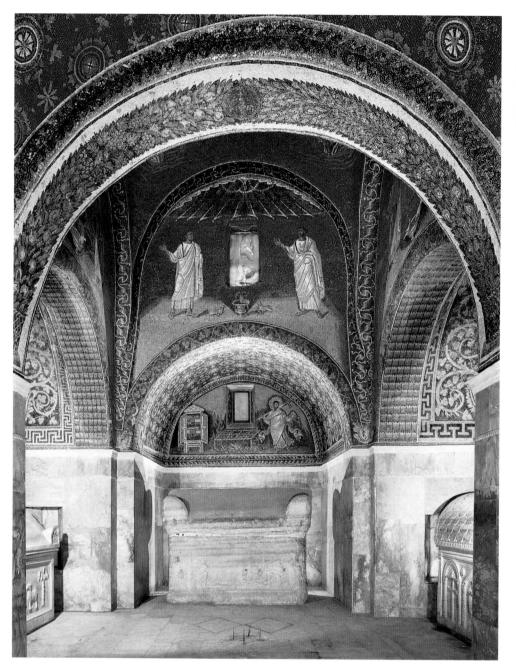

8.13 Interior of the mausoleum of Galla Placidia showing niche with two apostles (above) and the *Saint Lawrence* mosaic (below), Ravenna, c. 425–426.

Galla Placidia. Figure **8.13** is a view of a niche mosaic showing two apostles in togas who raise their right hands in the manner of Roman senators. Flanking a fountain are two doves symbolizing Christian souls who drink the baptismal water of eternal life. Below, the *Saint Lawrence* mosaic depicts the saint approaching the gridiron over a bed of fiery coals on which he was martyred. The rich, dark blue ceiling and the barrel vaults over the arms of the building represent the dome of heaven, blanketed with brightly lit stars (figs. 8.14 and 8.15).

Over the entrance is a large lunette (the semicircular wall surface) containing a mosaic of *Christ as the Good Shepherd* (fig. **8.14**). He is surrounded by six sheep, one of which he caresses lightly under the chin. His shepherd's crook has been replaced by a cruciform martyr's staff, which alludes to his own death by crucifixion. Like-

wise, Christ's robe of purple and gold is a sign of his assimilation of the emperor's royal status as well as of his future as King of Heaven. He sits on a rock, which is divided into three steps, evoking both the Trinity (the number 3) and the role of Saint Peter (the rock) in establishing the Church. The landscape setting, Christ's contrapposto, the shading and foreshortening of the sheep, and their cast shadows indicate the continuation of Hellenistic naturalism and its assimilation into Christian art. In figure 8.15, we are looking upward directly at a view of the star-studded barrel vault. Figure 8.16 shows a detail of geometric design that reveals the artist's delight in illusionism. But in the course of the next century, these naturalistic and illusionistic qualities would diminish, giving way to a flattening of space and an increase of spirituality in art.

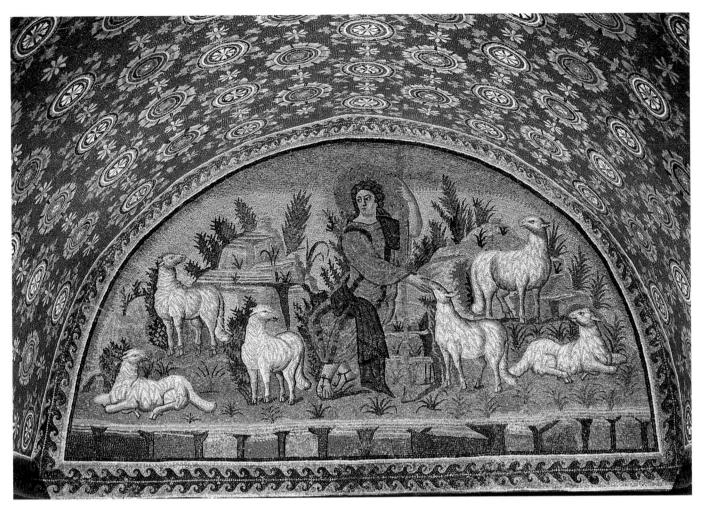

8.14 Christ as the Good Shepherd, the mausoleum of Galla Placidia, Ravenna, c. 425–426. Mosaic.

8.15 Detail of a barrel vault from the mausoleum of Galla Placidia, Ravenna, c. 425–426. Mosaic.

8.16 Detail of a geometric border from the mausoleum of Galla Placidia, Ravenna, c. 425–426. Mosaic.

Justinian and the Byzantine Style

During the fifth century, the western part of the Roman Empire was overrun by Germanic tribes from northern Europe. The Ostrogoths occupied the Italian port city of Ravenna until it was recaptured during the reign of the Byzantine emperor Justinian in A.D. 540. Under Justinian, the Eastern Empire rose to political and artistic prominence (see map).

San Vitale

Because of Ravenna's pivotal geographic position, it became the Italian center of Justinian's empire and the focus of his artistic patronage in Italy. He strove to restore unity to Christendom, and one expression of that effort can be seen in his building programs. Ravenna's most important early Byzantine church, San Vitale (figs. **8.17** and **8.18**), was commissioned by the city's bishop, Ecclesius. Construction continued until its dedication in 547 by Maximian, the archbishop of Ravenna. San Vitale was dedicated to Saint Vitalis, a Roman slave and Christian martyr who became the object of a growing cult from the end of the fourth century.

The exterior of San Vitale (fig. 8.17) is faced with plain brick, unbroken except by buttresses and windows. The domed central core and octagonal plan (fig. 8.18) of San Vitale diverge from the architecture of Western Christendom. Instead of having an east-west orientation along a longitudinal axis with the altar in the east and the entrance in the west, San Vitale is centrally planned. The narthex is

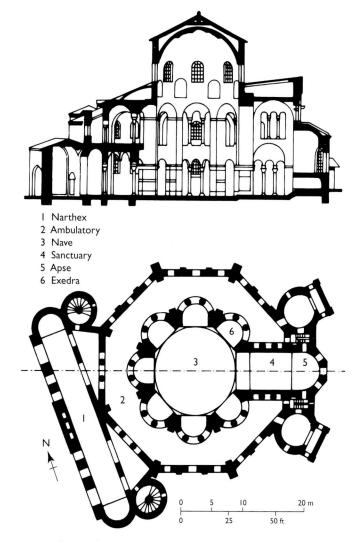

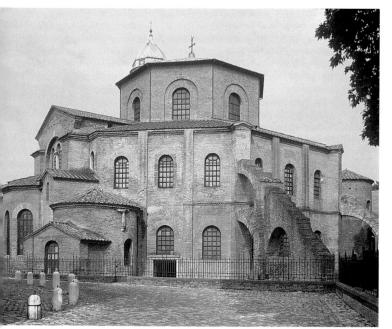

8.17 Exterior of San Vitale, Ravenna, 540–547.

8.18 Plan and section of San Vitale.

placed on the western side at an angle to the axis of the apse. The circular central space is equivalent to the nave of Western churches and is ringed by eight large pillars supporting eight arches. Beyond the arches are seven semicircular niches and the cross vault containing the altar. Each niche is surrounded by an ambulatory on the floor level and a **gallery** (perhaps reserved for women) on the second story. All three levels—ground, gallery, and clerestory have arched windows that admit light into the church.

The interior of San Vitale is richly decorated with mosaics and marble, which are illuminated by natural light. Looking eastward, toward the apse and the altar, one can see the large rectangular piers that support the main arches and the columns at the base of the smaller arches (fig. **8.19**). The interior is suffused with a glow of yellow light, resulting from the prevalence of gold in San Vitale's mosaics. They are among the best examples of Byzantine mural decoration.

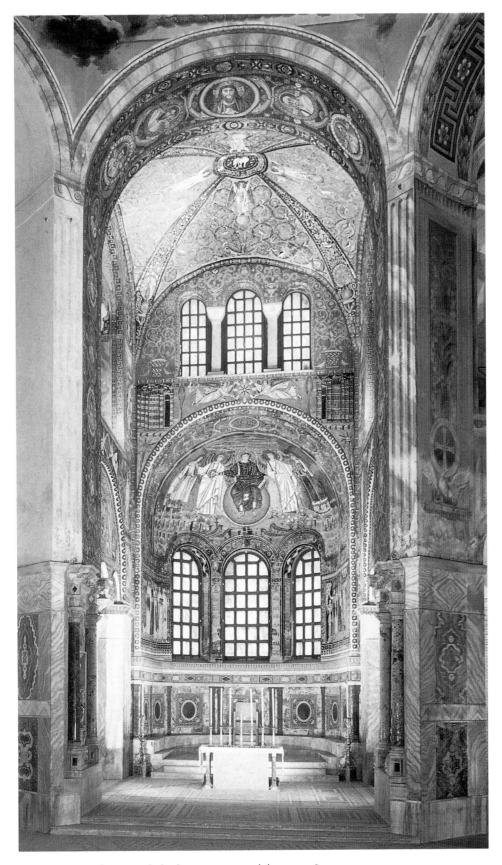

8.19 Interior of San Vitale looking east toward the apse, Ravenna.

8.20 Ceiling of the choir, San Vitale, Ravenna, c. 547. Mosaic.

The vaulted choir ceiling (fig. **8.20**) creates a natural architectural division into four curved triangles. Each is decorated with elaborate floral and animal designs. At the center, a circular wreath frames a haloed lamb in a starstudded blue sky. It symbolizes Christ as the Lamb of God (both Christ and the Lamb were associated with sacrifice). Four angels in white, Roman-style draperies stand on blue spheres and hold up the ring encircling the Lamb. Directly across from the Lamb, on the arched entrance to the choir, is Christ in another guise. Again framed by a circle, the bust-length figure of Christ is frontal, dark-haired, and bearded. This is his traditional Eastern (Byzantine) representation. His central position on the arch and his frontality compared with the apostles around him reinforce his triumphal role as leader of the Church.

The capitals, which are decorated with elaborate relief sculpture, no longer conform to the Greek or Roman Orders (fig. **8.21**). Instead, the architect achieved another kind of unity by virtue of geometric repetition. Both parts of the capital are trapezoidal, as is the curved section between the springing of the two arches. The large lower trapezoid is covered with vinescroll decoration, which,

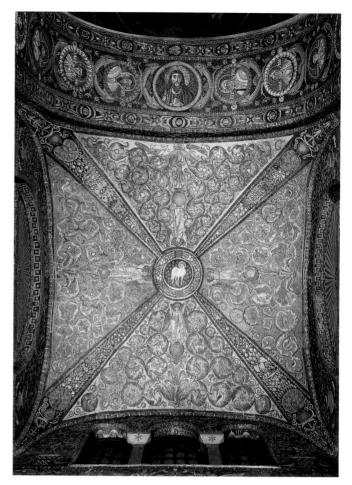

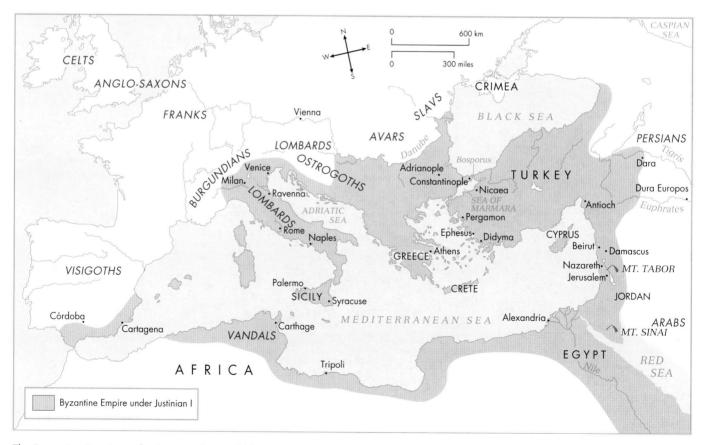

The Byzantine Empire under Justinian I, A.D. 565.

8.21 Detail of a capital, San Vitale, Ravenna, c. 540. Marble.

because of its symbolic associations, had become a popular Christian motif. Note that the five yellow flowers in the center are arranged to form a Greek cross—a cross with four equal arms—that echoes the yellow longitudinal cross in the trapezoid above. The cross is flanked by horses (probably a Near Eastern motif), each in front of a green tree, accentuating the Christian connection between the tree and the Cross of Christ.

The large mosaic (fig. **8.22**) in the apse of San Vitale depicts a young, beardless Christ, based on Western Apollonian prototypes. His halo contains an image of the Cross, and he wears a royal purple robe. Seated on a globe, Christ is flanked by two angels and hands a jeweled crown to Saint Vitalis. On the right, Bishop Ecclesius holds up a model of the church. Although there are still traces of naturalism in the landscape and hints of shading in figures and draperies, the representation is more conceptual than

8.22 Apse mosaic, San Vitale, Ravenna, c. 547.

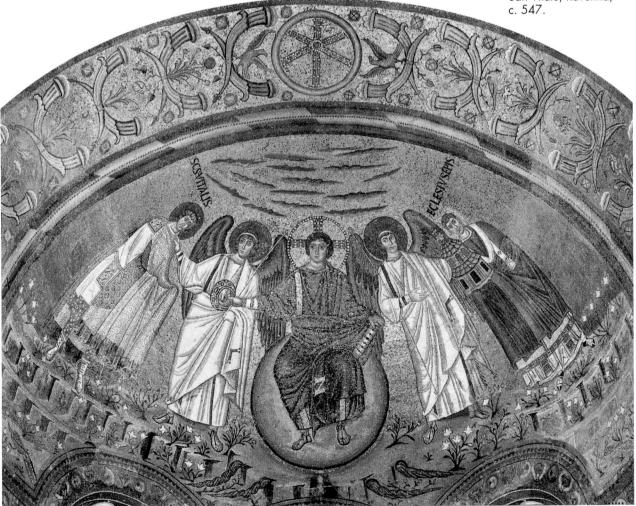

natural. The draperies do not convey a sense of organic bodily movement in space, and the figures are essentially, if not exactly, frontal. The absence of perspective is evident in the pose of Christ: he is not logically supported by the globe but rather hovers as if in midair.

On the two side walls of the apse are mosaics representing the court of Justinian and his empress, Theodora. On the viewer's left, and Christ's right, is Justinian's mosaic (fig. **8.23**). On Justinian's left (the viewer's right) the archbishop Maximian wears a gold cloak and holds a jeweled cross. He is identified by an inscription and stands with two other members of the clergy. On Justinian's right are court officials and his military guard, showing that his position is protected by the army. The gold background removes the scene from nature, thereby aiming to transport the viewer into a spiritual realm.

Opposite Justinian's mosaic, Theodora is depicted in an abbreviated apse with her court ladies on the right and two churchmen on the left (figs. **8.24** and **8.25**). The fig-

ures in this mosaic, like those in Justinian's, stand in vertical, frontal poses. Their diagonal feet indicate that they are not naturally supported by a horizontal, three-dimensional floor. An illusion of movement is created by repetition and elaborate, colorful patterns, rather than by figures turning freely in space. A good example of this typical Byzantine disregard of perspective appears in the baptismal fountain on the abbreviated Corinthian column at the left of the scene. The bowl tilts forward, which in a natural setting would cause the water to spill out. But the water itself forms a foreshortened oval, thereby creating some degree of three-dimensional illusion. In contrast, Theodora's halo is depicted as a flat circle.

Theodora had grown up in the theater and lived the life of a courtesan until her marriage to the emperor in 523. They became co-regents of the Eastern Empire four years later. Theodora was a woman of great intelligence who advised Justinian on political and religious policy.

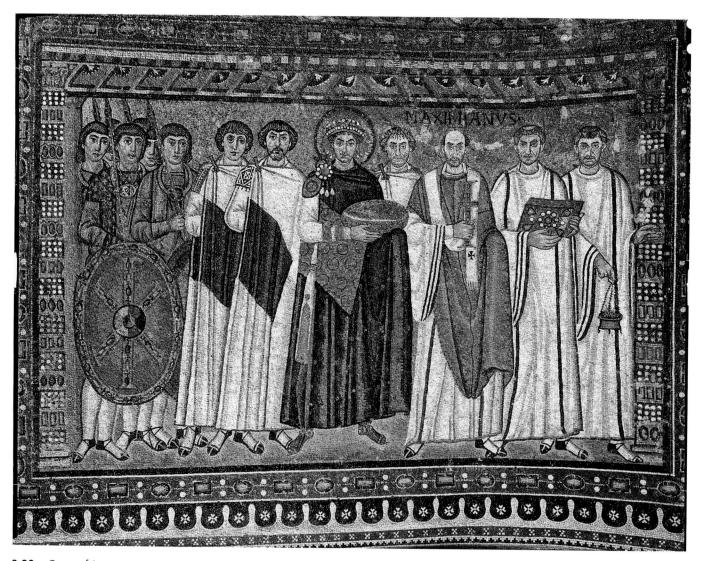

8.23 Court of Justinian, apse mosaic, San Vitale, Ravenna, c. 547. 8 ft. 8 in. \times 12 ft. (2.64 \times 3.65 m).

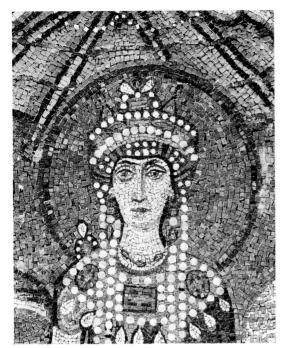

8.24 (left) *Theodora* (detail of fig. 8.25). Here there is still an attempt at shading on the side of the nose and under the chin. Removing the image from the illusion of naturalism, however, is the black outline. The tilted, irregular placement of the *tesserae* creates thousands of small shifting planes that reflect the outdoor light entering the church.

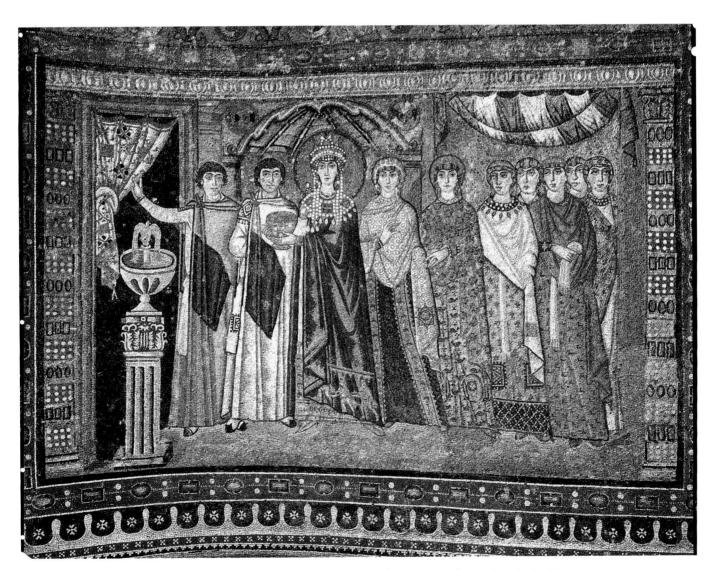

8.25 Court of Theodora, apse mosaic, San Vitale, Ravenna, c. 547. 8 ft. 8 in. \times 12 ft. (2.64 \times 3.65 m).

METHODS OF INTERPRETATION

The Mosaics of Justinian and Theodora, Emperor and Empress of the Byzantine Empire: Formalism, Iconography, Feminism, Biography

T he mosaic panels of the Byzantine emperor Justinian and empress Theodora, on the side walls of San Vitale's apse, lend themselves to several methodological approaches of interpretation. The artist designed these images for the specific purpose of showing the power, piety, and wealth of the Byzantine rulers. Formally, Justinian's mosaic is composed of a horizontal phalanx of churchmen and soldiers flanking the emperor. Their frontality forms a figural wall that directly confronts the viewer and creates a sense of unity. Justinian dominates the group by his central placement and royal purple cloak. In addition, his jeweled crown and halo elevate him above the others, accentuating his central importance.

Iconographically, there are a number of details designed to emphasize Justinian's Christian and military power. His halo sanctifies him and reminds viewers that he is the "Holy" Roman emperor, and the purple color of his cloak alludes to the costume of Roman emperors. The soldiers display a shield with the *Chi-Rho* emblem of Constantine, which places Justinian in a direct line of descent from the time of Constantine's conversion to Christianity and the foundation of Byzantium as a new Roman capital.

Reinforcing Theodora's role as co-regent with Justinian, the mosaic of Theodora is across the apse from Justinian's, thus sharing the most sacred area of the church. She is given a great deal of importance as the empress, but, from a **feminist** standpoint, certain subtle formal and iconographic elements show her to be slightly less powerful than her male spouse. Her mosaic is to Christ's left (the viewer's right) instead of in the preferred position on Christ's right (note the idea that the saved are "on the right hand of God"). Theodora, her churchmen, and her ladies-inwaiting are also set farther back in space than the figures in Justinian's mosaic and are proportionally smaller. They thus appear less assertive. The ladiesin-waiting seem particularly "ladylike," dressed as they are in jewels and in elaborately patterned, delicately embroidered robes.

Biography also plays a role in Theodora's iconographic representation, which may have been designed to change her image as a former courtesan and actress. Before marrying Justinian in 523 following their notorious romance, she transformed the memory of her dissolute past by means of a zealous program of moral reform. In her mosaic, she is shown as a pious ruler standing inside an abbreviated apse. She extends a gold bowl toward the baptismal fountain that signifies entry into the Christian faith. Reinforcing the notion that Theodora is a generous and devoted patron of the Church are the three gift-bearing Magi embroidered into the lower section of her purple robe.

The importance of light in Christian art is expressed in Byzantine mosaics such as these by the gold backgrounds and the reflective surfaces of the *tesserae*. Christ as "light of the world" provided the textual basis for such light symbolism. The concept echoes various Eastern sun cults of earlier periods. Constantine, too, used the designation *Sol Invictus* ("Invincible Sun") for himself. So, when the Byzantine artist depicted Justinian and Theodora with halos, it was to emphasize their combined roles as earthly and spiritual leaders.

The style of Justinian's and Theodora's heads is far removed from the type of Roman portraiture that preserved the features of its subjects. However, the stylistic distinction and positioning of people according to their status has been retained. For example, the prominent position of Theodora's mosaic is a function of her status as co-regent with her husband. It is subordinate to Justinian's by virtue of being on Christ's left—traditionally a less exalted position than his right, and Theodora herself is placed farther back in the picture space than Justinian. As a result, her image is less imposing. The emphasis on rank and hierarchy rather than on personality or portraiture reflects the highly structured nature of Byzantine society (see box). Another, even more subtle aspect of these mosaics is the way in which the artist shows the relationship of the emperor and empress to the central figure of Christ in the semidome of the apse. Despite the frontality of the standing figures, the objects they hold—the offerings of Theodora and Justinian, the crucifix of Maximian, and the gold tome and censer of the churchmen—are extended slightly toward the curved apse wall behind the altar. There is thus a correspondence among the iconography of the mosaics, the formal arrangement of figures and objects, and the architecture of the apse.

The symbolic character of these images is evident not only in their style and iconography but also in the virtual absence of any reference to the biographies of the emperor and empress. Since Justinian had never been to Ravenna, his mosaic had great political importance. It served both as his substitute and as a visual reminder of his power, emphasizing his political allegiance to Constantine and his religious devotion to Christ. By juxtaposing the Byzantine emperor with the local archbishop, the artist also alludes to Justinian's support from Ravenna's ecclesiastical hierarchy.

Maximian's lvoryThrone

In addition to monumental expressions of imperial and Church power in architecture, architectural sculpture, and mosaics, Byzantine artists produced small reliefs, ivories, church furniture, and ornamentation. The largest Early Christian ivory from Justinian's reign is the sixth-century throne of Maximian (fig. **8.26**), which was restored in 1884, 1919, and 1956. It is a high-backed chair, with a semi-

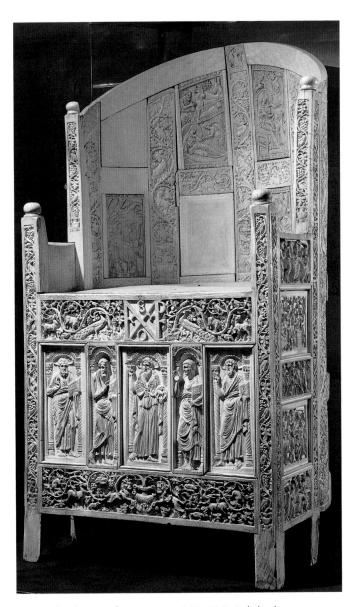

8.26 The throne of Maximian, 545–553. Polished ivory over wooden framework. Museo Arcivescovile, Ravenna. On the front, there are figures of John the Baptist and the four Evangelists (Christ's biographers). The scenes of Joseph on the side—the armrests—"announce" the scenes on the back: the childhood and miracles of Christ. Taken together, the scenes on the throne encompass the time of the Old and New Testaments. It is not known where the throne was made; possibilities include Antioch, Alexandria, Constantinople, and Ravenna itself.

circular seat and arms, which may have been a gift from Justinian to the archbishop. Although known as a throne, it was not used as such but was carried as a ritual chair in religious processions, with a silk or velvet cushion probably bearing such jeweled objects as a Gospel book or a cross.

The wooden core of Maximian's throne is covered with ivory plaques, which are elaborately carved in low relief. On the back of the throne are scenes of Christ's childhood and miracles. Old Testament scenes from the life of Joseph, as a prefiguration of Christ, decorate the armrests. In the front, below the seat, are the four Evangelists, individually framed and flanking John the Baptist at the center.

The detail in figure **8.27** shows two Evangelists set in niches framed by round arches and columns carved in spiral patterns. The narrow scallop-shell apses, together with the arches, are designed to look like halos. Each Evangelist carries the characteristic attribute of a book with the Cross on its cover and raises his right hand in the Roman gesture of oratory. Both wear Roman-style togas, whose folds create elaborate curvilinear patterns. The Evangelist at the right tilts his left foot downward so that it overlaps the ground in a diagonal plane like the feet in the mosaics of Justinian and Theodora.

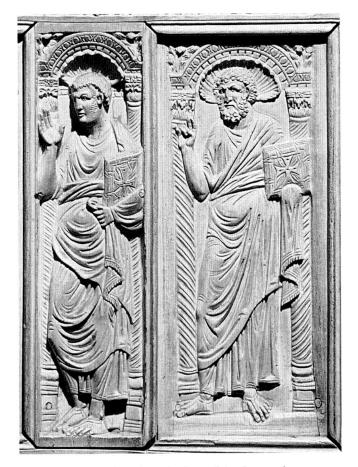

8.27 Two Evangelists, from the front of the throne of Maximian (detail of fig. 8.26).

Hagia Sophia

The undisputed architectural masterpiece of Justinian's reign is the basilica of Hagia Sophia (fig. **8.28**) in Constantinople; the name in Greek is "Holy (*hagia*) Wisdom (*sophia*)." As part of an extensive rebuilding campaign folowing the suppression of a revolt in 532, Justinian commissioned two Greek mathematicians, Anthemius of Tralles and Isidoros of Miletus, to plan Hagia Sophia. They were familiar with the work of Archimedes and particularly interested in the geometry of circles, parabolas, and curved architectural surfaces—all of which are reflected at Hagia Sophia. In their design they successfully combined elements of the basilica with enormous rising vaults, which soar over the biggest domed space to date in the West. The central dome is placed above four arches at right angles to each other and supported by four huge piers. The latter

are barely noticeable from the inside because the arches meet at the corners. The piers themselves are supported by buttresses, which can be clearly seen both in the plan (fig. **8.29**) and in the exterior view (fig. 8.28).

Whereas in Roman buildings domes were placed on drums, the dome of Hagia Sophia, like the earlier dome in the mausoleum of Galla Placidia, rests on **pendentives**—the four triangular segments with concave sides. Their appearance of suspension, or hanging, gives them their name (from the Latin word *pendere*, meaning "to hang"). They provide the transition from a square or polygonal plan to the round base of a dome or intervening drum and allow the architect to design larger and lighter domes. Pendentives are the principal Byzantine contribution to monumental architecture, and Hagia Sophia is the earliest example of their use on such a grand scale.

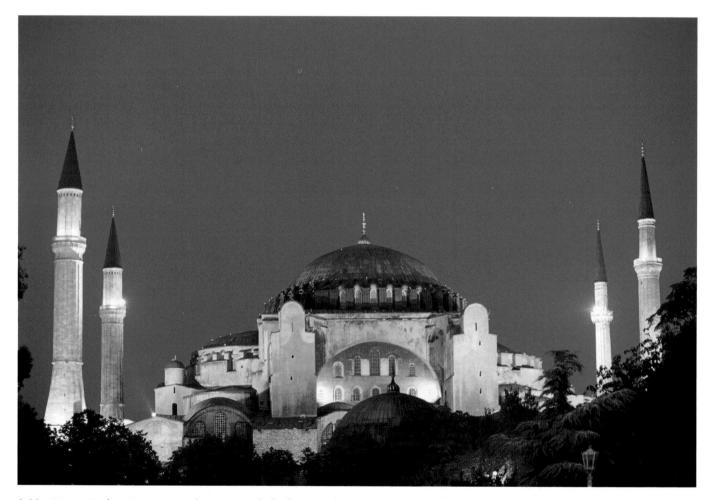

8.28 Hagia Sophia, Constantinople (now Istanbul), illuminated at night, completed 537. The four tall, slender towers, **minarets**, were added when the Turks captured Constantinople in 1453 and Hagia Sophia was converted into a mosque. The Christian mosaics in the interior were largely covered over and replaced by Islamic decorations. Today, Hagia Sophia is a state museum.

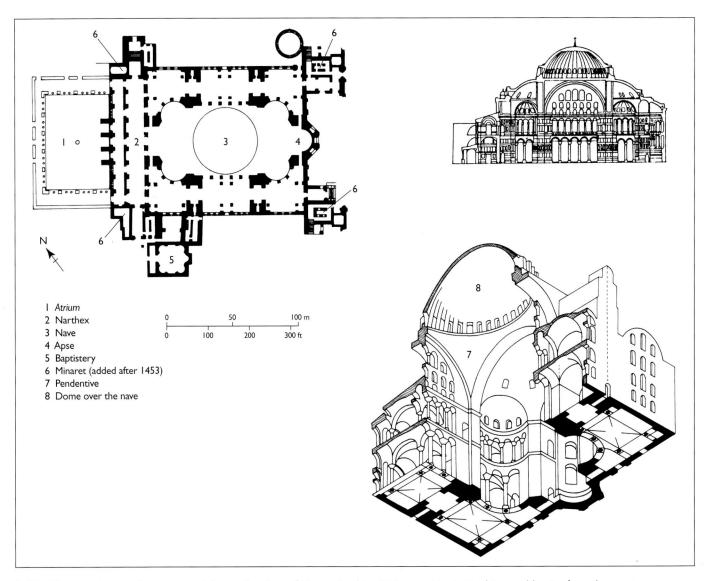

8.29 Plan, section, and **axonometric projection** of Hagia Sophia. Visitors to Hagia Sophia would enter from the west, through an *atrium* that no longer survives (1 on the plan). The double narthex (2) was covered by a row of nine groin vaults. Passing through the narthex, one stood opposite the apse at the far eastern end. The path from narthex to apse, along a longitudinal axis, is reminiscent of an Early Christian basilica. However, instead of a long symmetrical nave surmounted by a gable roof, Hagia Sophia has a huge central square supporting an enormous dome (8). At the eastern and western ends of the square, two semicircles are topped by smaller half domes. Surrounding each half dome are three semicircular apses with open arcades surmounted by even smaller half domes. Running from east to west along the axis are colonnaded side aisles on the first level and colonnaded galleries on the second level. Both are covered by groin vaults. Were it not for the central square, Hagia Sophia would resemble the typical centrally planned church, albeit on a massive scale. Note the impressive effect created by the open space of the nave, the high central dome, and the smaller half domes. The central dome is the earliest example of the use of pendentives on such a grand scale.

Hagia Sophia's dome was constructed of a single layer of brick, a relatively thin shell that minimized the weight borne by the pendentives. Nevertheless, the very size of the dome demanded buttressing. The exterior view (fig. 8.28) shows that each of the forty small windows at the base of the dome is flanked by a small buttress, strengthening from the outside the interior juncture of dome and pendentives, and transferring the dome's powerful outward thrust downward (see box, p. 291).

On the north and south sides of the nave, there are walls below the arches. Since their load-bearing function has been assumed by the four piers, they can be pierced with arcades and windows (fig. **8.30**). (Nonsupporting walls, which usually have large expanses of windows or

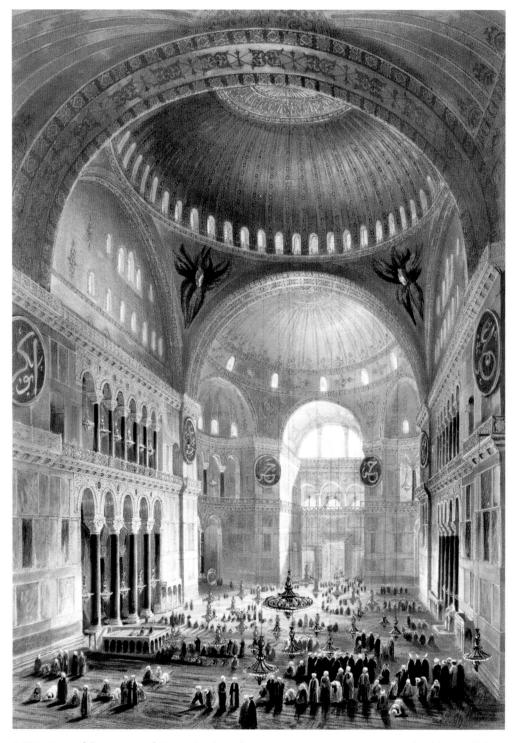

8.30 View of the interior of Hagia Sophia after its conversion to a mosque. Color lithograph by Louis Haghe, from an original drawing by Chevalier Caspar Fussati. This shows the dazzling effect of the mosaic decoration, which produced color and reflected light. Justinian's court historian described the dome as "a sphere of gold suspended in the sky." Recognizing Justinian's ambition to make Constantinople a new Rome, his court poet, Paul the Silentiary, asserted that with Hagia Sophia the Byzantine emperor had indeed caused Constantinople to triumph over its mother city—Rome.

Domes, Pendentives, and Squinches

Domes can be erected on circular or square bases. Ancient Roman domes like that of the Pantheon (see fig. 7.28) were usually on round bases. From the Byzantine era onward, however, it became common to place domes over square or rectangular spaces. This posed the architectural problem of how to create a smooth transition from a cube or rectangle to the round base of the dome or its drum. The two main solutions were the use of structural elements known as pendentives and **squinches.** Pendentives (figs. **8.31** and **8.33a**) are inwardly curving, triangular sections of vaulting between walls or arches set at right angles to each other. Four pendentives over a cubic space form a circle on which a dome or drum can be placed, as at Hagia Sophia (see fig. 8.30).

Squinches are small single arches (figs. **8.32** and **8.33b**) or a series of concentric corbeled arches (fig. **8.33c**) built across the corners of a square or polygonal space, as at the Great Mosque at Córdoba (cf. fig. 9.7).

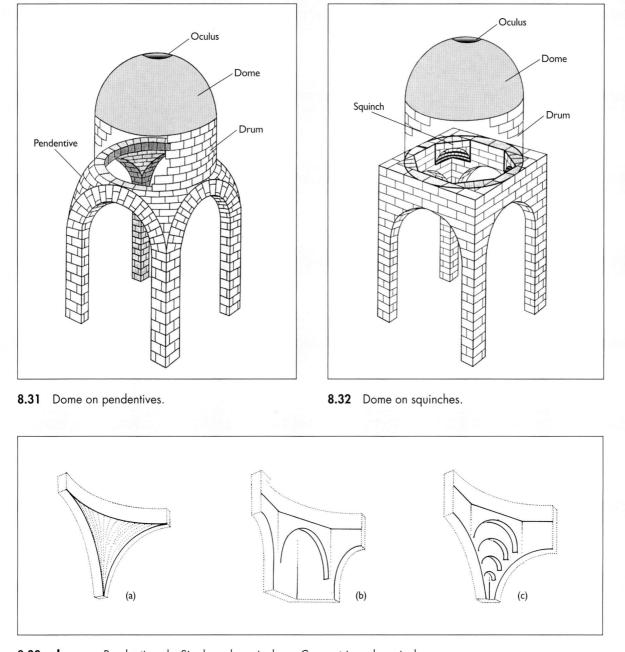

8.33a, b, c a. Pendentive. b. Single-arch squinch. c. Concentric-arch squinch.

other openings, are called **screen walls**.) The extensive use of windows and arcades at Hagia Sophia creates an overwhelming impression of light and space. At floor level, five arches connect the side aisles with the nave. Supporting these arches are large columns with intricately patterned capitals (fig. **8.34**) reminiscent of interlace. The small volutes reflect the persistence of Classical elements (see fig. 5.34), although in rudimentary form. Here they have been overtaken by the dazzling surfaces of the Byzantine style. At the second level, the galleries contain seven arches. The lunettes are pierced by two rows of windows, five over seven, and in each of the half domes there are five windows. Finally, a series of small windows encircling the lower edge of the dome permits rays of light to enter from all directions. Although the actual source of light is from the exterior, the shimmering reflections and predominance of gold create the impression that it originates from the interior. Justinian's court historian, Procopius of Caesarea, expressed this view when he described the dome as a "sphere of gold suspended in the sky."

Hagia Sophia was essentially an imperial building. In contrast to San Vitale, it was the personal church of the emperor and his court rather than a place of worship for the whole community. The clergy occupied one half of the central space and the emperor and his attendants the other. Like San Vitale, Hagia Sophia served Justinian's desire to unite Christendom under his leadership, to build churches, and to commission works of art that would express his mission as Christ's representative on earth.

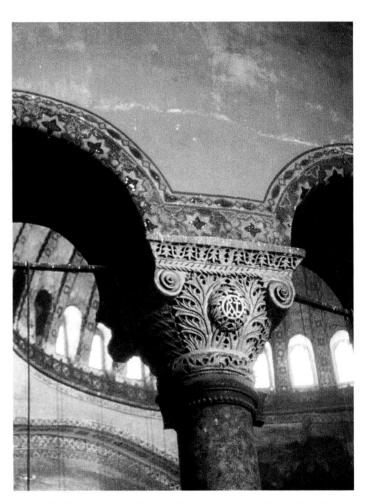

8.34 Detail of arcade spandrels and capital, Hagia Sophia.

CONNECTIONS

See figure 5.34. Diagram of an lonic capital and the architrave.

The Expansion of Justinian's Patronage

Justinian's desire to extend his patronage as far afield as possible conformed to his imperial ambition. He commissioned buildings not only in Italy and Constantinople, but throughout the Byzantine Empire, including the Balkans, North Africa, and the Near East. Among the most notable examples is the Church of Saint Catherine's monastery on Mount Sinai, which contains a large apse mosaic of *The Transfiguration* (fig. **8.35**). In this work, virtually all traces of landscape have been eliminated. A bearded, frontal Christ is suspended in a flat plane of gold. He is surrounded by a blue **mandorla** (the almond-shaped aureola) and wears white (a sign of his spiritual "transfigured" state), transmitting rays of white light toward the other figures. In this iconography, Christ is literally represented as "the light of the world." Three of his apostles, Peter, James, and John, fall backward, their awe revealed by their agitated gestures. Moses and Elijah, in contrast, occupy calm, vertical poses on either side of Christ. Compared with the apse mosaic of the *Good Shepherd* in the mausoleum of Galla Placidia (see fig. 8.14), this has a mystical quality that seems to transcend earthly time and space.

The very image of the Transfiguration in a church located on Mount Sinai is imbued with typological meaning, for it was there that Moses had been "transfigured" by light after receiving the Law from God, and it was at *the* Transfiguration that God acknowledged Christ as his son. Christ and the apostles are intended to embody the New Dispensation emerging from, and continuing, the traditions of the Old Dispensation established by Moses and Elijah. The figures in the frame medallions are prophets and apostles.

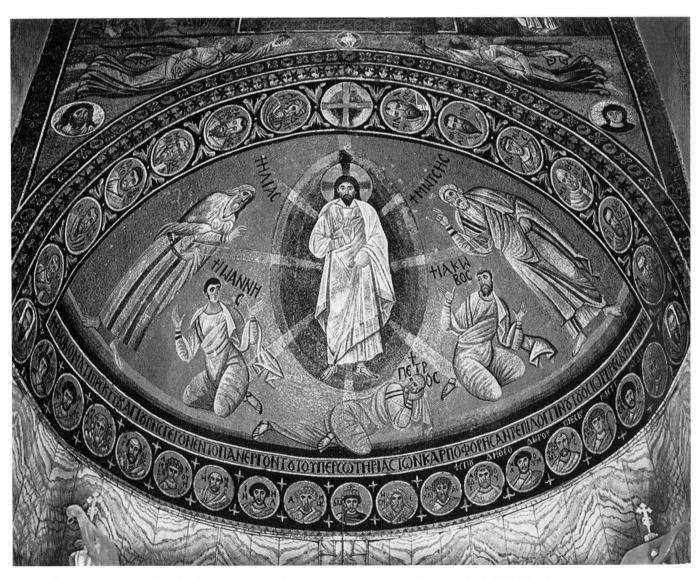

8.35 The Transfiguration, Church of Saint Catherine's monastery, Mount Sinai, Egypt, c. 550–565. Mosaic.

The Development of the Codex

Toward the end of first century, a new method of transmitting "miniature" imagery accompanying written texts came into use. This was the codex, which was the ancestor of the modern book. The ancient Egyptians, Greeks, and Romans had used the papyrus scroll (rotulus) for texts and their illustrations. On average, a rotulus measured some 10 to 11 yards (about 9 to 10 m) in length when unrolled. The codex was more practical and easier to manage. Its pages were flat sheets of relatively sturdy parchment or vellum (calfskin) (see box). They were bound together on one side and covered like a book, which made the codex easier to preserve than the rotulus. It was also possible to illustrate (or illuminate) the pages with richer colors. The Latin poet Martial praised the codex, which he called the "book with many folded skins," because it held the complete works of Virgil in a single volume.

The Vienna Genesis

Among the earliest codices to illustrate scenes from the Bible is the Vienna Genesis (its name is derived from its current location, the Nationalbibliothek in Vienna). Originally, the codex had ninety-six folios, of which twentyfour survive; these have forty-eight miniature illustrations. Each sheet is purple, which points to an imperial patron, while the gold and silver script is characteristically Byzantine. Most of the page contains text, relegating the images to the lower section.

Parchment

Parchment is a writing surface prepared from the skin of a sheep or goat. The term is from the Greek word *pergamina*, after the city of Pergamon in Asia Minor, where the monumental Hellenistic altar of Zeus was located (see figs. 5.76 and 5.77). It was in Pergamon that parchment was first used as a substitute for papyrus.

Figure 8.36 shows an illustration below the text that depicts an event in the story of Joseph from Genesis. Joseph sits in a prison, which is viewed from above. Outside, a few trees show that landscape, in however rudimentary a form, persisted as a way of setting a scene and conveying a sense of place. To the right of the prison, Potiphar's wife talks with the guard, her modest attire disguising her lust for Joseph. Inside the prison, the pharaoh's jailed butler and baker are unhappy because there is no one to interpret their dreams. Joseph informs them that dreams belong to God and asks what they dreamed. The butler reports his dream of a vine with three branches that sprouted blossoms and grapes, which he pressed into the pharaoh's cup. Joseph informed the butler that in three days the pharaoh would free him to resume his duties. The baker dreamed that he was carrying three white baskets on his head. The top basket was filled with bakemeats for the pharaoh, but birds ate them. Joseph told the baker that in three days the pharaoh would hang him from a tree and birds would eat his flesh. Both interpretations came true: the butler was rehired, and the baker was hanged.

Usually, as in figure **8.37**, there is more than one event depicted on a page. The narrative is continuous, without

8.36 Joseph Interpreting Dreams in Prison, trom the Vienna Genesis, early 6th century. Illuminated manuscript. Nationalbibliothek, Vienna.

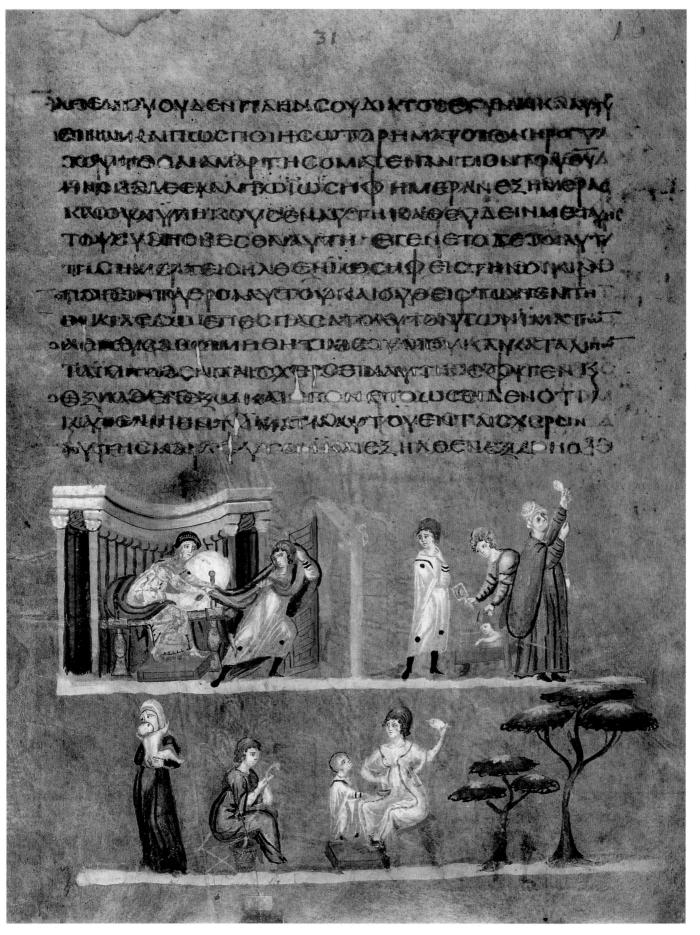

8.37 Joseph and Potiphar's Wife, from the Vienna Genesis, early 6th century. Illuminated manuscript. Nationalbibliothek, Vienna. It is not known where the Vienna Genesis was made, although it is believed to have originated in the Near East.

frames or dividers between scenes, and it has been suggested that such narratives are related to the continuous spiral frieze on Trajan's Column (see p. 231). This page depicts additional events from the life of Joseph. At the upper left, Potiphar's wife reclines in a colonnaded bedroom. She tries to lure Joseph, who turns to leave. To the right, continuing from the bedroom, Joseph gazes back toward the scene of the temptation he has resisted. An astrologer wearing a starry cape holds up a spindle. Between him and Joseph, Potiphar's wife tends a baby. In the lower register, one woman carries another infant, while two other women spin.

Image and Icon

A comparison of the small detail of the woman holding the infant in the codex (see fig. 8.37) with a sixth-century fresco from a funerary chapel in the Roman catacombs (fig. 8.38) highlights some significant differences in Early Christian style and meaning. The Vienna Genesis infant is anonymous and held facing his mother in an ordinary way. His proportions are relatively naturalistic, and he, like the woman, turns as if occupying three-dimensional space.

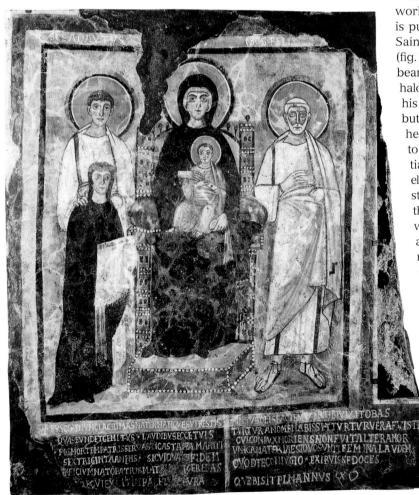

Represented in the catacomb fresco, on the other hand, are the *Virgin and Child Enthroned;* the figures here are clearly identifiable and command veneration from Christians. They are flanked by saints, while at the left stands the smaller image of the widow buried in the chapel.

Mary sits regally on a jeweled throne and is therefore shown in her aspect as Queen of Heaven. She had been proclaimed Theotokos (the "Bearer of God") in 431 at the Council of Ephesus, and this led to a cult of the Virgin. Evidence of that cult can be seen in her majestic portraval here. Christ, in such images, is the King of Heaven, seated on the throne that is his mother's lap. Unlike the Vienna Genesis infant, however, Christ is frontal, clothed, and rendered as a homunculus (a little man), babylike only in size and setting. His image conforms to the Christian metaphor in which Christ is conceived of as a miraculous babyking. This type of Virgin and Child (notwithstanding the togas worn by the saints) has an iconic character that is typical of Byzantine style. Images of this kind invite devotion and prayer through direct confrontation of holy personages by worshipers. The Vienna Genesis figures, in contrast, continue in the Classical tradition of relative naturalism. They invite identification by virtue of threedimensional space and the fact that they participate in a narrative sequence.

> An icon (usually a panel painting), as opposed to a work with iconic quality, is an image whose purpose is purely devotional. A good example is the icon of Saint Peter from the monastery of Saint Catherine (fig. **8.20**) showing the

(fig. 8.39), showing the bearded saint with a halo, a long cross, and his traditional attribute of the keys to heaven. The degree to which Early Christian icons absorbed elements from pagan styles is reflected in the Roman drapery with shaded folds and in the treatment of the face and neck. The halo is flat, but the buildings behind the figure recede

See fig. 7.58 Young Woman with a Stylus (sometimes called Sappho), from Pompeii, 1st century A.D.

in perspective. The three tondos of Christ, Mary, and an unknown saint are reminiscent of Roman painted portraits (cf. fig. 7.58).

8.38 Virgin and Child Enthroned with Saints Felix and Augustus, 528. Fresco. Commodilla catacomb, Rome.

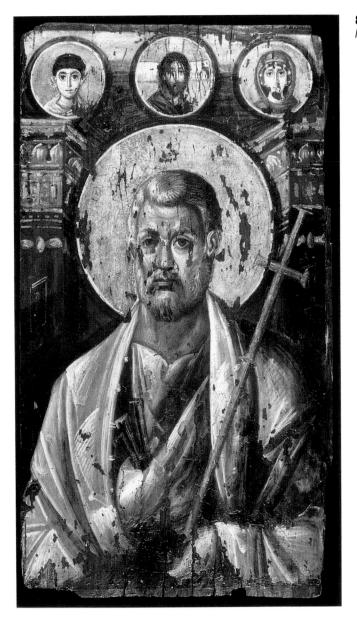

Later Byzantine Developments

The Byzantine style continued in Eastern and Western Christendom for several centuries following the age of Justinian. In the eighth and ninth centuries, the very nature of imagery became a subject of dispute. This is referred to as the Iconoclastic Controversy, in which the virtues and dangers of religious imagery were hotly debated. The Iconoclasts ("breakers of images"), centered in Eastern Christendom, followed the biblical injunction against worshiping graven images, and many of them destroyed works of art. They argued that images of holy figures in human form would lead to idolatry—worship of the image itself rather than what it represented. According to

8.39 Saint Peter, Church of Saint Catherine's monastery, Mount Sinai, Egypt, 6th or 7th century.

the Iconoclasts, it was permissible for religious art to depict designs, patterns, and animal or vegetable forms, but not human figures. The Iconophiles (those in favor of images) were centered in the West. They pointed to the tradition that Saint Luke himself had painted an image of the Virgin and Child. In 726, the Iconoclasts gained the support of Emperor Leo III and in 730 succeeded in having an edict issued against graven images, which contributed to the relatively minor role of sculpture in Byzantine art. When the edict was eventually lifted in 843, the Iconophile victory led to a revival of image making and renewed artistic activity in the Byzantine world. Mosaics and paintings were now officially encouraged, but sculpture-because it is three-dimensional-remained unacceptable to the Eastern Church. Byzantine art and architecture persisted throughout the empire, in Italy, and in Constantinople in the later phase of the style. Domed churches based on the Greek cross continued to appeal to Byzantine architects. Their interest in juxtaposing solid geometric forms such as the cube and the hemisphere is also found in metalwork (see box, p. 302).

The eleventh-century monastery churches of Hosios Loukas (dedicated to Saint Luke of Stiris) in Greece provide an example of ecclesiastical architecture removed from the centers of imperial power (figs. **8.40** and **8.41**). Although relatively modest in scale, the buildings have more elaborate exteriors than those of San Vitale. Instead of plain brick, the walls are decorated with patterns created by different colored brick and light stone. The greater variety of architectural spaces is also evident in the asymmetrical planes of the exterior walls.

One church is dedicated to the Virgin Theotokos. It is a simple Greek-cross plan with a dome at the center. The other church, the Katholikon, has a larger dome rising to a greater height and supported by marble paneled walls. The extensive interior mosaics of the Katholikon have uniform gold backgrounds, and the scenes from Christ's life are far less detailed than the mosaics at San Vitale. The iconography of the mosaics reflects post-Iconoclastic efforts to restore the power of imagery.

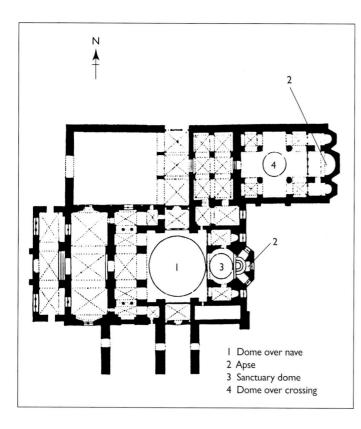

8.40 Plan of the monastery churches of Hosios Loukas (after Diehl), Greece, c. 1020.

The Katholikon, which contained the relics of Saint Luke, is noteworthy for the good state of preservation of its interior decoration. For example, the apse mosaic depicting the *Virgin and Child Enthroned* of around 1020 shows the figures in a gold space, isolated from the natural world (fig. **8.42**). Both are frontal, facing viewers directly and simply. The linear character of their style—despite some shading on the faces and on Mary's draperies—and the flat halos place them in an otherworldly realm. Echoing the strong black frame of Mary's halo is the Greek inscription flanking it, which means "Mother of God." Christ is represented in typical Byzantine fashion as a homunculus. He sits upright and makes a gesture of blessing, signifying his role as universal God and ruler.

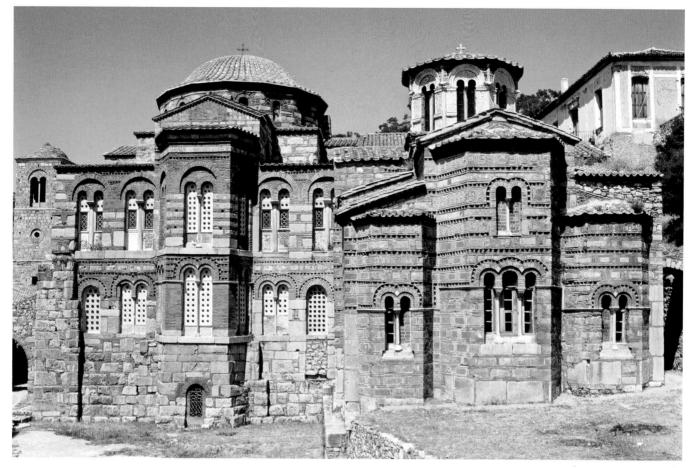

8.41 Monastery churches of Hosios Loukas, Greece, c. 1020.

8.42 Virgin and Child Enthroned, Katholikon, Hosios Loukas, Greece, c. 1020. Apse mosaic.

The *Crucifixion* mosaic contains the figures of Christ on the Cross, the Virgin Mary in blue, and Saint John, the youngest apostle, in pink and green (fig. **8.43**). Supporting the Cross is the abbreviated hill of Calvary; symbols of the sun and moon, referring to the eclipse that occurred when Christ died, are visible above the horizontal arm of the Cross. These, like Christ-as-baby-king, denote his future as ruler of the universe. The graceful S-shape of Christ's body defies the gravitational pull necessary for death by crucifixion. Also removing Christ from the natural world is the stylized patterning that makes his bone structure visible on the exterior of his body.

The poses and gestures of Mary and John are appropriate to the scene's death content. Mary's hands, for example, cross over each other, which is a visual echo of the Crucifixion itself. With her left hand she grasps the edge of her veil, as if retreating into herself. At the same time, her extended right hand indicates the sacrifice of her son, at whom she gazes sadly, thereby directing the viewer's attention to the central event. Saint John, on the other hand, leans against his right hand, a traditional gesture of mourning seen on Greek grave stelae (cf. fig. 5.67), which continues as a convention of mourning throughout Christian art. Both Mary and John seem to float in a divine space of gold.

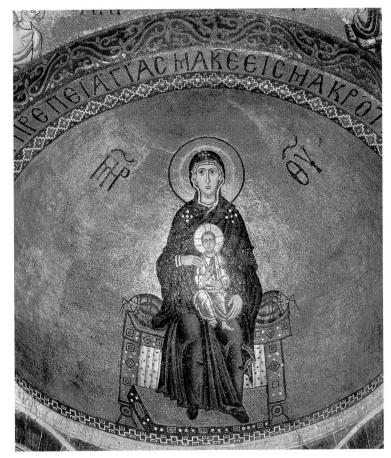

- CONNECTIONS -

See figure 5.67. Attic grave stele.

8.43 *Crucifixion,* Katholikon, Hosios Loukas, Greece, c. 1020. Mosaic.

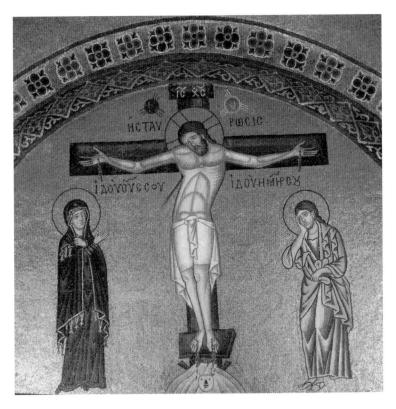

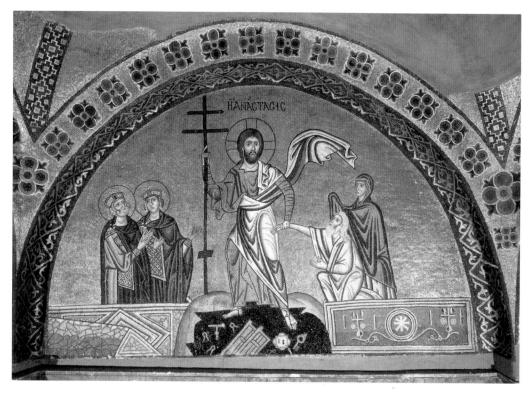

8.44 Harrowing of Hell, Katholikon, Hosios Loukas, Greece, c. 1020. Mosaic.

In the *Harrowing of Hell* (fig. **8.44**), Christ is centralized, as in the *Crucifixion*. He faces the viewer as the new Adam, triumphing over death and leading the original Adam to salvation. Eve, typologically paired with Mary, follows behind Adam. At the left, Kings Solomon and David, Old Testament types for Christ, gesture toward the miracle taking place before them. In contrast to Adam and Eve, their regal status is indicated by their robes and jeweled crowns,

and their divine roles as ancestors of Christ by their halos.

The late Byzantine image of Christ as *Pantokrator* ("Ruler of All") is an expression of post-Iconoclastic efforts to convey the abstract power of Christ. Such an image decorates the interior dome of the Hosios Loukas Katholikon (fig. **8.45**). It shows Christ at the center, hovering over the space below—an all-encompassing power in human form. This particular image was restored after the earthquake of

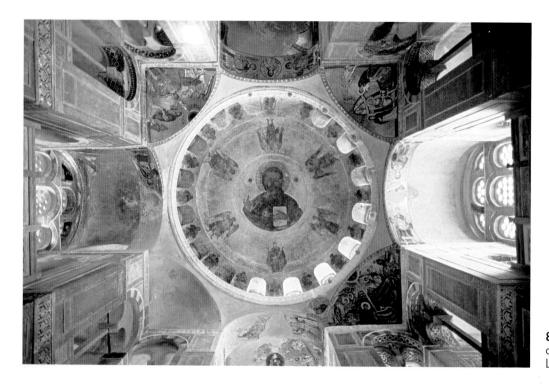

8.45 Central dome and apse, Katholikon, Hosios Loukas, Greece, c. 1020.

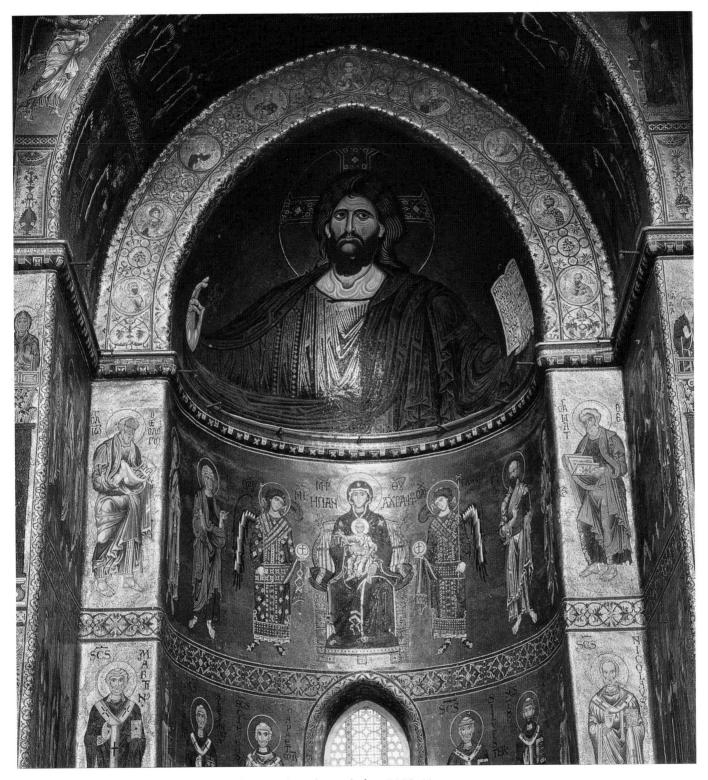

8.46 Pantokrator, from the abbey church of Monreale, Palermo, before 1183. Mosaic.

1593 and is not as well preserved as, for example, the twelfth-century *Pantokrator* mosaic from the abbey church of Monreale outside Palermo, in Sicily (fig. **8.46**). The latter is a powerful image of Christ's dominion over the universe. His huge figure fills the upper part of the apse and towers over the enthroned Virgin, his arms and drapery expanding to the sides of the apse. This Christ represents a

different order of being from the smaller figures around and below him. The harsh modeling and emphasis on surface patterns—the swirling designs in the face, hair, and neck, as well as the angular drapery folds—enhance the stern character of the *Pantokrator*. The function of such an image is to inspire awe and to command obedience, penance, and faith. **8.47** Christ, detail of a **deësis** mosaic, Hagia Sophia, 13th century. *Deësis* refers to an image showing Christ flanked by the Virgin and John the Baptist.

In contrast to the stern, overpowering image of the *Pantokrator*, the thirteenth-century mosaic of *Christ* from Hagia Sophia shows Christ on a somewhat more human level (fig. **8.47**). Compared with the San Vitale mosaics, in which Justinian and Theodora had been portrayed frontally, outlined in black, and devoid of personality, this Christ turns his head slightly and has an individualized, slightly downcast expression. Although the drapery folds on the left are rendered by dark blue lines, those on the right are slightly shaded. The background is gold, and the halo is entirely flat. The letters *IC* on the left and *XC* on the right stand for "Jesus Christ."

This depiction of Christ illustrates both the persistence of Byzantine style and its accessibility to change. Shading is evident in the cheeks, neck, and right hand. The edges of Christ's form are also indicated by shading rather than by a black outline. The deep eye sockets, the bags under the eyes, the creased forehead, and the downward curve around the mouth convey an air of melancholy.

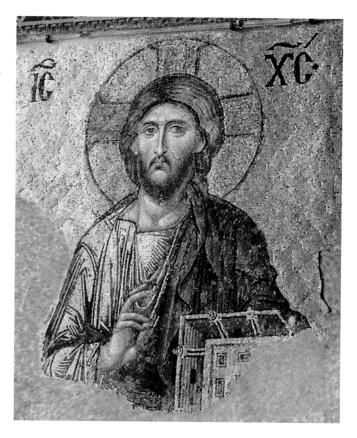

Byzantine Metalwork

The twelfth-century incense burner in the shape of a domed building (fig. **8.48**) shows the elaborate intricacy of late Byzantine metalwork. Its gold and silver material and the high quality of workmanship suggest that it was made for a court. The shape is that of a secular building (the crosses are a later addition), its centralized square plan having four domed apses between four triangular sections. The latter have curved, pyramidal roofs. Incense was burned inside the structure, and the scent escaped through the openwork spaces.

The meaning of the iconographic motifs, most in repoussé, is not certain. Separating the roof from the walls is a band of rosette and scroll designs in low relief, and animals (including a lion, a griffin, and a centaur) decorate the walls. Figures signifying Courage (an armed man) and Intelligence (a woman pointing to her head) are represented on the double door of one of the apses. Although such personifications are often found in Byzantine court art, their function and meaning in the context of this incense burner are unknown.

8.48 Incense burner in the shape of a domed building, 12th century. Gilded silver; $14\% \times 11\%$ in. (35.9 \times 30.1 cm). Procuratoria di San Marco, Venice.

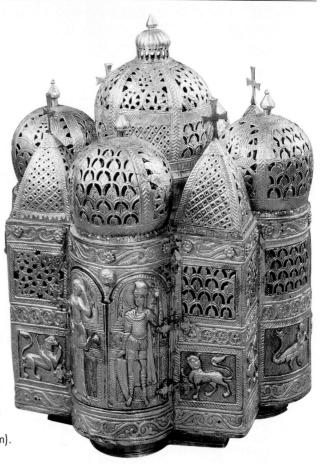

8.49 Andrei Rublev, *Old Testament Trinity*, early 15th century. Panel painting; $55\frac{1}{2} \times 44\frac{1}{2}$ in. (140.9 × 113.0 cm). Tretyakov Gallery, Moscow.

The Byzantine style continued in Russia well beyond the thirteenth century, as can be seen in the icons painted by the monk Andrei Rublev (c. 1370–c. 1430). His *Old Testament Trinity* (fig. **8.49**) depicts the three angels who appeared to Sarah and Abraham (the parents of Isaac) in Genesis 18:1–15. This event, which was later read by Christians as a prefiguration of the Trinity (Father, Son, and Holy Ghost), took on a typological meaning. Despite its damaged condition, Rublev's panel is notable for its rich color and elegant, flowing curves.

Most Russian churches were built up from a wooden core, according to a variation on the centrally planned Greek cross. Saint Basil's Cathedral in Moscow (fig. **8.50**) was commissioned by Tsar Ivan IV (Ivan the Terrible, 1534–1584). Its plan is an octagon, to which are attached eight chapels, each of which is surmounted by an onion dome and commemorates a military victory. Such domes are designed to protect the interior from the elements, especially snow. The colorful patterns and varied, crystalline shapes on the exterior reflect the sunlight and sparkle in much the same way as the *tesserae* of Byzantine mosaics. Legend has it that Ivan the Terrible so admired the cathedral, he had the architects blinded, thereby ensuring that they would never again design anything so great.

8.50 Barma and Postnik, Saint Basil's Cathedral, Moscow, 1554–1560.

Style/Period

100

300

500

EARLY CHRISTIAN 2nd-3rd century

EARLY CHRISTIAN/BYZANTINE 4th-5th century

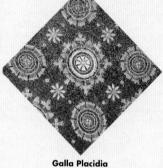

EARLY CHRISTIAN/BYZANTINE

6th-15th century

Saint Basil's Cathedral

Works of Art

Dura Europos synagogue (8.1-8.2) Christ as the Good Shepherd (8.3), Rome Christus-Sol (8.7), Saint Peter's, Rome

Early Christian sarcophagus (8.4), Santa Maria Antiqua, Rome Old Saint Peter's Basilica (**8.5**), Rome Santa Costanza (8.10-8.11), Rome Saint Paul outside the walls (8.8), Rome Galla Placidia (8.12–8.16), Ravenna

The Vienna Genesis

The Vienna Genesis (8.36-8.37 Virgin and Child Enthroned (8.38), Rome Hagia Sophia (8.28–8.30), Istanbul San Vitale (8.17, 8.19–8.25), Ravenna Throne of Maximian (8.26–8.27) The Transfiguration (8.35), Saint Catherine's monastery Icon of Saint Peter (8.39), Saint Catherine's monastery Hosios Loukas

(8.42-8.45) Greece

Pantokrator, abbey church of Monreale (**8.46**) Incense burner

(8.48)Deësis mosaic (8.47) Rublev, Old

Incense burner

Testament Trinity (8.49) Saint Basil's Cathedral (8.50), Moscow

Cultural/Historical Developments

Persecution of Christians; catacomb paintings created (2nd century)

Constantine becomes Roman emperor (306–337) Edict of Milan; Christianity legalized (313) Eusebius made bishop of Caesarea (c. 313) Constantine moves capital of Roman Empire to Constantine moves capital of Roman Empire to Byzantium (330) Books begin to replace scrolls (c. 360) Sack of Rome by Visigoths, led by Alaric (410) Spain overrun by Visigoths (414) Saint Augustine writes *City of God* (426) Celtic church established in Ireland by Saint Patrick (c. 430)

Attila becomes ruler of the Huns (433) Flowering of Maya civilization in

southern Mexico (late 400s) Sack of Rome by Goths; fall of Western

- Roman Empire (476) Armenian Church secedes from
- Byzantium and Rome (491) Ostrogoth kingdom
- established in Italy by Theodoric (c. 493)

Justinian becomes eastern Roman (Byzantine) emperor (527–565)

Saint Benedict founds the Benedictine Order (529)

Earliest Chinese roll paintings (c. 535) Plague devastates

- Europe (542-594) Saint David converts Wales to Christianity (c. 550)
- Origin of chess in India (c. 550)
- Lombard kingdom established in northern Italy (568)
- Birth of Muhammad c. 570 (d. 632) Buddhism firmly
- - established in Japan

(c. 575)

- Block printing of books in China (c. 600) Iconoclastic Controversy between the Byzantine emperor and the pope (726) Start of the First Crusade (1096)
- Fall of Constantinople (Byzantium) to the Turks (1453)
- Ivan IV (the Terrible) becomes tsar of Russia (1547)

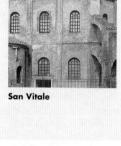

Rublev, Old Testament

Trinity

500

Window on the World Four

Developments in Buddhist Art (1st-7th centuries A.D.)

Rock-Cut Architecture

Toward the end of the first millennium B.C., in the low cliffs of western India, there developed a new type of monastic architecture (see map). Mountainsides were chiseled out to create caves that were imitations of freestanding wooden buildings. Most were located near well-traveled trade routes. These caves are of two main types: living spaces for monks called vihāras, and large, basilica-like spaces for congregational worship focused on a stupa. The latter are called chaitya halls. Vihāras generally consist of small, windowless cells surrounding a broad room used by the monastic community for eating, recitation, studying, and other communal activities. From the fifth century A.D., vihāras often had small shrines opening off the main space (cf. fig. W4.6) that contained sculptures of the Buddha. Early Buddhist caves provide the only physical record of the appearance of the more perishable wooden structures on which they were modeled. There are approximately a thousand such Buddhist sanctuaries dating from the late second century B.C. to the mid-second century A.D. Some evidence indicates that the caves were furnished inside and out with wooden balconies, doors, rafters, and other architectural elements. The interior walls were decorated with mural paintings and tapestries, illuminated by oil lamps.

The most famous examples of rockcut architecture in India are located in what is now the state of Maharashtra. In keeping with Buddhist practice, these monastic sites were removed from the center of town but were accessible to travelers as well as to local inhabitants. Inscriptions identify the caves' patrons as lay people, monks and nuns, and kings. *Chaitya* halls were remarkably similar in both architectural design and religious purpose to later Christian basilicas. A comparison of the interior of the *chaitya* hall at Karli (figs. **W4.1** and **W4.2**), which dates from c. 50–70, with the basilica of Santa Sabina of 423–432 in Rome (fig. **W4.3**) highlights the similarities as well as the differences.

Both have a triple entrance and a long, central nave with a semicircular apse at the far end opposite the entrance. The apse is the most sacred area in the *chaitya* hall, as in the basilica. The nave of the *chaitya* hall is preceded by a shallow space, or **veranda**, which is similar to the narthex of the basilica. Framing the nave of each are

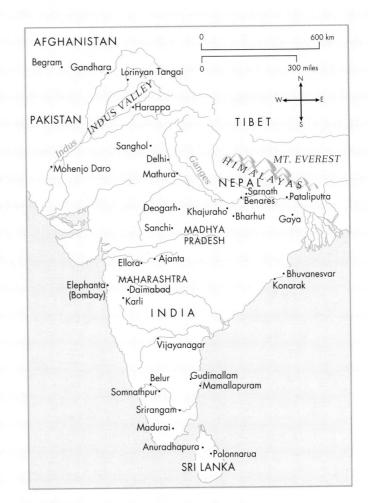

W4.1 Chaitya hall, Karli, Maharashtra, India, c. 50–70. Granite; nave 45 ft. (13.71 m) high. The term chaitya originally meant a mound or sacred place. It came to mean "place of worship" and was applied to the structure that housed a stupa—itself originally a hemispherical mound.

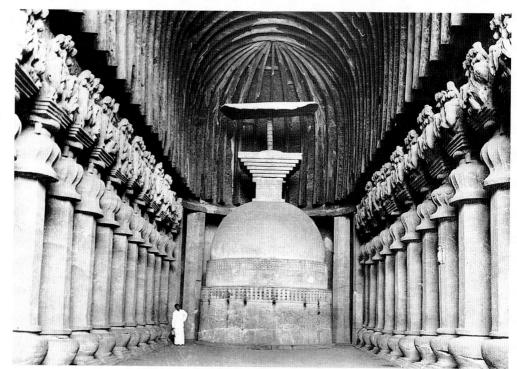

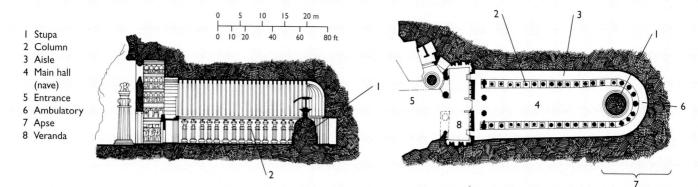

W4.2 Plan and section of the chaitya hall, Karli, Maharashtra, India.

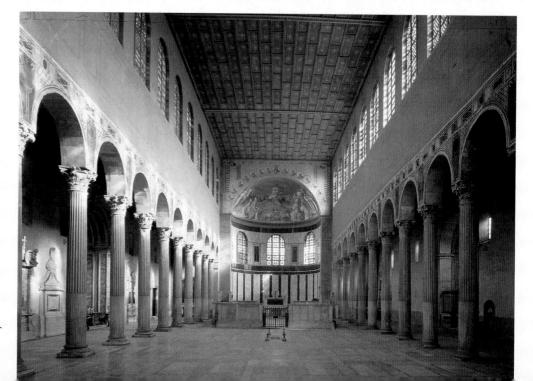

W4.3 Interior of Santa Sabina, Rome, 423–432.

rows of columns, which separate the nave from its side aisles. These, in turn, continue around the apse to form an ambulatory. By circumambulating the stupa (inside the apse of the *chaitya* hall), the Buddhist worshiper replicates the circular path of reincarnation in the quest for *nirvana*.

Often, remains or relics of a Christian saint were buried below the apse of the basilica in an underground **crypt**. Similarly, the apse of the *chaitya* hall contains a stupa (see p. 261), the funerary structure originally placed over the remains of Shakyamuni Buddha. And when worshipers enter the *chaitya* hall —as well as the basilica—they are drawn to the spiritual focal point by the formal arrangement of space and mass.

The *chaitya* hall differs from the basilica in several ways. Instead of a flat ceiling, that of the *chaitya* hall is barrel-vaulted. Its designation as "elephant-backed" reflects the association of the form with organic structure. The curved rafters visible in figure W4.1 are the original wooden elements used to replicate the prototype, rather than

to serve a structural purpose. The columns are thicker than those in Santa Sabina and are composed of a base (in the shape of a water jar), a thick shaft, and a capital, whose bell shape is similar to that on Emperor Ashoka's pillars (see p. 260). Above each bell capital at the Karli *chaitya* hall are two elephants and four riders facing the nave.

Aside from the capitals, there is no sculpture inside the chaitya hall at Karli. The veranda, however, is covered with large-scale reliefs; two of the most impressive flank the entrance (fig. W4.4). They show a royal mithuna (loving couple), whose style reflects an ideal of Indian sculpture that would continue for another nine centuries. Although they are made more monumental by the compact space they inhabit, their poses and gestures are casual and relaxed. The woman stands with her left leg bent behind her right, assuming the sensuous tribhanga (three-bends pose) of the Sanchi Yakshī (see fig. W3.13). Both the man and the woman convey the impression of specific people, possibly donors.

Gupta Sculpture

The Gupta Empire, which flourished in the fourth and fifth centuries, dominated the Ganges Valley and extended into the west and south. Its rulers encouraged developments in art and literature that lasted well beyond the period of their political sway. Though the Guptas were proponents of Hinduism, their patronage of the arts fostered the expansion of Buddhist art as well.

A Gupta figure of the *Preaching Buddha* from Sarnath in northern India (fig. **W4.5**) exemplifies a new type of Buddha image that emerged in the late fifth century. Its iconography reflects the evolution of a canon for depictions of Buddhist figures and is a particularly successful synthesis of iconic and narrative imagery. The figure is severe and still. The eyelids are

W4.4 (left) *Mithuna* from the façade of the *chaitya* hall, Karli, Maharashtra, India, c. 50–70.

> W4.5 (right) Preaching Buddha, from Sarnath, Uttar Pradesh, India, c. 475. Chunar sandstone; 5 ft. 3½ in. (1.61 m) high. The relief on the base of the throne shows the Wheel of the Law at the center. On either side are three disciples and a deer (referring to the Deer Park Sermon at Sarnath). Carved on the back of the throne are two rearing winged lions (leogryphs), which symbolize royalty. The halo is decorated with lotus motifs and flanked by celestial beings.

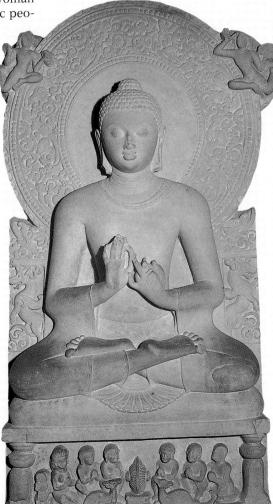

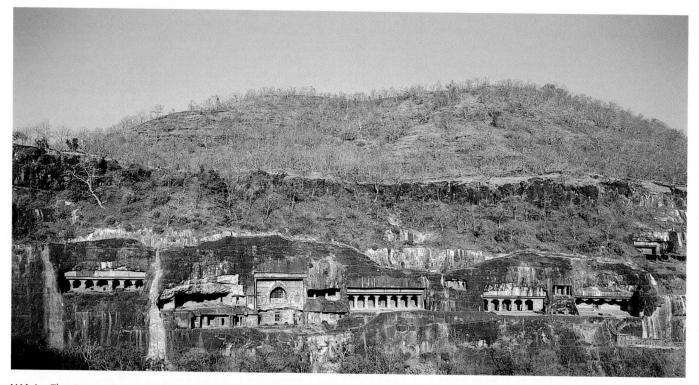

W4.6 The Ajanta Caves, Maharashtra, India, c. 450-500.

lowered, and the legs are folded into a yogic meditation pose. The hands in Dharmachakra mudrā symbolize the setting in motion of the Wheel of the Law. In addition to the ushnisha, ūrnā, and elongated earlobes (see p. 263) that were already part of the Buddha's iconography in the Kushan period, the Sarnath figure has many elements that evolved later. These include features drawn from nature such as the snailshell curls, eyebrows "like an archer's bow," and shoulders "like an elephant's trunk." Another canonical detail is the three rings on the neck. In the indigenous tradition of the prana-filled nude male torso from Harappa (see fig. W3.5) and the Standing Buddha from Gandhara (see fig. W3.14), this figure radiates a sense of inner energy.

The Ajanta Caves

(late 5th century A.D.)

The artistic legacy of the Gupta dynasty is evident in the spectacular Buddhist monastic site at Ajanta (figs. **W4.6** and **W4.7**). Ajanta is southwest of Sanchi and northeast of Bombay,

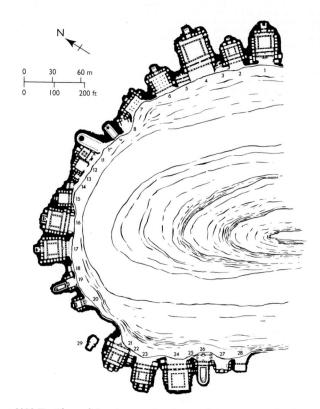

W4.7 Plan of the Ajanta Cave complex, Maharashtra, India, c. 450–500.

close to a strategic mountain pass connecting northern and southern India (see map, p. 305). Altogether there are thirty caves cut into a U-shaped river gorge, out of which *chaitya* halls and *vihāras* were carved in two phases. The earliest dates from the first century B.C. to the first century A.D., and the rest from the second half of the fifth century, when the region was ruled by the Vakataka dynasty.

The two later *chaitya* halls at Ajanta are more elaborate than the earlier one at Karli. The entrance to the *chaitya* hall in Cave 19 (fig. **W4.8**) is particularly well preserved. The view illustrated here shows the large lunetteshaped *chaitya* arch window through which light illuminates the cave and hits the stupa. Compared with the interior of the *chaitya* hall at Karli, much more sculpture and certain architectural features—such as the thick columns with "squashed cushion" capitals supporting a cornice and an upper row of carved reliefs—have been added

Indian Mural Painting

Recent microscopic analysis of the Ajanta murals shows that cave walls were covered with three layers of plaster. The final layer was tinted or painted to create a white ground for the paintings. The paint itself is a kind of tempera, which was probably made by mixing powdered mineral pigments with a gluey binder. Outlines were drawn in reddish brown, and forms were filled in with paint. Blue was rarely used, suggesting that its source was an expensive, imported mineral, perhaps lapis lazuli. Black pigment is thought to have been made from soot.

In addition to texts detailing artistic practice, one of the early sources of information on painting technique in India is the Gupta-period commentary on the *Kamasutra*, a Hindu treatise on the art of love. This describes the language of pose and gesture, the expression of mood and feeling, and the rendering of objects three-dimensionally.

(fig. **W4.9**). The walls are covered with small-scale, repeated painted images of enthroned buddhas with their attendant bodhisattvas.

The stupa is also decorated with reliefs, and its proportions have grown taller and thinner. A monumental statue of Shakyamuni Buddha stands in a niche framed by pillars supporting a *chaitya* arch. Both the axis pillar and *chattras* have become more complex.

Some of the greatest examples of monumental Indian painting survive in four of the Ajanta *vihāras* (see box). Secular paintings from this period are mentioned in texts, but they have not survived. The Ajanta frescoes, like the San Vitale mosaics at Ravenna,

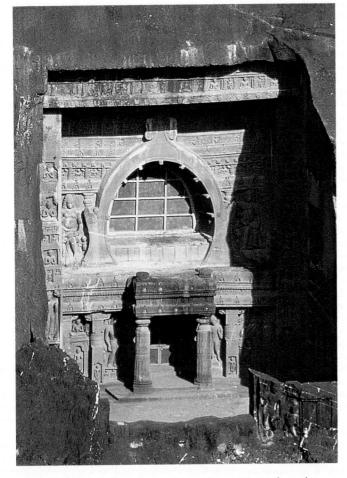

W4.8 Chaitya hall entrance, Ajanta Cave 19, Maharashtra, India, c. 450–500.

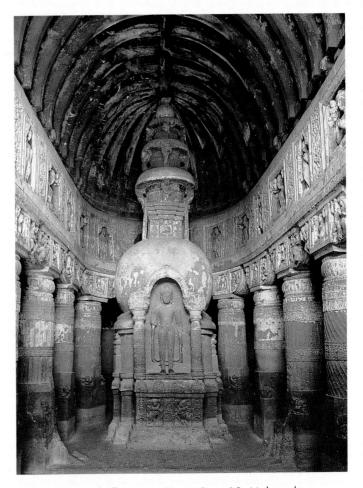

W4.9 Chaitya hall interior, Ajanta Cave 19, Maharashtra, India, c. 450–500.

W4.10 Prince Distributing Alms, Ajanta Cave 17, Maharashtra, India, c. 450–500.

constitute monumental religious programs with political significance. Their use of rich color and displays of opulence were intended to align political power with religious devotion. The large scene showing a *Prince Distributing Alms* (fig. **W4.10**) illustrates this combination. Despite the generosity of the prince, motivated as it is by his piety, his elaborate entourage, including horses and guards, as well as his rich attire express his love of worldly splendor and his ability to command it.

The famous *Padmapani*, or "Lotus Bearer" (from *padma*, meaning "lotus," and *pani*, meaning "hand"), is one of a pair flanking the entrance to the shrine at the rear of the *vihāra* in Cave 1 (fig. **W4.11**). The head reveals the sensuous naturalism of Indian art also evident in the *Yakshī* at Sanchi (see fig. W3.13). The *Padmapani* in the *tribhaṅga* pose, regally attired and attending the Buddha, is primarily a great emperor serving an even greater lord.

The imposing figure of the *Padmapani* reflects the continuing Indian interest in naturalism, which can be seen in the use of shading to convey organic form—for example, the underside of the chin, the curves of the shoulder and neck, and the natural depressions of the

face. In contrast to the Byzantine depiction of spirituality conveyed by flat, vertical planes, frontality, and iconic confrontation with the worshiper, the Ajanta murals convey it by an inner, meditative tranquility.

Even in a devotional scene, such as the Worship of the Buddha (fig. **W4.12**) from a pillar in Ajanta Cave 10, the figures turn as if in three-dimensional space. The sense of a natural setting is suggested by the floral designs and the fact that the Buddha's throne is at an oblique angle. Although the halo is flat, the head is rendered in three-quarter view.

See fig. W3.13 Yakshī—to the right of the elephant—from the east toraņa at Sanchi, Shunga and early Andhra periods, 1st century B.C.

W4.11 Padmapani, Ajanta Cave 1, Maharashtra, India, c. 450–500.

W4.12 Worship of the Buddha, from Ajanta Cave 10, Maharashtra, India, c. 450–500. Photo: Robert E. Fisher.

Buddhist Expansion in China

(2nd-7th centuries A.D.)

Buddhism declined in India, where it would become nearly extinct by the thirteenth century. This was due partly to a revival of Vedic religion, which has a complex association with the development of Hinduism. But Buddhism spread throughout much of the rest of Asia, where it has remained a dominant cultural force. It was transmitted along the Silk Roads throughout central Asia to China (see map) in about the first century A.D. and gained a foothold during the Han dynasty (c. 206 B.C.– A.D. 220). Beginning in the second century A.D., Buddhist texts (sutras) were translated from their original Indian languages, Sanskrit and Pali, into Chinese. Only then was Buddhism recognized in China as a school of thought distinct from Daoism. Over the next few centuries, Buddhism brought with it new artistic techniques and styles from central Asia, India, Iran, and the Mediterranean world. The eclectic nature of Chinese art at this time reflects the continuing exchange of goods and ideas. Contemporary accounts, particularly those of Buddhist pilgrims, vividly describe what the travelers saw.

By the fifth century A.D., under the Northern Wei dynasty (386–535), Buddhist art flourished in China. The early Wei rulers were originally from central Asia, and, to consolidate their position in China, they promoted Daoism and Buddhism rather than Confucianism, the established state doctrine. Like Ashoka and Constantine, the Wei presided over monumental building projects, using religion and religious art in the service of political power.

Their first great artistic program was at Yungang, in Shaanxi Province. Caves were cut into the cliffs and colossal statues carved from the existing rock (fig. **W4.13**). At Yungang, the influence of hundreds of central Asian Buddhist caves—themselves based on Indian *vihāras* and *chaitya* halls—is clear. The monumental stone Buddhas carved from these sandstone cliffs also show traces of the Gandharan style.

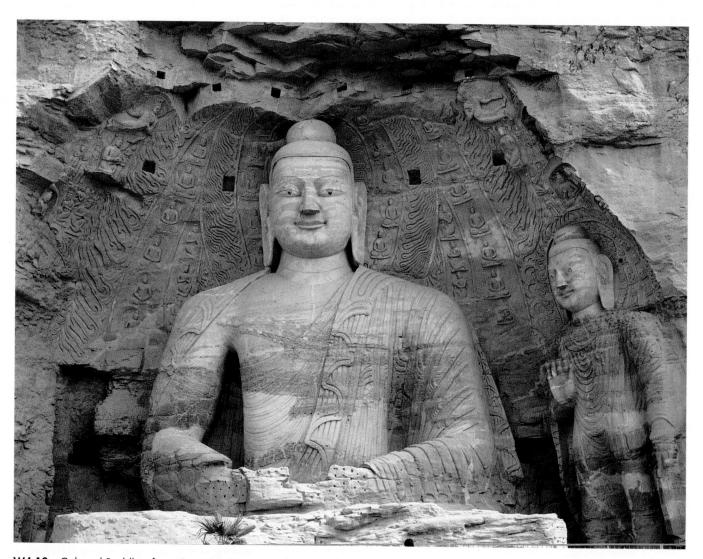

W4.13 Colossal Buddha, from Cave 20, Yungang, Shaanxi Province, China, c. 460–490. 45 ft. (13.71 m) high. For over thirty years, thousands of stoneworkers created such sculptures and carved out cave temples and cells in the Yungang cliffs. The project was proposed to the Wei rulers in 460 by the monk Tanyao.

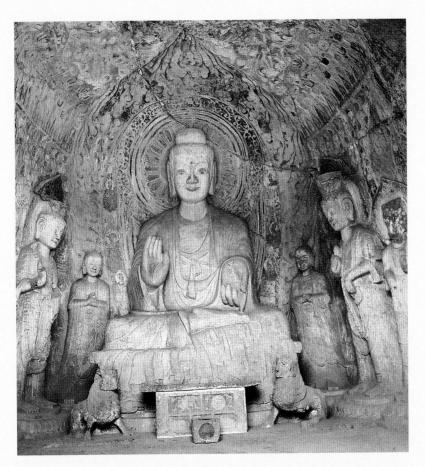

W4.14 Buddha with Disciples, from the Pinyang Cave, Longmen, Hunan Province, China, early 6th century.

The Buddha in figure W4.13 bears some resemblance to Gandharan sculpture, particularly in the smooth hair and flowing drapery that covers both shoulders. But the Yungang Buddha is psychologically more remote. All trace of Indian sensuousness has disappeared. The figure retains canonical features such as the ushnisha, elongated earlobes, and monk's robe, but the drapery folds are flatter and more stylized. The combination of the figure's colossal size and impassive gaze seems to elevate this Buddha to a spiritual plane that is beyond human time and place.

In 494, the Wei rulers moved their court southward to Luoyang. There they encountered a different form of Buddhism practiced by the native (Han) Chinese, which offered relief from the cycle of reincarnation through a less difficult route to *nirvana*. Groups known as Paradise Sects promised enlightenment in a resplendent paradise, attainable by anyone through faith, rather than exclusively through the rigors of monastic life. As in India, the popularity of Shakyamuni Buddha was rivaled by that of buddhas of the Past and Future. The cults of Maitreya and Amitabha, buddhas of the Future, invited believers to be reborn in paradise. These theological changes are noticeable in Buddhist art: for example, some images of Shakyamuni Buddha now appear to relate actively to worshipers. In addition, the number of representations of such buddhas as Maitreya, Amitabha, and Vairochana (the supreme cosmic Buddha) has increased.

When the Wei moved south, they took up a second major artistic program in the caves at Longmen. There the *Buddha with Disciples* (fig. **W4.14**) from the Pinyang Cave is the focal rockcut image inside the inner chapel. Shakyamuni sits cross-legged on a platform 19 feet (5.79 m) wide. His throne is guarded by the lions of royalty, and he is flanked by disciples. He no longer bows his head and lowers his eyelids to convey a state of inward meditation. Instead, in accordance with the Lotus Sutra (one of the canonical Buddhist texts) he gazes at worshipers, communicating directly with them. This active connection is reinforced by his enlarged hands: the right is held up in *abhaya mudrā* (the "have no fear" gesture), and the left points downward in *bhumisparsha mudrā* ("calling the earth to witness"). The figure's proportions are more elongated than at Yungang.

Shakyamuni's robe is now a Chinese garment. Its cascading folds are stylized as waterfalls and fishtails. In contrast to the relatively three-dimensional treatment of drapery at Yungang, this Buddha's robe is flatter and more linear; it is composed of repeated patterns. Such stylistic differences reflect the assimilation of foreign models into a more purely Chinese style. Similarly, the Longmen Buddha's fullcheeked, square-jawed facial type, with its almond-shaped eyes and smiling,

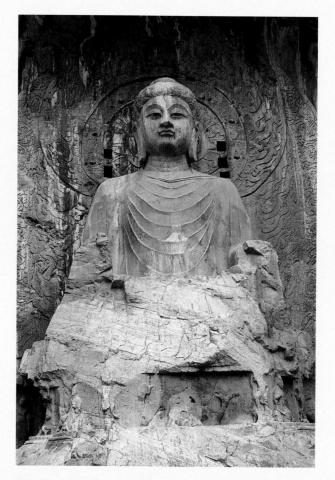

W4.15 Vairochana Buddha, Longmen Caves, Hunan Province, China, 672–675. Natural rock; approx. 49 ft. (14.93 m) high.

rosebud mouth, is distinctively Chinese. The flat, elaborately carved mandorla that surrounds the throne is filled with flames symbolizing the light of the Buddha's spirit.

The best example of the Longmen style was created under the Tang Dynasty (618–906), when China was again united and the arts flourished. As Buddhism developed in Tang China, the belief that buddhahood could be attained in this world grew in importance. Mystical rituals were intended to connect the earthly, material world with the formless, absolute world and to guide individuals along the path to spiritual awareness.

Figure W4.15 depicts *Vairochana Buddha,* the embodiment of Shakyamuni's spiritual nature and the most popular of the Five Great Buddhas of Wisdom. The figure's colossal size and simply rendered form enhance the Buddha's otherworldly quality. The original lotus throne, which has been lost, was conceived of as having one thousand petals, each corresponding to a single Buddhist cosmos with one hundred million Buddhist worlds. Vairochana (meaning "Resplendent") personifies the creativity of Buddhist *Dharma* and the Buddhist view of the universe. In one tradition—Huayen—Vairochana is the Universal Buddha. By association with him, China's emperors legitimized their claim to power.

Style/Period

BUDDHIST

8th-1st centuries B.C.

BUDDHIST 1st-7th centuries A.D.

Worship of the Buddha

Chaitya hall

Works of Art

Chaitya hall (W4.1), Karli Mithuna (W4.4), Karli

Ajanta Caves

(**W4.15**), Longmen Caves

Karli Santa Sabina (**W4.3**), Rome Ajanta Caves (**W4.6–W4.12**), Maharashtra Colossal Buddha (**W4.13**), Yungang Preaching Buddha (**W4.5**), Sarnath Buddha with Disciples (**W4.14**), Longmen Vairochana Buddha (**W4.15**), Longmen

Cultural/Historical Developments

Crucifixion of Jesus outside Jerusalem (c. A.D. 33) Galla Placidia erects mausoleum at Ravenna

(c. 425) End of Western Roman

- Empire (476) Building of Hagia Sophia, Constantinople (532–537)
 - Birth of Muhammad, founder of Islam (c. 570)

Colossal Buddha

Preaching Buddha

750 B.C.

0

The Early Middle Ages

Window on the World Five:

9

Mesoamerica and the Andes (1500 B.C.-A.D. 1500)

10 Romanesque Art

11 Gothic Art

Window on the World Six:

Buddhist and Hindu Developments in East Asia and South Asia (6th–13th centuries)

12 Precursors of the Renaissance

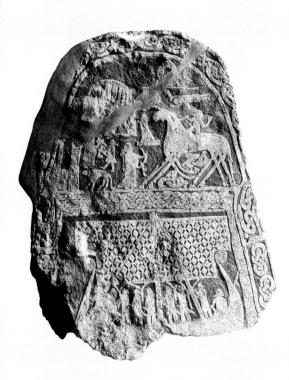

CHAPTER PREVIEWS

EARLY MIDDLE AGES, 5th-10th CENTURIES

Islam: birth of Muhammad in Mecca (c. 570) Islamic conquests (7th-8th centuries) Mosques; the Koran; calligraphy; Dome of the Rock Northern Europe: Anglo-Saxon metalwork Vikings (c. 800-1000): metalwork; rune stones; picture stones; Norse gods; Beowulf Denmark becomes Christian (965) Ireland: illuminated manuscripts; stone crosses; becomes Christian (5th century) Carolingian Europe: Charlemagne crowned Holy Roman emperor in Rome (800); Palace Chapel; monastic rule Ottonian Europe (10th-11th centuries): Saint Michael's at Hildesheim; Gospel book of Otto III Mesoamerica and the Andes, 1500 B.C.-A.D. 1500 Olmec (c. 1200–900 B.C.): colossal stone heads Teotihuacán (c. A.D. 350-650): pyramids; talud-tablero Maya (c. 1100 B.C .- A.D. 1500): calendars; ball game; Popul Vuh; Bonampak murals; Chichén Itzá Aztec Empire (c. 1300-1525) The Andes (c. 2500 B.C.-A.D. 500): Chavin; Paracas; Nazca; Moche; Tiwanaku; Wari

Inka Empire (c. 1438–1522): Machu Picchu

ROMANESQUE, 10th CENTURY-c. 1150

Feudalism; pilgrimage roads; Crusades; relics and reliquaries; Song of Roland Sainte-Foy (Conques); Saint-Pierre (Moissac); Saint-Lazare (Autun); Pisa Rib vaults; barrel vaults; groin vaults Stavelot Triptych; manuscripts Stave church (Norway); stone interlace Bayeux "Tapestry"; Battle of Hastings (1066); Norman conquest of Britain Precursors of Gothic: Caen; Durham

GOTHIC, 1147–13th/14th CENTURIES

Abbot Suger, Book of Suger; age of cathedrals Pointed arches; rib vaults; stained glass; flying buttresses French cathedrals: Chartres; Amiens; Reims Guilds; Magna Carta (1215); Scholasticism Sainte-Chapelle; Canterbury; Thomas à Becket Chaucer, Canterbury Tales; Salisbury Cathedral Spread of Gothic in Europe 19th-century Neo-Gothic Saint Patrick's Cathedral, New York

Buddhism and Hinduism in East and South Asia, 6th–13th Centuries

Paradise sects; pagodas; Horyu-ji; Hinduism; Hindu temples, Angkor Wat and Angkor Thom

RENAISSANCE PRECURSORS, 13th-14th CENTURIES

Humanist movement; Petrarch; Boccaccio Artists: Pisano; Cimabue; Giotto; Duccio; Ambrogio Lorenzetti; Orcagna; Simone Martini; Sluter; Limbourg brothers Dante, *Divine Comedy*; Saint Francis of Assisi Bubonic plague (Black Death) (1348) Hundred Years' War (1337–1453) International Gothic Style

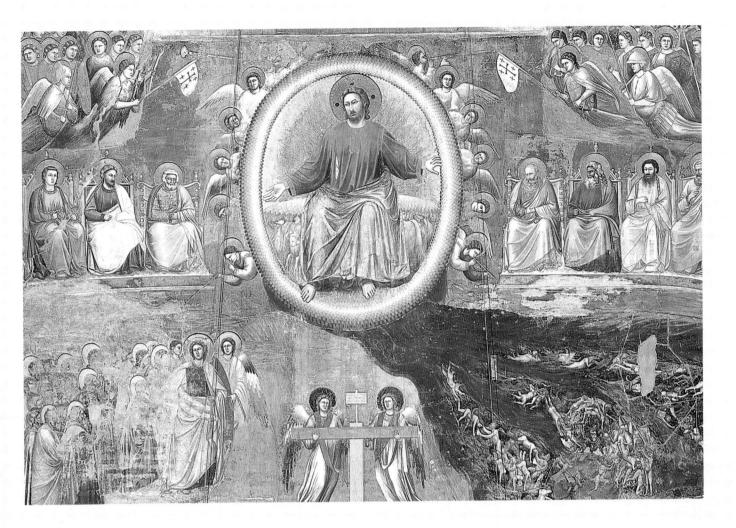

B y the Early Middle Ages, Christianity had become the prevailing religion of western Europe, and works of art were commissioned mainly for churches and Christian rulers. But following the rise of Islam in the early seventh century and subsequent Muslim conquests, Islamic art and architecture flourished in Spain until 1492 and influenced certain design patterns elsewhere in Europe. Invasions from the Viking north also introduced new art forms to the Continent.

In architecture, the crowning achievement of the European Middle Ages was the cathedral, with its soaring towers and imposing presence dominating medieval towns. As the Middle Age waned and a new interest in nature and naturalism emerged, Italian authors and artists began studying ancient Greek and Roman art and Greek and Latin texts. This launched the humanist movement, which coincided with the artistic revival called the Renaissance ("rebirth").

In the Far East, Buddhism and Hinduism persisted as major religions, influencing the creation of temples, monasteries, sculptures, and paintings. A synthesis of these two religions inspired the temple complex at Angkor Wat and the colossal towers of the Bayon at Angkor Thom.

In Mesoamerica, a relatively isolated area, several civilizations rose and fell from 1500 B.C. to A.D. 1500. The Aztec and the Inka in particular entered Western consciousness with the Spanish conquests of the sixteenth century.

3

The Early Middle Ages

I n western Europe, the term *Middle Ages* generally designates the period following the decline of the Roman Empire through the thirteenth or fourteenth century. *Early Middle Ages*, as used here, covers the pe-

riod roughly from the seventh to around the end of the tenth century.

As the Roman Empire declined, the Goths invaded much of western Europe and the Visigoths sacked Rome in 410. This hastened the collapse of the Roman imperial hierarchy as well as of Rome's control of its vast territory. In the early eighth century, Moors (from the Roman province of Mauretania in northwest Africa) conquered Spain, which had also been part of the Roman Empire. The Moors brought with them the new religion of Islam, to which they had been converted in the seventh century by Arab conquerors. Islam grew into a powerful force in parts of Europe, particularly in Spain. It flourished until the thirteenth century, when Christian armies reclaimed the Moorish strongholds—the *Reconquista*, or "Reconquest." The last of these was Granada, which fell in 1492, the year that Columbus sailed from Spain in search of a western route to India.

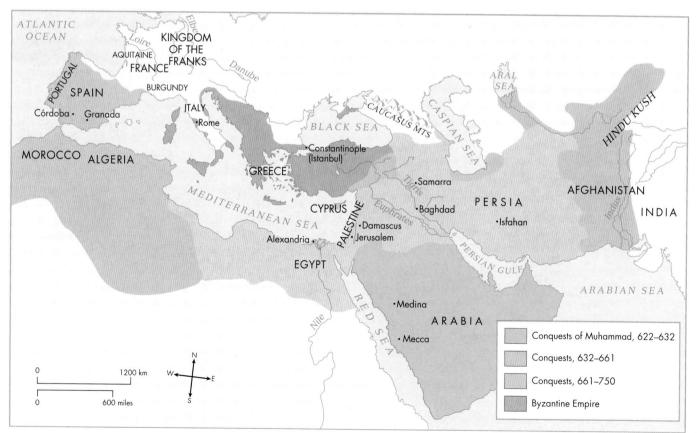

The expansion of Islam, 622–c. 750. 318

Islam

One of the world's great religions, Islam literally means "surrender [to God]." It was founded by the prophet Muhammad, who was born in Mecca, in western Arabia, around 570. He and his followers fled to the more hospitable neighboring city of Medina in 622, a watershed event called the Hijra that marks the starting point of the Islamic calendar. Within two years of Muhammad's death in 632, his successor, the first caliph (ruler) united Arabia under the new faith. Over the next twenty years, Islamic armies conquered large portions of the Byzantine Empire and the Middle East (see map). Controversy over the succession to the caliphate caused a political and religious schism in 661 that persists today. Islam is thus divided into two main sects: Sunni Muslims and Shiite Muslims. As a result of aggressive campaigns of conquest and conversion, a century after its founding Islam stretched from Afghanistan in the east to Portugal, Spain, and southwestern France in the west, where it rivaled Christianity.

Islam carries a relatively simple and straightforward message: the unity of the community of Muslims ("those who surrender") and their equality before Allah (God), who is single and absolute, and whose ultimate prophet was Muhammad. The holy book of Islam, the Koran (Qur'an), is believed to be the word of Allah as revealed to Muhammad in a series of visions. Another text, the Hadith, is a later compilation of traditions. Together, the Koran and the Hadith form the basis of Islamic belief and law. The Five Pillars of the faith are (1) the affirmation that there is no God but Allah and that Muhammad is his messenger; (2) ritual prayer facing the direction of Mecca five times a day; (3) almsgiving; (4) fasting and abstinence during the holy month of Ramadan; and (5) the *hadj*, an annual pilgrimage to Mecca that every devout Muslim strives to make at least once.

The most recent of the world's three monotheistic religions, Islam accepts Moses, Jesus, and others as prophets and forerunners of Muhammad. Like Judaism, Islam discourages the making of images that might be worshiped as idols. Muslim artists thus concentrated their creative energies on the development of nonfigurative forms, not only delighting the eye, but leading the mind to the contemplation of God. As a result, they excelled at calligraphy and geometric patterning.

The Dome of the Rock, Jerusalem

The earliest extant Islamic sanctuary is the Dome of the Rock in Jerusalem (fig. **9.1**). The structure encloses a rock outcropping that is sacred to Judaism and to Christianity as well as to Islam. Its exterior is faced with mosaics and marble. The building, which was inspired by round

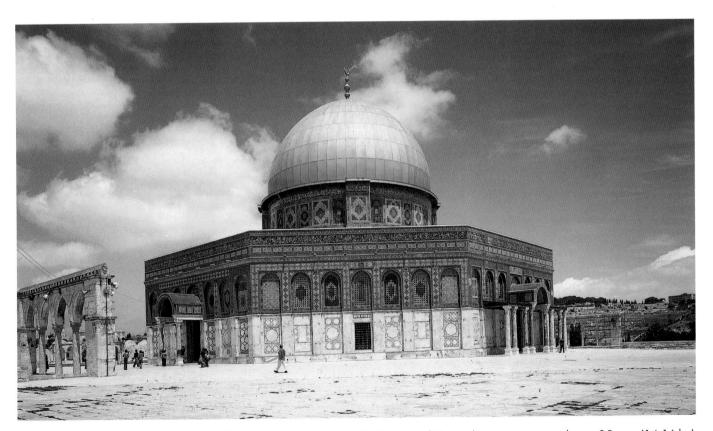

9.1 Dome of the Rock, Jerusalem, late 7th century. Also known as the Mosque of Omar, this was constructed on a 35-acre (14.16 ha) plateau in east Jerusalem. Muslims traditionally regard it as the site from which Gabriel led Muhammad through the heavenly spheres to Allah. Jews know the plateau as the Temple Mount—the location of Abraham's sacrifice of Isaac and of the first Jewish temple, built by King Solomon in the 10th century B.C.

Islamic Calligraphy

"Handwriting is jewelry fashioned by the hand from the pure gold of the intellect," wrote an early authority on Islamic calligraphy.¹

Since the Koran was originally revealed to Muhammad in the Arabic language, Muslims must read and recite from it only in Arabic. This has meant that, as Islam spread, the Arabic language and Arabic script spread as well. Because of its close association with the sacred text, writing is the most honored art in the Islamic world. It is also the most characteristic, uniting the diverse and far-flung community of believers. Writing adorns not only books, but also ceramics, metalwork, textiles, and buildings (such as the interior of the dome in figure 9.13). A great many calligraphic styles have developed over the centuries.

There are two main groups of scripts: the earliest, Kufic similar to Western printed letters and used today mainly for headings and formal inscriptions—and cursive, which evolved from the twelfth century on. Figure **9.2** illustrates a page from a ninth- or tenth-century manuscript of the Koran written in Kufic. It shows the Islamic interest in the linear complexity of texts as well as of designs. The abstract, linear rhythms of Islamic calligraphy lend themselves to a variety of visual effects, from the simple strength of early Kufic script to the intricacies of Sultan Suleyman's imperial emblem (fig. **9.3**).

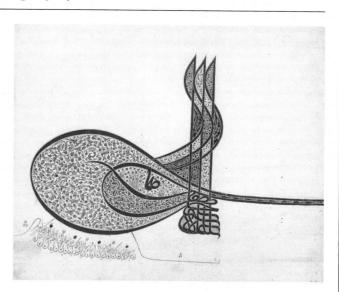

9.2 Page from the Kairouan manuscript of the Koran, written in Kufic, Tunisia, 9th–10th century. Ink, gold, and silver on blue dyed parchment; $11\% \times 14\%$ in. (28.7 \times 37.6 cm). Arthur M. Sackler Museum. Harvard University Art Museums. Francis H. Burr Memorial Fund.

Christian martyria, is a centrally planned octagon. Stylistically, the architectural ornamentation of the Dome of the Rock is a synthesis of Byzantine, Persian, and other Middle Eastern forms. Figure 9.1 illustrates the richness and complexity of the abstract patterning on the exterior, and the brilliant impression made by the **gilded** dome.

This was precisely the effect desired by Caliph Abd al-Malik, who commissioned it. According to a tenth-century source, he wanted a building that would "dazzle the minds" of Muslims and thereby distract them from the Christian buildings in Jerusalem.² This sentiment is a variant of the impulse to compete artistically, using height and size to express achievement and power. In the caliph's view, the splendor of his sanctuary would symbolically "blind" Muslims, preventing them from "seeing" beauty in monuments built by other faiths.

Mosques

Although Muslims may pray anywhere as long as they face Mecca, religious architecture became an important part of Islamic culture. In the earliest days of Islam, the faithful gathered to pray in the courtyard of the prophet Muhammad's home. From this developed the primary architectural expression of Islam—the mosque.

There are two main types of mosque: the *masjid* is used for daily prayer by individuals or small groups, while the larger *jāmi'* is used for congregational worship on Fridays, the Muslim sabbath. Although mosques around the world reflect local architectural traditions, most share certain basic features. These are a *sahn*, or enclosed courtyard (less common in later centuries), and a *qibla* (prayer wall) oriented toward Mecca. The *qibla* frequently has a *mihrāb* (small niche) set into it. *Jāmi'* mosques also contain a *minbar*, a pulpit from which an *imam* (religious teacher) leads the faithful. By the end of the seventh century, Muslim rulers were beginning to build larger and more elaborate

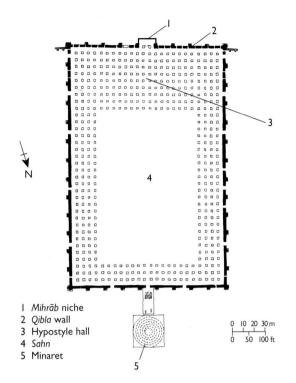

9.5 Plan of the Great Mosque, Samarra, 847–852.

structures. The exterior of a typical mosque includes one or more tall minarets, such as those added to Hagia Sophia when it was changed from a Christian church to a mosque (cf. fig. 8.28). From these towers, a *muezzin*, or crier, calls the faithful to prayer at the five prescribed times each day.

As Islam spread to the West and won more converts, new mosques were needed. The biggest of these was located in Samarra, on the banks of the Tigris River (fig. **9.4**). Built from 847 to 852 by Caliph al-Mutawakkil, it is now in ruins. Nothing remains of the lavish mosaics and painted plaster that decorated the interior. The plan (fig. **9.5**) shows

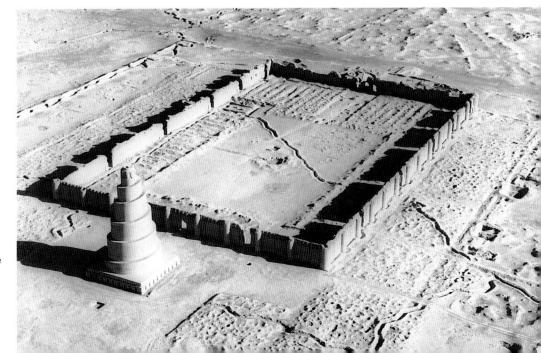

9.4 Great Mosque, Samarra (now in Iraq), 847–852. Approx. 10 acres (4.04 ha). Note the ziggurat style of the minaret, possibly reflecting the impact of Ancient Near Eastern influences on Islamic religious architecture.

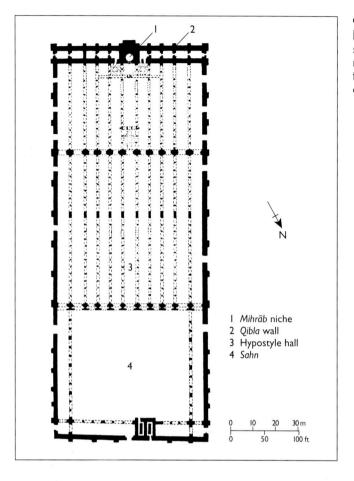

9.6 Plan of the Great Mosque, Córdoba, Spain, originally built 786–787. The additions from 832–848 and 961 are shown, but not the final enlargement of 987. The mosque is a rectangular enclosure with its main axis pointing southeast toward Mecca. Because Spain lies west of Mecca, this orientation is symbolic rather than exact.

the location of the 464 supports of the wooden hypostyle roof. These were arranged in rows around a huge, rectangular *sahn*. An unusual feature of this mosque is the single, cone-shaped minaret that rises 60 feet (18.29 m) on the north side. A ramp connects it with the main building, and leading to the top is a spiral stairway.

The most impressive example of a western Islamic mosque is the one built by Abd ar-Rahman I at Córdoba. The first Muslim ruler of Spain, he commissioned the mosque in 785 for his capital (fig. **9.6**). After its original construction (on the site of a church), the Great Mosque was enlarged in 832–848, 961, and 987. In the thirteenth century, Christians gained control of the Córdoba mosque and turned it into a cathedral, but enough of the original mosque survives to convey the magnificence of its design and ornamentation.

The system of double arches in the original mosque is unique, and it was used in each later addition. Filling the hypostyle interior are numerous columns either salvaged or derived from Roman and Early Christian buildings (fig. **9.7**). These columns were relatively short—under 10 feet (3.05 m) high. If they had supported the arches and vaults at that height, the interior illumination would have been

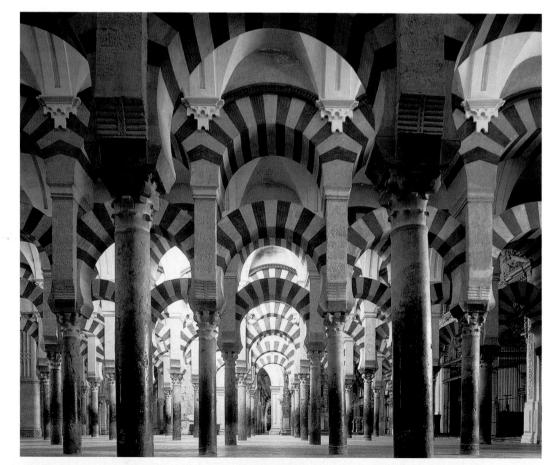

9.7 Arches of the Great Mosque, Córdoba, begun 786–787. Columns 9 ft. 9 in. (2.97 m) high. The interior space is larger than that of any present Christian church.

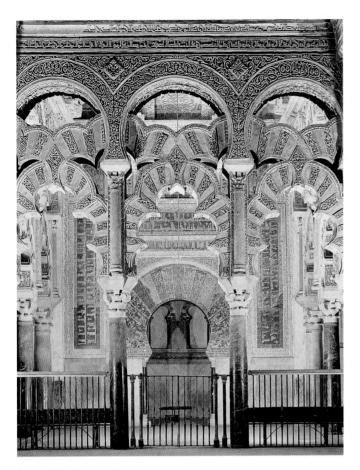

9.8 *Mihrāb* bay, the Great Mosque, Córdoba, c. 961–966.

inadequate. Instead, therefore, the architect constructed a series of double-height, horseshoe-shaped striped arches (using voussoirs of alternating red brick and pale yellow stones) to raise the ceiling height. The second tier of arches springs from posts on top of the lower columns and originally supported a tiled wooden roof. (This was replaced by vaulting in the sixteenth century.) The vast numbers of columns have been likened to a forest, and the colored arches create an impression of continual motion that enlivens the dimly lit interior. The multiplication of architectural elements here breaks up the flow of space, creating a sense of mystery.

As part of the second expansion phase in 961, the caliph ruling at Córdoba built a magnificent *mihrāb* in front of the *qibla* wall. To its north is an area reserved for the caliph and his retinue. This consists of three domed chambers entered through three tiers of lobed arches (fig. **9.8**), which crisscross each other to form an interlaced screen. The domes themselves are built in intricate geometric patterns—all of them different—on eight intersecting stone arches, or ribs. The central dome (fig. **9.9**) and the *qibla* wall have elaborate, Byzantine-inspired mosaics with gold backgrounds. This synthesis of structure and ornament in the Great Mosque at Córdoba became characteristic of later Islamic architecture.

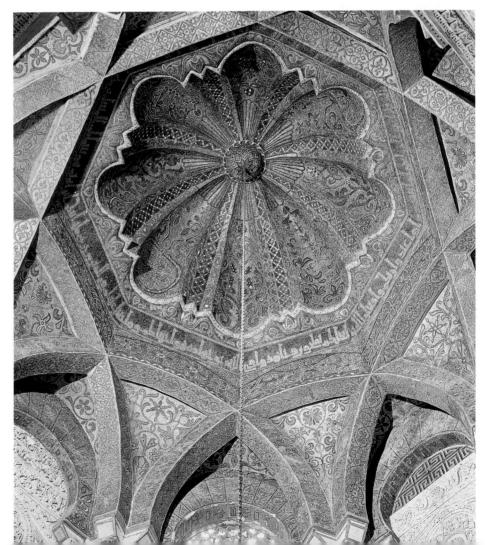

9.9 Dome in front of the *mihrāb*, the Great Mosque, Córdoba, c. 961–976. Mosaic.

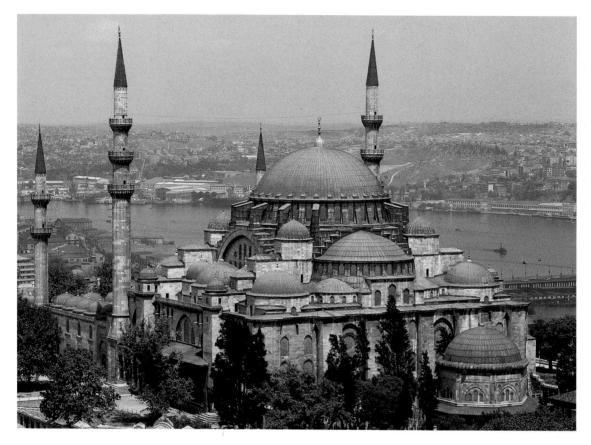

9.10 Sinan the Great, mosque of Suleyman I, Istanbul, Turkey, begun 1550. Sinan was a Greek who converted to Islam and, at the age of 47, became "Architect of the Empire." As supervisor of building in Istanbul and overseer of all public works, he was referred to as "Architect in the Abode of Felicity."

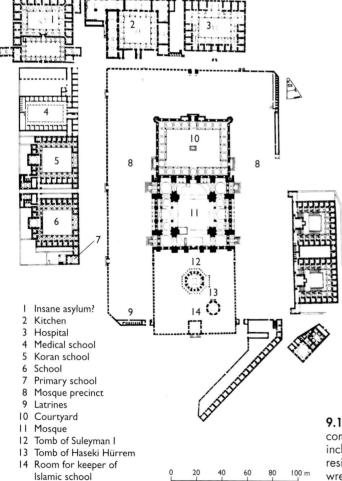

150

300 ft

In 1453, when Constantinople was conquered by the Ottoman Turks from central Asia, the city was renamed Istanbul. The Ottoman Empire grew rapidly, reached a peak in the sixteenth century, and lasted until 1922. It was under the Ottomans that Hagia Sophia (see Chapter 8) was transformed from a Byzantine church into a mosque.

The leading Ottoman architect was Sinan the Great (c. 1491–1588), known as Koca (the Architect). His most important work in Istanbul, the mosque of Suleyman I (figs. **9.10** and **9.11**), was part of an imperial complex begun in 1550. By aligning the mosque with the horizon, Sinan used the elevated site to enhance its monumental effect. His notion of an ideal geometric symmetry—particularly a circle inscribed in a square—is clear from the plan. His domes also express the symbolic significance of the circle as a divine shape with God at its center.

The large central dome, preceded by several levels of smaller domes and stepped, buttressed walls, seems to be bubbling up from the interior of the hill. Four minarets accent the exterior symmetry. The *sahn* (fig. **9.12**) is surrounded by a colonnade of arches, whose sizes correspond to the width of the twenty-four domes they support. The interior of the mosque (fig. **9.13**), despite restoration,

9.11 Plan of the mosque of Suleyman I and the imperial complex, Istanbul. In addition to the mosque, the vast complex includes seven colleges, a hospital and asylum, baths, two residences, a hostel, kitchens, tombs, a school, fountains, wrestling grounds, shops, and a courtyard. Altogether there are five hundred domes, of which the mosque's is the largest.

9.12 Courtyard (*sahn*) of the mosque of Suleyman I, Istanbul.

9.13 Interior of the mosque of Suleyman I, Istanbul.

9.14 The Luftullah Mosque, Isfahan, Iran, 1602–1616.

shows the influence of Hagia Sophia, with domes resting on pendentives and many small windows creating an impression of light streaming down from heaven. The *mihrāb* was decorated with blue, red, and white ceramic tiles arranged to create elaborate floral designs.

The seventeenth-century Luftullah Mosque in Isfahan shows the skill of Muslim artists in creating shimmering,

jewel-like surfaces composed of intricate floral and calligraphic tilework (fig. **9.14**). These are reminiscent of knotted carpets, for which Persia (modern Iran)—which became part of the Islamic world in the seventh century—was renowned. Their colorful rhythms reflect influences of nomadic textile traditions and of the Ancient Near Eastern taste for geometric patterns (see Chapter 2).

Northern European Art

For all intents and purposes, the early medieval Islamic influence on western Europe and its art was concentrated in the south, for the Austrasian ruler Charles Martel had halted the Muslim invasion of Europe at Tours, in central France. The north (see map, p.328) became a new focus of political and artistic activity, which was more influenced by Germanic tribes than by either Islam or Hellenistic-Roman tradition. The Germanic Angles and Saxons had invaded the British Isles in the fifth century A.D., and the Franks had invaded Gaul (hence the name France). A new craft was developed around the metalwork brought by the invaders.

Anglo-Saxon Metalwork

A good example of Anglo-Saxon metalwork is the seventhcentury purse cover from Sutton Hoo in East Anglia on the southeast coast of England (fig. **9.15**). It was part of a purse containing gold coins that was discovered among the treasures of a pagan ship burial. This was a practice in which the deceased was placed in a ship buried under a mound, reflecting the belief that boats carried the dead into the afterlife. The circumstances of the Sutton Hoo burial suggest that the deceased was a royal personage, for the ship (which in this case was never sent to sea) contained an abundance of treasures. The Anglo-Saxon epic *Beowulf* (see p. 328) describes the lavish burials of kings with armor and other valuable objects.

The purse's decoration is of gold cloisonné and crushed dark red garnets. It has echoes of Early Christian interlace designs (cf. fig. 8.21) as well as of the Scythian Animal Style (see fig. 2.33) and certain ancient Near Eastern motifs. The taste for flat, crowded, interlaced patterns infiltrated western Europe and continued through the Middle Ages. The arrangement of the decorative sections on the purse cover is symmetrical, as is each individual section or pair of sections. At the top, two geometric shapes filled with gold tracery flank a centerpiece containing four fighting animals whose jaws and legs are extended to form intertwining ribbons. This technique, in which animals merge into a design or into each other, had also been characteristic of Scythian gold objects (cf. fig. 2.33). Below, at the center of the purse cover, are two sets of animals. An eagle and a duck face each other and are symmetrically framed by a pair of frontal men flanked by animals in profile, the latter a motif derived from Ancient Near Eastern iconography. The merging animal forms suggest that the waves of invaders from the fifth century onward brought their artistic styles to western Europe.

9.15 Sutton Hoo purse cover, from East Anglia, England, c. 630. Gold with garnets and *cloisonné* originally on ivory or bone (since lost); 8 in. (20.3 cm) long. British Museum, London. A kidney-shaped gold frame encloses a border of garnets and glass set into *cloisons* (compartments) formed by a network of thin metal strips. At the top, there are three hinged strap holders for attaching the purse to a belt. At the bottom, a gold catch was used to keep the purse closed.

— CONNECTIONS

See figure 8.21. Detail of capital, San Vitale, Ravenna, c. 540.

See figure 2.33. Stag, from Kostromskaya, Russia, 7th century B.C.

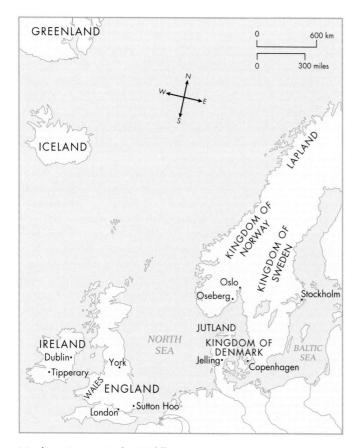

Northern Europe in the Middle Ages.

Beowulf

Beowulf is the earliest surviving manuscript of a European epic composed in the vernacular. Although clearly in the tradition of Germanic folklore, it has a strong sense of Christian morality. The epic is believed to have been written down in the eighth century, but the events it describes take place in the sixth century and the text is known from a late tenth-century manuscript.

Beowulf opens with a miracle that occurred in childhood—in the tradition of the births of Sargon of Akkad (see Chapter 2) and Moses. The child is Scyld Scefing, who drifts ashore in a boat and starts a new dynasty in Denmark. "Sent from nowhere," according to the text, "the Danes found him floating with gifts a strange king-child." Clearly this image was informed by echoes of Jesus as a baby king as well as of Moses in the bulrushes.

When Scyld Scefing dies, he is given a ship burial like that in which the Sutton Hoo purse cover was discovered. Scyld's burial ship is described as

... ring-prowed ...
 icy and eager armed for a king.
 ... From hills and valleys
 rings and bracelets were borne to the shore.
 No words have sung of a wealthier grave-ship

swords and ring-mail rich for drifting through the foaming tide far from that land. At last they hung high upon the mast a golden banner then gave him to the sea to the mounding waves....³

The epic is divided into two main parts. In the first, the hero Beowulf, a Swedish prince, offers his services to the king of Denmark, whose palace is being ravaged by the monster Grendel. Beowulf destroys Grendel and brings its head to the Danish king. In the second part, Beowulf has become a king. In his old age, he is mortally wounded in a battle with a monster. The epic concludes with a description of Beowulf's funeral rites and burial.

The Viking Era (c. 800-1000)

The Vikings were Scandinavian warriors who inhabited Norway, Sweden, and Denmark (Finland and Lapland belonged to different ethnic groups). They were known throughout Europe for their paganism and their ferocious, destructive raids. The best literary sources for Viking society are the sagas (prose narratives dealing with heroic figures and events) of Iceland, which was settled by the Norwegian Harald the Fairhair in the ninth century. The sagas also record the ancient oral traditions of Scandinavia and present a valuable account of its pre-Christian culture (see boxes, p. 330). Inhabited since the Stone Age, Scandinavia was an agricultural society, divided into small communities ruled by kings who were descended from royal families and elected to the throne.

In about 800, the Scandinavians developed sailing ships propelled by oars. This made extensive travel possible, and there is evidence of Viking incursions from Byzantium and the Baltics to northern France, the British Isles, Greenland, and North America. As a result, there are traces of Islamic, Byzantine, and Scythian influence in Viking art. For example, the animal headpost from a ship burial at Oseberg, Norway (fig. 9.16), is similar in conception to the Scythian lion-head finial from Kul Oba (fig. 9.17), a site between the Black Sea and the Sea of Azov in Russia. Both works are characterized by a compact monumental form, which is reinforced by the fiercely bared fangs of the lions. These works combine monumentality with elegant stylization, the finial more related to Achaemenid prototypes and the headpost to Anglo-Saxon interlace. Although the function of these objects is unknown, it is likely, given their leonine imagery, that they were guardians.

The pure interlace motif appears on a tenth-century axe from Denmark (fig. **9.18**). Its gold neck and silver inlay indicate the high status of the owner, who is thought to have been a member of Harald Bluetooth's court (see below). The combination of geometric design with natural elements such as foliage and a bird suggests familiarity with Anglo-Saxon metalwork.

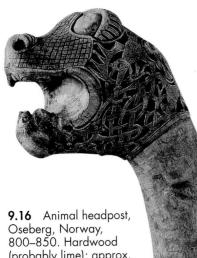

9.10 Animal headpost, Oseberg, Norway, 800–850. Hardwood (probably lime); approx. 23% in. (60.0 cm) high. University Museum of National Antiquities, Oslo.

9.18 Axe, from Mammen, Jutland, Denmark, Late Viking, c. 950–975. Silver inlay and gold; 6% in. (17.5 cm) long. National Museum, Copenhagen.

The Scandinavian Cosmos

For the Scandinavians, as for the ancient Greeks, the beginning of time was primeval chaos (*Ginnungagap*), a dark, formless abyss. An excerpt from *Saemund's Edda* (a myth written down in Scaldic by the thirteenth-century Icelandic author Snorri Sturluson) describes the Norse view of chaos:

In early times, When Ymir lived Was sand, nor sea, Nor cooling wave; No earth was found, Nor heaven above; One chaos all, And nowhere grass.⁴

In Norse myth, the ice giant Ymir emerged from the frost and ice blocks that filled the abyss. After he was killed, his blood caused the flood that destroyed his race. Only one giant survived, and, with his wife, he sailed off in a boat to father a new race of giants, the Jotun. (Note the similarity to the Sumerian flood myth and the Old Testament account of Noah.)

Unlike the ancient Greeks, who believed that the anthropomorphic Olympians had destroyed the primitive Giants, the Scandinavian giants continued to exist. They were in conflict with the gods, but they also made alliances with them and occasionally intermarried. In Greek mythology, the cosmic battle between the Giants and the Olympians had already taken place, but in Scandinavia the cosmic battle (*Ragnarok*, or "Twilight of the Gods") between these forces was set in the future, as is the Christian Apocalypse. Whereas in the Judeo-Christian tradition there had been a paradise (the Garden of Eden), in Norse myth peace and prosperity would come only after *Ragnarok*.

The Norse universe was polytheistic. It had been ordered by the chief god, Odin, who scheduled the seasons and established the positions of the sun and moon. He divided the universe into a tri-centric structure:

- Asgard The dwelling of the gods and location of Valhalla, where Odin presided over the dead warrior elite preparing for *Ragnarok*.
- **Midgard** Middle Earth, inhabited by people. The gods created Midgard from the dead body of Ymir. His flesh became the earth, his blood the sea, his hair the trees and plants. His skull was emptied and turned upside down to form the dome of heaven, and his brains were scattered and became clouds.
- **Utgard** Outer Earth, home of the Jotun. At the axis of the world was the tree Yggdrasil, where gods held daily council. (There are comparable tree cults elsewhere—for example, in Vedic India and Minoan Crete.)

GODS	ATTRIBUTES AND QUALITIES		
The Aesir		The Vanir	
Odin	God of wisdom, created the first human couple, god of Vikings and royal families, stole poetry from the Jotun and gave it to the human race. He also gave people the secret	Njord Frey Freyja	Sea god. Phallic fertility god, brother of Freyja. Goddess of war and beauty; fosters romance and leads the Valkyries.
	of writing and the runes. He was a shaman and the ruler of Valhalla.	Divine Groups	
Thor	God of Thunder, a giant gourmand, protector of the cosmos (comparable to Indra, Zeus, and Jupiter), wields a hammer.	Jotun Volur	Primeval giants. Wise women who know the history of the world.
Frigg Baldr	Wife of Odin. Fertility. Son of Odin and Frigg. God of Peace.	Norns	Fates, female powers who sit under the tree Yggdrasil.
Heimdall	Son of nine giant mothers. Guardian of the world at the end of the rainbow, originator of social classes.	Valkyries	Beautiful immortal virgins with gold and silver armor who decide which warriors wil be admitted to Valhalla after their death.
Loki	Fire god, troublemaker, trickster. Offspring of the Jotun and Odin's blood brother. At		They ride magnificent horses that are personifications of clouds.
Tyr	<i>Ragnarok,</i> Loki sides with the Jotun. God of war.	Elves Dwarfs	Fertility gods. Keepers of ancestor cults. Smith gods who inhabit the underground.

Rune Stones and Picture Stones

More specifically native to Scandinavia than interlace are inscriptions on upright boulders known as **rune stones** and images on **picture stones**. The earliest runes (letters of the runic alphabet) date from the third century, when the Vikings arrived in the north. Runes were also used by Germanic tribes, Goths, and Anglo-Saxons. In the Viking era, there were sixteen stick-shaped letters in the alphabet. The runic inscriptions on stones could be memorials or records of voyages, battles, and even daily activities. Only an initiated few could read the rune stones, which were intended to preserve the mythical, literary, and cultural history of Scandinavia.

The early ninth-century rune stone at Rök, in Sweden, has the first known runic inscription of an oral narrative in Scandinavia, a memorial dedicated by a Viking chieftain to his dead son (fig. **9.19**). The inscription on the side shown here praises Tjodrek (the Ostrogoth king Theodoric the Great, d. 520) as a brave king of sea fighters.

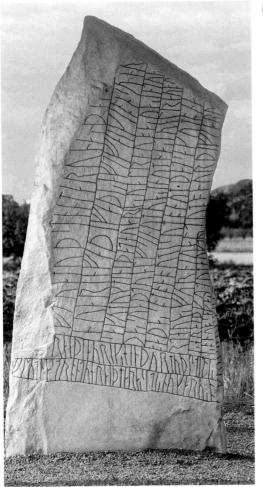

9.19 The Rök stone, Östergötland, Sweden, early 9th century.

9.20 Warrior Entering Valhalla, from Tjangvide, Gotland, Sweden, 8th–9th century. Limestone relief (newly repainted); 5 ft. 9 in. (1.75 m) high. Statens Historiska Museet, Stockholm.

The runic inscription at the side of the example in figure 9.20 says that the stone was "raised for his brother Hjoruv," and the image on the face of the stone confirms its memorial function. At the top, a warrior (presumably Hjoruv) rides Odin's eight-legged horse, Sleipnir, into Valhalla. Above are two more warriors (denoting battle), one falling and the other already dead. Welcoming Hjoruv into Valhalla by extending a drinking horn is a Valkyrie with long hair and a long skirt; a dog follows behind her. Above the dog, another Valkyrie offers a horn to a man with an axe. The shape over these two figures echoes the shape of the stone and represents the halls of Valhalla. On the lower half of the stone is a Viking ship filled with warriors and a sail decorated with a pattern of diamond shapes. This undoubtedly refers to the tradition of ship burials described in Beowulf and to the belief that the deceased sail into the afterlife. The scenes are framed with interlace, which also separates the upper and lower halves of the image.

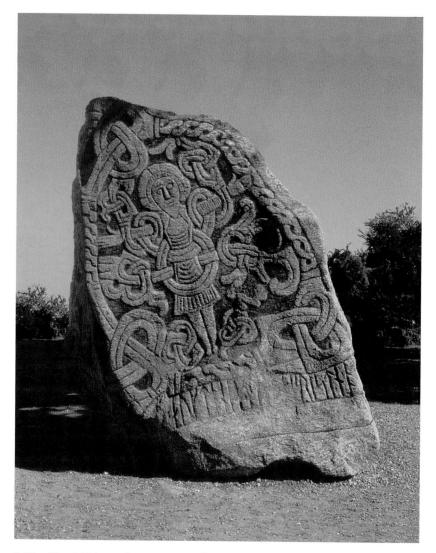

9.21 Harald Bluetooth's rune stone, from Jelling, Denmark, c. 965. According to a contemporary chronicler, a priest at Harald's court lifted a hot iron with his bare hands. Miraculously unharmed, he persuaded the king to become a Christian. An inscription on the other side of the stone states that "King Harald had these memorials made to Gorm, his father, and to Thyre, his mother. That Harald who won fame for himself, all Denmark, and Norway and made the Danes Christian."

Around 965, Denmark became Christian. Prior to that time, the Viking raids on northwestern Europe had been successful. But in 934, Germans invaded Denmark and brought Christian missionaries with them. Some thirty years later, the Danish king Harald Bluetooth (died c. 987) converted to Christianity and raised a huge rune stone at Jelling to commemorate the event (fig. **9.21**). Its surface is covered with interlace designs that flow into the arms of the image of Christ, who stands upright, faces front, and wears a short tunic. This representation is a good example of the integration of Christian imagery with pagan interlace.

Hiberno-Saxon Art

Because of its remote position, Ireland had escaped occupation by the Romans in the first and second centuries A.D. and invasion by Germanic hordes in the fifth century. According to tradition, Saint Patrick (c. 387–463) introduced Christianity into Ireland in the first half of the fifth century, and for the following 250 years Irish monasteries provided a haven for European scholars, becoming centers of classical and theological learning. In the Early Middle Ages, missionaries from Ireland were partly responsible for the spread of the Christian faith in mainland Europe. Among them was the Irish abbot Saint Columba, who established an outpost on the island of Iona in southwest Scotland from 563 to 597. Together with twelve close followers, he brought Christianity to the neighboring islands and converted all of Scotland.

During this period, there was a flowering of Christian art in Ireland and various other islands off the coast of northern Britain. Its style has been given a number of labels, including Insular and Hiberno-Saxon (*Hibernia* is Latin for "Ireland").

Stone Crosses

From the early seventh century to around 800, pagan interlace patterns were incorporated into Christian art. They were carved in relief on the large stone crosses that still dot the Irish countryside. Three types of interlace adorn the vertical and arms of a cross in Tipperary (fig. **9.22**). At the bottom, a single row of scrolls is repeated in the broken circle. The pedestal design has largely worn away with time. Generally, these Irish monumental crosses mark sacred places on roads.

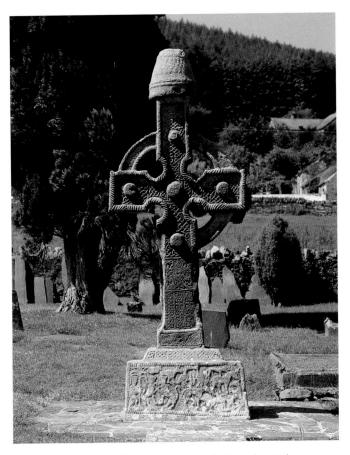

9.22 Celtic cross, Ahenny, Tipperary, Ireland, late 8th century. Granite. The use of interlace designs for stone carving was probably derived from their previous use in metalwork, as in the Sutton Hoo purse cover (fig. 9.15).

Manuscript Illumination

Another typical use of the pagan interlace in Christian iconography occurs in **illuminated manuscripts** (see box) produced by monks in Irish and English monasteries (see p. 340). The main impetus of their style may have originated in Ireland, and from there it infiltrated England and other parts of western Europe.

The page in figure **9.23** of the *Lion Symbol of Saint John* from the Book of Durrow is a relatively early example of medieval manuscript illumination from the second half of the seventh century. The lion is in profile, its mouth open and teeth bared as if growling or roaring. Note the dense patterning of the surface of its body with red and green diamond shapes. They are accentuated by a yellow outline that merges into stylized muscle, yellow and red feet, and green and brown striations toward the end of the tail. These colors, as well as the dot pattern on the face, are repeated in the interlace inside the border.

The artist has created a strict unity of color and form on this page. In the border, for example, the reds are reserved for the upper and lower sections, thereby repeating the horizontal of the lion's body as well as its color arrangement. The edges are crisp and clear, the colors contrasting, and the surfaces flat like those of the Sutton Hoo purse cover (fig. 9.15). Design-driven optical illusions are created in the interlace, as if a ribbon has been threaded and rethreaded through itself. This kind of illusory, mazelike play was to become more complex in the course of the Middle Ages. Such early medieval illuminated manuscripts

Manuscript Illumination

Illuminated manuscripts are hand-decorated pages of text. Great numbers of these texts were needed because of the importance of the Bible, and especially the Gospels, for the study and spread of Christianity. Most were made during the Middle Ages in western Europe, before the invention of the printing press. (The Chinese are thought to have used movable type from the eleventh century A.D., but printing was not known in Europe before the fifteenth century.) Medieval manuscripts were copied in monastery **scriptoria** (Latin for "writing places"). Medieval scribes had to know Latin and have good penmanship, excellent eyesight, and the ability to read the writing of other scribes whose manuscripts they were copying.

It is not known what tools the scribes had for illuminating the manuscripts, although it is obvious that compasses and rulers were used for the geometric designs. The magnifying glass had not yet been invented. The scribes' pigments consisted of minerals and animal or vegetable extracts. These were mixed with water and bound with egg whites to thicken the consistency. The paint was applied to vellum (as in the early codex), which is high-quality calfskin parchment, specially prepared and dried for manuscripts.

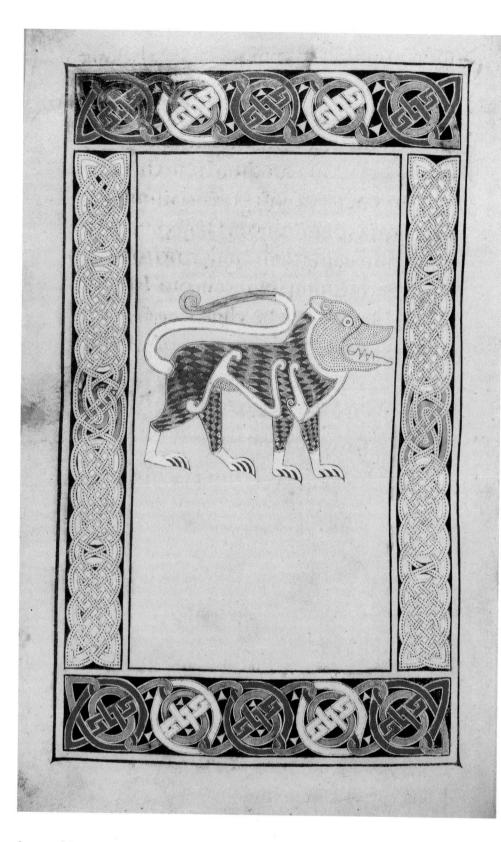

9.23 Lion Symbol of Saint John, from the Book of Durrow, fol. 191v, c. 650–700. Illuminated manuscript on vellum; $9\frac{4}{3} \times 5\frac{3}{4}$ in. (24.5 \times 14.5 cm). Library of Trinity College, Dublin, Ireland. This manuscript originally came from either Ireland or Northumbria in England. It represents Saint John the Evangelist as a lion surrounded by a rectangular border filled with interlace. Later, Saint John's symbol was changed to an eagle.

from northern Europe create a world of images that seems totally independent of the humanistic tastes of Greco-Roman tradition.

Perhaps the most famous Early Medieval Hiberno-Saxon illuminated manuscript is the Book of Kells, which dates from the late eighth or early ninth century. Its text consists of the four Gospels, written in Latin in 680 pages. The color and form of the manuscript illuminations have become more complex, with animal and human figures incorporated into the design of the letters. In the *T* of *Tunc*

on the folio illustrated in figure **9.24**, for example, the two arms of the letter stretch into the legs and claws of the animal whose head is in the curve of the *T*. The inside of the curve of the *T* contains more interlacing—notably protozoan creatures with prominent eyes. A small green head evolves into the red border around the *unc* of *Tunc*. At the left border of the page a dragon head emits ribbonlike flames. Human forms have also been added to the repertory. Three sets of small human heads appear in rectangular spaces, two on the right of the folio and one on the left.

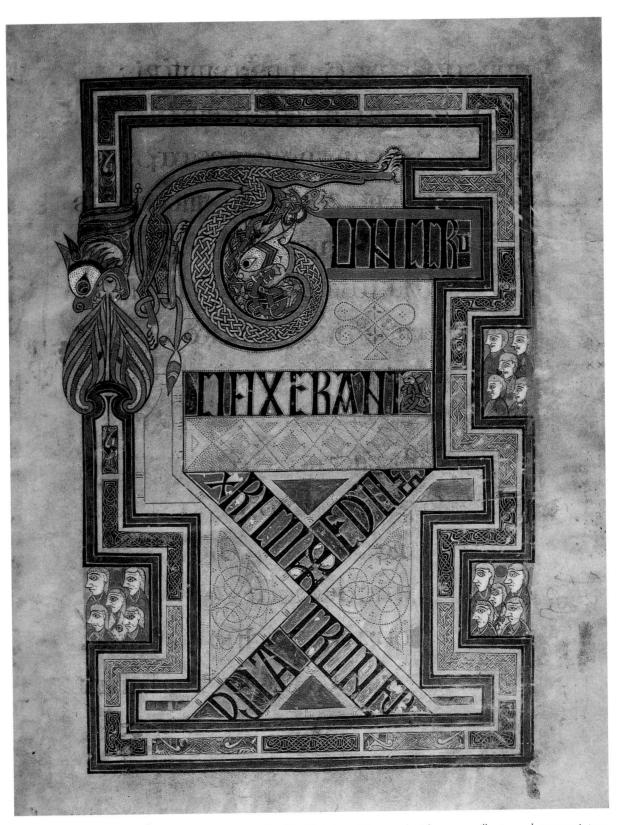

9.24 Tunc Crucifixerant XPI, from the Book of Kells, fol. 124r, late 8th or early 9th century. Illuminated manuscript on vellum; 9½ × 13 in. (24.1 × 33.0 cm). Library of Trinity College, Dublin, Ireland. This is a page from the Gospel of Matthew (27:38). The scribe has written: "Tunc crucifixerant XPI cum eo duo latrones" (Then they crucified Christ and, with him, two thieves).

Such delight in intricate detail was to continue in border imagery throughout the Middle Ages.

In addition to the obvious visual pleasure these designs gave their artists as well as their viewers, their purpose was to illuminate the "Word of God." The lower half of the page contains a large *Chi* (written as *X*), the beginning of Christ's Greek name and also a visual reference to the Cross. The interlacing that characterizes these manuscripts is thus echoed in the formal assimilation of iconography into text.

The Carolingian Period

The era of the Book of Kells corresponds to an important historical landmark in western Europe. On December 25, 800, the pope crowned Charlemagne (Charles the Great) Roman emperor at Saint Peter's in Rome. When Charlemagne came to power, he ruled a large part of western Europe, including France, Germany, Switzerland, Belgium, Holland, northern Spain, and Italy to the south of Rome. This territory was to be the subject of extensive political and religious controversy between the popes in Rome and the German emperors right up until the nineteenth century. It was named the Holy Roman Empire in the thirteenth century and lasted as such for over six hundred years (see map). Charlemagne was also king of the Franks from 771 to 814.

Charlemagne created a cultural revival intended to enhance his imperial image in the tradition of ancient Rome. The term used to describe the period—*Carolingian*—derives from the name of Charlemagne's grandfather, Charles Martel (*Carolus* is Latin for "Charles"), who had defeated the Muslim invasion at Tours. Under Charlemagne, monasteries expanded the network of learning throughout Europe in which Latin, as the language of the manuscript texts, had been kept alive. Besides the Latin language, Charlemagne wanted to revive other aspects of the Roman past. He established a political organization based on that of ancient Rome and a unified code of laws, created libraries, and pursued a program of educational reform.

To improve education in his empire, Charlemagne hired the English scholar Alcuin of York, in Northumbria, and invited him to his court at Aachen. Alcuin organized cathedral and monastic schools to promote Latin culture and language. He adopted from Aelius Donatus, who had taught Latin grammar and rhetoric in Rome, a curriculum and a grammar book that set the standard in western European schools until the end of the Middle Ages. The curriculum was divided into two sets of disciplines based on the Seven Liberal Arts. The *trivium* consisted of grammar, rhetoric, and dialectic, and the *quadrivium* of geometry, arithmetic, astronomy, and music.

The Palace Chapel

In the last decade of the eighth century, Charlemagne moved his capital and his court to Aachen (Aix-la-Chapelle in French), 45 miles (72 km) southwest of Cologne, near the modern Belgian–Dutch border. There he constructed a palace, together with offices, workshops, and other buildings. Of particular architectural importance was the palace chapel, which doubled as Charlemagne's personal chapel and a place of worship for the imperial court (figs. **9.25**, **9.26**, and **9.27**).

The Holy Roman Empire under Charlemagne, 814.

The palace chapel has certain features in common with the Church of San Vitale in Ravenna (see Chapter 8). Both are large, sturdy, centrally planned buildings; San Vitale is octagonal, and the palace chapel has a sixteen-sided outer wall and an octagonal central core surrounded by an ambulatory supporting a gallery. The gallery opens onto the central area through a series of arches, which allowed Charlemagne and his entourage to observe the celebration of the Mass. At the third level, the central core rises to a clerestory. To the front of the palace chapel, a square entrance flanked by round towers was added, with tower stairs leading to a throne room at the level of the gallery. Originally the chapel also had a walled courtyard around the entrance. From here visitors could catch a glimpse of the emperor at a window in the second level of the façade. This appearance of the ruler, visible to his subjects through a window, was an old royal tradition dating back to ancient Egypt and equating the ruler with the Sun.

Like Justinian, Charlemagne used the arts to enhance his political image. His architect, Odo of Metz, revived the massive piers and round arches of ancient Rome, which reinforced Charlemagne's claim to the Holy Roman Empire. As in the Colosseum (cf. fig. 7.19), the supports of the palace chapel decrease in size as they rise, creating a sense

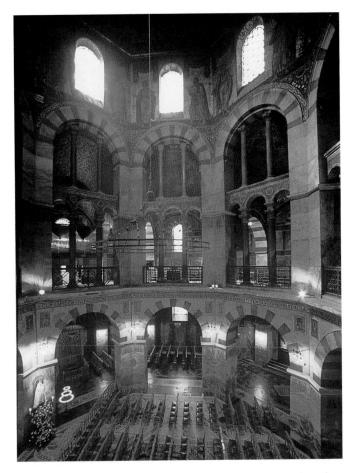

9.25 Odo of Metz, interior of Charlemagne's palace chapel, Aachen, 792–805.

of greater weight at ground level. In the gallery, triple arches are aligned with single round arches, and two central columns with Corinthian capitals stand between each set of piers. The result is a combination of the Justianic central plan with the monumental symmetry and order of the Roman buildings.

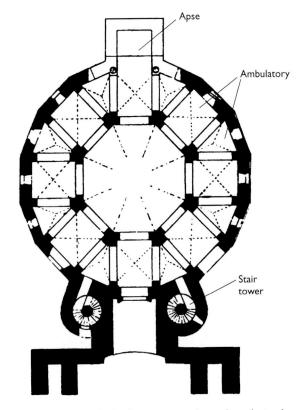

9.26 Plan (restored) of Charlemagne's palace chapel, Aachen.

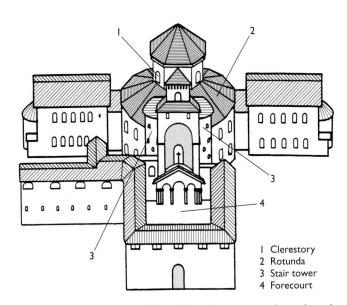

9.27 Reconstruction drawing of Charlemagne's palace chapel, Aachen.

Manuscripts

Because education was an important aspect of Charlemagne's Roman revival, manuscripts played a significant role in his efforts to bring back the learning and culture of Roman antiquity. Charlemagne's court at Aachen was the hub of his empire, but manuscripts were portable and thus an important form of artistic and educational communication.

A comparison of three manuscript illuminations made during Charlemagne's reign reflects the evolution of his Roman revival. The page of *Christ Blessing* was commissioned by Charlemagne and his wife, Hildegarde, in 781 from Godescalc, the court scribe (fig. **9.28**). Its dependence on Byzantine icons is clear in the enthroned Christ, who holds a book in his left hand and raises his right in a gesture of blessing. Christ is frontal, his head is framed by a flat halo including a cross, and the folds and edges of his

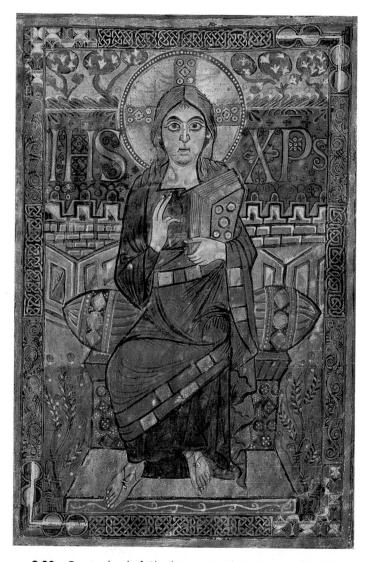

9.28 Court school of Charlemagne, *Christ Blessing*, from the Godescalc Gospels, Lat. 1203, fol. 3r, 781–783. Text written in gold and silver on vellum; $12 \times 8\frac{1}{4}$ in. (30.5 \times 20.9 cm). Bibliothèque Nationale, Paris.

stylized drapery are depicted as black lines. Despite some shading in the face, the slightly oblique footstool, and traces of landscape at the top of the scene, Christ's frontality and the overall patterning flatten the space. Symmetrical interlaced designs on the frame reflect the influence of Hiberno-Saxon art.

The depiction of *Saint John* in figure **9.29**, from the Coronation Gospels, demonstrates both a new interest in naturalism and the persistence of medieval style. The saint is seated in an architectural niche within a landscape. His pen is poised, and his drapery combines surface pattern with an indication of organic form. Shading defines the body contours, especially the face, with the head slightly inclined, although the halo remains flat. The position of the footstool—both inside and outside the frame—reveals the artist's struggle to reconcile early medieval and Greco-Roman traditions.

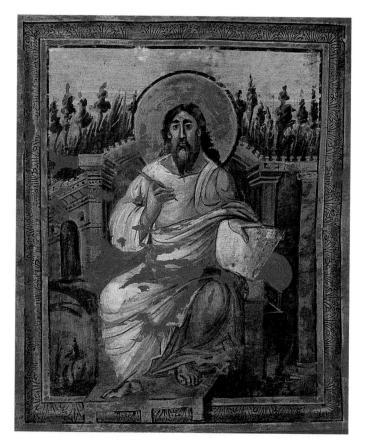

9.29 Saint John, from the Coronation Gospels, fol. 178v, late 8th century. Parchment; $12\frac{3}{4} \times 10$ in. (32.4×24.9 cm). Kunsthistorisches Museum, Vienna. Tradition has it that this codex (manuscript book) was discovered in Charlemagne's tomb and opened in the year 1000 by Otto III. It gained its name through the practice of German emperors who swore their coronation oaths on it.

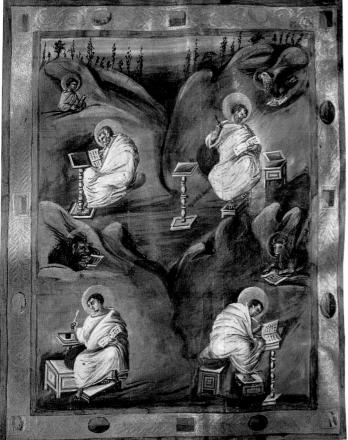

9.30 Four Evangelists, from a Carolingian Gospel book, palace chapel school, Aachen, early 9th century.

The *Four Evangelists* (see box) from a Carolingian Gospel book illustrated in figure **9.30** include the saints' symbols set in a landscape indicated by rolling hills. The oblique writing desks and stools define three-dimensional space, while the draperies define the forms and natural movement of the figures. This artist probably came from Constantinople, where the Hellenistic traditions had persisted most strongly.

After Charlemagne's death, a more apocalyptic approach to manuscript painting became the norm in French monasteries. At Tours, in central France, the Vivian Bible, named for the lay abbot Count Vivian, was dedicated to Charles the Bald around 845 to 846. The frontispiece to the Gospels, showing Christ in Majesty with the four Evangelists (fig. **9.31**), reflects a divergence from the Classical style as Charlemagne's revival of Roman antiquity waned.

The space is flatter, and the figures are connected by geometric designs rather than by landscape. In Christ's

Four Symbols of the Evangelists The Book of Revelation, written by Saint John the Divine, is

the last book of the New Testament. It opens as follows: "The Revelation of Jesus Christ, which God gave unto him, to shew unto his servants things which must shortly come to pass; and he sent and signified it by his angel unto his servant John: who bare record of the word of God, and of the testimony of Jesus Christ, and of all things that he saw."

Revelation and the

While John was on the Greek island of Patmos, Christ is said to have appeared to him and told him to convey his message to the world. The Book of Revelation is believed to be John's account of Christ's word and all that he is shown in heaven. It is a visionary work imbued with Scripture, literary tradition, the early efforts to establish Christianity, and influences from Judaism and Greco-Roman thought.

In Christian art, the four Evangelists are often represented in symbolic forms that are based on Chapters 4 and 5 of Saint John's vision (see fig. 9.30). They are a lion, a bull, a man (or angel), and an eagle. The lion came to stand for Saint Mark, the bull for Saint Luke, the man for Saint Matthew, and the eagle for Saint John.

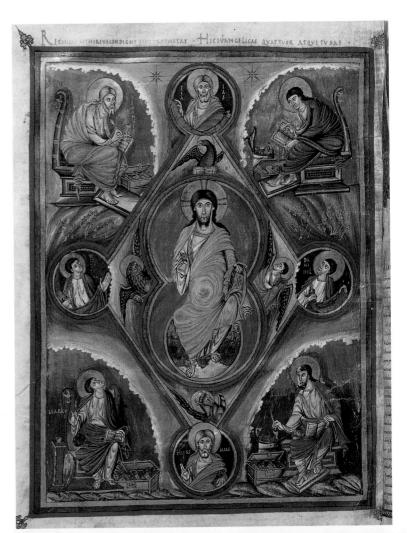

9.31 Christ in Majesty, Vivian Bible frontispiece, fol. 329v, c. 845–846. Bibliothèque Nationale, Paris.

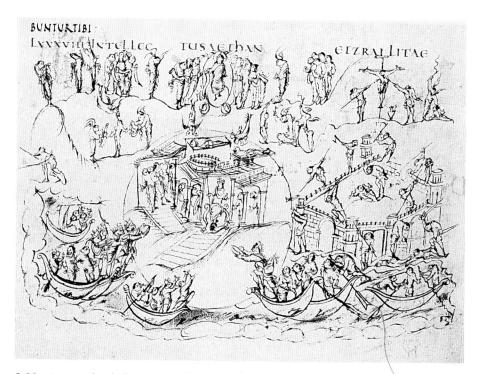

9.32 Reims school, illustration to Psalm 88, from the Utrecht Psalter, Ms. 32, fol. 51v, c. 825–850. $12\% \times 9\%$ in. (32.7 \times 25.1 cm). University Library, Utrecht.

swirling drapery, the artist departs from the more Classical drapery of the Carolingian Gospels. The Vivian Christ is suspended weightlessly on a flat circle representing the globe, and he is frontal. Although the Evangelists turn in space and their footstools are rendered obliquely, their poses are exaggerated. Saint Mark, in particular, twists his neck unnaturally. Compared with the manuscript paintings produced under Charlemagne, this and other later examples have a frenzied, agitated quality.

The Carolingian prayerbook known as the Utrecht Psalter of c. 825-850 introduced a new correspondence between word and image. The manuscripts created at Charlemagne's court had reflected the belief that biblical texts did not lend themselves to illustration. But the Utrecht Psalter, which was produced in Reims, in northern France, reflects a different view. The psalter itself consisted of the Old Testament Book of Psalms but was illustrated with line drawings in red-brown ink interspersed among the written text. Rather than illustrating a straightforward narrative, these drawings capture the essence of a particular set of metaphorical images. For example, the drawing that accompanies Psalm 88 (fig. 9.32) includes scenes of the Last Judgment and the Crucifixion in the top half, while the lower half denotes the sufferings of earthly life, with two figures in boats reaching out in supplication and, at the right, a castle on top of which soldiers are killing enemies. These scenes reflect the troubled words of the psalm-for example, verse 7: "Thy wrath lieth hard upon me, and thou has afflicted me with all thy waves;" and verse 9: "Mine eye mourneth by reason of affliction: Lord, I have called daily upon thee, I have stretched out my hands unto thee."

Monasteries

Of all the institutions in western Europe during the Middle Ages, the monastery was particularly important to Charlemagne's plan for controlling conquered territory and directing reforms in art and education (see box). Each monastery included a school, and this created a network through which artists and scholars could communicate with each other. The monastery was also a religious and administrative center, and performed an economic function through its agricultural production.

Charlemagne decided that monasteries should follow the Benedictine Rule, a series of regulations that had been devised by Saint Benedict of Nursia some two hundred years earlier, in the sixth century. According to Benedict's Rule, monks should live communally under the supervision of an abbot, devoting themselves to a strict routine of work, study, and prayer. Charlemagne convened a coun-

cil of abbots at Aachen to discuss the Rule and draw up a standard plan for Benedictine abbeys (fig. **9.33**). The council sent this plan to the abbot who was rebuilding the Saint Gall monastery in Switzerland, although it is not certain that the plan as it has been drawn up was that of a particular monastery that was ever built.

Figure **9.34** is a model constructed from the plan. About a hundred people were to form a self-sufficient community —almost a small town—occupying an area some 500 by 700 feet (about 152×213 m). The entrance to the monastery was from the west, through a passage between a hostel

Monasticism: Chastity, Obedience, and Poverty

Monasticism is a way of religious life in which an individual takes vows of chastity, obedience, and poverty, and serves God in relative seclusion. Monasticism began in the pre-Christian era among Middle Eastern Jews. The first Christian monks date from the third century. Some chose to live as hermits, isolating themselves individually from society and devoting themselves to prayer. Others withdrew into communal groups that formed the basis of the monastic tradition.

Many monks became expert in a particular art or craft, and the monasteries played an important role in medieval cultural life and education. Works of literature, science, and philosophy, in addition to religious texts, have survived in copies handwritten in the scriptoria of the monasteries.

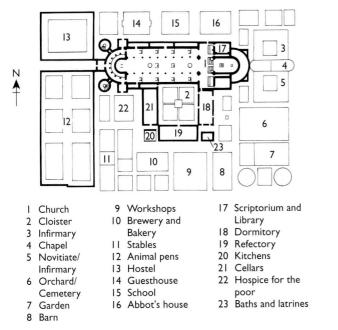

9.33 Plan of the monastery of Saint Gall, Switzerland, c. 820. This plan has been drawn from a tracing on five pieces of parchment, itself taken from an earlier document, from which scholars have been able to draw various conclusions about monastic life and architectural practice during the Carolingian period.

and stables. From there a gate led to a semicircular arcade flanked by two cylindrical towers and into the vestibule at the western end of a church. This combination of towers with an entrance, chapels, and galleries at the west of a Carolingian church is known as **westwork** (from the German term *Westwerk*). The church is designed along the lines of a basilica: at the eastern end are a transept, choir, apse, and altar (approached by seven steps); another apse was located at the west. The nave and aisles are screened off from each other. They contain additional altars to make it possible for each priest to say Mass every day.

To the east of the church was a novitiate (a building to house novices, or trainees) and an infirmary. Next to the infirmary stood the physicians' houses and a medicinal herb garden. Conveniently close was the cemetery, which doubled as an orchard. To the south, in the sunniest spot, was a square cloister surrounded by a covered portico, where the monks could walk. The cloister was flanked by the dormitory, with a bathhouse and lavatory, a **refectory** (dining hall), and a cellar. Outbuildings included a bakery, a brewhouse, and barns for farm animals. The plan of Saint Gall lays out the entire ideal monastery in meticulous, practical detail, right down to the shed for pregnant mares and foals.

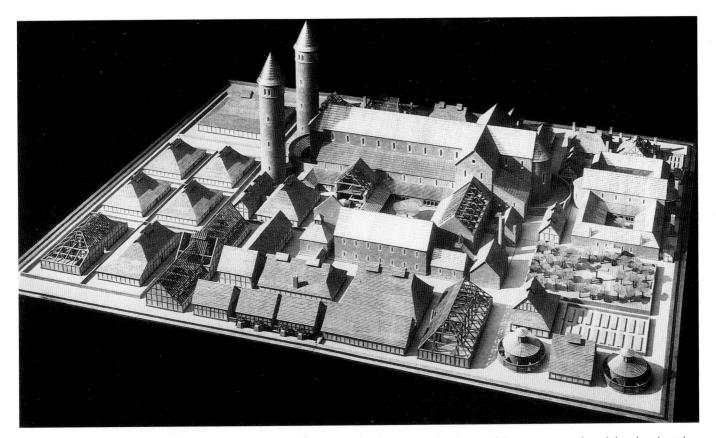

9.34 Reconstruction model of the monastery of Saint Gall, Switzerland, c. 820. The design of the monastery placed the church at the center and the buildings adjacent to it in approximate order of importance. The library and scriptorium were attached to the church, not far from the main altar. To the north were the abbot's house (connected to the transept by a private passage), guesthouse, and a school. The latter fulfilled Charlemagne's mandate that monasteries provide education even for those not intending to take holy orders.

Charlemagne's grandsons were ineffective rulers, and, by the end of the ninth century, Europe again fell prey to invaders. The Vikings took over Normandy (in northern France), and the Saxons resumed their control of Germany. The Saxon emperor Otto I the Great (ruled 936–973) was crowned by the pope in 962. He continued Charlemagne's revival of Classical antiquity as a way of reinforcing his own imperial position.

The Ottonian Period

Ottonian refers to the three rulers named Otto who stabilized the Holy Roman Empire after the disruptions following Charlemagne's death. Their empire included only Germany and parts of northern Italy, and was therefore smaller than Charlemagne's. The major architectural work of this period was the Benedictine abbey church of Saint Michael's at Hildesheim (figs. **9.35**, **9.36**, and **9.37**). It was commissioned by Bernward, bishop of Hildesheim (c. 960–1022), who had been the tutor of Otto III. Both visited Rome, where they studied ancient ruins.

The massive quality of Charlemagne's palace chapel also characterizes Saint Michael's. Although symmetry is maintained, the architectural variety—towers, round arches, sloping roofs, cylindrical and cubic forms—gives it a formal energy, reflected in the plan of the exterior section (fig. 9.36). The entrances are untypically located at the side aisles; note the triple eastern apses, the large western apse, and circular towers. The restored nave walls (fig. 9.37) are two stories high. The lower level is composed of an arcade, which is unusual in the alternation of a single pier with pairs of columns. Piercing the relatively plain upper story are small windows with round arches, which are the main source of interior illumination.

Saint Michael's bridges the gap between Carolingian architecture and the apparent simplicity of the new Romanesque style (see Chapter 10). Its plan was partly derived from Saint Gall, which, in turn, was related to the basilica. Through their contacts with Rome, Bernward and Otto III adopted Classical architectural features.

The metalwork at Hildesheim also shows the impact of Roman influence on Bernward and Otto. An impressive surviving example, commissioned before 1015, is the pair of bronze doors originally at the entrance (fig. **9.38**), the first large-scale works cast in one piece since antiquity. The emphasis on typology is apparent in the left-right pairing of Old and New Testament scenes, which the medieval viewer would have understood as meaning that the former

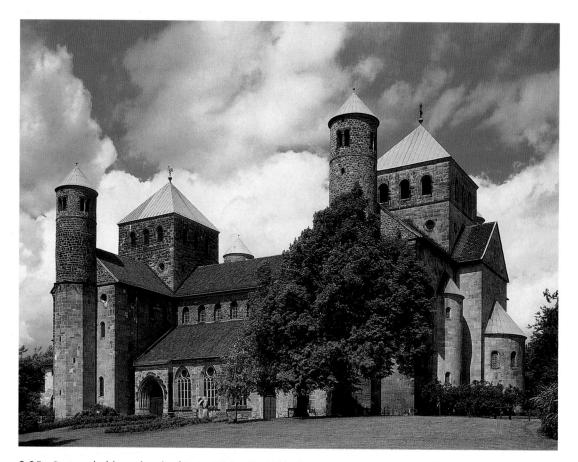

9.35 Restored abbey church of Saint Michael's, Hildesheim, c. 1001–1031. The building was destroyed during World War II.

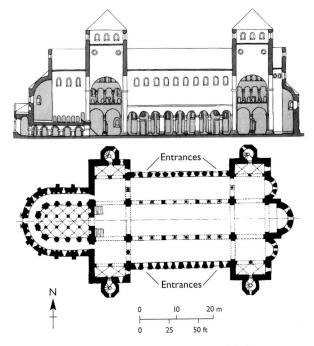

9.36 Section and plan of Saint Michael's, Hildesheim.

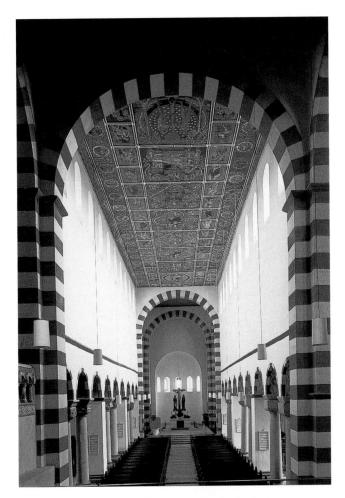

9.37 Restored interior of Saint Michael's, looking west, Hildesheim.

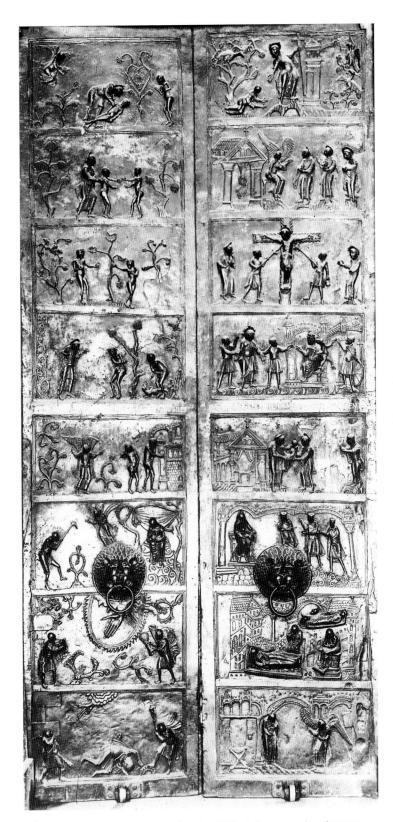

9.38 Bronze doors, Saint Michael's, Hildesheim, completed 1015. 16 ft. 6 in. (5.02 m) high. According to a contemporary biographer, Bishop Bernward was himself an expert goldsmith and bronze caster. He stayed with Otto III at his Roman palace, which was near the church of Santa Sabina (see fig. W4.3). The wooden doors of Santa Sabina are believed to have inspired the bronze doors of Saint Michael's.

prefigured the latter. The horizontal scenes are depicted in relatively high relief, and the thin, lively figures are well within the tradition of Byzantine and Carolingian style.

In the scene of Adam and Eve Reproached by God (fig. 9.39), the tree forms, especially at the far left, resemble Hiberno-Saxon interlace motifs. The serpent is a version of the fantastic creatures that populate works in the traditional Animal Style. But there is also a new dramatic character that is combined with fluid, linear rhythms-for example, the juxtaposition of figure with void. The hierarchy of pose and gesture is clearly delineated: God's superiority is denoted by his taller form, his admonishing gesture, and the fact that he is clothed. Adam cowers before God and covers his nakedness. The diagonal of his back is reinforced by the tree branch above him. He points to Eve behind him, cowering even more than he as she points to the serpent at her feet. The narrative movement starts with God and ends with the serpent (in the Bible, God condemns him to crawl forever on the ground): formal "uprightness" is thus an echo of moral "rightness." Furthermore, the intended left-to-right reading of the scene is a reversal of the biblical text, in which the serpent tempted Eve, who tempted Adam, who angered God.

Ottonian manuscript illuminations also reflect a change from Carolingian style. The two-dimensional, iconic image of Saint Luke in Otto III's Gospel book (fig. **9.40**), compared with the landscape setting of the *Four Evangelists* from the Gospel book of the Aachen court (fig. 9.30), is an example. Saint Luke sits on a rainbow inside a green mandorla suspended in a gold space. Instead of natural landscape, the Ottonian manuscript depicts an abbreviated rocky platform beneath Luke. This is flanked by two lambs drinking from water that flows from the rocks, but there is no rational relationship among these forms. Both the water and the lambs are suspended, like the saint, in gold. Their significance here is wholly symbolic, for the rocks denote the church building and the drinking lambs (cf. Christ as the Lamb of God) refer to rebirth through baptism. Whereas the Evangelists in the Aachen codex prepare to write, Saint Luke exuberantly holds up a decorative array of circular clouds containing angels and prophets. Directly over his own halo is the most prominent cloud with his symbol, the bull. Framing the scene are two columns with non-Classical, stylized cabbage-leaf capitals. These support an arch decorated with fanciful interlace that is more threedimensional than Hiberno-Saxon and Viking examples.

Ottonian ivories also reflect the departure from Carolingian Classicism. This is evident, for example, in the dedication panel from the so-called Magdeburg Antependium (fig. **9.41**). Said to be a gift from Otto I to Magdeburg, it shows a frontal Christ seated on a stylized wreath with his feet resting on a curved platform. He turns to Otto, who presents him with a model of the cathedral Church of Saint Mauritius (a third-century Roman general martyred in Africa). Saint Peter stands at the right, identified by his attribute, the key. The figures on this ivory lack the threedimensional, organic qualities of Charlemagne's Classical revival. Instead, they are short, stubby, and rather blocklike. Surface patterns on the draperies, as well as in the background, have replaced natural form.

Like the Ottonian abbey of Saint Michael's and the illumination of *Saint Luke* from the Gospel book of Otto III, the ivory is stylistically transitional. It reflects the waning of naturalism at the end of the Carolingian period and the trend toward the more iconic imagery that will become characteristic of Romanesque style.

9.39 Adam and Eve Reproached by God, from the bronze doors of Saint Michael's, Hildesheim (detail of fig. 9.38). Approx. 23 × 43 in. (58.3 × 109.3 cm).

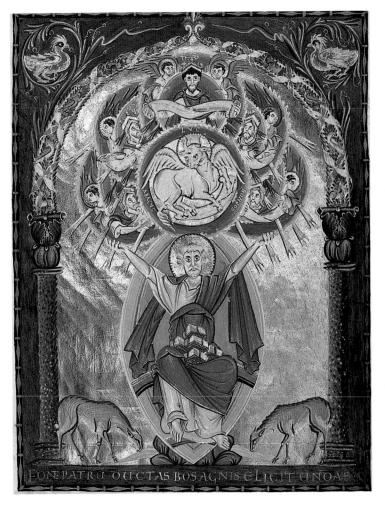

9.40 Saint Luke, from the Gospel book of Otto III, c. 1000. $13 \times 9\%$ in. (33.0 \times 23.8 cm). Bayerische Staatsbibliothek, Munich.

9.41 Christ Enthroned with Saints and Emperor Otto I, from Milan or Richenau, Ottonian, 962–973. Ivory; $5 \times 4\frac{1}{2}$ in. (12.7 \times 11.4 cm). Metropolitan Museum of Art, New York.

Style/Period

EARLY MIDDLE AGES 4th century

300

400

500

60

700

800

900

0001

EARLY MIDDLE AGES 5th century

EARLY MIDDLE AGES 6th century

EARLY MIDDLE AGES 7th century

EARLY MIDDLE AGES 8th century

Warrior Entering Valhalla

Mosque of

Suleyman I

EARLY MIDDLE AGES 9th century

EARLY MIDDLE AGES 10th century

MIDDLE AGES 11th century

MIDDLE AGES 12th century

MIDDLE AGES 13th century

BYZANTINE 15th century

ISLAMIC 16th-17th centuries Works of Art

Sutton Hoo purse cover

Book of Durrow

Sutton Hoo purse cover (9.15), East Anglia Book of Durrow (9.23) Dome of the Rock (9.1), Jerusalem

Celtic cross (9.22), Tipperary Coronation Gospels (9.29) Evangelistary of Godescalc (9.28) Charlemagne's palace chapel (9.25), Aachen Warrior Entering Valhalla (9.20), Tjangvide Book of Kells (9.24)

Book of Kells

Great Mosque **(9.7–9.9**), Córdoba Animal headpost **(9.16**), Oseberg Gospel book **(9.30**), palace chapel school, Aachen

Rök stone (**9.19**), Östergötland Monastery of Saint Gall (**9.33–9.34**), Switzerland Utrecht Psalter (**9.32**), Reims Vivian Bible (**9.31**), Paris. Great Mosque (**9.4**), Samarra Kufic Koran (**9.2**), Tunisia

Axe, Mammen, Jutland (9.18) Christ Enthroned with Saints and Emperor Otto I (9.41) Bluetooth's rune stone (9.21), Jelling

Gospel book of Otto III (9.40) Saint Michael's (9.35, 9.37-9.39), Hildesheim

Tugra of Suleyman

Mosque of Suleyman I (9.10, 9.12-9.13), Istanbul Illuminated tugra of Sultan Suleyman (9.3) Luftullah Mosque (9.14), Isfahan

Cultural/Historical Developments

Dedication of the city of Constantinople (300) Visigoths sack Rome (410)

Founding of Constantinople University (425) Last Roman legions leave Britain (476) End of Western Roman Empire (476)

Founding of Essex and Middlesex, kingdoms of

Anglo-Saxon England (527) Building of Hagia Sophia, Constantinople (532–537) Building of San Vitale, Ravenna (540–547) Golden era of Byzantine art (c. 550) Saint Columba (c. 521–597) settles on island of Iona and begins conversion of the Picts (563)

and begins conversion of the Picts (563) Birth of Muhammad, founder of Islam (c. 570)

Development of Gregorian chant as part of religious services (late 500s) Golden age of Celtic culture (600–800)

Saint Augustine establishes the archiepiscopal See of Canterbury (602)

Founding of monastery of Saint Gall (612) Death of Muhammad (632)

The Venerable Bede, English writer and historian (673-735)

Book of Durrow

- Beowulf, English epic (early 700s) Moors conquer North Africa and Spain (711–715) Byzantine emperor Leo III bans images in churches
- and provokes Iconoclastic Controversy (726) Victory of Charles Martel over Muslims at Battle of Tours (732)
- Charlemagne (742–814) crowned Holy Roman emperor at Rome; consolidates most of Europe into a single kingdom (800)
- Charlemagne establishes Carolingian schools; study of Latin texts encouraged (c. 800)

Vikings discover Iceland and invade England (c. 866)

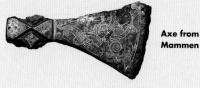

Period of Ottonian rule (919-1024) Completion of Koran (935) Beginning of Ottonian architecture (936)

- Great Schism between Rome and Constantinople (1054)
- Omar Khayyám writes Rubaiyat (c. 1100)

Saint Thomas Aquinas (1225-1274) writes Summa theologiae (1265–1273) Giotto di Bondone born (c. 1267)

Ottomans capture Constantinople, which becomes Turkish capital (1453)

Gospel book of Otto III

1200

Window on the World Five

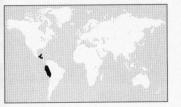

Mesoamerica and the Andes (1500 B.C.–A.D. 1500)

W hile the arts and cultures so far considered were flourishing in Europe, Africa, Australia, and the Far East, civilizations also rose and fell in the Americas. The Americas were isolated from the rest of the world by vast oceans, and to date there is scant archaeological evidence of contact. However, there are intriguing formal and conceptual similarities, as well as significant differences, between the cultures of the Americas and other civilizations contemporary with them.

The origins of the Native Americans have been traced to the arrival of Paleolithic peoples from Siberia to Alaska over a land mass (now the Bering Strait) that connected them during the last Ice Age. During the Paleolithic era, migrations to the south from the far north (Alaska and Canada) led to settlements in North and South America. By around 9000 B.C. or earlier, human culture had spread to the southernmost tip of South America. It was not until the fifteenth century that explorers, including Columbus, traveled to the Americas. With their subsequent conquest by Spain in the sixteenth century, many American civilizations were destroyed. The European invaders (particularly the Spanish) affected some of these cultures to such an extent that scholars now divide their history into pre-Columbian and post-conquest periods.

Mesoamerica

The arts of three major civilizations from Mesoamerica-the land mass connecting North and South America -are outlined here. These are Olmec, Teotihuacán, and Maya. Mesoamerica stretches from northern Mexico to Panama and includes the province in Mexico of the Yucatán, Belize, Guatemala, Honduras, and El Salvador (see maps). The archaeology of the region is in a state of flux, although advances have been made in deciphering Mesoamerican writing systems since the 1960s. Nevertheless, the complex nature of these civilizations remains little understood.

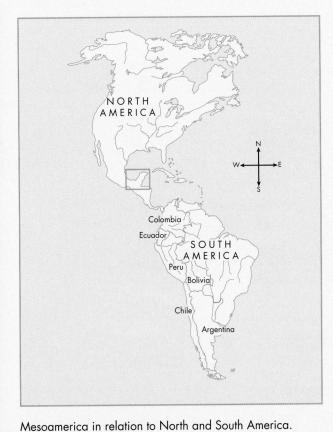

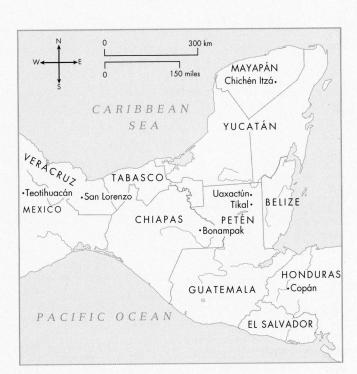

Mesoamerica.

The history of the region has been divided into three major phases: the Preclassic (or Formative), c. 2000 B.C. to A.D. 250/300; the Classic, c. 300 to 900; and the Postclassic, 900 to 1521. As elsewhere, a period of hunting and gathering (c. 11,000-7500 B.C.) preceded the development of agriculture, monumental stone architecture, and the organization of villages into social and political hierarchies. Examples of pottery as well as of figurines that probably served a fertility function survive from around 1800 B.C. By Late Preclassic, there is evidence of urbanization: temples were constructed on pyramidal platforms, and stone monuments containing portraits and inscriptions were carved.

Although Mesoamerica produced culturally distinctive civilizations and correspondingly distinct styles of art and architecture, certain important similarities appear in several of them. These include the development of (base 20) mathematics, an understanding of astronomy, hieroglyphic writing, books made of fig-bark paper or deerskin, and a complex calendar. The religions were polytheistic, requiring offerings to the gods, bloodletting rituals, and human sacrifice. One of the most intriguing Mesoamerican practices was a ritual ball game, which was played on a large rectangular court. As in modern soccer, players were not supposed to touch the ball with their hands. The movements of the ball were symbolic, apparently conceived of in relation to the sun and moon. Often, captives were forced to play, and losers, according to some scholars, could be sacrificed to the gods.

Olmec

(flourished c. 1200-900 B.C.)

The Olmec civilization, located in present-day Mexico, dates from Early to Middle Preclassic and had a lasting influence on the entire region. As in other areas of Mesoamerica, by around 900 B.C. Olmec society was stratified into a class of commoners and a ruling elite. The elite maintained a flourishing trade in exotic goods that were symbols of authority and status, especially jade, obsidian, and iron pyrites (used for mirrors). Most of the population were

W5.2 Colossal head, from San Lorenzo, Veracruz, Mexico, Olmec, c. 1000 B.C. Basalt; 70% in. (180.0 cm) high. Museo Regional de Veracruz, Jalapa, Mexico.

W5.1 Seated Jaguar, San Lorenzo, Veracruz, Mexico, Olmec, Early Preclassic, 1200–900 B.C. Basalt; 35½ in. (90.2 cm) high. Because this figure seems to represent shedding tears, it is believed to be an aspect of a rain god or a water deity. Elsewhere in Mesoamerica, the jaguar is the god of the underworld. This figure was found next to an underground canal, which is assumed to confirm its connection to a water cult.

farmers, who supported the priests and rulers with labor and goods.

Monumental stone sculptures of basalt such as the Seated Jaguar (fig. W5.1) were produced at San Lorenzo, in Veracruz, the oldest known Olmec site. The solid, blocklike forms remain characteristic of Mesoamerican art well into the Late Classic period. Merging with the features of a jaguaran animal indigenous to Mesoamerica and important in its mythology-is the physiognomy of a human child. The hands and feet are pawlike, but the pose and upright posture are human. Such combinations of human with animal elements are first seen in Olmec sculpture and continue in later Mesoamerican art.

The colossal basalt head in figure **W5.2** is one of ten that have been found at San Lorenzo. These heads, weighing between 5 and 20 tons, representing males, are probably portraits

of individual rulers. The fleshy, organic faces usually have broad, flat noses and thick lips; also characteristic is the tight, domed headdress with earflaps and a strap under the chin. Most of these colossal heads were defaced and buried. Similar sculptures are found at La Venta, a site that flourished from around 900 to 400 B.C., along with monumental public architecture and elaborate tombs containing jade offerings.

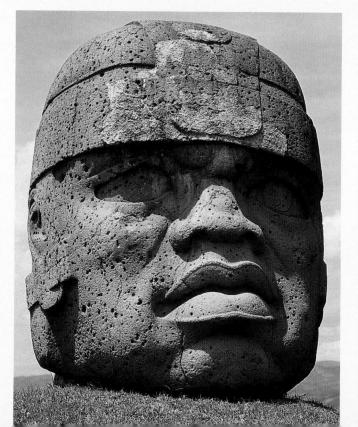

Teotihuacán

(flourished c. 350-650)

By A.D. 200, Teotihuacán had become a commercial city-state specializing in the manufacture of stone tools (especially of obsidian) and pottery. Between about 350 and 650, Teotihuacán was the biggest and most influential city anywhere in the Americas. It spread over an area of 8 square miles (20.7 sq km) and supported a population of as many as 200,000. The later Aztec culture dominated the region at the time of the Spanish conquest and attached mythical importance to the great ruins of Teotihuacán (an Aztec name, as are the names of many of the gods).

The most significant architecture at Teotihuacán was the ceremonial complex (figs. **W5.3** and **W5.4**) aligned with the Avenue of the Dead, which was 3 miles (4.8 km) long. The largest structure, called the Pyramid of the Sun by the Aztecs, was to the east of the avenue, near its center (see fig. W5.3). A stairway on the west side led to a platform at the top. This supported a two-room temple that has since disappeared. The slightly smaller Pyramid of the Moon was located at the north end of the avenue. Toward the southern

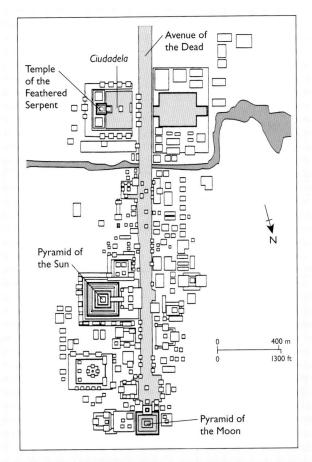

W5.4 Plan of Teotihuacán, c. 350-650.

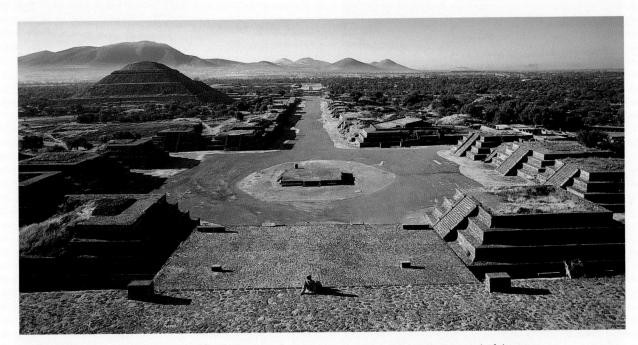

W5.3 View of Teotihuacán, c. 350–650. The Pyramid of the Sun as seen from the Pyramid of the Moon, Teotihuacán c. 350–650. Square base over 700 ft. (213.4 m) per side; over 210 ft. (64.0 m) high; 1,700,400 cubic yards (1.3 million m³) volume. The Moon Pyramid is somewhat smaller with a height of 130 ft. (39.62 m) and a base of 400×500 ft. (121.92 \times 152.40 m).

end was the *Ciudadela*, or citadel, a square large enough for crowds of 60,000 functioning as the religious and political center of Teotihuacán.

Surrounding the *Ciudadela* were temple platforms constructed in *talud-tablero* style (fig. **W5.5**). This style is typical of Teotihuacán architecture: the *tablero* is the framed vertical element built above a sloping base (the *talud*). The platform façades were faced with painted stucco, and their cores were reinforced with stone piers and filled with rubble embedded in clay.

Excavations at the *Ciudadela* have revealed dramatic monumental painted reliefs on the façade of a temple platform dedicated to the Feathered Serpent (called Quetzalcoatl by the Aztecs). The detail in figure **W5.6** shows massive, blocklike serpent heads with bared fangs, surrounded by a circle of feathers. They alternate with heads of Tlaloc, the rain god. Both are carved frontally, and their fixed gazes are reinforced by their wide, round eyes. The stylized geometry of these figures is characteristic of figural imagery at Teo-

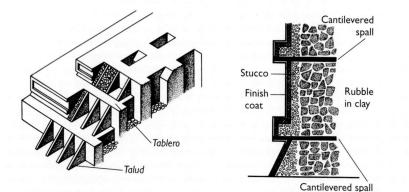

W5.5 Diagrams of a talud-tablero platform.

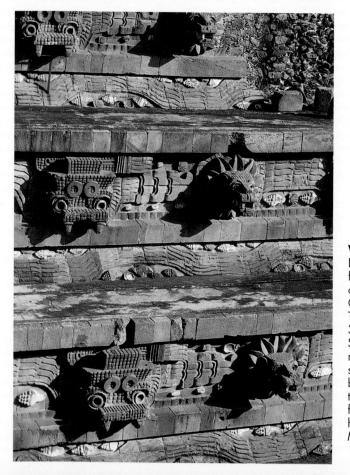

W5.6 (left) Detail of heads from the façade of the Temple of Quetzalcoatl, Teotihuacán, before 300. Painted relief. Skeletons of eighty men dressed as soldiers were found beneath this temple, possibly further evidence of human sacrifice in Mesoamerica. tihuacán, but the exact meaning of their iconography is not known.

That Tlaloc may have served an apotropaic function is suggested by his role—like that of the Gorgoneion—as a shield device. As such, he appears on a stele found at the Classic Maya site of Tikal and carved with the representation of a warrior in Teotihuacán costume (fig. **W5.7**), which may indicate the widespread influence of Teotihuacán. Dressed in full regalia with an elaborate feathered helmet and a shell necklace, he carries a shield decorated with the

W5.7 Detail of a warrior in Teotihuacán costume, from the side of stele 31, Tikal, Guatemala, Maya. University Museum, Philadelphia.

face of Tlaloc. The warrior is depicted with his head in profile and his torso slightly turned. But his shield is frontal, like the gods on the temple of Quetzalcoatl in the *Ciudadela*. The image of Tlaloc thus confronts viewers with a direct, and symbolically protective, gaze.

Around 650 to 750, the architectural complex along the Avenue of the Dead was burned, possibly by invaders, and the thriving city of Teotihuacán fell into decline. Its culture was kept alive, however, particularly through Aztec legends, and continued to influence the art and architecture of Mesoamerica for centuries.

Maya

(c. 1100 B.C.-A.D. 1500)

Maya civilization originated in the southern part of Mesoamerica and lasted until its destruction in the sixteenth century. It occupied eastern Mexico (particularly the Yucatán, Tabasco, and Chiapas), Belize, Guatemala, and the west of Honduras and El Salvador.

Maya culture developed not only the most complex writing system in Mesoamerica, but a sophisticated knowledge of mathematics and methods of observing celestial phenomena, recorded in books made from strips of bark paper (see box). The Maya created many important political and religious centers, each populated by an elite class of rulers, priests, and nobles, supported by a far more numerous class of farmers and artisans.

Hereditary rulers were theocratic that is, their claim to power rested on establishing a connection with the gods (see box). A wood carving from Tabasco of a *Maya Lord* (fig. **W5.9**), wearing a

W5.9 (right) *Maya Lord,* from Tabasco, Mexico, 6th century. Wood with hematite pigment; 14 in. (35.5 cm) high. Metropolitan Museum of Art, New York. Michael C. Rockefeller Memorial Collection. Bequest of Nelson A. Rockefeller, 1979 (1979.206.1063). Photograph © 1980 Metropolitan Museum of Art.

tan

The Maya Calendar

Several calendrical systems were developed by the Maya, all of them intimately related to seasonal change and astronomical phenomena. They were used in the service of religious rituals, ceremonies, and festivals. One of the most intriguing creations is the calendar round of fifty-two years, which developed in the Late Preclassic period (300 B.C.-A.D. 250).

Two time cycles within the calendar round have been identified. The 260-day count, which is still used by some contemporary Maya, is based on a sequence of thirteen periods, each of twenty days. Each day has specific omens that prophesy future events. The other cycle is based on a 365-day year consisting of eighteen months, each twenty days long. Five unlucky days are added at the end to round out the total.

The so-called "long count," which dates time from August 13, 3114 B.C., was developed after the calendar round, although precisely when is not known. It was used by the Olmecs and the Maya. The long count differed from the calendar round in being based on a 360-day year. Time, according to recent scholarship, was recorded in units of 400 years, 20 years, 20 days, and individual days.

The jade plaque known as the Leiden Plate (fig. **W5.8**) shows, on the front, an Early Classic Maya ruler from Tikal as he steps on the back of a defeated enemy, a typical iconographic motif in Maya stelae. The reverse shows glyphs indicating a long count date in the year 320, probably the day on which this particular ruler assumed power.

W5.8 The Leiden Plate. Jade; 8½ in. (21.6 cm) high. Rijksmuseum voor Volkenkunde, Leiden.

Maya Religion

The Maya believed in cycles of creation and destruction, ages of development, and an apocalyptic end of the world. They conceived of the universe as having three tiers: sky, earth, and underworld. The earth was a square or rectangle resting on the back of a crocodile. The four corners of the world were oriented to the cardinal directions and associated with specific colors. East was red like the sunrise, and west, where the sun sets, was black. North was white, and south was yellow. Supporting the Maya sky—conceived of as a two-headed serpent—was the great Tree of Life at the center of the world. When Maya died, they went to the underworld, or "place of night" (*Xibalba*), which had nine levels.

The Popol Vuh, a Late Postclassic epic history of the Quiche Maya (an important nation that flourished just before the Spanish conquest), relates the story of Hero Twins who defeat the Xibalbans in a ball game. The heroes ascend to heaven and become the sun and the planet Venus. In so doing, they are a model for Maya rulers who likewise hope to escape eternal night. The epic is known from a manuscript discovered in the nineteenth century.

Maya religion was polytheistic, and each god had multiple aspects. Hunabku was the omnipotent god who controlled the universe. The chief god Itzamna ("Lizard House") was depicted as an old man who invented writing; he was the god of science and knowledge. His wife, Ix Chel ("Lady Rainbow"), was the goddess of weaving, medicine, childbirth, and the moon. Together, Itzamna and Ix Chel produced all the other gods in the Maya pantheon. skirt and an elaborate necklace, kneels in a ritual pose. The Maya shared the pervasive Mesoamerican belief that the gods had given people their own blood when they created them. The gods thus had to be repaid in kind with human blood, and elaborate rites were performed in which rulers let their own blood—but only slightly—as a sign of their identification with the gods. The fate of their captives, however, was not so benign. Typically, four men would each hold a limb of the captive, while a fifth cut out the heart.

Classic Maya

Copán (early 5th century–c. 820) One of the best-preserved Classic Maya sites is Copán, in western Honduras. The reconstruction drawing (fig. **W5.10**) is based on the Late Classic period. It shows the temple pyramids with their stairways on the acropolis at the right, and the plaza with monumental carved stelae at the left. Copán artists used durable green volcanic tufa for architectural monuments and their sculptural decorations, which included elaborate portraits of Maya kings. The ball court

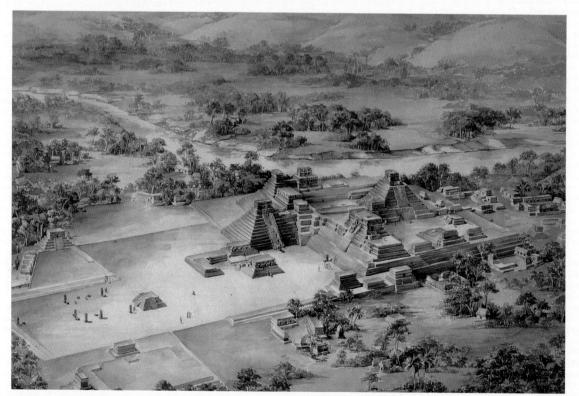

W5.10 Tatiana Proskouriakoff, reconstruction drawing of the site of Copán, Honduras, Maya, Late Classic.

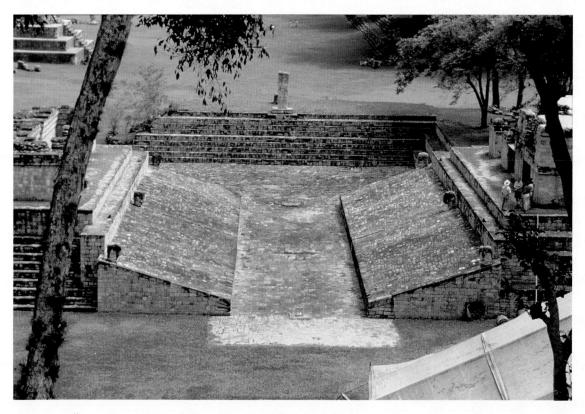

W5.11 Ball court, Copán, Honduras, Maya, Late Classic, c. 800.

at Copán (fig. **W5.11**) is one of the finest surviving examples of Classic architecture. It was dedicated in A.D. 738 by a king known as Eighteen Rabbit, who also presided over the construction of a large palace.

Also at Copán, archaeologists have discovered a scribal palace of the Classic period decorated with sculptures of the monkey-man god represented as a scribe (fig. **W5.12**). Scribes were members of the elite. The example illustrated here shows a scribe sitting cross-legged, like the Egyptian scribe (cf. fig. 3.20), and listening attentively. His necklace is similar to that worn by the *Maya Lord* (fig. W5.9), and his combination of human and animal features is reminiscent of the Olmec *Seated Jaguar* (fig. W5.1).

Maya scribes wrote with brush or feather pens, which they dipped into small pots made from conch shells. The writing liquid itself was either black or red pigment.

See figure 3.20. Seated scribe, from Saqqara, c. 2551–2528.

W5.12 Monkey-man scribal god, from Copán, Honduras, Maya, Late Classic, c. 600–900. Museo Municipal, Copán, Honduras.

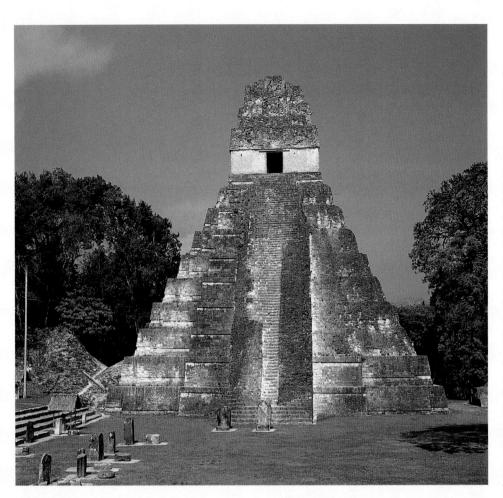

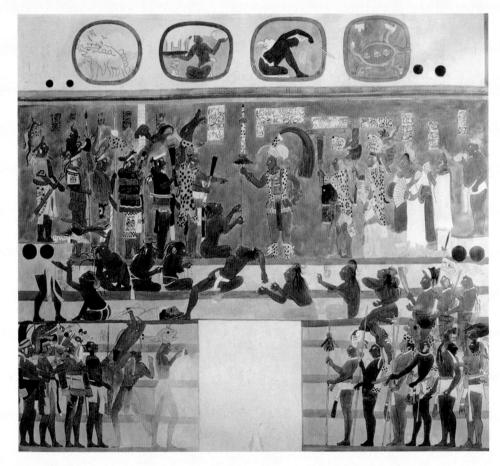

W5.13 Temple I, Tikal, Guatemala, Maya, before 800. Approx. 157 ft. (47.85 m) high.

Tikal: Temple I At Tikal, in the Petén region of modern-day Guatemala, Temple I (the Temple of the Jaquar) is one of six structures that reflect the increasing height of Maya temple pyramids (fig. W5.13). In its heyday, Tikal was one of the largest Classic Maya city-states. It had an elevated ceremonial complex consisting of rulers' tombs surmounted by temples, open squares, and ball courts. Temple I has nine layers supporting a temple, accessible by a staircase on the long side, and faces Temple II on the other side of an open square. The temple has two rooms with corbeled vaults and is crowned by a roof comb (the crestlike feature, originally decorated with painted sculpture). Beneath Temple I, archaeologists found the tomb of a ruler nicknamed "Au Cacao," which means "Lord Chocolate" (ruled c. 682–727): he was buried with jewelry, food and drink, and bone tubes incised with representations of the gods.

Bonampak: Mural Painting In 1946, at the Classic Maya site of Bonampak (in Chiapas, Mexico), a remarkable group of murals dating to the late eighth century was discovered. These depict narratives of battles, victory celebrations, and the torture and sacrifice of prisoners. The recopied mural in figure W5.14 illustrates the Mayan treatment of captured prisoners. The scene is set on a stepped pyramid with King Chaanmuan at the center of the top step. He wears a jaguar-skin jacket and is flanked by masked and costumed members of the nobility. Standing at the right is his principal wife wearing a white robe and holding a fan. Between the top step and the attendants at the bottom are nearly nude captives awaiting death. Some stare in shock at their hands, which drip blood. A dead captive lies below the ruler's staff, while a decapitated trophy head is beside his right foot.

W5.14 Reconstruction of a mural painting from Bonampak, Chiapas, Mexico, Maya, Classic, c. 790. Peabody Museum of Archaeology and Ethnology, Harvard University.

Postclassic Maya: Chichén Itzá (flourished 9th–13th centuries)

A Postclassic Maya people, the Itzá, flourished in northern Mexico. In their central city of Chichén Itzá (fig. W5.15), a more cosmopolitan Maya style assimilated forms from the Toltecs of central Mexico, as did Maya social and religious institutions. The many frescoes at Chichén Itzá-on the walls of the ball court and in the Temples of the Jaguars and the Warriors-are unfortunately in very poor condition. But the architecture at the site clearly reflects the continuing development of new forms. The view in figure W5.16 shows the Caracol, a circular temple, in the foreground, and in the distance the Temple of Kukulcan (called the Castillo) at the left and the Temple of the Warriors farther away at the right. Kukulcan—literally the Feathered (kukul) Serpent (can)-is mentioned in Maya records as the founder of Chichén Itzá's capital. The Temple of Kukulcan has corbeled vaulting, as at Temple I at Tikal, but unlike most Classic Maya temples it has multiple doorways and larger rooms. An earlier stage of the temple is encased by the terraced platform.

W5.15 Plan of the site of Chichén Itzá, Mexico.

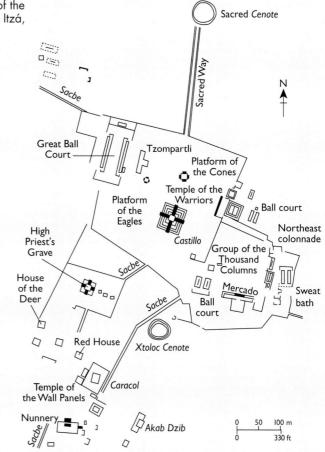

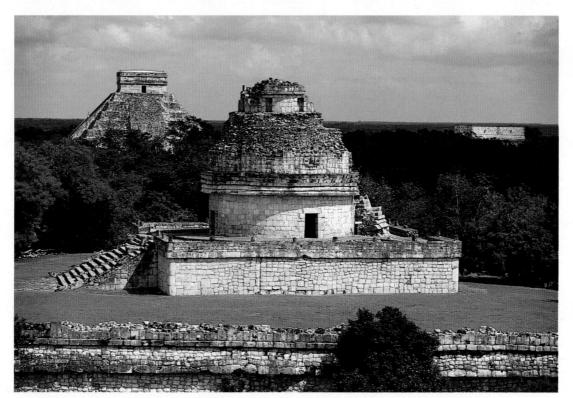

W5.16 View of Chichén Itzá showing the *Caracol* with the *Castillo* (left) and the Temple of the Warriors (right) in the distance, c. 800–1000. W5.17 Chacmool, Chichén Itzá, Mexico. 3 ft. 6 in. (1.07 m) high.

Inside this buried temple, there is a room containing a red throne in the shape of a jaguar, with jade eyes and shell fangs.

The so-called *Chacmool*, meaning "Jaguar King" or "Red Jaguar" (fig. **W5.17**), reclines at the top of the steps leading to the Temple of the Warriors. It turns its head abruptly, as if to stare toward the main open square. The *Chacmool* is a representation of a fallen warrior holding a plate believed to have been for sacrificial offerings.

Chichén Itzá declined in the thirteenth century, and the center of Maya civilization in the north shifted to a new capital at Mayapán. Today, despite the Spanish conquest in the sixteenth century, aspects of traditional Maya culture survive in Mesoamerica.

The Aztec Empire

(c. 1300-1525)

From around 1300, the Aztecs rose to dominance in the Valley of Mexico. They called themselves the Mexica, from which the name Mexico is derived, but their own name is from the legendary Lake Aztlán. Aztec tradition identifies the lake as the original site where they first settled into a recognizable cultural group. In the thirteenth century, according to Aztec tradition, their patron god (Huitzilopochtli), son of Mother Earth and god of the sun and of war, instructed them to leave the region of the lake. After a period of nomadic wandering, the Aztecs arrived at Lake Texcoco, also in the Valley of Mexico. They named the spot Tenochtitlán, and they eventually became the most powerful culture in the

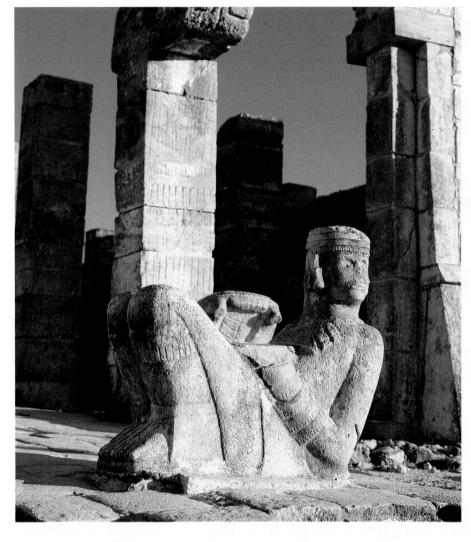

area. By the fifteenth century, the Aztec Empire was vast, its wealth was legendary, and its works of art of remarkable quality.

When Hernán Cortés, the Spanish conqueror, arrived in 1519 in what is today Mexico City, he found the dazzling capital of the Aztec Empire. It was built on a series of islands in the valley. The stone walls, towers, and temples of Tenochtitlán impressed the invaders, who joined forces with the enemies of the Aztecs and conquered them. Cortés destroyed the city and sent enormous quantities of plundered objects, most of gold and silver, to the queen of Spain. Although the spoils were subsequently melted down for the intrinsic value of their materials, caches of Aztec objects continue to be unearthed by archaeologists.

Aztec society was a warrior culture comprised of farmers and workers,

merchants, and a ruling elite. Teotihuacán (see p. 349), which had flourished centuries earlier, became a religious center—the site of the creation of the sun and moon—for the Aztecs. They assimilated the earlier gods into their own belief system, continuing the practice of bloodletting rituals and human sacrifice.

The fifteenth-century relief sculpture in figure **W5.18** shows the dismembered moon goddess Coyolxauhqui, sister of Huitzilopochtli. It was found at the base of the Templo Mayor in the capital city of Tenochtilán with the head facing the stairway. Coyolxauhqui's head, at a right angle to her neck, is feathered, and her face is decorated with bells. Her belt consists of a twoheaded snake with a knot at one end and a human skull at the other. Her arms and legs, adorned with jewelry, are severed from her body, and fanged

W5.18 Coyolxauhqui, Goddess of the Moon, from the Templo Mayor, Tenochtitlán, Mexico, 15th century. Volcanic stone; 88³/₅ × 79¹/₂ × 14³/₅ in. (225.0 × 201.9 × 37.1 cm). CNCA–INAH–MEX, Museo del Templo Mayor, Mexico City. This relief was discovered in 1978 by workmen digging up the cellar of a bookstore in Mexico City.

masks decorate her elbows, knees, and heels. The raised, flat carving is characteristic of Aztec relief sculpture.

Reflecting the warrior culture of the Aztecs is the terra-cotta *Eagle Warrior* (fig. **W5.19**) found in the Precinct of the Eagles at the Templo Mayor. A nobleman and member of the elite corps of Eagle Warriors, the figure wears the typical costume of eagles' wings and claws. Surrounding the head is the open beak of an eagle that functions as a kind of protective helmet. In battle itself, the aim of such warriors, in addition to territorial expansion, was to take the enemy alive for sacrifice to the Aztec gods.

After the Spanish conquest, the capital of Mexico City was built on the destroyed site of Tenochtitlán and a cathedral was erected on the location of the sacred precinct. **W5.19** Eagle Warrior, from the Templo Mayor, Tenochtitlán, Mexico, 15th century. Terracotta; $67 \times 46\frac{1}{2} \times 21\frac{3}{5}$ in. (170.2 × 118.1 × 54.9 cm). CNCA–INAH–MEX, Museo del Templo Mayor, Mexico City.

Art of the Andes

The Andes is the world's longest mountain range, which includes parts of modern Colombia, Ecuador, Peru, Bolivia, Argentina, and Chile; it also identifies one of the handful of world cultures that evolved as a pristine civilization (see map). Andean culture is often equated with that of the Inkas, who ruled for only a brief time before the arrival of the Spanish in the sixteenth century. Predating the Inkas, however, was a long and rich cultural tradition with defined artistic periods beginning about 2500 B.C., roughly 12,000 years after people are thought to have crossed the Bering Strait.

Andean art and architecture are remarkably complex, especially when one considers that the wheel, iron, and a clearly defined writing system were little used. The complexity is dependent on a system of duality pervading many abstract ideological concepts as

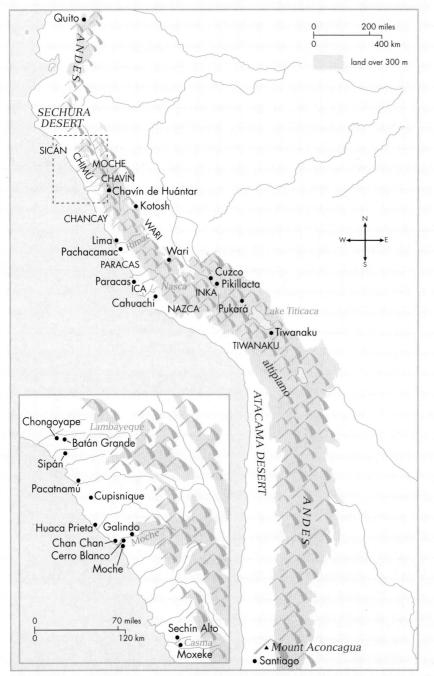

well as many of the visible physical attributes of the society. Fabrication of fine textiles embodying hierarchical and cultural messages is found in each phase of Andean artistic development. Textiles attained the highest level of technology, encompassed the longestknown continuous tradition of fiber art, and were among the most revered objects of Andean culture.

The dramatic and often inhospitable landscape of the Andes influenced its art and contributed to a worldview based on the concept of duality. The dry coastal areas of Peru, which include deserts where only one inch of rain falls annually, are rich in seafood and its nutrients. Highlands and mountains paralleling the coast, on the other hand, provide a contrasting environment where potatoes are often the only crop and conditions are optimal for llamas, alpacas, and other Camelidae that are important sources of fiber and fuel. Trade and reciprocity between these two regions, dating to the preceramic era (3000-1800 B.C.), have been documented. But the lowlands, or tropical jungle, a third geographic area, has not been fully documented because the climate does not permit preservation of cultural remains. Some evidence of interaction, however, particularly as regards imagery, does exist.

The central Andes.

Chavin: The Beginning

The earliest widespread style began in 900 B.C., the Late Initial period at Chavín-a ceremonial site located at what appears to have been a strategic position halfway between coast and jungle, in the center of two mountain ranges. and near the confluence of the Huachecsa and Mosna rivers. Chavín was well positioned for trading with the lowlands to the east, the surrounding highlands, and the coast. The complex at Chavín de Huántar is made up of two principal temples: the Old, dating from the Late Initial period (c. 900-500 B.C.), and the New, dating from the Early Horizon period (500-200 B.C.) (fig. W5.20). It was at Chavín that U-shaped pyramids facing a large plaza in the tradition of the coast, sunken circular courts in the tradition of the highlands, and various portrayals of snakes, raptors, and the jaguar were unified cohesively. The complex was constructed with large slabs of stone, a highland tradition that culminated in the spectacular architectural accomplishments of the Inkas over two thousand years later.

The Old Temple at Chavín, more than 300 feet in length, faced the sunrise and was approached from the west. Embedded in the walls of the temple were a series of larger-than-life heads, which may have represented the shamanic transformation of a priest into a feline or other animal. Staircases lead to a circular plaza lined with a carved stone frieze showing idealized figures and felines. Beneath the temple, a series of narrow passageways lead to the *axis mundi* ("world axis") of the anthropo-

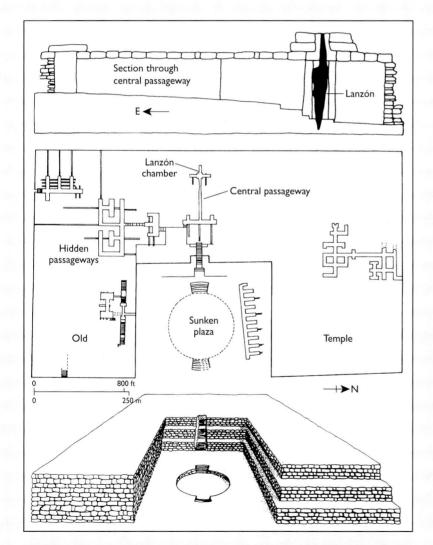

W5.20 Chavin de Huántar: (*top*) cross section, showing the location of the Lanzón at the end of a gallery; (*center*) plan, showing some of the galleries hidden within the temple; (*below*) the Old Temple and its sunken circular courtyard, Late Initial period, c. 900–500 B.C.

W5.21 Roll-out drawing of the Lanzón, from the Old Temple at Chavín de Huántar, Late Initial period, c. 900–500 B.C. The iconography of the Lanzón, clearly seen here, offers one of the oldest and most eloquent representations of Chavín de Huántar's supreme deity.

morphic Lanzón idol (fig. **W5.21**), a carved shaftlike piece of granite that extends above the chamber in which it is placed and represents the supreme deity, possibly an oracle. The iconography of the Lanzón embodies all the elements of the Chavín belief system, including a fanged mouth, a flat nose with flared nostrils, talons, and visual metaphors such as snake-like hair that are typical of Andean sculpture.

Evidence of portable Chavín objects such as carved stone bowls, gold repoussé crowns, and textiles have been found as far away as the south coast of Peru, a distance of some 300 miles, indicating the importance of this early cult oracle and its lasting influence on the art of the Andes.

Coastal Cultures and the Cult of Irrigation

Although Chavín was one of the defining influences on the Paracas (1000-200 B.C.) and Nazca (200 B.C.-A.D. 600) cultures from the south coast of Peru, the latter evolved a different type of imagery. Designs were based in part on the surrounding coastal desert, where subsistence was dependent on irrigation that harnessed resources from the nearby mountains. In 1927, over 400 graves containing well-preserved mummy bundles wrapped in textiles were discovered at the Paracas site of the necropolis of Wari Kayan. The numerous finds notwithstanding, the iconography portrayed on the graphic textiles is still debated.

It is in textiles that the Paracas culture was preeminent. Finely woven examples were reserved for the elite, and gifts of textiles were made to the gods. Beginning with Paracas, textiles were created with two complementary elements. Cotton, a stronger material used as the supporting warp threads or as a background, was grown on the coast. Wool, which absorbs dye more readily than cotton and can be spun into an extremely fine yarn, was supplied by highland Camelidae. The use of these media is another example of reciprocity or duality in the Andes, for the very structure of weaving reflects duality in the intertwining created by the intersection of the warp and weft threads. Many Paracas textiles were executed using embroidery, a technique that permits greater expressive range than the strictly geometric structure of weaving.

Textiles were used as clothing as well as grave offerings, and family members invested thousands of hours in making the offerings, often entire sets of clothes from turban to mantle. If not completed at the time of death, textiles were placed in the tomb in their unfinished state. Other grave offerings found in the mummy bundles were food, gold, and precious objects, including spondylus shells. These shells of the spiny oyster were traded with Ecuador throughout the pre-Columbian era and symbolized water.

Paracas textiles divide into two styles, Linear and Block, terms that describe the arrangement of the inherent design patterns. Both styles contain a multitude of images, the meaning

W5.22 Textile with "impersonator" figures, Paracus, Peru, Early Intermediate, c. 100–200. Plain weave with stem-stitch embroidery.

of which is still debated by scholars. Warrior figures wielding knives and hatchets are often seen; "impersonator" figures appear to be wearing face masks and nose ornaments (fig. W5.22). From the imagery found on the textiles as well as the archaeological record, it is possible to conclude that the Paracas state was more concerned with the immediate world than the earlier highland culture of Chavín had been. Realism and a sense of urgency are apparent in the design. Although the supernatural is still a factor, it is not the defining ideology that it had been during the Chavín era. Earlier Linear designs tended to concentrate on the supernatural while the slightly later, Block designs portray natural flora and fauna along with figures resplendent in ritual paraphernalia who are often anthropomorphized with simian feet. One scholar has proposed that these human impersonators are part of a conceptual structure of the universe and are wearing ritual symbolic costumes probably used in a ceremonial context related to celestial or agricultural phenomena.

Just south of Paracas, the Nazca culture (200 B.C.–A.D. 600) came to prominence along the coast. Most recognized for the monumental Nazca Lines carved in the desert, the art tends to be more naturalistic than earlier styles, with an emphasis on large-scale depictions not only in the earthworks still visible in the dark sands, but in ceramics and textiles as well. Nazca pottery is characterized

by the introduction of a slip-painted surface in which mineral pigments are mixed with clay to make a pliable medium for design. The pictorial elements are outlined in black, giving them an even stronger presence. Common themes are a heightened interest in crops through portrayal of fruits and vegetables, narrative scenes from everyday life, and ceremonial figures. The vessel illustrated here (fig. W5.23) shows the Andean taste for merging natural forms-of a fish, a feline, and a human-as well as for the lively animation of surfaces. This is a moment in Andean art when secular and religious imagery coexist.

While the Nazca flourished on the south coast of Peru, the Moche state (A.D. 100-700) was establishing itself on the north coast. Of the three coastal cultures, the Moche was the most distinctive. Notable in their artistic output are ceramic vessels, metalwork, and monumental architecture, in which the Moche were innovators, developing new techniques that led to increased production. This artistic expansion may have been the result of the fact that the Moche kingdom was the first true centralized state in the Andes. In order for this state to function, corporate labor was required to produce enough objects to disseminate and maintain an ideological hold over a large area. Both the realistic and ritual scenes on Moche pottery indicate the necessity of warfare in extending the power and territory of the Moche.

W5.23 (left) Vessel depicting composite fish, feline, and human figure, Nazca, Peru, 50–200. Ceramic. The Art Institute of Chicago. **W5.24** Moche portrait vessel of ruler, Peru, 400– 500. Terra-cotta; 12½ × 8¼ in. (31.7 × 22.5 cm) high. Museo Arqueológico Rafael Larco Herrera, Lima.

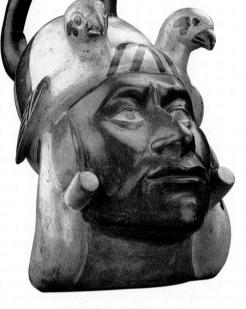

Moche pottery is divided into various styles, including narrative scenes and portrait heads molded in the round, vessels on which fine line painting illustrates a ceremonial ritual, and sexually explicit subjects that probably had a function relating to fertility. For the first time in Andean culture, mold-making techniques were developed to satisfy the need for increased production.

Moche portrait heads are unparalleled in Andean art. Researchers have identified portraits of approximately fifty subjects depicted at various stages of life. In its sense of humor and emphasis on personal themes, Moche pottery is distinctive. The portrait vessel of a ruler (fig. **W5.24**) reflects the organic naturalism characteristic of Moche heads.

The largest adobe structure in the Americas was built by the Moche at their capital, Cerro Blanco. The Huaca del Sol (Pyramid of the Sun), the main temple (originally over 165 feet tall), faces the somewhat smaller palace, the Huaca del Luna (Pyramid of the Moon), across an open plaza. It is estimated that over 100 million bricks were used in the layered construction of the larger pyramid. Most bricks were inscribed with their maker's mark. The stepped pyramids, decorated with murals and containing elite burials, would have been impressive monuments of a grandiloquent civilization. The massive canal system constructed by the Moche permitted a food supply, adequate for a ceremonial center of this size.

Contemporaneous metalwork is best known from the spectacular finds at Sipán in the late 1980s. Gilding, alloying, and soldering techniques were used by the Moche. Much of the ceremonial ornamentation was made of *tumbaga*, an alloy of gold, silver, and copper. The gold and turquoise earspool (fig. **W5.25**) from the Tomb of the Warrior Priest at Sipán depicts an elaborately attired warrior carrying a shield and sword. Predominantly gold, he is contrasted with the figures flanking him, who are shown to be attendants by their smaller scale. The sense of unified artistic organization in this piece is striking in the repeated formal rhythms and interlocking of the gold and turquoise.

W5.25 Earspool, from the Tomb of the Warrior Priest, Sipán, c. 300. Gold, turquoise, quartz, and shell; diameter 3½ in. (9.4 cm). Archeological Museum, Lambayeque, Peru.

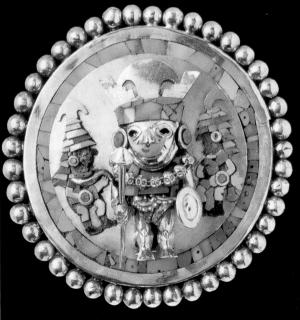

The Highland Empires of Tiwanaku and Wari

The ceremonial center of Tiwanaku is situated in modern-day Bolivia near the southern border of Lake Titicaca, the highest inland lake in the world. It is located strategically between the lowlands to the east and the high plateau to the west. One of a few sites in the Andes with massive stone architecture, its buildings were aligned cosmically with the sunrise and sunset. An artificial moat surrounding the core temples signified the sacred nature of these structures and related the complex to an island in Lake Titicaca. Thus, it is thought that the site of Tiwanaku (600-1000) was conceived as the axis mundi in much the same fashion as the Lanzón at Chavín.

The iconography of the monuments, either colossal freestanding godlike figures or mythical carvings of a variety of human and animal composite deities, is emblematic of the power and cosmic symbolism of the city. With a population of over 60,000, Tiwanaku was the capital of an expansionist empire that ranged from the lowlands of Bolivia through Peru and Chile to northern Argentina.

Construction of ceremonial buildings consisted of blocks of ashlar (a carved. square stone), sandstone, and andesite finely worked and fitted much like later Inka structures. In the tradition of the architecture at Chavín, there is a sunken plaza, a wall with tenon heads, and a monumental entrance-the Gateway of the Sun (fig. W5.26). It is the most recognizable monument at Tiwanaku, with a carved frieze on the portal depicting a central figure carrying a staff in each hand. The visage is metamorphosed into the sun, and rays emanating from the head are transformed into heads of mythical felines and other forms. This central deity is attended by composites of winged kneeling figures carrying spears. His frontality accentuates authority; his image is repeated in every medium used by the Tiwanaku.

The placement of the figures on the portal is symbolic of the apparent taste for order, which was important to the Tiwanaku and Wari. Design patterns are regulated and based on a set standard of hierarchical figures, an aesthetic reflected in the strict grids of certain Wari cities.

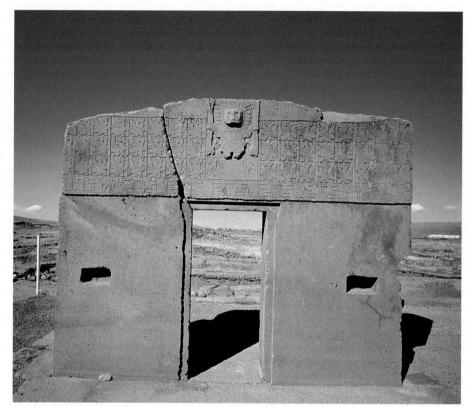

W5.26 The Gateway of the Sun, Tiwanaku, Bolivia, 500–700. Stone; 9 ft. 10 in. (2.99 m) high.

The Wari Empire (500–750) did not produce a site with architecture as spectacular as that of Tiwanaku, but in fiber arts the ideology of this culture unfolds its own permutations on the Gateway of the Sun theme. The way in which textiles are woven, with intersecting warps and wefts, provides a grid for Wari designs (fig. **W5.27**). Variations on both the ideological ideal and the changes in the way this message can be transmitted according to the arrange-

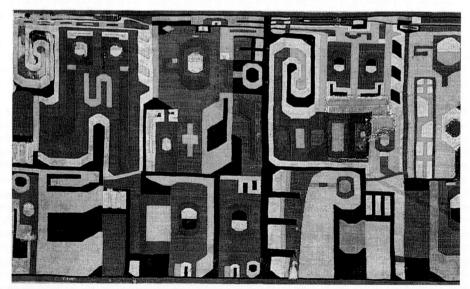

W5.27 Detail of a Wari tunic, from Peru, 600–1000. Cotton and camelid wool tapestry; whole textile $40\frac{3}{4} \times 20$ in. (103.5 \times 50.5 cm). Metropolitan Museum of Art, New York.

ment of the threads are the supreme expression of these textiles. Although the imagery was limited and was directly influenced by the Tiwanaku canon, Wari weavers abstracted the images through compression and expansion combined with alternation (in four directions-back and forth, up and down), making the encoded message harder to decipher. Perhaps the imagery was reduced to a shorthand that was perfectly legible to those familiar with its meaning. Because few Wari textiles survived the humidity of the highlands, most have been found in the dry coastal outposts of the empire, probably taken there to spread the encoded ideological message. Innovative terraced fields and widespread canalization gave this empire an agricultural advantage; but because of its dependence on nature, the supernatural elements required constant appeasement through representation and veneration. The relationship between the Tiwanaku and Wari empires remains one of the major unanswered questions among pre-Columbian scholars.

W5.28 Machu Picchu, Inka culture, near Cuzco, Peru, 15th–16th centuries.

The Inka Empire: The End of an Era (c. 1438–1532)

Nearly contemporary with the Aztecs and following the decline of the Tiwanaku and Wari cultures, another coastal kingdom, Chimor, rose to power in roughly the same area as the Moche. At the height of its influence in about 1400, the Chimú people of Chimor controlled two-thirds of the entire coast from the administrative center at Chan Chan. Shortly thereafter, another kingdom arose that would rival the Chimú. Its successors, the Inkas, are said to have come into power in 1438, at about the same time, and in much the same way, as the Aztecs in Mexico, having coalesced from a group of unexceptional tribes. The southern highland city of Cuzco, considered to be at the center of the world, was the Inka capital, and the Inka king was known as the Inka. For the Inkas, architecture was the highest expression of their art and political power. The iconographic message was not supplication to the gods, as it had been in the past, but projected an image of the Inkas as the true kings.

A highly organized political entity, the Inka Empire, which assimilated various cultural groups, contained over 20,000 miles of roads called Tawantinsuyo, or the Four Quarters, connecting the far reaches of its domain, stretching nearly 3,500 miles from Ecuador to Chile. Local governors controlled each quarter, where they collected taxes in amounts determined by an accurate census and computed on a knotted string, or *quipu*. In less than a century, the Inkas were ruled by a succession of thirteen kings, the first three of which are legendary.

The rapidity with which the Inkas consolidated power can be attributed in part to their shrewd management of the supernatural combined with myth and genealogy. Each king was venerated, and, after his death, his mummy was paraded publicly on a litter. To sustain their relationship with the gods, the Inkas sacrificed llamas, which were associated with the sun, and burned cloth as an offering of the highest status. On occasion, they took young children to the top of a mountain, killing them and offering them in service to the gods.

In the Cuzco region, there are many architectural monuments made of tremendous coursed ashlar blocks laid one on the other without mortar. The most famous Inka monument, Machu Picchu, is located at the northwest end of the Urubamba Valley, a short distance from Cuzco (fig. **W5.28**). This majestic site, built on a mountaintop

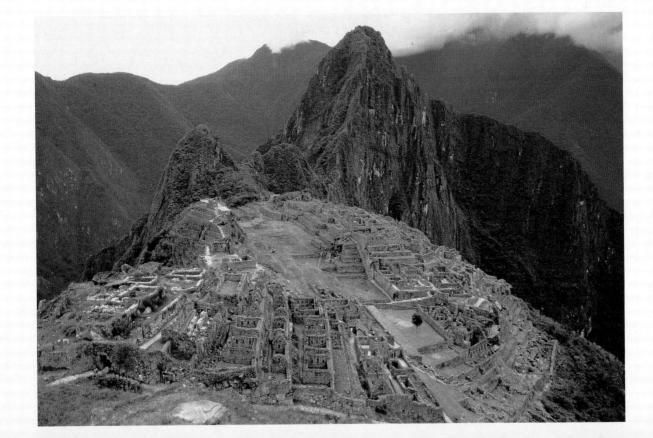

some 9,000 feet above sea level, relates architecturally to the distant mountains, the Urubamba River raging below, and the surrounding jungle. A number of large stones echoes the shapes of the mountains, and windows frame spectacular views. At the beginning of the twentieth century,

Machu Picchu was thought to have been the last stronghold of the Inkas and the site of a hidden treasure trove of gold, but now the site is identified as the royal estate of an Inka king.

Inka textiles and ceramics are standardized, typically decorated with nonfigurative geometric designs. More

original was the metalwork, much of it executed in gold, which was melted down by the conquistadors and taken to Spain.

The Inka Empire came to an end shortly after the arrival of the Spanish conquistador Francisco Pizarro in 1532.

Style/Period	Works of Art	Cultural/Historical Development
MESOAMERICA OLMEC c. 1200–900 b.c.	Seated Jaguar (W5.1), San Lorenzo Colossal head (W5.2), San Lorenzo	Greek Geometric period (c. 1000–700 в.с.) Colossal head Seated Jaguar
TEOTIHUACÁN c. a.d. 350–650	Temple of Quetzalcoatl (W5.6), Teotihuacán Warrior in Teotihuacán costume (W5.7), Tikal The Leiden Plate (W5.8) Teotihuacán (W5.3)	Sack of Rome by the Visigoths (410) Reign of Justinian (6th century)
MAYA c. 1100 b.ca.d. 1500	Maya Lord (W5.9), Tabasco Monkey-man scribal god (W5.12), Copán Copán (W5.10) Ball court (W5.11), Copán Temple I (W5.13), Tikal Mural painting (W5.14), Bonampak Chichén Itzá (W5.15-W5.16) Chacmool (W5.17), Chichén Itzá	Julius Caesar becomes dictator (49 B.C.) Death of Jesus (c. A.D. 33) Beginning of Gothic style in France (12th century Control of Gothic style in France (12th century) Mural painting
AZTEC c. 1300–1525	Coyolxauhqui (W5.18), Tenochtiilán Eagle Warrior (W5.19), Tenochtiilán	The Renaissance in Italy and northern Europe (1300–1550) Columbus sets sail for India (1492)
THE ANDES CHAVÍN c. 900–200 B.C.	Lanzón (W5.20–W5.21), Chavín de Huántar Eagle Warrior	Classical Greece (450–400 B.C.) Death of Alexander the Great (323 B.C.)
PARACAS c. 1000–200 b.c.	"Impersonator" textile (W5.22), Peru	
NAZCA c. 200 b.ca.d. 600	Fish/feline/human vessel (W5.23), Peru	Fish/feline/human vessel
MOCHE 100-700	Earspool (W5.25), Peru Portrait vessel (W5.24), Peru	Death of Muhammad (632)
TIWANAKU 600–1000	Gateway of the Sun (W5.26), Bolivia	Charlemagne crowned Holy Roman Emperor (80
WARI 500-750	Tunic (W5.27), Peru	Ottomans capture Constantinople (1453)
INKA c. 1438–1532	Machu Picchu (W5.28), Peru Gateway of the Sun	Pope Julius II begins the new Saint Peter's in Rom (1502) The Protestant Reformation begins (1517)

364

10 Romanesque Art

T he term *Romanesque* ("Romanlike") refers to a broad range of styles, embracing many regional variants, that flourished in western Europe in the eleventh and twelfth centuries. It is a stylistic rather than a

historical term, intended to describe medieval art that shares certain characteristics with ancient Roman architectural style. Similar features include round arches, stone vaults, thick walls, and exterior relief sculpture. In addition to adapting architectural elements from Rome, the Romanesque style reflects the taste for linear patterns of Hiberno-Saxon art, as well as influences from the Byzantine and Islamic traditions. Since Europe at this time was a patchwork of regions rather than of nations with centralized political administrations, scholars tend to identify the various styles by the name of the relevant geographical area—for example, Norman (from Normandy, in northwest France) or Burgundian, from Burgundy, in central France.

Reflecting the relative stability and prosperity of the Christian Church, there was an enormous surge in building activity, especially of cathedrals, churches, and monasteries. Monasteries owned significant tracts of land, which enhanced their political and economic power in Romanesque Europe. This contributed to the widespread revival of architectural sculpture and the ornamentation of Christian buildings. Since the most innovative Romanesque works were created in France, most of the buildings and works of art discussed in this chapter are French, with a few representative examples from Italy, Spain, and Norway.

Economic and Political Developments

During the late ninth century A.D., the Muslims continued their expansion in the south, and from the east the Magyars (an eastern European tribe whose language is related to Finnish) advanced in search of a permanent home. From the north came the Vikings, who occupied Normandy. By the second half of the eleventh century, the threat of invasion had decreased, largely because many pagans had been assimilated and converted to Christianity. The Magyars had settled in present-day Hungary. The Vikings had also become Christians, and their leaders were recognized as dukes by the French king. In 1066, Duke William II of Normandy invaded England, becoming its first Norman king—William I the Conqueror—and establishing feudalism as the prevailing social system in England (see box). In the early twelfth century, the Normans,

Feudalism

Feudalism (from the Latin word foedus, meaning "oath") was the prevailing, but loosely constructed, socioeconomic system of the Middle Ages. Under the feudal system, the nobility had hereditary tenure of the land. In theory, all land belonged to the emperor, who granted the use of certain portions of it to a king in return for an oath of loyalty and other obligations. The king, in turn, granted the use of land (including the right to levy taxes and administer justice locally) to a nobleman. He granted an even smaller portion to a local lord, for whom unpaid serfs, or peasants, worked the land. At each level of dependency, the vassal owed his loyalty to his lord and had to render military service on demand. In practice, however, these obligations were fulfilled only when the king or lord had the power to enforce them. The principal unit of feudalism was the manor. In exchange for their services, the serfs were allowed to cultivate a part of the lord's land for their own benefit.

Feudalism and serfdom declined from the thirteenth century onward, partly because of a growing cash economy and partly because of peasant revolts. In France, however, these social systems lingered on until the revolution of 1789. In Russia and certain other European countries, feudalism continued well into the nineteenth century. who were descended from the Vikings, expelled the Arabs from Sicily, and wrested control of much of southern Italy from the Byzantines. Muslim dominance of Spain had declined, and the Christians, maintaining their resistance from the mountains in the north, were poised to recapture most of the Iberian peninsula (modern Spain and Portugal).

The social structure of western Europe was based on the feudal system, with the economic and political core centered in manorial estates. Kings, dukes, and counts, to whom lesser barons and lords owed their allegiance, ruled these manors. But there was no centralized political order, and the main unifying authority remained with the pope in Rome. The Church played a vital role in the social and economic structures of secular life, owning a large amount of landed property—close to a third in France—and claiming the same temporal authority as the kings and nobles.

Despite conflicts between social classes engendered by feudalism and the manorial system, however, a degree of military and political equilibrium was achieved. This led to economic growth, especially in Italy, where Mediterranean trade routes were opened and several seaports (such as Naples, Pisa, Genoa, and Venice) became centers of renewed commercial activity. Manufacturing and banking flourished, and new groups of craftsmen and merchants arose. Cities and towns that had declined during the Early Middle Ages revived, and new ones were founded. Gradually, towns began to assert their independence from their lords and the Church. They demanded, and received, charters setting out their legal rights and obligations. Some even established republican governments.

Pilgrimage Roads

By the first half of the eleventh century, Christianity was in the ascendant in western Europe. The spirit of religious vitality affected almost all aspects of life and manifested itself particularly in the Crusades—a series of military campaigns, undertaken from 1095 and lasting into the fifteenth century, the primary purpose of which was to recover the Holy Land from the Muslims (see box).

Earlier in the Middle Ages, it was only penitent Christians who made pilgrimages to atone for their sins (see map, p. 367). From the eleventh century, however, it became customary for devout Christians generally to make pilgrimages, particularly to churches with sacred **relics**. These might be the physical remains of saints, remnants of their clothing, or other objects associated with them. Relics were often housed in a **reliquary**—a container for relics —of the type illustrated in figure 10.1 (see box, p. 368).

The two most sacred pilgrimage sites were Jerusalem and Rome. Jerusalem had been the site of Solomon's Temple and the Holy Sepulcher (see box, p. 369), of Jesus's Entry and Last Supper, of the events leading to his death, and of some of the miracles that followed. Rome was the center of Christendom in the West. It contained the papal residence and the tombs of Saints Peter and Paul. But journeys to these cities, especially Jerusalem, could be dangerous. A third choice, which became popular in the eleventh century, was the shrine of Saint James (Santiago in Spanish) at Compostela, in Galicia (a region of northwest Spain) (see box, p. 369).

The Crusades

The Crusades were a series of military expeditions from western Christendom, originally undertaken in the name of the Cross (*crux* in Latin), to recapture the holy places in Syria and Palestine from the Muslims.

The First Crusade began in 1095 and ended with the capture of Jerusalem in 1099. The Second (1147–1149), Third (1189–1192), and Fourth (1202–1204) Crusades met with varying degrees of success. Many rulers and nationalities participated in these early crusades, including the kings of England and France and the emperor of Germany. Several other expeditions to the Near East took place in the thirteenth century, but in 1291 Acre (near Haifa in modern Israel), the last Frankish foothold in the Near East, fell to the Muslims, and the original impetus behind the Crusades waned. Later Crusades were launched in other regions against non-Christians (for example, the Moors in Spain and the Slavs), heretics, and excommunicated Christian rulers. In 1464, Pope Pius II failed to win support for a last attempt at a Crusade to the Near East. An assortment of spiritual benefits and material motives encouraged men (and in one case children—in the Children's Crusade of 1212) to undertake these long and arduous journeys. Spiritual benefits included the remission of time that one's soul would spend in purgatory and the promise of becoming a martyr if one were killed. Material motives included the territorial ambitions of feudal princes, the first stirrings of Western colonialism, and the desire of Italian cities (especially Venice) to secure trading bases in the Levant.

The territorial gains of the early Crusades soon disappeared. More lasting results were seen in a widening division between western and eastern Christendom and the formation of orders of knighthood (notably the Knights of Saint John of Jerusalem and the Knights Templar), consisting of soldiers who took monastic vows and devoted themselves to military service against non-Christians.

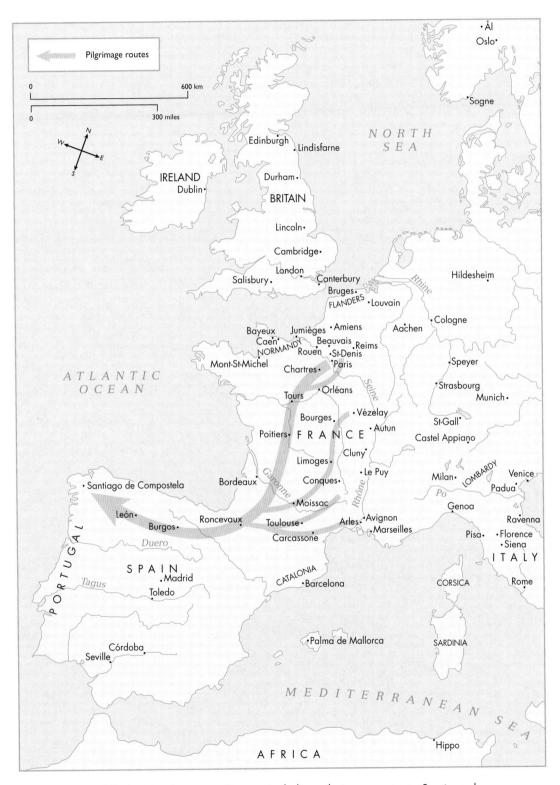

Romanesque and Gothic sites in western Europe, including pilgrimage routes to Santiago de Compostela.

The Stavelot Reliquary Triptych

One of the best examples of a Romanesque reliquary is the Stavelot Triptych (figs. **10.1** and **10.2**). It was probably commissioned in the twelfth century by Abbot Wibald of the imperial Benedictine abbey at Stavelot, in the region of the Meuse River in Belgium. The Stavelot reliquary contained relics believed to be of Christ's Cross—referred to as the True Cross to distinguish it from the crosses on which the two thieves were crucified.

It is the earliest known reliquary illustrating scenes from the popular medieval Legend of the True Cross. Each scene is composed of enamel on gold and is set in a circular frame. There are six scenes, three on each wing of the triptych. The wings are framed by Corinthian columns supporting round arches. In the central panel are two additional triptychs. The larger depicts the Cross with standing figures of Constantine and his mother, Saint Helena, who went to search for the True Cross. Two archangels occupy the space above the arms of the Cross. On the inside of the open wings are four Byzantine saints: Theodore and Demetrius at the right, and George and Procopius at the left. When closed (not illustrated here), the four Evangelists are visible on the exterior of the wings.

The smaller triptych shows an Annunciation when closed, but here we see a Crucifixion flanked by the Virgin and the apostle John. The sun and moon fill the spaces over the Cross. A recess inside the Crucifixion enamel contained a Byzantine parchment. On it was an inscription identifying the contents of a small silk pouch as fragments of the True Cross, the Holy Sepulcher, and the Virgin's dress. The pouch also contained the head of a nail, which was believed to have been a relic of one of the nails used in the Crucifixion.

The six scenes on the wings are divided into three Constantine scenes (on the left) and three Helena scenes (on the right). They focus on that part of the legend dealing with Constantine's conversion to Christianity and with Helena's discovery

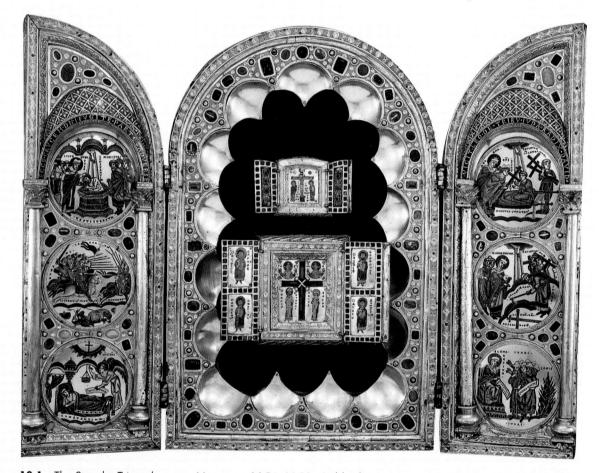

10.1 The Stavelot Triptych, open, Mosan, c. 1156–1158. Gold, *cloisonné* enamel; 19½ in. (48.4 cm) high, 26 in. (66.0 cm) wide, when open. The Pierpont Morgan Library, New York.

The shrine of Santiago also became associated with Charlemagne and therefore had a particular attraction for the French. Two generations earlier, Charlemagne's grandfather, Charles Martel, had ended the Muslim invasion of France at the Battle of Poitiers in 732. This association took on mythic proportions and was based on

Charlemagne's military campaign against the Muslims in Spain. According to tradition, Charlemagne dreamed of a star-filled road in the sky (the Milky Way). Saint James appeared in the dream, explaining that the stars pointed the way to his tomb and telling Charlemagne to follow them. In the popular French imagination, Charlemagne was the

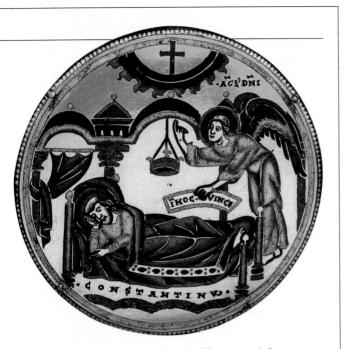

10.2 Vision of Constantine (detail of fig. 10.1, left wing).

of the True Cross. On the left, reading from the bottom, is the *Vision of Constantine* (fig. 10.2), his *Victory over Maxentius*, and his *Baptism*. On the right, the lowest scene shows Helena in Jerusalem, searching for the Cross. (According to the legend, Constantine was so impressed with the power of the Cross that he sent his mother to Jerusalem to find it.) Here Helena questions the Jews about the location of the Cross. In the middle scene, she is on Calvary as three crosses are excavated from the ground. At the top, the miracle of the True Cross is enacted. To discover which of the three crosses was Christ's, Helena had each in turn held over the body of a dead boy, whose funeral procession happened by. Only the True Cross restored him to life.

Taken as a whole, the message of these scenes to the medieval pilgrim was the power of the Cross and its role in establishing Christianity as the official religion of Rome. The *Vision of Constantine*, here represented as a dream, was the miracle that set in motion this sequence of events. An angel leans over Constantine's bed, points to a cross in the sky, and carries the inscription "In this sign you conquer."

The pairing of the Constantine and Helena episodes also pairs Rome (on the left) with Jerusalem (on the right). In so doing, the artist evokes the two most important pilgrimage sites and identifies Stavelot with them. When pilgrims traveled to Stavelot, they reinforced its identification with these sites. The pilgrims would also have associated Constantine with Charlemagne and known of the typological relationships of these two emperors with Christ and of Saint Helena with the Virgin.

first pilgrim to go to Compostela. Further enhancing the significance of Charlemagne's dream was its connection with important Christian events: the Vision of Constantine (see box), the angels' instruction to the shepherds that they would find the Christ child in a manger, and the Magi who followed a star.

Pilgrims, Relics, and the *Liber Sancti Jacobi* (Book of Saint James)

In the sense applied by the Church, the term *relic* refers to a personal memorial of a holy person. Often, relics were parts of the person—such as hair, bones, and fingernails or objects associated with them—such as the nails used to crucify Jesus. Relics are believed to have miraculous powers, including that of healing. But in order to benefit from the relic, one had to travel to it—that is, make a pilgrimage. The pilgrim then had to see the relic and, ideally, to touch it. If the relic could not be touched because of its fragility, then the reliquary could act as a substitute. In some cases, as at the Church of Sainte-Foy, pilgrims viewed the reliquary through an elaborate choir screen, which separated the ordinary worshiper from the most sacred space. Having absorbed the sacred into his own being, the pilgrim returned home.

In A.D. 42, James was beheaded by King Herod, becoming the first of Christ's apostles to be martyred. His remains were believed to have been "translated" (miraculously relocated) from Herod's Judaea to Spain. This miracle is celebrated on December 30 in the liturgical calendar of the Roman Church.

The Liber Sancti Jacobi was a twelfth-century guide in five books for pilgrims to the shrine of Santiago de Compostela. Book I contains hymns and liturgical texts related to Saint James. Book II describes his miracles. Book III glorifies his cult. Book IV purports to be a history of the events celebrated in the Song of Roland. The actual guide, Book V, describes the pilgrimage roads and the regions they traverse. For those who travel via Le Puy, a visit to Conques is regarded as essential. At the church, according to the guide, "many benefits have been granted there to the healthy no less than to the sick. In front of the portals of the basilica there is an excellent stream, more marvelous than what one is able to tell."¹

Once in Compostela, the pilgrims are introduced to the town and its cathedral, told how to behave and how they should be welcomed. The final destination of every pilgrim to Compostela is, of course, the richly decorated reliquary of Saint James.

Inspired by these stories as well as by the need to see and touch the relics, pilgrims traveled to Compostela. They followed four main routes across France, through the Pyrenees, and then westward. Along these roads, an extensive network of churches, hospices (or lodging places), and monasteries was constructed. The design and location of such buildings were a direct response to the ever-growing crowds of pilgrims. As we saw in the description of Saint Gall (see p. 341), monasteries were organized to accommodate the Rules of their founders and of the subsequent Orders that were established. Similarly, church plans were designed so that worshipers (especially the monks) could follow the strict routines of the relevant Order.

Solomon's Temple and the Holy Sepulcher

Solomon, the son of David and Bathsheba, was king of Israel from around 970 to 930 B.C. He was known for his great wisdom and his political centralization of Israel. The temple traditionally associated with him was originally located on the present site of the Dome of the Rock in Jerusalem (cf. fig. 9.1). It was seen as an expression of his own power and of Israel's international status. According to Josephus (see Chapter 7), Solomon and Herod enlarged an existing temple whose plan resembled that of the Tabernacle. This was a portable sanctuary some 105 by 75 feet (32×23 m), which had been built by Moses and was designed to be taken apart and reassembled as travel required.

The plan also had elements in common with temples built in other Mediterranean cultures. Solomon's Temple had an open courtyard, an interior holy area, and an inner sanctuary (the "holy of holies"). The inner sanctuary contained the Ark of the Covenant, a rectangular wooden chest covered with gold. It signified the presence of God to the Hebrews and was thus their most holy symbol. One entered the Temple through an eastern portico flanked by two hollow bronze columns.

Reflecting the political'sway of King Solomon and the relative peace and prosperity of his reign was the international character of the skilled laborers sent by King Hiram of Tyre, in Phoenicia, and the opulent imported materials they used to construct the Temple. The walls were lined with Lebanese cedar. Gold lined the inner sanctuary and covered the olive-wood doors separating the sanctuary from the nave and the nave from the portico. The altar in the nave was also gold, whereas that in the courtyard was bronze, a reflection of the more sacred status accorded the inner altar. In 587/6 B.C., Jerusalem fell, and Solomon's Temple was destroyed by Nebuchadnezzar (see Chapter 2), king of Babylon. The Ark of the Covenant disappeared and was never recovered.

The Holy Sepulcher refers to the rock cave in Jerusalem believed to have been the location of Christ's burial and resurrection. According to the Legend of the True Cross (see p. 368), Saint Helena found the tomb and had a church built on the site in the fourth century. In 614, this was destroyed by the Persians. A second church constructed in 626 was also destroyed, followed by a third structure around 1050. The Crusaders built a large church around 1130 that covered other sacred Christian sites, including Calvary. The present church dates to the nineteenth century.

In the typological system of reading history, the Christians paired both David and Solomon with Christ as exemplars of wise kingship, and Saint Helena with Mary. The Temple and the Holy Sepulcher were typologically paired with church buildings and Jerusalem with Christian cities throughout Christendom.

Architecture

In addition to accommodating the Rule of an Order, Romanesque architects had to construct churches big enough for the influx of pilgrims. At the same time, churches had to be structurally sound and adequately illuminated. The availability of materials often presented problems because of the great increase in building activity. More subjective considerations such as aesthetic appeal also had to be taken into account. These might be influenced by the wishes of a local religious order or a wealthy patron.

Sainte-Foy at Conques

Communication along the pilgrimage routes must have been constant, with pilgrims, masons, and other craftsmen continually traveling back and forth. It is thus not surprising that many Romanesque churches had similar features. The earliest surviving example of a pilgrimage church (fig. **10.3**) is dedicated to Sainte Foy, a thirdcentury virgin martyr known in English as Saint Faith. She was martyred in 303 while still a child because she refused to worship pagan gods. In the ninth century, her relics were transported to Conques. The Church of Sainte-Foy, which belonged to the Benedictine order (see Chapter 9), was erected over her tomb and stands today in Conques, a remote village on the pilgrimage route from Le Puy in southeastern France.

The single most important attraction for pilgrims to this church was the saint's relics. They were contained in an elaborate gold reliquary statue (fig. **10.4**), the head of which is believed to have been formed around the saint's skull. Its large size—it is a late antique mask that has been reused—accentuates the impression of aloof power conveyed by the statue. The figure is made of gold repoussé, with several sheets of gold placed over a wooden core for stability. The saint sits frontally as if enthroned, wearing a martyr's crown and a rich, gold robe covered with gems and Roman cameos.

The builders of Sainte-Foy, and of all pilgrimage churches, had to accommodate large crowds without interfering with the duties of the clergy. The plan in figure 10.5 shows how the traditional Latin-cross basilica was modified by extending the side aisles around the transept and the apse to form an ambulatory. This permitted the lay visitors to circulate freely, leaving the monks undisturbed access to the main altar in the choir. Three smaller apses, or radiating chapels, protrude from the main apse, and two chapels of unequal size have been added at the east side of the transept arms. Essentially, such architectural arrangements accommodated two social and temporal systems. One was based on the social world of the laity, while the other provided an architectural space for those whose daily lives followed another "order" of business and a liturgical calendar.

A new architectural development in Romanesque churches was the replacement of wooden roofs by stone

10.3 Aerial view of Sainte-Foy, Conques, Auvergne, France, c. 1050–1120. Apart from two 19th-century towers on the west façade, Sainte-Foy stands today as it did in the 12th century. It has a relatively short nave, side aisles built to the full height of the nave (so that there is no clerestory lighting), and a transept. The belfry, or bell tower, rises above the roof of the **crossing.**

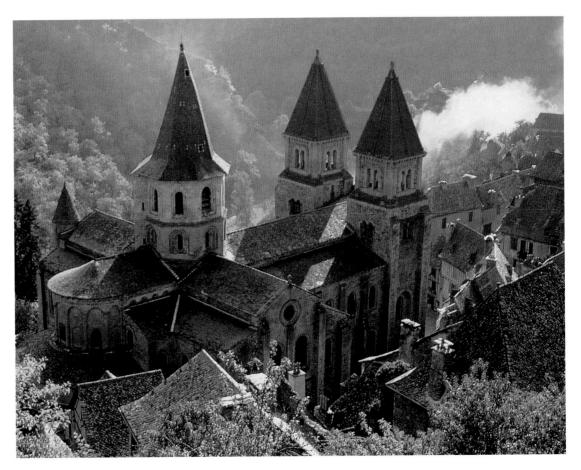

10.4 Reliquary statue of Sainte-Foy, Conques, late 10th–11th century. Gold and gemstones over a wooden core; 33½ in. (85.1 cm) high.

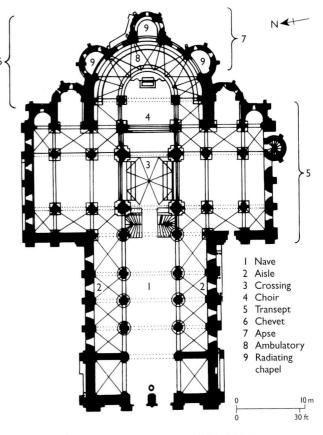

10.5 Plan of Sainte-Foy, Conques, c. 1050–1120.

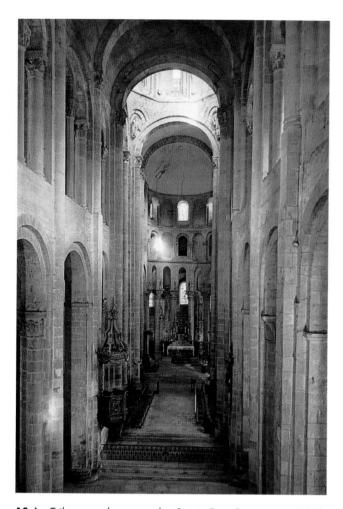

10.6 Tribune and nave vaults, Sainte-Foy, Conques, c. 1050–1120. Romanesque builders solved the problem of supporting the extra weight of the stone by constructing a second-story gallery, or tribune, over the side aisles as an **abutment**. Structurally, the gallery diverted the thrust from the side walls back onto the piers of the nave. It also provided an extra interior space for the pilgrims.

barrel vaults (fig. **10.6**), which lessened the risk of fire and improved the acoustics (music, particularly Gregorian chant, was an integral feature of the Christian liturgy). The stone vaults (fig. **10.7**) required extra support, or buttressing, to counteract the lateral thrust (sideways force) they exerted against the walls. At Sainte-Foy, **transverse ribs** cross the underside of the **quadrant**—i.e., the half-barrel vaults of the nave. They are supported by **cluster piers**, each of which is reinforced by four engaged half-columns. The piers accent the corners of the groin-vaulted wall sections, or **bays**, of the side aisles.

Romanesque churches were decorated with sculpture, painting, and wall hangings through which an illiterate general population could "read" the images. Tapestries, most of which are now lost, often hung along the aisles, adding color and warmth to the church interiors.

An important Romanesque development was the use of architectural sculpture, animating surfaces and illustrating Bible stories and saints' lives. Most pilgrimage churches had images carved in relief at the main entrance. The area immediately around the doorways, or **portals**, would have contained the first images encountered, and the reliefs were

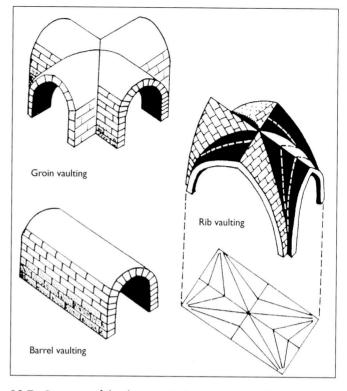

10.7 Diagram of the three main Romanesque vaulting systems: barrel vaulting, groin vaulting, and rib vaulting.

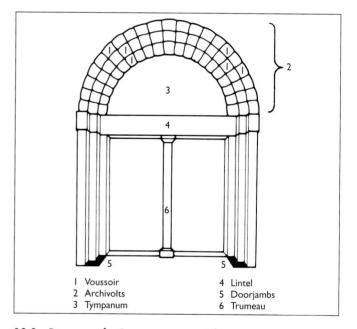

10.8 Diagram of a Romanesque portal.

therefore intended to attract the attention of the worshiper approaching the church. The general layout of medieval church portals is fairly consistent (fig. **10.8**); what varies from building to building is the program—the arrangement and meaning of the subjects depicted on each section.

At Conques, the relief sculpture on the western portal (figs. **10.9** and **10.10**) is confined to the **tympanum** and the lintel. The most usual scenes on Romanesque tympanums depicted Christ in Majesty or, as at Sainte-Foy, the *Last Judgment* (fig. **10.11**). It conforms to iconographic convention

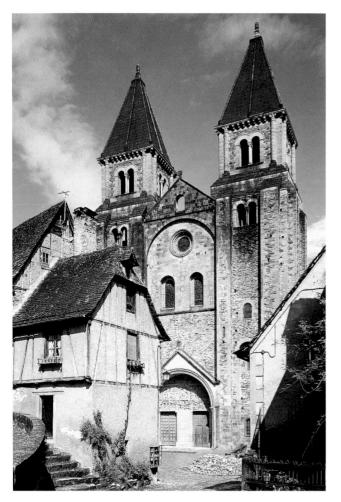

10.9 West entrance wall, Sainte-Foy, Conques, c. 1130.

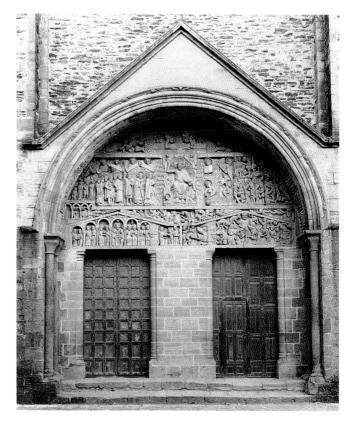

10.10 West portal with tympanum, Sainte-Foy, Conques, c. 1130. Stone; approximately 12 \times 22 ft. (3.66 \times 6.71 m).

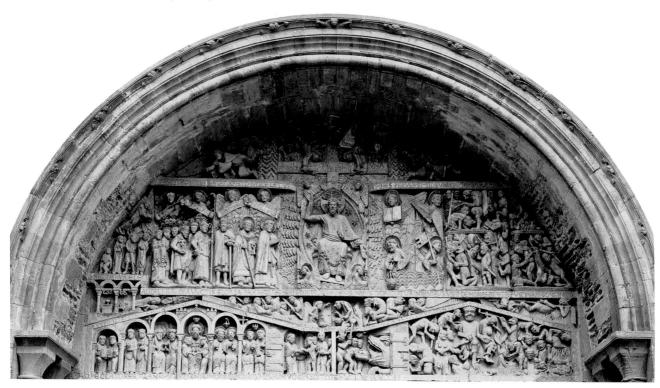

10.11 Last Judgment, tympanum of the west portal, Sainte-Foy, Conques, c. 1130. Jesus is both the central and largest figure. He is surrounded by a mandorla, an oval of light (an Eastern motif), and his halo contains the Cross. He raises his right hand, reminding the viewer that the souls on his right will be received in heaven—a visual rendition of the advantages of being "on the right hand of God."

in its overall arrangement. The figures on Christ's right (the viewer's left) and on his level are saints and churchmen. Above them, angels hold scrolls that form arches. Below, also on Christ's right, are figures framed by semicircular arches. A figure of Sainte Foy is shown prostrated before the hand of God. Christ's left hand is lowered toward hell. His gesture directs the viewer's attention to the damned souls falling and being tortured by devils. In the center of hell, on the viewer's right, is the crowned frontal figure of Satan. The punishments in hell are designed to fit the earthly crimes of the damned. Thus, at the far left, a prideful knight tumbles from his horse as a devil spears him with a pitchfork. Next on the (viewer's) right, a lustful woman is yoked to her lover by the neck. On the other side of Satan, reading from right to left, a devil forces molten metal down the throat of a forger; two devils roast a poacher with the head of a rabbit; and a man guilty of greed hangs with a purse (also hanging) around his neck. Note that the saved souls on Christ's right are neatly arranged under framing devices, whereas the damned, on Christ's left, appear jumbled and disordered.

At the center of the lintel, directly below Christ, the traditional right–left Christian symbolism is maintained. Two individual scenes are divided by a vertical. On Christ's right, angels welcome saved souls into heaven. On his left, a grotesque devil with spiked hair and a long nose brandishes a club at a damned soul. The latter bends over as if to enter the gaping jaws of a monster, which pokes its head through a doorway. This iconography conflates the Christian metaphors of the "gate of hell" and the "jaws of death."

Images of heaven and hell vary as Christian art develops. The basic arrangement of the *Last Judgment,* however, is fairly constant. It is a reminder of the passage of time and of the belief that the unrighteous will be condemned to "everlasting punishment: but the righteous [will enter] into life eternal" (Matthew 25:46).

Saint-Pierre at Moissac

To the southwest of Conques, on the route to Santiago de Compostela, the medieval pilgrim would probably pause at Moissac (figs. **10.12–10.15**). Figure 10.13 shows the plan of the abbey and church of Saint-Pierre, which were founded in the seventh century but destroyed and rebuilt

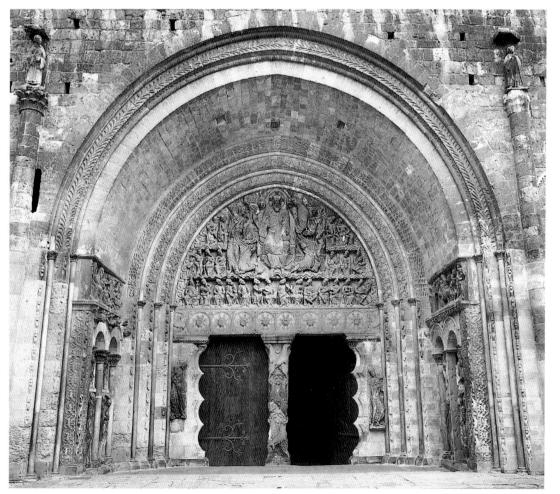

10.12 South porch, Saint-Pierre, Moissac, c. 1115–1135. 16 ft. 6 in. (5.03 m) diameter. According to local tradition, a dream sent by God inspired Clovis, king of the Franks, to found the abbey at Moissac. This is consistent with the visionary character of the tympanum's iconography.

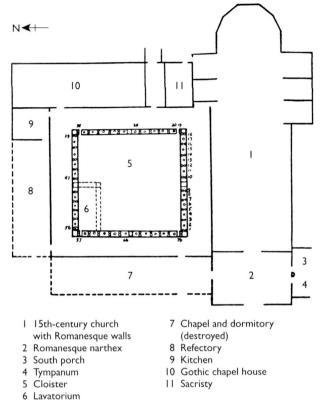

10.13 Plan of the abbey and church of Saint-Pierre, Moissac, France.

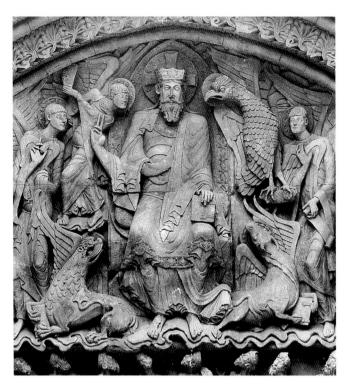

10.15 *Christ,* tympanum of the south porch (detail of fig. 10.12), Saint-Pierre, Moissac, c. 1115–1135.

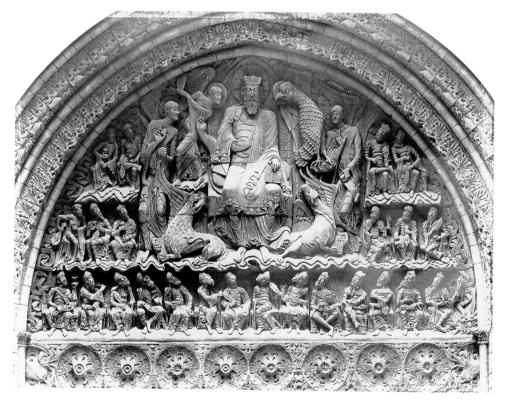

10.14 Tympanum of the south porch, Saint-Pierre, Moissac, c. 1115–1135. The imagery carved here is from the book of Revelation 4:2–7: "And behold, a throne was set in heaven, and one sat on the throne... And round about the throne were four and twenty seats: and upon the seats I saw four and twenty elders sitting, clothed in white raiment; and they had on their heads crowns of gold... And before the throne there was a sea [the wavy lines] of glass like unto crystal: and in the midst of the throne, and round about the throne, were four beasts full of eyes before and behind. And the first beast was like a lion, and the second beast like a calf, and the third beast had a face as a man, and the fourth beast was like a flying eagle."

several times. The Romanesque sections that survive are the cloister, the remains of the lower walls of the church, the south porch, and a tower. The most important Romanesque sculptures are on the south-porch entrance (fig. 10.12 and number 3 on the plan) and in the cloister (number 5 on the plan).

The tympanum over the south portal is filled with reliefs depicting the *Second Coming of Christ* (fig. 10.14), based on Revelation (see p. 339). The artist has eliminated the theological connection between the Second Coming and the Last Judgment—hence there is no representation of the damned and the saved, as at Conques. Instead, Christ is shown in Glory, surrounded by images derived from Saint John's apocalyptic vision (see caption). The tympanum is framed by floral motifs on the **archivolts** and by ten **rosettes** in the lintel.

The figure of Christ at Moissac (fig. 10.15) is proportionally larger than that at Sainte-Foy. He is rendered frontally, his presence commanding the scene, and in this respect the figure can be compared with the manuscript page depicting Christ in Majesty from the Stavelot Bible (fig. 10.16) (see box, p. 368), in which the monumental proportions of Christ are barely contained within the frame. His mandorla overlaps the inner edges of the illusionistic meander pattern. The four tondos at the corners of the page contain representations of the Evangelists' symbols. The two lower ones-the lion of Saint Mark and the bull of Saint Luke-gaze at each other and hold a Gospel book, referring to their roles as biographers of Christ. The angel and eagle (Saints Matthew and John, respectively) above Christ carry scrolls of prophecy.

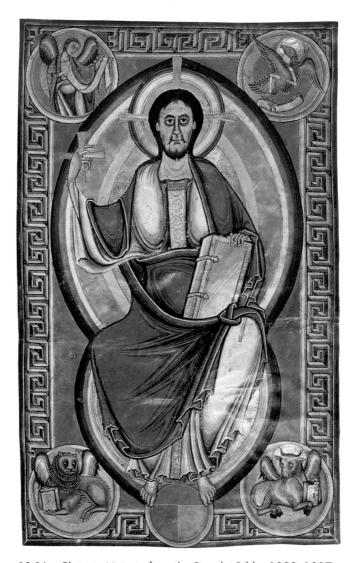

10.16 Christ in Majesty, from the Stavelot Bible, 1093–1097. Parchment; $22\frac{1}{2} \times 14\frac{1}{2}$ in. (57.5 \times 36.8 cm). British Library, London.

10.17 The elders, tympanum of the south porch (detail of fig. 10.14), Saint-Pierre, Moissac, c. 1115–1135.

In the tympanum at Moissac, the four symbols of the Evangelists and the twenty-four elders (fig. 10.17) focus their gaze on Christ. In the Stavelot illumination, on the other hand, the bull and lion seem to cower beneath Christ, while the eagle gazes upward, away from Christ, as does the lion, with a wistful, slightly apprehensive air. Only the angel looks directly at Christ, drawing the viewer's attention directly to him. At Moissac, this effect is multiplied through the tympanum figures, all of whom twist themselves and tilt their heads in order to see Christ, as if riveted by his power. The detail of the elder (fig. 10.18) shows not only the tilted head, but also the taste for elongated proportions and flat patterns in the Romanesque sculptural style. The beard is rendered as layers of very slightly curved, parallel lines, which are crossed by a diagonal layer of mustache. This pattern is repeated in the long strands of hair and short curls emerging from below the crown.

Another new surface on which Romanesque artists carved sculptures was the **trumeau**. At Moissac, the trumeau figures are even more elongated than the elders, necessitated by the thin, vertical architectural rectangle in which they are located. The relief of *Saint*

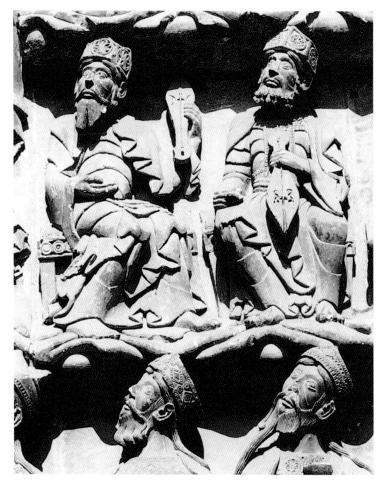

10.18 An elder, tympanum of the south porch (detail of fig. 10.14), Saint-Pierre, Moissac, c. 1115–1135.

10.19 Saint Paul, trumeau of Saint-Pierre, Moissac.

Paul (fig. **10.19**) is lengthened from the waist down, creating an unexpected shift in proportion. The flat drapery folds, despite suggesting the forms of the legs, do not really flow in relation to the body. The diagonal feet, like those in the mosaics of Justinian and Theodora at Ravenna (see Chapter 8), reinforce the illogical quality of the figure's support. In this case, the saint resembles a wooden puppet, hanging as if attached to the trumeau from behind.

The cloister, which was an important part of monastic life, is a prominent feature of Saint-Pierre. It was not only a place of relaxation and meditation for the monks, but also an earthly prefiguration of the peacefulness of heaven. At Moissac, the cloister contains many sculptures on its architectural surfaces.

The figure of Abbot Durand (fig. **10.20**) on the cloister pier is carved in even flatter relief than the *Saint Paul*. The figure is symmetrical and tightly enclosed by the arch and

10.20 Cloister pier with a relief of Abbot Durand, Saint-Pierre, Moissac, 1047–1072. Durand was bishop of Toulouse and abbot of Saint-Pierre, which prospered under his administration. He consecrated a church in the abbey complex in 1063 and commissioned several churches throughout the region under his authority. He is identified by a Latin inscription on the round arch.

10.21 Initial L and Saint Matthew, region of Agen-Moissac, c. 1100. $7\% \times 4$ in. (19.0 \times 10.2 cm). Ms. Lat. 254, fol.10. Bibliothèque Nationale, Paris.

its colonnettes. Abbot Durand is perfectly unified with his frame—his halo, hat, and the curve of his crook echo the round arch, and the crook's staff and the edge of his drapery conform to the outlines of the pier. His head sinks into his shoulders, thereby eliminating his neck and flattening the space. Reinforcing this two-dimensional effect is the frontality of the abbot and the verticality of his feet, which make no pretense of naturally supporting him.

A similar flattened treatment of space characterizes Romanesque manuscript illumination. The *Saint Matthew* in figure **10.21** resembles the relief of Abbot Durand in its frontality, relative symmetry, and setting. Matthew's feet are flat and contained in a patterned semicircle that echoes his halo and the round arch above it. The intertwined human, animal, and floral forms on the initial *L* are typical Romanesque manuscript motifs. Also typical is the contrast between the animation inherent in the initial and the more static, iconic quality of the saint. The interlaced forms are reminiscent of Viking and Anglo-Saxon metalwork, and possibly also of Islamic patterns.

The design on a capital from the Moissac cloister (fig. **10.22**) resembles the tight weave found in Islamic mosque decoration and carpets. Capitals decorated with geometric designs had been in use from the Early Christian period. They assimilated Islamic and Anglo-Saxon motifs

into nonfigural sculpture decoration in churches—a lasting effect of the Iconoclastic Controversy. But during the revival of monumental figurative sculpture in Romanesque churches, capitals offered artists a new surface for narrative scenes and individual figures as well as for geometric patterns.

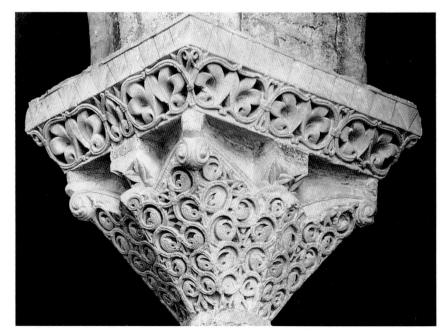

10.22 Capital, north gallery of the cloister, Saint-Pierre, Moissac, c. 1100.

A particularly exuberant Romanesque interlace related to that carved on the capital appears in an eleventh-century manuscript page illuminating the initial T (fig. **10.23**). Its energy is conveyed by the dynamic movement of intertwined forms. And because of their

dynamism, they have an organic character that borders on the figural, despite being geometric. The transition between nature and abstraction is enhanced by the interlaces flanking the *T*, which emerge from the mouths of birds.

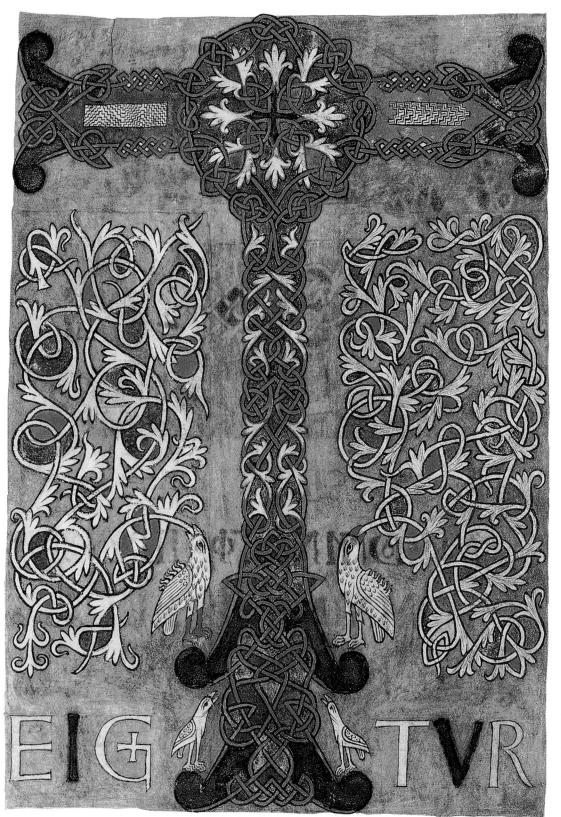

10.23 Initial *T*, from the sacramentary of Saint-Saveur de Figeac, 11th century. Ms. Lat. 2293, fol. 19v. Bibliothèque Nationale, Paris.

Autun

An example of a capital decorated with a narrative scene can be seen in the Flight into Egypt (fig. 10.24) at Autun Cathedral in Burgundy. Autun's sculptures were carved by Gislebertus, who signed his name on the tympanum. The capital shows the Holy Family fleeing the edict of King Herod, which decreed the death of all male children under the age of two. Joseph leads a lively, high-stepping donkey carrying Mary and Jesus out of Bethlehem into Egypt. The capital reflects the taste for elegant surface design characteristic of Romanesque sculpture. Decorative foliage is relegated to the background, and design-filled circles support the figures. Open and closed circle designs are repeated in the borders of the draperies, on Joseph's hat, on the halos, and in the donkey's trappings. Also typical are the repeated curves representing folds, which are carved into the draperies more for their patterned effect than to define organic quality. On Joseph's tunic, the surface curves enhance the impression of backward motion, as if the cloth had been blown by a sudden gust of wind. The Romanesque artist's disregard of gravity is evident in the figure of Jesus. He faces front, with his right hand resting on a sphere held by Mary. He is suspended between her knees, with no indication of support for his weight.

A similar taste for flat patterns and weightlessness characterizes the monumental tympanum at Autun (fig. **10.25**). It depicts a large, imposing, and timeless figure of

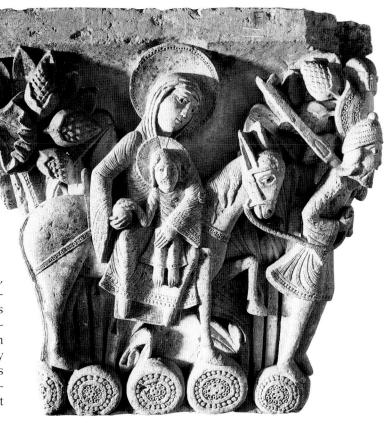

10.24 Gislebertus, capital depicting the *Flight into Egypt*, Cathedral of Saint-Lazare, Autun, Burgundy, France, c. 1130.

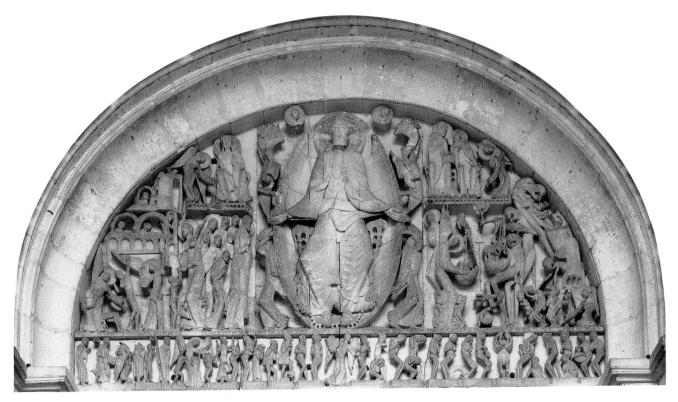

10.25 Gislebertus, Last Judgment, tympanum of the west portal, Cathedral of Saint-Lazare, Autun, Burgundy, c. 1120–1135.

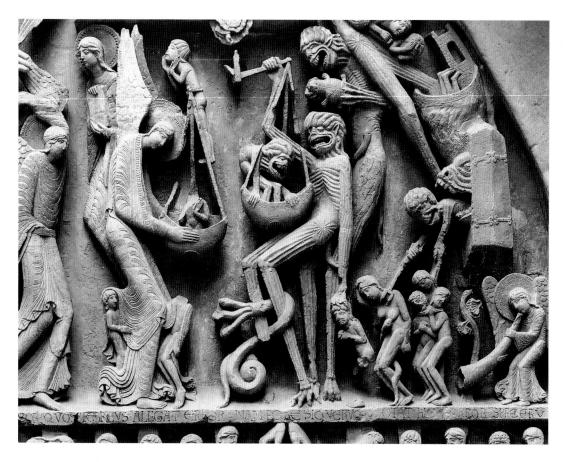

10.26 Gislebertus, Last Judgment (detail of fig. 10.25, showing the weighing of souls). Originally, the effect of scenes such as this was accentuated by colors, for most Romanesque architectural sculptures were brightly painted.

Christ appearing in majestic light at the Last Judgment. Surrounded by a mandorla supported by four angels, Christ sits frontally on a throne and spreads out his arms in a broad gesture proclaiming his divine presence. His drapery forms a pattern of flattened curves that correspond to the curved arms. Zigzags repeat the animated poses of the other figures as well as the diagonals of Christ's legs. On either side of Christ are two tiers of angels and souls-the saved at his right and the damned at his left. Christ's left hand indicates the weighing of the souls on the lower tier (fig. 10.26). The archangel Michael bends at the left of the scale and weighs a soul in human form, while two little souls huddle under his robe for protection. To the right of the scale, two grotesque devils weigh a tiny monstrous demon, who is trying to lower the scale in order to damn the saved soul. At the extreme right, several more damned souls fall downward, denoting their future in hell. In this detail, Gislebertus plays on the theme of physical weight and weightlessness as a metaphor for spirituality and salvation. The irony of his image is that the saved human soul seems to weigh more, for he pulls down the scale, and the damned soul weighs less. Since the damned are destined to "go down," their lesser "substance" is shown by the scale. The saved, on the other hand, "go up," but actually weigh more because of their greater spiritual substance. Just below the devil's side of the scale are small souls being tortured by a devil grasping their necks with tongs. At the far lower left of the tympanum, on the other hand, are two pilgrims (fig. 10.27), iden-

tifiable from their traveling bags and scallop shells. The latter were signs of pilgrimage and resurrection. Here, represented on the tympanum of a church on the pilgrimage road, the shells refer to the belief that pilgrimage is a route to salvation.

On the horizontal strip of stone above these figures, Gislebertus inscribed a verbal warning to accompany his imagery. He asserts that his images are an accurate portrayal of the future that awaits sinners.

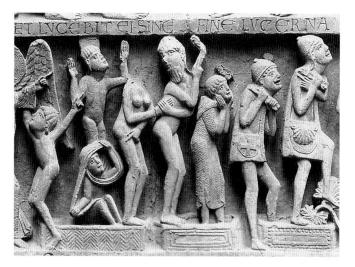

10.27 Gislebertus, *Last Judgment* (detail of fig. 10.25, showing two pilgrims).

The Stave Church of Norway and Stone Interlace

In Norway, the translation of early medieval manuscript interlace into monumental stone relief sculpture became characteristic of later Romanesque churches. A good example is on the twelfth-century west portal of Ål Cathedral (fig. **10.28**), where several elements of early medieval manuscript art are combined. The elaborate curvilinear interlace merges into floral and leaf designs, and is also transformed into animal forms. But rather than being relegated to capital and border designs, this assumes a conspicuous position on the doorjamb.

The derivation of such interlace from wood carving is evident in the headpost from the Oseberg ship burial (see p. 329). In Norway, the custom of building wooden churches (while stone was being adopted elsewhere) persisted into the thirteenth century. A few such stave churches survive-for example, that at Borgund (fig. 10.29). The walls are supported by a timber frame on a foundation of boulders. The frame supports a tall structure containing the nave and occasionally an apse. Projecting from the sides are sloping gables, whose surfaces resemble thatching. The points of the gables, like the prows of Viking ships, were decorated with animal heads, usually dragons. Above each door stood a cross, and at the top of the building was a turret and a spire. The elaborate wood carvings around the portals were similar to stone examples (cf. fig. 10.28).

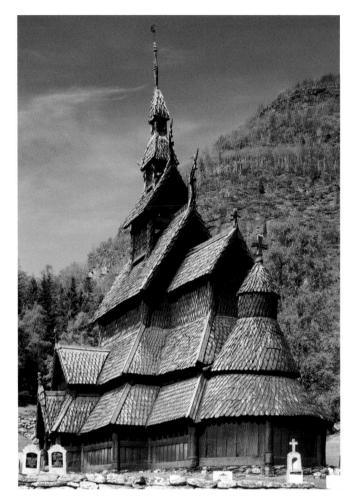

10.29 Borgund stave church, Sogne, Norway, second half of the 12th century.

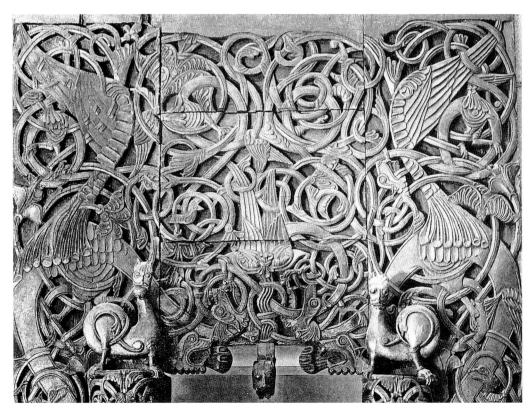

10.28 Decorative detail of interlace sculpture, right jamb of the west portal, Ål Cathedral, Norway, 12th century.

The Italian Romanesque Cathedral Complex at Pisa

The diversity of Romanesque architecture is evident not only in the contrasts between the stave churches of the north and French pilgrimage churches, but also in those of Italy, where Romanesque buildings were influenced by the Classical tradition. These rarely had façade towers or westwork, which were common in France and Germany. The paradigm for Italian Romanesque churches was the Early Christian basilica.

In 1062, the Republic of Pisa, a port on the west coast of Tuscany, defeated the Muslim naval force of Sicily, an island south of Italy. To celebrate their victory, the Pisans used the booty taken from enemy boats to raise funds for a new cathedral. Dedicated to the Virgin, the cathedral was begun the following year, consecrated in 1118, and eventually completed in 1272. In 1153, Pisa celebrated another victory at sea-this time against the Christian Republic of Amalfi, also in the south-by starting the construction of a baptistery opposite the cathedral façade. These two buildings are part of an extraordinary architectural complex that includes the famous "leaning tower" (built 1174-1271) and a thirteenth-century burial ground (the Campo Santo; fig. 10.30). The baptistery's rotunda-like appearance was derived from the Holy Sepulcher in Jerusalem (see box, p. 370), reflecting Pisa's trade with the East.

The cathedral itself (fig. **10.31**) is an amalgam of diverse influences. The entire exterior is of white marble, the

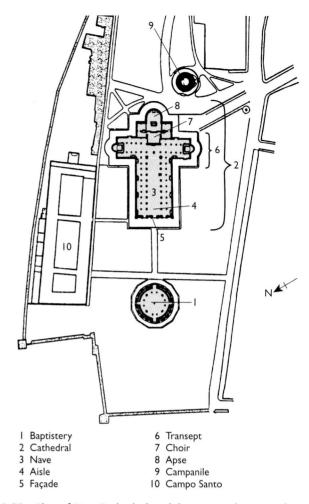

10.30 Plan of Pisa Cathedral and the surrounding complex.

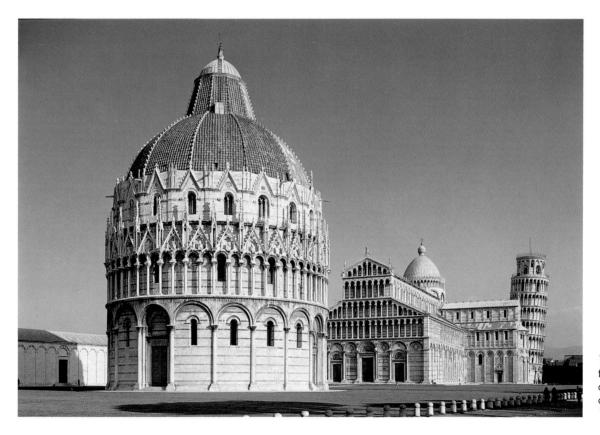

10.31 View of the baptistery, cathedral, and campanile, Pisa, 1053–1272.

material favored in ancient Rome. The cruciform plan (see fig. 10.30) is based on that of the Early Christian basilica with transept arms—each containing an apse at the end—double side aisles, and a flat wooden roof. Arcades separating the nave from the aisles are formed of round arches resting on columns with Corinthian and Byzantine capitals (fig. **10.32**). The apse mosaic is also in the Byzantine style. Islamic features occur in the elliptical dome over the crossing, the interior arch at the end of the nave, and the bronze griffin (now lost), which was looted by the Crusaders and adorned the pinnacle of the façade.

The façade differs from many French examples in the absence of a tympanum illustrating the Last Judgment. Instead, it has three entrances, each of which is flanked by a blind round arch, and is surmounted by four stories of freestanding columns forming arcaded galleries. The arcades continue around the building and create a dynamic surface pattern that unifies the whole. Similar arcades encircle the lower level of the baptistery wall; the upper stories and round dome are later.

Six stories of arcaded galleries are repeated on the cylindrical "leaning tower"—the **campanile** (bell tower) of the cathedral (fig. **10.33**). This was characteristic of Italian churches influenced by Byzantine tradition, in contrast to

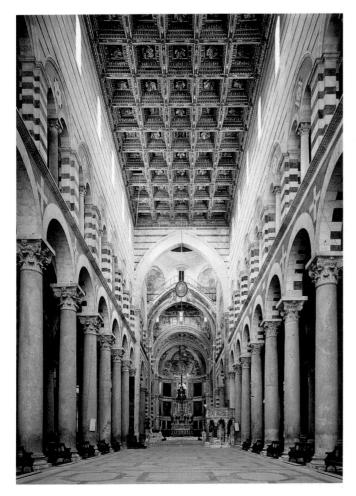

10.32 Nave of Pisa Cathedral, 12th century.

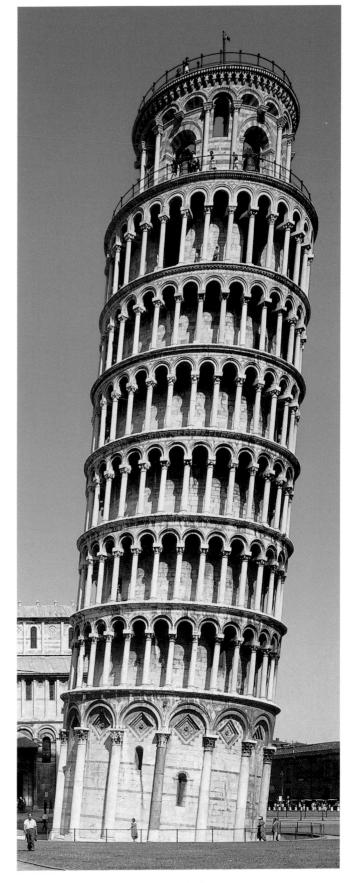

10.33 Campanile of Pisa Cathedral, 1174–1271.

northern Romanesque churches, where westwork was preferred. At Pisa, as elsewhere, the round arches are of Roman inspiration, and their repetition contributes to the sense of unity that pervades the entire complex. The tower leans because it was originally built on a soft foundation; efforts to compensate for the tilt have so far proved unsuccessful. It is now some 13 feet (3.96 m) out of plumb (or off its vertical axis). Recently, a new and firmer foundation has halted the gradual movement, which would eventually have caused the campanile to topple over.

The Romanesque style of architecture at Pisa spread south from northern Italy and the former Yugoslavia to Sardinia. In Tuscany, elements of the style—especially the interior and exterior surface patterns formed by alternating green and white marble—would remain characteristic for several centuries.

Mural Painting

In contrast to those of the Early Middle Ages, Romanesque churches and chapels contain some well-preserved monumental mural paintings. These had both a decorative and a didactic function. Usually, several painters would work on a particular series of murals. The program was generally planned by the principal artist, often in conjunction with a member of the clergy or other patron. A preliminary drawing, in *buon fresco*, was made to prepare outlines and certain details, and compasses were used for repeated curvilinear designs. The painting itself was usually *fresco secco*, possibly redampened so that the plaster would absorb the paint. Sometimes, however, tempera was applied as well. Generally the darker areas were painted before the highlights. In the final stage, the forms would be outlined in black or brown. As in Byzantine mosaics, this technique emphasized the figures rather than creating an illusion of three-dimensional space.

The frescoes in the chapel of Castel Appiano in northern Italy (fig. **10.34**), although damaged, are characteristic in their use of rich colors—blues, greens, browns, and yellows. In the semidome of the central apse, Mary and Christ are enthroned between two angels (fig. **10.35**). The scene is framed by a floral border, interrupted by the base of the throne, whose jeweled golden surface suggests Byzantine influence. A formal unity is created, as the background green repeats the shape of the border, while the blue

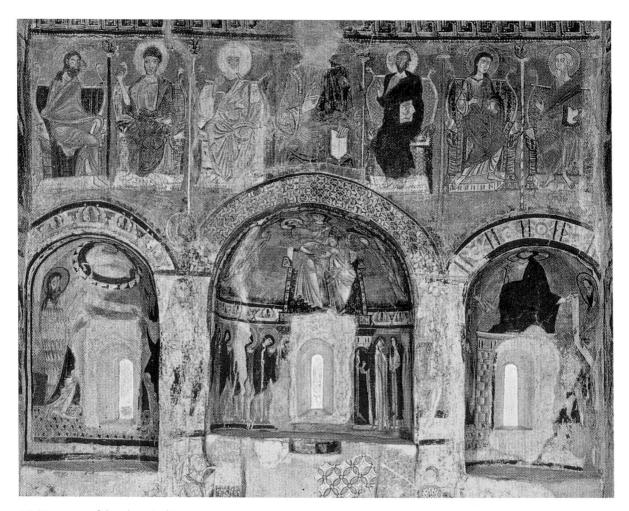

10.34 Apse of the chapel of Castel Appiano, Italy, c. 1200.

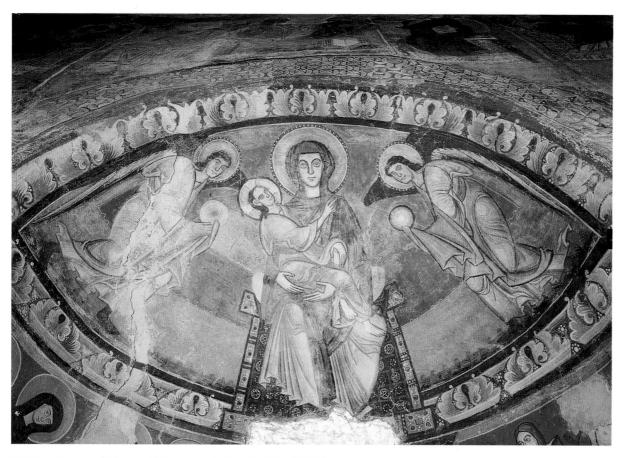

10.35 Mary and Christ with Two Angels (detail of fig. 10.34). Fresco.

repeats the pointed oval of the apse itself. Mary is frontal, staring directly at the viewer. Her draperies echo the background blue and green, and her flat halo repeats the color and beaded designs of the throne. This painting shares certain stylistic features with the capital shown in figure 10.24: although differing in proportions, Christ is a small man held in Mary's lap. His right hand extends upward in a gesture of benediction, and the draperies reflect a taste for elegant, curvilinear surface patterns.

The Bayeux "Tapestry"

One of the most intriguing Romanesque works of art is the so-called Bayeux "Tapestry," which depicts the Norman invasion of England in 1066 (figs. **10.36**, **10.37**, and **10.38**). It is nearly 230 feet (70.10 m) long and contains 626 human figures, 731 animals, 376 boats, and 70 buildings and trees. Such an undertaking probably involved several artists, technicians, and a general designer working together with a historian. Although invariably called a tapestry, the work is actually an embroidery, made by stitching eight colors

of wool onto bleached linen. We have no records of who the artists were, but most medieval embroidery was done by women, especially at the courts.

The "tapestry" may have been created for the cathedral of Bayeux in Normandy, near the northern coast of France. It is not recorded as being in the cathedral until the fifteenth century, and scholars disagree about its original location. The "tapestry" was probably commissioned by Bishop Odo of Bayeux, half-brother of William the Conqueror; the events depicted on it unfold from left to right and are accompanied by Latin inscriptions. The detail in figure 10.36 shows William the Conqueror leading a group of Norman nobles, including Odo, on a charge against the English. This scene takes place on Saturday morning, October 14, 1066, when William's army departed from Hastings to fight Harold, the Saxon king of England.

All the riders are helmeted and armed. Their chain mail is indicated by circular patterns within the outlines of the armor. Odo holds a mace, while the nobles carry banners, shields, and lances. The weapons, held on a diagonal, increase the illusion of forward movement, as Odo clashes with the enemy. The ground is indicated by a wavy line on a horizontal plane, but, aside from the overlapping of

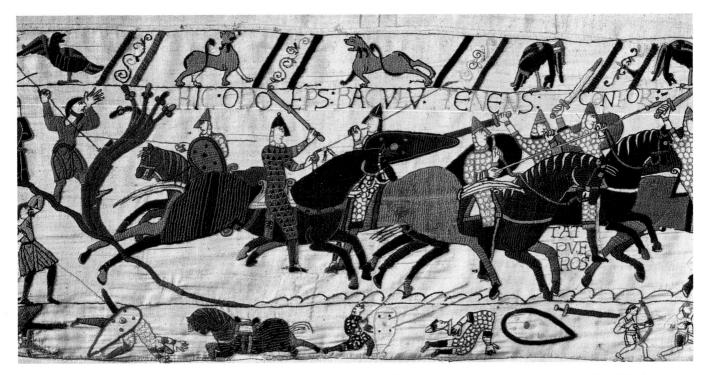

10.36 Detail of a battle scene showing Bishop Odo brandishing a mace, from the Bayeux "Tapestry," c. 1070–1080. Wool embroidery on linen, 20 in. (50.8 cm) high. Musée de l'Évêché, Bayeux. Note how the smooth texture of the linen contrasts with the rough texture of the raised woolen threads. Single threads were used for waves, ropes, strands of hair on the horses' foreheads, and the outlines of each section of color.

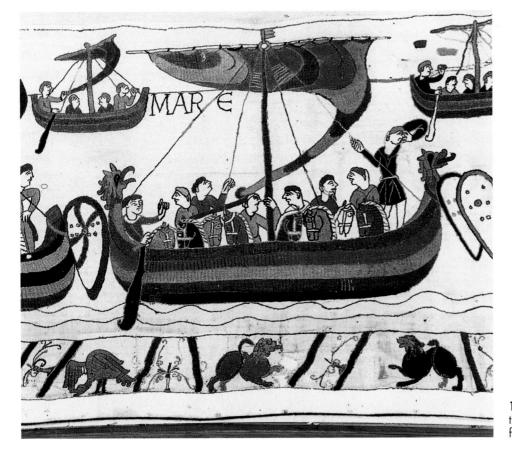

10.37 Detail of Viking ships from the Bayeux "Tapestry." *MARE* is Latin for "sea."

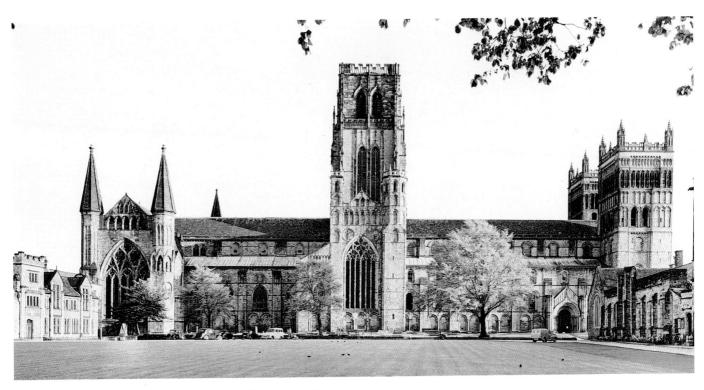

10.42 Exterior of Durham Cathedral, England, begun 1093.

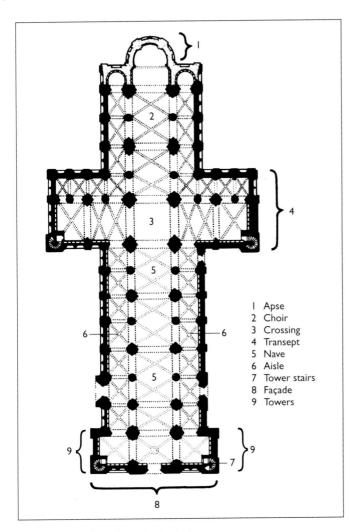

10.43 Plan of Durham Cathedral.

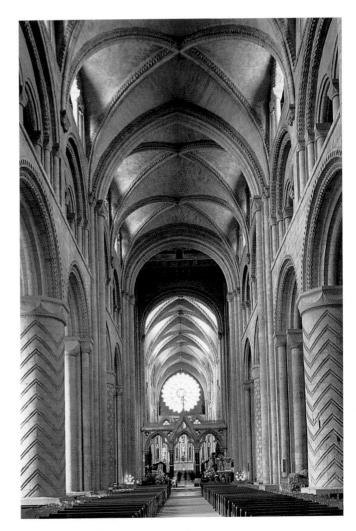

10.44 Nave, Durham Cathedral.

10.40 Plan of Saint-Étienne, Caen.

A few years after the completion of Saint-Étienne's nave, the French bishop of Durham, William of Calais, supervised the first European cathedral with rib vaults and pointed arches (see diagrams of arches, fig. 10.5). Durham had been an important religious center for centuries because it contained the relics of Saint Cuthbert, bishop of Lindisfarne in the seventh century. But William decided to erect a Norman cathedral (see figs. 10.42 and 10.43) in place of the existing Saxon church.

The vaults of the choir were finished by 1104, and the nave, finished in 1133, shows some of the advantages of combining the pointed arch with a second transverse rib (fig. 10.44). This divided the vault into seven sections and allowed for increased height, while relieving the massiveness of the Romanesque walls. It also made larger clerestory windows possible, which opened up the wall space and admitted more light. Surface decoration on the piers,

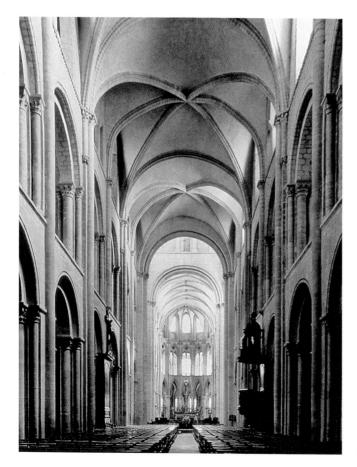

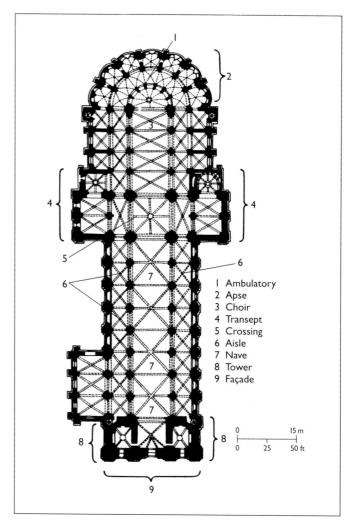

consisting of chevron and other patterns, and the interlaces of the nave arches contribute to the impression of lightness. They also reflect the continuing influence of Viking and Hiberno-Saxon design.

The success of Durham's vaulting inspired the builders of Saint-Étienne to change the original flat, wooden roof of the nave into sexpartite (six-part) stone vaulting (see fig. 10.41), a project that was completed in 1120. This, like the three-part façade, influenced the development of Early Gothic architecture, which is the subject of the next chapter.

10.41 Nave, Saint-Étienne, Caen, 1067–1087. The vaults date from 1115–1120.

certain groups of figures, there is little attempt to depict three-dimensional space. Above and below the narrative events are borders containing human figures (note the decapitated figure below), natural and fantastic animals, and stylized plant forms.

The Viking longboats from William's fleet (fig. 10.37) reflect the Scandinavian origins of the Normans. Ready to set sail for England, they are propelled by oars and a sail. The man at the far left steers the boat by means of the fixed, rotating rudder characteristic of Viking ships. The prows are decorated with carved dragon heads. Two shields are attached to the bow, and these are believed to have been antiramming devices.

Figure 10.38 shows several craftsmen putting finishing touches on the boats. Above, the figure on the left holds an adze, and the one on the right drills holes into which the oars will be inserted. The two figures below are using axes of the type illustrated in figure 9.18. Note that their feet are visible beneath the ship, a rudimentary attempt to create a sense of three-dimensional space.

Unlike the other Romanesque works of art discussed in this chapter, the Bayeux "Tapestry" is secular in subject. The events depicted in it are primarily historical, although they are shown from the Norman point of view. While the Latin text helps to explain the images, much of the narrative is transmitted through the pictures themselves, and many of the details remain puzzling.

Romanesque Precursors of Gothic: Caen and Durham

Beginning in the twelfth century, new developments would arise in the architecture of western Europe. The scale of cathedrals would be expanded by Gothic (see Chapter 11) architects, and new trends in naturalism would emerge in sculptural and pictorial styles. But Gothic architecture did not emerge suddenly or without precedent, and for a while it overlapped building in the Romanesque style.

Precursors of Gothic are seen in the abbey church of Saint-Étienne at Caen, in Normandy (figs. 10.39, 10.40, and 10.41) and at Durham Cathedral (figs. 10.42, 10.43, and 10.44) in northeastern England. Saint-Étienne was begun in 1067 at the behest of William the Conqueror, who was determined to impose Norman architecture in England as well as in northern France. The nave of Saint-Étienne was completed in 1087, with a flat wooden roof, followed by the façade (see fig. 10.39) around 1096 to 1100. The latter is organized into three distinct vertical sections —a central rectangle surmounted by a gable and flanked by towers-that accentuate its upward thrust. The three horizontal sections divided by thin stone stringcourses reflect the three stories of the interior. This type of façade would evolve into characteristic Gothic forms designed to emphasize the verticality of the wall as indicated by the height of the spires, which are a later Gothic addition.

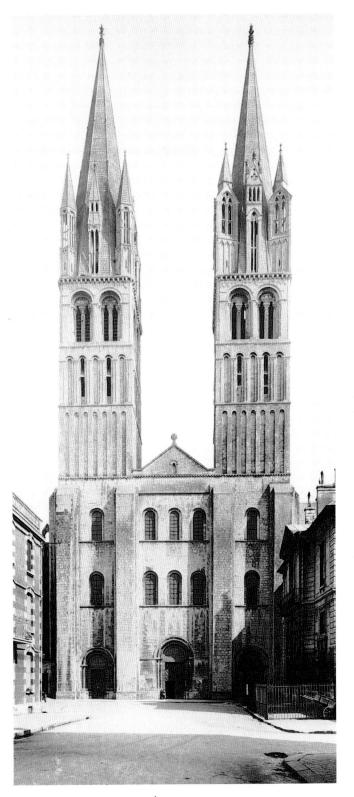

10.39 West façade, Saint-Étienne, Caen, Normandy, France, 1067–1087.

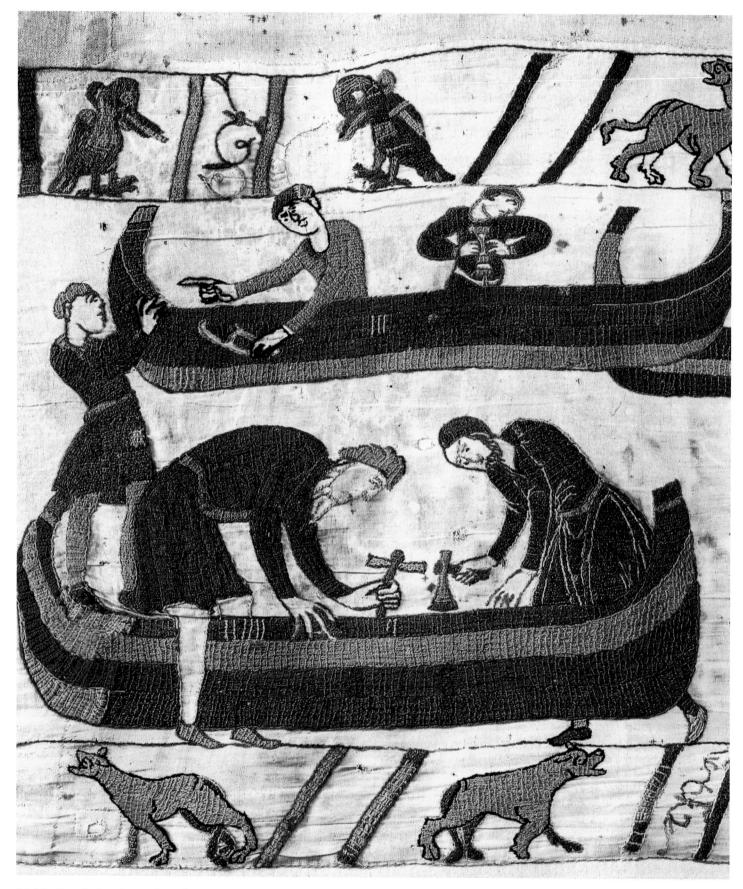

10.38 Detail of craftsmen from the Bayeux "Tapestry." (Figs. 10.36–10.38 by special permission of the city of Bayeux.)

Style/Period

ROMANESQUE 10th century

900

ROMANESQUE 11th century

Sacramentary, Saint-Sauveur de Figeac

ROMANESQUE 12th century

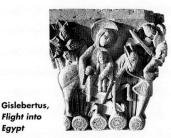

ROMANESQUE 13th century

Gislebertus, Last Judgment

Works of Art

Sacramentary, Saint-Sauveur de Figeac (10.23)

Church of Sainte-Foy (10.3–10.4, 10.6, 10.9–10.11), Conques Pisa Cathedral (10.31–10.33) Bayeux "Tapestry" (10.36–10.38) Stavelot Bible (10.16)

Bayeux "Tapestry"

New Testament initial L and Saint Matthew (10.21), Agen-Moissac Church of Saint-Pierre (10.12, 10.14-10.15, 10.17-10.20, 10.22), Moissac Interlace sculpture (10.28), Ål Cathedral, Norway Gislebertus, Last Judgment (10.25-10.27), Cathedral of Saint-Lazare, Autun Gislebertus, Flight into Egypt (10.24), Cathedral of Saint-Lazare, Autun Stavelot Triptych (10.1-10.2) Abbey church of Saint-Étienne (10.39, 10.41), Caen Pisa Cathedral campanile (10.33)

Borgund stave church (**10.29**), Sogne Durham Cathedral (**10.42**, **10.44**)

Chapel of Castel Appiano (10.34-10.35)

Castel Appiano

Cultural/Historical Developments

First canonization of saints (993)

Leif Ericsson reported to have discovered America (Nova Scotia and New England) (1000) Chinese make gunpowder (1000) Normans under William the Conqueror invade England (1066) Appearance of Halley's comet (1066) Excommunication of married priests (1074) Building of the Church of Santiago de Compostela, Spain, begins (1075) Building of the Tower of London begins (1078) Peter Abelard, French theologian and philosopher, born 1079 (d. 1142) Church of San Marco, Venice, completed (1094) First Crusade; Crusaders take Jerusalem (1095–1099)

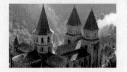

Sainte-Foy

Song of Roland, French heroic poem, written (c. 1100)

First appearance of Gothic architecture (mid-1100s) Carmelite Order founded (second half of 12th century)

Building of Nôtre-Dame, Paris (1163–1235) Founding of Oxford University (1167) Murder of Thomas à Becket at Canterbury (1170) Construction of Chartres Cathedral begins (1194)

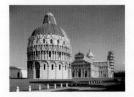

Pisa Cathedral complex

Founding of the University of Paris (the Sorbonne) (1200)

Francis of Assisi founds the Franciscan Order (1209) King John signs the Magna Carta, limiting the absolute powers of the monarchy (1215)

First Lateran Council of bishops establishes

confession, relic worship, and transubstantiation as Catholic doctrines (1215)

Genghis Khan, Mongol ruler, crosses Asia and Russia and threatens Europe (1206–1223) Founding of the Dominican Order (1216)

0

200

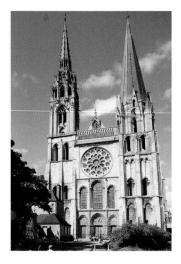

Gothic Art

G othic cathedrals are among the greatest and most elaborate monuments in stone. The term *Gothic* is applied primarily to the architecture, and also to the painting and sculpture, produced in western

Europe from about the middle of the twelfth century in France to the sixteenth century in some parts of Europe. The term was first used by Italians in the sixteenth century to denigrate the art preceding their own Renaissance style. Literally, *Gothic* refers to the Germanic tribes who invaded Greece and Italy, and sacked Rome in A.D. 410. The Goths were blamed for destroying what remained of the Classical style. In fact, however, the origins of Gothic art had nothing to do with what had happened several hundred years earlier. By the nineteenth century, when scholars realized the source of the confusion, it was too late. Gothic remains the accepted name of the style discussed in this chapter.

The Origins of the Gothic Style in France

The time and place in which the Gothic style emerged can be identified with unusual precision. It dates from 1137– 1144, and it originated in the Île-de-France, the region in northern France that was the personal domain of the French royal family. The credit for its invention goes to one remarkable man, Abbot Suger of the French royal monastery at Saint-Denis, which is about 6 miles (10 km) north of Paris.

Suger was born in 1084 and educated in the monastery school of Saint-Denis along with the future French king, Louis VI. Suger later became a close political and religious adviser to both Louis VI and Louis VII, and remained a successful mediator between the Church and the royal family. While Louis VII was away on the Second Crusade (1147–1149), Suger was appointed regent of France.

In 1122, Suger was named abbot of Saint-Denis, which had a special place in French history. Not only was Denis, the first bishop of Paris and the patron saint of France, buried there, but it was also the burial place of the French royal family. Suger conceived a plan to rebuild and enlarge the eighth-century Carolingian church of Saint-Denis. He intended to make it the spiritual center of France and searched for a new kind of architecture to reinforce the divine right of the king's authority and enhance the spirituality of his church. The rebuilding program did not start until 1137, and in the meantime Suger made extensive preparations. He studied the biblical account of the construction of Solomon's Temple and immersed himself in what he thought were the writings of Saint Denis. (Scholars now believe that Suger was reading the works of Dionysius, a sixth-century mystic theologian.)

Suger was inspired by the author's emphasis on the mathematical harmony that should exist between the parts of a building and the miraculous, even mystical, effect of light. This was elaborated into a theory based on musical ratios; the result was a system that expressed complex symbolism based on mathematical ratios. The fact that these theories about light and the mathematical symbolism of architecture could be attributed to Saint Denis made them all the more appealing to Abbot Suger. In his preoccupation with light, Suger was thinking in a traditional Christian framework, for the formal qualities of light had been associated with Christ and divinity since the Early Christian period. In his reconstruction of the church, Suger rearranged the elements of medieval architecture to express the relationship between light and God's presence in a distinctive way. None of the individual architectural devices that Suger and his builders used was new; it was the way in which he synthesized elements of existing styles that was revolutionary. Alone among great art patrons of this time, Suger wrote an extensive memoir of the work he commissioned and his reasons for commissioning it. The Book of Suger, Abbot of Saint-Denis describes the beginning of work on Saint-Denis as follows:

The first work on this church which we began under the inspiration of God [was this]: because of the age of the old walls and their impending ruin in some places, we

summoned the best painters I could find from different regions, and reverently caused these [walls] to be repaired and becomingly painted with gold and precious colors. I completed this all the more gladly because I had wished to do it, if ever I should have an opportunity, even while I was a pupil in school.¹

Early Gothic Architecture: Saint-Denis

Suger's additions to Saint-Denis consisted of a new narthex and west façade with twin towers and three portals (fig. **11.1**). Most of the original sculptural decoration on

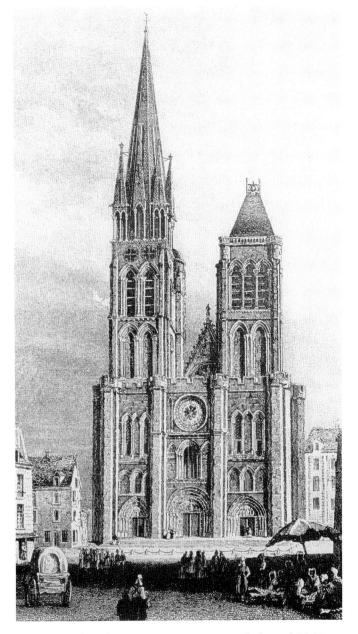

11.1 West façade, Saint-Denis, near Paris, dedicated 1140. After an engraving by A. and E. Rourgue, before the 19th-century restoration.

the portals has since been lost. On the interior, Suger retained the basic elements of the Romanesque pilgrimage choir that had made it possible for large crowds of pilgrims to visit the church without disturbing the clergy. A semicircular ambulatory in the apse permitted the lay public to circulate freely, while the clergy remained in the radiating chapels. But Suger combined these elements in an original way (figs. **11.2** and **11.3**).

Under Suger's revision, the arrangement of the chapels is a formal echo of the ambulatory, which creates a new sense of architectural unity. Suger's **chevet** (the east end of the church, comprising the choir, ambulatory, and apse) also emphasized the integration of light with lightness because the entire area was covered with **ribbed vaults**

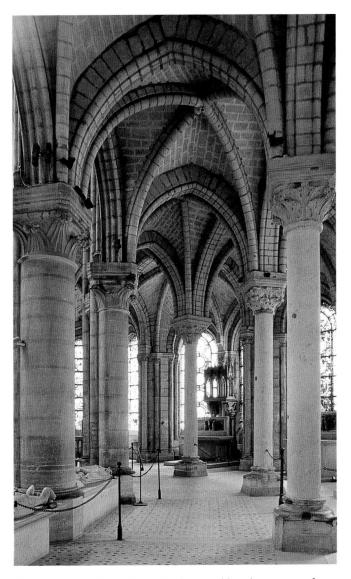

11.2 Interior of Saint-Denis. Each chapel bay has a pair of large stained-glass windows, delicate columns, and pointed vaults. The ambulatory and chapels have become a series of large windows supported by a masonry frame. Suger described the new effect as "a circular string of chapels, by virtue of which the whole [sanctuary] would shine with the miraculous and uninterrupted light of the most luminous windows."

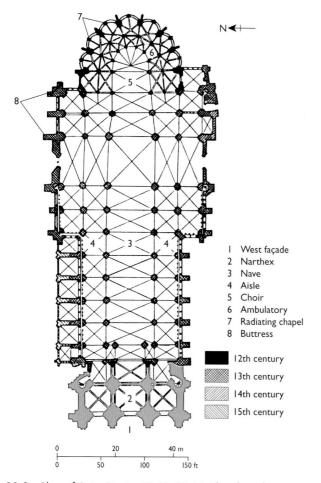

11.3 Plan of Saint-Denis, 1140–1144. The chapels are connected shallow bays, which form a second ambulatory parallel to the first. This arrangement creates seven wedge-shaped compartments radiating out from the apse. Each wedge is a trapezoidal unit (in the area of the traditional ambulatory) and a pentagonal unit (in the radiating chapel). The old nave and the choir were rebuilt in the High Gothic style between 1231 and 1281.

(fig. **11.4**) supported by pointed arches. The Romanesque builders, in contrast, had restricted the lighter vaulting to the ambulatory. The arches, in turn, were supported by slender columns, which further enhanced the impression of lightness. On the exterior, thin buttresses were placed between the chapels (fig. **11.3**) to strengthen the walls. Suger's new architectural approach attracted immediate attention because the effect was so different from the dark interiors and thick, massive walls of Romanesque architecture. He describes the effect of his changes on the interior light in the verses of the consecration inscription:

Once the new rear part is joined to the part in front, The church shines with its middle part brightened. For bright is that which is brightly coupled with the bright,

And bright is the noble edifice which is pervaded by the new light;

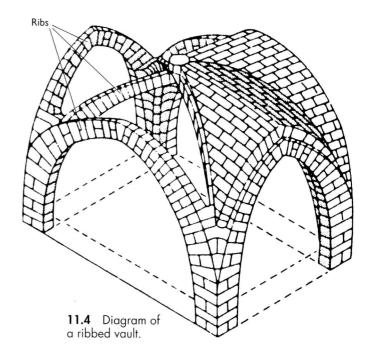

Which stands enlarged in our time, I, who was Suger, being the leader while it was being accomplished.²

The new style was particularly popular in northern and central France, where royal influence was strongest. From the 1230s to 1250, French architects designed over eighty cathedrals. Notwithstanding the close association of Gothic with France (it was soon dubbed *opus francigenum*, or "French work"), the style migrated north to England, south to Spain, and east to Germany. There was also an Italian Gothic period, although Italy was the region that welcomed the style least and rejected it soonest.

Elements of Gothic Architecture

Ribbed Vaults

In Gothic architecture, the ribbed vault (fig. 11.4) supersedes the earlier barrel vaults typical of Romanesque. The advantage of the ribbed vault is that it requires less buttressing, whereas the barrel vault exerts pressure along its entire length and thus needs strong buttressing. Since the weight of the ribbed vault is concentrated only at the corners of the bay, the structure can be buttressed at intervals, freeing up more space for windows. The ribs could be built before the intervening space (usually triangular or rectangular) was filled in. Adding ribs also enabled Gothic builders to reinforce the vaults and to distribute their weight more efficiently. Because of the weight-bearing capacity of the ribs, the vault's surfaces (the **web**, or infilling) could be made of lighter material.

Piers

As the vaults became more complex, so did their supports. One such support is the cluster, or **compound**, **pier** (fig. **11.5**). Although compound piers had been used in some Romanesque buildings, they became a standard Gothic feature. The ribs of the vaults formed a series of lines which were continued down to the floor by colonnettes resting on compound piers.

With this system of support, the Gothic builders created a vertical unity leading the observer's gaze to the clerestory windows, the architectural source of interior light. The pier supports, with their attached colonnettes branch-

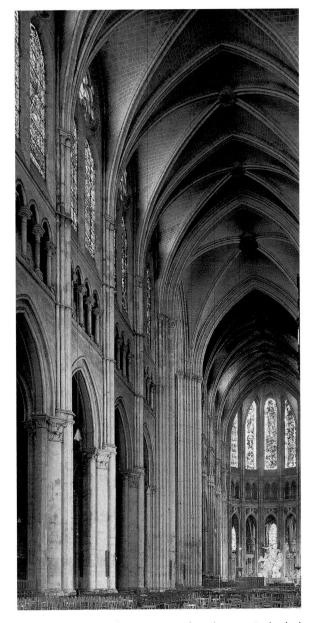

11.5 View of piers in the nave arcade, Chartres Cathedral, France, 13th century. The compound piers along the two sides of the nave are massive columnar supports to which clusters of colonnettes, or pilaster shafts, are attached. The clusters usually correspond to arches or vault ribs above them.

ing off into arches and vaults, have been likened to the upward growth of a tree.

Flying Buttresses

In Romanesque architecture, thick walls performed the function of buttressing. This decreased the amount of available window space, limiting the interior light. In the Gothic period, builders developed the flying buttress, an exterior structure composed of thin half arches, or flyers. This supported the wall at the point where the thrust of an interior arch or vault was greatest (fig. **11.6**).

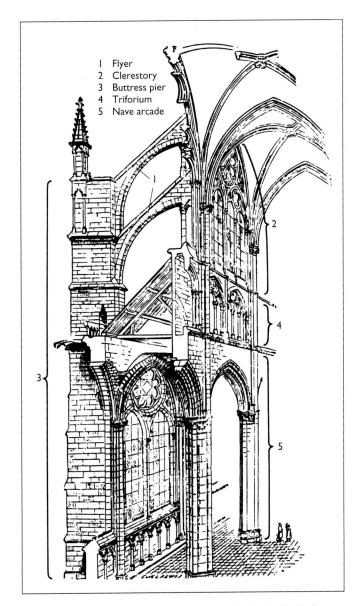

11.6 Section diagram of a Gothic cathedral (after E. Violletle-Duc). The **elevation** of the Gothic cathedral illustrates the flyers, which transfer interior thrusts to a pier of the exterior buttress. Since the wall spaces between the buttresses were no longer necessary for structural support, they could be pierced by large windows to increase the light.

Pointed Arches

The pointed arch, which is a characteristic and essential feature of Gothic architecture, can be thought of as the intersection of two arcs of nonconcentric circles. Examples are found in Romanesque buildings but in a much more tentative form. The piers channel the thrust of the pointed arch downward, minimizing the lateral, or sideways, thrust against the wall. Unlike round arches, pointed arches can theoretically be raised to any height regardless of the distance between their supports. The pointed arch is thus a more flexible building element with more potential for increased height. Dynamically and visually, the thrust is far more vertical than that of a round arch.

Stained-Glass Windows

Finally, the light that had so inspired Abbot Suger required an architectural solution. That solution was Suger's special use of the stained-glass window. Suger was not seeking natural daylight, but rather light that had been filtered through colored fragments of glass. Light and color were diffused throughout the interior of the cathedral, producing a different kind of radiance than had been achieved in Early Christian and Byzantine buildings. The predominant colors of Gothic stained glass tend to be blue and red in contrast to the golds that characterize most Byzantine mosaics.

Stained glass is translucent colored glass cut to form a window design. Compositions are made from pieces of colored glass formed by mixing metallic oxides with molten glass or fusing colored glass with clear glass. The artist cuts the individual pieces as closely as possible to the shape of the face or other individual feature to be represented. The pieces are then fitted to a model drawn on wood or paper, and details are added in black enamel.

The dark pigments are hardened and fused with the glass through firing (baking in a kiln). The pieces of fired glass are then arranged on the model and joined by strips of lead. Figure **11.7** shows a detail of a stained-glass window from Chartres Cathedral. Jeroboam, an Old Testament king, is shown praying before two golden calves. The red background is broken up, seemingly at random, into numerous sections. In the figures, however, the lead is arranged to conform either to an outline or to a logical location within the forms. Lead strips frame the head of the first calf and outline Jeroboam's crown. Once the pieces of stained glass are joined together, the units are framed by an iron armature and fastened within the tracery, or ornamental stonework, of the window.

Stained-glass windows were made occasionally for Early Christian and Byzantine churches and more often in the Romanesque period. In the Gothic period, stained glass became an integral part of religious architecture and a more prominent artistic medium.

11.7 Jeroboam Worshiping Golden Calves, detail of a **lancet** under the north **rose window** (see fig. 11.25), Chartres Cathedral, early 13th century.

The Age of Cathedrals

Chartres

By the time that the choir and west façade of Saint-Denis were completed, in about 1144, and even before Abbot Suger turned his attention to the rest of the church, other towns in northern France had been competing to build cathedrals in the new Gothic style. A cathedral is, by definition, the seat of a bishop (from the Greek word *kathedra*, meaning "seat" or "throne") and belongs to the city or town in which it is located. In contrast to churches such as Sainte-Foy (see Chapter 10), which were often built in rural areas, cathedrals required a more urban setting. Also consistent with increased urbanization in the twelfth century was the development of cathedral schools and universities. Their growing educational importance encroached on the relatively isolated monasteries that had proliferated in the earlier Middle Ages.

The construction of a cathedral was the largest economic enterprise of the Gothic era. It had a significant effect on neighboring communities as well as on the city or town itself. Jobs were created for hundreds of masons, carpenters, sculptors, stonecutters, and other craftsmen. When a cathedral was finished, it attracted thousands of pilgrims and other visitors, and this continual traffic stimulated the local economy. Cathedrals also provided a focus for community activities, secular as well as religious. Above all, they generated an enormous sense of civic pride among the townspeople.

Guilds

Medieval **guilds**, or gilds, were associations formed for the aid and protection of their members and the pursuit of common religious or economic goals. The earliest form of economic guild was the Guild Merchant, which was responsible for organizing and supervising trade in the towns. Efforts by merchants to exclude craftsmen from the guilds led in the twelfth and thirteenth centuries to the formation of the craft guilds. These comprised all practitioners of a single craft or profession in a town. Craftsmen had to be members of the guild before they could ply their trade.

The functions of the craft guilds included regulating wages and prices, overseeing working conditions, and maintaining

The cult of the Virgin Mary expanded during the Gothic period. Most of the great French cathedrals were dedicated to "Notre Dame"—that is, "Our Lady," or the Virgin. To avoid confusion, therefore, it is customary to refer to the cathedrals by the towns in which they are located. At Chartres, the Virgin Mary played a particularly significant role as the embodiment of the church building and the Bride of Christ. Her strong link to Chartres reflected the tradition that a pagan statue of a virgin and child worshiped in a nearby cave had prefigured the coming of Christ and the Virgin Birth. One effect of this legend was the preeminence of Chartres in Mary's cult.

The town of Chartres is approximately 40 miles (64 km) southwest of Paris. Its cathedral (cf. fig. 11.11) combines the best preserved early Gothic architecture with High Gothic, as well as demonstrating the transitional developments in between. For a town like Chartres, with only about 10,000 inhabitants in the thirteenth century, the building of a cathedral dominated the economy just as the structure itself dominated the landscape. At Chartres, the construction

tion continued off and on from around 1134 to 1220. The most intensive work, however, followed a fire in 1194, when the nave and choir had to be rebuilt.

The bishop and chapter (governing body) of the cathedral were in charge of contracting out the work. The funds, however, came from a much broader cross section of medieval French society. The church itself usually contributed by setting aside revenues from its estates. At Chartres, the canons (resident clergy) agreed in

11.8 Carpenters' Guild signature window, detail of a stained-glass window, Chartres Cathedral, early 13th century. This signature scene depicts two carpenters at work on a plank of wood lying across three sawhorses.

high standards of workmanship. Their effect, especially early on, was to ensure an adequate supply of trained workers and to enhance the status of craftsmen. They also provided charity to members in need and pensions to their widows.

The guilds had three grades of membership—masters, journeymen (paid assistants, *compagnons* in French), and apprentices. A precise set of rules governed the terms of apprenticeship and advancement to other grades. For promotion to the rank of master, a craftsman had to present to his guild a piece of work to be judged by masters. This is the origin of the term *masterpiece*.

1194 to give up their stipends (salaries) for three years so that the rebuilding program could begin. When the royal family or members of the nobility had a connection with a particular project, they also helped. At Chartres, Blanche, the mother of Louis IX, donated funds for the entire north transept façade, including the sculptures and windows. The duke of Brittany contributed to the southern transept. Other wealthy families of the region gave windows, and their donations were recorded by depicting their coats of arms in the stained glass.

Guilds (see box) representing specific groups of craftsmen and tradesmen donated windows illustrating their professional activities (fig. **11.8**). Pilgrims and less wealthy local inhabitants gave money in proportion to their means, often by buying relics or in gratitude for answers to prayers. These donations went toward general costs rather than to a designated use. There were thus economic and social distinctions not only in the size and nature of the contributions, but also in the degree to which they were publicly recognized.

Workers and Master Builders

Chartres was one of the over eighty cathedrals and large abbeys constructed in the region around Paris in the thirteenth century. Each one was an enormous undertaking fraught with problems, including fires and poor weather. To make matters worse, funds often ran out in the course of a building project, which meant that work came to a halt. Without banks, there was no system for building up capital or long-term financial planning. It also took three to six months for mortar to set, depending on the weather. And whenever work stoppages did occur, the workers were dismissed and moved on to other cathedrals that would hire them. As a result, the workforce often lacked continuity, which is reflected in stylistic variations of the finished building.

Supervising the construction of every cathedral was the master builder, usually a literate, well-traveled man who had been to school and apprenticed to an older master at the age of thirteen. Typically, he would be well paid and acquainted with both the clergy and the nobles helping to finance the project. He would also understand the iconographic significance of the artistic program. A sign of the high status of the master builder was the custom of inscribing his name in the labyrinth design on the cathedral floor. In some cases, he was even buried along with royal patrons and bishops in a cathedral he had built. The social position of the master builder was sufficiently high that it became a convention to criticize his vanity, for he was conceived of as building the City of God on earth (see box). We have seen from the story of the Tower of Babel (see fig. I.7) that the theme of architectural vanity is an ancient one: it is also explored in the classic play The Master Builder, by the nineteenth-century Norwegian writer, Henrik Ibsen (1828-1906).

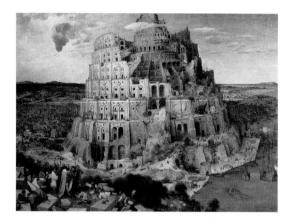

See figure 1.7. Bruegel the Elder, *The Tower* of Babel, 1563.

In the Gothic period, master builders worked from templates, which were birchwood replicas of numbered stones. Corresponding numbers were marked on the vaults and elevations to indicate the location of each stone. Each master builder designed his own template, which he took with him if he had to stop work on one cathedral and move on to another. The next master could then continue the work from his predecessor's drawings.

Stones were cut at a quarry and brought by a carter to the building site. There, a foreman sorted the stones according to size and shape, and assigned them to groups of eight to twelve workers. At Chartres, there were over four hundred workers to be supervised, and hundreds of stones were carted from a quarry 7½ miles (12 km) away from the site. Since there were no power tools, stones had to be individually cut and dressed. They were raised up by huge

Saint Augustine's City of God

Saint Augustine (354–430), bishop of Hippo in North Africa and later a doctor of the Church, had an immense impact on the development of Christian thought. His mother was a Christian and his father a pagan, and he himself embraced several philosophies before his baptism as a Christian in 387. He fought heresy and wrote prodigiously; his two best-known works are the *Confessions*, an autobiographical account up to the time of his conversion, and *The City of God (De civitate Dei)* (in 22 books), written between 413 and 426. The latter opens with a reply to the pagans, who sacked Rome under the leadership of Alaric the Goth in 410.

One of Augustine's main historical themes is the opposition of the Christian world to the non-Christian world. He contrasted the City of God, the Heavenly City, with the Earthly City, and transience with permanence: Most glorious is and will be the City of God, both in this fleeting age of ours, wherein she lives by faith, a stranger among infidels, and in the days when she shall be established in her eternal home.³

It is likely that Augustine had been influenced by Plato's *Republic* (see Chapter 5) and the work of other Classical philosophers as well as by Old Testament references to the city of Jerusalem. These are essentially architectural metaphors that extend through Christianity from its very beginnings. In a sense, every Christian church—especially the cathedral—was seen as a typological parallel to Solomon's Temple and as a metaphor for the city of Jerusalem and the Heavenly City of God.

11.9 Geometric architectural diagrams from the sketchbook of Villard de Honnecourt, c. 1225, from R. Willis. Bibliothèque Nationale, Paris.

cranes (of which there were four at Chartres) and by small cranes, or winches, which were powered by the workers themselves. At Chartres, some 45 tons of stone were raised in an average day. Scaffolds also had to be built because of the great heights involved, and workers had to learn how to protect themselves from accidents.

Since technology was limited, precision on the part of the master builder was crucial. His instruments were rudimentary; they consisted of a compass, a square, straightedges (rules), measuring rods, and proportional dividers. His template was organized according to geometric principles, which accounts for the overall formal unity of the cathedrals. Geometry was easy to replicate, so that even if several master builders worked at a particular cathedral, the completed building was a unified structure. Figures **11.9** and **11.10** illustrate pages from the only surviving sketchbook made around 1225 by a master builder known as Villard de Honnecourt. They show the geometric basis by which both architecture and human and animal forms were conceived and designed.

11.10 Geometric analysis of human and animal figures from the sketchbook of Villard de Honnecourt, c. 1225, from R. Willis. Bibliothèque Nationale, Paris.

The Exterior Architecture of Chartres

Chartres (fig. **11.11**) was constructed on an elevated site to enhance its visibility. The vertical plane of its towers seems to reach toward the sky, while the horizontal of the side walls (fig. **11.12**) carries one's gaze east toward the apse (fig. **11.13**). Figure 11.11 shows the west façade, whose towers illustrate the dynamic, changing nature of Gothic style. The southern tower, on the right, dates from before 1194 and reflects the transition from Late Romanesque to Early Gothic. The northern tower, begun in 1507, which is taller, thinner, and more elaborate than the southern tower, is Late Gothic. Its greater height reflects advances in structural technology as well as Suger's theological emphasis on verticality and light as expressions of God's presence.

The tripartite organization of Chartres' west façade is characteristic of most Gothic cathedrals. Like the Romanesque church of Saint-Étienne at Caen (see fig. 10.39), it is divided into three sections. Towers with a belfry flank

11.11 West façade of Chartres Cathedral, c. 1140–1150. Symmetry in the Classical sense was not a requirement of the Gothic designers. Gothic cathedrals are structurally, but not formally, symmetrical—that is, a tower is opposite a tower, but the towers need not be identical in size or shape.

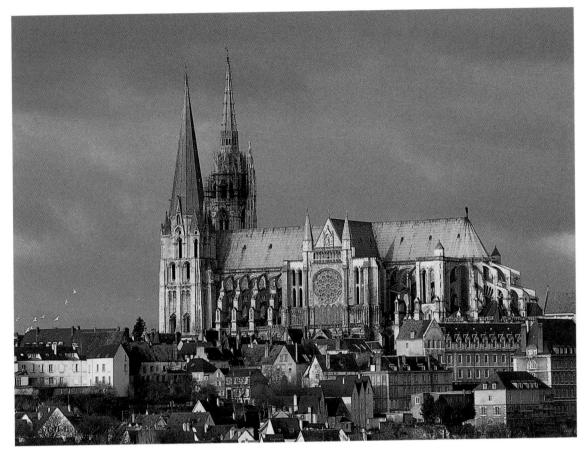

11.12 South wall of Chartres Cathedral, 13th century.

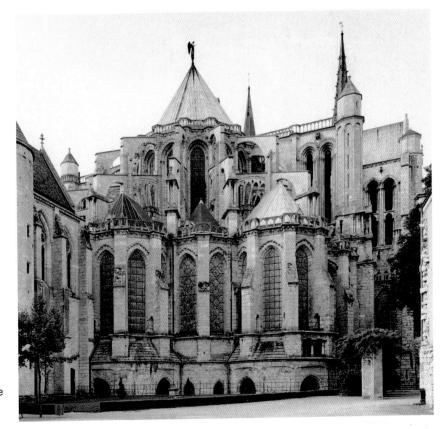

11.13 Apse of Chartres Cathedral, with radiating chapels and flying buttresses, 13th century. Visible in this view are three projecting, semicircular radiating chapels, the flying buttresses above them, and, at the top, the curved end of the roof.

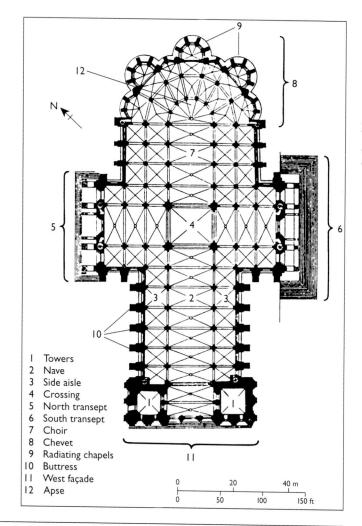

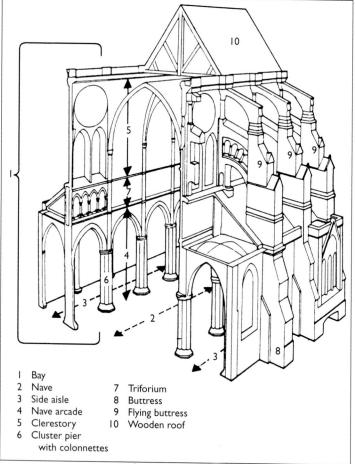

the central rectangle, which is further subdivided. The three portals consist of the same elements as the Romanesque abbey church at Conques (see fig. 10.8); above each portal is a tall, arched, stained-glass lancet window. Inscribed in the rectangle over the lancets is the round rose window, a feature of almost all Gothic cathedral entrance walls. Above the rose window, a gallery of niche figures representing Old Testament kings stretches between the two towers. Finally, the gallery is surmounted by a triangular gable with a niche containing a statue of the Virgin with the infant Christ. The repetition of triple elements portals, lancets, three horizontal divisions, and the triangular gable—suggests a numerical association with the Trinity (the Father, Son, and Holy Ghost).

In the rose window, too, there is a symbolic Christian significance in the arrangement of the geometric shapes. Three groups of twelve elements surround the small central circle. These refer to Christ's twelve apostles. The very fact that the rose window is a circle could symbolize Christ, God, and the universal aspect of the Church itself.

Proceeding counterclockwise around the southern tower, the visitor confronts the view in figure 11.12. This is one of two long, horizontal sides of the cathedral, parts of which are labeled in figure **11.14**. Visible in the photograph are the roof (**10** in fig. **11.15**), the buttresses (**8**) between the tower and the transept entrance, and the flying buttresses, or flyers (**9**), over the buttresses and, at the east end, behind the apse. This transept, which is on the south, has five lancet windows, a larger rose window than that of the west façade, and a similar gallery and triangular gable with niche statues.

Continuing east to the end of the cathedral, turning around, and facing west, the visitor sees the view of the apse in figure 11.13.

CONNECTIONS

See figure 7.40. Arch of Constantine, Rome, A.D. 81.

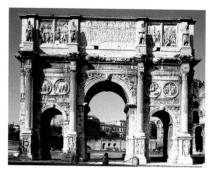

11.15 Perspective diagram and cross section of Chartres Cathedral.

The Exterior Sculpture of Chartres

On the exterior of Chartres there are so many sculptural details that it would take several volumes to consider them thoroughly. We shall therefore concentrate on a few of the most characteristic examples on the west and south sides of the cathedral.

Royal Portal (West Façade) As in Romanesque churches, Gothic church entrances, or portals (fig. **11.16**), are composed of certain standard elements. On the western entrance of Chartres (fig. **11.17**), there are three portals, together known as the Royal Portal. The central portal is slightly larger than the other two, an arrangement derived from the Roman triumphal arch (see fig. 7.40), which marked an entryway into a city. The derivation of the cathedral portal from the Roman arch highlights the symbolic parallel between the interior of the church and the Heavenly City of Jerusalem. Throughout the Middle Ages, entering a church was thought of as an earthly prefiguration of one's ultimate entry into heaven.

The sculptural decorations at Chartres, like those on Romanesque churches and cathedrals, had a didactic function. They were part of an iconographic program intended

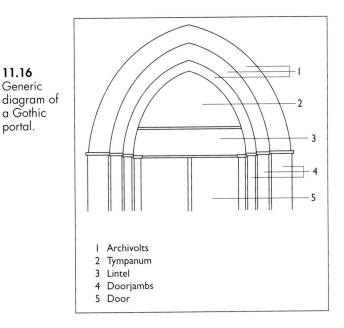

to convey particular messages. It is not known who the author of the program was, but it is possible that theologians at Chartres' cathedral school were involved in planning it.

In the most general sense, these portals remind the observer of the typological view of history, which was

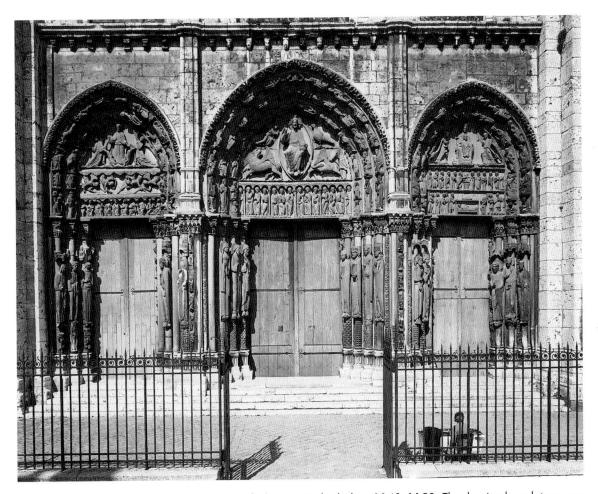

11.17 The three portals of the west façade of Chartres Cathedral, c. 1140–1150. The doorjamb sculptures are slender, columnar figures of Old Testament kings and queens—hence the name "Royal Portal."

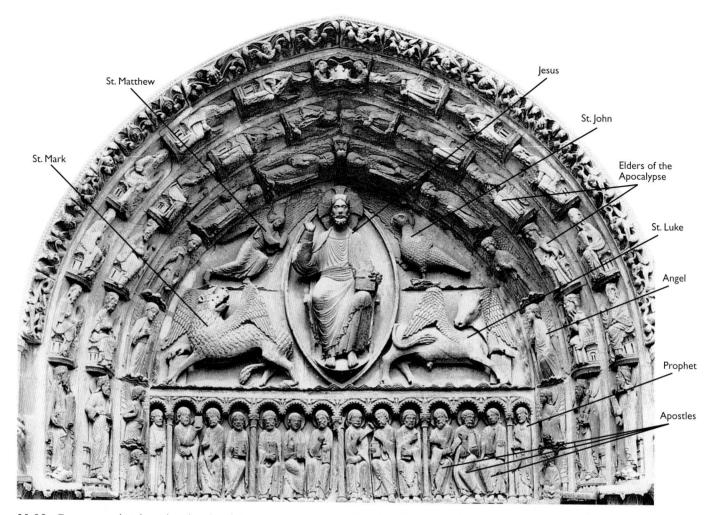

11.18 Tympanum, lintel, and archivolts of the central portal, west façade, Chartres Cathedral, c. 1145–1170. The scene on the tympanum represents the *Second Coming of Christ*, with the four apocalyptic symbols of the Evangelists: the eagle stands for John, the angel for Matthew, the lion for Mark, and the bull for Luke. The surface patterns on all of the tympanum figures are stylized—for example, Christ's drapery folds and the wings, the drapery, and the feathers and fur of the Evangelists' symbols. Christ is frontal, directly facing the visitors to the cathedral, as if reminding them of their destiny.

characteristic of Christian thought from its beginnings. The right, or southern, portal contains scenes of Christ's Nativity and childhood on a double lintel. An enthroned Virgin holding the Christ child occupies the tympanum, which is surrounded by the Seven Liberal Arts in the archivolts. The Liberal Arts as depicted here correspond to the trivium (Grammar, Rhetoric, and Dialectic) and the quadrivium (Arithmetic, Geometry, Astronomy, and Music) adopted from Donatus by Alcuin of York under Charlemagne (see Chapter 9). This curriculum reflects the importance of learning and the high status of the cathedral school as well as Mary's designation as one who "perfectly possessed" the Liberal Arts. On the left, or northern, tympanum and lintel are scenes of the Ascension. The archivolts contain the signs of the zodiac and symbols of the seasonal labors of the twelve calendar months.

The central portal juxtaposes Old Testament kings and queens on the doorjambs with the apocalyptic vision of Saint John the Divine above the door. The doorjamb statues, dating to around 1140–1150, are the oldest surviving examples of Early Gothic sculptural style. Each figure is slim and vertical, reflecting the shape of the colonnette behind. Separating each statue and each colonnette is a space decorated with floral relief patterns, which acts as a framing device.

As in Byzantine mosaics of the Early Christian period, the Old Testament kings and gueens are frontal. Their arms are contained within their vertical planes, and their halos are flat. Their feet slant downward on a diagonal, indicating that they are not naturally supported. As in the trumeau figure of Saint Paul at Moissac (see fig. 10.19), the drapery folds reveal the artist's delight in surface patterns. The repeated zigzags along the hems and circles at the elbows, along with the hair and beards, are stylizations. Compared with the Romanesque figures at Moissac, however, the kings and queens on the doorjambs at Chartres are more independent of their columns. Figures and columns are vertically aligned, but they are no longer merged in a manner reminiscent of early medieval interlace. Instead, they project forward from the column.

See figure 10.19. Saint Paul, trumeau of Saint-Pierre, Moissac, c. 1115–1135.

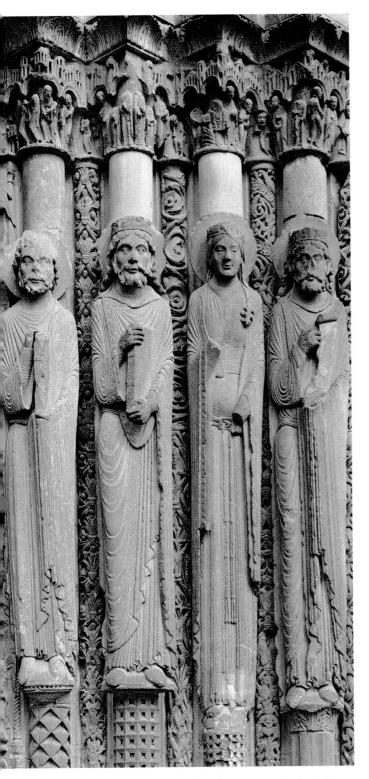

11.19 Doorjamb statues, west façade, Chartres Cathedral, c. 1145–1170.

The New Testament event represented over the central door (fig. **11.18**) is the *Second Coming of Christ* as described by John the Divine in the book of Revelation. On the tympanum, a seated Christ is surrounded by an oval mandorla and the four apocalyptic symbols of the Evangelists. Beneath the tympanum on the lintel, the twelve apostles are arranged in four groups of three. Each group is separated by a colonnette supporting round arches that resemble halos. At either end of the lintel stands a single

prophet, holding a scroll. Of the three archivolts, the outer two contain the twenty-four elders of the Apocalypse described by John the Divine. The inner archivolt contains twelve angels; the two in the center hold a crown over Christ's head, proclaiming his role as King of Heaven.

In contrast to the treatment of the same subject on the tympanum at the church of Saint-Pierre at Moissac (see fig. 10.14), the program at Chartres separates each group of figures into a discrete architectural element. This creates a greater sense of order and logic, and reduces the sense of crowding. It is thus easier to read this tympanum than its Romanesque predecessor. The resulting clarity is enhanced by the deeper relief and the minimal floral designs —here framing the outer archivolt. By now the influence of Islamic patterning, as well as of interlace, on monumental stone buildings in France has virtually disappeared.

Considered as an iconographic totality, the Royal Portal of Chartres offers the visitor a Christian view of history. The beginning and end of Christ's earthly life are placed over the right and left doors, respectively. The Old Testament kings and queens on the doorjambs are typological precursors of Christ and Mary, while the *Second Coming of Christ*, as envisioned by Saint John, dominates the central portal.

A comparison of the doorjamb statues from the Royal Portal (figs. **11.19** and **11.20**) with those on the south doorjambs reveals the stylistic changes that occurred from Early Gothic to the beginning of High Gothic.

11.20 Stylized drapery (detail of fig. 11.19).

The South Façade The saints on the left portal of the south transept (fig. **11.21**) conform less strictly than the figures on the Royal Portal to their colonnettes, and their feet rest naturally on a horizontal plane. They are no longer strictly frontal. They have facial expressions and are of different heights. The heads turn slightly, and there is more variety in their poses, gestures, and costumes. In the figure of *Saint Theodore* at the far left, for example, the right hip swings out slightly in response to the relaxation of the stance. The diagonal of the belt, apparently weighed down at the saint's left by a heavy sword, conveys a slight suggestion of movement in three-dimensional space.

This general increase in the sense of depth is enhanced

by the more deeply carved folds and facial features, as well as by the projecting, crownlike architectural elements over the figures' heads. The proportions of the figures have also changed in comparison to those on the west doorjambs and are no longer as tall and thin. Instead, they are wider and seem as if they might step down from their supports into the real world of the observer. Such changes from Early to High Gothic reflect a new, though fledgling, interest in human form and emotion that would continue to develop into Late Gothic.

Between the two doors of the central portal is the trumeau, also a feature of Romanesque cathedrals. It is decorated with a statue of the *Teaching Christ* (fig. **11.22**). He

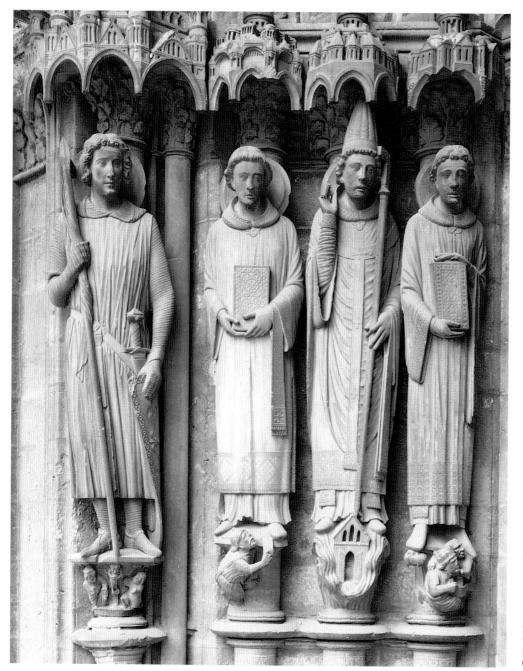

11.21 Saints Theodore, Stephen, Clement, and Lawrence, doorjamb statues, south transept, Chartres Cathedral, 13th century.

stands on a lion and a dragon, associated with the beasts and monsters of the Apocalypse, which denote Satan and the Antichrist. Still frontal and strictly vertical, Christ's pose makes him seem more aloof than the doorjamb saints. At the same time, however, he is shown teaching rather than judging and is thus more emotionally accessible to the viewer.

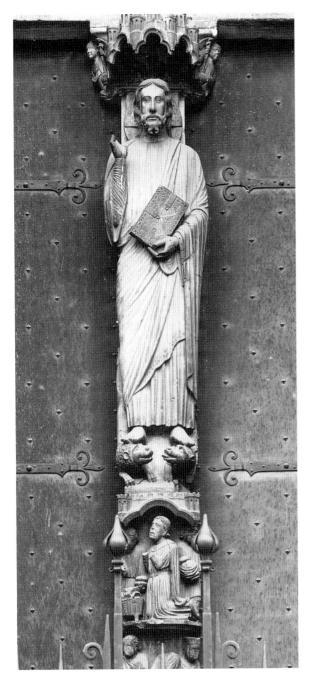

11.22 Teaching Christ, trumeau, south transept, Chartres Cathedral, 13th century. Christ's earthly role as a teacher is reflected by the book in his left hand, and his divinity by his gesture of blessing. The act of standing on symbols of Satan and the Antichrist signifies Christ's triumph over the forces of evil.

Antichrist

The notion of the Antichrist, mentioned in the First Epistle of Saint John (2:18 and 2:22), is about the end of time and is apocalyptic in nature. It developed in Europe along with the spread of Christianity and became a powerful force in the Western imagination. The Antichrist is not Satan, but an incarnation of evil, a "Final Enemy," and a "Last Emperor," who takes over from Satan at the end of the world and presides over killing, torture, and universal destruction. Many traditional myths and legends were absorbed into the notion of the Antichrist, who was used for political as well as for religious purposes.

The image of the Antichrist appealed to visionary writers and was frequently illustrated in Christian art. Antichrist iconography was derived from the apocalyptic beasts and monsters described in the book of Revelation. Early Christian allusions to his appearance mention huge stature, bloodshot eyes, white eyelashes, pointed hair, gigantic teeth, sickle-shaped fingers, and a double skull. When he walked, according to one account, he left green footprints.

Around 950, one Brother Adso wrote a biography of the Antichrist, which attracted an enormous popular following. In Adso's version, the Antichrist was born in Babylon, educated in magic, and capable of performing miracles. He rebuilt the Temple of Jerusalem, circumcised himself, and claimed to be the son of God. The twelfth-century liturgical *Play of Antichrist* portrayed the fate of Christianity as depending on the German emperor and warned against the weakness of the French. Various reform movements within the Church similarly took advantage of Antichrist propaganda.

The first woman mystic who significantly influenced Antichrist imagery was the German abbess Hildegard of Bingen (1098–1179). Among her writings is the *Liber scivias* (*The Book of Knowing the Ways of Light*), in which she detailed twenty-six visions, including an account of the Antichrist's birth from Mother Church and his subsequent destruction. She writes that he was born of a licentious woman and emerged from her body with a black head covered with dung. He had fiery eyes, donkey's ears, a lion's mouth and nostrils, and gnashing teeth. When he tried to climb to heaven, a clap of thunder forced him to his death.

In the thirteenth century, the Antichrist was often represented as a three-headed tyrant (fig. **11.23**), which was a reference to his claim to be God and the Trinity. In 1242, a widely quoted verse reflected fears of a Mongol invasion: "When twelve hundred years and fifty After the birth from the dear Virgin are completed, Then will be born demonfilled Antichrist."⁴

11.23 Antichrist as a Three-headed Tyrant, from the Harley Manuscript, fol. 127r, 1527. British Library, London.

The Interior of Chartres

The overwhelming sensation on entering Chartres Cathedral from the western entrance is one of height. Its nave is the earliest example of High Gothic architectural style. The view in figure **11.24** shows the nave from the Royal Portal entrance, looking east toward the curved apse. The ceiling vaults of the nave rise nearly 120 feet (37.58 m) and are only about 45 feet (13.72 m) wide.

The new height achieved by Gothic builders was made possible by the buttressing system, the effect of which can be seen in the clerestory (see fig. 11.15). The latter is supported at two points by flyers, allowing more space for windows. In each bay, the clerestory windows consist of two lancets under a small round window. At the far end, in

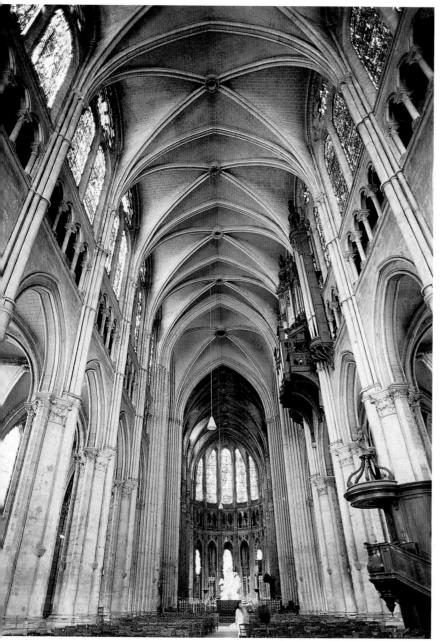

the apse, the clerestory lancets are taller, but there are no round windows.

Proceeding down the nave, from west to east, one arrives at the crossing (see fig. 11.24) and the two transept entrances. Figure **11.25** shows the north rose window illuminated by outside light filtering through the stained glass. Dominating the interior entrance walls, these window arrangements are like colossal paintings in light. Their intensity varies according to weather conditions and times of day. At the center of the rose window, a small circle contains an image of Mary and the infant Jesus surrounded by twelve even smaller circles.

Each series of geometric shapes around the center of the rose window numbers twelve—an implicit reference to the twelve apostles. The first series after the tiny circles contains

> four doves and eight angels. Twelve Old Testament kings, typological precursors of Christ, occupy the squares. The twelve quatrefoils contain gold lilies on a blue field, symbols of the French kings. The outer semicircles represent twelve Old Testament prophets, who are types for the New Testament apostles.

> The central lancet depicts Saint Anne with the infant Virgin Mary. At the left are the high priest Melchizedek and King David, and on the right are King Solomon and the priest Aaron—all Old Testament figures. In these windows, as in the west façade sculptures, the lower images act as visual and symbolic supports for the upper images: the New Dispensation is built on the Old. Here, the additional genealogical link between Christ and Saint Anne is arranged vertically, with Mary as an infant in the lancet below and as the Virgin Mother above, at the center of the rose window.

> Wherever possible and appropriate, Gothic artists integrated Christian dogma into the cathedrals. Such buildings were designed as supreme monuments to the glory of God. They were also unified expressions of the skills of the architects, sculptors, artists, and other craftsmen who contributed to them.

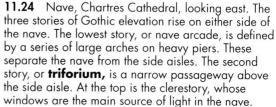

11.25 Rose window and lancets, north transept, Chartres Cathedral, 13th century. Note that the north windows are larger and more elaborate than the earlier west-façade windows. The north lancets are taller and thinner than those on the west. The north rose window is larger and has a greater variety of geometric shapes within it. Additional windows have also been inserted between the lancets and rose window. The rose window measures over 42 feet (12.80 m) in diameter. The windows between the rose window and lancets are decorated with royal coats of arms, which proclaim the divine right of French kings. They also serve as a signature recording the donation of the north transept by Blanche, the queen mother.

Later Developments of the French Gothic Style

Chartres, completed in 1220, set the standard for other great French cathedrals built in the High Gothic style. Height and luminosity were the criteria by which they were measured. The cathedral at Reims, northeast of Paris, was the next to be built, from 1211 to about 1290. Its nave was 125 feet (38.10 m) high. Amiens, also to the north, was begun in 1220, and its nave reached a height of 144 feet (43.89 m). Each nave was wider than the last, but the ratio of height to width continued to increase.

Amiens

The High Gothic cathedral at Amiens (figs. **11.26–11.31**), like Chartres, was built on the site of a church that had burned down. Because it was conceived from the start

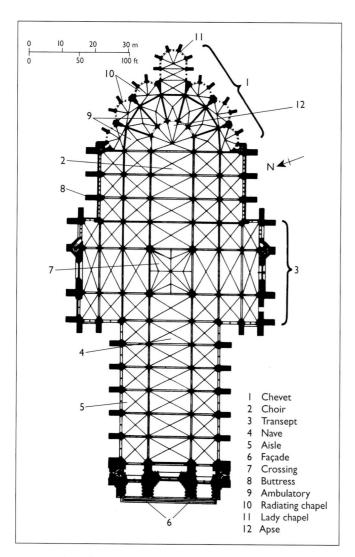

11.26 Plan of Amiens Cathedral.

as a Gothic structure, the plan (fig. **11.26**) is more unified than that of Chartres. Transept entrances and the towers, for example, are symmetrical. There is also a new integration of parts with the whole in the construction of the nave (fig. **11.27**). Each feature is now in the service of height, and the elements of the wall work together to carry one's gaze upward in a soaring thrust toward the vaults and the source of light through the clerestory

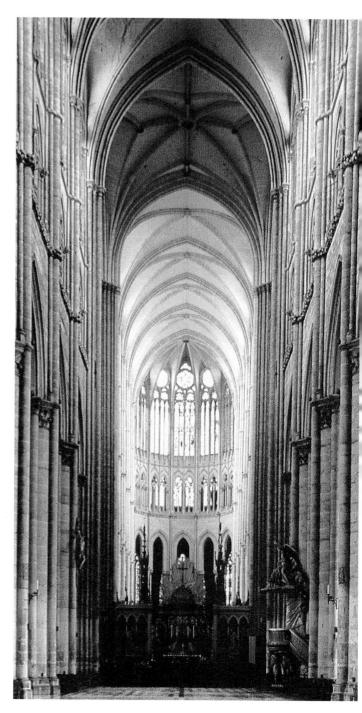

11.27 Nave vaults, Amiens Cathedral, 1220–1269.

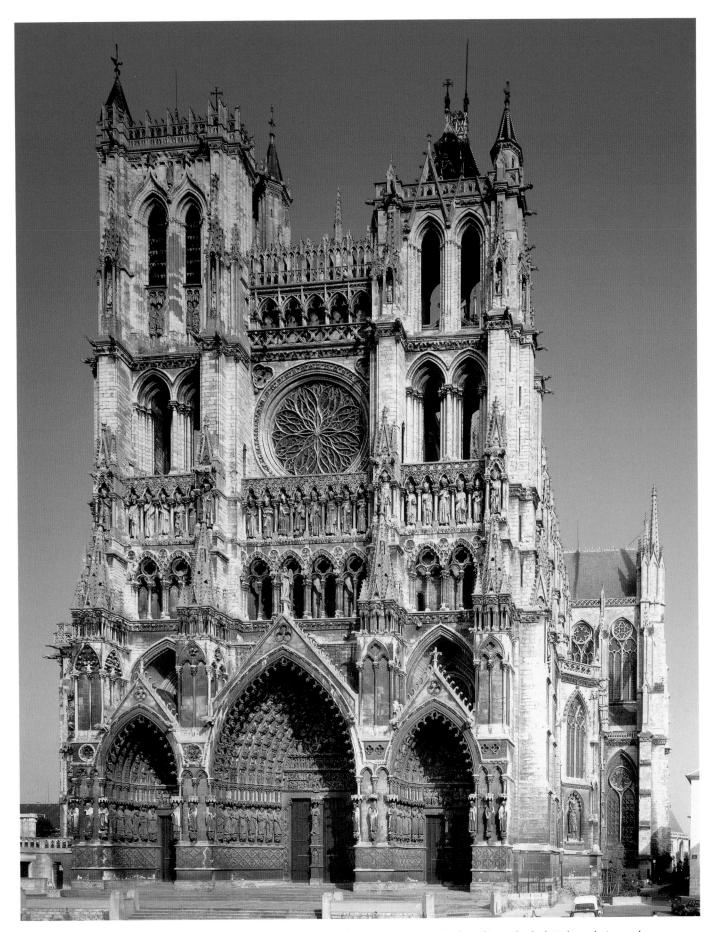

11.28 West façade, Amiens Cathedral, France, 1220–1269. Three architects worked on this cathedral: Robert de Luzarches, Thomas de Cormont, and Regnault de Cormont.

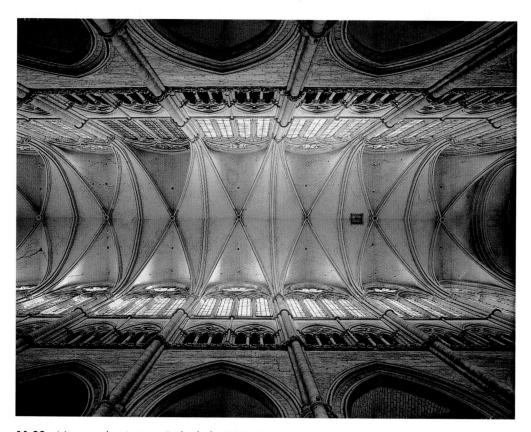

11.29 Nave vaults, Amiens Cathedral, 1220–1269.

windows. The view of the choir vaults in figure **11.29** shows the "uplifting" effect of light and lightness on the delicate upper-story colonnettes and on the webbing of the vaults.

Two trumeau statues at Amiens exemplify certain developments in Gothic sculptural decoration: the *Beau Dieu* ("Beautiful God," fig. **11.30**) and the *Vierge dorée* ("Gilded Virgin," fig. **11.31**). The *Beau Dieu* is carved in deeper relief than the *Teaching Christ* from Chartres (see fig. **11.22**), and the right arm is more extended. The hemline is no longer horizontal, but appears to rise up in the middle, which creates more open space and fluid drapery movement. As at Chartres, Christ stands on apocalyptic monsters—here, a lion and a basilisk (a legendary serpent having a deadly glance and poisonous breath), again denoting Satan and Antichrist.

The Vierge dorée was carved about twenty years after the Beau Dieu and seems even more independent of its architectural background. Whereas the trumeau figures of Christ have an iconic character, the Virgin is represented in more human terms. Although she is the Queen of Heaven by virtue of her crown, she turns to gaze not at the viewer, but at her infant. She holds him on her left arm, while the diagonal drapery folds convey the impression that a shift in her stance helps support his weight. The statue is unusual in combining monumental form on the exterior of a cathedral with an intimate depiction of the mother–child relationship.

11.30 Beau Dieu, central portal, west façade, Amiens Cathedral, c. 1225–1230.

11.31 Vierge dorée, south portal, Amiens Cathedral, c. 1250. Note the implicit references to the Crucifixion (the arrangement of the angels holding the halo) and to the doctrine of the Trinity (the number of angels).

Reims

At Reims, the west façade (fig. **11.32**) and interior view of the nave (fig. **11.33**) show the extent to which cathedral designs were becoming progressively elongated, with an increasingly vertical thrust. The proportions of the arches

at Reims are taller and thinner than those at Chartres, and the plan (fig. **11.34**, p. 418) is longer and thinner. The radiating chapels are deeper than at Chartres, and the transepts are somewhat stubby, appearing to merge into the choir with little or no break. Because Amiens was designed slightly later than Reims, however, its height is

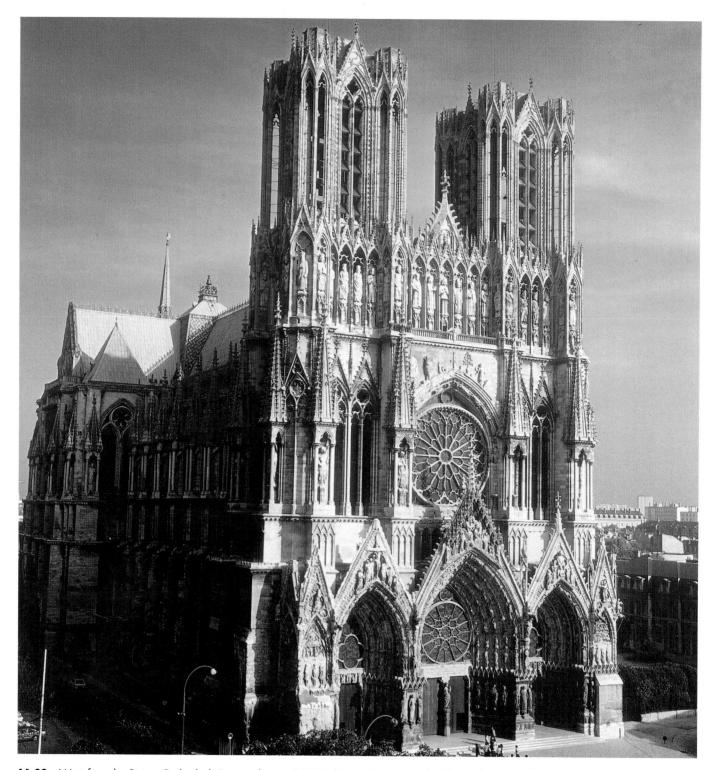

11.32 West façade, Reims Cathedral, France, begun 1211. The window space has been dramatically increased at Reims as a result of continual improvements in the buttressing system. The tympanums on the façade, for example, are filled with glass rather than stone. At Reims, the portals are no longer recessed into the façade, but are built outward from it.

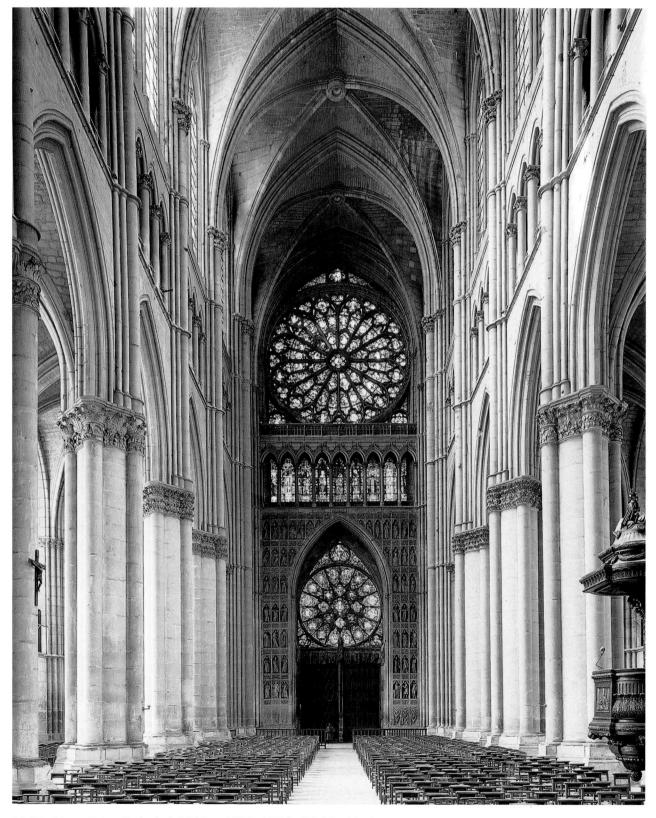

11.33 Nave, Reims Cathedral, 1211–c. 1290. 125 ft. (38.10 m) high.

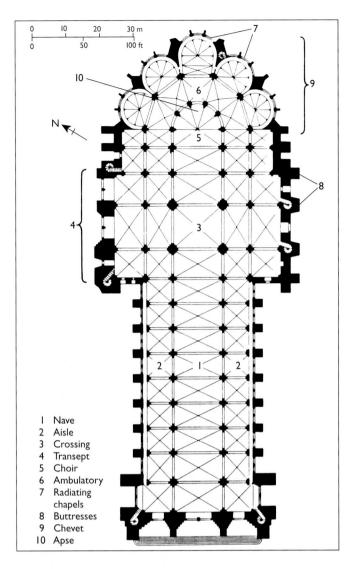

11.34 Plan of Reims Cathedral (after W. Blaser).

both absolutely and proportionately greater, and its nave proportionately narrower than at Reims.

The exterior surfaces at Reims are filled with greater numbers of sculptures than at either Chartres or Amiens. In contrast to the increased verticality of the architecture, the sculptures have become more naturalistic, as can be seen in the doorjamb statues on the west façade at Reims (fig. **11.35**). Rather than being vertically aligned and facing the viewer as at Chartres, the Reims figures turn to face each other, interacting in a dramatic narrative and engaging the spaces between them. The drapery folds reflect human anatomy, poses, and gestures in a more pronounced way than even at the south transept of Chartres. This is one of the earliest examples in the monumental Christian art of western Europe of an interest in the relationship between drapery and the human form it covers.

The two left-doorjamb figures represent the angel Gabriel and Mary. They enact the scene of the Annunciation, in which Gabriel announces the birth of Jesus to Mary. On the right, in the Visitation scene, Mary visits her cousin Elizabeth and tells her that she is three months pregnant. Elizabeth informs Mary that she herself is six months pregnant. Her son will be John the Baptist, Jesus's second cousin and childhood playmate.

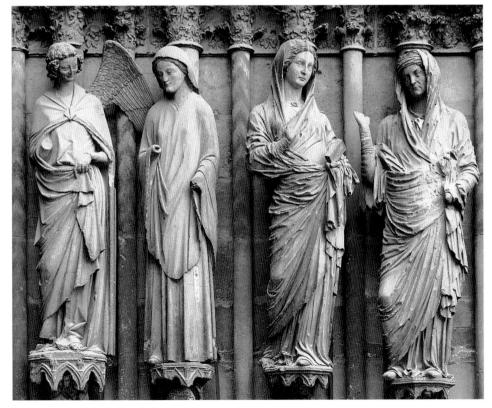

11.35 Annunciation and Visitation, doorjamb statues, Reims Cathedral, c. 1225–1245.

Gothic Architecture and Scholasticism

This heading was the title of a small book published in 1951 by the art historian Erwin Panofsky. He showed the way in which Scholasticism influenced the Gothic style in terms of its clear, hierarchical systems. Among the examples he used to show this connection was an illustration from a thirteenth-century manuscript (fig. **11.36**). At the upper left, the king sits on a throne and is enclosed by a tripartite Gothic arch. He is the largest figure on the page, and his frame is the most elaborate architectural element. His greater verticality and his higher placement are consistent with his position as ruler. Interior is separated from exterior, which appears in the buildings to the right. Other figures, including members of the clergy, are arranged in three horizontal rows.

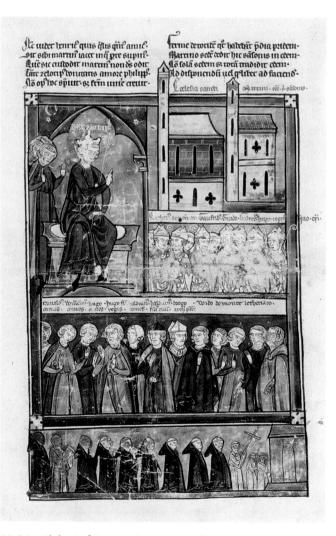

11.36 Philip I of France Granting Privileges to the Priory of Saint-Martin-des-Champs, France. c. 1250. Book illumination, ms. 1359, fol. 6. Bibliothèque Nationale, Paris.

The same organizing principle can be seen in an illustration from the early fourteenth-century manuscript of the *Life of Saint Denis* (fig. **11.37**). Its elaborate frame is Late Gothic, and the vines make it a metaphor of the Church itself by reference to Christ's "I am the vine" (see Chapter 8). At the top, Saint Denis, the largest figure, sits on a lion throne, which connects him typologically with King Solomon, and his Church with Solomon's Temple. The abbreviated cathedral entrance over the saint's head emphasizes his position as archbishop of France. His scroll winds around and forms a lintel-like horizontal under the clerestory windows.

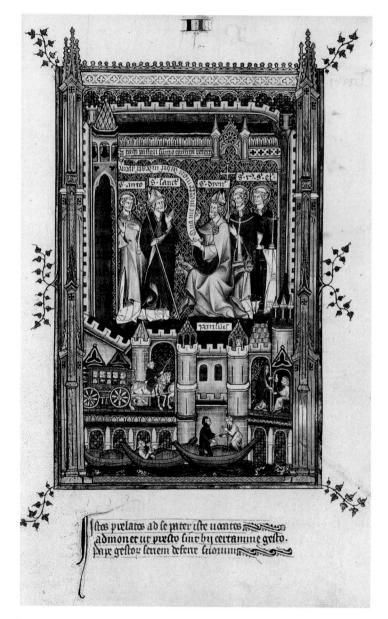

11.37 Scene from the *Life of Saint Denis*, completed 1317. Book illumination, ms. fr. 2091, vol. II, fol. 125. Bibliothèque Nationale, Paris. This manuscript was commissioned during the reign of Philip IV (the Fair). It contains twenty-seven illuminations of the life of Saint Denis. In this scene, the saint asks two others (Saints Antonin and Saintin) to write his biography.

The scene below depicts the everyday life of the Earthly City—in this case fourteenth-century Paris. A coach enters the city gate on the upper left, a doctor checks his patient's urine sample on the right, and in the boats a wine taster and two men complete a commercial transaction. Travel, medicine, and trade are among the transient activities of daily life, while the saints above are engaged in the loftier pursuit of preserving the name and memory of Saint Denis through his image and biography.

Scholasticism was a philosophical method combined with theology. It explained spiritual truth by a kind of inquiry based on analogy and was designed to reconcile faith and reason. The foundations of Scholasticism were laid by Saint Augustine's juxtaposition of the Earthly and Heavenly Cities of Jerusalem (see p. 400). Augustine argued that, although understanding can precede faith, faith leads to understanding. His aesthetic argument, that beauty is symmetry and that there should be a harmonious relation of parts to the whole, is consistent with the visual and structural order of Gothic style.

At the end of the eleventh century, Anselm (c. 1033– 1109), the archbishop of Canterbury (see below), established a program based on Augustine's ideas. In the 1130s, the theologian Peter Abelard (1079–1142) published *Yes and No*, a treatise applying the dialectic method to theology, arguing from reason (*ratio*) on the one hand, and for and against an issue (*quaestio*) on the other. About this time, the writings of Aristotle were revived in western Europe. By the thirteenth century, his logical system had been absorbed into Scholasticism.

The work that summed up Scholasticism at its peak was the *Summa theologiae* of Thomas Aquinas (c. 1225–1274). Influenced by Aristotelian logic, Aquinas discussed doctrine according to a system of argument, counterargument, and solution. This system established the relationship between faith and reason, and concluded that, far from being at odds, the one actually complements the other.

The architectural solutions that became typical of the Gothic cathedral are, in a sense, parallel to Scholastic logic. The sculptures and stained glass constitute an illustrated Bible. According to Panofsky, the Scholastic clarification of faith by intellectual demonstration parallels the articulation of the cathedral. For him, Amiens best illustrates a "final" resolution in creating a uniformity of divergent features.

What began with Suger's desire for transparency in architecture led to the philosophical pursuit of a new totality. At Amiens, the three-part nave (counting its two side aisles) corresponds to the three-part transept (the two entrances and the section crossing the nave). The expansion of the nave into the five-part choir creates a logical transition to the semicircular ambulatory in the apse. And the curve of the ambulatory leads one naturally into the radiating chapels. The symmetrical towers repeat the symmetry of the transepts farther east and stand as equals on either side of the western entrance. Here, therefore, by the process of philosophical debate (*disputatio*), the Gothic architects finally arrived at *concordantia* (the harmonious reconciliation of seemingly contradictory elements).

Applying Scholasticism to architecture, Panofsky cites

the example of the rose window. At Saint-Denis (fig. 11.1), he argues, the window is too small; at Amiens (fig. 11.28), it is crowded by the surrounding elements. But at Reims (fig. 11.32), a solution has been found. There the architect has opened up the west façade wall and set the rose window inside the pointed arch of another huge window. As a result, the rose window is more logically connected to the west wall. Instead of being a round window in a rectangular wall as at Saint-Denis, Chartres, and Amiens, it is now a window in a window in a wall.

The new window-with the pointed arch-serves a transitional purpose because it shares a structure with the wall and colored glass with the rose window. Whether viewed from the exterior (fig. 11.32) or from the interior (fig. 11.33), the aesthetic effect is striking in the grand vertical sweep of the wall. This is then unified by the repeated rose window inscribed in the pointed arch window over the door. (Note that in the exterior view, the rose window is repeated in each of the three tympanums.) The east-towest view of the nave (fig. 11.33) accentuates the larger size of the upper rose window compared with the lower. Although such an arrangement would appear to defy structural logic, it works because the eye is immediately drawn upward. This effect has a theological, as well as an architectural, purpose. It synthesizes the traditional association of height and greatness with the belief that spiritual perfection is attained in the light of the Heavenly City.

Sainte-Chapelle

The transcendent quality of Gothic light is nowhere more evident than in the reliquary chapel of Sainte-Chapelle in Paris (fig. 11.38). It was commissioned by King Louis IX (who was canonized in 1297) and epitomizes the rayonnant style. Here the walls literally become glass, as the stone supports diminish. There is no transept, which allows the tall, thin colonnettes to rise uninterruptedly from a short, dimly lit first story. This clear distinction between the lower darkness and the upper light is an architectural mirror of traditional Christian juxtapositions associating darkness with the lower regions of hell, the Earthly City, and the pre-Christian era of the Old Testament. Light, in this context, signifies the Heavenly City and the enlightened teachings of the New Testament. The same parallelism between Old and New Testaments determined the iconography of the scenes represented in the stained-glass windows. These metaphors are reinforced by the ceiling vaults, which are painted blue and decorated with gold stars in the form of fleurs-de-lis-the emblem of the French kings.

The original impetus behind the construction of Sainte-Chapelle is also based in tradition. From Byzantium, Louis IX obtained crucifixion relics believed to be fragments of the True Cross, the Crown of Thorns, the lance, sponge, and a nail. At the time of their arrival, Louis went to the gates of Paris to receive them. (This was in imitation of the last event in the Legend of the True Cross—see Chapter 10—when the Cross is restored to Jerusalem and the townspeople welcome it at the city gate.) The relics were placed in the large, Gothic-style gold and glass reliquary in the apse.

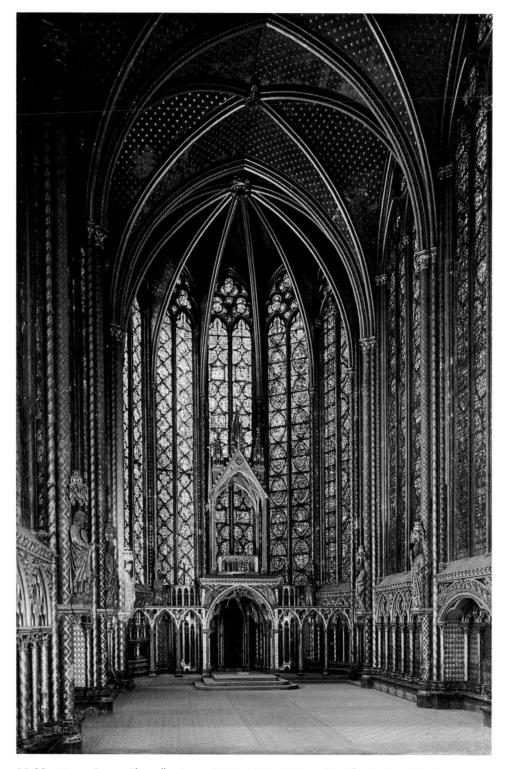

11.38 Nave, Sainte-Chapelle, Paris, 1243–1248. 32.0×99.5 ft. (9.75×30.33 m). Thomas de Cormont, who also worked on Amiens Cathedral, designed Sainte-Chapelle. It was the chapel of the French kings, located on the Île de la Cité and attached to the palace.

English Gothic

Within a generation of the new choir at Saint-Denis, the Gothic style had spread beyond France to other countries. Among the first to adopt the new style was England. Since its defeat by the Normans in 1066, there had been commercial, cultural, and political contacts between the two countries.

Canterbury Cathedral

The Gothic style in England begins with the choir of Canterbury Cathedral (figs. **11.39–11.44**), in the southeastern county of Kent. It was originally built in the Norman style, which developed in England after the Norman conquest. In 1174, a fire destroyed the choir, and architects were summoned from France and England to advise on reconstruction. The French architect William of Sens began the new work with stone imported from Caen; five years into the project, he died of a 50-foot fall from the scaffolding, and an English architect, also named William, took over.

11.39 Choir, Canterbury Cathedral, 1174–1184.

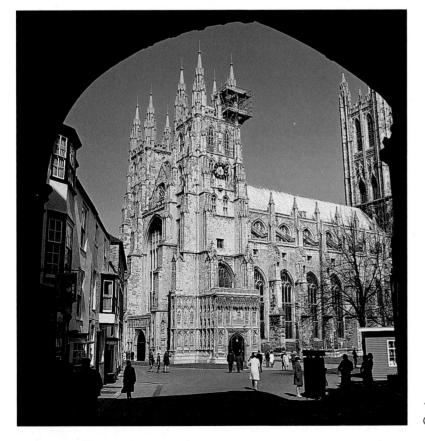

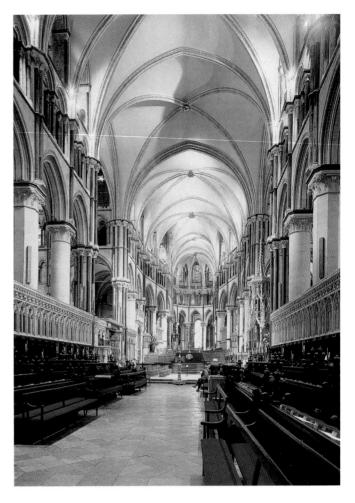

^{11.40} View of Canterbury Cathedral.

11.41 Plan of Canterbury Cathedral.

In the reconstruction of the choir, a Gothic superstructure was erected over the crypt, which was inside the remaining Norman walls. A monk of Canterbury, one Gervase, described the new Gothic elements and their effect. He noted that the number of piers had increased (by six), as had their length (by nearly 12 feet [3.66 m]), drawing attention also to the more elaborately carved capitals, the use of marble and different-colored stone, and the sexpartite arched-rib vaulting held in place by a keystone. The decorations observed by Gervase remained typical of English Gothic and were derived from the taste for Anglo-Saxon interlace (cf. the lower arches in fig. 11.42).

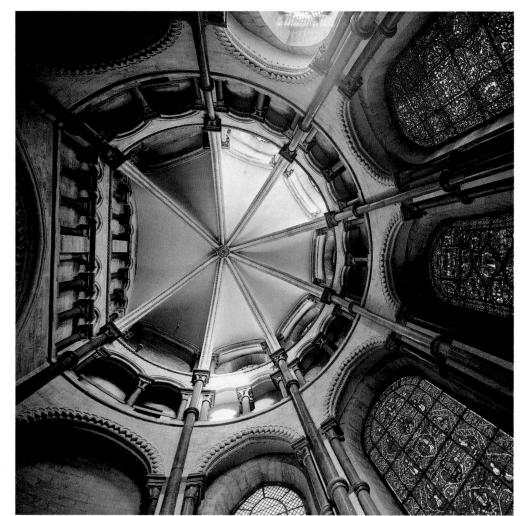

11.42 Vault, Corona Chapel, Canterbury Cathedral.

11.43 *Return of the Messengers from the Promised Land,* detail of window, Corona Chapel, Canterbury Cathedral, 13th century.

Thomas à Becket

Thomas à Becket (c. 1118–1170) was a close friend of King Henry II of England. He was appointed chancellor in 1155 and allied himself with Henry against the Church. Once elected archbishop of Canterbury (in 1162), however, Becket changed his allegiance, now siding with the Church in matters of taxation and legal jurisdiction. The conflict between the secular and ecclesiastical courts escalated and enraged the king. Henry is recorded as having declared in a fit of anger: "Is there no one who will rid me of this low-born priest?"

Four knights obliged. They rode to Canterbury and found the archbishop praying before the altar in the west transept of the cathedral. They killed him, and afterward Henry reportedly did penance for the murder. In 1173, Becket was canonized and became the object of a pilgrimage cult. The Corona Chapel (fig. 11.42) was built as a reliquary to house his scalp, which was severed from his head by the assassin's blow. In 1220, Saint Thomas's remains were transferred to the Trinity Chapel. William the Englishman added two shrines—the Trinity and Corona Chapels—for Thomas à Becket (see box), whose cult attracted pilgrims to Canterbury (see box, p. 425). These additions made the plan more elongated and more complex than French Gothic cathedrals (fig. 11.41). The view of the ceiling of the Corona Chapel (fig. 11.42) shows the crownlike, octagonal organization of the vaults and the variations in the supports. Also distinguishing Canterbury from French Gothic and increasing its complexity is the combination of round and pointed arches in the same structure.

The stained glass in Canterbury Cathedral, on the other hand, is similar in style to French examples. Figures are elongated, outlined in black, and occupy a relatively flat space. The details illustrated here have typological content and also refer to the theme of pilgrimage. In *Return of the Messengers from the Promised Land* (fig. 11.43), two men shoulder a huge bunch of grapes and walk with a pilgrim's stick. The weight, centrality, and slightly cruciform shape allude to the Crucifixion, whereas the grapes refer to the Eucharist.

Solomon and the Queen of Sheba (fig. 11.44) was an iconographic type for the Adoration of the Magi. Both Sheba and the three kings travel from east to west, Sheba to visit Solomon and the Magi to see Jesus. This journey is symbolically replicated when one enters the cathedral and proceeds along the nave to the main altar supporting a crucifix. Solomon was a type for Jesus, who calls himself "the new Solomon" in the Gospel of Matthew. When the pilgrim traveled to Canterbury, it was to venerate the relics of Thomas à Becket as Sheba had bowed before Solomon and the Magi had knelt before Jesus.

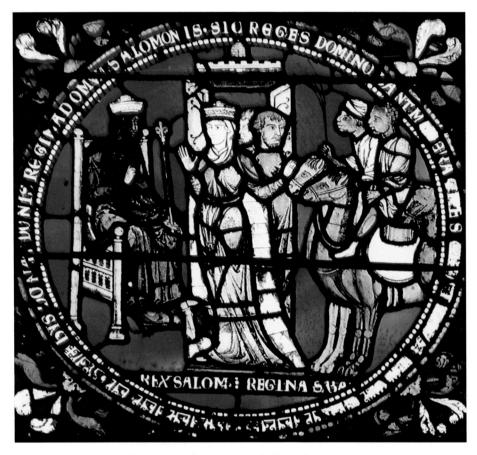

11.44 Solomon and the Queen of Sheba, detail of window, Canterbury Cathedral, late 12th century.

Chaucer's Canterbury Tales (c. 1387)

The pilgrimage to Canterbury became the subject of one of the canonical works of English literature: Geoffrey Chaucer's *Canterbury Tales*. Chaucer (c. 1340–1400) held several offices at the English court and in April 1388 decided to make a pilgrimage to Saint Thomas à Becket's shrine. The *Canterbury Tales* is a work of some 17,000 lines in prose and verse, predominantly rhyming couplets. The General Prologue describes thirty-one pilgrims, including Chaucer, gathered at the Tabard Inn at Southwark, the main entry to London from the south. The innkeeper, who is joining them, offers a free meal to whoever tells the best tale. If each person tells two tales, he proposes, the way will seem shorter. They take him up on his offer and recount tales ranging from versions of myths and fables to popular stories of the time. Several tales are harshly satirical and criticize the corruption of both the Church and society. The Prologue offers a vivid description of contemporary life. This is reflected in the broad spectrum of society represented by the pilgrims. They include a knight and a reeve (a bailiff or steward of a manor), a cook and a carpenter, a prioress and a pardoner (seller of indulgences). The most colorful character is the Wife of Bath, who extols the pleasures of the flesh, condemns celibacy, and enjoys her good fortune in having survived five husbands. Her tale, which is based on a medieval romance, reflects her philosophy. A convicted rapist is given one year to discover what women most want. An old hag offers him the answer in exchange for granting her one wish. He agrees, and she demands that he marry her. When they are in bed, she asks if he prefers her ugly and faithful, or beautiful and unfaithful. He leaves the decision to her, and she rewards him by becoming both beautiful and faithful.

Salisbury Cathedral

English Gothic, as in the different-colored stone and elongated plan at Canterbury, was typically more varied than French Gothic. Salisbury Cathedral (figs. **11.45** and **11.46**) was built from 1220 onward in a relatively homogeneous style. It has a cloister (**7** in fig. 11.45), a feature of monastic communities that the English adopted as part of their cathedral plans. In contrast to French cathedrals, Salisbury has a double transept and a square apse. Its chapter house (**8** in fig. 11.45) is octagonal, which also distinguishes English from French Gothic. The large square is a cloister attached to the south side of the cathedral. Apart from the cloister and a small porch on the north side of the nave, the plan is relatively symmetrical. The double transept and the square apse differ from the corresponding parts of a typical French Gothic cathedral.

Characteristic of English cathedrals, Salisbury is set in a cathedral close, a precinct of lawns and trees. Whereas French cathedrals usually rise directly from the streets and squares of a town, emphasizing their verticality, Salisbury is integrated into the natural landscape, with horizontal planar thrusts. It has fewer stained-glass windows and, therefore, less need for exterior buttressing. The view of the chapter-house ceiling (fig. **11.47**) shows the fanning out of the central pier into a vault that reverses the shape of the fan. The fan ribs join those of the vault and resemble the spokes of an inverted umbrella.

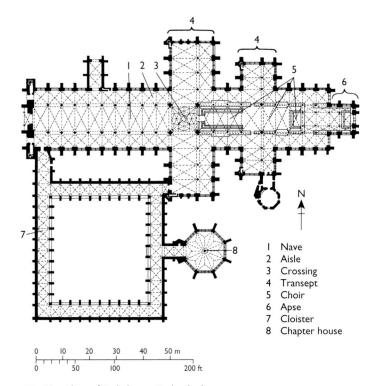

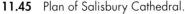

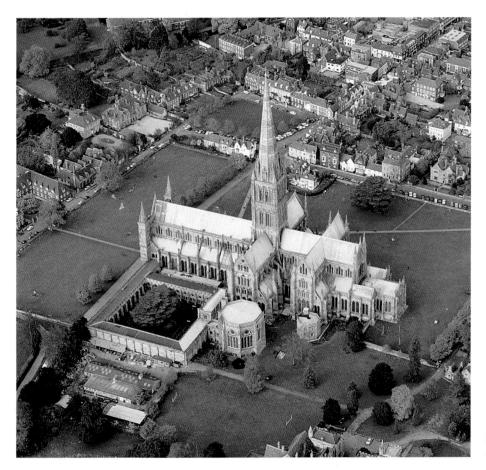

11.46 Salisbury Cathedral, England, begun 1220. The magnificent tower and spire were added in the 14th century.

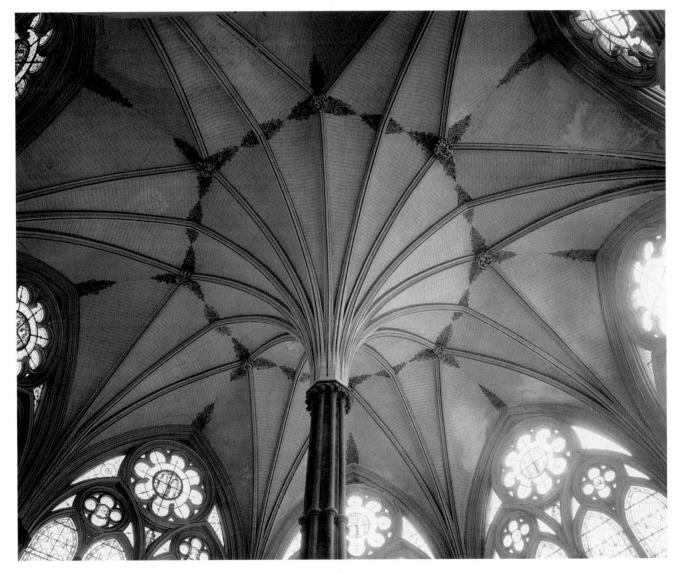

11.47 Vault, chapter house, Salisbury Cathedral, 1263–1284.

King's College Chapel, Cambridge

Fan vaulting became characteristic of English Gothic, one of the most spectacular examples being the chapel at King's College, Cambridge (fig. **11.48**). Its tall, unbroken supports exemplify the late Perpendicular style. The college was founded by Henry VI in 1440, and he was probably in-

volved in the plan of the chapel, assisted by the resident master mason, Reginald Ely. As at Sainte-Chapelle, the weight of the walls is supported by external buttresses, which are masked by chapels on either side. William Wordsworth's sonnet "Tax not the royal Saint with vain expense," written in 1822, was inspired by King's College Chapel and refers to the elegance and cost of such work.

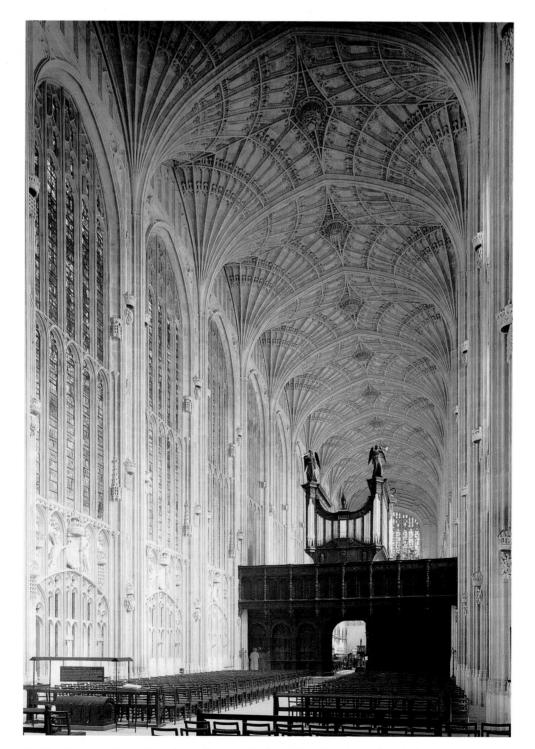

11.48 King's College Chapel, Cambridge, England. The chapel was founded in 1441, and its vaulting was designed by John Wastrell in 1508–1515.

cloth industry, in the fifteenth century. The town hall at Louvain (known in Flemish as Leuven), which dates to 1448, is another example of secular Gothic architecture. It has an elaborate façade with three towers, one at each side and a third over the central gable (fig. **11.54**).

In the nineteenth-century Neo-Gothic style (see Chapter 20), aspects of Gothic were revived, especially in England and America. Figure **11.55** is an aerial view of Saint

11.54 Town hall, Louvain, Belgium, 1448.

Patrick's Cathedral in New York City, designed by James Renwick and William Bodrigue. It was built from 1858 to 1879, and the spires were completed in 1888. The basic elements of Gothic—a cruciform plan, a west–east orientation, pointed arches, and architectural layout—are retained. Nor has its imposing verticality been overshadowed by the much taller skyscrapers that were built subsequently.

11.55 Aerial view of Saint Patrick's Cathedral, New York, 1858–1879; spires, 1888.

In terms of secular architecture, the Doges' (Senators') Palace on the Piazza San Marco is characteristic of Venetian Gothic (fig. **11.53**). The first two stories of the façade consist of a lower portico surmounted by an open loggia. These create a striking pattern of light and dark formed by the slightly pointed arches and the lobed openings. The upper-story façade is a more solid wall, faced with a pink and white surface pattern that lightens its effect. Above this is a row of slender pinnacles that repeat the intricate, curvilinear patterns of the lower levels. Because Venice had been for centuries an important seaport on the east coast of Italy, its architecture reflects the cosmopolitan character of the city.

Belgium, which was in the diocese of Cologne, in Germany, was well known for its town halls and guild halls. These reflected the commercial successes, especially of the

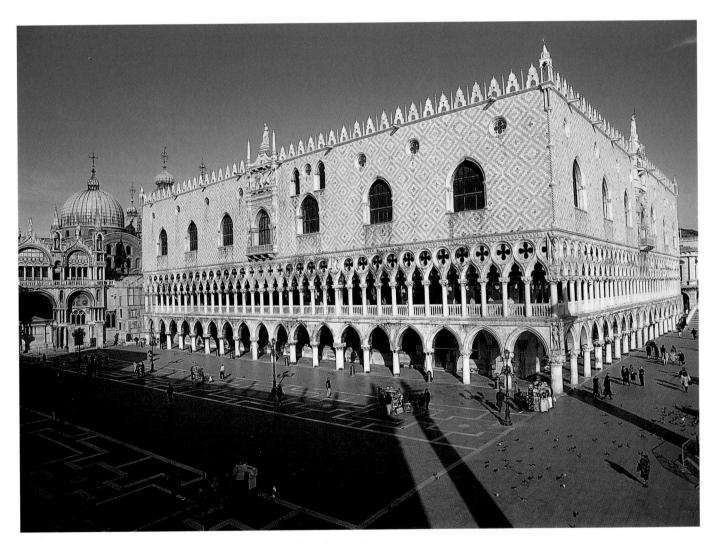

11.53 Doges' Palace, Venice, Italy. The façade dates from the 1420s.

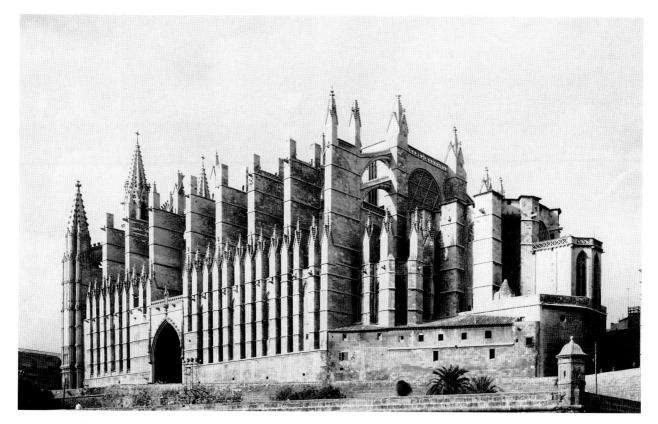

11.51 Southeast view of Palma de Mallorca Cathedral, island of Mallorca, begun 1306.

In 1306, the enormous cathedral of Palma on the Spanish island of Mallorca was begun (fig. **11.51**). Here it is shown from the southeast, where it towers over the edge of the sea. It is one of many buildings inspired by the ouster of Muslims from major cities in southern Europe just before the middle of the thirteenth century. The cathedral is noteworthy for its huge buttresses as well as for the Islamic influence evident on the entrance arch.

Among the most notable examples of the Gothic style in central Europe is Prague Cathedral, commissioned in 1344 by Emperor Charles IV. The original designs were made by a Frenchman who died in 1356, and work was resumed by Peter Parler (1333–1399), a member of a family of master masons active in southern Germany. The view illustrated here (fig. **11.52**) shows the vertical emphasis of the pinnacled buttresses around the apse and the radiating chapels.

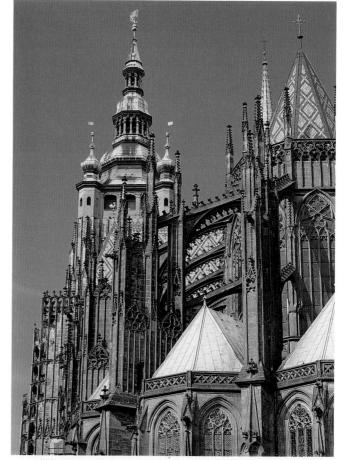

11.52 Apse, Prague Cathedral, Czech Republic.

The Spread of Gothic

In Italy, the Gothic style was a continuation of Italian Romanesque, but it was also influenced by French Gothic. A good example of early Italian Gothic is the façade of Siena Cathedral, which dates to around 1284–1299 (fig. **11.49**). It was designed by Giovanni Pisano (active c. 1265–1314), whose father, Nicola, is discussed in the next chapter. Although retaining the dark marble stripes of Italian Romanesque (see Chapter 10), the general organization of the façade is Gothic. There are three portals surmounted by sharply pointed arches, which recur in the triangular gables. A rose window dominates the center of the façade. In contrast to the French examples, however, most of the relief sculpture is on the tympanums. Other sculptures, on the gables and around the doors, are free-standing.

The largest Italian Gothic cathedral is in the northern city of Milan (fig. **11.50**). Begun in 1386, it is also one of the later examples of the style: the choir and transepts were not completed until 1450. The huge, imposing form looms over the square, combining massive size with delicate surface patterns. It is likely that the final structure reflects the debates between local Milanese architects and experts from France and Germany who advised on the project. The lacy effect of traceries, multiple windows, and thin, vertical spires is far more elaborate than the façade of the earlier, and more purely Italian, Siena Cathedral.

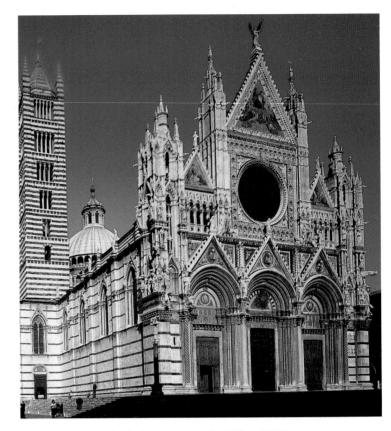

11.49 Siena Cathedral, Tuscany, Italy, 1284–1299.

11.50 Milan Cathedral, Milan, Italy, begun 1386.

Style/Period

GOTHIC

200

1300

Sainte-Chapelle

GOTHIC 13th century

Chartres Cathedral

GOTHIC

Reims Cathedral

GOTHIC 15th century

NEO-GOTHIC 19th century

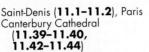

Reims Cathedral

Chartres Cathedral (11.5, 11.11–11.13, 11.17–11.22, 11.24–11.25) Reims Cathedral (11.32–11.33, 11.35) Amiens Cathedral (11.27–11.31) Salisbury Cathedral (11.46, 11.47 Carpenters' Guild signature window (11.8), Chartres

Virgin of the Annunciation

Jeroboam Worshiping Golden Calves (11.7), Chartres

Sketchbook of Villard de Honnecourt (11.9-11.10)

Sainte-Chapelle (**11.38**), Paris Philip I Granting Privileges to Saint-Martin-des-Champs (**11.36**) Giovanni Pisano, Siena Cathedral (**11.49**)

Palma de Mallorca Cathedral (11.51) Scene from the Life of Saint Denis (11.37) Prague Cathedral (11.52) Milan Cathedral (11.50)

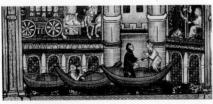

Life of Saint Denis

Doges' Palace (**11.53**), Venice King's College Chapel (**11.48**), Cambridge Town hall (**11.54**), Louvain

Antichrist as a Three-Headed Tyrant (11.23)

Saint Patrick's Cathedral (11.55), New York

Cultural/Historical Developments

Suger named abbot of Saint-Denis (1122) Birth of Moses Maimonides, Jewish religious philosopher, 1134 (d. 1204) Game of chess introduced into England (c. 1150) University of Paris founded (1150) First silver florins minted at Florence (1189)

Second Coming of Christ

King John signs Magna Carta (1215) Dominican Order founded (1216) Death of Francis of Assisi (1226) Kublai Khan ruler of the Mongols (1260–1294) Arabic numerals introduced into Europe (late 1200s) Arabic numerals introduced into Europe (late 1200s Dante Alighieri, Italian poet, author of *The Divine Comedy* (1265–1321) Jacopo da Voragine (c. 1228–1298) publishes *The Golden Legend*, a collection of apocryphal religious stories (1266–1283) Marco Polo travels from Venice to China

(1271 - 1295)

Thomas Aquinas writes Summa Theologiae (1273) Rise of Florence as a leading commercial center (1280s)

Fall of Acre; end of Christian rule in the East (1291)

Doges' Palace

Milan Cathedral

Carpenters' Guild window

Window on the World Six

Buddhist and Hindu Developments in East Asia and South Asia (6th–13th centuries)

n 1210, the Mongols, central Asian nomads who were feared in Europe as the Antichrist, began their conquest of China (see map, p. 436). Leading the so-called Mongol hordes was Genghis Khan. Fifty years later, his sons ruled a vast territory. By 1279, his grandson Kublai Khan had founded the Yuan dynasty and become its first emperor. This conquest resulted in a unification of China, which would be ruled by khans until 1368. Under Mongol control, China continued to trade with western Europe, exporting silk cloth, ceramics, and carpets. These relatively transportable items exposed Europeans to Far Eastern art forms and motifs, some of which occasionally appear in Western art.

The Venetian merchant Marco Polo (c. 1254–1324) wrote an account of his travels in Asia; although its authenticity has been doubted, the Western image of the Far East during the thirteenth century was long based on this source.

Buddhist Paradise Sects

The Buddhist Paradise sects responsible for the change in the representation of the Buddha between the period of the Yungang caves and those at Longmen (see Window Four) fostered a new imagery in painting. Spectacular examples of paradise iconography from the eighth century have been found in caves at Dunhuang. Nearly 1,000 miles (1,609 km) west of Yungang, the Dunhuang oasis was the easternmost stop on the Silk Route in central Asia.

Buddha Preaching the Law (fig. W6.1) from Cave 17 at Dunhuang shows the rich, bright colors used to express the wealth of Amitabha's Great Western Paradise. The Buddha sits cross-legged under an elaborate

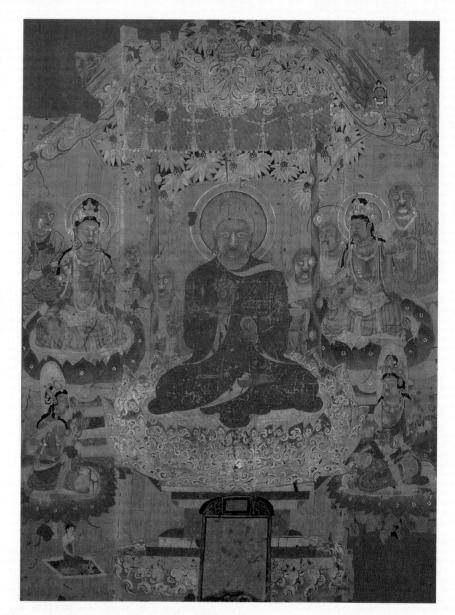

W6.1 Buddha (Shakyamuni or Amitabha) Preaching the Law, Cave 17, Dunhuang Province, China, early 8th century. Ink and colors on silk; 11 ft. 6 in. (3.50 m) high. British Museum, London. Both this Buddha image and the one in figure W6.2 were part of an important cache of manuscripts and art hidden by the monks of Dunhuang in the 11th century. It was discovered in 1907–1908 by Sir Aurel Stein, an English archaeologist, who sent as much of the hoard as he could to the British Museum in London. Many such banners were apparently produced in monastery workshops. They were sold to pilgrims as offerings to be laid in Dunhuang's famous Caves of the Thousand Buddhas. The blank space at the bottom of each image was intended for its donor's customized dedication inscription.

W6.2 Shakyamuni Buddha Preaching on Vulture Peak, Cave 17, Dunhuang Province, China, 8th century. Silk embroidery; 20 ft. (6.09 m) high. British Museum, London. This large image, created entirely of fine stitches in silk thread, demonstrates the high level of skill attained by Chinese embroiderers in rendering three-dimensional forms.

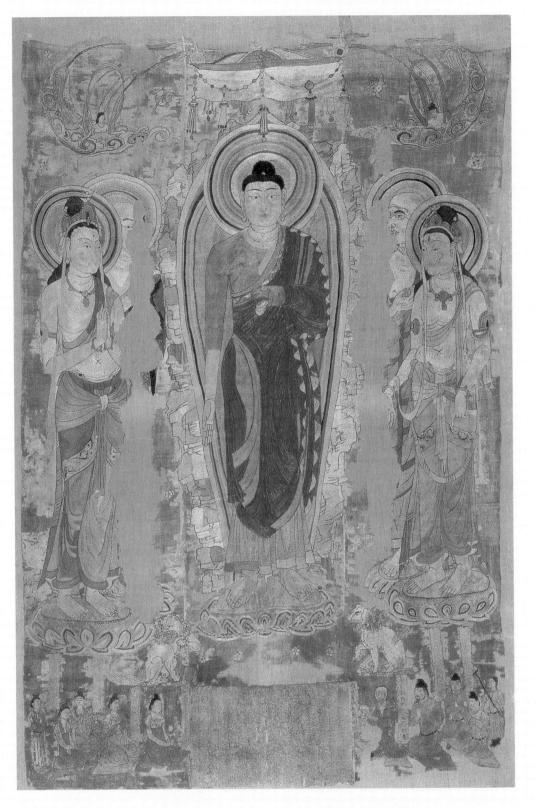

canopy on a lotus throne, which symbolizes *nirvana*, his blue hair contrasting sharply with the bright orange of his robe. Four elegantly attired bodhisattvas sit at the corners of his throne. Behind the Buddha, to the left and right, are two sets of three monks who appear to turn in space. Their small size indicates their lesser status, and four of the six reinforce the Buddha's central position and iconic quality by focusing their gaze on him. The tiny female donor in the lower left corner had a male counterpart on the right, but all that remains is his hat.

Among the doctrines related to the Paradise sects was Tiantai, according to which everyone could achieve buddhahood. This belief derived from the Lotus Sutra's doctrine that faith, rather than deeds, could lead to salvation. The silk embroidery of *Shakyamuni Buddha* Preaching on Vulture Peak (fig. W6.2) depicts the Buddha propounding the Tiantai Law, as described in the Lotus Sutra. He stands under a canopy on a small lotus throne, surrounded by a mandorla, against a backdrop of rocks representing the Vulture Peak. Two bo-dhisattvas stand on either side of him, with a pair of small lion guardians below. At the bottom of the image are tiny figures of donors.

The Pagoda

The interiors of many of the Yungang and Dunhuang caves contained multistoried towers. These became the characteristic Buddhist structure of the Far East (China, Korea, and Japan; also known as east Asia). Beginning in the seventh century, pagodas-as they were called by the Portuguese living in India-were a synthesis of Indian stupas and Chinese military watchtowers. Like stupas, pagodas have a reliquary function and a setting that leaves enough space for worshipers to circumambulate them, although later Far Eastern pagodas can actually be entered. The pagoda was conceived in sections that were stacked one on top of the other and tapered toward the top. Each section had an eavelike cornice projecting over it. A pyramidal form at the top was surmounted by a vertical element symbolizing the axis pillar of the World Mountain. Inside the caves, these spires merged into the roof.

The pagoda developed from an interior towerlike structure into an exterior, freestanding one made of wood, brick, or stone in several variations on the basic form. Some types were extremely elaborate. The individual tiers ranged from two to fifteen in number, although seven was standard. An early eighth-century pagoda with nine tiers

W6.3 Pagoda, Yunshusu, Mount Fang, Hopei (Hebei) Province, China, early 8th century.

is illustrated in figure W6.3, while the mid-eleventh-century example in figure W6.4 has thirteen.

Very little early Chinese architecture survives, but its descendants are

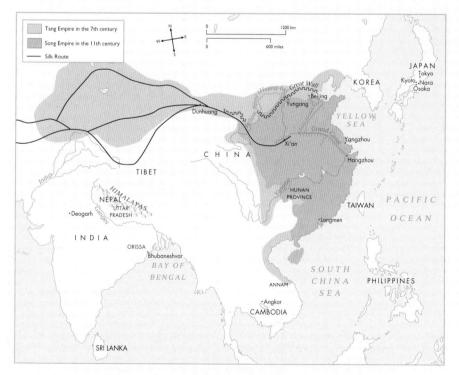

East Asia.

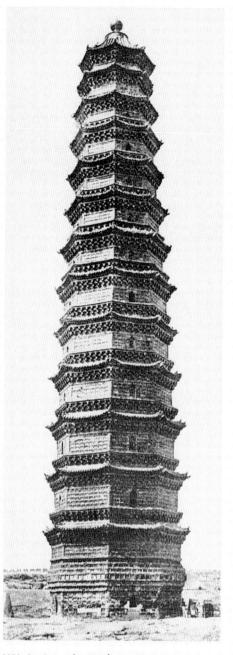

W6.4 Pagoda, Kaifeng, Hunan Province, China, mid-11th century.

found elsewhere in the Far East. From early on, the pagoda was assimilated throughout east Asia into Buddhist architectural complexes, especially monasteries. Besides signifying the spiritual force of Buddhism, the pagoda was believed to represent the passage of time. Relics embodied the past, the structure itself the present, and its height the future aspirations of faith. Like the towers of Gothic cathedrals, pagodas were the tallest part of Buddhist monasteries and were thus visible from afar. In each case, the vertical plane functions as a visual statement of presence, power, and piety.

The Buddhist Monastery: Horyu-ji

Buddhism reached Japan from China through images and sutras sent by the Korean kingdom of Paekche in the middle of the sixth century. Chinese culture was of great interest to Japan at the time. The imported religion flourished under the patronage of Japan's first great leader, Prince Shotoku (574–622). He founded what became the monastery of Horyu-ji (*ji* meaning "temple") in Nara (which from 710 to 784 was the capital of Japan), 25 miles (40 km) east of Osaka.

Horvu-ji's five-tiered pagoda (Gojuno-to), dating from the late seventh century, is a good example of a pagoda in a monastic community (fig. W6.5). The gently sloping hills on the outskirts of Nara provide a natural enclosure for the monastery complex (fig. W6.6), which not only is the earliest surviving Buddhist architectural group in Japan, but also includes the oldest wooden temple in the world. In addition to the pagoda, the small complex consisted of a *kondo* (the Golden Hall: fig. W6.7), a cloister, temples, living quarters for the monks, and a gate. The complex was arranged on an eastwest axis that ran from the gate, between the kondo and the pagoda, to a refectory (now destroyed). The pagoda faces the kondo, creating a balance of asymmetrical structures.

W6.5 Five-storied pagoda (*Goju-no-to*), monastery of Horyu-ji, Nara, Japan, late 7th century.

The *kondō* (fig. W6.7), also derived from a Chinese building type, is supported by a stone plinth oriented to the cardinal points of the compass. Stairs at the center of each side lead to double doors. The basic elevation is post-and-lintel, with the lintel inserted into the upper part of the post (figs. W6.8 and W6.9). The points where the post and lintel join are reinforced by brackets decorated with carvings. Such brackets channeled the thrust of the tile roof through the wooden posts and into the main foundation supports, and remained a strong design element in later Japanese architecture. By making the inner posts taller than those at the ends, it was possible to create a curved roof supported by the extended, projecting (cantilevered) lintels.

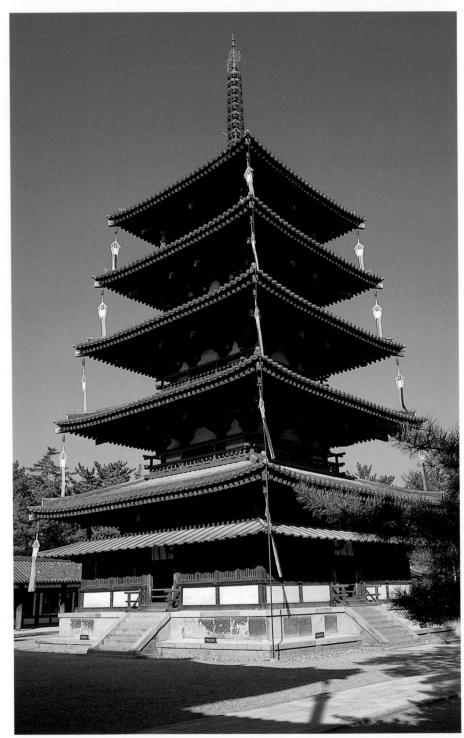

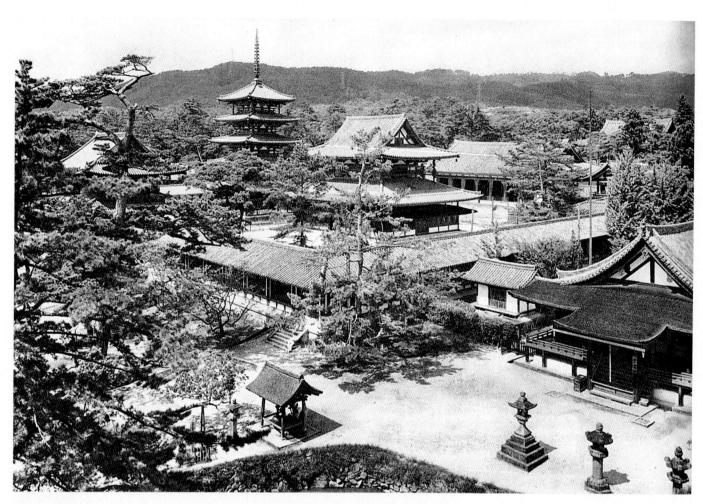

W6.6 View of the monastery of Horyu-ji, Nara, Japan, late 7th century. Prince Shotoku's original temple complex was burned in 670 and rebuilt nearby as the monastery of Horyu-ji.

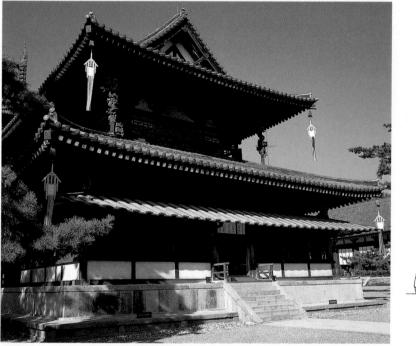

W6.7 Kondō (Golden Hall), Horyu-ji, Nara, Japan, late 7th century.

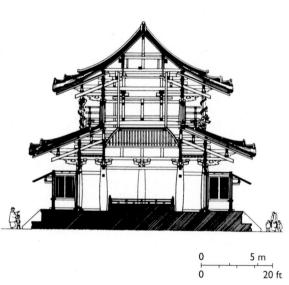

W6.8 Diagram section of the Horyu-ji kondo.

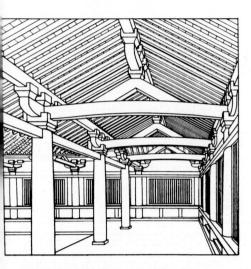

W6.9 Drawing of part of the Horyu-ji *kondō;* gallery, showing post-and-lintel construction.

Hinduism

Hinduism is the only major religion without a founder, being based on an accumulation of sacred and devotional texts, myths, rituals, and practices. Its origins lie somewhere in the second millennium B.C., following the Aryan invasion of the Indian subcontinent. Hindus conceive of the universe as cyclical, destroyed by fire, and dissolving into the ocean at the end of each cosmic age, to be reborn again and again. This universe is conceived of as an egg, separated into three regions where gods, humans, and demonsthe forces of order on the one hand and of chaos on the other-battle for control. Hinduism recognizes this cosmic struggle as a necessary, even desirable, search for balance between opposing forces.

The Hindu gods appear in many manifestations, and in art the varied iconography of a single deity represents its different aspects. Often, like Vishnu (see fig. W6.12), the gods are represented with multiple limbs and heads as a sign of their superhuman powers. Each deity is believed to embody a truth that transcends its physical guise, and images are a conduit for bringing the divine world into contact with the human world. By making sculptures of the gods beautiful-following certain canons of proportion and form, clothing and anointing the figures, and so forth-deities can be

induced to inhabit their representations. Priests chant in Sanskrit, the sacred language of Hinduism, pray, and make offerings to attract the gods.

The Hindu pantheon is vast and includes deities assimilated from indigenous nature cults (such as yakshas and vakshis), as well as from early Aryan religion. The abode of the gods is Mount Meru, the mythical World Mountain whose axis links earth to heaven. A trio of male gods is responsible for the great cycles of cosmic time: Brahma (the Creator), Vishnu (the Preserver), and Shiva (the Destroyer). Each has a powerful female energy, his shakti. While Hindus identify themselves as either Vaishnavite or Shaivite (devotees of Vishnu or Shiva, respectively), they honor multiple deities.

Embodying the multiplicity characteristic of Hinduism. Shiva is both destructive and creative. He is associated with male sexual energy and procreation (worshiped in the form of a lingam, or phallus, or in anthropomorphic quise astride his bull. Nandi), as well as with asceticism and sacred texts (in the form of a meditating yogi with matted hair, clad in an animal skin). He is the three-eyed lord of the beasts and of the battlefield (symbolized by his trident), and patron god of the arts. His consort is Uma, daughter of the Himalaya Mountains. Their elephantheaded, pot-bellied son Ganesh is popularly worshiped as the remover of obstacles.

Vishnu keeps the universe in equilibrium. According to the creation myth illustrated in figure W6.12, he dreams the plan of the universe at the beginning of each cycle of existencehence, we are living Vishnu's dream, and what we perceive as reality is actually illusion. Vishnu has ten avatars, or manifestations, among them a fish, tortoise, boar, man-lion, a dwarf who encompasses the universe in three strides, and Rama, the hero of the Ramayana epic. (Hanuman, a monkeygeneral who helps Rama, is a popular god.) Vishnu's best-loved avatar is Krishna, the blue-skinned, flute-playing erotic trickster god. In each of these forms, Vishnu saves the world from destruction by demons. To upstage Buddhism, its younger rival, Hinduism, incorporated the Buddha as another avatar of Vishnu.

Among Hinduism's many important female deities are Sarasvati (goddess of learning) and Lakshmi (goddess of fortune). The holy rivers Ganga (Ganges) and Yamuna (Jumna) are worshiped as fertility goddesses. Collectively, Hindu goddesses may be thought of as embodying aspects of Devi, the Great Mother. Like Shiva, Devi is both creative and destructive: she is a voluptuous, maternal nurturer, and she is also Kali, the skeletal, bloodthirsty hag who eats children; she is both a subservient consort of a male god and Durga, the superwarrior whose strength combines that of the male gods to defeat an otherwise invincible Buffalo Demon. Devi is also worshiped in the ancient form of the Sapta Matrikas, the Seven Mothers. She is closely associated with nature and fertility, and is sometimes represented as a voni (female sex organ) encircling a lingam, thus symbolizing the conjunction of female and male energies. Outside mainstream Hinduism, goddess worship is a powerful force in esoteric Tantric sects (Buddhist as well as Hindu), whose practices may include ritual sexual intercourse and offering sacrificial animal blood to the goddess.

One of the central Hindu beliefs is reincarnation leading to nirvana, the ultimate release from the cycle of rebirth, when the soul unites with the cosmos. Each incarnation is a stage in the long journey toward liberation from this illusory world, and progress toward nirvana depends on karma, the guality of behavior in a current or previous life. While in the world, everyone is ruled by Dharma, the Law, in addition to which each hereditary social class (varnas, or caste) has its own code of conduct. Society is divided into an elite, ritually pure Brahmin caste, whose men are traditionally priests; a warrior and ruler Kshatriya caste; an artisan and merchant Vaishya caste; and a peasant Shudra caste. Those beneath caste, considered ritually polluted, were known as Untouchables until they were renamed Harijans (Children of God) by Mahatma Gandhi (1869–1948) in an attempt to improve their social status. While hereditary caste is no longer all-important in the lives of Hindus, one must still be born Hindu in order to be Hindu.

The Hindu Artist

For Hindus, art is an expression that transcends the individual artist. The creation of religious art is a hereditary vocation and an act of devotion, an offering to the gods. Hindu artistic activity centers around temples, much as the cathedral towns of medieval Europe were a focus of Christian artistic production. Some Hindu artists were organized into guilds, which tended to be composed of family groups and within which skills were passed from one generation to the next. The guilds set ethical and artistic standards as well as rules regulating the lives of their members. They set prices and arranged contracts. Duties were strictly divided by rank, including those of the chief architect (sutradhara), the general overseer, the head stonemason, and head image maker (sculptor). Each supervised a particular aroup of workers. Brahmins, who were expert in art theory and iconography, were in charge of quality and content. The Vaishyas under them were regarded as skilled laborers.

Artists and their families who lived and worked at temple sites were so numerous that thriving communities grew up around them. Since temples were the intellectual as well as spiritual centers of their communities, schools were established, and festivals were held in their vicinity.

The financing of Hindu temple construction was primarily in the hands of royal patrons. It was supported by donations of money, cattle (sacred to Hindus), objects of value, land grants, and services from others. Contributions to temples were partly motivated by the donor's hope of accumulating good *karma* and of receiving divine assistance. Since Hindu temples amassed considerable wealth, which included land, they became major employers and landlords. In southern India, there are vast temple complexes that were once cities within cities, employing hundreds of specialized artists.

The Hindu Temple

The roots of Hinduism predated Buddhism in south Asia by some fifteen hundred years, and the newer faith borrowed many ideas and artistic motifs from the older one. Hinduism also spread to other regions, particularly to southeast Asia, although to a lesser degree than Buddhism.

The earliest sacred structures on the Indian subcontinent may have been *vedikās* (railings) that surrounded trees and stones to mark places of spiritual significance. As Vedic religion developed, Brahmin priests constructed temporary, open-air fire altars according to a strict geometric system. Hindu temple architecture evolved from these two traditions. (Although fire altars are rarely built today, the ancient practice of worshiping at very simple outdoor shrines continues.)

The sophisticated mathematics of Hindu temples was codified in texts called *Shilpa shastras,* in which temples were conceptualized as both anthropomorphic forms and as mandalas (cosmic diagrams connecting the human world with the celestial). The temples are believed to concentrate divine energy and anchor sacred space along a world axis.

Basically, Hindu temples, like Greek temples, are houses for deities. Images abound, and worship takes place throughout temple precincts. A temple's main cult image is contained within its inner sanctuary, or *garbha griha* ("womb chamber"), which is a small, windowless, cube-shaped *cella*. This dark, intimate space is typically perfumed with incense and lit by the glow of oil lamps. Priests and worshipers perform *puja*—devotions. The protective, womblike function of the Hindu temple is reflected by the thickness of the ceiling and the *cella* walls.

Hindu worship is not congregational in the Western sense. Instead. priests perform elaborate sacred rites on behalf of their communities. Puja at a temple begins with sunrise, when a priest opens the chamber of the "womb" and salutes the door guardians. In a ritual involving all the senses, he sounds a bell and claps to expel negative spirits, arouse the deity or deities, and announce his presence. He then chants hymns and mantras (ritual sacred formulas), accompanied by mudras (symbolic hand gestures). Vessels are readied for the cleansing and dressing of images, which are anointed, draped with garlands, and offered specially prepared food. When the priest has completed his ceremonial duties, he circumambulates the statue clockwise. bows, and leaves the sanctuary.

For Hindus, the temple was one stop on a long metaphorical journey in the quest for spiritual perfection. In the course of this journey, worshipers progress from a large to a small space, from natural light to a dark interior, and from the illusory complexities of the material world to spiritual simplicity.

These beliefs are reflected in the concepts underlying temple construction. First, a sacred site is chosen—a grove for its links to early tree cults, a river for its life-giving water, or a mountain by association with Mount Meru. Several

years are then dedicated to purifying the ground and ridding it of evil and impure spirits. Sacred cows graze on the site in order to enhance its fertility. The ground plan is thought of as a mandala, which maps divine space. This is a geometric "picture" of the pantheon and a miniature manifestation of the cosmos in which the temple represents Mount Meru. After its plan has been laid out, a temple's proportions are arranged according to a unit of measurement deemed to be in alignment with cosmic harmony. Finally, foundation stones are placed in the ground, and construction begins (see box).

The materials of which Hindu temples are built, like the Hindu social structure, were conceived of hierarchically in the early Shilpa shastras. Some recommended stone and wood for the higher classes of society, while others related materials to gender. Generally, however, most Hindu temples were of stone, and the color of the stone was associated with a particular caste-white being reserved for Brahmins. Either stone was quarried and bricks baked near a building site, or the materials were floated to the site on barges or brought on wood rollers by elephants. Stone blocks were shaped by masons and hauled up onto the structure by a pulley system. They were then held in place with iron clamps. In what remained basically a post-and-lintel elevation system, Hindu temples had projecting lintels made possible by the strength of the clamps. The main supporting elements were stone columns, and doors were of wood. Window bars were stone copies of wooden prototypes. Hindu temple

architecture is characterized by a wealth of regional variations on two general temple types—the northern and southern—differing primarily in the forms of their towers.

The Vishnu Temple (6th century)

The early sixth-century Temple of Vishnu at Deogarh, in Uttar Pradesh (figs. **W6.10** and **W6.11**), exemplifies early northern-style Hindu temples. This relatively simple, one-chambered structure was crowned by a *shikhara* (northern-style tower), most of which is now in ruins. Its cubic *garbha griha* stood on a raised plinth and was accessible by a stairway on each side. The dark corner rectangles on the plan mark lesser shrines dedicated to different gods. The temple's relief sculpture, with its rounded, rhythmically swaying forms, embodies the classic Gupta style. In the

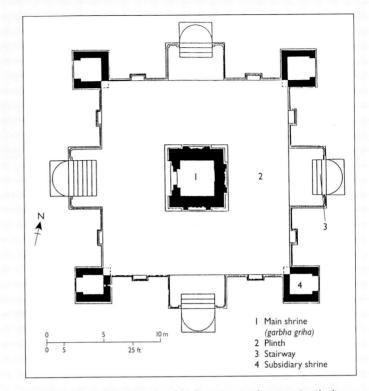

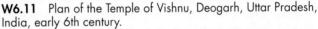

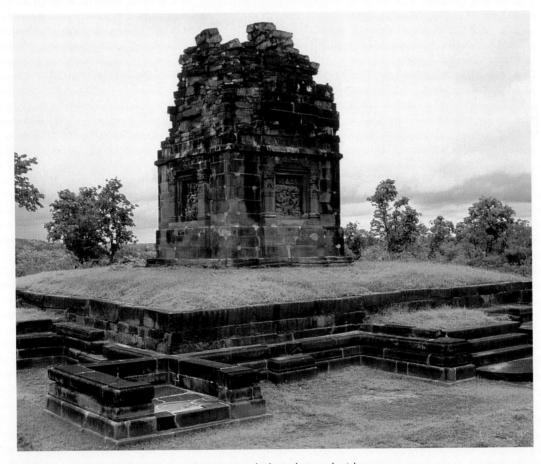

W6.10 Temple of Vishnu, Deogarh, Uttar Pradesh, India, early 6th century.

W6.12 Vishnu Sleeping on Ananta, relief panel, south side, Temple of Vishnu, Deogarh, Uttar Pradesh, India, early 6th century.

view shown here, one of the framed panels containing reliefs is visible.

The relief panel of Vishnu Sleeping on Ananta (fig. W6.12), on the south side, depicts the origin of the universe and the forces of evil within it. The large reclining figure of Vishnu, whose four arms reflect his powers, dominates the image. Crowned and jeweled, he dreams the universe into existence as he sleeps on Ananta, the Endless Serpent encircling the world, whose cobra hood frames the god's head. Holding Vishnu's foot is his wife, Lakshmi, the goddess of fortune. As his shakti, she represents his female nature, which energizes his male self to conceive of, and give birth to, the universe. Time is set in motion when a lotus flower emerges from Vishnu's navel. Among the gods at the top of the relief, the first deity, the fourheaded Brahma, sits on the lotus. Holding the tools of a builder, he will construct the world. The four figures below Vishnu to the right represent the god's weapons and prepare to do battle against two demons, Madhu and Kaitabha, at the left. The demons were born from Vishnu's ear, and tried to destroy Brahma, but Vishnu killed them instead.

The doorway at the west of the temple that leads to the *garbha griha* (fig. **W6.13**) is framed by a series of elements. The lintels and doorjambs are decorated with reliefs of foliage and various theological guardians. Within the upper corners, the river goddesses Ganga and Yamuna bless the sanctuary by pouring their waters over the threshold. Set in a square panel over the doorway is Vishnu enthroned on Ananta's coils. Here, as in the large relief on the south, Lakshmi strokes his foot to stimulate his cosmic dream.

a part of the C

W6.13 West doorway, Temple of Vishnu, Deogarh, Uttar Pradesh, India, early 6th century.

The Orissan Temple (8th–13th centuries)

By the eighth century, Hindu temples had become extremely complex structures. They varied according to period, region, patronage, and cult affiliation. From the eighth to the thirteenth centuries, Orissa, in eastern India, was a center of architectural development with a relatively consistent evolution of style. Figure **W6.14** is a diagram of the elevation of a typical Orissan temple, which shows the extent to which architectural style had become elaborated.

The mid-tenth-century Mukteshvar Temple of Shiva at Bhubaneshvar (figs. **W6.15** and **W6.16**) illustrates the Orissan version of northern-style temple architecture. This is the only one of India's famed "temple-cities" to survive. It originally had some seven thousand temples, of which about five hundred still exist, as do some of the *Shilpa shastras* on which they were

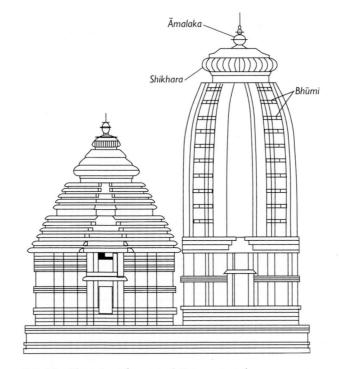

W6.15 Elevation of a typical Orissan temple.

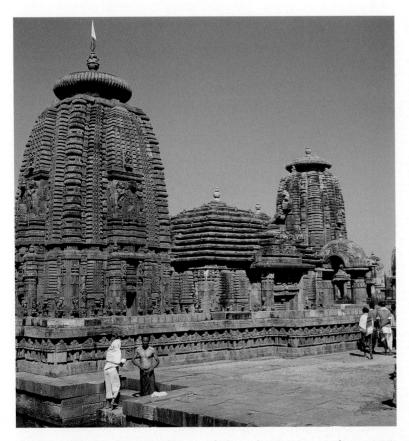

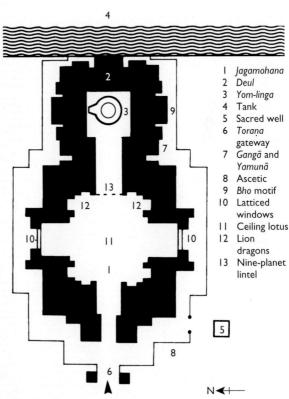

W6.14 Mukteshvar Temple of Shiva, Bhubaneshvar, Orissa, India, c. 950. Sandstone. The temple compound is entered through a *toraṇa* (gateway) on the right. Inside the *garbha griha* at the heart of the temple, the focus of worship is a Shiva *lingam* inside a *yoni*. At the far left is a sacred water tank used for ritual bathing.

W6.16 Plan of Mukteshvar Temple of Shiva, Bhubaneshvar, Orissa, India, c. 950.

based. This view of the exterior shows the towering superstructure that rises over the garbha griha. The tower consists of a lobed shikhara, surmounted by an *āmalaka* (finial in the shape of a notched ring). An assembly hall (mandapa) has also been added. The projecting veranda was used for meditation and reading as well as for dancing and ceremonies. The slightly convex outline of the exterior, which has been referred to as "expanding form," is an architectural expression of prana. This small temple's vertical and horizontal planes are unified by the carved detail covering its surface. The repetition of stacked ridges (bhūmi) on the superstructure is complemented by a rich variety of organic and abstract forms designed to welcome Shiva.

The meaning of these forms is associated with the Hindu concept of the temple as a manifestation of Mount Meru; the very term for the towers, shikhara, means "mountain peak." The term bhūmi, meaning "earth" (in the sense of "soil"), has similar symbolic connections with landscape. The crowning amalaka symbolizes the spiritual heights achieved when one transcends the reincarnation cycle. As an elaboration of the ancient Indian axis pillar, this finial was placed directly over the garbha griha so that the most sacred and highest points of the temple were in alignment.

Synthesis of Buddhism and Hinduism at Angkor

Hinduism and Buddhism spread from India to southeast Asia and were assimilated into the local belief systems. Under the Khmer Empire (sixth to thirteenth centuries) in Cambodia, the main local contribution to the imported religions was the cult of the Devaraja (god

king), in which Hinduism and Buddhism merged. The royal Khmer capital was the city of Angkor, founded by the late ninth-century king, Indravarman. His rule was notable for the development of an irrigation system that made rice the economic backbone of Cambodia during the Khmer period. Under the patronage of Indravarman, characteristic Khmer architectural features were first established. These included temple complexes consisting of several buildings united in an axial plan. Relatively modest at first, these royal temple complexes grew in size and splendor as each Devaraja sought to outdo his predecessor.

Angkor Wat (12th century)

In the twelfth century, Khmer architecture culminated in the massive complex of interconnected waterways, roadways, terraces, monastic buildings, and shrines called Angkor Wat (*wat* meaning "temple"). These were built in gray-black sandstone, under the patronage of Suryavarman II (ruled c. 1113– 1150), and dedicated to Vishnu. The temple's central icon depicted Suryavarman in the guise of Vishnu. The plan of the central complex (fig. **W6.17**) shows the characteristic rectangle arranged in an east-west orientation and

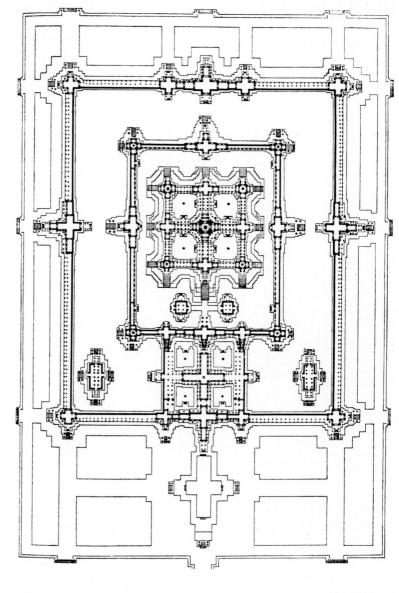

W6.17 Plan of the central complex at Angkor Wat, Cambodia, c. 1113–1150.

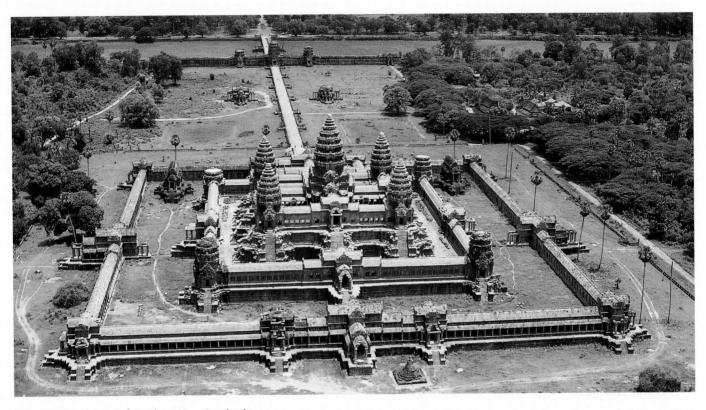

W6.18 Aerial view of Angkor Wat, Cambodia.

concentric colonnaded galleries. An inner rectangle (fig. **W6.18**), three stories high, has five towered shrines and connecting colonnades accessible by stairways. At the focal point of this complex is the central temple, which stands for Mount Meru. Thus the entire conception is a two- and three-dimensional mandala of the cosmos. At the same time, the temple had a mortuary significance and was designed as a memorial to its patron. This is reflected in the frequent representations of the death god Yama in the relief sculptures covering the walls. In addition, the temple's unconventional orientation toward the west reinforces its association with death.

The main roadway leading to Angkor Wat (fig. **W6.19**) is flanked by balustrades in the shape of giant water serpents, which are cosmic fertility symbols. There is elaborate surface decoration on the tall towers, with their flamelike motifs, and the supporting

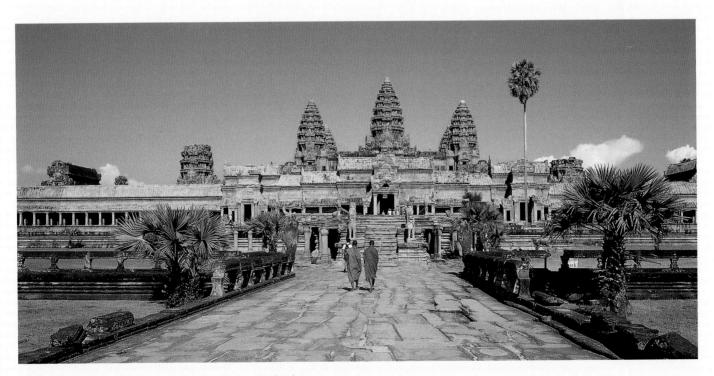

W6.19 Roadway approaching Angkor Wat, Cambodia.

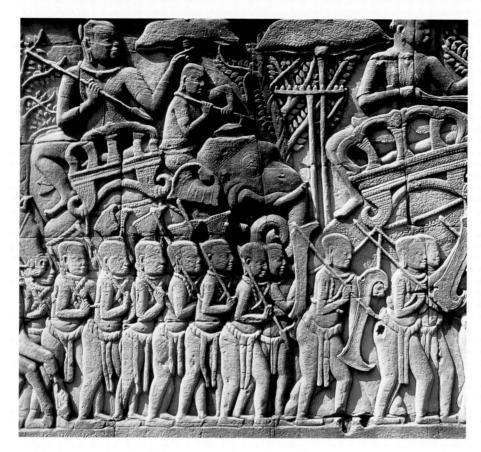

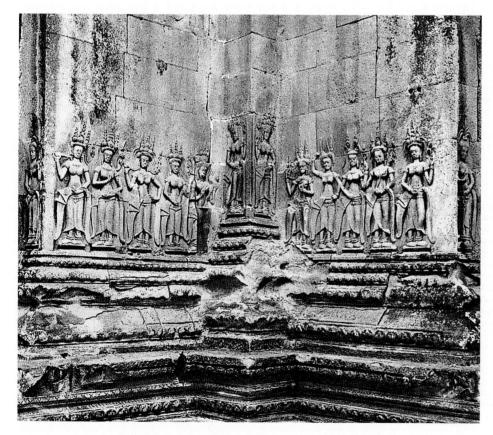

W6.20 Army on the March, Angkor Wat, Cambodia, first half of 12th century. Sandstone.

stone columns. As in Hindu temples, the towers at Angkor are tiered, overlaying a basic vertical plane with repeated horizontal bands. This repetition is broken only at the peaks, which, as in India, stand for the highest spiritual state of being.

Angkor Wat is covered with nearly 13,000 square feet (1,208 m²) of intricate relief sculpture. As on the towers, the low relief depicting an *Army on the March* (fig. **W6.20**) is characterized by repetitive detail, which can be hypnotic in effect. The elephant-drawn chariot creates a formal counterpoint, its curves and diagonals combined with expansive forms.

An isocephalic frieze of celestial Apsaras (fig. W6.21)-courtesans and dancers, probably water nymphsadorns the exterior wall of a gallery. They provide a visual transition from the carved moldings to the plain wall and thus are integrated with the architecture. The Apsaras are portrayed dancing on short horizontal platforms that repeat the projections of the molding. Each figure faces outward and appears to sway with the music. They seem to greet visitors with seductive grace, while also referring to the spiritual heights symbolized by the peaks of the towers. This synthesis of the spiritual with the erotic is characteristic of much Hindu sculpture, particularly at transition points. The detail of the frieze (fig. W6.22) shows one of the dancers, whose jewelry is carved in low-relief patterns that contrast with her voluptuous breasts and ample proportions. Echoing her S-shape pose are the framing arch and her belt. The combination of physical sensuousness with an otherworldly inward gaze is typical of Hindu aesthetics.

W6.21 Apsaras, exterior wall of a gallery, Angkor Wat, Cambodia.

W6.22 *"Water Nymph,"* detail of a frieze, Angkor Wat, Cambodia. © photo: Daniel Entwistle.

Angkor Thom (13th century)

Angkor was abandoned after being sacked by a neighboring ruler. By the beginning of the thirteenth century, the Buddhist Khmer king, Jayavarman VII (ruled 1181–1218), had planned a new capital and sacred precinct at the nearby Angkor Thom, meaning "Great Angkor" (fig. **W6.23**). There, the city walls have huge gateways with towers on which monumental images of the Devaraja's face are carved (fig. **W6.24**). The most important temple at Angkor Thom, the Bayon, was Buddhist and also incorporates local ancestor cults. As at Angkor Wat, the Angkor Thom temple was intended to replicate the cosmic center and to identify it as the king's power base. The height of the large central tower (see fig. W6.23) is equal to its depth below ground, uniting the subterranean realm with earth and sky. Similarly, the wide moat around the complex was identified with the cosmic ocean. Jayavarman VII's huge face over the entrance proclaims his union with the mountain and his symbolic role as "King of the Mountain"—specifically, the King of Mount Meru.

The Buddhist era at Angkor was short-lived. With the death of Jayavarman VII and the subsequent decline of Angkor's importance, Hinduism was revived in Cambodia.

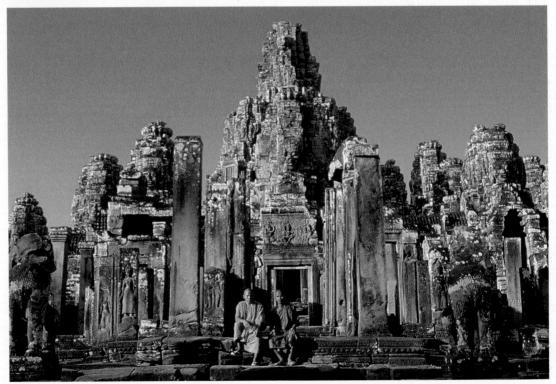

W6.23 Bayon temple, Angkor Thom, Cambodia, c. 1200.

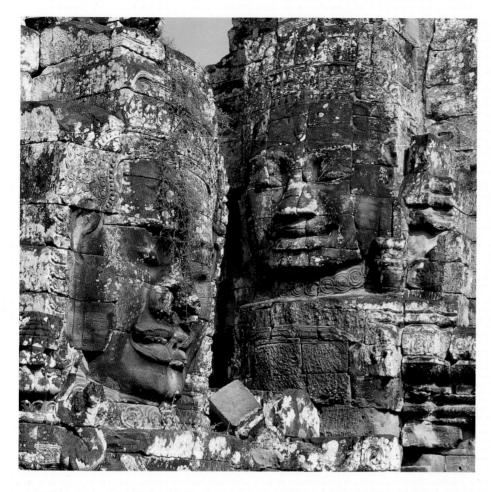

W6.24 Towers with monumental faces of the Devaraja, Bayon, Angkor Thom, Cambodia.

Style/Period

60

8th century

Pagoda, Horyu-ji, Nara

9th-11th centuries

HINDUISM 6th century

8th-13th centuries

BUDDHISM/HINDUISM SYNTHESIS 12th century

13th century

Works of Art

Monastery (**W6.6**), Horyu-ji, Nara Pagoda (**W6.5**), Horyu-ji, Nara Kondō (**W6.7**), Horyu-ji, Nara

Buddha Preaching the Law (W6.1) Dunhuang Province Pagoda (**W6.3**), Hopei Province

Shakyamuni Buddha Preaching on Vulture Peak (W6.2), Dunhuang Province

Vishnu Sleeping on Ananta, Deogarh, **Uttar Pradesh**

Mukteshvar Temple of Shiva, Bhubaneshvar, Orissa (**W6.15**)

Angkor Wat (**W6.18–W6.19**) Army on the March (**W6.20**), Angkor Wat Apsaras (**W6.21**), Angkor Wat "Water Nymph" (**W6.22**), Angkor Wat

Angkor Thom (W6.23-W6.24)

Shakyamuni Buddha **Preaching on Vulture** Peak, Dunhuang Province

Pagoda (W6.4),

Temple of Vishnu

Pradesh

Deogarh, Uttar

Kaifeng, Hunan Province

(W6.11-W6.13),

- (c. 600)
 Death of Prince Shotoku, "founder" of Buddhism in Japan (c. 622)
 Death of Muhammad (632)
 Development of the pagoda (7th 11th control of the pagoda) (7th-11th centuries) Japan's capital moves from Nara to Kyoto (794)
 - Charlemagne crowned Holy Roman emperor (800) Chinese porcelain introduced to central Asia via Silk Road (9th century)

Cultural/Historical Developments

Chinese emperor persecutes Buddhism (845) First book printed in China (868)

- Completion of Koran (935) Chinese discover gunpowder (1000)
- Muslim dominance of India (c. 1000-1750)
- Chinese use movable type (1041)
- Suryavarman II rules Khmer Empire, Cambodia (1113–1150)

- Mongols begin conquest of China (1210) Signing of the Magna Carta (1215) Kublai Khan rules the Mongols (1260–1294)
- Marco Polo travels from Venice to China (1271 - 1295)

Water Nymph,"

Angkor Wat

Towers with monumental faces of the Devaraia. Angkor Thom

300

12

Precursors of the Renaissance

Thirteenth-Century Italy

During the eleventh and twelfth centuries, Italy continued to be accessible to Byzantine influences, par-

ticularly through its eastern port cities of Venice and Ravenna. Around the turn of the thirteenth century, however, momentous developments in Italy, inspired by imperial Roman traditions, laid the foundations for a major shift in western European art and culture.

The name given to the period of Italian history from the thirteenth through the sixteenth centuries is the *Renaissance*—the French word for "rebirth" (*rinascimento* in Italian). Dating the beginning of Renaissance style remains an issue of debate, and some would consider the works in this chapter to be late Gothic. But the term *Renaissance* denotes a self-conscious revival of interest in ancient Greek and Roman texts and culture that is reflected in the work of most of the artists discussed here. Italy was the logical place for such a revival since the model of imperial Rome was part of its own history and territory (see map, p. 451).

Nicola Pisano

Around 1260, Nicola Pisano (active c. 1258–before 1284) carved the marble pulpit (fig. **12.1**) for the Baptistery in Pisa. The relief of the *Nativity* (fig. **12.2**) provides a good example of the Roman heritage in Italian medieval art. It is crowded with figures, including, from left to right at the bottom, a bearded Joseph, two midwives washing the infant Jesus in a basin, and sheep and goats. The largest figure, showing the influence of Etruscan and Roman tomb effigies, is Mary, whose monumentality and central position evoke her connections with the earth goddesses of antiquity. Despite the Christian subject, the forms are

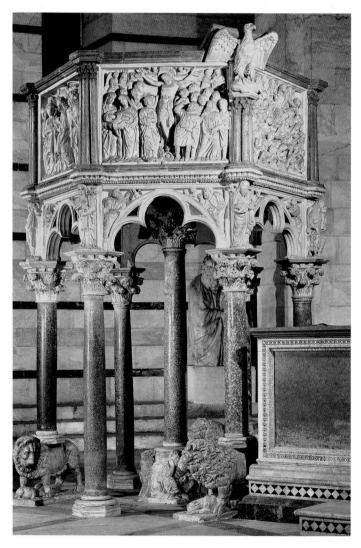

12.1 Nicola Pisano, pulpit, Pisa Baptistery, 1259–1260. Marble; 15 ft. (4.57 m) high. Nicola probably came from southern Italy and trained at the court of Frederick II. When Frederick died in 1250, Nicola went north to Tuscany. He and his son Giovanni settled in Pisa, where they worked mainly in marble.

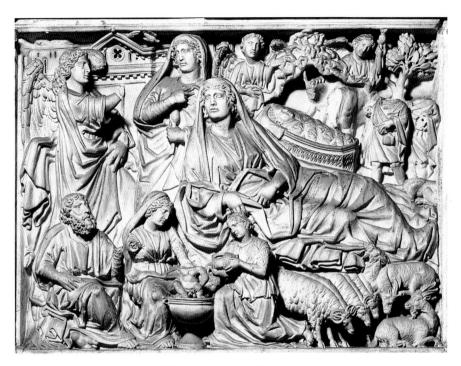

12.2 Nicola Pisano, relief of the Nativity, also showing the Annunciation (upper left), the Annunciation to the Shepherds (upper right), and the Washing of the Infant Jesus (lower center), pulpit, Pisa Baptistery, 1259–1260. Marble; approx. 34 in. (86.4 cm) high.

reminiscent of imperial Roman reliefs. Most clearly related to the Roman past is the artist's rendition of draperies, which identify the organic, three-dimensional movements of figures in space.

Furthermore, the pulpit as a whole shows a fusion of Gothic arrangement (the combination of columns with Corinthian capitals and trilobed arches) with the round arches of the Roman (and Romanesque) styles. Every other column rests on a lion, which recalls typological parallels between the Old and New Testaments. In that context, the lions refer to Solomon's throne and here denote the foundation of the teachings of Jesus.

Both the conception and execution of the pulpit reflect the cultural and stylistic crosscurrents to which Nicola Pisano had been exposed at the court of the Holy Roman emperor, Frederick II, as well as to Roman sculpture in Pisa. During the first half of the thirteenth century, Frederick controlled territories in southern Italy, and his patronage brought French and German artists as well as Italians to his court at Capua, just north of Naples. There, imported and local elements were combined with Frederick's personal taste for ancient Roman styles. Like many rulers before and after him, Frederick used the revival of Classical antiquity for political purposes, relating his accomplishments to those of imperial Rome.

Training an Artist

In the Middle Ages and Renaissance, artists learned their trade by undertaking a prolonged period of technical training in the shop of a master artist. Young men became apprentices in their early teens either because they had already shown talent or because their families wanted them to be artists. Artists usually came from the middle class, often from families of artists. Quite a few married into such families and went into business with their in-laws.

The term of apprenticeship varied, but apprentices began learning their trade at the most menial level. They mixed paints, prepared pigments and painting surfaces, and occasionally worked on less important border areas or painted the minor figures of a master's composition. By the time an apprentice was ready to start his own shop, he had a thorough grounding in techniques and media. He would

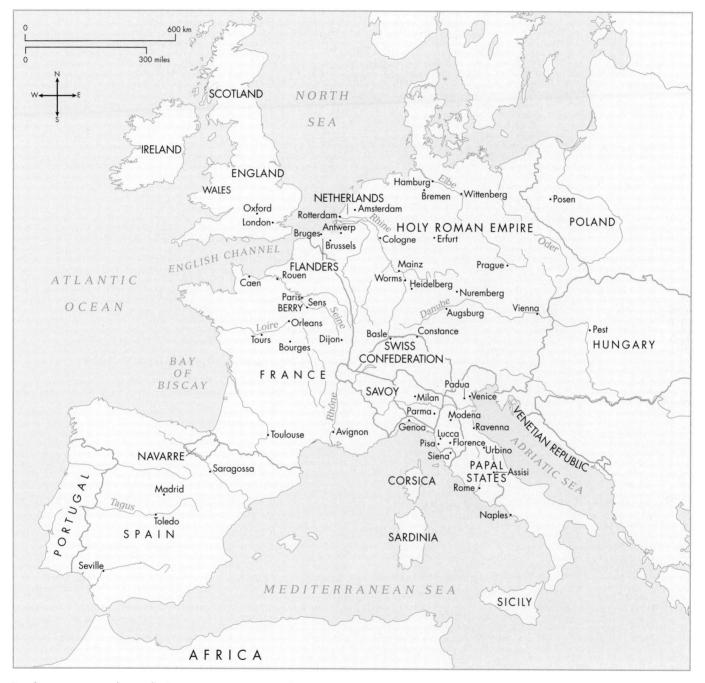

Leading art centers during the Renaissance in western Europe.

probably also have assimilated elements of his master's style.

Renaissance artists were an influential professional group, and the increased demand for art was the result of growth in the sources of patronage. During the Middle Ages, most of the patronage had been ecclesiastic (i.e., from Church authorities). In the Renaissance, more art was also commissioned by civic or corporate groups and by wealthy individuals. The commissions were generally sealed by legal contract between artist and patron, and these contracts have become important documentary sources for modern art historians.

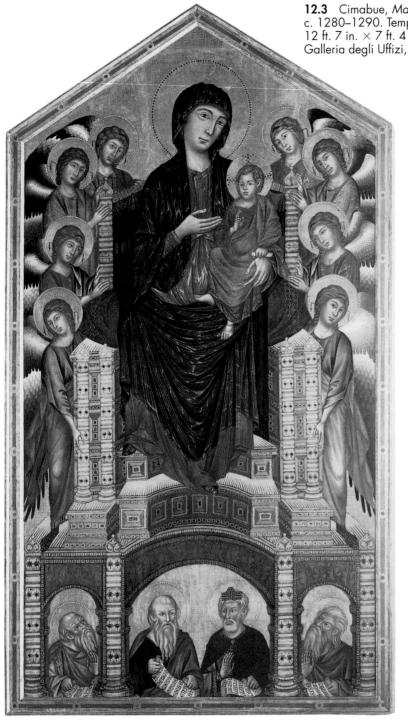

Cimabue

Byzantine influence remained strong in Italy, as can be seen in the monumental *Madonna Enthroned* (fig. **12.3**) by Cimabue (active 1272–1302). The gold background, the lines of gold in Mary's drapery, and the long, thin proportions are characteristic of Byzantine style. The elaborate throne has no visible support at the back but seems instead to rise upward, denying the material real-

12.3 Cimabue, Madonna Enthroned, c. 1280–1290. Tempera on wood; 12 ft. 7 in. × 7 ft. 4 in. (3.84 × 2.24 m). Galleria degli Uffizi, Florence.

> ity of its weight. As in Byzantine and medieval art, the Christ child is depicted with the proportions and gestures of a man. The four prophets at the foot of the throne embody the Old Dispensation as the foundation of the New.

Fourteenth-Century Italy

Cimabue is generally thought of as the last great painter working in the Byzantine tradition. The rise of humanism-a movement inspired by the revival of classical texts-in the fourteenth century reflected, but also significantly extended, the High Gothic interest in nature. Humanists began to collect ancient texts, establishing major libraries of Greek and Roman authors. Artists began to study the forms of antiquity by observing Roman ruins. And gradually a new synthesis emerged in which nature-including human character and human form-became the ideal pursued during the Renaissance. Awareness of the Classical revival began to be reflected in the works of Italian authors such as Dante, Petrarch, and Boccaccio, who discussed art and artists in a new, psychological way.

Literacy among the general population increased, and works of literature dealt more and more with art and artists, bringing their

achievements to a wider public. Another important feature of the Renaissance in Italy was a new attitude to individual fame. While most medieval artists remained anonymous, those of the Renaissance frequently signed their works. The very fact that the names of many more Italian artists of the thirteenth and fourteenth centuries are documented than in the Early Christian and medieval periods in Europe attests to the artists' wish to record their identity and to preserve it for posterity. **12.4** Giotto, Madonna Enthroned (Ognissanti Madonna), c. 1310. Tempera on wood; 10 ft. 8 in. \times 6 ft. 8 in. (3.25 \times 2.03 m). Galleria degli Uffizi, Florence. Despite Giotto's fame, few of his works are undisputed. This is the only panel painting unanimously attributed to him. It was commissioned for the Church of Ognissanti (All Saints) in Florence.

Giotto

The artist who most exemplified, and in large part created, the new developments in painting was Giotto di Bondone (c. 1267–1337). He was born in the Mugello Valley near Florence and lived mainly in that city, which was the center of the new Renaissance culture. His fame was such that he was summoned all over Italy, and possibly also to France, on various commissions.

Boccaccio, an ardent admirer of ancient Rome, described Giotto as having brought the art of painting out of medieval darkness into daylight. He compared Giotto with the Greek Classical painter Apelles as a master of clarity and illusionism. Petrarch, who was an avid collector of Classical texts and had written extensively about the benefits of nature, owned a painting by Giotto. In his will, he bequeathed the work to his lord. "The beauty of this painting," wrote Petrarch around 1361, "the ignorant cannot comprehend, but masters of the art marvel at it."1 Petrarch thus shared Boccaccio's view that Giotto appealed to the intellectually and artistically enlightened. Ignorance, by implication, was associated with the "darkness" of the Middle Ages.

Giotto became the subject of a growing number of anecdotes about artists that became popular from the fourteenth century onward. The anecdotal tradition is itself indicative of the Classical revival and derives from accounts of Classical Greek painters who were renowned for their illusionistic skill.

In Dante's *Purgatory* (see box, p. 454), Giotto and Cimabue are juxtaposed as a lesson in the transience of earthly fame:

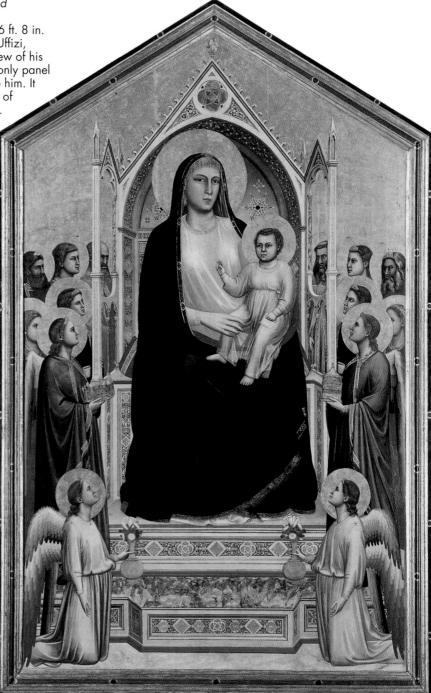

O empty glory of human powers! How short the time its green endures at its peak, if it be not overtaken by crude ages! Cimabue thought to hold the field in painting, and now Giotto has the cry, so that the fame of the former is obscured.²

A comparison of Giotto's *Madonna Enthroned* (fig. **12.4**) of about 1310 with Cimabue's (see fig. 12.3) illustrates their different approaches to space and to the relationship between space and form. Both pictures are

Dante's Divine Comedy

The Florentine poet Dante Alighieri (1265–1321) wrote *The Divine Comedy*, a long poem divided into three parts: *Inferno* (Hell), *Purgatorio* (Purgatory), and *Paradiso* (Paradise). Dante describes a week's journey in the year 1300 down through the circles of hell to Satan's realm. From there, he climbs up the mountain of purgatory, with its seven terraces, and finally ascends the spheres of heaven.

The Roman poet Virgil, author of the Aeneid, guides Dante through hell and purgatory. The very fact that Dante chooses Virgil as his guide is evidence of the growing interest in Roman antiquity. According to Dante, because Virgil lived in a pre-Christian era, he cannot continue past purgatory into paradise. Instead, it is Beatrice, Dante's deceased beloved, who guides him through heaven and presents him to the Virgin Mary.

Long valued for its literary and spiritual qualities, Dante's poem is equally important for its insights into medieval and early Renaissance history. In the course of his journey, Dante encounters many historical figures to whom he metes out various punishments or rewards, according to his opinion of them.

Tempera: Painstaking Preparation and Delicate Detail

Examples of the use of tempera are found in ancient Egypt. From the medieval period through the fifteenth century, however, it was the preferred medium for wooden panel paintings, especially in Italy, lending itself to precise details and clear edges.

For large panels, such as those illustrated in figures 12.3 and 12.4, elaborate preparations were required before painting could begin. Generally, a carpenter made the panel from poplar, which was glued and braced on the back with strips of wood. He also made and attached the frame. Apprentices then prepared the panel, under the artist's supervision, by sanding the wood until it was smooth. They sealed it with several layers of size, a glutinous material used to fill in the pores of the panel and to make a stable surface for later layers. Strips of linen reinforced the wood to prevent warping. The last step in the preparation of the panel was the addition of several layers of gesso, a water-based paint thickened with chalk and size. Once each layer of gesso had dried, the surface was again sanded, smoothed, and scraped. The gesso thus became the support for the artwork.

At this point, painting could begin. Using a brush, the artist lightly outlined the figures and forms in charcoal before reinforcing the outline in ink or incising it with a stylus. The decorative gold designs, halos, and gold background were applied next and were polished so that they would glow in the dark churches.

Apprentices made the paint by grinding pigments from mineral or vegetable extracts to a paste and suspending them in a mixture of water and egg. The artist then applied the paint with small brushes made of animal hair. Once the artist had completed the finishing touches, the painting was left to dry—a year was the recommended time—and then it was varnished. tempera on panel (see box) and were intended as altarpieces (see box, p. 455). Both have elaborate thrones (Giotto's with Gothic pointed arches), Byzantine gold backgrounds, and flat, round halos that do not turn illusionistically with the heads. Whereas Cimabue's throne rises in an irrational, unknown space (there is no floor), Giotto's is on a horizontal support approached by steps. In contrast to Cimabue's long, thin, elegant figures, Giotto's are bulky, with draperies that correspond convincingly to organic form and obey the law of gravity. Giotto has thus created an illusion of three-dimensional space—his figures seem to turn and move as in nature.

Whereas Cimabue uses lines of gold to emphasize Mary's drapery folds, Giotto's folds are rendered by shading. Giotto's V-shaped folds between Mary's knees identify both their solidity and the void between them, while the curving folds above the waist indicate a slight spatial turn and direct the viewer's attention to Jesus.

A comparison of the two figures of Jesus reveals at once that Giotto was more interested in the reality of childhood than Cimabue. Cimabue's infant retains aspects of the medieval homunculus. He has a small head and thin proportions, and he is not logically supported on Mary's lap. Giotto's Jesus, on the other hand, has chubby proportions and rolls of baby fat around his neck and wrists; he sits firmly on the horizontal surface of Mary's leg. Although Giotto's Jesus is depicted in a regal pose, his right hand raised in a gesture of blessing, his proportions are more natural than those of Cimabue.

It was precisely in the rendition of nature that Giotto seemed to his contemporaries to have surpassed Cimabue and to have revived the forms of antiquity, heralding the emergence of a new generation of artists.

The Arena Chapel

The best-preserved examples of Giotto's work are the paintings in the Arena Chapel in Padua, a town about 25 miles (40 km) southwest of Venice. In the second half of the thirteenth century, under a republican form of government, a group of Paduan lawyers developed an interest in

Altarpieces

An altarpiece is a devotional panel painting (usually tempera on wood) (see fig. **12.5**). After the church's Lateran Council of 1215, the priest was moved to the front of the altar in order to engage worshipers in the sacred drama of the Mass. This freed up the back of the altar for an image. From the thirteenth century onward, altarpieces became more common and increasingly elaborate. They typically had a fixed base (the **predella**), surmounted by one or more large panel paintings. In most cases, the large panels contain the more iconic images—such as an enthroned Virgin and Jesus, or individual saints—and the predella panels contain narrative scenes related to the larger figures.

Taking as examples the illustrations in this chapter, figures 12.3 and 12.4 would have been altarpiece panels. Figure 12.15a is a reconstruction of the front of Duccio's Maestà, the original of which replaced a small, undistinguished early thirteenth-century panel painting. Duccio's large panel of the Enthroned Virgin and Christ surrounded by saints and angels rests on a predella with scenes of Jesus's early life—from the Annunciation at the left to Jesus among the Doctors at the right, and individual figures between the narrative scenes. Above is a row of saints under round arches surmounted by pinnacles with scenes from Mary's later life—starting with the Annunciation of her death and ending with her Burial. Most of the upper sections of the pinnacles are lost.

Simone Martini's Saint Louis Altarpiece (see fig. 12.24) shows the saint crowning his brother Robert in the larger panel. Small scenes on the predella depict events from the saint's life.

In Italy, wings (side panels) would occasionally have been attached with hinges. These wings would then "close" the altarpiece when it was not on display or being used for a service. In the North, hinged wings were the norm. The Ghent Altarpiece (see Chapter 13), for example, is particularly elaborate; figure 13.65 shows the altarpiece closed so that the paintings on the outside of the wings are visible.

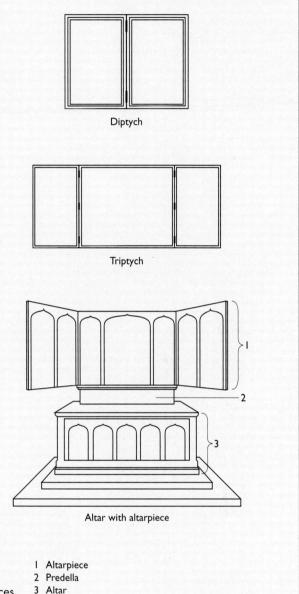

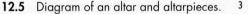

Roman law, which led to an enthusiasm for Classical thought and literature. Roman theater was revived, along with Classical poetry and rhetoric. As the site of an old and distinguished university, Padua was a natural center for a humanist revival, which acknowledged the primacy of individual intellect, character, and talent. Giotto, more than any other artist, transformed these qualities into painting.

The Arena Chapel (named after the old Roman arena adjacent to it) was founded by Enrico Scrovegni, Padua's wealthiest citizen—hence its designation as the Scrovegni Chapel. Having inherited a fortune from his father, Reginaldo Scrovegni, whom Dante had consigned to the seventh circle of hell for usury (moneylending), Enrico commissioned the chapel and its decoration as an act of atonement. The building is a simple, barrel-vaulted, rectangular structure, faced on the exterior with brick and pilaster strips. The interior is decorated with one of the most remarkable and best-preserved fresco cycles in Western art (fig. **12.6**). Architectural elements are kept to a minimum: the south wall has six windows while the north wall is solid, making it an ideal surface for fresco painting (see box, p. 457). The west wall, which has one window divided into three lancets, is covered with an enormous *Last Judgment* (see fig. 12.10).

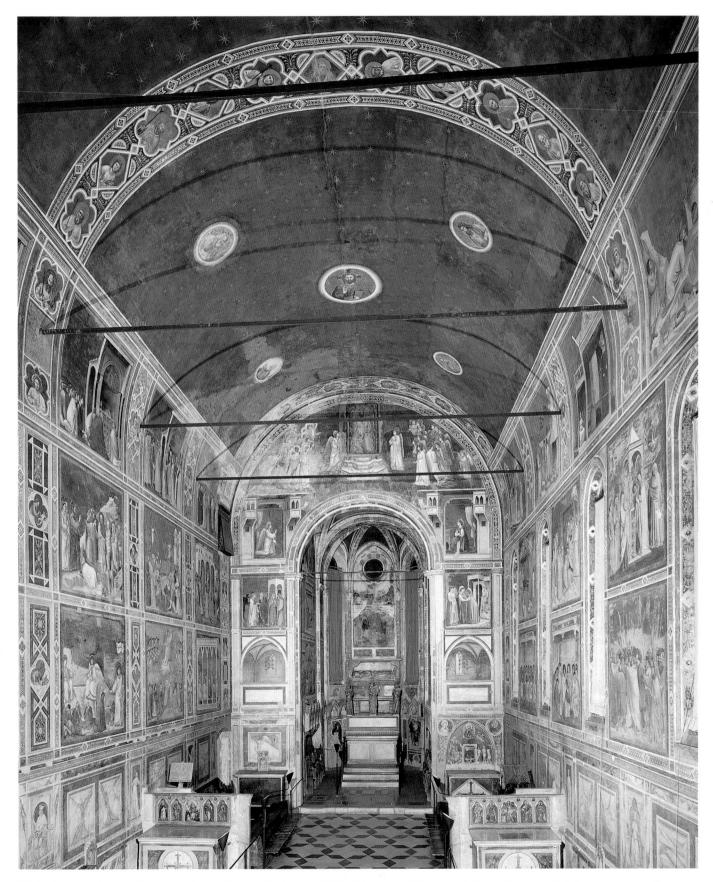

12.6 Interior view, looking east, Arena Chapel, Padua, c. 1305. At the top of the round chancel arch, which is reminiscent of Roman triumphal arches, there is a tempera panel set into the plaster wall, depicting God the Father enthroned. He summons the angel Gabriel and entrusts him with the Annunciation of Jesus's birth to Mary.

Fresco: A Medium for Speed and Confidence

From the thirteenth to the sixteenth centuries, there was a significant increase in the number of monumental fresco cycles, especially in Italy.

Fresco cycles were typically located on plaster walls in churches, public buildings, or private palaces, and large scaffolds were erected for such projects. First, the wall was covered with a layer of coarse plaster, called the **arriccio**, which was rough enough to hold the final layer of plaster. When the first layer had dried, the artist found his bearings by establishing the exact center of the surface to be painted and by locating the vertical and horizontal axes. He blocked out the composition with charcoal and made a brush drawing in red ocher pigment mixed with water. These drawings are called *sinopie* (*sinopia* in the singular) after Sinope, a town on the Black Sea known for the red color of its earth.

Once the artist completed the *sinopia*, he added the final layer of smooth plaster (*intonaco*) to the walls one patch at a time. The artist applied the colors to the *intonaco* while it was still damp and able to absorb them. Thus, when the plaster dried and hardened, the colors became integrated with it. Each patch was what the artist planned to paint in a single day—hence the term *giornata*, the Italian word for a day's work. Because each *giornata* had to be painted in a day, fresco technique encouraged advance planning, speed of execution, broad brushstrokes, and monumental forms. Sometimes small details were added in tempera, and certain colors, such as blue, were applied *secco* (dry). These have been largely lost or turned black by chemical reaction. On the north and south walls, three levels of rectangular scenes illustrate the lives of Mary, her parents Anna and Joachim, and Jesus. Below the narrative scenes on the north and south walls are Virtues and Vices (see box), disposed according to traditional left–right symbolism. As the viewer enters the chapel, the Virtues are on the right and the Vices on the left. Facing the observer is the chancel arch, containing *Gabriel's Mission* at the top, two other events from Jesus's life (the *Betrayal of Judas* on the left and the *Visitation* on the right), and two illusionistic chapels.

Immediately below *Gabriel's Mission*, separated into two sections on either side of the arch, is the *Annunciation* (fig. **12.7**). The setting is a rectangular architectural space with balconies that seem to project outward. Equally illusionistic are the pieces of cloth that appear to hang on poles attached to the balconies.

Illusion is an important aspect of theater, and in the Arena Chapel the space in which the sacred drama unfolds

Virtues and Deadly Sins

The seven Christian Virtues and Vices, or Deadly Sins, are commonly personified in Christian art. The seven Virtues are divided into four Cardinal Virtues—Prudence, Temperance, Fortitude, and Justice—and three Theological Virtues—Faith, Hope, and Charity.

The seven Vices vary slightly but generally consist of Pride, Covetousness, Lust, Envy, Gluttony, Anger, and Sloth.

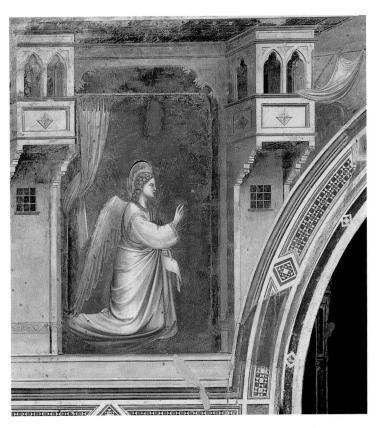

12.7 Giotto, Annunciation, Arena Chapel, Padua, c. 1305. Fresco.

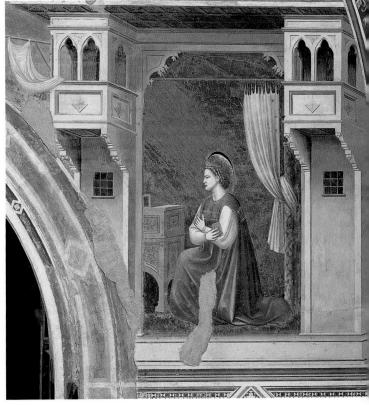

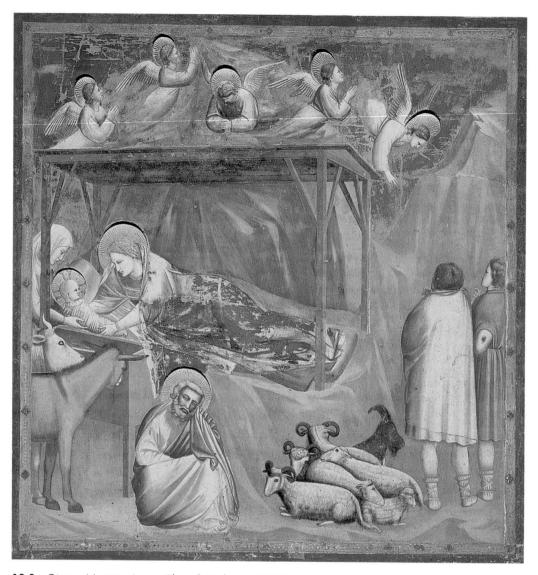

12.8 Giotto, Nativity, Arena Chapel, Padua, c. 1305. Fresco.

has been compared with a stage. In the *Annunciation*, for example, the painted space is three-dimensional but narrow, and the architecture—like a stage set—is small in relation to the figures. Gabriel and Mary face each other across the span of the actual arch, while the viewer observes them as if through the "fourth wall" of a stage.

The combination of Classical restraint and psychological insight in Giotto's frescoes may be related to the contemporary revival of Roman theater in Padua. Although there is no documentary evidence for it, the pictures suggest that, in creating the most dramatic fresco cycles of his generation, Giotto was influenced by this revival as well as by the traditional Christian mystery plays performed in front of churches. This combination of influences may also explain Giotto's dramatic depictions of pose and gesture.

In the Annunciation, both Mary and Gabriel are rendered as solid, sculpturesque figures, their poses identified mainly by their drapery folds. Gabriel raises his right hand in a gesture of greeting. Mary holds a book, signifying that Gabriel has interrupted her reading, a conventional detail in Annunciation scenes that is taken from the Apocrypha. As Gabriel makes his announcement, diagonal rays of light enter Mary's room. The lack of a logical or natural source for this light emphasizes that it is divine light, emanating from heaven. As such, it is prophetic of the symbolic light, or *enlightenment*, that Christ will bring to the world. Equally prophetic is Mary's gesture, for her crossed arms refer forward in time to the Crucifixion. According to Christian doctrine, this is the means by which salvation is achieved.

A comparison of the Arena Chapel Nativity (fig. **12.8**) with Nicola Pisano's Nativity on the Pisa pulpit (see fig. 12.2) illustrates Giotto's reduction of form and content to its dramatic essence. In Giotto's fresco, as in Nicola's sculpture, more than one event is shown within a single space. Nicola combines the Nativity with the Washing of the Infant Jesus and the Annunciation to the Shepherds at the upper right. Giotto combines the Annunciation to the Shepherds at the right with the Nativity at the left. Both artists use simple, massive draperies that naturally outline human form and monumentalize the figures. But Nicola's composition is more crowded, and the dramatic relationships between figures do not have the power of Giotto's version.

Giotto's shepherds are rendered in back view and stand riveted by the angel's announcement. In the *Nativity*, the human figures are reduced to four: Mary, Jesus, Joseph, and a midwife. A single foreshortened angel above the shed

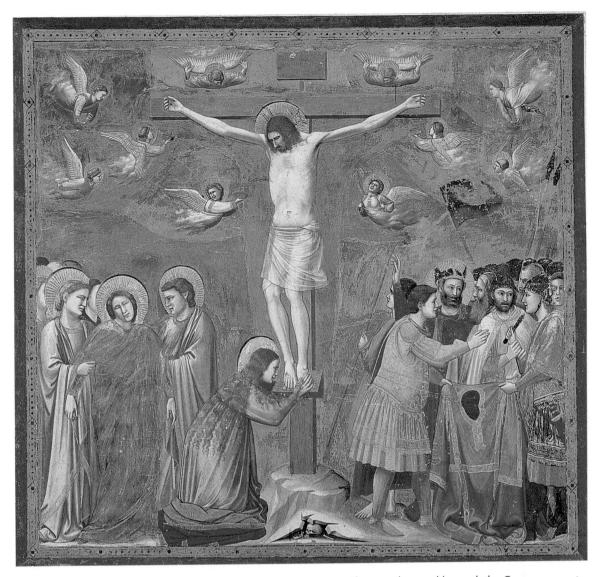

12.9 Giotto, *Crucifixion*, Arena Chapel, Padua, c. 1305. Fresco. The raised ground beneath the Cross represents the Hill of Calvary (from the Latin *calvaria*, meaning "skull"). According to tradition, Jesus was crucified on the Hill, or Place, of the Skull outside Jerusalem. The skull that appears in the opening of the rock is Adam's—a reminder of the tradition that Jesus was crucified on the site of Adam's burial. Both that tradition and its visual reference here are typological in character, for Jesus was considered the new Adam and the redeemer of Adam's sins.

gazes down at the scene, interrupting the left-to-right flow of the other angels toward the shepherds and focusing the viewer's attention onto the Nativity.

A sculpturesque Joseph dozes in the foreground, withdrawing from the intimate relationship between mother and infant. Giotto accentuates this by the power of a gaze that excludes a third party. Nicola's Mary, on the other hand, stares forward while Jesus lies in the manger behind her. Rather than emphasize the dramatic impact of the mother's first view of her son, Nicola monumentalizes Mary as an individual maternal image and, in the *Nativity*, relegates Jesus to the background. In the *Washing of Jesus*, the same Mary towers over her infant but does not make eye contact with him.

Giotto reinforces his perception of the mother-child relationship in the depiction of the animals. Among the sheep, he repeats the theme of protection and physical closeness. In the ox and ass at the manger, he plays on the Christian meaning of their glances and merges it with the emotional significance of the gaze. The ass looks down and fails to see the importance of the event before him. He thus becomes a symbol of ignorance and sin. The ox, however, stares at the gaze of Mary and Jesus, recognizing its importance in Christian terms and also replicating the role of the outsider looking in, like the viewer, on a dramatic confrontation.

In contrast to the *Annunciation*, the *Crucifixion* (fig. **12.9**) takes place outdoors, on a narrow, rocky, horizontal ground. Jesus hangs heavily from the Cross, his neck and shoulders forced below the level of his hands. His arms are elongated, his muscles are stretched, and his rib cage is visible beneath his flesh. Transparent drapery reveals the form of his body. Family and friends are gathered to the right of the Cross. Mary, dressed in blue, slumps in a faint, her weight supported by Saint John and an unidentified woman. Forming a diagonal bridge from Mary and John to the Cross is the kneeling figure of Mary Magdalen, traditionally understood to have been a prostitute before she became one of Jesus's most devoted followers. In this

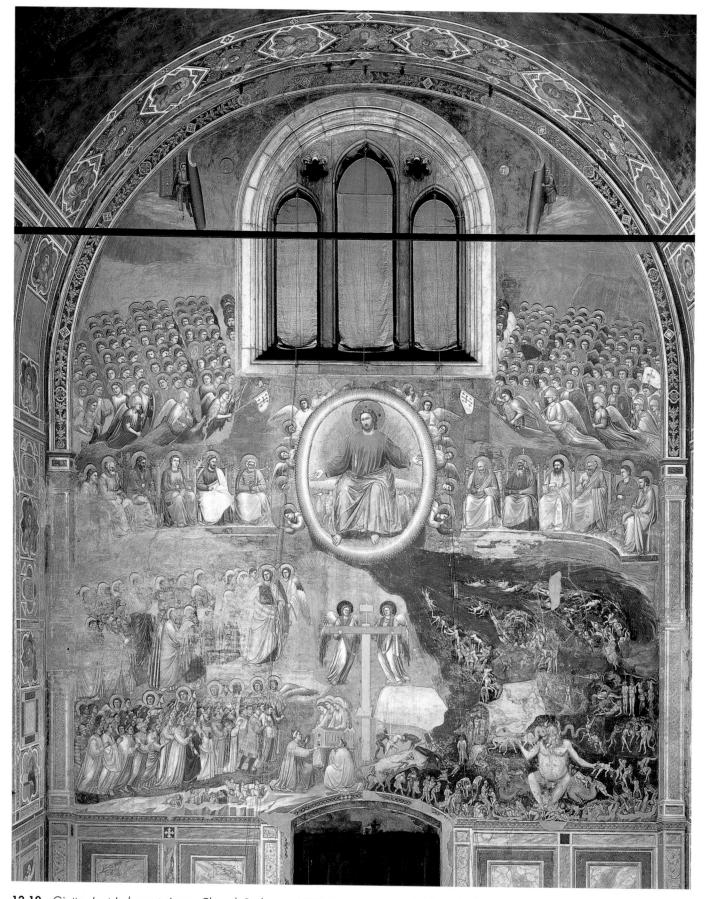

12.10 Giotto, Last Judgment, Arena Chapel, Padua, c. 1305. Fresco; approx. 33 ft. \times 27 ft. $\frac{3}{4}$ in. (10.06 \times 8.38 m).

painting, she wears her hair long, an iconographic convention denoting her penance.

In contrast to the formal and psychological link between Jesus and his followers on his right (our left), there is a void immediately to the left of the Cross. The symbolic distance between Jesus and his executioners is reinforced by the diagonal bulk of the Roman soldier leaning to the right. The group of soldiers haggles over Jesus's cloak, which one soldier prepares to divide up with a knife. (See Matthew 27:35: "they... parted his garments, casting lots.") Framing the head of a Roman soldier in the background is a halo, which sets him apart from the others and identifies him as Longinus, who converted to Christianity and became a martyr.

The sky is filled with two symmetrical groups of mourning angels. Like a Greek chorus, they echo and enhance the human emotions of Jesus's followers. The spatial positions of the angels are indicated by varying degrees of foreshortening, the two above the arms of the Cross being the most radically foreshortened. Two angels extend cups to catch the blood flowing from the **stigmata**—the wounds of Jesus. The greater formal activity and melodrama of the angels act as a foil to the restraint of the human figures.

Chronologically, the last scene in the chapel is the *Last Judgment* (fig. **12.10**), which fulfills the Christian prophecy of Christ's Second Coming. The finality of that event corresponds to its location on the west wall of the Arena Chapel, where it is the last image to confront viewers on their way out. The fresco occupies the entire wall; the host of heaven, consisting of military angels, is assembled on either side of the window. Above the angels, two figures roll up the sky, to reveal the golden vaults of heaven.

Below the window, Christ is enthroned in a circle of light, surrounded by angels. Seated on a curved horizontal platform on either side of Christ are the twelve apostles. Christ's right hand summons the saved souls, while his left rejects the damned. He inclines his head to the lower left of the fresco (his right), where two levels of saved souls rise upward. At the head of the upper group stands the Virgin Mary, who appears in her role as intercessor with Christ on behalf of humanity.

Giotto's hell, conventionally placed below heaven and on Christ's left, is the most medieval of the Arena Chapel frescoes. It is surrounded by flames emanating from the circle around Christ. In contrast to the orderly rows of saved souls, those in hell are disordered—as in the Romanesque example from Conques (see fig. 10.11). The elaborate visual descriptions of the tortures inflicted on the damned by the blue and red devils, and their contorted poses, are reminiscent of medieval border figures, whether on manuscripts or church sculptures.

The large, blue-gray Satan in the depths of hell is typical of the medieval taste for monstrous forms merging with each other. Satan swallows one soul while the serpentine creatures who emerge from his ears bite into other souls, an image of oral aggression that appears in many medieval manuscripts. Dragons on either side of Satan's rear also swallow souls, and from the ear of one of the dragons rises a ratlike creature biting into a soul, who falls back in despair. The falling and tumbling figures emphasize the

See figure 10.11. Last Judgment, Sainte-Foy, Conques, c. 1130.

Christian conception of hell as disordered, violent, and located among the lowest realms of the universe.

Directly below Christ, two angels hold the Cross, which divides the lower section of the fresco into the areas populated by the saved and the damned. Giotto's reputation for humor is exemplified in the little soul behind the Cross who is trying to sneak over to the side of the saved. Toward the bottom of hell, a mitered bishop is approached by a damned soul holding a bag of money, possibly hoping to buy an indulgence. Besides being a criticism of corruption in the Church, this detail may be an implied reference to Reginaldo Scrovegni's financial sin, for which his son tried to atone through his patronage of the Arena Chapel. Not surprisingly, Enrico is placed on the side of the saved (fig. **12.11**). As he kneels, his drapery falls on the ground in soft

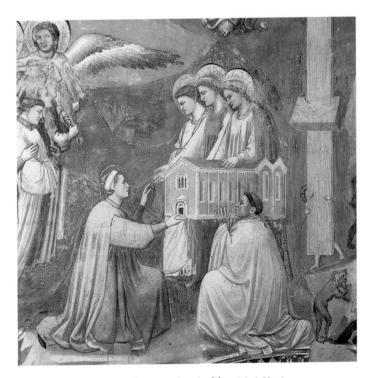

12.11 Giotto, *Last Judgment* (detail of fig. 12.10), Arena Chapel, Padua, c. 1305. Enrico Scrovegni, assisted by a monk, lifts up a model of the Arena Chapel and presents it to Mary and two other figures. Scrovegni holds the model and faces the exterior of the entrance wall, the interior of which contains the *Last Judgment*. The monk's cloak looks as if it is falling out of the picture plane over the doorway arch, an illustration of Giotto's taste for illusionism as well as of his sense of humor.

12.12 Giotto, Justice, Arena Chapel, Padua, c. 1305. Fresco.

folds, suggesting the weight of the fabric. Such portrayal of the donor within a work of art was to become characteristic of the Renaissance.

Before leaving the Arena Chapel, we consider the Virtue of *Justice* (fig. **12.12**) and the Vice of *Injustice* (fig. **12.13**), which illustrate the contemporary Italian concern with government. Two forms of government prevailed in Italy as the Renaissance dawned. Popes and princes ruled the relatively authoritarian states, while republics and communes were more democratic. Although the latter were, in practice, more often oligarchies (governments controlled by a few aristocrats) than democracies in the modern sense, the concept of a republican government was based on the Classical ideal.

Justice is personified as an enthroned queen in a Gothic architectural setting. She holds a Nike in her right hand, as did Phidias's Athena in the Parthenon *naos* (see fig. 5.57), indicating that justice brings victory. Justice also leads to good government and a well-run state, with all the benefits that this implies. Painted as an imitation relief in the rectangle at the bottom of the picture are images of dancing, travel (men on horseback), and agriculture.

The Vice of *Injustice* (fig. 12.13), in contrast, shows a tyrant enclosed inside a crenellated castle and separated from both the viewer and his subjects by a row of trees. Cracks in the walls denote the stress and instability of unjust government. And at the bottom of the fresco, we see the results of tyranny—pillage, rape, and war.

12.13 Giotto, Injustice, Arena Chapel, Padua, c. 1305. Fresco.

Giotto's Saint Francis

Although Giotto's acknowledged masterpiece is the Arena Chapel in Padua, he himself was a citizen of Florence. In that city, he later decorated two surviving chapels in the Gothic Franciscan church of Santa Croce. These were the family chapels of two leading banking families, the Bardi and the Peruzzi. In the Bardi Chapel, Giotto painted scenes from the life of Saint Francis (see box, p. 463), whose cult was one of the most prominent in Italy. Because of Saint Francis's insistence on poverty, the issue of decorating Franciscan churches became controversial. Likewise, the role of rich patrons in commissioning works of art depicting the lives of saints highlighted the contrast between wealthy patrons and the message of the works they commissioned.

Saint Francis pursued poverty in imitation of Christ, with whom he identified, particularly in receiving the stigmata. Giotto depicted the *Stigmatization of Saint Francis* (fig. **12.14**) in a fresco on the outer wall of the Bardi Chapel. The scene takes place in a rocky, mountainous landscape dotted with a few trees. A church stands at the right. As in the Arena Chapel, landscape and architecture are subordinate to the human figures and reinforce them. The cubic mass of Saint Francis from the waist down is mirrored in the building and the base of the mountain. The diagonal of the torso repeats the slanting triangle of the mountaintop in reverse.

12.14 Giotto, *Stigmatization of Saint Francis,* exterior of the Bardi Chapel, Santa Croce, Florence, after 1317. Fresco.

Despite the mystical content of the event, Giotto represents Saint Francis as a solid, threedimensional figure and conveys a sense of physical reaction to the experience of religious transport. Francis is shown as if "taken aback" by the force of light rays emanating from his vision.

By virtue of the fresco's location on the chapel's exterior wall, the scene is the first to be encountered by visitors. Its purpose must have been at least partly to proclaim the spiritual sentiments of the Bardi family, whose commercial acumen and wealth were widely known.

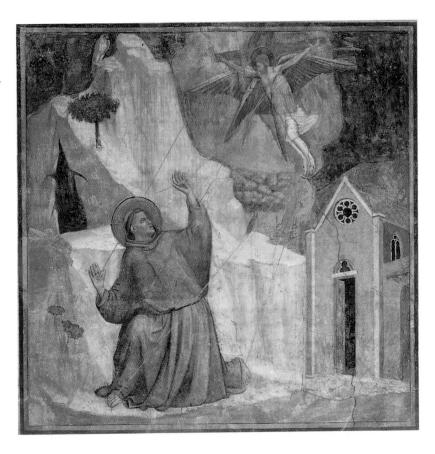

Saint Francis of Assisi (1181/2-1226)

Saint Francis was the son of a rich merchant in the Umbrian town of Assisi. As a young man, Francis made a pilgrimage to Rome, where he felt a sudden sense of identification with a beggar and traded clothes with him. For the first time in his life of privilege, Francis experienced poverty and realized its spiritual potential. He then renounced his father's wealth and dedicated his life to poverty. In 1224, while he was praying and meditating on the mountain of La Verna, he looked into the rising sun and saw a vision of Jesus on the Cross. Jesus's arms were the outstretched wings of a seraph (a type of angel). Scars corresponding to the wounds of the crucified Christ are then believed to have appeared on Saint Francis's body (a phenomenon known as "stigmatization"). In 1209, Francis received the pope's permission to found an Order of friars, the Franciscan Order. He established a strict, simple Rule, insisting that his followers—the Friars Minor—live by the work of their own hands or by begging. They were forbidden to accept money or property in exchange for services. Pope Innocent III approved the Rule in 1209–1210, and Francis traveled to Spain, eastern Europe, and Egypt to spread his message.

Around 1212, a noblewoman of Assisi, Clare, decided to follow the Rule of Saint Francis. When other women joined her, Francis established a separate community with Clare as its abbess. Her followers became known as the Poor Clares. The power of the Franciscan movement attests to its wide appeal, and, in the course of the thirteenth century, Franciscan churches proliferated. So-called "daughter houses," established by the Poor Clares, also sprang up throughout Europe.

Partly because of the large number of Saint Francis's fol-

lowers and partly because of conflict over the rigors of his Rule, the Franciscans split into two factions. The Spiritualists adhered to strict interpretation of the Rule, whereas the Conventualists took a more flexible position.

After Saint Francis received the stigmata, he wrote his most famous work, *The Canticle of Brother Sun*. It is a long hymn in praise of the divine presence he believed resided in nature:

- Praised be You, my Lord, with all your creatures,
- especially Sir Brother Sun,
- Who is the day and through whom You give us light.
- And he is beautiful and radiant with great splendor; and bears a likeness of You, Most High One.
- Praised be You, my Lord, through Sister Moon and the stars,
- In heaven You formed them clear and precious and beautiful.³

This hymn reflects the role of Saint Francis in the new emphasis on nature that developed in the later Gothic period and that would characterize much of the Renaissance. Saint Francis's Rule heralded a shift from monastic isolation to greater involvement—largely through preaching—with urban populations, especially the poor.

On July 6, 1228, two years after his death, Francis was canonized by Pope Gregory IX. His remains are in the thirteenthcentury basilica of San Francesco in Assisi, which is the center of his cult.

Duccio's Maestà

The leading early fourteenth-century artists in Siena, Florence's rival city, worked in a style that was influenced by Byzantine tradition. Siena was ruled by a group known as the Nine, which was in charge of public commissions. The Nine were particularly devoted to the Virgin, for they believed her intercession had been responsible for a major thirteenth-century military victory over Florence. Her cult was a significant feature of Sienese culture, and she was the city's patron saint. Siena called itself "the Virgin's ancient city" (vetusta civitas virginis).

In 1308, the prominent Sienese painter Duccio di Buoninsegna (active 1278–1318) was commissioned to produce a new altarpiece for the high altar of the cathedral. It was to honor the Virgin, whose image is the largest in the entire work. The completed altarpiece was two-sided and originally consisted of over fifty panels, several of which have been lost; some of the dismantled panels are now in museums elsewhere. In its original state, Duccio's Maestà was about as high as the monumental altarpieces by Cimabue and Giotto discussed above but was considerably wider (about 13 feet, or 4 m). Its former appearance has been reconstructed in photo montage by the art historian John White. The front (fig. 12.15) exalts the Virgin as Queen of Heaven-maestà means "majesty." She occupies the large horizontal panel, the sides of her throne opening up as if to welcome the viewer. In the crowd surrounding her are two of the apostles, John the Evangelist and Peter. The other ten apostles appear under the small round arches above. The lower sections of the pinnacles contain scenes of Mary's last days, beginning on the left with the Annunciation of the Death of the Virgin and ending with the Burial of the Virgin on the right. At the bottom are predella panels with scenes of Jesus's early life, from left to right: the Annunciation of his birth, the Nativity, Adoration of the Magi, Presentation in the Temple, Massacre of the Innocents, Flight into Egypt, and Jesus among the Doctors. Standing by each of these events is the Old Testament prophet interpreted as having foretold it.

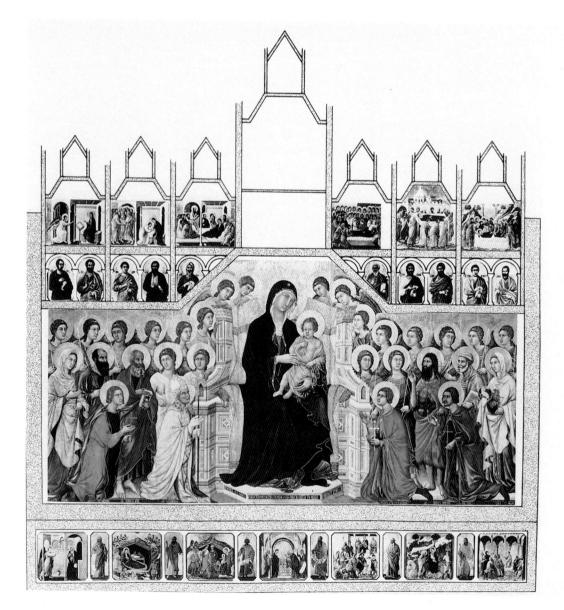

12.15a John White, photo montage of Duccio's Maestà (front), 1308-1311. This is Duccio's only signed work (signed on the base of the throne). According to the commission contract, which was signed October 9, 1308, Duccio was paid for every day that he worked on the altarpiece. For those days that he did not work, his pay was docked.

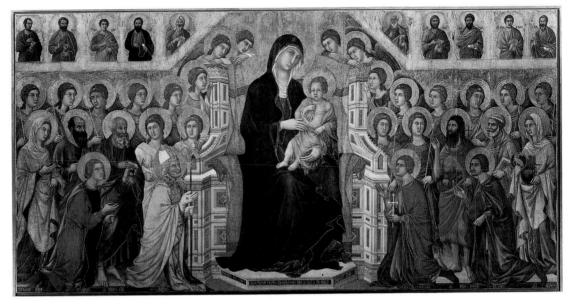

The four registers on the reconstructed back of the *Maestà* (fig. **12.16**) depict the Passion in twenty-six scenes. The largest, at the center, is the *Crucifixion*. The six pinnacle scenes illustrate Christ's miraculous appearances after his death, and on the predellas are scenes of his ministry.

The iconography of the altarpiece covers the full range of the Virgin's majesty and of her maternity. In 1311, when Duccio completed the *Maestà*, it was carried in a triumphal procession, accompanied by pipes and drums, from his studio to the cathedral.

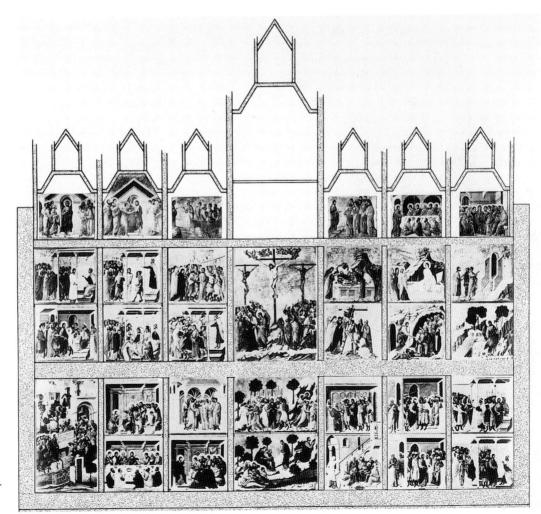

12.16 John White, photo montage of Duccio's *Maestà* (back), 1308–1311.

The Kiss of Judas

Duccio and Giotto exemplify two major currents in early fourteenth-century Italian painting. Duccio was more closely tied to the Byzantine tradition, whereas Giotto was steeped in the humanist revival of Classical antiquity. These relationships can be clarified by comparing three examples of the Kiss of Judas: a Byzantine mosaic (fig. 12.17), Duccio's panel below the Crucifixion in the Maestà (fig. 12.18), and the Arena Chapel fresco (fig. 12.19). All three represent the moment when Judas identifies Jesus to the Romans with a kiss. In the mosaic and in Duccio's panel, Jesus is nearly frontal, and Judas leans over in a sweeping curved plane to embrace him. Their heads connect, but in neither case do Judas's lips actually touch Jesus's face. Both scenes take place outdoors, against a gold sky. The figures in the mosaic face the viewer and are only minimally engaged with each other. They are outlined in black, and their diagonal feet accentuate the two-dimensionality of their space. As the largest figure, Jesus stands out as the most significant; he has a jeweled halo and wears the purple robe of royalty, denoting his future role as King of Heaven.

Duccio's panel is more densely packed with figures than the mosaic is. This, together with the landscape background, conveys an illusion of greater depth. The more subtle shading of the drapery folds also gives the figures a greater sense of three-dimensional form. In the mosaic, the apostles at the right wear Roman-style togas and stand in vertical planes. The only sign of emotion at the arrest of their leader is the slight agitation of their tilted heads. In the Duccio, however, the apostles break away from the central crowd and rush off to the right. Their long, curvilinear planes have the quality of a graceful dance movement performed in unison. At the left, Saint Peter also turns from Jesus, but, in a rage, he cuts off the ear of Malchus, the servant of the high priest.

Giotto's version of the *Kiss of Judas* (fig. 12.19) lives up to his reputation among humanist authors for having reintroduced naturalism to painting. The fresco is virtually devoid of landscape forms that might distract viewers from the central event. Nor do any of Giotto's figures face the picture plane. Most are focused on the dramatic confrontation between Jesus and Judas. These two, in turn, are locked in each other's gaze, surrounded ominously by

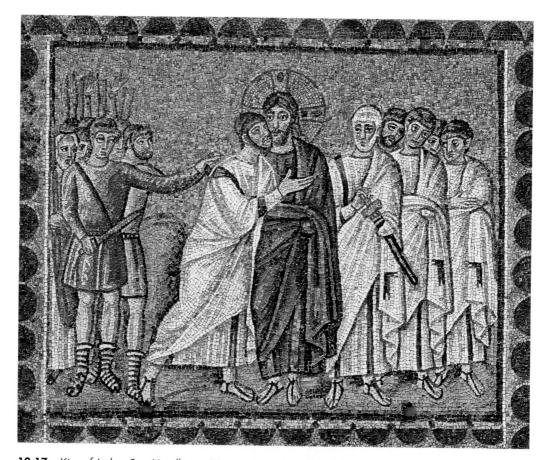

12.17 Kiss of Judas, Sant'Apollinare Nuovo, Ravenna, early 6th century. Mosaic.

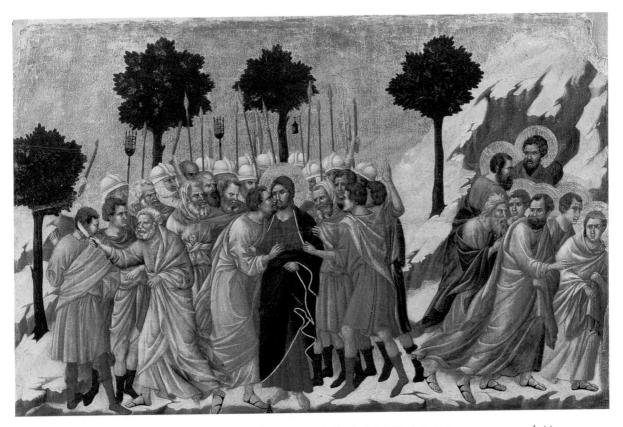

12.18 Duccio, *Kiss of Judas,* from the *Maestà,* from Siena Cathedral, 1308–1311. Tempera on panel. Museo dell'Opera del Duomo, Siena.

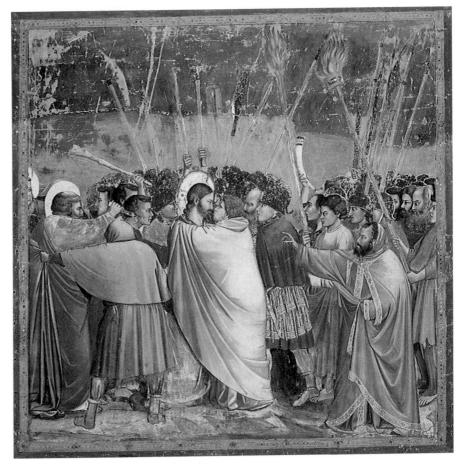

12.19 Giotto, *Kiss of Judas,* Arena Chapel, Padua, c. 1305. Fresco.

the helmets framing their heads. Over Jesus's head, the two hands holding stakes accentuate the rage of the mob against him; none of the stakes is vertical, as in the Duccio, those behind Jesus seeming to radiate from an unseen point. In this convergence of forms, therefore, Giotto signals the violence of Jesus's death and also his ultimate triumph.

Giotto is the first Western artist since ancient Rome to have depicted figures in back view. In the Kiss of Judas, he places three figures as if in different stages of a turn: the pointing man at the right is in three-quarter view; Judas turns farther to the right as his yellow cloak envelops Jesus; and the hooded man in gray is seen directly from the rear. Together, these three create a sense of movement from right to left across the picture plane, counteracting the left-right flow of the narrative. Another countermotion can be seen in the figure of Saint Peter, who raises his hand behind the head of the hooded man and vigorously cuts off the ear of Malchus. Saint Peter does not, as in Duccio's scene, turn away from Christ. The thrust of his blow interacts with the gesture of the hooded figure, whose very presence conveys an air of foreboding. His facelessness, characteristic of the executioner, may allude to Jesus's imminent death on the Cross.

Ambrogio Lorenzetti and the *Effects of Good Government*

Twenty-seven years after the triumphal procession for Duccio's Maestà, the innovative Sienese artist Ambrogio Lorenzetti (active 1319-1347) painted Allegories of Good and Bad Government for the Palazzo Pubblico (Town Hall) of Siena. Figure 12.20, like Giotto's Justice (fig. 12.12), illustrates the effects of good government on a city-in this case, Siena. In contrast to the Maestà, Ambrogio's Allegory is secular and reflects the new humanist interest in republican government. He depicts a broad civic panorama with remarkable realism. In the foreground (from left to right), women wearing the latest fashions dance and sing in celebration of the joys of good government; people ride on horseback among the buildings, whose open archways reveal a school, a cobbler's shop, and a tavern; farmers are shown entering the city to sell their produce. On top of a building in the background, one worker carries a basket and another a slab; they seem to be laying bricks. In this imagery, Lorenzetti suggests that both agricultural prosperity and architectural construction are among the advantages of good government.

12.20 Ambrogio Lorenzetti, Effects of Good Government in the City and the Country, from the Allegory of Good Government, Sala della Pace, Palazzo Pubblico, Siena, 1338–1339. Fresco; entire wall 46 ft. (14.02 m) long. Ambrogio was one of two artist brothers who were active in the first half of the fourteenth century. Both were born and worked in Siena, and they are believed to have died in the Black Death since nothing is heard of them after 1347. Ambrogio also worked in Florence, where he was exposed to Giotto's style. The Allegory of Good Government, which has considerable documentary value as well as artistic merit, is considered his

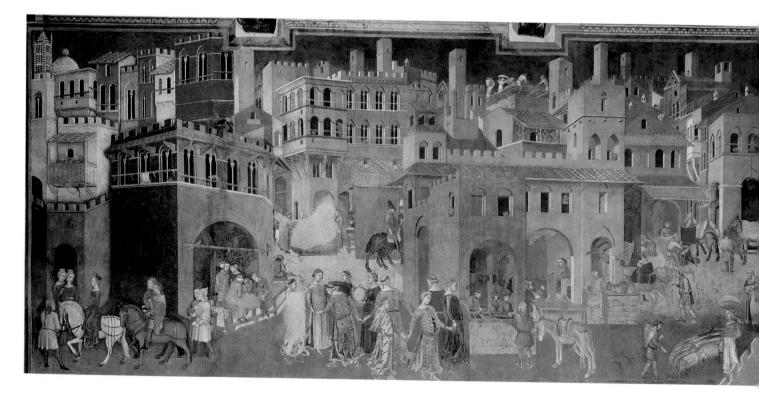

Just outside the city walls, people ride off to the country. Below, a group of peasants tills the soil, and the cultivated landscape visible in the distance draws the viewer into an almost unprecedented degree of spatial depth. Floating above this tranquil scene, an allegorical figure of Security holds a scroll with an inscription reminding viewers that peace reigns under her aegis. And should one fail to read the inscription, she provides a pictorial message in the form of a gallows. Swinging from the rope is a criminal executed for violating the laws of good government. Accompanying Ambrogio's vision of prosperity and tranquillity, therefore, is a clear warning of the consequences of social disruption.

Just behind the left foot of Security, Ambrogio has included the statue of the legendary she-wolf who nursed Romulus and Remus. Pro-

> jecting from the city's wall, she seems to survey the surrounding countryside. At the same time, the wolf makes explicit the link between ancient Rome and Siena (see fig. 6.2).

Stylistically, Ambrogio's Allegories fall between

Giotto and Duccio. Al-

though the Allegory of Bad

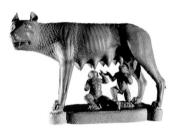

See figure 6.2. *Capitoline Wolf,* Rome, c. 500 B.C.

Government is severely damaged, certain details are clear. The detail in figure **12.21** shows two soldiers attacking a woman, rendered in a graceful S-curve. Above are the feet of two hanged criminals, echoing the exemplary gallows of Security. Despite its violence, the scene lacks the

12.21 Ambrogio Lorenzetti, detail showing soldiers attacking a woman, from the *Allegory of Bad Government*, Palazzo Pubblico, Siena, 1338–1339. Fresco.

Boccaccio on the Black Death

The bubonic plague of 1348 killed some 25 million people. It was carried by a bacterium in fleas that lodged in the fur of common rodents. The effects of the Black Death were described by Boccaccio in the preface of the *Decameron*, a collection of 100 stories set in fourteenth-century Italy:

1348. The mortal pestilence then arrived in the excellent city of Florence. . . . It carried off uncounted numbers of inhabitants, and kept moving . . . in its early stages both men, and women too, acquired certain swellings, either in the groin or under the armpits. Some of these swellings reached the size of a common apple . . . people called them plague-boils . . . the deadly swellings began to reach . . . every part of the body. Then . . . began to change into black or livid blotches . . . almost everyone died within the third day . . . even to handle the clothing or other things touched by the sick seemed to carry with it that same disease. . . .

Some persons advised that a moderate manner of living, and the avoidance of all excesses, greatly strengthened resistance to this danger. . . Others . . . affirmed that heavy drinking and enjoyment . . . were the most effective medicine for this great evil. . . .

The city was full of corpses . . . there was not enough blessed burial ground . . . they made huge trenches in every churchyard, in which they stacked hundreds of bodies in layers like goods stowed in the hold of a ship, covering them with a bit of earth until the bodies reached the very top.⁴

There was, as Boccaccio observed, a general air of penance on the one hand and a "seize the day" mentality on the other. **12.22** Andrea Orcagna, detail showing figures invoking Death, from the *Triumph of Death*, 1360s. Fresco. Museo dell'Opera di Santa Croce, Florence.

As a result of the disasters that swept through Europe during the first half of the fourteenth century, artists became drawn to such subjects as the Triumph of Death. Andrea di Cione—known as Orcagna (active c. 1343–1368)—painted a monumental fresco in the church of Santa Croce in Florence in which he combined the theme with depictions of hell and the Last Judgment. Although the work survives only in fragments, its message of impending doom remains clear.

The detail in figure **12.22** shows two cripples and two blind men invok-

ing Death. The anxious gesture of one of the sightless men contrasts with the wide-eyed stares of the cripples. The inscription reads: "Since prosperity has departed, O Death, the medicine of all pain, come and give us our last supper." In another fragment of Orcagna's *Triumph of Death* (fig. **12.23**), two men gaze at an eclipse of the sun. Since contemporary documents related the eclipse of 1333 to subsequent flooding, it is likely that this detail associates those events with both the Old Testament Flood and the apocalyptic "day of . . . wrath" (Revelation 6:12–17).

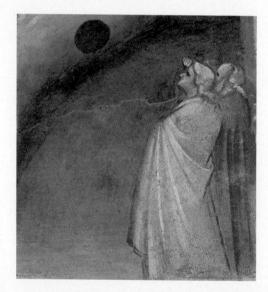

12.23 Andrea Orcagna, detail showing two men watching an eclipse of the sun, from the *Triumph of Death*, 1360s. Fresco. Museo dell'Opera di Santa Croce, Florence.

dramatic power that characterizes Giotto's work. But Ambrogio's figures are closer to Giotto's than to Duccio's in their sense of mass and volume. Nor are their draperies trimmed with gold, as Duccio's often are.

Ambrogio Lorenzetti's monumental secular paintings were the first of their kind in Western art since Christianity had become the official religion of Rome. They reflected the shift that had occurred in patronage, which was no longer exclusively tied to the Church-even in Siena, where the Virgin's cult was at its strongest. As Lorenzetti's work reveals, the new cultural and intellectual concerns of the early fourteenth century had resulted in a revolutionary development in style. Giotto had created a new approach to painted space, influenced as he was by the sculpture of Nicola Pisano and his son Giovanni, by Roman ruins, and by discoveries of Classical texts. For the first time since Greco-Roman antiquity, human figures occupy threedimensional settings. Backgrounds are no longer gold, but rather defined by natural blue skies or landscape. Architecture is set at an oblique angle to the picture plane, creating an illusion of spatial recession.

A series of disasters in western Europe disrupted the activities of the next generations of fourteenth-century artists. In 1329 there was famine, an eclipse followed by a flood in 1333, and a smallpox epidemic in 1335 that killed thousands of children. In the early 1340s, both the Bardi and Peruzzi banks failed, and in 1348 the bubonic plague—called the Black Death—devastated Europe (see box, p. 470). In Florence and Siena, between 50 and 70 percent of the residents died, resulting in population shifts, economic depression, and radical changes in artistic patronage and style.

Contemporary sermons document the resurgence of religious fervor following the Black Death. In the visual arts, there was a revival of certain aspects of the Byzantine style. The increasingly humanist style of the first half of the century yielded to a more pessimistic view of the world, with greater emphasis on death and damnation. The innovations of Giotto and other early fourteenth-century artists remained in abeyance and were revived by the first generation of Italian painters, sculptors, and architects of the fifteenth century.

The International Gothic Style

An entirely different mood characterized works commissioned by the courts in fourteenth-century Italy and France. Their wealth made it possible to import

12.24 Simone Martini, Saint Louis Altarpiece, c. 1317. Tempera on panel; main panel $78\frac{3}{4} \times 54\frac{1}{4}$ in. (200.0 \times 137.8 cm). Galleria Nazionale, Naples. The predella panels contain scenes from the life of Saint Louis. The altarpiece is signed: "Symon de Senis me pinxit" (Simon of Siena painted me). artists from different regions and to pay them well. The resulting convergence of styles, generally known as International Gothic, continued into the fifteenth century; the best fourteenth-century examples were executed under French patronage.

Simone Martini

In the Angevin court at Naples, French taste predominated, even in the work of Italian artists. King Robert of Anjou was the younger brother of Louis of Toulouse, who had joined the Franciscan Order of the Friars Minor. When elected to the rank of bishop in 1296, Louis renounced the throne in favor of Robert and died a year later. Amid rumors that he had usurped the throne, Robert commissioned the Sienese artist Simone Martini to paint the altarpiece illustrated in figure **12.24**. The date of the commission, 1317, coincided with Louis's canonization.

The enthroned Franciscan saint is dressed in embroidered velvet robes and wears a bishop's miter. He is placed against a rich gold background with a raised gold halo and border inside the frame. In keeping with courtly taste, especially that of Naples, the drapery was originally decorated with real jewels embedded in the panel. Simone Martini's attraction to such taste is further evident in the fluid, curvilinear robes, the jeweled crozier (bishop's staff) and crowns, the long, thin hands, and pale, delicate faces of his figures. Two angels crown Saint Louis as he bestows the earthly crown on his brother. Through his large size, central position, and frontality, Louis is endowed with an imposing, iconic presence, whereas Robert is portrayed in miniature and in profile. It is clear that Simone (and presumably his patron) intended the viewer to perceive the saint as the more important figure and his ecclesiastic office as more powerful than that of the earthly ruler. The gold fleurs-de-lis on the blue background of the frame identify the scene with the French royal family, which reinforced the legitimacy of Robert's claim to the throne.

Simone's Annunciation (fig. 12.25), painted in 1333 after the artist left Naples, shows the International Gothic taste for elongated forms and delicate detail. The elegant S-shape of Mary's pose, the angel Gabriel's fluttering cloak, and the abundance of gold are typical of courtly International Gothic style. Compared with Giotto's *Annunciation* (see fig. 12.7) in the Arena Chapel, Simone's is filled with a wealth of elaborate features. Mary holds the traditional book, showing that Gabriel has interrupted her reading, and she seems startled. The lilies symbolize Mary's purity, while the palm branch carried by Gabriel is a sign of death and alludes to the Crucifixion of Jesus. Note also that the prophets in the small tondos hold scrolls that refer to prophecies believed by Christians to have foretold the coming of a savior.

A striking feature of Simone's *Annunciation*, and one that also occurs in northern art, is the raised lettering of the angel's announcement—"Hail, Mary, full of grace, God is with you." His words extend from his mouth to Mary's ear, connoting her receptivity to God's Word and illustrating the medieval tradition that she was impregnated through her ear. Jesus thus becomes "the Word . . . made flesh," as written in the Gospel of John (1:14).

12.25 Simone Martini, Annunciation, 1333. Tempera and gold leaf on panel; $42\frac{1}{2} \times 43\frac{1}{2}$ in. (108.0 \times 110.5 cm). Galleria degli Uffizi, Florence. Parts of the altarpiece were apparently painted by Simone's brother-in-law, for both artists signed the painting.

Claus Sluter

Toward the end of the fourteenth century, France was ruled by Charles V. Two of his brothers—Philip the Bold (1342–1404) and Jean, Duc de Berry (1340–1416)—presided over lavish courts, which were enriched by their ambitious patronage. The sumptuousness of the works produced for them shows the degree to which the courts were removed from the real world. France and other areas of Europe were, at the time, suffering continual upheaval from the ravages of the Hundred Years' War.

Philip's court was located at Dijon, in the Burgundy region of central France. His wife, Margaret of Flanders (parts of Belgium and northern France), provided a link with the North. Reflecting the international character of his court and his patronage, Philip commissioned an architect from Paris and a sculptor from the Netherlands to design a Carthusian monastery—the Chartreuse de Champmol—near his Dijon palace. This building was to house the family tombs. Philip's competition with the king is suggested by the fact that his architect had worked for Charles in Paris and that the monastery's portal followed Charles's lead in placing portrait sculptures of living people on the doorjambs—a site formerly reserved for Old Testament kings, queens, and prophets, and for Christian saints.

Philip's sculptor, Claus Sluter (active 1379–1406), placed a figure of the Virgin Mary on the trumeau of the portal (figs. **12.26** and **12.27**). She is crowned, but her character is primarily maternal. Although the architectural feature above her is entirely Gothic and Sluter worked in an essentially Gothic tradition, a comparison of his *Virgin* with the thirteenth-century *Vierge dorée* at Amiens (see fig. 11.31) shows the degree to which he has transformed the

CONNECTIONS

See figure 11.31. Vierge dorée, c. 1250.

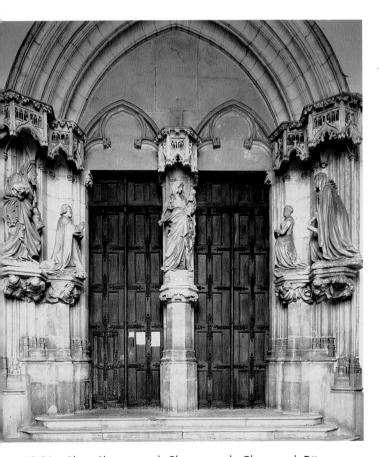

12.26 Claus Sluter, portal, Chartreuse de Champmol, Dijon, 1385–1393. The sculptor Claus Sluter was born in Haarlem, the Netherlands. After he went to the court of Philip the Bold, he was quickly promoted to the position of *imagier* and *valet de chambre*.

12.27 Claus Sluter, Virgin Mary and Christ, central trumeau of portal, Chartreuse de Champmol, Dijon, 1385–1393. (Detail of 12.26.)

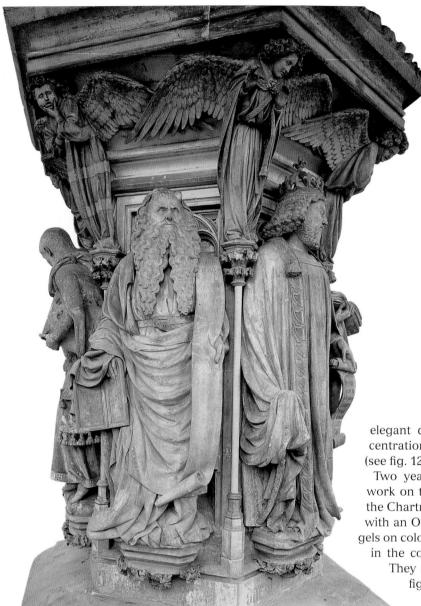

representation of human figures. Sluter's *Virgin* turns more freely in space and gazes on a Jesus who is more childlike than his Gothic predecessors. Jesus's floppy head and chubby proportions, articulated by the drapery folds, indicate that Sluter was a careful observer of children. He has represented the physical and psychological character of this infant Jesus with a new, naturalistic accuracy, while Mary is animated by the sweep of her billowing draperies. The arrangement of the folds emphasizes her spatial flexibility and creates a sense of dynamic energy.

Mary's gaze, focused as it is on Jesus, is repeated by the doorjamb figures. Philip (on the left) and Margaret (on the right) are represented kneeling in prayer and facing the Virgin. They adore the Queen of Heaven as she adores the Child. Leaning over the noble pair and interceding on their behalf are saints, John the Baptist and Catherine. Sluter contrasts the rhythmic orchestration of deeply carved, **12.28** Claus Sluter, Well of Moses, Chartreuse de Champmol, Dijon, begun 1395. Painted stone; interior diameter of basin 23 ft. 6 in. \times 23 ft. 7 in. (7.16 \times 7.19 m).

elegant drapery curves with the fixed, arrested concentration of the doorjamb figures on Mary and Jesus (see fig. 12.26).

Two years after completing the portal, Sluter set to work on the Well of Moses, a monumental fountain for the Chartreuse (fig. **12.28**). It stands on a hexagonal base with an Old Testament figure on each side. Six small angels on colonnettes between the life-sized figures lean over

in the compressed space under the edge of the basin. They spread their wings to form an arch over each figure. Their crossed arms allude to the Crucifixion, originally represented by a great Cross (now lost), which was set in stone carved in imitation of Golgotha. This was supported by

the "well," just as the Old Testament was seen as the foundation of the New. Christ was thus the "fountain of life" the *fons vitae*.

The figure of Moses is a powerful, thoughtful patriarch. His lined face, strong nose, and slight frown give the sculpture a portraitlike quality. But the features are overwhelmed by the swirling energy of the beard and by the stunted horns emerging from his head. These became an iconographic convention in representations of Moses, whose radiance on descending from Mount Sinai with the Tables of the Law was mistranslated as "horned." The Ten Commandments were interpreted as a prefiguration of the new Christian order signified in the great Crucifix over the fountain. And it is to this event that the inscription of Moses's scroll refers: "The whole assembly of the congregation of Israel shall kill it [the lamb] in the evening" (Exodus 12:6).

The Limbourg Brothers

In northern Europe, manuscript illumination was the primary medium of painting at the turn of the century. The illuminated manuscripts of the Limbourg brothers were among the most impressive works of art produced at the court of Jean, Duc de Berry. Jean, an ardent patron, collected jewels and books, tapestries and goldwork, and led a life of immense luxury. The three Limbourg brothers— Paul, Herman, and Jean—came from the Netherlands, first to the Burgundy court and then to Berry. They made Books of Hours, which are prayer books organized according to

the liturgical calendar. The most famous of these is the *Très Riches Heures du Duc de Berry* (the Very *Rich Hours of the Duke of Berry*).

Books of Hours were illuminated manuscripts made for lav people, and most were commissioned by the aristocracy and upper middle class. They were expensive heirlooms, prized by their owners and passed down from one generation to the next, and were sources of learning and aesthetic pleasure. Their contents vary but generally include the prayers to be said at the eight canonical hours of the day. By the fourteenth century, Books of Hours had become best-sellers, and, for the first time in the Christian era, they were even more popular outside clerical circles than the Bible. Most were produced in France, England, and the Netherlands, while Italy, Spain, and Germany were more likely to import them. Their significance for

> **12.29** Limbourg brothers, Annunciation, from the Très Riches Heures du Duc de Berry, 1413–1416. Illumination, 8½ × 5‰ in. (22.2 × 13.5 cm). Musée Condé, Chantilly, France.

the rise of literacy in the fourteenth century is problematic, although it is clear that literacy did increase in the later Middle Ages. Strictly speaking, one did not have to be able to read to enjoy Books of Hours: merely gazing on their illuminations was considered a form of prayer, and, in any case, their owners would have known the contents by heart. The primary function of these images was to evoke identification through prayer as a route to salvation.

The manuscript page of the *Annunciation* from the *Très Riches Heures* (fig. **12.29**) shows Mary interrupted at her *prie-dieu* (a type of prayer desk) by Gabriel's arrival. He

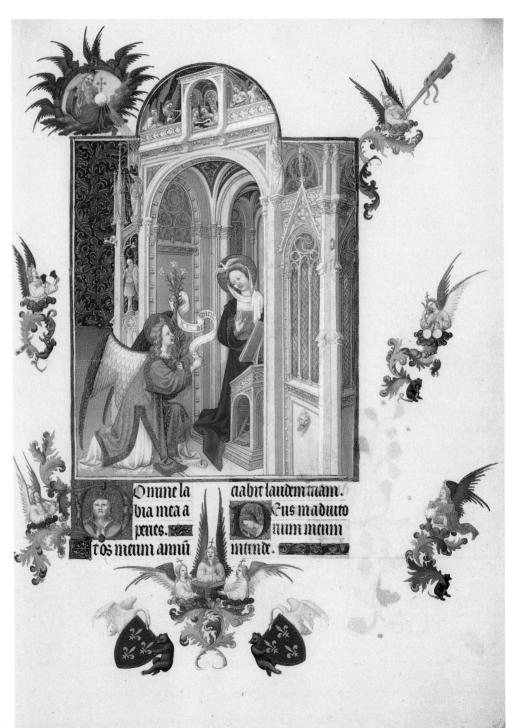

carries three lilies, signifying the purity of the Virgin, and a scroll with the inscription *"Ave gratia plena"* ("Hail [Mary] full of grace"). The scene takes place in a Gothic chapel (despite the round arch) decorated with delicate stone tracery offset by a sumptuous blue-brocade backdrop. An angelic choir makes music on the chapel roof, and at the left are statues of two prophets. In the upper left, outside the frame, God the Father appears in a winged circle of light. He holds an orb with a cross and sends down to Mary the impregnating rays of his light. Decorating the rest of the border are musician angels (those beneath the text are singing angels) intertwined with elegant, curvilinear foliate forms. Jean de Berry's two coats of arms are held by his emblems, the swan and the bear, and serve as the signature of his patronage.

The manuscript page illustrating the month of January (fig. **12.30**) shows the day on which gifts were exchanged at the court of Berry. The depiction of precise details is

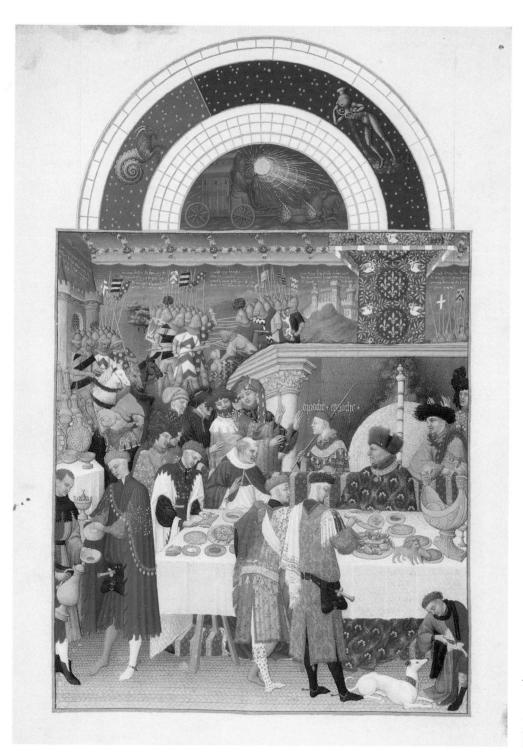

12.30 Limbourg brothers, January, from the Très Riches Heures du Duc de Berry, 1413–1416. Illumination, 8¾ × 5⅓ in. (22.2 × 13.5 cm). Musée Condé, Chantilly, France. typical of the Limbourg brothers, here concentrating on rich material textures. The duke is seated at a table filled with plates of food, a gold saltcellar at the far right, and a pair of dogs nibbling from the dishes. Jean wears a fur cap and an elaborate blue-and-gold brocade robe. Behind him is a golden wicker fire screen, and the man in red on the duke's right is inviting visitors to enter. The words "approach, approach" are lettered in gold above his head. On the background tapestry, a battle from the Trojan War is fought by soldiers in medieval armor. The identity of the battle is indicated by lines of verse written across the sky. In the foreground, various courtiers in patterned robes partake of the feast, while a white dog waits eagerly for a morsel of food at the lower right corner. Perhaps the richest area of the page is the red canopy over the fireplace. It contains blue circles decorated with the *fleurs-de-lis* of French royalty, golden foliage, white swans, and two brown bears. Swans and bears were the duke's heraldic devices, and a gold statuette of each surmounts the tips of the saltcellar on the table. In the semicircle above are the zodiac signs that correspond to January.

Such representation of observed detail entered the vocabulary of painting in the course of the fourteenth century. The art of the courts seems to have ignored the effects of the disasters that swept western Europe in the first half of the century. The International Gothic style persisted into the fifteenth century, but the major innovations in art from 1400 resume the developments introduced by Giotto.

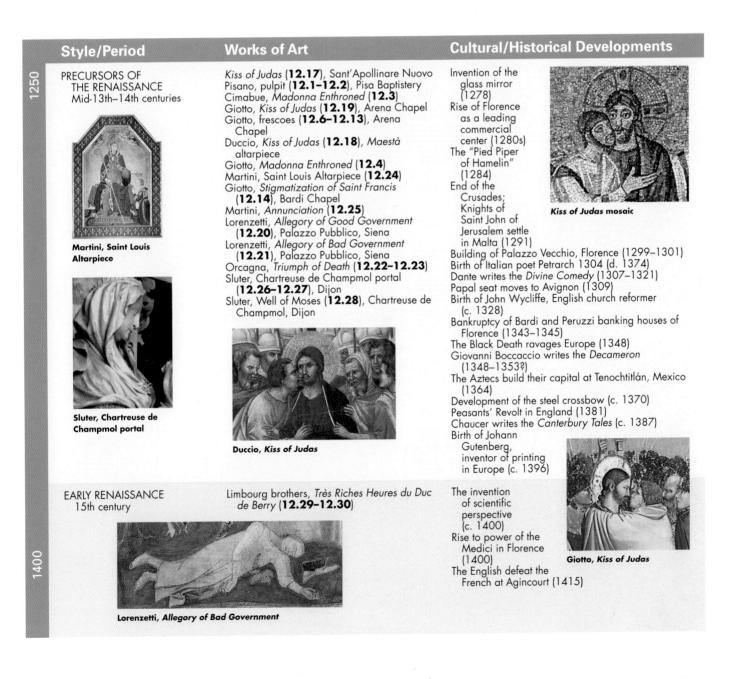

Notes

Introduction

 Cited by Martha Joukowsky, A Complete Manual of Field Archaeology: Tools and Techniques of Field Work for Archaeologists (Englewood Cliffs, N.J., 1980), p. 1.

Chapter 1

- Abbé Henri Breuil, Four Hundred Centuries of Cave Art, trans. Mary E. Boyle (New York, 1979).
- James McNeill Whistler, "The Ten o'Clock Lecture," Princes Hall, London, 1885.
- Jennifer Isaacs, ed., Australian Dreaming: 40,000 Years of Aboriginal History (New York, 1980), p. 69.

Chapter 2

- Cited by Diane Wolkstein and Samuel Noah Kramer, Inanna, Queen of Heaven and Earth: Her Stories and Hymns from Sumer (New York, 1983), p. 105.
- Quoted in James Gardner and John Maier, Gilgamesh: Translated from the Sin-leqi-unninnī Version (New York, 1984), p. 57.
- Cited by Spiro Kostof, A History of Architecture: Settings and Rituals (New York, 1985), p. 60.
- Cited by Linnea H. Wren and David J. Wren, eds., Perspectives on Western Art, 2 vols. (New York, 1987–1994), I, p. 13.
- 5. Cited by Kostof, pp. 133-134.

Chapter 3

- Cited by Miriam Lichtheim, Ancient Egyptian Literature, I: The Old and Middle Kingdoms (Berkeley, 1975), pp. 205–206.
- 2. T. G. H. James, An Introduction to Ancient Egypt (New York, 1979), pp. 149–154.
- 3. Cited by Lichtheim, pp. 43-44.
- Herodotus, II: History of Greece, trans. A. D. Godley, Loeb Classical Library (Cambridge, Mass., 1982), p. 124.
- Akhenaten, "Hymn to the Sun," in Ancient Egyptian Literature: An Anthology, trans. John L. Foster (Austin: University of Texas Press, 2001), p. 6.

Chapter 5

- 1. Plutarch, "The Life of Pericles," in *Lives*, vol. III, trans. Bernadotte Perrin, Loeb Classical Library (Cambridge, Mass., 1984), p. 36.
- Cited by John Onians, Art and Thought in the Hellenistic Age: The Greek World View, 350–50 B.C. (London, 1979), p. 46.

Window on the World Two

- Treasures from the Bronze Age of China: An Exhibition from the People's Republic of China (New York: Metropolitan Museum of Art, 1980), p. 45.
- Florian Coulmas, The Writing Systems of the World (Oxford, 1989); Georges Jean, Writing: The Story of Alphabets and Scripts (London, 1992); Andrew Robinson, The Story of Writing (London, 1995).
- A Source Book in Chinese Philosophy, trans. and comp. Wing-Tsit Chan (Princeton, 1963), p. 30.
- 4. Cited by Bradley Smith and Wan-go Weng, China: A History in Art (London, 1973), p. 44.

Chapter 7

- 1. Virgil, *The Aeneid*, trans. Robert Fitzgerald (New York, 1983), VI.847–853.
- Cited by William L. MacDonald, *The Architec*ture of the Roman Empire (New Haven, 1982), pp. 31–32.
- Josephus, Jewish Wars VII.5.132; cited in J. J. Pollitt, The Art of Rome, c. 753 B.C.-A.D. 337: Sources and Documents (New York, 1996), p. 159.
- 4. Marcus Aurelius, *Meditations* V.1, 2; cited in Pollitt, p. 185.
- 5. Homer, Odyssey, trans. A. T. Murray, Loeb Classical Library (Cambridge, Mass., 1984), pp. 120–126, X.2.

Chapter 9

1. Robert Irwin, Islamic Art in Context: Art, Architecture, and the Literary World, Perspective Series (New York, 1997), p. 254.

- Franz Rosenthal, "Abu Haiyun al-Tawhidi on Penmanship," Ars Islamica 13–14 (1948): 18; cited in Anthony Welch, Calligraphy in the Arts of the Muslim World (Austin, Texas, 1979).
- 3. *Beowulf: A Verse Translation,* trans. Frederick Rebsamen (New York, 1991), p. 2.
- Cited by H. A. Guerber, *Myths of the Norse*men: From the Eddas and the Sagas (1909; repr. New York, 1992), p. 3.

Chapter 10

 William Melczer, The Pilgrim's Guide to Santiago de Compostela (New York, 1993), pp. 103–104.

Chapter 11

- Cited by Erwin Panofsky, Abbot Suger on the Abbey Church of St.-Denis and Its Art Treasures, ed., trans., and annotated Erwin Panofsky, 2nd ed. trans. Gerda Panofsky-Soergel (Princeton, 1979), p. 43.
- 2. Cited ibid., p. 51.
- Saint Augustine, The City of God (De Civitate Dei), bk. 6, trans. George E. McCracken, Loeb Classical Library (Cambridge, Mass., 1978), p. 11.
- Cited by Bernard McGinn, Antichrist: Two Thousand Years of the Human Fascination with Evil (San Francisco, 1994), p. 15.

Chapter 12

- Cited by Laurie M. Schneider, ed., Giotto in Perspective (Englewood Cliffs, N.J., 1974), p. 29.
- Dante, Purgatory II.91–95, in Millard Meiss, Painting in Florence and Siena after the Black Death (Princeton, 1951), p. 5.
- Cited by Linnea H. Wren and David J. Wren, eds., Perspectives on Western Art, 2 vols. (New York, 1987–1994), I, p. 270.
- 4. Cited ibid., pp. 274-277.

Glossary

Abacus: the flat slab that forms the topmost unit of a Doric column and on which the architrave rests.

Abhaya: see mudrā.

- Abstract: in painting and sculpture, having a generalized or essential form with only a symbolic resemblance to natural objects.
- Abutment: the part of a building intended to receive and counteract the thrust, or pressure, exerted by vaults and arches.
- Academy: (a) the gymnasium near Athens where Plato taught; (b) from the eighteenth century, the cultural and artistic establishment and the standards that they represent.
- Acanthus: a Mediterranean plant with prickly leaves, supposedly the source of foliage-like ornamentation on Corinthian columns. Achromatic: free of color.
- Acrylic: a fast-drying, water-based synthetic paint medium.
- Aedicule: (a) a small building used as a shrine; (b) a niche designed to hold a statue. Both types are formed by two columns or pilasters supporting a gable or pediment.
- Aerial (or atmospheric) perspective: a technique for creating the illusion of distance by the use of less distinct contours and a reduction in color intensity.
- Aesthetic: the theory and vocabulary of an individual artistic style.
- Aesthetics: the philosophy and science of art and artistic phenomena.
- Agora: the open space in an ancient Greek town used as a marketplace or for general meetings.
- Airbrush: a device for applying a fine spray of paint or other substance by means of compressed air.
- Aisle: a passageway flanking a central area (e.g., the corridors flanking the **nave** of a **basilica** or **cathedral**).
- Alabaster: a dense variety of fine-textured gypsum, usually white and translucent, but sometimes gray, red, yellow, or banded, used for carving on a small scale.
- Allegory: the expression (artistic, oral, or written) of a generalized moral statement or truth by means of symbolic actions or figures.
- Altar: (a) any structure used as a place of sacrifice or worship; (b) a tablelike structure used in a Christian church to celebrate the Eucharist.
- Altarpiece: a painted or sculpted work of art designed to stand above or behind an altar.
- Amalaka: a finial in the shape of a notched ring (derived from a fruit) atop a northern-style Hindu temple's shikhara.
- Ambulatory: a vaulted passageway, usually surrounding the apse or choir of a church.
- Amphitheater: an oval or circular space surrounded by rising tiers of seats, as used by the ancient Greeks and Romans for plays and other spectacles.
- Amphora: an ancient Greek two-handled vessel for storing grain, honey, oil, or wine.
- Analogous hues: hues containing a common color, though in different proportions. Anda: the dome of a Buddhist stupa, its egg
- Ança: the dome of a buddhist stupa, its egg shape symbolizing the arc of the heavens. Aniconic: depicting a figure, usually a deity,
- symbolically instead of anthropomorphically. Annular: ring-shaped, as in an annular barrel vault.
- Apocalypse: (a) a name for the last book of the New Testament, generally known as the Revelation of Saint John the Divine; (b) a prophetic revelation.
- Apostle: in Christian terminology, one of the twelve followers, or disciples, chosen by Christ

to spread his Gospel; also used more loosely to include early missionaries such as Saint Paul. *Apotropaion:* an object or device designed to

- avert, or turn aside, evil. Apsaras: celestial dancers seen in south and southeast Asian religious art.
- Apse: a projecting part of a building (especially a church), usually semicircular and topped by a half-dome or vault.
- Aquatint: a print from a metal plate on which certain areas have been "stopped out" to prevent the action of the acid.
- Aqueduct: a man-made conduit for transporting water.
- Arabesque: literally meaning "in the Arabian fashion," an intricate pattern of interlaced or knotted lines consisting of stylized floral, foliage, and other motifs.
- Arcade: a gallery formed by a series of arches with supporting columns or piers, either freestanding or blind (i.e., attached to a wall).
- freestanding or blind (i.e., attached to a wall). Arch: a curved architectural member, generally consisting of wedge-shaped blocks (voussoirs), which is used to span an opening; it transmits the downward pressure laterally.
- Archaeometry: a branch of archaeology that dates objects through the use of various techniques such as amino-acid and radiocarbon dating. Architrave: the lowest unit of an entablature,
- resting directly on the capital of a column.
- Archivolt: the ornamental band or molding surrounding the **tympanum** of a Romanesque or Gothic church.
- Arena: the central area in a Roman amphitheater where gladiatorial spectacles took place.
- Armature: (a) a metal framework for a stainedglass window; (b) a fixed, inner framework supporting a sculpture made of a flexible material.
- Arriccio: the rough first coat of plaster in a fresco.
- Assemblage: a group of three-dimensional objects brought together to form a work of art.
- Asymmetrical: characterized by asymmetry, or lack of balance, in the arrangement of parts or components.
- Atmospheric perspective: see aerial perspective.
- Atrium: (a) an open courtyard leading to, or within, a house or other building, usually surrounded on three or more sides by a colonnade; (b) in a modern building, a rectangular space off which other rooms open.
 Attic: in Classical architecture, a low story placed
- above the main entablature.
- Attribute: an object closely identified with, and thought of as belonging to, a specific individual —particularly, in art, a deity or saint.
- Avant-garde: literally the "advanced guard," a term used to denote innovators or nontraditionalists in a particular field.
- Axis: an imaginary straight line passing through the center of a figure, form, or structure and about which that figure is imagined to rotate.
- Axonometric projection: the depiction on a single plane of a three-dimensional object by placing it at an angle to the picture plane so that three faces are visible.
- **Balance:** an aesthetically pleasing equilibrium in the combination or arrangement of elements.
- Baldacchino: a canopy or canopylike structure above an altar or throne.
- Balustrade: a series of balusters, or upright pillars, supporting a rail (as along the edge of a balcony or bridge).
- **Baptistery:** a building, usually round or polygonal, used for Christian baptismal services.

- Barrel (or tunnel) vault: a semicylindrical vault, with parallel abutments and an identical cross
- section throughout, covering an oblong space. Base: (a) that on which something rests; (b) the lowest part of a wall or column considered as
- a separate architectural feature. **Basilica:** (a) in Roman architecture, an oblong building used for tribunals and other public functions; (b) in Christian architecture, an early church with similar features to the Roman prototype.
- Bas-relief: see low relief.
- Bay: a unit of space in a building, usually defined by **piers**, **vaults**, or other elements in a structural system.
- Beaverboard: a type of fiberboard used for partitions and ceilings.
- Bhūmi (literally "earth"): the stacked ridges that horizontally segment a northern-style Hindu temple's shikhara.
- Bhūmisparsha: see mudrā.
- Binder, binding medium: a substance used in paint and other media to bind particles of pigment together and enable them to adhere to the support.
- Biomorphic: derived from or representing the forms of living things rather than abstract shapes.
- Bister, bistre: a brown medium made from the soot of burnt wood.
- Black-figure: describing a style of Greek pottery painting of the sixth century B.C., in which the decoration is black on a red background.
- Blind niche: see niche.
- **Bodhisattva:** one of many enlightened Buddhist deities who delay their own nirvana in order to help mortals attain enlightenment.
- **Book of Hours:** a prayer book, intended for lay use, containing the devotions, or acts of worship, for the hours of the Roman Catholic Church (i.e., the times appointed for prayer, such as Matins and Vespers).
- Broken pediment: a pediment in which the cornice is discontinuous or interrupted by another element.
- Bronze: a metal alloy composed of copper mixed with tin.
- Buon fresco: see fresco.
- **Burin:** a metal tool with a sharp point to incise designs on pottery and **etching plates**, for example.
- **Burr**: in **etching**, the rough ridge left projecting above the surface of an engraved **plate** where the design has been incised.
- **Bust:** a sculptural or pictorial representation of the upper part of the human figure, including the head and neck (and sometimes part of the shoulders and chest).
- Buttress: an external architectural support that counteracts the lateral thrust of an **arch** or wall.
- *Caduceus:* the symbol of a herald or physician, consisting of a staff with two snakes twined around it and two wings at the top.
- **Calligraphy:** handwriting designed to be beautiful; **calligraphic** writing or drawing can be expressive as well as beautiful.
- **Camera obscura:** a dark enclosure or box into which light is admitted through a small hole, enabling images to be projected onto a wall or screen placed opposite that hole; the forerunner of the photographic camera.
- Campanile: Italian for bell tower, usually freestanding, but built near a church. Canon: a set of rules, principles, or standards
- used to establish scales or proportions.
- **Canopic:** relating to the city of Canopus in ancient Egypt.

- **Canopic jar:** a vessel in which ancient Egyptians preserved the viscera of the dead.
- Cantilever: a long, low architectural support that enables a cantilevered element such as an eave or a cornice to project horizontally without vertical support at the far end.
- Capital: the decorated top of a column or pilaster, providing a transition from the shaft to the entablature.
- **Caricature:** a representation in art or literature that distorts, exaggerates, or oversimplifies certain features.
- Cartonnage: layers of linen or papyrus glued together and usually coated with stucco.
- **Cartoon:** (a) a full-scale preparatory drawing for a painting; (b) in more modern usage, a comical or satirical drawing.
- Cartouche: an oval or scroll-shaped design or ornament, usually containing an inscription, a heraldic device, or (as in Egypt) a ruler's name.
- **Carving:** creating an image by removing material from an original material.
- Caryatid: a supporting column in post-andlintel construction carved to represent a human or animal figure.
- Casein: a light-colored, protein-based substance derived from milk, used in the making of paint, adhesives, etc.
- **Casting:** a process in which liquefied material, usually metal, is formed by being poured into a mold; the mold is removed when the material has solidified, leaving a **cast** object in the shape of the mold.
- *Castrum* (pl. *castra*): an ancient Roman fortress; a Roman encampment.
- Catacomb: an underground complex of passageways and vaults, such as those used by Jews and early Christians to bury their dead.
- Cathedral: the principal church of a diocese (the ecclesiastical district supervised by a bishop). Cella: the main inner room of a temple, often
- containing the cult image of the deity. **Centering:** the temporary wooden framework
- used in the construction of **arches**, **vaults**, and **domes**. Centrally planned: radiating from a central point.
- **Ceramics:** (a) the art of making objects from clay or other substances (such as **enamel** and porcelain) that require **firing** at high temperatures; (b) the objects themselves.
- Chaitya arch: a splayed, horsehoe-shaped curve derived from the profile of a barrel-vaulted chaitya hall; used to frame doors, windows, and gables, and as a decorative motif in early south Asian architecture.
- Chaitya hall: a U-shaped Buddhist structural or rock-cut chamber for congregational worship centered on a **stupa**.
- Chancel: that part of a Christian church, reserved for the clergy and choir, in which the altar is placed.
- Chapter house: a meeting place for the discussion of business in a cathedral or monastery.
- Château: French word for a castle or large country house.
- *Chattra:* a royal parasol crowning the **dome** (*anda*) of a Buddhist **stupa**, symbolically honoring the Buddha.
- Chaurī: a royal fly-whisk, symbolically honoring the Buddha.
- Chevet: French term for the east end of a Gothic church, comprising the choir, ambulatory, and radiating chapels.
- Chiaroscuro: the subtle gradation of light and shadow used to create the effect of threedimensionality.
- Chinoiserie: a Western style popular in the eighteenth century, reflecting Chinese motifs or qualities.
- Choir: part of a Christian church, near the altar, set aside for those chanting the services; usually part of the **chancel**.
- Chroma: see intensity.
- Chromatic: colored or pertaining to color.

- Chryselephantine: consisting of, or decorated with, gold and ivory.
- Circumambulate: to walk around something, especially an object of worship or veneration.
- **Circus:** in ancient Rome, an oblong space, surrounded by seats, used for chariot races,
- games, and other spectacles. *Cire-perdue:* see lost-wax bronze casting.
- **Citadel:** a fortress or other fortified area placed in an elevated or commanding position.
- **Clerestory:** the upper part of the main outer wall of a building (especially a church), located above an adjoining roof and admitting light through a row of windows.
- Cloisonné: a multicolored surface made by pouring enamels into compartments outlined by bent wire fillets, or strips.
- **Cloister:** in a **monastery**, a covered passage or **ambulatory**, usually with one side walled and the other open to a courtyard.
- Close: an enclosed space, or precinct, usually next to a building such as a **cathedral** or castle.
- **Cluster** (or **compound**) **pier**: a **pier** composed of a group, or cluster, of **engaged column** shafts, often used in Gothic architecture.
- Codex (pl. codices): sheets of parchment or vellum bound together—the precursor of the modern book.
- **Coffer, coffering:** a recessed geometrical panel in a ceiling.
- **Collage:** a work of art formed by pasting fragments of printed matter, cloth, and other materials (occasionally **three-dimensional**) to a flat surface.
- Colonnade: a series of columns set at regular intervals, usually supporting arches or an entablature.
- **Colonnette:** a small, slender **column**, usually grouped with others to form **cluster piers**.
- Color wheel: a circular, two-dimensional model illustrating the relationships of the various hues. Column: a cylindrical support, usually with three
- parts—base, shaft, and capital. Complementary colors: hues that lie directly
- opposite each other on the color wheel. Compluvium (pl. compluvia): a square opening in the roof of a Roman atrium through which
- rain fell into an *impluvium*. Composition: the arrangement of formal
- elements in a work of art.
- Compound pier: see cluster pier. Conceptual art: art in which the idea is more
- important than the **form** or **style**.
- **Cone mosaic**: a surface decorated by pressing pieces (usually colored and of conical shape) of stone or baked clay into damp plaster.
- **Content:** the themes or ideas in a work of art, as distinct from its **form**.
- **Contour:** a line representing the outline of a figure or form.
- *Contrapposto* (or counterpoise): a stance of the human body in which one leg bears the weight, while the other is relaxed, creating an **asymmetry** in the hip-shoulder **axis**.
- **Contrast:** an abrupt change, such as that created by the juxtaposition of dissimilar colors, objects, etc.
- **Convention:** a custom, practice, or principle that is generally recognized and accepted.
- **Corbeling:** brick or masonry **courses**, each projecting beyond, and supported by, the one below it; the meeting of two corbels would create an **arch** or **vault**.
- Corinthian: see Order.
- Cornice: the projecting horizontal unit, usually molded, that surmounts an **arch** or wall; the topmost member of a Classical **entablature**. Counterpoise: see *contrapposto*.
- Courses: horizontal layers of brick or masonry in a wall.
- **Crayon:** a stick for drawing formed from powdered **pigment** mixed with wax.
- **Crenellated:** having a series of indentations, like those in a battlement.

- **Cromlech**: a prehistoric monument consisting of a circle of **monoliths**.
- Crosshatching: a pattern of superimposed parallel lines (hatching) on a two-dimensional surface used to create shadows and suggest three-dimensionality.
- **Crossing:** the area in a Christian church where the **transepts** intersect the **nave**.
- **Cross section:** a diagram showing a building cut by a vertical **plane**, usually at right angles to an **axis**.
- Cross vault: see groin vault.
- Cruciform: shaped or arranged like a cross. Crypt: a chamber or vault beneath the main body of a church.
- Cuneiform: a form of writing consisting of wedge-shaped characters, used in ancient Mesopotamia.
- **Cupola:** a small, domed structure crowning a roof or **dome**, usually added to provide interior lighting.
- Curvilinear: composed of, or bounded by, curved lines.
- Cyclopaean masonry: stone construction using large, irregular blocks without mortar.
- Cylinder seal: a small cylinder of stone or other material engraved in intaglio on its outer surface and used (especially in Mesopotamia) to roll an impression on wet clay.
- Daguerreotype: mid-nineteenth-century photographic process for fixing positive images on silver-coated metal plates.
- Decussis: the Latin numeral ten (X).
- **Deësis:** a tripartite **icon** in the Byzantine tradition, usually showing Christ enthroned between the Virgin Mary and Saint John the Baptist.
- **Dendrochronology:** a science using the annual rings of trees to determine the chronological order and dates of historical events.
- Dharmachakra: see mudrā.
- Dhyāna: see mudrā.
- Diorite: a type of dark (black or gray) crystalline rock.
- **Diptych:** a writing tablet or work of art consisting of two panels side by side and connected by hinges.
- **Dolmen:** a prehistoric structure consisting of two or more **megaliths** capped with a horizontal slab.
- Dome: a vaulted (frequently hemispherical) roof or ceiling, erected on a circular base, which may be envisaged as the result of rotating an arch through 180 degrees about a central axis. Doric: see Order
- Doric: see Ord
- **Dressed stone:** blocks of stone that have been cut and shaped to fit in a particular place for a particular purpose.
- **Drip technique:** a painting technique in which paint is dripped from a brush or stick onto a horizontal canvas or other **ground**.
- **Drum:** (a) one of the cylindrical blocks of stone from which the **shaft** of a **column** is made; (b) the circular or polygonal wall of a building surmounted by a **dome** or **cupola**.
- **Drypoint:** an **engraving** in which the image is scratched directly into the surface of a metal **plate** with a pointed instrument.
- Earthenware: pottery that has been either airdried or fired at a relatively low temperature. Easel: a frame for supporting a canvas or
- wooden panel. *Echinus:* in the **Doric Order**, the rounded
- molding between the necking and the *abacus*. Edition: a batch of prints made from a single plate or print form.
- Egg and dart: a decorative molding consisting of alternating oval (egg) and downwardpointing (dart) elements.
- **Elevation**: an architectural diagram showing the exterior (or, less often, interior) surface of a building as if projected onto a vertical **plane**.
- **Emulsion:** a light-sensitive chemical coating used to transfer photographic images onto metal **plates** or other surfaces.

- Enamel: a vitreous coating applied by heat fusion to the surface of metal, glass, or pottery. See also cloisonné.
- Encaustic: a painting technique in which pigment is mixed with a binder of hot wax and fixed by heat after application.
- Engaged (half-) column: a column, decorative in purpose, that is attached to a supporting wall.
- Engraving: (a) the process of incising an image on a hard material, such as wood, stone, or a copper plate; (b) a print or impression made by such a process.
- Entablature: the portion of a Classical architectural Order above the capital of a column.
- Entasis: the slight bulging of a Doric column, which is at its greatest about one third of the distance from the base.
- Etching: (a) a printmaking process in which an impression is taken from a metal plate on which the image has been etched, or eaten away by acid; (b) a print produced by such a process.
- Etching ground: a resinous, acid-resistant substance used to cover a copper plate before an image is etched on it.
- Eucharist: (a) the Christian sacrament of Holy Communion, commemorating the Last Supper; (b) the consecrated bread and wine used at the sacrament.
- Evil eye: a malicious glance which, in superstitious belief, is thought to be capable of causing material harm.
- Façade: the front or "face" of a building.
- Facing: an outer covering or sheathing.
- Faïence: earthenware or pottery decorated with brightly colored glazes (originally from Faenza, a city in northern Italy).
- Fantasy: imagery that is derived solely from the imagination.
- Figura serpentinata: a snakelike twisting of the body, typical of Mannerist art.
- Figurative: representing the likeness of a recognizable human (or animal) figure.
- Finial: a small decorative element at the top of an architectural member such as a gable or pinnacle, or of a smaller object such as a bronze vessel.
- Fire (verb): to prepare (especially ceramics) by baking in a kiln or otherwise applying heat.
- Fixing: the use of a chemical process to make an image (a photograph, for example) more permanent.
- Fleur-de-lis: (a) a white iris, the royal emblem of France; (b) a stylized representation of an iris, common in artistic design and heraldry.
- Flutes, fluting: a series of vertical grooves used to decorate the shafts of columns in Classical architecture.
- Flying buttress, or flyer: a buttress in the form of a strut or open half-arch.
- Foreground: the area of a picture, usually at the bottom of the picture plane, that appears nearest to the viewer.
- Foreshortening: the use of perspective to represent a single object extending back in space at an angle to the picture plane.
- Form: the overall plan or structure of a work of art. Formal analysis: analysis of a work of art to determine how its integral parts, or formal
- elements, are combined to produce the overall style and effect. Formal elements: the elements of style (line,
- shape, color, etc.) used by an artist in the composition of a work of art. Formalism: the doctrine or practice of strict
- adherence to stylized shapes or other external forms
- Forum: the civic center of an ancient Roman city, containing temple, marketplace, and official buildings.
- Found object (or objet trouvé): an object not originally intended as a work of art, but presented as one.

- Fresco: a technique (also known as buon fresco) of painting on the plaster surface of a wall or ceiling while it is still damp, so that the pigments become fused with the plaster as it dries
- Fresco secco: a variant technique of fresco painting in which the paint is applied to dry plaster; this is often combined with **buon** fresco, or "true" fresco painting.
- Frieze: (a) the central section of the entablature in the Classical Orders; (b) any horizontal decorative band.
- Functionalism: a philosophy of design (in architecture, for example) holding that form should be consistent with material, structure, and use
- Gable (or pitched) roof: a roof formed by the intersection of two planes sloping down from a central beam.
- Gallery: the second story of a church, placed over the side aisles and below the clerestory. Garbha griha (literally "womb chamber"): a
- small, cubical sanctuary that is the sacred core of a Hindu temple.
- Genre: a category of art representing scenes of everyday life.
- Geodesic dome: a dome-shaped framework consisting of small, interlocking polygonal units
- Geometric: (a) based on mathematical shapes such as the circle, square, or rectangle; (b) a style of Greek pottery made between c. 900 and 700 B.C., characterized by geometric decoration.
- Gesso: a white coating made of chalk, plaster, and size that is spread over a surface to make it more receptive to paint.
- Gilding: a decorative coating made of gold leaf or simulated gold; objects to which gilding has been applied are gilded or gilt.
- Glaze: (a) in oil painting, a layer of translucent paint or varnish, sometimes applied over another color or ground, so that light passing through it is reflected back by the lower surface and modified by the glaze; (b) in pottery, a material applied in a thin layer that, when fired, fuses with the surface to produce a glossy, nonporous effect.
- Glyptic art: the art of carving or engraving, especially on small objects such as seals or precious stones.
- Gospel: one of the first four books of the New Testament, which recounts the life of Christ.
- Gouache: an opaque, water-soluble painting medium.
- Greek cross: a cross in which all four arms are of equal length.
- Grisaille: a monochromatic painting (usually in shades of black and gray, to simulate stone sculpture).
- Groin (or cross-) vault: the ceiling configuration formed by the intersection of two barrel vaults.
- Ground: in painting, the prepared surface of the support to which the paint is applied.
- Ground plan: a plan of the ground floor of a building, seen from above (as distinguished from an elevation).
- Guilds: organizations of craftsmen, such as those that flourished in the Middle Ages and Renaissance.
- Half-column: see engaged column.
- Halo: a circle or disk of golden light surrounding the head of a holy figure.
- Happening: an event in which artists give an unrehearsed performance, sometimes with the participation of the audience.
- Harmika: a square platform surmounting the dome of a Buddhist stupa.
- Hatching: close parallel lines used in drawings and prints to create the effect of shadow on three-dimensional forms. See also crosshatching.
- Hierarchical proportion or scale: the representation of more important figures as larger than less important ones.

- Hieroglyphic: written in a script (especially in ancient Egypt) whose characters are pictorial representations of objects.
- Highlight: in painting, an area of high value color.
- High relief: relief sculpture in which the figures project substantially (e.g., more than half of their natural depth) from the background surface.
- Hôtel: in eighteenth-century France, a city mansion belonging to a person of rank. Hue: a pure color with a specific wavelength.
- Hydria: an ancient Greek or Roman water jar. Hypostyle: a hall with a roof supported by rows of columns.
- Icon: a sacred image representing Christ, the Virgin Mary, or some other holy person.
- Iconography: the analysis of works of art through the study of the meanings of symbols and images in the context of the contemporary culture.
- Iconology: the study of the meaning or content of a larger program to which individual works of art belong.
- Idealized, idealization: the representation of objects and figures according to ideal standards of beauty rather than to real life.
- Ideograph: a written symbol standing for a concept, usually formed by combining pictographs.
- Ignudi (pl.): nude figures (in Italian).
- Illuminated manuscript: see manuscript.
- Illusionism, illusionistic: a type of art in which
- the objects are intended to appear real. Impasto: the thick application of paint, usually oil or acrylic, to a canvas or panel.
- Impost block: a block between a capital of a column and the springing of an arch.
- Impluvium (pl. impluvia): a basin or cistern in the atrium of a Roman house to collect
- rainwater falling through the *compluvium*. Incise: to cut designs or letters into a hard
- surface with a sharp instrument. Incised relief: see sunken relief.
- Inlay: to decorate a surface by inserting pieces of a different material (e.g., to inlay a panel with contrasting wood).
- Installation: a three-dimensional environment or ensemble of objects, presented as a work of art.
- Insula (pl. insulae): an ancient Roman building or group of buildings standing together and forming an apartment block.
- Intaglio: a printmaking process in which lines are incised into the surface of a plate or print form (e.g., engraving and etching).
- Intensity: the degree of purity of a color; also known as chroma or saturation.
- Interlace: a form of decoration composed of strips or ribbons that are intertwined, usually symmetrically about a longitudinal axis. Ionic: see Order.

Isocephaly, isocephalic: the horizontal alignment of the heads of all the figures in a composition

- Isometric projection: an architectural diagram combining a ground plan of a building with a view from an exterior point above and slightly to one side.
- Ithyphallic: an image having an erect or prominent phallus.
- Jambs: the upright surfaces forming the sides of a doorway or window, often decorated with sculptures in Romanesque and Gothic churches
- Japonisme: the Japanese aesthetic as absorbed by the West in the latter part of the nineteenth century.
- Jatakā: a tale recounting an incident in one of the Buddha's lives, frequently depicted in Buddhist
- Keystone: the wedge-shaped stone at the center of an arch, rib, or vault that is inserted last, locking the other stones into place.

- Kiln: an oven used to bake (or fire) clay Kondo: the main hall of a Japanese Buddhist
- temple, where religious images are kept. Kore (pl. korai): Greek word for maiden; an Archaic Greek statue of a standing female, usually clothed.
- Kouros (pl. kouroi): Greek word for young man; an Archaic Greek statue of a standing nude youth.
- Krater: a wide-mouthed bowl for mixing wine and water in ancient Greece.
- Kufic: an early form of Arabic script in which letters are relatively uncursive; used later for headings and formal inscriptions.
- Kylix: an ancient Greek drinking cup with a wide, shallow bowl.
- Lamassu (pl.): in Assyrian art, figures of bulls or lions with wings and human heads.
- Lancet: a tall narrow, arched window without tracery.
- Landscape: a pictorial representation of natural scenery
- Lantern: the structure crowning a dome or
- tower, often used to admit light to the interior. Lapis lazuli: a semiprecious blue stone; used to prepare the blue pigment known as ultramarine.
- Lares and penates: (a) in ancient Rome, the tutelary gods of the household; (b) figuratively, one's most valued household possessions.
- Latin cross: a cross in which the vertical arm is longer than the horizontal arm, through the midpoint of which it passes.
- Leaf and dart: a decorative design consisting of alternating leaf- and dart-shaped elements.
- Lekythos (or lecythus): an ancient Greek vessel with a long, narrow neck, used primarily for pouring oil.
- Linear: a style in which lines are used to depict figures with precise, fully indicated outlines.
- Linear (or scientific) perspective: a mathematical system devised during the Renaissance to create the illusion of depth in a two-dimensional image, through the use of straight lines converging toward a vanishing point in the distance.
- Lintel: the horizontal cross beam spanning an opening in the post-and-lintel system.
- Lithography: a printmaking process in which the printing surface is a smooth stone or plate on which an image is drawn with a crayon or some other oily substance.
- Load-bearing construction: a system of construction in which solid forms are superimposed on one another to form a tapering structure.
- Loggia: a roofed gallery open on one or more sides, often with arches or columns.
- Longitudinal section: an architectural diagram giving an inside view of a building intersected by a vertical plane from front to back.
- Lost-wax bronze casting (also called cireperdue): a technique for casting bronze and other metals.
- Low relief (also known as bas-relief): relief sculpture in which figures and forms project only slightly from the background plane.
- Luminism: an American nineteenth-century art style emphasizing the effect of light on landcape.
- Lunette: (a) a semicircular area formed by the intersection of a wall and a vault; (b) a painting, relief sculpture, or window of the same shape.
- Machtkunst: art used in the service of a military or other authority; literally, "power art" in German.
- Magus (pl. Magi): in the New Testament, one of the three wise men who traveled from the East to pay homage to the infant Christ.
- Mandala: a cosmic diagram in Asian art.
- Mandapa: a northern-style Hindu temple's assembly hall.
- Mandorla: an oval or almond-shaped aureola, or radiance, surrounding the body of a holy person.

- Manuscript: a handwritten book produced in the Middle Ages or Renaissance. If it has painted illustrations, it is known as an illuminated manuscript.
- Martyrium: a church or other structure built over the tomb or relics of a martyr.
- Masonite: a type of fiberboard used in insulation and paneling.
- Mastaba: a rectangular burial monument in ancient Egypt.
- Mausoleum (pl. mausolea): an elaborate tomb (named for Mausolos, a fourth-century-B.C. ruler commemorated by a magnificent tomb at Halikarnassos).
- Meander pattern: a fret or key pattern originating in the Greek Geometric period.
- Medium (pl. media): (a) the material with which an artist works (e.g., watercolor on paper); (b) the liquid substance in which pigment is suspended, such as oil or water.
- Megalith: a large, undressed stone used in the construction of prehistoric monuments.
- Megaron: Greek for "large room"; used principally to denote a rectangular hall, usually supported by columns and fronted by a porch, traditional in ancient Greece since Mycenaean times.
- Memento mori: an image, often in the form of a skull, to remind the living of the inevitability of death.
- Menhir: a prehistoric monolith standing alone or grouped with other stones.
- Metonym: an allusion to a subject through the representation of something related to it or a part of it.
- Metope: the square area, often decorated with relief sculpture, between the triglyphs of a Doric frieze.
- Mezzanine: in architecture, an intermediate, lowceilinged story between two main stories.
- Mezzotint: a method of engraving by burnishing parts of a roughened surface to produce an effect of light and shade.
- Mihrāb: a niche, often highly ornamented, in the center of a qibla wall, toward which prayer is directed in an Islamic mosque.
- Minaret: a tall, slender tower attached to a mosque, from which the muezzin calls the Muslim faithful to prayer.
- Minbar: a pulpit from which a Muslim (Islamic) imam addresses a congregation in a jāmi' mosque.
- Miniature: a representation executed on a much smaller scale than the original object.
- Mithuna: a loving couple, symbolizing unity, in ancient south Asian art.
- Mobile: a delicately balanced sculpture with movable parts that are set in motion by air currents or mechanical propulsion
- Modeling: (a) in two-dimensional art, the use of value to suggest light and shadow, and thus create the effect of mass and weight; (b) in sculpture, the creation of **form** by manipulating a pliable material such as clay.
- Module: a unit of measurement on which the proportions of a building or work of art are based.
- Molding: a continuous contoured surface, either recessed or projecting, used for decorative effect on an architectural surface.
- Monastery: a religious establishment housing a community of people living in accordance with religious vows
- Monochromatic: having a color scheme based on shades of black and white, or on values of a single hue.
- Monolith: a large block of stone that is all in one piece (i.e., not composed of smaller blocks), used in megalithic structures.
- Monumental: being, or appearing to be, larger than life-sized.
- Mosaic: the use of small pieces of glass, stone, or tile (tesserae), or pebbles to create an image on a flat surface such as a floor, wall, or ceiling

- Mosque: an Islamic (Muslim) house of worship of two main types: the masjid, used for daily prayer by individuals or small groups; and the jāmi', used for large-scale congregational prayer on the Friday sabbath and on holidays.
- Motif: a recurrent element or theme in a work of art
- Mudrā: a symbolic hand gesture, usually made by a deity, in Hindu or Buddhist art. Common Buddhist mudrās include abhaya mudrā (right hand raised, palm outward and vertical), meaning "fear not"; dhyāna mudrā (hands in lap, one resting on the other, palms up, thumb tips touching), signifying meditation; Dharmachakra mudrā (hands at chest level, palms out, thumb and forefinger of each forming a circle), representing the beginning of Buddhist teaching; and bhumisparsha mudrā (left hand in lap, right hand reaching down, palm in and vertical, to ground level), symbolizing Shakyamuni Buddha's calling the earth to bear witness at the moment of his enlightenment.
- Mural: a painting on a wall, usually on a large scale and in fresco.
- Naive art: art created by artists with no formal training.
- Naos: the inner sanctuary of an ancient Greek temple.
- Narthex: a porch or vestibule in early Christian churches
- Naturalism, naturalistic: a style of art seeking to represent objects as they actually appear in nature
- Nave: in basilicas and churches, the long, narrow central area used to house the congregation.
- Necking: a groove or molding at the top of a column or pilaster forming the transition from shaft to capital.
- Necropolis (pl. necropoleis): an ancient or prehistoric burial ground (literally "City of the Dead").
- Nemes: a head cloth worn by the pharaohs of ancient Egypt.
- Neutral: lacking color; white, gray, or black. Niche: a hollow or recess in a wall or other
- architectural element, often containing a statue; a blind niche is a very shallow recess.
- Nike: a winged statue representing Nike, the goddess of victory
- Nonrepresentational (or nonfigurative): not representing any known object in nature.
- Obelisk: a tall, four-sided stone, usually monolithic, that tapers toward the top and is
- capped by a pyramidion. Objet trouvé: see found object.
- Obverse: the side of a coin or medal considered to be the front and that bears the main image. Oculus: a round opening in a wall or at the apex of a dome.
- Oenochoe: an ancient Greek wine jug.
- Oil paint: a slow-drying and flexible paint
- formed by mixing pigments with the medium of oil.
- One-point perspective: a perspective system involving a single vanishing point.
- Opisthodomos (or opisthodome): a back chamber, especially the part of the naos of a temple farthest from the entrance.
- Orant: standing with outstretched arms as if in praver.
- Orchestra: in an ancient Greek theater, a circular space used by the chorus.
- Order: one of the architectural systems (Corinthian, Ionic, Doric) used by the Greeks and Romans to decorate and define the postand-lintel system of construction.
- Organic: having the quality of living matter.
- Orthogonals: the converging lines that meet at the vanishing point in the system of linear perspective.
- Pagoda: a multistoried Buddhist reliquary tower, tapering toward the top and characterized by projecting eaves.

- **Painterly:** in painting, using the quality of color and **texture**, rather than line, to define form.
- Palette: (a) the range of colors used by an artist; (b) an oval or rectangular tablet used to hold and mix the **pigments**.
- Palette knife: a knife with a flat, flexible blade and no cutting edge, used to mix and spread paint.
- **Papyrus:** (a) a plant found in ancient Egypt and neighboring countries; (b) a paperlike writing material made from the pith of the plant.
- Parapet: (a) a wall or rampart to protect soldiers; (b) a low wall or railing built for the safety of people at the edge of a balcony, roof, or other steep place.
- Parchment: a paperlike material made from bleached and stretched animal hides, used in the Middle Ages for manuscripts.
- Pastel: a crayon made of ground pigments and a gum binder, used as a drawing medium.
- Patina: (a) the colored surface, often green, that forms on **bronze** and copper either naturally (as a result of oxidation) or artificially (through treatment with acid); (b) in general, the surface appearance of old objects.
- Patron: the person or group that commissions a work of art from an artist.
- Pedestal: the base of a column, statue, vase, or other upright work of art.
- Pediment: (a) in Classical architecture, the triangular section at the end of a gable roof, often decorated with sculpture; (b) a triangular feature placed as a decoration over doors and windows.
- **Pendentive:** in a domed building, an inwardly curving triangular section of the **vaulting** that provides a transition from the round **base** of the **dome** to the supporting **piers**.
- Peplos: in ancient Greece, a woolen outer garment worn by women, wrapped in folds about the body.
- Peripteral: surrounded by a row of columns or peristyle.
- Peristyle: a colonnade surrounding a structure; in Roman houses, the courtyard surrounded by columns.
- **Perspective:** the illusion of depth in a twodimensional work of art.
- **Pictograph:** a written symbol derived from a **representational** image.
- Picture plane: the flat surface of a drawing or painting.
- Picture stone: in Viking art, an upright boulder with images incised on it.
- **Piece-molding:** a complex technique for shaping pottery, metal, or glass objects between an inner core and an outer mold; especially suited to elaborate decoration.
- Pier: a vertical support used to bear loads in an arched or vaulted structure.
- Pietà: an image of the Virgin Mary holding and mourning over the dead Christ.
- **Pigment:** a powdered substance that is used to give color to paints, inks, and dyes.
- Pilaster: a flattened, rectangular version of a column, sometimes load-bearing, but often purely decorative.
- Pillar: a large vertical architectural element, usually freestanding and load-bearing. Pitched roof: see gable roof.
- Plane: a surface on which a straight line joining any two of its points lies on that surface; in general, a flat surface.
- Plate: (a) in engraving and etching, a flat piece of metal into which the image to be printed is cut; (b) in photography, a sheet of glass, metal, etc., coated with a light-sensitive emulsion.
- Plinth: (a) in Classical architecture, a square slab immediately below the circular base of a column; (b) a square block serving as a base for a statue, vase, etc.
- Podium: (a) the masonry forming the base of a temple; (b) a raised platform or pedestal.Polychrome: consisting of several colors.

- Polyptych: a painting or relief, usually an altarpiece, composed of more than three sections.
- **Portal:** the doorway of a church and the architectural composition surrounding it.
- **Portico:** (a) a **colonnade**; (b) a porch with a roof supported by **columns**, usually at the entrance to a building.
- **Portrait:** a visual representation of a specific person, a likeness.
- **Portraiture:** the art of making portraits. **Postament:** (a) a **pedestal** or **base;** (b) a frame of
- molding for a relief.
- Post-and-lintel construction: an architectural system in which upright members, or posts, support horizontal members, or lintels.
- **Prana:** the fullness of life-giving breath that appears to animate some south and southeast Asian sculpture.
- **Predella:** the lower part of an **altarpiece**, often decorated with small scenes that are related to the subject of the main panel.
- Primary color: the pure hues—blue, red, yellow from which all other colors can in theory be mixed.
- Print: a work of art produced by one of the printmaking processes—engraving, etching, and woodcut.
- Print matrix: an image-bearing surface to which ink is applied before a **print** is taken from it.
- **Program:** the arrangement of a series of images into a coherent whole.
- *Pronaos*: the vestibule of a Greek temple in front of the *cella* or *naos*.
- **Proportion:** the relation of one part to another, and of parts to the whole, with respect to size, height, and width.
- **Propylaeum** (pl. **propylaea**): (a) an entrance to a temple or other enclosure; (b) the entry gate at the western end of the Acropolis, in Athens.
- Protome (or protoma): a representation of the head and neck of an animal, often used as an architectural feature.
- **Provenience:** origin, derivation; the act of coming from a particular source.
- **Psalter:** a copy of the Book of Psalms in the Old Testament, often illuminated.
- Pseudoperipteral: appearing to have a peristyle, though some of the columns may be engaged columns or pilasters.
- Pulpit: in church architecture, an elevated stand, surrounded by a **parapet** and often richly decorated, from which the preacher addresses the congregation.
- Putto (pl. putti): a chubby male infant, often naked and sometimes depicted as a Cupid, popular in Renaissance art.
- **Pylon:** a pair of truncated, pyramidal towers flanking the entrance to an Egyptian temple.

Pyramidion: a small pyramid, as at the top of an obelisk.

- *Qibla:* a wall inside the prayer hall of a **mosque** that is oriented toward Mecca and is, therefore, the focus of worship.
- Quadrant (or half-barrel) vaulting: vaulting whose arc is one-quarter of a circle, or 90 degrees.
- Quatrefoil: an ornamental "four-leaf clover" shape —i.e., with four lobes radiating from a common center.
- Radiating chapels: chapels placed around the ambulatory (and sometimes the transepts) of a medieval church.
- Radiocarbon dating: a method of dating prehistoric objects based on the rate of degeneration of radioactive carbon in organic materials.
- **Rayograph:** an image made by placing an object directly on light-sensitive paper, using a technique developed by Man Ray.
- **Realism, realistic:** attempting to portray objects from everyday life as they actually are; not to be confused with the nineteenth-century movement called Realism.
- **Rebus:** the representation of words and syllables by pictures or symbols, the names of which

sound the same as the intended words or syllables.

- **Rectilinear:** consisting of, bounded by, or moving in, a straight line or lines.
- **Red-figure:** describing a style of Greek pottery painting of the sixth or fifth century B.C., in which the decoration is red on a black background.
- **Refectory:** a dining hall in a **monastery** or other similar institution.
- Register: a range or row, especially when one of a series.
- Reinforced concrete: concrete strengthened by embedding an internal structure of wire mesh or rods.
- Relief: (a) a mode of sculpture in which an image is developed outward (high or low relief) or inward (sunken relief) from a basic plane;
 (b) a printmaking process in which the areas not to be printed are carved away, leaving the desired image projecting from the plate.
- Reliquary: a casket or container for sacred relics.
- Repoussé: in metalwork, decorated with patterns in relief made by hammering on the reverse side.
- **Representational:** representing natural objects in recognizable form.
- **Reverse:** the side of a coin or medal considered to be the back; opposite of **obverse**.
- **Rhyton:** an ancient drinking vessel usually shaped like an animal or part of an animal (typically, the head).
- Rib: an arched diagonal element in a vault system that defines and supports a ribbed vault.
- Ribbed vault: a vault constructed of arched diagonal ribs, with a web of lighter masonry in between.
- Romanticize: to glamorize or portray in a romantic, as opposed to a realistic, manner.
- **Roof comb:** an ornamental architectural crest on top of a Maya temple.
- Rosette: circular stylization of a rose. Rose window: a large, circular window
- decorated with **stained glass** and **tracery**. **Rosin:** a crumbly resin used in making varnishes and lacquers.
- Rotunda: a circular building, usually covered by a dome.
- Rune stone: in Viking art, an upright boulder with characters of the runic alphabet inscribed on it.
- **Rusticate**: to give a rustic appearance to masonry blocks by roughening their surface and beveling their edges so that the joints are indented.
- Sahn: an enclosed courtyard in an Islamic mosque, used for prayer when the interior is full.
- Salon: (a) a large reception room in an elegant private house; (b) an officially sponsored exhibition of works of art.
- Sanctuary: (a) the most holy part of a place of worship, the inner sanctum; (b) the part of a Christian church containing the **altar**.
- Sarcophagus: a stone coffin, sometimes decorated with a relief sculpture.
- Sarsen: a large sandstone block used in prehistoric monuments.
- Saturation: see intensity.
- Satyr: an ancient woodland deity with the legs, tail, and horns of a goat (or horse), and the head and torso of a man.
- Schematic: diagrammatic and generalized rather than specifically relating to an individual object.
- Scientific perspective: see linear perspective. Screen wall: a nonsupporting wall, often pierced by windows.
- Scriptorium (<u>pl. scriptoria</u>): the room (or rooms) in a **monastery** in which **manuscripts** were produced.
- Scroll: (a) a length of writing material, such as papyrus or parchment, rolled up into a

cylinder; (b) a curved **molding** resembling a scroll (e.g., the **volute** of an **Ionic** or **Corinthian capital**).

- Sculptured wall motif: the conception of a building as a massive block of stone with openings and spaces carved out of it.
- Sculpture in the round: freestanding sculptural figures carved or modeled in three dimensions.
- Secondary colors: hues produced by combining two primary colors.
- Section: a diagrammatic representation of a building intersected by a vertical plane.
- Serapaeum: a building or shrine sacred to the Egyptian god Serapis.
- Serekh: a rectangular outline containing the name of a king in the Early Dynastic period of ancient Egypt.
- Seriation: a technique for determining a chronology by studying a particular type or style and analyzing the increase or decrease in its popularity.
- *Sfumato:* the definition of form by delicate gradations of light and shadow.
- Shading: decreases in the value or intensity of colors to imitate the fall of shadow when light strikes an object.
- Shaft: the vertical, cylindrical part of a column that supports the entablature.
- Shikhara: (literally "mountain peak"), a northernstyle Hindu temple tower surmounting a garbha griha, typically curved inward toward the top, with vertical lobes and horizontal segments (bhūmi), and crowned by āmalaka.
- Sibyl: a prophetess of the ancient, pre-Christian world.
- Silhouette: the outline of an object, usually filled in with black or some other uniform color.
- Silkscreen: a printmaking process in which pigment is forced through the mesh of a silkscreen, parts of which have been masked to make them impervious.
- Size, sizing: a mixture of glue or resin that is used to make a ground such as canvas less porous so that paint will not be absorbed into it.
- Skeletal (or steel-frame) construction: a method of construction in which the walls are supported at ground level by a steel frame consisting of vertical and horizontal members.
- *Skene:* in a Greek theater, the stone structure behind the *orchestra* that served as a backdrop or stage wall.
- Slip: in ceramics, a mixture of clay and water used (a) as a decorative finish or (b) to attach different parts of an object (e.g., handles to the body of a vessel).
- **Spacer:** a small peg or ball used to separate metal, pottery, or glass objects from other objects during processes such as **casting**, **firing**, and mold-blowing.
- **Spandrel:** the triangular area between (a) the side of an **arch** and the right angle that encloses it or (b) two adjacent arches.
- Sphinx: in ancient Egypt, a creature with the body of a lion and the head of a human, an animal, or a bird.
- *Spolia:* materials taken from an earlier building for re-use in a new one.
- Springing: (a) the architectural member of an arch that is the first to curve inward from the vertical; (b) the point at which this curvature begins.
- Squinch: a small single arch, or a series of concentric corbeled arches, set diagonally across the upper inside corner of a square building to facilitate the transition to a round dome or other circular superstructure.
- Stained glass: windows composed of pieces of colored glass held in place by strips of lead.
- State: one of the successive printed stages of a print, distinguished from other stages by the greater or lesser amount of work carried out on the image.
- Steel-frame construction: see skeletal construction.

- Stele: an upright stone slab or pillar, usually carved or inscribed for commemorative purposes.
- Step pyramid: a pyramid constructed of mastaba forms of successively decreasing size.
- Stereobate: a substructure or foundation of masonry visible above ground level.
- Stigmata (pl.): marks resembling the wounds on the crucified body of Christ (from *stigma*, "a mark" or "scar").
- Still life: a picture consisting principally of inanimate objects such as fruit, flowers, or pottery. Stratigraphy: a technique for determining a
- chronology by studying the relative locations of layers of material in an archaeological site.
- Stringcourses: decorative horizontal bands on a building.
- Stucco: (a) a type of cement used to coat the walls of a building; (b) a fine plaster used for moldings and other architectural decorations.
- Stupa: in Buddhist architecture, a dome-shaped or rounded structure made of brick, earth, or stone, containing the relic of a Buddha or other honored individual.
- Style: in the visual arts, a manner of execution that is characteristic of an individual, a school, a period, or some other identifiable group.
- Stylization: the distortion of a representational image to conform to certain artistic conventions or to emphasize particular qualities.
- Stylobate: the top step of a stereobate, forming a foundation for a column, peristyle, temple, or other structure.
- Stylus: a pointed instrument used in antiquity for writing on clay, wax, papyrus, and parchment; a pointed metal instrument used to scratch an image on the plate used to produce an etching.
- Sunken (or incised) relief: a style of relief sculpture in which the image is recessed into the surface.
- **Support:** in painting, the surface to which the **pigment** is applied.
- Suspension bridge: a bridge in which the roadway is suspended from two or more steel cables, which usually pass over towers and are then anchored at their ends.
- Symmetria: Greek for symmetry.
- Symmetry: the aesthetic balance that is achieved when parts of an object are arranged about a real or imaginary central line, or **axis**, so that the parts on one side correspond in some respect (shape, size, color) with those on the other.
- Symposium: (a) a drinking party; (b) a social gathering at which there is a free exchange of ideas.
- Synthesis: the combination of parts or elements to form a coherent, more complex whole.
- Taberna: part of a Roman building fronting on a street and serving as a shop.
- **Talud-tablero:** an architectural **style** typical of Teotihuacán sacred structures in which paired elements—a sloping **base** (the **talud**) supporting a vertical **tablero** (often decorated with sculpture or painting)—are stacked, sometimes to great heights.
- Tectonic: of, or pertaining to, building or construction.
- Tell: an archaeological term for a mound composed of the remains of successive settlements in the Near East.
- Tempera: a fast-drying, water-based painting medium made with egg yolk, often used in fresco and panel painting.
- Tenebrism: a style of painting used by Caravaggio and his followers in which most objects are in shadow, while a few are brightly illuminated.
- **Tenon:** a projecting member in a block of stone or other building material that fits into a groove or hole to form a joint.
- Tensile strength: the internal strength of a material that enables it to support itself without rupturing.

- Terra-cotta: (a) an earthenware material, with or without a glaze; (b) an object made of this material.
- Tertiary color: a hue produced by combining a primary color and a secondary color.
- *Tessera* (pl. *tesserae*): a small piece of colored glass, marble, or stone used in a **mosaic**.
- Texture: the visual or tactile surface quality of an object.
- Tholos: (a) a circular tomb of beehive shape approached by a long, horizontal passage;(b) in Classical times, a round building modeled on ancient tombs.
- Three-dimensional: having height, width, and depth.
- Thrust: the lateral force exerted by an **arch**, **dome**, or **vault**, which must be counteracted by some form of **buttressing**.
- Tondo: (a) a circular painting; (b) a medallion with **relief** sculpture.
- Toraṇa: a ritual gateway in Buddhist architecture.
- Trabeated: constructed according to the postand-lintel method.
- Tracery: a decorative, interlaced design (as in the stonework in Gothic windows). Transept: a cross arm in a Christian church,
- placed at right angles to the **nave**. **Transverse rib**: a **rib** in a **vault** that crosses the
- **nave** or **aisle** at right angles to the **axis** of the building.
- Travertine: a hard limestone used as a building material by the Etruscans and Romans.
- **Tribhanga:** in Buddhist art, the "three bends posture," in which the head, chest, and lower portion of the body are angled instead of being aligned vertically.
- Tribune: (a) the apse of a basilica or basilican church; (b) a gallery in a Romanesque or Gothic church.
- Triforium: in Gothic architecture, part of the nave wall above the arcade and below the clerestory.
- Triglyph: in a Doric frieze, the rectangular area between the **metopes**, decorated with three vertical grooves (glyphs).
- Trilithon: an ancient monument consisting of two vertical megaliths supporting a third as a lintel.
- **Trilobed:** having three rounded projections.
- Triptych: an altarpiece or painting consisting of one central panel and two wings.
- *Trompe l'oeil:* illusionistic painting that "deceives the eye" with its appearance of reality.
- Trumeau: in Romanesque and Gothic architecture, the central post supporting the lintel in a double doorway.
- **Truss construction:** a system of construction in which the architectural members (such as bars and beams) are combined, often in triangles, to form a rigid framework.
- Tufa: a porous, volcanic rock that hardens on exposure to air, used as a building material.
- **Tumulus** (pl. **tumuli**): an artificial mound, typically found over a grave.
- Tunnel vault: see barrel vault.
- **Tympanum:** a **lunette** over the doorway of a church, often decorated with sculpture.
- Type: a person or object serving as a prefiguration or symbolic representation, usually of something in the future.
- Typology: the Christian theory of types, in which characters and events in the New Testament (i.e., after the birth of Jesus) are prefigured by counterparts in the Old Testament.
- Underpainting: a preliminary painting, subsequently covered by the final layer(s) of paint.
- Uraeus (pl. uraei): a stylized representation of an asp, often included on the headdress of ancient rulers.
- Urņā: in Buddhist art, a whorl of hair or protuberance between the eyebrows of a Buddha or other honored individual.

Ushnisha: a conventional identifying topknot of hair on an image of Shakyamuni Buddha, symbolic of his wisdom.

Value: the degree of lightness (high value) or darkness (low value) in a hue.

- Vanishing point: in the linear perspective system, the point at which the **orthogonals**, if extended, would intersect.
- Vanitas: a category of painting, often a still life, the theme of which is the transitory nature of earthly things and the inevitability of death.
- Vault, vaulting: a roof or ceiling of masonry constructed on the arch principle; see also barrel vault, groin vault, quadrant vaulting, ribbed vault.
- Vedikā: a railing marking off sacred space in south Asian architecture, often found surrounding a Buddhist stupa or encircling the axis-pillar atop its dome (anda).
- Vehicle: a term often used interchangeably with medium to mean the liquid in which pigments are suspended but not dissolved and which, as it dries, binds the color to the surface of the painting.
- Vellum: a cream-colored, smooth surface for painting or writing, prepared from calfskin.

- Veranda: a pillared porch preceding an interior chamber, common in Hindu temples and Buddhist *chaitya* halls.
- Verisimilitude: the quality of appearing real or truthful.
- Vihāra: Buddhist monks' living quarters, either an individual cell or a space for communal activity.
- Villa: (a) in antiquity and the Renaissance, a large country house; (b) in modern times, a detached house in the country or suburbs.

Visible spectrum: the colors, visible to the human eye, that are produced when white light is dispersed by a prism.

- Vitreous: related to, derived from, or consisting of glass.
- Volute: in the Ionic order, the spiral scroll motif decorating the capital.
- **Voussoir**: one of the individual, wedge-shaped blocks of stone that make up an **arch**.
- Wash: a thin, translucent coat of paint (e.g., in watercolor).
- Watercolor: (a) paint made of **pigments** suspended in water; (b) a painting executed in this **medium**.

- Wattle and daub: a technique of wall construction using woven branches or twigs plastered with clay or mud.
- Web: in Gothic architecture, the portion of a ribbed vault between the ribs.
- Westwork: from the German Westwerk, the western front of a church, containing an entrance and vestibule below, a chapel or gallery above, and flanked by two towers.
- White-ground: describing a style of Greek pottery painting of the fifth century B.C., in which the decoration is usually black on a white background.
- Wing: a side panel of an altarpiece or screen.
- Woodcut: a relief printmaking process in which an image is carved on the surface of a wooden block by cutting away those parts that are not to be printed.
- Yaksha, yakshī: indigenous south Asian fertility deities, respectively male and female, later assimilated into Buddhist art.
- Ziggurat: a trapezoidal stepped structure representing a mountain in ancient Mesopotamia.

Suggestions for Further Reading

General

- Adams, Laurie. Art on Trial: From Whistler to Rothko. New York: Walker, 1976.
- ——. Art and Psychoanalysis. New York: HarperCollins, 1993.
- The Methodologies of Art: An Introduction. New York: HarperCollins, 1996.
- . Looking at Art. Englewood Cliffs, N.J.: Prentice-Hall, 2002.
- . World Views: Topics in Non-Western Art. New York: McGraw-Hill, 2004.
- Arntzen, Etta, and Robert Rainwater. *Guide to the Literature of Art History*. Chicago: American Library Association, 1980.
- Barasch, Moshe. Theories of Art: From Plato to Winckelmann. New York: New York University Press, 1985.
- Modern Theories of Art, I: From Winckelmann to Baudelaire. New York: New York University Press, 1990.
- Baxandall, Michael. Patterns of Intention: On the Historical Explanation of Pictures. New Haven: Yale University Press, 1985.
- Bois, Yve-Alain. Painting as Model. Cambridge, Mass.: MIT Press, 1990.
- Broude, Norma, and Mary D. Garrard, eds. Feminism and Art History: Questioning the Litany. New York: Harper & Row, 1982.
- , eds. The Expanding Discourse: Feminism and Art History. New York: HarperCollins, 1992.
- Bryson, Norman. Vision and Painting: The Logic of the Gaze. New Haven: Yale University Press, 1983.
- Vision and Painting. New Haven: Yale University Press, 1987.
- , et al., eds. Visual Theory: Painting and Interpretation. New York: Cambridge University Press, 1991.
- Cahn, Walter. Masterpieces: Chapters on the History of an Idea. Princeton: Princeton University Press, 1979.
- Carrier, David. *Principles of Art History Writing.* University Park, Pa.: Pennsylvania State University Press, 1991.
- Chadwick, Whitney. Women, Art, and Society. 3rd ed. New York: Thames & Hudson, 2002.
- Chicago, Judy, and Miriam Schapiro. In Anonymous Was a Woman. Valencia, Calif.: Feminist Art Program, California Institute of the Arts, 1974.
- Chilvers, Ian, and Harold Osborne, eds. *The Oxford Dictionary of Art*. New York: Oxford University Press, 1988.
- Clark, Kenneth M. The Nude: A Study in Ideal Form. Garden City, N.Y.: Doubleday, 1959.
- Clark, Toby. Art and Propaganda in the Twentieth Century: The Political Image in the Age of Mass Culture. New York: Abrams, 1997.
- Derrida, Jacques. *The Truth in Painting*. Trans. Geoff Bennington and Ian McLeod. Chicago: University of Chicago Press, 1987.
- Ehresmann, Donald L. Architecture: A Bibliographic Guide to Basic Reference Works, Histories, and Handbooks. Littleton, Col.: Libraries Unlimited, 1984.
- ——, Fine Arts: A Bibliographic Guide to Basic Reference Works, Histories, and Handbooks. 3rd ed. Englewood, Col.: Libraries Unlimited, 1990.
- Eliade, Mircea. A History of Religious Ideas. Trans. Willard R. Trask. 3 vols. Chicago: University of Chicago Press, 1978.
- Elsen, Albert E. The Purposes of Art: An Introduction to the History and Appreciation of Art. 4th ed. New York: Holt, Rinehart & Winston, 1981.

- Encyclopedia of World Art. 17 vols. New York: McGraw-Hill, 1959–1987.
- Fine, Elsa Honig. *Women and Art.* Montclair, N.J.: Allanbeld & Schram, 1978.
- Flynn, Tom. The Body in Three Dimensions. New York: Abrams, 1998.
- Freedberg, David. *The Power of Images: Studies in the History and Theory of Response*. Chicago: University of Chicago Press, 1989.
- Gedo, Mary Mathews. Looking at Art from the Inside Out: The Psychoiconographic Approach to Modern Art. New York: Cambridge University Press, 1994.
- Getlein, Mark. Gilbert's Living with Art. 7th ed. New York: McGraw-Hill, 2005.
- Gombrich, Ernst. Art and Illusion: A Study in the Psychology of Pictorial Representation (1960). Millennium ed., with new preface by author. Princeton: Princeton University Press, 2000.

——. The Image and the Eye: Further Studies in the Psychology of Pictorial Representation. Ithaca, N.Y.: Cornell University Press, 1982.

——. Meditations on a Hobby Horse, and Other Essays on the Theory of Art (1963). 4th ed. Oxford: Phaidon, 1985.

——. Shadows: The Depiction of Cast Shadows in Western Art. London: National Gallery, 1995.

- Hall, James. Illustrated Dictionary of Symbols in Eastern and Western Art. New York: Harper-Collins, 1994.
- ——. Dictionary of Subjects and Symbols in Art. Rev. ed. London: Murray, 1996.
- Harris, Ann Sutherland, and Linda Nochlin. Women Artists, 1550–1950. Los Angeles: Los Angeles County Museum of Art; New York: Random House, 1976.
- Harrison, Charles, and Paul Wood, eds. Art in Theory, 1900–1990: An Anthology of Changing Ideas. Cambridge, Mass.: Blackwell, 1993.
- Hauser, Arnold. The Philosophy of Art History. New York: Knopf, 1958.
- ——. The Social History of Art. 3rd ed. 4 vols. New York: Routledge, 1999.
- Hedges, Elaine, and Ingrid Wendt. In Her Own Image: Women Working in the Arts. New York: McGraw-Hill, 1980.
- Heller, Nancy G. Women Artists: An Illustrated History, 4th ed. New York: Abbeville, 2003.
- Hess, Thomas B., and Elizabeth C. Baker, eds. Art and Sexual Politics: Women's Liberation, Women Artists, and Art History. New York: Macmillan, 1973.
- Hinz, Berthold. Art in the Third Reich. Trans. Robert Kimber and Rita Kimber. New York: Pantheon, 1979.
- Holt, Elizabeth Gilmore, ed. A Documentary History of Art. 2 vols. Princeton: Princeton University Press, 1981.
- Kemp, Martin. The Science of Art: Optical Themes in Western Art from Brunelleschi to Seurat. New Haven: Yale University Press, 1990.
- Kleinbauer, W. Eugene. Modern Perspectives in Western Art History: An Anthology of Twentieth-Century Writings on the Visual Arts (1971). Toronto: University of Toronto Press, 1989.
- Kleinbauer, W. Eugene, and Thomas P. Slavens. Research Guide to Western Art History. Chicago: American Library Association, 1982.
- Kostof, Spiro. *The Architect: Chapters in the History of the Profession* (1977). Berkeley: University of California Press, 2000.
- . A History of Architecture: Settings and Rituals (1985). 2nd ed. Rev. Greg Castillo. New York: Oxford University Press, 1995.
- Kris, Ernst, and Otto Kurz. Legend, Myth, and Magic in the Image of the Artist: An Historical Experiment. New Haven: Yale University Press, 1979.

Kultermann, Udo. *The History of Art History*. New York: Abaris, 1993.

- Lever, Jill, and John Harris. *The Illustrated Dictionary of Architecture, 800–1914.* 2nd ed. Boston: Faber & Faber, 1993.
- Levine, Lawrence W. Highbrow/Lowbrow: The Emergence of Cultural Hierarchy in America. Cambridge, Mass.: Harvard University Press, 1988.
- McCoubrey, John W. American Art, 1700–1960: Sources and Documents. Englewood Cliffs, N.J.: Prentice-Hall, 1965.
- Mayer, Ralph. The Artist's Handbook of Materials and Techniques. 5th ed. New York: Viking, 1991.
- ——. The HarperCollins Dictionary of Art Terms and Techniques. 2nd ed. New York: Harper-Collins, 1991.
- Mitchell, W. J. T. Picture Theory: Essays on Verbal and Visual Representation. Chicago: University of Chicago Press, 1994.
- Munsterberg, Hugo. A History of Women Artists. New York: Potter, 1975.
- Murray, Peter, and Linda Murray. *The Penguin Dictionary of Art and Artists.* 7th ed., rev. New York: Penguin, 1997.
- Nochlin, Linda. Women, Art, and Power: And Other Essays. New York: Harper & Row, 1988.
- Ocvirk, Otto G., et al. Art Fundamentals: Theory and Practice. 10th ed. New York: McGraw-Hill, 2005.
- Panofsky, Erwin. Meaning in the Visual Arts: Papers in and on Art History. Garden City, N.Y.: Doubleday, 1955.
- . Idea: A Concept in Art Theory. Columbia: University of South Carolina Press, 1968.
- ——. Perspective as Symbolic Form. New York: Zone Books, 1991.
- Parker, Rozsika, and Griselda Pollock. Old Mistresses: Women, Art, and Ideology. New York: Pantheon, 1982.
- Penny, Nicholas. *The Materials of Sculpture*. New Haven: Yale University Press, 1993.
- Petersen, Karen, and J. J. Wilson. Women Artists: Recognition and Reappraisal from the Early Middle Ages to the Twentieth Century. New York: Harper & Row, 1976.
- Pollock, Griselda. Vision and Difference: Femininity, Feminism and Histories of Art (1988). London: Routledge. 2003.
- Praz, Mario, Mnemosyne: The Principle between Literature and the Visual Arts. Princeton: Princeton University Press, 1970.
- Pultz, John. The Body and the Lens: Photography 1839 to the Present. New York: Abrams, 1995.
- Reid, Jane Davidson, ed. The Oxford Guide to Classical Mythology in the Arts, 1330–1990s. 2 vols. New York: Oxford University Press, 1993.
- Roth, Leland M. Understanding Architecture: Its Elements, History, and Meaning. New York: HarperCollins, 1993.
- Saxl, Fritz. A Heritage of Images: A Selection of Lectures. Harmondsworth: Penguin, 1970.
- Schiller, Gertrud. Iconography of Christian Art. Trans. Janet Seligman. 2 vols. Greenwich, Conn.: New York Graphic Society, 1971.
- Scully, Vincent. Architecture: The Natural and the Man-Made. New York: St. Martin's, 1991.
- Sporre, Dennis J. The Creative Impulse: An Introduction to the Arts. 7th ed. Upper Saddle River, N.J.: Prentice-Hall, 2005.
- Stephenson, Jonathan. The Materials and Techniques of Painting (1989). New York: Thames & Hudson, 1993.
- Summerson, John. The Classical Language of Architecture (1963). Cambridge, Mass.: MIT Press, 1984.

- Trachtenberg, Marvin, and Isabelle Hyman. Architecture, from Pre-History to Postmodernity. 2nd ed. New York: Abrams, 2002.
- Van Keuren, Frances. Guide to Research in Classical Art and Mythology. Chicago: American Library Association, 1991.
- Verhelst, Wilbert. Sculpture: Tools, Materials, and Techniques. 2nd ed. Englewood Cliffs, N.J.: Prentice-Hall, 1988.
- Watkin, David. The Rise of Architectural History. Chicago: University of Chicago Press, 1983.
- Westermann, Mariët. A Worldly Art: The Dutch Republic, 1585–1718. New York: Abrams, 1996.
- Williams, Raymond. Culture and Society, 1780– 1950 (1958). New York: Harper & Row, 1966.
 — The Sociology of Culture. New York:
- Schocken, 1982. Winternitz, Emanuel. Musical Instruments and
- Their Symbolism in Western Art. New York: Norton, 1967. Wittkower, Rudolf. Allegory and the Migration of
- Symbols. London: Thames & Hudson, 1977.
- Wittkower, Rudolf, and Margot Wittkower. Born under Saturn: The Character and Conduct of Artists, a Documented History from Antiquity to the French Revolution (1963). New York: Norton, 1969.
- Wodehouse, Lawrence, and Marian Moffett. A History of Western Architecture. Mountain View, Calif.: Mayfield, 1989.
- Wolff, Janet. The Social Production of Art. 2nd ed. New York: New York University Press, 1993.
- Wölfflin, Heinrich. Principles of Art History: The Problem of the Development of Style in Later Art (1932). Trans. M. D. Hottinger. New York: Dover, 1956.
- ——. Classic Art: An Introduction to the Italian Renaissance (1952). 5th ed. Trans. Peter Murray and Linda Murray. London: Phaidon, 1994.
- ——. The Sense of Form in Art: A Comparative Psychological Study. Trans. Alice Muehsam and Norma A. Shettan. New York: Chelsea, 1958.
- Wollheim, Richard. Art and Its Objects: With Six Supplementary Essays (1980). 2nd ed. New York: Cambridge University Press, 1992.
 Painting as an Art. Princeton: Princeton
- University Press, 1987. Wren, Linnea H., and David J. Wren, eds. Perspec-
- *tives on Western Art.* 2 vols. New York: Harper-Collins, 1987–1994.
- Yates, Frances A. The Art of Memory (1966). London: Routledge, 1999.

The Art of Prehistory

- Amiet, Pierre, ed. Art in the Ancient World: A Handbook of Styles and Forms. Trans. Valerie Bynner. New York: Rizzoli, 1981.
- Bandi, Hans-Georg, and Henri Breuil. The Art of the Stone Age: Forty Thousand Years of Rock Art. 2nd ed. Trans. Ann E. Keep. London: Methuen, 1970.
- Bataille, Georges, *Lascaux; or, The Birth of Art: Prehistoric Painting.* Trans. Austryn Wainhouse. Lausanne: Skira, 1955.
- Breuil, Henri. Four Hundred Centuries of Cave Art (1952). Trans. Mary E. Boyle. New York: Hacker, 1979.
- Castleden, Rodney. *The Making of Stonehenge*. London: Routledge, 1993.
- Chauvet, Jean-Marie, Eliette Brunel Deschamps, and Christian Hillaire. Dawn of Art: The Chauvet Cave, the Oldest Known Paintings in the World. Trans. Paul G. Bahn. New York: Abrams, 1996.
- Chippindale, Christopher. Stonehenge Complete. Exp. ed. London: Thames & Hudson, 2004.
- Clottes, Jean, and Jean Courtin. The Cave beneath the Sea: Paleolithic Images at Cosquer. New York: Abrams, 1996.

- Finegan, Jack. *Light from the Ancient Past.* 2 vols. 2nd ed. Princeton: Princeton University Press, 1974.
- Gimbutas, Marija. The Gods and Goddesses of Old Europe, 7000–3500 B.C.: Myths, Legends, and Cult Images. Berkeley: University of California Press, 1974.
- Graziosi, Paolo. *Paleolithic Art.* New York: McGraw-Hill, 1960.
- James, Edwin O. From Cave to Cathedral: Temples and Shrines of Prehistoric, Classical, and Early Christian Times. London: Thames & Hudson, 1965.
- Leroi-Gourhan, André. Treasures of Prehistoric Art. New York: Abrams, 1967.
- ——. The Dawn of European Art: An Introduction to Paleolithic Cave Painting. New York: Cambridge University Press, 1982.
- Powell, T. G. E. Prehistoric Art. New York: Praeger, 1966.
- Ruspoli, Mario. The Cave of Lascaux: The Final Photographs. New York: Abrams, 1987.
- Sieveking, Ann. *The Cave Artists*. London: Thames & Hudson, 1979.
- Sandars, N. K. Prehistoric Art in Europe. 2nd ed. Pelican History of Art. New Haven: Yale University Press, 1985.
- Twohig, Elizabeth Shee. The Megalithic Art of Western Europe. New York: Oxford University Press, 1981.
- Wainwright, Geoffrey. The Henge Monuments: Ceremony and Society in Prehistoric Britain. London: Thames & Hudson, 1989.

The Ancient Near East

- Akurgal, Ekrem. The Art of the Hittites. New York: Abrams, 1962.
- Bottéro, Jean. Mesopotamia: Writing, Reasoning, and the Gods. Trans. Zainab Bahrani and Marc Van De Mieroop. Chicago: University of Chicago Press, 1992.
- Collon, Dominique. First Impressions: Cylinder Seals in the Ancient Near East. London: British Museum Press, 1987.
- Crawford, Harriet. Sumer and the Sumerians. 2nd ed. New York: Cambridge University Press, 2004. Ferrier, R. W., ed. The Arts of Persia. New Haven:
- Yale University Press, 1989. Frankfort, Henri. *The Art and Architecture of the*
- Ancient Orient. 5th ed. Pelican History of Art. New Haven: Yale University Press, 1996.
- Ghirshman, Roman. The Arts of Ancient Iran from Its Origins to the Time of Alexander the Great. Trans. Stuart Gilbert and James Emmons. New York: Golden Press, 1962.
- Gilgamesh: Translated from the Sîn-leqi-unninnī Version. Trans. James Gardner and John Maier. New York: Knopf, 1984.
- Groenewegen-Frankfort, H. A. Arrest and Movement: An Essay on Space and Time in the Representational Art of the Ancient Near East. Cambridge, Mass.: Belknap Press, 1987.
- Groenewegen-Frankfort, H. A., and Bernard Ashmole. Art of the Ancient World: Painting, Pottery, Sculpture, Architecture from Egypt, Mesopotamia, Crete, Greece, and Rome. New York: Abrams, 1972.
- Harper, Prudence, Joan Aruz, and Françoise Tallon, eds. *The Royal City of Susa: Ancient Near Eastern Treasures in the Louvre.* New York: Metropolitan Museum of Art, 1992.
- Kramer, Samuel Noah. The Sumerians: Their History, Culture, and Character. Chicago: University of Chicago Press, 1963.
- ———. History Begins at Sumer: Thirty-nine Firsts in Man's Recorded History. 3rd rev. ed. Philadelphia: University of Pennsylvania Press, 1981.
- Leick, Gwendolyn. A Dictionary of Ancient Near Eastern Architecture. New York: Routledge, 1988.

- Lloyd, Seton. The Archaeology of Mesopotamia: From the Old Stone Age to the Persian Conquest (1978). Rev. ed. London: Thames & Hudson, 1984.
- Lloyd, Seton, and Hans W. Müller. Ancient Architecture: Mesopotamia, Egypt, Crete. New York: Electa/Rizzoli, 1986.
- Mellaart, James. The Earliest Civilizations of the Near East. New York: McGraw-Hill, 1965.
- ———. Çatal Hüyük: A Neolithic Town in Anatolia. New York: McGraw-Hill, 1967.
- Moortgat, Anton. *The Art of Ancient Mesopotamia.* Trans. Judith Filson. New York: Phaidon, 1969.
- Moscati, Sabatino, ed. *The Phoenicians* (1988). New York: Rizzoli, 1999.
- Muscarella, Oscar W. Bronze and Iron: Ancient Near Eastern Artifacts in the Metropolitan Museum of Art. New York: Metropolitan Museum of Art, 1988.
- Oates, Joan. Babylon. Rev. ed. London: Thames & Hudson, 1986.
- Oppenheim, A. Leo. Ancient Mesopotamia: Portrait of a Dead Civilization. Rev. ed. Chicago: University of Chicago Press, 1977.
- Parrot, André. *The Arts of Assyria*. Trans. Stuart Gilbert and James Emmons. New York: Golden Press, 1961.
- ——. Sumer: The Dawn of Art. Trans. Stuart Gilbert and James Emmons. New York: Golden Press, 1961.
- Porada, Edith, and Robert H. Dyson. The Art of Ancient Iran: Pre-Islamic Cultures. Rev. ed. New York: Greystone Press, 1967.
- Reade, Julian. Mesopotamia. 2nd ed. London: British Museum Press, 2000.
- Roux, Georges. Ancient Iraq. 3rd ed. New York: Penguin, 1992.
- Saggs, Henry W. F. The Greatness That Was Babylon: A Survey of the Ancient Civilization of the Tigris-Euphrates Valley. Rev. ed. London: Sidgwick & Jackson, 1988.
- Woolley, Leonard. The Art of the Middle East, Including Persia, Mesopotamia, and Palestine. New York: Crown, 1961.
- . The Development of Sumerian Art. Westport, Conn.: Greenwood Press, 1981.

Ancient Egypt

- Aldred, Cyril. Akhenaten and Nefertiti. New York: Viking Press, 1973.
- Egyptian Art in the Days of the Pharaohs, 3100–320 B.C. New York: Oxford University Press, 1980.
- Andrews, Carol. Ancient Egyptian Jewelry. New York: Abrams, 1991.
- Badawy, Alexander. A History of Egyptian Architecture. 3 vols. Berkeley: University of California Press, 1954–68.
- Brier, Bob. Egyptian Mummies: Unraveling the Secrets of an Ancient Art. New York: Morrow, 1994.
- Davis, Whitney. *The Canonical Tradition in Ancient Egyptian Art*. New York: Cambridge University Press, 1989.
- Doxiadis, Euphrosyne. The Mysterious Fayum Portraits: Faces from Ancient Egypt. New York: Abrams, 1995.
- Edwards, I. E. S. *The Pyramids of Egypt.* Rev. ed. New York: Penguin, 1991.
- El Mahdy, Christine, ed. The World of the Pharaohs: A Complete Guide to Ancient Egypt. London: Thames & Hudson, 1990.
- The Egyptian Book of the Dead: The Book of Going Forth by Day, Being the Papyrus of Ani (Royal Scribe of the Divine Offerings). Trans. Raymond O. Faulkner. San Francisco: Chronicle. 1994.
- Gardiner, Alan H. Egypt of the Pharaohs. Oxford: Oxford University Press, 1978.

- Hayes, William C. The Scepter of Egypt: A Background for the Study of the Egyptian Antiquities in the Metropolitan Museum of Art. 2 vols. Cambridge, Mass.: Harvard University Press, 1960.
- James, T. G. H. Egyptian Painting and Drawing in the British Museum. London: British Museum Press, 1985.
- James, T. G. H., and W. V. Davies. Egyptian Sculpture. Cambridge, Mass.: Harvard University Press, 1983.
- Lange, Kurt, and Max Hirmer. Egypt: Architecture, Sculpture, Painting in Three Thousand Years. 4th ed. London: Phaidon, 1968.
- Lurker, Manfred. The Gods and Symbols of Ancient Egypt: An Illustrated Dictionary. Rev. ed. Trans. Barbara Cummings. New York: Thames & Hudson, 1982.
- Martin, Geoffrey T. The Hidden Tombs of Memphis: New Discoveries from the Time of Tutankhamun and Ramesses the Great. London: Thames & Hudson, 1991.
- Panofsky, Erwin. Tomb Sculpture: Four Lectures on Its Changing Aspects from Ancient Egypt to Bernini. Foreword by Martin Warnke. New York: Abrams, 1992.
- Priese, Karl-Heinz. *The Gold of Meroë*. New York: Metropolitan Museum of Art, 1993.
- Redford, Donald B. Akhenaten: The Heretic King. Princeton: Princeton University Press, 1984.
- Reeves, Nicholas. The Complete Tutankhamun: The King, the Tomb, the Royal Treasure. New York: Thames & Hudson, 1990.
- Robins, Gay. Women in Ancient Egypt. Cambridge, Mass.: Harvard University Press, 1993.
 ——. Proportion and Style in Ancient Egyptian Art. Austin: University of Texas Press, 1994.
- Schäfer, Heinrich. Principles of Egyptian Art. Rev. ed. Trans. John Baines. Oxford: Griffith Institute, 1986.
- Smith, William Stevenson, and William Kelly Simpson. The Art and Architecture of Ancient Egypt. Rev. ed. New Haven: Yale University Press, 1988.
- Strouhal, Eugen. Life of the Ancient Egyptians. Trans. Deryck Viney. Norman: University of Oklahoma Press, 1992.
- Taylor, John H. *Egypt and Nubia*. London: British Museum Press, 1991.
- Walker, Susan, and Morris Bierbrier. Ancient Faces: Mummy Portraits from Roman Egypt. 2nd ed. London: British Museum Press, 2000.
- Wilkinson, Charles K. Egyptian Wall Paintings: The Metropolitan Museum of Art's Collection of Facsimiles. New York: Metropolitan Museum of Art. 1983.
- Wilkinson, Richard H. Reading Egyptian Art: A Hieroglyphic Guide to Ancient Egyptian Painting and Sculpture. New York: Thames & Hudson, 1992.
- Woldering, Irmgard. Gods, Men and Pharaohs: The Glory of Egyptian Art. Trans. Ann E. Keep. New York: Abrams, 1967.
- Wolff, Walther. The Origins of Western Art: Egypt, Mesopotamia, the Aegean. New York: Universe, 1989.

The Aegean

- Barber, R. L. N. The Cyclades in the Bronze Age. Iowa City: University of Iowa Press, 1987.
- Boardman, John. Pre-Classical: From Crete to Archaic Greece. Harmondsworth: Penguin, 1978.
- Chadwick, John. *The Mycenaean World*. Cambridge, Eng.: Cambridge University Press, 1976.
- Doumas, Christos. The Wall-Paintings of Thera. Trans. Alex Doumas. Athens: Thera Foundation, 1992.
- Getz-Preziosi, Pat. Sculptors of the Cyclades: Individual and Tradition in the Third Millennium B.C. Ann Arbor: University of Michigan Press, 1987.

- Graham, J. Walter. *The Palaces of Crete*. Rev. ed. Princeton: Princeton University Press, 1987.
- Hampe, Roland, and Erika Simon. The Birth of Greek Art from the Mycenaean to the Archaic Period. New York: Oxford University Press, 1981.
- Higgins, Reynold A. *Minoan and Mycenaean Art.* New rev. ed. London: Thames & Hudson, 1997.
- Hood, Sinclair. The Arts in Prehistoric Greece. Pelican History of Art. Harmondsworth: Penguin, 1978.
- ———. The Minoans: The Story of Bronze Age Crete. New York: Praeger, 1981.
- Hurwit, Jeffrey M. The Art and Culture of Early Greece, 1100–480 B.C. Ithaca, N.Y.: Cornell University Press, 1985.
- Immerwahr, Sara A. Aegean Painting in the Bronze Age. University Park: Pennsylvania State University Press, 1990.
- Jenkins, Ian. *The Parthenon Frieze*. Austin: University of Texas Press, 1994.
- McDonald, William. Progress into the Past: The Rediscovery of Mycenaean Civilization. 2nd ed. Bloomington: Indiana University Press, 1990.
- Marinatos, Spyridon N., and Max Hirmer. *Crete and Mycenae*. Trans. John Boardman. New York: Abrams, 1960.
- Morgan, Catherine. Athletes and Oracles: The Transformation of Olympia and Delphi in the Eighth Century B.C. Cambridge, Eng.: Cambridge University Press, 1990.
- Morgan, Lyvia. The Miniature Wall Paintings of Thera: A Study in Aegean Culture and Iconography. Cambridge, Eng.: Cambridge University Press, 1988.
- Mylonas, George E. Mycenae and the Mycenaean Age. Princeton: Princeton University Press, 1966.
- Nilsson, Martin P. The Minoan-Mycenaean Religion and Its Survival in Greek Religion. 2nd rev. ed. New York: Biblo and Tannen, 1971.
- Palmer, Leonard R. Mycenaeans and Minoans: Aegean Prehistory in the Light of the Linear B Tablets. 2nd rev. ed. Westport, Conn.: Greenwood Press, 1980.
- Renfrew, Colin. The Emergence of Civilisation: The Cyclades and the Aegean in the Third Millennium B.C. London: Methuen, 1972.
- Willetts, R. F. *The Civilization of Ancient Crete*. Berkeley: University of California Press, 1977.

The Art of Ancient Greece

- Arafat, K. W. Classical Zeus: A Study in Art and Literature. Oxford: Clarendon, 1990.
- Ashmole, Bernard. Architect and Sculptor in Classical Greece. New York: New York University Press, 1972.
- Beazley, John D. Attic Red-Figure Vase-Painters. 2nd ed. 3 vols. New York: Hacker, 1984.
- ——. The Development of the Attic Black-Figure. Rev. ed. Berkeley: University of California Press, 1986.
- Biers, William. The Archaeology of Greece: An Introduction. 2nd ed. Ithaca, N.Y.: Cornell University Press, 1996.
- Boardman, John. *Greek Art.* New rev. ed. New York: Thames & Hudson, 1985.
- ——. *The Parthenon and Its Sculptures.* Austin: University of Texas Press, 1985.
- ———. Athenian Red-Figure Vases, the Classical Period: A Handbook. New York: Thames & Hudson, 1989.
- . Athenian Black-Figure Vases: A Handbook. Corrected ed. New York: Thames & Hudson, 1991.
- ——. Athenian Red-Figure Vases, the Archaic Period: A Handbook. New York: Thames & Hudson, 1991.
- ——. Greek Sculpture, the Archaic Period: A Handbook. New York: Thames & Hudson, 1991.

——. Greek Sculpture, the Classical Period: A Handbook. New York: Thames & Hudson, 1991.Brilliant, Richard. Arts of the Ancient Greeks. New York: McGraw-Hill, 1973.

- Camp, John M. The Athenian Agora: Excavations in the Heart of Classical Athens. Updated ed. New York: Thames & Hudson, 1992.
- Carpenter, Rhys. The Esthetic Basis of the Greek Art of the Fifth and Fourth Centuries B.C. Bloomington: Indiana University Press, 1959.
- . Greek Sculpture: A Critical Review. Chicago: University of Chicago Press, 1960.
- . The Architects of the Parthenon. Baltimore: Penguin, 1970.
- Carpenter, Thomas H. Art and Myth in Ancient Greece: A Handbook. New York: Thames & Hudson, 1991.
- Chitham, Robert. The Classical Orders of Architecture. 2nd ed. New York: Rizzoli, 2005.
- Cook, Robert M. Greek Art: Its Development, Character, and Influence. New York: Farrar, Straus, Giroux, 1973.
- Coulton, J. J. Ancient Greek Architects at Work: Problems of Structure and Design. Ithaca, N.Y.: Cornell University Press, 1977.
- Dinsmoor, William B. The Architecture of Ancient Greece. 3rd ed. New York: Norton, 1975.
- Francis, Eric David. Image and Idea in Fifth-Century Greece: Art and Literature after the Persian Wars. London: Routledge, 1990.
- Havelock, Christine M. Hellenistic Art: The Art of the Classical World from the Death of Alexander the Great to the Battle of Actium. 2nd ed. New York: Norton, 1981.
- Kampen, Natalie Boymel. Sexuality in Ancient Art: Near East, Egypt, Greece, and Italy. Cambridge: Cambridge University Press, 1996.
- Koloski-Ostrow, Ann Olga, and Claire L. Lyons, eds. Naked Truths: Women, Sexuality, and Gender in Classical Art and Archaeology. London: Routledge, 1997.
- Kraay, Colin M., and Max Hirmer. Greek Coins. New York: Abrams, 1966.
- Lawrence, A. W. *Greek Architecture*. 5th ed. Pelican History of Art. New Haven: Yale University Press, 1996.
- Onians, John. Art and Thought in the Hellenistic Age: The Greek World View, 350–50 B.C. London: Thames & Hudson, 1979.
- Bearers of Meaning: The Classical Orders in Antiquity, the Middle Ages, and the Renaissance. Princeton: Princeton University Press, 1988.
- Papaioannou, Kostas. *The Art of Greece*. Trans. I. Mark Paris. New York: Abrams, 1989.
- Pedley, John Griffiths. *Greek Art and Archaeology*. 2nd ed. New York: Abrams, 1998.
- Pollitt, J. J. The Art of Greece, 1400–31 B.C.: Sources and Documents. Englewood Cliffs, N.J.: Prentice-Hall, 1965.
- ——. Art and Experience in Classical Greece. Cambridge, Eng.: Cambridge University Press, 1972.
- ——. The Ancient View of Greek Art: Criticism, History, and Terminology. New Haven: Yale University Press, 1974.
- ——. Art in the Hellenistic Age. Cambridge, Eng.: Cambridge University Press, 1986.
- Richter, Gisela M. A. Archaic Greek Art against Its Historical Background: A Survey. New York: Oxford University Press, 1949.
 - ____. Kouroi. 3rd ed. New York: Phaidon, 1970.
- ——. The Sculpture and Sculptors of the Greeks. 4th ed., rev. New Haven: Yale University Press, 1970.
- ——. A Handbook of Greek Art. 9th ed. New York: Da Capo, 1987.
- Ridgway, Brunilde Sismondo. *The Severe Style in Greek Sculpture*. Princeton: Princeton University Press, 1970.
- ———. Fifth-Century Styles in Greek Sculpture. Princeton: Princeton University Press, 1981.

- ed. Chicago: Ares, 1993. ——. Hellenistic Sculpture, II. Madison: Univer-
- sity of Wisconsin Press, 2000. Robertson, Martin. A History of Greek Art. 2 vols.
- London: Cambridge University Press, 1975.
- Roes, Anna. Greek Geometric Art, Its Symbolism and Its Origin. London: Oxford University Press, 1933.
- Schefold, Karl. Myth and Legend in Early Greek Art. Trans. Audrey Hicks. New York: Abrams, 1966.
- ——. Gods and Heroes in Late Archaic Greek Art. Trans. Alan Griffiths. New York: Cambridge University Press, 1992.
- Schmidt, Evamaria. *The Great Altar of Pergamon.* Trans. Lena Jaeck. Boston: Boston Book and Art Shop, 1965.
- Scully, Vincent. The Earth, the Temple, and the Gods: Greek Sacred Architecture. Rev. ed. New Haven: Yale University Press, 1979.
- Smith, R. R. R. Hellenistic Sculpture: A Handbook. New York: Thames & Hudson, 1991.
- Stewart, Andrew. Greek Sculpture: An Exploration. New Haven: Yale University Press, 1990.
 ——. Art, Desire, and the Body in Ancient
- Greece. Cambridge, Eng.: Cambridge University Press, 1997. Stobart, J. C. The Glory That Was Greece. 4th ed.
- New York: Praeger, 1984. Vermeule, Emily. *Greece in the Bronze Age*. Chi-
- cago: University of Chicago Press, 1972. ———. Aspects of Death in Early Greek Art and
- Poetry. Berkeley: University of California Press, 1979. Webster, T. B. L. The Art of Greece: The Age of
- Hellenism. New York: Crown, 1966.
- Whitley, James. Style and Society in Dark Age Greece: The Changing Face of a Pre-literate Society, 1100–700 B.C. Cambridge, Eng.: Cambridge University Press, 1991.

The Art of the Etruscans

- Bloch, Raymond. Etruscan Art. Greenwich, Conn.: New York Graphic Society, 1965.
- Boëthius, Axel. Etruscan and Early Roman Architecture. 2nd integrated ed. Rev. by Roger Ling and Tom Rasmussen. New York: Penguin, 1978.
- Bonfante, Larissa, ed. Etruscan Life and Afterlife: A Handbook of Etruscan Studies. Detroit: Wayne State University Press, 1986.
- *Etruscan: Reading the Past.* Berkeley: University of California Press/British Museum, 1990.
- ——. Etruscan Mirrors. New York: Metropolitan Museum of Art, 1997.
- Brendel, Otto J. *Etruscan Art*. 2nd ed. New Haven: Yale University Press, 1995.
- Buranelli, Francesco. The Etruscans: Legacy of a Lost Civilization from the Vatican Museums. Memphis, Tenn.: Lithograph, 1992.
- de Grummond, Nancy Thomson, ed. A Guide to Etruscan Mirrors. Tallahassee Archaeological News, 1982.
- Harris, William Vernon. Rome in Etruria and Umbria. Oxford: Clarendon, 1971.
- Macnamara, Ellen. Everyday Life of the Etruscans. Cambridge, Mass.: Harvard University Press, 1991.
- Mansuelli, Guido Achille. *The Art of Etruria and Early Rome*. Trans. C. E. Ellis. New York: Crown, 1964.
- Pallottino, Massimo. Etruscan Painting. Trans. M. E. Stanley and Stuart Gilbert. Geneva: Skira, 1952.
- Richardson, Emeline H. The Etruscans, Their Art and Civilization. Chicago: University of Chicago Press, 1964.

- Spivey, Nigel, and Simon Stoddart. *Etruscan Italy:* An Archaeological History. London: Batsford, 1992.
- Sprenger, Maja, Gilda Bartoloni, and Max Hirmer. The Etruscans: Their History, Art, and Architecture. Trans. Robert Erich Wolf. New York: Abrams, 1983.
- Steingräber, Stephan, ed. Etruscan Painting: Catalogue Raisonné of Etruscan Wall Paintings. Trans. Mary Blair and Brian Phillips. New York: Johnson Reprint, 1986.
- Ward-Perkins, J. B. Roman Architecture (1974). Milan/London: Electa/Phaidon, 2003.

Ancient Rome

- Andreae, Bernard. *The Art of Rome*. Trans. Robert Erich Wolf. New York: Abrams, 1977.
- Bianchi Bandinelli, Ranuccio. Rome, the Center of Power, 500 B.C. to A.D. 200. Trans. Peter Green. New York: Braziller, 1970.
- ——. Rome, the Late Empire: Roman Art, A.D. 200–400. Trans. Peter Green. New York: Braziller, 1971.
- Brendel, Otto J. Prolegomena to the Study of Roman Art. New Haven: Yale University Press, 1979.
- Brilliant, Richard. Roman Art from the Republic to Constantine. London: Phaidon, 1974.
- ———. Pompeii A.D. 79: The Treasure of Rediscovery. New York: Potter, 1979.
- D'Ambra, Eve. Roman Art. New York: Cambridge University Press, 1998.
- Feder, Theodore H. Great Treasures of Pompeii and Herculaneum. New York: Abbeville, 1978. Goldscheider, Ludwig. Roman Portraits. New York:
- Oxford University Press, 1940. Guillaud, Jacqueline, and Maurice Guillaud. Fres-
- *coes in the Time of Pompeii*. New York: Potter, 1990.
- Hanfmann, George M. A. Roman Art: A Modern Survey of the Art of Imperial Rome (1964). New York: Norton, 1975.
- Heintze, Helga von. Roman Art (1972). New York: Universe, 1990.
- Henig, Martin, ed. Handbook of Roman Art: A Comprehensive Survey of All the Arts of the Roman World. Ithaca, N.Y.: Cornell University Press, 1983.
- Jenkyns, Richard., ed. *The Legacy of Rome: A New Appraisal*. New York: Oxford University Press, 1992.
- Krautheimer, Richard. Rome: Profile of a City, 312–1308 (1980). Princeton: Princeton University Press, 2000.
- Ling, Roger. Roman Painting. New York: Cambridge University Press, 1991.
- MacDonald, William L. The Architecture of the Roman Empire: An Introductory Study (1965). Rev. ed. New Haven: Yale University Press, 1982.
- ——. The Pantheon: Design, Meaning, and Progeny (1976). Cambridge, Mass.: Harvard University Press, 2002.
- Pollitt, J. J. The Art of Rome c. 753 B.C.-A.D. 337: Sources and Documents. New York: Cambridge University Press, 1983.
- Ramage, Nancy H., and Andrew Ramage. The Cambridge Illustrated History of Roman Art. Cambridge: Cambridge University Press, 1991. ——. Roman Art: Romulus to Constantine. 4th ed.
- Upper Saddle River, N.J.: Prentice-Hall, 2005. Robertson, Donald S. Greek and Roman Architec-
- ture. 2nd ed. Cambridge, Eng.: Cambridge University Press, 1969.
- Sear, Frank. Roman Architecture. Rev. ed. London: Batsford, 1989.
- Strong, Donald E. Roman Imperial Sculpture: An Introduction to the Commemorative and Decorative Sculpture of the Roman Empire down to the Death of Constantine. London: Tiranti, 1961.

------. Roman Art. 2nd ed. Pelican History of Art. New Haven: Yale University Press, 1995.

- Vermeule, Cornelius. European Art and the Classical Past. Cambridge, Mass.: Harvard University Press, 1964.
- Vitruvius. The Ten Books on Architecture. Trans. Morris Hicky Morgan. Reprint of 1914 edition. New York: Dover, 1960.
- Ward-Perkins, John B. Roman Architecture (1976). New York: Electa/Rizzoli, 1988.
- ——. Roman Imperial Architecture (1981). New Haven: Yale University Press, 1994.
- Wells, Colin M. *The Roman Empire*. 2nd ed. Cambridge, Mass.: Harvard University Press, 1995. Wheeler, Mortimer. *Roman Art and Architecture*
- (1964). New York: Thames & Hudson, 1985.
- Wilkinson, L. P. *The Roman Experience*. New York: Knopf, 1974.
- Zanker, Paul. The Power of Images in the Age of Augustus. Trans. Alan Shapiro. Ann Arbor: University of Michigan Press, 1988.

Early Christian and Byzantine Art

- Age of Spirituality: Late Antique and Early Christian Art, Third to Seventh Century. New York: Metropolitan Museum of Art, 1979.
- Beckwith, John. The Art of Constantinople: An Introduction to Byzantine Art (330–1453). 2nd ed. New York: Phaidon, 1968.
- ———. Early Christian and Byzantine Art. 2nd ed. New York: Penguin, 1979.
- Boyd, Susan A. Byzantine Art. Chicago: University of Chicago Press, 1979
- Christe, Yves, et al. Art of the Christian World, A.D. 200–1500: A Handbook of Styles and Forms. New York: Rizzoli, 1982.
- Demus, Otto. Byzantine Art and the West. New York: New York University Press, 1970.
- ——. Byzantine Mosaic Decoration: Aspects of Monumental Art in Byzantium. New Rochelle, N.Y.: Caratzas, 1976.
- Ferguson, George W. Signs and Symbols in Christian Art. New York: Oxford University Press, 1967.
- Gough, Michael. *The Origins of Christian Art.* London: Thames & Hudson, 1973.
- Grabar, André. Byzantium: Byzantine Art in the Middle Ages. Trans. B. Forster. London: Methuen, 1966.
- ——. The Beginnings of Christian Art, 200–395. Trans. Stuart Gilbert and James Emmons. London: Thames & Hudson, 1967.
- ——. The Golden Age of Justinian, from the Death of Theodosius to the Rise of Islam. Trans. Stuart Gilbert and James Emmons. New York: Odyssey, 1967.
- Kitzinger, Ernst. Byzantine Art in the Making: Main Lines of Stylistic Development in Mediterranean Art, 3rd–7th Century. Cambridge, Mass.: Harvard University Press, 1980.
- Krautheimer, Richard. Studies in Early Christian, Medieval, and Renaissance Art. New York: New York University Press, 1969.
- *Early Christian and Byzantine Architecture.* 4th ed. Pelican History of Art. New York: Penguin, 1986.
- Lane Fox, Robin. *Pagans and Christians* (1987). San Francisco: Harper San Francisco, 1995.
- Lowrie, Walter. Art in the Early Church (1947). New York: Norton, 1969.
- Mainstone, Rowland J. Hagia Sophia: Architecture, Structure, and Liturgy of Justinian's Great Church. London: Thames & Hudson, 1988.
- Mango, Cyril. Byzantine Architecture. New York: Rizzoli, 1985.
- ——. The Art of the Byzantine Empire, 312–1453: Sources and Documents (1972). Toronto: University of Toronto Press, 1986.

- Mancinelli, Fabrizio. *Catacombs and Basilicas: The Early Christians in Rome*. Trans. Carol Wasserman. Florence: Scala, 1981.
- Mathew, Gervase. Byzantine Aesthetics. London: Murray, 1963.
- Mathews, Thomas. Byzantium: From Antiquity to the Renaissance. New York: Abrams, 1998.
- Morey, Charles Rufus. Early Christian Art: An Outline of the Evolution of Style and Iconography in Sculpture and Painting from Antiquity to the Eighth Century. 2nd ed. Princeton: Princeton University Press, 1953.
- Oakeshott, Walter. The Mosaics of Rome: From the Third to the Fourteenth Centuries. London: Thames & Hudson, 1967.
- Rice, David T. *The Appreciation of Byzantine Art.* London: Oxford University Press, 1972.
- Schapiro, Meyer. Late Antique, Early Christian, and Mediaeval Art. New York: Braziller, 1979.
- Stevenson, James. The Catacombs: Rediscovered Monuments of Early Christianity. London: Thames & Hudson, 1978.
- Volbach, Wolfgang, and Max Hirmer. *Early Christian Art.* Trans. Christopher Ligota. New York: Abrams, 1962.
- von Simson, Otto G. Sacred Fortress: Byzantine Art and Statecraft in Ravenna. Princeton: Princeton University Press, 1987.
- Weitzmann, Kurt. Studies in Classical and Byzantine Manuscript Illustration. Chicago: University of Chicago Press, 1971.
- . Art in the Medieval West and Its Contacts with Byzantium. London: Variorum, 1982.
- , et al. The Icon. New York: Knopf, 1982.
- The Early Middle Ages
- Aldhouse-Green, Miranda. *Celtic Art.* New York: Sterling, 1997.
- Alexander, Jonathan J. G. Medieval Illuminators and Their Methods of Work. New Haven: Yale University Press, 1992.
- Atil, Esin. Art of the Arab World. Washington, D.C.: Smithsonian Institution, 1975.
- Backes, Magnus, and Regine Dölling. Art of the Dark Ages. Trans. F. Garvie. New York: Abrams, 1971.
- Backhouse, Janet, ed. The Lindisfarne Gospels. Oxford: Phaidon, 1981.
- Backhouse, Janet, D. H. Turner, and Leslie Webster. The Golden Age of Anglo-Saxon Art, 966– 1066. Bloomington: Indiana University Press, 1984.
- Barasch, Moshe. Gestures of Despair in Medieval and Early Renaissance Art. New York: New York University Press, 1976.
- Basing, Patricia. Trades and Crafts in Medieval Manuscripts. London: The British Library, 1990.
- Beckwith, John. Early Medieval Art: Carolingian, Ottonian, Romanesque (1969). New York: Oxford University Press, 1985.
- Blair, Sheila S., and Jonathan M. Bloom. *The Art and Architecture of Islam, 1250–1800.* New Haven: Yale University Press, 1994.
- Braunfels, Wolfgang. Monasteries of Western Europe: The Architecture of the Orders. Trans. Alastair Laing. London: Thames & Hudson, 1972.
- Brown, Peter, ed. The Book of Kells. New York: Knopf, 1980.
- Calkins, Robert G. Illuminated Books of the Middle Ages. Ithaca, N.Y.: Cornell University Press, 1983.
- Conant, Kenneth John. Carolingian and Romanesque Architecture, 800 to 1200. 4th ed. Pelican History of Art. New Haven: Yale University Press, 1993.
- Davis-Weyer, Caecilia, ed. Early Medieval Art, 300–1150: Sources and Documents (1971). Toronto: University of Toronto Press, 1986.
- Diebold, William J. Word and Image: An Introduction to Early Medieval Art. Boulder, Col.: Westview, 2000.

- Dodwell, C. R. *The Pictorial Arts of the West,* 800–1200. Pelican History of Art. New Haven: Yale University Press, 1993.
- Ettinghausen, Richard. Arab Painting. Geneva: Skira, 1977.
- Ettinghausen, Richard, and Oleg Grabar. *The Art and Architecture of Islam, 650–1250*. New York: Penguin, 1987.
- Fernie, Eric. The Architecture of the Anglo-Saxons. London: Batsford, 1983.
- Finlay, Ian. Celtic Art: An Introduction. London: Faber, 1973.
- Frishman, Martin, and Hasan-Uddin Khan, eds. The Mosque: History, Architectural Development and Regional Diversity. London: Thames & Hudson, 2002.
- Grabar, André, and Carl Nordenfalk. Early Medieval Painting from the Fourth to the Eleventh Century: Mosaics and Mural Paintings. New York: Skira, 1957.
- Grabar, Oleg. *The Formation of Islamic Art.* Rev. and enl. ed. New York: Yale University Press, 1983.
- Grant, Michael. The Dawn of the Middle Ages, A.D. 476–814. New York: McGraw-Hill, 1981.
- Grube, Ernst J. Architecture of the Islamic World: Its History and Social Meaning (1978). Ed. George Michell. New York: Thames & Hudson, 1984.
- Henderson, George. From Durrow to Kells: The Insular Gospel-Books, 650–800. London: Thames & Hudson, 1987.
- ———. Early Medieval (1972). Toronto: University of Toronto Press, 1993.
- Henry, Françoise. Irish Art in the Early Christian Period, to 800 A.D. Ithaca, N.Y.: Cornell University Press, 1965.
- . Irish Art during the Viking Invasions, 800–1020 A.D. Ithaca, N.Y.: Cornell University Press, 1967.
- Hinks, Roger P. Carolingian Art: A Study of Early Medieval Painting and Sculpture in Western Europe (1935). Ann Arbor: University of Michigan Press, 1966.
- Horn, Walter W., and Ernest Born. Plan of Saint Gall: A Study of the Architecture and Economy of and Life in a Paradigmatic Carolingian Monastery. 3 vols. Berkeley: University of California Press, 1979.
- Hubert, Jean, Jean Porcher, and W. F. Volbach. *Europe of the Invasions*. Trans. Stuart Gilbert and James Emmons. New York: Braziller, 1969.
 ——. The Carolingian Renaissance. New York: Braziller, 1970.
- Irwin, Robert. Islamic Art in Context: Art, Architecture, and the Literary World. New York: Abrams, 1997.
- Kendrick, Thomas D. Anglo-Saxon Art to A.D. 900 (1938). New York: Barnes & Noble, 1972.
- Kidson, Peter. The Medieval World. New York: McGraw-Hill, 1967.
- Kitzinger, Ernst. Early Medieval Art in the British Museum. Rev. ed. Bloomington: Indiana University Press, 1983.
- Laing, Lloyd, and Jennifer Laing. Art of the Celts. New York: Thames & Hudson, 1992.
- Lasko, Peter. Ars Sacra, 800–1200. 2nd ed. Pelican History of Art. New Haven: Yale University Press, 1994.
- Martindale, Andrew. The Rise of the Artist in the Middle Ages and Early Renaissance. New York: McGraw-Hill, 1972.
- Megaw, Ruth, and Vincent Megaw. Celtic Art: From Its Beginnings to the Book of Kells. Rev. and exp. ed. New York: Thames & Hudson, 2001.
- Mütherich, Florentine, and Joachim E. Gaehde. Carolingian Painting. New York: Braziller, 1976.
- Nordenfalk, Carl. Celtic and Anglo-Saxon Painting: Book Illumination in the British Isles, 600– 800. New York: Braziller, 1977.
 - ——. Early Medieval Book Illumination. New York: Rizzoli, 1988.

- Pächt, Otto. The Rise of Pictorial Narrative in Twelfth-Century England. Oxford: Clarendon, 1962.
- ———. Book Illumination in the Middle Ages: An Introduction. London: Miller, 1986.
- Panofsky, Erwin. Tomb Sculpture: Four Lectures on Its Changing Aspects from Ancient Egypt to Bernini (1964). New York: Abrams, 1992.
- Papadopoulo, Alexandre. Islam and Muslim Art. Trans. Robert Erich Wolf. New York: Abrams, 1979.
- Pevsner, Nikolaus. An Outline of European Architecture. 7th ed. Baltimore: Penguin, 1970.
- Richardson, Hilary, and John Scarry. An Introduction to Irish High Crosses. Dublin: Mercier, 1990.
- Rickert, Margaret. Painting in Britain: The Middle Ages. 2nd ed. Pelican History of Art. Harmondsworth: Penguin, 1965.
- Saalman, Howard. Medieval Architecture: European Architecture, 600–1200. New York: Braziller, 1962.
- Schimmel, Annemarie. Calligraphy and Islamic Culture. New York: New York University Press, 1984.
- Snyder, James. Medieval Art: Painting, Sculpture, Architecture, 4th–14th Century. New York: Harry N. Abrams, 1989.
- Stokstad, Marilyn. *Medieval Art.* 2nd ed. Boulder, Col.: New York: Westview, 2004.
- Tasker, Edward G. *Encyclopedia of Medieval Church Art*. Ed. John Beaumont. London: Batsford, 1993.
- Verzone, Paolo. The Art of Europe: The Dark Ages from Theodoric to Charlemagne. New York: Crown, 1968.
- Ward, Rachel. Islamic Metalwork. New York: Thames & Hudson, 1993.
- Wilson, David M. Anglo-Saxon Art: From the Seventh Century to the Norman Conquest. London: Thames & Hudson, 1984.
- Wilson, David M., and Ole Klindt-Jensen. Viking Art. 2nd ed. Minneapolis: University of Minnesota Press, 1980.
- Wormald, Francis. Collected Writings. Vol. I: Studies in Medieval Art from the Sixth to the Twelfth Centuries. New York: Oxford University Press, 1984–1988.
- Zarnecki, George. Art of the Medieval World: Architecture, Sculpture, Painting, the Sacred Arts. New York: Abrams, 1975.

Romanesque Art

- Busch, Harald, and Bernd Lohse, eds. *Romanesque Sculpture*. Trans. Peter Gorge. London: Batsford, 1962.
- Cahn, Walter. Romanesque Bible Illumination. Ithaca, N.Y.: Cornell University Press, 1982.
- Clapham, Alfred W. Romanesque Architecture in Western Europe. Oxford: Clarendon, 1959.
- Demus, Otto. Romanesque Mural Painting. New York: Abrams, 1970.
- Evans, Joan. Art in Medieval France, 987–1498 (1963). Oxford: Clarendon, 1969.
- Focillon, Henri. *The Art of the West in the Middle Ages.* Ed. Jean Bony. Trans. Donald King. 2 vols. Ithaca, N.Y.: Cornell University Press, 1980.
- Forsyth, Ilene H. The Throne of Wisdom: Wood Sculptures of the Madonna in Romanesque France. Princeton: Princeton University Press, 1972.
- Gibbs-Smith, Charles H. The Bayeux Tapestry. London: Phaidon, 1973.
- Grabar, André, and Carl Nordenfalk. *Romanesque Painting from the Eleventh to the Thirteenth Century: Mural Painting.* Trans. Stuart Gilbert. New York: Skira, 1958.
- Grape, Wolfgang. The Bayeux Tapestry: Monument to a Norman Triumph. New York: Prestel, 1994.

- Hearn, Millard F. Romanesque Sculpture: The Revival of Monumental Stone Sculpture in the Eleventh and Twelfth Centuries. Ithaca, N.Y.: Cornell University Press, 1981.
- Holt, Elizabeth G. A Documentary History of Art. 3 vols. Princeton: Princeton University Press, 1981–1986.
- Jacobs, Michael. Northern Spain: The Road to Santiago de Compostela. San Francisco: Chronicle, 1991.
- Kennedy, Hugh. Crusader Castles. Cambridge: Cambridge University Press, 1994.
- Kubach, Hans E. Romanesque Architecture. New York: Electa/Rizzoli, 1988.
- Künstler, Gustav. Romanesque Art in Europe. Greenwich, Conn.: New York Graphic Society, 1968.
- Little, Bryan D. G. Architecture in Norman Britain. London: Batsford, 1985.
- Måle, Émile. Religious Art in France, the Twelfth Century: A Study of the Origins of Medieval Iconography. Bollingen Series, 90:1. Princeton: Princeton University Press, 1978.
- ——. Art and Artists of the Middle Ages. Redding Ridge, Conn.: Black Swan, 1986.
- Nichols, Stephen G., Jr. Romanesque Signs: Early Medieval Narrative and Iconography. New Haven: Yale University Press, 1983.
- Petzold, Andreas. *Romanesque Art.* New York: Abrams, 1995.
- Platt, Colin. The Architecture of Medieval Britain: A Social History. New Haven: Yale University Press, 1990.
- Radding, Charles M., and William W. Clark. Medieval Architecture, Medieval Learning: Builders and Masters in the Age of Romanesque and Gothic. New Haven: Yale University Press, 1992.
- Saxl, Fritz. English Sculptures of the 12th Century. Ed. Hanns Swarzenski. London: Faber & Faber, 1954.
- Schapiro, Meyer. Romanesque Art: Selected Papers. New York: Braziller, 1977.
- ———. The Romanesque Sculpture of Moissac. New York: Braziller, 1985.
- Stoddard, Whitney S. Art and Architecture in Medieval France: Medieval Architecture, Sculpture, Stained Glass, Manuscripts, the Art of the Church Treasuries. New York: Harper & Row, 1972.
- Swarzenski, Hanns. Monuments of Romanesque Art: The Art of Church Treasures in North-Western Europe. 2nd ed. Chicago: University of Chicago Press, 1974.
- Tate, Robert B., and Marcus Tate. *The Pilgrim Route to Santiago*. Oxford: Phaidon, 1987.
- The Year 1200. 2 vols. New York: Metropolitan Museum of Art, 1970.
- Thompson, Daniel V. The Materials and Techniques of Medieval Painting. New York: Dover, 1956.
- Zarnecki, George. Romanesque Art. New York: Universe, 1971.
- Zarnecki, George, Janet Holt, and Tristram Holland. English Romanesque Art, 1066–1200. London: Weidenfeld & Nicolson, 1984.

Gothic Art

- Alexander, Jonathan J. G., and Paul Binski, eds. Age of Chivalry: Art in Plantagenet England, 1200–1400. London: Royal Academy of Arts, 1987.
- Andrews, Francis B. The Mediaeval Builder and His Methods. Mineola, N.Y.: Dover, 1999.Armi, C. Edson. The "Headmaster" of Chartres
- Armi, C. Edson. The "Headmaster" of Chartres and the Origins of "Gothic" Sculpture. University Park: Pennsylvania State University Press, 1994.
- Aubert, Marcel. Gothic Cathedrals of France and Their Treasures. Trans. Lionel Kochan and Miriam Kochan. London: Kaye, 1959.

——. The Art of the High Gothic Era. Trans. Peter Gorge. New York: Crown, 1965.

- Blum, Pamela Z. Early Gothic Saint-Denis: Restorations and Survivals. Berkeley: University of California Press, 1992.
- Bony, Jean. The English Decorated Style: Gothic Architecture Transformed, 1250–1350. Ithaca, N.Y.: Cornell University Press, 1979.

 French Gothic Architecture of the Twelfth and Thirteenth Centuries. Berkeley: University of California Press, 1983.
 Bowie, Theodore, ed. The Sketchbook of Villard de

- Bowie, Theodore, ed. *The Sketchbook of Villard de Honnecourt* (1959). Westport, Conn.: Greenwood, 1982.
- Brieger, Peter H. English Art, 1216–1307. Oxford: Clarendon, 1957.
- Camille, Michael. The Gothic Idol: Ideology and Image-Making in Medieval Art. New York: Cambridge University Press, 1989.

——. Gothic Art: Glorious Visions. New York: Abrams, 1996.

- Erlande-Brandenburg, Alain. *Gothic Art*. Trans. I. Mark Paris. New York: Abrams, 1989.
- Favier, Jean. The World of Chartres. Trans. F. Garvie. New York: Abrams, 1990.
- Frankl, Paul. *Gothic Architecture*. Rev. ed. Paul Crossley. Pelican History of Art. New Haven: Yale University Press, 2000.
- Frisch, Teresa G. Gothic Art, 1140–c.1450: Sources and Documents (1971). Toronto: University of Toronto, 1987.
- Gerson, Paula Lieber, ed. Abbot Suger and Saint-Denis: A Symposium. New York: Metropolitan Museum of Art, 1986.
- Grodecki, Louis. *Gothic Architecture* (1976). Trans. I. Mark Paris. New York: Electa/Rizzoli, 1985.
- Grodecki, Louis, and Catherine Brisac. *Gothic Stained Glass, 1200–1300.* Ithaca, N.Y.: Cornell University Press, 1985.
- Henderson, George D. S. Gothic. Baltimore: Penguin, 1967.
- ------. Chartres. Baltimore: Penguin, 1968.
- Jantzen, Hans. High Gothic: The Classic Cathedrals of Chartres, Reims, Amiens (1962). Trans. James Palmes. Princeton: Princeton University Press, 1984.
- Katzenellenbogen, Adolf. The Sculptural Programs of Chartres Cathedral: Christ, Mary, Ecclesia (1959). New York: Norton, 1964.
- Lord, Carla. Royal French Patronage of Art in the Fourteenth Century: An Annotated Bibliography. Boston: Hall, 1985.

Måle, Émile. The Gothic Image: Religious Art in France of the Thirteenth Century. New York: Harper & Row, 1972.

——. Religious Art in France, the Thirteenth Century: A Study of Medieval Iconography and Its Sources. Princeton: Princeton University Press, 1984.

- ——. Religious Art in France, the Late Middle Ages: A Study of Medieval Iconography and Its Sources. Princeton: Princeton University Press, 1986.
- Martindale, Andrew. *Gothic Art* (1967). New York: Thames & Hudson, 1985.
- Meulen, Jan van der. Chartres: Sources and Literary Interpretation: A Critical Bibliography. Boston: Hall, 1989.
- Panofsky, Erwin, and Gerda Panofsky-Soergel. eds. Abbot Suger on the Abbey Church of St.-Denis and Its Art Treasures. 2nd ed. Princeton: Princeton University Press, 1979.
- Panofsky, Erwin. Gothic Architecture and Scholasticism. New York: World, 1957.
- Pevsner, Nikolaus, and Priscilla Metcalf. The Cathedrals of England. 2 vols. Harmondsworth: Viking, 1985.
- Pope-Hennessy, John. Italian Gothic Sculpture. 3rd ed. Oxford: Phaidon, 1986.

- Sandler, Lucy Freeman. Gothic Manuscripts, 1285–1385. A Survey of Manuscripts Illuminated in the British Isles 5. 2 vols. London: Miller, 1986.
- Sauerländer, Willibald. *Gothic Sculpture in France,* 1140–1270. Trans. Janet Sondheimer. New York: Abrams, 1972.
- Swaan, Wim. The Gothic Cathedral (1969). London: Ferndale, 1981.
- Voelkle, William. The Stavelot Triptych: Mosan Art and the Legend of the True Cross. New York: Pierpont Morgan Library, 1980.
- von Simson, Otto G. The Gothic Cathedral: Origins of Gothic Architecture and the Medieval Concept of Order. 3rd ed. Princeton: Princeton University Press, 1988.
- Watson, Percy. Building the Medieval Cathedrals. Cambridge: Cambridge University Press, 1976.
- Wieck, Roger S. Time Sanctified: The Book of Hours in Medieval Art and Life. 2nd ed. New York: Braziller, 2001.
- Williamson, Paul. *Gothic Sculpture*, 1140–1300. New Haven: Yale University Press, 1995.
- Wilson, Christopher. The Gothic Cathedral: The Architecture of the Great Church, 1130–1530. Rev. ed. New York: Thames & Hudson, 2000.

Precursors of the Renaissance

- Barasch, Moshe. Giotto and the Language of Gesture. Cambridge: Cambridge University Press, 1987.
- Barolsky, Paul. Giotto's Father and the Family of Vasari's Lives. University Park, Pa.: Pennsylvania State University Press, 1992.
- Baxandall, Michael. Giotto and the Orators: Humanist Observers of Painting in Italy and the Discovery of Pictorial Composition, 1350–1450. Oxford: Oxford University Press, 1971.
- Bomford, David. Italian Painting before 1400. London: National Gallery Publications, 1989.
- Borsook, Eve. The Mural Painters of Tuscany: From Cimabue to Andrea del Sarto. 2nd ed. New York: Oxford University Press, 1980.
- Borsook, Eve, and Fiorella Superbi Gioffredi. Italian Altarpieces 1250–1550: Function and Design. Oxford: Clarendon, 1994.
- Burckhardt, Jacob. The Civilization of the Renaissance in Italy. New York: Modern Library, 2002.
- Campbell, Lorne. Renaissance Portraits: European Portrait-Painting in the 14th, 15th, and 16th Centuries. New Haven: Yale University Press, 1990.
- Cennini, Cennino. *The Craftsman's Handbook (II Libro dell'Arte)* (1954). Trans. Daniel V. Thompson, Jr. New York: Dover, 1954.
- Chiellini, Monica. *Cimabue*. Trans. Lisa Pelletti. Florence: Scala, 1988.
- Cole, Bruce. Giotto and Florentine Painting, 1280– 1375. New York: Harper & Row, 1976.
- ——. Sienese Painting: From Its Origins to the 15th Century. New York: Harper & Row, 1980.
- ——. The Renaissance Artist at Work: From Pisano to Titian. New York: Harper & Row, 1983.
- Davis, Howard McP. Gravity in the Paintings of Giotto (1971). 1971. Reprinted in Schneider, 1974.
- Maginnis, Hayden B. J. Painting in the Age of Giotto: A Historical Reevaluation. University Park, Pa.: Pennsylvania State University Press, 1997.
- Martindale, Andrew. The Rise of the Artist in the Middle Ages and Early Renaissance. New York: McGraw-Hill, 1972.
- ——. Simone Martini. New York: New York University Press, 1988.
- Meiss, Millard. French Painting in the Time of Jean de Berry: The Late Fourteenth Century and the Patronage of the Duke. 2nd ed. New York: Braziller, 1969.
- ——. Painting in Florence and Siena after the Black Death: The Arts, Religion, and Society in the Mid-Fourteenth Century (1951). Princeton: Princeton University Press, 1978.

- Meiss, Millard, and Elizabeth H. Beatson. The "Belles Heures" of Jean, Duke of Berry: The Cloisters, the Metropolitan Museum of Art. New York: Braziller, 1974.
- Moskowitz, Anita Fiderer. *The Sculpture of Andrea and Nino Pisano*. Cambridge: Cambridge University Press, 1986.
- Rosenberg, Charles M., ed. Art and Politics in Late Medieval and Early Renaissance Italy, 1250– 1500. Notre Dame, Ind.: University of Notre Dame Press, 1990.
- Schneider, Laurie M., ed. *Giotto in Perspective*. Englewood Cliffs, N.J.: Prentice-Hall, 1974.
- Smart, Alastair. The Dawn of Italian Painting, 1250– 1400. Ithaca, N.Y.: Cornell University Press, 1978.
- Stubblebine, James H., ed. Giotto: The Arena Chapel Frescoes. New York: Norton, 1969. Ducento Painting: An Annotated Bibli-
- ography. Boston: Hall, 1983. ——, Assisi and the Rise of Vernacular Art. New
- York: Harper & Row, 1985. Vasari, Giorgio. The Lives of the Most Eminent
- Painters, Sculptors and Architects. Trans. Gaston du C. de Vere. New York: Abrams, 1979.
- White, John. Duccio: Tuscan Art and the Medieval Workshop. New York: Thames & Hudson, 1979.
 ——. The Birth and Rebirth of Pictorial Space. 3rd ed. Cambridge, Mass.: Belknap, 1987.

The Early Renaissance

- Adams, Laurie Schneider. Key Monuments of the Italian Renaissance. Boulder, Col.: Westview, 2000.
- Alazard, Jean. The Florentine Portrait. New York: Schocken, 1968.
- Alberti, Leon Battista. Ten Books on Architecture (1955). Ed. J. Rykwert. Trans. J. Leoni. New York: Transatlantic Arts, 1966.
- ——. On Painting (1966). Trans J. R. Spencer. Rev. ed. Westport, Conn.: Greenwood, 1976.
- Ames-Lewis, Francis. Drawing in Early Renaissance Italy. Rev. ed. New Haven: Yale University Press, 2000.
- Antal, Frederick. Florentine Painting and Its Social Background: The Bourgeois Republic before Cosimo de' Medici's Advent to Power, Fourteenth and Early Fifteenth Centuries (1948). Cambridge, Mass.: Belknap, 1986.
- Barolsky, Paul. Infinite Jest: Wit and Humor in Italian Renaissance Art. Columbia: University of Missouri Press, 1978.

——. Walter Pater's Renaissance. University Park, Pa.: Pennsylvania State University Press, 1987.

- Baxandall, Michael. Painting and Experience in Fifteenth-Century Italy. 2nd ed. Oxford: Oxford University Press, 1988.
- Beck, James. Italian Renaissance Painting. New York: Harper & Row, 1981.
- Bennett, Bonnie A., and David G. Wilkins. *Donatello*, Oxford: Phaidon, 1984.
- Berenson, Bernard. Italian Painters of the Renaissance. 2 vols. London: Phaidon, 1968.
- ——. Italian Pictures of the Renaissance: Florentine School. 3 vols. London: Phaidon, 1968.
- ———. The Drawings of the Florentine Painters (1938). 3 vols. Chicago: University of Chicago Press, 1973.
- The Italian Painters of the Renaissance. Ithaca, N.Y.: Cornell University Press, 1980.
- Blunt, Anthony. Artistic Theory in Italy, 1450–1600. New York: Oxford University Press, 1994. Bober, Phyllis P., and Ruth O. Rubinstein. Renais-
- sance Artists and Antique Sculpture: A Handbook of Sources. New York: Oxford University Press, 1986.
- Borsook, Eve. The Mural Painters of Tuscany: From Cimabue to Andrea del Sarto. 2nd ed. New York: Oxford University Press, 1980.

- Butterfield, Andrew. *The Sculptures of Andrea del Verrocchio*. New Haven: Yale University Press, 1997.
- Chastel, André. The Studios and Styles of the Italian Renaissance. New York: Odyssey, 1966.
- Christiansen, Keith. *Gentile da Fabriano*. Ithaca, N.Y.: Cornell University Press, 1982.
- —, Laurence B. Kanter, and Carl Brandon Strehle, eds. Painting in Renaissance Siena, 1420–1500. New York: Metropolitan Museum of Art, 1988.
- Clark, Kenneth. The Art of Humanism. London: Murray, 1983.
- Cole, Alison. Virtue and Magnificence: Art of the Italian Renaissance Courts. New York: Abrams, 1995.
- d'Ancona, Mirella L. The Garden of the Renaissance: Botanical Symbolism in Italian Painting. Florence: Olschki, 1977.
- Edgerton, Samuel Y., Jr. The Renaissance Rediscovery of Linear Perspective. New York: Harper & Row, 1976.
- Gilbert, Creighton E., ed. *Renaissance Art.* New York: Harper & Row, 1973.

—, ed. Italian Art, 1400–1500. Sources and Documents. Englewood Cliffs, N.J.: Prentice-Hall, 1980.

- Goffen, Rona, ed. *Masaccio's Trinity*. Cambridge: Cambridge University Press, 1998.
- Goldthwaite, Richard A. *The Building of Renaissance Florence: An Economic and Social History*. Baltimore: Johns Hopkins University Press, 1982.
- Gombrich, Ernst H. The Heritage of Apelles: Studies in the Art of the Renaissance. Ithaca, N.Y.: Cornell University Press, 1976.
- ——. *Symbolic Images* (1972). 3rd ed. Chicago: University of Chicago Press, 1985.
- ——. New Light on Old Masters (1986). London: Phaidon, 2000.
- Greenstein, Jack M. Mantegna and Painting as Historical Narrative. Chicago: University of Chicago Press, 1992.
- Grendler, Pl. Schooling in Renaissance Italy: Literacy and Learning, 1300–1600. Baltimore: Johns Hopkins University Press, 1989.
- Hale, J. R. Artists and Warfare in the Renaissance. New Haven: Yale University Press, 1990.
- Harbison, Craig. The Mirror of the Artist: Northern Renaissance Art in Its Historical Context. New York: Abrams, 1995.
- Hartt, Frederick. A History of Italian Renaissance Art. 5th ed. New York: Abrams, 2003.

Heydenreich, Ludwig H., and Paul Davies. Architecture in Italy, 1400–1600. New Haven: Yale University Press, 1996.

- Hibbert, Christopher. The House of Medici: Its Rise and Fall. New York: Morrow Quill, 1980.
- Hind, Arthur M. History of Engraving and Etching. 3rd ed., rev. Boston: Houghton Mifflin, 1923. Horster, Marita. Andrea del Castagno. Ithaca,
- N.Y.: Cornell University Press, 1980. Jacks, Philip. The Antiquarian and the Myth of An-
- tiquity: The Origins of Rome in Renaissance Thought. Cambridge: Cambridge University Press, 1993.
- Janson, Horst W. *The Sculpture of Donatello* (1957). Princeton: Princeton University Press, 1963.
- Kemp, Martin. Behind the Picture: Art and Evidence in the Italian Renaissance. New Haven: Yale University Press, 1997.
- Kent, Dale. Cosimo de'Medici and the Florentine Renaissance. New Haven: Yale University Press, 2000.
- Krautheimer, Richard, and Trude Krautheimer-Hess. *Lorenzo Ghiberti*. Princeton: Princeton University Press, 1982.
- Lavin, Marilyn A. Piero della Francesca: The Flagellation (1972). Chicago: University of Chicago Press, 1990.

- Lee, Rensselaer W. Ut Pictura Poesis: The Humanistic Theory of Painting. New York: Norton, 1967. Lightbown, Ronald. Sandro Botticelli. 2 vols.
- Berkeley: University of California Press, 1978. Lowrey, Bates. Renaissance Architecture. New
- York: Braziller, 1962. Machiavelli, Niccolò. *Florentine Histories*. Trans. Laura F. Banfield and Harvey C. Mansfield, Jr.
- Princeton: Princeton University Press, 1988. Murray, Peter. Renaissance Architecture. New
- York: Rizzoli, 1985. Panofsky, Erwin. Renaissance and Renascences in
- Western Art. New York: Harper & Row, 1972. ———. Studies in Iconology: Humanistic Themes in the Art of the Renaissance. New York: Harper
- & Row, 1972. Panofsky, Erwin, and Dora Panofsky. Pandora's
- Box: The Changing Aspects of a Mythical Symbol. 2nd ed., rev. New York: Harper & Row, 1965.
- Pater, Walter. The Renaissance: Studies in Art and Poetry (1893). Ed. Donald L. Hill. Berkeley: University of California Press, 1980.
- Pope-Hennessy, John. The Portrait in the Renaissance (1963). Princeton: Princeton University Press, 1979.
- *An Introduction to Italian Sculpture*. 4th ed. 3 vols. London: Phaidon, 1996.
- Prager, Frank D., and Gustina Scaglia. Brunelleschi: Studies of His Technology and Inventions. Cambridge, Mass.: MIT Press, 1970.
- Rabil, Albert, Jr. Renaissance Humanism: Foundations, Forms, and Legacy. 3 vols. Philadelphia: University of Pennsylvania Press, 1988.
- Rosenberg, Charles M. The Este Monuments and Urban Developments in Renaissance Ferrara. Cambridge: Cambridge University Press, 1997.
- Ruggiero, Guido. Violence in Early Renaissance Venice. New Brunswick, N.J.: Rutgers University Press, 1980.
- Saxl, Fritz. A Heritage of Images: A Selection of Lectures. Ed. Hugh Honour and John Fleming. Harmondsworth: Penguin, 1970.
- Seidel, Linda. Jan van Eyck's Arnolfini Portrait: Stories of an Icon. Cambridge: Cambridge University Press, 1993.
- Seymour, Charles, Jr. The Sculpture of Verrocchio. Greenwich, Conn.: New York Graphic Society, 1971.
- Seznec, Jean. The Survival of the Pagan Gods: The Mythological Tradition and Its Place in Renaissance Humanism and Art. Trans. Barbara F. Sessions. Princeton: Princeton University Press, 1995.
- Thomson, David. Renaissance Architecture: Critics, Patrons, Luxury. Manchester: Manchester University Press, 1993.
- Turner, A. Richard. Renaissance Florence: The Invention of a New Art. New York: Abrams, 1997.
- Valentiner, W. R. Studies of Italian Renaissance Sculpture. London: Phaidon, 1950.
- Wackernagel, Martin. The World of the Florentine Renaissance Artist: Projects and Patrons, Workshop and Art Market. Trans. Alison Luchs. Princeton: Princeton University Press, 1981.
- Weiss, Roberto. The Renaissance Discovery of Classical Antiquity. 2nd ed. Oxford: Blackwell, 1988.
- Wind, Edgar. Pagan Mysteries in the Renaissance. Rev. and enl. ed. Oxford: Oxford University Press, 1980.
- Wittkower, Rudolf. *Idea and Image: Studies in the Italian Renaissance*. New York: Thames & Hudson, 1982.
- ——. Architectural Principles in the Age of Humanism. 4th ed. New York: St. Martin's, 1988.
- Wölfflin, Heinrich. Renaissance and Baroque. Trans. Kathrin Simon. Ithaca, N.Y.: Cornell University Press, 1966.
 - ——. Classic Art: An Introduction to the Italian Renaissance. Trans. L. and P. Murray. 5th ed. London: Phaidon, 1994.

Woods-Marsden, Joanna. The Gonzaga of Mantua and Pisanello's Arthurian Frescoes. Princeton: Princeton University Press, 1988.

The High Renaissance in Italy

- Ackerman, James S. *The Architecture of Michelangelo.* 2nd ed. Chicago: University of Chicago Press, 1986.
- Barolsky, Paul. *Michelangelo's Nose: A Myth and Its Maker.* University Park, Pa.: Pennsylvania State University Press, 1990.
- Why Mona Lisa Smiles and Other Tales by Vasari. University Park, Pa.: Pennsylvania State University Press, 1991.
- Brown, David Alan. Leonardo's Last Supper: The Restoration. Washington, D.C.: National Gallery of Art, 1983.
- Brown, Patricia Fortini. Venetian Narrative Painting in the Age of Carpaccio. New Haven: Yale University Press, 1988.
- ——. Art and Life in Renaissance Venice. New York: Abrams, 1997.
- Castiglione, Baldesar. *The Book of the Courtier* (1528). Rev. ed. Trans. G. Bull. Baltimore: Penguin, 1976.
- Chastel, André. The Sack of Rome, 1527. Trans. Beth Archer. Princeton: Princeton University Press, 1983.
- Clark, Kenneth M. Leonardo da Vinci. New York: Penguin, 1993.
- Collins, Bradley I. Leonardo, Psychoanalysis and Art History: A Critical Study of Psychobiographical Approaches to Leonardo da Vinci. Evanston, III.: Northwestern University Press, 1997.
- de Tolnay, Charles. Michelangelo. 2nd rev. ed. 5 vols. Princeton: Princeton University Press, 1969–1971.
- Eissler, K. R. Leonardo da Vinci: Psychoanalytic Notes on the Enigma. New York: International Universities Press, 1961.
- Fischel, Oskar. Raphael. Trans. B. Rackham. 2 vols. London: Spring Books, 1964.
- Freedberg, Sydney J. Painting of the High Renaissance in Rome and Florence. Rev. ed. 2 vols. New York: Hacker, 1985.
- Painting in Italy, 1500–1600. 3rd ed. Pelican History of Art. New Haven: Yale University Press, 1993.
- Gilbert, Creighton E. Michelangelo: On and Off the Sistine Ceiling. New York: Braziller, 1994.
- Goffen, Rona. Piety and Patronage in Renaissance Venice: Bellini, Titian, and the Franciscans. New Haven: Yale University Press, 1986.
- . Giovanni Bellini. New Haven: Yale University Press, 1989.
- , ed. *Titian's "Venus of Urbino."* Cambridge: Cambridge University Press, 1997.
- ———. Titian's Women. New Haven: Yale University Press, 1997.
- Hall, Marcia, ed. Raphael's "School of Athens." New York: Cambridge University Press, 1997. Heydenreich, Ludwig H. Leonardo: The Last Sup-
- per. London: Allen Lane, 1974.
- Hibbard, Howard. Michelangelo. 2nd ed. New York: Harper & Row, 1985. Humfrey, Peter. Painting in Renaissance Venice.
- New Haven: Yale University Press, 1995.
- Huse, Norbert, and Wolfgang Wolters. The Art of Renaissance Venice: Architecture, Sculpture, and Painting, 1460–1590. Trans. E. Jephcott. Chicago: University of Chicago Press, 1990.
- Kemp, Martin, ed. Leonardo on Painting: An Anthology of Writings. Trans. Martin Kemp and Margaret Walker. New Haven: Yale University Press, 1989.
- Leonardo da Vinci. *The Notebooks*. Trans. Edward MacCurdy. 2 vols. New York: Braziller, 1958.
- Levey, Michael. *High Renaissance*. Harmondsworth: Penguin, 1975.

- Murray, Linda. The High Renaissance and Mannerism: Italy, the North, and Spain, 1500–1600. New York: Oxford University Press, 1977.
- Panofsky, Erwin. Problems in Titian, Mostly Iconographic. New York: New York University Press, 1969.
- Partridge, Loren. The Art of Renaissance Rome, 1400–1600. New York: Abrams, 1996.
- Partridge, Loren, and Randolph Starn. A Renaissance Likeness: Art and Culture in Raphael's Julius II. Berkeley: University of California Press, 1980.
- Pedretti, Carlo. *Leonardo da Vinci on Painting: A Lost Book.* Berkeley: University of California Press, 1964.
- ———. Leonardo: Studies for the Last Supper from the Royal Library at Windsor Castle. Ivrea: Olivetti, 1983.
- Pope-Hennessy, John. Raphael. New York: New York University Press, 1970.
- ——. Italian High Renaissance and Baroque Sculpture. 3rd ed. New York: Phaidon, 1986.
- Riess, Jonathan B. The Renaissance Antichrist: Luca Signorelli's Orvieto Frescoes. Princeton: Princeton University Press, 1995.
- Robertson, Giles. *Giovanni Bellini*. New York: Hacker, 1981.
- Rosand, David. Titian. New York: Abrams, 1978.
- ——. Painting in Cinquecento Venice: Titian, Veronese, Tintoretto. Rev. ed. New Haven: Yale University Press, 1997.
- Ruggiero, Guido. The Boundaries of Eros: Sex Crime and Sexuality in Renaissance Venice. New York: Oxford University Press, 1985.
- ———. Binding Passions: Tales of Magic, Marriage, and Power at the End of the Renaissance. New York: Oxford University Press, 1993.
- Saslow, James M. Ganymede in the Renaissance: Homosexuality in Art and Society. New Haven: Yale University Press, 1986.
- ——. The Poetry of Michelangelo: An Annotated Translation. New Haven: Yale University Press, 1991.
- Settis, Salvatore. Giorgione's Tempest: Interpreting the Hidden Subject. Chicago: University of Chicago Press, 1990.
- Steinberg, Leo. Leonardo's Incessant Last Supper. New York: Zone Books, 2001.
- Tafuri, Manfredo. Venice and the Renaissance. Trans. Jessica Levine. Cambridge, Mass.: MIT Press, 1989.
- Turner, A. Richard. *Inventing Leonardo*. Berkeley: University of California Press, 1993.
- Vasari, Giorgio. Vasari on Technique. Trans. Louise S. Maclehose. New York: Dover, 1960.
- Wethey, Harold E. *The Paintings of Titian*. 3 vols. London: Phaidon, 1969–.
- Wilde, Johannes. Venetian Art from Bellini to Titian. Oxford: Clarendon, 1981.

Mannerism and the Later Sixteenth Century in Italy

- Ackerman, James S. Palladio. London: Penguin, 1991.
- Cellini, Benvenuto. Autobiography. Trans. J. A. Symonds. Ed. John Pope-Hennessy. London: Phaidon, 1960.
- Cochrane, Eric. Florence in the Forgotten Centuries, 1527–1800: A History of Florence and the Florentines in the Age of the Grand Dukes. Chicago: University of Chicago Press, 1973.
- Cox-Rearick, Janet. The Drawings of Pontormo: A Catalogue Raisonné with Notes on the Paintings. Rev. ed. 2 vols. New York: Hacker, 1981.
- Dynasty and Destiny in Medici Art: Pontormo, Leo X, and the Two Cosimos. Princeton: Princeton University Press, 1984.
- ———. Bronzino's Chapel of Eleonora in the Palazzo Vecchio. Berkeley: University of California Press, 1993.

- Freedberg, Sidney J. Parmigianino: His Works in Painting. Cambridge, Mass.: Harvard University Press, 1950.
- Hauser, Arnold. Mannerism: The Crisis of the Renaissance and the Origin of Modern Art. Cambridge, Mass.: Belknap, 1986.
- Holt, Elizabeth Gilmore, ed. A Documentary History of Art. Vol. 2: Michelangelo and the Mannerists, the Baroque and the Eighteenth Century. Princeton: Princeton University Press, 1981.
- Pope-Hennessy, John. *Cellini*. London: Macmillan, 1985.
- Shearman, John K. G. Mannerism (1967). Harmondsworth: Penguin, 1977.
- Smythe, Craig Hugh. Mannerism and Maniera. 2nd ed. Vienna: IRSA, 1992.
- Tomlinson, Janis. From El Greco to Goya: Painting in Spain, 1561–1828. New York: Abrams, 1997.
- Würtenberger, Franzsepp. Mannerism: The European Style of the Sixteenth Century. New York: Holt, Rinehart & Winston, 1963.

Sixteenth-Century Painting and Printmaking in Northern Europe

- Benesch, Otto. The Art of the Renaissance in Northern Europe: Its Relation to the Contemporary Spiritual and Intellectual Movements. Rev. ed. London: Phaidon, 1965.
- ——. German Painting, from Dürer to Holbein. Trans. H. S. B. Harrison. Geneva: Skira, 1966.
- Chastel, André. *The Age of Humanism: Europe*, 1480–1530. Trans. Katherine Delavenay and E. M. Gwyer. New York: McGraw-Hill, 1964.
- Cuttler, Charles D. Northern Painting from Pucelle to Bruegel, Fourteenth, Fifteenth, and Sixteenth Centuries. Fort Worth: Holt, Rinehart & Winston, 1991.
- Davies, Martin. Rogier van der Weyden: An Essay with a Critical Catalogue of Paintings Assigned to Him and to Robert Campin. New York: Phaidon, 1972.
- Friedländer, Max J. Early Netherlandish Painting. 14 vols. Trans. Heinz Norden. New York: Praeger, 1967–1976.
- ——. From Van Eyck to Bruegel. Trans. Marguerite Kay. 3rd ed. New York: Phaidon, 1969.
- Fuchs, Rudolf H. Dutch Painting. New York: Oxford University Press, 1978.
- Gilbert, Creighton E. History of Renaissance Art: Painting, Sculpture, Architecture throughout Europe. New York: Abrams, 1973.
- Harbison, Craig. The Mirror of the Artist: Northern Renaissance Art in Its Historical Context. New York: Abrams, 1995.
- Hayum, Andrée. The Isenheim Altarpiece: God's Medicine and the Painter's Vision. Princeton: Princeton University Press, 1989.
- Hind, Arthur M. A History of Engraving and Etching from the Fifteenth Century to the Year 1914. 3rd rev. ed. New York: Dover, 1963.
- ——. An Introduction to a History of Woodcut: With a Detailed Survey of Work Done in the Fifteenth Century. New York: Dover, 1963.
- Koerner, Joseph Leo. The Moment of Self-Portraiture in German Renaissance Art. Chicago: University of Chicago Press, 1993.
- Lane, Barbara G. The Altar and the Altarpiece: Sacramental Themes in Early Netherlandish Painting. New York: Harper & Row, 1984.
- Melion, Walter S. Shaping the Netherlandish Canon: Karel van Mander's Schilder-boeck. Chicago: University of Chicago Press, 1991.
- Mellinkoff, Ruth. The Devil at Isenheim: Reflections of Popular Belief in Grünewald's Altarpiece. Berkeley: University of California Press, 1988.
- Panofsky, Erwin. Early Netherlandish Painting: Its Origin and Character (1958). 2 vols. New York: Harper & Row, 1971.
- *Life and Art of Albrecht Dürer.* Princeton: Princeton University Press, 2005.

- Pevsner, Nikolaus, and Michael Meier. *Grünewald*. New York: Abrams, 1958.
- Philip, Lotte Brand. The Ghent Altarpiece and the Art of Jan van Eyck. Princeton: Princeton University Press, 1971.
- Snyder, James. Northern Renaissance Art: Painting, Sculpture, the Graphic Arts from 1350 to 1575. 2nd ed. Upper Saddle River, N.J.: Prentice-Hall, 2005.
- Stechow, Wolfgang. Northern Renaissance Art, 1400–1600: Sources and Documents (1966). Evanston, Ill.: Northwestern University Press, 1989.

The Baroque Style in Western Europe

- Adams, Laurie Schneider. Key Monuments of the Baroque. Boulder, Col.: Westview, 2000.
- Alpers, Svetlana. The Art of Describing: Dutch Art in the Seventeenth Century. Chicago: University of Chicago Press, 1983.
- . Rembrandt's Enterprise: The Studio and the Market. Chicago: University of Chicago Press, 1988.
- ——. The Making of Rubens. New Haven: Yale University Press, 1995.
- Avery, Charles. Bernini, Genius of the Baroque. London: Thames & Hudson, 1997.
- Bazin, Germain. Baroque and Rococo. New York: Thames & Hudson, 1985.
- Berger, Robert W. Versailles: The Chateau of Louis XIV. University Park, Pa.: Pennsylvania State University Press, 1985.
- Blunt, Anthony. Art and Architecture in France, 1500–1700. 5th ed. New Haven: Yale University Press, 1999.
- Blunt, Anthony, et al. *Baroque and Rococo: Architecture and Decoration*. New York: Harper & Row, 1982.
- Brown, Christopher. Scenes of Everyday Life: Dutch Genre Painting of the Seventeenth Century. London: Faber & Faber, 1984.
- Brown, Jonathan. Velázquez: Painter and Courtier. New Haven: Yale University Press, 1986.
- ———. The Golden Age of Painting in Spain. New Haven: Yale University Press, 1991.
- Carrier, David. Poussin's Paintings: A Study in Art-Historical Methodology. University Park, Pa.: Pennsylvania State University Press, 1993.
- Clark, Kenneth. Rembrandt and the Italian Renaissance (1966). New York: Norton, 1968.
- Domínguez Ortiz, Antonio, Alfonso E. Pérez Sánchez, and Julián Gállego. Velázquez. New York: Metropolitan Museum of Art, 1989.
- Enggass, Robert, and Jonathan Brown. *Italy and Spain, 1600–1750: Sources and Documents.* Englewood Cliffs, N.J.: Prentice-Hall, 1970.
- Friedländler, Walter F. *Caravaggio Studies* (1955). New York: Schocken, 1969.
- Garrard, Mary D. Artemisia Gentileschi: The Image of the Female Hero in Italian Baroque Art. Princeton: Princeton University Press, 1989.
- Gerson, Horst. Rembrandt Paintings. Trans. Heinz Norden. Ed. Gary Schwartz. New York: Reynal, 1968.
- Goldscheider, Ludwig, ed. Vermeer, the Paintings: Complete Edition. 2nd ed. London: Phaidon, 1967.
- Grimm, Claus. Frans Hals: The Complete Work. Trans. Jürgen Riehle. New York: Abrams, 1990.
- Haak, Bob. The Golden Age: Dutch Painters of the Seventeenth Century. Trans. Elizabeth-Willems-Treeman. New York: Abrams, 1984.
- Haskell, Francis. *Patrons and Painters: A Study in the Relations between Italian Art and Society in the Age of the Baroque.* Rev. and enl. ed. New Haven: Yale University Press, 1980.

- Haverkamp-Begemann, E. *Rembrandt: The Nightwatch*. Princeton: Princeton University Press, 1982.
- Held, Julius, and Donald Posner. Seventeenth- and Eighteenth-Century Art. New York: Abrams, 1974.
- Hibbard, Howard. Bernini. Baltimore: Penguin, 1966.
- ———. Caravaggio. New York: Harper & Row, 1983.
- Hill, G. F., and Graham Pollard. Renaissance Medals from the Samuel H. Kress Collection at the National Gallery of Art. London: Phaidon, 1967. Kahr, Madlyn M. Dutch Painting in the Seven-
- teenth Century. 2nd ed. New York: HarperCollins, 1993.
- Kitson, Michael. The Age of Baroque. London: Hamlyn, 1976.
- Koning, Hans. The World of Vermeer, 1632–1765. New York: Time-Life, 1967.
- Martin, John R. *Baroque*. New York: Harper & Row, 1977.
- Minor, Vernon Hyde. Baroque and Rococo: Art and Culture. New York: Abrams, 1999.
- Moir, Alfred. *The Italian Followers of Caravaggio*. 2 vols. Cambridge, Mass.: Harvard University Press, 1967.
- ——. Anthony van Dyck. New York: Abrams, 1994.
- Montagu, Jennifer. Roman Baroque Sculpture: The Industry of Art. New Haven: Yale University Press, 1989.
- Nicolson, Benedict. The International Caravaggesque Movement: Lists of Pictures by Caravaggio and His Followers throughout Europe from 1590 to 1650. Oxford: Phaidon, 1979.
- Norberg-Schulz, Christian. Late Baroque and Rococo Architecture. New York: Rizzoli, 1985.
- ——. Baroque Architecture. New York: Rizzoli, 1986.
- Orso, Steven N. Velázquez, Los Borrachos, and Painting at the Court of Philip IV. Cambridge: Cambridge University Press, 1993.
- Powell, Nicolas. From Baroque to Rococo: An Introduction to Austrian and German Architecture from 1580 to 1790. London: Faber, 1959.
- Rosenberg, Jakob. *Rembrandt: Life and Work*. Rev. ed. Ithaca, N.Y.: Cornell University Press, 1980.
- Rosenberg, Jakob, Seymour Slive, and E. H. ter Kuile. Dutch Art and Architecture, 1600 to 1800. 3rd ed. Pelican History of Art. New York: Penguin, 1977.
- Schama, Simon. The Embarrassment of Riches: An Interpretation of Dutch Culture in the Golden Age (1987). New York: Vintage, 1997.
- Schwartz, Gary. Rembrandt, His Life, His Paintings. New York: Penguin, 1991.
- Scribner, Charles, III. Peter Paul Rubens. New York: Abrams, 1989.
- ——. Gianlorenzo Bernini. New York: Abrams, 1991.
- Slive, Seymour. Rembrandt and His Critics, 1630– 1730. New York: Hacker, 1988.
- ——, ed. Frans Hals. Munich: Prestel, 1989.
- Snow, Edward. A Study of Vermeer. Rev. and enl. ed. Berkeley: University of California Press, 1994.
- Stechow, Wolfgang. Dutch Landscape Painting of the Seventeenth Century. 3rd ed. Oxford: Phaidon, 1981.
- Strong, Roy. Van Dyck: Charles I on Horseback. New York: Viking, 1972.
- Sutton, Peter C. The Age of Rubens. Boston: Museum of Fine Arts, 1993.
- Varriano, John. Italian Baroque and Rococo Architecture. New York: Oxford University Press, 1986.
- Wallace, Robert. *The World of Bernini, 1598–1680.* New York: Time-Life, 1970.
- Waterhouse, Ellis K. Roman Baroque Painting. Oxford: Phaidon, 1976.

- Wedgwood, C. V. The World of Rubens, 1577– 1640. New York: Time-Life, 1967.
- Welu, James A., and Pieter Biesboer, eds. Judith Leyster: A Dutch Master and Her World. New Haven: Yale University Press, 1993.
- Wheelock, Arthur K., Jr. Jan Vermeer. New York: Abrams, 1988.
- Wheeler, Arthur K., Jr., Susan J. Barnes, and Julius S. Held. Anthony Van Dyck. Washington, D.C.: National Gallery of Art, 1990.
- White, Christopher. *Rembrandt*. London: Thames & Hudson, 1984.
- ———. Peter Paul Rubens: Man and Artist. New Haven: Yale University Press, 1987.
- Wittkower, Rudolf. Bernini: The Sculptor of the Roman Baroque. 4th ed. London: Phaidon, 1997.
 ——. Art and Architecture in Italy, 1600–1750.
- 6th ed. 3 vols. Pelican History of Art. New Haven: Yale University Press, 1999.
- Wright, Christopher. The French Painters of the Seventeenth Century. Boston: Little, Brown, 1985.

Rococo and the Eighteenth Century

- Abrams, Ann Uhry. *The Valiant Hero: Benjamin West and Grand-Style History Painting*. Washington, D.C.: Smithsonian Institute, 1985.
- Alpers, Svetlana, and Michael Baxandall. *Tiepolo and the Pictorial Intelligence*. New Haven: Yale University Press, 1994.
- Antal, Frederick. Hogarth and His Place in European Art. London: Routledge & Kegan Paul, 1962.
- Bryson, Norman. Word and Image: French Painting of the Ancien Régime. Cambridge: Cambridge University Press, 1981.
- Burke, Joseph. English Art, 1714–1800. Oxford: Clarendon, 1976.
- Châtelet, Albert, and Jacques Thuillier. French Painting, from Le Nain to Fragonard. Trans. James Emmons. Geneva: Skira, 1964.
- Conisbee, Philip. *Painting in Eighteenth-Century France*. Ithaca, N.Y.: Cornell University Press, 1981.
- Crow, Thomas E. Painters and Public Life in Eighteenth-Century Paris. New Haven: Yale University Press, 1985.
- Duncan, Carol. The Pursuit of Pleasure: The Rococo Revival in French Romantic Art. New York: Garland, 1976.
- Frankenstein, Alfred Victor. *The World of Copley,* 1738–1815. New York: Time-Life, 1970.
- Grasselli, Margaret Morgan, and Pierre Rosenberg. *Watteau, 1684–1721.* Washington, D.C.: National Gallery of Art, 1984.
- Hitchcock, Henry R. Rococo Architecture in Southern Germany. London: Phaidon, 1968.
- Kalnein, Karl Wend Graf, and Michael Levey. Art and Architecture of the Eighteenth Century in France. Harmondsworth: Penguin, 1972.
- Kimball, Fiske. The Creation of the Rococo Decorative Style (1943). New York: Dover, 1980.
- Levey, Michael. Rococo to Revolution: Major Trends in Eighteenth-Century Painting. New York: Oxford University Press, 1977.
- Manners and Morals: Hogarth and British Painting, 1700–1760. London, Tate Gallery, 1987.
- Minguet, J. Philippe. *Esthétique du Rococo*. Paris: Vrin, 1966.
- Palladio, Andrea. *The Four Books of Architecture*. 1738. Reprint of the Isaac Ware edition. New York: Dover, 1965.
- Paulson, Ronald. The Art of Hogarth. London: Phaidon, 1975.
- Pignatti, Terisio. *The Age of Rococo*. Trans. Lorna Andrade. London: Cassell, 1988.
- Posner, Donald. Watteau: A Lady at Her Toilet. New York: Viking, 1973.

- Rosenberg, Pierre. *Chardin, 1699–1779.* Ed. Sally W. Goodfellow. Trans. Emilie P. Kadish and Ursula Korneitchouk. Cleveland: Cleveland Museum of Art, 1979.
- Rosenblum, Robert. Transformations in Late Eighteenth-Century Art (1967). Princeton: Princeton University Press, 1970.
- Snodin, Michael. Rococo: Art and Design in Hogarth's England. London: Trefoil Books/Victoria and Albert Museum, 1984.
- Summerson, John. The Architecture of the Eighteenth Century. New York: Thames & Hudson, 1986.
- Wittkower, Rudolf. *Palladio and Palladianism* (1974). New York: Thames & Hudson, 1983.

Neoclassicism: The Late Eighteenth and Early Nineteenth Centuries

- Arnason, H. H. The Sculptures of Houdon. London: Phaidon, 1975.
- Boime, Albert. Art in an Age of Revolution, 1750– 1800. Chicago: University of Chicago Press, 1987.
- Art in an Age of Bonapartism, 1800–1815 (1990). Chicago: University of Chicago Press, 1993.
- Bryson, Norman. Tradition and Desire: From David to Delacroix. New York: Cambridge University Press, 1984.
- Burchard, John, and Albert Bush-Brown. The Architecture of America: A Social and Cultural History. Boston: Little, Brown, 1966.
- Cooper, Wendy A. Classical Taste in America, 1800–1840. Baltimore: Baltimore Museum of Art, 1993.
- Eitner, Lorenz. Neoclassicism and Romanticism, 1750–1850: An Anthology of Sources and Documents. New York: Harper & Row, 1989.
- An Outline of Nineteenth-Century European Painting: From David through Cézanne.
 2 vols. New York: HarperCollins, 1996.
- Elsen, Albert E. *Rodin*. New York: Museum of Modern Art, 1963.
- ———. Auguste Rodin: Readings on His Life and Work. Englewood Cliffs, N.J.: Prentice-Hall, 1965.
- Friedländer, Walter F. David to Delacroix (1952). Trans. Robert Goldwater. Cambridge, Mass.: Harvard University Press, 1980.
- Honour, Hugh. *Neo-Classicism.* Harmondsworth: Penguin, 1987.
- Irwin, David. English Neoclassical Art: Studies in Inspiration and Taste. London: Faber & Faber, 1966.
- Jaffe, Irma B. Trumbull: The Declaration of Independence. New York: Viking, 1976.
- Lindsay, Jack. Death of the Hero: French Painting from David to Delacroix. London: Studio, 1960.
- McLaughlin, Jack. Jefferson and Monticello: The Biography of a Builder. New York: Holt, 1988.
- Middleton, Robin, and David Watkin. Neoclassical and 19th-Century Architecture. 2 vols. New York: Electa/Rizzoli, 1987.
- Nanteuil, L. de. Jacques-Louis David. New York: Abrams, 1985.
- Novotny, Fritz. Painting and Sculpture in Europe, 1780–1880. Pelican History of Art. Harmondsworth: Penguin, 1980.
- Roberts, Warren E. Jacques-Louis David, Revolutionary Artist: Art, Politics, and the French Revolution. Chapel Hill: University of North Carolina Press, 1989.
- Rosenblum, Robert. *Transformations in Late Eighteenth-Century Art.* Princeton: Princeton University Press, 1970.
- ——. Jean-Auguste-Dominique Ingres (1967). New York: Abrams, 1985.
- Roworth, Wendy Wassyng, ed. Angelica Kauffmann: A Continental Artist in Georgian England. London: Reaktion, 1992.

- Rykwert, Joseph, and Anne Rykwert. *Robert and James Adam: The Men and the Style.* New York: Electa/Rizzoli, 1985.
- Stillman, Damie. English Neo-classical Architecture. 2 vols. London: Zwemmer, 1988.
- Vaughan, Will, and Helen Weston, eds. Jacques-Louis David's "Marat." New York: Cambridge University Press, 1999.

Romanticism: The Late Eighteenth and Early Nineteenth Centuries

- Athanassoglou-Kallmyer, Nina M. Eugène Delacroix: Prints, Politics, and Satire, 1814–1822. New Haven: Yale University Press, 1991.
- Bindman, David. William Blake: His Art and Times. New Haven: Yale Center for British Art, 1982.
- Born, Wolfgang. American Landscape Painting: An Interpretation. New Haven: Yale University Press, 1948.
- Börsch-Supan, Helmut. Caspar-David Friedrich. 2nd ed. New York: te Neues, 1990.
- Brion, Marcel. Art of the Romantic Era: Romanticism, Classicism, Realism. New York: Praeger, 1966.
- Clark, Kenneth. The Romantic Rebellion: Romantic versus Classic Art. New York: Harper & Row, 1973.
- Clay, Jean. Romanticism. Trans. Daniel Wheeler and Craig Owen. New York: Vendome, 1981.
- Courthion, Pierre. Romanticism. Trans. Stuart Gilbert. Geneva: Skira, 1961.
- Eitner, Lorenz. Géricault's "Raft of the Medusa." London: Phaidon, 1972.
- ——. Géricault: His Life and Work. London: Orbis, 1983.
- Faxon, Alicia Craig. Dante Gabriel Rossetti. New York: Abbeville, 1989.
- Gage, John. J. M. W. Turner: A Wonderful Range of Mind. New Haven: Yale University Press, 1987.
- Harris, Enriqueta. Goya. Rev. ed. London: Phaidon, 1994.
- Hilton, Timothy. Pre-Raphaelites. New York: Abrams, 1971.
- Honour, Hugh. *Romanticism*. New York: Harper & Row, 1979.
- Jobert, Barthélémy. *Delacroix*. Princeton: Prince-- ton University Press, 1998.
- Kroeber, Karl. British Romantic Art. Berkeley: University of California Press, 1986.
- Licht, Fred. Goya: The Origins of the Modern Temper in Art. New York: Harper & Row, 1983.
- López-Rey, José. Goya's Caprichos: Beauty, Reason and Caricature. 2 vols. Princeton: Princeton University Press, 1953.
- Mendelowitz, Daniel M. A History of American Art. 2nd ed. New York: Holt, Rinehart & Winston, 1970.
- Murphy, Alexandra R. Jean-François Millet. Boston: Museum of Fine Arts, 1984.
- Nochlin, Linda. The Body in Pieces: The Fragment as a Metaphor of Modernity. London: Thames & Hudson, 1994.
- Parry, Ellwood C., III. The Art of Thomas Cole: Ambition and Imagination. Newark, Del.: University of Delaware Press, 1988.
- Pérez Sánchez, Alfonso E., and Eleanor A. Sayre. Goya and the Spirit of Enlightenment. Boston: Museum of Fine Arts, 1989.
- Powell, Earl A. Thomas Cole. New York: Abrams, 1990.
- Praz, Mario. *The Romantic Agony*. New York: Oxford University Press, 1983.
- The Pre-Raphaelites. London: Tate Gallery, 1984.
- Prideaux, Tom. The World of Delacroix, 1798-1863. New York: Time-Life, 1966.
- Raine, Kathleen. William Blake. New York: Oxford University Press, 1970.
- Rosenblum, Robert, and Horst W. Janson. Nineteenth-Century Art. Rev. ed. New York: Abrams, 2005.

- Truettner, William H., and Alan Wallach, eds. Thomas Cole: Landscape into History. New Haven: Yale University Press, 1994.
- Vaughan, William. German Romantic Painting. New Haven: Yale University Press, 1980.
- ——. Romanticism and Art. New York: Thames & Hudson, 1994.
- Walker, John. John Constable. New York: Abrams, 1991.
- Wilton, Andrew. Turner and the Sublime. Chicago: University of Chicago Press, 1981.
 Turner in His Time. New York: Abrams, 1987
- Wolf, Bryan Jay. Romantic Re-vision: Culture and Consciousness in Nineteenth-Century American Painting and Literature. Chicago: University of Chicago Press, 1982.

Nineteenth-Century Realism

- Ashton, Dore. Rosa Bonheur: A Life and a Legend. New York: Viking, 1981.
- Barger, M. Susan, and William B. White. The Daguerreotype: Nineteenth-Century Technology and Modern Science (1991). Baltimore: Johns Hopkins University Press, 2000.
- Boime, Albert. A Social History of Modern Art. 3 vols. Chicago: University of Chicago Press, 1987–2004.
- Cachin, Françoise, Charles S. Moffet, and Michel Melot, eds. Manet, 1832–1883. New York: Metropolitan Museum of Art, 1983.
- Carrier, David. High Art: Charles Baudelaire and the Origins of Modernist Painting. University Park, Pa.: Pennsylvania State University Press, 1996.
- Clark, T. J. The Absolute Bourgeois: Artists and Politics in France, 1848–1851 (1973). Berkeley: University of California Press, 1999.
- ———. Image of the People: Gustave Courbet and the 1848 Revolution (1973). Berkeley: University of California Press, 1999.
- Eisenman, Stephen F. Nineteenth-Century Art: A Critical History. 2nd ed. New York: Thames & Hudson, 2002.
- Elsen, Albert. *Rodin*. New York: Museum of Modern Art, 1963.
- Farwell, Beatrice. Manet and the Nude: A Study of Iconography in the Second Empire. New York: Garland, 1981.
- Fried, Michael. Courbet's Realism. Chicago: Uni-
- versity of Chicago Press, 1990. Gosling, Nigel. Nadar. New York: Knopf, 1976.
- Hamilton, George H. Manet and His Critics (1954).
- New Haven: Yale University Press, 1986. Homer, William Innes. *Thomas Eakins: His Life*
- and Art. New York: Abbeville, 1992. Isaacson, Joel. Manet: Le Déjeuner sur l'Herbe.
- New York: Viking, 1972.
- Janson, H. W. Nineteenth-Century Sculpture. New York: Abrams, 1985.
- Johns, Elizabeth. Thomas Eakins: The Heroism of Modern Life. Princeton: Princeton University Press, 1983.
- Krell, Alan. Manet and the Painters of Contemporary Life. London: Thames & Hudson, 1996.
- Lindsay, Jack. *Gustave Courbet: His Life and Art.* New York: State Mutual Reprints, 1981.
- McKean, John. Crystal Palace: Joseph Paxton and Charles Fox. London: Phaidon, 1994.
- Maison, K. E. Honoré Daumier: Catalogue Raisonné of the Paintings, Watercolours, and Drawings. 2 vols. Greenwich, Conn.: New York Graphic Society, 1968.
- Meredith, Roy. Mr. Lincoln's Camera Man, Mathew B. Brady. 2nd rev. ed. New York: Dover, 1974.
- Needham, Gerald. Nineteenth-Century Realist Art. New York: Harper & Row, 1988.
- Newhall, Beaumont. *The History of Photography:* From 1839 to the Present. 5th ed. New York: Museum of Modern Art, 1999.

- Nicolson, Benedict. Courbet: The Studio of the Painter. New York: Viking, 1973.
- Nochlin, Linda. Realism and Tradition in Art, 1848– 1900: Sources and Documents. Englewood Cliffs, N.J.: Prentice-Hall, 1966.
- Novak, Barbara. American Painting of the Nineteenth Century. 2nd ed. New York: Harper &
- Row, 1979. O'Gorman, James F. Three American Architects: Richardson, Sullivan, and Wright, 1865–1915.
- Chicago: University of Chicago Press, 1991. Passeron, Roger. *Daumier*. Trans. Helga Harrison.
- New York: Rizzoli, 1981. Reff, Theodore. Manet, Olympia. New York: Vik-
- ing, 1977. Schneider, Pierre. *The World of Manet, 1832–1883*. New York: Time-Life, 1968.
- Sullivan, Louis. The Autobiography of an Idea. New York: Dover, 1956.
- Touissaint, Hélène. *Gustave Courbet*, 1819–1877. London: Arts Council of Great Britain. 1978.
- Tucker, Paul H., ed. Manet's Le Déjeuner sur l'Herbe. New York: Cambridge University Press, 1998
- Weisberg, Gabriel P., ed. *The European Realist Tradition*. Bloomington: Indiana University Press, 1982.

Nineteenth-Century Impressionism

Bell, Quentin. Ruskin. New York: Braziller, 1978. Boggs, Jean Sutherland, et al. Degas. Exh. cat.

- New York: Metropolitan Museum of Art, 1988. Clark, T. J. The Painting of Modern Life: Paris in the Art of Manet and His Followers. Rev. ed.
- Princeton: Princeton University Press, 1984. Gerdts, William H. American Impressionism. 2nd ed. New York: Abbeville, 2001.
- Guth, Christine. Art of Edo Japan: The Artist and the City 1615–1868. New York: Abrams, 1996.
- Hanson, Anne Coffin. Manet and the Modern Tradition. New Haven: Yale University Press, 1977.
- Hanson, Lawrence. Renoir: The Man, the Painter, and His World. London: Frewin, 1972.
- Herbert, Robert L. Impressionism: Art, Leisure and Parisian Society. New Haven: Yale University Press, 1988.
- Higonnet, Anne. Berthe Morisot's Images of Women. Cambridge, Mass.: Harvard University Press, 1992.
- Kelder, Diane. The French Impressionists and Their Century. New York: Praeger, 1970.
- Kendall, Richard. Degas: Beyond Impressionism. London: National Gallery Publications, 1996.
- Locke, Nancy. Manet and the Family Romance. Princeton: Princeton University Press, 2001.
- Mathews, Nancy Mowll. Mary Cassatt. New York: Abrams, 1987.
- Nochlin, Linda. Impressionism and Post-Impressionism, 1874–1904: Sources and Documents. Englewood Cliffs, N.J.: Prentice-Hall, 1966.
- Pissarro, Joachim. Camille Pissarro. New York: Abrams, 1993.
- Pool, Phoebe. Impressionism. New York: Praeger, 1967.
- Prideaux, Tom. *The World of Whistler, 1834–1903*. New York: Time-Life, 1970.
- Rewald, John. *The History of Impressionism*. 4th rev. ed. New York: Museum of Modern Art, 1973.
- ——. Studies in Impressionism. New York: Abrams, 1986.
- Rouart, Denis. *Renoir*. New York: Skira/Rizzoli, 1985.
- Smith, Paul. Impressionism: Beneath the Surface. New York: Abrams, 1995.
- Spate, Virginia. Claude Monet: Life and Work. New York: Rizzoli, 1992.

Tucker, Paul Hayes. Claude Monet: Life and Art. New Haven: Yale University Press, 1995.

Walker, John. James McNeill Whistler. New York: Abrams, 1987.

Post-Impressionism and the Late Nineteenth Century

- Andersen, Wayne. Gauguin's Paradise Lost. New York: Viking, 1971.
- Badt, Kurt. The Art of Cézanne. Trans. Sheila Ann Ogilvie. Berkeley: University of California Press, 1965.
- Champigneulle, Bernard. *Rodin*. Trans. J. Maxwell Brownjohn. New York: Thames & Hudson, 1986.
- Collins, Bradley, Jr. Van Gogh and Gauguin: Electric Arguments and Utopian Dreams. Boulder, Col.: Westview, 2001.
- d'Alleva, Anne. Arts of the Pacific Islands. New York: Abrams, 1998.
- Denvir, Bernard. Toulouse-Lautrec. New York: Thames & Hudson, 1991.
- ———. Post-Impressionism. New York: Thames & Hudson, 1992.
- Edvard Munch: Symbols and Images. Washington, D.C.: National Gallery of Art, 1978.
- Eggum, Arne. Edvard Munch: Paintings, Sketches, and Studies. Trans. Ragnar Christophersen. London: Thames & Hudson, 1984.
- Eisenman, Stephen F. Gauguin's Skirt. London: Thames & Hudson, 1997.
- Geist, Sidney. Interpreting Cézanne. Cambridge, Mass.: Harvard University Press, 1988.
- Gogh, Vincent van. The Complete Letters of Vincent van Gogh. 2nd ed. Trans. J. van Gogh-Bonger and C. de Dood. 3 vols. Boston: Little, Brown, 1978.
- Goldwater, Robert. Paul Gauguin. New York: Abrams, 1972.
- Gordon, Robert, and Andrew Forge. Degas. New York: Abrams, 1988.
- Gowing, Lawrence, ed. Cézanne: The Early Years, 1859–72. New York: Abrams, 1988.
- Hamilton, George H. Painting and Sculpture in Europe, 1880–1940. 6th ed. Pelican History of Art. New Haven: Yale University Press, 1993.
- Heller, Reinhold. Edvard Munch: The Scream. New York: Viking, 1972.
- Holt, Elizabeth Gilmore, ed. The Expanding World of Art, 1874–1902. New Haven: Yale University Press, 1988.
- Huisman, Philippe, and M. G. Dortu. *Toulouse-Lautrec*. Garden City, N.Y.: Doubleday, 1973.
- Jullian, Philippe. *The Symbolists*. 2nd ed. New York: Dutton, 1977.
- Mainardi, Patricia. The End of the Salon: Art and the State in the Early Third Republic. Cambridge, Eng.: Cambridge University Press, 1993.
- Pickvance, Ronald. Van Gogh in Arles. New York: Metropolitan Museum of Art, 1984.
- ———. Van Gogh in Saint-Rémy and Auvers. New York: Metropolitan Museum of Art, 1986.
- Post-Impressionism: Cross-Currents in European and American Painting, 1880–1906. Washington, D.C.: National Gallery of Art, 1980.
- Rewald, John. Post-Impressionism: From Van Gogh to Gauguin. 3rd ed. New York: Museum of Modern Art, 1978.
- ——. Studies in Post-Impressionism. New York: Abrams, 1986.
- Rubin, William, ed. Cézanne, the Late Work: Essays. New York: Museum of Modern Art, 1977.
- Russell, John. Seurat. New York: Praeger, 1965. Schapiro, Meyer. Vincent van Gogh. New York:
- Abrams, 2003.
- sionism: A Study of the Theory, Technique, and Critical Evaluation of Modern Art. Chicago: University of Chicago Press, 1984.

- Smith, Paul. Seurat and the Avant-Garde. New Haven: Yale University Press, 1997.
- Stang, Ragna. Edvard Munch: The Man and His Art. Trans. Geoffrey Culverwell. New York: Abbeville, 1988.
- Thomson, Belinda, Gauguin. New York: Thames & Hudson, 1987.
- Thomson, Richard, et al. *Toulouse-Lautrec*. New Haven: Yale University Press, 1991.
- Wood, Mara-Helen, ed. Edvard Munch: The Frieze of Life. London: National Gallery Publications, 1992.

Turn of the Century: Early Picasso, Fauvism, Expressionism, and Matisse

- Arnason, Hjorvardur H. History of Modern Art: Painting, Sculpture, Architecture, Photography. 5th ed. Upper Saddle River, N.J.: Prentice-Hall, 2004.
- Barr, Alfred H., Jr. *Matisse, His Art and His Public* (1951). New York: Arno, 1966.
- Bascom, William Russell. African Art in Cultural Perspective: An Introduction. New York: Norton, 1973.
- Ben-Amos, Paula G. *The Art of Benin*. 2nd rev. ed. London: British Museum, 1995.
- Berlo, Janet, and Lee A. Wilson. Arts of Africa, Oceania, and the Americas: Selected Readings. Englewood Cliffs, N.J.: Prentice-Hall, 1993.
- Blier, Suzanne Preston. The Royal Arts of Africa: The Majesty of Form. New York: Abrams, 1998.
- Chipp, Herschel B. Theories of Modern Art: A Source Book by Artists and Critics. Berkeley: University of California Press, 1968.
- Duncan, Alastair. Art Nouveau. London: Thames & Hudson, 1994.
- Duthuit, Georges. The Fauvist Painters. Trans. Ralph Manheim. New York: Wittenborn, Schultz, 1950.
- Elderfield, John. *The Cut-Outs of Henri Matisse*. New York: Braziller, 1978.
- Flam, Jack D. Matisse: The Man and His Art, 1869– 1918. Ithaca, N.Y.: Cornell University Press, 1986.
- . Matisse on Art. Rev. ed. Berkeley: University of California Press, 1995.
- ____. Matisse and Picasso: The Story of Their Rivalry and Friendship. Cambridge, Mass.: Westview, 2003.
- Gordon, Donald E. *Expressionism: Art and Idea*. New Haven: Yale University Press, 1987.
- Hahl-Koch, Jelena. *Kandinsky*. Trans. Karin Brown et al. New York: Rizzoli, 1993.
- Herbert, James D. Fauve Painting: The Making of Cultural Politics. New Haven: Yale University Press, 1992.
- Kerchache, Jacques, Jean-Louis Paudrat, and Lucien Stéphan. Art of Africa. Trans. Marjolijn de Jager. New York: Abrams, 1993.
- Lloyd, Jill. German Expressionism: Primitivism and Modernity. New Haven: Yale University Press, 1991.
- Magnin, André, and Jacques Soulillou. Contemporary Art of Africa. New York: Abrams, 1996.
- Messer, Thomas M. Vasily Kandinsky. New York: Abrams, 1997.
- Myers, Bernard Samuel. The German Expressionists: A Generation in Revolt. New York: Praeger, 1956.
- Perani, Judith, and Fred T. Smith. *The Visual Arts of Africa: Gender, Power, and Life Cycle Rituals.* Upper Saddle River, N.J.: Prentice-Hall, 1998.
- Prelinger, Elizabeth. Käthe Kollwitz. Washington, D.C.: Yale University Press/National Gallery of Art, 1992.
- Richardson, John. A Life of Picasso. I: 1881–1906. New York: Random House, 1991.
- Rubin, William, ed. "Primitivism" in 20th Century Art. 2 vols. New York: The Museum of Modern Art, 1984.

- Russell, John. The World of Matisse, 1869-1954. New York: Time-Life, 1969.
- Schmutzler, Robert. Art Nouveau. Trans. Edouard Roditi. New York: Abrams, 1962.
- Schneider, Pierre. Matisse. Trans. M. Taylor and B. S. Romer. New York: Rizzoli, 1984.
- Steinberg, Leo. Other Criteria: Confrontations with Twentieth-Century Art (1972). New York: Oxford University Press, 1975.
- Taylor, Brandon. Avant-Garde and After: Rethinking Art Now. New York: Abrams, 1995.
- Vogt, Paul. Expressionism: German Painting, 1905-1920. Trans. Antony Vivis. New York: Abrams, 1980.

Cubism, Futurism, and Related **Twentieth-Century Styles**

- Ashton, Dore. Twentieth-Century Artists on Art. New York: Pantheon, 1985.
- Barr, Alfred H., Jr. Picasso: Fifty Years of His Art (1946). New York: Museum of Modern Art, 1974. Cubism and Abstract Art: Painting, Sculpture, Constructions, Photography, Architecture, Industrial Art, Theatre, Films, Posters, Typogra-
- phy (1936). Cambridge, Mass.: Belknap, 1986. Bayer, Herbert, Walter Gropius, and Ise Gropius. Bauhaus, 1919–1928 (1938). New York: Museum
- of Modern Art. 1975 Blake, Peter. Frank Lloyd Wright, Architecture and
- Space. Baltimore: Penguin, 1964. Brown, Milton. The Story of the Armory Show:
- The 1913 Exhibition That Changed American Art. 2nd ed. New York: Abbeville, 1988. Chipp, Herschel B. Picasso's Guernica: History,
- Transformations, Meanings. Berkeley: University of California Press, 1988.
- Cooper, Douglas. The Cubist Epoch (1970). Oxford: Phaidon, 1976.
- Cowling, Elizabeth, and John Golding. Picasso: Sculptor/Painter. London: Tate Gallery, 1994.
- Curtis, William J. R. Le Corbusier: Ideas and Forms. New York: Rizzoli, 1986.
- Doesburg, Theo van. Principles of Neo-Plastic Art. Trans. Janet Seligman. Greenwich, Conn.: New York Graphic Society, 1968.
- Elsen, Albert E. Origins of Modern Sculpture: Pioneers and Premises. New York: Braziller, 1974.
- Fry, Edward F. Cubism. New York: Oxford University Press, 1978.
- Geist, Sidney. Brancusi: The Sculpture and Drawings. New York: Abrams, 1975.
- Brancusi: The Kiss. New York: Harper & Row, 1978.
- Golding, John. Cubism: A History and an Analysis, 1907-1914. 3rd ed. Cambridge, Mass.: Harvard University Press, 1988.
- Gray, Camilla. The Russian Experiment in Art, 1863-1922. Rev. and enl. ed. New York: Thames & Hudson, 1986.
- Green, Christopher, ed. Picasso's Les Demoiselles d'Avignon. Cambridge, Eng.: Cambridge University Press, 2001.
- Harrison, Charles, Francis Frascina, and Gill Perry. Primitivism, Cubism, Abstraction: The Early Twentieth Century. New Haven: Yale University Press, 1993.
- Hilton, Timothy. Picasso (1975). New York: Thames & Hudson, 1985.
- Hultén, Pontus. Futurism and Futurisms. New York: Abbeville, 1986.
- Hunter, Sam, and John Jacobus. American Art of the Twentieth Century: Painting, Sculpture, Architecture. New York: Abrams, 1973.
- Hunter, Sam, John Jacobus, and Daniel Wheeler. Modern Art. 3rd ed. Upper Saddle River, N.J.: Prentice-Hall, 2005.
- Jaffé, Hans L. C. De Stijl, 1917-1931: The Dutch Contribution to Modern Art. Cambridge, Mass .: Belknap, 1986.

- Kuenzli, Rudolf, and Francis M. Naumann. Marcel Duchamp: Artist of the Century. Cambridge, Mass.: MIT Press, 1989.
- Larkin, David, and Bruce Brooks Pfeiffer, eds. Frank Lloyd Wright: The Masterworks. New York: Rizzoli 1993
- Lodder, Christina. Russian Constructivism. New Haven: Yale University Press, 1983.
- Mondrian, Piet C. Plastic Art and Pure Plastic Art, 1937, and Other Essays, 1941-1943. New York: Wittenborn, Schultz, 1951.
- Overy, Paul. De Stijl. New York: Thames & Hudson, 1991.
- Pfeiffer, Bruce Brooks, and Gerald Nordland, eds. Frank Lloyd Wright in the Realm of Ideas. Carbondale: Southern Illinois University Press, 1988
- Read, Herbert. A Concise History of Modern Painting (1959). 3rd ed. New York: Praeger, 1975.
- Richardson, John. A Life of Picasso. II: 1907-1917. New York: Random House, 1996.
- Rosenblum, Robert. Cubism and Twentieth-Century Art. Rev. ed. New York: Abrams, 2001.
- Rubin, William, ed. Pablo Picasso: A Retrospective. New York: Museum of Modern Art, 1980. Picasso and Braque: Pioneering Cubism.
- New York: Museum of Modern Art, 1989. Schiff, Gert, ed. Picasso in Perspective. Engle-
- wood Cliffs, N.J.: Prentice-Hall, 1976. Silver, Kenneth E. Esprit de Corps: The Art of the
- Parisian Avant-Garde and the First World War. 1914-1925. Princeton: Princeton University Press, 1989
- Taylor, Joshua C. Futurism. New York: Museum of Modern Art, 1961.
- Tisdall, Caroline, and Angelo Bozzolla. Futurism. New York: Oxford University Press, 1978.
- Tomkins, Calvin. Duchamp: A Biography (1996). New York: Holt, 1998.
- Weiss, Jeffrey S. The Popular Culture of Modern Art: Picasso, Duchamp, and Avant-Gardism. New Haven: Yale University Press, 1994.
- Whitford, Frank. Bauhaus. London: Thames & Hudson, 1984.
- Wilkin, Karen. Georges Braque. New York: Abbeville, 1991.
- Wright, Frank Lloyd. American Architecture. Ed. E. Kaufmann. New York: Horizon, 1955.
- Zhadova, Larissa A. Malevich: Suprematism and Revolution in Russian Art, 1910-1930. Trans. Alexander Lieven. London: Thames & Hudson, 1982

Dada, Surrealism, Fantasy, and the United States between the Wars

- Alexandrian, Sarane. Surrealist Art (1970). Trans. Gordon Clough. London: Thames & Hudson, 1985.
- Arp, Hans. Arp on Arp: Poems, Essays, Memories. Ed. Marcel Jean. New York: Viking, 1972.
- Baigell, Matthew. The American Scene: American Painting of the 1930's. New York: Praeger, 1974.
- Barr, Alfred H., Jr., ed. Fantastic Art, Dada, Surrealism (1936). New York: Arno, 1969.
- Bearden, Romare, and Harry Henderson. A History of African-American Artists: From 1792 to the Present. New York: Pantheon, 1993.

Dachy, Marc. The Dada Movement, 1915-1923. Trans. Michael Taylor. New York: Skira/Rizzoli, 1990.

- Davidson, Abraham A. Early American Modernist Painting, 1910-1935. New York: Harper & Row, 1981
- Eldredge, Charles C. Georgia O'Keeffe. New York: Abrams, 1991.
- Foucault, Michel. This Is Not a Pipe. Trans. J. Harkness. Berkeley: University of California Press. 1983.
- Franciscono, Marcel. Paul Klee: His Work and Thought. Chicago: University of Chicago Press, 1991

- Herrera, Hayden. Frida Kahlo: The Paintings. New York: HarperCollins, 1991.
- Homer, William Innes. Alfred Stieglitz and the American Avant-Garde. Boston: New York Graphic Society, 1977.
- Lane, John R., and Susan C. Larsen, eds. Abstract Painting and Sculpture in America, 1927-1944. Pittsburgh: Pittsburgh Museum of Art, Carnegie Institute, 1984.
- Levin, Gail. Edward Hopper: An Intimate Biography. New York: Knopf, 1995.
- Lippard, Lucy R., ed. Surrealists on Art. Englewood Cliffs, N.J.: Prentice-Hall. 1970.
- Lynes, Barbara Buhler. O'Keeffe, Stieglitz, and the Critics, 1916-1929 (1989). Chicago: University of Chicago Press, 1991.
- Masheck, Joseph, ed. Marcel Duchamp in Perspective (1975). Cambridge, Mass.: Da Capo, 2002.
- Norman, Dorothy. Alfred Stieglitz, an American Seer (1973). New York: Aperture, 1990.
- 1939. Trans. James Emmons. New York: Rizzoli, 1977
- Powell, Richard J. Black Art and Culture in the Twentieth Century. London: Thames & Hudson, 1997
- Richter, Hans. Dada: Art and Anti-Art. New York: Abrams, 1965
- Rubin, William S. Dada and Surrealist Art. New York: Abrams, 1968.
- Russell, John. Max Ernst: Life and Work. New York: Abrams, 1967.
- Schwarz, Arturo. Man Ray: The Rigour of Imagination. New York: Rizzoli, 1977.
- , ed. The Complete Works of Marcel Duchamp. 3rd ed. 2 vols. London: Greenridge, 1997
- Stich, Sidra. Anxious Visions: Surrealist Art. New York: Abbeville, 1990.
- Sylvester, David. Magritte: The Silence of the World. New York: Abrams, 1992.
- Waldberg, Patrick. Surrealism. New York: Oxford University Press, 1978.
- Wheat, Ellen Harkins. Jacob Lawrence: American Painter. Seattle: University of Washington Press, 1986.

Abstract Expressionism

- Albright, Thomas. Art in the San Francisco Bay Area, 1945-1980. Berkeley: University of California Press, 1985.
- Alloway, Lawrence. Topics in American Art since 1945. New York: Norton, 1975.
- Ashton, Dore. American Art since 1945. New York: Oxford University Press, 1982.
- About Rothko (1983). Cambridge, Mass .: Da Capo, 2003.
- Barron, Stephanie, ed. Degenerate Art: The Fate of the Avant-Garde in Nazi Germany. Los Angeles: Los Angeles County Museum of Art, 1991.
- Doss, Erika. Benton, Pollock, and the Politics of Modernism: From Regionalism to Abstract Expressionism. Chicago: University of Chicago Press, 1991.
- Francis, Richard H. Jasper Johns. New York: Abbeville, 1984.
- Frasina, Frances, ed. Pollock and After: The Critical Debate. 2nd ed. New York: Routledge, 2000.
- Geldzahler, Henry. New York Painting and Sculpture: 1940-1970. New York: Dutton, 1969.
- Gordon, John. Louise Nevelson. New York: Praeger. 1967.
- Greenberg, Clement. Art and Culture: Critical Essays (1961). Boston: Beacon, 1965.
- Guberman, Sidney. Frank Stella: An Illustrated Biography. New York: Rizzoli, 1995.
- Herbert, Robert L, ed. Modern Artist on Art: Ten Unabridged Essays. 2nd ed. Mineola, N.Y.: Dover, 2000.

Picon, Gaëtan. Surrealists and Surrealism, 1919-

- Hertz, Richard. Theories of Contemporary Art. 2nd ed. Englewood Cliffs, N.J.: Prentice-Hall, 1993.
- Hess, Thomas B. Willem de Kooning. Exh. cat. New York: Museum of Modern Art, 1968.
- Howell, John, ed. Breakthroughs: Avant-Garde Artists in Europe and America, 1950–1990. New York: Rizzoli, 1991.
- Hughes, Robert. *The Shock of the New*. 2nd ed. New York: McGraw-Hill, 1991.
- Hunter, Sam. An American Renaissance: Painting and Sculpture since 1940. New York: Abbeville, 1986.
- Johnson, Ellen H. Modern Art and the Object: A Century of Changing Attitudes. New York: Harper & Row, 1976.
- ed. American Artists on Art: From 1940 to 1980. New York: Harper & Row, 1982.
- Krauss, Rosalind E. The Originality of the Avant-Garde and Other Modernist Myths. Cambridge, Mass.: MIT Press, 1985.
- ———. Passages in Modern Sculpture. Cambridge, Mass.: MIT Press, 1989.
- Lipman, Jean. Calder's Universe. Philadelphia and London: Running Press, 1989.
- Lucie-Smith, Edward. Movements in Art since 1945. New ed. London: Thames & Hudson, 2001.
- O'Connor, Francis V. Jackson Pollock. New York: Museum of Modern Art, 1967.
- Reinhardt, Ad. Art-as-Art: The Selected Writings of Ad Reinhardt (1975). Ed. Barbara Rose. Berkeley: University of California Press, 1991.
- Rose, Barbara. Frankenthaler. New York: Abrams, 1971.
- ——. American Art since 1960. Rev. ed. New York: Praeger, 1975.
- ——. Jackson Pollock: Drawing into Painting. New York: Museum of Modern Art, 1980.
- Rosenberg, Harold. Art on the Edge: Creators and Situations. New York: Macmillan, 1975.
- . The Tradition of the New. New York: Da Capo, 1994.
- Rosenblum, Robert. Frank Stella. Harmondsworth: Penguin, 1971.
- Russell, John. The Meanings of Modern Art. Rev. ed. New York: Icon, 1989.
- Sandler, Irving. The Triumph of American Painting: A History of Abstract Expressionism. New York: Harper & Row, 1970.
- ——. American Art of the 1960s. New York: Harper & Row, 1988.
- Selz, Peter. Art in Our Times: A Pictorial History, 1890-1980. New York: Abrams, 1981.
- Smith, David. David Smith—Sculpture and Writing (1968). Ed. Cleve Gray. New York: Thames & Hudson, 1988.
- Tomkins, Calvin. The Scene: Reports on Post-Modern Art. New York: Viking, 1976.
- Waldman, Diane. Mark Rothko, 1903–1970: A Retrospective. New York: Abrams, 1978.
- Wheeler, Daniel. Art since Mid-Century: 1945 to the Present. New York: Vendome, 1991.

Pop Art, Op Art, Minimalism, and Conceptualism

- Alloway, Lawrence. American Pop Art. New York: Collier, 1974.
- . Robert Rauschenberg. Washington, D.C.: Smithsonian Institution, 1976.
- Baker, Kenneth. *Minimalism: Art of Circumstance*. New York: Abbeville, 1988.
- Battcock, Gregory, ed. Minimal Art: A Critical Anthology (1968). Berkeley: University of California Press, 1995.
- Bourdon, David. Warhol. New York: Abrams, 1989. Crichton, Michael. Jasper Johns. Rev. & exp. ed.
- New York: Whitney Museum/Abrams, 1994.

- Crow, Thomas. The Rise of the Sixties: American and European Art in the Era of Dissent, 1955–69. London: Laurence King, 2005.
- Frith, Simon, and Howard Horne. Art into Pop. London: Methuen, 1987.
- Geldzahler, Henry, and Robert Rosenblum. Andy Warhol: Portraits of the Seventies and Eighties. London: Anthony d'Offay Gallery/Thames & Hudson, 1993.
- Goodyear, Frank H., Jr. Contemporary American Realism since 1960. Boston: New York Graphic Society, 1981.
- Lippard, Lucy R. Six Years: The Dematerialization of the Art Object from 1966 to 1972. New York: Praeger, 1973.
- ——. Pop Art. New York: Thames & Hudson, 1985.

—_____. Mixed Blessings: New Art in a Multicultural America. New York: Pantheon, 1990.

- Livingstone, Marco. Pop Art: A Continuing History. New York: Abrams, 1990.
- Lucie-Smith, Edward. Art in the Seventies. Ithaca, N.Y.: Cornell University Press, 1980.
- . Art in the Eighties. New York: Phaidon, 1990.

——. American Art Now. New York: William Morrow, 1985.

- McShine, Kynaston, ed. Andy Warhol: A Retrospective. New York: Museum of Modern Art, 1989.
- Meyer, Ursula. Conceptual Art. New York: Dutton, 1972.
- Rose, Barbara. Claes Oldenberg. New York: Museum of Modern Art, 1970.
- Russell, John, and Suzi Gablik. Pop Art Redefined. London: Thames & Hudson, 1969.
- Varnedoe, Kirk. Jasper Johns: A Retrospective. New York: Museum of Modern Art, 1996.

Varnedoe, Kirk, and Adam Gopnik, eds. Modern Art and Popular Culture: Readings in High and

Low. New York: Museum of Modern Art, 1990. Warhol, Andy. America. New York: Harper & Row, 1985.

Innovation, Continuity, and Globalization

- Alloway, Lawrence. Christo. New York: Abrams, 1969.
- Auping, Michael. Susan Rothenberg: Paintings and Drawings. New York: Rizzoli, 1992.
- Baal-Teshuva, Jacob, ed. Christo: The Reichstag
- and Urban Projects. Munich: Prestel, 1993. Barents, Els. Cindy Sherman. Munich: Schirmer/ Mosel, 1982.
- Barrette, Bill. Eva Hesse Sculpture: Catalogue Raisonné. New York: Timken, 1989.

Battcock, Gregory. Super Realism: A Critical Anthology. New York: Dutton, 1975.

- Beardsley, John. Earthworks and Beyond: Contemporary Art in the Landscape. 3rd ed. New York: Abbeville, 1998.
- Bourdon, David. Christo. New York: Abrams, 1972. Bruggen, Coosje van. Bruce Nauman. New York: Rizzoli, 1988.
- Carmean, E. A., Jr., et al. The Sculpture of Nancy Graves: A Catalogue Raisonné with Essays. New York: Hudson Hills, 1987.
- Carrier, David. The Aesthete in the City: The Philosophy and Practice of American Abstract Painting in the 1980s. University Park, Pa.: Pennsylvania State University Press, 1994.
- Chicago, Judy. The Dinner Party: A Symbol of Our Heritage. Garden City, N.Y.: Anchor/ Doubleday, 1979.
- ——. The Birth Project. Garden City, N.Y.: Doubleday, 1985.
- Cruz, Amanda, Elizabeth A. T. Smith, and Amelia Jones. *Cindy Sherman: Retrospective*. London: Thames & Hudson, 1997.
- Danto, Arthur C. History Portraits/Cindy Sherman. New York: Rizzoli, 1991.

- Flam, Jack, ed. Robert Smithson: The Collected Writings. Berkeley: University of California Press, 1996.
- Frank, Peter, and Michael McKenzie. New, Used, and Improved: Art for the Eighties. New York: Abbeville, 1987.
- Gilmour, John C. Fire on the Earth: Anselm Kiefer and the Postmodern World. Philadelphia: Temple University Press, 1990.
- Godfrey, Tony. The New Image: Painting in the 1980s, New York: Abbeville, 1986.
- Goldberg, RoseLee. Performance Art: From Futurism to the Present. Rev. ed. New York: Thames & Hudson, 2001.
- Haskell, Barbara. Agnes Martin. New York: Whitney Museum of American Art, 1992.
- Henri, Adrian. Total Art: Environments, Happenings, and Performances. New York: Praeger, 1974.
- Hobbs, Robert. Robert Smithson: Sculpture. Ithaca, N.Y.: Cornell University Press, 1981.
- Hobbs, Robert, Wendy Steiner, and Marcia Tucker. Andres Serrano: Works 1983–1993. Philadelphia: Institute of Contemporary Art, University of Pennsylvania, 1994.
- Hunter, Sam. Valerie Jaudon: New Masters. Exh. cat. Berlin: Amerika Haus, 1983.
- Koons, Jeff. The Jeff Koons Handbook. New York: Rizzoli, 1992.
- Laporte, Dominique G. Christo. Trans. Abby Pollak. New York: Pantheon, 1986.
- Lippard, Lucy R. *Eva Hesse*. New York: New York University Press, 1976.
- Marshall, Richard, et al. Robert Mapplethorpe. New York: Whitney Museum of American Art, 1988.
- ——. Jean-Michel Basquiat. New York: Whitney Museum of American Art, 1992.
- Meyer, Ursula, ed. Conceptual Art. New York: Dutton, 1971.
- Ratcliff, Carter. Komar and Melamid. New York: Abbeville, 1988.
- Rosen, Randy, and Catherine C. Brawer, eds. Making Their Mark: Women Artists Move into the Mainstream, 1970–85. New York: Abbeville, 1989.
- Sandler, Irving. Art of the Postmodern Era: From the Late 1960s to the Early 1990s. New York: HarperCollins, 1996.
- Smithson, Robert. The Writings of Robert Smithson: Essays with Illustrations. Ed. Nancy Holt. New York: New York University Press, 1975.
- Stachelhaus, Heiner. Joseph Beuys. Trans. David Britt. New York: Abbeville, 1991.
- Storr, Robert. Chuck Close. New York: Museum of Modern Art, 1998.
- Tisdall, Caroline. Joseph Beuys. New York: Solomon R. Guggenheim Museum, 1979.
- Vaizey, Marina. Christo. New York: Rizzoli, 1990.
- Wolf, Jahn. The Art of Gilbert and George; or, An Aesthetic of Existence. Trans. David Britt. London: Thames & Hudson, 1989.

African Art

1996.

- Bascom, William Russell. African Art in Cultural Perspective. New York: Norton, 1980.
- Ben-Amos, Paula G. *The Art of Benin*. 2nd rev. ed. London: British Museum Press, 1995.
- Berlo, Janet Catherine, and Lee Anne Wilson, eds. Arts of Africa, Oceania, and the Americas: Selected Readings. Englewood Cliffs, N.J.: Prentice-Hall, 1993.
- Blier, Suzanne Preston. The Royal Arts of Africa: The Majesty of Form. New York: Abrams, 1998.
- Kerchache, Jacques, Jean-Louis Paudrat, and Lucien Stéphan. Art of Africa. Trans. Marjolijn de Jager. New York: Abrams, 1993. Magnin, André, and Jacques Soulillou, eds. Con-

temporary Art of Africa. New York: Abrams,

Perani, Judith, and Fred T. Smith. The Visual Arts of Africa: Gender, Power, and Life Cycle Rituals. Upper Saddle River, N.J.: Prentice-Hall, 1998.

Buddhist Art

- Bechert, Heinz, and Richard Gombrich, eds. The World of Buddhism. London: Thames & Hudson, 1991.
- Fisher, Robert E. Buddhist Art and Architecture. New York: Thames & Hudson, 1993.
- Rowland, Benjamin. *The Evolution of the Buddha Image* (1963). New York: Arno, 1976.
- Seckel, Dietrich. Art of Buddhism. Trans. Ann E. Keep. New York: Crown, 1964.
- Zwalf, W., ed. Buddhism: Art and Faith. New York: Macmillan, 1985.

Chinese Art

- The Arts of China. 3 vols. Tokyo: Kodansha, 1968– 1970.
- Barnhart, Richard M., James Cahill, Wu Hung, Yang Xin, Nie Chongzheng, and Lang Shaojun. *Three Thousand Years of Chinese Painting*. New Haven: Yale University Press, 1997.
- Confucius. Analects. Ed. Bradley Smith and Wango Weng. In Bradley Smith and Wan-go Weng. China: A History in Art. New York: Doubleday, 1973.
- Laozi. Daode jing. Ed. Wing-tsit Chan. In Wingtsit Chan. A Source Book in Chinese Philosophy. Princeton: Princeton University Press, 1969.
- Loehr, Max. The Great Painters of China. New York: Harper & Row, 1980.
- Rawson, Jessica, ed. The British Museum Book of Chinese Art. New York: Thames & Hudson, 1993.
- Sickman, Laurence C. S., and Alexander Soper. Art and Architecture of China. Pelican History of Art. Harmondsworth: Penguin, 1971.
- Speiser, Werner. *The Art of China: Spirit and Society.* Trans. George Lawrence. New York: Crown, 1961.
- Treasures from the Bronze Age of China. Exh. cat. New York: Metropolitan Museum of Art, 1980.
- Tregear, Mary. Chinese Art. Rev. ed. New York: Thames & Hudson, 1997.
- Vainker, S. J. Chinese Pottery and Porcelain: From Prehistory to the Present. London: British Museum Press, 1991.

Far Eastern Art (General)

- Bussagli, Mario. Oriental Architecture. Trans. John Shepley. 2 vols. New York: Electa/Rizzoli, 1989. Lee, Sherman E. A History of Far Eastern Art. 5th
- ed. New York: Abrams, 1994. Louis-Frédéric. The Temples and Sculpture of
- Southeast Asia. Trans. Arnold Rosin. London: Thames & Hudson, 1965.
- Martynov, Anatolii I. *The Ancient Art of Northern Asia*. Urbana: University of Illinois Press, 1991.

Indian Art

- Asher, Catherine B. Architecture of Mughal India. New York: Cambridge University Press, 1992.
- Basham, Arthur Llewellyn. The Wonder That Was India. London: Sidgwick & Jackson, 1987.
- Behl, Benoy K. The Ajanta Caves: Artistic Wonder of Ancient Buddhist India. New York: Abrams, 1998.
- Brown, Percy. Indian Architecture. 6th repr. ed. Bombay: Taraporevala, 1976.

- Coomaraswamy, Ananda K. History of Indian and Indonesian Art. New York: Dover, 1965.
- Craven, Roy C. Indian Art: A Concise History. Rev. ed. New York: Thames & Hudson, 1997.
- Dallapiccola, Anna L., and Stephanie Zingel-Avé Lallemant, eds. *The Stúpa: Its Religious, Historical, and Architectural Significance*. Wiesbaden: Steiner, 1979.
- Goetz, Hermann. The Art of India: Five Thousand Years of Indian Art. 2nd ed. New York: Crown, 1964.
- Harle, James C. The Art and Architecture of the Indian Subcontinent. 2nd ed. Pelican History of Art. Harmondsworth: Penguin, 1987.
- Huntington, Susan L., and John C. Huntington. The Art of Ancient India: Buddhist, Hindu, Jain. New Haven: Yale University Press, 1994.
- Lannoy, Richard. The Speaking Tree: A Study of Indian Culture and Society. New York: Oxford University Press, 1974.
- Meister, Michael W., and M. A. Dhaky, eds. Encyclopaedia of Indian Temple Architecture. Philadelphia: University of Pennsylvania Press, 1983.
- Michell, George. The Hindu Temple: An Introduction to Its Meaning and Forms. Chicago: University of Chicago Press, 1988.
- ——. The Penguin Guide to the Monuments of India. 2 vols. New York: Viking, 1989.
- Nou, Jean-Louis, Amina Okada, and M.C. Joshi. Taj Mahal. New York: Abbeville, 1993.
- Rowland, Benjamin. Art and Architecture of India: Buddhist, Hindu, Jain. Pelican History of Art. Harmondsworth: Penguin, 1977.
- Sivaramamurti, Calambur. The Art of India. New York: Abrams, 1977.
- Soundara Rajan, K. V. Indian Temple Styles: The Personality of Hindu Architecture. New Delhi: Munshiram Manoharlal, 1972.
- Volwahsen, Andreas. *Living Architecture: Indian.* Trans. Ann E. Keep. New York: Grosset & Dunlap, 1969.
- Weiner, Sheila L. Ajanțā: Its Place in Buddhist Art. Berkeley: University of California Press, 1977.
- Zimmer, Heinrich. *Myths and Symbols in Indian Art and Civilization* (1946). Princeton: Princeton University Press, 1992.

Japanese Art

- Akiyama, Terukazu. Japanese Painting. Treasures of Asia. Geneva: Skira, 1977.
- Mason, Penelope. *History of Japanese Art.* 2nd ed. Upper Saddle River, N.J.: Prentice-Hall, 2005.

Paine, Robert T., and Alexander Soper. *The Art* and Architecture of Japan. 3rd ed. Pelican History of Art. Harmondsworth: Penguin, 1981.

Stanley-Baker, Joan. Japanese Art. Rev. and exp. ed. New York: Thames & Hudson, 2000.

Yoshikawa, Itsuji. *Major Themes in Japanese Art.* Trans. Armins Nikovskis. New York: Weatherhill, 1976.

Japanese Woodblock Prints

- Andö, Hiroshige. One Hundred Famous Views of Edo (1986). New York: Braziller/Brooklyn Museum, 1992.
- Chibbert, David. The History of Japanese Printing and Book Illustration. New York: Kodansha, 1977.
- Lane, Richard. Images from the Floating World: The Japanese Print, Including an Illustrated Dictionary of Ukiyo-e. New York: Putnam, 1978.
- Amy Newland and Chris Uhlenbeck, eds. Ukiyo-e: The Art of Japanese Woodblock Prints. New York: Smithmark, 1994.

Mesoamerican and South Pacific Art

- Blocker, H. Gene. The Aesthetics of Primitive Art. Lanham, Md.: University Press of America, 1994.
- Caruana, Wally. *Aboriginal Art.* 2nd ed. New York: Thames & Hudson, 2003.
- Coe, Michael D. *The Maya*. 5th ed. New York: Thames & Hudson, 1993.
- Coote, Jeremy, and Anthony Shelton, eds. *Anthropology, Art, and Aesthetics*. New York: Oxford University Press, 1992.
- Corbin, George A. Native Arts of North America, Africa, and the South Pacific: An Introduction. New York: Harper & Row, 1988.
- Kubler, George. The Art and Architecture of Ancient America: The Mexican, Maya, and Andean Peoples. 3rd ed. Pelican History of Art. New Haven: Yale University Press, 1990.
- Mexico: Splendors of Thirty Centuries. New York: Metropolitan Museum of Art, 1990.
- Miller, Mary Ellen. The Art of Mesoamerica: From Olmec to Aztec. 3rd ed. New York: Thames & Hudson, 2001.
- Pasztory, Esther. Pre-Columbian Art. New York: Cambridge University Press, 1998.
- Spinden, Herbert J. A Study of Maya Art, Its Subject Matter and Historical Development (1913). New York: Dover, 1975.
- Stone-Miller, Rebecca. The Art of the Andes from Chavín to Inca. 2nd ed. New York: Thames & Hudson, 2002.
- Townsend, Richard. The Ancient Americas: Art from Sacred Landscapes. Chicago: Art Institute of Chicago, 1992.

Native American Art

- Corbin, George A. Native Arts of North America, Africa, and the South Pacific: An Introduction. New York: Harper & Row, 1988.
- Feest, Christian F. Native Arts of North America. Rev. ed. London: Thames & Hudson, 1992.
- Hunt, Mary Austin. Taos Pueblo (1930). Photographed by Ansel Adams and described by Mary Austin. Boston: New York Graphic Society, 1977.
- Whiteford, Andrew. North American Indian Arts. New York: Golden Press, 1970.

Oceanic Art

- Barrow, Terence. The Art of Tahiti and the Neighbouring Society, Austral and Cook Islands. New York: Thames & Hudson, 1979.
- Corbin, George A. Native Arts of North America, Africa, and the South Pacific: An Introduction. New York: Harper & Row, 1988.
- Hanson, Allan, and Louise Hanson, eds. Art and Identity in Oceania. Honolulu: University of Hawaii Press, 1990.

Persian Painting and Miniatures

- Binyon, Laurence, J. V. S. Wilkinson, and Basil Gray. *Persian Miniature Painting* (1931). New York: Dover, 1971.
- Canby, Sheila R., ed. Persian Masters: Five Centuries of Painting. Bombay: Marg, 1990.
- ——. Persian Painting. New York: Thames & Hudson, 1993.
- Titley, Norah M. Persian Miniature Painting and Its Influence on the Arts of Turkey and India: The British Library Collections. Austin: University of Texas Press, 1984.

Acknowledgments

Many of the line drawings in this book have been specially drawn by Taurus Graphics, Kidlington, and the maps have been rendered or re-rendered by Patti Isaacs of Parrot Graphics. McGraw-Hill is grateful to all who have allowed their plans and 5 diagrams to be reproduced. Every effort has been made to contact the copyright holders, but should 5 there be any errors or omissions, they would be pleased to insert the appropriate acknowledgement in any subsequent edition of this publication.

- map p. 32 From Abbé H. Breuil, Quatre Cents Siècles d'Art. Montignac: Centre d'É-5 tudes et de Documentation Préhistorique, 1979. From Spiro Kostof, A History of Ar-5 1.18
- chitecture: Settings and Rituals. Oxford: Oxford University Press, 1985. " 1985. Drawings by Richard Tobias. John McKenna illustration and 2.5

- design. 2.9 From Lois Fichner-Rathus, Understanding Art. Upper Saddle River, NJ: Prentice-Hall, Inc., 1986. " 1986. Reprinted by permission of Prentice-Hall, Inc., Upper Saddle River, NJ. 2.28 From Henri Frankfort, Art & Archi-
- tecture of the Ancient Orient. London: Yale University Press, Pelican History of Art Series, 1970.
- From Quirke and Spencer, eds., 3.3, 3.4 British Museum Book of Ancient Egypt. London: British Museum Press, 1992.
- From W. Stevenson Smith, The Art 3.14 and Architecture of Ancient Egypt. London: Yale University Press, Peli-8 can History of Art series, 1981.
- 3.28 From Phipps and Wink, Invitation to the Gallery. New York: McGraw-Hill, 1987.
- From Richard Tansey and Fred 3.29 Kleiner, Gardner's Art Through the Ages, 10e. Fort Worth: Harcourt Brace College Publishers, 1996. From Reynold A. Higgins: The Ar-4.4
- chaeology of Minoan Crete. Henry Z. Walck, Random House, Inc., 1973. 4.14 From Christos Doumas, Thera. Lon-
- don: Thames & Hudson Ltd, 1983. Fondazione Giorgio Cini, Instituto di 4.18
- Storia dell'Arte, Venice.

4.19	Drawn by P. P. Platt after Piet de Jong, from Reynold A. Higgins, <i>Mi</i> -	W4.2
5.23	noan & Mycenaean Art. London: Thames & Hudson Ltd, 1983. John McKenna illustration and	W4.7
5.23	design.	
5.30	From Boardman et al, <i>The Oxford</i> <i>History of Classical Art.</i> Oxford: Ox- ford University Press, 1997.	9.5, 9
5.36	From John Boardman, Greek Sculp-	
0100	ture: The Classical Period. London:	9.11
	Thames & Hudson Ltd, 1985.	
5.37	From John Griffiths Pedley, Greek	
	Art and Architecture. New York: Si- mon & Schuster, 1993.	W5.5
5.43, 5.44	From John Boardman, Greek Sculp-	W5.5
5.45, 5.44	ture: The Classical Period. London:	
	Thames & Hudson Ltd, 1985.	W5.1
5.38, 5.39,	5.40, 5.49, 5.64 From Leland M.	
	Roth: Understanding Architecture,	
	Boulder, CO: Westview Press, 1994.	10.15
5.54	From B. F. Cook, <i>The Elgin Marbles</i> . London: British Museum Press, 1984.	10.13
6.6b	Museo Archeologico, Florence, Italy.	
6.11	From Mario Moretti, <i>Cerveteri</i> . Insti-	11.4
0.11	tuto Geografico De Agostins,	
	Navaro, 1984.	
W2.2	From Treasures from the Bronze Age	
	of China. New York: Metropolitan	44.0
7 10 7 19	Museum of Art, 1980. 7.16 From Leland M. Roth: <i>Under-</i>	11.6
7.10, 7.12,	standing Architecture. Boulder, CO:	11.10
	Westview Press, 1994.	
7.21	From Frank Sear, Roman Architec-	11.20
	ture. London: B. T. Batsford Ltd,	
	1982.	
8.5	From Leland M. Roth, Understanding	11.4
	Architecture, Boulder, CO: Westview Press, 1994.	11.43
8.6	From Lois Fichner-Rathus, Under-	
0.0	standing Art. Upper Saddle River,	W6.8
	NJ: Prentice-Hall, Inc. " 1986.	
	Reprinted by permission of Prentice-	
	Hall, Inc., Upper Saddle River, NJ.	
8.9	From Richard Tansey and Fred	W6.
	Kleiner, Gardner's Art Through the Ages, 10e. Fort Worth: Harcourt	wo.
	Brace College Publishers, 1996.	
8.33	From Spiro Kostof, A History of Ar-	W6.
	chitecture: Settings and Rituals. Ox-	
	ford: Oxford University Press, 1985 "	
	1985. Drawings by Richard Tobias.	12.5

N4.2 British Architectural Library: Royal Institute of British Architects, London. N4.7 From Robert E. Fisher, Buddhist Art and Architecture. London: Thames & Hudson Ltd, 1993. From Richard Tansey and Fred 9.5. 9.36 Kleiner, Gardner's Art Through the Ages, 10e, Fort Worth: Harcourt Brace College Publishers, 1996. From Godfrey Goodwin, History of 9.11 Ottoman Architecture. London: Thames & Hudson Ltd, 1971. By per-mission of Mrs G. T. M. Goodwin. From George Kubler, Art and Archi-W5.5 tecture of Ancient America, 3rd ed. London: Yale University Press, 1984. W5.15 Drawing by Jean Blackburn from Michael D. Coe, The Maya, 5th ed. London: Thames & Hudson Inc., 1993 From Meyer Schapiro: The Sculpture 10.13 of Moissac. New York: George Braziller, Inc., 1985. From Lois Fichner-Rathus, Under-11.4 standing Art. Upper Saddle River, NJ: Prentice-Hall, Inc., 1986. " 1986. Reprinted by permission of Prentice-Hall, Inc., Upper Saddle River, NJ. 11.6 From Dictionnaire raisonné de l'architecture francaise. Paris, 1859-68. 11.16 John McKenna illustration and design 11.26 From Richard Tansey and Fred Kleiner, Gardner's Art Through the Ages, 10e. Fort Worth: Harcourt Brace College Publishers, 1996. 11.45 From Leland M. Roth, Understanding Architecture, Boulder, CO: Westview Press, 1994. W6.8, W6.9 From Laurence Sickman and Alexander Soper, The Art and Archi-tecture of China. London: Yale University Press, Penguin History of Art series, 1971. From Susan Huntington, Art of An-W6.11 cient India. New York: Weatherhill Inc., 1993. W6.16 From Traveler's Key to Northern India. New York: Alfred A. Knopf Inc., 1983

John McKenna illustration and design.

Picture Credits

- I.1 Amsterdam, Van Gogh Museum (Vincent van Gogh Foundation)
- I.2 © Daniel Schwartz/Lookat, Zurich
- I.3 © akg-images/Jean-Louis Nou
- I.4 The Museum of Modern Art, New York. Given anonymously. Digital Image © The Museum of Modern Art/Licensed by SCALA/ Art Resource, NY. © 2006 Artists Rights Society (ARS), New York/ADAGP, Paris
- I.5 Photograph © 2006 Museum Associates/ LACMA. © 2006 C. Herscovici, Brussels/ Artists Rights Society (ARS), New York
- I.6 Osterreichische Nationalbibliothek, Vienna
- I.7 Erich Lessing/Art Resource, NY
- I.8 Image © 2006 Board of Trustees, National Gallery of Art, Washington, DC, Paul Mellon Collection, National Gallery of Art, Washington, DC. 1983.1.46
- I.9 Réunion des Musées Nationaux/Art Resource, NY
- I.10 Artothek
- I.11 The Museum of Modern Art, New York. Digital Image © The Museum of Modern Art/ Licensed by SCALA/Art Resource, NY. © 2006 Artists Rights Society (ARS), New York/ProLitteris, Zurich I.14 © 2006 Estate of Alexander Calder/Artists
- Rights Society (ARS), New York
- I.21, I.22, I.24, I.25 The Museum of Modern Art, New York. Purchase. Digital Image © The Museum of Modern Art/Licensed by SCALA/Art Resource, NY. © 2006 Artists Rights Society (ARS), New York/Beeldrecht, Amsterdam
- I.23 The Museum of Modern Art, New York. Gift of Nelly van Doesburg. Digital Image © The Museum of Modern Art/Licensed by SCALA/Art Resource, NY. © 2006 Artists Rights Society (ARS), New York/Beeldrecht, Amsterdam
- 1.1a, b Erich Lessing/Art Resource, NY
- 1.1c © akg-images/Erich Lessing
- 1.2 Musée d'Aquitaine, Bordeaux, France. © Mai-rie, Bordeaux Photo: Jean-Michel Arnaud
- 1.3 Réunion des Musées Nationaux/Art Resource, NY
- 1.4 Bridgeman-Giraudon/Art Resource, NY
- 1.5, 1.6, 1.7, 1.8 Courtesy of J. Clottes, the Regional Office of Cultural Affairs, Rhône-Alpes, and the Ministry of Culture and Communication. (Direction du Patrimoine, sous Direction de l'Archélogie)
- 1.9 Photo: Jean Vertut, Issy-les-Moulineaux
- 1.10a Jean Dominique Lajoux, Paris
- 1.10b From Abbe Breuil: Four Hundred Centuries of Cave Art, opp. P. 167/By permission of the Syndics of the Cambridge University Library
- 1.12 Colorphoto Hans Hinz
- 1.13 Douglas Mazonowicz/Art Resource, NY
- 1.14 Claudio Emmer
- 1.15 Institut Amatller d'Art Hispanic. © Museo
- Arqueologico Nacional de Madrid 1.16 © Robert Frerck/Robert Harding Picture Li-
- brary, London 1.17 James Wellard/Sonia Halliday Photographs
- 1.19, 1.20 J. Allan Cash Ltd., London
- 1.21 © Felix Zaska/Corbis
- 1.22 Art Resource, NY
- 1.26 © English Heritage Photograph Library, London
- W1.1 George Chaloupka Collection, Darwin
- W1.2 Ron Ryan/Coo-ee Picture Library, Elwood, Victoria
- W1.4 Powerstock/Zefa, London
- 2.1 Jericho Excavation Fund, British School of Archaeology in Jerusalem
- 2.2 Cornucopia/Susanna Hickling

- 2.3 James Mellaart, London
- 2.4 right, 2.7, 2.30, 2.35, 2.36 © Bildarchiv Preussischer Kulturbesitz/Art Resource, NY
- 2.6, 2.19b Erich Lessing/Art Resource, NY
- 2.10a, b The Pierpont Morgan Library/Art Resource, NY 2.11, 2.15, 2.24, 2.25, 2.26, 2.27 © The Trustees
- of The British Museum
- 2.12, 2.13 Courtesy of the Oriental Institute of the University of Chicago. All rights reserved
- 2.14a University of Pennsylvania Museum (image # 150029) 2.14b University of Pennsylvania Museum (image
- # 150848)
- 2.16a, b Scala/Art Resource, NY
- 2.17, 2.19a, 2.21a, b, 2.29, 2.31 Réunion des Musées Nationaux/Art Resource, NY
- 2.18 Museum of Fine Arts, Boston, Francis Barlett Donation of 1912, 26.289 Photograph © 2006 Museum of Fine Arts, Boston
- 2.20 © Erwin Boehm, Mainz
- 2.22 Scala/Art Resource, NY
- 2.32 The Metropolitan Museum of Art, Purchase, Joseph Pulitzer Bequest, 1966 (66.173). Photograph © 1983 The Metropolitan Museum of Art
- 2.33 Boltin Picture Library/Bridgeman Art Library 2.34 Archaeological Museum, Ufa, Photograph by Bruce White
- 2.37 Bridgeman-Giraudon/Art Resource, NY
- 2.38 The Metropolitan Museum of Art. Fletcher Fund, 1954 (54.3.3). Photograph © 1982 The Metropolitan Museum of Art
- 3.1, 3.2, 3.19, 3.40, 3.41, 3.42 Scala/Art Resource, NY
- 3.5, 3.8, 3.9, 3.34, 3.36, 3.43, 3.44, 3.47 © The Trustees of The British Museum
- 3.11 SEF/Art Resource, NY
- 3.12 Carolyn Clark/Spectrum Colour Library, London
- 3.15, 3.33 Erich Lessing/Art Resource, NY
- 3.17a, b © Archivo Iconografico, S. A./Corbis
- 3.18 a, b King Menkaure (Mycerinus) and Queen, Egyptian, Old Kingdom, Dynasty 4, reign of Menkaure, c. 2490-2472 B.C. Found in Egypt, Giza, Menkaure Valley Temple, Grevwacke, 4 ft. 61/2 in. high. Museum of Fine Arts, Boston, Harvard University-Museum of Fine Arts Expedition, 11.1738. Photo-graph © 2006 Museum of Fine Arts, Boston, SC116543
- 3.20, 3.23 Bridgeman-Giraudon/Art Resource, NY
- 3.21, 3.22 Museum of Fine Arts, Boston. Harvard University-Museum of Fine Arts Expedition, 14.720 Photograph © 2006 Museum of Fine Arts, Boston
- 3.24 The Metropolitan Museum of Art, Gift of Edward S. Harkness, 1914 (14.3.17). Photograph © 1993 The Metropolitan Museum of Art
- 3.25 The Metropolitan Museum of Art, Purchase, Edward S. Harkness Gift, 1926 (26.7.1394). Photograph © 1983 The Metropolitan Museum of Art
- 3.26 Museum of Fine Arts, Boston. Harvard University-Museum of Fine Arts Expedition, 20.1822. Photograph © 2006 Museum of Fine Arts, Boston
- 3.27 The Metropolitan Museum of Art, Levi Hale Willard Bequest, 1890 (90.35.1). Photograph © The Metropolitan Museum of Art
- 3.31 Photograph of the Court of Temple of Amun-Mut-khonsu, by Wim Swaan. Getty Research Institute, Research Library, 96.P.21
- 3.32 The Metropolitan Museum of Art. Rogers Fund, 1928 (28.3.18). Photograph © 2005 The Metropolitan Museum of Art

- 3.35 Werner Forman/Art Resource, NY
- 3.37 Hirmer Foto Archiv, Munich
- 3.38a, b, 3.39, 3.50 Bildarchiv Preussischer Kulturbesitz/Art Resource, NY
- 3.45 Egyptian Expedition of The Metropolitan Museum of Art, Rogers Fund, 1930 (30.4.21). Photograph © 1978 The Metropolitan Museum of Art
- 3.46 Luise Villota/Bruce Coleman, Inc.
- 3.48 Courtesy of W. V. Davies, London
- 3.49 By permission of the Syndics of Cambridge University Library
- 4.1, 4.9 Erich Lessing/Art Resource, NY
- 4.2, 4.25 © Studio Kontos, Athens
- 4.3, 4.11 Hirmer Foto Archiv, Munich
- 4.5, 4.21 SEF/Art Resource, NY
- 4.6, 4.13, 4.15, 4.16 Nimatallah/Art Resource, NY
- 4.7, 4.28a, b Craig and Marie Mauzy, Athens, Greece
- 4.8 Ancient Art and Architecture Collection, Pinner, UK
- 4.10 Alison Frantz Collection, American School of Classical Studies at Athens. Courtesy of Craig and Marie Mauzy, Athens, Greece
- 4.12, 4.20 Scala/Art Resource, NY
- 4.17 Archaeological Society at Athens
- **4.19** Drawn by P. P. Platt after Piet de Jong, from Reynold A. Higgins, Minoan & Mycenean Art, London: Thames & Hudson Ltd. 1983
- 4.22 Eric Hosking/Bruce Coleman, Inc.
- 4.23 © Vanni Archive/Corbis
- 4.27 Nimatallah/Art Resource, NY
- 5.1, 5.5a, 5.6 © Studio Kontos, Athens 5.3, 5.9, 5.51, 5.52a, 5.53 © The Trustees of The
- British Museum
- 5.4, 5.29, 5.60, 5.65 Nimatallah/Art Resource, NY

5.12, 5.13, 5.71, 5.72 Réunion des Musées Na-

5.19a, b, c The Metropolitan Museum of Art,

5.21a, b, 5.22a, b, 5.42 © Craig and Marie Mauzy,

5.35a, 5.77, 5.78 Bildarchiv Preussischer Kultur-

5.47 Sonia Halliday Photographs 5.48, 5.52b, 5.56 © akg-images/Peter Connolly

5.57 Photograph courtesy of the Royal Ontario

5.58 Deutsches Archaeologisches Institut-Athens

5.73 The Metropolitan Museum of Art, Rogers

The Metropolitan Museum of Art

6.1 Museo delle Antichita Etrusche e Italiche, Uni-

6.3, 6.4, 6.5, 6.6a, b, 6.7, 6.13a, b Scala/Art Re-

Fund, 1943 (43.11.4). Photograph © 1985

5.67 National Archaeological Museum, Athens

5.69 Ny Carlsberg Glyptothek, Copenhagen

5.68a Foto Marburg/Art Resource, NY

5.50a, b, 5.70 Giraudon/Art Resource, NY

5.20 Lauros/Giraudon/Bridgeman Art Library

5.33, 5.68b Erich Lessing/Art Resource, NY

besitz/Art Resource, NY

Fletcher Fund, 1932 (32.11.1). Photograph

© 1997 The Metropolitan Museum of Art

- 5.7, 5.14, 5.15, 5.16, 5.17, 5.24, 5.25, 5.26a, b, 5.27, 5.28, 5.31, 5.41, 5.59, 5.61, 5.66a, b
 - Scala/Art Resource, NY
 - 5.10, 5.55 Hirmer Foto Archiv, Munich 5.11 Photo: Christa Koppermann/Studio Koppermann, Gauting, Munich

tionaux/Art Resource, NY

5.18, 5.63 J. Allan Cash Ltd., London

Athens, Greece

5.35b Photo Peter A. Clavton

5.45 Vanni/Art Resource, NY

Museum, © ROM

5.62 A. F. Kersting, London

5.74, 5.75 © Araldo de Luca

versita di Roma

source, NY

6.2 Erich Lessing/Art Resource, NY

6.8, 6.10 Hirmer Foto Archiv, Munich

6.9, 6.12 Alinari/Art Resource, NY

5.32 Delphi Museum

W5.8a, b, W5.11, W5.12, W5.18 © Justin Kerr,

W5.9 The Metropolitan Museum of Art. The Mi-

W5.10 © President and Fellows of Harvard Col-

W5.13, W5.17, W5.22, W5.26, W5.28 Tony Mor-

W5.14 © President and Fellows of Harvard Col-

Burger. (T 1051.1 - 48-63-20/17561)

W5.16 © Robert Francis/South American Pictures

W5.23 The Art Institute of Chicago, Kate S. Buck-

phy © The Art Institute of Chicago

rera, Lima, Peru

tan Museum of Art

10.3 Erich Lessing/Art Resource, NY

source, NY

Library

10.10, 10.24 Photo Zodiaque

10.17, 10.18 Photo by David Finn

2293, fol. 19v, initial

10.29 © Steinar Myhr/NN/Samfoto

10.33, 10.42 A. F. Kersting, London

of the City of Bayeaux

10.39 Foto Marburg/Art Resource, NY

10.41 Anthony Scibilla/Art Resource, NY

Cambridge University Library

11.2 Anthony Scibilia/Art Resource, NY

Halliday Photographs

11.31 James Austin

11.27 Scibilia/Art Resource, NY

11.32 Collection Roger-Viollet

11.36 Snark/Art Resource, NY

11.38 Art Resource, NY

1527

11.11 John Elk III/Bruce Coleman, Inc.

11.22, 11.28 Giraudon/Art Resource, NY

11.24 Bob Burch/Bruce Coleman, Inc.

11.33 Peter Willi/Bridgeman Art Library

Bridgeman Art Library

11.1 From Abbot Suger on the Abbey Church of

11.5, 11.39, 11.48, 11.51 A. F. Kersting, London

11.47 © Angelo Hornak Library 11.8 Sonia Halliday and Laura Lushington/Sonia

11.9, 11.10 Foto Marburg/Art Resource, NY

11.12 Adam Woolfitt/Woodfin Camp & Associates

11.13, 11.17, 11.18, 11.19, 11.20, 11.21, 11.30,

11.23 By permission of the British Library, Harl.

11.37 Bibliothèque Nationale de France, Paris/

11.7, 11.25, 11.29, 11.35, 11.42, 11.43, 11.44,

Saint-Denis and its Art Treasures/Repro-

duced by permission of the Syndics of the

10.34, 10.35 Hirmer Fotoarchiv, Munich 10.34, 10.35 minut rotoatent, manuel
 10.36, 10.37, 10.38 Tapisserie de Bayeux, Musée de l'Évéché, Bayeux, by special permission

10.22 James Austin, Bourne, Cambridge

Lat. 254, fol. 10

10.28 Ål Cathedral, Norway

10.44 © Bill Wassman

W5.24 © Museo Arqueológico Rafael Larco Her-

W5.25 © UCLA Fowler Museum of Cultural His-

W5.27 The Metropolitan Museum of Art, The Mi-

10.1, 10.2 The Pierpont Morgan Library/Art Re-

10.4, 10.11, 10.20, 10.25 © Paul M.R. Maeyaert 10.6, 10.9, 10.31, 10.32 Scala/Art Resource, NY

10.12, 10.15, 10.26 Réunion des Musées Na-tionaux/Art Resource, NY

10.16 British Library, London/Bridgeman Art

10.21 Bibliothèque Nationale de France, Paris. Ms.

10.23 Bibliothèque Nationale de France, Paris. Ms.

10.14, 10.19, 10.27 Giraudon/Art Resource, NY

tory. Photo: Susan Einstein

W5.19 John Bigelow Taylor/Art Resource, NY

rison/South American Pictures

Metropolitan Museum of Art

chael C. Rockefeller Memorial Collection,

Bequest of Nelson A. Rockefeller, 1979

(1979.206.1063). Photograph © 1980 The

lege. All rights reserved. Peabody Museum,

Harvard University. (T738 - 50-63-20/18487/

lege. All rights reserved. Peabody Museum,

Harvard University. Photograph by Hillel

ingham Endowment, 1955.2100. Photogra-

chael C. Rockefeller Memorial Collection,

Bequest of Nelson A. Rockefeller, 1979 (1979.

206.393). Photograph © 1982 The Metropoli-

New York

T738)

- 6.14 Museum of Fine Arts, Boston. Gift of Mr. and Mrs. Cornelius C. Vermeule III, 1975.99. Photograph © 2006 Museum of Fine Arts, Boston
- 6.15 The Art Archive
- 6.16 Ancient Art and Architecture Collection, Pinner, UK
- W2.1 © Joe Sohm/The Image Works
- W2.4, W2.5, W2.7, W2.8, W2.9, W2.10, W2.11 Courtesy, The Cultural Relics Bureau, People's Republic of China, and The Metropolitan Museum of Art, New York. Photograph by Seth Joel
- W2.6 © The Cleveland Museum of Art, 2001, Purchase from the J. H. Wade Fund, 1930.730
- 7.3, 7.45, 7.61 © Araldo de Luca 7.4, 7.8, 7.39, 7.41, 7.44, 7.47 Alinari/Art Resource, NY
- 7.6 Fototeca Unione
- 7.9, 7.49 Photo Peter A. Clayton 7.11 Giancarlo Costa Fotografo, Milan
- 7.13, 7.20, 7.29 © akg-images/Peter Connolly
- 7.14, 7.19, 7.34, 7.35, 7.40, 7.48, 7.50, 7.51, 7.55, 7.57, 7.58, 7.62 Scala/Art Resource, NY
- 7.17 © Alinari Archives/Corbis
- 7.18 Mary Evans Picture Library, London
- 7.22 © D&J Heaton/Spectrum Colour Library
- 7.23 A. F. Kersting, London 7.25, 7.54, 7.60 © Canali Photobank
- 7.27, 7.33 © akg-images/Pirozzi
- 7.30 Image © 2006 Board of Trustees, National Gallery of Art, Washington, DC, Samuel H. Kress Collection. 1939.1.24. (135)/PA
- 7.31 © akg-images/Hilbich
- 7.32 Nimatallah/Art Resource, NY
- 7.36, 7.37 National History Museum, Bucharest
- 7.38 SEF/Art Resource, NY
- 7.42 The Metropolitan Museum of Art, Purchase, Joseph Pulitzer Bequest, 1955 (55.11.5). Photograph by Schecter Lee. Photograph © 1986 The Metropolitan Museum of Art 7.43 The Art Archive
- 7.46 Deutsches Archaeologisches Institut, Rome
- 7.52 © Araldo de Luca/Corbis
- 7.53 Museo Archeologico Nazionale
- 7.56 Edimedia, Paris
- 7.59 The Metropolitan Museum of Art, Rogers Fund, 1920 (20.192.1). Photograph © 1987 The Metropolitan Museum of Art
- 7.63 Fotografica Foglia, Naples
- 7.64 © The Trustees of The British Museum
- 7.65, 7.66, 7.68 © 2006 Martha Cooper/Peter Arnold, Inc., New York
- 7.67 Courtesy of Bardo Museum, Republic of Tunisia
- 7.69 © Ruggero Vanni/Corbis
- W3.1, W3.3a, W3.10 Scala/Art Resource, NY
- W3.2 Borromeo/Art Resource, NY
- W3.3b Archaeological Survey of India, New Delhi
- W3.3c Robert Harding Picture Library, London
- W3.4a National Museum of India, New Delhi, In-
- dia/The Bridgeman Art Library
- W3.4b © Angelo Hornak Library (London) courtesy of the National Museum of New Delhi, India
- W3.5a, W3.17 © akg-images/Jean-Louis Nou
- W3.5b, c National Museum, New Delhi
- W3.6 Ashmolean Museum, Oxford
- W3.7, W3.13 Douglas Dickins, London
- W3.8 © Archaeological Museum, Sarnath, Varanasi/The Bridgeman Art Library
- W3.9 © Ann & Bury Peerless
- W3.12 © Archivo Iconografico, S.A./Corbis
- W3.14 © Bildarchiv Preussischer Kulturbesitz/ Art Resource, NY
- W3.15 © Trustees of the National Museums of Scotland 2006
- W3.16 Courtesy of American Institute of Indian Studies, Varanasi
- 8.1 Princeton University Press/Art Resource, NY
- 8.2 The Jewish Museum, NY/Art Resource, NY
- 8.3, 8.26 © Canali Photobank
- 8.4 Alinari/Art Resource, NY

- 8.7, 8.8, 8.10, 8.11, 8.12, 8.13, 8.14, 8.15, 8.16, 8.19, 8.20, 8.21, 8.22, 8.23, 8.24, 8.25, 8.27, 8.38, 8.48, 8.50 Scala/Art Resource, NY
- 8.17 © akg-images/Heiner Heine
- 8.28 © Stock Photos/Corbis
- 8.30 © Historical Picture Archive/Corbis
- 8.34 Marvin Trachtenberg
- 8.35 Reproduced through the courtesy of the Michigan-Princeton-Alexandria Expedition to Mount Sinai
- 8.37 Osterreichische Nationalbibliothek, 8.36. Vienna
- 8.39 St. Catherine's Foundation, London
- 8.41, 8.42, 8.43, 8.44 © Studio Kontos, Athens
- 8.45 © Ruggero Vanni/Corbis
- 8.46 Giraudon/Art Resource, NY
- 8.47 Werner Forman/Art Resource, NY
- 8.49 Tretyakov Gallery, Moscow/Bridgeman Art Library
- W4.1 Archaeological Survey of India, New Delhi
- W4.2 Scala/Art Resource, NY
- W4.4, W4.8, W4.9, W4.11 © akg-images/Jean-Louis Nou
- W4.5 © Ann & Bury Peerless
- W4.6 © Richard Ashworth/Robert Harding Picture Library W4.12 Photo: Robert E. Fisher
- W4.13, W4.14, W4.15 Werner Forman/Art Re-
- source, NY 9.1 A. F. Kersting, London
- 9.2 Courtesy of the Arthur M. Sackler Museum, Harvard University Art Museums, Francis H. Burr Memorial Fund (1967.23). © Presi-
- dent and Fellows of Harvard College 9.3 The Metropolitan Museum of Art, Rogers Fund, 1938 (38.149.1). Photograph © 1986
- The Metropolitan Museum of Art 9.4 Images supplied by aerofilms.com
- 9.7 Scala/Art Resource, NY
- 9.8 Institut Amatller d'Art Hispanic 9.9 Raffaello Bencini, Florence
- 9.10 Jane Taylor/Sonia Halliday Photographs
- 9.12, 9.13 © Giamberto Vanni/Art Resource, NY
- 9.14 © Ann & Bury Peerless
- 9.15 © The Trustees of The British Museum
- 9.16 University Museum of National Antiquities, Oslo, Norway/Photo by Eirik Irgens Johnsen
- 9.17 Werner Forman/Art Resource, NY
- 9.18 Photo: Lennart Larsen, the National Museum of Denmark
- 9.19 Pressens Bild, Stockholm
- 9.20 J. Allan Cash, Ltd., London
- 9.21 National Museum of Denmark, Copenhagen
- 9.22 © akg-images/Andrea Jemolo
- 9.23 Library of Trinity College, Dublin, The Board of Trinity College, Dublin, TCD MS. 57 (Book of Durrow) fol. 191v 9.24 Library of Trinity College, Dublin, The Board
- of Trinity College, Dublin TCD MS 58 (Book of Kells) fol. 124r
- 9.25 © akg-images/Hilbich

18 - fol. 178v

Lat. 1, fol. 329v

9.37 Scala/Art Resource, NY

4453, fol. 135v

9.34 Photo by Wim Cox, Cologne 9.35, 9.39 Erich Lessing/Art Resource, NY

W5.1 Courtesy of Michael D. Coe

Tikal #60.4.358)

W5.2 Werner Forman/Art Resource, NY

9.38 Foto Marburg/Art Resource, NY

9.30 © akg-images

9.28 Bibliothèque Nationale de France, Paris. Ms. lat. 1203, folio 3 recto 9.29 Kunsthistorisches Museum, Vienna. SK X111

9.31 Bibliothèque Nationale de France, Paris Ms.

9.32 © University Library, Utrecht (Ms. 32, f. 51v)

9.40 Bayerische Staatsbibliothek, Munich CLM

9.41 The Metropolitan Museum of Art, Gift of

W5.3 © Adina Tovy/Robert Harding Picture Library

W5.7 University of Pennsylvania Museum (image

W5.6 Tony Morrison/South American Pictures

George Blumenthal, 1941 (41.100.157). Pho-

tograph © The Metropolitan Museum of Art

- 11.40 Spectrum Colour Library, London
- 11.46 © London Aerial Photo Library/Corbis 11.49 © Canali Photobank
- 11.50 Lauros Giraudon/Art Resource, NY 11.52 Joe Cornish/Arcaid
- 11.53 Cameraphoto/Art Resource, NY
- 11.54 David Simpson, Septon, Belgium
- 11.55 © Jose Fuste Raga/Corbis
- W6.1, W6.2 © The Trustees of The British Museum
- W6.3, W6.4 Prof. Sekino Masaru, Tokyo University
- W6.5, W6.7 © Christopher Rennie/Robert Har-
- ding Picture Library
- W6.6 Photo credit: Shogakukan, Tokyo
- W6.11 © akg-images/Jean-Louis Nou
- W6.12 Borromeo/Art Resource, NY

- W6.13 Courtesy of American Institute of Indian Studies, Varanasi W6.15 Douglas Dickins, London W6.18 Paul John Miller/Black Star, New York
- W6.19 © Ann & Bury Peerless
- W6.20 © T. Hall/Robert Harding Picture Library
- W6.21 Eliot Elisofon/Getty Images
- W6.22 © Daniel Entwistle
- W6.23 © Keren Su/Corbis
- W6.24 Giraudon/Art Resource, NY
- 12.1, 12.6, 12.7, 12.8, 12.9, 12.10, 12.11, 12.12, 12.13, 12.17, 12.18, 12.19, 12.20, 12.21, 12.24, 12.25 Scala/Art Resource, NY
- **12.2** Alinari/Art Resource, NY **12.3** Galleria degli Uffizi, Florence, Italy/Bridge-

- 12.4, 12.14 © Canali Photobank
- 12.15a From John White, Duccio, published by Thames & Hudson Ltd./By permission of Thames & Hudson Ltd., London
- 12.15b Quattrone, Florence
- 12.16 From John White, Duccio, published by Thames & Hudson Ltd./By permission of
- Thames & Hudson Ltd., London 12.22 Santa Croce, Florence, Italy/Bridgeman Art
- Library 12.23 Nicolo Orsi Battaglini/Art Resource, NY
- 12.26, 12.27 © Paul M.R. Maeyaert

- man Art Library
- 12.28 Erich Lessing/Art Resource, NY
- - 12.29, 12.30 Giraudon/Art Resource, NY

Index

Page numbers in **boldface** refer to illustrations.

А

Aachen, Germany: Charlemagne's palace chapel, 336-337, 337

abacus, 163, 261

- abbey church of Monreale (Palermo), Pantokrator mosaic, 301, 301
- abbey church of Saint-Étienne, Caen, 390-392, 390-391, 401
- abbey church of Saint Michael, Hildesheim, 342-344, 342-344; bronze doors, 342-344, 343, 344
- abbey church of Saint-Pierre, Moissac, 374-380, 374, 375, 377-379, 407
- Abbot Durand (relief, Saint-Pierre, Moissac), 378-379, 378
- Abd al-Malik, Caliph, 321
- Abd ar-Rahman III, caliph of Córdoba, 322 Abduction of Europa (Berlin Painter), 146-147,

146

Abelard, Peter, 420

abhaya mudrā, 265

Aboriginal rock art, 41-43

- abstract art, 5, 11, 25
- Abu Simbel, Egypt, 112; temple of Ramses II, 112, 112
- Abu Temple statues (Tell Asmar), 59, 59, 60, 256 acanthus-leaf design, 162
- Achaemenid Empire, 77-79; art, 260; drinking vessel. 79. 79
- Achilles and Ajax Playing a Board Game (Exekias), 145
- Achilles and Penthesilea (Exekias), 146, 146
- Achilles and Penthesilea (Penthesilea Painter), 147, 147

achromatic works, 22

Acropolis (Athens), 169, 169; damage to, 170; Erechtheum, 176–178, 177, 178; friezes, 174; metopes, 174; naos, 176; Parthenon, 3, 4, 6, 169-174, 170-175; pediments, 172-174; plan, 169, 169, 170-176; temple of Athena Nike, 176, 177. See also Parthenon

Adam, 268

- Adam and Eve Reproached by God (abbey church of Saint Michael), 344, 344
- Adoration of the Lamb by All Saints (Eyck), 455

Adoration of the Magi (as subject), 269

- Adso, Brother, 409
- Aegean culture, 117–133; map, 117; painting, 121, 144. See also Cycladic civilization; Minoan civi-
- lization; Mycenaean civilization Aegean islands, 77
- Aegisthos, 128
- Aelius Donatus, 336
- Aeneas, 16, 210, 239, 251
- Aeneas Fleeing Troy (relief, Carthage), 251, 251
- Aeschylos, 128, 140
- Aesir, 330

aesthetic value of art, 4, 13

- Aestheticism, see "Art for Art's Sake"
- Afghanistan: destruction of art in, 6, 13
- Africa, see Algeria; Egypt, ancient; Egypt, Roman
- and Byzantine period; Nubia afterlife, beliefs about: prehistoric, 28. See also death; Egypt, ancient; Egypt, Roman and Byzantine period: tombs and burials
- Agamemnon, 128; "Mask of Agamemnon," 132. See also Treasury of Atreus
- agora, 217

- Agra, India: Taj Mahal, 3 agriculture: beginning of, 44, 51
- Ahenny, Tipperary: Celtic cross, 333, 333
- aisles: of basilicas, 218
- Aix-la-Chapelle, Germany, see Aachen Ajanta Caves, India, 305, 308-311, 308, 310;
- chaitya halls, 309, 309
- Ajax, 145

Akhenaten (Amenhotep IV), pharaoh of Egypt, 106-108; cartouches, 86, 86, 106; sculptures of, 106. 107

Annunciation (Limbourg brothers), 474, 475-476

Annunciation and Visitation (Reims Cathedral), 418

Antichrist as a Three-headed Tyrant (Harley Manu-

Apadana Hall, palace of Darius I (Persepolis), 77,

Aphrodite, 142; Aphrodite of Melos (Venus de Milo),

184-185, 184. See also Venus; individual works

Aphrodite of Knidos (Praxiteles), 180, 180, 185

Aphrodite of Melos (Venus de Milo), 184-185, 184

Apocalypse, 409. See also Antichrist; Revelation,

Apollo, 138, 142, 147, 165–166, 166; temple of (Cor-

Apollodorus of Damascus: Basilica Ulpia, 218, 219

Apoxyomenos (Athlete with a Strigil) (Lysippos),

aqueducts, 225-226; Roman, 225-226, 225, 233

Ara Pacis (Altar of Peace), Rome, 230-231, 230,

archees, 223 arch(es), 291, 291; ancient Near Eastern, 73; of Constantine, 235–236, 235, 236, 405; Etruscan, 195; Indian, 262–263; Ishtar Gate, 73; Islamic, 322; Mycenaean, 129; Peruvian, 362; pointed,

398; Roman, 4, 213, 213; of Titus, 234–235, 234; triumphal, 4, 234, 235

archaeological heritage: plundering of, 131; pro-

Archaic style, Greek: architecture, 160-162; sculp-

architectural decorations: ancient Near Eastern,

72; Cambodian, 446-448; Chinese, 206; Gothic,

405-409, 415, 418; Greek, 161, 165-168, 172-

175, 177-178; Hellenistic, 187; Indian, 307, 311,

442; pre-Renaissance, 449-450, 473-474; Ro-

68-69; Buddhist, see Buddhist architecture; Byz-

antine, 288-293, 298-303; Chinese, 202, 436; co-

lossal, 103; Early Christian, see Early Christian

architecture; Egyptian, see Egypt, ancient, archi-

tecture; English, see English architecture; Etrus-

ccan, 190; functional purpose of, 11; Gothic, 395–399, 401–418, 421–432; Greek, 160–162, 164–178; Hindu, 12; Indian, 3, 306, 441–443; Japanese, 437–439; Mesoamerica, 350; Minoan, 421–422

121-122; monumental stone, 44; Mycenaean,

127, 129-131; Neolithic, 45; Persian, 77-78; Pe-

ruvian, 362-363; precursors of Gothic, 390-392;

psychological responses, 11; Roman, 213-236,

272-285, 306; Romanesque, 371-375, 384-385.

See also cathedrals; churches; Orders of archi-

I-1

tecture; temples and shrines

manesque, 372, 373-375, 377-379, 381-382

architecture, 2, 11-12; ancient Near Eastern, 54,

ture, 150–152; vase painting, 145–146, 145

Apollo of Veii (Etruscan bronze), 192, 192

inth), 160, 160, 164; temple of (Delphi), 138, 138, 139; temple of (Veii), 190, 190, 192

Annunciation (Simone Martini), 472, 472

Anselm, archbishop of Canterbury, 420

Anthemius of Tralles, 288

Antichrist, 409

Antinous, 240

Anu. 55 Anubis, 83

77

Book of

180. 181

Apsaras, 446, 446

apses, 218, 273

231

arcades, 223

Apocrypha, 268

script), 409, 409

Antinous, 240, 240

Antoninus Pius, 211

Apelles of Kos, 20, 148, 453

apprenticeship, 399, 450–451

Arc de Triomphe, Paris, 73

Arch of Constantine (Rome), 4

archaeology, 14; and art history, 13

Arch of Titus, 234-235, 234

tection of, 6, 75, 114

archaeometry, 14

Archaic smile, 152

anthropomorphism, 141, 263

- Akhenaten and Nefertiti and their children (relief), 106-109. 107
- Akhetaten (Tell el-Amarna), Egypt, 106
- Akkadians, 62-63; culture, 58; head of an Akkadian ruler, 62, 63
- Akrotiri, Santorini, 124
- Ål Cathedral, Norway, 383, 383
- Albers, Josef, 2-3
- Alberti, Leon Battista, 2, 7, 9
- Alcuin of York, 336, 406 "Alexander Mosaic," see Battle of Issos mosaic Alexander the Great, 79, 83, 115, 137, 148, 178, 180, 182–183, 254; head of, from Pergamon, 183,
- 183; mosaic of, 149 Alexandria, 83
- Algeria: rock paintings, 44; Timgad, 214, 215
- Alkibiades, 141
- Allegories of Good and Bad Government (Lorenzetti), 468-469
- alphabet: Greek, 136
- Altamira, Spain: cave paintings, 40, 40
- Altar of Peace, see Ara Pacis
- Altar of Zeus, Pergamon, 186, 187
- Altarpiece of the Lamb (Ghent Altarpiece) (Jan van
- Evck), 455 altarpieces, 455, **455**; pre-Renaissance, **452–453**, **464–465**, **467**, **471–472** altars: Christian, 272, 455, **455**; Hindu, 440
- āmalaka, 444
- Amanishakheto, tomb of, 114-115, 115
- Amarna period, Egypt, 106
- Amazons, 159, 174 ambulatories, 276, 307, 370
- Amenhotep IV, pharaoh of Egypt, see Akhenaten
- Amiens Cathedral, France, 384, 412-415, 412-415, 420
- Amitabha Buddha, 313, 434–435. See also Buddha
- Amon, 83, 115
- Amon-Mut-Khonsu, temple of, Luxor, 102, 102
- Amon-Ra, temple of (Karnak), 100, 101
- Amor, 142. See also Cupid; Eros
- Amorites, 67
- amphitheaters, 223. See also Colosseum
- amphora, Greek, 141, 143, 145, 145; Archaic style, 145, 145, 146; Geometric style, 143, 143; Orientalizing style, 130, 143-144, 144
- Anatolia, ancient, 52-54, 68. See also Çatal Hüyük Anatolian goddess giving birth (sculpture, Çatal Hüyük), 53, 53
- ancient world, see Egypt, ancient; Greece, ancient; Near East, ancient
- anda, 262

lions

ankh, 103

- Andean cultures, 358-364; coastal cultures, 360-364; map, 358; textiles, 358, 360, See also Inka Empire; Moche culture; Nazca culture; Paracas culture; Tiwanaku culture; Wari culture Andrea di Cione, see Orcagna, Andrea
- Angkor Thom, Cambodia, 447-448; Bayon temple,
- 447, 447-448
- Angkor Wat, Cambodia, 444-448, 444-447
- Anglo-Saxons, 327, 331; interlace, 423; metalwork, 327; motifs, in Romanesque style, 379 aniconical representation, 262

Eastern art, 61, 74; cave paintings, 32-33, 40, 42;

on Indian capitals, 260–261; Indus Valley, 255– 256; Middle Ages, 327; Neolithic, **44**; Paleolithic,

31, 33-34, 37-40; Scythian, 205. See also bulls;

- animal headpost (Oseberg), 328, 329
- Animal Style: Medieval, 344
- animals in art: Aboriginal, 43; in ancient Near

Annunciation (as subject), 269

Annunciation (Giotto), 457-458, 457, 472

architraves, 163

- archivolts, 372, 372, 376, 404, 405; Gothic, 405, 405 Arena Chapel, Padua: Giotto's frescoes, 454-462,
- 456-462, 466-468, 467

arenas, 224

- Ares, 142
- Arian heresy, 270
- Ariège, France: cave art, 36
- Aristogeiton, 136
- Aristophanes, 140
- Aristotle, 137-138, 140, 178, 420
- Ark of the Covenant, 370
- armature, 52
- arms and armor: Dacian, 233
- Army on the March (Angkor Wat), 446, 446
- Arrangement in Black and Gray (Portrait of the Artist's Mother) (Whistler), 10, 10, 16, 17, 18 arriccio, 457
- art: appreciation of, 13; collecting, 12-13; creative impulse, 2-3, 7-8; definitions of, 4; formal elements, 18-25; origins of, 9; role in society, 4, 11; values of, 4-6; verbal descriptions of, 7
- "Art for Art's Sake," 13, 39
- art history: feminist, 96; interpretative approaches, 13-18; reasons to study, 1-2; women in, 16 art market, 4
- art works: dating of, 14; material value of, 4; plundering of, 131; psychological effect of, 6; as
- spoils of war, 5–6, 12–13
- Artaxerxes I, king of Persia, 77
- Artemidoros, mummy case of (Faiyum), 250, 250 Artemis, 142, 147
- artists: apprentices, 450-451; biographies and autobiographies of, 16, 186; cave artists, 39; compared to gods, 7-8; individual identity of, in Renaissance, 452, 453; motives of, 2-3; Plato's view of, 140; status of, 141, 186, 240. See also women artists

Aryans, 74, 439

- Ascension (as subject), 269
- Asgard, 330
- Ashoka, emperor of India, 5, 254, 260
- Ashokan pillars, 260, 260
- Asia: maps, 255. See also China; India: Indus Valley civilization; Japan; Korea
- Aspasia, 140
- Assisi, Italy, 463
- Assiut, Egypt, 98; Lady Senuwy, statue of, 98, 98
- Assurbanipal, king of Assyria, 69
- Assurnasirpal II, king of Assyria, 69-70, 70
- Assyria, 69-73, 77, 113, 115
- astronomy, 49
- asymmetrical balance, 19
- Ateban, son of lepmatath: mausoleum of (Dougga, Tunisia), 252, **252**
- Aten, 83, 106
- Athena, 142, 170; statue in Parthenon, 3, 4, 176, 176; temple of Athena Nike, 176, 177
- Athena, Herakles, Atlas, the Golden Apples of the
- Hesperides (Olympia), 166, **167**, 168, **168** Athena Battling with Alkyoneus (Pergamon), 186, 187
- Athens, Greece, 140, 169, 178. See also Acropolis athletic competition: Greek, 136, 138
- Atlantis myth, 126
- atrium, 212
- Attalos I, king of Pergamon, 186
- attic, 233
- Augustine of Hippo, Saint, 400, 420; City of God and Confessions, 400
- Augustus Caesar, emperor of Rome, 186, 210, 211,
- 212, 217, 230-231, 239-240, 239, 242
- Augustus of Prima Porta, 239-240, 239
- Australia: aboriginal art, 41-43
- autobiographies, artists', 16
- Autun Cathedral, France, 381-382, 381-382
- avatars, 439
- axes: Viking, 328, 329, 390
- axis, 213
- axis mundi, 359, 362 axonometric projections, 289
- Axum, 115
- Aztecs, 356-357; culture, 349; sculpture, 357

В

- Baal Hammon, 251-252
- "Baby bottle" vessel (Carthage), 252, **252** Babylon, 5, 67–68, 69, 73–74; Ishtar Gate, 73–74, **73**; Old Babylonian period, 67; ziggurats, 15 Babylonians 77

Bolivia, see Tiwanaku culture

Book of Durrow, 333, 334

Book of Revelation, 339

Book of Two Wavs, 89

105

249

185, 185

Brahma the Creator, 439

bricks, 212: glazed, 74

method, 203

8, 15, 400

Brutus, 217

310, 311

marks of, 264

Hinduism, 444

(Bihar), 260, 260

buon fresco, 120

Buonarroti

Buonarroti,

Buddhist art: canons of, 307-308

Buddhist sculpture, 260-265

burials, see tombs and burials

buttresses, 213; flying, 397, 397

Romanesque style, 365

busts: Roman, 237, 237-238, 241-242

11, 261

313

Brahmin (supreme god), 258

Brahmin caste, 258, 439, 440

British Museum (London), 6

bubonic plague of 1348, 470, 471

Book of Kells, 206, 334-335, 335

Book of the Dead, 89, 89, 105

Books of Hours, 474-475, 475

Borgund stave church (Sogne), 383, 383

Boxer (Hellenistic sculpture), 185–186, 185

Boxing Children (fresco, Thera), 126, 126, 144

Bonampak, Mexico: Mayan murals, 354, 354

Bondone, Giotto di, see Giotto di Bondone

Bonaparte, Napoleon, see Napoleon Bonaparte

Book of Suger, Abbot of Saint-Denis, The, 394–395

books and manuscripts: ancient, development of,

Boscotrecase, villa near Pompeii: fresco, 246, 246,

Boy Wrestling with a Goose (Hellenistic sculpture),

Brancusi, Constantin, 5; Bird in Space, 5, 5, 14, 18

Breuil, Henri, 35, 36, 39; copy of cave art, 35, 36, 36

bronzes, 5, 14; ancient Near Eastern, 63; Chinese,

Bruegel, Pieter, the Elder: Tower of Babel, The, 8,

Buddha: Birth of the Buddha (Gandhara), 258, 259.

263; Buddha Preaching the Law (Dunhuang), 434–435, **434**; Buddha with Disciples (Longmen

caves), 313–314, 313; colossal Buddha (Yungang

caves), **312**; colossal statues of, in Afghanistan, 6; iconography of, 307–308, 313; life of, 258; *Preaching Buddha* (Sarnath), 307–308, **307**; rel-

ics of, 436; Seated Buddha (Mathura), 264, 264;

Shakyamuni Buddha Preaching on Vulture Peak,

435, 435; Standing Buddha (Gandhara), 263-264,

263, 308; Vairochana Buddha (Longmen caves),

314, 314; Worship of the Buddha (Ajanta Cave),

Buddha with Disciples (Longmen caves), 313-314,

buddhas, 260; multiplicity of, 313-314; thirty-two

Buddhism, 258–265; in China, 312–314; and Hindu-

ism, 439; in Japan, 437–438; map, **255**; mission-aries, 254; monasteries, 260, 437–438; Paradise

sects, 434-435; spread of, in east and south Asia,

434-448; spread of, in India, 5; synthesis with

260; chaitya halls, 306; in Japan, 437-438; stupas,

Buddhist architecture, 260-265; Ashokan pillars,

building materials: Etruscan, 190; Roman, 212

post-and-lintel construction; vaults

building techniques, see arch(es); architecture;

bull capitals: Achaemenid, 78, 78; Ashoka pillar

(Binar), 200, 200 bulls: Indus Valley, 256, 261; kneeling bull (Proto-Elamite sculpture), 74, 75, 75; lyre (Ur), 60, 61,

62; Mohenjo Daro seal, 255, 256; as motifs, 60;

Toreador Fresco (Knossos), 120, **121**, 132. *See also* Hall of Running Bulls

Byzantine architecture: churches, 398; influence on

Michelangelo, see Michelangelo

203, 203; Etruscan, 190, 190, 191; Greek, 154-

155, 154; lost-wax casting of, 62; and piece-mold

Bronze Age: China, 203-206; Greece, 117

294; Early Christian, 294-295; Egyptian, 89, 98,

- Bacchus, 142. See also Dionysos Bacchus and the Four Seasons (Badminton Sarcophagus), 236, 237
- Badminton Sarcophagus, see Bacchus and the Four Seasons
- balance in art, 18-19
- Baldr, 330
- ball court (Copán), 353, 353
- balustrades, 176
- baptism, Christian, 272
- Baptism of Christ (as subject), 269
- baptisteries, 276; Pisa Cathedral, 384-385, 384, 385
- barbarians: and Greeks, 186: the word, 136
- Bardi Chapel (Santa Croce, Florence), 462-463, 463 Barma and Postnik: Saint Basil's Cathedral, Moscow. 303. 303
- barrel vaults, 213, 372, 372. See also vaults
- base, column, 79
- Basilica Ulpia (Apollodorus of Damascus), 218, 219
- basilicas, 217, 218; Christian, 272-275, 305-307, 385; Latin-cross design, 370; Old Saint Peter's, Rome, 272, 272, 273; Roman, 219, 272
- bas-relief, see low relief
- baths, Roman, 221-222, 221-222; of Caracalla, 221, 221, 222; Hadrian's Villa, 216, 216
- Battle of Hastings, see Bayeux "Tapestry
- Battle of Issos mosaic (Pompeii), 148, 149, 183
- Battle of the Milvian Bridge, 235, 270
- Battle of Tours (Poitiers), 327, 336, 368
- Bayeux "Tapestry," 387–390, 388–389 bays, 372
- beaker (from Susa), 74, 74
- Beaker People, 48
- Bearded Man (Mohenjo Daro), 256, 256 Beau Dieu, Amiens Cathedral, 414, 415
- beauty: ideal, 14
- Becket, Thomas à, see Thomas à Becket

Berlin Painter: Abduction of Europa, 146-147, 146

Betrayal of Images, The (Magritte), 6-7, 7, 17, 18

Bible: Apocrypha, 7; Christian, 268; illustrated, 340;

Stavelot, 376-377, 376; Vienna Genesis, 294-296,

294, 295; Vivian, 339-340, 339. See also Gos-

Bible moralisée: God as Architect (God Drawing the

Bihar: bull capital, Ashokan pillar, 260, 260

Bingen, Hildegard of, see Hildegard of Bingen

Birth of the Buddha (Gandhara), 258, 259, 263

bison with turned head (La Madeleine), 31, 31

black-figure technique (Greek vase painting), 145

bodyguard of Emperor Qin (tomb of Emperor Qin,

Lintong, China), 3, 16, 206, 206, 207, 207, 208

Boghazköy, Turkey, see Hattusas, Turkey

Boccaccio, Giovanni, 452, 453; Decameron, 470

biographies of artists, 16. See also Vasari, Giorgio

Universe with a Compass) (Reims), 7, 7, 8, 16, 18-19

Bernward, bishop of Hildesheim, 342, 343

- Belgium: architecture, 431-432
- Benedict of Nursia, Saint, 340

Berry, Jean, duc de, 473, 475

Betrayal of Judas (as subject), 269

pels; manuscript illumination

biographical interpretation, 286

bison (Tuc d'Audoubert), 31, 31

Bird in Space (Brancusi), 5, 5, 14, 18

binder (medium), 30

biomorphic shapes, 20

Black Death, 470, 471

bodhisattvas, 258, 260

Bodrigue, William, 432

birth legends, 62

blind niches, 277

Benedictine Order, 340-341 Benedictine Rule, 340

Beowulf, 327, 328

Berbers, 250

Bes 83

bhūmi, 444

Church, the, see Catholic Church; Christianity

Church of Holy Wisdom, see Hagia Sophia, Istanbul

churches: Byzantine, 288-293, 303; Early Chris-

tian, 272, **272–276**, **280–285**, **306**; Frankish, **337**;

Gothic, 395-399, 402-418, 421-432: northern

Europe, 383; orientation of, 272-273; plan of, 20; pre-Renaissance, 456–463, 473; precursors of

Gothic, 390-392; Romanesque, 371-375, 377-

378, 381, 384–385; symbolism, 12. See also bap-

tisteries; basilicas; cathedrals; temples and shrines

Cimabue, 7, 452; Madonna Enthroned, 452, 452,

cinerary urns, Etruscan, 194-195; from Chiusi, 194,

in the shape of a hut (Tarquinia), 194–195, 195

city attacked with a battering ram (relief, palace of

city planning, 190; Mesoamerica, **349**, **352–353**, **355**; Neolithic, 52, 53; Roman, 214, **214–215**, **218**

Classical style, Greek: architecture, 163-179; Early,

Classical texts: collecting of, in Renaissance, 452;

clay tablet with pictographic text (Jemdet Nasr),

coffins, Egyptian, 88, 100, 109, 250; of Djehuty-

colonnade and court of Amenhotep III (Luxor),

color, 21-23; Albers on, 2-3; expressive qualities of,

colossal head (San Lorenzo, Vera Cruz), 348, 348

columns, 79; caryatid, 178; Egyptian, 101-102, 102;

commemorative architecture: Roman, 230-236

Commodilla catacomb, Rome: Virgin and Child En-

Composition (The Cow), four studies (van Does-

throned with Saints Felix and Augustus, 296, 296

freestanding, 227; Greek, 161, 162; IO2;
 freestanding, 227; Greek, 161, 162; Indian, 307;
 Minoan, 123; Persian, 78, 78, 260; Roman, 231–232;
 Trajan's, 231–232, 231, 232, 237, 260. See

23; pigments, 30; symbolic meaning, 23; value

(Faiyum), 250, 250. See also sarcophagi

nekht, 100, 100; mummy case of Artemidoros

classicism (modern): in Renaissance, 449-450

153; influence of, 186; sculpture, 152-159, 153;

Cione, Andrea di, see Orcagna, Andrea

circumambulation, 11, 261, 307

circuses: Roman, 223, 224-225, 224

cire-perdue bronze casting, 62, 154

citadels: Hittite, 68; Mycenaean, 128

Assurnasirpal, Nimrud), 70, 71

city-states: Greek, 137; medieval, 366

civic architecture: Roman, 218-224

classical (word), 158, 186

vase painting, 146-148

Clement, Saint, 408, 408

clerestory windows, 101, 218

Clovis, king of the Franks, 347

cloisters: Saint-Pierre (Moissac), 378

coins: Greek, 163. See also medals

colossal Buddha (Yungang caves), 312

also Orders of architecture; pillars

Commodus, emperor of Rome, 211

Colosseum (Rome), 212, 223-224, 223, 337

study of, in Renaissance, 455

Claudius, emperor of Rome, 211

clay: glazing, 74. See also pottery

194, 196; in the form of a house (Chiusi), 195, 195;

Cicero, 191

circles, 20

58.58

cloisonné, 327

cluster piers, 372

codices, 294-296

collecting art, 12-13

colonnades, 171, 212

colossal architecture, 103

Colossus (Roman statue), 224

scales, 22, 23 color wheel, 22, 22

Columba, Saint, 333

comitium, 218

communism, 6, 15

compluvium, 212

composition, 18

burg), 24-25

complementary colors, 22

Composite Order, 234

coffers, 229

102, 102

453-454, 455

Circus Maximus, 224

- Byzantine art, 271, 280–303; influence in Middle Ages, 338, 386; metalwork, 302, **302**; mosaics, 293, 297, 299-301, 302, 466; painting, 297; sculpture's minor role in, 297
- Byzantine Empire, 280; map, 282. See also Constantinople
- Byzantium, see Constantinople

C

- Caen, France: abbey church of Saint-Étienne, 390-392, 390-391, 401
- Caesar, Julius, see Julius Caesar
- Caesar (word), 210
- Caesar Augustus, see Augustus Caesar
- Cailliaud, F., 114; Tomb of Amanishakheto, 114-115,
- 115
- caldarium, 221
- Calder, Alexander: *Cat*, **19**, 20, **20** calendars, *2*; Mayan, 351, **351** Caligula, emperor of Rome, 211

- caliphate, 319
- calligraphy: Chinese, 204, 204; Islamic, 320
- Calling of Matthew (as subject), 269
- Cambodia, 444-448; Angkor Thom, 447, 447-448; Angkor Wat, 444-448, 444-447
- Cambridge, England: King's College Chapel, 428,
- 428 campaniles, 385; Pisa Cathedral, 384-385, 384,
- 385 Campus Martius, 230
- canon of Polykleitos, 158, 180
- canons of proportion: Buddhist, 307-308: Egyptian,
- 94; Greek, 141, 158, 180. See also proportion canopic coffinette (of Tutankhamon), 108, 109
- canopic jars, of Neshkons, 88, 88
- Canopus, Hadrian's Villa (Tivoli), 217, 217
- Canterbury Cathedral, England, 422-425, 422-425; pilgrimage to, 425
- cantilever construction, 437-438
- canvas paintings: Neoclassical, 9; Post-Impressionist, 10; Surrealist, 7
- capitals (architectural), 79; Byzantine, 282-283; Early Christian, 283; Greek, 160; Indian, 260; Minoan, 123; Persian, 78, 78; Romanesque, 379, 379, 381. See also columns; Orders of architecture
- Capitoline Wolf (Etruscan bronze), 191, 191, 469
- Caracalla, emperor of Rome, 211, 242; Baths of (Rome), 221, 221, 222; bust, 242, 242
- cardo, 214
- Carnac (Brittany): dolmens, 47, 47; menhirs, 46, 46, 49
- Carolingian period, 336-342; manuscript illumination, 338-340
- Carpaccio, Vittore, 10

Carpenters' Guild signature window (Chartres),

- 399, 399
- Carrey, Jacques: East Pediment of the Parthenon in 1674, The, 172–173, **172**

Carter, Howard, 108-109

- Carthage, 250-252; Aeneas Fleeing Trov (relief), 251, **251**; "baby bottle" vessel, 252, **252**; stelae, 251; the Tophet, 251, 251
- cartonnage, 88
- carving, 29, 30. See also ivory carving; sculpture
- caryatids, 161, 178, **178**
- Cassius, 217
- caste system, Hindu, 258, 439
- Castel Appiano, chapel of (Italy), 386-387, 386-387
- castra (military camp), 214
- Cat (Calder), 20, 20
- catacombs, 269-270. See also tombs and burials Çatal Hüyük (Anatolia), 52-54, 60; Anatolian god-
- dess giving birth (sculpture), 53, 53; layout, 52, 53 cathedrals: age of, 398-418; construction of, 4, 396, 398-418; Gothic style, 12; meaning of, in Middle
- Ages, 398. See also churches: Gothic architecture Catholic Church: as art patron, 13, 365; land hold-
- ings of, 366. See also Christianity; papacy Catlin, George, 9; White Cloud, Head Chief of the Iowas, The, 9
- Cavalryman (sculpture, tomb of Emperor Qin, Lintong, China), 207, 208

- cave art: Aboriginal, 42-43; dating, 39; Europe, 32-40; meanings, 32, 39; Paleolithic, 33-40. See also chaitva halls
- ceiling paintings: Early Christian, 277
- cella, 57, 226
- Celtic cross (Ahenny, Tipperary), 333, 333
- Celts, 48. See also Hiberno-Saxon art
- Cenni di Pepo, see Cimabue centaurs, 164-165, 165, 174, 174
- centerings, 213
- Central America, see Mesoamerica centrally planned buildings, 276-279
- Cerberos, 142
- Ceres, 142
- Cerveteri, Italy: sarcophagus, 196, 197, 198: Tomb of the Shields and the Chairs, 195-196, 195, 196.198
- Chacmool (Chichén Itzá), 355, 356
- chaitya arch windows, 309
- chaitya halls, 305; Karli (Maharashtra), 305, 306, 307, 307
- Chakra, 259
- chapel of Castel Appiano, Italy, 386-387, 386-387
- Charlemagne, Holy Roman Emperor, 336, 342, 368-369; map of empire, 336; palace chapel, Aachen, 336-337, 337. See also Carolingian period
- Charles IV, Holy Roman Emperor, 430
- Charles V, king of France, 473
- Charles Martel, 327, 336, 368
- Charles the Bald, king of France, 339
- Chartres Cathedral, France, 398–412, 402–411; cross section, 404, 404, 410; exterior architecture, 401-404; exterior sculpture, 405-409, 405-409; interior, 395, 395, 397, 397, 410-411, 410; plan, 404, 404; portals, 405, 405, 406, 407; Royal Portal, 405-407; stained-glass windows, 398, 398, 399, 399, 410, 411
- Chartreuse de Champmol, Dijon, 473-474, 473-474
- chattra, 262
- Chaucer, Geoffrey, 425; Canterbury Tales, 425
- chaurīs, 265
- Chauvet Jean-Marie 32
- Chauvet cave (Ardèche Valley): cave paintings, 33, 33 34 34
- Chavín de Huántar, 359, **359**
- Cheramyes Master: Hera of Samos, 152, 152 chevets, 395
- Chi-Rho, 271
- Chichén Itzá, Mexico, 355-356, 355-356
- children's art, 2-3
- Chimú people, 363
- China: art history, 13; Bronze Age, 203–206; bronzes, 203, **203**; Buddhism in, 312–314; calligraphy, 204, 204; contact with Rome, 254; Great Wall, 202, 202; history, 202; Longmen caves, 314, 314; maps, 201; Neolithic, 202-203; pottery, 202-203; Qin warriors, 3, 206, 206, 207, 207, 208; sculpture, 3; tombs, 201; trade with West, 434; Warring States period, 206; Yungang caves, **312** "Chinese Horse" (Lascaux), 37, 38, 38
- Christ, see Jesus Christ
- Christ (Saint-Pierre, Moissac), 375, 376
- Christ as Good Shepherd mosaic (mausoleum of Galla Placidia, Ravenna), 278, 279
- Christ as the Good Shepherd (catacomb of Priscilla, Rome), 270, 270
- Christ Blessing (Godescalc Gospels), 338, 338
- Christ in Majesty (Stavelot Bible), 376-377, 376 Christ in Majesty (Vivian Bible), 339-340, 339
- Christian art: compared to Roman art, 268, See

monasteries; monasticism; papacy

Christus-Sol mosaic (Rome), 274, 274

chryselephantine statues, 164, 171

chronology: of art works, 14; and calendars, 2

chromatic works, 22

also Early Christian art Christian Mausoleum of the Julii (Rome), 274, 274 Christianity: differences from pagan religions, 268;

early, 268-270; missionaries, 268, 332; origins,

266, 267; persecution of, 268; pilgrimages, 366-

369; role of art, 4; Scriptures, 268; symbolism,

271. See also Bible; Catholic Church; churches;

compound piers, 397, 397

concrete, 212

cone mosaics, see mosaics

Confucianism, 205

- Confucius (Kongzi), 205 Conques, France: Sainte-Foy, 370-374, 371-373, 391, 461; Sainte-Foy church, 369
- Constantine I ("the Great"), emperor of Rome, 4, 210-211, 235, 241, 270, 276, 286, 368-369; Arch of, 235-236, 235, 236, 405; monumental head, 241.241
- Constantinople (Byzantium, Istanbul), Turkey, 210-211, 272, 324–326; basilica of Hagia Sophia, 288– 292, **288, 289, 290, 292,** 302, **302**, 321, 324, 326; founding of, 270; mosque of Suleyman I, 324, 324-325
- content of artworks, 24

contrapposto, 154, 158

- conventions in art: ancient Near Eastern, 56; Buddhist, 307-308; Egyptian, 94; Greek, 141, 158, 180 Copán, Honduras, 352-353, 352-353; ball court,
- 353, 353; Monkey-man scribal god (statue), 353, 353

copper, 203

- corbeling (architecture), 92, 130
- Córdoba, Spain, 322; Great Mosque, 291, 322-323, 322-323
- Corinth, Greece: temple of Apollo, 160, 160, 164
- Corinthian Maid, The (Wright), 9, 9, 16
- Corinthian Order, 162, 163
- Cormont, Regnault de, 413
- Cormont, Thomas de, 413, 421
- cornices, 163
- Corona Chapel, Canterbury Cathedral, 422-425, 423-424
- Coronation Gospels: Saint John, 338, 338

Cortés, Hernán, 356 Cosquer, Henri, 32

- Cosquer cave: jellyfish (painting), 32, 33
- Council of Ephesus, 296
- Council of Nicaea, 270
- courses, 130
- court and pylon of Ramses II (Luxor), 102, 102 Court of Justinian mosaic (Ravenna), 284, 284;
- methods of interpretation, 286
- Court of Theodora mosaic (Ravenna), 284, 285; methods of interpretation, 286
- Cowboy, The (Hanson), 7
- Coyolxauhqui, 356
- Coyolxauhqui, Goddess of the Moon (Tenochtitlán), 356–357, 357
- craft guilds, 399
- Crassus (Roman statesman), 217
- creative impulse, 2-3, 7-8; as procreation, 2-3
- cremation: Roman, 270
- crenellation, 70
- Crete, 119. See also Minoan civilization
- Crocus Gatherer (Thera), 126, 126, 128
- cromlechs, 47-50
- Cross, Christian, 272
- cross vaults, see groin vaults
- crosses: northern European, 333; stone, Irish, 333 crosshatching, 21, 21
- crowns, of Egypt, see deshret crown; hedjet crown Crucifixion (as subject), 269
- Crucifixion (Giotto), 459-461, 459
- Crucifixion mosaic (Hosios Loukas), 299, 299
- cruciform church, 273, 370, 385
- Crusades, 366; and Jerusalem sites, 370
- crypts, 307. See also tombs and burials
- cultural property: protection of, 6
- cuneiform, 58, 58, 68
- Cupid, 142, 239, 276; Augustus of Prima Porta, 239-240, 239. See also Eros
- curia, 218
- Cuzco, Peru, 363
- Cyclades islands, 117
- Cycladic civilization, 117-118; sculpture, 117-118, 118
- Cyclopaean masonry, 68, 128
- Cyclops, see Polyphemos
- cylinder seals, 58, 58
- Cyrus II ("the Great"), king of Persia, 77

D

da Vinci, Leonardo, see Leonardo da Vinci Dacians, 233; helmet, 233, 233; vase, 233, 233 drama: Greek, 140

dressed stone, 226

Mycenaean, 132

drums, column, 162

468, 467

378

E

Ea, 55

361

172-173, 172

Edict of Milan, 270, 272

egg-and-dart motif, 161

and Lower, 81-82

293, 293, 296, 297

75

Elektra, 128

Elgin Marbles, 6

Elijah, prophet, 293

Ely, Reginald, 428

Enki (Ea), 55

entasis, 162

Enlil, 55

engaged columns, 227

echinus, 163

Durga, 439

dromos (roadway), 130

Durrow, Book of, 333, 334

Dying Lioness (Nineveh), 70, 71

Dreamtime (Aboriginal), 42

dreams, 64-65

drawings: Cubist, 24; Gothic, 401; Surrealist, 20

Dream of Queen Maya (Madhya Pradesh), 258, 259

drinking vessels: Achaemenid, 79, 79; Chinese, 205;

Duccio di Buoninsegna, 464; Kiss of Judas, 466-

Dunhuang caves, China, 434-435, 434-435, 436

70, 72; palace of Sargon II, 70, 72

Dura Europos: synagogue, 266-267, 267

Dürer, Albrecht, 2, 7; Self-Portrait (1500), 2

Durham Cathedral, England, 390-392, 392

Eagle Warrior (Tenochtitlán), 357, 357

art on, 296. See also Byzantine art

Early Classical style (Greece), 153, 194

gian period; Middle Ages; Vikings

Eastern Europe: fall of communism, 6

Country (Lorenzetti), 468-469

Eastern Orthodox Church, see Byzantine art

398. See also Byzantine architecture

Dur Sharrukin (Khorsabad), 70; Lamassu figures,

Durand, abbot of Saint-Pierre, Moissac, 378-379,

Early Christian architecture: basilicas, 306; churches,

Early Christian art, 271-279; influence of Roman

Early Middle Ages, see Anglo-Saxons; Carolin-

earspool (Tomb of the Warrior Priest, Sipan), 361,

East Pediment of the Parthenon in 1674 (Carrey),

Effects of Good Government in the City and the

Egypt, ancient, 81-115; architecture, 3, 11, 90-93,

101, 101; coffins, 250; conventions in art, 94; dy-

nasties, 83; family life, 84; foreign contacts and

conquests, 109–115; goldwork, 4; map, **82;** Mid-dle Kingdom, 98–100; mummies, 3, 250; and Near

East, 69, 77; New Kingdom, 100-109; Old King-

dom, 90-97; paintings and frescoes, 100, 105-

106, 120-121; pharaohs, 3; religion, 82; sculp-

ture, 94-97, 150; temples, 100-104, 101; Upper

250; Saint Catherine's monastery (Mount Sinai),

Egypt, Roman and Byzantine period: painting,

Elamites, 5, 74, 75; kneeling bull (sculpture), 74, 75,

embroideries, 387. See also Bayeux "Tapestry"

England: Anglo-Saxon metalwork, 327, 333; Nor-

man invasion, 365, 387. See also London, England

elders (sculpture, Moissac), 377, 377

elevations: of a Gothic cathedral, 397

Elizabeth I, queen of England, 9

Elves (Norse fertility gods), 330

encaustic technique, see painting

Entombment (as subject), 269

Ephesus, Council of, 296

Epic of Gilgamesh, 59

English architecture: Gothic, 422-428

Entry into Jerusalem (as subject), 269

epic poetry, see Gilgamesh; Homer; Virgil

468, 467; Maestà, 455, 464-465, 464-465, 466-

- Dada, 17 Daedalos, 8
- Dancing Girl (Mohenjo Daro), 257, 257
- Dancing Satyr fresco (Pompeii), 244, 244
- Dante Alighieri, 2-3, 452, 453; Divine Comedy, The,
- 454 Daoism, 205
- Darius I ("the Great"), king of Persia, 77, 152
- Dark Ages, 318
- dating systems and calendars, 2
- dating techniques, archaeological, 14
- death: Egyptian view of, 87; Etruscan view of, 194; Greek view of, 141
- death masks, 3, 132, 210
- Death of the Children of Niobe (Niobid Painter), 147-148, 147
- Deconstructionist interpretation, 17
- decumanus, 214
- Deir el-Bahri, Egypt: funerary temple of Hatshepsut, 104, 104; king and queen of Punt (relief),
- 110, 110
- deities, see gods and goddesses
- Delacroix, Eugène, 16
- Delian League, 170
- Delos, Greece, 150; Terrace of the Lions, 150, 150 Delphi, Greece, 138; oracle, 136, 227; Siphnian Treasury, 161, 161, 178; Temple of Apollo, 138, 138. 139
- Demeter, 142
- democracy (word), 137
- Demosthenes, 183; portrait statue (Polyeuktos), 183. 183
- dendrochronology, 14 Denis, Saint, 394, 419–420, **419**
- Denmark, 328, 332; Viking rune stones, 319-321, 332, 332
- Deogarh, India: Temple of Vishnu, 441-442, 441-442

Dijon, France: Chartreuse de Champmol, 473;

Diskobolos (Discus Thrower) (Myron), 155-156,

Doesburg, Theo van: Composition (The Cow), 24-

Dome of the Rock (Jerusalem), **319**, 370 domes, 213, 291, **291**; Byzantine, 288, **289**, **291**,

cenaean, 130; Roman, 213, 213, 228-229, 291

Doryphoros (Spear Bearer) (Polykleitos), 158, 158,

300; construction of, 291; Islamic, 323-324; My-

25, 25; Composition (The Cow), four studies, 24-

Diocletian, emperor of Rome, 211, 269, 270

Chartreuse de Champmol sculptures (Sluter),

Deposition (as subject), 269

Dido, queen of Carthage, 251

Djehuty-nekht, coffin of, 100, 100

Doges' Palace (Venice), 431, 431

Domitian, emperor of Rome, 211, 235

donors: portrayed in art, 462

Dorian Greeks, 136, 162

180, 193, 236, 239

doorjambs, 372, 372, 404, 405

Doric Order, 162–163, 162, 171

dove, Christian symbol, 272

dragon finial (Qin-Zun), 206, 206

Domus Aurea (Nero's Golden House), 224

Dougga, Tunisia: mausoleum, 252, 252

473-474, **473-474**

Dionysos, 142, 179, 274

- Derrida, Jacques, 17
- deshret crown, 99, 99
- Devaraja faces (Angkor Thom), 448
- Devi, 439

Diana, 142

digital art, 11

diptychs, 455

dolmens, 47, 47

domus, 212

156

25

Dharma, 259, 439 dhvāna mudrā, 264 dialectic method, 420

- Epidauros, Greece: theater, 179, 179 equestrian portraits/sculpture: Roman, 240-241, 241 Erechtheum (Acropolis, Athens), 176-178, 177, 178 Ereshkigal, 55 Eros, 142; Sleeping Eros (Hellenistic), 185, 185. See also Cupid Eshmoun, 252 Ethiopia, 115 Etruscan civilization, 189-200; Archaic style, 192; architecture, 190; cinerary urns, 194-195, 194; Classical style, 192; funerary art, 194-200; map, 189; mirrors, 191; pottery, 191; sarcophagi, 196-198; sculpture, 190, 191–193; temples, 190; tomb paintings, 198-200; tombs, 195-196; urban architecture, 195 Etruscans, 189-200; language of, 189; Romanization of, 200; and Rome, 210 Eumenes II, king of Pergamon, 186 Euphrates River, 54, 128, 140 Europe: maps, 328, 336, 367, 451 Eusebius, bishop of Caesarea, 270 Evangelists: symbols of, 339, 376–377, 406, 407. See also John the Evangelist; Luke; Mark; Matthew Evans, Sir Arthur, 119 Eve. 268 Exekias, 145; Achilles and Ajax Playing a Board Game, 145; Achilles and Penthesilea, 146, 146 Expulsion of the Money Changers (as subject), 269 Eyck, Jan van: Altarpiece of the Lamb (Ghent Altarpiece), 455; Virgin in a Church, The, 12, 12, 23 eye of Horus, see wedjat F facing, 74 faïence, 122 Faiyum, Egypt: painting, 250, 250 fan vaults, 427, 428 female Cycladic idol (Amorgos), 117-118, 118 female head (Uruk), 56, 56, 60, 126 feminism, 6, 16, 96 feminist interpretation, 286 Ferlini, Giuseppe, 114 fertility cults: Neolithic, 46; Paleolithic, 29-30 feudalism, 365–366 figurative art, 6, 24. See also illusion; images Filippovka Cemetery, 76 finials: Chinese, 205, 206, **206** First Triumvirate, 217 Flagellation (as subject), 269 Flanders, see Belgium Flight into Egypt (as subject), 269 Flight into Egypt (Gislebertus), 381, 387 floor plans, 12 Florence, Italy, 453; Santa Croce, 462-463, 463; Santa Croce, frescoes, 470, 470 fluted columns, 162 flying buttresses, 397, 397 foreshortening, 148 forgeries, 5 formal elements of art, 18-25 formal interpretation, 286 formalism, 13-14 fortifications, see citadels Forum Julium, 217-218 Forum Romanum, 217 forums, Roman, 217-218, 218 Four Evangelists (Carolingian Gospel book), 339, 344 Four Noble Truths (Buddhist), 259 Four-ram wine vessel (Ningziang Xian), 205, 205 Foy, Saint: reliquary statue, 370, 371
- France: cave paintings, 32–40; Roman architecture in, 225–226, **225**, 233. See also Paris
- Francis of Assisi, Saint, 463, **463**; Canticle of Brother Sun, The, 463
- Franciscan Order, 462-463
- Franks, 327, 336
- Frederick II, Holy Roman Emperor, 449
- French Revolution of 1789, 6, 365
- fresco (generally): cycles, 457; techniques, 120, 457 fresco murals: Aegean (Thera), 124; Byzantine, 297;
- Early Christian, 270, 277, 296-297; Egyptian,

- 105; Etruscan, 190, 199; Greek, 149; Indian, 310-311; Jewish, 267; Minoan, 120, 121-122, 123, 124-126, 124-126; Mycenaean, 128; Roman, 243-249
- fresco secco, 120
- Freud, Sigmund, 13, 17, 140
- Frey, 330
- Freyja, 330
- friezes, 163; Ship Fresco (Thera), 124
- Frigg, 330 frigidarium, 221
- funerary art, see cinerary urns; coffins; sarcophagi; tombs and burials
- funerary temple of Hatshepsut, Deir el-Bahri, 104, 104
- funerary texts, 89
- Fur-covered Cup, Saucer, and Spoon (Le Déjeuner en Fourrure) (Oppenheim), 14, 15, 16, 17, 23
- G
- gable roofs, 273 Gabriel, archangel, 457-458, 457, 472, 474 Galatea, 7
- Galla Placidia, Empress, 277; mausoleum of, 277-279, 277, 278, 279
- galleries (in churches), 280
- Gandhara: sculpture, 263, 312-313
- Gandhi, Mahatma, 439
- Ganesh, 439
- garbha griha, 12, 440
- Gateway of the Sun (Tiwanaku), 362, 362
- Gauls, 186
- Gautama, Siddhartha, see Buddha
- Geneva Convention, 6
- Genghis Khan, 434
- Genoa, Italy, 366
- Geometric amphora (Greek pottery), 143, 143 Geometric style (Greek), 143
- German tribes, 331; art styles, 327; and fall of Rome, 280; folklore, 328
- Germany: Middle Ages, 342; Nazi era, 5-6. See also German tribes
- Gervase (monk of Canterbury), 423
- gesso, 454
- Ggantija (Tower of the Giants), Gozo, Malta, 45, 45, 46
- Ghent Altarpiece (Jan van Eyck), 455
- gilded domes, 321
- Gilgamesh, 16, 59
- Gioconda, La, see Mona Lisa
- giornata, 457
- Giotto di Bondone, 2-3, 7, 453-463, 468, 471; Arena Chapel frescoes, 454-462, 456-462, 466-468, 467; Kiss of Judas, 466-468, 467; Last Judgment, 455, 460-461, 461; Madonna Enthroned, 453-454, 453, 455; Stigmatization of Saint Francis (Bardi Chapel), 462-463, 463
- Gislebertus (sculptor), 381; Autun Cathedral sculptures, **381–382**, 387
- Giza, Egypt: pyramid complex, 92, 92
- gladiatorial contests, 224
- glass: in windows, 398
- glazing, of clay, 74
- glyptic art, 58, 255
- God as Architect (God Drawing the Universe with a Compass) (from Bible moralisée), 7, 8, 16, 18-19 "Goddess" fresco (Mycenae), 128, 128
- Godescalc (scribe), 338
- Godescalc Gospels, 338, 338
- gods and goddesses: ancient Near Eastern, 53: anthropomorphic, 141; artists compared to, 7-8; Carthaginian, 250; Egyptian, 83; female, 118; fertility, 29-30; Greek and Roman, 8, 142; Hindu, 439; kings as, 84; Scandinavian, 330; transition between humans and, 64; worship of, continuing during Christian era, 266. See also religions Goering, Hermann, 5, 6
- Goethe, Johann Wolfgang von, 13
- Gogh, Vincent van, 4, 16; Self-Portrait before His Easel, 1-2, 1, 16

Goju-no-to pagoda (Nara, Japan), 437-438, 437-439 goldwork: Achaemenid, 79; Minoan, 132; Mycenaean, 132; Scythian, 75-76; use in art, 4

Good Shepherd, 270, 272

- gorgoneion, 146
- Gospel book of Otto III, 344, 345
- Gospels: illuminated manuscripts, 335, 338–339 Gothic architecture: architectural sculpture, 414, 418; cathedrals, 12; elements of, 396–398; En-glish, 423, 426–428; High, 410, 412; Italian, 429; Norman style, 422; rayonnant style, 420; Romanesque precursors, 390-392; and Scholasticism, 419-421; spread of, to European countries and America, 429-432; Venetian, 431. See also stainedglass windows
- Gothic style: Late, 449; origins in France, 394-396; the term, 394. See also International Gothic style; stained-glass windows
- Goths, 212, 318, 331, 394, 400
- Gozo, Malta, 45 Granada, Spain, 318
- grave circles, Mycenaean, 131, 131
- grave robbers, 131
- grave stelae: Carthage, 251, 251, 252, 252; Greek, 159, 182, 182, 299. See also stelae
- graves, see tombs and burials
- Great Baths, The, Hadrian's Villa, Tivoli (Piranesi), 216, 216
- Great Mosque (Córdoba), 291, 322-323, 322-323
- Great Mosque (Samarra), 321-322
- Great Sphinx (Giza), 93, 93
- Great Stupa, Sanchi (Madhya Pradesh), 11, 261-262, 261, 262
- Great Wall of China, 202, 202
- Greece, ancient, 136-187; civilization of, vs. barbarians, 186; gods and religion, 8, 141, 142, 160; government, 136-137; literature and drama, 139-140; map, 137; philosophy, 136–137; science, 138–139; theater, 159; tombs and burials, 159; women in, 140, 198. See also Aegean culture; Hellenistic period
- Greek architecture: Early Classical style, 163-168; temples, 11, 190. See also Acropolis; Orders of architecture
- Greek art: Archaic style, 145–146, 150–152, 160–162; Classical style, 146–148, 152–159; coins, **163**; Geometric style, 143; mosaics, 148; Orientalizing style, 143-144, 150; painting, 7, 143-148; Roman copies of, 210; vases, 143-148, 144-148, 191. See also Classical style, Greek
- Greek language, 136, 210
- Greek mythology, 119, 142, 330 Greek sculpture, 150–159, 180–185; architectural, 160–179; bronzes, 154; Early Classical style, 153; Parthenon, 3, 4, 6
- Greek texts, see Classical texts
- Greeks (Hellenes): and Etruscans, 189; in Italy, 189; names for, 127; origins of, 136
- Gregorian chant, 372
- Gregory IX, Pope, 463
- groin vaults, 213, 372, 372
- ground plans, 12
- Guatemala, see Maya civilization; Tikal
- Gudea, ruler of Lagash, 64, 65
- Gudea with a temple plan (statue, Lagash), 64, 65
- guilds: medieval, 399
- Gupta Empire, 307–308

Hal Saflieni, Malta, 46

67-68, 67, 106

Han dynasty, 312

Guti people, 64

Н

Hades, 142

halo, 268

- Hadith (Islamic book), 319
- Hadrian, emperor of Rome, 211, 235, 236, 240, 270 Hadrian's Villa (Tivoli), 214-217, 216, 217 Hagia Sophia, Istanbul, 288–292, **288–290**, **292**, 302, **302**, 321, 324, 326

Hall of Running Bulls (Lascaux), 37, 37

handprints (Pech-Merle), 35, 35

Hannibal, Carthaginian general, 250

Hanson, Duane, 7; Cowboy, The, 7

Hamilcar Barca, Carthaginian general, 250

Hammurabi, king of Babylon, 67; law code of, 5,

Hapy, 83: hymn to, 81 Harald Bluetooth, king of Denmark, 332; rune stone of, 319–321, 332, **332** Harappa, see Indus Valley civilization Harley Manuscript, 409, 409 harmikā, 262 Harmodios, 136 Harrowing of Hell (as subject), 269 Harrowing of Hell (Hosios Loukas mosaic), 300, 300 Harvester Vase (Hagia Triada), 123, 123 hatching, 21, 21 Hathor, 83 Hatshepsut, pharaoh of Egypt, 103-104; statue of, 103, 103 Hattusas, Turkey: Lion Gate, 68, 68, 70 head of an Akkadian Ruler (Nineveh), 62, 63 head of Gudea (Lagash), 64, 64 Hebe, 142 hedjet crown, 84, 99, 99 Hegeso, stele of, 159, **159**, 182 Heimdall, 330 Helen of Troy, 128 Helena, Saint, 368-369, 370 Heliopolis, Egypt, 91, 106 Helios, 142 Hellas (historical name for Greece), 127 Hellenes, see Greeks Hellenistic period: art collecting, 13; portraiture, 250; sculpture, 182–187; women in, 140 Henry II, king of England, 424 Henry VI, king of England, 428 Hephaistos, 142 Hera, 142 Hera of Samos (Cheramyes Master), 152, 152 Herakles, 142. See also Hercules Herculaneum, 13, 212, 243–249 Hercules, 142, 193, 248; Etruscan bronze mirror, 191, 193, 193; Labors of, 166, 167, 167, 168, 168 Hercules Strangling the Serpents (Pompeii), 248-249, 248, 249 Hermes, 142 hermits, 340 Herod, king of Judaea, 381 Herodotos, 88, 92, 113, 117, 189 Hestia, 142 Hiberno-Saxon art, 332–335; influence on Roman-esque style, 365; interlace motifs, 333, 344; manuscript illumination, 338; stone crosses, 333 Hierakonpolis, Egypt: Palette of Narmer, 84-85, 85-86 hierarchical proportion, 60, 85 hieroglyphs, Egyptian, 86-87 high relief, 30. See also relief sculpture highlights, 246 Hijra, 319 Hildegard of Bingen, 409; Liber scivias, 409 Hildesheim, Germany: abbey church of Saint Michael, 342-344, 342-344 Hindu temples, 440-444; construction of, 4, 440; designs, 12 Hinduism, 312, 439–444; artists, 440; caste system, 258; gods and goddesses, 439; sculpture, 10-11; spread of, in east Asia, 439-448; synthesis with Buddhism, 444. See also Hindu temples; Mughal art hippodromes, 225 Hittite war god (relief, Hattusas), 68, 69 Hittites, 68 Holy Family, 268 Holy Roman Empire, 336; map, 336. See also Carolingian period; Ottonian period Holy Sepulcher, 370, 384 Homer, 127, 128, 139, 140 homunculus, 387, 452 Honduras, see Copán; Mesoamerica horses: monumental, 240-241 Horus, 83 Horyu-ji monastery (Nara, Japan), 437-438, 437-439 Hosios Loukas monastery churches (Greece), 297-301, 298, 300; mosaics, 299-300

House of the Faun (Pompeii), 213

House of the Silver Wedding (Pompeii), 213 House of the Vettii (Pompeii), 248–249, 248, 249 houses (domestic): Roman, 213-214. See also villas hues, 21 Huitzilopochtli, 356 humanism, 452, 466, 471 Hundred Years' War, 473 Hunefer (scribe): Book of the Dead, 105, 105 hydria, 141, 145, 145 hyena and panther (cave painting, Chauvet cave), 33. 33 Hyksos, 83, 100, 110 hypostyle halls, 100

Iaia of Kyzikos, 140 Ibsen, Henrik: Master Builder, The, 400

Iceland, 328

Iconoclastic Controversy, 10, 297

iconographic interpretation, 286 iconography, 14–15

iconology, 14-15

icons, 4; Byzantine, 296; destruction of, 297

idealized art, 24; Greek, 159

ideographs, Chinese, 204

idolatry, 10, 319; and Iconoclasts, 297 idols: Aegean, 118; Andean, 359, 359; Cycladic,

117-118

Iktinos of Athens, 158, 170

Île-de-France, 394

Iliad (Homer), 139

illuminated manuscripts, see manuscript illumination

illusion: art and, 6-7, 457-458

illusionism, 6, 24; Greek, 148

images: magic of, 9-11, 39; prohibition of, 10, 319; textual meaning of, 14-15 Imhotep, 90

impersonator figures (Paracas culture), 360

impluvium, 212

- impost block, 78
- Inanna (Ishtar), 55, 56
- incense burner in the shape of a domed building, 302. 302
- incised lines, 31
- India: Hinduism in, 439; maps, 254, 255, 305; Tai Mahal, 3, 3, 19; Vedic period, 258. See also Hinduism; Mughal art
- Indian architecture: monastic, 305-307; rock-cut, 305 - 307

Indian painting: mural, 309-311

Indian sculpture, 307; Gupta, 307-308

Indians, American, see Native Americans

- individuality in art, 183
- Indo-Europeans (Aryans), 258 Indo-Greeks, 254

Indravarman, Khmer king, 444

Indus Valley civilization, 254-265. See also Mohenjo Daro culture

inhumation, 270

- initial L and Saint Matthew (illumination, region of Agen-Moissac), 379, 379 initial T (illumination, sacramentary of Saint-Saveur
- de Figeac), 380, 380
- *Injustice* (Giotto), 462, **462** Inka Empire, 358, 363–364; architecture, 363–364, 363; metalwork, 364
- inlay, 56
- Innocent III, Pope, 463

insulae (apartment blocks), 214, 214

- intaglio, 58
- intensity, 22
- Interior of the Pantheon, The (Panini), 227, 229 interlace designs, 205, 327, 380, 380, 383, 383, 423
- International Gothic style, 471-477
- intonaco, 457
- Ionian Greeks, 136, 162

Ionic Order, 162, 163, 171, 174

- Iphigenia, 128
- Iran, ancient, 74, 77-79. See also Persia/Persians
- Iraq, see Mesopotamia Ireland, 332-333; stone crosses, 333. See also
- Hiberno-Saxon art

- Islam, 319-326; conquests, 115; map, 318; prohibition of images, 10; Sunni and Shiite divisions, 319 Islamic architecture: influence on European architecture, 430; influence on Romanesque style, 365, 379; mosques, 321-326 Islamic art: calligraphy, 319, 320; scripts (Kufic and cursive), 320 isocephaly, 174 Israel, see Jerusalem Istanbul, Turkey, see Constantinople Italian architecture: Gothic, 429; Romanesque, 384-386 Italy, ancient: Greeks in, 189. See also Etruscan civilization; Rome, ancient Italy, modern: Byzantine influence, 449, 452, 464, 466, 471; city-states, 366; commerce in eleventh century, 366; in fourteenth century, 452; government forms, 462; Norman conquests, 365-366. See also Florence, Italy; Italian architecture; Mi-lan, Italy; Padua, Italy; Pisa, Italy; Ravenna, Italy; Renaissance culture; Rome, Italy; Siena, Italy; Tivoli, Italy; Venice, Italy ithyphallic figures, 256 Itzá Maya, 355 Ivan IV ("the Terrible"), tsar of Russia, 303 ivory carving: Christ Enthroned with Saints and Emperor, 344, 345 J jade: Chinese, 203; Mayan, 351, 351 James the Apostle, Saint, 369. See also Santiago
 - de Compostela
- jāmi' mosque, 321

Iris, 142

Ishtar, 55

Isis, 83

Iron Age: Etruscan, 191

irrigation systems, 51, 54

Isidoros of Miletus, 288

Ishtar Gate (Babylon), 73-74, 73

Isfahan, Iran: Luftullah Mosque, 326, 326

- January (Limbourg brothers), 475, 476-477
- Japan: adoption of Chinese culture, 437 Japanese architecture, 437-438
- iatakā. 262
- Jayavarman VII, Khmer king, 447
- Jelling, Denmark: Harald Bluetooth's rune stone, 319-321, 332, 332
- Jemdet Nasr: clay tablet, 58, 58
- Jericho, 52; plastered skull, 52, 52, 88
- Jeroboam Worshipping Golden Calves (Chartres), 398, **398**
- Jerusalem, 234-235, 370, 400; Dome of the Rock, 319, 370; pilgrimages to, 366
- Jesus among the Doctors (as subject), 269
- Jesus Christ: Byzantine representations, 283-284, 283, 293, 293; Deësis mosaic, 302, 302; depictions in art, 296, 338, 339, 387; founder of Christianity, 266; as Good Shepherd, 270; Gothic, 409; as homunculus, 296; monogram of, 271; as Pantokrator, 301, 301; scenes from life of, 269. See also Christianity; Crucifixion; Last Supper
- jewelry: Etruscan, 193; Nubian, 115; Peruvian, 361. See also goldwork; silverwork
- Jewish wars, 234-235
- Jews/Judaism, 266-267, 268, 340; prohibition of images, 10
- John the Baptist, Saint, 272
- John the Evangelist (the Divine), Saint, 268, 339, 339; depictions of, 338; symbols of, 339
- Jonah, 272
- Joseph, Saint, 268
- Joseph and Potiphar's Wife (Vienna Genesis), 294-296, 295
- Joseph Interpreting Dreams in Prison (Vienna Genesis), 294, **294**
- Josephus: History of the Jewish Wars, 235
- Jotun, 330
- journeymen, 399
 - Judaism, see Jews/Judaism
- Judas, 466, 466-467 Judas (as subject), 269

- Julius Caesar, 211, 217; bust, 237, 237; Commentaries, 217 Juno 142 Jupiter, 8, 142 Justice (Giotto), 462, 462, 468 Justinian I, emperor of Byzantium, 280, 290, 292, 293; Court of Justinian mosaic, 284, 284, 286 Κ ka, 87 Kaifeng, China: pagoda, 436, 436 Kali, 439 Kallikrates of Athens, 170 Kamares ware, 123, 123 Kamasutra, 309 kangaroo with Lightning Man (rock painting, Australia), 43, 43 Kant, Immanuel, 13, 17 Karli, Maharashtra, India: chaitva hall, 305, 306. 307, 307 karma, 258, 439 Karnak: temple of Amon-Ra, 100, 101 Kassandra, 128 Kassites, 68 Kells, Book of, 206, 334-335, 335 keystones, 213 Khafre, pharaoh of Egypt, 95; pyramid, 91, **91**, 95; statue, 94, **94–95**, 95, 99 Khamerernebty, queen of Egypt, 95; statue, 95, 96, 99, 103, 150-152 Khan, see Genghis Khan; Kublai Khan Khmer Empire, 444-448 Khufu, pharaoh of Egypt: pyramid, 91, 91, 95 kilns, 31 king and queen of Punt (relief, Deir el-Bahri), 110, 110 King Assurnasirpal II hunting lions (relief, Nimrud), 70, 71 King's College Chapel, Cambridge, England, 428, 428 Kiss of Judas (as subject), 269 Kiss of Judas (Duccio), 466-468, 467 Kiss of Judas (Giotto), 466-468, 467 Kiss of Judas mosaic (Sant'Apollinare Nuovo, Ravenna), 466-468, 466 Klee, Paul, 2-3 Klytemnestra, 128 kneeling bull (Proto-Elamite sculpture), 74, 75, 75 Knidian Treasury (Delphi), 161 Knights of Saint John of Jerusalem, 366 Knights Templar, 366 Knossos, Crete: palace of Minos, 119-121, 119, 120, 121, 122

Koca, see Sinan the Great

- kondō (Golden Hall), Horyu-ji, Nara, 437, 438-439 Kongzi, see Confucius
- Koran (Qu'ran), 6, 319, 320; Kufic manuscript of, 320
- kore (female) figures, 152, 153, 159 Korea: kingdom of Paekche, 437 kouros (male) figures, 151, 151 krater, 141, 145, 145 Krishna, 439 Kritios, 153 Kritios Boy, 153-154, 153 Kublai Khan, 434 Kufic script, 320 Kul Oba, Russia: lion-head finial, 328, 329 Kush, 110. See also Nubia
- Kushan period, 263-265
- Kuyuk the Great Khan (Persian miniature), 450 kylix, 141, 145, 145

L

- La Madeleine, France: cave sculpture, 31, 31 La Venta (Olmec site), 348 Labors of Herakles (relief, Olympia), 166, 167, 168, 168 labyrinth, 119
- Lagash, Iraq, 64-65; Gudea with a temple plan (statue), 64, 65; head of Gudea, 64, 64 Lake Titicaca, South America, 362
- Lakshmi 439 442 442 Lamassu figures (Dur Sharrukin), 70, 72 Lamentation (as subject), 269 lancet windows, 398, 398, 410, 411 landscape painting, 11; Roman, 294; Roman frescoes, 247 Landscape with Boats (Pompeii), 246, 247 Lanzón idol (Chavín), 359, 359 Laocoön and His Two Sons (Hellenistic sculpture), 186, 186, 249 lapis lazuli, 60 Lapith and Centaur (Parthenon), 6 lapiths and centaurs, 164-165, 165, 174, 174 Lascaux caves (Dordogne): map, 37, 37-39; paintings, 37, 37 Last Judgment (Congues), 372-374, 373, 461 Last Judgment (Giotto), 455, 460-461, 461 Last Judgment (Gislebertus), 381-382, 381, 382 Last Supper, 268 Last Supper (as subject), 269 Late Classical style (Greece), 178-182 Latin America, see Andean cultures; Mesoamerica; Mexico Latin language, 210, 336 law code of Hammurabi, 67-68, 67, 106 Lawrence, Saint, 408, 408 leaf-and-dart motif, 161 "Leaning Tower" of Pisa, 384–385, 384, 385 Leiden Plate, 351, 351 lekythos, 141, 145, 145, 148 Leo III, Holy Roman Emperor, 297 Leonardo da Vinci: Freud on, 17; Mona Lisa, 4, 6; Notebooks, 7 Leptis Magna, Libya: circus, 223, 224–225, 224 Leroi-Gourhan, André, 35, 38, 39 Leto, 142 Liber Sancti Jacobi (Book of Saint James), 369 Libya, see Leptis Magna Life of Saint Denis (Gothic illumination), 419-420, 419 light, 21-23; symbolism of, 286, 394 Lightning Man (Namarrkon), 43, 43 Limbourg brothers (Paul, Herman, and Jean), 475-477; Très Riches Heures du Duc de Berry, 474-475, 475-476 Linear A and B scripts (Minoan), 123 lines, 19–20, **19**, **20**; expressive qualities of, 19–20, 20; types of, 19 lingam, 439 lintel-and-tenon construction, 48, 49, 49 lintels, 48, 73, 79, 372, 372, 404, 405; Gothic, 405, 405. See also post-and-lintel construction lion capital, Ashoka pillar (Uttar Pradesh), 260, 260 Lion Gate (Hattusas), 68, 68, 70 Lion Gate (Mycenae), 128, 129, 130 lion-head finial (Kul Oba), 328, 329 "Lion Panel" (Chauvet cave), 34, 34 Lion Symbol of Saint John (Book of Durrow), 333, 334 lions: Achaemenid drinking vessels, 79, 79; Ashoka pillar, 260; in Buddhist art, 264, 265; of Delos, 150; Lion Gate, Mycenae, 129 literature: Mesopotamian, 58, 59 load-bearing construction, 57 Loki, 330 London, England: British Museum, 6 Longmen caves, China, 314, 314, 434 Longmen style, 313-314 Lorenzetti, Ambrogio, 468; Allegories of Good and Bad Government, 468-471, 468-469 Loriyan Tangai, Gandhara, Pakistan: model of a stupa, 264 lost-wax casting process: Chinese, 203; Greek, 62, 154 Lotus Sutra, 313, 435 Louis VI, king of France, 394 Louis VII, king of France, 394 Louis IX, king of France (Saint), 399, 420 Louis XIV, king of France, 3 Louis of Toulouse, Saint, 471-472, 471 Louvain, Belgium: town hall, 432, 432

Louvre, Paris (Perrault, Le Vau, Le Brun): Mu-

seum, 5

- low relief, 30. See also relief sculpture Luftullah Mosque (Isfahan), 326, 326 Luke, Saint, 268, 297, 339, 344, 345; symbols of, 339 Luxor, Egypt: temple complex, 102, 102 Luzarches, Robert de, 413 Lydia, 77 lyre (Ur), 60, 61, 62 Lysippos of Sikyon, 180; Apoxyomenos (Athlete with a Strigil), 180, 181; Socrates, 141, 141, 180, 182 Μ Maat, 83 Macedonia, 83; empire, 183 Machu Picchu, Peru, 363–364, **363** Madonna Enthroned (Cimabue), 452, 452, 453-454 455
- Madonna Enthroned (Giotto), 453-454, 453, 455 Maestà (Duccio), 455, 464-465, 464-465, 466-468, 467 Magdeburg Antependium, 344, 345 Magritte, René: Betrayal of Images, The, 6-7, 7, 17, 18 Magyars, 365 Mahaparinirvana, 259, 261 Maia, 142 Maitreya Buddha, 313 male Cycladic flute player (statue, Keros), 117, 118 Mallorca: Palma Cathedral, 430, 430 Malta: Ggantija (Tower of the Giants), 45, 45, 46; mother goddess, 45–46, **45**, 118; temples, 45 Mammen, Denmark: axe, 328, **329**, 390 mammoths and horses (Chauvet cave), 34, **34** "Man is the measure of all things," 141 mandalas, 262, 440 mandapa, 444 mandorla, 293, 381, 406; Romanesque, 373, 376-377, 376 Manetho, 83 mantra, 440 manuscript illumination: Carolingian, 338-340; Early Christian, 295; Gothic, 8, 419; Hiberno-Saxon, 333–335, **334–335**; Islamic, **320**; northern European, 475; Ottonian, **345**; pre-Renaissance, **475–476**; Romanesque, **376**, 379, **379–380** manuscripts, see books and manuscripts Marathon, Battle of, 152 marble, 212, 242; color of, 242 Marcus Agrippa, 225, 227 Marcus Aurelius, emperor of Rome, 211, 235, 236, 240-241, 241 Margaret of Flanders, 473 Marinatos, Spyridon, 124 Mark, Saint, 268, 339; symbol of, 339 Marriage at Cana (as subject), 269 Mars (Roman god), 142 Mars of Todi (Etruscan bronze), 192-193, 192 Martial, 294 Martini, Simone, 471-472; Annunciation, 472, 472; Saint Louis Altarpiece, 455, 471–472, **471** martyria, 272, 276 martyrium of Santa Costanza (Rome), 276, 276, 277 martyrs: Christian, 268 Marx, Karl, 15-16 Marxism, 15-16 Mary, Virgin, 268, 457-458, 457, 472; associations with church buildings, 12; cult of, 296, 399; depictions in art, 296, 297, 387; as Queen of Heaven, 296; Theotokos ("Christ-bearing"), 296, 297; Virgin and Child Enthroned mosaic (Hosios Loukas), 299, 299; Virgin and Child Enthroned with Saints Felix and Augustus (Rome), 296, 296; Virgin in a Church, The (Jan van Eyck), 12, 12, 23 Mary and Christ with Two Angels (Castel Appi-
- ano), 386-387, 387
- Mary Magdalen, Saint, 459
- *masjid* mosque, 321 "Mask of Agamemnon" (Mycenae), 3, 131–132, **132** mask of Tutankhamen, 108, 108
- masks: Egyptian, 88, 108; Mycenaean, 3, 132. See also death masks

- Mass, Christian, 268, 455 Massacre of the Innocents (as subject), 269
- mastabas, 90, 90
- master builders (of Gothic cathedrals), 400-402 Master or Mistress of the Beasts motif, 122
- masters (of guilds), 399
- Mater Matuta (Etruscan cinerary statue), 194, 194
- mathematics: Greek, 138-139
- Mathura, India, sculpture, 263, 264–265; Seated Buddha, 264–265, **265** Matthew, Saint, 268, 339, 379, 379; symbol of, 339
- Mauretania, 318
- Maurya period, India, 260-261
- mausolea: Carthaginian, 252; Early Christian, 276, 277-279
- mausoleum of Galla Placidia (Ravenna), 277-279, 277, 278, 279
- Maximian, archbishop of Ravenna, 280, 287; throne of, 287, 287
- Maya, Oueen, mother of the Buddha: Dream of Queen Maya, 258, 259
- also Bonampak; Chichén Itzá; Copán; Tikal
- Maya Lord (Tabasco), 351-352, 351, 353
- Maya warrior in Teotihuacán costume (relief, Tikal), 350-351, 350
- meander patterns, 143, 143
- Mecca, Arabia, 319
- medals: Greek, 163
- Medes, 72, 77
- medium (binder), 30
- Medusa, 144, 146
- Meegeren, Han van, 5
- megaliths: European, 45-50; Neolithic, 45-49
- megarons: Minoan, 121, 121; Mycenaean, 127, 127; plan, 160

Melgart, 252

- men and women hunting kangaroos (rock painting, Australia), 42, 43
- Menelaus, 128
- Menes, king of Egypt, 82, 83, 84
- menhirs, 46, 46
- Menkaure, pharaoh of Eqypt, 95; pyramid, 91, 91, 95; statue, 95, 96, 99, 103, 150–152
- Menkaure and Queen Khameremebty (statue, Giza), 95, 96, 99, 103, 150-152
- menorah, 234-235, 266
- Mercury, 142 Merce, Nubia, 113–114; pyramids, 114, **114;** "Shield ring," 114, 115
- Meru, see Mount Meru
- Mesoamerica, 347–357; map, **347**. See also Aztecs; Maya civilization; Mexico, ancient; Olmec civilization
- Mesolithic era, 44
- Mesopotamia, 54-68; religion, 55-56. See also Akkadians; Assyria; Babylon; Sumer; Ur; Uruk; ziggurats
- metalwork: Achaemenid, 79; ancient Near Eastern, 54; Anglo-Saxon, 327; Byzantine, 302; Carolingian, 343-344; northern European, 329. See also bronzes; cloisonné; goldwork; silverwork
- methods of interpretation of art works, 13-18; biographical, 286; Court of Justinian mosaic (Ravenna), 286: Court of Theodora mosaic (Ravenna), 286; feminist, 286; formal, 286; iconographic, 286

metopes, 163

Mexico, ancient: pyramids, 348. See also Aztecs; Maya civilization; Mesoamerica

Michelangelo Buonarroti, 2-3, 7, 16

- Middle Ages: definition, 318; Early, 318-345; feudalism in, 365; maps, 328. See also Anglo-Saxons; Carolingian period; Gothic architecture; Gothic style; Hiberno-Saxon art; Islam; manuscript illumination; Ottonian period; Romanesque style; stained-glass windows; Vikings
- Middle East, ancient, see Near East, ancient
- Midgard, 330
- mihrāb, 321, 323
- Milan, Italy: Cathedral, 429, 429 Milvian Bridge, Battle of the, 235, 270

- mimesis, 16
- Mimi hunters (Australia), 42, 43, 201
- minarets, 288, 289, 321
- minbar, 321
- Minerva, 142
- Minoan civilization, 119-126, 136; frescoes, 123, 124; painting, 144; pottery, 123, 123; religion, 122-123; scripts, 123

naos, 160

439

Narcissus, 9

narthex. 272

naves, 218

105, 106

burials

Palette of Narmer

Native Americans, 9

Naxos, Greece, 150

necking, column, 162

Nemes headdress, 93

burials, 46, 52, 53

Neptune, 142

Nergal, 55

432

184

Ninhursag, 55 Niobe, 147, **147**

Njord, 330

nirvana, 258, 435, 439

also abstract art

Norman style, 422

Normans, 365-366

Normandy, 342

Norns, 330

Nofret: statue of, 95, 97, 98

Noli me tangere (as subject), 269

Roman and Byzantine period

North America, see Native Americans

Nefertari, queen of Egypt, 112

Neo-Babylonian Empire, 73–74

Neo-Punic stele (Tunisia), 252, 252

Neo-Gothic architecture, 432

Neo-Sumerian culture, 64-66

Nerva, emperor of Rome, 211

New York Kouros, 150-152, 151

Nile river, 81-82; hymn to Hapy, 81

Netherlands, see Belgium

New Testament, 268

Nicaea, Council of, 270

Nativity (as subject), 269

Naples, 366, 471

Napoleon Bonaparte: conquests, 5

narrative, 232; continuous, 294–296

Nativity (Pisano), 449, 450, 458-459

nationalistic value of art, 4-6

Nativity (Giotto), 458-459, 458

sance, 468; Roman, 236

Nara, Japan: monastery of Horyu-ji, 437-438, 437-

Narmer (Menes?), pharaoh of Egypt, see Menes;

naturalism, 6, 24; in Early Christian art, 296; Egyp-

tian, 105, 106; Greek, 141, 161, 180; in Indian art,

310; medieval, 344; Mycenaean, 132; in Renais-

Near East, ancient, 3; influence on Greek art, 144; Neolithic era, 51–52. See also Hittites; Mesopo-

Nebamun hunting birds (painting, Thebes), 105,

necropolis, 195; Malta, 46. See also tombs and

Neolithic era: in Egypt, 81; in Europe, 44-50; plas-

Nero, emperor of Rome, 8, 211, 214, 224, 268

New York, N.Y.: Saint Patrick's Cathedral, 432,

Nike, 142; Winged Nike (from Samothrace), 184,

Nike Adjusting Her Sandal (Acropolis, Athens), 177

Nimrud, Iraq: city attacked with a battering ram

non-Western art, 1, 2. See also Andean cultures;

Mesoamerica; Mughal art; Native Americans

nonrepresentational/nonfigurative art, 11, 25. See

North Africa, see Carthage; Egypt, ancient; Egypt,

Australia; Buddhist art; China; India; Japan;

(relief, palace of Assurnasirpal), 70, 71; King As-

surnasirpal II (sculpture), 69, 70; King Assur-

Nîmes, France: Pont du Gard, 225-226, 225, 233

nasirpal II hunting lions (relief), 70, 71

Nineveh, 72; Dying Lioness (relief), 70, 71

Niobid Painter: kalyx krater, 147, 147

"No day without a line" (proverb), 20

tered-skull sculptures, 3, 52, 52, 88; tombs and

Nebuchadnezzar, king of Babylon, 15, 73, 370

Nefertiti, queen of Egypt, 106; bust, 106, 107

Nefrura: statue with Senenmut, 104, 104

Nazca culture (Peru), 360; pottery, 360, 361

tamia; Persia/Persians; Scythians

Naram-Sin, ruler of Akkad, 63-64; stele of, 5

- Minos, king, 119
- mirrors: Etruscan, 191, 193, 193
- missionaries: Christian, 268
- mithuna, 307
- Mithuna (Karli), 307, 307 Moche culture (Peru), 360-361; architecture, 361; metalwork, 361, 361; pottery, 360-361, 361
- Mocking of Jesus (as subject), 269
- modeling (clay), 31
- modeling lines, 21
- Mohenjo Daro culture: seals, 256
- Moissac, France: Saint-Pierre, 374-380, 374, 375, 377-379, 407
- Mona Lisa (Leonardo), 4, 6
- monasteries: Byzantine, 298-300; Carolingian and Ottonian, 341-344; Irish, 332; Japanese, 438; medieval Christian, standard plan for, 340-341
- monastery churches of Hosios Loukas (Greece), 297-301, 298, 300; mosaics, 299-300
- monasticism, 340
- Mongols, 434
- monkey-man scribal god (statue, Honduras), 353, 353
- monoliths, 46
- monotheism: Christian, 268; Egyptian, 106
- Monreale, see abbey church of Monreale
- mosaics: ancient Near Eastern, 54; Byzantine, 293, 297, **302**, **466**; Early Christian, **274**, 275, **277**, **279**, **282–285**; Mesopotamian cone, 54 Moscow: Saint Basil's Cathedral, 303, 303
- Moses, 10, 293, 474
- Moses Giving Water to the Twelve Tribes of Israel (Dura Europos), 266, **267**
- Mosque of Omar, see Dome of the Rock
- mosques, 321-326; Iran, 326; Iraq, 321; Jerusalem,
 - 319; Spain, 322-323; Turkey, 324-325
 - Mother goddess" (Malta), 45-46, 45, 118
- Mount Meru, 439, 440
- Mount Sinai, Egypt: Saint Catherine's monastery, 293, 293, 296, 297
- mud-brick building, 52
- mudrā (Hindu), 264, 440
- Mughal art: architecture, Taj Mahal (Agra), 3, 3, 19
- Muhammad, Prophet, 10, 319
- Mukteshvar Temple of Shiva (Bhubaneshvar, Orissa), 443–444, **443**
- mummies and mummification: Egyptian, 3, 87-88 mummy case of Artemidoros (Faiyum), 250, 250
- murals: Aegean (Thera), 124; Byzantine, 297; Early Christian, 270, 296-297; Egyptian, 105, 111; Etruscan, 190, 199; Greek, 149; Indian, 310-311; Jewish, 267; Mesoamerican, 354; Minoan, 120, 121-122, 123, 124-126, 124-126; Myce-
- naean, 128; pre-Renaissance, 456-463, 467-470; Roman, 243-249; Romanesque, 386-387 Muses, 275
- music: Christian church, 372

mystery plays, 458

Nanna (Sin), 55

Nanna ziggurat (Ur), 66, 66

- musical instruments: ancient Near Eastern, 60, 61-62
- Muslims: defeat at Tours, 336; entry in Europe, 365; expulsion from Europe, 430. See also Islam Mut. 83
- Mycenae, Greece, 127; "Mask of Agamemnon," 3 Mycenaean civilization, 127-133, 136; goldwork,
- 132; shrines, 127; tombs, 131
- Myron, 155; Diskobolos (Discus Thrower), 155-156, 156 mystery cults, 266

mythology: Greek and Roman, 8, 9, 212, 330;

Scandinavian, 330. See also gods and goddesses

northern European art: maps, 328; Middle Ages, 327-345 Northern Wei dynasty, 312–313 Norway, 328; stave churches, 383 122 Nubia, 109–115; "eggshell" pottery, 110, 110; map, 82; Napatan period, 113; pyramids, 114, 114-115 Nubians bringing offerings to Egypt (fresco, Thebes), 111, **111** nude in art: Greek, 152, 180 Nude male torso (Mohenjo Daro), 257, 257, 263, 308 () obelisks, 101, 101 Octavian, see Augustus Caesar Octopus Vase (Crete), 123, 123 oculus, 227 Odin, 330, 331 Odo, bishop of Bayeux, 387-390, 388, 389 Odo of Metz, 337; Charlemagne's palace chapel, 336–337, **337** Odysseus, 144 Odysseus Being Attacked by the Laestrygonians (Rome), 244-245, 245 Odyssey (Homer), 139-140, 144 301. 301 Oedipus complex, 17-18 oenochoe, 141, 145, 145 Officer (statue, tomb of Emperor Qin, Lintong, China), 207, 207 Ognissanti Madonna, see Madonna Enthroned (Giotto) oil paintings: Neoclassical, 9; Netherlandish, 11; Post-Impressionist, **10**; Surrealist, **7** Old Saint Peter's, Rome, 272–273, **272**, **273** Old Testament, 268 Old Testament Trinity (Rublev), 303, 303 Olmec civilization, 348, 351 Olympia, Greece, 167; temple of Zeus, 163-168, 164, 165, 166, 176 172 - 174Olympic (Panhellenic) Games, 136, 167 Opening of the Mouth ceremony, 89, 105-106, 105 pathos, 182 opisthodomos, 160-161 Oppenheim, Meret, 16; Fur-covered Cup, Saucer, and Spoon (Le Déjeuner en Fourrure), 14, 14, 15, 16, 17, 23 opus francigenum, 396 opus vermiculatum, 149 orant figures, 266 Orcagna, Andrea: Triumph of Death, 470, 470 Orders, monastic, see monasticism Orders of architecture, 160, 162-163; Byzantine, 282; Corinthian, 162; Doric, 162; Ionic, 162 Orestes, 128 organic forms: in sculpture, 263 Pelops, 164 Orientalizing style (Greece): pottery, 143-144, 144; sculpture, 150 Orissa, India: Temple of Shiva, 443-444, 443; temples, 443-444, 443 Oseberg, Norway: animal headpost, 328, 329 147 Osiris, 83 Östergötland, Sweden: Rök stone, 331, 331 Ostia, Italy: insulae, 214, 214 Ostrogoths, 280, 331 Otto I ("the Great"), Holy Roman Emperor, 342, 344 Otto III, Emperor, 342, 343; Gospel book, 344, 345 Ottoman Empire, 324 Ottonian period, 342-345; architecture, 342; ivory carving, 344 Ovid, 7, 212; Metamorphoses, 210, 212 Perseus, 144 Ρ Padmapani (Ajanta Cave 1), 310, 311 Padua, Italy, 454-455; Arena Chapel frescoes (Giotto), 454-462, 456-462, 466-468, 467 Paekche (Korea), kingdom of, 437

- pagan religions, 268
- pagodas: Chinese, 436, 436; Japanese, 437-438 painting, 7; mythical origin of, 9 paintings: Aboriginal, 42–43; Egyptian, 105, 111;
- Greek, 144-148; Paleolithic, 33-40. See also fresco murals; icons; manuscript illumination; murals; oil paintings; portraits; rock painting; specific countries; specific periods; specific styles

palace of Darius I (Persepolis), 77, 78, 78; Apadana Hall, 77, 77 palace of Minos (Knossos), 119-121, 119, 120, 121, palace of Sargon II (Dur Sharrukin), 70, 72 palaces: Assyrian, 70, 72; Minoan, 119-122; Mycenaean, 127, 127; Persian, 77-78 Paleolithic era: chronology, 28-29; cultures, 28; painting, 32-40; sculpture, 29-31; Upper, 28-40. See also cave art Palermo, Sicily: abbey church of Monreale, 301, 301 Palestine, 366 Palette of Narmer, 84–85, **85–86**. *See also* Menes Palma Cathedral, Mallorca, 430, **430** Pancaspe, 148 panel paintings: Byzantine, 303; Netherlandish, 11; pre-Renaissance, 452-453; preparation for tempera painting, 454 Panini, Giovanni Paolo: Interior of the Pantheon, The, 227, 229 Panofsky, Erwin, 419-420 pantheism, 268 Pantheon (Rome), 213, 227-229, 228, 291 Pantokrator mosaic (abbey church of Monreale), papacy, 271, 273 papyrus, 85, 98 Paracas culture (Peru): textiles, 360, 360 Paradise sects, Buddhist, 313 parapets, 45, 176 parchment, 294 Paris, France: Saint-Denis, 395-396, 395, 396, 420; Sainte-Chapelle, 420, 421 Paris, prince of Troy, 128 Parler, Peter, 430 Parthenon (Acropolis, Athens), 3, 169–174, 170– 174; cult sculpture, 3, 4; friezes, 174, 175; metopes, 174, 174; pediment sculptures, 6, 172-174, patriarchs, 271 Patrician with Two Ancestor Busts (Rome), 238, 238 Patrick, Saint, 332 patrons, 3; in Renaissance, 451, 471 Paul, Saint (Saul of Tarsus), 268; sculptures, 377-378, 378, 406 Paul the Silentiary, 290 pavonazzetto, 242 Paynedjem's Book of the Dead, 89, 89 Pech-Merle, France: handprints, 35, 35 pedestals, 118 pediments, 163 Peisistrates, 136 pendentives, 288, 291, 291 Pentecost (as subject), 269 Penthesilea, 146, 147 Penthesilea Painter: Achilles and Penthesilea, 147, Peplos Kore, 152, 153, 159 Pergamon, 186, 294; Great Altar of Zeus, 186, 187; head of Alexander from, 183, 183 Perikles, 140, 169-170 peripteral temples, 160, 227 peristyles, 171, 212 Perpendicular Gothic style, 428 Persephone, 142 Persepolis, 77; palace of Darius I, 77, 77 Persia/Persians, 77-79, 83, 115, 169-170, 174, 176; Battle of Issos mosaic, 149; manuscript illumination, 450; rivalry with Greece, 136-137, 152, 254. See also Achaemenid Empire Peru, see Andean cultures; Inka Empire; Moche culture; Nazca culture; Paracas culture Peter, Saint, 273; icon, 296, 297 Petrarch (Francesco Petrarca), 452, 453 pharaohs, 3, 82-84 Phidias, 164, 170, 174, 175, 176; coin with design after, 163, 163

Philip I of France Granting Privileges to the Priory of Saint-Martin-des-Champs (illumination), 419, 419

Philip II, king of Macedon, 178, 182 Philip the Bold, duke of Burgundy, 473 Phoebus, 142 Phoenicians, 189, 250 photography, 9 Picasso, Pablo, 2–3 pictographs: Chinese, 204; Sumerian, 58 picture plane, 18 picture stones, Scandinavian, 331 pictures, see images; paintings piers, 234, 396, 397; compound, 397 Pietà (as subject), 269 pigments, 30; cave art, 37; for writing, 98 pilasters, 195 pilgrimage churches, 370-380 pilgrimages, Christian, 366-369, 425; map, 367; routes, 369 pillars, 79; of Ashoka, 260–261. See also columns Pippin, Horace, 2-3 Piraeus, Greece, 169 Piranesi, Giovanni: Great Baths, The, Hadrian's Villa, Tivoli (etching), 216, 216 Pisa, Italy, 366, 384; baptistery pulpit, 449, 449-450, 458–459; campanile (Leaning Tower), 384–385, 384, 385; cathedral, 384–385, 384, 385; cathedral complex, 384-386, 384 Pisano, Giovanni, 429, 449, 471 Pisano, Nicola, 449-450, 471; pulpit, Pisa Baptistery, 449, 449-450, 458-459 Pius II, Pope, 366 plane of relief, 18 planes, 18 plastered skull (Jericho), 52, 52, 88 Plato, 13, 17, 126, 137, 140, 141, 178, 180; on art and artists, 140; Republic, 400 plinth, 70 Pliny the Elder, 8, 16, 140, 180; Natural History, 214 Pliny the Younger, 212, 214 Plutarch, 170 Pluto (Greek god), 142 podium, 226 poetry, see literature pointed arches, 398 polis (Greek city-state), 137 Polo, Marco, 434 polychrome, 43 Polyeuktos: Demosthenes, 183, 183 Polykleitos of Argos, 158–159; Doryphoros (Spear Bearer), 158, **158**, 180, 193, 236, 239; Wounded Amazon, 158-159, 159, 186 Polyphemos, 144 Polyphemos Painter: amphora, 130, 143-144, 144 Pompeii, 13, 212, 243-249; Battle of Issos mosaic, 148, 149, 183; four styles of fresco, 243; House of the Faun, 213; House of the Silver Wedding, 213; House of the Vettii, 248-249, 248, 249; Landscape with Boats, 246, 247; Villa of the Mysteries, 243-244, 243, 244; Young Woman with a Stylus, 245-246, 245, 296 Pompeiian red, 243 Pompey (Roman statesman), 217 Pont du Gard, near Nîmes, France, 225-226, 225, 233 Pontifex Maximus, 230 Poor Clares, 463 popes, see papacy Popol Vuh, 352 porch (pronaos), 226 porphyry, 242 portals: Gothic, 405, 405; pre-Renaissance, 473; Romanesque, 372, 372-373, 404 porticoes, 160 Portrait bust of a young Flavian lady, 238, 238 Portrait bust of an older Flavian lady, 238-239, 238 portraits, 2-3, 9-10; Byzantine, 286; Egyptian, 94-99, 103-104, 107, 250; Etruscan, 194; Greek, 141; Hellenistic, 183; Moche, 361; Roman, 237, 237-242, 286. See also masks; self-portraits

Portugal: Moorish rule, 366

Portunus, Temple of (Rome), 226, 226

- Poseidon, 142
- Poseidon/Zeus (bronze statue), 155, 155

post-and-lintel construction, 48, 48, 49, 79, 130, 162 Postnik, see Barma and Postnik poststructuralism, 17 potter's wheel, 54 pottery: ancient Near Eastern, 74; Iranian, 74; Minoan, 123, 123; Nubian "eggshell," 110, 110; Peruvian 361 See also terra-cotta: vases Prague Cathedral, Czech Republic, 430, 430 prana, 257 Praxiteles, 180; Aphrodite of Knidos, 180, 180, 185 pre-Columbian art, see Andean cultures; Mesoamerica Preaching Buddha (Uttar Pradesh), 307-308, 307 predella, 455 prehistory, 28. See also Mesolithic era; Neolithic era; Paleolithic era; Stone Age Presentation in the Temple (as subject), 269 Presentation of Nubian tribute to Tutankhamon (wall painting, Thebes), 111, 111 Priam, 128 registers, 55 primary colors, 21 Prince Distributing Alms (Ajanta Cave), 310, 310 Prince Rahotep and his wife Nofret (statue), 95, 97, 420 98 printing: invention of, 333 prism, 21 Procopius of Caesarea, 292 programs (of art works), 15 Prometheus, 8 proportion: in Egyptian art, 94; in Greek architecture, 172; in Greek sculpture, 158 Propylaea (Acropolis, Athens), 169 prothesis, 143 Proto-Elamite culture, 75 Protogenes, 20 Protoliterate cultures, 55 protomes, 144 provenience, 75 psalters: Utrecht, 340, 340 pseudoperipteral temples, 227 Psyche, 276 psychoanalysis, 17-18 psychobiography, 17 psychological effect of art, 6, 11 Ptah, 83 Ptolemy, 83; dynasty, 113 public works: Roman, 225 puja, 440 pulpits, 449-450; Pisa Baptistery (Pisano), 449, 449-450, 458-459 Punic religion, 252 Punic Wars, 250-251. See also Phoenicians Punt, 109-110 Pygmalion, 7 pylon temples, 101-103, 101, 102 Pyramid Texts, 89 pyramids, 90-93 Egyptian, 90-93; cross section of, 92, 92; Giza, 91, 91-93, 95; and intentions of builders, 3, 11; step, 90, 90 Mesoamerica, 349, 355 Mexico, 349-350, 349 Nubian, 114, 114-115 Pythian Games, 138

qibla, 321

Qin (Shihuangdi), emperor of China, 3, 16, 201-202 Qin warriers (tomb of Emperor Qin, Lintong, China), 3, 16, 206, 206, 207, 207, 208 guadrants, 372

- queen's megaron (palace of Minos, Knossos), 121, 121
- Quetzalcoatl, 350; Temple of, Teotihuacán, 350, 350
- Quiche Maya, 352
- Quintilian, 9
- quipu, 363
- Qur'an, see Koran
- R
- Ra (Re), 83 radiating chapels, 370

radiocarbon dating, 14

- Rahman, Abd ar-, see Abd ar-Rahman III Rahotep, prince of Egypt: statue of, 95, 97, 98 Rama, 439
- Ramses II, pharaoh of Egypt, 112
- Ravenna, Italy, 277, 280, 449; Court of Justinian mosaic, 284, 284, 286; Court of Theodora mosaic, 284, 285, 286; mausoleum of Galla Placidia, 277
- 279, 277, 278, 279; San Vitale, 280-286, 280-284, 327, 337; Sant'Apollinare Nuovo, mosaic, 466-468, 466; throne of Maximian, 287, 287
- rayonnant style, 420
- realism, 24; Greek, 185. See also naturalism; photography
- rebuses, 271
- red-figure technique (Greek vase painting), 145, 146
- Reed Painter: Warrior by a Grave, 148, 148
- refinements (Greek architecture), 172
- Regnault de Cormont, 413
- Reims Cathedral, France, 412, 416-418, 416-418,
- Reinach, Salomon, 39
- reincarnation, 439
- relics: of Buddha, 436; of Christian saints, 307, 366, 369: of True Cross, 368
- relief sculpture, 30, 231; ancient Near Eastern, 71; Byzantine, 287; Early Christian, 271; Egyptian, 85, 107, 110; Greek, see Greek sculpture; Indian, 259, 265; Mesoamerican, 350; northern European, **383**; Paleolithic, 30; Persian, **78**; Ro-man, **230–232**, **234–237**, **251**; Romanesque, 376– 382. See also architectural decorations relieving triangle, 130
- religions: Egyptian, 82; prohibition of images, 10. See also Buddhism; Christianity; gods and goddesses; Hinduism; Islam; Jews/Judaism
- religious architecture: symbolism, 11. See also basilicas; Buddhist architecture; cathedrals; churches; mosques; synagogue; temples and shrines religious value of art. 4
- religuaries: Christian, 366; Romanesque, 368-369.371
- reliquary statues, 371
- Renaissance culture: maps, 451; precursors of, 449-476; the term, 449. See also humanism
- Renwick, James, 432
- repoussé technique, 133
- representational art, 6, 24
- Resurrection (as subject), 269
- Resurrection of Lazarus (as subject), 269 Return of the Messengers from the Promised Land (window, Corona Chapel), 422-425, 424
- Revelation, Book of, 339
- revolutions, see French Revolution of 1789
- rhytons, 123
- Riace, Italy: bronzes found near, 156–157, 157
- ribbed vaults, 372, 372, 395-396, 396
- Road to Calvary (as subject), 269
- Robert de Luzarches, 413
- Robert of Anjou, 471-472
- rock-cut architecture: Chinese, 312-314; Egyptian, 98; Indian, 305-307, 306, 308-311
- rock painting: Aboriginal, 41-43; Neolithic, 44; Paleolithic, 33-40. See also cave art
- Rök stone, Sweden, 331, 331
- Rokeby Venus, see Venus with a Mirror (Rokeby Venus)
- Roman art
 - architecture, 210, 212-235; aqueducts, 225-226, 225, 233; arches, 4; basilicas, 219; baths, 216; circuses, 223, 224–225, 224; commemorative, 230-236; domestic, 212-217; forums, 218, 218; influence in Middle Ages, 337, 365; insulae, 214, 214; public buildings, 217–226; religious, 226– 229; temples, 226; urban planning, 214; villas, 216
 - painting: murals, 243-249, 245
 - sculpture, 3, 236–242; ancestral images, 238; equestrian monuments, 240-241; portraits, 237-242; tomb reliefs, 449-450
- Roman Catholic Church, see Catholic Church Roman revival (Charlemagne's), 336

- Roman texts, see Classical texts
- Romanesque style, 344, 365-392; churches, 370-380, 384, 390–392, 398; manuscript illumination, 379; map, 367; mural painting, 386-387; the term, 365
- Romania, 233
- romanticized art, 24
- Rome, ancient
 - art and culture: art collecting, 13; funerary art, 236; influence of Egypt and Carthage, 250-252; libraries, 232; literature, 210; portraiture, 210, 231, 245; religions, 210; women, 210, 238-
 - 239
 - founding of, 210
 - population and housing, 214
 - Republic and Empire, 209–252, 254; chronology, 211; conquests, 115, 182, 186; emperor worship, 268; and Etruscans, 189; fall of, 212, 280, 318; maps, 189, 209; persecution of Christians, 268-269; split between Western and Eastern, 271; supremacy of, 186
- sack of (410), 318, 394, 400
- Rome, Italy: Ara Pacis (Altar of Peace), 230-231, 230, 231; Arch of Constantine, 4, 235-236, 235, 236, 405; Arch of Titus, 234-235, 234; Basilica Ulpia, 218, 219; Baths of Caracalla, 221, 221, 222; Colosseum, 212, 223-224, 223, 337; equestrian statue of Marcus Aurelius, 240-241, 241; a "marble city," 242; martyrium of Santa Costanza, 276, 276, 277; Pantheon, 213, 227-229, 228, 291; pilgrimages to, 366; Saint Paul outside the Walls, 275, 275; Saint Peter's necropolis, 274, 274; Santa Sabina, 305, **306**, 343; Temple of Portunus, 226, 226; Trajan's Column, 231-232, 231, 232, 237, 260; Trajan's markets, 220, 220. See also Vatican
- Romulus and Remus, 191, 191, 210
- roof combs, 354
- rose windows, 404, 410, 411, 420. See also stainedglass windows
- Rosetta Stone, 86, 87
- rosettes, 376
- rotundas, 227
- royal-guards relief (Persepolis), 78, 78
- Rublev, Andrei, 303; Old Testament Trinity, 303, 303 rune stones, 331-332, 331-332; northern European,
 - 331-332
- Ruskin, John, 10
- Russia: art stolen in World War II, 5-6; Byzantine style, 303; painting, 303. See also Scythians

S

- sacramentary of Saint-Saveur de Figeac: initial T, 380. 380
- sacrifice, 45, 120; in Christianity, 268; human, 251-252, 352, 354, 356, 363
- Saharan rock painting (Tassili, Algeria), 44, 44 sahn, 321

406

407

- Saint Basil's Cathedral, Moscow, 303, 303
- Saint Catherine's monastery, Mount Sinai, 293,
- 293; Saint Peter, 296, 297
- Saint-Denis: monastery school of, 394 Saint-Denis, church of, Paris, 395–396, **395**, **396**, 420
- Saint-Étienne, Caen, 390-392, 390-391, 401
- Saint Gall monastery, Switzerland, 340-341, 341, 369
- Saint John (Coronation Gospels), 338, 338
 - Saint Lawrence mosaic (mausoleum of Galla Placidia), 278, 278
- Saint-Lazare, Cathedral of, Autun, 381-382
- Saint Louis Altarpiece (Simone Martini), 455, 471-472, 471
- Saint Luke (Gospel book of Otto III), 344, 345
- Saint Michael's, Hildesheim, Germany, 342-344, 342-344
- Saint Patrick's Cathedral, New York, 432, 432 Saint Paul (Saint-Pierre, Moissac), 377-378, 378,

Saint Paul outside the Walls, Rome, 275, 275

Saint Peter's Basilica (Old), Rome, 272, 272, 273

Saint-Pierre, Moissac, 374-380, 374, 375, 377-379,

Sainte-Chapelle, Paris, 420, 421 Sainte-Foy, church of, Conques, 370–374, 371– 373, 391, 461 saints: Christian, 268. See also relics Salisbury Cathedral, England, 426, 426-427 Samarra: Great Mosque, 321–322 Samothrace: Winged Nike (Winged Victory) from, 184, 184 samsara, 258 San Lorenzo, Veracruz, Mexico, 348; Olmec sculpture, 348, 348, 353 San Vitale, church of (Ravenna), 280-286, 280, 281, 282, 283, 284, 327, 337; methods of interpretation, 286 Sanchi, Madhya Pradesh, India: Great Stupa, 261-262, 261, 262 sanctuaries, 11-12, 160; Neolithic, 45 Sanskrit language, 258, 439 Santa Croce, Florence: Bardi Chapel frescoes, 462-463, 463; Triumph of Death (Orcagna), 470, 470 Santa Maria Antiqua, Rome: sarcophagus, 271-272.271 Santa Sabina, basilica of (Rome), 305, 306, 343 Sant'Apollinare Nuovo, church of (Ravenna), mosaic, 466-468, 466 Santiago de Compostela, 366, 368-369 Santorini, Greece, see Thera Sappho, 140 Sappho (fresco), see Young Woman with a Stylus Sapta Matrikas (Seven Mothers), 439 Saqqara, Egypt: King Zoser's pyramid, 90–91, 90; seated scribe (statue), 97, **97**, 353 Sarasvati, 439 sarcophagi: Early Christian, 271–272, **271**; Egyp-tian, 90; Etruscan, **197**, **198**; Roman, 236, **237** sarcophagus of Ramtha Visnai (Vulci), 198, 198 Sargon I, king of Akkad, 62, 63 Sargon II, king of Assyria, 70; Great Inscription, 72; palace, 70, 72 Sarnath, Uttar Pradesh: Preaching Buddha, 307-308, 307 Satan, 460 saturation, 22 Saul of Tarsus, see Paul, Saint Saussure, Ferdinand de. 17 Saxons, 342. See also Anglo-Saxons; Hiberno-Saxon art; Ottonian period Scandinavia, 328–332; myths, 330. See also Denmark; Norway; Sweden; Vikings scarabs, 88, 88 Schliemann, Heinrich, 5, 127 Scholasticism, 419-421 Scotland, 333 screen walls, 292 scribes: Egyptian, 97; medieval, 333 scriptoria, 333 scripts: cuneiform, 58, 58; hieroglyphic, 86-87; Islamic, 320; Minoan, 123. See also writing scriptures: Christian, 268 scrolls, 98; papyrus (*rotulus*), 294 Scrovegni, Enrico, 455, 461–462, **461** Scrovegni, Reginaldo, 455, 461 sculpture (generally), 2; materials, 2; metal, 62-63; mythical origin, 9; public, 11. See also architectural decorations; bronzes; equestrian portraits/ sculpture; relief sculpture; sculpture (in the round) sculpture (in the round): abstract, 5, 5; Aegean, 118; ancient Near Eastern, 56, 59–60, 63–65, 70; Buddhist, see Buddhist sculpture; Chinese, 3, 3, 206-208, 312-314; Egyptian, 94-97, 94-99, 103-104, 107, 150; Etruscan, 191-192, 194, 197; Greek, 3, 4, 6, 141, 150-159, 150-159, 160-179, 176, 180–185, 180–181; Hellenistic, 182–187, 183– 186; Hindu, 10-11; Indian, 260, 263-265, 307; Indus Valley, 256-257; Mesoamerican, 353, 356-**357**; Minoan, **122**; Neolithic, 3, 52, **52–53**, 88; Nubian, **113**; Olmec, **348**; Paleolithic, 29–31, **29–**

449–450; Surrealist, **15**

Scythian Animal Style, 74, 327

Scythians, 72, 74, 77, 233; Animal Style, 205; goldwork, 328, 329; stags, 74, 75, 76, 76, 327

31; Roman, 3, 236-242, 237-242, 238, 240-241,

seals: Indus Valley, 255, 256; Mesopotamian cylinder. 58 Seated Buddha (Gandhara), 264, 264 Seated Buddha (Mathura), 264-265, 265 Seated Jaguar (San Lorenzo), 348, 348, 353 seated scribe (statue, Saggara), 97, 97, 353 Seated statue of Khafre (Giza), 94, 94-95, 95, 99 Second Coming of Christ (Chartres), 406, 407 secondary colors, 21 Selene, 142 self-portraits, 2; Dürer, 2; van Gogh, 1-2, 1, 16; Post-Impressionist, 1 Semele 142 semiology, 16–17, 20 Semites, 62, 67, 250 Senenmut, 103, 104; statue, 104, **104** Senis, Symon di, see Martini, Simone Senuwy, Lady, of Assiut, Egypt, 98, 98 Septimius Severus, emperor of Rome, 211 Serapaeum (Alexandria), 216 Serapis, 83, 216 serekh, 85, 86, 86; from Palette of Narmer, 86, 86 serfdom, 365 seriation, 14 Sesostris I, pharaoh of Egypt, 99; portrait statues. 94, 99, 99 Sesostris III, pharaoh of Egypt, 99; portrait statue, 99.99 Seth, 83 Seven Deadly Sins, the, 457 Seven Liberal Arts, the, 406 Seven Wonders of the ancient world, 163 Severe style (Greek), 152 Severus Alexander, emperor of Rome, 211 shading, 21 shaft (of column), 79, 162 Shah Jahan, Mughal emperor of India, 3 Shakyamuni Buddha, 313 Shakyamuni Buddha Preaching on Vulture Peak (Dunhuang), 435, 435 shaman (Trois-Frères cave), 35, 36, 36 shamanism, 35, 203 Shamash (Utu), 55 Shang dynasty (China), 203-205 shapes, 20–21, 21; expressive qualities of, 20–21; types of, 21 shield ring (Meroë), 114, 115 Shilpa shastras (Hindu texts), 440 ship burials, 328 Ship Fresco (Thera), 124, 124, 125, 312-313 ships: Viking, 387-390, 388 Shiva: Temple of (Bhubaneshvar, Orissa), 443-444, 443 Shiva the Destroyer, 439 Shotoku, Prince, 437 shrines, see temples and shrines Shunga period, India, 261-263 sibyls, 227; Temple of the Sibyl (Tivoli), 227, 227 Sicily, 366 Siddhartha Gautama, Prince, see Buddha Siena, Italy, 464; Cathedral, 429, **429**, 430; Palazzo Pubblico, frescoes, 468-471, 468-469 silk paintings and embroidery: Chinese, 434-435 Silk Route, 254, 434; map, 255 silverwork: Byzantine, 302; Dacian, 233, 233; kneeling bull (Proto-Elamite sculpture), 74, 75, 75 Sin. 55 Sinan the Great (Koca, "the Architect"), 324 sinopie, 457 Sipán, Peru, 361; earspool (Tomb of the Warrior Priest), 361, 361 Siphnian Treasury (Delphi), 161, 161, 178 Sistine Chapel, Vatican: ceiling frescoes (Michelangelo), 227 skulls: Neolithic plastered, 3, 52, 52, 88 Sleeping Eros (Hellenistic sculpture), 185, 185 slip, 143 Sluter, Claus, 473-474; Chartreuse de Champmol, Dijon, sculptures, 473-474, 473-474 Snake Goddess (Knossos), 122, 122 Socrates, 137, 141, 180; bust (Lysippos), 141, 141, 180, 182 Sogne, Norway: Borgund stave church, 383, 383

Solomon, king of Israel, 319, 370. See also Temple of Solomon Solomon and the Queen of Sheba (stained-glass window, Canterbury), 422-425, 425 Sophokles, 140 South America, see Andean cultures south Asia, see India; Indus Valley civilization Soviet Union. see Russia space: architectural, 11-12; three-dimensional, illusion of, 454 spacers, 203 Spain: conquest of New World, 347; Moorish rule, 318, 366 Spain, ancient: cave paintings, 32-40; Greeks in, 189 spandrels, 234 Sparta, Greece, 140, 178 spectrum, visible, 21, 21 sphinxes: Giza, 93, 93; Greek, 161; of Tahargo (Nubia), 113, 113 spolia, 236 spouted jar (Crete), 123, 123 springing, 213 squares, 20 squinches, 291, **291** stadiums, 225 stained-glass windows, 15, 398, **398–399, 411, 417**, **421, 424–425** standing bison (painting, Altamira cave), 40, 40 Standing Buddha (Gandhara), 263-264, 263, 308 state portraits, see portraits stave churches: Borgund, Sogne, 383, 383 Stavelot abbey, Belgium, 368-369 Stavelot Bible, 376; Christ in Majesty, 376-377, 376 Stavelot Triptych, 366, 368-369, 368-369 Steichen, Edward, 5 Stein, Sir Aurel, 434 stelae: ancient Near Eastern, 63, 67; Carthaginian, 252: Greek, 159, 159: of Tikal, Guatemala, 350-351, 350. See also grave stelae; law code of Hammurabi; victory stele of Naram-Sin Stele of Hegeso, 159, **159**, 182 step pyramid of Zoser (Saqqara), 90–91, **90** Stephen, Saint, 408, 408 stereobate, 162 stigmata, 461, 463 Stigmatization of Saint Francis (Giotto), 462-463, 463 Still Life of Silver Objects (Pompeii), 246, 247 still-life painting, 11; Roman, 247 stone: meaning of, 46, 96 Stone Age: in western Europe, 28-40. See also Aboriginal rock art; Mesolithic era; Neolithic era; Paleolithic era stone carving: ancient Near Eastern, **55–56**, **64–65**, **69–72**; Egyptian, **85–87**; Mesoamerican, **348**, 351; northern European, 333 stone circles, see cromlechs; Stonehenge stone crosses, 333 stone interlace, 383 Stonehenge, England, 18, 47-50, 47-50; function of, 49-50 stratigraphy, 14 stringcourses, 390 structuralism, 16-17 stupas, 11, 261, 261-262, 307; model of, from Loriyan Tangai, 264, 264; Sanchi (Madhya Pradesh), 261 styles of art: terminology, 24-25 stylized art, 24 stylobate, 162 subject matter, 24 sublimation, 18 Suetonius, 212, 224 Suger, abbot of Saint-Denis, 394-396 Suleyman I ("the Great"), Sultan: illuminated tugra, 320, 320; mosque, Istanbul, 324, 324-325 Sumer, 59-61; language, 58; mythology, 58 sunken relief, 30 Supper at Emmaus (as subject), 269 supports, painting, 30 Surrealism, 17 Suryavarman II, Khmer king, 444. See also Angkor Wat

- Susa, Iran, 74; beaker, 74, 74; stele of Naram-Sin, 63-64, 63 Sutton Hoo purse cover, 327
- Sweden, 328; Viking rune stones, 331, 331 Switzerland: Saint Gall monastery, 340-341, 341
- symbols: prehistoric use of, 28-29
- symmetria, 158
- symmetry, 18
- Symon di Senis, see Martini, Simone

synagogue (Dura Europos), 266-267, 267 Syria, 366. See also synagogue

- Т
- tabernae, 214
- tablinium, 213
- Tahargo, sphinx of, 113, 113
- Taj Mahal, Agra, India, 3, 3, 19
- Taliban of Afghanistan, 6
- talud-tablero platforms, 350, 350
- Tang dynasty, China, 314 Tanit, 251–252, **252**
- Tantric sects, 439
- Taoism, see Daoism
- tapestries, 387; Norman, 388-389. See also textiles
- Tarquinia, Italy: Etruscan tomb paintings, 198, 199
- Teaching Christ trumeau (Chartres), 408-409, 409, 414
- Tell Asmar, 59-62; Abu Temple statues, 59, 59, 60, 256
- tempera painting: Etruscan, 190; Netherlandish, 8; Renaissance, 454
- temple of Amon-Mut-Khonsu (Luxor), 102, 102
- temple of Amon-Ra (Karnak), 100, 101
- temple of Apollo (Corinth), 160, **160**, 164
- temple of Apollo (Delphi), 138, 138, 139
- temple of Apollo (Veii), 190, **190**, 192 temple of Athena Nike (Acropolis, Athens), 169, 176, 177
- temple of Athena Parthenos, see Parthenon
- Temple of Fortuna Virilis, see Temple of Portunus temple of Hatshepsut (Deir el-Bahri), 103-104, 104
- Temple of Portunus (Rome), 226, 226
- Temple of Quetzalcoatl (Teotihuacán), 350, 350
- temple of Ramses II (Abu Simbel), 112, 112
- Temple of Solomon (Jerusalem), 366, 370, 400
- Temple of the Sibyl (Tivoli), 227, 227
- Temple of Vesta (Tivoli), see Temple of the Sibyl
- Temple of Vishnu (Deogarh), 441-442; Vishnu Temple, 441-442
- temple of Zeus (Olympia), 163-168, 164, 165, 166, 176; pediments, 164-166, 165, 166
- temples and shrines: ancient Near Eastern, 57, 66; Chinese, 312-314; Egyptian, 101-102, 104, 112, 160; Etruscan, 190, 226; Greek, 11, 138-139, 160-178, 160-162, 164-178, 226, 272; Hellenistic, 187; Hindu, 4, 12; Indian, 261-262, 306, 308-311, 441-443; Khmer (Cambodia), 444-448; Mesoamerican, 354-355; Mesopotamian, 54; Neolithic, **45–49**; Peruvian, **359**; Roman, 226–227, **226–229**, 272; round, 227. *See also* churches;
- mosques; synagogue Tenochtitlán, Mexico, 356–357
- tenons, 49, 49
- Teotihuacán, Mexico, 349-351, 349, 356; architecture, 349-350; relief sculpture, 350, 350
- tepidarium, 221
- terra-cotta: Etruscan, 190; Mesoamerican, 357; Minoan, 120; Qin warriors, 3, 16
- Terrace of the Lions (Delos), 150, 150
- tertiary colors, 21
- tesserae, 149, 275
- tetrarchy, 270 textiles: Chinese, **434–435**; Peruvian, **360**, **362**. See also tapestries
- texture in art, 23; fur, 14
- theaters: Greek, 179, **179**, 225; outdoor, 179; Ro-man, **223–224**, 458. *See also* drama
- Thebes, Egypt, 102; Nebamun hunting birds (painting), 105, **105**, 106; Nubians bringing offerings to Egypt (fresco), 111, **111**
- thefts, art, 4
- Theodora, Empress, 284; Court of Theodora mosaic (Ravenna), 284, 285, 286

- Theodore, Saint, 408, 408
- Theodoric the Great, Ostrogoth king, 331
- Theodosius I, Emperor, 277
- *Theotokos, see* Mary, Virgin Thera (Santorini), 124–126; frescoes, 124, **124, 125**, 144, 312-313

triumphal arches, 4, 73, 233-237, 234, 235; in

Christian churches, 273; Roman, 234-236

Trojan War, 127, 128, 139, 140, 145, 174, 186, 210

trumeau, 372, 372, 377, 404; Teaching Christ

Tunc Crucifixerant XPI (Book of Kells), 206, 334-335, 335

Turkey, see Anatolia; Çatal Hüyük; Constantino-

Tutankhamon, pharaoh of Egypt, 108-109; coffin

tympanums, 372, 372, 373, 375, 376, 377, 381,

Unknown Barbarian (Parthian?) (Roman sculpture),

Uruk (Erech, Warka), Irag, 55-58; cone mosaics,

vase, 55, 55, 56; White Temple, 57, 57

Uttar Pradesh, India: Ashokan pillar, 260, 260

Vairochana Buddha, Longmen Caves (Hunan), 314,

value scale, 22; black and white, 22; color, 23

van Gogh, Vincent, see Gogh, Vincent van

ers, Sculptors, and Architects, The, 16

Veii, Italy: temple of Apollo, 190, 190, 192

Venetian architecture: Gothic, 431

van Meegeren, Han, see Meegeren, Han van

Vapheio, near Sparta, 132; gold cups, 132, 132

Vasari, Giorgio, 7; Lives of the Most Excellent Paint-

vases: ancient Near Eastern, 55, 74; Greek, 143-

Vatican, Rome, Italy: Saint Peter's Basilica, 272,

vaults: Gothic, 396, 426-428; Roman, 213, 213,

Velázquez, Diego: Venus with a Mirror (Rokeby Ve-

148; Greek, shapes, 145; Minoan, 123; Nubian,

54, 54; female head (sculpture), 56, 56, 60, 126;

Nubian tribute to (wall painting), 111, 111

of, 108, 109; mask of, 108, 108; presentation of

Tuc d'Audoubert: bison (cave sculpture), 31, 31

Trois-Frères cave (Ariège), 35, 36, 36

(Chartres), 408-409, 409, 414

tugra of Sultan Suleyman, 320, 320

Tunisia, see Carthage; Phoenicians

tunnel vaults, see barrel vaults

typology, 268; Christian, 272

Tyrrhenians (Etruscans), 189

Ur, 60; Nanna ziggurat, 66, 66

urns, cinerary, see cinerary urns

Ur-Nammu, ruler of Ur, 66

ūrnā ("whorl of hair"), 264

ushnīsha ("topknot"), 264

Utrecht Psalter, 340, 340

Vairochana Buddha, 313, 314

Valerian III, emperor of Rome, 277

Valley of the Kings (Egypt), 108

van Eyck, Jan, see Eyck, Jan van

varnas, see caste system

110. See also pottery

279; Romanesque, 372

Vedic religion, 263, 312

vedikās, 262, 440

272, 273; Sistine Chapel, 227

Utu (Shamash), 55

Vakataka dynasty, 309

Valkyries, 330, 331

value (color), 22

Vanir, 330

Vedas, 258

vehicle, 30

nus), 6

vellum, 294

underpainting, 18 UNESCO Convention, 6

ple; Hattusas; Troy

Triumvirate, First, 217

trompe-l'oeil, 6-7, 148

Trojan horse, 186

Troy, 5, 127

tufa, 190, 212

tumuli, 195

404, 405

242, 242

Utgard, 330

V

314

Upanishads, 258

Tyr, 330

U

- tholoi, Mycenaean, 130, 130, 227
- Thomas à Becket, 424
- Thomas Aquinas, Saint, 420; Summa theologiae, 420
- Thomas de Cormont, 413, 421
- Thor, 330
- throne of Maximian (Ravenna), 287, 287
- thrones: Byzantine, 287
- Thucydides, 140 Thutmose I, pharaoh of Egypt, 104
- Thutmose II, pharaoh of Egypt, 103
- Thutmose III, pharaoh of Egypt, 103, 104
- Tiantai Law, 435
- Tiberius, emperor of Rome, 211, 266 Tiglath-Pileser I, king of Assyria, 69
- Tigris River, 54
- Tikal, Guatemala, 350; stele, 350-351, 350; Temple I,
 - 354, 354
- Timgad, Algeria, 214, 215, 233, 237
- Titans and Olympians myth, 174, 186
- Titicaca, Lake, 362
- Titus, emperor of Rome, 211, 223, 234, 235; Arch of, 234–235, **234**
- Tivoli, Italy: Hadrian's Villa, 214-217, 216, 217;
- Temple of the Sibyl, 227, 227
- Tiwanaku culture, 362–363; architecture, 362, 362 Tjangvide, Sweden: Warrior Entering Valhalla, 331, 331
- Tlaloc, 350-351
- tomb of Amanishakheto (Meroë), 114-115, 115
- tomb of Emperor Qin (Lintong, China), 206-207
- Tomb of the Augurs (Tarquinia), 198, 199
- Tomb of the Leopards (Tarquinia), 198, 199
- Tomb of the Shields and the Chairs (Cerveteri), 195–196, **195**, **196**, 198
- tombs and burials, 4; Carthaginian, 251–252;
 Early Christian, 279; Egyptian, 98; Etruscan, 189–190, 195–199; Greek, 182; Mycenaean, 130, 130-131; Paleolithic, 28; Roman, 270. See also catacombs; coffins; mausolea; mummies and mummification; pyramids; sarcophagi
- tondos, 245
- toraņa, 262, 262

traceries, 230

transepts, 273

293, 293

travertine, 212

triforium, 410

triglyphs, 163

triptychs, 455

trilithon, 48, 49

130

Trajan's Forum, 218

transverse ribs, 372

Tree of Life (Maya), 352

trilobed architecture, 45

- Toreador Fresco (Knossos), 120, 121, 132
- totems, 42
- Tours (Poitiers), Battle of, 327, 336, 368 Tower of Babel, 7–8, 73

town hall (Louvain, Belgium), 432, 432

town planning, see city planning

Transfiguration (as subject), 269

Transitional style (Greek), 152–153

treasuries (of Greek temples), 161

brothers), 474-475, 475-476

tribal art, see Native Americans

tree-ring dating, see dendrochronology

tribhanga ("three bends posture"), 263

Triumph of Death (Orcagna), 470, 470

Tower of Babel, The (Bruegel), 8, 8, 15, 400

Trajan, emperor of Rome, 211, 214, 218, 233, 235,

231, 232, 237, 260, 296; markets of, 220, 220

Transfiguration mosaic (Saint Catherine's, Sinai),

Treasury of Atreus (Mycenae), 128, 129, 130-131,

Trés Riches Heures du Duc de Berry (Limbourg

237-238; bust, 237-238, 237; Column of, 231-232,

Venice, Italy, 366, 449; Doges' Palace, 431, 431 Venus, 7, 142; Aphrodite of Knidos (Praxiteles), 180, 180, 185; Aphrodite of Melos (Venus de Milo), 184-185, 184

Venus of Laussel (Dordogne), 30, 30

Venus of Willendorf (Austria), 29-30, 29, 118

Venus with a Mirror (Rokeby Venus) (Velázquez), 6 Veracruz, Mexico, see San Lorenzo

verandas, 305

Vermeer, Jan, 5

Versailles, palace of (Le Brun, Le Vau, Hardouin-Mansart), 3

Vespasian, emperor of Rome, 211, 223, 224, 235 Vesta, 142

Victoria (Roman goddess), 142

- victory stele of Naram-Sin (Susa), 63-64, 63
- Vienna Genesis, 294-296, 294, 295
- Vierge dorée, Amiens Cathedral, 414, 415, 473 Vigée-Lebrun, Élisabeth, 16
- vihāra, 305
- Vikings, 328-332, 342, 365; metalwork, 328, 329, 390; rune stones, 331-332; ships, 387-390, 388 Villa of the Mysteries, Pompeii, 243-244, 243, 244
- Villanovan period, 191, 194

Villard de Honnecourt: sketchbook, 401, 401

- villas: Roman, 214-215, 216-217, 243-244, 243, 244 vines (Christian symbol), 274
- Virgil, 210, 454; Aeneid, 251
- Virgin and Child Enthroned mosaic (Hosios Lou-
- kas), 299, 299 Virgin and Child Enthroned with Saints Felix and Augustus (Rome), 296, 296
- *Virgin in a Church, The* (Jan van Eyck), 12, **12**, 23 Virgin Mary, see Mary, Virgin
- Virgin Mary and Christ (Sluter), 473–474, **473** Virtues and Vices, Christian, 457
- Vishnu Sleeping on Ananta (Deogarh), 439, 442, 442
- Vishnu Temple, see Temple of Vishnu
- Vishnu the Preserver, 439
- Visigoths, 318
- Vision of Constantine, Stavelot Triptych, 368-369, 369

Visitation (as subject), 269

- visual arts, 2
- visual language, 7, 18–25
- Vitruvius, 190, 218; De architectura, 190
- Vivian Bible: Christ in Majesty, 339–340, 339
- Volur, the, 330
- volutes, 163

- voussoirs, 213, 226, 372, 372, 404 Vulcan, 142 Vulci, Italy: sarcophagus, 198, 198 W wall paintings, see murals Wandjinas (Cloud Spirits), 42, 42 war god: Hittite, 68, 69 Wari culture (Peru): textiles, 362-363, 362 Wari Kayan, Peru, 360 Warka, see Uruk Warrior by a Grave (Reed Painter), 148, 148 Warrior Entering Valhalla (Viking rune stone), 331, 331 Warrior from Riace (bronze), 156–157, 157 Washing of the Feet (as subject), 269 Wastrell, John, 428 "Water Nymph" (Angkor Wat), 446, **447** wattle-and-daub construction, 190 weaving, see textiles web (of ribbed vaults), 396 wedjat (eye of Horus), 88, 88 Weeks, Kent, 112 Well of Moses (Sluter), 474, 474 westwork, 341 wet drapery," 176 Wheel of the Law (Buddhism), 259, 261 Whistler, James Abbott McNeill, 7, 39; Arrangement in Black and Gray (Portrait of the Artist's Mother), 10, 10, 16, 17, 18 White, John: photomontage of Maestà (Duccio), 464-465 White Cloud, Head Chief of the Iowas, The (Catlin), 9 white-ground technique (Greek vase painting), 145, 148 White Temple (Uruk), 57, 57
- Whitney, Gertrude Vanderbilt, 5
- Wibald, abbot of Stavelot, 368
- Willendorf, Venus of, see Venus of Willendorf William I ("the Conqueror"), king of England (Duke William II of Normandy), 365-366, 387, 390
- William of Calais, bishop of Durham, 391
- William of Sens, 422
- William the Englishman, 422, 424
- windows: lancet, 398, 398, 410, 411; stained-glass. 15, 398, 398-399, 411, 417, 421, 424-425
- Winged Nike (Winged Victory) (from Samothrace), 184, 184

- witchcraft, 9
- wolf: symbol of Rome, 191
- Wölfflin, Heinrich, 14
- women: associations with architecture, 12; depiction of, 126; Etruscan, 193; feminism, 6, 16, 96; Greek 140
- women artists 16
- wood carving: Mesoamerican, 351; northern European, 329
- wood panels, 454
- Woolley, Sir Leonard, 60
- Wordsworth, William, 428
- World War II: art plunder in, 5-6
- Worship of the Buddha (Ajanta Cave), 310, 311
- Wounded Amazon (Polykleitos), 158-159, 159, 186 Wounded Chimera (Etruscan bronze), 191-192, 191 Wright, Joseph, of Derby: Corinthian Maid, The, 9,
- 9, 16
 - writing: ancient Near Eastern, 58, 67; Chinese, 204, 204; Egyptian, 86-87, 87; Greek, 136; Islamic, 320; Mesopotamian, 58; northern European, 331-332. See also scripts
 - Х

"X ray" style, 43 Xerxes, king of Persia, 77, 152 Xia dynasty (China), 202

Y

yaksha/yakshī, 263, 263, 307, 310 yogi: Indus Valley seal, 256, 256 voni, 439 Young Woman with a Stylus (Pompeii), 245–246, 245, 296

Yuan dynasty, China, 434 Yungang caves, China, 312, 434, 436

Yunshusu, China: pagoda, 436, 436

Ζ

- Zeus, 142; Altar of (Pergamon), 186, 187; coin, 163; Poseidon/Zeus, 155; temple of (Olympia), 163-168, 164, 165, 166, 176
- Zeuxis, 7, 148
- Zhou dynasty, China, 205
- ziggurats, 4, 15, 56-57, 70, 72; Ur, 66, 66
- Zoroaster, 77
- Zoser, king of Egypt, 90